HAROLD E. WETHEY

THE PAINTINGS OF TITIAN

III.–THE MYTHOLOGICAL AND HISTORICAL PAINTINGS

Titian's Escutcheon: Document of Knighthood. 1533.

Pieve di Cadore, Casa di Tiziano

Frontispiece:

Bacchus and Ariadne. Detail. 1520–1522.

London, National Gallery (Cat. no. 14)

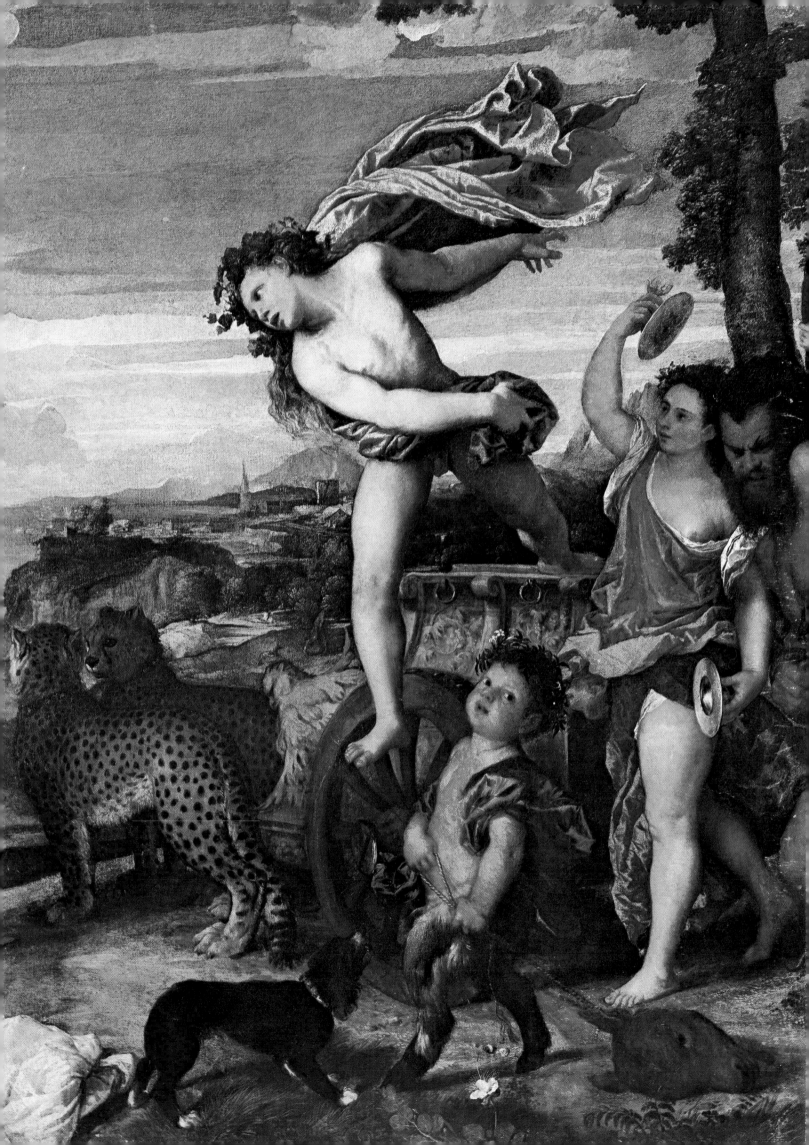

THE PAINTINGS OF
TITIAN

COMPLETE EDITION
BY HAROLD E · WETHEY

III · THE MYTHOLOGICAL AND
HISTORICAL PAINTINGS

PHAIDON

ISBN 0 7148 1425 3
MADE IN GREAT BRITAIN
PRINTED BY THE UNIVERSITY PRESS · ABERDEEN

CONTENTS

PREFACE

WITH Titian III, *The Mythological and Historical Paintings*, the project to publish an up-to-date and comprehensive catalogue of the great Venetian's work is completed. What started out as a two-volume study to be issued at one time had to be expanded as the vastness of the material became more and more evident. The actual writing of these volumes began in 1962. By 1966 it seemed clear that the only possible method was to prepare one volume at a time, a procedure for which considerable precedent exists in dealing with subjects of large dimensions.

The present volume is organized upon the same system as the first two, i.e., text and bibliography followed by three separate catalogues: the authentic works, school pieces and wrong attributions, and finally lost paintings. A few pictures of largely workshop character have been listed in the authentic catalogue as a matter of convenience. Placed after the catalogues are the Addenda to Volumes I and II, which primarily include material published subsequent to 1969 and 1971. Exacting connoisseurship, uninfluenced by pride of ownership, has been a major goal in this study of Titian. Collectors, museums, and dealers are understandably optimistic about their possessions, a fact that is often a decisive factor in some publications. The documentation of Titian's paintings is extraordinarily abundant. By means of letters written by him and his patrons, and the publications of close contemporaries and friends, such as Lodovico Dolce and Pietro Aretino and with less accuracy Giorgio Vasari, it is possible to establish the authenticity of many paintings. Crowe and Cavalcaselle in their great pioneer study of Titian completed nearly a hundred years ago (1877) made excellent use of the material then available. Since their time much new documentation has been discovered. Zarco del Valle's presentation of the Granvelle letters in 1888 and Voltelini's documents brought out in 1892, 1894, and 1898 are among those that appeared subsequent to Crowe and Cavalcaselle's monograph. The inventories of the Aldobrandini, Queen Christina, and the Odescalchi (unpublished), the sales of Charles I of England, and other archival records have added much valuable information. Of the greatest significance are the testaments and inventories of Charles V and Philip II, as well as the many still unpublished inventories of the Spanish royal collections. Two of them, the inventories of 1666 and 1686 were studied by Ives Bottineau as far back as 1956 and 1958. The same author's book *L'Art de cour dans l'Espagne de Philippe V* (Bordeaux, 1960) also contains essential material related to the Spanish collections. Pedro Beroqui as early as 1925–1927 called attention to the Spanish inventories in connection with the paintings by Titian now in the Prado Museum. Nevertheless, much of the documentation available since 1888 has been overlooked hitherto.

As with the previous volumes, the original paintings themselves have been studied on many separate occasions, nearly all of them for a last time in 1970–1973, with the exception of the *Flaying of Marsyas* at Kremsier which could not be visited. All available X-rays have been examined in the preparation of all three volumes. The few X-rays of Titian's paintings in the Prado Museum had previously been unknown to scholars, although they date from about 1930. Dr. Xavier de Salas, now director of the Prado, revealed their existence to me as he had recently done to Professor Harald Keller. My wish to have more taken materialized only in the case of *Tityus* and *Sisyphus* (Cat. no. 19) because of the lack

of equipment at the Prado. I am also indebted to Dr. Salas for his coöperation in obtaining new and excellent, large photographs of the pictures by Titian in Madrid.

My wife, Dr. Alice Sunderland Wethey, also an art historian, has assisted me constantly in the preparation of all three volumes. She has accompanied me during periods of research in Europe which add up to a total of four and one-half years. In this connection the extensive travel and research in Europe were made possible by several summer grants from the Rackham Foundation of the University of Michigan, by a grant from the American Council of Learned Societies in 1967–1968 and in 1971–1972 by a generous fellowship from the John Simon Guggenheim Foundation. These volumes could not have been written without my wife's constant collaboration. The clerical preparation of a manuscript of this length and complexity is in itself an onerous task. She has also engaged in research of a more professional nature in making herself an expert in heraldry in order to deal with the various coats-of-arms in Titian's paintings, and particularly for this volume to explain Titian's own escutcheon and titles, as well as the battle-flags. The section on Titian's Titles and Devices and the study of Titian's Painted Clocks are signed by her. She contributed the discussion of the escutcheons of Niccolò Aurelio and his Bagarotto wife, whose family device she discovered inside the silver bowl in *Sacred and Profane Love*.

I am indebted to a number of other scholars in the preparation of this volume, especially to Charles Hope of Oxford and Cambridge who generously agreed to undertake the lengthy task of reading the typescript. His knowledge of the documentary material on Titian in the Italian archives is without peer. Again Dr. Annie Cloulas and I engaged in correspondence on various problems, and Dr. Emma Mellencamp came to the rescue on puzzles ranging from costume to botany. Mrs. Enriqueta Harris Frankfort and Miss Jennifer Montagu of the Warburg Institute in London aided in the difficult search for photographs of prints. The staffs of the libraries of the Courtauld Institute in London, the Biblioteca Hertziana, and the American Academy in Rome made the complexities of research less arduous in the completion of all three volumes. In Venice my work was most graciously facilitated by Dr. Terisio Pignatti, director of the Museo Correr, and Dr. Francesco Valcanover, Soprintendente alle Gallerie, and the staff of the Biblioteca Marciana. Dr. Italo Faldi, director of the Galleria Nazionale of Rome, helped me in connection with the war-time history of the Naples *Danaë*, as did Dr. Rike Wankmüller of the Oberfinanzdirektion in Munich. Dr. Jaromir Neumann supplied excellent photographs of the *Flaying of Marsyas* at Kremsier, while both he and Dr. Eduard Safarik provided valuable data on the same picture. Dr. Erich Schleier was responsible for the taking of new X-rays of the *Venus and Cupid with an Organist* in Berlin-Dahlem. At the Zwinger Gallery in Dresden Dr. Angelo Walther gave me every facility to study the Titianesque paintings in storage, and he allowed me to examine several recent X-rays of the *Sleeping Venus* by Giorgione and Titian. In London at the National Gallery I was shown many courtesies by Sir Martin Davies and Cecil Gould.

Dr. Justus Müller Hofstede of Bonn University, the leading expert on the early work of Rubens, gave me the benefit of his knowledge, particularly regarding the controversial attribution to the Fleming of the portrait of *Alfonso d'Este* in the Metropolitan Museum in New York. Mrs. Fern Rush Shapley of the Kress Foundation at the National Gallery in Washington again provided an example in her profound knowledge of Italian painting and was a source of inspiration in both her scholarship and

her humanity. Several other scholars are thanked in connection with specific problems in the Catalogue and in the notes to the text. I am most grateful to all who have offered opinions and assistance over the past several years. Again I must thank Keith Roberts of the Phaidon Press for his understanding and enthusiasm, and Miss Helen Hall, former curator of the University of Michigan's Museum of Art, for her invaluable suggestions in the final reading of the page proofs.

On 27 August 1976 the four-hundredth anniversary of Titian's death will be commemorated. I should like to think of these three volumes on *The Paintings of Titian* as a modest tribute to the great Venetian master.

Ann Arbor, Michigan, 5 August 1974 HAROLD E. WETHEY

I. VENICE AT THE DAWN OF THE SIXTEENTH CENTURY

Titian, like other artists of his day, rarely knew a tranquil political existence; rather he saw Italy disrupted by the power struggle between the Spanish–Austrian Hapsburg Empire and the imperial ambitions of the French monarchy, in a situation compounded by the rapacity of the reigning popes.[1] Italy, of course, did not exist as a political entity, when the country was fragmented into several principalities of various dimensions. The Spanish Neapolitan holdings embraced the largest territory, virtually the whole southern half of the peninsula from l'Aquila across to Pescara and down to the foot of Italy with Sicily included as well. The ever-expanding papal states were centred in Rome, but the ambitious Alexander VI (1492–1503) tried to carve out an empire in the Romagna, and his successor, Julius II (1503–1513), sought to maintain it and to add the principality of Ferrara. Florence had its special troubles with and without the Medici. Milan, at first under the Sforza and subsequently the French until the Spanish victory at Pavia (1525), thereafter remained subjected to a series of Spanish governors.

Venice had joined the defensive league that drove the French king Charles VIII out of Italy after the victory of Fornovo in 1495, but the French were soon back under Louis XII in 1499, and the Republic on this occasion quickly shifted sides and entered into an alliance with him. The Venetians had extended their frontier to the River Adda just east of Milan, and the Veneto thus included Bergamo and Brescia to the west, Belluno and Cadore to the north, and stretched as far east as Udine and Aquileia. Other possessions were scattered along the Adriatic coast and throughout the Greek islands, which included Cyprus and Crete. Venetian territory on the mainland was so extensive at the beginning of the sixteenth century that it particularly alarmed Pope Julius II, who joined the League of Cambrai in a secret ratification in that north French town on 4 December 1508. Extraordinary indeed was this alliance of virtually all of the warring European states against Venice. Those usually implacable enemies, the king of France, Emperor Maximilian, Ferdinand, sovereign of Spain and Naples, and Pope Julius II, joined together in what was called a league of defence against Venice. Yet the sides continued to shift with somewhat dizzying rapidity. Julius II, who began the conflict by excommunicating Venice on 27 April 1509, was the first to make peace with the city. The lowest point of the war for the Venetians was reached with the disastrous defeat on 14 May 1509 at Agnadello, not far east of Milan, when 4000 soldiers were reported slain and Bartolomeo d'Alviano, the Venetian leader and hero of Cadore in 1508, was captured and taken to France as prisoner. Meantime the Emperor Maximilian entered the Veneto from the Tyrol and held Padua briefly in 1509 before his forces were expelled in mid-July. The pope, suddenly fearful of the French and imperial armies, reversed his position and lifted the interdict on Venice in February 1510. The Venetian government and its

1. Ludwig Pastor, *History of the Popes*, English edition, St. Louis, 1891–1953, 40 vols., provides an indispensable mine of information for the history of Italy. Pastor, VI (1902), devoted to Alexander VI (1492–1503) and Julius II (1503–1513), is particularly pertinent here. John Lynch, 1964, is recommended for the history of Spain in the sixteenth century.

ambassadors were geniuses at dividing their enemies.[2] The depredations of the French and German troops only served to encourage the cities of Brescia, Verona, and Padua in their desire to return to the rule of the Serenissima. However, the tangled web of Venetian history in the relations to the papacy, the principalities of Italy, the kingdom of France, and the Hapsburg Empire is not our main concern here. Suffice it to repeat that the political situation did not settle down to any extent until the defeat of Francis I at Pavia in 1525 by the troops of Charles V and the establishment of Spanish hegemony over the peninsula.[3] In consequence of this Duke Alfonso d'Este of Ferrara and his nephew Marquis Federico II Gonzaga of Mantua perforce became faithful supporters of the Spanish cause. The latter, raised to the rank of Duke by Charles V in 1530, entertained the Emperor lavishly at Mantua when he came to Italy to be crowned Holy Roman Emperor at Bologna that year, and again on his return for consultations with Clement VII in 1532–1533.[4]

The city of Venice in the first decade of the sixteenth century, with its population, large for that period, estimated at about 110,000,[5] enjoyed enviable prosperity, not because of its size, but because of its trade throughout the entire Mediterranean world. By its partisans Venice was declared to be the new Rome, meaning thereby the centre of the universe, a considerable hyperbole indeed, despite her economic superiority, her cultural achievements in the publications of the Aldine press, and the greatness of her art. Just then Giovanni Bellini had opened untrodden paths as a painter in developing the new luminism and richness of colour harmonies that characterize his late style in the *Transfiguration* in Naples, the *Religious Allegory* in Florence (Uffizi), and the *San Zaccaria altarpiece* (1505). They help to explain the indescribable beauty, in addition to the penetrating characterization, of his portrait of *Fra Teodoro of Urbino*, dated 1515 (London).[6] Most astonishing of all is the *Lady at Her Toilet* in Vienna (Plate 28), where the seventy-five-year-old master met the challenge of his pupils Giorgione and Titian (Plate 31) on their own ground. That Giovanni himself created the technical methods of the early sixteenth century is proven by the first two pictures mentioned, painted about 1490, and many others of the last decade of the century. In this period Giorgione spent some months or possibly two to three years in Giovanni's shop, but alas, he died young at the age of thirty-three in 1510, six years earlier than his venerable master.[7] The maturity of Giorgione is inextricably intertwined with the style of Titian's youth, and, although all historians agree on that point, the conclusions drawn therefrom differ widely.

Just previous to the great danger that threatened Venetian life and throughout that politically alarming period, her painters were immersed in poetic reverie. Giorgione began where Giovanni Bellini left off, even though his master outlived him. Their major differences lie in subject matter, and

2. The bibliography on Venetian history in the sixteenth century is vast: Marino Sanuto's *Diarii*, 1496–1533, published in Venice 1879–1903, 58 vols; Pietro Bembo's *Istoria veneziana*, covering the years 1487–1513, exists in several editions, 1551, collected works, 1729, etc. Hazlitt's *The Venetian Republic* (first edition, 1915) still serves as an invaluable reference, and a well-written brief account is the recent book by D. S. Chambers, 1970.

3. The sum of 80,000 ducats was the price that Venice was ordered to pay to Charles V for leaving her in freedom and relative tranquillity. Whether it was ever paid is uncertain, even though

Charles was in perpetual need of money. Venice escaped a disaster such as the sack of Rome (1527).

4. For Titian's portraits of Charles, painted in these years, see Wethey, II, 1971, pp. 18–20, Cat. nos. 20, L–3, L–4.

5. Hazlitt, edition 1966, II, p. 922.

6. As St. Dominic; for the inscription Davies, 1961, p. 61, no. 1440; Robertson, 1968, p. 153.

7. For Giorgione (1477–1510): Richter, 1937; the most recent and exhaustive study is Pignatti's, 1969.

in the enigmatic quality of Giorgione's imagination in such a painting as the *Tempest* (Plate 1), which has given rise to so many theories as to its meaning.[8] This is the poetic world of Jacopo Sannazaro's *Arcadia* (first printed at Venice in a pirated edition of 1502), where life is a dream of perfection. Marcantonio Michiel in 1530, when he saw the *Tempest* in the house of Gabriele Vendramin, described the painting as 'a small landscape on canvas with the tempest with the gypsy and soldier'.[9] Even this near-contemporary was indifferent to the exact meaning of the work, in which the elegantly dressed youth with staff cannot be a soldier but rather a romantic shepherd, whose association with the young woman nursing a baby can scarcely be regarded as coincidental.[10]

Titian first appeared on the Venetian scene when he worked on the frescoes of the Fondaco dei Tedeschi, already a young master of extraordinary accomplishment. According to his friend, Lodovico Dolce, writing in 1557: Titian, 'drawing and painting with Giorgione ..., became so skilful in art that ... he was allocated the façade over the *Merceria*, being then scarcely twenty years of age.' Giorgione's façade on the Grand Canal had been finished by 11 December 1508,[11] and if Dolce's words are historically precise, Titian began as Giorgione's assistant in working on the façade on the Grand Canal and then took over alone the façade on the *Merceria*. This passage has fundamental significance in understanding Titian's career, since he had been a pupil, as had Giorgione himself, of Giovanni Bellini. His training in Giovanni's workshop remains perceptible, yet Titian's early style is so similar to Giorgione's, even after the latter's death in 1510, that confusion as to attributions to the two artists has long existed and still continues unabated. Dolce's statement is also fundamental in that it implies Titian's birth about 1488–1490. He is, moreover, confirmed by Vasari, who visited Titian's workshop in 1566, at which time he gives the master's age as seventy-six.[12]

8. The interpretation advanced by the late Edgar Wind (1969) that the male figure symbolizes Fortitude and the young woman nursing the baby, Charity, is ingenious but contradictory to the poetic and romantic nature of the picture.

9. Michiel, edition by Frimmel, 1888, p. 106: 'El paesetto in tela cun la tempesta cun la cingana et soldato, fo de mano de Zorzi da Castelfranco.' The small picture, 0·83×0·73 m., is as stated on canvas. See Pignatti, 1969, p. 101, Cat. no. 13. The collector, Gabriele Vendramin, is the major figure in Titian's *Vendramin Family* in London (Wethey, II, 1971, Cat. no. 110, Frontispiece).

10. The fact that this youth is not a soldier is made all the clearer by comparison with the picture belonging to the Marquess of Northampton, where the man wears armour and carries a halberd and the young woman, now clothed, attends a small child (illustrated by Wind, 1969, pl. 10). In another similar picture, attributed to Palma il Vecchio in the Philadelphia Museum of Art, the man's costume is also military (*loc. cit.*, pl. 12).

In a lengthy and scholarly study of the *Tempest*, Nancy De Grummond (1972, pp. 5–48) arrives at the conclusion that the true subject of the picture is the 'Legend of St. Theodore'. She points out St. Theodore's significance as the patron saint of Venice, prior to the adoption of St. Mark, and she identifies the dome in the background as the Venetian church of S. Salvatore, rebuilt *c.* 1506, where the relics of the saint were deposited. The background might be Euchaita, also known as Theodoropolis, the site of Theodore's martyrdom. The mother and child are associated with St. Theodore's feat in slaying a dragon to whom a child was about to be given in tribute. She also proposes that the nude woman may be Theodore's own mother, whom according to another legend he saved from a dragon.

The main difficulty in accepting Mrs. De Grummond's arguments lies in the lack of any suggestion of a warrior saint giving battle to a dragon. The nude young woman nursing a baby does not easily fit the episodes in the legend of St. Theodore, and the virtually invisible dragon, placed in heraldic fashion over an archway in the background, is not adequate for the situation. The fact that St. Theodore was regarded as a protector against storms would be a convincing aspect, if the romantic figures and Arcadian setting were in any way suitable to this new interpretation.

11. Dolce, 1557, edition 1960, pp. 164, 201; edition Roskill, 1968, pp. 116, 186: 'Per questo Titiano lasciando quel goffo Gentile hebbe mezo de accostarsi a Giovanni Bellino: ma ne anco quella maniera compiutamente piacendogli, elesse Giorgio da Castelfranco. Disegnando adunque Titiano e dipingendo con Giorgione (che cosìera chiamato) venne in poco tempo così valente nell'arte, che dipingendo Giorgione la faccia del fondaco de' Tedeschi, che riguarda sopra il Canal Grande, fu allogata a Titiano, come dicemmo, quell' altra, che soprastà alla merceria, no havendo egli allora a pena venti anni.'

12. Vasari's *Vite* confused the issue by giving the birthdate of Titian as 1480 at the beginning of his biography in the edition of 1568, just two years after his visit to the Venetian's home in the Casa Grande. That year is obviously a printer's error for 1488 or 1489. The situation is complicated by the fact that Titian himself

After the death of Giorgione in October 1510, struck down by the plague at the age of thirty-three, it fell to the lot of the young Titian, aged about twenty-two, to complete certain of the deceased painter's unfinished works.[13] The most celebrated of these is the *Sleeping Venus* (Plates 6, 7, 9) in Dresden, which Marcantonio Michiel saw in Casa Marcello in 1525 and described as the 'Sleeping Venus with Cupid by Giorgione, in which the Cupid and landscape were finished by Titian'.[14] Very few scholars have seriously doubted that the painting in Dresden is the very work that Michiel saw,[15] now bereft of the Cupid, whose figure was painted over in 1843 because of its bad state of conservation. At the same time the toes of the right foot of Venus were eliminated (compare the *Venus of Urbino*, Plate 73) with the result that the long outline of the left leg is now unbroken. Giorgione in his *Sleeping Venus* established the theme of the recumbent female nude in Venetian painting, a theme which was to have repercussions throughout the history of art. The 'sleeping' Venus is also in a sense an invention of Giorgione's, although Dr. Meiss, in his brilliant article called 'Sleep in Venice', has pointed out anticipations of the idea in ancient art and also in slightly earlier Renaissance painting.[16] The belief that Giorgione was to any extent inspired by the woodcut of a sleeping nymph in Francesco Colonna's *Hypnerotomachia Poliphili* (1499) appears to me a little far-fetched.[17] Surely the so-called *Sleeping Ariadne* (Figure 23), of which there are several antique and Renaissance versions,[18] played a major part in the whole concept of the sleeping goddess, however different in composition.

It is in a sense a pity to belabour a work of such extraordinary beauty as Giorgione's. The essential sensuality of the theme is muted by the remoteness of the figure. The long, flowing lines of the naturally studied human body contribute to idealization through simplification of form to a degree that Titian himself never sought to achieve. Even though the younger master followed Giorgione's

wrote to Philip II of Spain on 1 August 1571 requesting payment for pictures for which he claimed to have received no remuneration for eighteen years. He pretended to be in want for lack of money and concluded with the statement that he was ninety-five years old (C. and C., 1877, II, p. 538; Cloulas, 1967, p. 276). All of these claims are exaggerated. In Titian's defence it must be remembered that Philip II did not reward the artist adequately for numerous masterpieces, both religious works for the Escorial and mythological subjects to adorn the royal palaces.

All of the evidence on the controversial matter of Titian's birthdate was assembled in Wethey, I, 1969, pp. 40–42, and briefly summarized in Wethey, II, 1971, p. 1, note 1. The highest figure for his age is that given in the death record ('Libro Mortuorum', folio 125) of Titian's parish church of San Canciano, where he is said to have died at the age of 103 on 27 August 1576. Most recent scholars are in agreement as to the artist's death at about eighty-six (see Dolce-Roskill, 1968, pp. 320–322; Pignatti, 1969, p. 14; Pallucchini, 1969, I, pp. 1–3). In that period people frequently did not know exactly when they were born. Baptismal records in parish churches never lie, but those of Titian's native Pieve di Cadore have been destroyed, probably during the Battle of Cadore in 1508 (see Cat. no. L–3). For the matter of old age in the Renaissance, see Gilbert, 1967, pp. 7–32.

The evidence that Titian died of a fever in his old age and not of the plague is supported by Fabbro using my argument that his burial in the Frari would not have been possible for a plague victim (Fabbro, 1973, pp. 1–6).

13. Document referring to his death in Richter, 1937, p. 304; Pignatti, 1969, p. 160.

14. 'La tela della Venere nuda, che dorme in un paese cun Cupidine, fo de mano de Zorzo da Castelfranco, ma lo paese et Cupidine forono finiti da Titiano.' Michiel-Frimmel, 1888, p. 88; Richter, 1937, p. 304; Pignatti, 1969, p. 160.

15. See Cat. no. 38, under 'The Controversy' for arguments against this identification.

16. Meiss, 1966, pp. 348–362. See figs. 33, 34, the Mantegnesque 'Allegory of Mantua', in which the sleeping nude anticipates Giorgione.

17. First proposed by Saxl, 1957, I, p. 162. Colonna, 1499, is unpaged; it occurs in chapter seven, which begins, 'Poliphilo narra'. The theory of some writers that the tree trunk in the centre of the landscape, just above Venus' hand, is a phallic symbol does not seem compatible with the art of Giorgione or Titian. A similar detail appears at the left side of the *Adoration of the Shepherds* in Vienna, by a follower of Giorgione (Pignatti, 1969, pl. 152; Wethey, I, 1969, Cat. no. X–1).

18. The example illustrated here was acquired by Julius II in 1512 and thought to represent Cleopatra (Mauro, 1562, p. 117). See Meiss, 1966, p. 351; Amelung, 1908, II, pp. 636–643, no. 414. Bieber (1967, pp. 112–113, 145) classifies the type as originating in the Hellenistic school of Pergamon, and she follows the traditional identification of the nymph as Ariadne. Otto Kurz (1953, p. 174) appears to hold the same opinion. See also note 206.

composition in the *Venus of Urbino* (Plates 72, 73), the fact that the latter is shown awake modifies the psychological aspect of the situation, as does the specific setting in a palace interior. A very beautiful drawing, attributed to Giorgione at Darmstadt (Plate 8), illustrates how the greater naturalism in the structure of the body can shift the mood.[19] In both cases the figure sleeps, but here the accents in the rendering of the anatomy are more incisive and thus far less generalized.

The distinction among textures, the flesh, the white sheet, and the deep-red velvet pillow that supports Venus' shoulders (Plate 9) all add to the magical effect produced by the Dresden *Venus*. The hillock at the left provides a foil to the head of the sleeping goddess, whose majestic form seems to flow across the landscape. The elements contributed by Titian are clearly in the setting, as Marcantonio Michiel specified. Indeed the buildings at the right are virtually identical with those in the background (Plates 5, 6) of Titian's *Noli Me Tangere* in the National Gallery at London:[20] the same farm-house with central round-arched entrance and the same barn with long pitched roof covered with thatch. These are the Alpine buildings that Titian knew so well in the region of his native Cadore, but the blue peaks of the mountains do not appear in the distance as they do in later works. The relatively low-lying landscape, devoid of animal or human life, here suitably reinforces the quiescent mood of the entire picture. The loss of the Cupid seated at the goddess' feet is irremediable, and one cannot even be certain that the little figure held a bird in his left hand as well as an arrow in his right.[21] However, the great beauty of the Dresden *Venus* is unforgettable despite numerous losses of paint and much restoration. It remains to a considerable degree the undisputed masterpiece of the female nude in the entire history of Renaissance painting.

Fondaco dei Tedeschi

GIORGIONE and Titian here on the Exchange for German merchants (Fondaco dei Tedeschi) painted in fresco, that most fragile of media for the exterior of a building in any climate. The original authorization for the rebuilding of the Fondaco specified that no sculpture and no marble of any kind could be used on the edifice. Nevertheless, the Venetian senate relented to the extent that they allowed a marble plaque of the lion of St. Mark to be placed over the marble portal on the southern façade and also on each of the two small towers facing the canal. Over the portal was inscribed the name of the Doge Lorenzo Loredan as follows: PRINCIPATUS LEONARDI LOREDANI INCLIJTI DUCIS. ANNO SEXTO.[22] At Venice, lying in the sea, fresco in the open air was soon dimmed beyond repair. Even in 1541–1542, when Vasari saw Giorgione's and Titian's paintings, they must have been already somewhat deteriorated, just a few years after their execution in 1508. That may in small part account for the Florentine's rather contemptuous attitude toward these great works in his first edition of the *Vite*. He speaks only of 'heads and pieces of figures very well done and vividly coloured'.[23] Lodovico Dolce,

19. Red chalk on paper, 140×190 mm.; Tietze and Tietze-Conrat, 1944, p. 173, no. 706, as Giorgione.
20. Wethey, I, 1969, Cat. no. 80.
21. See Cat. no. 38, under Condition.
22. See Cat. no. 18, History. The small towers were destroyed in the restorations of 1836 (Selvatico, 1847, p. 168). The inscription is recorded by Milesio, 1715, p. 30.
23. Vasari, *Le vite*, 1550, II, p. 577: 'teste e pezzi di figure, molto ben fatte, e colorite vivacissimamente.' Vasari does not mention Titian at all in connection with the Fondaco in the first edition.

a friend of Titian, writing in 1557 helps very little, although he does specify the important facts that Giorgione painted the façade on the Grand Canal and Titian the southern façade, which is on land and over the Merceria.[24] Here Dolce gives high praise to the *Judith* [the *Allegory of Justice*], which he describes as 'most wonderful in design and colour'. This section, which was placed high above the doorway on land, is well known from prints by Piccino in 1658 and Zanetti in 1760 and from the remains which were detached from the wall as recently as 1966–1967 (Figures 8–10).

For all the fame of Giorgione's west façade, very little is known about it. The print in Albrizzi's *Forestiero illuminato* (Figure 1), published in 1772, shows, although dimly, that a single full-length figure occupied the space between each pair of windows in the *piano nobile* and in the top storey. Decorative ornament is vaguely suggested in the lower part of the façade corresponding to the height of the arcade in the centre of the ground storey.[25] The standing *Female Nude*, now in the Accademia at Venice,[26] occupied a position between the top windows, just to the right of the long pilaster (Figure 2) that reaches to the ground storey at the left limit of the ground-level arcade.[27] Zanetti's etching (1760) of the same figure (Figure 4) provides the best record of the lovely female nude, whose ideal beauty clearly implies a study of the antique. Two other figures by Giorgione are known only in Zanetti's etchings, the *Seated Nude Girl* (Figure 5) and a *Seated Nude Male* (Figure 6), both of which maintain attitudes of *contrapposto* but have no attributes to suggest their meaning.[28] The bodies assume an angularity which even approaches awkwardness, and yet they have a high degree of charm.[29] The drawing of *Cupid with Bow* (Figure 7) in the Metropolitan Museum, attributed to Giorgione, recalls Vasari's vague reference to 'an angel in the guise of Cupid' in the second edition of his *Vite* (1568). Tietze-Conrat cautiously proposed that it might be a study for a detail of the frescoes of the Fondaco, an idea which seems reasonable. The drawing would at any event represent the style of such figures, even if the direct connection cannot be proved.[30]

Further hints of the main façade are supplied by Ridolfi in 1648, who writes of 'trophies, nude

In his second edition (1568)-Milanesi, IV, p. 91, he adds little save his own puzzlement that he does not understand the significance of the frescoes painted 'secondo la sua fantasia'. Tietze-Conrat (1958, pp. 245–248) tried to make out a case, which she admitted was 'daring', for interpreting Vasari's words to mean that Giorgione's frescoes represented fragments of antique sculpture. Nothing in other writers' descriptions or in the prints by Zanetti (Figures 4–16) supports such a theory, and she herself admitted that Vasari's statement that they were 'vividly coloured' offered a problem.

24. Dolce (1557), edition 1960, pp. 201–202. The *Merceria* contained a number of shops dealing in cloth, i.e. merceries. Sansovino (1561, folio 17v.) specifies the west façade as Giorgione's work.

25. Albrizzi's book, a guide to Venice, contains a number of line engravings of churches and major buildings. The first edition, Venice, 1772, p. 232, shows the Fondaco and suggestions of figures on Giorgione's façade on the Grand Canal. No indication of the frescoes on the corner of Titian's southern façade is given. In the second edition, 1796, p. 190, the plate is worn, with a resultant loss of details. The fenestration of the Fondaco in this print (Figure 1) is entirely different from that on the building as it exists today (Figure 2): two sets of paired windows are missing. Nevertheless, Marieschi's etching of *c.* 1750 shows the fenestration

essentially as it still remains, but includes in addition iron grilles over the windows, the original lily-shaped chimneys, and the turret on each angle of the main façade. He omitted windows on the southern façade, however. The turrets were destroyed as recently as the restorations of 1836. See Cat. no. 18, History. Therefore Albrizzi's print is inexact in the representation of the *piano nobile*, but even more so in the top storey, where he placed two small square windows instead of a full-length window with a small square one above. I believe that these discrepancies are to be explained by the carelessness of the print-maker and not by subsequent rebuildings.

26. Detached only in 1937: see Zanetti, 1760, fig. 3; Moschini-Marconi, 1962, pp. 125–126.

27. Illustrated by Foscari, 1936, figs. 10–11.

28. Zanetti, *Varie pitture a fresco*, Venice, 1760, figs. 1, 2.

29. These characteristics seem to me to identify the *Christ and the Adulteress* in Glasgow as by Giorgione (Wethey, I, 1969, Cat. no. X–4, Plate 204).

30. Vasari (1568)-Milanesi, IV, p. 91; Tietze-Conrat, 1940, p. 32; Tietze and Tietze-Conrat, 1944, p. 174, no. 712: red chalk, 158×63 mm.; Pignatti, 1969, p. 127, cat. no. A36, attributes the drawing to Titian.

figures, heads in chiaroscuro, and on the corners a geometrician who measures the ball of the world, perspectives of columns and between them men on horseback and other fantasies, where one sees how practiced he [Giorgione] was in managing colours in fresco'.[31] Zanetti interpreted the geometers as 'philosophers measuring the globe',[32] but that is virtually equivalent. The *Seated Nude Male* (Figure 6) is placed against a painted pier and a painted round column, raised slightly behind him, and thus gives a hint of the use of 'perspectives'. From this etching it is possible to suspect that Giorgione provided the forerunners of the columned portico in Titian's *Pesaro Madonna*.[33] Further literary evidence in the matter of the architectural settings of Giorgione's façade on the Grand Canal survives in Milesio's description of 1715. He writes of two architectural perspectives of Corinthian columns in the middle of the façade and coloured figures in niches.[34] Albrizzi's print (Figure 1) incorrectly shows a broader space in the centre of the west façade, by virtue of his omission of two sets of paired windows. However, the architectural perspectives in fresco probably gave the illusion of greater breadth than really existed. The men on horseback between columns in perspective, recorded by Ridolfi, must have been located here, if one combines the evidence of Milesio and Ridolfi. A drawing attributed to Pordenone, really a sketch after the frescoes on the façade of the Palazzo d'Anna (Figure 3), shows a rearing horse and a rider in armour with drawn sword.[35] Giorgione's work on the Fondaco may have been the inspiration for this detail, and in fact the whole drawing serves to give us some notion of the appearance of frescoed façades. None of the original façades of this sort survives intact, but drawings, prints, and descriptions help to reconstruct them in our minds. The 'heads' in chiaroscuro (Ridolfi) were probably intertwined in the arabesques of characteristic Renaissance classical ornament, a typical example of which is the marble revetment by Antonio Lombardo, originally in the d'Este castle at Ferrara and now in the Hermitage at Leningrad.[36] The fresco ornament on the Fondaco was painted, according to Vasari, by Morto da Feltre, who stopped for a time in Venice on his return from Florence, presumably en route for a visit to his native Feltre in the Alps, north of Venice.[37] It is not surprising that Giorgione had an assistant to carry out the ornament, and undoubtedly others laid in the architectural settings, for such were the workshop methods from the Middles Ages through the Renaissance and Baroque periods, with rare exceptions.

31. In the life of Giorgione, Ridolfi (1648)–Hadeln, I, p. 100: 'della facciata verso il Canale . . . nella quale divise trofei, corpi ignudi, teste a chiaro scuro; e ne'cantoni fece Geometri, che misurano la palla del Mondo, prospettive di colonne, e trà quelle, uomini a cavallo e altre fantasie dove si vede quanto egli fosse pratico nel maneggiar colori a fresco.'

32. Zanetti, 1771, p. 94.

33. See Wethey, I, 1969, Cat. no. 55, Plate 28. See also a discussion of this matter in the present volume, Addenda I, Cat. no. 55.

34. 'Quanto di maestoso e vago può far l'Architettura civile, tanto fu dimostrato con due lontananze di Colonnati Corinteii davanti le due Sale del primo appartamento e nel mezo di detta Facciata dell' Insigne Pennello di Giorgione da Castel Franco con ripartite e proporzionate vaghe figure colorate a nichi proprii . . .' (Milesio, 1715, p. 43).

35. Foscari, 1936, pp. 55–57, fig. 38, called attention to this drawing in relation to Giorgione's frescoes on the façade of the Fondaco. The drawing, in the Victoria and Albert Museum in London, is in sepia ink, 412×553 mm.; published by Hadeln, 1924, p. 149 (copy of Pordenone); Tietze and Tietze-Conrat, 1944, p. 238, Cat. no. A1332 (as a copy of Pordenone's mural on the Palazzo d'Anna, Venice).

36. Planiscig, 1921, p. 223. See further references to Antonio Lombardo on page 30.

37. Vasari (1568)–Milanesi, V, p. 204: 'Perchè venutogli a noia lo stare a Firenze si trasferì a Vinegia; e con Giorgione da Castelfranco ch'allora lavorava il Fondaco dei Tedeschi, si mise a aiutarlo facendo gli ornamenti di quella opera.'

Lorenzo Luzzo, called Morto da Feltre (1470–1526) is a minor Venetian, to whom various Giorgionesque pictures have been incorrectly attributed. See Ridolfi (1648)–Hadeln, I, p. 106; L. Venturi, 1910, pp. 362–376, re-established his personality; Berenson, 1957, I, p. 120. The Casa Tauro at Feltre has single figures in fresco between windows on the façade, in which Morto da Feltre was clearly following the precedent of Giorgione (L. Venturi, *loc. cit.*, p. 373).

Titian was not one of these subordinates. It has often been thought that he worked after Giorgione's designs in his frescoes on the southern façade, which lay on the land side looking toward the mercers' shops. Using Dolce's assertion that Giorgione was jealous of Titian's success on the Fondaco, some recent writers have held that Titian's commission remained entirely independent of Giorgione here.[38] This cliché of jealousy among artists is so common that one wonders whether it should be taken seriously. Ridolfi related that Titian later was jealous of his pupil Tintoretto and that their friendship was thus ruptured, a story which is quite probably an invention of the Venetian historian.[39] Nearly all writers since the time of Crowe and Cavalcaselle have assumed that Giorgione was responsible for the design of all of the frescoes, including Titian's on the southern façade.[40] The styles of the two men are remarkably similar, to the extent that the entire career of the young Titian has been the subject of continuing controversy as to whether some of the early religious compositions and portraits are by him or by Giorgione.[41] It must be remembered that the payment to Giorgione on 11 December 1508 was for the painting on the façade ('la pictura facta sopra la faza') and that it does not include Titian's southern façade.[42] The conclusion is that Titian's work was not yet finished, but unluckily the document of payment to him is not preserved or is as yet undiscovered. We have a better idea of Titian's frescoes, however, because of somewhat more detailed descriptions by early writers. Two fragments (Figures 10, 11) were removed as recently as 1967, though in wretched condition, under layers of grime and painted over completely at the time of various restorations. The difficult process of first cleaning off the superimposed layers of paint and dirt and then of transferring the original parts to canvas was carried out by the Soprintendenza under Francesco Valcanover by the well-known technician Leonetto Tintori.[43] Over the central doorway of this façade is a lion of St. Mark in marble and above that the paired round-arched windows of the *piano nobile*. In the space over the pair of windows placed exactly above the doorway, Titian painted *Judith*, brandishing her sword in her right hand and her bare foot firmly planted on the severed head of Holofernes (Figures 8–10). A half-length soldier in armour and helmet looks up at her from our left. That the artist was interested in spatial projection can be deduced from the drawing of the block-like setting. Actually the fresco could barely be seen from the street because of its high location and the narrow passages at the pedestrians' disposal. The figure of *Judith* is surely an *Allegory of Justice* as Crowe and Cavalcaselle decided nearly a century ago.[44] On the same level but at the left was a frieze of *Putti and Fantastic Beasts* (Figure 11), the second

38. Calvesi, 1970, p. 192; Vasari's claim that a member of the Barbarigo family appointed Titian to work on the Fondaco may be explained by the fact that Bernardo Barbarigo was commissioner of the salt monopoly, which involved the Fondaco (C. and C., 1877, I, p. 94). Dolce writes: 'una Giudit mirabilissima ...come della miglior cosa...Onde Giorgione...stette alcune giorni in casa, come disperato.' (Dolce, 1557, edition 1960, pp. 201–202; edition 1968, p. 186; see also above, note 11).

39. Ridolfi (1648)–Hadeln, II, p. 13.

40. C. and C., 1877, I, p. 88; they pointed out the incongruity of personal animosity between the two artists, when one considers that Titian completed the deceased Giorgione's paintings (*loc. cit.*, pp. 94–95).

41. Giorgione–Titian problem, see Wethey, I, 1969, pp. 8–9, 169–170, 174; Wethey, II, 1971, pp. 8–14; and the present volume.

42. Pignatti, 1969, p. 61, has already remarked upon this fact.

43. Valcanover, 1967, pp. 266–268; described by C. and C., 1877, I, pp. 89–90.

44. Vasari naïvely thought that the armoured man was a German and suggested that the *Judith* represented Germania, presumably because the Fondaco was the German Merchants' Exchange. He also, in his life of Giorgione (vol. IV, pp. 95–97), attributed the 'Germania' to that artist. Writing chiefly from memory, he understandably made such errors. However, the evidence that Titian painted the frescoes on the southern façade is overwhelming. Minerbi (1936, pp. 170–177) is the one writer to argue that Vasari was right, and his entire article is based upon false premises.

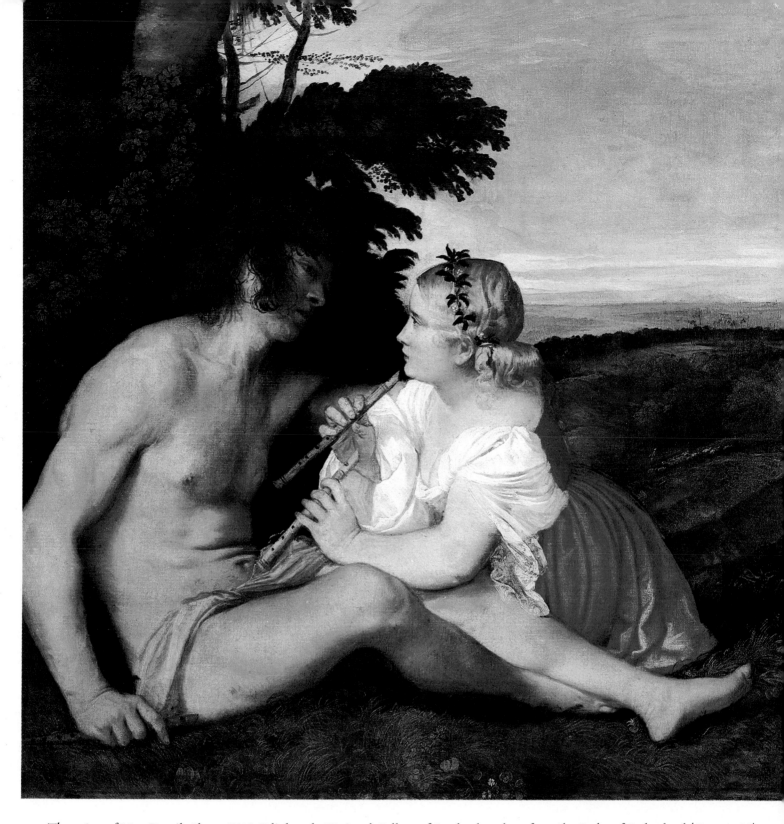

Three Ages of Man. Detail. About 1515. Edinburgh, National Gallery of Scotland, on loan from the Duke of Sutherland (Cat. no. 36)

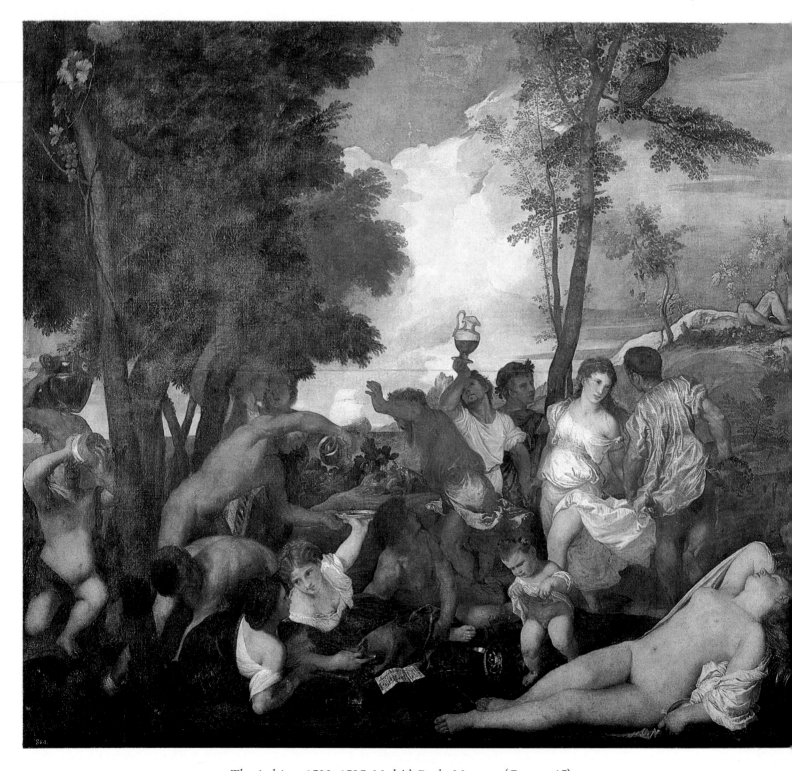

The Andrians. 1523–1525. Madrid, Prado Museum (Cat. no. 15)

fragment to be saved in recent years, and in a better state of preservation than one could hope for. This frieze was always in monochrome, according to the early writers. A nude woman, full length, usually identified as *Eve* (Figure 13), stood at the end of the south wall in the *piano nobile* at the far left toward the Rialto bridge.[45] Another frieze of 'animals and arabesques' ran along the wall over her head.[46] Two nude men (possibly large *putti*) occupied the space on the southern wall of the turret, one of whom according to Ridolfi held a cloth like a sail and the other a tablet inscribed with letters he could not read, surely an inscription with the name of Doge Lorenzo Loredan, similar to or identical with the one quoted above.[47] At the other end of the southern façade, in a corresponding position, were two clothed men, one called a 'Levantino' (a Levantine or Easterner) and the other a 'Compagno della Calza'. Here too was a nude female figure, which Milesio called a *Venus*. If the print by François Mole (Figure 14) is correctly associated with this fresco, it may have been an allegory of *Spring*.[48] Although the physical type corresponds to that of the Fondaco ladies, as seen through the eyes of a Frenchman *c.* 1700, proof that she belongs to Titian's series is wanting. The *Compagno della Calza* (Figure 16), removed very badly in 1937, is a mere shadow of the original. His red and white striped costume and red cloak have so darkened that the entire body is red–black today. He is not the same figure as the 'Compagno della Calza' so well known in Zanetti's print (Figure 15). The latter, too, wore red hose and a red cloak according to the eighteenth-century writer, but it is obvious that we have two different figures here.[49] The young noblemen of the Compagnie della Calza [famous societies of Venetian youths which flourished *c.* 1460–1560] continued to wear the costume of parti-coloured hose ('calza') even in the sixteenth century, when they took part in Carnival and state festivities and also in important weddings. They invited distinguished visitors such as Federico Gonzaga to join their ranks.[50] The youth known as the Levantine must be lost, since he would surely have worn the turban and long robe that always distinguish Easterners in Venetian Renaissance painting.[51]

In a surprising statement made in his *Diarii* on 12 November 1512, Marcantonio Michiel identified a figure of a man on the corner of the Fondaco toward San Bartolomeo as representing a well-known contrabandist named Zuan Favro, then in prison. Cicogna speculated that he might be the nude man

45. Boschini, 1664, p. 141; Milesio, 1715, p. 44.

46. In this area Edgar Wind (1969, pp. 12–14) arbitrarily placed the *Allegory of Peace* (Figure 17). Although his argument that *Peace* and *Justice* would logically be placed near each other is reasonable, the early descriptions leave no place for *Peace* here on the southern façade. Milesio writes: 'Sopra la detta Figura [*Eve*] corre un Fregio a chiaroscuro che cinge tutta la detta Facciata con animali. Rabeschi, ed altre varie fantasie.'

47. Boschini, 1664, p. 141; Milesio, 1715, pp. 30 and 44: 'nel muro della Toretta vi sono doi Uomini nudi ne' quali si vede pelle, carne, muscoli, et attitudine . . . alquanto danneggiati dal Tempo.' Ridolfi (1648)–Hadeln, pp. 154–155, added the other details. Salvatico (1847, pp. 166–168) laments the destruction of two of the best preserved figures when the towers were removed in 1836.

48. Milesio, 1715, p. 44: 'Nell' altro cantone, verso la Calle della Bissa vedesi una Venere nuda, un Levantino, et un Cavalier di quelli Giovini nobili Veneti antichi detti della Calza.' Brunetti (1941, p. 77) is the only writer who has hitherto associated the Mole print with the Fondaco dei Tedeschi.

49. Zanetti, 1760, p. VII. Paola della Pergola, 1955, p. 42, and

Pignatti, 1969, p. 150, cat. no. V–36, have called attention to the fact that two different figures are involved. Ridolfi (1648)–Hadeln, I, p. 15, casually refers to 'un Suizzero e un Levantino'.

50. See a contemporary account by Sansovino (1581)–Martinioni, 1663, pp. 406–407; Molmenti, 1910, I, pp. 257–260; C. and C., 1877, I, pp. 279–280. L. Venturi, 1908–1909, gives a detailed history of these organizations. He thought that Titian's youths may have been members of the 'Immortali', founded in 1507. Each organization was distinguished by the colours worn. Venturi drew heavily on the manuscripts in the Biblioteca Correr, Venice, i.e. Cod. Gradenigo Dolfin, no. 49, C. 46 and no. 155. Plate 3 of the latter reproduces from the Fondaco a figure in a red doublet, red and white sleeves, a brown cloak, the left leg in red and the right leg in white and yellow stripes. This manuscript was called to my attention by Miss Jennifer Fletcher.

51. See Gentile and Giovanni Bellini's *St. Mark Preaching in Alexandria* (Robertson, 1968, pl. CIX). Pignatti identified Figure 16 as the *Levantino*, but he now shares my opinion.

2

with one leg lifted who was still dimly visible in 1860 among Titian's frescoes on the third level.[52] The popular belief that some of the figures among these paintings were other contemporaries of the artist further increases the mystery of their meaning, which also puzzled Vasari.

With so little precise visual and literary evidence it is impossible to establish an iconographic scheme either for Giorgione's façade on the Grand Canal or for Titian's on the south. The print of the *Allegory of Peace* by Hendrik van der Borcht the Younger is reasonably accepted as based on a lost work by Giorgione. There is no support for the theory that it reflects a fresco formerly on the Fondaco. The only possibility would be that it held a position on the north façade over the Rio del Fontico. Here there were said to have been friezes in the middle, but in 1715 they had already been destroyed by the north winds.[53] In the case of the two beautiful fragments of women (Figure 12) etched by Zanetti in 1760 we have his word that he copied them from Titian's southern façade, and he implies that they were on the wall near the Rialto bridge in remarking that he would have liked to reproduce all of the figures in this section but that they were too badly destroyed. These beautiful figures, particularly the nude, reveal considerable maturity as an artist on Titian's part, and it has been remarked that they are stylistically rather close to the ladies in *Sacred and Profane Love* (Plate 20).[54] What a pity that the great masterpieces on the Fondaco dei Tedeschi by Giorgione and Titian are lost forever![55]

Pastoral Concert *(Fête Champêtre)*

THE problem of the authorship of the *Pastoral Concert* (Plates 2, 3) is one of the most vexed in the entire history of art. Italian scholars and their followers in recent years have tended more and more to assign the entire work to Titian in his earliest and most Giorgionesque phase. Traditionally, since the picture first appeared in Jabach's collection in the sixteen-fifties, it has been regarded as a typical Giorgione. The solution of the puzzle seems to me to have been reached by Madeleine Hours of the Louvre, based upon the study of the pigment and the X-rays taken in 1949.[56] The composition appears to have been laid out by Giorgione, but the picture was completed in the main by Titian. Of the figures only the seated nude girl (Plate 2), a plump young peasant of Arcady, has enough in common with the girl nursing the baby in Giorgione's *Tempest* (Plate 1) to justify the belief that she is Giorgione's creation. The standing nude woman (Plate 3) with her fulsome abdomen does not precisely meet one's

52. Cicogna, 1860, p. 389. This hitherto unnoticed remark of Michiel is significant because of the early date of 1512. It may be, nevertheless, pure legend. Zuan Favro's career is related by Sanuto (xv, columns 282, 283, 329, 331) from 28 October 1512 to November 13, 1512. He had been imprisoned, escaped to refuge in San Zaccaria, then turned himself in to the Council of Ten with a plea for pardon. The Council returned him to prison for six years.

53. Milesio, 1715, p. 45: 'In questa Facciata non si scorge quasi più ni meno il colorito, non che le figure e particolarmente in alto. Dal mezo in giù vedesi qualque Fregio, ma il Bello fatto dalla virtù del sudetto Giorgione è stato divorata dalla Tramontana.'
 Edgar Wind (1969, pp. 14–15, 39), in placing the *Allegory of Peace* on Titian's southern façade to the left of the *Allegory of Justice*, disregarded the frieze which occupied this space (Figure 11). The fact is that no place for it appears to have been available on

Titian's façade. Marieschi's print (Wind, 1969, fig. 56) shows a large blank wall in the left side of the top storey of the southern façade, but that is an error because all other sources show two windows here, just as they exist today. L. Justi (edition 1926, II, pp. 257–258) in his acceptance of van der Borcht's print as reproducing a fresco by Giorgione on the Fondaco dei Tedeschi, made no attempt to find a position for it.

54. See Cat. no. 33.

55. In 1715 the Fondaco contained a remarkable collection of pictures by major Venetian masters (Milesio, 1715, pp. 36–42). In the court the same writer describes three chiaroscuro friezes in fresco containing arabesques, heads of Roman Emperors, *putti*, and grotesque masks. Attributed to Giorgione, they have left no trace today (Milesio, 1715, p. 45).

56. See references in Cat. no. 29, under Condition.

conception of Titian's sense of ideal beauty, yet it is here that the X-rays appear to prove that Titian took great liberties with Giorgione's design. They show under the surface that originally the nude girl stood upright in a frontal position, more like the *Judith* in Leningrad and Giorgione's nude woman from the Fondaco dei Tedeschi (Figure 4).[57] The pigment now visible presents a totally new pose in a striking *contrapposto* with the legs crossed (they are not so underneath). The graceful movement of the body is emphasized by the long line of the left arm, engaged in pouring water from a large glass pitcher into a sarcophagus-like fountain. The fact that the head originally turned in the opposite direction to look at the group seated upon the earth conveyed a very different meaning. The young woman with the pitcher is indeed the most complete case of a hybrid Giorgione–Titian, for the head still retains features closely reminiscent of Giorgione's *Laura* in Vienna.[58] The most incontestably Titianesque figure is the richly garbed youth in rose velvet and grey-white hose, who plays the lute so professionally (Plate 2). His rose-coloured cap and his general elegance unmistakably recall Titian's portrait of a *Young Man in a Red Cap* (c. 1516) in the Frick Collection in New York.[59] On the other hand, the peasant youth with long shaggy hair and rustic costume, who purposefully contrasts with the young aristocrat at his side, strikes one as stylistically not unlike Giorgione's *Self Portrait as David* in Brunswick.[60] The frequently proposed likeness to the shaggy-haired youth in Titian's *Miracle of the Irascible Son* in the frescoes at Padua is less compelling.[61]

The landscape speaks most eloquently of all for Titian's predominance in this composition, which Giorgione must have begun. To start with a detail, the shepherd with his flock of sheep, in the right middle distance (Plate 3), is virtually a signature of the master from Cadore. A similar vignette appears in *Sacred and Profane Love* (1514), again at the right and in the distance (Plate 19).[62] Even slightly earlier the shepherd and his flocks in tiny form are discernible in the *Holy Family with a Shepherd in a Landscape* (c. 1510) in London.[63] Still more notable is the charming pastoralism of the herdsman either seated or driving his sheep and cattle, as in the *Madonna and Child with St. Catherine and a Rabbit* in Paris and the *Madonna and Child with St. Catherine and the Infant Baptist in a Landscape* in London, where considerably later, c. 1530, Titian retained the same charming motive. The *Landscape with Shepherd and Flocks* at Hampton Court is a virtual enlargement from one of these religious compositions, attributable to a close follower.[64]

Most significant, however, is the general composition of the landscape of the *Pastoral Concert* (Plate 3) in the way the spectator himself is brought into the setting by the handling of the tree at the left, in which the upper branches are cut off by the picture frame. A familiar and characteristic example of the same device is the setting of Titian's *Bacchus and Ariadne* (Plate 48). The strong, solid mass of branches and leaves fills the spaces in the right middle ground of the *Pastoral Concert*, and their rounded structure repeats the general shape of the group of three actors seated upon the ground. Through the

57. Photographs in Pignatti, 1969, pls. 12, 55, 56.

58. Verheyen, 1968, pp. 220–227, for an iconographic study of this portrait; also Pignatti, 1969, p. 99, cat. no. 10.

59. Wethey, II, 1971, Cat. no. 116, Plate 22.

60. Wethey, II, 1971, Plates 6, 7.

61. Pallucchini, 1969, p. 21; Morassi, 1964, pl. 1; and others; photograph, Wethey, I, 1969, Plate 142.

62. Also in the left distance of the *Noli Me Tangere* in London, Wethey, I, 1969, Plate 71.

63. *Loc. cit.*, Plate 8, Cat. no. 43. Giorgione introduced a few sheep in the background of the *Judgment of Solomon* in the Uffizi, but not with the same effect (Pignatti, 1969, pl. 31).

64. Wethey, I, 1969, Plates 34, 35; Wethey, III, Cat. no. X–19, Hampton Court.

centre and slightly to the left the eye is carried into the far distance, where two trees, thinly leaved and largely transparent, are seen in their full height, and thus they help to establish the spatial distance. A similar compositional purpose is fulfilled by the architectural structures at their right. Already developed in the *Pastoral Concert* are the landscape formulae of the Ferrara *Bacchanals* (Plates 39, 48, 57) and of the *Madonnas* of which we have just spoken, in fact of all Titian's landscape settings up to 1530 or thereabouts. Even a late *poesia* (1554) such as the *Venus and Adonis* (Plate 84) diverges little from Titian's early transmutation of landscape into an Arcadian setting of poetic conception and compositional purpose.

Giorgione's landscape, as best represented in the *Tempest* (Plate 1), is of a very different sort. Set at a distance from the spectator, the small figures and the trees are seen nearly in their full height in the middle ground. The clearly outlined tree trunks rise high, topped by a relatively small and solid structure of leaves. The horizontal foot-bridge over the stream and the walls of the city, which meander as they diminish into the distance, connect and unite the varied sections of the composition. Consistently Giorgione's landscapes are seen from above, as we note again in the *cassone* panels of the *Trial of Moses* and the *Judgment of Solomon* in the Uffizi,[65] where there recur the same thinly outlined trees with the masses of leaves only in the upper section. His formula for the architectonic structure of landscape is closer to Giovanni Bellini's in his later works, such as the *Religious Allegory* (c. 1490) in the Uffizi. Here, even earlier, Bellini had created the mood of reverie in the atmosphere of a late summer day, while the spectator remains at a distance. In Bellini's *Transfiguration* in Naples, the large figures dominate the setting, yet the warmth and beauty of the landscape, even though stark in individual details, are epoch-making in their effect upon Giorgione and the young Titian.[66]

The exact literary meaning of the *Pastoral Concert* (Plates 2, 3) remains the subject of much speculation. Writers agree only that it is an Arcadian theme based on the romantic belief that life in Arcady is one of perfect happiness, where the cares and sordidness of ordinary living do not exist. Here forever is a golden afternoon, in a setting of lush pastoral beauty, where poets such as Jacopo Sannazaro may sing, shepherds watch their flock, and 'naked' nymphs may be glimpsed rushing through the forest. Dolce states specifically that Titian alluded to Sannazaro in certain mythological pictures.[67] The *Idylls* of Theocritus and Vergil's *Eclogues* and *Georgics* are the ultimate sources.[68] Later in the fourteenth century Petrarch and Boccaccio revived this antique tradition of the beauty of pastoral life. Petrarch wrote: 'Here you will find . . . only happiness and simplicity and liberty and that desirable state that is a mean betwixt poverty and wealth, a sober humble and gentle country life. . . . As for the rest, you will find here soft air, gentle breezes, sunny spaces, clear streams, a river full of fish, shady woods, dark caves, grassy nooks, and smiling meadows; you will hear the lowing of cattle, the singing of birds, and the murmuring of waters; and here you will find a pleasant valley, hidden, as it were and called, from that circumstance, the Vale Enclosed.'[69]

65. Pignatti, 1969, pls. 25, 31; also lost works: Pignatti, figs. 45, 46.
66. Robertson, 1968, pls. LXXI, LXXXIII, and *passim*. More distant are the landscape settings of the late Madonnas (*loc. cit.*, *passim*).
67. Nash, *Sannazaro*, 1966, p. 43; Dolce in *Dialogo . . . dei colori* (1565), edition 1913, p. 92, says: 'o più tosto alludendo alla pittura che descrive il Sannazaro nella sua Arcadia.'
68. The *editio princeps* of Theocritus appeared in Venice, Aldus, 1495.
69. Petrarch, *Epistolae Familiares*, XVI, 6, translation by Wilkins, 1958, pp. 170–171.

The beauty of the landscape of the *Pastoral Concert* is one imagined by the poets. All of the elements of perfection are here, and in the right distance the inevitable shepherd tends his flocks.[70] The four figures are clearly divided into two pairs of lovers. The rustic shepherd with his unruly shock of hair and country dress is accompanied by his plump young mistress, who listens intently as she holds her recorder (or *flauto dolce*), unselfconscious about her nudity, and devoted to him alone. The richly garbed, aristocratic youth momentarily lifts his hand from the lute as he explains some poetic theme in the vein of Sannazaro[71] or Theocritus. At the left the elegant pose of the nude woman, an ideally studied arrangement of body in Renaissance *contrapposto*, with rose drapery, equally studied, about her legs, provides the greatest contrast to the seated peasant girl. The motivation for her action of pouring water from the glass pitcher into the rectangular basin, a Renaissance fountain, is indeed puzzling.[72] Since the X-rays reveal that this pose and action were not the original intention but rather an erect standing position,[73] one wonders whether Titian did not arrive at this solution for purely aesthetic reasons of composition and design. At any event the standing girl is surely the companion of the aristocratic lutanist, for whom she, at the moment at least, shows not the slightest concern. It may be conjectured that the higher born youth's fortunes in love were less constant and secure than those of the peasant, whose plump mistress devotes her attention to him alone. Surely the contrast between the two couples provides an unmistakable symbol of fidelity in love among the lowly and a degree of inconstancy among the more sophisticated aristocracy. Gilbert Lawall in his study of Theocritus' *Pastorals* interprets the poems in pairs; for example, he sees Idylls I and II as a 'pastoral-urban' diptych.[74] This grouping does not exactly apply to the pairs of lovers in our picture, inasmuch as Idyll I, involving two men, is set in the Arcadian countryside, while Idyll II, devoted to city life, concerns the impassioned girl Simaetha and the deceitful Delphis, who soon deserts her.

The nudity of the two young women in contrast to the fully clothed youths has been the source of puzzlement to most critics. First it should be observed that their nudity is relatively modest, in that the seated girl has her back turned and the standing woman holds her left arm in a way so as to conceal her breasts, similarly to a *Venus Pudica*, while the drapery partially covers her legs. The extensive use of nude figures both male and female is so widespread in the Renaissance that it became a convention,

70. Titian's particular fondness for this theme has just been discussed above.

71. Sannazaro's *Arcadia*, in the main written in the fourteen-eighties, received the compliment of a pirated edition in Venice in 1502 and an apparently authorized publication under the direction of Pietro Summonte at Naples in 1504. For an English translation see Ralph Nash's version of Sannazaro, *Arcadia and Piscatorial Eclogues*, Detroit, Wayne State University, 1966.

 Pietro Bembo (1470–1547), the Venetian poet, historian, and courtier, published his romantic work, *Gli Asolani*, at Venice, Aldus, 1505. He visited the court of Caterina Cornaro at Asolo in 1495 and appears to have begun almost immediately to write the idealized and imaginary account of life and love there. But this paradise is set in an aristocratic court, and therefore has little to do with the Giorgione–Titian *Pastoral Concert*. An English translation of Bembo's *Gli Asolani* by Rudolf B. Gottfried (Bloomington, Indiana University Press, 1954) is based upon the edition of 1553 by Scotto in Venice, which includes the several revisions made by Bembo himself before his death.

Bembo's appearance much later in life is preserved in Titian's portrait in the National Gallery in Washington, a ruinous picture in Naples, and in prints after Titian's lost portrait of Bembo in profile, *c.* 1547 (Wethey, II, 1971, Cat. nos. 15, 16, Plates 90, 254; also Cat. no. X–11, Plates 256, 257).

72. Calvesi (1970, p. 206) proposed that the pitcher of water makes the standing nude the allegory of *Temperance* and therefore implies 'l'amor temperato', which appears to suggest 'intellectual love'. Nevertheless, the normal allegory of *Temperance* pours water from a pitcher into a bowl of wine in clearly defined symbolism (Mâle, 1925, p. 321). In the *Pastoral Concert* the lady pours water into water. An antique relief (Richter, 1937, pl. LXVI) in the Museo Archeologico at Venice shows a woman pouring water with a similar gesture.

73. See Cat. no. 29, Condition.

74. Lawall, *Theocritus' Coan Pastorals*, Washington–Cambridge, 1967, pp. 14–33.

a sign, so to speak, that the event took place in antiquity. To be sure, the young men's early sixteenth-century costumes in the *Pastoral Concert* result in some incongruity. Nevertheless, nudity in art is unmistakable evidence of the passion for classical antiquity that prevailed throughout Italian art of the fifteenth and sixteenth centuries. On the sarcophagi, which were the main sources of Renaissance artists, the human body is, more often than not, shown in full nudity, and the same holds for statues, particularly of deities and later Emperors.[75]

To the modern eye the nude girls, provided only with accessory draperies, in the presence of fully clothed men, will undoubtedly always cause perplexity. It has been suggested that the ladies are invisible nymphs, and thus is explained not only their nudity but also the apparent unawareness of their presence on the part of the young men.[76] The convention of invisibility in Renaissance poetry and in fairy tales is common enough. Professor Fehl quotes and illustrates the incident in Ariosto's *Orlando Furioso* (1532) in which the nude Angelica makes herself invisible by placing in her mouth a magic ring given her by Ruggiero to escape the dragon.[77] Perhaps the best known case of invisibility in English literature is *A Midsummer-Night's Dream*, where Oberon and the fairies are unseen to others on the stage but perfectly visible to the audience, who must be informed of this situation by the dialogue. Although Professor Fehl's explanation of the *Pastoral Concert* is perfectly reasonable, the attitudes of the nude ladies do not suggest it. The country girl is too intently absorbed in the words and actions of the rustic youth, and the unmistakably different ranks of society of the two women appear to eliminate their classification merely as 'nymphs'. And whoever has heard of a short, fat 'nymph'? The same objections apply to Edgar Wind's theory that the lack of clothing indicates that the ladies are 'divine presences, superior spirits, from whose fountain the mortal musicians are nourished'.[78] Another very skilfully presented analysis of the *Pastoral Concert* is Professor Patricia Egan's.[79] She interprets the picture as the *Allegory of Poetry* based directly upon a 'Tarocchi' card[80] labelled 'Poesia', in which a clothed girl seated beside a fountain plays a recorder, while with her left hand she holds a silver vase in a position of pouring. In the *Pastoral Concert* the two attributes of the Tarocchi card, it will be noticed, are divided between the two women. Professor Egan is one of the few scholars to note and comment upon the 'social' contrast between the peasant couple and the handsomely dressed youth and his elegantly posed mistress. She interprets them as representing the higher and lower forms of poetry as elucidated in Aristotle's *Poetics*, which Aldus at Venice published in 1508.[81] The arguments are indeed persuasive, but they still leave unanswered the fact that these people are human beings, and that the three seated upon the ground do not appear to be allegorical in meaning.[82]

75. See Bober, *Drawings after the Antique by Amico Aspertini*, 1957.
76. Fehl, 1957, pp. 153–168.
77. Ariosto, *Orlando furioso* (1532), edition Papini, Florence, 1903, p. 117, Canto x, 108–109; Fehl, *loc. cit.*, p. 162.
78. Wind, 1968, p. 143, note.
79. Egan, 1959, pp. 303–313.
80. Tarochi was a Renaissance card game. The card illustrated by Egan, *loc. cit.*, p. 303, fig. 2, is Ferrarese *c.* 1465. Seznec (1953, pp. 137–143) explains the meaning of the game, which seems to have originated in the mid-fifteenth century.

81. Egan, *loc. cit.*, p. 306. She also refers the two buildings in the background to the same division, i.e. the rustic building of wood would correspond to the peasant youth and the broad façade with arcade to the aristocrat. Miss Egan interprets this façade as a palace, which she agrees is unknown in an actual building. To me it looks more like the façade of a Romanesque church with blind arcades and a rose window in the centre.
82. Dr. Winternitz, 1967, p. 50, also finds it difficult to associate the two couples of the *Pastoral Concert* with symbolism that would make the picture an *Allegory of Poetry*.

The *Pastoral Concert* has long been regarded as one of the most enchanting as well as among the most enigmatic works of the Italian Renaissance. The golden world and the Arcadian dream of the poet's imagination are nowhere fulfilled with a greater subtlety of expression and sheer beauty of vision. The only dissenters were Crowe and Cavalcaselle, and we suspect that it was primarily the former who, because of Victorian morality, was unfavourable to this painting. They admitted 'very great charm in the warmth and tinted colouring of the figures and landscape. . . . There is no conscious indelicacy, yet we stand on the verge of the lascivious.' They concluded that Giorgione 'would have treated it with more nobleness of sentiment without defects of form or neglect of nature's fineness' and they attributed the picture to an 'imitator of Sebastiano del Piombo'.[83] Subjectivity in criticism is universal, and moreover, the yardstick of morality which flourished in the nineteenth century has long passed out of favour.

An interesting drawing in the British Museum, which might be entitled *Arcadian Musicians* (Plate 4), is rather charming but at the same time decidedly puzzling. The fact that Lefèbre engraved it *c.* 1680 under Titian's name attests to its long-standing recognition.[84] At once it is obvious that the seated girl holding a recorder is directly copied from the painting of the *Pastoral Concert* (Plate 3), but drapery has been added over the legs and across the abdomen. The muscular youth plays an elaborately decorated viola da gamba, and the legs bare high above the knees as well as his sleeves rolled nearly to the shoulder tell us that he is a shepherd. His strange costume with a cloak seemingly knotted about his waist does not provide a solution so far as dating is concerned. The woodland setting with sleeping sheep and the distant mountains with a village and church tower below provide the pastoral Arcadian atmosphere of the Giorgionesque idyll in early Cinquecento Venice. Giorgione was a natural attribution, followed by Domenico Campagnola, and first and last Titian.[85] The Tietzes after much debate finally decided on Titian, but in two periods, the girl earlier and different in technique than the rest of the composition.[86] They thought it possible that the seated woman was copied from a lost drawing by Giorgione rather than after the picture in the Louvre. Moreover, there has always been the question whether the drawing is preparatory for or a copy after a painting. A weak picture of the same subject did once exist in the collection of Count Kaunitz in Vienna.[87] Its quality is so inferior that in a photograph it appears to be a copy after Lefèbre's print, a belief that is supported by the reversed composition in the painting like that of the print. The drawing in the British Museum is qualitatively far superior to the other versions of this curious derivation from the *Pastoral Concert*, yet the author remains elusive.

83. Crowe and Cavalcaselle, 1871, II, pp. 146–147.
84. Signed 'Lefèbre del. et sculp.', 'TITIANVS INV' and 'J. Van Campen Formis Venetys'. See Morassi, 1954, p. 184.
85. Richter, 1937, p. 233, no. 3, ascribed to D. Campagnola; Kurth, 1926–1927, pp. 288–293, as Domenico Campagnola; *idem*, 1937, p. 139, the same opinion; Pallucchini, 1969, I, p. 22 (Titian).
86. Tietze and Tietze-Conrat, 1944, p. 319, no. 1928. Pen and ink, 224×226 mm. A copy of this drawing, slightly wider, 217×317 mm., is in the National Museum at Warsaw, Poland. The drawing is weaker throughout and the shadows are rendered in wash, all of which suggests a seventeenth-century date (Mrozinska, 1958, pp. 26–27, as after Titian).

87. Photograph in the Witt Library of the Courtauld Institute, London, under Giorgione. Canvas, 0·42×0·50 m. (Kurth, 1926–1927, p. 289, illustrated). Count Kaunitz's large collection was auctioned at Munich in 1899. The subsequent location of the picture is unknown. The viola-da-gamba player, a drawing in the Morgan Library in New York, is a free copy after the figure in our drawing (Plate 4). The Tietzes (1944, pp. 120–121, cat. no. 403, size 188×84 mm.) placed it close to Paris Bordone, but evidence for an attribution is slight.

Cassone Panels

IN the limbo surrounding Titian and Giorgione lie several *cassone* panels: small paintings on wood. The *cassone* was a large chest, usually given as a precious wedding gift and destined for the trousseau of the bride.[88] Some panels are so tiny that they must have decorated a box for jewels or toilet articles, as in the case of those with the legend of *Leda and the Swan* in Padua. This erotic theme was undoubtedly regarded as a suitable aphrodisiac for a young bride. Very few scholars would attribute the essentially modest pieces to a great master,[89] although photographs flatter a work whose elements of style are clearly Giorgionesque. But who were these Giorgionesque painters? That is the great problem. We know that Titian as well as Giorgione in the first decade of the sixteenth century adopted a style in which small figures appear in a lush landscape, yet lesser men imitated them. The quality is about the same in the *Birth of Adonis* and the *Death of Polydorus*, also at Padua (Plate 10),[90] where the flat blue sky and rather sketchily painted figures have, nevertheless, considerable charm and animation. The compositions are loosely strung together in a narrative technique in which the landscape to a certain degree holds them together. Today the little figures arouse interest for their picturesque costumes and lively movements, rather than for their classical legends. They dance merrily about the tree in the *Birth of Adonis*, as the baby is removed from the tree trunk into which his mother, Myrrha, has just been transformed. Delightful details such as the rabbit, the buck and the hind fill the space just to the left. The rather grim story of the *Death of Polydorus* includes a fiery furnace in the centre background, but the scene does not otherwise reflect the violence of the murder on the right side of the panel. Here lies the decapitated Polydorus, and nearby a young man in striped hose and fluttering ribbons flourishes the halberd with which he has just severed Polydorus' head. A passion for antique lore, particularly Ovid's *Metamorphoses*, runs throughout these decorative works of the Renaissance.[91]

Among the best surviving Venetian *cassoni* are the *Orpheus and Eurydice* at Bergamo and the *Apollo and Daphne* at Venice. The former (Plate 11) is a mere wreck: the whole landscape has turned dark brown, either because of chemical changes or as a result of incompetent restorations during the past 450 years. Despite its ruinous state the originality of the artist's macabre interpretation remains. The sense of terror here evoked is unique, especially the Bosch-like gate of hell with its smoke and red flames at the upper right. The anguish of the grief-stricken Orpheus, who glances back, notwithstanding the warning not to do so, adds to the dramatic intensity, which is exceptional in Venetian mythological paintings of this period. At the left Eurydice sits rather complacently, as the strange-looking serpent bites her heel and thus causes her premature death, almost immediately after her wedding. In her second appearance, at the extreme right, Eurydice in white floats back into the shadows after Orpheus had turned to look at her, just as the story relates. It is altogether possible that Titian had read not only

88. Schubring, 1923, in his large work on the *cassoni*, includes all Italian schools of the fifteenth century, but relatively few of the Venetian school.
89. Cat. no. X–22 contains the opinions of the major scholars; illustrated by Berenson, 1957, pls. 665, 666; Pignatti, 1969, pp. 138, 139. The iconography is studied in the Catalogue. It

should be restated that the second scene includes a girl holding a baby and a well dressed youth holding a sprig of flowers, elements which are similar to those in Giorgione's *Tempest* (Plate 1).
90. Cat. no. X–2 includes a study of the complex iconography and diverse opinions as to authorship.
91. On this subject see Panofsky, 1969, p. 140, note 3.

Ovid's *Metamorphoses* but also Vergil's *Georgics*, because it is in Vergil that the sense of horror is created:

> 'Even the jaws of Taenarus, the lofty portals of Dis, he entered and the grove that is murky with black terror, and came to the dead, and the king of terrors, and the hearts that know not how to soften at human prayers.'[92]

Because of its dramatic content nearly all present-day writers give this panel to Titian. From a stylistic point of view the great rock, with its trees that grow aslant because of the winds, is very close to the rocky background of Titian's fresco of *St. Anthony and the Miracle of the Jealous Husband* in the Scuola del Santo at Padua.[93]

In the *Apollo and Daphne* at Venice (Plate 12), one of the most charming of the Giorgionesque *cassoni* panels, the composition is unusually lively because of the energetic movements of the chief figures. The landscape maintains a brown tone throughout, perhaps due to chemical changes, while the sky in its pale blue differs considerably from other panels, principally those in the Museo Civico at Padua (Plate 10). The attribution of the *Apollo and Daphne* has wandered until recent years, during which Pallucchini's proposal of Paris Bordone has had unusual success. Yet with his limited mentality that master is difficult to associate with a work of such charm. Nor could he have managed the figures in movement with such grace, achieved by their terpsichorean attitudes and fluttering draperies. The earlier attributions to Giorgione and Titian are more satisfactory, but here again any degree of certainty eludes us.[94] The familiar story is, on the other hand, clearly told.[95] Apollo at the left slays the great python, which seems to have been on a section of the panel now lost. In the principal scene at the right Daphne is transformed into a laurel tree as she thus escapes the hot-footed, love-inflamed Apollo. Cupid in the left centre distance is a reminder that he loosed the arrows, of which one made Apollo fall in love and the other caused Daphne to flee. Apollo in both cases wears rose and Daphne white, colours which may be associated with an impassioned state on the one hand and with purity on the other. The presence of the same episodes in the same order in Zoan Rossi's wood-cut illustration of Ovid's *Metamorphoses*, published in Venice in 1497, has reasonably been assumed to have been known to the painter of the *cassone* panel.[96]

Pastoralism and the Antique

BY 1515 Titian had come completely into his own, even when his subject-matter remained in the same Arcadian realm as the *Pastoral Concert* (Plates 2, 3) and other Giorgionesque works. Today no critic will doubt the authorship of the *Three Ages of Man* and of *Sacred and Profane Love* (Plates 13–20). The tranquillity of mood and serene beauty of the figures are distinctly Titian's. Although an allegory, the *Three Ages of Man* is primarily concerned with youth and the passionate nature of the young lovers. The girl's blonde beauty and calm restraint provide a foil to the man's dark colouring and latent energy.

92. Vergil, Loeb Library edition, 1930, Georgics IV, 467–470, translation by H. Rushton Fairclough.
93. Dated 1510–1511: Wethey, I, 1969, Cat. no. 95, Plate 141.
94. See Cat. no. X-4 for the variety of opinions. Another problem is the matter of dating. If by Paris Bordone, who was born in 1500, the panel would have to be dated as late as *c.* 1520.
95. Ovid, *Metamorphoses*, I, 452–567.
96. Justi, 1926, pp. 312, 321; Stechow, 1932, p. 25.

The attitude of his powerful body, his tousled hair, and the expression of his face project the fiery nature of youth in love. The girl, in a rose dress with white sleeves, gazes fondly into his eyes. Her crown of myrtle, the plant of Venus and 'symbol of everlasting love', points up the situation.[97] The man holds a recorder in his right hand resting upon the ground, a detail which many except the musicologist, Dr. Winternitz, have failed to observe.[98] The girl, with the fingers of both hands placed upon the keys of her two recorders, appears to pause after playing them, since the mouthpieces are directed toward her lips. It has been suggested that the recorders are 'symbols of amorous union, and the simultaneity of their sounds signifies the harmony of souls.[99]

Infancy, maturity, and old age, the Three Ages of Man, are symbolized by the two sleeping babies at the right, by the mature couple at the left, and by the old man in the right middle ground, who holds two skulls. The pair of infants will reach fulfillment as young lovers, but they too must die, as the two skulls held by Old Age remind us. The dead tree trunk, another symbol of death, is being supported by the blue-winged Cupid to prevent death from overtaking the sleeping babies. The ruined chapel with unmistakable Gothic windows is probably associated with the solace offered by the Church and the belief in life after death. Yet the emphasis in the picture lies in the devoted idealism and passion of young love. Much later in life, c. 1570, Titian introduced the concept of the Three Ages of Man as the three heads representing Youth, Maturity, and Old Age in the *Allegory of Prudence*, now in the National Gallery at London. This handsome work, also known as *Titian's Self Portrait with Orazio and Marco Vecellio*, represents an entirely different tradition of the tripartite division of life.[100] The early iconography of the *Three Ages of Man* is Titian's own creation. No exact prototype in the ancient world exists for this charming poetic evocation of the beauty of life when love is young, to be followed by the inevitability of death.[101] The bucolic nature of the theme and the belief in a Golden Age in antiquity do, however, lie at the root of the conception here, as they do in the poetry of Jacopo Sannazaro and Pietro Bembo. The riddle of the Sphinx has only the most tenuous relationship to Titian's romantic conception.[102] The compositional organization of the *Three Ages of Man* involves the placing of the main group at one side and a balance achieved by colour and light in the disposition of the other elements. The opening of a deep corridor of space, usually at one side of the picture, but in this case down through the centre, is a favourite scheme of both Giorgione and Titian, which passed into the repertory of the Venetian school. Here Titian owes very little to earlier artists except Giovanni Bellini and Giorgione, whose Arcadian landscape-settings are the direct forerunners of the *Three Ages of Man*. The sleeping infants in Mantegna's engraved *Bacchanal with the Wine Vat* did, however,

97. Panofsky, 1939, p. 161.

98. Winternitz, 1967, pp. 48–50.

99. *Loc. cit.*, p. 51; these two Renaissance recorders appear to be substitutes for the antique double flute or *aulos*. Panofsky (1969, pp. 94–96) held that the girl is offering a recorder to the youth that he might join in an amorous duet. This view is similar to Vasari's comment (1568-Milanesi, VII, p. 435) on a lost version (see Literary Reference no. 1): 'un pastore ignudo ed una forese chi gli porge certi flauti, perchè suoni con bellissimo paese.' The idea that the flutes are phallic symbols (Studdert-Kennedy, 1958, p. 51) is a product of the Freudian era, and, it seems to me, highly exaggerated.

100. See Wethey, II, 1971, Cat. no. 107.

101. In Pigler, 1956, II, pp. 475–476 Titian's *Three Ages of Man* heads the list as the first of this iconographic type.

102. This legend related that Oedipus guessed the answer to the riddle and the Sphinx then killed herself. The question was: 'What is four-footed, three-footed, and two-footed?' The answer: 'Man', i.e. Infancy, Old Age, and Maturity. The riddle was known to the Greek playwrights (See *Encyclopaedia Britannica*, 11th edition, 1910, XXV, p. 663).

provide a suggestion for the interwoven poses of the two babies, also asleep.[103] Over the prototype the master improved vastly in every respect, above all in the babies' utter charm and innocence, while the winged cherub is entirely new.

The Renaissance belief in the Golden Age of Antiquity explains why such pictures as the *Three Ages of Man* and *Sacred and Profane Love* were painted. So far as antique art itself is concerned, Titian early had some familiarity with it, but he absorbed this knowledge and created anew. The reliefs on the sarcophagus of the latter picture (Plate 17) are superior to the relatively coarse workmanship of most Roman sculpture. Titian's figures have a rhythm and grace all their own, and they are made of flesh and blood, just as are the exquisite reliefs on the pedestal of *St. Peter Enthroned, Adored by Alexander VI and Jacopo Pesaro*, another work of this period.[104] Here the subject matter relates to the island of Paphos and the cult of Aphrodite. The male torso in armour and a Praxitelean pose in another figure likewise afford proof that Titian had studied fragments of antique sculpture.[105] Such homage to Roman art is in no way surprising since North Italian and Venetian artists for a century had collected and made drawings after antique fragments. Jacopo Bellini, whose own paintings retain the flowing Gothic line of the late International Style, nevertheless in his Sketchbook recorded numerous antique reliefs and fragments that he had seen.[106] His son-in-law, Andrea Mantegna, the greatest lover of the antique among Italian masters of the Quattrocento, developed his style upon the models of ancient marbles,[107] a fact so well known that it need not be expanded upon here. The same holds for the formation of collections of antiquities by the great lady Isabella d'Este at Mantua and the princes of Italy in general.[108] Cardinal Domenico Grimani's gift of his collection, formed in Rome, did not arrive in Venice until fairly late in 1525,[109] so that it is not pertinent in relation to Titian's early works. Giovanni Bellini, in spite of his father's example and his close association with his brother-in-law Mantegna, showed little interest in basing his mature style upon the Roman past. His *Feast of the Gods* (Plate 46) is proof enough thereof[110] and his *Episode from the Life of Publius Cornelius Scipio* in Washington, a commission probably inherited after Mantegna's death, is so exceptional in his career that the attribution is frequently doubted.[111] Giorgione and Titian in general followed in the footsteps of Giovanni and developed their sense of colour and luminism from his example, and their homage to the antique took on a highly personal expression.

Venetian sculpture of the late Quattrocento and of the turn of the century had become more dedicated to the antique than Venetian painting. The case of Antonio Rizzo is similar to that of the painters in a work such as his celebrated *Eve* (c. 1480) in the Ducal Palace, where the pose is derived from the Venus Genetrix, but the structure of the body has very little to do with the generalization

103. Heinemann, 1928, p. 37.
104. About 1512. See Wethey, I, 1969, Cat. no. 132, Plates 144–146.
105. See also the Roman Emperor in the background of Titian's *Miracle of the Speaking Infant* in the frescoes of the Scuola del Santo at Padua, dated 1510–1511 (Wethey, I, 1969, pp. 128–129); Brendel, 1955, pp. 113–125.
106. Degenhart and Schmitt, 1972, pp. 139–168; also Jacopo Bellini's 'Sketchbook' published by Victor Golubew, 1912. One volume includes the date 1430.
107. Kristeller, 1901, gives the most complete account of the artist.
108. Isabella's collection: Inventory published by D'Arco, 1857, II,

p. 134; Verheyen, *The Paintings in the Studiolo of Isabella d'Este at Mantua*, New York, 1971.
109. See Wethey, I, 1969, p. 18. Sanuto records the death of Cardinal Grimani in Rome in 1523 and the exhibition of the marbles in the Ducal Palace at Venice two years later (Sanuto, XXXIV, column 387; XXXIX, columns 427–428).
110. See below, pages 33, 37, 143–145.
111. Robertson, 1968, pp. 132–133, questions the attribution; Shapley, 1968, p. 42, fig. 99 (Bellini and his studio after Mantegna's death in 1506).

of antique types. On the other hand, Tullio Lombardo and his brother Antonio Lombardo, both of them sons of Pietro Lombardo, devoted themselves without reservations to antique models as early as the last decade of the fifteenth century.[112] They had access to antique remains in North Italy, and it is not known whether they ever visited Rome.[113] The figure sculptures of the tomb of Andrea Vendramin (c. 1492–1495) in SS. Giovanni e Paolo at Venice by Tullio, assisted by his brother Antonio, display knowledge of Roman prototypes in the disposition of draperies, in the armour, and in the head types.[114] Particularly characteristic of Tullio are abundant masses of curly hair and heavy Roman noses. The signed *Adam* in the Metropolitan Museum of Art, which originally stood on the side of the Vendramin tomb, in its Antinöus-like head and softly idealized body comes perilously close to the vacuity of Antonio Canova.[115] Antonio's marble reliefs, dated 1508 (Figure 25), from the d'Este Castle at Ferrara have a decorative charm despite their calculated antiquarianism. In this same year Giorgione and Titian were at work upon the Fondaco dei Tedeschi, where their debt to the antique lay in the extensive use of the nude and in their personal sense of ideal beauty. A high degree of dependence on Roman models is perhaps more logical in sculpture than in painting, since the prototypes themselves were marbles. In his relief of the *Coronation of the Virgin* (c. 1500) in S. Giovanni Crisostomo at Venice, Tullio Lombardo adhered to strict isocephalism, Roman draperies and curly hair *all' antica*. The ultimate in Venetian Romanizing art is reached in the large marble reliefs of the life of St. Anthony of Padua in his burial chapel in the Chiesa del Santo at Padua. There, in Antonio Lombardo's *Miracle of the Speaking Infant* (1505), the women are all late Hellenistic or Roman Junos, powerful in physique, with classical profiles, wavy hair, and Augustan draperies. A few years later (1510–1511) Titian painted the same subject in the Scuola del Santo, just across the piazza. The isocephalism of the groups and the statue of a Roman Emperor in the background are the only concessions to antiquity in this scene, wherein contemporary Renaissance costume and the lively attitudes of the figures create a moving drama, as the baby miraculously speaks to defend his mother's honour.[116] Tullio Lombardo's two later reliefs (1525) in the Cappella del Santo[117] maintain his virtual 'Neo-classicism', for which no close parallel exists in contemporary Venetian painting.

We have already noted that the sarcophagus of *Sacred and Profane Love* (c. 1514) (Plate 17) is intended as an antique, yet the drawing and modelling are entirely in Titian's own personal style. The beautiful figure of the nude Venus (Plate 24), seated at the right, is justly one of the most admired of the Renaissance. She is a close relative of Giorgione's *Sleeping Venus* (Plate 9) and of the nudes on the Fondaco dei Tedeschi. In fact, it has even been proposed that the two ladies, preserved only in Zanetti's print (Figure 12), are merely repeated in the Borghese picture,[118] but their relationship and that of the

112. The major source for Venetian sculpture of the Renaissance is Planiscig, 1921. The dates of the Lombardi are as follows: Pietro (c. 1435–1515) and his sons, Antonio (c. 1458–1516) and Tullio (c. 1455–1532).

113. An interesting fact is the dependence on Leonardo's *Last Supper* (finished 1497) in S. Maria delle Grazie in Milan that Tullio revealed in his unfinished relief of the same subject in S. Maria dei Miracoli at Venice (illustrated by Planiscig, 1921, fig. 241).

114. The Vendramin tomb was being carved in 1493 according to the *Diarii* of Marino Sanuto states Planiscig, 1921, p. 238, but the

Diarii begin in 1496. Confirmed by Mosto, 1966, p. 249, without precise reference. An unpublished document by Sanuto must be the source.

115. Reproduced by Pope-Hennessy, 1958, pl. 141; also Seymour, 1966, pl. 143.

116. Wethey, I, 1969, Cat. no. 93, Plates 139, 140.

117. Planiscig, 1921, pp. 215–255 and summaries in Pope-Hennessy, 1958, and Seymour, 1966, for the work of Antonio and Tullio Lombardo.

118. Nordenfalk, 1952, pp. 101–108, made this suggestion.

two figures in *Sacred and Profane Love* (Plate 20) are not at all identical. So here again Titian's homage to the antique is made on his own terms. It is restricted to the sense of the physical beauty of the nude and to the thematic material. As for the iconography, the numerous theories have been recorded chronologically in the Catalogue in the order of their appearance. The ultimate solution is yet to be reached, although virtually no one doubts that the nude with the flaming lamp is Venus, generally thought to be the 'Celestial Venus' of Marsilio Ficino. The problem remains whether Titian really meant the reluctant lady in Renaissance dress to represent the 'Terrestrial Venus'. She wears gloves, which form no part of the iconography of Venus in any period. Gloves in Titian's portraits are usually associated with aristocratic rank.[119] Her single rose satin sleeve on her right arm is another unexplained element, which may have been introduced solely for balance of colour. Above all she appears to be unmoved by the appeals of the nude goddess. The open fields to the right (Plate 19) reveal a church tower, but also a pair of lovers in erotic embrace, a flock of sheep, and huntsmen. In the left background (Plate 18) the path is steep and obscure, and it culminates in an Alpine town with two great round towers of mediaeval aspect. We are reminded of the choice of Hercules between the flowery path of Pleasure and the harsh road of Virtue.[120]

The possibility arises that the clothed lady is Chastity, who resists the blandishments of Venus, a solution which was first advanced by Charles de Tolnay. The white costume may symbolize her purity, as in the Florentine picture of the *Battle Between Amor and Chastity* in the National Gallery at London, and the closed girdle is a well-known reference to Chastity.[121] Nonetheless, the enigma of *Sacred and Profane Love* still remains without a definitive solution.

119. Gloves are rare indeed in mythological and allegorical painting, a fact which implies that Titian placed them upon the hands of the clothed woman for a specific iconographical reason, still not elucidated.

Young aristocrats in Titian's portraits usually hold their gloves, as does Prince Philip when not shown in armour (see Wethey, II, 1971, Plates 20, 22, 29, 100, 113, 179, 180). Ecclesiastic donors wear them in the case of Jacopo Pesaro and Altobello Averoldo (*loc. cit.*, Plates 25–27). In Titian's *Laura dei Dianti* the Negro servant holds her gloves (*loc. cit.*, Plate 41), while in other portraits of women the hands are usually bare. Popes and other churchmen more often than not have no gloves.

120. The most famous example is Annibale Carracci's picture from the Palazzo Farnese at Rome, now in the gallery at Capodimonte, Naples. See Martin, 1965, pp. 44–47; Posner, 1971, p. 40, cat. no. 93; Panofsky, 1930, pp. 124–130, 173–180.

In regard to the various rabbits and the horsemen with greyhound in the background of *Sacred and Profane Love*, it is probably unsafe to infer that they have an iconographic significance of an erotic nature or of any kind at all (cf. Panofsky, 1969, p. 116). Giovanni Bellini and his shop used such motifs as a standard means of enlivening the landscape in a wide variety of religious works; examples are: the *Resurrection* in Berlin, where there are two rabbits on a rock above the empty tomb (Robertson 1968, pl. LV); the *St. Jerome* in Washington also with two rabbits (*loc. cit.*, pl. LVIIIb); the *Immaculate Conception* in S. Pietro Martire, Murano, in which two horsemen appear in the left background (*loc. cit.*, pl. CV); the *Madonna and Saints* in S. Francesco della Vigna at Venice, with a horseman at the left (*loc. cit.*, pl. CVIA);

the *Madonna* in Detroit with rabbits in the right middle distance (*loc. cit.*, pl. CVIb); the *Deposition* in the Accademia, Venice, again with two rabbits in the left middle distance (*loc. cit.*, pl. CXX); *Christ Blessing* in a private collection in Switzerland with a pair of rabbits in the low-lying landscape under the right elbow of Christ (Heinemann, 1960, fig. 86); also a painting after Giovanni Bellini in the Courtauld Institute, London, a *Death of St. Peter Martyr* with a mounted hunter and dogs in the background (Heinemann, 1960, fig. 284).

In Titian's religious paintings rabbits occur as well: The *Madonna of the Rabbit* in the Louvre, had, besides the one under her hand, other rabbits partly visible (Wethey, I, 1969, Plate 34; Wethey, III, Addenda I, Cat. no. 60); in the *Rest on the Flight* in the Escorial, a pair of rabbits appears in the right foreground (Wethey, I, 1969, Plate 40); and in the *Last Supper*, also in the Escorial, a rabbit is embroidered on the pillow of the seat of Judas (Wethey, I, 1969, Plate 116).

Mantegna's *Agony in the Garden*, now in London, has three rabbits on the road circling around the mount at the right and a fourth rabbit in the left-centre of the picture near Christ. Vittore Carpaccio's *Birth of the Virgin*, no. 155 in the Accademia Carrara in Bergamo, shows two rabbits eating lettuce in the front room. No doubt an extensive survey of Venetian and north Italian painting would turn up a plethora of other examples. [Alice S. Wethey]

121. De Tolnay, 1970, p. 39; see also Wind, 1968, pp. 142–145, for other theories. The suitability of the theme of Chastity may be questioned in a wedding picture, especially when the bride had been previously married.

The extraordinary fact that an animal's head, that of a cow or a dog, is located just to the left of Chastity has escaped attention hitherto, because it seems to have been painted over at some early period.[122] If Titian originally intended to include the animal, then it must have had some iconographic significance. Thus far no explanation for this detail has been forthcoming.

At the risk of further digression, it should be pointed out that the scene of whipping on the sarcophagus appears to show the jealous Mars beating Adonis, another of Venus' lovers. The nude female would then be Venus herself, but the male figure with large pole at the right remains unexplained. At the extreme left is Priapus, whose body turns into a herm at the legs. Anyone who sees this figure in the proper light cannot doubt the emphasis on his genitalia, his distinguishing attribute. Priapus, god of gardens, horticulture, and fertility, was the son of Venus and Dionysus, and he therefore finds a logical place here. The riderless horse, which seems to defy the attendant figures, is clearly inspired by the bronze quadriga of St. Mark's (Plates 25, 26), but this detail has been interpreted in a wide variety of ways from 'chastity' to 'unbridled passion'. The rose bush in the centre with its large wing-shaped leaves is a very strange variety, yet botanical experts agree that it may be an early form of the wild rose because of the recognizable rose and leaves upon the sarcophagus just above.

The coat-of-arms (Plates 21, 22) in the centre of the sarcophagus is that of Niccolò Aurelio, grand chancellor of Venice in 1523–1524. The second escutcheon, that of his wife, the daughter of the formerly renowned professor of law, Bertuccio Bagarotto of the University of Padua, lies in the low silver bowl on the rim of the sarcophagus (Plate 20A). The marriage of Niccolò Aurelio and Bagarotto's daughter in May 1514 was noted with astonishment by Marino Sanuto in his *Diarii*,[123] because the bridegroom was then secretary of the Council of Ten, and the bride's father had been executed as a traitor by the same Council in 1509. On the theory that the picture commemorates this wedding, it should be dated in 1514, a time which corresponds to the widely accepted date, about 1515, based upon the style of the picture. The large size of this work on canvas eliminates the possibility that it decorated a *cassone*. Schubring's classification of it as a 'cornice picture' is not convincing.[124] It might have been intended as an 'over-mantel', if not exhibited on a wall, in the way it now hangs in the museum of the Villa Borghese.

At the same period when Titian painted the *Three Ages of Man* and *Sacred and Profane Love*, he was equally busy with religious compositions. Among the most delightful works, likewise filled with the idealism of youth, are the *Madonna of the Cherries* in Vienna, the *Rest on the Flight into Egypt* at Longleat, the *Tribute Money* at Dresden, the lovely *Salome* in the Doria Pamphili Collection at Rome, and many others. In his portraiture the dreamy spirit of the Giorgionesque lingers on in *Young Man with Cap and Gloves* at Garrowby Hall and the *Young Man in a Plumed Hat* at Petworth.[125]

122. See Cat. no. 33, Condition.
123. See Cat. no. 33, the Escutcheons and History, with documentation on the Bagarotto and Aurelio families. The Venetian form of the name is Bertuzi Bagaroto.

124. Schubring, 1915 or 1923, p. 417, no. 886.
125. See Chronological List of Titian's works, with references to catalogue numbers in Wethey, Volumes I and II.

II. THE MONUMENTAL PHASE
AND THE BEGINNINGS OF
CENTRAL ITALIAN INFLUENCES

THE sudden and dramatic turn of events in Titian's career came with the unveiling of the *Assumption* (Figure 18) in the Frari at Venice on 20 May 1518, the day of S. Bernardino.[126] The turmoil and excitement expressed in the attitudes of the Apostles and the upward sweep of the Madonna, whose arms are outstretched in a gesture of triumph, create a crescendo of emotion comparable with a full orchestra at the climax of a symphony. Venice had known nothing of such full-blooded drama hitherto.[127] As a matter of fact, Dolce implied in 1557 that the Venetian public and other artists were shocked by the picture at first, but they soon came to realize its greatness.[128] The explanation of this abrupt change in Titian's style lies to a certain degree in the subject and in its position on the high altar[129] but mainly in a new knowledge of artistic developments in Rome. Although Titian had never been there, others had, and it may have been Lorenzo Lotto who first showed him drawings after Raphael's *Disputa* (1507). Lotto himself never evolved the dynamism of Titian, despite the fact that he had been in Rome, presumably *c.* 1508–1512, previous to his visit to Venice *c.* 1514.[130] Other Venetian visitors too, whose names we do not know, had seen the new masterpieces of the Vatican Palace and Michelangelo's ceiling of the Sistine Chapel. Alfonso d'Este made a hurried visit to Rome in July 1512 to seek to appease the hostile pope Julius II, but he was forced to flee to escape imprisonment. Extraordinarily enough, under the circumstances, he managed to see Michelangelo's vault of the Sistine Chapel in July, five months before its official unveiling in October 1512, and it is said that he ordered a picture from Michelangelo.[131] Pietro Bembo's and Andrea Navagero's travels back and forth from the papal court at Rome and to Venice gave Titian ample opportunity to keep abreast of artistic innovations.[132] It was at this time (*c.* 1513) that, according to Lodovico Dolce, Leo X invited Titian to Rome, an offer that he wisely chose to forgo.[133]

All of a sudden, at the very time that Titian was painting the *Assumption* (1516–1518), an increased

126. See Wethey, I, 1969, Cat. no. 14.
127. Mantegna's *Assumption of the Virgin*, still preserved, in the Ovetari Chapel of the church of the Eremitani was well known to Titian. The attitude of the Madonna with arms outstretched certainly anticipates Titian, although the figure is static; and the Apostles, grouped below and looking upward, could not have escaped his attention. Illustrated by Cipriani, 1963, pl. 33.
128. Dolce–Roskill, 1968, pp. 186–188. Ridolfi's story of more than a century later, that the monks disapproved of the *Assumption* and that they were only convinced of its quality after the Emperor's legate offered to buy it, is surely apocryphal (Ridolfi (1648)–Hadeln, I, p. 163). No document or writer of Titian's day makes any such reference. The Emperor Charles V first came to know Titian when the artist painted his portrait at Bologna in 1530 (Wethey, II, 1971, pp. 19–20).
129. On the attribution of the design of the altar frame to Titian

and its relation to the arched entrance to the choir, see Rosand, 1971, pp. 196–198.
130. Lotto is documented in Rome in March 1509. The chronology of his early life was worked out by Berenson, 1905, pp. 103–105, 110–111.
131. Alfonso reached Rome on 4 July 1512 and fled secretly on the 19th (Pastor, vol. VI, 1902, pp. 419–420; Cartwright, edition 1926, pp. 61–64). The vault had been finished by October 1511, but the lunettes at the sides still remained to be done (Freedberg, 1961, pp. 112–114).
132. For Bembo see Dionisotti, 1966 and also Wethey, II, 1971, p. 82; for Navagero, Cicogna, 1853, VI, pp. 172–348. Marcantonio Michiel's visits from Venice to Rome and Naples during the pontificate of Leo X are reported in his unpublished *Diarii* (see Cicogna, *Memorie dell' Istituto Veneto*, IX, 1860, pp. 360–425).
133. Dolce (1557), ed. 1960, pp. 204–205; Roskill ed., 1968, p. 192.

dynamism appeared in Raphael's *Transfiguration* and Sebastiano del Piombo's fresco of the same subject in S. Pietro in Montorio at Rome. The latter was planned in the same year of 1516, it is said on a design of Michelangelo.[134] Yet the actual painting of the *Transfiguration* was delayed until 1521.[135] Raphael's large composition is also a trifle later than Titian's, started by mid-1518 and finished by Giulio Romano and other pupils in 1522 after the master's death.[136] Nevertheless, Titian's inspiration in the *Assumption* lies clearly in the masterpieces which had just preceded his in Rome, even though he transformed Central Italian ideas to his own purpose. There is no precedent for the great triangle of figures in red, the Madonna herself and the two Apostles below, the one at the left facing the spectator and the other at the right facing inward with arms outstretched. Here are richness of colour and luminism which belong solely to the Venetian tradition and at this point to Titian in particular.

When Titian went to Ferrara in November 1519 he saw in the castle of Alfonso d'Este the cartoon for Raphael's *Story of Leo IV*, i.e. *Leo IV's Victory over the Saracens at Ostia* (Figure 28) and two other cartoons, those of *St. Michael* and the portrait of *Giovanna d'Aragona*. The originals of the last two are now in the Louvre.[137] None of these full-scale preparatory drawings is preserved today, and it is curious that Raphael himself set so little store by them that he gave them away[138] to please a princely patron. In this same month of November 1519 Titian, then in Ferrara, accompanied Dosso Dossi on a visit to Mantua to see Isabella d'Este's *Studiolo* and the works of Mantegna.[139] This association with Dosso Dossi meant another contact with Central Italian art. His brother Battista Dossi was almost certainly the painter from Ferrara who was recorded in Raphael's shop at Rome in September 1518, when the famous master sent him to Venice to buy colours and directed him to stop at Ferrara to consult with Duke Alfonso d'Este about the work that he had ordered of Raphael.[140] At that time Battista may well have visited Titian's workshop and have told him of recent artistic events in Rome.

134. Vasari (1568)–Milanesi, v, p. 569; this statement of Vasari is generally accepted as a fact; see Freedberg, 1961, p. 389.

135. Freedberg, *loc. cit.*

136. Golzio, 1936, pp. 71, 146: under way in July 1518; finished by Giulio Romano and others by May 1522.

137. Raphael sent the cartoon of 'una historia di Papa Leone IV' in November 1517 (Golzio, 1936, pp. 62–63), which would reasonably appear to be the Battle of Ostia. Leo X appears prominently in the guise of Leo IV (Figure 28) in the composition which is datable *c.* 1515–1516 (Oberhuber, 1962, pp. 46–54; Dussler, 1966, pp. 93–94). The fresco is believed to have been painted in great part by Giulio Romano, who followed Raphael's cartoon. The *St. Michael* was a second gift of the artist to Alfonso d'Este according to a letter of 21 September 1518 (Golzio, pp. 74–75) to soothe again the duke, because a picture for the *Camerino* had still not been delivered. On 29 December 1518 Alfonso requested as a gift the cartoon for the portrait of *Giovanna*. In a letter of 2 March 1519 Raphael agreed to this third gift, but he noted that a pupil had been dispatched to Naples to prepare the portrait (Golzio, pp. 76–77).

138. It may be that the *St. Michael* was presented by Alfonso d'Este to Charles V in 1533. Charles Hope suggested to me the probability that Raphael's cartoon of the Louvre picture was involved, since the documents state that Titian was asked to select three pictures to be given to the Emperor and no mention of the painters thereof is made. Alfonso's gift of three pictures has

usually been assumed to be three works by Titian himself: a *Judith*, a *St. Michael*, and a *Madonna* (see Wethey, I, 1969, p. 3). They were dispatched to Genoa for shipment to Spain (documents in Gronau, 1928, pp. 244–245), but they have been lost, and the first two are not traceable in any of the Spanish inventories. Just a sheer guess: the *Madonna* might be the *Madonna and Child with SS. George and Dorothy*, *c.* 1515, in the Prado Museum. We have no data on this work until it was presented to the Escorial by Philip II in 1593 (Wethey, I, 1969, p. 109, Cat. no. 65). It does not figure in the correspondence between Philip II and Titian (see Cloulas, 1967). The most highly prized picture which Charles V coveted and shortly received was Titian's portrait of *Alfonso d'Este*, which he had hung in his own bedroom at Bologna during the conferences with Pope Clement VII in 1533 (documents in Gronau, *loc. cit.*). This picture might be the portrait now in the Metropolitan Museum of Art in New York (see Wethey, II, 1971, Cat. no. 26; also in the present volume, Addenda II).

139. See below, note 203. Dosso Dossi probably knew Titian as early as 1516, when the painter from Ferrara made a trip to Venice and again the following year (Gibbons, 1968, p. 28). Although Dolce said that Dosso had studied painting with Titian in Venice, this detail is more likely a piece of *campanilismo* (Dolce–Roskill, p. 92). It does prove that the two artists knew each other.

140. Golzio, 1936, pp. 75–76.

Battista again appeared in Raphael's shop in January 1520,[141] just three months before his master's death. Thereafter he returned to Ferrara.[142] As for Dosso Dossi himself, a visit to Rome has been widely accepted but also doubted. His trip to Florence in November 1517 has been acknowledged as a fact, at a time when he might have gone on to the papal city.[143] Others have proposed a Roman sojourn between November 1519 and 21 March 1520.[144] This digression on Dosso Dossi is prompted by the fact that Titian's *Madonna and Child with SS. Francis, and Aloysius and a Donor* (1520) in Ancona[145] is obviously inspired in its composition by Raphael's *Madonna of Foligno* (1511), which then adorned the high altar of the church of the Aracoeli in Rome. Someone had unmistakably shown Titian a drawing after Raphael's composition, in which the Madonna in the sky, in the centre, is balanced by figures below at each side in order to create a triangular design.[146] Inasmuch as Dosso Dossi adopted this same composition in several paintings, he seems logically to have transmitted the important compositional idea to Titian.[147] The second unmistakable evidence of dependence upon works of art in Rome occurs in Titian's *Resurrection Altarpiece* in Brescia, dated 1522, where the much admired figure of St. Sebastian[148] repeats the pose of Michelangelo's sculpture of the *Bound Slave*, now in the Louvre.[149] Thenceforth the art of Michelangelo and Raphael became more fully known in Venice and North Italy. Raphael's cartoon for the tapestry of the *Conversion of St. Paul* arrived in 1521 in the collection of Cardinal Domenico Grimani.[150] Just at this time Titian was preparing his greatest mythological paintings for Alfonso d'Este's *Camerino* at Ferrara, to be considered shortly. It may be remarked, in connection with the effect of Michelangelo's achievements upon the Venetian, that Titian's lost *Martyrdom of St. Peter Martyr* (1526–1530), now known only in copies and prints,[151] reaches a high point of drama and excitement which reflects, in the poses of the actors, some familiarity with

141. *Loc. cit.*, p. 122.
142. Gibbons, 1968, pp. 26–29.
143. *Loc. cit.*, p. 27.
144. Mezzetti, 1965, pp. 18–19, 59. Dosso and Titian made a short visit to Mantua to see the works of Mantegna in November 1519, and on 21 March 1520 Alfonso Paolucci, a d'Este representative at the papal court, wrote to Duke Alfonso d'Este that Raphael intended to write to Dosso Dossi, then at Ferrara, to speak in his behalf to the Duke of his failure to deliver the picture for the *Camerino* in the d'Este castle. This would imply that Raphael knew Dosso. Mezzetti also emphasized the importance of the Roman experience for Dosso's development. According to Middeldorf (1965, pp. 171–172) the impact of Raphael's style on Dosso's work was very great, whereas Gibbons (1968, p. 27) held that 'there is no firm evidence, documentary or stylistic, that Dosso was ever there.'
145. Wethey, I, 1969, Cat. no. 66, Plate 24, dated 1520. Here I held that Titian must have seen a drawing of Raphael's *Madonna of Foligno*, now in the Vatican Pinacoteca, but I did not suggest Dosso Dossi as the intermediary. Charles Hope first proposed to me the importance of Dosso in this connection.
146. Other writers have said that Titian saw a print of the *Madonna of Foligno*, but none existed before 1520. Marcantonio Raimondi's engraving of a *Madonna in the Sky* is not identical in composition with Raphael's work, and moreover, the important figures of the saints below are wanting.
147. Dosso's compositions based on the *Madonna of Foligno* are:

Madonna and Child with SS. George and Michael, Modena, Pinacoteca, undated, c. 1520 (Gibbons, 1968, cat. no. 44, pl. 45); *Madonna and Child with SS. John the Baptist and John the Evangelist*, Florence, Uffizi, c. 1520–1522 (Gibbons, cat. no. 20, pl. 48); *Madonna and Child with SS. Roch and Sebastian*, Budrio, Pinacoteca, c. 1520–1521 (Gibbons, cat. no. 8, pl. 50); *Madonna and Saints*, Modena, Cathedral, dated 1522, does not repeat Raphael's composition, although the Madonna and Child are in the sky (Gibbons, cat. no. 46, fig. 46).
148. Wethey, I, 1969, Cat. no. 92, Plates 72, 74.
149. Then still in Michelangelo's studio at Rome; about 1546 the artist presented both sculptures of the *Bound Slaves* to Roberto Strozzi, who was in exile from Florence and then living in Lyons (de Tolnay, IV, 1954, p. 97).
150. Marcantonio Michiel (Frimmel edition, 1888, p. 104) saw the cartoon in Cardinal Grimani's palace that year. In 1528 he noted (*loc. cit.*, p. 98) the original tapestries, which had been looted in the sack of Rome in 1527, i.e. the *Preaching of St. Paul in Athens* (wrongly called Pope Leo) and the *Conversion of St. Paul*, in the house of Zuan Antonio Venier at Venice. Other writers have called attention to these facts, notably the late Ruth W. Kennedy (1963, pp. 12–13), whose belief in Titian's dependence on specific Roman works seems to me too generous.
151. Wethey, I, 1969, Cat. no. 133; the copy now in the church has been attributed both to N. Cassana and J. C. Loth. The donors, the Medici, once owned copies by both (see Addenda I).

3

the vault of the Sistine Chapel. The murderer's *contrapposto* is derived from the Libyan Sibyl and the general muscularity of the physiques and their violent attitudes are Michelangelesque. Yet this composition is one of Titian's greatest and was so regarded by Vasari. The integration of the landscape, which is entirely Venetian, with the motivation of the figures results in a unique masterpiece despite some inspiration from the art of the colossus of the south, Michelangelo.

During these same years, when Titian rose to his first heights as a painter of the monumental and the dramatic, he continued to produce portraits of such direct and appealing simplicity as the *Man with a Glove* in the Louvre.[152] The *Lady at Her Toilet* also in the Louvre (Plate 31), slightly earlier *c.* 1515, appears to be neither a double portrait nor an Allegory of Vanity.[153] The young woman wears a green dress and a white blouse or *camicia* here, as well as in the two lesser versions in Prague and Barcelona (Plates 29, 32), while the man is dressed in a dark rose doublet. The small parapet in the foreground is the familiar compositional device used by Titian in portraits and in his early paintings of the *Madonna and Child*.[154] Giovanni Bellini's lovely *Lady at Her Toilet* (Plate 28) in Vienna, signed and dated 1515, is closely contemporary with Titian's picture, but it differs notably in the absence of the man and in the presentation of the girl nude. She appears to be adjusting her headdress as she looks at the reflection in the two round mirrors. This work looks forward to Titian's *Venus at Her Toilet* (Plate 127) more than to the young artist's Louvre composition. One of Titian's most celebrated single figures of this period is the *Flora* (Plate 35), *c.* 1520–1522, in the Uffizi. Sumptuous of body and Titian-haired, she is robed in white, and holds pink and white roses as though offering them with her right hand, while with her left hand she supports a cloak of pale rose damask against her décolletage. The ring on the knuckle of her fourth finger apparently has no special significance. The Roman nose and idealized head are *all' antica*, but still more so is the draping of her gown (*camicia*), leaving one breast exposed in a way reminiscent, not by accident, of Alcamenes' *Venus Genetrix* (Figure 20). However, in ancient sculpture Diana and numerous other female personalities wear a similar costume. By the mid-sixteenth century this tradition was so widespread in Italian painting and in the School of Fontainebleau that the single nude breast became a symbol of 'female figures associated with antiquity, especially goddesses'. Flora, goddess of spring and flowers, was frequently linked with courtesans in the Renaissance period. In antiquity her festival was celebrated in Rome from 28 April until 3 May before her temple near the Circus Maximus.[155]

The extraordinarily beautiful *Lucretia* (Plate 37) has been a source of puzzlement to many critics, first because the composition is unique and secondly because the canvas has suffered greatly from the effects of time and restoration. Even though nothing exactly like it exists in a single figure by Titian, the rhythmic *contrapposto* in the movement of the body and the flowing drapery fit well enough with the style of the *Andrians* and the *Bacchus and Ariadne* (Plates 48, 57). The rose drapery provides a large area of colour against the lovely white flesh, and both gain brilliance against the grey stone column.

152. 1520–1522. See Chronological List of Works; also Wethey, II, 1971, Cat. no. 64, Plates 29–32.

153. See Cat. no. 22 for the earlier theories that historical personages were represented here.

154. The *Gypsy Madonna* (*c.* 1510) and the *Madonna of the Cherries* (*c.* 1515), see Wethey, I, 1969, Cat. nos. 47, 49. For early portraits, Wethey, II, 1971, Plates 2–22. Antonello da Messina, Giovanni Bellini, Giorgione, and many other Venetian artists employed this device in the later Quattrocento and early Cinquecento.

155. See Cat. no. 17 for her association with courtesans. Seyfert, 1957, p. 238, for her cult in antiquity.

The motivation of Lucretia's suicide, as she shields her face from the violence she is about to commit, appears at first somewhat melodramatic, but on further consideration it impresses as a stroke of imagination on a high creative level. The mountainous landscape with its hazy distance and the blue sky with handsome white clouds add further evidence of Titian's hand in a work that has been largely overlooked. In the case of the *Venus Anadyomene* at Edinburgh (Plate 36) agreement is unanimous that it is a painting of extraordinary refinement and beauty, the figure comparable with the much admired sleeping girl of the *Andrians* (Plate 58) and the nude Venus of *Sacred and Profane Love* (Plate 24). The pose, the draughtsmanship, and the delicate modelling combine to create a work of classical restraint, a vision of ideal beauty. Not even the *Sleeping Venus* in Dresden (Plate 9) is more removed from purely physical sensuality. She is indeed a goddess who arises fully grown, born from the sea, as she wrings the water from her long chestnut locks. The rich textural quality of the hair suggests the physical existence of the figure to a greater degree than any other aspect of the composition. Colours are very subtle and limited to the medium-blue sky and greyish-green water, against which the pearl-like tones of the body and the chestnut tints of the hair are silhouetted. The antique nature of the theme of the *Venus Anadyomene* is so self-evident that little comment has been made about it by most writers. The subject of the *Venus Anadyomene* [literally 'rising from the sea'], alternately called the *Birth of Venus*, was famous in antiquity because of a celebrated painting by Apelles, which was said to have been brought to Rome by Augustus.[156] Titian's visual source was a Roman statue, one of a prevalent type in which the goddess wrings or arranges her hair nonchalantly (Figures 21, 23). The three-quarter length and the inclined body of Titian's *Venus* imply inspiration from such figures. She is not derived from a *Venus Pudica* like the *Medici Venus*, whose right arm shields her breasts and whose left arm hovers vaguely over her lower middle. Botticelli's celebrated *Birth of Venus* in the Uffizi at Florence is a *Venus Pudica*, based on the Medici statue, but freely interpreted, with her left hand sustaining the ends of her streaming golden hair. The left arm of Titian's *Venus Anadyomene* implies not so much the gesture of modesty as the motive of wringing the hair, and at the same time it has a major importance in the formal structure of the composition. The dating of the *Venus Anadyomene* has in recent years moved ahead to *c.* 1525 from the early period *c.* 1517. The mastery of form in rendering the ideal nude body is that of a mature artist, who had reached the phase of the Ferrara mythological pictures (Plates 39, 48, 57).

Humiliation of Frederick Barbarossa by Pope Alexander III

IN 1522–1523 Titian was forced by the Council of Ten, the executive body of the Venetian government, to complete a large mural on canvas for the Sala del Maggior Consiglio.[157] The subject was the

156. See Pliny, edition 1968, p. 127. The same iconography as Titian's was employed by Giulio Romano in his small fresco in the ceiling of the Sala dei Venti of the Palazzo del Te at Mantua, dated 1527–1528 (Hartt, 1958, p. 115, fig. 193).

157. The documentation is very confused because the subjects ordered from different painters are not mentioned. Titian painted two pictures, the second the *Battle* (unspecified) in 1536–1537. His first association with the murals for the Council of Ten came in May 1513, when he applied to paint a 'Battle' without recompense except the cost of the colours and salaries for two youths ('garzoni'), who assisted in mechanical matters (see Cat. no. L–3, Documentation).

In August 1522 Titian was ordered by the Council of Ten to finish the first mural by June 1523 on the threat that he would have to return payments already received from the salt brokerage (Cat. no. L–6, Documentation). Tebaldi's letter of 31 August

Humiliation of Frederick Barbarossa by Pope Alexander III,[158] one of a series of pseudo-historical events represented in the great hall and a type of composition not usually associated with the Venetian master. It was destroyed in the devastating fire in the Ducal Palace in 1577 and replaced by a picture of the same subject (Figure 29) painted by Federico Zuccaro (1582), with the result that we have no precise idea about Titian's composition. It has been proposed that Zuccaro followed the general outlines of Titian's work and that he did little more than 'restore' the earlier composition, but there is no justification for such a theory.[159] To be sure, Zuccaro's crowding of the bystanders looks old-fashioned and such could have been the case in Titian's version, but it is more likely that he employed isocephalism (see below). There must have been some originality in Titian's presentation because Sansovino characterized it as the most unusual in the hall ('la più rara pittura in questo luogo'). The only precise information we have concerns the portraits of the bystanders, who included prominent men of the period: Pietro Bembo, Jacopo Sannazaro, Andrea Navagero, Fra Giocondo the architect, Agostino Beazzano, and several prominent Venetian politicians.[160] Pietro Aretino, later Titian's great personal friend, did not appear because he did not settle in Venice until 1527.

The scenes of the life of Pope Alexander III (1159–1181) were largely mythical, since legends about his pontificate had multiplied considerably.[161] The contest between the pope and the Emperor Frederick Barbarossa had been settled in the pope's favour by the battle of Legnano in May 1176, followed by the peace of Anagni the next November. On a visit to Venice in July 1177 Alexander received the Emperor, who knelt before the pope's throne and accepted his absolution and blessing. The myth that the pope placed his foot on the Emperor's neck was adopted by Titian as well as by Federico Zuccaro, when he repeated the subject, still extant, in the Ducal Palace (Figure 29). At any event the design of the *Humiliation* could have had little to do with Titian's other great works of that period: the *Assumption* (1516–1518) in the Frari or the *Bacchanals* (1518–1525) for Ferrara. He probably had no particular enthusiasm for painting an historical event, but he was bound to do it for reasons of local prestige and the financial rewards of the salt monopoly. Nevertheless, if preserved, the mural would have given us an aspect of Titian's genius for which we have little evidence. Only the *Miracle of the Speaking Child*

1522 reported that Titian was working in the Ducal Palace in the morning but that he was also engaged on the *Bacchus and Ariadne* for Alfonso d'Este (Cat. no. 14, Documentation).

158. The subject is established by Sansovino (1561, p. 18), who specifically describes it as 'del Papa che mette i piedi su la gola di Federigo, l'altro d'una zuffa, ma fatta ultimamente ne' quali a parteper parte si veggono i miracoli del suo divino intellecto'. From this brief reference it is clear that the *Humiliation* was painted first. Sansovino in 1581 (folio 129v) repeated that the *Humiliation* was Titian's first picture for the Ducal Palace. The several documents published by Lorenzo in 1868 do not make it clear what the subjects were. See, however, Huse, 1972, pp. 56–71.

159. Sansovino (1581, folio 129) describes Titian's mural: 'Il Pontifice condotto con l'Imperatore *in Chiesa* di San Marco'. Vasari, VII, p. 432, on the other hand places the scene at the portal ('alla porta della chiesa').

 Tietze-Conrat, 1940, pp. 15–39, developed the theory that Federico Zuccaro 'restored' Titian's painting and that a drawing by Malombra also reflects it. The same idea was first proposed by Tietze, 1936, pp. 128–129, i.e. that Zuccaro essentially followed

Titian's destroyed mural. Federico Zuccaro's mural was painted in 1582 and further elaborated on a short stop at Venice in 1603 (Venturi, vol. IX, part V, pp. 842, 847).

 It has been thought that Giuseppe Porta Salviati (who passed the years 1539–1563 in Venice) based his fresco of the same subject on Titian, when he painted the scene in the Sala Regia of the Vatican Palace (Venturi, IX, part 7, p. 432 and Huse, 1972, pl. 42; also Roskill, 1968, p. 283).

160. The dates of these men are: Pietro Bembo, 1470–1547; Jacopo Sannazaro, 1458–1530; Lodovico Ariosto, 1474–1533; Andrea Navagero, 1483–1529; Fra Giocondo the architect, 1433–1515; Agostino Beazzano, c. 1490–1549.

161. The true history of the chaotic events of the pontificate of Alexander III are recounted by Mann, X, 1925, pp. 110–124; Brezzi, 1960, pp. 183–189. The whole Venetian cycle of murals is recorded by Sansovino, edition Martinioni, 1663, pp. 326–334, as well as in the first edition of 1581. The series of frescoes (c. 1407) by Spinello Aretino in the Sala dei Priori of the Palazzo Pubblico at Siena is also devoted to the legendary history of Alexander III, a cycle which is the subject of a doctoral dissertation by Margaret Rajam for the University of Michigan.

(1510–1511) at Padua[162] and the *Presentation of the Virgin* (1534–1538) in Venice supply any hint of his method of handling a crowd.[163] In these two works he adopted the classical High Renaissance tradition of aligning the heads in a horizontal row (isocephalism) without sacrificing variety of posture and movement within this geometric scheme. Titian may have adhered to the same method of composition in the *Humiliation* rather than stack up superimposed rows of heads in mediaeval fashion as Federico Zuccaro was to do later. Just in these years (1518–1525) Titian was engaged in creating the three mythological pictures for Alfonso d'Este of Ferrara, to be placed in the newly constructed *Camerino* adjoining the d'Este Castle. They rank among the most delightful in the gaiety of their spirit and among the most admired masterpieces of the entire Renaissance period. To them our attention is now turned.

Alfonso d'Este's *Studiolo* at Ferrara

IN the period of Duke Alfonso I d'Este and his wife Lucrezia Borgia, five rooms were reconstructed and redecorated in the passage-way that connected the castle at Ferrara with the palace across the piazza (Figure 26). The interiors have since been so completely modified that today there is little or no trace of Alfonso's great contribution to the Renaissance.[164] The marble balcony overlooking the piazza in the centre of the exterior wall is one of the few surviving and presumably original architectural elements. This covered passage-way, generally known as the *Via Coperta*, had been begun in 1471 and was apparently enlarged before its completion in 1477.[165] The rooms seem to have constituted the choice suite for honoured guests, and here the youthful Federico Gonzaga resided on his visit to Ferrara in the summer of 1517.[166]

In February 1518 the *Via Coperta* was again somewhat rebuilt, and it must have been totally re-decorated. Alfonso's taste for art patronage and his desire to be surpassed by no other prince led him to make the *Via Coperta* one of the marvels of the Renaissance. He surely had been inspired to compete with the *Studiolo* and other rooms in the Ducal Palace at Mantua, on which his sister Isabella d'Este lavished so much thought and energy.

The likelihood that the rooms of the *Via Coperta* were redecorated rather than totally rebuilt is suggested by the short duration of the work, which began in February 1518 and was finished in May 1520 to the extent that Isabella d'Este was able to stay there as guest.[167] Titian had enquired where his

162. Wethey, I, 1969, Cat. no. 93, Plate 139.

163. *Loc. cit.*, Cat. no. 87, Plates 36–39.

164. The *Via Coperta* is now occupied by the prefect of Ferrara. A fire in 1634 seems to have ravaged the interior (Campori, 1874, p. 582; Cittadella, 1875, p. 16).

165. Zevi, 1960, p. 350, figs. 590–592; Hope, 1971, p. 649.

166. Letter of 31 May 1517, published by Hope, 1971, p. 649, Appendix.

167. Charles Hope again has called attention to new documentation, specifically the account books of 1518–1519 in the Archivio Estense at Modena. See Hope, *loc. cit.*, p. 649, note 46. His conclusion is that the building of 1471–1477 was totally destroyed and rebuilt because of work on the foundations. One document reads 'renew *part* of the foundations and drive poles' ('renover parte di fondamenti e palifichare'); a payment of 13 February 1518 and later similar payments. If entirely new foundations were laid in February, I doubt that the work could have reached the level of the windows by May 1518. Even today Italian builders in Rome and other cities rarely dismantle a structure completely. They usually maintain the shell of the building, even when the interior is extensively modified.

It is uncertain whether Titian's drawing of a balcony of Venetian style ('alla maniera de li pogioli de questa terra') could have been used for the *Via Coperta*; letter of 19 February 1517 (i.e. 1518, new style); see C. and C., Italian edition, 1877, I, p. 148; Campori, 1874, p. 585; Venturi, 1928, p. 104.

Renaissance painters' versatility is well known. Titian also designed for Alfonso d'Este in 1529 a golden cup adorned with reliefs (Campori, 1874, p. 60).

first painting [*Worship of Venus*] was to be placed on the long wall, which had space for three pictures—this in Tebaldi's letter of 23 April 1518.[168] Titian had last been in Ferrara in the spring of 1516, so it would appear that the size and shape of the room had not been changed notably in the renovations. Otherwise Tebaldi would have made some reference to a rearrangement of the space to be allotted to the artist.

The series of marble reliefs by Antonio Lombardo, most of which are now in the Hermitage at Leningrad (Figure 25), has generally been assumed to have a provenance from the *Via Coperta* and even to have bestowed the name *Camerini d'alabastro* on the five smallish rooms. Campori, however, correctly placed Lombardo's sculpture in the castle, contiguous to the *Via Coperta* ('attigui alle stanze'), and in a poetic passage evoked the word alabaster figuratively to imply the great beauty of the new rooms.[169] One of these reliefs is dated 1508, ten years before Alfonso began the new work on the *Via Coperta*. Moreover, they are carved in Carrara marble, not in alabaster, and finally they do not appear in the Inventory of the rooms made on 17 April 1598.[170] Charles Hope has discovered and published a letter of Stazio Gadio, written at Ferrara on 1 June 1517 to Isabella d'Este in Mantua, in which he describes the *Camerino di marmo* in the castle, and quite obviously the Lombardo reliefs were there: 'a most beautiful room, made entirely of marble of Carrara . . . with figures, foliage, very beautiful, excellently worked, small vases and figures ancient and modern and of marble and metal'.[171]

As a matter of fact only the *Studiolo*, the relatively small display piece, which contained pictures by Titian and Giovanni Bellini, was given the name *Camerino d'alabastro*, at least so in the Inventory of 17 April 1598.[172] All of the rooms were still intact at the time of the acquisition of the Ferrarese state by the papacy under Clement VIII Aldobrandini. Cardinal Pietro Aldobrandini had taken possession

168. Campori, 1874, p. 587; Hope, 1971, p. 640, note 35.
169. Campori, 1874, p. 582; C. and C., 1877, I, p. 173, unspecific as to the exact location of Lombardo's reliefs; Walker (1956, p. 3), following Schlosser (1913, pp. 93–95), seems to have believed that Antonio Lombardo's marble reliefs were located in the *Via Coperta*, and he implies in the *Studiolo*; likewise Robertson, 1968, p. 134.
170. Mezzetti, 1965, pp. 137 ff.
171. Hope, 1971, p. 649.
 The marble reliefs by Antonio Lombardo were presumably removed from the castle at Ferrara by Cesare d'Este after his discovery that the paintings by Titian, Bellini, and Dosso Dossi had been carried off to Rome by Cardinal Pietro Aldobrandini, or later in 1608 after he gave Cardinal Scipione Borghese permission to remove the remaining pictures from the *Via Coperta*.
 No document has as yet been discovered to establish the date when they were transferred to the d'Este castle at Sassuolo near Modena. Lionello Venturi (1912, pp. 306–308) states that the castle was owned in the Napoleonic period by a Frenchman, Espagnac. He apparently took the reliefs to Paris, where they were acquired by Frédéric Spitzer, who exhibited eighteen pieces at the Trocadéro in 1878. After the Spitzer sale of 1893 they passed to Leningrad and are now exhibited in the Hermitage Museum. See also Piot, 1878, pp. 594–597; Planiscig, 1921, p. 223 states that Antonio Lombardo's reliefs came from the d'Este villa, Belriguardo (he called it Bellosguardo), but he supplies no evidence for this provenance. A. Venturi, X, part I,

1935, pp. 397–400, assumed that the reliefs had decorated a fireplace and that they came from the *Via Coperta*.
 The room adjoining the *Camerino d'alabastro* (i.e. the *Studiolo*) is described in the Inventory of 17 April 1598 as having a very elaborate fireplace of *coloured* marbles, which does not correspond to Antonio Lombardo's white marble sculpture: 'Adornamento di marmoro di Carrara, diaspero, porfido, serpentino, et marmoro macchiato, del camino della camera contigua al camerino d'alabastro' (Mezzetti, 1965 [p. 140] unpaged). This central room in the suite of five had access to the marble balcony.
172. Mezzetti, *loc. cit.*, unnumbered, i.e. the second folio of the Inventory of 17 April 1598. The foreword states that this is an inventory of the possessions of Cesare d'Este made at the command of Cardinal Aldobrandini. The very vagueness of the inventory and its failure to mention the names of Titian, Bellini, and Dosso Dossi in connection with the *Studiolo* (it simply reads 'dipinte con figure') suggest that the Cardinal already had plans to make off with the important works of art, even though he acknowledged that they were the property of Cesare d'Este. Cesare managed to save a few paintings and transfer them to Modena, but we do not know when or how. He had Titian's *Tribute Money* (Wethey, I, 1969, Cat. no. 147, Plates 67, 68) and the portrait of his grandmother *Laura dei Dianti* (Wethey, II, 1971, Cat. no. 24, Plates 41–43). Neither of these pictures was in the *Via Coperta* so far as we know.
 Vasari's account of Titian's works at Ferrara is very confused, done from memory. He placed the *Tribute Money* in an armoire in the *Studiolo* (Vasari (1568)–Milanesi, VII, p. 434). However, the

of the city on 29 January 1598.[173] Later, on 1 December of the same year the Cardinal carried off to Rome all of the important pictures from Alfonso d'Este's *Studiolo*, i.e. his study, in the *Via Coperta*.[174] The Inventory of 17 April 1598 is as vague as possible, listing principally the relatively immovable architectural components of the five rooms: the carved marble enframements of doorways and windows, the gilded carved mouldings, the benches of marble in the windows, etc. The duke's bedroom had painted pictures (*quadri* di pittura) and a carved canopy over the bed. The *Studiolo* or *Camerino d'alabastro* had 'pictures with figures' (*dipinti con figure, et oro*), that is, this document makes no mention that these pictures included three by Titian, one by Giovanni Bellini and one by Dosso Dossi. This Aldobrandini inventory, a copy of which was sent to Cesare d'Este, is a bold-faced piece of deception. It hardly seems possible that Cesare d'Este was so disinterested and so unintelligent as to be unaware of the value of these works of art, but it would appear that Cardinal Aldobrandini intended to conceal their precise number and their great importance. At any event we know from the letter written by Annibale Roncaglia from Ferrara on 1 December 1598 to Cesare d'Este at Modena that Cardinal Pietro Aldobrandini had removed the five masterpieces from Alfonso d'Este's *Studiolo*.

When Alfonso II d'Este (1559–1597) died without legitimate male heir, he had named his illegitimate cousin Cesare d'Este as his successor. The pope Clement VIII, Ippolito Aldobrandini, demanded the principality of Ferrara as a papal fief and even went to Ferrara for a six-months stay to make sure of his claim. Lucrezia d'Este, the elderly duchess of Urbino and the last of the legitimate d'Este line, joined the Aldobrandini faction and made Cardinal Pietro Aldobrandini her sole heir. After great difficulties, however, an agreement was reached between Cesare d'Este and the Aldobrandini, whereby Cesare was to retain the art collections, the library and half of the artillery. On 29 January 1598 Cardinal Aldobrandini entered Ferrara and took possession of the city in the name of the papacy, the day after Cesare d'Este had departed to set up his court at Modena. Consequently when Cardinal Pietro stripped the *Studiolo* of its masterpieces in December 1598 he committed a clear breach of the original agreement, but worse was the dispersal of the group, one of the supreme achievements of Renaissance art.

From the careful description in the letter of Annibale Roncaglia and from the dimensions of the five rooms provided in the otherwise vague Inventory of 17 April 1598, the sizes and shapes of the rooms in the *Via Coperta* and the arrangement of the pictures in the *Studiolo* may be established (Plate 38, Figure 27).[175] Without going into the complexities of the changing projects due to the failure of both Fra Bartolomeo and Raphael to supply paintings for Alfonso d'Este's *Studiolo*, we shall concentrate on

Inventory of 1543 lists it in the 'primo camerino adorato', the first 'Golden Room') in the castle (Walker, 1956, p. 36; Hope, 1971, p. 649). A document of 1559 notes it in the door of a cupboard in the 'studio delle medalie', possibly the same Golden Room (document, courtesy of Charles Hope).

173. Pastor, XXIV, 1933, p. 395. Clement VIII himself went to Ferrara to make good his claims to the principality; entering on 8 May 1598 he remained there until November (Pastor, *loc. cit.*, pp. 398–404).

174. Venturi, 1882, p. 113, first published Roncaglia's letter to Cesare d'Este, then living at Modena; reprinted by Hope, 1971, p. 641.

175. Hope, 1971, pp. 641–649. On p. 642 he has shown the arrangement of the five rooms in the Via Coperta. It seems likely that

the space with cross lines in his drawing was the *guardaroba* (wardrobe), directly behind the *Studiolo*.

My illustration (Figure 27) is based upon Hope's plan on p. 645, but it was redrawn by Dr. Elizabeth Sunderland in order to take into account the probable thicknesses of the walls and to suggest possible sizes and shapes for the window and door openings and the fireplace. The only recorded architectural measurements are the interior dimensions of the room, given as 18× 10 feet in an Inventory of Este property in Ferrara, dated 1598, now in the Museo del Risorgimento in Ferrara. The relevant part was published by Mezzetti (1965, p. 144). The Ferrarese foot measured 40·4 cm. (*Encyclopedia italiana*, XXVII, 1935, p. 168) and the scale of the plan as drawn by Dr. Sunderland is 1 centimetre to 1 Ferrarese foot.

the final appearance of the room.[176] First, however, arises the question of an all-over iconographic scheme for the pictures. That they dealt with bacchanalian subjects is obvious, and equally evident is their inspiration from ancient literature of a highly erotic nature. The Renaissance fashion of palace decoration concerned with the love affairs of the Gods is well known. Alfonso d'Este, like many another Renaissance prince, enjoyed both the beauty of Renaissance art and the erotic subject matter. That he himself had a share in choosing Philostratus' *Imagines*, Ovid's *Fasti*, and Catullus' *Carmina* as the literary sources for his pictures can be taken for granted. That he sent instructions as to what he wanted is unquestionable. Titian's letter of 1 April 1518 concerning the *Worship of Venus*, directed to Alfonso in the flattering terms due to a Prince, proves that he had received directions. Titian writes: 'The information included seems so beautiful and ingenious . . . that I am all the more confirmed in my opinion that the greatness of the art of the ancient painters was in great part and above all aided by those great Princes who most ingeniously ordered them, from which they thereafter acquired such fame and praise.[177]

Nevertheless, the general scheme appears to have been conceived with a wide range of possibilities, as one reviews the considerable variety of subjects as well as the frequent changes, as the decoration of the room progressed. Titian's *Bacchus and Ariadne* is reasonably assumed to have replaced Raphael's projected *Triumph of Bacchus in India*, even though a quite different subject.[178] When Raphael proposed to substitute for it a *Hunt of Meleager*,[179] it is difficult to imagine any connection at all iconographically with the other paintings in the *Studiolo*. Giles Robertson has called attention to a much neglected hint that Mario Equicola, a humanist at the court of Isabella d'Este after 1508, might have made suggestions to Duke Alfonso about literary material to be used for paintings in the *Studiolo*.[180] When visiting Ferrara in 1511 he wrote Isabella d'Este, then at Mantua, as follows: 'It pleases the Duke that I should

176. The bibliography on this subject is extensive. It is not my purpose here to summarize all of the arguments advanced by various scholars. A full account of each of the four pictures by Giovanni Bellini and Titian is given in the Catalogue, nos. 12–15.

Eugenio Battisti's article in *Commentari*, 1954, pp. 191–216, was the first to attack the problem of the *Studiolo* and the arrangement of the pictures by Titian and Bellini and Dosso, as well as the part played by Raphael and Fra Bartolomeo. Shortly thereafter Walker's important book of 1956 (pp. 36–40) arrived at the general arrangement of the *Studiolo* by means of Roncaglia's description of 1598. Battisti in his later book (1960, pp. 112–144) elaborated upon the subject and included the material on the literary sources which Walker had stressed. Battisti's reliance on a drawing in the Biblioteca Nacional in Madrid as Titian's study for the *Andrians* (Barcia, 1906, no. 7643) has not been accepted by other writers. The composition, a much later variant dependent upon the *Andrians*, may have been produced in Rome when the pictures belonged to the Ludovisi Collection. Battisti's several reconstructions of various phases of Alfonso's plans for the *Studiolo* have now been superseded.

For Fra Bartolomeo's part see the *Worship of Venus*, Cat. no. 13, and for Raphael's unfulfilled contributions see *Bacchus and Ariadne*, Cat. no. 14.

177. Campori, 1874, p. 586; see the Italian original also under Cat. no. 13, Chronology.

178. Raphael sent a drawing of his projected picture to Alfonso d'Este, and the cluttered Mannerist composition is preserved in Garofalo's picture in Dresden. Reproduced by Battisti, 1960, fig. 55; also Hope, 1971, fig. 20. Admittedly it is not fair to judge Raphael as reinterpreted by Garofalo.

179. In Costabili's letter of 11 September 1517 (Golzio, 1936, p. 54) he reported to Alfonso d'Este that Raphael would paint another subject rather than the *Triumph of Bacchus* because Pellegrino da Udine had already done that subject at Ferrara. On the last of February 1519 Bagnacavallo wrote that he had seen two drawings in Raphael's workshop, one a *Hunt of Meleager* and the other a *Triumph of Bacchus* (Golzio, 1936, p. 93). He stated that both pictures would be sent before Easter. The whole matter is purely academic because Raphael died before painting anything for Ferrara.

It seems to me probable that Alfonso d'Este rejected the substitution of the *Hunt of Meleager*. After Raphael's death Alfonso demanded the return of fifty *scudi* paid in advance for 'una pictura', no subject mentioned, although Golzio assumed it was the *Triumph of Bacchus* (Golzio, 1936, pp. 122–123) and there is no mention of the second picture. Gould (1969, pp. 7–9, note 10) speculated that Raphael still planned to send both subjects, i.e. two pictures, to Ferrara. Hope (1971, p. 716) has already doubted this theory; but he believes that the *Hunt of Meleager* was the final choice.

180. Robertson, 1968, p. 134.

stay here eight days: the reason is the painting of a room in which there will be six fables or stories. I have already found them and given them to him in writing.'[181] Although this happened a few years before any of the pictures by Bellini, Titian, and Dosso Dossi was painted, it may well have marked the inception of Alfonso d'Este's plans for his *Studiolo*.

The interior of the *Via Coperta*, as we have seen, was subdivided into five rooms, the series beginning next to the castle with the Duke's bedroom. Then followed the narrow *Studiolo*, where the celebrated paintings by Titian and Giovanni Bellini were hung. The third chamber is distinguished on the exterior by the balcony of marble, which still survives. Upon the scanty descriptions but most useful dimensions provided in the Inventory of 17 April 1598 is based the conjectural reconstitution of the interiors. The arrangement of the five rooms has thus been blocked out by Charles Hope, although the architectural structure itself cannot be determined (Figure 27).

The Duke's bedroom was decorated by Dosso and Battista Dossi with a frieze of sixteen landscapes and nine ceiling paintings.[182] The second room, curiously narrow, became Alfonso's private *Studiolo*, also known as the *Camerino d'alabastro*, where his greatest treasures were hung. Other Renaissance princes before him had started the fashion of the *Studiolo*: Federico da Montefeltro in his palaces at Urbino and Gubbio, and, of course, Isabella d'Este at Mantua. As one entered the *Studiolo* from the bedroom one saw on the short wall at one's left Titian's *Bacchus and Ariadne* (Plate 38). On the long wall hung the *Andrians*, next to it the Bellini *Feast of the Gods*, and lastly the *Worship of Venus*, the end wall being occupied by Dosso Dossi's so-called *Bacchanal of Men*, now lost.[183] The effect of the *Feast of the Gods* between the *Andrians* and the *Worship of Venus* was indeed stately and reserved. Compared with the rhythmic dance of the young women and youths of the *Andrians*, movement is totally lacking in the *Feast*. The draped Lotis of Bellini and the sleeping Ariadne of Titian could scarcely afford a greater contrast, not solely because of the partial dress of the one and the voluptuous nudity of the other, but also because of the sheer beauty and abandon of the Ariadne.

Titian brought the colours into harmonious relation and his repainting of the landscape of the *Feast* achieved a considerable unity among the three pictures upon the long wall. Nevertheless it is obvious that the three paintings on that wall were never planned in relation to each other. Doubtless Titian himself, when he spent several weeks in Ferrara in the spring of 1529, arrived at the final solution. None other was possible except isolating the *Feast* upon the end wall in place of the now lost *Bacchanal of Men* by Dosso Dossi. Giovanni Bellini's fame and the unquestionable superiority of his masterpiece over anything of which Dosso was capable were surely responsible for the decision taken.

181. 9 October 1511: 'Al Sr. Duca piace reste qui octo dí; la causa è la pictura di una camera nella quale vanno sei fabule overo historie. Già le ho trovate et datele in scritto' (Luzio and Renier, 1899, p. 8, note 1).
 Edgar Wind's proposal (1948, pp. 60–61) that the paintings by Titian correspond to Pietro Bembo's theories of love in *Gli Asolani*: Chaotic Love (*Worship of Venus*), Harmonious Love (*The Andrians*), and Transcendent or Divine Love (*Bacchus and Ariadne*) has not found acceptance. The history of the execution of the paintings contradicts any such preconceived scheme.
182. See Hope, 1971, pp. 643–644; Mezzetti, 1965, pp. 60–61; Gibbons, 1968, pp. 28–29.
183. Dosso's *Bacchanal* is usually regarded as the picture in the

National Gallery in London (see Walker, 1956, pp. 36–37, fig. 20; Gould, 1962, pp. 53–55, no. 5279; Gould, 1969, p. 6, pl. 4). Taken to Rome along with the pictures by Bellini and Titian, Dosso's *Bacchanal* appears in the Aldobrandini Inventory of 1603, no. 154 (Onofrio, 1964, p. 162) as a 'large picture of more Gods with a ram, chameleon, and a panoply (?)' ('un quadro grande di più Dei con un montone un camaleonte, et un armatura del Dosso'). See also Gibbons, 1968, pp. 241–243. Charles Hope has pointed out that the Aldobrandini picture from Ferrara does not correspond to the London picture (Hope, 1971, p. 641, note 4).
 Battisti (1960, p. 125) placed three pictures in the *Studiolo* on the long wall containing two windows opposite the two Titians and the Bellini, but there seems to have been no space for such a scheme.

Worship of Venus

EACH of Titian's pictures is so enchanting that it remains difficult to prefer one to the other. The *Worship of Venus* (1518–1519), the first delivered (Plates 39, 42–45), might have remained his only picture in the room so far as the artist knew at this point. It is generally agreed that he had been sent Fra Bartolomeo's sketch (Plate 40) for the same subject. Titian adopted the idea of the presiding statue of Venus, but he moved her to the right side. Otherwise only the nymph with raised arm holding the mirror corresponds in any way to the Florentine's composition. He would have arrived at a centralized design, based on the principle of axial symmetry, and he would have built a pyramid of figures about the statue. Such were the traditions of Leonardo, of the Florentine school in general, as well as of Fra Bartolomeo and of Raphael in his Florentine period.

Titian composed in such a way that the statue of Venus and the two nymphs at the right are balanced at the left by the masses of trees with their warm, rich, green foliage extending over more than half of the composition. The description by the late Greek writer, Philostratus the Elder, the source surely proposed by Duke Alfonso d'Este, is followed to an extraordinary degree of exactness: The trees with spaces between to walk in; the Cupids gathering apples from the branches, and below, other Cupids collecting the apples in baskets; they eat, they sleep, they toss the apples. Some wrestle; others embrace; the one who draws his bow at the right aims an arrow that makes the wounded fall in love. Interestingly, the pair embracing at the front right consists of a boy with short curly blonde hair and blue wings and a girl Cupid [sic] with long chestnut hair reaching down over her shoulders. The two nymphs, one of them in white and the other in a rose skirt and white blouse who raises aloft a mirror [so described by Philostratus, though here it resembles a tambour], are there to do honour to Venus, who presides over the general gaiety. And all of this is 'heavenly love' [again according to Philostratus]. Titian added the charming rabbit in the centre of the middle ground, which a tiny Cupid is petting, because, I believe, the artist loved rabbits. Philostratus[184] also justifies its inclusion as follows: 'But there is no shooting at the hare since they are trying to catch it alive as an offering most pleasing to Aphrodite. For you know, I imagine, what is said of the hare—that it possesses the gift of Aphrodite to an unusual degree.' In the distance rise a tiny church tower and the long sloping roof of a farm house, so familiar in Titian's early works.

The ancient Roman sources in the *Worship of Venus* are minimal. The statue of Venus perforce by its very subject owes something to the antique. Her left hand holds the drapery about her knees as in the type known in many Roman copies, but best represented in the *Venus of Melos* (Paris). Her right hand in a rather unusual motive offers a sea shell, since she was born from the waves of the sea and floated to shore upon a shell. As for the rest of the composition, I see no classical borrowings at all. The two nymphs at the right (the canvas has been cut down a few inches here) are pure Titian in their abandon and gaiety.[185]

184. Philostratus the Elder, *Imagines*, I, 6. Cat. no. 13 includes quotations of the literary sources.
185. Otto Brendel sees dependence on an antique sarcophagus of the *Story of Medea* at Mantua (Brendel, 1955, p. 117, fig. 7), but I cannot detect the slightest similarity in dress or in movement to the Titian nymph with the mirror.

Cherubs and *putti* were especially beloved of Renaissance artists as the most charming creatures possible in which an artist could study nature and at the same time allow his imagination full play. One immediately thinks of Luca della Robbia's raucously rushing cherubs in the *Cantoria* (1431–1438) in the Opera del Duomo at Florence and Verrochio's enchanting fountain figure, the *Putto with a Dolphin* in the Palazzo Vecchio at Florence. Titian had seen none of these, but the Renaissance tradition was widely established and he knew well Donatello's high altar (1446–1450) of Sant'Antonio at Padua, although not yet the same artist's *Cantoria* at Florence or his pulpit at Prato.[186] Donatello's boyish cherubs are among the most delightful and the most salty of the entire Renaissance. Titian must have loved and admired them, even though he did not imitate the style of the Quattrocento master. The immediate precedent for Titian's Cupids are the cherubs who bear the Virgin heavenward (Figure 18) in his own *Assumption of the Virgin* (1516–1518).[187] Yet the differences are at the same time considerable, explainable by the subject matter, in the one case religious, in the other profane. The Cupids of the *Worship of Venus* are fuller-grown, chubby, frolicking, and mischievous. They have abundant curly hair, some with blue wings and others with wings of pink and white. The variety of their actions and movements is extraordinary—captivating and imaginative as only a very great master can conceive them. They diminish in size from foreground to distance, as the laws of perspective demand, and farthest away is a little group of five, who play ring-around-the-rosy. The distant landscape and sky are bluish, as customary in Titian's work, but the rich green of the luxuriant trees establishes the predominant colour. For the sheer beauty of these delightful Cupids none else can compare, save such an exquisite figure as the Christ Child in Michelangelo's early marble group of the *Madonna and Child* at Bruges,[188] but the spirit is, of course, somewhat solemn there.

Bacchus and Ariadne

THE most vigorous of all the paintings in Alfonso d'Este's *Studiolo* was the *Bacchus and Ariadne*, now in London (Plates 48–56). As one entered from the Duke's bedroom, one must have been impelled instantly to turn to the left and look at this masterpiece on the end wall. The pitch of excitement could scarcely have been greater, as Bacchus, naked save for rose-coloured drapery, which itself contributes to the dash and the leap, first espies the wandering Ariadne. She gathers her abundant blue and white draperies and is about to flee, frightened at the appearance of the young god with his spirited, clamorous train of followers. Titian made it obvious that this was their first meeting: 'so he [Bacchus] spoke and jumped from the chariot lest she be frightened by the tigers.' The handsome beasts in the picture are cheetahs, which Titian must have seen in the d'Este zoo at Ferrara.[189] Bacchus himself, with

186. For Donatello, see H. W. Janson's *Donatello*, 1957, pls. 259a–263b. Other great Florentine masters of the *putto* were, of course, Desiderio da Settignano and Antonio Rossellino.
187. See Wethey, I, 1969, Plates 18–19.
188. Tolnay, I, 1943, pl. 44.
189. Ovid, *Ars Amatoria*, I, 525–564. See Cat. no. 14, Iconography, for a discussion of the sources of the *Bacchus and Ariadne*.
 Renaissance princes made a habit of collecting exotic animals.

A letter from Louis XI of France to the Duke of Ferrara in 1479 thanked him for the gift of a handsome leopard (Lloyd, 1971, p. 62). It may be recalled that Alfonso d'Este wrote on 29 May 1520 to his agent Tebaldi in Venice, requesting that Titian paint from life a 'gazelle' that Joanni Cornaro had in his possession at Venice (Campori, 1874, p. 590). Tebaldi replied that when he and Titian had gone to see the animal, they had learned that it had died and had been thrown into a canal ('andato in compagnia

his athletic leap involving Renaissance *contrapposto*, was surely observed from nature. Titian's control of anatomical rendering is masterly, but it is the spirit of youthful determination and amorous intent which makes Bacchus an unequalled figure in both movement and irrepressible high spirits.[190] The Renaissance principle of opposition and contrast is used here with particularly telling effect in the major action: the timorous Ariadne, clothed and seen from the back, is poised for flight, while the ardent youth, naked and in frontal view, leaps to intercept her.[191]

In the procession, most captivating is the baby satyr, a wreath of jasmin leaves and blossoms in his hair, as he gaily marches along, accompanied by his black dog and dragging the head of a calf. What a mischievous, joyous infant he is! The bacchante with blue skirt and rose tunic raises one cymbal, in a most beautifully rhythmic pose, ready to strike the other cymbal in her left hand. Her sturdy leg comes out clear and strong, and its splendid state of preservation is remarkable. She is echoed by a second bacchante in white, who swings her tambourine with spirit. A bronze-skinned Herculean individual, heavily bearded, is entwined with snakes, which he appears to be about to overcome. Here Titian followed Catullus' words 'girding themselves with serpents' in a figure which has misled many critics and spectators into identifying him as Laocoön.[192] Except for the serpents nothing about the pose, the physique, or the head displays any similarity to the well-known late Hellenistic group in the Vatican Museum. Near him the shaggy-legged satyr raises part of the lower leg of an ox like a weapon in his right hand. Grape-leaves crown his head and girdle his waist. He grips in his left hand a long pole also entwined with large grape-leaves, exquisitely painted and most lovely in the variegated tones of green. This pole must be intended as the thyrsus carried by the followers of Bacchus, even though it is not topped by the normal pine cone. In the right distance the fat drunken Silenus, a wreath of grapes and vine leaves on his head, lies asleep upon an ass, prevented from falling to the ground by an elderly attendant. Another male figure at the very edge of the picture struggles forward, bowed down by the weight of a cask of wine. Titian did not attempt to reproduce antique draperies with archaeological fidelity, as Andrea Mantegna had done before him. The draperies in the *Bacchus and Ariadne* conform to no specific kind of dress. They function as colour and movement and play their part in space relationships—most notably in the figure of Bacchus, whose rose drapery against the blue sky of the distance helps to bring him forward in the centre foreground.

Exquisite details are present everywhere in the extraordinary beauty of the green foliage of the trees and of the light, fresh, green grape-leaves that cling to them. Charming flowers accent the foreground: beside the snake-bearer a purple iris and a tall columbine and between his feet a spiny plant commonly

di Tiziano alla casa dei Cornaro per vedere quella Gazzella, ma colà gli fu detto che era morta . . . gli fu risposto che la bestia era stata gettata in un canale'; *loc. cit.*). They were shown a picture of it by Giovanni Bellini. This matter has been discussed by Mrs. Shapley (1945, pp. 27–30) and the Tietzes (1949, pp. 90–95).

Later in 1532 Titian painted for Federico Gonzaga the portrait [*sic*] of a strange animal that had arrived in Venice from Alexandria (C. and C., 1877, I, pp. 454–455; Braghirolli, 1881, pp. 56–57; Wethey, I, 1969, p. 17).

190. I cannot agree with Otto Brendel (1955, p. 188, fig. 11) and Panofsky (1969, p. 143, fig. 53) that Titian was inspired by the Orestes sarcophagus, now in the Museo Laterano in the Vatican.

This very mediocre figure corresponds only in that his head turns to our left and that his right arm with dagger cuts across the torso, but the arm is lifted up high and Orestes does not even leap.

191. Any relationship of these two figures to the traditional composition of an *Annunciation* seems doubtful (Gould, 1969, p. 21).

192. Roncaglia in his letter to Cesare d'Este on 1 December 1598 describes the *Bacchus and Ariadne* as 'quadro di mano di Tiziano dove era dipinto Lacoonte' (A. Venturi, 1882, p. 113; Hope, 1971, p. 641). Hans Tietze (1936, I, p. 191) took it to mean that Titian had painted a picture of the Laocoön for Ferrara and failed to recognize the fact that the *Bacchus and Ariadne* was the work involved.

known as a horsetail (*equicetum*); just below the baby satyr (Plate 52) the glorious white blossom with its crown of fragile stamens and the trailing vine of the Mediterranean caper (*capparis spinosa*).[193] That Titian observed and painted flowers so delicately has hitherto been largely overlooked.

As one turns from details to look at the whole composition of the *Bacchus and Ariadne*, one is struck by Titian's ability to recreate the gay ebullience of the golden age of antiquity in the way a Renaissance man imagined it. The spirit is remarkably like that of a late antique relief now in the British Museum (Plate 55)—the dance-like movements, the sheer joyousness, and the abandon to pure physical pleasure. However, no implication is intended that the artist had seen this particular sculpture.[194] Titian here produced a great Venetian masterpiece. The colour has the richness and warmth known only to himself and anticipated only by Giovanni Bellini and Giorgione. The landscape is close at hand, not a distant background as in the work of Perugino and Raphael. The only centralized figure is the baby satyr, who stands exactly in the middle of the canvas; otherwise the figures are disposed freely, most of them to the right, yet an all-over balance is attained through the miraculous handling of masses and colour. The *Bacchus and Ariadne* is a unique achievement that flowered from the imagination of a supreme genius.

The Andrians

IN Alfonso d'Este's *Studiolo* the *Andrians* occupied the first space on the long wall, with the *Bacchus and Ariadne* at its left on the end wall and the *Feast of the Gods* by Bellini at its right. If Titian planned any compositional unity among these pictures, it is restricted to the landscape. The masses of trees on the left side of the *Andrians* do adjoin those on the right side of the *Bacchus and Ariadne*. The free view of distant landscape and sky then opens to the opposite side in each case. Of figure relationship between the two compositions, there is none. The intermediate background of the *Feast of the Gods* (Plate 47) does effect a degree of unity in the similarity of trees and leaves, which lessens the shock of the total disparity between the stately bearing of actors of the *Feast of the Gods* and the rhythmic movement of the figures in the paintings that flank it.

In the *Andrians* (Plates 57–64) the dancing movements and the swaying bodies convey the spirit of Bacchanalian abandon, and the extraordinary beauty of the sleeping nude Ariadne brought the picture great renown. The *Andrians* was long the most admired of the four paintings from Ferrara after they reached the cosmopolitan centre of Rome, and references to it and its copies far exceed those to all of the others. The sleeping Ariadne (Plate 58) inspired the Baroque artists of Rome to an extraordinary degree, among them Poussin, Pietro da Cortona, and Carlo Maratta.[195] A cluster of leaves was added

193. Often cultivated for its buds, which are used in sauces, the caper displays snowy white or very pale pink flowers. It grows in the crevices of rocks or the crannies of old walls, and in Rome its profusion of blossoms may be seen in late June on vine clusters in many parts of the city. See Everard and Morley, 1970, plate 148D for the best pictorial representation, and the colour plate illustrating 'cappero' in the *Enciclopedia italiana*, VIII, 1930, p. 894. The horsetail and other plants described here were identified with

the help of Dr. Emma Mellencamp and members of the Botany Department of the University of Michigan.

194. British Museum, cat. no. 2193, a copy *c.* A.D. 100 of a prototype of the fourth century B.C. Another relief of the identical subject, but of lesser quality in the carving, is cat. no. 6726 in the Museo Nazionale at Naples; Alinari photograph 11164; also reproduced by Bieber, 1961, fig. 802, as Augustan.

195. See Walker, 1956, *passim*; Blunt, *Poussin*, 1967, *passim*.

over her middle in Podestà's engraving of the *Andrians* (*c.* 1636) and in Rubens' free copy (Plate 66); it apparently existed when Van Dyck sketched the composition (*c.* 1622–1623).[196] This detail, now mercifully removed, would logically have been added in Rome during the ownership of Cardinal Pietro Aldobrandini in the early years of the seventeenth century. Titian portrayed her nude on the authority of Catullus (*Carmina*, LXIV, 64–71) (see colour reproduction).

The composition unfolds across the picture space. At the extreme left (Plate 57) a fat Silenus drinks deeply from a jug while behind him a male figure carries a large urn of wine upon his shoulders. Toward the centre two young men, the left one nude and the right one in a rose-coloured tunic, bend and flow in a dance, which creates an oval pattern in the design, as the nude youth pours wine into the upraised cup of the girl (Plate 64), who reclines below.[197] These two youths produce a slightly off-centre accent, about which the entire composition revolves (Plate 57). Just to the right and slightly behind are two other dancing males; the one, in a white tunic, holds aloft a pitcher of wine and faces forward, while the second, in a rose tunic with grape-leaves in his hair, looks over his shoulder. These two young men, seen in three-quarter view, furnish a link to the dancing girl, whose white costume floats gracefully with the movements of the dance. The principle of opposition and contrast is again carried through in the male companion, who faces inward and reveals the breadth of his handsome rose tunic, as he holds a garland of leaves in his right hand. High above in the background a powerfully built, yet elderly and grey-haired man lies asleep (Plate 63). He is usually identified as a river god. Just in front of the dancing couple is the urinating *putto*, an altogether charming little fellow and quite inoffensive in his babyish motivation. This theme occurs frequently in antique sculpture on sarcophagi and in fountain figures.[198] It has been demonstrated that the child represents *Laughter*, since the same motive in Francesco Colonna's *Hypnerotomachia* of 1499 is so labelled.[199] Philostratus himself includes this figure: 'He [Dionysus] leads Laughter and Revel, two spirits most gay and fond of the drinking bout.[200] At the left two girls, each holding a recorder, recline upon the grass (Plate 64), and a nude youth bends forward to scoop wine in his pitcher from the stream of wine, which flows upon the island of Andros. Another nude male sits in a marked *contrapposto* to their right, and he appears to fondle a girl's ankle.[201] The handsome effect of this powerful male with his heavy thatch of hair has been remarked by various writers and the conclusion drawn that Titian must have seen a fragment of Michelangelo's cartoon of the *Battle of Cascina*. There was a figure in a similarly remarkable state of

196. Walker, *loc. cit.*, figs. 41, 58, 60; Van Dyck's 'Italian Sketch-book', Adriani edition, 1940, pl. 56 (53).
197. Panofsky (1969, p. 20, fig. 116) proposed that Titian borrowed the nude youth from a drawing by Beccafumi. This drawing at Chatsworth is also known in a copper engraving (catalogued by Sanminiatelli, 1967, p. 132, no. 2; p. 137, no. 3, datable about 1525).
 Felton Gibbons' (1968, p. 14) idea that the nude youth is derived from the Borghese warrior is open to question for the simple reason that the straight-armed pose of the antique work is unlike the rhythmic flow of Titian's youth.
198. See the sarcophagus in Paris (Vermeule, I, 1960, part 5, fig. 16). It is difficult to follow Panofsky's (1969, pp. 99–101) association of the theme of the *Three Ages of Man* with the *Andrians*.
199. The Greek inscription is upon the pediment-like frame. The

book is unpaged but it appears in Chapter 8, p. 7. The identification was made by Harry Murutes (1973, pp. 518–525). Mr. Murutes also believes that the sleeping girl represents Sleep (*Kōmos*), as defined in Byzantine dictionaries. Panofsky rejected the general theory that she is the abandoned Ariadne and proposed that she should properly be regarded simply as a maenad (Panofsky, 1969, p. 102). See also note 206.
200. The absence of Bacchus and his train in the *Andrians* is most obviously explained by their appearance in the painting of *Bacchus and Ariadne* (Plates 48–50).
201. There has been some tampering with the left leg of this man, possibly due to paint losses which have been repaired or to changes for the sake of modesty. X-rays of this section might resolve the issue.

contrapposto at the extreme right of Michelangelo's dismembered composition.[202] The celebrated cartoon, removed from the Palazzo Vecchio to the Medici Palace at Florence in 1515, was cut into pieces, all of which are now lost. The theory has been advanced that Titian saw some of the fragments at Mantua in 1519 and so copied the pose of this particular figure.[203] That may well be the case, but it has not been established that this very fragment had yet reached Mantua.

The two girls reclining upon the grass, dressed in more or less contemporary Renaissance garments, pause in their playing of the recorders, and one lifts her large flat wine cup to be refilled. It is this girl who has traditionally been identified as Violante, Titian's presumed mistress. The placing of the signature TITIANVS on the edge of her blouse and the violets that nestle against her breasts[204] are responsible for the romantic legend. The music (Plate 60) before them upon the ground has been transcribed and studied more than once. The text reads:

'Qui boyt et ne reboyt
Il ne scet que boyre soit.'

The word 'Canon' at the side of the sheet indicates that the melody is to be sung by several voices, and the music has been tentatively attributed to a Flemish composer, Adrian Willaert,[205] who lived at the Ferrarese court in the fifteen-twenties. Though each of the girls holds a recorder and a third one is partially visible among the cups near the girl's foot, the dance must be at the moment accompanied by singing voices.

Other details should also be mentioned. The heads of two rustic youths behind the nude who sways

202. Best seen in the grisaille copy at Holkham Hall; see Tolnay, 1943, I, pl. 232; also known in a copy drawing in the Albertina at Vienna (Köhler, 1907, p. 158, fig. 91).

203. Sestola's letter to Isabella d'Este, dated 22 November 1519, reported that Dosso Dossi and Titian had come from Ferrara to Mantua and that they had seen her *Studiolo* and the works of Mantegna (Luzio, 1913, p. 218). It has been assumed that they also saw fragments of the *Battle of Cascina* in the house of Uberto Strozzi because of the somewhat Michelangelesque youth in Titian's *Andrians*. It must be pointed out that there is no mention of Michelangelo in Sestola's letter and that we do not know when Uberto Strozzi took fragments of the cartoon to Mantua. They are mentioned much later by Vasari (1568)–Milanesi, VII, p. 161, as being in Uberto Strozzi's house: 'alcuni pezzi che se veggono ancora in Mantova in casa di Messer Uberto Strozzi.' The problem arises as to who was this Uberto of the Mantuan branch of the Strozzi family. In the genealogical tables assembled by Litta-Passerin, vol. VI, tavola XIV, appears an Uberto Strozzi (1505–1553), son of Tommaso Strozzi who had married Francesca Castiglione, sister of the famous writer, Baldassare Castiglione. This Uberto Strozzi went to Rome as a youth and in 1539 became an Apostolic notary. Buried in S. Maria sopra Minerva in Rome, his tomb is reproduced in a line drawing by Litta. These data do not help in establishing when the fragment of Michelangelo's cartoon reached Mantua. Even if Vasari is correct in fixing upon the name of Uberto Strozzi, this man might have inherited it from his father or from another relative. About 1546 Michelangelo gave both of the 'Slaves' now in the Louvre to Roberto Strozzi of the Florentine branch of the family, then living in exile in Lyons. See above, note 149.

That Titian lifted the pose from the cartoon has been assumed

by Tietze (1936, p. 103) and Panofsky (1969, p. 20) without explanation as to how it came about. Gibbons (1968, p. 14) flatly stated that the whole composition of the *Andrians* as well as the reclining youth are indebted to the *Battle of Cascina* and that Titian's picture is a Romanist archaeological work. This view appears to me extreme. Charles Hope (1971, p. 715, note 11) proposes that Titian saw fragments of the cartoon on his visit to Mantua in 1523. The history of the cartoon for the *Battle of Cascina* was fully studied by Wilhelm Köhler, 1907, pp. 115–172; a summary in De Tolnay, 1943, I, pp. 209–219, pl. 232.

Rubens' *Baptism* from the Jesuit church of Mantua, now in the Antwerp Museum, does not help in solving this problem. It is generally agreed that the giant nudes at the right, removing their clothes, were inspired by the fragments of Michelangelo's cartoon, then in Mantua. However, Rubens did not actually reproduce any specific figure by Michelangelo, so that this work does not help in establishing what fragments were known to him. The reclining youth in Titian's *Andrians* has no counterpart in Rubens' *Baptism*.

204. See Wethey, I, 1969, pp. 13–14; II, 1971, Cat. no. X–115, Plate 222. The violets are present in this portrait of the so-called *Violante* in Vienna, which seems to be a work of Palma il Vecchio, although others have attributed it to Titian. No one has suggested that she was Cecilia, Titian's mistress and mother of Pomponio (born 1524) and Orazio (born 1525), whom he married during her severe illness in November 1525.

205. The major study was published by Smith, 1953, pp. 52–56. Dart (1954, p. 17) offers some disagreement, but Winternitz (1967, pp. 51–52) accepts Smith's findings. Panofsky (1969, p. 101, note) adds some musical theory supplied by the musicologist, Professor E. E. Lowinsky.

as he pours the wine seem to be no more than fillers. In the background, between the waving hands of the two dancing males, can be seen the sea and a handsome boat with four great sails full-blown in the breeze, the faithless Theseus departing [rather than Dionysus, arriving, according to Philostratus]. A charming vignette just below reveals a seated peasant accompanied by his hound (Plate 61) and meditating over a large crater in antique style. A crystal vase adds a lovely touch of transparent glass against the thick green foliage. At the extreme upper left are brilliantly painted fresh green leaves and a luscious cluster of fully ripened white grapes. At the upper right upon a branch sits a guinea-fowl (Plate 59), accurately rendered with tiny spots of white pigment, solemn and motionless as though disapproving of the frolicking that goes on below.

The *Andrians* is one of Titian's great achievements, a work for which there is no real precedent save his own *Bacchus and Ariadne* (Plates 48, 57), then so recently completed. It is an invention of sheer genius, which brooks no explanation through stylistic borrowings from this and that Renaissance or antique source. The beauty of the landscape, the massing of trees at the left, the lovely distance of sea, sky, and clouds provide the perfect Arcadian setting for the revellers. The several figures are woven into the tapestry, in which each takes his inevitable place. A major accent lies in the two male figures whose waving arms and bending bodies create an ellipse enclosing those upon the ground beneath them. To the right the three dancing men and the girl spread across like a wall, and the composition ends with the unforgettably beautiful nude Ariadne fallen into deep sleep, unabashed in her sheer voluptuousness (Plate 58). The numerous copies, already commented upon, are eloquent evidence how much other painters have admired her. Generally known as 'Ariadne', there is no absolute proof that she is the hapless maiden whom both Theseus and Bacchus loved and left; yet her presence in the *Andrians* as Theseus sails away is perfectly appropriate. Some prefer to call her simply a nymph or maenad, but Ariadne herself was the leader of the maenads.[206] A convincing case has been developed to prove that she symbolizes Drunken Sleep (Revel) following the Renaissance interpretation of the Greek word, *kōmos*, which Philostratus used in his text.[207] As she lies with her right arm behind her head, which rests upon an over-turned urn, her beautiful nude body is stretched out in an attitude of profound sleep and sensual abandon. Although the pose adheres to the traditional ancient formula for Sleep, no figure survives from antiquity that equals Titian's in the exquisite delicacy of modelling and beauty of form. Nevertheless, the Renaissance master must in this case have been inspired by one of the many sleeping Naiads, usually called 'the sleeping Ariadne'. Unlike Titian's 'Ariadne' (Plate 58), the Roman and Hellenistic sculptures of this type are virtually always clothed, but with one breast exposed. They occur on Roman sarcophagi even more frequently than in single statues.[208] One of the best known examples in the round is the handsome, though much restored, 'Sleeping Ariadne' in the Vatican Museums (Figure 24).[209]

206. Margarete Bieber (1961, pp. 112–113, 145) accepts the traditional identification of the sleeping girl as the abandoned Ariadne. Meiss (1966, p. 352) pointed out that Ariadne could also be identified as the leader of the maenads. The source is Propertius, *The Elegies*, II, III, 18. Panofsky (1969, p. 102) and Fehl (1957, p. 165) definitely prefer to call her a nymph.

207. Murutes, 1973, p. 521.

208. Examples cited by Meiss, 1966, figs. 12, 13, 22. The Mantuan drawing, *c.* 1480 (Plate 62) in the West Berlin drawing collection may indicate a source in Mantua. See Winner, 1967, p. 110; Fiocco, 1969, p. 45, fig. 14.

209. Bieber (1961, pp. 112–113) regards the Ariadne as a Hellenistic type of the school of Pergamon. Amelung also (1908, II, no. 414, Taf. 57) considered this statue to be Greek. The belief is widely

With the completion of the Ferrara mythological compositions, Titian established himself as the greatest of all artists in this realm. Mantegna's famous paintings in Isabella d'Este's *Studiolo* at Mantua may already have seemed somewhat stilted and old-fashioned. To be sure not everyone would have agreed to this judgment in 1529. For Titian the Ferrara pictures were only a beginning in a career that had just reached maturity. Yet the gaiety and carefree spirit of youth reached a climax here, and it is doubtful that Titian ever surpassed or equalled them in that respect. His later *poesie* for Philip II (Plates 83, 84, 134, 141, 142, 143), great as they are, involve a soberer view of life.

Titian in the Decade 1530–1540

IN the fifteen-thirties Titian's reputation spread even beyond the confines of the Italian peninsula. Earlier, in 1510–1511, he had travelled to work in nearby Padua and Vicenza,[210] and from 1516 he had visited Ferrara, particularly in connection with his great mythological pictures for Alfonso d'Este's *Studiolo*, which we have just studied. The advent of Charles V to be crowned Holy Roman Emperor at Bologna marked a turning point in Titian's career. Federico Gonzaga arranged to have Titian come from Venice to Mantua, there to paint the new Emperor's portrait, according to a letter of 11 October 1529,[211] but the Emperor actually sat for the artist at Bologna at the time of the coronation ceremonies, which took place on 24 February 1530. On the Emperor's later return to Italy, this time to confer with Pope Clement VII after their bitter warfare, Federico Gonzaga again urged Titian to come to Mantua in a letter of 7 November 1532.[212] However, it was for a second time in Bologna that the Emperor allowed Titian to prepare his portraits. Ferrante Gonzaga, then at Bologna, wrote to his brother Federico on 14 January 1533 that Titian's new likeness had been greatly praised.[213] Indeed Charles V was so delighted with the artist's work that he issued a patent of nobility and conferred upon him the title of Knight of the Golden Spur and Count of the Lateran Palace.[214] Some time during this period

held that the sleeping nude female in the *Pardo Venus* (Plates 74–76, Cat. no. 21) and other works by Titian and Giorgione was inspired by the mediocre woodcut in Francesco Colonna's *Hypnerotomachia* (1499). Proposed by Saxl (1957, I, p. 162), the idea has been accepted by Kahr (1966, p. 119) and by Meiss (1966, p. 350). However, the only points in common are that the woman is nude and that she is asleep upon the ground, and the woodcut is so inferior that I doubt whether a great master such as Titian would have taken notice of it.

210. Wethey, I, 1969, p. 10, Cat. nos. 93–95.

211. A letter from Calandra, the ducal chancellor at Mantua, to Malatesta, the duke's agent in Venice, the text to be published by its discoverer, Charles Hope (see Wethey, II, 1971, pp. 3 and 19). This first portrait, now lost, may have been *Charles V in Armour with Drawn Sword* (Wethey, *loc. cit.*, Cat. no. L–3, pp. 191–193).

 It has often been suggested that Titian may have met Correggio and have seen his works on a trip through Parma *enroute* from Mantua to Bologna late in 1529 or in 1532 (Boschini, 1660, edition 1666, p. 34).

212. Charles V appears to have reached Mantua on that very day, 7 November 1532 (Sanuto, LVII, columns 219–222). He seems to

have remained there until he left for Bologna, which he entered in the rain on 12 December at 11 p.m. (Sanuto, LVII, column 363). Foronda, 1914, p. 368, is probably in error as to Charles' whereabouts in November 1532.

213. Wethey, *loc. cit.*, p. 91 and Cat. no. L–4 and Cat. no. 20, Plates 51, 55. Of the three portraits painted by Titian in January and February 1533, only the *Charles V with Hound* in the Prado Museum at Madrid has escaped the fires in the royal palaces, first that of El Pardo in 1604 and the later one of the Alcázar in 1734. In addition to the portraits for Charles himself, Titian promised to send a replica of 'the Emperor's portrait' to Federico Gonzaga.

214. The original document is now framed and on display in the Casa di Tiziano in Pieve di Cadore, the artist's birthplace. See also: Wethey, II, 1971, p. 4, note 20. Because these letters patent were issued in Barcelona, Palomino (1724; edition 1947, p. 793) assumed that Titian had gone to Spain in 1553 [*sic*], and he even claimed that paintings in the Franciscan church at Puebla de Sanabria (Zamora) were painted then. These works, which disappeared in the nineteenth century, could not have been by Titian. The convent is in ruins and the small parish church contained no pictures when visited in August 1973.

or in the following year the Emperor commanded the painter to go to Spain in order to portray the Empress Isabella and their son, Prince Philip, aged seven. Titian procrastinated for several months and finally avoided the arduous journey to Valladolid,[215] luckily indeed for the development of his career. Otherwise the tremendous activity of this decade would have been drastically curtailed. Titian saw the Emperor again in May 1536, when he attended a conference at Asti in the retinue of Federico Gonzaga, but the high point of his relationship to Charles V was to come still later, during the artist's visits to Augsburg in 1548 and 1550–1551.[216]

Writers have often said that the fifteen-thirties marked a period of relaxation in artistic activity in Titian's career. Any such notion reflects a disregard of the numerous lost works for Charles V and his court,[217] as well as the lost *Roman Emperors* for Mantua. About twenty-five portraits survive from this period, when Titian's services were in demand not only by the Spanish–Austrian court, but also by Italian princes, including the Duke and Duchess of Urbino. For them he created the *Venus of Urbino* (Plate 73), the portrait of *La Bella*, as well as their own portraits.[218] The major patron remained Federico Gonzaga, Duke of Mantua, whose activities as a collector reached a high point at this time. Work at Mantua took Titian thither on many occasions, most often during Charles V's visits and in the later years of the decade.[219] Of the Gonzaga Titians, scattered since the sale of the Mantuan collection to Charles I of England in 1627–1628, the masterpieces of religious art are now in the Louvre at Paris.[220]

215. Documentation in Wethey, *loc. cit.*, p. 4, note 21.
216. Wethey, II, 1971, pp. 35–38, 41–44. Charles V's stay at Asti lasted from 26 May until 23 June 1536 (Foronda, 1914, 424–425).
217. Tietze, 1936, pp. 144–168, entitled his entire chapter on this period as 'creative pause' ('schöpferische Pause'). Among the lost portraits, in addition to those of Charles V, belong *Cornelia Malaspina*, favourite of Francisco de los Cobos, of 1530 (Wethey, II, 1971, Cat. no. L–22), and a portrait of Cobos himself, of 1542 (*loc. cit.*, Cat. no. L–8a). Still preserved are *Alfonso d'Avalos* of 1533 (Wethey, *loc. cit.*, Cat. no. 9, Plate 56) and the *Allocution of Alfonso d'Avalos, Marchese del Vasto* (Wethey, II, 1971, Cat. no. 10, 1539–1541).

The celebrated *Annunciation*, now lost, was presented to the Empress Isabella in 1537 (Wethey, I, 1969, Cat. no. 10, painted in 1536). Cassiano dal Pozzo's description of the picture, seen by him at Aranjuez in 1626, is quoted there and its history traced until its disappearance in 1814. The *Annunciation* was kept in the chapel of the castle of Simancas (Valladolid) during the lifetime of Charles V and the Empress Isabella. It is listed in an obscure place in the Inventory of 1561 after Charles' death (Beer, 1891, p. CLXXIV, no. 254). Since it does not appear in the detailed inventory of the chapel of Aranjuez after Philip II's death (see Sánchez Cantón, 1956–1959, I, pp. 108–117), it must have been taken there from Valladolid in the early seventeenth century, i.e. before 1626.
218. See Chronological List. About sixty works are datable in each of the most active decades, the fifteen-thirties, -forties, and -fifties.
219. The earliest visit took place briefly in November 1519 in company with Dosso Dossi to see Isabella d'Este's art collection

(see note 203). In February 1523 Titian stopped at Mantua (Braghirolli, 1881, p. 6) on the invitation of Duke Federico. Shearman (1965, p. 174) compiled a list of eleven visits to Mantua in connection with his study of Titian's portrait of *Giulio Romano*. As he pointed out, the suggested one of 1527–1528 is undocumented. It is also unlikely that Titian made the intended trip to Mantua with the *Roman Emperors* in the fall of 1538 (Luzio, 1913, p. 89, note), since they were not finally shipped until 4 January 1540 (see Cat. no. 12, Documentation). Letters to and from Federico Gonzaga and his emissaries establish the following occasions for Titian's sojourns at the Gonzaga court during the ten-year period: July 1530, October 1530, August 1532, September 1533, May 1536 when the artist accompanied the Duke to Asti, Christmas 1538, and November 1540; the urgent invitation of 7 November 1532 to go to Mantua doubtless concerned the return of Charles V to Bologna and Federico's arrangement for Titian to paint further portraits (References and the letters published by Braghirolli, 1881, are the major sources for this information: pp. 16, 49; 24, 37; 30; 26–27; 19, 50; 24–25; 36, 67; for November 1540, see Aretino, *Lettere*, edition 1957–1960, I, pp. 162–163).

A still unpublished letter of 11 October 1529 concerned Federico Gonzaga's desire to have Titian in Mantua when Charles V arrived (see note 211 above).
220. Also of this period is the *Presentation of the Virgin* (1534–1538) in the Accademia at Venice, the work of largest scale and one of the artist's major compositions of his entire career. The *Assumption of the Virgin* (1530–1532) at Verona should also be remembered (see Addenda I, Cat. no. 15).

III. HISTORICAL PAINTINGS

Roman Emperors

ONE of the artist's most ambitious projects, the series of eleven *Roman Emperors* was finished in the relatively short period of three years. Having promised to paint them in July 1536, Titian delivered *Augustus* (Figure 35) in April 1537. The major part of the work extended from mid-summer 1538, after the completion of the *Battle*, and through the following year until late 1539.[221] Paintings and sculptured busts of Roman Emperors enjoyed an enormous popularity during the Renaissance period. Even today most of the European royal palaces and other great residences, such as the Villa Borghese, have sets of Emperors, some antique and others Renaissance and Baroque in origin. Philip II, Titian's greatest patron, in the latter part of his reign owned copies of the artist's *Roman Emperors* at Mantua, as well as twelve busts in coloured marbles presented to him by the Cardinal of Montepulciano, and another series of twelve busts, also surely Italian. The garden on the south-west side of the Alcázar in Madrid was known as the Jardín de los Emperadores because of the sculptured busts located there.[222] The Vatican and Capitoline museums in Rome and also the Louvre in Paris possess a goodly number of ancient busts of Roman Emperors. In painting they are less frequent than in sculpture, but Andrea Mantegna's eight medallions, each enclosed within a wreath (1472–1474), in the Camera degli Sposi of the castle at Mantua, were justly celebrated and well known to Titian. The earlier artist also followed Suetonius' *The Twelve Caesars* in that he chose the first eight in the Roman biographer's list in the same order: Julius Caesar, Augustus, Tiberius (Figure 30), Caligula, Claudius, Nero, Galba, and Otho. The names prominently inscribed in the medallions survive except for those of Claudius and Nero, which have been defaced. Mantegna, the great student of antique art, painted an imitation coin of each Emperor as an ornament against his shoulder. That is proof enough of his intention to be as authentic as possible in representing the features of each ruler. Nevertheless, because of a certain degree of stylization in the decorative organization of the ceiling, he achieved less individual characterization than did Titian in his lost series.

Titian, as a matter of fact, painted eleven rather than twelve Emperors, adding Vitellius, Vespasian, and Titus (Figures 34–38, 40–45), to those listed above.[223] The reason is easily understood because the

221. See Cat. no. L–12, Documentation, for the letters that make it possible to follow the progress of the project. Except for the *Augustus* (1537), the *Roman Emperors* were probably all shipped from Venice to Mantua before 4 January 1540. We have no verification that Titian kept his promise to send three in September 1537.

222. For the painted copies see Cat. no. L–12, Literary Reference no. 3. The busts of *Roman Emperors* are recorded in the inventory of Philip II's possessions made after his death: see Sánchez-Cantón's publication of the Inventory of 1600–1602 (1956–1959, II, pp. 179–182). Here are listed the usual twelve *Roman Emperors* in half length with heads of white marble and the rest in coloured jasper. Another set of twelve is said to be in relief, 'de relieve'. The unpublished Alcázar Inventory, 1636, folios 51–52, places all

twenty-four in the Jardín de los Emperadores on the western side of the south façade of the Alcázar, but they are all described as busts. Consequently the term 'de relieve' must be disregarded. A full-length marble statue of *Charles V in Armour* also stood in the garden. It was not the famous bronze by Leone Leoni, which represents *Charles V Overcoming Heresy*, now in the Prado Museum. Gil González Dávila in 1623 (p. 310) makes a brief reference to this garden and the sculptures in it.

223. Simply because Roman Emperors were normally grouped in sets of twelve, following Suetonius' lives, both Dolce (1557-edition 1968, p. 194) and Vasari (1568–Milanesi, VII, p. 442) erroneously stated that Titian painted all twelve. The Mantuan Inventory of 1627 (Luzio, 1913, pp. 89–90) gives eleven to Titian and one to Giulio Romano. This attribution is also in error since

room, the Gabinetto dei Cesari in the Ducal Palace in Mantua, is so small that it allows only eleven spaces (Figure 31). The copies of the lost originals that now occupy the upper part of the wall are arranged beginning at the left as one faces the window. *Julius Caesar* is on the left of the window and on the right *Augustus*. Turning to our right, clockwise, we see *Tiberius*, *Caligula*, and *Claudius*. Again to the right, the entrance wall with the door in the centre presents *Nero* at the left of the door, *Galba* over the door, and *Otho* on the right side. On the fourth wall hang the portraits of *Vitellius* and *Vespasian*, while *Titus* is placed over the small door that leads into the Sala di Ganimede (earlier called the Sala dei Falconi). In this small chamber a twelfth picture hangs by itself, a very strange portrait that should be *Domitian* (Figure 50), but does not correspond to any of the engravings or painted copies. The attribution of it at Mantua is to Giulio Romano, yet, the lamentable condition of the canvas notwithstanding, the quality does not seem worthy of him. For the lower part of the walls in the Gabinetto dei Cesari, Giulio Romano provided beneath each Emperor an episode from his life. These paintings, a few of which survive in Paris and at Hampton Court, have been studied by Frederick Hartt and Egon Verheyen, the latter of whom prepared a hypothetical reconstruction of the Gabinetto.[224]

The stylistic importance of the eleven *Roman Emperors* in Titian's development during the fifteen-thirties has been largely overlooked by art historians.[225] These massive figures fill the picture space in a way that is eminently characteristic of Italian Mannerism. Titian's main contact with the style, as evolved in central Italy, came about through his numerous visits to Mantua and his knowledge of the work of Giulio Romano, who was busily engaged there from late 1524 until his death in 1546.[226] The *Roman Emperors* adhere to the formula of the state portrait in which the ruler is presented as something of a demi-god. An early and exceptionally stunning example is Sebastiano del Piombo's *Clement VII* (1526) in Naples, which the artist endowed with an imperial elegance and god-like aloofness.[227] Titian himself in his stupendous portrait of the *Doge Andrea Gritti* (*c.* 1535–1538) in Washington imbued his sitter with the sweeping power and ferocious intensity of some great, all-conquering monarch of Biblical Persia or Dynastic Egypt, a heightening of personality that goes far beyond the gentle improvement upon the features of Charles V and Philip II in his state portraits of the Hapsburgs.[228]

Lamo, the biographer of Bernardino Campi, wrote in 1584 (pp. 77–78), during Campi's lifetime, that he added the *Domitian*. This Emperor figures as no. XII in Aegidius Sadeler's prints (Figure 46). I cannot account for the *Emperor* (Figure 50) that was placed in the Sala di Ganimede in recent years.

224. Vasari, *loc. cit.*, refers to Giulio's stories of the Emperors' lives; also in the life of Giulio Romano, Vasari, V, pp. 544–545 and Hartt, 1958, pp. 170–179. The most interesting is the scene of 'Nero Playing While Rome Burns', a mythical event that originates in Suetonius and has no historical basis. See also Verheyen (1966, pp. 170–175) on Giulio Romano's stories for the Gabinetto dei Cesari and his reconstruction of their location beneath the relevant *Emperors*. Hartt (*loc. cit.*, pp. 176–177) also studied the ceiling frescoes, which are thematically related to the *Emperors*. None of the problems concerning Giulio Romano lies within the scope of a book on Titian. The photograph of the room, taken in 1972, was kindly supplied by Dr. Giovanni Paccagnini, then soprintendente.

225. Although Pallucchini (1969, p. 98) agrees that 'la crisi manieristica' begins with the portraits of the *Emperors*, he tends to place this general development later in the fifteen-forties (*loc. cit.*). Tietze (1936, p. 187 ff.) also dated the Mannerist development essentially in the fifteen-forties.

226. Hartt, 1958, p. 68 and *passim*. Giulio was born in Rome, and became Raphael's chief assistant. Hetzer (1923, pp. 243–248) has perhaps exaggerated the importance of Giulio Romano in the evolution of Titian's style.

227. Dussler, 1942, p. 136, no. 37.

228. In the National Gallery of Art at Washington. Dated by Wethey, II, 1971, p. 24 and Cat. no. 50, in 1535–1538. Pallucchini, 1969, p. 282, assumed the portrait to be posthumous, *c.* 1545, because of the monumentality of the composition.

For the state portraits of the Hapsburgs, Wethey, *loc. cit.*, Cat. nos. 21, 22, 78–84.

The true quality of the *Roman Emperors*, which perished in the Alcázar fire at Madrid in 1734,[229] is difficult to judge from the engravings and from the mediocre copies that have survived. Nevertheless, the handling of paint surfaces as well as the composition of the so-called *Hannibal* (Plate 67) give us some notion of the effect of these imperial portraits. The massive physique in the Mannerist spirit recalls Giulio Romano's *Alexander the Great*, which, on the other hand, lacks the pictorial beauty of Titian's picture.[230] Titian's own *Christ Crowned with Thorns* in the Louvre, with its muscular participants and violence of action, also bears comparison with the *Hannibal* and accounts for the dating of the latter *c.* 1545 by some writers rather than in 1532–1534, when a picture of *Hannibal* was painted for the Duke of Urbino.[231]

Titian's study of Roman coins in preparing the characterizations of his eleven *Emperors* is clearly borne out in the heads, just as his friend Lodovico Dolce reported in 1557. The notable exception is the *Augustus* (Figures 35, 35a), whose features do not conform to the well-known appearance of that Emperor. The drooping moustache and the curly hair are entirely the product of Titian's imagination and yet this painting, the first to be delivered, in 1537, must have been evolved with considerable thought. *Augustus* holds the baton of authority in his right hand and places his left upon the globe of the world, a curious anachronism. The architectural pier to the right in Sadeler's engraving is also repeated in Bernardino Campi's painted copy in Naples, but in general the settings in these portraits by Titian appear to have consisted of a plain background.[232] In preparing the other ten portraits Titian paid more serious attention to Roman coins. They were readily available to him in the collections of Venetian humanists and aristocrats, such as Andrea Odoni, whose portrait by Lorenzo Lotto (1527) introduces not only his marbles but also coins upon the table.[233] Especially important was the bequest of Cardinal Domenico Grimani's collection of antiques to the Venetian state and their installation in the Ducal Palace in September 1525.[234] The artist also had access to the Gonzaga antiques at Mantua. His friend Jacopo Strada collected coins, about which he published a book in 1553, but his activity may have begun too late to have been accessible to Titian in 1537.[235] Pietro Bembo owned marble busts of Julius Caesar, Domitian, and later Emperors.[236] It is therefore not surprising to discover that Titian's portraits are based on actual likenesses, as may be observed by comparison with the coins issued by the several Emperors (Figures 34–45a).

The gaunt, beardless features of *Julius Caesar* (Figures 34, 34a) are relatively authentic; he holds the

229. A complete account in Cat. no. L–12, History. The full bibliography on these pictures in Madrid has been overlooked by writers on Titian as late as 1969. Their description, when located in the Galeria del Mediodía in the Inventories of 1666, 1686, and 1700, was published by Bottineau in 1958, and the report of their destruction in 1734 was quoted by Beroqui in 1930 and Bottineau in 1960.
230. Hartt, 1958, pl. 466. This author notes (p. 218) the influence of Titian's *Roman Emperors* on this picture.
231. See Cat. no. 20 for full data.
232. The Düsseldorf drawing of *Augustus* shows a pilaster decorated with armour and shields, but these details are not present in any of the painted copies. See Cat. no. L–12, Drawings, p. 237.
233. Berenson, *Lotto*, 1956, p. 98, fig. 219; see also Marcantonio Michiel, Frimmel edition, 1888, p. 84.

234. Sanuto, XXXIV, 27 August 1523, column 387; XXXIX, September 1525, columns 427-428. According to the fullest inventory of the Grimani Collection in the Ducal Palace, that of the year 1586, there were eight busts of Emperors. Of these, Julius Caesar, Vitellius, and Vespasian were the only Emperors included in Suetonius' biographies. Augustus and Domitian had been identified among them by Pietro Bembo in a letter of 6 August 1525 (Paschini, 1927, pp. 155, 157).
235. Strada's *Epitome thesauri antiquitatum* was published at Lyons in both Latin and French in 1553. For a short biography of this remarkable man (*c.* 1515-1588) see Wethey, II, 1971, pp. 141-142.
236. Marcantonio Michiel, Frimmel edition, 1888, p. 24.

baton of authority and is crowned with a laurel wreath, a symbol of his rank. On the evidence of Aegidius Sadeler's print this composition, one of the most forceful, must have been an exceptionally handsome picture. The best of the surviving painted copies is the one formerly in the Schaffer Collection in Barcelona (Figure 32), even though the expression has become mild and less dramatic. Titian sought to achieve variety among the portraits of the Emperors, in the turn of the heads of the first two in opposite directions. Others, such as *Tiberius* (Figures 36, 36a) and *Caligula* (Figures 37, 37a), appear in profile, the first to the left and the second to the right. Back view as opposed to front view affords further contrast to avoid monotony in these two and in the *Titus* (Figure 45). The laurel wreath upon the head is also worn by the Emperors in alternation. *Caligula*, shown as a young man, clearly derived from a coin, is unusually handsome in his splendid Renaissance cuirass. In this instance the mild features of Caligula's coin predominate in the artist's conception, which does not characterize the savage tyrant that Suetonius describes.[237] For the cuirass of *Claudius* (Figures 38, 39) Titian had the loan of a suit of armour made for Guidobaldo II della Rovere of Urbino by the Negroli armourers of Milan and datable *c.* 1529. The cuirass of this suit by good fortune survives in the Bargello Museum at Florence, while other pieces have been identified in Leningrad and New York.[238] *Claudius* in profile faces *Caligula* and turns his back upon *Nero* (Figure 40), a burly man in full face, without a laurel wreath. The fierce intensity of his face, which is rather fat as in the coin (Figure 40a), reflects the usual reputation of Nero as unremittingly cruel and licentious. *Galba* (Figure 41) shows the elderly, serious face of the man who overthrew Nero and survived himself only six months. His head is turned toward his predecessor in what must have been an impressive composition of considerable dramatic power. In *Otho* (Figures 42, 42a) we see the coarse-featured assassin of his predecessor, whose own reign lasted only three months. Little would be known about Otho if his biographies by Suetonius and Plutarch had not survived. The coin no doubt aided Titian, but the design of the armour and the placing of the baton across the torso, as well as the turn of the head to the right, were evolved in his scheme for the interrelation of the designs of the entire series. Titian unmistakably felt the degeneracy and coarseness of the last four Emperors, all of whom are essentially repulsive, and he omitted the laurel wreath except in the case of *Titus*. The corpulence depicted in *Vitellius* (Figures 43, 43a) is borne out by the coin of this man, who ruled for only eight months; he surpassed even the legendary Nero in cruelty and immorality. The *Vespasian* shows a bald, fat, and unsympathetic figure, as the antique portrait indicates, but Vespasian's prosperous reign endured (70–79 A.D.), and he did much to reconstruct Rome after the devastation under Nero. Finally we have *Titus*, to whom Titian conceded a laurel crown (Figures 45, 45a), represented as a burly and energetic leader, as the painter imagined him. The physical bulk of these last rulers is projected in the ancient portraits of the medalist coin-makers, which provided the point of departure for the painter's interpretation in nearly every case. That *Titus* brought the series to a close is stressed by the placement of the body, which registers a complete stop at the right but is turned toward *Vespasian* at the left. Significantly the twelfth Emperor, the *Domitian* (Figures 46, 46a), painted

237. Many printed editions of Suetonius' *The Twelve Caesars* were available from the second half of the fifteenth century. Titian would have had access to the Aldine editions of Venice issued in 1516 and 1521 (Brunet, v, 1864, pp. 579–580).

238. I am indebted for this information to Mr. Stuart Pyhrr, a young and enthusiastic student of armour. The fact that Guidobaldo I of Urbino married Elisabetta Gonzaga, sister-in-law of Isabella d'Este, would explain the connection with the Gonzaga court. Data about the armour in Florence, Bargello: *Catalogo*, 1971, p. 34, nos. 772 and 778, fig. 11.

by Bernardino Campi a quarter of a century later at Mantua, in 1562,[239] is not integrated into the series, despite the fact that the artist imitated Titian. For one thing, the figure faces in the same direction as *Titus*, whereas Titian consciously sought variety in the pose and the direction of each Emperor in relation to his neighbours. As a matter of fact Campi's *Domitian* never hung in the Gabinetto dei Cesari. When exhibited in the Ducal Palace at Mantua, it may have been placed in the small adjoining room, the Sala di Ganimede. Aegidius Sadeler included the *Domitian* in his engraved series of the *Twelve Emperors*, and later Campi's picture was erroneously attributed to Giulio Romano in the Inventory of 1627, as noted below in Cat. no. L-12.

That Titian's *Roman Emperors* were greatly admired cannot be doubted. The fact that so many copies of the complete set were painted during the artist's lifetime is demonstration enough. Bernardino Campi (1562) alone made five sets of copies, for Philip II, the Emperor Ferdinand, and various Spanish notables. Fermo Ghisoni, a follower of Giulio Romano, provided copies (1574) for the then powerful Spanish minister Antonio Pérez, copies which after his imprisonment were apparently sold to Emperor Rudolf II at Prague. All of the surviving painted copies are in exceptionally bad condition, so that none of them nor Aegidius Sadeler's engravings afford any true idea of Titian's originals. Critical evaluation is not wanting, in the earliest instance Lodovico Dolce's in 1557, who wrote that they were of such perfection ('tanta perfettione') that many people travelled to Mantua solely to see them. Agostino Carracci is quoted as describing them as 'very beautiful and beautiful in such a way that none can equal them.'[240]

The Battle

THREE large battle scenes were projected by three great Italian masters in the sixteenth century, Leonardo's *Battle of Anghiari* (1503–1506) and Michelangelo's *Battle of Cascina* (1504–1505), both for the Grand Council Hall of the Palazzo Pubblico at Florence,[241] and Titian's *Battle Scene* for the Great Council Hall in the Ducal Palace at Venice. Yet it is an ironic fact that not one of them has survived: Titian's was destroyed by fire in 1577 and the other two never even reached a state of completion. Leonardo's and Michelangelo's cartoons, however, made a profound impression upon their contemporaries, even though they were soon destroyed.[242] Titian's, the last of the three, first undertaken

239. Lamo, 1584, pp. 77–78. See also Cat. no. L-12.
240. 'Molto bella e bella in modo che no si può fare più ne tanto', said to be written upon his copy of Vasari's *Lives* (Milanesi note in Vasari (1568)–Milanesi, VII, p. 442, note 2.)
241. See Wilde, 1944, pp. 65–81, for the history of the Grand Council Hall in Florence, which was built for the same purpose as the Sala del Consiglio Maggiore of the Ducal Palace at Venice. The new republic of Florence, set up in 1494 after the expulsion of the Medici, was inspired by the Venetian constitution, which impressed the liberal Florentines as a model form of government.
242. Leonardo's *Battle of Anghiari*, commemorating a Florentine-papal victory over the Milanese *c.* 1440, was begun in February–March 1504, but he stopped work before 12 May 1506. His attempt to adopt encaustic technique resulted in failure, since the paint ran down the wall. On 30 May 1506 Leonardo obtained permission to return to Milan, and to abandon this commission forever. The remains of the mural disappeared when Vasari rebuilt the hall for Cosimo dei Medici as his state audience hall in 1563. See Gould, 1954, pp. 117–129, for a reconstruction of the *Battle of Anghiari* by means of literary descriptions and the numerous preserved drawings.

The *Battle of Cascina* was to represent a victory over the Pisans in 1364. Michelangelo prepared his cartoon between December 1504 and 28 February 1505, but he stopped work on the mural within the year, and at the fall of the republic in 1512 the entire project of the Grand Council Hall collapsed. The room was turned into a barracks, only to be rebuilt a half century later by Vasari. For an account of the *Battle of Cascina*, the fullest is Köhler, 1907, pp. 115–172. Also see Tolnay, 1943, I, pp. 105–109, 209–219. Drawings by Hartt, 1969, pp. 45–61.

in 1513–1516, reached its final stage and was actually painted in its entirety in 1537–1538.²⁴³ His work, too, produced a strong impact upon other artists during its short existence of forty years and through the medium of engravings in the next century.

The major question concerning Titian's *Battle* is the uncertainty of the subject. It was number five in a series on the long wall facing San Giorgio, and Titian's work on canvas covered Guariento's ruinous fresco of the *Battle of Spoleto*. Francesco Sansovino in 1581 gave it the same title, while Vasari in 1568 had thought it represented a Venetian defeat at Chiaradadda (i.e. Agnadello) in 1509. Ridolfi in 1648 named it the *Battle of Cadore*, a Venetian victory over Emperor Maximilian in 1508. Since Ridolfi's day, and most especially from the mid-nineteenth century to the present, that name has clung to Titian's destroyed mural. The original documents speak of the scene only as the *Battle*, yet the weight of early evidence makes it part of the series of twenty-two largely mythical events in the twelfth-century struggle between the papacy and the Emperor Frederick Barbarossa.

The composition is preserved in an anonymous engraving in the Albertina at Vienna (Figure 52) and in a small painted copy, kept in storage in the Uffizi at Florence (Figure 51).²⁴⁴ Although it is best known in Giulio Fontana's engraving (Figure 54), there can be no doubt that Fontana elaborated freely on the original mural, which was still to be seen in his day. Fontana's entire landscape background varies so radically from that of the painted copy that one cannot be sure of his accuracy. The encampment of soldiers is neatly set apart from the battle, and the burning town of Spoleto(?) upon the mountains above belches great columns of smoke that are sharpened in their outlines in the engraving. More than that, Fontana added the procession of armoured soldiers on horseback to the right, that is, the whole cavalcade to the right of the white horse and the bulky soldier at the lower edge, for whom a page is fastening a shoulder piece. One of these additional soldiers carries a large banner upon which appear three 'leopards'. Fontana, apparently uncertain about heraldry, seems to have thought that this banner was a Venetian battle flag. Even Ridolfi mistook it for the emblem of St. Mark, and he suspected that the standing soldier in the right foreground was Bartolomeo d'Alviano, the *condottiere* for the Venetians at Cadore.²⁴⁵ Ridolfi's description shows that he had Fontana's engraving in front of him as he wrote, rather than a painted copy or the anonymous print (Figure 52). The leopard flag does not exist in the latter or in the Uffizi painted copy (Figure 51), which shows a pennant of rose-red stripes on white (or silver) beyond the centre of the bridge. While the leopard flag may be an invention of Fontana, the mysterious striped banner appears in all three versions of the *Battle* (Figures 51, 52, 54). These two standards have misled all writers who believed that they had reference to Venetian leaders at the Battle of Cadore. In his report to the Doge the *condottiere* D'Alviano wrote that he had set his

243. The documentation and the historical account of Titian's *Battle* are reported in my Cat. no. L–3.
244. Among other lost painted copies, see the *Conflict of Cadore* in Bartolomeo della Nave's collection in Venice—which later passed to Archduke Leopold Wilhelm (Cat. no. L–3, Literary References no. 3).
245. Ridolfi (1648)–Hadeln, I, p. 165. Bartolomeo d'Alviano (1455–1515) a celebrated *condottiere*, born at Todi, was made lord of Pordenone by the Venetian State as a reward for the victories won for Venice. Following his impressive defeat of the Imperial

forces at Cadore in 1508, he was captured by the French on 14 May 1509 and held prisoner for four years. On his liberation in 1513, he led the Venetian forces and fought with the French against the Spanish troops commanded by the Marchese di Pescara. He lost his life in the battle of Marignano on 14 September 1515. The Venetian government honoured him with burial in Santo Stefano at Venice. His memorial, a full-length standing statue in marble, is still to be seen in the church, over the door leading to the cloister (Cicogna, 1853, VI, p. 173; Crollolanza, 1886, I, p. 36; Pieri, 1955, I, pp. 587–591).

own banner upon the bridge, yet his battle standard was decorated with a unicorn purifying water.[246] Among the other flags one seems particularly relevant to the Battle of Spoleto: the red banner with the white cross of the Crusades in the middle distance (Figure 51). It is a symbol of the Christian church.[247]

Panofsky thought that the rose stripes on silver (he says 'barry of gules and argent') were d'Alviano's arms and that the banner added on the right side of Fontana's print was that of the Cornaro family.[248] However, neither conforms to the escutcheon of these families. On the other hand, the eagle of the Empire is unmistakable on the large fluttering standard above the white charger at the upper left, although it is not clear whether the Hohenstaufen or the Hapsburg eagle is intended. In any case, these are the Imperial forces that are being driven into a rout as men and horses are hurtled down the mountain side. Since Barbarossa was the victor at Spoleto, we are all the more convinced that Titian painted a *Battle* with little regard for history or legend. Crowe and Cavalcaselle,[249] who believed the subject to be the Battle of Cadore, thought that Titian did not wish to overemphasize the Imperial defeat at a time when the Venetians were on friendly terms with the Hapsburg Emperor, Charles V.

Titian painted his great mural in 1537–1538, thirty years after the Battle of Cadore took place in early March of 1508, and three hundred and seventy years after the legendary Battle of Spoleto.[250] He knew the countryside of his native Cadore well, with its Alpine peaks and the towers of the city above. All else is the product of his imagination for he had never seen Spoleto and the battle there was mythical.[251] His intentions are best judged in the large black crayon drawing in the Louvre (Figure 53) and the mediocre painted copy in the Uffizi (Figure 51). The swift sketch already contained the essential elements, which he modified later in detail. The white horse foreshortened he retained at the right, while the original artilleryman below became a bulky soldier in armour, whose shoulder piece is being adjusted by a page. Because of his prominence this figure has, as already noted, been identified both as the *condottiere*, Bartolomeo d'Alviano, and the 'provveditore', Giorgio Cornaro. If the facts of Cadore were followed, he could have been neither, since Cornaro was not present and d'Alviano should be one of the armoured soldiers charging the enemy on horseback. The girl who had fallen into the river, her foreshortened bare leg scraping the bank, is an artistic diversion and the only detail to

246. Gelli, 1916, p. 641; the banner, which d'Alviano used in the defence of Bracciano against Pope Alexander VI, is illustrated here. He lost it in the defeat at Vicenza in 1513.

247. Galbreath, 1930, p. 5. The Bandinelli escutcheon of the pope Alexander III, which was of diapered gold (*loc. cit.*, p. 70 and pl. IV), is absent.

248. Panofsky, 1969, p. 181. The Venier family, who had no association with the Battle of Cadore, had an escutcheon of rose and silver stripes (Crollalanza, 1886; Rietstap, 1934). Crowe and Cavalcaselle (1877, II, pp. 8, 11, 13) were the first to argue that the 'three lions passant' were the insignia of the Cornaro family, since Giorgio Cornaro was the 'provveditore' of the campaign at Cadore (see also Cat. no. L–3). The title 'provveditore' had a special significance in Venetian government. It is defined as 'titolo di carica e di dignità nella republica di Venezia' (Tommaseo and Bellini, 1879). The confusion of the terms 'leopard' and 'lion' is colourfully explained in the courtly phraseology of Oswald Barron (1910–1911, p. 325). He writes that the leopard is 'like the lion at all points. But as the lion looks forward the leopard should look sidelong, showing his whole face. ... As the lion rampant is the normal lion, so the normal leopard is the leopard passant, the adjective being needless.' Barron goes on to say that if, as some modern armorists do in the interest of a more realistic terminology, one insists on naming as lions such promenading beasts as those in the royal coat-of-arms of England [or those in the flag of the *Battle* print], one must describe them as 'three lions passant guardant', otherwise they cannot be reconstructed properly from the written description alone. It has not been possible to trace the source of the 'argent', i.e. 'silver', in the term 'three lions passant argent' (Panofsky, 1969, p. 181), since silver in heraldic engravings is represented by the white of the page and these beasts in Fontana's print are done in the diagonal hatching that to a specialist stands for green (Allcock, 1962, p. 15). [A. S. Wethey]

249. C. and C., 1877, II, pp. 7–8.

250. See Cat. no. L–3.

251. Tietze-Conrat's claim that the walled city resembles Spoleto is a flight of the imagination (1945, p. 206, note 24).

which Lodovico Dolce in 1557 gave much attention.[252] He admired the leg! A copy at Bergamo once passed as Titian's original (Figure 57). In a day when the foreshortened human figure and the nude body were much exploited by artists, it is curious that none of the writers of Titian's day commented upon the boldly foreshortened body of the dead youth in the left foreground. The fact is that such figures were widely used by Italian painters of the period, and the naked flesh provided a foil to the many suits of armour. Although the colour of the Uffizi copy (Figure 51) may be assumed to follow the scheme of the original, few conclusions can be drawn from this much reduced and frankly mediocre painting. The white horses stand out most against the gloom of the battlefield and the preponderance of dark steel armour. Occasional spots of red come through in the costumes. The rose and silver of the banner near the bridge affords a welcome contrast, and in the distant centre one can discern tiny red flags and the large red banner bearing a white cross.

To the modern eye Titian's original sketch (Figure 53) has more brilliancy than the finished picture, but we are judging the latter through a small copy and deprived of the full scale of the mural. The concept of the battle over a bridge is a brilliant achievement, for the bridge supplies a stable feature over which the torrent of the mêlée may flow. It was so successful that others adopted the composition, most notably Rubens in his celebrated *Battle of the Amazons* now in Munich (Figure 58). It must be admitted that the Fleming eighty years later improved upon the original, which he could have known only in a painted copy and in prints. Earlier drawings (Figure 56), if really by Rubens, show that he had long been interested in the composition. He achieved greater concentration by eliminating the mountainous background and the flaming city. Other pictures of a battle on a bridge that owe a debt to Fontana's print after Titian are Luca Giordano's *Battle of the Amazons* in Naples and, to a lesser degree, Pieter Lastman's *Battle of Constantine and Maxentius* in Bremen.[253]

Artists before Titian had introduced a bridge in a battle scene, but not as the central motive of the entire composition. Giulio Romano's *Battle of Constantine* in the Vatican *c.* 1523–1524 with the small Milvian bridge in the right background is an unlikely source of inspiration.[254] Neither does the bridge closely resemble Leonardo's, which is also inconspicuous in the background, but rather it is a creation of Titian's own imagination. The great contemporary fashion of a battle scene fraught with excited, rearing, charging, and frightened horses does have antecedents in the work of Leonardo and Giulio Romano, both of whom must have inspired Titian, even though he knew their work in Rome and Florence only in small copies and drawings. He had become acquainted with Giulio Romano personally at Mantua as early as November 1529 when Federico Gonzaga called him there preparatory to painting Charles V's first portrait at Bologna in January 1530.[255] He also visited Mantua in 1536, just before he was forced to begin in earnest to paint the mural of the *Battle*.[256] Titian had plenty of opportunity to keep abreast of artistic developments in central Italy even before his stay in Rome in 1545–1546. As early as November 1519, on what was apparently his first trip to Mantua, he accompanied Dosso Dossi

252. Dolce (1557)–Roskill, pp. 190–191.
253. See Cat. no. L–3 for derivants.
254. Hartt, 1958, pp. 43–48, fig. 58.
255. Wethey, II, 1971, p. 19, note 77; also in the present volume note 219. According to Foronda (1914, pp. 329–333) Charles V landed at Genoa and travelled via Piacenza and Parma to Bologna,

not stopping at Mantua until after the coronation in February 1530.
256. Braghirolli, *loc. cit.*, p. 30. The battle scenes in the Sala di Troia of the Ducal Palace at Mantua were begun in 1538, too late to have affected Titian (see Hartt, 1958, pp. 179–182).

from Ferrara as reported in a letter of 22 November, in which Sestola wrote to Isabella d'Este that the two artists had come to Mantua to see her *Studiolo* and the Mantegnas.[257] There is no reference to the presence of any fragments of Michelangelo's cartoon of the *Battle of Anghiari* at Mantua as early as 1519. We know only from Vasari in 1568 that some pieces belonged to Uberto Strozzi at Mantua, and from a letter by Guglielmo Sangalletti of 1575 that he attempted to sell them to Grand Duke Cosimo dei Medici at that time.[258] The theory that the fragments had reached Mantua fifty-six years earlier has yet to be proved.[259] Therefore it is most unlikely that they could have specifically influenced Titian at this time.

In the Louvre sketch (Figure 53) Titian displayed remarkable skill in representing the flow of battle like a mighty torrent, which rises from the lower right, sweeps over the bridge, and descends at the left, while massed troops march diagonally toward the castle at the upper left. The artist was concerned here with the whole rather than details. Yet a few figures rise above to accentuate the composition: majestic indeed is the horseman with the great helmet at the top right, about to advance over the bridge; another fine horse closes the composition at the lower left. Even though individual figures are subordinated to the whole, the full-length nude in back view on the left side and the artilleryman facing inward at the lower right are impressive. Great battle scenes had been painted a century earlier; one thinks immediately of Paolo Uccello's *Battle of San Romano*, but perhaps most of all of Piero della Francesca's *Victory of Constantine* at Arezzo (1452–1466). Yet the static nature of such works of the Quattrocento has nothing in common with Titian's violent fray. It was rather Leonardo, some of whose studies of horses and riders must have been known to the Venetian—the drawings for the Trivulzio monument, for the Sforza statue, and the *Battle of Anghiari*—that prepared the way for Titian's *Battle*. The rearing horses, the charging of cavalrymen and their clashing in battle to create an overpowering effect of men and beasts in mortal combat, all this Titian achieved after he had studied Leonardo's drawings.[260] As to just how he came to know them, we are uninformed. But they were widely circulated by the fifteen-thirties, when Titian began his final studies for his battle composition. Leonardo, dead at Amboise in 1519, had already become a legend. From the numerous artists who had visited Rome and the many who sought refuge in Venice in 1527 after the calamity of the sack of the papal capital, Titian had ample opportunity to keep abreast of central Italian developments.[261] Machiavelli's description of the Battle of Anghiari may have led Titian to dramatize his *Battle* by placing the main action upon a bridge. Machiavelli's account describes a group of Florentine horsemen driving Niccolò Piccinino and his soldiers across the bridge below the town of Anghiari, only to be chased back themselves in turn. A series of routs across the bridge lasted for four hours until Niccolò decided to retreat to Borgo San Sepolcro.[262] The leading role of the bridge here just might have appealed enough to Titian's imagination for him to make it the central motive of his composition.

257. Sestola's letter to Isabella d'Este in Luzio, 1913, p. 218. See note 203, above.

258. Vasari (1568)–Milanesi, VII, pp. 161–162; see also account in De Tolnay, 1943, I, pp. 210–211.

259. Felton Gibbons (1968, p. 14) assumes that Titian and Dosso Dossi saw these fragments in Mantua as early as 1519, but the date of their arrival at Mantua has not been established, and it is very doubtful that they had reached the city so early. It is reasonable to assume that Sestola's letter of 1519 would have contained some reference to them. See note 203.

260. See Clark and Pedretti, 1968, I, pp. XXXII–XLI and corresponding illustrations. Raphael's cartoon for the *Conversion of St. Paul* with its rearing horses had been in Venice since 1521 (see note 150).

261. See Wethey, I, 1969, pp. 17–21.

262. Niccolò Machiavelli, *Istorie fiorentine*, first published Florence, 1532.

In addition to the large sketch of the entire mural (Figure 53), a number of studies of horses by Titian have luckily survived. Best known is the sheet in the Uffizi (Figure 59) in black crayon and white gesso. The horse rears and the soldier in armour raises his sword to strike an unseen enemy as he tramples over a fallen man. This superb study of movement of horse and rider is fully realized, and the artist repeated the group at the left side of the bridge, just below the yellow and black banner of the Empire (Figure 51), and this soldier is clearly an Italian on the winning side, as he charges against the tangled mass of fallen Germans. The armoured figure is more finished in this study than in the other two drawings. The rather rough sketch of a head of a *Wounded Man* (Figure 55) on the reverse of the same sheet was surely preparatory for the same painting, although one cannot find him in this fray. The two other drawings of horsemen, one in Munich (Figure 61) and one in Oxford (Figure 60), have been the subject of disagreement among critics. Tietze-Conrat first proposed that the Munich rider was Titian's own study for Orazio Vecellio's mural (1562–1564) of the *Battle between the Forces of Emperor Frederick Barbarossa and the Roman Barons near Castel Sant' Angelo in Rome* (Cat. no. L–4). Her argument is based upon Vasari's mention of 'a foreshortened horse who jumps over an armed soldier which is very beautiful'. The Munich drawing does depend more upon outline than the one in Florence, but it is next to impossible to be dogmatic on this issue. The Oxford rider (Figure 60), which is admittedly very close in the technical handling of the medium, has enough similarity to the soldier falling over backward to have been a study for the man on the lower left side of the Uffizi copy and Fontana's print (Figure 54). Rubens appears to have admired that figure, as demonstrated in the drawing attributed to him in the Albertina. The three drawings of horsemen by Titian are superb studies of violent action and remarkable in their understanding of the horse. One would not have expected this particular skill of the Venetian painter up to this time, great as he was in all aspects of his art. Studies of the horse, such as these, stood him in good stead later when he was to paint the celebrated equestrian portrait, *Charles V at Mühlberg*.[263] The loss of the mural of the *Battle* is all the more to be regretted, because nothing at all of this type of composition survives from the master's career.

263. Wethey, II, 1971, Cat. no. 21, Plates 141–144.

IV. MOSTLY GODDESSES

The *Venus of Urbino* and *Jupiter and Antiope* (*'The Pardo Venus'*)

F OR a quarter of a century after Giorgione's death, the *Sleeping Venus* at Dresden (Plate 9) remained in Titian's mind. Indeed he most probably painted two or three versions of the same theme himself, but certainty is wanting since the pictures are lost.[264] That the master repeated the pose of the sleeping woman in the so-called *'Pardo Venus'* or *Jupiter and Antiope* (Plates 74–76), which he designed as late as 1535–1540, is generally agreed. That work, however, involves other iconographic matters, to which we shall return shortly. For the general public the *Venus of Urbino* in the Uffizi (Plates 72, 73) remains the supreme embodiment of the Goddess of Love among Titian's several interpretations of the subject. The flowing lines of the ideally beautiful nude repeat those of the Dresden *Venus* (Plate 9), and Giorgione's intention survives in the emergence of the right foot from beneath the crossed legs. The disappearance of this detail in the Dresden picture is all the more troublesome on comparison of the two figures. More important modifications have been made, to be sure, in the location of the goddess upon a couch within a handsome Renaissance palace. Moreover, she is wide awake and fully conscious of her charms, as she gazes languidly at the spectator and rests her right arm upon a white pillow, while she lightly grasps a cluster of red roses. The dark green curtain behind her, the red of the couch spread with white sheets and the subdued light of the interior provide a muted foil for the resplendent beauty of the nude body. Awake though the lady is, there is not the slightest suggestion of self-consciousness or lascivious intent on the part of the artist. Even the great Victorian scholars, Crowe and Cavalcaselle, gave unqualified approval to this erotic masterpiece. The same model is often thought to have posed for the *Girl in a Fur Coat* in Vienna, despite the greater reticence in the face of the lovely young creature.[265] The problem of symbolism in the *Venus of Urbino* is given attention in the Catalogue (No. 54). In these days of iconographic interpretation the essentially pictorial aspects of paintings are sometimes allowed to fall into the background. The charming little dog, for example, is a favourite in Titian's pictures and does not necessarily imply any esoteric intention.

The subject matter of the *'Pardo Venus'* is among the most puzzling on record. Titian himself, in the famous letter to Philip II requesting payments long over-due, refers to it as 'the nude in a landscape with a satyr', but his titles of other works are equally casual.[266] The first description by a Spanish

264. See the *Sleeping Venus with Roses* at Darmstadt (Plate 179) and related items (Cat. no. X–36). Among the several examples, some of them surely copies (Cat. no. L–13–Cat. no. L–17), was one in the Spanish Royal Collection. Another, the property of Queen Christina at Rome, included roses and a standing Cupid (Cat. no. L–18).

265. Wethey, II, 1971, Cat. no. 48, Plate 73. This masterpiece was never in Urbino. Charles I of England purchased it in Spain.

266. Simancas, Estado, legajo 1336, folios 27–28. Di Venetia li XXII dicembre MDLXXIIII. Attached to this letter is: Memoriale a sua Mtà. catholica per Titiano et Horatio suo figliolo:

Primo che sia posto nel bilanzo la pensione in Milano di

Horatio mio figliolo, acciò senza tanti travagli et fatiche et interessi possi goder la gratia fatta da sua Mtà.

Item, le pitture mandate a sua Mtà. in diversi tempi da anni vinticinque in qua sono queste, et solamente parte et non tutte; in ciò desidera dal signor Alons pittor di sua Mtà. sia agionto quelle che mancano, per non racordarmele tutte.

Venere con Adonis.

Calisto graveda da Giove.

Ateon sopragionge al bagno.

Andromeda ligada al saso.

L'Europa portata dal Torro.

Christo nel horto alla oratione.

53

writer, Argote de Molina, in 1582, reads as follows: 'Titian, Jupiter transformed into a satyr, contemplating the beauty of the handsome Antiope, who is asleep'.[267] The canvas then adorned a principal room in the palace of El Pardo,[268] near Madrid, where it remained until presented as a gift to Prince Charles of England in 1623. The anonymous compiler of the El Pardo Inventory of 1614–1617 made do with: 'a large canvas by Titian … of Venus-Danaë with a satyr at her feet and Cupid.'[269] Such inaccuracies in inventories are by no means unusual, and as a matter of fact the word Danaë is inserted between the lines. Yet the painter-writer, Vicente Carducho, in 1633 also believed that the theme was Jupiter and Antiope.[270] The name 'Venus of El Pardo' first appears in van der Doort's catalogue of Charles I's collection in 1639, a quite natural way of indicating its provenance.[271] The fact that this title has clung to the picture for centuries is also an indication of the puzzling nature of the iconography.

Antiope is briefly mentioned by Homer, who merely records that she slept with Zeus and had two sons by him.[272] Euripides' lost play *Antiope*, of which several fragments exist, is believed to be reflected in Hyginus' account. Here the later part of her life is given greater importance, that is, her numerous trials, especially her abuse by Dirce, who was in turn punished by Antiope's sons.[273] The earliest representation of Antiope with Jupiter in ancient art so far discovered is in a Roman mosaic of the second century from Palermo, where Antiope is standing and appears to attempt to run away.[274] In Renaissance versions of Jupiter's seduction of Antiope, he appears as a satyr, and the source, a favourite of Titian as well as one of the primary Latin handbooks of the period, is Ovid's *Metamorphoses*, where the affair appears in the list of Jupiter's exploits that were woven into tapestry by Arachne: 'in a satyr's image hidden, Jove filled lovely Antiope with twin offspring.'[275] Ovid does not specify that Antiope was asleep, and there are examples in Renaissance art where she is awake.[276] However, the pictorial

La tentatione de i Ebrei con la monetta a Cristo.
Christo nel sepolcro.
La santa Maria Madalena.
Li tre Maggi d'oriente.
Venus con Amor [che] gli tien il spechio.
La nuda con il paese con il satirro.
La Cena del Nostro Signor.
Il martirio di san Lorenzo, con li altri molti che non mi aricordo.
(Letter quoted by C. and C., 1877, II, pp. 539–540 and Cloulas, 1967, pp. 278–280).
 Titian's claim of lack of payment for twenty-five years represents a lapse of memory. Philip II ordered full payment of his Milanese pension in 1565 (Simancas, Estado, Legajo 1221, no. 59).
267. 'Ticiano. Jupiter convertido en Sátiro contemplando la belleza de la hermosa Antiope que está dormida' (quoted from Argote de Molina, 1582, p. 20, and also by Calandre, 1953, p. 39). The belief that the identification as *Jupiter and Antiope* is modern therefore cannot be maintained (see Panofsky, 1969, p. 191; Meiss, 1965, p. 354, thought that it originated in the eighteenth century).
268. This palace was reconstructed under Charles V (1543); completed c. 1568 under Philip II; decorated with the still extant frescoes by Gaspar Becerra and assistants in 1561–1562. The destruction of the portrait gallery and ten masterpieces of Titian on 13 March 1604 is mentioned in Cat. no. 21 under History and also in Wethey, II, 1971, p. 203. In recent years the palace has been the official residence of General Francisco Franco. The monograph on El Pardo by Luis Calandre, 1953, is well docu-

mented; see also Iñiguez Almech, 1952, pp. 108–113; Martín González, 1970, pp. 5–41.
269. 'Sala de Antecamara. Un lienzo grande de ticiano pintado al olio que llaman él de la Vénus Danae con un sátiro a los pies y cúpido …' (unpublished inventory: 'Palacio de El Pardo 1614–1617', Legajo 27, folio 2vv. In the margin the following words were added later: 'este lienzo se llevó el príncipe de Gales agr le dió su Mag.'). The El Pardo inventory of 1564 calls her simply the Danaë (see Cat. no. 21, History in Spain).
270. Carducho (1633), edition 1933, p. 109.
271. Millar, edition 1960, p. 19, no. 16.
272. Homer, The *Odyssey*, XI, 260.
273. Hyginus, Latin edition by Rose, 1934, chapters VII–VIII; English edition by Graves, 1960, pp. 30–31; also Apollodorus, Book III, v. 5, translation by Frazer, 1954, p. 337. Further references in note 267, above. The gigantic Hellenistic sculptured group in the Museo Nazionale at Naples, known as the *Toro Farnese*, is the best known example of the punishment of Dirce, who was tied to the horns of bulls and dragged to death.
274. Cook, 1940, III, p. 467; also Soth, 1964, fig. 3.
275. Ovid, *Metamorphoses*, VI, 110–111. The literary tradition that Jupiter appeared as a satyr was well established. See for instance, Nonnos, *Dionysiaca*, XXXI, 217; XXXIII, 310–304, a late mythographer. Satyrs specifically denoted lasciviousness (Dolce, 1565, edition 1913, p. 91).
276. Soth, *loc. cit.*, fig. 7; represented on a playing board by Hans Kels in the Kunsthistorisches Museum at Vienna.

tradition of the subject, in which the satyr-Jupiter approaches the sleeping Antiope with seduction unmistakably his intention, does exist in a print by the monogramist LD after Primaticcio (Plate 79).[277] The presence of the eagle clinches the identification of this satyr as Jupiter. That the lady should be taken by surprise in her sleep and so unable to protect herself is the most natural assumption possible and would reduce her culpability. Another well-known example of the sleeping Antiope approached by Jupiter occurs on a Venetian chest in the museum at Schwerin.[278]

The present inclination is to reject the possibility that the sleeping woman and satyr of the 'Pardo Venus' are really Antiope and Jupiter. Correggio's famous picture in the Louvre, long thought to be the same subject, is also now doubted and has recently become the 'Terrestrial Venus'.[279] The lack of a literary prototype in which Antiope is specified as asleep is a major argument for the abandonment of the traditional interpretation, yet Primaticcio (Plate 79) and some others created a pictorial tradition, which was carried on by Watteau.[280] In the 'Pardo Venus' the presence of Cupid drawing his bow as he alights upon a tree above Antiope-Venus suggests amorous consequences in store.

The strange part of Titian's Louvre picture is that the two sides of the composition seem to lack thematic unity. The huntsman at the left has been thought to be Adonis, and therefore the sleeping lady would be Venus—but why the prominent satyr in such a case? Actaeon has also been proposed, yet the beautiful nude woman cannot be Diana,[281] for lack of any attribute or relation to her legends. More-over, who are the satyr at the left side and the girl with the basket of fruit (Ceres?)? In the right background the huntsmen and their dogs seem bent upon their prey, and two dogs attack the stag clearly visible not far beyond the sleeping woman. Two tiny nude bathing women beneath the trees in the centre distance are fillers, who also by their small size help to establish distance. Possibly the picture represents a mythological fantasy, in which Titian unconventionally imagined an Arcadian land peopled with loosely identified characters from antique lore. To be sure, such freedom of artistic expression is uncharacteristic of the Renaissance period, and it is impossible to make out a strong case for this interpretation.

The closest parallel to the 'Pardo Venus' is Titian's drawing at Bayonne called Landscape with Nymphs and Satyrs (Plate 77)[282] with its surprising thematic similarity to the Louvre picture: a wooded scene with widely spaced trees and small figures of satyrs, a large goat, and a nymph scattered throughout, and even a sleeping woman in the middle distance. The smallness of the figures, however, changes the character of the drawing as compared with the larger scale of the elements of the Louvre painting. Nevertheless, the two are alike in both subject matter and landscape, a circumstance also noted by

277. Soth, loc. cit., fig. 4. Panofsky, 1969, pp. 190–193, and Verheyen, 1965, pp. 321–340, do not mention Primaticcio's print. Catalogued by Passavant, 1864, VI, p. 190, no. 71.

278. Soth, loc. cit., fig. 6.

279. In the Mantuan inventory of 1627 she is called 'Venere e Cupido che dorme con un satiro' (Luzio, 1913, p. 90, no. 3 and p. 171, no. 36; Soth, 1964, pp. 539–542; Verheyen, 1965, pp. 321–340; Laskin, 1965, pp. 543–545; Meiss, 1966, p. 358; Panofsky, 1969, p. 191; Gould, 1973).

280. Watteau, canvas, 0·72 × 1·10 m.; see Adhémar, 1950, no. 182. The print of Jupiter and Antiope by Annibale Carracci is dated 1592 (Calvesi, 1965, fig. 206).

When the eagle accompanies Jupiter who approaches a sleep-ing female, the subject is unmistakably the Antiope legend. In the iconographic file of the Warburg Institute in London numerous examples of the sleeping nymph and satyr exist, but not all represent Jupiter and Antiope. Among those with the eagle are: the print by Virgil Solis (Bartsch, IX, 256, 88), a drawing by B. Picart (British Museum, Inv. no. 1922-8-11-9) and the print by Primaticcio (Plate 79). For three copies after Van Dyck's painting of the subject see Decoen, c. 1932, pp. 1–7.

The two-page list of this theme by Pigler is convincing only in part.

281. Nordenfalk, 1947–1948, p. 44, pl. 109.

282. Bean, 1960, no. 172, in the Musée Bonnat, Bayonne; sepia ink, 265 × 405 mm.

Tietze and Tietze-Conrat.[283] Lomazzo's description[284] of a picture that was in Pomponio's house after his father's death does show some slight iconographic relation to our painting, but it must have been another version, since the 'Pardo Venus' had reached Spain before 1574. Lomazzo reads: 'A Venus who sleeps, with satyrs who uncover the most secret parts ('che gli scoprono le parti più occulte') and other satyrs around who eat grapes and laugh like drunkards and in the distance is Adonis in a landscape who follows the hunt.' The suggestion that in the 'Pardo Venus' the huntsman symbolizes 'Active Life', Venus and the satyr 'Voluptuous Life', and the seated couple 'Contemplative Life' does not impress one as a satisfactory solution to this enigma.[285] In the matter of pictorial sources or parallels for the Louvre picture (Plates 74–76) numerous theories have been advanced. That the sleeping nude *Antiope* (or *Venus*) is a descendant of Giorgione's *Sleeping Venus* (Plate 9) everyone agrees. She is one in the long line of Titian's fulsome, but idealized, recumbent nudes. The pose of the seated satyr (Pan?) at the left does strikingly resemble that of *Pan* in a Titianesque drawing owned by Curtis O. Baer of New Rochelle.[286] However, theories that the hunting scene was 'transcribed' by Titian from an illustration of Ovid's *Metamorphoses vulgare historiado* (Venice, 1508) and that a marble vase in the Cesi Gardens at Rome supplied the main group of the picture have not generated much enthusiasm.[287] Because of its puzzling nature and its conglomerate iconographic themes the 'Pardo Venus' will remain a debatable issue as to its meaning. That it is one of Titian's most beautiful landscapes and a work of extraordinary imaginative qualities is not likely to be challenged.

Danaë and Venus and Adonis

TITIAN's conception of the recumbent female nude underwent a total transformation in the fifteen-forties because of his months in Rome. The first result was the *Danaë with Cupid* (Plate 81) in which the heroic scale of the main figure and the more solid, sculpturesque technique were inspired by Michelangelo. Painted in 1545–1546 for Cardinal Alessandro Farnese, the *Danaë* remained in the Farnese Palace in Rome for more than a century until all of the Farnese pictures were moved to Parma. Lodovico Dolce in 1557 called it 'the loveliest of the nude figures for Cardinal Farnese, which Michelangelo saw with amazement more than once'.[288] Only slightly less dramatic was the reinterpretation involved in Titian's several versions of the *Venus* (Plates 105, 113, 114, 122) in these later years. Michelangelo's favourable comment upon the *Danaë* as reported by Vasari is well-known, even

283. Tietze and Tietze-Conrat, 1936, p. 182, fig. 160; *idem*, 1944, no. 1871.

284. Lomazzo, *Idea del Templo*, 1590, p. 133. Antonio Pérez' 'Inventario' of 1585, folio 473, contains a subject of this sort with no artist's name supplied. It is described as 'otro quadro de Vénus y Cupido y un sátiro que los descubre'. Only Titian's *Adam and Eve* includes the artist's name (see Addenda I, Cat. no. 1).

285. Panofsky, 1969, p. 192. Professor Fehl, 1957, pp. 167–168, believes that the sleeping nude woman is invisible. For further ideas on this subject, see the *Pastoral Concert*.

286. Tietze, 1936, fig. 7; Tietze and Tietze-Conrat, 1944, cat. no. 1948, pl. LIX; dark brown ink, 213×152 mm. (as Titian); Panofsky, 1969, p. 193, fig. 199 (not Titian).

287. Kennedy, 1963, p. 26, note 79. The question how Titian

could have been familiar with the Cesi Garden before he went to Rome in 1545 does not appear to have been considered. *Idem*, 1956 (1958), p. 240.

288. Dolce (1557), edition 1960, p. 161 and edition Roskill, 1968, pp. 110–111. Ridolfi in the following century stated that the picture was painted for Ottavio Farnese (Ridolfi (1648)–Hadeln, I, p. 178). Crowe and Cavalcaselle (1877, II, pp. 119, 122) accepted this erroneous history in the belief that Ottavio, a layman, was a more suitable patron for this theme. Every writer since has followed the same error. Only Roskill (*loc. cit.*, p. 260) comments upon the conflict in the sources.

Cardinal Farnese had the *Danaë* in his 'Camera propria' at Rome in 1581 (see Cat. no. 5, History).

Danaë with Nursemaid. 1553–1554. Madrid, Prado Museum (Cat. no. 6)

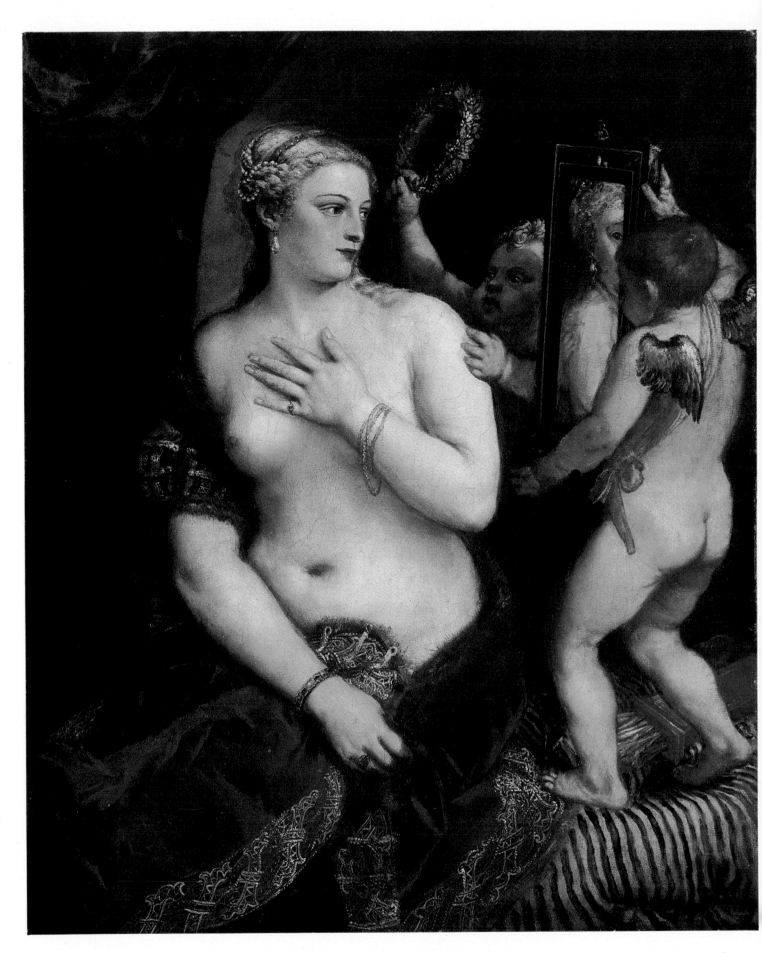

Venus at her Toilet with Two Cupids. About 1552–1555. Washington, National Gallery of Art, Mellon Collection (Cat. no. 51)

though he qualified his admiration of the colour and the style by the remarkable assertion that 'it is a pity that in Venice they do not learn from the beginning to draw well.'[289] The great Florentine surely recognized the pose of the Danaë with one knee raised, which had passed from his own Medici tombs into the repertory of Italian art. Even though Titian did not visit Florence until 1546, after he had completed the Naples Danaë, the figures of the tombs were known to him in drawings and models. He had also known the composition of Michelangelo's *Leda* (Plate 78) in a copy by Giorgio Vasari, which the Florentine took to Venice in 1541 and sold to the Spanish ambassador, Diego Hurtado de Mendoza.[290] Differences, are, however, notable, for Michelangelo, following an antique tradition, depicted the actual intercourse between Leda and the swan. Titian by the position of the Danaë only suggests her anticipation in an attitude inherent in the theme, as the golden shower hovers above and Cupid turns away, somewhat startled by the apparition. The presence of Venus' son in this picture is justified by his association in amorous affairs, even if the literary sources do not mention his attendance. He is included in classical reliefs of *Leda and the Swan*, among them a work recorded in a Renaissance drawing of the Codex Coburgensis.[291] Titian may have seen an ancient sculpture of this type in Rome in 1545–1546. He was not alone in including a Cupid with the Danaë, and it remained for Primaticcio to have Cupid playfully try to prevent the nursemaid from collecting the golden rain in her jug (Plate 80). The *contrapposto* and the rather heroic nature of Titian's Cupid do suggest the antique. The Lysippian *Cupid Bending His Bow*, as other writers have previously observed, comes closest to the Venetian painter's conception of the son of Venus, yet this Renaissance god of love is still no more than an adaptation, if Titian ever knew the Greek composition in a Roman copy.[292] The version in the British Museum (Figure 22) is the best example in marble, the original of which was presumably a bronze by Lysippos. Its popularity is attested by thirty-nine surviving marble replicas, as well as fragments and copies in gems.[293]

Curiously enough the Farnese–Naples *Danaë* (Plate 81) has been regarded as superior to the later picture, in Madrid (Plate 83), by some writers, who seemed to feel that the drapery over the leg was a concession to modesty. The stronger outlines and more solidly modelled bodies of the first version, painted in Rome under the inspiration of Michelangelo and of the Florentine-Roman schools in general, appeals to critics who prefer *disegno* to *colore*. To others the more illusionistic style of the Madrid picture, with its incomparable richness and subtlety of colour, appears infinitely lovelier (Plate 83). The later picture also has the advantage of a superior state of preservation. In little ways Titian changed his conception of the theme in 1553–1554, when he painted this great *Danaë with Nursemaid* for Prince Philip of Spain. The ugly old woman with her back turned, spreading her apron to catch the golden coins, makes a dramatic and slightly humorous contrast to the languid nude girl, who gazes upward (Plates 85, 90) at the shower of gold, in which Jupiter descends. The flesh is now soft and resilient, and the planes merge with exquisite delicacy. The colours are indescribably

289. Vasari (1568)–Milanesi, VII, p. 447.
290. Panofsky, 1969, p. 146. Panofsky classifies Titian's *Danaë* as the 'Leda type'.
291. Noted by Saxl, 1957, p. 169; see also Reinach, 1912, pp. 222, 231; Panofsky, 1969, fig. 154.
292. Panofsky (1969, p. 147) thought that Michelangelo's *Risen*

Christ in S. Maria sopra Minerva influenced the pose of Titian's Cupid, while Brendel (1955, p. 121, note 31) proposed the Ara Grimani in the Archaeological Museum at Venice (illustrated by Wethey, I, 1969, Plate 20).
293. F. P. Johnson, 1927, pp. 104–116.

lovely in their fusion of tones: the blue sky at the right, the rose curtain at the left, and the rose cover beneath the nursemaid against the white sheets and pillows. The body of the girl is painted with unequalled delicacy of tone. No other female nude in Titian's entire repertory of mythological subjects has greater refinement of mood, notwithstanding the sensual nature of the theme. Details such as the expressive right hand and the enchanting little sleeping puppy contribute to the sensitivity of the artist's interpretation. Nevertheless, the *Danaë* of Madrid provoked the disapproval of Crowe and Cavalcaselle, whose Victorian puritanism is evident in their statement that 'the Danaë of Madrid is not different in any essential particular from that of Naples. It is only coarser and more realistic.'[294] Among the many school pieces, replicas and copies, only the *Danaë with Nursemaid* in Vienna (Plate 82) can be regarded as in great part the work of Titian. Here *c.* 1555–1560 Titian modified the position of the nursemaid, who holds a silver platter to catch the coins, and the head of Jupiter is still visible in the sky.[295] Other minor changes include the rose and the coins lying upon the sheet, but the delicacy and subtleties of the Madrid *Danaë* are wanting.

Titian's first *Danaë*, as we have seen, was painted at Rome for Cardinal Alessandro Farnese in 1545–1546, and the second, more mature version reached Philip II eight years later. There is some reason to believe that the artist's first *Venus and Adonis* also came into existence during the master's Roman sojourn and was intended as a companion piece for the *Danaë*. Ridolfi's statement in 1648 that the picture hung in the Farnese Palace at Rome is confirmed by the Roman inventory of the following year, and the work reappears in the Parma inventory of 1680.[296] As a matter of fact, Titian carried out no further commissions for the Farnese after he left Rome, and for understandable reasons. Neither Pope Paul III nor Cardinal Alessandro Farnese ever gave him any recompense for the mythological paintings or for the portraits of the pope and his family, which number among the greatest master-pieces of the Renaissance period.[297] The only known payment of the Farnese to Titian was that of July 1543, when the artist received fifty ducats for travelling expenses from Venice to Bologna and return, at the time he painted *Paul III without Cap*.[298] Vasari is the source of the tradition that the Farnese never gave Titian any remuneration for his pictures.[299]

The curious fact is that the Farnese *Venus and Adonis*, known today in a print by Sir Robert Strange

294. Crowe and Cavalcaselle, 1877, II, pp. 227–229. They even gave an exaggeratedly incorrect report of the condition of the canvas.

295. The Madrid *Danaë* originally included a face of Jupiter or an eagle in the clouds (see Cat. no. 6, Condition). Some of the better paintings based upon Titian's *Danaë* are Cat. nos. X–10–X–13, Plates 198–201. Copies after the major versions by Titian himself are listed along with Cat. nos. 5, 6, and 7.

296. Ridolfi (1648)–Hadeln, I, p. 179; the recently discovered Inventory of 1649 will be published by Charles Hope (see Cat. no. L–19). A number of paintings, which do not appear in the preserved list of works sent from Rome to Parma in 1662, had reached the latter city by the time that the Inventory of 1680 was compiled.

297. For Paul III's portraits, see Wethey, II, 1971, Cat. nos. 72–76, which include the famous *Paul III without Cap* and *Paul III and His Grandsons*, both in Naples. Cat. nos. 29–31 comprise *Cardinal Alessandro Farnese, Pierluigi Farnese*, and *Ranuccio Farnese*. Cat.

nos. L–12 to L–15 are concerned with lost portraits, which include one of Ottavio Farnese.

298. Wethey, II, 1971, Cat. no. 72, Documentation.

299. Vasari (1568)–Milanesi, v, pp. 627–628, in the life of Perino del Vaga. Yet the artist continued to count on the possibility of a benefice for his son, Pomponio, and as late as 1567 he made a gift of two pictures, a *Magdalen* and a *Martyrdom of St. Peter Martyr*. On 17 May 1567 Titian wrote to the Cardinal to ask if the pictures, dispatched two months earlier, had been received and to bring up the matter of the benefice (see Ronchini, 1864, pp. 142–143, for the letter; also Wethey, I, 1969, p. 28 and notes 158, 159). He expected payment in this form.

On 31 May 1567 Titian again wrote to Cardinal Farnese, and he enclosed Cort's engraving of the *Trinity* (Wethey, I, 1969, Cat. no. 149), but he made no further reference to the Cardinal's silence (unpublished letter in the Pierpont Morgan Library, New York).

of 1769 (Plate 95), conforms in its details to the later version in New York (Plate 97), even as to Adonis' costume. The Cupid, awake and holding a dove at the left side, also appears in the Washington version (Plate 98), and in all three cases there are two dogs.[300] The eighteenth-century engraving does not permit a judgment of Titian's technique. Moreover, some variation in the details of the trees and in the addition of the conspicuous plants at the left raise the question whether Sir Robert modified them to suit his own taste. Therefore it would seem that Titian repeated the elements of his first composition of 1545–1546, when he returned to the subject of *Venus and Adonis* much later, c. 1560–1565 (Plates 97, 98). The free, illusionistic style and more monochromatic use of colour characterize the late versions.

We are on solid ground when we turn to Titian's *Venus and Adonis* which was shipped directly to Prince Philip, who was then in London subsequent to his marriage to Queen Mary Tudor. Philip's own letter, dated at London on 6 December 1554 and addressed to the Spanish ambassador at Venice, Francisco de Vargas, complained that the canvas had suffered because it was folded when packed, an injury still visible in the picture.[301] Even more interesting is Titian's well-known letter, written early that year, in which he explained his theory of the composition: 'Because the *Danaë* which I have already sent to your Majesty was visible entirely in the front part, I have wanted in this other *poesia* to vary and to show the opposite part [of the body] so that it will make the room in which they are to hang more pleasing to see.'[302] Philip praised its 'perfection', and nearly all critics agree that this version of the *Venus and Adonis* (Plates 84, 86, 87, 89–92) is much the finest of the several canvases of the subject. Adonis' rose draperies are set off against the flesh tints of Venus' body and the dark red velvet, upon which she sits. The clear blue sky with white clouds adds another fine colour note against the figures and the greenish brown landscape. The goddess' pose, as several scholars have observed, appears to have been inspired by the figure of Hebe at the wedding banquet in Raphael's Hall of Psyche (Plate 88) in the Villa Farnesina at Rome. The positions of the figures are reversed but the general conception is similar in the two cases, and there is no doubt that Titian saw Raphael's frescoes during his stay in Rome in 1545–1546. Other theories as to influences include knowledge on Titian's part of Correggio's *Jupiter and Io* (now in Vienna), which he would have seen on a visit to Mantua.[303] A popular antique relief, known in both ancient and Renaissance copies, called the 'Bed of Polyclitus', is another probable source for the idea of placing the bodies of the female and male figures in back and front view respectively.[304] This motive, in which the female body is placed in marked *contrapposto*, was familiar to Renaissance masters from antique gems, among them specimens in the possession of the Grimani family of Venice. Enea Vico's engravings of the gems made their compositional devices accessible to sixteenth-century artists.[305] A more remote parallel is that somewhat impassioned love scene with the figures in intimate relation on a relief from the *Ara Grimani* in the Archaeological Museum at Venice.[306]

The major fact, however, is that Titian's interpretation constitutes an unprecedented composition

300. The uncertainty arises as to whether the print by Strange is instead really after the New York *Venus and Adonis* from the Mariscotti Palace in Rome. In view of Irvine's and Buchanan's evidence in 1804 and 1824, that the print was made after the lost Farnese version, the situation is puzzling (see Cat. no. L–19).

301. See Cat. no. 40, Documentation.

302. *Loc. cit.* Actually the proper pairing of the *poesie* was not observed after Philip II's time.

303. Suida, 1936, pp. 109–111.

304. Kennedy, 1956, p. 240; Gombrich, 1963, p. 37; Panofsky, 1969, p. 151, and others.

305. Bober, 1963, p. 83, pl. XXII.

306. Brendel, 1955, p. 122, fig. 22.

which is the creation of a great genius. His literary source was clearly Ovid's *Metamorphoses*.[307] In Titian's painting the amorous encounter of the goddess Venus with her young lover Adonis is vividly evoked. The small Cupid lies asleep on the bank at the upper left, and his bow and arrow hang upon the tree nearby, for his work is done. Venus tries to detain Adonis from leaving her for the hunt with his three hounds on leash. Here Titian disregarded Ovid, who tells us that Venus, departing first, returned to her chariot drawn through the clouds by swans. This independence of his literary source was observed with disapproval as early as 1584 by Raffaello Borghini.[308] However, Titian preferred the drama of Venus' futile attempt to dissuade her lover in his determination to follow the hunt. The story ends, of course, with Adonis' death from the wounds inflicted by a boar and Venus' transformation of him into an anemone. In Titian's picture a reminder of Venus' subsequent departure is the tiny figure of the goddess in a chariot upon the clouds (Plate 91), at the upper right, both painted in pale rose. Doves replace Ovid's swans. From her figure a ray of light descends into the grove of trees below, where Adonis, now virtually invisible, lies wounded unto death. The large golden urn is apparently overturned to indicate Venus' sudden movement to restrain Adonis. The same detail is found in the left corner of the *Bacchus and Ariadne* at London (Plate 56) and in the *Andrians* at Madrid (Plate 57), where again swift action takes place.[309]

Titian repeated the composition of Philip II's *Venus and Adonis* on at least two occasions, but with some help from the workshop. The best example is that in the National Gallery in London (Plates 93, 94), apparently done, not long after the original, on request from a patron. The second and badly damaged repetition, belonging to the Earl of Normanton (Plate 190), is much more difficult to judge, despite its illustrious provenance from the collections of Queen Christina and the Duke of Orléans. Moreover, it hangs very high in the Normanton gallery and the only available photograph dates from 1902. Another replica, now vanished from public view (Plate 191), which also has an Orléans provenance, last appeared in the sale of Baron von Heyl in 1930.[310] Much farther removed from Titian and not even produced in his workshop is a composition which weakly copies the Prado original (Plate 84) but adds a ridiculous red hat bedecked with rose ribbons, planted upon Adonis' head (Plate 196). The entire figure of the youth lacks dignity in the way he is turned into a clumsily dressed boy, in place of the powerful athletic male of Titian's own creation. The smaller, sketch-like version (Plate 194) in the Duke of Northumberland's collection at Alnwick Castle diverges far more and does not reproduce the background and general setting of the original composition. The sleeping Cupid, his bow, and his quiver are all omitted from the left side. The general darkness of the colours as well as the avoidance of direct dependence on any of Titian's works mark this item as a Baroque imitation, many of which are known to have existed.[311]

307. See Cat. no. 40 for the quotations from Book X.
308. Borghini, 1584, pp. 94–95; also Lee, 1940, p. 238; Panofsky, 1969, p. 151.
309. Panofsky (1969, p. 151, note) interpreted the overturned urn 'to allude to the frustration of Venus' love for Adonis'. The overturned urn in the Brescia ceiling (Figure 66) does not involve movement.
310. Both the Normanton and von Heyl paintings are reproduced in the appendix because the copy photographs are inadequate (Plates 190, 191).
311. The many later copies of the *Venus and Adonis* and the Literary References are listed after Cat. nos. 42 and 44. The total runs between thirty and forty which are based upon the Prado and Farnese types. The Odescalchi Inventory of 1713 alone listed six copies of *c.* 1700 after the presumed originals in that collection, which had been acquired from Queen Christina (Cat. no. 42, Literary References).

Michelangelesque Interlude: The *Four Condemned*

THE effect of Michelangelo's art upon Titian during the months at Rome in 1545–1546 come through unmistakably in the Farnese *Danaë* (Plate 81), both in the more solid, sculpturesque modelling of the body and in the pose. These non-Venetian traits have been recognized for four centuries. After his return to Venice the artist still occasionally drew on memories of his Roman experience, in such compositions as *Christ Crowned with Thorns* (c. 1546–1550) in the Louvre, the single figure of the *Ecce Homo* (1547) in Madrid, and other later religious themes.[312] In these relatively few instances Christ and religious personages take on an heroic, muscular form, which reflects the predominantly Michelangelesque canon of the mid-sixteenth century. In relation to the wide range of Titian's art in religious and mythological subjects as well as in portraiture, the Michelangelesque aspect is essentially limited. During the year and a half between Titian's return from Rome in June 1546 and his departure to Charles V's court at Augsburg on 6 January 1548, he had time to finish works left in his studio and to begin a few others.[313] At Augsburg during his nine months sojourn he undertook a large number of portraits of the Hapsburg court, among the most notable of which is the *Charles V at Mühlberg* in the Prado Museum.[314] In portraiture, reflections of Michelangelesque enthusiasms have no part. However, Mary of Hungary's commission for a set of the '*Four Condemned*', documented in 1548–1549, did give Titian the opportunity to make his fullest excursion into colossal form, combined with all the violence of Michelangelo's *Last Judgment* in the Sistine Chapel.[315] The abiding horror of these scenes from Greek myths, devoted to eternal punishment in Tartarus, is the equivalent of the direness of hell-fire in Christian imagery. Nowhere is the gloomy Hapsburg turn of mind more evident than in the selection of these grim subjects by Mary of Hungary as decoration of the great hall in her new pleasure château at Binche near Brussels, and two or three canvases arrived in time for the lavish festivities that she, as Spanish regent of the Netherlands, arranged on 28 August 1549 in honour of her brother, Emperor Charles V, and her nephew, Prince Philip.[316]

Across the large canvas of *Tityus* (Plates 99, 101, 102) is sprawled his gigantic body, naked and chained to the sharp cruel rocks, as the eagle gnaws at his liver to the end of time. Technically, the painting is superb in every detail, from the magnificent black eagle to the venomous viper at the lower right. And Titian, composing the heroic body with absolute mastery of the giant's anatomy and tortured foreshortened position, enlists our sympathy over the dreadful fate of this legendary man of

312. Wethey, I, 1969, Cat. no. 26; *loc. cit.*, Cat. no. 32; also in the *Apparition of Christ to the Madonna* (c. 1554) at Medole (*loc. cit.*, Cat. no. 13), *Christ Carrying the Cross* (*loc. cit.*, Cat. nos. 24, 25); the *Martyrdom of St. Lawrence* (1548–1557) in the Gesuiti at Venice (*loc. cit.*, Cat. no. 114), and the *Tribute Money* (1568) in London (*loc. cit.*, Cat. no. 148).

313. See Chronological List of Paintings.

314. Wethey, II, 1971, pp. 35–38.

315. Dated 1536–1541. See Tolnay, V, 1960. It appears problematical whether Titian knew and was influenced by Michelangelo's famous drawing of *Tityus* now at Windsor Castle (Popham and Wilde, 1949, cat. no. 429) in view of the great differences in composition. In each case the preying bird is an eagle, although totally unrelated in design. Titian made no attempt to paint a vulture, as Ovid specified. Robert Storer, professor of Ornithology

at the University of Michigan, assured me that the bird is an eagle. Titian must have seen them frequently in his native Alps.

316. The full documentation of the *Four Condemned* is included in Cat. no. 19, as well as the various problems related to the histories of the pictures at Binche and their later appearances in the several inventories of the Spanish royal palaces. There is no need to repeat this complex and contradictory material in the text.

The Spanish use of the word 'furias' or 'furiae' for the *Four Condemned* has classical Roman precedent. For the word 'furiae' meaning evil men or criminals, see *Thesaurus linguae latinae*, VI, 1912–1926, column 1615, B per comparationem; also *Oxford Latin Dictionary*, 1971, fascicle III, p. 749, 'furia', item 3. Cicero in *Pro Sestio* uses the word 'furiae' in the sense of madmen (H. Gardner, Loeb edition, 1957, pp. 186–187, paragraph 112).

such physical power, now utterly helpless. Moreover, richness of colour is not wanting in the sun-darkened flesh and black hair placed against a broad expanse of golden-brown drapery and a wide background of bluish-grey sky. Amid the green ivy at the lower right the black serpent approaches his victim, and at the lower left flames and smoke arise from a fissure in the rocks. It is indeed un-expected and astonishing that Titian, renowned for the seductive beauty of his feminine nudes and the gay abandon of his Bacchanalian figures, should render so successfully the horror of eternal torture. The literary sources of the story of Tityus are Vergil's *Aeneid*, vi, 595–600 and Ovid's *Metamorphoses*, iv, 457–458,[317] but from the beginning Titian's Tityus was often incorrectly thought to be Prometheus, who suffered the same fate. Even Calvete de Estrella, who described the pictures at Binche in 1549, made this mistake in identification. The same writer also erred in reporting that in *Sisyphus* (Plate 100) the doomed man was shown rolling a stone up a hill, a stone that slipped from his grasp each time he reached the top, whereas Titian's painting depicts him bowed beneath the huge rock, which he carries upon his shoulders. A work of far less interest compositionally than the *Tityus*, in quality it still surpasses anything of which a Spanish copyist was capable, yet it has sometimes been attributed to the court painter, Sánchez Coello.[318] Sisyphus appears girt with a white loin cloth tied at the waist by a dark reddish-brown fabric. The sky, now blackened, and the rocks are painted in a scale of brownish tones. Although the third painting, *Tantalus*, disappeared at the time of the fire of 1734 in the Alcázar at Madrid, the composition is known in Sanuto's engraving (Plate 104). The condemned demigod lies backward, forever unable to reach the fruit of the tree above or to drink of the water that surrounds him. A variety of legends explain the reason for his punishment: that he had stolen the food of the gods, that he served them the flesh of his son Pelops, etc.[319] The pose of Tantalus suggests that Titian had admired the antique *Fallen Gaul* from the Grimani Collection, now in the Museo Archeologico in Venice.[320] Titian's recent sojourn in Rome in 1546 is reflected here in the free rendering of the Castel Sant'Angelo in the background as well as in a sort of miniature Colosseum, from which flames roar heavenward. No visual record of the *Ixion* exists, though references to it occur in several royal inventories until its destruction in the Alcázar fire of 1734. In the three surviving compositions, how-ever, there is ample testimony to the importance of Titian's Roman experience and of his acquaintance with Michelangelo's *Last Judgment* in the creation of these scenes of the Underworld, which lie outside the main stream of his pictorial development.

317. I am indebted to Dr. I. Grafe for the *Aeneid* reference.

318. All *Four Condemned* were brought to Spain by Mary of Hungary and all are included in her inventory dated Cigales 19 October 1558 (see Cat. no. 19, Documentation, item 6). The identification of *Tityus* and *Sisyphus* as copies by Sánchez Coello has long been abandoned. Confusion about the attributes of mythological characters also exists in contemporary literature. Giulio Camillo's book on symbolism, published at Florence in 1550 (pp. 37, 71), describes Tantalus as lying beneath a stone and as symbolic of vacillation and timidity, whereas the weighty stone belongs to Sisyphus.

This small volume, entitled *L'Idea del Theatro dell'eccellen. M. Giulio Camillo*, was dedicated to the Spanish ambassador at Venice, Diego Hurtado de Mendoza. A copy appears in the inventory of Hurtado de Mendoza's library, no. 3639, when Philip II sent the ambassador's vast collection of manuscripts and books to the Escorial in 1576 (Gregorio de Andrés, 1964, vii, p. 211). The inventory also reports that 201 sheets of pergamin, painted in watercolour by Titian were included with the book. The attribution is most improbable, but we shall never have final proof, since the volume and the watercolours were lost in the Escorial fire of 1671 (Gregorio de Andrés, 1970, p. 53, with typographical error; the date of the deposit of the books at the Escorial should read 1576).

Another highly dubious attribution is that of a missal, said to have been illuminated by Titian. The Grand Duke of Tuscany sent it as a gift to Philip II according to a letter, dated 18 August 1587, of the Venetian ambassador (*Calendar*, Venetian, viii, p. 306).

319. See Cat. no. 19, Iconography.

320. Brendel, 1955, p. 122, and Panofsky, 1969, p. 148.

The Reclining Venus

IN 1545 during his sojourn at Rome, Titian adopted a new composition for the theme of the reclining Venus, and he repeated it in four major works, those now in Madrid, Berlin, and Florence (Plates 105, 107, 113, 114). Abandoning the model of the *Sleeping Venus* in Dresden (Plate 9) and of the *Venus of Urbino* (Plate 73), where the head rests at the left side and the nude figure, posed upon the back, has softly undulating outlines, he reversed the arrangement. Now the head is at the right side of the picture, the upper part of the torso is raised against the pillows, and the goddess rests to a greater degree upon her side. The right arm is more fully represented, and the hand touches the leg just above the knee. In every respect the articulation of the body attains more completeness: the folds of flesh build up the structure of the torso, the breasts stand out more firmly, and the bony formation of the knees is revealed. The figure has greater solidity, a phenomenon due to the painter's contact with Central Italian art during his stay in Rome, and the body becomes more heroic in scale. She is now unmistakably the Goddess of Love, matchless in her mature and perfect beauty. In Titian's autograph works every detail is exquisitely drawn and modelled, and the theme, despite its frankly erotic nature, is managed without insistence on lascivious appeal.

The first painting in the new series of reclining Venuses was specifically intended for Charles V, as the artist himself stated in his letter to the Emperor dated at Rome on 8 December 1545. Titian delivered it to him 'as commanded in the name of his majesty', when he visited Augsburg, according to a letter of 1 September 1548.[321] This work is generally believed to be the signed *Venus and Cupid with an Organist* (Plates 105, 106, 108) now in the Prado Museum. Although absolute historical proof is wanting, this version, of such extraordinarily high quality and stylistically of proper date, is much the best candidate. Venus herself dominates the scene as she turns to listen to Cupid, who whispers in her ear. Her sumptuous body maintains the pose that we have just described and that Titian repeated in other compositions of the subject (Plates 107, 113, and 114). The surpassingly beautiful head (Plate 106), the exquisitely painted jewels, and the charming *entente* between Venus and Cupid are in every respect far superior to any other version of the theme. The rather handsome youth with dark chestnut hair is clothed in a black velvet jacket over golden sleeves and golden hose. This golden colour recurs in the elaborate chain about his neck and in the wood-carved decoration upon the organ, in the centre of which stands a Medusa head with serpents in her hair. A black dagger, with a few touches to suggest inlaid gold, is barely visible in his belt. With a somewhat meditative air the young man looks downward at the beautiful nude body of Venus, almost abstractedly, and without any suggestion of lascivious

321. The letter of 1545 is reproduced on page 126 (by courtesy of the Fondation Custodia, Lugt Collection, Institut Néerlandais, Paris). Other documents are cited in Cat. no. 47, History.

It is possible that Titian sent still another *Venus* to Charles V, the one mentioned by Aretino in a letter of December 1554 (Aretino, *Lettere*, edition 1957, II, p. 455), unless the reference is to the painting delivered at Augsburg six years earlier in 1548.

See Cat. no. 49 for reasons why the Uffizi *Venus with a Partridge* cannot be the *Venus* painted for Charles V. The original owner of the Uffizi *Venus* was surely an Orsini.

That Titian ever painted a picture of the victories of Charles V, or made drawings for them is doubtful. He expressed a diplomatic wish to do so in the letter of 8 December 1545 and again in one of 22 April 1560 (Cloulas, 1967, p. 244). There seem to have been frescoes illustrating Charles' victories in the Dávila palace at Plasencia, already destroyed by 1778 (Ponz, tomo VII, carta V, 75). No evidence exists that designs by Titian were used. Crowe and Cavalcaselle (1877, II, p. 306, note) list references which prove to be erroneous.

concentration. The scene takes place in an open loggia in an arrangement of parallel planes. At the right the red velvet curtain is looped upward, as in all other compositions of the same subject, while a red velvet coverlet lies beneath the goddess' gleaming flesh and over the white sheets and pillows. The Renaissance park in the background involves elements typical of the mid-sixteenth century: parallel rows of trees converging toward a vanishing point and a graceful satyr fountain topped by an urn, from which the water sprays. Erotic symbolism must be implied by the resting stag and the embracing couple in the left distance. The peacock alighted upon the fountain may refer to the pride of Venus herself, yet this decorative bird as well as the donkey may have no symbolic meaning at all. The current tendency to allot an iconographic role to every object in a picture frequently exaggerates the significance of simple decorative or illustrative features. The general consideration of the musical theme here and in other paintings of the reclining Venus will be deferred for later discussion.

The major change in the *Venus and Dog with an Organist* (Plates 109–113), also in the Prado Museum, is the substitution of a dog for the Cupid and the resultant slight modification in the attitude of Venus. She looks downward and fondles the lively animal, whereas in the signed picture she turns her head to the side, as Cupid whispers in her ear. The position of her left arm therefore varies slightly as well. In both pictures the pearl necklaces and bracelets have only slightly different patterns, while the coiffure of the signed version (Plate 106) is much richer and decorated with pearls.[322] On all counts the signed painting (Plates 105, 106) is handsomer, and in particular the head of Venus and the figure of the youthful organist are more ingratiating. The darkened landscape and the much repainted grey sky, which have suffered greatly, explain the somewhat dull effect of the second version. Titian himself was surely responsible for the beautiful figure of Venus, while his assistants took over subordinate details. The doubt, often expressed, that the present work could be by Titian's own hand is explained by the damage inflicted when it fell into a river, as it was *enroute* to Paris in French hands in 1814.[323] The dirty condition of the canvas before the restoration of 1965 also contributed to the low estimates of its quality by earlier critics. In its present state this version is, to be sure, a work of much less importance than the signed painting in the same museum.

The third version of *Venus and Cupid with an Organist*, at Berlin (Plates 114–118), differs in many respects from the two in the Prado Museum. The Alpine landscape, which replaces the Renaissance park, carries the eye across valleys and through a village to a mountain lake, and ends in the ultramarine peaks so familiar to the artist from his earliest youth. The barking Maltese dog (Plate 120), a new and amusing contribution, appears only in this instance among the compositions dedicated to Venus. A sketch of a similar dog (Plate 119) in the National Museum at Stockholm may not be the preliminary study for the Berlin picture because of its calm relaxed attitude, but it is equally charming and another case of Titian's sympathetic rendering of pets. In the sketch, far better preserved than this detail of the painting, the decorative organization of the clusters of shaggy white hair is something of a tour-de-force.[324] So far as the two figures are concerned, the pose of the Venus closely repeats that

322. In the nearly identical background a curious addition near the fountain is the pair of deer involved in amorous play. Thus the erotic symbolism, already present in the embracing couple and the stag at the left, is increased.

323. See Beroqui, 1926, pp. 86–87; *idem*, 1946, p. 84. Restored in Paris by Bonnemaison and returned to Madrid in 1816.

324. Oil sketch on brown paper, 222×293 mm., published by Tietze, 1949, p. 181, and 1950, p. 409, pl. 104. See also Cat. no. 48.

of the signed picture in Madrid (Plate 105), while in the accessories there are minor variations such as the thin gold chain around her neck and the filmy veil over her middle. Her bracelets are similar to those worn by the goddess in the second Prado *Venus* (Plate 113). Her face (Plate 118) has a bland look compared with the others (Plate 106), but close examination reveals that the broad cheek has been damaged and restored and that there are serious losses in the forehead as well. One of the most extraordinary aspects of the signed Berlin picture is the young organist who, dressed in a dark red jacket with striped golden sleeves, golden breeches and hose, turns to admire the goddess. With his youthful face and curly hair he appears to be an idealization of Prince Philip of Spain at the age of twenty-one.[325] The resemblance to the marble bust from the workshop of Leone Leoni (Plate 116) is striking, even though both artists gave a generalized account of Philip's Hapsburg features. An allegorical portrait is never an exact realistic rendering of an individual, and neither are state portraits of rulers. This rather romantic interpretation will doubtless meet with opposition from some scholars. If correct, it supplies a date for the Berlin *Venus*, since Titian went to Milan to paint certain portraits ('ciertos retratos') in December and early January 1548–1549 on Philip's first and only visit to Italy. He was then only twenty-one, but triumphal processions greeted him everywhere, as was considered befitting the son of the Holy Roman Emperor and heir apparent to the Spanish and Hapsburg dominions. In any case the Berlin *Venus and Cupid with an Organist* (Plates 114–118) is a fully signed masterpiece, entirely by Titian's own hand. The deep-red velvet hanging and the velvet coverlet, upon which the goddess reclines, maintain the same general tonality as in other compositions of the same subject. The Alpine landscape adds much, both in imaginative qualities and in sheer beauty of colour, to this handsome work.

Although *Venus with Cupid and a Partridge* in the Uffizi (Plate 107) lacks the organist, the poses of the goddess and her son are repeated from the signed *Venus* in the Prado (Plate 105). Even the bracelets are similar, and the only notable divergence lies in the coiffure with its ropes of pearls. Yet the quality throughout the painting falls off so greatly that it must be regarded as largely a workshop production. The dullness of the landscape, totally lacking in the usual technical brilliance, is surprising, and even the usual deep-blue mountains are almost colourless. The Venus herself has a certain majesty and physical splendour, while the Cupid is either by an assistant or much repainted. The date *c.* 1550 is normally accepted, because the strong outlines and solid modelling correspond in a general way to the style of the *Danaë* in Naples of 1545–1546 (Plate 81) and the three versions of *Venus with an Organist* (Plates 105, 113, 114). The bird on the window-sill appears to be a partridge, sacred to the Love-goddess because of its reputation among the ancients for lasciviousness.[326] The dark band of feathers,

325. Other scholars have concurred in this identification: Berenson, 1932, p. 568 and 1957, p. 184; Panofsky, 1969, p. 122; also Wethey, *Archivo*, 1969, pp. 129–138; *idem*, II, 1971, pp. 42–43.
326. Charbonneau–Lassay, 1940, pp. 304–305. The bird has frequently been identified as an owl, incorrectly it appears.
 Titian on two other occasions introduced a partridge into a painting. In the *Last Supper* in the Escorial (Wethey, I, 1969, Cat. no. 46, Plates 117, 118) a partridge is perched on the rim of the brass basin in the foreground, drinking from the liquid contained in it. In the *Annunciation* in San Rocco, Venice (*op. cit.*, Cat. no. 9, Plate 58) an identical bird walks toward the Madonna in the

foreground. In both cases these birds were called quails, but Panofsky (1969, p. 30) has convincingly identified the one in the *Annunciation* as a red-legged partridge. The two genera are quite similar in shape, although those familiar with the European species say that the quail is much smaller and therefore the two should not easily be confused.
 The difficulty arises in finding a reasonable symbolic explanation for the appearance in religious paintings of a bird which most commonly is used as a symbol of lasciviousness. In general the partridge represents evil (Charbonneau–Lassay, 1940, pp. 504–506). On the other hand, the quail represents good and symbolizes

which gives the effect of a mask over its eyes, endows the bird with an almost human face and provides it with an erotic role similar to that of the lutanist or the organist in Titian's other compositions. Dogs and doves were credited in the ancient world with lasciviousness and also associated with goddesses of love. It is possible that the dog in this and other paintings of Venus by Titian connotes pagan sensuality and not Christian fidelity.[327] New elements, then, have been introduced in the Uffizi *Venus* in the form of a partridge, the barking terrier (?) at the goddess' feet, and Cupid's quiver and arrows nearby. The charming still-life of roses in a glass vase refers to Venus, who also holds a cluster of roses, as she does in the *Venus of Urbino* (Plate 73). The darkened and dirty condition of the picture accounts in part for the dull impression, and it is altogether possible that proper cleaning would reveal a work of higher quality than is now visible.

Some ten or fifteen years after painting the *Venus with an Organist*, Titian returned to the musical theme in two compositions of *Venus and Cupid with a Lute Player*. The major elements are the same in the two examples, one in New York (Plates 121, 122, 124) and the other in Cambridge, England (Plates 123, 125). Cupid is now about to place a crown of roses and myrtle upon the lovely creature's head, and the lute player strums his instrument, as he sits upon the couch with his back turned to the spectator. This juxtaposition of the back view of the youth opposed to the full face view of the goddess is a familiar Renaissance device, which Titian employed here and on other occasions (Plates 105, 113, 114), to bring out the splendor of the sumptuous nude Venus. The masterpiece in New York is of extraordinarily high quality and shows no obvious intervention of assistants. Even the curtains, which in most versions of the reclining Venus are less skilfully painted, have brilliancy in the sheen of the materials and the highlights. Although technical experts say that the head was repainted at the end of the sixteenth century, it is a work of such great beauty that it is cause for wonder that any of the master's followers could paint so well. The chief colours are provided by the red curtain and the lutanist's golden breeches and golden sleeves, his light-beige jacket, and his deep-blue cloak and cap.

the eucharist, maternal love, etc. (*loc. cit.*, pp. 502–504). Only the bird on the ledge of the *Venus and Cupid with a Partridge* in Florence (this volume, Cat. no. 49) seems to have a proper symbolic role, for the partridge was sacred to Venus. Panofsky (*loc. cit.*) refers to the curious belief that the partridge was able to conceive by a wind that had blown past a male, or even by hearing his mating call. Thus by extension this bird could suitably be introduced into a painting of the *Annunciation* to symbolize that Christ was conceived of the Holy Ghost, as foretold in the angelic salutation. However, Panofsky does not mention the bird in the *Last Supper*, and there seems to have been no attempt to explain it in any of the literature on the painting.

A brief survey of partridges in early Venetian painting also fails to shed any light on the problem. Bartolomeo Vivarini's *Madonna and Child and Saints*, signed and dated 1465, in Naples (Berenson, 1957, pl. 111), shows a partridge standing at the left of the base of the throne. Antonello da Messina in his *St. Jerome in his Study*, now in London (Hartt, 1969, colour pl. 49), introduced a decorative partridge in the left foreground. In the *Supper at Emmaus*, in S. Salvatore, Venice (Robertson, 1969, pl. LXXXIa), a partridge appears on the pavement in front of the table. In Catena's *St. Jerome in his Study* in London (Heinemann, 1960, pl. 279) a partridge advances across the floor toward the saint.

Finally a lost painting of the *Virgin of Sorrows* by Bellini, of which a copy exists in S. Pietro d'Orzio in the province of Bergamo (Heinemann, 1960, pl. 267), had a partridge in the foreground. A unifying thread of argument that might connect these diverse subjects through the partridge is elusive.

As purely decorative motifs partridges were frequently used in ancient paintings and mosaics. They appear, for example, in the detached wall decoration of two Etruscan tombs displayed in the museum of Tarquinia and in a Roman floor mosaic in the museum of Tarentum. In general they are not common in early Christian art, although an exceptional example exists in a pavement mosaic of the early-Christian basilica of Aquileia (Cabrol and Leclerq, XIV, 1939, p. 303, 'perdrix'). Perhaps iconologists have tried to read too much symbolic meaning in the fauna of sixteenth-century pictures. These birds may merely indicate Titian's Renaissance interest in nature and still-life painting, elsewhere exemplified in his exquisite details of flowers. [Alice S. Wethey]

327. Reff (1966, pp. 360–361) interprets the dog here as an 'emblem of loyalty and the power of true love'. He also explains the lion supporting the table as 'physical force conquered by love'. Actually the carved lion on the table would more likely be heraldic, if it has any meaning.

Venus is rather statuesque, in part because of the erect position of the head as Cupid places the crown upon her hair. That constitutes the chief difference in her pose in comparison with the three versions of *Venus with an Organist*. Most beautiful of all is the landscape with its distant blue mountains and its golden-yellow fields, in which swans are discovered in a lake at the left. Erotic symbolism is noted in the nude satyrs dancing in a circle and a nude man playing a bagpipe as he leans against a tree.

The second version of *Venus and Cupid with a Lute Player* (Plates 123, 125) has a somewhat darker tonality, due to chemical changes and the effects of time. The weakest part is the rather ugly face, which, as X-rays show, was in left profile at an earlier stage. The body of Venus herself has retained its magnificence, primarily as Titian painted it. The landscape, also of great beauty, inspired an eloquent description by another celebrated painter, J. M. W. Turner. Despite his elaborate language, his account of the Cambridge *Venus* has rather exceptional interest: 'Brilliant, clear and with deep-toned shadows, it makes up the equilibrium of the whole by contrasting its variety with the pulpy softness of the female figure, glowing with all the charms of colour, bright, gleaming, mellow, full of all the voluptuous luxury of female charms, rich and swelling. The sight must return and rest there, although the landscape insensibly draws the eye away to contemplate how valuable is its introduction. To keep up that union of interest and support its assistance in attracting the eye from the right hand of the picture can be no small honour.'[328]

Titian painted five major compositions of Venus on a musical theme. They include the *Venus and Cupid with an Organist* in Berlin (Plates 114, 115), the two versions of the subject in Madrid (Plates 105, 106, 109, 113), and the *Venus and Cupid with the Lute Player* in New York and another in Cambridge. The principal reason for all of these compositions was the painting of a beautiful nude female figure. She is clearly marked as Venus by the presence of her son, but even when Cupid is absent (Plate 113) no one can doubt that she is the goddess of love. The introduction of an organist, who appears to play music for Venus' entertainment, is an entirely new idea of Titian's. The next step was to have the goddess herself perform, as is the case in the *Venus and Cupid with a Lute Player* (Plates 122, 123), where she holds a recorder as she appears to pause while Cupid places a wreath upon her head. Titian may well have been familiar with the *Greek Anthology*, in the Aldine edition printed at Venice in 1503, in which there appears an epigram with the dedication of a flute (i.e. recorder) to Venus: 'Opis, giving glory to his fatherland, the holy city of Athena, offered this pleasant flute, child of the black earth, that he wrought by the help of Hephaestus, to Aphrodite, having been vanquished by love for beautiful Bryson.'[329] The viola da gamba at the extreme right and the open books of music leave no doubt that a duet has been performed.[330] That the duet may have been, or will be, amorous as well as musical

328. Ziff, 1963, p. 136. The New York version is later than the one in Cambridge, as indicated by the unfinished details and the freer technique.

329. *Greek Anthology*, 1918, v, p. 13, nos. 20; Hutton, 1935, pp. 148–149, for the Aldine edition.

330. Dr. Winternitz (1967, pp. 52–53) has identified the music marked 'Bassus' as intended for the viola da gamba. The book labelled 'Tenor' is said to be suitable for the lutanist's voice (Studdert-Kennedy, 1958, pp. 349–351). Professor Einstein, as quoted by the latter (*loc. cit.*) thought that he could decipher the

name of the celebrated Verdelot, composer and performer of madrigals at Venice, written in reverse upon the music, and he even found the word 'bella' to identify a specific madrigal. Studdert-Kennedy conceded that he himself could not discover either of these words on the music of the Cambridge picture. His special interest in Renaissance music allowed him to speculate on the intentions of the artist and even to identify the model as one of two famous courtesans noted for improvisation of music, either Franceschina or Marietta Bellamo, and the lutanist as a young man named Hippolito.

could easily be implied. Otto Brendel, in a brilliant study of the New York *Venus*, saw Neoplatonic symbolism in the new and unusual subject of Venus accompanied by a musician. Vision and hearing are held to be the finest of the senses. Beauty is enjoyed through the power of vision primarily, and secondly through the sense of hearing. Brendel documented his theories with impressive quotations from Marsilio Ficino, Pietro Bembo, and Baldassare Castiglione. In a scholarly exchange of letters Ulrich Middeldorf raised the issue as to the degree that Titian's pictures of the recumbent Venus were intended to be symbolic only. He pointed out that the Renaissance tradition recorded in Brantôme's *Femmes galantes* and the story tellers from Boccaccio onward reflect an earthy tradition in matters concerning love.[331] The sense of touch is less susceptible to symbolic interpretation, and it is significant that the goddess' feet unmistakably rest against the organist's back in all cases save the Berlin version (Plate 114). The glance of the musician is directed toward the lady's face in three of the pictures, but in both Prado compositions (Plates 105, 113) his eyes fall upon the sumptuous curves of her body. Just to what degree Titian thought out his compositions in symbolic terms is, of course, open to question. He certainly was no philosopher, even though he must have been well versed in a number of literary works by Ovid, Theocritus, Vergil, etc. Abstract symbolic concepts could have been suggested by a literary friend, possibly Dolce or Aretino. Basically one cannot ignore the erotic intention, although it would be excessive to hold that these pictures were intended primarily as aphrodisiacs. It is not without significance that Titian himself often refers in his letters to his mythological works in simple language. The picture which he called 'a bath' ('un bagno'), in preparation for Alfonso d'Este in 1517, must have been a mythological theme containing female nudes.[332] In his letter to Charles V, dated Rome 8 December 1545, the artist mentions 'una figura di Venere' destined for the Emperor.[333] Surely Titian's major purpose was to paint beautiful pictures at a time when the antique legends of the gods and goddesses enjoyed great favour. That he found new and unprecedented ways to illustrate them is unequivocal testimony to his genius, not only as a painter of supreme gifts, but also as the possessor of imaginative qualities of the highest order.

Venus at her Toilet

ANOTHER extraordinary new creation is Titian's *Venus at Her Toilet*, the finest and most celebrated version of which is now in Washington (Plates 127–129). This is the only surviving picture of the subject entirely by the master's own hand. Here the goddess is accompanied by two Cupids, one of whom holds the mirror with back turned to the spectator. The second Cupid is about to place a wreath of laurel and tiny white flowers upon her head, as he also does in the *Venus and Cupid with a Lute Player* (Plates 122, 123). The dark crimson velvet robe, fur-lined, has slipped from her shoulders and covers the lower part of the body. The torso, nude except for the shielding of one breast by the left arm, is superbly painted and slightly more idealized in the greater simplification of surfaces of flesh than in the pictures of the reclining Venus (Plates 105, 113, 114). The head too has a classic beauty

331. Brendel, 1946, pp. 65–75; Brendel and Middeldorf, 1947, pp. 332. Campori, 1874, p. 585.
 65–69. It is not possible to repeat here all of the literary allusions 333. Letter of Charles V dated 8 December 1548, see page 126.
and the finely spun arguments presented by both scholars.

about it, proud and serene. Every detail is exquisite, for instance, the impeccable drawing and modelling of her left hand, which rests upon her chest. The full-length Cupid, in back view, shows the same mastery and a great amount of charm, even in the way he stands with slightly bent knees. Since the subject concerns an ancient goddess, it is natural to seek out antique prototypes, and it is a measure of Titian's genius that nothing exactly comparable is known in ancient art. The shielding position of the left arm somewhat suggests the type of *Venus Pudica*, best known in the famous Medici Venus in the Uffizi, but Titian modified the pose and placed both arms in a diagonal position to establish a strong compositional pattern.[334] A fresco of the first century B.C. depicts a lady dressing her hair with the assistance of a maid, while a Cupid holds a mirror (Figure 23A). The scene at Pompeii could not have been known to Titian, nearly three centuries before it was excavated. He might have seen something similar during his stay in Rome, or perhaps a seated Venus on an antique bronze mirror could have suggested the theme to him.[335] That the goddess of love and beauty should be represented at her toilet is, on the other hand, the most natural of subjects. However Titian came to select it, he achieved one of his most remarkable and happiest innovations in a work of consummate beauty. A similar picture, seen by Ridolfi in the mid-seventeenth century in the famous collection of Niccolò Crasso at Venice, is described as 'Venus who is looking in a mirror with two Cupids'. Van Dyck's sketch (Plate 126) is assumed, and quite reasonably, to preserve the composition of the Crasso picture. The major differences from the Washington version are that both Cupids hold the mirror and the one at the right turns his head to look outward at the spectator. It appears most probable that Crasso's picture was also an original by Titian's own hand.[336]

Among the numerous variants of Titian's *Venus at Her Toilet with Two Cupids* (Plate 130), the one now in the Wallraf–Richartz Museum at Cologne appears to be the best. It has an illustrious history, from its first appearance in 1638 in the collection of Bartolomeo della Nave at Venice, where it carried an attribution to Titian's brother, Francesco Vecellio. Since that was only sixty-two years after Titian's death, the traditional attribution may be correct, and the rather hard technique is perfectly compatible with Francesco's known work. Twenty years later, when Archduke Leopold Wilhelm owned the painting, it had just one Cupid (Plate 215), and only during the present century the inner Cupid was uncovered during the cleaning and restoration of the canvas.[337] An equally celebrated history distinguishes a more remote copy, in which the single Cupid seems to be experiencing some difficulty holding the mirror. This example (Plate 131) belonged to Queen Christina of Sweden when she lived in the Palazzo Riario at Rome; it later passed to the Duke of Orleans at Paris in 1721, and some years ago it was acquired by the Bergsten family of Stockholm.[338] Here the draperies do not depend as closely upon the Washington original (Plate 127) as in the Cologne version (Plate 130), although the jewellery does. The addition of Cupid's bow in Venus' right hand changes the motivation of the

334. The classification of the pose as the Venus Pudica was made by Poglayen–Neuwall, 1934, p. 358 and adopted by Mrs. Shapley, 1971–1972, p. 93.

335. Bernoulli in his book *Aphrodite*, 1873, pp. 305–309, lists several examples of Venus with a mirror in ancient paintings, gems, bronzes, and terracottas. The *Greek Anthology* contains a dedication of a mirror to Aphrodite, as follows: 'To Aphrodite by Lais. I Lais who laughed exultant over Greece, I who held

that swarm of young lovers in my porches, lay my mirror before the Paphian' (Mackail, 1911, Chapter II, p. 138, no. XXII).

336. See Cat. no. L–26.

337. See Cat. no. 52, History. The picture was sold from the royal Austrian Collection in 1856. Recent owners of especial interest were Marzell von Nemes at Budapest and lastly Adolf Hitler, who intended it for his projected museum at Linz.

338. Cat. no. 53.

drapery, and in general the drawing as well as the application of the paint are less skilful throughout. Only one other derivative from Titian's masterpiece can be considered here, the *Venus Alone at Her Toilet* (Plate 133) in the museum of the Ca' d'Oro at Venice. A German scholar some years ago tried to establish this item as Titian's first study, later developed into the Washington composition (Plate 127).[339] Obviously the reverse is the case, for the elimination of the mirror and Cupids leaves the posture of Venus without any logical motivation. The rendering of the Ca' d'Oro *Venus* is weak and timid in modelling and draughtsmanship. The curious table-covering and the large jewel-box at the right as well as the curtain are additions of the copyist, who was not one of Titian's best imitators.

An entirely different situation prevails in regard to the lost *Venus Clothed at Her Toilet with One Cupid*, which exists only in a copy but in this instance by another great master, Peter Paul Rubens (Plate 132).[340] Titian's original was almost certainly the painting which the Spanish consul at Venice announced had been shipped to Philip II on 6 December 1567. It appears also in the list of pictures for which Titian had never been paid, when he wrote the famous letter of complaint to the King's Minister, Antonio Pérez, on 22 December 1574, there described as 'Venus with Cupid who holds the mirror for her'. Thereafter Titian's *Venus* is cited in 1626 by Cassiano dal Pozzo, who added the fact that she wore a shift ('camicia'). The fullest descriptions occur in the palace inventory of 1636: 'A Venus with nude breasts with a crimson garment which may be raised up, with a bracelet of pearls on the right and a ring on the finger of the left hand, and a nude Cupid with a mirror, in which she is looking.'[341] In a most amusing comment on this picture Richard Cumberland in 1787 wrote as follows: 'A Venus admiring herself in a Mirror, which Cupid holds up to her face. . . . The characters both of one and the other, are certainly of wanton cast [sic]; the person half uncovered, half concealed, with such a studied negligence of dress, and so much playfulness of expression and attitude, that the draperies seem introduced for no other purpose but to attract the attention more strongly to the charms they do not serve to hide.'[342]

The Venus wearing a shift proved to be much less popular than the nude Venus, a verdict with which most critics today would agree.[343] Even as transmitted to posterity by Rubens (Plate 132), the composition is less handsome and the pose lacks the regality of the goddess in Washington (Plate 127). The addition of the white drapery, which appears to be a shift, has led to the classification as a Venus Genetrix since, like Alcamenes' sculpture (Figure 20) of that subject, the lady is essentially clothed.[344] Why Titian sent this composition to Philip II instead of the masterpiece now in Washington can only be conjectured. At this time the King's major building project had become the church and monastery of the Escorial, for which the Venetian master was supplying a considerable number of religious paintings.[345] Titian may have learned from the Spanish ambassador that Philip in 1567, aged only forty, already felt himself becoming old. His increasing religious fanaticism had surely been bruited abroad, and the reactions of the Counter Reformation against Renaissance liberalism reached a peak under the anti-humanist pope Pius IV (1559-1565) and his successor, Pius V (1565-1572).

339. See Cat. no. X–37.

340. For Rubens' copy, see L–27, Copy no. 1.

341. See Cat. no. L–27 for full details and the original Spanish quotations.

342. Cumberland, 1787, pp. 17–18.

343. See adaptations by Veronese's school, Cat. no. X–38.

344. So proposed by Poglayen–Neuwall, 1934, p. 372 and Mrs. Shapley, 1971–1972, p. 93.

345. See Wethey, I, 1969. Index for the catalogue of some thirty works for the Escorial.

V. THE *POESIE* FOR PHILIP II

TITIAN met Prince Philip, heir of Charles V, for the first time in December 1548 at Milan, on the only visit of the prince, then twenty-one, to Italy, when the artist began certain portraits ('ciertos retratos').[346] In 1551 they saw each other at Augsburg on several occasions, when the prince sat for his celebrated portrait in armour now in the Prado Museum.[347] However, they were never to meet again after Titian departed for Venice in May, and the prince returned to Spain the following month to become regent in the Emperor's absence. Consequently, plans to have the artist paint a series of mythological episodes for the prince, later the king, must have been laid during the winter of 1550–1551 at Augsburg, where Charles V was holding court. Undoubtedly from the beginning the subject matter, which appears to have been suggested by Titian and his humanist friends, was based on the poems of Ovid. Philip himself, well versed in religion and politics under the guidance of his tutor Martínez Siliceo, then a professor at the University of Salamanca, soon to become Cardinal and Primate of Spain as archbishop of Toledo, was also thoroughly educated in languages, Spanish, French, Italian, and particularly Latin. Surely not ignorant of the classics, Vergil, Livy, and Horace, which he must have read in Latin as a youth, Philip later owned Ovid's *Metamorphoses* in the Italian translation by Lodovico Dolce, dated Venice, 1553.[348] Nevertheless, his visit to Italy in December and January 1548–1549 was the major factor in his decision to become a collector of works of art and to choose Titian as his preferred painter. At Genoa, where the streets were lined with triumphal arches extolling Charles V and his heir apparent, Philip tarried more than two weeks, lodged in the luxurious new Renaissance villa of Andrea Doria.[349] Later at Mantua he remained from 13 to 17 January 1549; the Duke Francesco Gonzaga received him with the same splendour that his father, Federico II Gonzaga, had accorded Charles V during his visits there in 1529–1530 and again in December 1532. The house of Gonzaga was staunchly allied to Spain, a good reason why Philip honoured them with a longer sojourn than anywhere else in Italy save Genoa. Here Philip was without any doubt introduced to the masterpieces of Andrea Mantegna, the famous *Studiolo* of Isabella d'Este, the decorations of Giulio Romano in the ducal palace and the Palazzo del Te, and the works of Correggio, as well as the large collection of religious paintings by Titian and his *Roman Emperors* (Figures 34–45). At Augsburg there were other masterpieces by Titian, and soon at Brussels in the collection of his aunt, Mary of Hungary, the Spanish regent, Philip had an opportunity to admire for the first time Titian's *Charles V at Mühlberg* and several other portraits by the artist as well as a number of his religious pictures.[350]

346. Beer, 1891, p. CXLIII, no. 8372, document of payment of 1000 gold *scudi* to Titian. See also Wethey, II, 1971, p. 41, note 145.
347. Wethey, II, 1971, Cat. no. 78, Plates 174–176, documented 1550–1551.
348. Among the books in Philip II's library in the Alcázar at Madrid according to the Inventory of 1600 after the king's death (Sánchez Cantón, 1956–1959, I, p. 166, no. 1200).
349. See Calvete de Estrella's chronicle of Philip's voyage, edition 1873–1874, pp. 31–50. At Genoa he was received by Cardinal Doria as legate of Paul III, ambassadors from Naples and Sicily,

the Duke of Florence and others. Duke Ottavio Farnese, his brother-in-law, and Cardinal Alessandro Farnese sent ambassadors but did not travel to Genoa personally.
350. See Wethey, I, 1969, Cat. no. 32, *idem*, II, 1971, Cat. nos. 20, 21, 53, L-3, L-4, L-6, L-20, and p. 202. Titian's paintings of *Tityus*, *Sisyphus*, and *Tantalus* (Cat. 19) were displayed at Mary of Hungary's Château de Binche on the occasion of the festival given on 28 August 1549 in honour of Charles V and Prince Philip.

The possibility that the *Venus and Cupid with an Organist* (Plate 114) was painted for Prince Philip in 1548–1549 has been dealt with above. However, the *poesie*, as Titian called them for the first time in his letter to Philip dated 23 March 1553, began with the *Danaë* (Plates 83, 85, 90) and the *Venus and Adonis* (Plates 84, 86–92).[351] They were planned as a pair according to Titian's own explanation in a letter of 1554 to Philip elsewhere quoted.[352] Nevertheless, several years passed before they could be exhibited together, since the *Danaë* arrived in Madrid apparently not long before the Prince's departure for England on 13 July 1554 for his wedding to Queen Mary Tudor. The *Venus and Adonis*, shipped directly to England on 10 September 1554, may have been taken to Brussels a year later when Philip returned there. At any event he did not see Spain again until August 1559, when as King of Spain he re-entered the country of his birth, never to leave it again. It is altogether likely that in the meantime Philip kept the *Venus and Adonis* and other prize possessions with him in Brussels, and that he took it in his personal baggage on the homeward journey. The problem of where and how all of the *poesie* were exhibited in the Spanish royal palaces will be examined after a study of Titian's other pairs of mythological paintings.

The next *poesia* to be delivered was the *Perseus and Andromeda* (Plates 134, 135, 136). In the well-known letter of 10 September 1554, when the *Venus and Adonis* was shipped to London, Titian announced that he had in preparation a *Perseus and Andromeda*, which would have a still different attitude,[353] as well as a *Medea and Jason*. Writing to Titian from Ghent on 7 September 1556, Philip acknowledged the receipt of the 'pictures' in good condition.[354] That they included the promised fable of Andromeda cannot be doubted, and Lodovico Dolce in 1557 confirmed the correct date of the picture, since he listed the *Perseus and Andromeda* among the works painted for Philip.[355] Although the canvas is now seriously darkened and very little original colour survives, it still reveals extraordinary vigour and imagination. Cast in the heroic mould of Titian's style after his Roman sojourn, Andromeda still retains a feminine grace despite her powerful physique with its inevitable echoes of Michelangelo. Athletically posed, chained but swinging in terpsichorean fashion, Andromeda's figure is exceptional, even on comparison with the late goddesses such as the stern Diana of the Edinburgh *Diana and Callisto* (Plates 143, 149) or the vengeful huntress of the *Death of Actaeon* (Plate 152). A transparent greyish veil flutters down her side and across her middle as she appears suspended against a dark rock. Perseus, in rose with his yellow tunic visible above his knees, descends inward, brandishing a sword with intent to slay the sea monster, a gorgeously decorative although ferocious-looking creature. The yellow-and-grey sky, the blue-green water, and the spots of red coral (metamorphosed in Ovid's account) in the foreground afford some colour in this magnificent but much faded canvas. The water in particular shows free, illusionistic brush-work.

The several *poesie* that Titian created for Philip II have relatively little iconographic inter-relationship. The fact that Perseus was the offspring of Danaë and Jupiter, whose procreation is illustrated in the

351. Complete documentation is provided in Cat. nos. 6 and 40.
352. See Cat. no. 40, Documentation, for the letter.
353. '... una altra vista diversa da queste.' 'Queste' in the plural refers to the *Danaë* and the *Venus and Adonis*. Letter quoted by Cloulas, 1967, p. 227, note 2. See also my Cat. no. 30, Dating.
354. The precise titles of the paintings are not mentioned in this letter, but the series of letters about the proper packing leave no

doubt that the *Perseus and Andromeda* was in this shipment. See Cat. no. 30.

355. For the mistaken dating of the picture in 1562–1565 and also in 1567, see Cat. no. 30, Incorrect Dating. The survival of this composition in Venetian art has been demonstrated in the publication of a stone relief (Keller, 1969, p. 147, Abb. 29).

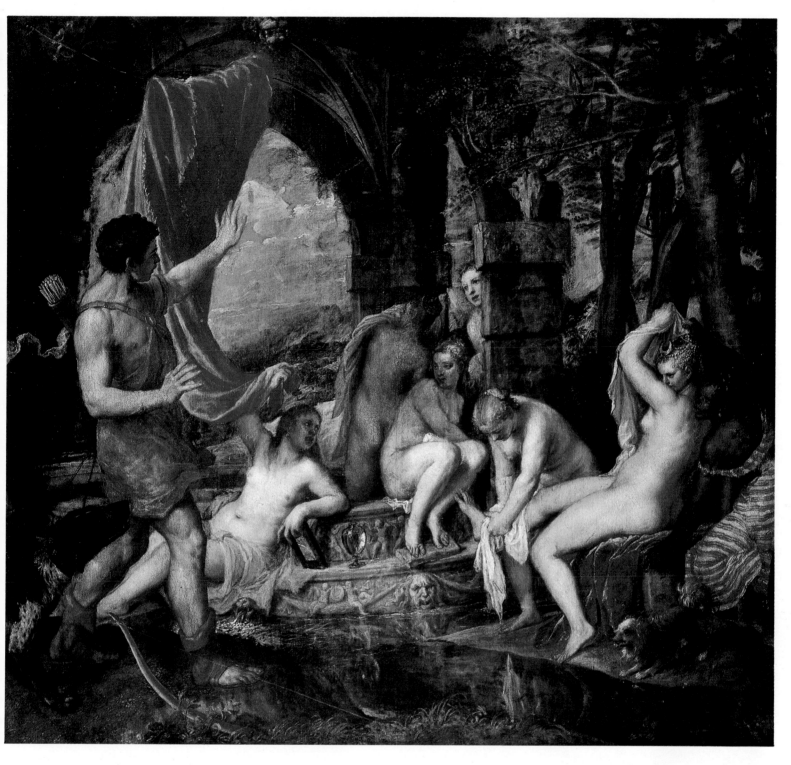

Diana and Actaeon. 1556–1559. Edinburgh, National Gallery of Scotland, on loan from the Duke of Sutherland (Cat. no. 9)

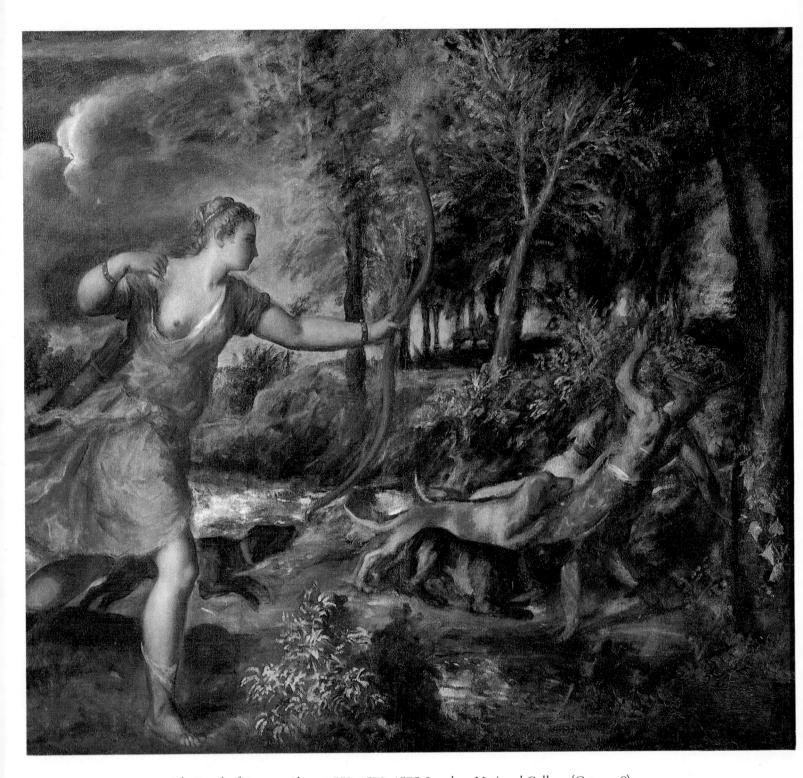

The Death of Actaeon. About 1559; 1570–1575. London, National Gallery (Cat. no. 8)

first of the series (Plate 83), accounts for the selection of this third legend. On the other hand, Titian's promise to send a *Medea and Jason* apparently as a companion piece is puzzling. Their story was recounted by Ovid in his *Metamorphoses*, Book VII, likewise the literary source of the amours of the earlier three pictures.[356] However, Titian shortly abandoned that subject, possibly as providing no suitable episode to illustrate as a foil to the *Perseus and Andromeda*,[357] and we find no further reference to it. Indeed no composition seems ever to have been executed as the specific pendant of the *Perseus*.

The next set of pictures, finished and shipped in 1559, offers no iconographic problems, since the two paintings devoted to Diana (Plates 142–150) are a pair both in subject and in style, and like the others they are inspired by Ovid's *Metamorphoses*.[358] The first, *Diana and Actaeon*, concerns the tragic mishap of the young hunter who unintentionally happened upon Diana and her nymphs when they were bathing naked in a remote grotto of the forest. Titian chose the sudden drama of the encounter, in which Actaeon, a youth of heroic physique, throws up his arms in astonishment and stops abruptly at the sight of the array of lusciously beautiful maidens. They shrink in fright and attempt to conceal their bodies, Diana being assisted by a Negro maid. Even the dog at the goddess's side barks his somewhat humorous disapproval, and only the girl drying Diana's feet seems unaware of the intruder. The landscape and wooded bower of extraordinary beauty include one bay of a vaulted passage sustained by rusticated piers of High Renaissance design, clearly intended to be a ruined grotto. The vault itself seems to be groined, its form being somewhat obscured by the decoration of painted bands and other motifs, including a stag and a dog (Plate 142). Panofsky's explanation is well taken in that Titian thought of Ovid's 'grotto' in terms of Renaissance rustication, i.e. 'the natural style'.[359] Actually Ovid describes 'a native arch of living rock and soft tufa' rather than an architectural design.

Unparalleled master that he was, Titian constructed in the *Diana and Actaeon* a V-shaped composition of basic simplicity, yet with a highly complex interrelation of figures and other elements, nearly all of them in slightly oblique positions. Earlier, in the *Martyrdom of St. Lawrence* of c. 1548, he had taken his first bold steps in composing obliquely into the depth of the picture space, yet closing the design at each side. These fresh ideas were to be adopted by other Venetian masters such as Tintoretto and Jacopo Bassano and to lead directly to the Baroque style of spatial organization.[360] In the *Diana and Actaeon* the sheer beauty in the drawing and painting of the female nudes is virtually incomparable even in Titian's own work and indeed in the entire history of art. These lovely creatures combine seeming naturalism in their emotional reactions with ideal physical beauty, and only Diana herself in

356. Ovid's passage concerning Perseus' rescue of Andromeda, whom he thereafter married, is quoted in Cat. no. 30.

357. See Cat. no. L–10.

358. Ovid is quoted in Cat. nos. 9 and 10.

359. Panofsky interpreted the vault as Gothic and devoted two paragraphs to the meaning that the Gothic style had in the minds of sixteenth-century theorists. It is a very informative digression indeed (Panofsky, 1969, pp. 157–158 and note 47), but it is not entirely relevant to this picture. A pen tracing of the architecture in Titian's painting reveals, on the contrary, a Renaissance groined vault carried on semicircular rusticated arches and rusticated piers, only one of the four of which is clearly visible. Coloured bands, which decorate and emphasize the groins of the vault, give the superficial effect of a pointed arch that misled Panofsky. For confirmation one has only to look at Schiavone's copy of this picture, now in Vienna, and at Teniers' copy (Plate 214), which, in delineating a second rusticated pier and more of the round arches and groined vault, demonstrate that Titian's structure was wholly Renaissance. Pallucchini (1969, p. 161) also calls the architecture a portico 'on rusticated pilasters . . . still in the style of Giulio Romano'.

360. Wethey, I, 1969, pp. 34, 79, 139, Plate 178. These facts have also been observed by Professor Waterhouse in his excellent study of the *Diana and Actaeon* (1952, pp. 16, 19–20) and accepted by Panofsky (1969, p. 155).

her more ample form is set apart as a goddess.[361] The exquisite bodies of the chaste maidens gain in contrast with the masculine muscularity of the giant Actaeon, whose very astonishment betrays his youth. The unusual sumptuousness of colour in the *Diana and Actaeon* has escaped no one. The brilliant rose of the large curtain at the left is reaffirmed in the red of the velvet cushion beneath the body of Diana and in the rose of Actaeon's sandals. The dusky Negro girl in a white shift patterned with salmon and yellow stripes provides a telling foil to the fair-skinned goddess, while Actaeon in golden drapery and the seated nymph with a powder-blue veil over her thighs balance the scale. The deep blue of the sky and the ultramarine of the distant mountains have extreme richness against the greyish arch and the green foliage. Curious details are the reflections in the foreground stream of Diana's barking puppy, of the perfume jar, and of the back of the Negress. On the other hand, Actaeon's bow dropped beside the young hunter and the prominent hound are elements of the story. Providing a grim prophecy of the horrifying sequel of this unfortunate encounter between mortal and goddess, the skull on the rusticated pier foretells the transformation of Actaeon into a stag and his savage death, torn to pieces by his own hunting dogs (see colour reproduction).

The companion picture, the *Diana and Callisto* (Plates 143, 148–150), also based upon Ovid, relates the misfortune of the girl Callisto, who had been seduced by Jupiter, when he appeared to her disguised, in the most preposterous of ways, as the Goddess Diana. The moment chosen in Titian's painting is the bath 'in a gently murmuring stream', when the other nymphs disrobe Callisto and discover her pregnancy, and Diana with imperious gesture banishes her from the company of her virgins. There is no hint of the unhappy sequel, Callisto's subsequent transformation into a bear and her life of misery, as she wandered alone hiding from wild beasts and huntsmen. Instead the two reliefs upon the fountain provide an unobtrusive link in iconography with the companion picture in their reference to the story of Actaeon. The one shows a stag fleeing from the standing goddess and the other a stag approaching the seated Diana. By contrast with her role in the other painting as victim of intrusion, Diana is here represented as commanding judge. Seated beneath a canopy of cloth of gold, suitable to her divinity, she watches the rich yellow drapery being ripped with sweeping gesture from the cringing Callisto's body by the standing nymph at the left, whose own ample profile is somewhat confusing to the spectator. That this nymph was sometimes identified as the pregnant one, even by the painter's contemporaries, is clearly indicated by the change in the group made by Titian in the second version of this composition, now in Vienna (Plate 154). The handsome colour composition again emphasizes rose and golden yellow against blue, just as in the *Diana and Actaeon*, but here the golden areas predominate and against them are contrasted the pale bodies of the girls and their limited draperies of rose and blue. Among the extraordinarily subtle repetitions of colour may be mentioned the pink of the quiver at the lower right, which restates the tone of Callisto's boots at the left. A more neutral brown is provided by the pier and the dog, while again, as in the companion picture, the sky breaks through in glorious ultramarine blue, but in this instance with a centre of golden clouds against the

361. The pose of the crouching girl with her right arm across her breast may have been suggested by the *Crouching Venus* (Fig. 23), as Gould has pointed out (1972, IV, p. 464). However, the theory that the pose of the nymph with back turned is lifted from Ugo da Carpi's chiaroscuro woodcuts after Parmigianino (Panofsky, 1969, p. 156) seems far-fetched. I do not believe that a supremely great master such as Titian often relied upon mediocre woodcuts or sarcophagi to arrive at the pose of a figure.

light-green trees. Classic allusion is present in the *putto* with the grey urn, which is a direct quotation from antique sculpture, the major one in the two paintings. This figure was a favourite fountain motive in late antiquity, examples being preserved in the Vatican Museum and the Museo dei Conservatori in Rome.[362] In the centre foreground a dark-brown hunting dog, nearly invisible in photographs, crouches in an attitude suggestive of shame and a second hound peers out mournfully at the right. As in the companion piece, the *Diana and Actaeon*, the tightly bound group of figures leads obliquely from the sides inward. The two pictures formed a balanced pair with the story of Actaeon at the left, where the brilliant rose curtain creates a stop. The golden canopy above the goddess's head is employed for the same compositional purpose at the right side of the two pendant works.

As explained in the catalogue,[363] the nude figures have suffered grievously from excessive scrubbing and cleaning in the past centuries and as late as forty years ago. For example, the abdomen and navel of Callisto have been stripped down to the raw canvas in removing added veils, which were less objectionable than the present state. Nevertheless, the essential beauty of the nudes survives even in the superhuman figure of the Diana, whose body shows more losses than that of any other. These two great masterpieces, the *Diana and Actaeon* and the *Diana and Callisto*, are works of breath-taking beauty and replete with imaginative qualities of unparalleled brilliance. Yet evaluation of them in the past has been astonishly reserved. Waagen[364] called them 'motley and mannered' although he did have praise for the landscapes. Frank Jewett Mather,[365] with some words of approval, still felt it necessary to say that 'the surplusage of nudity was such as the "depraved Emperor" would have relished'! Much earlier Crowe and Cavalcaselle,[366] despite their Victorian inhibitions, wrote with some enthusiasm of these two compositions. They declared, however, that these late works lack the 'poetry and freshness of the Bacchanals' (Plates 39–64).

In recent times one of the major problems has been to place these paintings stylistically in the development of the late Renaissance. Tietze classified them as Mannerist and saw the influence of Parmigianino and Giulio Romano.[367] The elongation of the bodies is a clearly Mannerist element of the mid-century, present here, as in others of the master's works at this time. Most notable in that respect are the figures of the huge Actaeon and the Diana herself, the tall imperious goddess of the *Diana and Callisto*. Nevertheless, the compositional organization of the two pictures displays no similarity to the Mannerism of Central Italy, where the bringing of figures to the front plane in a vertical wall-like structure is typical, and none to that of other schools which exploit an exaggerated spatial depth as did Daniele da Volterra and Tintoretto. Titian's two masterpieces devoted to the legends of Diana surely rank among the most original and the most beautiful paintings in the entire history of European art.

The replica of the *Diana and Callisto* in Vienna (Plate 154) has the advantage of having survived in a far better state of preservation than the more famous version in Edinburgh.[368] Its high quality allows of no reasonable reservations as to whether it is the work of Titian, although various details reflect the

362. Brendel, 1955, Fig. 16.
363. Cat. no. 9, Condition, for both canvases.
364. Waagen, 1854, II, pp. 31–32.
365. Mather, 1936, p. 271. How little Mather understood the young Philip, who was fully aware of Titian's genius! Besides he was

never Roman Emperor but King of Spain and the Spanish Dominions.
366. C. and C., 1877, II, pp. 280–287.
367. Tietze, 1936, I, pp. 219–220.
368. It is probably the work purchased by Maximilian II of Austria in 1568. See Cat. no. 11, History.

assistance of the workshop. One can detect the less skilful hand of a pupil in several figures, among them the girl closest to Diana, whose head bears a physical resemblance to the work of Girolamo Dente. The identification of this nymph as a portrait of Titian's daughter Lavinia[369] does not bear historical examination, since she had married and left Venice in 1555 and in 1561 she had died.[370] Several major changes were introduced in the Vienna composition, most notably the elimination of the opulent woman standing at the left, who distracts attention from Callisto in the Edinburgh picture. She is replaced by a half-kneeling girl, whose position causes the glance to fall directly upon the hapless Callisto. Here, too, transparent draperies were added later, apparently *c.* 1600, for in Cort's engraving of 1566 (Plate 216) they are lacking while they appear in Teniers' copy *c.* 1651 (Plate 202). The large, handsome fountain with round basin, topped by a statue of Diana with a stag, is an important and effective innovation, which is responsible for the elimination of the girl seated at Diana's feet in the first version. The big crouching dog in the foreground is replaced by one of Titian's amusing little barking puppies, while the large gloomy hound at the right remains. The landscape in this second version is somewhat less sumptuous than in the first, but the deep-blue sky and the setting are still very handsome. Criticism has in general done little justice to this fine painting.

Titian informed Philip II in a letter of 19 June 1559 that he had already begun the *Rape of Europa* and *Actaeon Attacked by His Dogs* and that he had finished the two companion pieces of the Diana legend.[371] Although the *Death of Actaeon* (Plates 151–153) seems to be a logical choice as the sequel to *Diana and Actaeon* (Plate 142), Titian never finished the picture and it was therefore never delivered to the Spanish king.[372] The painter must have realized that the subject is rather gruesome and not a fitting companion for the gay and somewhat humorous story of Europa being suddenly and unexpectedly carried off by the white bull (Plate 141). Dominating the scene in her Olympian stature, Diana looses an arrow and herself partakes in the killing of the hapless Actaeon. Thus Titian diverged from Ovid's description, in which the hounds tore to pieces their own master, by then transformed into a deer. The fact that only Actaeon's head has as yet been changed into that of a stag makes the drama all the more cruel. As Panofsky has pointed out, Titian treated the legend with considerable freedom in imagining the goddess herself as the executioner. The striding huntress is conceived in the terms of mid-sixteenth-century Mannerist elongation to a degree even more notable than in the related episodes of *Diana and Actaeon* and *Diana and Callisto* (Plates 142, 143). The absence of the string on the bow and of the arrow which appears to have been shot is evidence of the unfinished condition. However, Diana's rose-coloured dress, with short skirt and one breast revealed *all'antica*, is in a state of virtual completion according to Titian's late, illusionistic style of brushwork. Gould[373] is probably right in believing that the lateness of style explains the little positive colour and the absence of ultramarine in

369. Stix, 1914, pp. 344–346. The Vienna picture is datable *c.* 1566, after Lavinia's death.

370. See Wethey, II, 1971, p. 5, note 27, Cat. nos. 59–61, Plates 187, 188. Lavinia's death seems to have been brought on by bearing six children in as many years. Even if she lived as late as 1573, she was no longer in Venice (Cadorin, 1833, pp. 57, 123). Titian's illegitimate daughter, Emilia, was born about 1548 and married to Andrea Dossena about 1568 (Brunetti, 1935, pp. 175–184; Wethey, I, 1969, p. 14, note 74).

371. See Cat. no. 8, History, for the documentation.

372. Because of the subject matter, the picture is considered here. The problems involved in its ultimate provenance are explained in Cat. no. 8.

373. Gould (June 1972, pp. 464–469); he has drawn attention to a deep shadow on the head of the Angel in Titian's San Salvatore *Annunciation* (Wethey, I, 1969, Plate 62). He thus rejects Keller's theory that Diana's head was repainted in the seventeenth century.

the sky. His date of 1562–1566 might be advanced even further to 1570–1575, contemporary with the *Nymph and Shepherd* (Plate 168). Nevertheless, the ochre colour throughout the landscape is clearly still in a preparatory phase, lacking any suggestion of final glazes. Even the figures of Actaeon and the dogs are merely blocked in. Nevertheless, the picture is a magnificent example of Titian's late style and tells much about his technical methods. The splashing of the paint upon the bush in the left foreground and on the other bushes and trees in the landscape is masterly in the creation of form by suggestion. In the compositional structure, the goddess at the left does not quite balance the setting and the smaller figures of Actaeon and the hounds, again an indication of the incomplete state. However, the execution is so far advanced that one wonders whether Titian's decision to abandon the picture, because it was not suitable as a pendant to the *Rape of Europa*, was wholly independent, or whether it might have been prompted by the advice of the Spanish ambassador, García Hernández.

One of the last of Titian's *poesie* for Philip II, the *Rape of Europa* (Plates 138–141), is first mentioned as having been begun in Titian's letter of 19 June 1559, there coupled by the artist with the *Death of Actaeon*, as we have seen. The shipment to Genoa for delivery to Spain is recorded in letters of 10 and 26 April 1562, and the painting reappears in the letter of 1574 among the several works for which Titian said he had received no payment. In 1704 through a lamentable act of largesse, the French-born Philip V bestowed the *Rape of Europa*, as well as the two *Dianas* now in Edinburgh, on the Duc de Gramont, the French ambassador in Madrid, thus contributing to the thinning of the royal Hapsburg collections.[374] The *Rape of Europa* is one of Titian's most brilliantly imagined works and one for which no true precedent exists. He saw the episode as high comedy in which the girl, legs and arms flying, is abruptly carried off by Jupiter, who had so artfully deceived her in the form of a white bull. Apparently docile and innocent in playing with the young maiden, as described by Ovid, the wily Jupiter induced the guileless Europa to climb upon his back, whereupon he took off over the sea, as she clung to one horn. Suitable to the comedy are the two cupids following in pursuit overhead and a third, who mockingly trails along, riding in similar fashion upon a dolphin's back. The composition in a long diagonal direction seems to follow from the sudden action; even so, oblique design had been an integral part of Venetian artistic practice since Giorgione first conceived the *Sleeping Venus* (Plate 9). Nevertheless, the figure in the latter is parallel to the picture plane, where as in this late work a slight turn of direction inward is implied, which, as in the *Dianas* in Edinburgh (Plates 142, 143), foretells the later developments of Baroque spatial depth.

To do justice in words to this masterpiece is virtually impossible. In beauty of colour and in mastery of technical handling the late style of the great master has here reached its fulfillment. The white shift of Europa and her pale flesh tones are managed with the greatest subtlety against the white bull. The sea with its iridescent lights is truly dazzling, as from foreground to the distant mountains it slowly coalesces with the haze of the horizon. The crags and rocky slopes, glimpsed through veiled lights and opalescent colours, are created by the magical effects of the brush, and conjure up an illusion of space and atmosphere that knows no precedent and understandably dazzled later masters of landscape. In all aspects, in the interpretation of the subject, in the subtle treatment of compositional

374. The complete history of the *Rape of Europa* in the Spanish royal collections and subsequently is reported in Cat. no. 32, History.

elements, and in the incomparable brushwork and handling of the colours, Titian's *Rape of Europa* remains an unparalleled performance.

The iconography of this *poesia* of Europa and the various theories about it have been set forth in detail in the catalogue. In addition to the well-known passage in Ovid, which is quoted there, it has recently been shown that Titian must have read Achilles Tatius, whose poem had been translated into Italian by the artist's friend, Lodovico Dolce.[375] This literary source mentions the mountainous distance, where we see the tiny figures of Europa's companions (Plate 138) watching with astonishment. The gay dolphins in the foreground and the pursuing cupids in the air above are also accounted for.

Whether Titian intended to establish a literary continuity among all the mythological works that he planned for Philip II is a moot question. Europa, it seems, was the sister of Cadmus, the founder of Thebes. Ovid himself recalls that Actaeon was the grandson of Cadmus,[376] but whether this relationship played any part in Titian's selection of these themes is uncertain. Yet surely, as previously mentioned, he must have been motivated in his choice of the legend of *Perseus and Andromeda* (Plate 134) by the fact that the hero was the son of the Danaë by Jupiter and that the scene of the *Death of Actaeon* (Plate 152) is the immediate episodic sequel to *Diana and Actaeon* (Plate 142). The compositions of the *Perseus and Andromeda* (Plate 134) and the *Rape of Europa* (Plate 141), each with a setting upon the sea, go together very well visually. On the other hand, none of the surviving correspondence between Titian and Philip II gives any hint that they were conceived as a pair. Indeed, we shall see that the grouping of the *poesie*, as they were hung in the royal palace of Madrid, followed no consistent norm, at least after the period of Philip II.

The *Poesie* and the Spanish Royal Palaces

TITIAN's great mythological works were never intended for a particular room in a specific Spanish palace, as were the cycles of paintings in Isabella d'Este's *Camerino* at Mantua, Alfonso d'Este's *Studiolo* at Ferrara, or various rooms in Federico Gonzaga's palaces at Mantua. The entire history of the Spanish court prior to the seventeenth century shows that no permanent capital existed but that the court moved from town to town and that the rulers lived in various mediaeval castles or frequently in a more recently built palace of one of their noblemen. When Charles V, born at Ghent, first visited Spain he was housed in an essentially rudimentary fashion. On spending his honeymoon with the Empress Isabella at Granada in 1526, he chose to stay in the Moorish palace of the Alhambra, a fact which prompted him to arrange for the construction of the celebrated Renaissance structure known as the palace of Charles V.[377] During his visits to Italy, first for his coronation at Bologna in February 1530, his introduction to the splendours of art and architecture led him further to realize the inadequacy of the mediaeval castles of Spain for an Emperor of his international rank. It was he who initiated the

375. Cat. no. 32, Iconography: sources are quoted here and evaluated.
376. Cat. no. 9, Iconography.
377. Charles never visited Granada again and never saw the handsome building with its great circular court. Begun in 1527, its

walls were largely complete by 1568, but it has been finished only in 1972. See Chueca Goitia, 1953, pp. 211–221. A large monograph on the building by Professor Earl Rosenthal will be published soon.

modernization of the castle (Alcázar) at Madrid and the other at Toledo, both in the year 1537. Neither was completed until after his death, the one in Madrid about 1565 and the great structure atop the hill at Toledo not until 1584.[378] Philip II's career during his long reign, was also characterized by moving from one castle or palace to another, partly because of the traditional way that Spanish monarchs lived and to some extent because the buildings were all in a state of reconstruction until the last years of his life. The reason why he frequently moved his choice art collection is consequently understood. Although Prince Philip had spent his youth mainly at Valladolid,[379] he choose the Alcázar at Toledo as a residence when he, as king, returned to Spain from the Netherlands in August 1559. There his new and third bride, Isabel de Valois, aged fourteen, came for the solemnization of their marriage in Toledo Cathedral on 3 January 1561. It was here at Toledo that Philip received Titian's *Diana and Actaeon* and *Diana and Callisto* in August 1560,[380] so that the king and his bride possessed the most handsome works of art imaginable to decorate the Grand Hall or the bridal suite of the Alcázar. When Philip decided to move to Madrid in May 1561, never returning for any long period to Toledo, he must have taken with him Titian's two masterpieces, which he had had in his possession for less than one year. What happened to them later in Philip's reign we leave for speculation below. At Madrid most of the living quarters were obviously habitable by this time. The other residence, El Pardo Palace, in the outskirts of Madrid, served primarily as a refuge for pleasure and for hunting, yet it is the only one which still survives. Totally rebuilt from 1543 to 1568,[381] it housed the greatest array of portraits by Titian ever assembled in one place until that gallery with all its contents was consumed by fire on 13 March 1604.[382] One mythological picture by Titian, *Jupiter and Antiope*, still known as the 'Pardo Venus' (Plate 74), is cited there in the Inventory of 1564 and again in 1582, and it remained constantly at El Pardo, as proven by several literary sources, in one of the main halls. Untouched by the fire of 1604, it was presented as a gift to Prince Charles of England on his celebrated visit to Madrid in March 1623.[383] Philip II may well have kept some of Titian's *poesie* in the principal castle (Alcázar) at Madrid during the fifteen-sixties and -seventies, but not a single one is recorded there in the Inventory made after his death in 1598. Correggio's famous *Leda*[384] appears among the pictures in the series of five rooms called the Guardajoyas,[385] which were on the ground floor on the west side of the castle

378. Iñiguez Almech, 1952, pp. 59–63 and pp. 101–108; Chueca Goitia, 1953, pp. 163–169. Neither building survives today—the Alcázar at Madrid was almost totally destroyed by fire in 1734 and replaced by the present royal palace in the mid-eighteenth century. The Alcázar at Toledo, ruined in the civil war in 1936–1938, has been rebuilt but without its original splendour.

379. The palaces at Valladolid, some of which date from the early sixteenth century, were not grandiose structures except the new one built by Francisco de los Cobos (Chueca Goitia, 1953, p. 88, fig. 59, finished *c.* 1535). At Charles V's death (1558) the castle at Simancas in the outskirts of Valladolid contained a vast amount of his belongings. The Inventory of 1561 includes the famous *Annunciation* by Titian (see note 217; for the Inventory of 1561, Beer, 1891; and Wethey, I, 1969, Cat. no. 10).

 Charles V's collection of religious pictures and portraits went with him to the monastery of Yuste on his retirement in 1556, but passed to Philip II on the Emperor's death two years later (Wethey, I, 1969, pp. 116, 166; *idem*, II, 1971, pp. 88, 193, 195).

380. See Cat. no. 9, History.

381. Iñiguez Almech, 1953, pp. 108–113. See also note 268 above.

382. The portrait gallery at El Pardo contained much of Mary of Hungary's collection, which she had assembled at Brussels and then had taken to Cigales (Valladolid) on her retirement to Spain in 1556 (see Wethey, II, 1971, pp. 202–203; El Pardo inventories: Calandre, 1953, pp. 39–97). On her death Philip II inherited the pictures.

383. See Cat. no. 21, History.

384. Sánchez Cantón, publication of Philip II's inventories, 1956–1959, II, p. 234, no. 199. The *Leda*, which had earlier been in the collection of Antonio Pérez (unpublished Inventory, 1585, folio 474, the artist's name omitted), later became the property of Rudolf II at Prague. It is now in the Staatliche Gemäldegalerie at Berlin after having belonged to Queen Christina and the Duke of Orléans (Kühnel–Kunze, 1963, p. 31, no. 218).

385. 'Guardajoyas' could be translated as 'treasure rooms' or in German as 'Schatzkammer'.

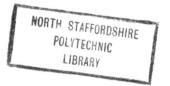

(Figure 62, Rooms 118–122). Otherwise portraits predominated, and among them were Titian's *Charles V at Mühlberg, Charles V with Hound*, and *Philip II in Armour*.[386] The palace at Aranjuez was even more of a country estate than El Pardo, and in the last fifteen years of Philip's life a favourite resort for long sojourns in spring and autumn.[387] By a process of elimination, it may be assumed that Philip had his collection of *poesie* and other mythological pictures by Titian installed at Aranjuez about 1584, when the new buildings became habitable. Philip's Inventory of Aranjuez is lost except for an account of the religious objects in the chapel and its sacristy.[388] Other possibilities for the location of the mythological works are ruled out, since they could not have been at Segovia or in Andalucia and certainly not in the royal apartments of the great monastery at the Escorial, where the king endured his last physical agonies and died in the summer of 1598.[389]

When we reach the early seventeenth century we are on safer ground, for all of the major mythological paintings had been gathered into the palace (Alcázar) in Madrid either by Philip III or far more likely by Philip IV (1621–1665), who rivalled his grandfather as an art collector.[390] The first mention of them is found in Gil González Dávila's description of Madrid, published in 1623. In writing of the Alcázar he says: 'On the south there is a delicious view. Near this gallery the King writes, signs, and has his office. Nearby is a garden adorned with fountains and statues of Roman Emperors and the one of the great Charles V. Near it are some rooms filled with paintings of different fables by the hand of the great Titian.'[391] On Cassiano dal Pozzo's[392] visit to Madrid in 1626, he described the major paintings with great admiration and in detail, especially those by Titian, but he is very vague as to their exact

386. Wethey, II, 1971, Cat. nos. 20, 21, 78. The portrait 'of Charles V at Mühlberg' had hung in the fifth room of the Casa del Tesoro (a section of the palace), and here also was the *Allegorical Portrait of Philip II (Lepanto)* (Wethey, *loc. cit.*, Cat. no. 84). The few religious paintings then in Madrid comprised the *Adam and Eve* (Wethey, I, 1969, Cat. no. 1; see also this volume, Addenda I), now in the Prado Museum. The canvases of a paired *Ecce Homo* and *Madonna with Clasped Hands* (Wethey, *loc. cit.*, Cat. no. 35) are lost, while the famous pair on slate and marble, then in the 'lower oratory', still survive in the Prado Museum (Wethey, *loc. cit.*, Cat. nos. 32, 77).

387. Originally a small country palace built in 1387, Philip II developed it into a Renaissance estate with extensive wooded gardens. The rebuilding began on plans of Juan Bautista de Toledo (1564), but, redesigned by Francisco de Herrera in 1569 and 1574, it seems to have been essentially completed by 1584 (Iñiguez Almech, 1953, pp. 113–119). The vast palace and urbanization in which it is set today are the result of rebuilding throughout the eighteenth century (Kubler, 1957, pp. 215–221, with plan and photographs).

388. Sánchez Cantón, 1956–1959, I, pp. 108–117; only Titian's *Entombment* is reported as in the chapel (p. 117; see also Wethey, I, 1969, Cat. no. 38). The *Annunciation* (Wethey, I, 1969, Cat. no. 10) was brought there from Simancas in the early seventeenth century. Cassiano dal Pozzo's lengthy description places it there in 1626.

389. Inventories and other descriptions of the major palaces prove that the mythological pictures were not there and not in Valladolid. Philip's greatest architectural project was, of course, San Lorenzo del Escorial, begun in 1563 and finished, except for the tombs, before he died. For the Escorial's architecture see

Schubert, 1924, pp. 37–66; Chueca Goitia, 1953, pp. 361–366; also the two-volume publication *Escorial*, Madrid, 1963. The bibliography on the subject is vast.

390. Philip III (1598–1621) moved the court back to Valladolid for a time (1601–1606) but he returned to Madrid in 1606, and thereafter it became the permanent capital of Spain. See León Pinelo, edition 1931, pp. 53, 70.

391. González Dávila, 1623, p. 310. The last line is puzzling in its archaic Spanish 'En el ay unas quadras, accompañadas de pinturas de diferentes fábulas'. The word 'quadra' is the equivalent of the English 'quarters'. Carducho in 1633 writes of the king's dining-room as 'desde la quadra adonde come su magestad' (edition 1933, p. 106).

392. Cassiano dal Pozzo served as secretary to Cardinal Francesco Barberini on the visit of the papal legation to Spain in 1626. The manuscript is Barberini latino 5689 in the Vatican Library at Rome. It is an accurate copy, not in Cassiano's own hand. I am much indebted to Enriqueta Harris Frankfort for calling my attention to the manuscript and for allowing me to have a complete copy made from the microfilm that she acquired for the Warburg Institute in London. Mrs. Frankfort and Dr. Gregorio de Andrés, formerly librarian of the Escorial Monastery (1972, Anejo, pp. 3–33), have recently published the full Italian text of the sections on the Escorial with commentaries. Mrs. Frankfort has kindly called my attention to an error on p. 4, note 5, in which El Greco's *Allegory of the Holy League* is said to have entered the Escorial only in 1654. This is an error of her non-art-historian collaborator, who confused the picture with the oil sketch in the National Gallery at London (see Wethey, 1962, II, Cat. nos. 116, 117).

location. Cassiano does make it clear that they were hung in three rooms in the same vicinity. He writes: 'in the last apartment on the ground floor of this palace which they call the vaulted rooms (*bóvedas*), one sees the following famous paintings, and this vaulted apartment, with outside walls all around, is plastered, at slightly less than a man's height, with tiles of blue rosettes . . . at the left hand there are some rooms from which one descends to the Plaza.'[393] Here were the *Diana and Actaeon* and *Diana and Callisto* (Plates 142, 143) placed together, and he praised them enthusiastically. In a small adjoining room he saw a copy of *Perseus and Andromeda* (Plate 134) and Titian's *Venus and Adonis* (Plate 84), and a number of portraits of queens of Spain and Mary Tudor. In still another, larger hall, centred with a marble fountain topped by a reclining woman holding a cornucopia, he described with delight and at some length the *Danaë* (Plate 83), and he gave rapt attention to Jupiter's face (now lost) in the clouds. Next to the *Danaë* hung the *Rape of Europa* (Plate 141) and more portraits, one of a 'Venetian Lady', which he attributed to Titian. In another small room ('saletta') with windows on a secret garden, he saw *Tarquin and Lucretia* (Plate 164) 'bellissima', but he thought Tarquin's costume was too modern! Nearby *Venus and Cupid with an Organist* (Plate 105) was to be admired with its 'very beautiful landscape, which ends with a very large alley of two rows of trees'. Next to it hung the double portrait of *Charles V and the Empress Isabella*.[394] Likewise in this same 'saletta' were an *Allegory* that Cassiano interpreted as a story of Psyche,[395] another portrait of *Charles V*, and *Venus Clothed at Her Toilet with One Cupid*,[396] all of them said to be by Titian. At this point the writer quotes the remark of a courtier, the truth of which may be doubted: 'Every time that the queen comes down to this apartment, all of the pictures where there is nudity are covered.' The visitor then continued on through numerous rooms, where he examined nine portraits, Rubens' large *Adoration of the Kings* (now in the Prado Museum), and hundreds of other paintings.

The conclusions reached are that only the *Diana and Actaeon* and *Diana and Callisto* were grouped as a pair in the way that Titian had planned, since the original intentions of the artist seem to have been forgotten after the death of Philip II. The exact locations of the galleries and smaller rooms are not clearly indicated by Cassiano dal Pozzo, but it appears that they were in great part on the ground floor and on the south west side of the palace as implied by González Dávila in 1623. Undoubtedly their installation was more or less provisional so far as Philip IV was concerned. In exactly these years (1611–1626) the Alcázar was undergoing another major rebuilding programme under the direction of the chief architect, Juan Gómez de Mora.[397] Summer quarters for the king were constructed on the ground floor of the northern side of the palace, a move prompted by the intense heat of Madrid in midsummer. This total reorganization of the king's living quarters is clearly reflected in the Inventory of 1636, although it still leaves some puzzles.[398] Vicente Carducho, writing in 1633, comments upon the changes: 'I saw the vaulted rooms which have been rebuilt below the level of the patios which

393. Cassiano dal Pozzo, 1626, folios 120v–121. He notes here copies of Correggio's *Ganymede* and of Parmigianino's *Cupid*.

394. Wethey, II, 1971, Cat. no. L–6, Plate 151, Rubens' copy of the lost original.

395. Actually this picture was an early Baroque forgery; see Cat. no. 1, Literary Reference no. 2.

396. Cat. no. L–27.

397. Iñiguez Almech, 1953, p. 93. The wooden model (Figure 64) in the Museo Municipal is believed to be connected with this rebuilding *c.* 1626. The entire façade in early Baroque style belongs to the same period and architect.

398. 'Inventario de pinturas del Alcázar, 1636', Archivo del Palacio, Madrid, legajo 9, folios 36 ff.

have a view to the north (Fig. 62), a convenience which they have arranged for the royal personages during the summer, and they are adorned with many paintings. I admired the buildings which had formerly been low, dark, and uninhabitable; and now the quarters are agreeable and very well furnished (power and art are so strong) that the king and queen no longer need to leave the court in summer.'[399] To reach the new suite one descended by 'the stairway which leads from the northern gallery to the lower and vaulted rooms for the summer'.[400] In 1636 most of Titian's mythological pictures were in a rather private room of the summer quarters which is described as the 'last room of the vaulted chambers (*bóvedas*) which has a window on the east where his Majesty withdraws after dining'. It immediately adjoined the summer dining-room. In this retreat he had assembled his favourite Titians: the *Adam and Eve*[401] and next to it the *Tarquin and Lucretia* (Plate 164) followed by *Venus and Cupid with an Organist* (Plate 105). Then the two pictures of *Diana and Actaeon* and *Diana and Callisto* (Plates 142, 143) remained together, for virtually no one could fail to see that they were pendants. Next there came the *Rape of Europa* (Plate 141), the *Venus and Adonis* (Plate 84) and the *Danaë* (Plate 83) and at the end a copy of *Perseus and Andromeda* (Plate 134). Now this comparatively small room, dedicated to Titian, contained only nine pictures, and in addition it had one mirror and two buffets. By contrast the king's summer dining-room, which adjoined, had twenty-one pictures, and the decorations of his summer bedroom comprised twenty-two large portraits of his ancestors and three important pictures by Titian, *Venus Clothed at Her Toilet, Religion and Spain*, and the double portrait of *Charles V and Empress Isabella*. It is manifest that Philip IV's private 'withdrawing room' had the special honour of containing only masterpieces by Titian and indeed all of those that the artist had called the *poesie* for the king's grandfather, Philip II. They were no longer scattered through three adjacent rooms, as they had been when Cassiano dal Pozzo visited Madrid. In fact Philip IV had made his personal quarters a haven of beauty much as Alfonso d'Este and Isabella d'Este each had done with a *Camerino*. *Adam and Eve* had no iconographic right to be here, but with good reason Philip IV included a work of such beauty, while the *Venus and Cupid with an Organist* (Plate 105) by its theme fitted even better.[402]

Another and drastic renovation of the Alcázar took place under the direction of Velázquez, who became general superintendent of the reconstruction in 1643 and continued in this post until his death seventeen years later.[403] The collection of paintings was extensively relocated and rehung. In the

399. Vicente Carducho (1633), edition 1865, pp. 343-344; edition 1933, pp. 105-106. He goes on to describe the new constructions for entertainment in the park at the north of the palace.

400. 'Escalera que va desde la galería del Cierço al quarto bajo y bóvedas del verano' (Inventory, 1636, folio 29). From the description it appears that the new rooms were somewhat below ground level and clearly on the north side of the palace (Figure 62), where the columns indicate the Galería del Cierzo (Gallery of the North Wind). Since Figure 62 represents the plan of the ground level, the new vaulted rooms below the ground do not appear. It is difficult to determine whether they ran the full length of the north side of the palace. However, the room is said to have had a window on the east so that would imply a location in the extreme north east in the lower part of the angle tower.

401. Wethey, I, 1969, Cat. no. I, Plate 162; *idem*, III, Addenda I, Cat. no. I.

402. Cat. no. 47, History. This picture apparently first came to Spain in 1604.

403. It is not the purpose here to follow in detail the extensive architectural work carried on at this time. The major recent studies on the subject are Azcárate, 1960, pp. 357-385 and Iñiguez Almech, 1960, I, pp. 649-682. The series of rooms across the south front of the palace on the main floor were rebuilt and redecorated, i.e. the Galería del Mediodía (Gallery of the South) and the Salón Grande (sometimes called the New Room or Pieza Nueva and later the Hall of Mirrors, i.e. Salón de los Espejos [*c.* 1623-1659]) and the Octagonal Room (Pieza Ochavada). The plan (Figure 65) published by Justi (1889, p. 96) represents the main floor (*piano nobile*; called the first floor in Europe and the second floor in America). The Ochavada (1646-1648) necessitated the demolition of a mediaeval tower which occupied that space.

Southern Gallery (Galería del Mediodía), devoted largely to portraits, the *Roman Emperors*, on their arrival from England *c.* 1652, were placed high upon the wall, and nearby in the Hall of Mirrors (Galería de los Espejos) was *Charles V at Mühlberg*. Titian's mythological pictures now received an entirely new setting. Instead of being placed together in a rather small room for Philip IV's private delectation on the north side of the palace, they were transferred to a long, formal picture gallery on the south and west, bordering on the Garden of Emperors in the same region where they were to be found back in 1623. In the Inventory of 1666, compiled by Juan Bautista del Mazo, Velázquez's son-in-law, the new hall is known as the Lower Gallery on the Garden of the Emperors and in the Inventory of 1686 it is first named the 'Bóvedas de Ticiano'. Primarily pictures by the great master found a place here, and they comprised Philip II's *poesie* as well as other works by Titian acquired later. Most famous of these later acquisitions of Philip IV were the *Worship of Venus* (Plate 39) and *The Andrians* (Plate 57), *Venus and Dog with an Organist* (Plate 113), and a few copies which passed as originals.[404] The installation of the paintings on the walls under Velázquez's direction had little or no connection with the iconography of the subjects. The *Diana and Callisto* (Plate 143) and *Diana and Actaeon* (Plate 142) were located with the *Rape of Europa* (Plate 141) between them. Twenty canvases provided a superb picture gallery, nearly all of them then thought to be by the Venetian master.[405] The exhibition of paintings in the 'Vaulted Rooms of Titian' (*Bóvedas de Ticiano*) remained virtually unchanged until the fire of 1734, when the old palace was so devastated that it had to be totally demolished to make way for the enormous eighteenth-century structure, which still exists today. The documentation concerning the great fire is abundant, and it has been published in a thorough fashion in recent years by Ives Bottineau.[406] The fire broke out on Christmas Eve 1734, when the royal family were living in the palace of Buen Retiro on the opposite side of Madrid. While the flames raged, the Franciscan friars of the nearby monastery of San Gil worked valiantly to remove the treasures of the palace. The vaulted rooms (*bóvedas*) escaped with slight, if any damage at all, because a strong wind swept the flames upward, and, moreover, the lower rooms on the first floor were constructed of masonry.[407] The major halls on the upper principal story suffered badly with the resultant loss of royal portraits by Titian and of his *Roman Emperors*.[408] The reason for the rather lengthy digression about the fire of 1734 is that most writers assume that all of the pictures in the Alcázar suffered from the flames or were blistered by the heat. Such, however, was not the case, since many of the most famous works were removed immediately and those in the lower vaulted chambers escaped virtually uninjured. Fortunately, the

404. The copies and wrong attributions included *Perseus and Andromeda* (Cat. no. 30, Literary Reference no. 1); *Orpheus* (Cat. no. X–31); *Cupid Blindfolded* (Cat. no. 4, copy no. 3); an *Allegory* (Cat. no. 1, Literary Reference, no. 2); a *Sleeping Venus* (Cat. no. L–15). There were two versions of *Venus at Her Toilet with Cupid* (Cat. no. L–27, History) and a *Decapitation of St. John the Baptist* (Bottineau, 1958, p. 324, no. 885). The fable of Perseus mourned by a goddess wearing a crown of flowers (Bottineau, 1958, p. 324, no. 886) sounds like Ribera's *Death of Adonis*, now in the Cleveland Museum of Art.

405. Ives Bottineau, 1956, and 1958, pp. 318–325, published both of the Inventories of 1666 and 1686. However, I have examined in the Archivo del Palacio the original documents of these two and others inventories, beginning with those of Philip II.

406. Bottineau, 1960, pp. 476–496. On pages 624–625 he reproduces Jean Ranc's succinct report of the losses of pictures.

407. *Loc. cit.*, p. 492; i.e. the ground floor.

408. The Galería del Mediodía (then also called the Salón Dorado), the Octagonal Room, and the Hall of Mirrors, which lay directly on the façade, suffered total destruction. Paintings were cut from their frames, among them Titian's *Charles V at Mühlberg* and *Philip II in Armour*. The latter (see Wethey, II, 1971, Cat. no. 78, History) was reported in the Inventory of 1734 as in good condition. The former was said to be in bad condition, but the figure of the Emperor still remains well preserved today (Wethey, II, 1971, Cat. no. 21). One can imagine that the canvas must have looked like a wreck as it lay on the floor in the Convent of San Gil after it had been hurriedly cut out of its frame.

most celebrated of Titian's mythological works were located in these galleries, and so the flames did not reach them, and there is no evidence of serious damage.[409] Moreover, the unpublished and in general unconsulted inventory made after the fire indicates in nearly every case whether or not a painting was damaged.[410] A minor court painter, Juan García de Miranda, was put in charge of relining and restoring damaged pictures. Although the payments that he received for sponges, canvas, glue, colours and the like are recorded in the documents, not a single name of a specific composition is anywhere mentioned.[411] Pedro de Madrazo, director of the Prado Museum in the middle of the nineteenth century, consulted the royal inventories when he prepared his catalogues, but his work is extremely summary and replete with error. In one edition of the Prado catalogue, that of 1872, he cited five pictures by Titian as having been restored by Juan García de Miranda after the fire of 1734, but he was indulging in pure speculation. There is no evidence at all that any of them were damaged in the fire.[412] Madrazo himself eliminated that information from his next catalogue, dated 1873, and all subsequent editions. However, Crowe and Cavalcaselle repeated the name of Miranda, and they gave the catalogue of 1872 as their reference.[413] From them these wrong data have been repeated by writers on Titian down through the year 1969.

409. A document of 2 July 1735 states that after the fire the pictures were stored in the vaulted chambers (*bóvedas*) of the palace, the Armoury, the house of the Marqués de Bedmar and next to the church of San Justo. The last mentioned group appears to have contained the works in need of restoration.

'Señor d. Juan Bauptista Reparaz Secretario del Rey Nuestro Señor y Contralor de su Real Casa: las pinturas que se han inventariado con intervención de ese oficio y el de Grefier, después de la quema del Palazio, y se hallan en sus bóbedas, y Armería, y casa del Marqués de Bedmar, se separan a la que se ha tomado junto a la Parrochia de San Justo en Madrid, y para que en ella se cuelguen y compongan por Don Juan de Miranda . . .'.
(signed) 'El Marqués.'

See also Bottineau, 1960, pp. 624–625. It should also be remembered that the fables of Diana (Cat. nos. 9, 10) and the *Rape of Europa* (Cat. no. 32) had left Spain in 1704 when the French-born Philip V gave them to the Duc de Gramont, the French ambassador, who shortly presented them to the Duc d'Orléans (documents cited by Bottineau, 1960, p. 233).

410. 'Inventario general de todas las pinturas que se han libertado del incendio . . . de 1734.' Archivo del Palacio, Madrid. The chaos which existed at this time is manifest in the brevity of the entries and their irregularity. Many are identified merely as 'portrait'. The condition is usually specified as 'bien tratado' (well preserved) or 'maltratado' (badly preserved). After restoration the major works were taken to the palace of Buen Retiro until the new Royal Palace was ready for occupancy. When Charles III came to live in the palace in 1764 the painted ceilings by Tiepolo, Mengs, Maella, and others were not yet completed.

411. Documents in the Archivo General del Palacio: Bellas Artes, Legajo 38; also Sección Personel, Caja no. 686/27. Juan García de Miranda, *pintor de cámara*, at a salary of 2000 ducats per year, was put in charge of restorations on 15 April 1735. Several documents were transcribed for me in 1972 by Teófilo Bombín Peña, archivist of the Royal Palace. They do not throw any light on the paintings by Titian and for that reason are not quoted here. The only hint in reference to exact pictures is the statement of García de Miranda's nephew and assistant, Pedro Rodríguez de Miranda, that they had worked on the repair ('compostura') of canvases that had been in the Cuarto Nuevo before the fire of 1734 (Bottineau, 1960, p. 404, note 33). This room, more commonly called the Salón de los Espejos, contained Titian's *Charles V at Mühlberg* (Wethey, II, 1971, Cat. no. 21) and the *Allegorical Portrait of Philip II* (*loc. cit.*, Cat. no. 84), and the *Four Condemned* (the present volume, Cat. no. 19).

A short biography of Juan García de Miranda (1677–1749) was written by Ceán Bermúdez (1800, II, pp. 169–173), but Palomino (1724) did not include him; further details in Bottineau, 1960, p. 495 and index.

412. Madrazo, 1872, pp. 678–682. The pictures that were said, incorrectly, to have been restored by Juan García de Miranda are *Venus and Adonis* (Cat. no. 40); *Venus and Cupid with an Organist* (Cat. no. 47); *Venus and Dog with an Organist* (Cat. no. 50); the *Allocution of the Marchese del Vasto* (Wethey, II, 1971, Cat. no. 10); *Adam and Eve* (Wethey, I, 1969, Cat. no. 1). Some recent Prado catalogues have returned to these old errors but they no longer include the name of García de Miranda.

413. C. and C., 1877, II, p. 406, note, regarding the *Adam and Eve*, a picture to which they give this title rather than the *Temptation* or the Germanic *Fall of Man*.

VI. THE LATE MYTHOLOGICAL PAINTINGS

Cupid Blindfolded and *Tarquin and Lucretia*

SOME nine late paintings remain to be mentioned in addition to those specifically intended for Philip II and other late compositions already studied, such as *Venus and Cupid with a Lute Player* (Plates 122, 123), which seemed most suitably grouped together in their iconographic relationships. The *Cupid Blindfolded* of the Villa Borghese, *c.* 1565 (Plates 155, 158, 159), stands very near in style to the *Diana and Callisto* at Edinburgh (Plate 143). The same tall Mannerist physique prevails in the clothed Venus in the one case and the nude imperious Diana in the other. Moreover, the brush work is characterized by Titian's late, illusionistic handling. Otherwise by the nature of their themes, they have little in common. The startling drama of the discovery of Callisto's pregnancy creates a high-pitched mood, while the Venus who binds the eyes of her trouble-making son, Anteros, appears to meditate, as she turns her head toward her other son, Eros (Cupid). The good god of Love, his brother, has whispered in his mother's ear to encourage her in her dutiful task. At the right two nymphs, half-kneeling, look on attentively, as they take charge of Anteros' bow and arrows to prevent him from creating more amorous havoc. They with Venus must represent the three Graces, as thought from their earliest mention in 1613, for they wear the traditional Renaissance garb of nymphs, notably the one in the foreground, whose left breast is uncovered.[414] All have the classical profile suitable to characters from antique lore. The colours display great beauty and richness, the bad state of preservation notwithstanding. Venus, wearing a diadem of pearls and rubies and dressed in a white tunic and blue stole, stands out against a rose curtain and dark green panel. At the right the draperies of the Graces have two shades of rose against the once glorious blue mountains and sunset sky, while the blindfold is pale yellow against the superbly painted body and the varicoloured wings of Anteros (Plate 158).

A work of extraordinary beauty is the *Cupid Blindfolded* in Washington (Plates 156, 160), whose composition is directly based upon the left portion of the Borghese picture (Plate 155), with only the landscape eliminated. A partial additional figure of a woman with platter upraised was painted over by the artist himself, until brought to light in a recent cleaning and restoration. The original composition would have been strange indeed, if the entire figure of the woman had been retained. The technique in painting the lavish dress shows extraordinary dexterity throughout. Venus wears a golden Renaissance costume, instead of the white tunic *all'antica* that usually befits a goddess. Only the short sleeve, slit in contemporary fashion, leaving the arm bare, tells us that she is a goddess and not a Venetian lady. The exquisitely jewelled baldric placed obliquely across her chest is purely decorative and an innovation over the Borghese prototype.[415] Also new is the crescent-shaped diadem, while the pearl earrings and pearl necklace occur frequently in Titian's paintings. Despite the great beauty of the

414. Other theses are expounded in Cat. no. 4, Iconography.
415. A jewelled baldric worn obliquely across the breast is common in later Spanish costume of the seventeenth century. A famous example is Velázquez's *Infanta Margarita* in the Prado Museum (Reade, 1951, pls. 53, 60). I am much indebted to Dr. Emma Mellencamp for her expert analysis of the costume.

Washington picture the pretty face and general lavishness give the tone of an advertisement for cosmetics. An un-Titianesque emptiness of character prevails, and the general elegance is nearer, in fact, to the style of Paolo Veronese. Various attributions have been proposed, principally to Damiano Mazza and Lambert Sustris,[416] but neither is an entirely satisfactory solution.

In the case of *Tarquin and Lucretia* in the Fitzwilliam Museum (Plates 161, 164, 166) and the replica in Bordeaux (Plate 165) no such puzzle exists, since the latter is obviously a simplified workshop replica.[417] The great contrast in quality is obvious even in a photograph. Titian's conception of the subject is unusual in that Tarquin, dagger in hand, attacks Lucretia, whereas the normal tradition shows Lucretia stabbing herself.[418] Nevertheless, the legend as Livy told it allows for Titian's interpretation, that is the actual assault, when Tarquin threatened to kill both her and the slave and then to claim that he had caught them in adultery. Therefore Lucretia submitted to Tarquin's ravishing of her, told her husband of the attack, and then committed suicide. The sequel, involving the murder of Tarquin for his crime, never caught on in pictorial representation. This brilliant, late dramatic work at Cambridge demonstrates the astonishing vigour of the aged master in the interpretation of a scene of violence, unlike any mythological story that he had attempted hitherto. The violence notwithstanding, the drama is projected through the postures of the figures. Lucretia's terror and anguish are suggested only by her outflung arms and the slight backward tilt of her body before the onrush of her attacker. There is no grimacing, no cheap melodrama. Titian maintained a Renaissance sense of balance and understatement so that Lucretia's nude beauty is the true centre of the attention. Her head (Plate 161) has equal beauty, if less serenity, than the *Venus at Her Toilet* (Plate 129). The soft, diffused lights in the modelling of her fulsome body show clearly that this picture is later than the *Venus* in Washington (Plate 127).

Equally dazzling is the beauty of colour, achieved as usual within a limited range of tones. The green curtains, the white bed, and its green coverlet serve as background for Tarquin's rich garb. The green velvet breeches, a green-and-gold doublet, and vivid red stockings provide the richest aspects of the colour composition. To these elements are added Tarquin's reddish hair and beard, while Lucretia, golden-haired, and large in stature, is painted in soft pinkish flesh-tones, which go bluish and sometimes neutral beige in the shadows. Her pearl necklace and earrings, and her bracelets set with pearls and rubies again recall the *Venus at Her Toilet* in Washington. At the lower left the slave in a red-visored hat draws back the curtain to witness the scene.

A third picture of *Tarquin and Lucretia* (Plate 167), in Vienna, is directly based upon the Cambridge original (Plate 164) in a composition which is like a detail of the latter. Yet the costumes, physical types, and other variations do not seem to fall within Titian's realm of invention. Moreover, the slapdash application of the paint in broad rough strokes goes far beyond anything else attributable to Titian, even though the quality is high. Palma il Giovane may have done this picture in imitation of

416. Shapley, 1968, p. 188. See also Cat. no. X–5.
417. See Cat. no. 35 for details of the condition of the Bordeaux picture, which van der Doort (1639) described as defaced, when in Charles I's collection. No other authentic composition of this same theme, Tarquin's attack upon Lucretia, by Titian exists. Her suicide is represented in Cat. no. 26, Plate 37.

418. A Raphaelesque drawing at Windsor also shows Tarquin attacking but in a somewhat different composition (Popham and Wilde, 1949, no. 812). It would have been known in Agostino Veneziano's engraving dated 1524 (Bartsch, XIV, p. 169, no. 208).

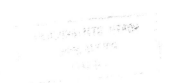

the elderly master. The reddish-brown curtain of the bed in the background is the chief colour against which Lucretia in a white costume and golden hair is set, while Tarquin also wears mainly white with a red scarf. The shadows upon his torso are a mixture of red and yellow, and the lower part of his body consists of confused, shapeless strokes of red and white pigment.

Another aspect of Titian's artistic personality is seen in the late ceiling pictures, notably the single figure in the vestibule of the Library of St. Mark's. The extraordinarily beautiful painted enframement is a fine piece of architectural illusionism (*quadratura*), in which the flat ceiling gives the impression of height and recession (Plate 162). This work by Cristoforo Rosa (1559–1560) was not designed by Titian, who painted the octagonal canvas (Plate 163) in which sits a lovely draped female figure. She symbolizes *Sapienza*, usually translated as *Wisdom* or possibly *Learning*, a theme suitable to the location in a library, although the scroll and book of the scholar and the laurel wreath of the great poets are her only attributes. This allegorical lady is serene and idealized, characterized by the exquisite quality of beauty with which Titian endowed his interpretations of Venus and the female characters of antique myth. In the design there is little suggestion of foreshortening to take into consideration the position of the spectator below (*di sotto in su*). The abundant rose drapery over the knees and reaching to the right shoulder provides the major colour over a white *camicia*, which is arranged *all'antica* with one breast exposed. The rose turns to a grey-green in the shadow over the ankles, and the fluttery veil to the upper right is a pale yellow. The broad banderole, unadorned with any inscription, is essentially white. The widely held opinion that Titian was thinking of Raphael's *Sibyls* in S. Maria della Pace at Rome, when he designed this figure, is questionable. Whereas a general restlessness pervades Raphael's *Sibyls*, Titian's painting remains serene and introspective, as the lines flow quietly.

Allegories of Brescia

THE three *Allegories of Brescia*, which Titian painted in 1565–1568, were destroyed only a few years later, yet the situation is unique in that the instructions sent to the artist have been preserved. An unidentified scholar in 1565 gave him a detailed programme explaining exactly what should be painted and listing the precise figures to be included.[419] There can be no doubt that this custom prevailed widely in the Renaissance period and that Titian's series for Alfonso d'Este *Studiolo* (Plates 38–64) also followed specific directions about the subject matter, sent to him by his patron. In the Brescia pictures the compositions and the placing of the figures were, of course, left to the artist's own invention, and it is significant to note that in Rubens' drawing after Titian (Figure 68)[420] and in Cornelius Cort's print (Figure 66) a few minor details mentioned in the programme are omitted. Even though the handsome drawing in the British Museum is very much in Rubens' own personal style so far as the figures are concerned, the theory that he followed Titian's own lost drawing cannot be doubted.[421]

419. Document, pp. 251–255. Because no other such precise series of instructions has survived from Titian's career, I include a discussion of them in the text rather than in Cat. no. L–1.

420. Tietze-Conrat (1954, pp. 209–210) deserves great credit for

having discovered that Rubens' drawing follows the iconography of Titian's *Allegory of Brescia*.

421. Rubens' drawing in the British Museum is in pen and sepia, 317×379 mm. (see Hind, 1923, II, no. 25).

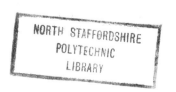

It conforms accurately to the instructions, summarized below, that were sent to Titian from Brescia.

The first picture, the *Allegory of Brescia* (Figure 68), was to include a personification of the city as a woman, accompanied by Mars and Minerva. The latter, it is explained, is the peaceful goddess, while Mars exemplifies the city's military exploits. Three nymphs were to be seated below, partly nude and with garlands of reeds and water plants upon their heads and flowers in their hands. Each was to have an urn of flowing water, one of iron, the second of lead, and the third of crystal. However, for compositional reasons Titian included only one overturned urn in the lower centre. Brescia was to be a beautiful woman of serious, mature, and venerable aspect, suspended in the air and richly but not regally garbed. The lion skin in her hand [omitted by Titian and Rubens] and the club at her feet were to refer to the legend that Hercules slew the Hydra near Brescia, at what is now Lago d'Idro, and thereafter founded the city.[422] Uncrowned and clothed *all'antica* in long white garments, which were to be girdled in blue and knotted on the left shoulder, she was to be represented with bare arms as well as a bare right breast, in her right hand an image of Faith like those on Vespasian's coins.[423] At Brescia's right Minerva was to wear an antique helmet on her head, as seen in certain Athenian coins, adorned with a sphinx in the middle of the helmet and two griffins at the sides. In her right hand she was to hold the olive branch and at her feet was to stand her owl [omitted by Titian and Rubens]. At the left of Brescia Mars was to be 'a large, robust, terrible and ferocious man, richly armed as a soldier *all'antica*, with shining helmet and on top of it a wolf or a real plume; the cuirass all gilded, his arms and legs nude'.[424]

The *Forge of Vulcan* was the second picture mentioned, in which Vulcan and the Cyclopes are fashioning a suit of armour on a mountainside while great flames flare up in the background. Titian substituted a mountain of rocks and a tunnel at the left. Again the lion in the lower section refers to Hercules. Cornelius Cort's print, dated 1572, after Titian's drawing (Figure 66) is the closest record of the composition, and it was long thought to be the only pictorial survivor until Tietze-Conrat identified the drawing by Rubens. To be sure, the print made from Titian's drawing does not enable us to judge the effectiveness of the composition, but the *di sotto in su* design reveals Titian's increased interest in the foreshortening of an entire scene, developed here to a greater degree than in his earlier ceiling pictures (1541–1544), now in S. Maria della Salute at Venice.[425]

The third picture, *The Allegory of Ceres and Bacchus*, gave the principal position to Ceres, who was to be a majestic, matronly woman, dressed as a nymph in yellow changing to green, and with nude arms as in the 'medals of Vespasian (Figure 67) in copper and in silver'.[426] Bacchus at her left was to take second place. A young man without beard, but with smiling face and long flowing hair, dissolute, licentious, and fat like a man of good cheer, he must be nude, wearing buskins or ankle boots on the

422. Cavriolo, 1585, pp. 4–5.
423. Mattingly, 1930, II, p. 167, no. 716, pl. 29, no. 2. On coins of Vespasian and Domitian, Faith holds corn ears and poppy, i.e. the same attributes as Ceres (see Mattingly, *op. cit.*, Index, Fides).
424. *Loc. cit.*, IV, p. 148, no. 996. The bird 'Pico' to be placed at Mars' feet was also eliminated.
425. Wethey, I, 1969, Cat. nos. 82–84, Plates 157–159.

426. The medals of Vespasian, where Ceres appears on the obverse, commemorate the safety of the wheat supply and are datable A.D. 77–78 (Mattingly, 1930, II, Index: Ceres). Some of them show Ceres standing, holding two wheat ears in the right hand and a long vertical sceptre in the left (*loc. cit.*, p. 173, no. 735); in others she holds a torch instead of the sceptre (*loc. cit.*, p. 175, Titus; pp. 176, 744, Domitian).

authority of Vergil. Below the figures were to be two reclining male river-gods. Ceres, as the goddess of agriculture and of the harvest, symbolized the material wealth and prosperity of the city of Brescia, whereas Bacchus, the god of wine and fertility, implied related pleasures.[427]

Titian not only accepted these exacting provisions (by no means all of which have been presented in this summary), he in fact replied with approval and gratitude. In his day the humanist was the artist's guide and collaborator. The following words were used in Titian's letter on 20 August 1565 in sending his thanks to the governing officials of Brescia: 'I have received the directions that your excellencies have sent me, in the matter of the paintings, which seem to me most beautiful so that, in respect to Poetry, I find myself enlightened.' The outcome of the commission was less happy, for the Brescian authorities declared that the paintings delivered were not by Titian's own hand, and they consequently offered only one-thousand ducats for the three works. Finally on 3 June 1569 the artist wrote a long and dignified letter to the bishop of Brescia, asking him to mediate and to bring the dispute to a close.[428] The fact may have been that the artist's workshop had a large share in the preparation of the compositions. On the other hand, they may have been carried out in the artist's latest, very free style, which would perhaps have seemed incomprehensible to the authorities of the city.

Nymph and Shepherd and Boy with Dogs

TITIAN's very latest style in mythological pictures is fully expressed in the Nymph and Shepherd c. 1570 (Plate 168) at Vienna and in the Boy with Dogs c. 1570–1575 (Plate 169) at Rotterdam. Most notable are the soft fused tones of pigment, which suggest the object in space. The stronger outline and the relatively clearly modelled form of early works, such as the Sacred and Profane Love (Plates 20, 23, 24) or the Bacchanals from Ferrara (Plates 39, 48, 57), have given way to a much greater illusionism. This development is also discernible throughout his late religious compositions, for example, the Martyrdom of St. Lawrence in the Gesuiti at Venice as early as 1548–1557, which to be sure is in part explained by the night setting. Still greater is that tendency in the Escorial version of the same subject, completed ten years later.[429] With the Christ Crowned by Thorns c. 1570–1575 in Munich the sketch-like technique is carried so far that the picture has sometimes been regarded as unfinished or a pre-paratory study.[430] Neither explanation appears to be entirely correct, but rather it is the most extreme case of fragmented form of Titian's last years that is represented here. The late Pietà in Venice, left unfinished and carried to completion by Palma il Giovane, still maintains the structure of figures and

427. See Seyffert, 1901: Dionysus and Ceres.
428. See Cat. no. L-1. Niccolò Stoppio, a somewhat unscrupulous dealer, stated in a letter of 29 February 1568 that Titian was too feeble to hold a brush and that his works at this period were painted by pupils (Zimmerman, 1901, pp. 850–851). This claim is surely highly exaggerated, particularly in view of Vasari's evidence to the contrary in 1566. He describes the late style 'condotte di colpi, tirate via di grosso e con macchie di maniera che da presso non si possono vedere e di lontano appariscono perfetti' (Vasari-Milanesi, VII, p. 452).

See also Tietze-Conrat's serious account of Titian's late workshop (1946, pp. 76–88).
429. Wethey, I, 1969, Cat. nos. 114, 115, Plates 178–181.
430. The picture is very large and therefore not possibly a sketch or modello. See Wethey, I, 1969, Cat. no. 27, Plates 133, 135.

In portraiture, by nature of its representational purpose, the late illusionistic style is less extreme, but it does exist in famous works such as the Jacopo Strada, the Triple Portrait, and others (Wethey, II, 1971, Cat. no. 100, Plates 206, 207; Cat. no. 104, Plates 209, 213; Cat. no. 107, Plates 211, 212).

architectural setting, while the all-enveloping twilight contributes much to the mood of tragic resignation.[431] A silvery body-colour upon the canvas unifies the rich muted tones of the entire picture. The theme of the *Nymph and Shepherd* (Plate 168) could scarcely be more different, but the technical procedure remains the same. The only positive colours here involve the rose cloak with fur collar, the white of the youth's undergarment, and the girl's liberally displayed body lying upon a tiger skin. The generally greyish-brown setting is essentially monochromatic, except for the distant sunset sky and the vaguely suggested clouds, while mountains at the left are created through atmospheric perspective. Technically the *St. Sebastian c.* 1575 at Leningrad[432] comes closest to the *Nymph and Shepherd* in the soft modelling and the generally diffused tones. To a certain degree the rustic, poetic intention of early mythological works such as the *Three Ages of Man* (Plates 13–16) has survived, but what a reversal of mood! The girl's pose, displaying her buttocks so fully and unabashedly to the spectator, has no exact counterpart in the artist's work.[433] The psychological temper of the aged Titian has transformed a piece of bucolic poetry in a way that even surpasses the boldness of the often-remarked standing nude nymph on the left side of the *Diana and Callisto* in Edinburgh (Plates 143, 150). For Titian, then in his eighties, when he painted the *Nymph and Shepherd*, life no longer held any surprises, and he felt under no compulsion to exercise restraint in revealing man's innate eroticism. Even here, however, he did not indulge in the kind of vulgarity that cheapens the work of Giulio Romano in his illustrations of the Hall of Psyche in the Palazzo del Te at Mantua.[434]

In conclusion, it should be remarked that Teniers' copy of Titian's *Nymph and Shepherd* in one of his pictures of the *Gallery of Leopold Wilhelm at Brussels* (Plates 202, 203) has far greater clarity in outlines, with the result that he brings out more sharply the mountain peaks, the goat which nibbles the tree at the right, and the shepherd with his flocks in the right distance. The explanation is not in the fading of Titian's original, but in the fact that Teniers, a Flemish master, sharpened the details in a way that conforms to the tradition of northern artists. Other compositions in Titian's late career involving two lovers in a landscape did exist; one of them survives in a relatively good copy, the *Mars and Venus* at Vienna (Plate 221). The figure of Venus strikes one as a later reworking of the *Danaë* (Plates 81, 83) in a picture the original of which must have been of very high quality. This impression is reinforced by the exceptionally beautiful drawing of a *Nymph and Shepherd* by Van Dyck (Plate 225), which in the 'Italian Sketchbook' is labelled Titian. The cuirass and sword at the side must mean that the subject here was also *Mars and Venus* with the Cupid hovering above them.[435] A school variant of this composition, of considerably lesser quality, is the one at Petworth, the *Nymph and Satyr* (Plate 222), where the characters are sylvan lovers, rather than god and goddess.[436]

The *Boy with Dogs* (Plate 169) at Rotterdam is unmistakably a fragment of a large composition, perhaps on the scale of *Jupiter and Antiope* (the 'Pardo Venus') (Plates 74–76). For that reason no one

431. Wethey, I, 1969, Cat. no. 86, Plates 136–138. See also Addenda I in the present volume for the theory that the main group was begun much earlier *c.* 1557. The glazes added by Palma il Giovane also explain the more finished surfaces.

432. Wethey, I, 1969, Cat. no. 134, Plate 194. The background and the objects at the lower left, possibly armour, are obviously incomplete.

433. The theory that the pose reflects Giulio Campagnola's en-

graving of a reclining girl with back turned, really carries little conviction (illustrated by Kristeller, 1907, pl. 13).

434. Hartt, 1958, Plates 254–263.

435. The half-length cherub seems to be a later addition, not by Van Dyck. See Adriani, 1940, p. 68, no. 106.

436. The half-length compositions of *Nymph and Satyr* (Plates 226–228) are so remote from Titian's own paintings that they do not necessarily reflect lost originals by the master.

has found a solution to the puzzle of the primary subject of the picture. The apprehensive-looking boy in a rose-coloured shift restrains the handsome white retriever, as he rests his left arm over the animal's back. He seems to be guarding the mother dog, black-haired with white legs and white marking on the nose. Her gentle, protective attitude, as she nurses two brown-and-black puppies, is so sympathetically rendered that one cannot doubt Titian's fondness of animals.[437] The late style of this painting places it between the *Nymph and Shepherd* (Plate 168) and the *Flaying of Marsyas* at Kremsier (Plates 170–172), if anything nearer to the latter. The *sfumato* in the painting of the boy's figure and the stormy background, wherein a few flashes of red appear amid dimly suggested houses, all contribute to the mysterious, foreboding atmosphere of this strange painting.

Flaying of Marsyas

HORROR in subject and representation recurs in a few of Titian's late works. The *Martyrdom of St. Lawrence* at the Escorial, with its feverish activity, is more shocking in the depiction of torture than the slightly earlier version of the same legend.[438] The *Death of Actaeon* (Plate 152) likewise is more terrible than usual, since only the head of the hapless youth has been transformed into that of a stag, while his human body is intact as his own dogs leap upon him and the cruel avenging Diana looses her arrow. Moreover, the *Forge of Vulcan* (Figure 66), formerly at Brescia, has a violence about it not essential to this theme and unlike Tintoretto's rather exultant interpretation of the subject in the Ducal Palace at Venice.[439] Even earlier in Titian's *Tityus* (Plates 99, 101, 102) there is evidence that the normally serene classical master understood terrible physical suffering. In the scenes of the Passion of Christ, such as the Prado *Entombment,* the *Christ Crowned with Thorns* in Munich, and numerous other masterpieces, compassion for the Saviour prevails over other considerations.[440] The *Flaying of Marsyas* at Kremsier (Plates 170–172) is another matter, since the cruelty and goriness of the interpretation exceed any other conception by Titian. Underlying this presentation is the assumption that Marsyas deserved such punishment for having had the temerity to challenge a god, an idea set forth by Titian's friend Lodovico Dolce,[441] but we live in an age in which the validity of these essentially literary events is taken less seriously. Still, it is hard to avoid a feeling of revulsion at the sight of Marsyas' unjust fate. The gory execution is presented in the same spirit as the martyrdom of a Christian saint—St. Bartholomew flayed alive or St. Peter crucified head down.

Stylistically the *Flaying of Marsyas* represents the latest Mannerist phase of Titian's art. It stands very close indeed to the *Martyrdom of St. Lawrence* (1564–1567) in the Escorial, with an increase in the elimination of space in depth and in the massing of the actors in the foreground. Thus Titian anticipates the late methods of his pupil El Greco in his vision of glory in the *Burial of the Conde de Orgaz* and in

437. The nursing puppies seem to have been overlooked by some writers. See Cat. no. 2. A close counterpart to the boy restraining a dog constitutes a detail in the *Flaying of Marsyas* (Plate 170).
438. Wethey, I, 1969, Cat. nos. 114, 115, Plates 179–181.
439. Tietze, *Tintoretto,* London, 1948, pl. 226.
440. Wethey, I, 1969, Cat. nos. 36, 37, Plates 75–78; Cat. no. 27, Plate 133.

441. 'E chi mandasse un Apollo che scorticasse Marsio? Per Marsia si denota la temerità. Perciochè fu temerario colui a provocar un Dio a cantare, o sonàr seco: e meritò che gli avvenisse quel fine che gli avvenne che fu l'esser iscorticato' (Dolce, 1565, edition 1913, p. 92).

numerous compositions of the end of the sixteenth century.[442] It should be remarked, without attempting to underestimate the importance of the *Flaying of Marsyas*, that the execution is in part by an assistant, probably Girolamo Dente. The brutal figure of the man at the left wearing a Phrygian cap and involved in the torture of Marsyas is twin brother of the major executioner who stabs St. Lawrence with a long forked instrument in the picture at the Escorial.[443] Other relations to the master's late works include the boy with a dog at the lower right, who so closely resembles the *Boy with Dogs* in Rotterdam (Plate 169). The whole composition is derived, but with considerable variation, from Giulio Romano's *Flaying of Marsyas* (c. 1534) in the Palazzo del Te at Mantua, illustrated here by the preparatory drawing in Paris (Plate 173). Apparently for the first time in Renaissance art Marsyas is placed head downward instead of strung upright on a tree.[444] The upright position is common on antique sarcophagi and appears in such a famous work as Raphael's *Apollo and Marsyas* in the Vatican (Plate 174). Even the disposition of the figures by Titian follows Giulio Romano closely: at the left the three men, one with lyre, another in the foreground bending over (Titian has him kneel), and the standing man behind him. At the right the satyr with pail again repeats Giulio Romano, while the other two differ in attitude. Titian had, of course, seen the frescoes in Mantua, but he paid his last visit there in 1540, so far as we know.[445] He had either sketched Giulio's composition or the latter had given him the original drawing. Then some thirty years later Titian turned to this work as the starting point for his own more highly developed composition. Giulio's drawing (Plate 173) shows even more clearly than the badly preserved painting in the Palazzo del Te at Mantua[446] that Titian had followed his predecessor's grouping, even though the final results are as unlike as possible.

The element of Titian's *Flaying of Marsyas* that has seemed revolting to most people is the detail of the dog in the foreground lapping up the pool of Marsyas' blood.[447] Some Greek and Roman versions of the fable hold that the blood was transformed into the River Marsyas, a tributary of the Euphrates.[448] That may be the reason for Titian's inclusion of this gruesome detail, as well as of the satyr with a pail at the right side. Ovid, on the other hand, who was Titian's literary source in so many cases, preferred another tradition, that the tears of the onlookers became 'the clearest river in all Phrygia', named after Marsyas.[449] Considerable difference of opinion exists as to the identity of certain figures in Titian's painting. General agreement prevails that the seated elderly man at the right side is King Midas and that his heavy dejection reflects Michelangelo's *Jeremiah* in the Sistine chapel. He is a tragic figure, as he sadly views the horrible fate of Marsyas, so pitilessly punished. Midas himself, the mythical

442. See Wethey, 1962, I, pp. 55–58.

443. Wethey, I, 1969, Plate 181.

444. Discovered by Hartt, 1958, p. 111. On a red-figured Greek vase, excavated in 1923, in the Museo Nazionale at Taranto (case 50), Apollo is dressed in a long robe in three flounces, holds a lyre, and wears a laurel crown, while Marsyas, holding the knife (!), looks at him.

Another composition in which Marsyas is flayed upside down is that of Andrea Schiavone in the Louvre. See Fröhlich–Bum, 1913, p. 143, fig. 8. Tietze and Tietze-Conrat (1944, p. 252, no. 1442, Louvre, no. 5452) thought that his drawing might have influenced Titian's painting, but that theory seems most improbable in view of the master's obvious reworking of Giulio Romano's prototype.

At the festivals of Binche, given in August 1549 by Mary of Hungary for her young nephew Prince Philip of Spain, Titian's *Four Condemned* were displayed (see Cat. no. 19). Calvete de Estrella (edition 1930, II, pp. 5–6) also saw there paintings of the *Musical Contest Between Apollo and Marsyas* and the *Flaying of Marsyas*. No evidence is forthcoming, however, that Titian was the painter of the Marsyas scenes.

445. Aretino, *Lettere*, edition 1957, I, p. 162.

446. Hartt, 1958, fig. 172.

447. Panofsky, 1969, p. 171, stresses this detail as one of his reasons for doubting Titian's authorship of the picture.

448. See Pauly's *Realencyclopädie*, XXVIII, 1930, p. 1991; Hyginus, edition Rose, fable 165.

449. See Cat. no. 16, Iconography, for Ovid's account.

Phrygian king, had favoured Marsyas' music over Apollo's. 'All approved the judgment of the sacred mountain god. And yet it was challenged and called unjust by Midas' voice alone. The Delian God did not suffer ears so dull to keep their human form . . . in this one feature he was punished, and wore the ears of a slow-moving ass.'[450] In Titian's picture the ass's ears are invisible, if indeed the artist included them at all. The highly sympathetic mood in the presentation of Midas gives the impression that Titian himself shared Midas' reflections on the cruelty with which fate so often afflicts mankind. If it had been the artist's purpose to show the triumph of divinity and the just punishment of those who challenge the gods, he might have been less violent, less bitter. Apollo, the victor, has generally been identified with the youth at the left, who plays the viola da braccio.[451]

The disillusion and weariness of old age play a major part in Titian's interpretation of the *Flaying of Marsyas*, which for some critics represents a culmination of his creative genius. To others, however, the *Pietà* in Venice[452] seems a more fitting conclusion to the long and unique career of such a great master. Here the profundity of mood and the resignation in the face of death are combined with a harmonious richness of colour and design which would be difficult to surpass.

Titian's Unique Genius

WHEN we think back across the years of Titian's career as a painter of mythological themes, there loom impressively his optimism and joyousness combined with a sense of physical beauty that has rarely been equalled. In his earliest youth his works had a poetic and dream-like quality, mood-invoking; his themes are set in a land of Arcadian perfection, as it was known to the poets, especially Jacopo Sannazaro. Giorgione, among painters, is regarded by general agreement as the creator of this style, but it is anticipated by the teacher of both, Giovanni Bellini, in his later religious compositions, most notably in the *Allegory* in the Uffizi and the *Transfiguration* in Naples. That the 'Giorgionesque style' admirably befitted the romantic spirit of the age is, of course, demonstrated by its all-pervading dominance in the first two decades of the Cinquecento, when virtually every Venetian painter adopted it—not just Titian, Palma il Vecchio, Sebastiano del Piombo, and Cariani, but lesser men, whose very identities often elude us. By 1509, when Titian began the frescoes on the southern façade of the Fondaco dei Tedeschi, he had so fully absorbed Giorgione's spirit that their works were virtually indistinguishable. Whether he actually assisted Giorgione on the west façade (1508) we shall never know, since only Giorgione received payment for it. Yet the inspiration for the young master from Cadore surely lay there, as it did in the early mythological paintings. Without question Titian completed Giorgione's *Sleeping Venus* (Plate 9) in Dresden and almost certainly the *Pastoral Concert* (Plate 3).

The same source of inspiration is equally compelling in his portraits before 1520. Yet Titian paid more heed than his predecessor to 'nature' and rarely, if ever, left any doubt as to the kind of men portrayed. He gave us not only the physical appearance of the sitter, but also an understanding of the

450. Ovid, *Metamorphoses*, XI, 172–179; also Hyginus-Rose, p. 135, no. 1665.

451. In Cat. no. 16 the diverse opinions as to the identification of Apollo are set forth.

452. Wethey, I, 1969, Cat. no. 86, Plates 136–138.

inner man. As only the very greatest portraitists could do, he revealed character to an astonishing degree in such works as the *Young Man with Cap and Gloves* at Garrowby Hall and *Parma the Physician* at Vienna.[453] In his own day Titian was regarded as a student of nature, chiefly because of his portraiture which, in the first half of his career, loomed especially large in the minds of his contemporaries. It was through this branch of his painting that he reached that early high point in prestige, the occasions of his two visits to Bologna in 1530 and 1532–1533 to prepare the state portraits of Emperor Charles V.[454] After his fame had thus suddenly spread across Europe, well over half his sitters are recorded in the next two decades. It is doubtless not excessive to regard Titian as the greatest of Italian portraitists.

Titian's independence and originality appear in early religious works of such grandeur and monumental forcefulness as the *Assumption* (1516–1518) in the church of the Frari at Venice (Figure 18). No earlier composition in Venice had prepared the way, yet genius is inexplicable, as with Masaccio, whose *Tribute Money* had no true precedent. Titian's *Madonna of the Pesaro Family* (Figure 19) also burst forth upon the Venetian scene (1526) unannounced in all its splendour and complete in the perfect interrelation of the figures and their setting. With the three Bacchanalian subjects for Alfonso d'Este at Ferrara (Plates 39–64) the artist recreated the golden age of antiquity, saturated with the gaiety, the vigour, and the unrestrained abandon of the pagan gods, nymphs, and satyrs, as described by Theocritus, Ovid, Catullus, and Vergil. No other Renaissance painter entered more fully into the spirit of these romantic writers of the distant past. Some critics may argue that Titian's conception of antiquity was intuitive, that he grasped the meaning of ancient literature without necessarily having much knowledge of it. To a limited degree that is true. Certainly the great painter was no scholar of the cast of Pietro Bembo or of his friend, Lodovico Dolce. Just as he was able to sense the emotional state of a sitter and therefore able so graphically to record in his portrait the very nature of the man, so he had an acute sense of human life. Fundamental emotional responses to life, love, and death are unchanging throughout the ages. To a great genius it is given to comprehend them, and Titian possessed in supreme measure such insight and power. Nevertheless, Titian must also have read widely and have thoroughly absorbed Ovid's *Metamorphoses* and *Fasti*, Boccaccio's *Genealogy of the Gods* and the literature readily available in the Aldine editions published in Venice. Without being a scholar, Titian was a cultivated man of a period when a broad knowledge of Latin was commonplace, and the truly learned mastered Greek. Titian's close friend, Pietro Aretino, whose political machinations have given him the reputation of a scoundrel, nevertheless belonged to the humanist and literary circle because of his plays and epic poetry. The painter also had another humanist friend in Lodovico Dolce, author of plays and poetry, translator from the Latin and Greek, and as well the composer of the *Dialogo della Pittura* (1557).[455] Other learned scholars at times formed part of Titian's circle, for instance Diego Hurtado de Mendoza, Spanish Ambassador to Venice (1539–1546), whose vast collection of Greek, Arabic, and Latin manuscripts now forms the nucleus of the great Escorial library.

453. See Wethey, II, 1971, pp. 10–15, and *passim*.

454. *Loc. cit.*, pp. 18–22. The absolute proof of Charles V's portrait in 1530 rests not only on Vasari but also on Leonardi's letter of 18 March 1530 (see Gronau, 1904, p. 13).

455. According to Ridolfi (1648–Hadeln, I, p. 205), Titian painted pictures of the stories of Iphigenia, the Spartans, the loves of Leucippus and Clitophon [after Achilles Tatius], but none is traceable today, if Ridolfi's attributions were correct. It is significant that Dolce wrote plays on Iphigenia and Medea.

Not only was the artist familiar with ancient and with contemporary Arcadian literature, but he also knew something of the art of the ancient Romans, particularly the sculpture. From the time of Jacopo Bellini and Andrea Mantegna, Venetian sculptors and painters had studied Roman fragments.[456] Early in his career Titian included the statue of a Roman Emperor in the background of his fresco of the *Miracle of the Speaking Infant* at Padua.[457] Rarely did he thus copy the antique, but rather he caught its spirit, a matter already stressed above. In Rome, during his stay in the Belvedere Palace in 1545–1546 at the invitation of Paul III and Cardinal Alessandro Farnese, the artist had the fullest opportunity of his life-time to absorb the grandeur of the past. In the letter of December 1545 addressed to Emperor Charles V, which is reproduced here in facsimile (page 126), he stated specifically that he was inspired by his study of 'these most marvelous ancient stones'.[458] The generally florid literary style and the courtly adulation expressed toward the person of the Emperor give a strong impression that a humanist friend such as Pietro Bembo or Giovanni Della Casa may have composed the letter for the artist.[459] Notwithstanding the enthusiasm for antiquity here expressed, Titian remained true to himself. Michelangelo's heroic power impressed him more, a fact so well known in the *Danaë* (Plate 81) which Titian painted for Cardinal Alessandro Farnese. Without a doubt he would have developed a more fundamental devotion to the antique, if he had been born in Rome. Having made his first and only visit there in middle life, when already a celebrated painter, the experience affected him much less than it would otherwise have done. Titian's knowledge of Roman literature was more significant in relation to his painting of mythological themes. He understood the past to the extent that he could endow the stories of the poets with unforgettable pictorial form. He possessed, moreover, an extraordinary sense of balance, harmony, and good taste. In that respect he was endowed with a 'classical' mentality. He never indulged in the vulgarity which Giulio Romano displayed in such frescoes as the *Wedding of Psyche and Cupid* in the Palazzo del Te at Mantua.

Titian's religious compositions at the same period reveal like qualities of restraint in such lovely paintings as the *Madonna and Child and St. Catherine with a Rabbit* in Paris or the *Madonna and Child with St. Catherine and the Infant Baptist* in London. Even the *Entombment* in Paris,[460] notwithstanding the tragic theme and the profundity of its drama, retains a sense of controlled grief which makes the tragedy all the more compelling. The large pageant of the *Presentation of the Virgin* in the Accademia at Venice is effectively unified through its strong formal organization.[461] By the use of isocephalism and by the slow movement of the numerous figures, the artist attained the order and serenity befitting the event.

One is prone to forget Titian's tremendous versatility, which permitted him at the very same time to paint the celebrated mural of the *Battle* (Figures 51–61). Here in a brilliant composition of violent

456. See the present volume, pages 19–20, 43–47.
457. Wethey, I, 1969, Plate 139.
458. A very remarkable book, *Le antichità della città di Roma*, by Lucio Mauro and Ulisse Aldrovandi, published in Venice in 1542 and in an expanded edition of 1556, gives an excellent account of the antique sculptures then to be seen in the papal galleries and private collections. These works were therefore available to Titian during his Roman sojourn in 1545–1546.
459. The handsome penmanship also indicates that a professional

scribe prepared the letter. This document of 1545 was not known to Tietze-Conrat in her brilliant study of 'Titian as a Letter Writer' (1944, pp. 117–123), in which she contrasted the artist's simple direct messages with the literary rhetoric of formal letters to important patrons. The attribution of those written in Venice to Pietro Aretino and later Verdizotti was first proposed by Ridolfi (1648–Hadeln, I, p. 208).
460. Wethey, I, 1969, Cat. nos. 59, 60, 36.
461. *Loc. cit.*, Cat. no. 87, Plates 36–39.

action he overcame the immense technical problems inherent in such a theme, which might have been regarded as totally antithetical to his 'classical' nature.[462] Versatility is a sign of true greatness. It is given to few masters to attain extraordinary distinction in works of such originality and imaginative power as Titian achieved in religious compositions, in portraiture, and in mythological subjects. As a man of the Renaissance and as an Italian he loved beauty for its own sake. His taste was formed early by Giorgione's *Sleeping Venus* (Plate 9), a masterpiece which he remembered for a quarter century and repeated with variations in the *Venus of Urbino* (Plate 73). Although the later nudes take on a more heroic cast, following the trends of the mid-century, a picture such as the Madrid *Danaë* (Plates 83, 85) has lost none of the feminine qualities, rather are they increased by the softer, more fluid brushwork in the handling of the flesh and the heightened magic in the illusionistic tones of the accessories.[463] The *Venus and Cupid with an Organist* in Madrid (Plates 105, 106) and the later *Venus at Her Toilet* in Washington (Plates 127–129) are works of great beauty upon clearly erotic themes, but they are presented with the dignity befitting the goddess. The imaginative powers of the artist were at their height when he created these compositions, for which there are no exact forerunners, even in his own earlier compositions. He struck out into new directions in the two great paintings devoted to Diana now in Edinburgh (Plates 142–150), inventions of considerable complexity, yet presented with the greatest clarity. In the maturity of his art and his personal life, he could conceive a work of such high comedy and pictorial splendour as the *Rape of Europa* (Plates 138–141). As for colour, from the fifteen-twenties and thereafter, it is generally agreed that Titian was the greatest master of his age. In reality he used few colours, mainly rose, green, blue and white, and he created a most extraordinary sense of richness in the way he manipulated them. Words do not suffice to do justice to the genius of such a master or to describe the breadth, the profundity, and the sheer beauty of his art.

462. Titian must have been familiar with Leonardo's drawings for the *Battle of Anghiari*. He had also been exposed to Central Italian Mannerism, but he made use of these ideas only when the occasion demanded and produced a work of such stirring drama as the *Christ Before Pilate* in Vienna (*loc. cit.*, pp. 25–27, Cat. no. 21).

463. See colour reproduction. Kenneth Clark (1956, pp. 183–187) has stressed the phenomenon of the few poses with which Titian chose to present his figures of the recumbent nude female.

BIBLIOGRAPHY

R. Abbondanza, 'Bertuccio Bagarotto', *Dizionario biografico degli italiani*, v, 1963, pp. 169–170.

Achilles Tatius, *The Adventures of Leucippe and Clitophon*, London, Loeb Library, translation by S. Gaselee, 1917.

Gian Alberto dell'Acqua, *Tiziano*, Milan, 1955.

Hélène Adhémar, *Watteau, sa vie, son oeuvre*, Paris, 1950.

Gert Adriani, *Van Dycks Italienisches Skizzenbuch*, Vienna, 1940.

——, *Herzog Anton Ulrich Museum*, Brunswick, 1969.

Albo Nazionale, Famiglie nobili dello Stato Italiano (Associazione Historiae Fides), Milan, 1955.

Giovanni Battista Albrizzi, *Forestiere illuminato intorno le cose più rare della città di Venezia*, Venice, 1772 and also 1796.

Alcázar, Madrid, Inventories (the original manuscripts are in the Archivo del Palacio, Madrid):

Inventory of Philip II (1598–1610, but mainly 1600–1602), see:

Sánchez Cantón, *Inventarios reales, bienes muebles que pertenecieron a Felipe II*, Madrid, 1956–1959, 2 vols.

Rudolf Beer, 'Inventare aus dem Archivo del Palacio', *Jahrbuch der Kunsthistorischen Sammlungen des Allerhöchsten Kaiserhauses*, Vienna, XIV, 1893, II. Theil, pp. I–LXX; XIX, 1898, pp. CXVIII–CLXXVI.

Inventories of the XVII and XVIII Centuries:

Alcázar, Madrid, Inventory of 1623, unpublished manuscript.

Alcázar, Madrid, Inventory of 1636, unpublished manuscript, folio number on every fifth page.

Alcázar, Madrid, Inventories of 1666 and 1686, see:

Ives Bottineau, 'L'Alcázar de Madrid et l'inventaire de 1686', *Bulletin hispanique*, LVIII, 1956, pp. 421–452; LX, 1958, pp. 30–61, 145–179, 289–326, 451–483.

Alcázar, Madrid, Inventory of 1700 (after the death of Charles II), unpublished manuscript.

Alcázar, Madrid, Inventory of 1734 (after the destruction of the old palace by fire), unpublished manuscript.

Alcázar, Madrid, Inventory of 1746–1747 (after the death of Philip V); the pictures were then in Buen Retiro Palace; unpublished manuscript.

Alcázar, Madrid, Inventory of 1772, unpublished manuscript.

See also:

Cassiano dal Pozzo, 1626.

Aldobrandini Collection, Rome, see: Onofrio, 1964; Pergola, 1960, 1962, 1964.

Federigo Alizeri, *Guida artistica per la città di Genova*, Genoa, 1846, 3 vols.

Hubert Allcock, *Heraldic Design*, New York, 1962.

J. L. Allen and E. E. Gardner, *A Concise Catalogue of the European Paintings in the Metropolitan Museum of Art*, New York, 1954.

Alnwick Castle: 'Catalogue of Pictures', 1930 (manuscript). See also: Newcastle-on-Tyne.

G. E. Ambrose, *Catalogue of Pictures, the Lansdowne Collection*, London, 1897.

Ambrosiana Gallery, Milan:

Dell'Acqua, Paredi and Vitale, *L'Ambrosiana*, Milan, 1967.

Guida sommaria, 1907.

See also: Borromeo, 1625.

Walter Amelung, *Die Sculpturen des Vaticanischen Museums*, Berlin, 1908, II.

Winslow Ames, *Great Drawings of All Time*, I, Italian School, 1962.

——, *Italian Drawings from the 15th to the 18th Century*, London, 1963.

Amiens: *Catalogue descriptif des tableaux et sculptures du Musée de Picardie*, Amiens, 1899.

Amsterdam, Rijksmuseum, *Catalogue of Paintings*, 1961.

Jaynie Anderson, 'Some Documents Relating to Giorgione's Castelfranco Altarpiece', *Arte veneta*, XXVII, 1973, pp. 290–299.

Gregorio de Andrés, *Documentos para la historia del monasterio de San Lorenzo el Real de El Escorial*, Madrid, 1964.

——, *Real Biblioteca de El Escorial*, Madrid, 1970.

Anonimo, see: Marcantonio Michiel.

Anonimo del Tizianello, see: Tizianello.

APC: Art Prices Current, London, I, 1907–1908—XLVIII, 1970–1971.

Apollodorus (of Athens): *Apollodorus*, translated by Sir James Frazer, London, 1921, Loeb Library.

Apollonius Rhodius, see: Wendel, 1935.

Apsley House: *Paintings at Apsley House*, London, 1965. See also: Wellington, 1901.

Apuleius, *Golden Ass*, London, Loeb Library, 1924.

Aranjuez: 'Inventarios, Real Sitio de Aranjuez', 1700 and 1800, unpublished manuscripts in Madrid, Archivo del Palacio.

Archives, see: Alcázar, Madrid; Simancas (Valladolid), Archivo General.

Carlo d'Arco, *Delle arti e artifici di Mantova*, Mantua, 1857, 2 vols.

Aretino, *Del primo (-sesto) libro de le lettere*, Paris, 1609, 6 vols.

——, *Lettere sull'arte*, edition Milan, 1956–1957; see also: Innamorati.

——, *Poesie*, Lanciano, 1930, 2 vols.

Giulio Carlo Argan, *L'Amor sacro e l'amor profano*, Milan, 1950.

Gonzalo Argote de Molina, 'Discurso sobre la montería' (1582), *Biblioteca venatoria*, Madrid, 1882.

Ferdinando Arisi, *Il Museo Civico di Piacenza*, Piacenza, 1960.

Wart (Eduardo) Arslan, *I Bassano*, Milan, 1960.

——, 'Un ritratto inedito di Tiziano', *Dedalo*, XI, part 2, 1930–1931, pp. 1363–1365.

Art Union, see: Lord Ashburton.

Arundel, Earl of, Collection:

 Catalogus of Naamlist van Schilderijen van der Graaf von Arundel verkopt den 26 September 1684 (reprinted by Gerard Hoet in 1752).

 See also: Betcherman, 1970; Cust, 1911; Hervey, 1921.

Lord Ashburton (Alexander Baring), Collection: 'Visits to Private Galleries: The Collection of the Right Honorable Lord Ashburton, Bath House, Piccadilly', *Art Union*, 1847, pp. 122–127; also 1873, 3 February, p. 12.

K. Asplund, *Collection Bergsten*, Stockholm, 1943.

José M. Azcárate, 'Noticias sobre Velázquez en la corte', *Archivo español de arte*, XXXIII, 1960, pp. 357–385.

Jean Babelon, *Titien*, Paris, 1950.

Bache Collection: *Catalogue of the Paintings of the Bache Collection*, New York, 1929 and 1937.

F. Back, see: Darmstadt.

Rosaline Bacou, *Great Drawings of the Louvre Museum*, I, *The Italian Drawings*, New York, 1968.

Giovanni Baglione, *Le vite dei pittori, scultori et architetti*, Rome, 1642; reprint, 1935.

Nicolas Bailly (1709–1710)—Engerand, *Inventaire des tableaux du roi*, Paris, 1899.

Ludwig Baldass, 'Die Venezianer der Wiener Gemälde-galerie', *Belvedere*, V, 1924, pp. 86–96.

——, 'Tizian im Banne Giorgiones', *Jahrbuch der Kunsthistorischen Sammlungen in Wien*, N.F., XVII, 1957, pp. 101–156.

——, 'Zur Erforschung des Giorgionismo bei den Generationsgenossen Tizians', *Jahrbuch der Kunsthistorischen Sammlungen in Wien*, N.F., XXI, 1961, pp. 69–88.

——, and Günther Heinz, *Giorgione*, Vienna, 1964.

Alessandro Ballarin, 'Profilo di Lamberto d'Amsterdam, Lamberto Sustris', *Arte veneta*, XVI, 1962, pp. 61–81.

——, 'Lamberto d'Amsterdam (Lamberto Sustris): le fonti e la critica', *Atti dell'Istituto Veneto di Scienze, Lettere ed Arti*, CXXI, 1962–1963, pp. 335–366.

——, 'I Veneti all'esposizione: Le seizième siècle européen—del Petit Palais', *Arte veneta*, XIX, 1965, pp. 238–240.

——, 'Osservazioni sui dipinti veneziani del Cinquecento . . . di Praga', *Arte veneta*, XIX, 1965, pp. 59–82.

——, 'Pittura veneziana nei musei di Budapest, Praga, e Varsavia', *Arte veneta*, XXII, 1968, pp. 237–255.

——, *Tiziano*, Florence, 1968 (I diamanti d'arte, no. 37).

Nino Barbantini, *Scritti d'arte inediti e rari*, Venice, 1953.

Barbarigo della Terrazza Collection, see: Bevilacqua, 1845; Levi, 1900; Savini-Branca, 1964.

Cardinal Francesco Barberini, see: Cassiano dal Pozzo.

Angel M. Barcia, *Catálogo de la colección de dibujos originales de la Biblioteca Nacional*, Madrid, 1906.

Germaine Barnaud and Madeleine Hours, 'Etudes sur deux tableaux du Titien intitulés Tarquin et Lucrèce', *Bulletin du Laboratoire du Musée du Louvre*, no. 9, 1964, pp. 19–30.

Oswald Barron, 'Heraldry', *Encyclopaedia Britannica*, 11th edition, XIII, pp. 311–330.

Adam Bartsch, *Le peintre graveur*, Leipzig and Vienna, 1818–1876, 21 vols.; French edition, 1854–1876.

G. Baruffaldi, *Vite dei pittori e scultori ferraresi* (1733), Ferrara, 1844–1846, 2 vols.

Renzo Baschera, 'Un Ecce Homo di Tiziano', *Arte cristiana*, Milan, XLIX, 1941, pp. 57–58 (a picture by a follower of Murillo which the author wrongly attributes to Titian).

Armand Baschet, 'Documents inédits tirés des archives de Mantoue concernant la personne de messer Pietro Aretino', *Archivio storico italiano*, Florence, 3rd series, part 1, 1866, pp. 104–130.

——, 'Chronique vénitienne du passé', *Gazette des beaux-arts*, I, 1859, pp. 76–80.

Eugenio Battisti, 'Disegni inediti di Tiziano e lo studio d'Alfonso d'Este', *Commentari*, V, 1954, pp. 191–216.

——, 'Postille documentarie su artisti italiani a Madrid e sulla collezione Maratta', *Arte antica e moderna*, III, 1960, pp. 77–89.

——, *Rinascimento e barocco*, Rome, 1960.

Kurt Bauch, 'Zu Tizian als Zeichner', *Walter Friedländer zum 90. Geburtstag*, Berlin, 1965, pp. 36–41.

Engelbert Baumeister, 'Eine Studie Tizians für Die Schlacht von Cadore', *Münchner Jahrbuch der bildenden Kunst*, N.F., 1924, pp. 20–25.

Jacob Bean, *Les dessins italiens de la collection Bonnat*, Paris, 1960.

R. Beatniffe, *The Norfolk Tour*, 1773.

Fernand Beaucamp, *Le Peintre lillois Jean-Baptiste Wicar (1762–1834), son oeuvre et son temps*, Lille, 1939, 2 vols.

E. de Beaumont, 'Etat de dépenses de la maison de Philippe d'Autriche', *Gazette des beaux-arts*, XXVI, 1869, I, pp. 84–89.

Rudolf Beer, 'Acten, Regesten und Inventare aus dem Archivo General zu Simancas', *Jahrbuch der Kunsthistorischen Sammlungen des Allerhöchsten Kaiserhauses*, Vienna, XII, 1891, II Theil, pp. XCI–CCIV.

——, 'Inventare aus dem Archivo del Palacio', *Jahrbuch der Kunsthistorischen Sammlungen des Allerhöchsten Kaiserhauses*, Vienna, XIV, 1893, II. Theil, pp. I–LXX (Philip II); XIX, 1898, pp. CXVII–CLXXVII.

 See also: Alcázar, Madrid, Inventory of Philip II.

C. F. Bell, *Christ Church Drawings*, Oxford, 1914.

Jacopo Bellini, *Die Skizzenbücher*, Brussels, 1912, 2 vols.

 See also: Degenhart and Schmitt, 1972.

Pietro Bellori, *Le Vite dei pittori, scultori, et architetti moderni*, Rome, 1672.

Francesco Beltrame, *Tiziano Vecellio e il suo monumento*, Milan, 1853.

Pietro Bembo, *Delle lettere*, Venice, 1560, 4 vols.; also edition Verona, 1743, 5 vols.

 See also: Giulio Coggiola.

——, *Della istoria veneziana*, Venice, 1590. Frontispiece the Bartolozzi print after Titian; also edition 1747.

Otto Benesch, 'Die fürsterzbischöfliche Gemäldegalerie in Kremsier', *Pantheon*, I, 1928, pp. 22–26.

Otto Benesch, *Collected Writings*, II, *Netherlandish Art of the 15th and 16th Centuries. Flemish and Dutch Art of the 17th Century. Italian Art. French Art*, edited by Eva Benesch, London, 1971.

——, 'Titian and Tintoretto', ibid., pp. 135–150. (First published in *Arte Veneta*, XII, 1958, pp. 79–90.)

Emmanuel Bénézit, *Dictionnaire*, Paris, 1910–1920; edition 1948–1955, 8 vols.

R. H. Benson, *The Holford Collection*, London, 1924; 2nd edition, London, 1927, 2 vols.

Erich van der Bercken, 'Some Unpublished Works by Titian and Tintoretto', *Burlington Magazine*, XLIV, 1924, pp. 108–113.

——, see also A. L. Mayer and Erich van der Bercken, 1927.

Petrus Berchorius, *Ovid Moralisé*, edition J. Engels, Utrecht, 1966.

Bernard Berenson, *Venetian Painters of the Renaissance*, London, 1894 and 1906.

——, 'De quelques copies d'après des originaux perdus de Giorgione', *Gazette des beaux-arts*, 3 période, XVIII, 1897, pp. 274–278.

——, *Study and Criticism of Italian Art*, London, 1901, and later editions, 1908, 1912, 1920, 1930.

——, *North Italian Painters of the Renaissance*, London, 1907.

——, *Pictures in the Collection of Joseph Widener*, Philadelphia, 1931, 3 vols; the section on Italian Painting by Berenson; the whole edited by W. R. Valentiner.

——, *Italian Pictures of the Renaissance*, Oxford, 1932.

——, *Lotto* (1905), Milan, 1955; London, 1956.

——, *Italian Pictures of the Renaissance, Venetian School*, London, 1957.

——, *Italian Pictures of the Renaissance, Central Italian and North Italian Schools*, London, 1968.

Bergamo: *Accademia Carrara, Catalogo*, by Franco Russoli, 1967.

Adolf Berger, see: Archduke Leopold Wilhelm.

Paul Bergner, *Verzeichnis der Gräflich Nostitzschen Gemälde-Galerie*, Prague, 1905.

Berlin, see: Irene Kühnel-Kunze, 1931 and 1963; Peter Dreyer, 1972.

Johann Jacob Bernoulli, *Aphrodite*, Leipzig, 1873.

Pedro Beroqui, 'Adiciones y correcciones al catálogo del Museo del Prado', *Boletín de la Sociedad Castellana de Excursiones*, VI, 1913–1914, pp. 466–473.

——, *Tiziano en el Museo del Prado*, Madrid, 1946, with appendix by Elias Tormo; first published in a series of articles in the *Boletín de la Sociedad Española de Excursiones*, XXXIII–XXXV, 1925–1927.

——, 'Memoria de las pinturas que se han sacado de palacio', *Boletín de la Sociedad Española de Excursiones*, 1930, pp. 192–193.

——, *El Museo del Prado. Notas para su historia*, Madrid, 1933.

A. Bertolotti, *Artisti veneti in Roma*, Venice, 1884.

Besançon: *Besançon, le plus ancien musée de France*, Paris, 1951.

Lita Rose Betcherman, 'The York House Collection and its Keeper', *Apollo*, XCII, October 1970, pp. 250–259.

W. R. Betcherman, 'Balthazar Gerbier in Seventeenth-century Italy', *History Today*, 1961, pp. 325–333.

G. C. Bevilacqua, *Insigne pinacoteca della nobile veneta famiglia Barbarigo della Terrazza*, Venice, 1845.

Jan Bialostocki, 'The Eye and the Window', *Festschrift für Gert von der Osten*, Cologne, 1970, pp. 159–176.

Margarete Bieber, *Laocoön. The Influence of the Group since its Rediscovery*, New York, 1942; second edition, Detroit, 1967.

——, *The Sculpture of the Hellenistic Age*, New York, 1961.

J. C. J. Bierens de Haan, *L'Oeuvre gravé de Cornelis Cort*, The Hague, 1948.

Alice Binion, 'From Schulenberg's Gallery and Records', *Burlington Magazine*, CXII, 1970, pp. 297–303.

Charles Blanc, *Le trésor de la curiosité tiré des catalogues de vente*, Paris, I, 1857; II, 1858.

E. Maurice Bloch, 'Rembrandt and the López Collection', *Gazette des beaux-arts*, VI series, XXIX, 1946, pp. 175–186.

Henry T. Blodget, 'Titian's St. Catherine in Boston', *Burlington Magazine*, CXI, 1969, pp. 544–548.

Sir Anthony Blunt, 'Titian's Perseus' (letter), *Burlington Magazine*, CV, 1963, p. 281.

——, *The Paintings of Nicolas Poussin, a Critical Catalogue*, London, 1966.

——, *Nicolas Poussin*, New York, 1967, 2 vols.

Phyllis P. Bober, *Drawings after the Antique by Amico Aspertini*, London, 1957.

——, 'The Census of Antique Works of Art known to Renaissance Artists', *The Renaissance and Mannerism, Studies in Western Art. Acts of the Twentieth International Congress of the History of Art*, Princeton, 1963, II, pp. 82–89.

Giovanni Boccaccio, *Genealogie Deorum*, edition Bari, 1951.

——, *La genealogia degli Dei*, edition Venice, 1581.

——, *De claris mulieribus*: English translation, see: Henry Parker, Lord Morley.

O. Bock von Wülfingen, 'Tizians Danae', in *Festgabe für S. K. H. Kronprinz Rupprecht von Bayern*, Munich, 1954, pp. 68–84.

——, *Tiziano Vecellio: Danae* (reprint of above article as a pamphlet), Stuttgart, 1958.

Wilhelm Bode, *Beschreibendes Verzeichnis der Gemälde im Kaiser Friedrich Museum*, Berlin, 1904.

——, 'Ein Tizian im Magazin der Wiener Akademie-Galerie', *Kunstchronik*, N.F., XXVII, no. 2, 1915, p. 17.

——, 'Venus mit dem Orgelspieler', *Amtliche Berichte, Berliner Museen*, XXXIX, 1918, pp. 94–106.

——, 'Eine neuentdeckte Venus mit dem Orgelspieler von Tizian', *Amtliche Berichte, Berliner Museen*, XLVII, 1926, pp. 2–5; also in *Der Kunstwanderer*, 1926, pp. 187–188.

Ferdinando Bologna and Raffaello Causa, *Fontainebleau e la maniera italiana*, Naples, 1952.

Bonaparte collection:
 Abate Guattani, *Galleria del Senatore Luciano Bonaparte*, Rome, 1808.
 Lucien Bonaparte, *Choix de gravures à l'eau-forte d'après les peintures . . . de Lucien Bonaparte*, London, 1812.
Benedetto Bonelli, *Monumenta ecclesiae tridentinae. Notizie historico-critiche della chiesa di Trento*, Trent, 1762.
Maurizio Bonicatti, *Aspetti dell' umanesimo nella pittura veneta dal 1455 al 1515*, Rome, 1964.
Bordeaux: *La Femme et l'artiste de Bellini à Picasso*, catalogue by Gilberte Martin-Méry, 1964.
 See also: Lacour and Delpit, 1855; Oscar Gué, 1862.
Tancred Borenius, *Catalogue of the Pictures at Doughty House*, London, I, 1913.
——, 'A New Titian', *Burlington Magazine*, LXII, 1933, pp. 153–157.
——, *Catalogue of Pictures and Drawings . . . Earl of Harewood*, Oxford, 1936.
——, 'The Pictures at Hampton Court', *Burlington Magazine*, LXXX–LXXXI, 1942, pp. 185–186.
—— and Cust, see: Northwick Park.
Borghese Collection, see: Pergola, 1964 and 1965.
Raffaello Borghini, *Il riposo*, Florence, 1584; also edition 1807.
Camillo Borromeo, 'Ancora dell' Amor Sacro', *Rassegna d'arte*, III, 1903, p. 43.
Cardinal Federico Borromeo, *Il museo del cardinale Federico Borromeo* (1625), edited by Luca Beltrami, Milan, 1909.
Marco Boschini, *La carta del navegar pitoresco*, Venice, 1660; also new annotated edition by Anna Pallucchini, Venice, 1966.
——, *Le minere della pittura . . . di Venezia*, Venice, 1664.
——, *Le ricche minere della pittura*, Venice, 1674 (a second edition of the preceding item); 'Breve instruzione, Premessa a *Le ricche minere*', reprinted in Anna Pallucchini's edition of *La carta del navegar pitoresco*, Venice, 1966, pp. 701–756.
——, *I gioieli pittoreschi, virtuoso ornamento della città di Vicenza*, Venice, 1676.
Boston: Museum of Fine Arts, *Summary Catalogue of European Paintings*, Boston, 1955.
Giovanni Gaetano Bottari, *Raccolta di lettere*, Rome, 1754–1773, 7 vols.; edition by Stefano Ticozzi, Milan, 1822–1825, 8 vols. See also: Gualandi.
Ives Bottineau, 'L'Alcázar de Madrid et l'inventaire de 1686', *Bulletin hispanique*, LVIII, 1956, pp. 421–452; LX, 1958, pp. 30–61, 145–179, 289–326, 451–483.
——, 'Philip V and the Alcázar at Madrid', *Burlington Magazine*, XCVIII, 1956, pp. 68–74.
——, *L'Art de cour dans l'Espagne de Philippe V, 1700–1746*, Bordeaux, 1960.
——, 'False Attributions: The Inventory of Elizabeth Farnese', *Apollo*, LXXIX, 1964, pp. 31–34.
Willelmo Braghirolli, *Tiziano alla corte dei Gonzaga*, reprint from *Atti e memorie della Real Accademia Virgiliana*, Mantua, 1881.

Pietro Brandolesi, *Pitture, sculture, architetture ed altre cose notabili di Padova*, Padua, 1795.
Riciotti Bratti, 'Notizie d'arte e di artisti', *Nuovo archivio veneto*, N.S. XV, tomo XXX, 1915, pp. 435–485.
Fernand Braudel, *The Mediterranean and the Mediterranean World in the Age of Philip II*, edition London, 1972.
Anton Breitenbach, *Geschichte der Erzbischöflichen Galerie in Kremsier*, Brünn, 1924.
Otto J. Brendel, 'The Interpretation of the Holkham Venus', *Art Bulletin*, XXVIII, 1946, pp. 65–75.
——, 'Letter to the Editor', *Art Bulletin*, XXIX, 1947, pp. 67–69.
——, 'Borrowings from Ancient Art in Titian', *Art Bulletin*, XXXVII, 1955, pp. 113–125.
R. Brenzoni, 'L'altare dell' Assunta e l'urna sepolcrale del Vescovo Galesio Nichesola nella cattedrale di Verona', *Bollettino d'arte*, XLII, 1957, pp. 338–341.
Brescia, see: Spini, 1585; Zamboni, 1778.
Paolo Brezzi, 'Alessandro III', *Dizionario biografico degli italiani*, II, 1960, pp. 183–189.
Bridgewater Collection: *Catalogue of the Bridgewater and Ellesmere Collections*, London, 1907.
Robert C. Broderick, *Concise Catholic Dictionary*, St. Paul, 1944.
Jacques Charles Brunet, *Manuel du Libraire*, Paris, 1860–1865, 5 vols.
Mario Brunetti, 'Una figlia sconosciuta di Tiziano', *Rivista di Venezia*, XIV, 1935, pp. 175–184.
Mario Brunetti, Manlio Dazzi, and Guido Gerbini, *Il fondaco nostro dei Tedeschi*, short preface by Giuseppe Pession, Venice, 1941.
Joshua Bruyn, 'Notes on Titian's Pietà', *Album Amicorum J. G. van Gelder*, The Hague, 1973, pp. 66–75.
William Buchanan, *Memoirs of Painting*, London, 1824, 2 vols.
Ernst Buchner, *Ältere Pinakothek*, Munich, 1936.
Duke of Buckingham, see: Addington MS. 17915 (198. L. 6), London, British Museum; Davies, 1907; Fairfax, 1758.
Budapest, Museum of Fine Arts, see: Térey, 1924; Pigler, 1937 and 1967; Garas, 1965.
Buen Retiro Palace, Madrid, see: Alcázar, Madrid, 1747.
W. Bürger (pseudonym of Théophile Thoré, French critic), *Trésors d'art exposés à Manchester en 1857*, Paris, 1857.
Jacob Burckhardt, *Beiträge zur Kunstgeschichte von Italien* (Basel, 1898), edition Berlin, 1911.
——, 'Die Kultur der Renaissance in Italien' (1859), in *Gesammelte Werke*, Basel, 1955.
Rezio Buscaroli, *La pittura di paesaggio in Italia*, Bologna, 1935.
Douglas Bush, *Mythology and the Renaissance Tradition in English Poetry*, edition New York, 1963.
J. Byam Shaw, *Paintings by Old Masters at Christ Church Oxford*, London, 1967.
C. and C., see: Crowe and Cavalcaselle.
Fernand Cabrol and Henri Leclerq, *Dictionnaire d'archéologie chrétienne et de liturgie*, Paris, 1924–1953, 15 vols.

Giovanni Battista Cadorin, *Dei tre quadri dipinti da Tiziano per la sala del Palazzo Pubblico di Brescia*, Venice, 1878 (20 page pamphlet in the Library of the Istituto d'Arte e d'Archeologia, Rome, reprinted from *Rivista cadorina*, 1875).

Giuseppe Cadorin, *Dello amore ai veneziani di Tiziano Vecellio delle sue case in Cadore e in Venezia*, Venice, 1833.

——, *Nota dei luoghi dove si trovano opere di Tiziano*, San Fior di Conegliano, 1885.

Luis Calandre, *El palacio del Pardo*, Madrid, 1953.

Calendar of Letters, Despatches, and State Papers, Spanish, London, IX, 1912; XI, 1916.

Maurizio Calvesi, 'La morte di bacio, Saggio sull' ermetismo di Giorgione', *Storia dell' arte*, nos. 7–8, 1970, pp. 179–233.

Juan Christoval Calvete de Estrella, *El felicíssimo viage del muy alto y muy poderoso Príncipe Don Phelippe, Hijo del Emperador Carlos Quinto*, Antwerp, 1552; also edition, Madrid, 1930, 2 vols.; French edition: *Le très-heureux voyage fait par . . . Don Philippe, fils du grand empereur, Charles-Quint*, Brussels, 1873–1884, 5 vols.

Conte Piero Guelfi Camajani, *Dizionario araldico*, Milan, 1940.

Cambridge, Fitzwilliam Museum:

 See: Goodison and Robertson, 1967.

 F. R. Earp, *A Descriptive Catalogue of the Pictures in the Fitzwilliam Museum*, Cambridge, 1902.

 Treasures of Cambridge, 1959.

 Fitzwilliam Museum, 15th and 16th Century Drawings, 1960.

Ettore Camesasca, see: Aretino.

Giuseppe Campori, *Raccolta di cataloghi ed inventari inediti*, Modena, 1870.

——, 'Tiziano e gli Estensi', *Nuova Antologia*, XXVII, 1874, pp. 581–620.

Giordana Canova, *Paris Bordon*, Venice, 1964.

——, 'Nuove note a Paris Bordone', *Arte veneta*, XXII, 1968, pp. 171–176.

G. Cantalamessa, 'R. Gallerie di Venezia', *Le Gallerie Nazionali Italiane. Notizie e documenti*, Rome, 1896.

Eugene B. Cantelupe, 'Titian's Sacred and Profane Love Re-examined', *Art Bulletin*, XLVI, 1964, pp. 218–227.

Capellen, see: Meyer zur Capellen.

G. B. Carbone and G. B. Rodella, *Le pitture e sculture di Brescia*, Brescia, 1760.

Vicente Carducho, *Diálogos de la pintura*, Madrid, 1633; also in Sánchez Cantón, *Fuentes literarias*, II, Madrid, 1933, pp. 63–115.

——, Documentos (testamento y inventarios), see: Caturla.

Carlos V, see: Charles V.

Giuseppe Carpani, *Apologia del libro della imitazione pittorica . . . di Andrea Maier Veneziano*, Ferrara, 1820.

Nolfo di Carpegna, *Catalogue of the National Gallery, Barberini Palace*, Rome, 1969.

Richard B. Carpenter, 'Woman, Landscape and Myth', *College Art Journal*, XXI, 1962, pp. 246–249.

Julia Cartwright, *Isabella d'Este, Marchioness of Mantua* (1903), edition London, 1926.

Cassel, see: Eisenmann, 1888.

Auguste Castan, 'Monographie du Palais Granvelle à Besançon' (with inventory of 1607), *Mémoires de la Société d'Emulation de Doubs*, 4th series, II, 1867 (i.e. 1866), pp. 109–139.

Giorgio Castelfranco, 'Note su Giorgione', *Bollettino d'arte*, XL, 1953, pp. 298–310.

Catullus, *Carmina*, London, Loeb Library, 1924, translated by F. W. Cornish.

María Luisa Caturla, 'Documentos en torno a Vicencio Carducho', *Arte español*, 1968–1969, pp. 145–221.

Raffaello Causa, *IV Mostra dei restauri, catalogo*, Naples, 1960.

Giovanni Battista Cavalcaselle, 'Spigolature tizianesche', *Archivio storico dell' arte*, IV, 1891, pp. 3–8.

——, *La pittura friulana del rinascimento*, edited by Giuseppe Bergamini, Vicenza, 1973.

——, 'Disegni e appunti' [MS. Cod. It. IV, 2030–2035 (12,271–12,276), Venice, Biblioteca Marciana]; further material in the library of the Victoria and Albert Museum, London. See also: Moretti.

Helia Cavriolo, *Delle historie bresciane*, translated into Italian by Patritio Spini, Brescia, 1585.

Juan Agustín Ceán Bermúdez, *Diccionario histórico de los más ilustres profesores de las bellas artes en España*, Madrid, 1800, 6 vols.

G. F. Cecconi, *Roma sacra e moderna*, Rome, 1725.

D. S. Chambers, *The Imperial Age of Venice, 1380–1580*, London, 1970.

Philippe de Champaigne, 'Inventaire', *Archives de l'art français*, VIII, 1892, pp. 182–199.

L. Charbonneau-Lassay, *Le bestiaire du Christ*, Bruges, 1940.

Charles I of England:

 'État de quelques tableaux exposés en vente à la maison de Somerset, May 1650'; see Cosnac, pp. 413–418.

 'Inventory of the Effects of Charles I, 1649–1652', Harley Manuscript no. 4898, British Museum (copy of the eighteenth century, according to Oliver Millar).

 W. L. F. Nuttall, 'King Charles I's Pictures and the Commonwealth Sale', *Apollo*, October 1965, pp. 302–309.

 'Pictures Belonging to King Charles I at His Several Palaces, Appraised and Most of Them Sold by the Council of State. Order of March 23, 1649' (n.d., *c.* 1650), Manuscript no. 79A, Victoria and Albert Museum, London.

 'Pictures Belonging to King Charles I' (*c.* 1660), from St. James's Palace (Victoria and Albert Museum Library).

 'Pictures, Statues, Plate and Effects of King Charles I, 1649–1651', London, Public Records Office, no. LR 2/124 (see Millar, 1970–1972).

 R. Symonds, Diary: 'Notes on Painting', 1650–1652, British Museum, Egerton MS., no. 1636.

 See also: Cosnac, 1885; Millar, 1970–1972; 'Relación', Madrid, 1623; van der Doort, 1639.

 See also: Cosnac, 1885, Appendix, 'État de quelques tableaux exposés en vente à la maison de Somerset May 1650', pp. 413–418.

Charles I of England: *continued*
W. L. F. Nuttall, 'King Charles I's Pictures and the Commonwealth Sale', *Apollo*, October, 1965, pp. 302–309.
R. Symonds, Diary: 'Notes on Painting', 1650–1652, British Museum, Egerton MS., no. 1636.
'Pictures Belonging to King Charles I' (*c.* 1660), from St. James's Palace (Victoria and Albert Museum Library).
Oliver Millar, *The Inventories and Valuations of the King's Goods, 1649–1651*, Glasgow, The Walpole Society, vol. XLIII, 1970–1972.

Charles V, Holy Roman Emperor:
Charles-Quint et son temps, Ghent, Musée des Beaux-Arts, 1955.
Carlos V y su ambiente, Exposición homenaje en el IV centenario de su muerte, Toledo, 1958.
Inventory of 1561: Rudolf Beer, 'Archivo General de Simancas', *Jahrbuch der Kunsthistorischen Sammlungen des Allerhöchsten Kaiserhauses*, Vienna, XII, 1891, II. Theil, pp. CLXVI–CLXXVII.
See also: *Cronaca* (1529–1530), edition 1892; Gachard, 1855; Pinchart, 1856; Foronda y Aguilera, 1914; Sánchez Loro, 1958.

Jean Chevalier (and others), *Dictionnaire des symboles*, Paris, 1969.
Edward Cheyney, 'Original Documents Relating to Venetian Painters and their Pictures in the Sixteenth Century', *Miscellanies of the Philobiblon Society*, XIV, 1872–1876, pp. 3–112.
Chicago: *Paintings in the Art Institute*, Chicago, 1961.
William Chiffinch, *A Catalogue of the Collection of Pictures Belonging to King James II*, London, Bathoe, 1758.
Christ Church, Oxford:
Paintings and Drawings, London, The Matthiesen Gallery, 1960.
See also: F. Bell; Byam Shaw; Sidney Colvin; K. T. Parker.
Christina, Queen of Sweden:
'Inventario della Regina Christina, 1662–1663', Palazzo Riario, Rome. MS. Riksarkivet, Stockholm, Azzolino-samlingen, no. K 44.
See also: Denucé, 1932 (Antwerp Inventory, 1656); Geffroy, 1855 (Stockholm Inventory, 1652); Granberg, 1896, 1897; Odescalchi Archives, Rome; Stockholm, 1966.
Fernando Chueca Goitia, *Arquitectura del siglo XVI*, Ars Hispaniae, Madrid, 1953.
Giuseppe Ciani, *Storia del popolo cadorino*, 1856 and 1862; also edition Treviso, 1940.
Ciaconius (Alfonso Chacón), *Vitae et res gestae pontificum romanorum*, Rome, 1601; edition 1677, 4 vols.
Emmanuel Antonio Cicogna, *Delle iscrizioni veneziane*, Venice, 1824–1853, 6 vols; *idem, Istituto Veneto*, 1860.
——, *Saggio di bibliografia veneziana*, Venice, 1847.
Leopoldo Cicognara, *Relazione di due quadri di Tiziano Vecellio*, Venice, 1816.

Niccolò Cipriani, *La galleria palatina nel Palazzo Pitti a Firenze, repertorio illustrato*, Florence, 1966.
Renata Cipriani, *All the Paintings of Mantegna*, New York, 1963.
Cesare Cittadella, *Catalogo istorico dei pittori, scultori, ferraresi*, Ferrara, 1782–1783, 4 vols. in 2.
Luigi Napoleone Cittadella, *Notizie . . . relative a Ferrara*, Ferrara, 1864; another edition 1868.
Sir Kenneth Clark, *The Nude, A Study in Ideal Form*, New York, 1956.
—— and Carlo Pedretti, *The Drawings of Leonardo da Vinci in the Collection of Her Majesty the Queen at Windsor Castle*, London, 2nd edition, 1968, 3 vols.
Graziano Paolo Clerici, 'Tiziano e la Hypnerotomachia Poliphili', *La bibliofilia*, XX, 1918–1919, pp. 183–203.
Cleveland Museum of Art: *The Venetian Tradition*, 1955.
Annie Cloulas, 'Documents concernant Titien conservés aux Archives de Simancas', *Mélanges de la Casa de Velázquez*, Madrid, III, 1967, pp. 197–286.
Giulio Coggiola, 'Per l'iconografia di Pietro Bembo', *Atti del Reale Istituto Veneto*, LXXIV (serie 8, XVII, part 2), 1914–1915, pp. 473–514.
Francesco Cognasso, *L'Italia nel Rinascimento*, vol. V of *Società e costume*, Turin, 1965.
Luigi Coletti, *All the Paintings of Giorgione*, Italian edition, Milan, 1955; English edition, New York, 1961.
C. H. Collins Baker, *Catalogue of the Petworth Collection of Pictures*, London, 1920.
——, *Catalogue of the Pictures at Hampton Court*, London, 1929.
——, 'Catalogue of Pictures at Alnwick Castle' (MS. at Alnwick).
Cologne: *Katalog der italienischen, französischen und spanischen Gemälde bis 1800 im Wallraf-Richartz Museum*, 1973, by Brigitte Klesse.
Francesco Colonna, *Hypnerotomachia Poliphili*, Venice, 1499; photographic reprint, London, Gregg, 1969.
Sir Sidney Colvin, *Oxford Drawings*, Oxford, 1903–1907, 3 vols.
W. G. Constable, 'Dipinti di raccolte inglesi alla mostra d'arte italiana a Londra', *Dedalo*, anno X, 1929–1930, vol. III, pp. 723–767.
——, *Canaletto*, Oxford, 1962, 2 vols.
A. B. Cook, *Zeus, A Study in Ancient Religions*, Cambridge, 1914–1940, 3 vols.
Sir Herbert Cook, 'Correspondance de l'étranger, Angleterre', *Gazette des beaux-arts*, II, 1896, pp. 335–340.
——, *Giorgione*, London (1900), edition 1907.
——, *Reviews and Appreciations of Some Old Italian Painters*, London, 1912.
See also: Cust and Cook.
Richard Cooke, 'Titian's Santo Spirito Ceiling: An Alternative Reconstruction', *Burlington Magazine*, CXIII, 1971, p. 734.
W. A. Copinger, *Heraldry Simplified*, Manchester, 1910.
Corsini Collection, Florence, see: Gerspach, 1906.

Gabriel Jules Cosnac, *Les richesses du palais Mazarin*, Paris, 1885.

Clino Cottafavi, 'Camerini di corte nova', *Bollettino d'arte*, VII, 1927–1928, pp. 616–623.

Couché, see: Orléans Collection.

Courtauld Institute:

 General Catalogue of the Courtauld Institute Galleries, London, 1960, revised 1968 and 1970.

G. B. di Crollalanza, *Dizionario storico-blasonico*, Pisa, 1886.

Goffredo di Crollalanza, *Enciclopedia araldico-cavalleresca*, Bologna, 1964.

Cronaca del soggiorno di Carlo V in Italia (1529–1530), edited by Giuseppe Romano, Milan, 1892.

Sir Joseph Archer Crowe and Giovanni Battista Cavalcaselle, *History of Painting in North Italy*, London, 1871, 2 vols.; edition London, 1912, 3 vols. (with notes by T. Borenius).

——, *Life and Times of Titian*, London, 1877, 2 vols.; edition of 1881, same pagination; Italian edition, *Tiziano, la sua vita e suoi tempi*, Florence, 1877–1878, 2 vols.

——, *Raffaello*, Florence, 1884–1891.

——, 'Letters and Notes' (MS., Library of the Victoria and Albert Museum, London).

Crozat Collection, see: Stuffmann, 1968.

Jacob Cuelvis, 'Thesoro chorographico de las Espannas', dated 1599 (Harley MS. 3822, British Museum).

Richard Cumberland, *An Accurate and Descriptive Catalogue of the Several Paintings in the King of Spain's Palace at Madrid*, London, 1787.

H. M. Cundall, 'Drawings at Windsor Castle', *Connoisseur*, XCI, 1933, pp. 353–360.

Lionel Cust, 'Venetian Art at the New Gallery', *Magazine of Art*, XVIII, 1895, pp. 208–211.

——, *Anthony van Dyck*, London, 1900.

——, *A Description of the Sketch-book by Sir Anthony Van Dyck, Used by Him in Italy 1621–1627*, London, 1902 (with inadequate notes).

——, 'The Lovers by Titian', *Burlington Magazine*, XXIX, 1916, p. 373.

——, 'Titian at Hampton Court Palace', *Apollo*, VII, 1928, pp. 47–52.

—— and Herbert Cook, 'The Lovers at Buckingham Palace', *Burlington Magazine*, IX, 1906, pp. 71–79.

—— and Mary Cox, 'Notes on the Collection Formed by Thomas Howard, Earl of Arundel', *Burlington Magazine*, XIX, 1911, pp. 278–286, 323–325.

Carlo D'Arco, see: Arco, 1857.

Darmstadt:

 Carl Seeger, *Das Grossherzogliche Museum zu Darmstadt, Die Gemäldegalerie*, 1843.

 F. Back, *Verzeichnis der Gemälde, Landesmuseum*, 1914.

Martin Davies, *The Earlier Italian Schools*, National Gallery Catalogues, London, 1961.

Randall Davies, 'An Inventory of the Duke of Buckingham's Pictures at York House in 1635', *Burlington Magazine*, X, 1906–1907, pp. 376–382.

Hugo Debrunner, 'A Masterpiece by Lorenzo Lotto', *Burlington Magazine*, LIII, 1928, pp. 116–127.

Jean Decoen, 'Les trois versions de Jupiter et Antiopé d'Antoine Van Dyck', *Clarté, Revue d'art*, c. 1932, pp. 1–7.

Nancy Thomson De Grummond, 'Giorgione's Tempest: the Legend of St. Theodore', *L'Arte*, nos. 18–20, 1972, pp. 5–53.

Bernhard Degenhart and Annegrit Schmidt, 'Ein Musterblatt des Jacopo Bellini mit Zeichnungen nach der Antike', *Festschrift Luitpold Dussler*, Munich, 1972, pp. 139–168.

D.E.I.: *Dizionario enciclopedico italiano*, Rome, vols. I–XIII, 1955–1961.

H. Delaroche, *Catalogue d'une collection précieuse de tableaux*, Paris, 1811.

—— and Alexandre Paillet, *Catalogue des tableaux de la célèbre galerie Giustiniani*, Paris, 1812.

A. J. J. Delen, *Catalogue des dessins anciens*, Cabinet des Estampes de la Ville d'Anvers, Brussels, 1938.

dell'Acqua, see: Acqua.

della Pergola, see: Pergola.

Giuseppe Delogu, *Tiziano, Amor sacro e amor profano*, Milan, c. 1948 (colour plates).

Jean Denucé, *De Antwerpsche 'Konstkamers', inventarissen van kunstverzamelingen*, The Hague, 1932.

de Tolnay, see: Tolnay.

Detroit:

 Catalogue of a Loan Exhibition of Paintings by Titian, Detroit, Institute of Arts, 1928.

 Catalogue of Paintings, Detroit, Institute of Arts, 1944.

Lázaro Díaz del Valle, 'Epílogo y nomenclatura de algunos artífices', 1659, in Sánchez Cantón, *Fuentes literarias para la historia del arte español*, Madrid, II, 1933.

T. F. Dibdin, *Aedes Althorpianae. Pictures at Althorp*, London, 1822.

G. Dionisotti, 'Edgar Wind, Bellini's Feast of the Gods' (review), *Art Bulletin*, XXXII, 1950, pp. 237–239. Reply by Wind and rejoinder by Dionisotti, *loc. cit.*, XXXIII, 1951, pp. 70–71.

G. Dionisotti, 'Pietro Bembo', *Dizionario biografico degli italiani*, Rome, VIII, 1966, pp. 133–151.

L. Dolce, *Dialogo della pittura* (1557), edition by Paola Barocchi, Bari, 1960; edition with English translation and commentary by Mark W. Roskill, New York, 1968.

——, *Lettere di diversi eccellentissimi huomini raccolte da diversi libri tra le quali se ne leggono molte non più stampate*, Venice, 1554, 1558, 1559.

——, *Dialogo di M. Lodovico Dolce nel quale si raggiona delle qualità e proprietà dei colori*, Venice (1565), edition Lanciano, 1913.

——, *Imprese nobili et ingeniose di diversi principi et altri personaggi illustri nell'arme et nelle lettere*, Venice, G. Porro, 1562, 1578; enlarged edition, 1583.

Leonardo Donà (Donato), *La correspondenza da Madrid dell' ambasciatore Leonardo Donà (1570–1573)*, edited by Mario Brunetti and Eligio Vitale, Venice, 1963.

Cesare D'Onofrio: see Onofrio, 1964.

Kate Dorment, 'Tomb and Testament. Architectural Significance in Titian's Pietà', *Art Quarterly*, XXXV, 1972 [1973], pp. 399–418.

Dosso Dossi (documents), see: A. Venturi, 1892; Mezzetti, 1965; Gibbons, 1968.

Eugen Dostal, 'Studien aus der erzbischöflichen Galerie in Kremsier', *Casopis Matice Moravské*, XLVIII, 1924, pp. 32–40. (Dostal in Valentiner, 1930, no. 26).

Dresden: *Catalogue des tableaux de la galerie electorale à Dresde*, Dresden, 1765.

 See also: Julius Hübner, 1872; Karl Woermann, 1887; Posse, 1929; Ebert, 1963.

Peter Dreyer, *Tizian und sein Kreis, 50 Venezianische Holzschnitte aus dem Berliner Kupferstichkabinett*, Berlin, 1972.

——, 'Ugo da Carpios venezianische Zeit im Lichte neuer Zuschreibungen', *Zeitschrift für Kunstgeschichte*, XXXV, 1972, pp. 282–301.

Dubois de Saint Gelais, see: Orléans Collection.

Dulwich: *Catalogue of the Pictures*, revised by Sir Edward Cook, London, 1926.

M. J. Dumesnil, *Histoires des plus célèbres amateurs étrangers*, Paris, 1860.

Luitpold Dussler, *Italienische Meisterzeichnungen*, Frankfort, 1938, and Munich, 1948.

——, *Sebastiano del Piombo*, Basle, 1942.

——, *Raffael, Kritisches Verzeichnis der Gemälde, Wandbilder, und Bildteppiche*, Munich, 1966.

——, Review of Pallucchini's *Tiziano*, *Pantheon*, XXVIII, 1970, pp. 549–550.

Dutartre: *Catalogue des tableaux . . . composant le cabinet du feu M. Dutartre*, Paris, 19 March 1804.

Lazare Duvaux, *Livre-journal de Lazare Duvaux (1748–1758)*, Paris, 1873, published by Louis Courajod, 2 vols.; also photographic reprint, 1965.

Duveen Pictures in Public Collections in America, New York, 1941.

F. R. Earp, see: Cambridge, Fitzwilliam Museum.

Angus Easson, 'The Source of Titian's "Bacchus and Ariadne"', *Journal of the Warburg and Courtauld Institutes*, XXXII, 1969, pp. 396–397.

Hans Joachim Eberhardt, 'Zur Datierung von Tizians Veroneser Assunta in die Jahre 1528 bis 1532', *Mitteilungen des Kunsthistorischen Institutes in Florenz*, XX, 1971, pp. 222–223.

Hans Ebert, *Kriegsverluste der Dresdener Gemäldegalerie*, Dresden, 1963.

Edinburgh:
 Catalogue of Paintings and Sculpture, Edinburgh, 1957.
 Shorter Catalogue of the Paintings of the National Gallery of Scotland, by Colin Thompson and Hugh Brigstocke, Edinburgh, 1970.

Patricia Egan, 'Concert Scenes in Musical Paintings of the Renaissance', *American Musicological Society*, XIV, 1961, pp. 184–195.

——, 'Poesia and the Fête Champêtre, *Art Bulletin*, XLI, 1959, pp. 303–313.

Hermann Egger, Review of Adriani's *Anton Van Dyck Italienisches Skizzenbuch*, *Die graphischen Künste*, 1942.

Robert Eigenberger, *Die Gemäldegalerie der Akademie der Bildenden Künste in Wien*, Vienna, 1927, 2 vols.

Peter Eikemeier, see: Kultzen and Eikemeier.

Herbert von Einem, 'Tizians Madonna mit sechs Heiligen im Vatican', *Wallraf–Richartz Jahrbuch*, XXXIII, 1971, pp. 99–114.

Oscar Eisenmann, *Katalog der Königlichen Gemälde-Galerie zu Kassel*, Cassel, 1888.

Theodor Elze, 'Der Cottimo der deutschen Nation in Venedig', *Beilagen Königliche Akademie der Wissenschaft*, XVI, Bd. II, 1881.

Giulio B. Emert, *Fonti manoscritte inedite per la storia dell' arte nel trentino*, Florence, 1939.

Andrea Emiliani, *Bronzino*, Busto Arsizio, 1960.

Enciclopedia italiana, Rome, 1929–1939, 35 vols.; Appendix, 1938–1961, 5 vols.

Fernand Engerand, 'Les restaurations du tableau de Titien, Jupiter et Antiope', *Chronique des arts, supplément de la Gazette des beaux-arts*, 1898, pp. 158–159.

Eduard R. V. Engerth, *Gemälde, Kunsthistorische Sammlungen, I, Italienische, Spanische, und Französische Schulen*, Vienna, 1884; *II, Niederländische Schulen*, Vienna, 1892.

Eppuldurcombe House, see: Worsley, 1804.

El Escorial, 1563–1963, Madrid, 1963, 2 vols.

Escorial Inventories, see: Zarco Cuevas, 1930.

Espasa-Calpe, i.e. *Enciclopedia universal ilustrada*, Espasa-Calpe, Barcelona, vols. I–LXX, 1920–1930.

Prince d'Essling, *Les livres à figures vénitiens de la fin du XV siècle et du commencement du XVI*, Paris and Florence, 1908.

Grose Evans, 'Notes on Titian's Venus and the Lute Player', *Art Bulletin*, XXIX, 1947, pp. 123–125.

John Evelyn, *Diary and Correspondence*, Oxford, 1955, 6 vols.

Barbara Everard and Brian D. Morley, *Wild Flowers of the World*, New York, 1970.

Hans Gerhard Evers, *Peter Paul Rubens*, Munich, 1942.

Gerhard Ewald, *Johann Carl Loth*, Amsterdam, 1965.

Giovanni Fabbiani, 'Il Cadore per la vittoria di Lepanto', *Archivio storico di Belluno, Feltre, e Cadore*, XLII, no. 197, 1971, pp. 112–124.

Celso Fabbro, 'Documenti su Tiziano e sulla famiglia Vecellio nella Casa di Tiziano a Pieve di Cadore', *loc. cit.* XXX, 1959, pp. 133–135.

——, Fabbro, 'L'esecuzione e la distruzione degli affreschi tizianeschi della antica chiesa arcidiaconale di Pieve di Cadore', *Archivio storico di Belluno, Feltre e Cadore*, XXXIII, 1962, no. 159, pp. 67–75; nos. 160–161, pp. 131–143.

——, 'Tiziano, i Farnese e l'Abbazia di San Pietro in Colle nel Cenedese', *Archivio storico di Belluno, Feltre e Cadore*, XXXVIII, 1967, nos. 178–179, 1967, pp. 1–18.

——, 'Documenti relativi a Tiziano nei suoi rapporti con Carlo V e Filippo II conservati negli archivi reali di Simancas', *loc. cit.*, XXXVIII, 1967, pp. 87–95.

——, 'Tiziano non è morto di peste', *loc. cit.*, XLIV, nos. 202–203, 1973, pp. 1–7.

Brian Fairfax, *Catalogue of the Curious Collection of Pictures of George Villiers, Duke of Buckingham*, London, Bathoe, 1758.

Farnese Inventories, see: Campori, 1870; Filangieri di Candida, 1902; 'Fondo Farnese, Farnesiana, nos. 1176–1177', Archivio di Stato, Naples, Inventories 1626, 1651, 1668.

Philip Fehl, 'The Hidden Genre: A Study of Giorgione's Concert Champêtre in the Louvre', *Journal of Aesthetics and Art Criticism*, XVI, 1957, pp. 153–168.

——, 'Realism and Classicism in the Representation of a Painful Scene: Titian's Flaying of Marsyas', *Czechoslovakia Past and Present*, II, 1969, pp. 1387–1415.

——, 'Rubens' Feast of Venus Verticordia', *Burlington Magazine*, CXIV, 1972, pp. 159–162.

Stefano Fenaroli, *Dizionario degli artisti bresciani*, Brescia, 1877.

José Fernández Montaña, *Felípe II . . . en relación con artes e artistas*, Madrid, 1912.

Ferdinando Ferrajoli, 'Considerazioni sulla Danae di Tiziano', *Emporium*, XCI, 1940, pp. 147–148.

Ferrara: *Catalogo della esposizione della pittura ferrarese del cinquecento*, Ferrara, 1933.

Oreste Ferrari and Giuseppe Scavizzi, *Luca Giordano*, Naples, 1966, 3 vols.

Pasquale Nerino Ferri, *Catalogo riassuntivo della raccolta di disegni antichi e moderni posseduti dalla R. Galleria degli Uffizi di Firenze*, Rome, 1890–1897.

Arnaldo Ferriguto, *Attraverso i misteri di Giorgione*, Castelfranco, 1933.

Cardinal Fesch: *La collection du Cardinal Fesch*, Rome, 1845, 2 vols.

Antonio Filangieri di Candida, 'La Galleria Nazionale di Napoli', *Le gallerie nazionali italiane*, V, Rome, 1902, pp. 208–354 (Farnese inventories).

Benjamin Fillon, *Inventaire des autographes et documents historiques*, Paris, 1879, 3 vols.

Giuseppe Fiocco, *Un Tiziano, la Venere dalle colombe*, Milan, 1942.

——, *Giovanni Antonio Pordenone*, Padua, 1943, 2nd edition.

——, 'Un Tiziano recuperato', *Arte veneta*, XI, 1957, pp. 202–204.

——, 'La casa di Alvise Cornaro', *Bolletino del museo civico di Padova*, LVII, 1968, pp. 7–67.

Oskar Fischel, 'Der Mädchenkopf aus Tizians Schlacht von Cadore', *Kunstchronik und Kunstmarkt*, XXXIII, 1922, pp. 411–415.

——, *Tizian*, Klassiker der Kunst, Stuttgart, third edition, 1907; fifth edition, 1924.

——, 'A Sheet of Sketches by Anthony Van Dyck', *Old Master Drawings*, VIII, 1933, pp. 20–23.

Fitzwilliam Museum, Cambridge:
F. R. Earp, *A Descriptive Catalogue of the Pictures in the Fitzwilliam Museum*, Cambridge, 1902.
Treasures of Cambridge, 1959.
Fitzwilliam Museum, 15th and 16th Century Drawings, 1960.
See also: Goodison and Robertson, 1967.

Jennifer Fletcher, 'Marcantonio Michiel's Collection', *Journal of the Warburg and Courtauld Institutes*, XXXVI, 1973, pp. 382–385.

Florence, Bargello:
Mostra delle armi storiche, Catalogo di, Bruno Thomas e Lionello G. Boccia, Florence, 1971.

Florence, Pitti Gallery, see: Gotti, 1872 and 1875; Cipriani, 1966; Francini-Ciaranfi, 1956 and 1964; Jahn-Rusconi, 1937.

Florence, Uffizi, see:
Gotti, 1872 and 1875.
Catalogo dei dipinti, Florence, 1926.
Catalogo topografico illustrato, Florence, 1929–1930.
P. N. Ferri, 1890–1897.
Salvini, 1964 and other editions.

José M. Florit, 'Inventario de los cuadros y objetos de arte en la quinta real llameda La Ribera en Valladolid', *Boletín de la Sociedad Española de Excursiones*, XIV, 1906, pp. 153–160.

O. H. Förster, *Kölner Kunstsammler*, Berlin, 1931.

Richard Förster, 'Philostrats Gemälde in der Renaissance', *Jahrbuch der königlich preussischen Kunstsammlungen*, XXV, 1904, pp. 15–48.

——, 'Wiederherstellung antiker Gemälde durch Künstler der Renaissance', *Jahrbuch der königlich preussischen Kunstsammlungen*, XLIII, 1922, pp. 126–136.

Gino Fogolari, 'Le tavolette votive della Madonna dei Miracoli di Lonigo', *Dedalo*, anno II, vol. III, 1922, pp. 580–598.

——, 'La Venere di Dresda e quella di Giorgione in Casa Marcello', *Ateneo veneto*, 116, 1934, pp. 323–329; reprinted in Fogolari's *Scritti d'arte*, Milan, 1946, pp. 283–289.

See also: *Mostra di Tiziano*, 1935.

Tamara Fomiciova, *Tiziano Vecellio* (in Russian), Moscow, 1960.

——, 'I dipinti di Tiziano nelle raccolte dell' Ermitage', *Arte veneta*, XXI, 1967, pp. 57–70.

Vincenzo Forcella, *Iscrizioni delle chiese e d'altri edifici di Roma*, Rome, 1869–1884, 14 vols.

Foronda y Aguilera, *Estancias y viajes del emperador Carlos V*, Madrid, 1914.

Erik Forssman, 'Über Architekturen in der venezianischen Malerei des Cinquecento', *Wallraf-Richartz Jahrbuch*, XXIX, 1967, pp. 108–114.

Lodovico Foscari, *Affreschi esterni a Venezia*, Milan, 1936.

Anna Maria Francini-Ciaranfi, *La Galleria Palatina* (Pitti), Florence, 1956 and 1964.

Scipione Francucci, *La galleria dell'illustrissimo e Reverendissimo Signore Scipione Cardinale Borghese* (Rome, 1613), published Arezzo, 1647.

Enriqueta Harris Frankfort, 'Cassiano dal Pozzo on Velázquez', *Burlington Magazine*, CXII, 1970, pp. 364–373.

——, 'La misión de Velázquez en Italia', *Archivo español de arte*, XXXIII, 1960, pp. 109–136.

Enriqueta Harris Frankfort and Gregorio de Andrés, 'Descripción del Escorial por Cassiano dal Pozzo', *Archivo español de arte*, XLV, 1972, Anejo, pp. 3–33.

Sydney J. Freedberg, *Painting of the High Renaissance in Rome and Florence*, Cambridge (Mass.), 1961, 2 vols.

——, *Italian Painting 1500–1600*, London and Baltimore, 1971.

Kurt Freise, *Pieter Lastman, sein Leben und seine Kunst*, Leipzig, 1911.

F. E. W. Freund, 'Paintings of Titian in America', *International Studio*, New York, XC, 1928, pp. 35–41.

Franz Freyczi, 'Urkunden und Regesten', *Jahrbuch der Kunsthistorischen Sammlungen des Allerhöchsten Kaiserhauses*, V, 1887, p. XXV.

R. Freyhen, 'The Evolution of the Caritas Figure in the Thirteenth and Fourteenth Centuries', *Journal of the Warburg and Courtauld Institutes*, XI, 1948, pp. 68–86.

Frick Collection:
Frick Collection, New York, 1949.
Frick Collection, Paintings, New York, 1968, I and II.

Walter Friedlaender, 'La tintura delle rose', *Art Bulletin*, XX, 1938, pp. 320–324.

——, 'The Domestication of Cupid', *Studies in Renaissance and Baroque Art presented to Anthony Blunt*, London, 1967, pp. 50–52.

Theodore von Frimmel, *Blätter für Gemälde Kunde*, Vienna, 1909, I.

——, 'Tizians Skizze zum Petrus Martyr', *Studien und Skizzen zum Gemäldekunde*, Vienna, III, 1917, pp. 33–38.

Gustav Frizzoni, 'Serie di capolavori dell'arte italiana nuovamente illustrati', *Archivio storico dell'arte*, V, 1892, pp. 9–25.

Lili Fröhlich-Bum, 'Andrea Meldolla genannt Schiavone', *Jahrbuch der Kunsthistorischen Sammlungen des Allerhöchsten Kaiserhauses*, Vienna, XXXI, 1913, pp. 137–220.

——, 'Die Zeichnungen Tizians', *Jahrbuch der Kunsthistorischen Sammlungen in Wien*, N.F., II, 1928, pp. 194–198.

——, 'Zu Giorgione', *Belvedere*, VIII, 1929, pp. 8–13.

——, Review of Hans Tietze's *Titian*, *Art Bulletin*, XX, 1938, pp. 444–446.

Roger Fry, 'Monthly Chronicle', *Burlington Magazine*, XLII, 1923, p. 54.

——, 'The Bridgewater Titians', *Burlington Magazine*, LXII, 1933, pp. 4–10.

Louis P. Gachard, *Retraite et mort de Charles-Quint au monastère de Yuste*, Brussels, 1855.

——, *Relations des ambassadeurs vénitiens sur Charles-Quint et Philippe II*, Brussels, 1855.

Donald L. Galbreath, *Papal Heraldry*, Cambridge, 1930; second enlarged edition, 1972.

Luciano Gallina, *La Accademia Gallina in Lovere*, Bergamo, 1957.

Carlo Gamba, 'La Venere di Giorgione rintegrata', *Dedalo*, IX, 1928–1929, pp. 205–209.

Klara Garas, 'Giorgione e Giorgionismo au XVII siècle', *Bulletin du Musée Hongrois des Beaux-Arts*, no. 25, 1964, pp. 51–80; no. 28, 1966, pp. 69–93.

——, 'The Ludovisi Collection of Pictures in 1633', *Burlington Magazine*, CIX, 1967, pp. 287–289, 339–348.

——, 'Die Entstehung der Galerie des Erzherzogs Leopold Wilhelm', *Jahrbuch der Kunsthistorischen Sammlungen in Wien*, N.F., XXVII, 1967, pp. 139–180.

——, 'Die Schicksale der Sammlung des Erzherzog Leopold Wilhelm', *Jahrbuch der Kunsthistorischen Sammlungen in Wien*, N.F., XXVIII, 1968, pp. 181–278.

——, 'La collection des tableaux du château royal de Buda au XVII siècle', *Bulletin du Musée Hongrois des Beaux-Arts*, nos. 32–33, 1969, pp. 91–121.

——, 'Die Bildnisse des Pietro Bembo in Budapest', *Acta Historiae Artium*, February 1970, pp. 57–67.

Elizabeth E. Gardner, 'Dipinti rinascimentali del Metropolitan Museum nelle carte di G. B. Cavalcaselle', *Saggi e memorie di storia dell'arte*, VIII, 1972, pp. 68–74.

Juan Antonio Gaya Nuño, 'Notas al catálogo del Museo del Prado', *Boletín de la Sociedad Española de Excursiones*, LVIII, 1954, pp. 101–142.

——, *Historia y guía de los museos de España*, Madrid, 1968.

Giovanni Gaye, *Carteggio d'artisti*, Florence, 1839–1840, 2 vols.

Auguste Geffroy, *Notices et extraits des manuscrits*, Paris, 1855.

H. Geissler, *Christoph Schwarz* (doctoral dissertation), Freiburg-im-Breisgau, 1960.

Jacopo Gelli, *Devise, motti, imprese di famiglie e personaggi italiani*, Milan, 1916.

Genoa: *Cento opere di Van Dyck. Catalogo della mostra*, Palazzo dell' Accademia, 1955.

Giuseppe Gerola, 'Per la fortuna di un soggetto del Tiziano', *L'Arte*, XII, 1908, pp. 455–456.

M. Gerspach, 'La Galerie Corsini à Florence', *Les Arts*, no. 52, April 1906, pp. 12–30.

Olga von Gerstfeldt, 'Venus und Violante', *Monatshefte für Kunstwissenschaft*, III, 1910, pp. 365–376.

Felton Gibbons, *Dosso and Battista Dosso*, Princeton, 1968.

—— and Lionello Puppi, 'Dipinti inediti o poco noti di Dosso e Battista Dosso', *Arte antica e moderna*, VIII, 1965, pp. 311–313.

Creighton Gilbert, 'On Subject and Non-Subject in Italian Renaissance Pictures', *Art Bulletin*, XXXIV, 1952, pp. 202–216.

——, 'When did a Man in the Renaissance Grow Old?', *Studies in the Renaissance*, XIV, 1967, pp. 7–32.

Josiah Gilbert, *Cadore or Titian's Country*, London, 1869.

B. Giustinian, *Historie cronologiche dell'origine degl'ordini militari*, Venice, 1692.

Giustiniani Collection, Rome, see: Delaroche, 1812; Landon, 1812; Salerno, 1960.

Glasgow:
Catalogue, Descriptive and Historical of the Pictures in the Glasgow Galleries and Museums, Glasgow, 1935.
Catalogue of Italian Paintings. Illustrations, Glasgow, 1970.

G. Glück, *Rubens und sein Kreis*, Vienna, 1933.

Gustav Glück and August Schaeffer, *Die Gemäldegalerie. Alte Meister*, Vienna, 1907.

Umberto Gnoli, 'Amor sacro e profano', *Rassegna d'arte*, II, 1902, pp. 177–181.

——, 'L'Arte italiana in alcune gallerie francesi di provincia', *Rassegna d'arte*, VIII, 1908, pp. 155–159.

F. M. Godfrey, 'L'Amor sacro e profano', *Apollo*, L, 1949, pp. 86–91.

——, 'The Venetian Venus and Giorgione', *Apollo*, LXIII, 1955, pp. 69–73 (popular account).

George Goldner, 'A Source for Titian's "Nymph and Shepherd"', *Burlington Magazine*, CXVI, 1974, pp. 392, 395.

Vincenzo Golzio, *Raffaello nei documenti*, Vatican, 1936.

——, *La galleria e le collezioni della R. Accademia di San Luca*, Rome, 1939.

Gyorgy Gombosi, *Palma Vecchio*, Klassiker der Kunst, Stuttgart–Berlin, 1937.

——, *Moretto da Brescia*, Basle, 1943.

E. H. Gombrich, 'Renaissance Artistic Theory and the Development of Landscape Painting', *Gazette des beaux-arts*, 6 période, XLI, 1953, pp. 335–360.

——, 'The Style all'antica, Imitation and Assimilation', *Studies in Western Art: Acts of the Twentieth International Congress of the History of Art*, II, Princeton, 1963, pp. 31–41.

Gil González Dávila, *Teatro de las grandezas de la villa de Madrid*, Madrid, 1623.

Juan José González Martínez, 'El Palacio de El Pardo en el siglo XVI', *Boletín del Seminario de Estudios de arte y arqueología en Valladolid*, XXXVI, 1970, pp. 5–41.

Angel González Palencia, *Gonzalo Pérez*, Madrid, 1946, 2 vols.

J. W. Goodison, 'Titian's Venus and Cupid with a Lute-Player in the Fitzwilliam Museum', *Burlington Magazine*, CVII, 1965, pp. 521–522.

—— and G. H. Robertson, *Catalogue of Paintings, Italian Schools*, Fitzwilliam Museum, Cambridge, 1967.

St John Gore, 'Pictures in National Trust Houses', *Burlington Magazine*, CXI, 1969, pp. 238–258.

T. Gottheiner, 'Rediscovery of Old Masters at Prague Castle', *Burlington Magazine*, CVII, 1965, pp. 601–606.

Aurelio Gotti, *Le gallerie di Firenze*, Florence, 1872, pp. 333–336.

——, *Le gallerie e i musei di Firenze, discorso storico*, Florence, 1875, pp. 382–386: Inventory of pictures brought from Urbino to Florence in 1631.

Cecil Gould, 'Leonardo's Great Battle-piece, a Conjectural Reconstruction', *Art Bulletin*, XXXVI, 1954, pp. 117–129.

——, *The Sixteenth-Century Venetian School*, London, National Gallery, 1959.

——, 'The Perseus and Andromeda and Titian's Poesie', *Burlington Magazine*, CV, 1963, pp. 112–117.

——, *Titian*, London, 1969 (Colour Library Series).

——, *Titian, The Studio of Alfonso d'Este and Titian's Bacchus and Ariadne*, London, National Gallery, 1969.

——, 'The Cinquecento at Venice', *Apollo*, 95–96, 1972, I, May, pp. 376–381; II, June, pp. 464–469; III, 'Tintoretto and Space', July, pp. 32–37; IV, 'Pordenone versus Titian', August, pp. 106–110.

——, *The School of Love and Correggio's Mythologies*, London, National Gallery, 1973.

Olaf Granberg, *Drottning Kristinas Tafvelgalleri på Stockholms slott och i Rom*, Stockholm, 1896.

——, *La galerie de tableaux de la Reine Christine de Suède*, Stockholm, 1897.

Mary A. Grant, *The Myths of Hyginus*, Lawrence, Kansas, University of Kansas Publications, no. 34, 1960.

Granvelle:

 Granvelle Inventory 1600, in *Jahrbuch der Kunsthistorischen Sammlungen der Allerhöchsten Kaiserhauses*, VII, 1888, no. 4656.

 Auguste Castan, 'Monographie du Palais Granvelle à Besançon (with inventory)', *Mémoires de la Société d'Emulation de Doubs*, 4 série, II, 1867 (i.e. 1866), pp. 109–139.

 Letters of Granvelle, see: Zarco del Valle, 1888.

Algernon Graves, *A Century of Loan Exhibitions, 1813–1912*, London, 1913–1915, 5 vols.

——, *Art Sales*, London, 1921, 3 vols.

Robert Graves, *The White Goddess*, paper-back edition, New York, 1966.

Ester Grazzini-Cocco, 'Pittori cinquecenteschi padovani', *Bollettino del Museo Civico di Padova*, III, 1927, nos. 3–4, pp. 89–117.

The Greek Anthology, translated by W. R. Paton, Loeb edition, 5 volumes, London and New York, 1918.

Ferdinand Gregorovius, *History of the City of Rome in the Middle Ages*, translated by Anne Hamilton, London, 1902, VIII, part 2.

Lady Gregory, *Hugh Lane's Life and Achievement*, New York, 1921.

Georg Gronau, 'Titians Himmlische und Irdische Liebe', *Repertorium für Kunstwissenschaft*, XXVI, 1903, pp. 177–179.

——, *Titian*, English edition, London, 1904 (German edition, Berlin, 1900).

——, 'Die Kunstbestrebungen der Herzöge von Urbino', *Jahrbuch der königlich preussischen Kunstsammlungen*, XXIV, 1904, Beiheft, pp. 1–33. Italian edition: *Documenti artistici urbinati*, Florence, 1936, pp. 1–8, 85–113. Extract of the Inventory of 1631 also published earlier: see Gotti, 1875.

——, Review of Hugo von Kilènyi, 'Ein wiedergefundenes Bild des Tizian', *Monatshefte der Kunstwissenschaftlichen Literatur*, III, 1907, pp. 7–8.

——, 'Zur Geschichte der Caesarenbilder von Tizian', *Münchner Jahrbuch*, III, 1908, pp. 31–34.

——, 'Giorgione', Thieme-Becker, *Künstler-Lexikon*, XIV, 1921, pp. 86–90.

——, 'Alfonso d'Este und Tizian', *Jahrbuch der Kunsthistorischen Sammlungen in Wien*, N.F., II, 1928, pp. 233–246 (with documents).

Georg Gronau, in W. R. Valentiner, *Das unbekannte Meisterwerk*, Berlin, 1930.

——, *Georg Gronau, 1868–1937, Verzeichnis seiner Schriften*, Florence, 1938. Also in *Rivista d'arte*, XX, 1938.

Lucio Grossato, *Il Museo Civico di Padova*, Venice, 1957.

——, *Affreschi del cinquecento in Padova*, Milan, 1966.

Orlando Grosso, *Catalogo delle gallerie di Palazzo Rosso, della pinacoteca di Palazzo Bianco e delle collezioni di Palazzo Communale*, Genoa, 1931.

Vicomte de Grouchy, 'Everhard Jabach, collectionneur parisien', *Mémoires de la Société de l'Histoire de Paris et de l'Ile de France*, XXI, 1894, pp. 1–66, 217–292.

——, see also: Guiffrey and de Grouchy, 1892.

H. A. Grueber, *Coins of the Roman Republic in the British Museum*, London, 1910, 3 vols.

Gustav Gruyer, *L'Art ferrarais à l'époque des princes d'Este*, Paris, 1897, 2 vols.

Michelangelo Gualandi, *Memorie originali italiane risguardanti le belle arti*, Bologna, I, 1840; second serie 1841, serie terza, 1842; III, 1843, 1844, 1845.

Oscar Gué, *Catalogue des tableaux*, Bordeaux, 1862.

Conte Piero Guelfi-Camajani, *Dizionario araldico*, Milan, 1940.

Guida sommaria . . . della Biblioteca Ambrosiana, Milan, 1907.

Jules Guiffrey and Vicomte de Grouchy, 'Les peintres Philippe et Jean-Baptiste de Champaigne', *Nouvelles archives de l'art français*, VIII, 1892, pp. 172–218.

Georg Habich, 'Die Imperatoren-Bilder in der Münchner Residenz', *Monatshefte für Kunstwissenschaft*, I, 1908, pp. 189–191.

Detlev von Hadeln, 'Beiträge zur Tintorettoforschung', *Jahrbuch der königlich preuszischen Kunstsammlungen*, Berlin, XXXII, 1911, pp. 25–58.

——, 'Domenico Campagnola', Thieme-Becker, *Künstler-Lexikon*, V, 1911, pp. 449–451.

——, 'Nadalino da Murano', *Zeitschrift für bildende Kunst*, N.F., XXIV, 1913, pp. 163–167.

——, 'Damiano Mazza', *Zeitschrift für bildende Kunst*, N.F., XXIV, 1913, pp. 249–254.

——, 'Girolamo Dente', Thieme-Becker, *Künstler-Lexikon*, IX, 1913, pp. 81–82.

——, 'Über Zeichnungen der früheren Zeit Tizians', *Jahrbuch der königlich preuszischen Kunstsammlungen*, Berlin, XXXIV, 1913, pp. 224–250.

——, Review of Hetzer's *Die frühen Gemälde*, in *Kunstchronik*, N.F., XXXI, 1920, pp. 931–934.

——, 'Eine Zeichnung Tizians', *Jahrbuch der preuszischen Kunstsammlungen* XLIII, 1922, pp. 106–108.

——, 'A Drawing after an Important Lost Work by Pordenone', *Burlington Magazine*, XLIV, 1924, p. 149.

——, *Zeichnungen des Tizian*, Berlin, 1924.

——, *Venezianische Zeichnungen der Hochrenaissance*, Berlin, 1925.

——, 'Another Version of the Danaë by Titian', *Burlington Magazine*, XLVIII, 1926, pp. 78, 83.

——, *Titian's Drawings*, London, 1927.

——, 'Veronese's Venus at Her Toilet', *Burlington Magazine*, LIV, 1929, pp. 115–116.

——, 'Das Problem der Lavinia-Bildnisse', *Pantheon*, VII, 1931, pp. 82–87.

——, 'Tizians Venus mit Lautenspieler', *Pantheon*, X, 1932, pp. 273–278.

——, 'Girolamo di Tiziano', *Burlington Magazine*, LXV, 1934, pp. 88–89.

John R. Hale (editor), *Renaissance Venice*, London, 1973.

Hamilton collection, see: Garas, 1967.

N. G. L. Hammond and H. H. Scullard, *The Oxford Classical Dictionary*, 2nd edition, Oxford, 1970.

Daniel G. Hannema, *Catalogue of the D. G. van Beuningen Collection*, Rotterdam, 1942.

——, *Chefs d'oeuvres de la collection D. G. van Beuningen*, Paris, Petit Palais, 1952.

Franz Hardy, 'Two Lost Portraits by Titian Rediscovered', *Connoisseur*, January, 1971, pp. 21–27 (wrong attributions).

Harewood Collection, see: Borenius, 1936.

Harley Manuscript, no. 4898, London, British Museum, 'The Inventory of the Effects of Charles I, 1649–1652'.

Ann Sutherland Harris, 'Letter regarding Titian's Pesaro Madonna', *Art Bulletin*, LIV, 1972, pp. 116–118.

Harris, see: Enriqueta Harris Frankfort.

Thomas Perrin Harrison and H. J. Leon, *The Pastoral Elegy, An Anthology*, Austin, 1939.

G. F. Hartlaub, *Giorgione's Geheimnis*, Munich, 1925.

——, 'Antike Wahrsagungsmotive in Bildern Tizians', *Pantheon*, XXVII, 1941, pp. 250–253.

——, 'Tizians Liebesorakel und seine Kristallseherin', *Zeitschrift für Kunst*, IV, 1950, pp. 35–48.

——, *Zauber des Spiegels*, Munich, 1951.

Frederick Hartt, *Giulio Romano*, New Haven, 1958, 2 vols.

——, *Italian Renaissance Art*, New York, 1969.

——, *Michelangelo Drawings*, New York, 1969.

Francis Haskell, *Patrons and Painters*, New York, 1963.

——, 'Giorgione's Concert Champêtre and its Admirers', the Fred Cook Memorial Lecture, 3 March 1971, *Journal of the Royal Society of Arts*, pp. 543–555.

Louis Hautecoeur, *École italienne et école espagnole*, Musée National du Louvre, Paris, 1926.

William C. Hazlitt, *The Venetian Republic, A.D. 409–1797*, first edition 1915; edition New York, 1966.

Fritz Heinemann, *Tizian*, Munich, 1928 (dissertation).

——, *Giovanni Bellini e i Belliniani*, Venice, 1962, 2 vols.

——, 'Die Ausstellung venezianischer Kunst in Stockholm', *Kunstchronik*, XVI, 1963, pp. 61–68.

——, Über unbekannte oder wenig bekannte Werke Tizians', *Arte veneta*, XXI, 1967, pp. 210–213.

——, 'Tizian', *Kindlers Malerei Lexikon*, V, 1968, pp. 517–530.

Rudolf J. Heinemann, *Sammlung Schloss Rohoncz*, Lugano, 1958.

—— and others, *Sammlung Thyssen-Bornemisza*, Castagnola, 1971, 2 vols.

Heinz, see: Klauner and Heinz.

Julius S. Held, 'Flora, Goddess and Courtesan', *Essays in Honor of Erwin Panofsky*, edited by Millard Meiss, New York University, 1961, pp. 201–218.

——, 'Rubens' Het Pelsken', *Essays in the History of Art Presented to Rudolf Wittkower*, London, 1967, pp. 188–192.

Philip Hendy, 'Titian at Hertford House', *Burlington Magazine*, XLVI, 1925, pp. 236–240.

——, *Catalogue of the Exhibited Paintings and Drawings*, Isabella Stewart Gardner Museum, Boston, 1931.

Alexandre Henne, *Histoire du règne de Charles-Quint en Belgique*, Brussels, 1859, 10 vols.

Federico Hermanin, *Il mito di Giorgione*, Spoleto, 1933.

J. Hernández Díaz, A. Sancho Corbacho and F. Collantes de Terán, *Catálogo . . . de la provincia de Sevilla*, III, Seville, 1951.

Mary F. S. Hervey, *The Life, Correspondence and Collections of Thomas Howard, Earl of Arundel*, Cambridge, 1921.

Erich Herzog, *Die Gemäldegalerie der staatlichen Kunstsammlungen Kassel*, Cassel, 1961.

Theodor Hetzer, *Die frühen Gemälde Tizians*, Basel, 1920.

——, 'Studien über Tizians Stil', *Jahrbuch für Kunstwissenschaft*, I, 1923, pp. 203–248.

——, 'Über Tizians Gesetzlichkeit', *Jahrbuch für Kunstwissenschaft*, VI, 1928, pp. 1–20.

——, 'Vecellio, Tiziano', Thieme-Becker, *Künstler-Lexikon*, XXXIV, 1940, pp. 158–171.

——, *Tizian. Geschichte seiner Farbe*, Frankfurt, 1948.

Gilbert Highet, *The Classical Tradition*, Oxford and New York, edition 1967.

Arthur M. Hind, *Catalogue of Drawings by Dutch and Flemish Artists*, London, British Museum, II, 1923.

J. P. Hodin, 'Legenden om Giorgione På Ny', *Konst og Kultur*, XXXVIII, 1955, pp. 209–227.

Paul Hofer, 'Die Pardo Venus Tizians', *Festschrift Hans R. Hahnloser, zum 60. Geburtstag*, Basel and Stuttgart, 1961, pp. 341–360.

Sir Charles Holmes, 'Titian's Venus and Adonis in the National Gallery', *Burlington Magazine*, XLIV, 1924, pp. 16–22.

——, 'L'Amor Piqué' (letter), *Burlington Magazine*, XLVII, 1925, p. 272.

Sir Richard R. Holmes, 'Peter Oliver and John Hoskins', *Burlington Magazine*, IX, 1906, pp. 109–113.

Niels von Holst, 'La pittura veneziana tra il Reno e la Neva', *Arte veneta*, V, 1951, pp. 131–140.

G. J. Hoogewerff and J. Q. van Regteren Altena, *Arnoldus Buchelius Res Pictoriae, Quellenstudien*, XV, The Hague, 1928.

Charles Hope, 'The "Camerini d'Alabastro" of Alfonso d'Este', *Burlington Magazine*, CXIII, 1971, I, pp. 641–650; 1972, II, pp. 712–721.

——, 'Documents Concerning Titian', *Burlington Magazine*, CXV, 1973, pp. 809–810.

Horace, *The Odes and Epodes*, translated by C. E. Bennett, London and Cambridge, 1960.

Madeleine Hours, 'La découverte de la verité', *France, Illustration*, Noël, 1950, n.p.

——, 'Examen sommaire fait au laboratoire d'études scientifiques de la peinture du Musée du Louvre sur le tableau de Giorgione, Le Concert Champêtre', *Bollettino d'arte*, XL, 1953, p. 310.

——, *Les secrets des chefs-d'oeuvre*, Paris, 1964.

——, 'A propos de quelques radiographies récentes', *Revue du Louvre, Bulletin du Laboratoire du Musée du Louvre*, supplément no. 12, 1968, pp. 52–53.

—— and S. Delbourgo, 'Les altérations de la couche picturale sous l'objectif du microscope', *Laboratoires et recherches des Musées de la France, Anales*, 1970, pp. 4–7.

Louis Hourticq, 'La fontaine d'amour de Titien', *Gazette des beaux-arts*, 4 période, XIII, 1917, pp. 288–298.

——, *La jeunesse de Titien*, Paris, 1919.

——, 'Un nouveau Titien', *Revue de l'art ancien et moderne*, XLI, 1922, pp. 182–192.

——, *Le problème de Giorgione*, Paris, 1930.

Julius Hübner, *Catalogue de la galerie royale de Dresde*, Dresden, 1872, fourth edition.

Adeline Hulftegger, 'Notes sur la formation des collections de peintures de Louis XIV', *Bulletin de la Société de l'Histoire de l'Art Français*, année 1954 (pub. 1955), pp. 124–134.

Sir Abraham Hume, *Notices of the Life and Times of Titian*, London, 1829.

Norbert Huse, *Studien zu Giovanni Bellini*, New York, 1972.

James Hutton, *The Greek Anthology in Italy until the Year 1800*, Ithaca, 1935.

Hyginus, *Fabulae*, Leyden, 1934, published by H. I. Rose; English translation by Mary A. Grant, Lawrence (Kansas), 1960.

F. Ingersoll-Smouse, 'Une oeuvre de la vieillesse de Titien', *Gazette des beaux-arts*, 5 période, XIII, 1926, pp. 89–92.

Francisco Iñiguez Almech, *Casas reales y jardines de Felipe II*, Madrid, 1952.

——, 'La Casa del Tesoro, Velázquez y las obras reales', in *Varia Velazqueña*, I, pp. 649–682, Madrid, 1960.

G. Innamorati, 'Pietro Aretino', *Dizionario biografico degli italiani*, IV, 1962, pp. 89–104.

'Inventario general de los objetos artísticos y efectos de todas clases existentes en el Real Museo de pintura y escultura', Prado Library, Madrid, 1857, manuscript [pictures without specified provenance came from the Royal Palace].

Inventories of Philip II and later Spanish monarchs, see: Alcázar, Madrid; Madrid, Royal Palace.

The Italian Garden, Colloquium, Dumbarton Oaks, Washington, 1972.

Nicola Ivanoff, 'Il ciclo dei filosofi della Libreria Marciana a Venezia', *Emporium*, CXL, 1964, pp. 207–210.

——, 'Un saint Sébastien de Giuseppe Caletti au Musée des Beaux-Arts d'Épinal', *Revue du Louvre*, XV, 1965, pp. 258–262.

——, 'La Libreria Marciana', *Saggi e memorie*, VI, 1968, pp. 35–78.

Everhard Jabach, see: Grouchy, 1898; O. H. Förster, 1931.

Emil Jacobs, 'Das Museum Vendramin und die Sammlung Reynst', *Repertorium für Kunstwissenschaft*, XLVI, 1925, pp. 15–38.

Michael Jaffé, 'Rubens and Giulio Romano at Mantua', *Art Bulletin*, XL, 1958, pp. 326–329.

——, *Van Dyck's Antwerp Sketchbook*, London, 1966, 2 vols.

——, 'Rubens as Collector of Drawings', *Master Drawings*, VII, 1966, pp. 127–148.

——, 'Rubens' Roman Emperors', *Burlington Magazine*, CXII, 1971, pp. 300–301.

——, 'Pesaro Family Portraits, Pordenone, Lotto, and Titian', *Burlington Magazine*, CXIII, 1971, pp. 696–702.

——, 'Figure Drawings Attributed to Rubens, Jordaens, and Cossiers in the Hamburg Kunsthalle', *Jahrbuch der Hamburger Kunstsammlungen*, XVI, 1971, pp. 39–50.

A. Jahn-Rusconi, *La Reale Galleria Pitti*, Rome, 1937.

Anna Jameson, *The Collection of Pictures of W. G. Coesvelt of London*, London, 1836.

——, *Companion to the Most Celebrated Private Galleries in London*, London, 1844.

Horst W. Janson, *The Sculpture of Donatello*, Princeton, 1957, 2 vols.

Gotthard Jedlicka, 'Über einige Spätwerke von Tizian', *Das Werk*, XXXIV, Heft 2, 1947, pp. 37–52.

Franklin P. Johnson, *Lysippos*, Durham, 1927.

John G. Johnson Collection: *Catalogue*, Philadelphia, 1941. See also: Barbara Sweeny, 1972.

William M. Johnson, 'Les débuts de Primatice à Fontainebleau', *Revue de l'art*, no. 6, 1969, pp. 8–18.

Thomas Jones, *Memoires of Thomas Jones (1742–91)*, Glasgow, Walpole Society, vol. XXXII, 1946–1948.

Karl Justi, 'Verzeichnis der früher in Spanien befindlichen, jetzt verschollenen oder ins Ausland gekommenen Gemälde Tizians', *Jahrbuch der königlich preuszischen Kunstsammlungen*, Berlin, X, 1889, pp. 181–186 (an out-of-date and incomplete account).

——, *Diego Velázquez and His Times*, English edition, London and New York, 1889.

——, *Miscellaneen aus drei Jahrhunderten*, Berlin, 1908, 2 vols.

Ludwig Justi, *Giorgione*, Berlin, editions 1908 and 1925, 2 vols.

Madlyn Kahr, 'Titian and the Hypnerotomachia Poliphili, Woodcuts and Antiquity', *Gazette des beaux-arts*, 6 période, LXVII, 1966, pp. 118–127.

Kansas City: *Handbook of the Collections in the William Rockhill Nelson Gallery of Art*, Kansas City, 1973.

C. M. Kaufmann, *Catalogue of Foreign Paintings Before 1800*, London, Victoria and Albert Museum, 1973.

Harald Keller, *Tizians Poesie für König Philipp II von Spanien*, Wiesbaden, 1969.

Hayward Keniston, *Francisco de los Cobos, Secretary to the Emperor Charles V*, Pittsburgh, 1959.

Ruth W. Kennedy, 'Tiziano in Roma', *Il mondo antico nel Rinascimento*, Florence, 1956 (published 1958), pp. 237–243.

——, *Novelty and Tradition in Titian's Art*, Northampton, 1963.

——, 'Apelles Redivivus', *Essays in Memory of Karl Lehman*, New York, 1964, pp. 160–170.

S. Kennedy North, 'The Bridgewater Titians', *Burlington Magazine*, LXII, 1933, pp. 10–15.

Joy Kenseth, 'Titian's St. Catherine of Alexandria', *Boston Museum Bulletin*, LXVII, 1969, pp. 175–188.

Khevenhüller, see: Voltelini, XIII, 1892, no. 9433.

Franz Kieslinger, 'Tizian Zeichnungen', *Belvedere*, XII, 1934–1936, pp. 170–174.

Hugo von Kilényi, *Ein wiedergefundenes Bild des Tizian*, Budapest, 1906.

Fiske Kimball, 'Rubens' Prometheus', *Burlington Magazine*, XCIV, 1952, pp. 67–68.

Frederike Klauner, 'Venezianische Landschaftdarstellung von Jacopo Bellini bis Tizian', *Jahrbuch der Kunsthistorischen Sammlungen in Wien*, N.F., XVIII, 1958, pp. 121–150.

—— and G. Heinz, 'Zur Symbolik von Giorgiones Drei Philosophen', *Jahrbuch der Kunsthistorischen Sammlungen in Wien*, N.F., XV, 1955, pp. 145–168.

—— and Vinzenz Oberhammer, *Katalog der Gemäldegalerie*, Teil I, Vienna, 1960.

Solomon Kleiner, *The Belvedere*, Munich, 1965 (reprint).

Brigitte Klesse: see Cologne, 1973.

Wilhelm Köhler, 'Michelangelos Schlachtkarton', *Kunstgeschichtliches Jahrbuch der K. Zentral-Kommission*, I, 1907, pp. 115–172.

Karl Köpl, 'Urkunden, Acten, Regesten, und Inventare aus dem K. K. Statthalterei-Archiv in Prague', *Jahrbuch der Kunsthistorischen Sammlungen des Allerhöchsten Kaiserhauses*, X, 1889, pp. LXIII–CC: Prague Inventory 1718, no. 6232; Prague Inventory 1723, no. 6233; Prague Inventory, 1737, no. 6234; Prague Inventory 1763, no. 6235; XII, 1891, II. Theil, pp. III–XC.

Kremsier, see: Benesch, 1928; Breitenbach, 1924; Dostal, 1924; Neumann, 1965; Safarik, 1964.

Kress Collection: *Kress Collection, Paintings and Sculpture*, Washington, National Gallery of Art, 1959 (illustrations only).

See also: Suida, 1951; Suida and Shapley, 1956; Shapley, 1968, 1971–1972, 1973.

Paul Kristeller, *Andrea Mantegna*, London, 1901.

——, *Giulio Campagnola*, Berlin, 1907.

George Kubler, *Arquitectura de los siglos XVII y XVIII*, Ars Hispaniae, Madrid, 1957.

Irene Kühnel-Kunze, Staatliche Museen, Berlin, *Die Gemäldegalerie, Die italienischen Meister, 16. bis 18. Jahrhunderts*, Berlin, 1931.

——, *Verzeichnis der ausgestellten Gemälde des 13. bis 18. Jahrhunderts im Museum Dahlem*, Berlin, 1963.

Rolf Kultzen and Peter Eikemeier, *Venezianische Gemälde des 15 und 16 Jahrhunderts*, Munich, Alte Pinakothek, 1971.

Betty Kurth, 'Über ein verschollenes Gemälde Tizians', *Zeitschrift für bildende Kunst*, LX, 1926–1927, pp. 288–293.

Otto Kurz, 'Huius nympha loci', *Journal of the Warburg and Courtauld Institutes*, XVI, 1953, pp. 171–177.

P. Lacour and J. Delpit, *Catalogue du Musée de Bordeaux*, Bordeaux, 1855.

Paul Lacroix, 'Musée du Palais de l'Ermitage, sous le règne de Catherine II', *Revue universelle des arts*, 1861, vols. XIII–XV.

Lacroix, 1855, see: Rubens.

Georges Lafenestre, *La vie et l'oeuvre de Titien*, Paris, 1886.

La Granja (Segovia), Palace of San Ildefonso:
'Inventario de La Granja, 1746', Archivo del Palacio, Madrid.
'Inventario del Palacio de San Ildefonso, 1814', Archivo del Palacio, Madrid.
See also: Bottineau, 1960.

Alessandro Lamo, *Discorso di Alessandro Lamo intorno alla scoltura et pittura dove ragiona della vita et opere ... di ... Bernardino Campo pittore cremonese*, Cremona, 1584; reprinted in *Notizie istorische dei pittori di Cremona*, Cremona, 1774.

Charles P. Landon, *Galerie Giustiniani*, Paris, 1812.

Lansdowne Collection, see: Ambrose, 1897.

B. Irgens Larsen, 'Tizians Amore sacro e profano', *Kunst og Kultur*, XXXVIII, 1955, pp. 81–95.

Myron Laskin, Letter, *Art Bulletin*, XLVII, 1965, pp. 543–544.

Joseph Lavallée, *Galerie du Musée Napoléon*, Paris, 1804, II and III.

La Vrillière Collection, Paris, see: Sauval, 1724.

Gilbert Lawall, *Theocritus' Coan Pastorals*, Washington–Cambridge, 1967.

The Lawrence Gallery: *First Exhibition, A Catalogue of 100 Original Drawings by Sir P. P. Rubens*, London, 1835.

Alfredo Lazzarini and Giovanni del Puppo, *Castelli friulani*, Udine, 1901.

Lee Collection: *Catalogue of the Lee Collection*, Courtauld Institute of Art, University of London, 1967.

Rensselaer W. Lee, 'Ut Pictura Poesis: The Humanistic Theory of Painting', *Art Bulletin*, XXII, 1940, pp. 197–263.

Leeds: *National Exhibition of Works of Art*, 1868.

Valentine Lefèbre, *Opera selectiora quae Titianus Vecellius Cadubriensis et Paulus Calliari Veronensis invenerunt ac pinxerunt quae que Valentinus Lefebre Bruxellensis delineavit et sculpsit*, Venice, 1682.

Manfred Leithe-Jasper, 'Alessandro Vittorias Medaille auf Francesco Acquaviva Herzog von Atri', *Mitteilungen der Österreichischen Numismatischen Gesellschaft*, XVIII, 1974 (in press).

Leningrad, Hermitage Museum:
Catalogue of Paintings (in Russian), Leningrad–Moscow, 1958.
The Hermitage, Leningrad, Mediaeval and Renaissance Masters, English edition, London, 1967 (by the curatorial staff of the Hermitage).
See also: Somof, 1899; Liphart, 1912; Fomiciova, 1960 and 1967.

Antonio de León Pinelo, *Anales de Madrid, Reinado de Felipe III, 1598 a 1621*, Madrid, 1931.

Pompeo Leoni: Marqués de Saltillo, 'La herencia de Pompeyo Leoni', *Boletín de la Sociedad Española de Excursiones*, XIII, 1934, pp. 95–121.

Lermolieff (pseudonym), see: Giovanni Morelli.

Archduke Leopold Wilhelm, 'Inventar, 1659', published by Adolf Berger, *Jahrbuch der Kunsthistorischen Sammlungen des Allerhöchsten Kaiserhauses*, Vienna, I, 1883, II. Theil, pp. LXXXVI–CXIV.
See also: Garas, 1967 and 1968.

Cesare A. Levi, *Le collezioni veneziane*, Venice, 1900.

Mirella Levi d'Ancona, *The Iconography of the Immaculate Conception in the Middle Ages and Early Renaissance*, New York, College Art Association, 1957.

Michael Levey, *A Concise History of Painting*, New York, 1962.

Milton J. Lewine, 'An Inventory of 1647 of a Roman Art Collection', *Arte antica e moderna*, V, 1962, pp. 306–315.

Alphons Lhotsky, *Festschrift des Kunsthistorischen Museums zur Feier des fünfzigjährigen Bestandes*, Zweiter Teil, *Die Geschichte der Sammlungen*, Vienna, 1941–1945, 2 vols. (with continuous paging).

Giuseppe Liberali, 'Lotto, Pordenone, e Tiziano a Treviso', *Memorie. Istituto veneto di scienze, lettere ed arti*, XXXIII, fascicolo III, 1963, pp. 45–67.

Lille: *Musée des Beaux-Arts, Musée Wicar, Notice des dessins*, Lille, 1889.

E. de Liphart, *Il catalogo delle gallerie imperiali dell' Ermitage*, St. Petersburg, 1912.

Gian-Giuseppe Liruti, *Notizie delle vite ed opere scritte da' letterati del Friuli*, Venice, 1760–1780, 3 vols.

Conte Pompeo Litta and Passerin, *Celebri famiglie italiane*, Milan, 1819–1923, 16 vols.

Liverpool: *Walker Art Gallery. Catalogue*, 1963.

Joan Barclay Lloyd, *African Animals in the History of Art and Architecture* (Studies in the History of Art and Architecture), Oxford, 1971.

Achille Locatelli Milesi, 'Il problema d'una composizione giorgionesca', *Emporium*, XLIII, 1916, pp. 308–313.

Charles Loeser, 'Tiziano e Tintoretto' in *I disegni degli Uffizi in Firenze*, Florence, 1922, vol. I (in 10 vols., directed by Giovanni Paggi).

Giovanni Paolo Lomazzo, *Trattato dell' arte de la pittura*, Milan, 1584 (photographic reprint, Hildesheim, 1968).

——, *Idea del tempio della pittura*, Milan, 1590 (photographic reprint, Hildesheim, 1965).

London:
Catalogue of the Pictures at Grosvenor House, London, 1913.
Exhibition of Italian Art, Royal Academy, 1930.
Exhibition of Works by Holbein and Other Masters of the Sixteenth Century, Royal Academy, 1950–1951.
Flemish Art, 1300–1700, Royal Academy, 1953–1954.
See also: Wallace Collection; Gould, 1959.

Roberto Longhi, 'Giunte a Tiziano', *L'Arte*, XXVIII, 1925, pp. 40–45; reprinted in *Saggi e ricerche, 1925–1928*, Florence, 1967, pp. 9–18.

——, 'Cartella Tizianesca', *Vita artistica*, II, 1927, pp. 216–226; reprinted in *Saggi e ricerche, 1925–1928*, Florence, 1967, pp. 233–244.

——, *Officina ferrarese* (1934), Florence, 1956 (2nd edition).

——, *Viatico per cinque secoli di pittura veneziana*, Florence, 1946.

L. Loostrøm, *Konstsamlingarna på Säfsholm*, 1882.

Carla Greenhaus Lord, *Some Ovidian Themes in Italian Renaissance Art*, Columbia University doctoral dissertation, 1968 (microfilm by University Microfilms, Ann Arbor).

Giovanni Battista Lorenzi, *Monumenti per servire alla storia del Palazzo Ducale di Venezia*, Venice, 1868.

Lovere, see: Gallina, 1957.

Lucian [Lucianus Samosatensis], *Dialogues*, London, 1888, translated by Howard Williams.

Ludovisi Inventory, see: Garas, 1967.

Gustav Ludwig, 'Tizian und dessen Verwandte', *Italienische Forschungen*, IV, 1911, pp. 131–136.

——, 'Archivalische Beiträge . . . Venezianischen Malerei', *Jahrbuch der königlich preuszischen Kunstsammlungen*, XXIV, 1903, Beiheft, pp. 114–118; XXV, 1905, pp. 1–159.

Frits Lugt, *Les marques de collections de dessins et d'estampes*, Amsterdam, 1921.

——, 'Italiaansche kunstwerken in Nederlandsche verzamelingen', *Oud Holland*, LIII, 1936, pp. 97–135.

——, *Répertoire des catalogues des ventes publiques*, The Hague, 3 vols., 1938, 1953, 1964.

——, *Les dessins italiens dans les collections hollandaises*, Paris, 1962.

Alessandro Luzio, 'Tre lettere di Tiziano al Cardinale Ercole Gonzaga ed altre spigolature tizianesche', *Archivio storico dell' arte*, III, 1890, pp. 207–210.

——, *La Galleria dei Gonzaga*, Milan, 1913.

—— and Rodolfo Renier, 'La coltura e le relazioni letterarie', *Giornale storico della letteratura italiana*, XXXIV, 1899, pp. 1–97.

John Lynch, *Spain under the Hapsburgs*, Oxford, 1964.

Niccolò Machiavelli, *Historie fiorentine*, Florence, 1532.

J. W. Mackail, *Select Epigrams from the Greek Anthology*, London, 1911.

Pedro de Madrazo, *Catálogo de los cuadros del Real Museo de Pintura*, Madrid, 1843; editions 1854, 1873, and 1910.

——, *Catálogo descriptivo e histórico del Museo del Prado, Escuelas italianas y españoles*, Madrid, 1872, 715 pages, the fullest account of these schools. The preface states that the first 254 pages were printed in 1868 but that war delayed the publication. The addenda in pp. 659–685 contains material which Madrazo had culled, in a too rapid examination, from the royal inventories. His numerous errors have been corrected by Beroqui, Bottineau, and Wethey. Nearly all other writers continue to perpetuate them.

——, *Viaje artístico de tres siglos por las colecciones de cuadros de los reyes de España*, Barcelona, 1884.

Madrid, 1965: Exposición, *El Reloj en el arte*, Sociedad de Amigos de Arte.

Madrid, see also: Alcázar; Madrazo; Prado Museum; Sánchez Cantón.

Madrid, Royal Palace:

Inventory of 1816 (after the Napoleonic occupation), in the Archivo del Palacio.

Inventory of 1834 (after the death of Ferdinand VII in 1833), in the Archivo del Palacio, 'Testamentarias reales', Legajo 17.

Lodovico Magugliani, *Introduzione a Giorgione ed alla pittura veneziana del rinascimento*, Milan, 1970.

Andrea Maier, *Della imitazione pittorica, della eccellenza delle opere*, Venice, 1818.

Vittorio Malamani, *Memorie del Conte Leopoldo Cicognara*, Venice, 1888, 2 vols.

Émile Mâle, *L'Art religieux de la fin du moyen-âge en France*, Paris, 1925.

Manchester:

Catalogue of the Art Treasures of the United Kingdom, 1857.

European Old Masters, Manchester City Art Gallery, 1957.

Between Renaissance and Baroque: European Art 1520–1600, Manchester, 1965.

See also: Bürger, 1857.

J. Manilli, *Villa Borghese fuori di Porta Pinciana*, Rome, 1650.

Horace K. Mann, *The Lives of the Popes in the Middle Ages*, X, London, 1925.

Bertina Suida Manning, *Paintings from the Collection of Walter P. Chrysler, Jr.*, Portland, 1956.

——, 'Titian, Veronese, and Tintoretto in the Collection of Walter P. Chrysler, Jr.', *Arte veneta*, XVI, 1962, pp. 49–60.

Carlo Maratta, Inventory of His Collection, made in Rome in 1724; the collection was purchased by Philip V of Spain. Inventory at Simancas, Spain, Legajo 4807, first published in the *Revista de archivos, bibliotecas y museos*, VI, 1876, pp. 128–129, 143–145; republished by Battisti, *Arte antica e moderna*, III, 1960.

V. Marchese, *Memorie dei più insigni pittori, scultori ed architetti domenicani*, Florence, 1854.

Rudolf Marggraff, *Katalog der Königlichen Gemälde Galerie in Augsburg*, Munich, 1869.

Giovanni Mariacher, *Palma il Vecchio*, Milan, 1968.

——, *Arte a Venezia dal medioevo al settecento, Catalogo della mostra*, Venice, 1971.

P. J. Mariette, 'Abecedario . . . Titien Vecelli (1720)', *Archives de l'art français*, X, 1858–1859, pp. 301–340.

Remigio Marini, 'Non è Giorgionesco il primo Titiano', *Emporium*, 128, 1958, pp. 2–16.

F. R. Martin, 'A Patriotic Speech by Titian', *Burlington Magazine*, XLIII, 1923, pp. 304–305.

John R. Martin, *The Farnese Gallery*, Princeton, 1965.

J. J. Martín González, 'El palacio de El Pardo en el siglo XVI', *Boletín del Seminario de Estudios de Arte y Arqueología*, Valladolid, XXXVI, 1970, pp. 5–41.

Gilberte Martin-Méry, *La femme et l'artiste, Catalogue*, Bordeaux, 1964.

Martinioni, see: Sansovino-Martinioni.

Garibaldo Marussi, 'Il seicento veneto a Udine', *Le arti*, VIII, 1968, no. 10, pp. 34–37.

Mary of Hungary (sister of Charles V):

Testament of Mary of Hungary, written in French and signed by her on 27 September 1558 at Cigales (Valladolid). Four copies in Spanish were made immediately after her death. The testament was opened on 19 October 1558 in the presence of Princess Juana (Simancas, A. G., Patronato Real 31–25, folios I–VIII. Seen by me in July 1973).

Brussels Inventory 1556 (Spanish copy of the lost French original) published by Alexandre Pinchart, 'Tableaux et sculptures de Marie d'Autriche, reine douairière de Hongrie' (partial listing of portraits from Simancas, Legajo 1093) in *Revue universelle des arts*.

Cigales Inventory 1558: Simancas, Legajo 1017, folios 143v–145v, dated 19 October 1558, final date 'primero de abril 1560 años, contaduria mayor, primera época Roger Patié thesorero' (see Beer, 'Acten, Regesten und Inventare aus dem Archivo General de Simancas', *Jahrbuch der Kunsthistorischen Sammlungen des Allerhöchsten Kaiserhauses*, Vienna, XII, 1891, II. Theil, no. 8436, pp. CLVIII–CLXIV). Omitted by Beer and Pinchart is Legajo 1017, folios 1–5, 'De retratos e liencos e papeles en que están algunas cosas pintadas.

The section relating to portraits is published by Claudio Pérez Gredilla in *Revista de archivos, bibliotecas y museos*, VII, 1877, pp. 250–252.

F. Mason Perkins, 'An Unpublished Painting by Titian', *Art in America*, IX, 1920–1921, pp. 223–226.

Frank J. Mather, Jr., 'An Exhibition of Venetian Paintings', *The Arts*, X, 1926, p. 312.

——, *Venetian Painters*, New York, 1936.

Harold Mattingly, *A Catalogue of Roman Coins in the British Museum, Vespasian to Domitian*, London, I, 1923, II, 1930, IV, 1968.

Lucio Mauro and Ulisse Aldrovandi, *Le antichità della città di Roma*, Venice, edition 1542, enlarged editions, 1556, 1558, 1562.

Fabio Mauroner, *Le incisioni di Tiziano*, Venice, 1941.

Maxwell-White, see: Sewter and Maxwell-White, 1972.

August L. Mayer, 'Zwei unbekannte Gemälde aus Tizians Spätzeit', *Belvedere*, V, 1924, pp. 184–185.

——, 'Tizianstudien', *Münchner Jahrbuch*, II, 1925, pp. 267–286.

——, 'Dr. Justi on Giorgione', *Burlington Magazine*, XLIX, 1926, p. 52.

——, *El Greco*, Munich, 1926.

——, 'Versteigerung der Sammlung von Heyl', *Pantheon*, VI, 1930, p. 482.

——, 'Rundschau', *Pantheon*, VIII, 1931, pp. 307–308.

——, 'Anotaciones a algunos cuadros del Museo del Prado', *Boletín de la Sociedad Española de Excursiones*, XLII, 1934, pp. 291–299.

——, 'A propos d'un nouveau livre sur le Titien', *Gazette des beaux-arts*, 6 période, XVIII, 1937, pp. 304–311.

——, 'Beiträge zu Tizian', *Critica d'arte*, III, 1938, pp. 30–32.

——, 'Quelques notes sur l'oeuvre de Titien', *Gazette des beaux-arts*, 6 période, XX, 1938, pp. 289–308.

——, 'Niccolò Aurelio, The Commissioner of Titian's Sacred and Profane Love', *Art Bulletin*, XXI, 1939, p. 89.

—— and Erich van der Bercken, *Malerei der Renaissance in Italien*, Potsdam, 1927.

Arthur McComb, *Agnolo Bronzino*, Cambridge, 1928.

Christian von Mechel, *Verzeichnis der Gemälde der kaiserlichköniglichen Bilder-Gallerie in Wien*, Vienna, 1783; French edition, Basle, 1784.

Cosimo III dei Medici, *Viage de Cosimo por España (1668–1669)*, Madrid, 1933.

Millard Meiss, 'Sleep in Venice', *XXI International Congress of the History of Art, Held at Bonn in 1964*, Berlin, 1967, III, pp. 271–279 (a short version of the following item).

——, 'Sleep in Venice. Ancient Myths and Renaissance Proclivities', *Proceedings of the American Philosophical Society*, 109, 1965, pp. 348–382.

Emma H. Mellencamp, 'A Note on the Costume of Titian's Flora', *Art Bulletin*, LI, 1969, pp. 174–177.

Henriette Mendelsohn, *Das Werk der Dossi*, Munich, 1914.

Luigi Menegazzi, *Il Museo Civico di Treviso*, Venice, 1964.

Vincenzo Menegus Tamburin, 'Diciasette pergamene della regola di Vinigo—Pieve di Cadore (1314–1649)', *Atti dell' Istituto Veneto di Scienze, Lettere ed Arti*, CXXVIII, 1970, pp. 575–597.

Jürg Meyer zur Capellen, 'Überlegungen zur Pietà Tizians', *Münchner Jahrbuch*, III. Folge, XXII, 1971, pp. 117–132.

Julius Meyer and Wilhelm Bode, *Gemälde Galerie*, Berlin, 1878.

Amalia Mezzetti, *Dosso e Battista ferraresi*, Milan, 1965.

——, 'Le Storie di Enea del Dosso nel Camerino d'Alabastro', *Paragone*, XVI, no. 189, 1965, pp. 71–84.

Emile Michel, 'Au pays de Giorgione et de Titien', *Revue de l'art*, XXI, 1907, pp. 421–436.

Marcantonio Michiel, *Notizia d'opere di disegno (c. 1532)*; edition Jacopo Morelli, Bassano, 1800; edition G. Frizzoni, Bologna, 1884; edition Theodor Frimmel, Vienna, 1888; English edition G. C. Williamson, London, 1903. See also: Cicogna, 1860; Fletcher, 1973.

Ulrich Middeldorf, 'Letter to the Editor about the Holkham Venus', *Art Bulletin*, XXIX, 1947, pp. 65–67.

——, 'Die Dossi in Rom', *Festschrift für Herbert von Einem*, Berlin, 1965, pp. 171–172.

Milan:

Ambrosiana Gallery, see: Ambrosiana.

Brera Gallery, see: Modigliani, 1950.

G. B. Milesio, 'Beschreibung des deutschen Hauses in Venedig' (MS. of 1715), published by G. M. Thomas in *Königlich Bayerische Akademie der Wissenschaft*, I, Cl. XVI, Bd. II, Munich, 1881, pp. 19–51 (reprint in Bibliotheca Hertziana).

Oliver Millar, 'Notes on British Painting from Archives', *Burlington Magazine*, XCVII, 1955, pp. 255–256.

——, *Abraham van der Doort's Catalogue of the Collections of Charles I (1639)*, Glasgow, The Walpole Society, vol. XXXVII, 1958–1960.

——, *The Inventories and Valuations of the King's Goods, 1649–1651*, Glasgow, The Walpole Society, vol. XLIII, 1970–1972.

Piero de Minerbi, 'Gli affreschi del Fondaco dei Tedeschi a Venezia', *Bollettino d'arte*, XXX, 1936, pp. 170–177.

——, *La Tempesta di Giorgione e l'Amore sacro e profano di Tiziano*, Milan, 1939.

H. Mireur, *Dictionnaire des ventes d'art*, Paris, 1912, 7 vols.

A. P. de Mirimonde, 'La musique dans les allégories de l'amour', *Gazette des beaux-arts*, 6 période, LXVIII, 1966, pp. 265–290.

Ettore Modigliani, *Catalogo della Pinacoteca di Brera*, Milan, 1950.

Liselotte Möller, 'Bildgeschichtliche Studien zu Stammbuchbildern: Die Kugel als Vanitassymbol', *Jahrbuch der Hamburger Kunstsammlungen*, II, 1952, pp. 157–175.

Bruno Molajoli, *Musei ed opere d'arte in Napoli attraverso la guerra*, Naples, 1948.

——, *Notizie su Capodimonte, Catalogo delle gallerie e del museo*, Naples, 1958, 1964, and later editions.

——, *Il Museo di Capodimonte*, Naples, 1961.

Pompeo Molmenti, *La storia di Venezia nella vita privata*, Bergamo, 1910–1913, 3 vols.

Agnes Mongan and Paul Sachs, *Drawings in the Fogg Museum of Art*, Cambridge, Mass., 1940.

Giovanni Battista Montelatici, *Villa Borghese fuori di Porta Pinciana*, Rome, 1700.

Antonio Morassi, *Giorgione*, Milan, 1942.

——, 'Esordi di Tiziano', *Arte veneta*, VIII, 1954, pp. 178–198.

——, *Titian*, Milan and New York, 1964.

——, 'Titian', *Encyclopedia of World Art*, XIV, New York, 1967, pp. 132–158.

——, 'Ritratti giovanili di Tiziano', *Arte illustrata*, II, May–June, 1969, pp. 20–35.

Giovanni Morelli [pseudonym Lermolieff], *Die Werke italienischer Meister in den Galerien von München, Dresden, und Berlin*, first edition, Berlin, 1880; preface dated 1877.

——, *Le opere di maestri italiani nelle gallerie di Monaco, Dresda e Berlino*, Bologna, 1886 (translation of the German edition).

——, *Kunstkritische Studien*, Leipzig, 1890–1893, 3 vols.

——, *Italian Painters*, edition London, 1892, 1893, 2 vols.

——, *Della pittura italiana*, Milan, 1897.

See also: Richter and Morelli.

Jacopo Morelli, 1800, see: Marcantonio Michiel.

'Archivio Morelliano, Zibaldone, no. 72' (MS.), Biblioteca Nazionale Marciana, Venice.

Lino Moretti, *G. B. Cavalcaselle, Disegni da antichi maestri, Catalogo della mostra*, Verona–Venice, 1973.

Mario Moretti, *Museo Nazionale d'Abruzzo, L'Aquila*, l'Aquila, 1968.

Brian D. Morley, see: Everard and Morley.

Gaetano Moroni, *Dizionario di erudizione storico-ecclesiastico*, Venice, 1840–1879, 103 vols., plus indices in 6 vols.

Alfred Morrison, *Catalogue of the Collection of Autograph Letters*, London, 1883–1892, 6 vols.

Gianantonio Moschini, *Guida per la città di Venezia*, Venice, 1815, 2 vols.

——, *Guida per la città di Padova*, Padua, 1817.

V. Moschini, 'Nuovi allestimenti e restauri alle gallerie di Venezia', *Bollettino d'arte*, XVII, 1957, pp. 74–81.

Sandra Moschini Marconi, *Gallerie dell' Accademia di Venezia, Opere d'arte del secolo XVI*, Rome, 1962.

Andrea da Mosto, *I dogi di Venezia*, Milan, 1966.

Mostra di Tiziano. Catalogo delle opere, edited by Gino Fogolari, Venice, 1935.

Mostra dei Vecellio a Belluno, see: Valcanover, 1951.

Maria Mrozinska, *Disegni veneti in Polonia. Catalogo della Mostra*, Venice, 1958.

Cornelius Müller-Hofstede, 'Untersuchungen über Giorgiones Selbstbildnis in Braunschweig', *Mitteilungen des Kunsthistorischen Instituts in Florenz*, VIII, 1957–1959, pp. 13–34.

Jenny Müller-Rostock, 'Ein Verzeichnis von Bildern aus dem Besitze des van Dyck', *Zeitschrift für bildende Kunst*, N.F., XXXIII, 1922, pp. 22–24.

Munich, see: Reber, 1895; Tschudi, 1911; F. Dörnhöffer, 1930; Buchner, 1936; *Alte Pinakothek*, Munich, 1958; Kultzen and Eikemeier, 1971.

Michelangelo Muraro and others, *Pitture murali nel Veneto e tecnica dell' affresco. Catalogo*, Venice, 1960.

Lodovico A. Muratori, *Annali d'Italia*, Rome, 1752–1754, 12 vols.

Harry Murutes, 'Personifications of Laughter and Drunken Sleep in Titian's Andrians', *Burlington Magazine*, CXV, 1973, pp. 518–525.

G. K. Nagler, *Die Monogrammisten*, Munich and Leipzig, 1860, 5 vols.

Nantes: *Musée Municipal des Beaux-Arts. Catalogue*, by Marcel Nicolle, Nantes, 1913.

Naples, see: Causa, 1960; Filangieri di Candida, 1902; Molajoli, 1958; Rinaldis, 1911, 1927–1928, 1932.

Jaromir Neumann, 'Titian's Apollo and Marsyas', *Umêní*, IX, 1961, pp. 325–327 (in Czech).

——, *The Flaying of Marsyas*, London, 1965; also German edition, Prague, 1962.

——, 'Das Inventar der rudolfinischen Kunstkammer von 1607–1611', *Analecto Reginensia, Queen Christina of Sweden, Documents and Studies*, Stockholm, 1966, pp. 262–265.

Jaromir Neumann, *Guide to the Picture Gallery of Prague Castle* (*Rudolphinum*), Prague, 1967.

Newcastle-on-Tyne: *Noble Patronage*, Exhibition of Alnwick Pictures, 1963.

New York, see:

Bache Collection, 1929 and 1937.

Frick Collection, see under Frick.

Knoedler and Co., 1938: *Venetian Paintings of the XV and XVI Centuries.*

Metropolitan Museum, see: Wehle, 1940; J. L. Allen and E. E. Gardner, 1954; Zeri and Gardner, 1973.

World's Fair: Catalogue of Paintings and Sculpture, *Masterpieces of Art*, New York World's Fair, New York, 1939 and also 1940.

Benedict Nicolson, 'Venetian Art in Stockholm', *Burlington Magazine*, CV, 1963, pp. 32–33.

Nonnos, *Dionysiaca*, edition by W. H. D. Rouse, H. J. Rose, and L. R. Lind, London, Loeb Library, 1940.

Carl Nordenfalk, 'Die wiedergefundenen Gemälde des Van Dyck', *Jahrbuch der königlich preuszischen Kunstsammlungen*, LIX, 1938, pp. 36–47.

——, 'Tizians Darstellung des Schauens', *Nationalmuseum Arsbok*, 1947–1948 (1950), pp. 39–60.

——, 'Titian's Allegories on the Fondaco dei Tedeschi', *Gazette des beaux-arts*, 6 période, XI, 1952, pp. 101–108.

Christopher Norris, 'Titian: Notes on the Venice Exhibition', *Burlington Magazine*, LXVII, 1935, pp. 127–131.

Northbrook Collection: Jean P. Richter and W. H. James Weale, *A Descriptive Catalogue of the Pictures Belonging to the Earl of Northbrook*, London, 1889.

Northwick Park: T. Borenius and L. Cust, *Catalogue of the Pictures at Northwick Park*, London, 1921.

Nostitz Collection: Paul Bergner, *Verzeichnis der Gräflich Nostitzschen Gemälde-Galerie*, Prague, 1905.

M. A. Novelli, 'Luigi Anichini', *Dizionario biografico degli italiani*, III, 1961, pp. 324–325.

W. L. F. Nuttall, see: Charles I of England.

Vinzenz Oberhammer, *Die Gemäldegalerie des Kunsthistorischen Museums in Wien*, Vienna, 1959, 2 vols. (selected masterpieces in colour).

——, 'Christus und die Ehebrecherin, ein Frühwerk Tizians', *Jahrbuch der Kunsthistorischen Sammlungen in Wien*, N.F., XXIV, 1964, pp. 101–136.

——, 'Gedanken zum Werdegang und Schicksal von Tizians Grabbild', *Studi di storia dell' arte in onore di Antonio Morassi*, 1971, pp. 152–161.

See also: Klauner and Oberhammer.

Konrad Oberhuber, 'Die Fresken der Stanza dell' Incendio im Werk Raffaels', *Jahrbuch der Kunsthistorischen Sammlungen in Wien*, N.F., XXII, 1962, pp. 23–72.

Odescalchi Archives, Palazzo Odescalchi, Rome:

'Contratto fatto fra l'Illustrissimo Signore Principe Livio Odescalchi ed il Signore Marchese Pompeo Azzolino con l'inventario dei mobili esistenti nel Palazzo del Marchese Ottavio Riario alla Lungara, 1692' (Inventory of Queen Christina's possessions), vol. II, M 2, folios 465v–471.

'Nota dei quadri della Regina Christina di Svezia divisi in ogni classe d'autori' (no date, probably after her death in 1689), vol. V, B 1, no. 16.

'Inventari Bonarum Heredita Clare Memoriae Ducis D. Liviis Odescalchi', November 1713, vol. V, D 2. Compiled by Giuseppe Ghezzi pittore and Bonaventura Lamberti pittore.

'La compra dei quadri da noi fatta a nome della serenissima A. R. del Duca d'Orleans, Regente di Francia, dall' Eccmo. Signore Don Baltasar Odescalchi Duca di Bracciano, 2 settembre 1721', vol. V, B 1, no. 18. (The sale of 1721 was published by Granberg, 1896 and 1897, using the manuscript copy in the Archivio Palatino at Rome).

Karl Oettinger, 'Giorgione und Tizian am Fondaco dei Tedeschi', *Belvedere*, XI, 1932, pp. 44–50.

——, 'Die wahre Giorgione-Venus', *Jahrbuch der Kunsthistorischen Sammlungen in Wien*, N.F., XIII, 1944, pp. 113–139.

Ugo Ojetti, 'Della quadreria Giovanelli', *Dedalo*, VI, 1925–1926, pp. 133–136.

Loredana Olivato, 'Storia d'un'avventura edilizia . . . Palazzo Cornaro della Regina', *Antichità viva*, XII, no. 3, 1973, pp. 27–49.

Cesare d'Onofrio, 'Inventario dei dipinti del Cardinale Pietro Aldobrandini, compilato da G. B. Agucchi nel 1603', *Palatino*, VIII, 1964, pp. 15–20, 158–162, 202–211.

Johannes A. F. Orbaan, *Documenti sul barocco in Roma*, Rome, 1920.

Orléans Collection:

Dubois de Saint Gelais, *Description des tableaux du Palais Royal*, Paris, 1727.

J. Couché, *Galerie des tableaux du Palais Royal*, Paris, 1786–1788, 1808.

Champier and Sandoz, *Le Palais Royal*, Paris, 1900.

Casimir Stryienski, *La galerie du Regent*, Paris, 1913.

See also: Odescalchi sale, 1721.

Sergio Ortolani, 'Le origini della critica d'arte a Venezia', *L'Arte*, 1923, pp. 1–17.

Angela Ottina della Chiesa, *Accademia Carrara*, Bergamo, 1955.

William Young Ottley, see: Stafford, 1818.

Ovid, *Ars Amatoria*, translated by J. H. Mozley, Loeb Library, London, 1929.

——, *Fasti*, translated by Sir James G. Frazer, Loeb Library, London, 1931.

——, *Metamorphoses*, translated by F. J. Miller, Loeb Library, London, 1929 and later editions.

Ovid Moralisé, see: Petrus Berchorius, and P. de Vitry.

Oxford, see: Christ Church.

Oxford Classical Dictionary, see: Hammond and Scullard.

Leandro Ozzola, 'Venere ed Elena (Amor sacro ed Amor Profano)', *L'Arte*, IX, 1906, pp. 298–302.

——, 'Studi su Tiziano', *Zur Kunstgeschichte des Auslandes*, Heft 138, 1939 (with a totally false chronology, which ignores all documents).

Leandro Ozzola, *La Galleria di Mantua*, Palazzo Ducale, Mantua, 1953.

Giovanni Paccagnini, *Il palazzo ducale di Mantova*, Turin, 1969.

Francisco Pacheco, *Arte de la pintura* (1638), edition by Sánchez Cantón, Madrid, 1956, 2 vols.

Alexandre Paillet, see: H. Delaroche.

Rodolfo Palluchini, *I dipinti della Galleria Estense*, Rome, 1945.

——, *I capolavori dei musei veneti. Catalogo della mostra*, Venice, 1946.

——, *La giovinezza del Tintoretto*, Milan, 1950.

——, 'Una mostra di pittura veneziana a Londra', *Arte veneta*, VII, 1952, pp. 209–210.

——, *Tiziano, Conferenze*, I, Bologna, 1953; II, Bologna, 1954.

——, 'La mostra del centenario a Manchester', *Arte veneta*, XI, 1957, pp. 257–258.

——, 'Studi Tizianeschi', *Arte veneta*, XV, 1961, pp. 286–295.

——, 'Studi Tizianeschi', *Arte veneta*, XVI, 1962, pp. 122–123.

——, *Tiziano*, Florence, 1969, 2 vols.

——, 'Una nuova Pomona di Tiziano', *Pantheon*, XXXIX, 1971, pp. 114–125.

Joan de Palma, *Vida de la serenísima Infanta Sor Margarita de la Cruz*, Seville, 1653.

I. M. Palmarini, 'Amor sacro e amor profano ò La Fonte d'Ardenna', *Nuova Antologia*, 4 serie, vol. 100, 1902, pp. 410–422.

——, 'Amor sacro e amor profano', *Rassegna d'arte*, III, 1903, pp. 40–43.

Antonio Palomino, *El parnaso español pintoresco laureado con las vidas de los pintores y estatuarios eminentes españoles*, Madrid, 1724; modern edition, Madrid, 1947.

Erwin Panofsky, 'Eine tizianische Allegorie', *Hercules am Scheidewege*, Hamburg, 1930, pp. 1–9.

——, 'Der gefesselte Eros', *Oud Holland*, I, 1930, pp. 193–217.

——, *Studies in Iconology*, New York, 1939.

——, *Meaning in the Visual Arts*, Garden City, 1955.

——, *Renaissance and Renascences in Western Art*, New York, 1960.

——, *Essays in Honor of Erwin Panofsky*, edited by Millard Meiss, New York, 1961, 2 vols.

——, 'Classical Reminiscences in Titian's Portraits', *Festschrift für Herbert von Einem zum 16 Februar 1965*, Berlin, 1965.

——, *Problems in Titian, Mostly Iconographic*, New York, 1969 (posthumous publication).

Pier-Alessandro Paravia, 'Sopra la palla di Tiziano detta della Concezione. Lettera di Pier-Alessandro Paravia al signore avvocato Dottor Andrea della Libera', Treviso, 1822, pp. 3–10, estratta dal *Giornale, Scienze e Lettere delle Provincie Venete*, n. XVIII, 1822.

Antonio Parazzi, *Appendici alle origini e vicende di Viadana e suo distretto*, Viadana, 1894.

El Pardo Palace, Madrid:

Description: Argote de Molina, *Biblioteca venatoria* (1582), edition Madrid, 1882.

Fire of 1604: Antonio de León Pinelo, *Anales de Madrid reinado de Felipe III, años 1598–1621*, edition 1931, Madrid.

Inventories (manuscripts in the Archivo del Palacio, Madrid):

1564: Sánchez Catón, 1934, pp. 69–75; Calandre, 1953, pp. 151–155.

1614–1617.

1674.

Paris:

1954: *Chefs d'oeuvres vénitiens*, Musée de l'Orangerie.

1965: *Le XVI siècle européen. Dessins du Louvre*, 1965.

1965–1966: *Le seizième siècle européen, peintures et dessins dans les collections publiques françaises*, Paris, Louvre, 1965–1966.

Henry Parker, Lord Morley, *Forty-six Lives*, translated from Boccaccio's *De claris mulieribus*, edited by Herbert G. Wright, London, 1943.

K. T. Parker, *Catalogue of the Collection of Drawings in the Ashmolean Museum*, Oxford, 1956, 2 vols.

——, *Disegni veneti di Oxford, Catalogo della mostra*, Venice, 1958.

Domenico A. Parrino, *Teatro eroico e politico de' governi de' vicere del regno di Napoli*, Naples, 1692–1694, 3 vols.

Sisto Ramón Parro, *Toledo en la mano*, Toledo, 1857, 2 vols.

Gustav Parthey, *Wenzel Hollar*, Berlin, 1853.

Pio Paschini, 'Le collezioni archeologiche dei prelati Grimani del cinquecento', *Rendiconti, Atti della Pontificia Accademia Romana di Archeologia*, serie III, V (annata accademica 1926–1927), Roma, 1928, pp. 149–190.

J. D. Passavant, *Le peintre-graveur*, Leipzig, 1860–1864, 6 vols.

Ludwig Pastor, *History of the Popes*, St. Louis, 1891–1953, 40 vols.

Pauly's Realencyclopädie der classischen Altertumswissenschaft, vols. XI, 1907; XXVIII, 1930.

Antonio Pérez:

'Inventario, 1585', in the Archivo de Protocolos, Madrid, Antonio Márquez, Notary, Legajo no. 989.

Pérez Pastor, *Memorias de la Real Academia Española*, X, 1910, pp. 324–327.

Gregorio Marañón, *Antonio Pérez*, Madrid, 1948, 2 vols.

J. Pérez de Guzmán, 'Las colecciones de cuadros del Príncipe de la Paz', *La España moderna*, año 12, tomo 140, 1900, p. 123.

Alfonso E. Pérez Sánchez, *Inventario de los cuadros*, Madrid, Real Academia de Bellas Artes de San Fernando, 1964.

——, *La pintura italiana del siglo XVII en España*, Madrid, 1965.

——, 'Diego Polo', *Archivo español de arte*, XLII, 1969 [i.e. 1970], pp. 43–54.

A. Ritter von Perger, 'Studien zur Geschichte d. K. K. Gemäldegalerie im Belvedere zu Wien', *Berichte und Mittheilungen des Altertums-Vereins zu Wien*, Vienna, VII, 1864, pp. 101–163.

Paola della Pergola, *Galleria Borghese*, I, *dipinti*, 1955; II, *dipinti*, 1959.

Paola della Pergola, *Giorgione*, Milan, 1955.

——, 'L'Inventario del 1592 di Lucrezia d'Este', *Arte antica e moderna*, II, 1959, pp. 342–351.

——, 'Gli inventari Salviati', *Arte antica e moderna*, III, 1960, pp. 193–200.

——, 'Gli inventari Aldobrandini' (del 1611, del 1626), *Arte antica e moderna*, III, 1960, pp. 425–444.

——, 'Gli inventari Aldobrandini del 1682', *Arte antica e moderna*, V, 1962, pp. 316–322; VI, 1963, pp. 61–87, 175–191.

——, 'L'Inventario Borghese del 1693', *Arte antica e moderna*, VII, 1964, pp. 219–230, 451–467; VIII, 1965, pp. 202–217.

Perkins, see: Mason Perkins.

Marilyn Perry, 'The Statuario Publico', *Saggi e memorie*, VIII, 1972, pp. 75–150.

Eugen Petersen, 'Zu Meisterwerken der Renaissance', *Zeitschrift für bildende Kunst*, N.F., XVII, 1906, pp. 179–187.

——, 'Tizians Amor Sacro e Profano und Willkürlichkeiten moderner Kunsterklärung', *Die Galerien Europas*, about 1900, pp. 97–104.

Philadelphia, see: John G. Johnson Collection.

Philip II of Spain, see: Alcázar, Madrid.

Sir Claude Phillips, *The Picture Gallery of Charles I*, London, 1896.

——, *The Later Works of Titian*, London, 1898.

——, 'Titian's Perseus and Andromeda', *The Nineteenth Century*, May 1900.

——, *The Earlier Works of Titian*, London, 1906.

Duncan Phillips, *The Leadership of Giorgione*, Washington, 1937.

Piacenza, Museo Civico, see: Arisi, 1960.

Gilbert C. Picard, 'Le portrait d'Hannibal, hypothèse nouvelle', *Studi annibalici*, Accademia Etrusca di Cortona, Cortona, 1964, pp. 195–207.

Nicolas de Pigage, *Catalogue raisonné et figuré des tableaux de la galerie electorale de Düsseldorf*, Basle, 1778.

Piero Pieri, 'Bartolomeo d'Alviano', *Dizionario biografico degli italiani*, Rome, I, 1955.

Andor Pigler, *Catalogue of the Museum of Fine Arts* (in Hungarian), Budapest, 1937.

——, *Barockthemen*, Budapest, 1956, 2 vols.

——, *Katalog der Galerie alter Meister*, Budapest, 1967, 2 vols.

Terisio Pignatti, *Giorgione*, Milan, 1969; English edition, London, 1971.

——, 'Über die Beziehungen zwischen Dürer und dem jungen Tizian', *Anzeiger des germanischen Nationalmuseums*, 1971–1972, pp. 69–70.

——, 'The Relationship Between German and Venetian Painting in the late Quattrocento and early Cinquecento', in *Renaissance Venice*, London, 1973, pp. 244–273.

——, *Venetian Drawings in American Collections*, Washington, National Gallery, 1974.

Eugenio Pilla, *Tiziano, il pittore dell' Assunta*, Naples, 1969 (homage).

Alexandre Pinchart, 'Tableaux et sculptures de Marie d'Autriche, reine douairière de Hongrie', *Revue universelle des arts*, III, 1856, pp. 127–146.

——, 'Tableaux et sculptures de Charles V', *Revue universelle des arts*, III, 1856, pp. 225–239 (includes Charles V's Brussels Inventory of 1556; also published by Gachard).

Paolo Pino, *Dialogo della pittura*, 1548, edition Paris, 1960.

Eugène Piot, La sculpture à l'exposition rétrospective au Trocadéro', *Gazette des beaux-arts*, XVIII, 1878, pp. 576–579.

Luigi Pippi, *Orologi nel tempo da una raccolta*, Milan, 1966.

Leo Planiscig, *Venezianische Bildhauer der Renaissance*, Vienna, 1921.

H. J. Plenderleith and A. E. A. Werner, *The Conservation of Antiquities and Works of Art*, London, 1971.

Pliny: *The Elder Pliny's Chapters on the History of Art*, translated by K. Jex-Blake with commentary by E. Sellers, Chicago, 1968.

Stephen Poglayen-Neuwall, 'Tizianstudien', *Münchner Jahrbuch*, N.F., IV, 1927, pp. 59–70.

——, 'Eine tizianeske Toilette der Venus', *Münchner Jahrbuch*, N.F., VI, 1929, pp. 167–169.

——, 'Titian's Pictures of the Toilet of Venus and their Copies', *Art Bulletin*, XVI, 1934, pp. 358–384.

——, 'The Venus of the Ca d'Oro and the Origin of the Chief Types of the Venus at the Mirror from the Workshop of Titian', *Art Bulletin*, XXIX, 1947, pp. 195–196.

Antonio Ponz, *Viage de España*, Madrid, X–XVIII, 1772–1794; also edition Madrid, 1947, 1 vol.

Arthur Pope, *Titian's Rape of Europa*, Cambridge, 1960.

Sir John Pope-Hennessy, *Italian Renaissance Sculpture*, London, 1958; second edition, 1971.

A. E. Popham, *Italian Drawings Exhibited at the Royal Academy* (1930), London, 1931.

——, 'The Authorship of the Drawings of Binche', *Journal of the Warburg and Courtauld Institutes*, III–IV, 1939–1941, pp. 55–57.

—— and Johannes Wilde, *Italian Drawings of the XV and XVI Centuries . . . at Windsor Castle*, London, 1949.

Anny E. Popp, 'Tizians Lukrezia und Tarquin der Wiener Akademie', *Zeitschrift für bildende Kunst*, LVI, 1921, pp. 9–13.

Josef Poppelreuter, 'Sappho und die Najade, Tizians Himmlische und Irdische Liebe', *Repertorium für Kunstwissenschaft*, XXXVI, 1913, pp. 41–56.

Donald Posner, *Annibale Carracci*, London, 1971, 2 vols.

Hans Posse, *Königliche Museen zu Berlin, Die Gemäldegalerie des Kaiser-Friedrichsmuseums*, Berlin, editions 1909 and 1913.

——, *Die staatliche Gemäldegalerie zu Dresden. Katalog der alten Meister*, Dresden, 1929.

——, 'Die Rekonstruktion der Venus mit dem Cupido von Giorgione', *Jahrbuch der preuszischen Kunstsammlungen*, LII, 1931, pp. 28–35.

Cassiano dal Pozzo, 'Legatione del Signore Cardinal [Francesco] Barberino in Francia', 1625, Vatican Library, MS. Barberini latino 5688.

Cassiano dal Pozzo, 'Legatione del Signore Cardinale [Francesco] Barberino in Spagna', 1626, Vatican Library, MS. Barberini latino 5689.

Prado Museum, Madrid:
 Catálogo de las pinturas, Madrid, 1963 (and numerous earlier editions).
 'Inventario general de los cuadros', 1857, manuscript in the Prado Museum Library.
 See also: Madrazo; Sánchez Cantón; Gaya Nuño.

Prague:
 Castle, see: Rudolf II.
 Inventories 1718, 1721, see: Köpl.

Lucia and Ugo Procacci, 'Il carteggio di Marco Boschini con il Cardinale Leopoldo dei Medici', *Saggi e memorie di storia dell' arte*, IV, 1965, pp. 87–114.

Prodromus zum Theatrum Artis Pictoriae (1735), see: Stampart.

Propertius, *The Elegies*, translated by H. E. Butler, London, Loeb Library, 1912.

Public Records Office, see: Charles I of England.

Luigi Pungileoni, *Elogio storico di Raffaello Santi da Urbino*, Urbino, 1829.

Lina Putelli, *Tiziano Vecellio da Cadore*, Turin, 1966 (novelized booklet).

Carlo L. Ragghianti, 'Sul metodo nello studio di disegni', *Le arti*, III, 1940–1941, pp. 9–19.

Olga Raggio, 'The Myth of Prometheus', *Journal of the Warburg and Courtauld Institutes*, XXI, 1958, pp. 44–62.

Raleigh (North Carolina): *Catalogue of Paintings*, North Carolina Museum of Art, by W. R. Valentiner, 1956.

Richard H. Randall, 'Ingres and Titian', *Apollo*, 82, 1965, pp. 366–369.

Brian Reade, *The Dominance of Spain*, *1550–1660*, London, 1951.

Franz von Reber, *Katalog der Gemäldegalerie*, Munich, 1895; also English edition, 1907.

Alfred Rehder, *Manual of Cultivated Trees and Shrubs*, New York, 1949.

Theodore Reff, 'The Meaning of Titian's Venus of Urbino', *Pantheon*, XXI, 1963, pp. 359–366.

——, 'The Meaning of Manet's Olympia', *Gazette des beaux-arts*, 6 période, LXIII, 1964, pp. 111–122.

George Reford, *Art Sales*, London, 1888, 2 vols.

Salomon Reinach, *Répertoire des reliefs*, Paris, 1912, 3 vols.

'Relación de la salida que hizo desta villa el serenísimo príncipe de Gales. Dase cuenta de las joyas que su Majestad dió el 9 de septiembre al principe . . . La pintura de Venus de Ticiano que estaba en el Pardo'. Archivo del Palacio, Madrid, 1623.

Eugenio Riccomani, *Il seicento ferrarese*, Milan, 1969.

Daniel D. Rich, 'A New Titian', *Bulletin of the Art Institute of Chicago*, XXII, 1928, pp. 62–63.

George M. Richter, 'Titian's Venus and the Lute Player', *Burlington Magazine*, LIX, 1931, pp. 53–59.

——, 'The Bridgewater Titians', *Apollo*, XVIII, 1933, pp. 3–5.

——, 'Landscape Motives in Giorgione's Venus', *Burlington Magazine*, LXIII, 1933, pp. 211–223.

——, 'Unfinished Pictures by Giorgione', *Art Bulletin*, XVI, 1934, pp. 272–290.

——, *Giorgio da Castelfranco*, Chicago, 1937.

——, 'Lost and Rediscovered Works by Giorgione', *Art in America*, XXX, 1942, pp. 141–157, 211–224.

Gisela M. A. Richter, *The Engraved Gems of the Greeks, Etruscans and Romans*, London, 1968 and 1971, 2 vols.

J. P. Richter and Giovanni Morelli, *Italienische Malerei der Renaissance im Briefwechsel* (*1876–1891*), editor, Gisela Richter, Baden-Baden, 1960.

Charles Ricketts, *Titian*, London, 1910.

Carlo Ridolfi (1648)-Hadeln, *Le maraviglie dell'arte*, edition by Hadeln, Berlin, 1914–1924, 2 vols.

E. Ridolfi, 'R. R. Gallerie di Firenze', *Le gallerie italiane*, III, Rome, 1897, pp. 171–186.

J. B. Rietstap, *Armorial général*, Gouda, I, 1884, II, 1887; reprinted with corrections, Berlin, 1934.
 See also: Rolland, 1938.

Aldo de Rinaldis, *Guida del Museo Nazionale di Napoli*, II, Pinacoteca, Naples, 1911; second edition, 1927–1928.

——, *La Galleria Nazionale d'Arte Antica di Roma*, Rome, 1932.

Aldo Rizzi, 'Un paesaggio di Titiano', *Acropoli*, Rivista d'arte, anno III, 1963, pp. 232–236 [dubious work].

Keith Roberts, *Art into Art. Works of Art as a Source of Inspiration* (catalogue), London, 1971.

Giles Robertson, *Vincenzo Catena*, Edinburgh, 1954.

——, *Giovanni Bellini*, Oxford, 1968.

——, 'The X-Ray Examination of Titian's Three Ages of Man in the Bridgewater House Collection', *Burlington Magazine*, CXIII, 1971, pp. 721–726.
 See also: Goodison and Robertson, 1967.

E. S. G. Robinson, 'Punic Coins of Spain and their Bearing on the Roman Republican series', *Essays in Roman Coinage presented to Harold Mattingly*, Oxford, 1954, pp. 34–53.

J. C. Robinson, 'The Gallery of Pictures by Old Masters Formed by Francis Cook', *Art Journal*, XLVII, 1885, pp. 133–137.

A. Roccaboni, *Pittura veneta*, *Prima mostra d'arte antica delle raccolte private veneziane*, Venice, Museo Civico, 1947.

Max Roldit, 'The Collection of Pictures of the Earl of Normanton at Somerley, Hampshire', *Burlington Magazine*, IV, 1904, pp. 11–25.

J. C. Rolfe, see: Suetonius.

H. V. Rolland, *Planches de l'armorial général de J. B. Rietstap*, The Hague, 1938, 6 vols. bound in 3.

Hyder E. Rollins, *A New Variorum Shakespeare, the Poems*, XXII, 1938.

Rome, Galleria Nazionale, see: Rinaldis, 1932; Carpegna, 1969.

Amadio Ronchini, 'Delle relazioni di Titiano coi Farnesi', *Deputazioni di storia patria per le provincie modenesi e parmesi*, *Atti e Memorie*, Modena, II, 1864, pp. 129–146.

Max Rooses, *L'Oeuvre de P. P. Rubens*, Brussels, 1886–1892, 5 vols.

David Rosand, 'Titian in the Frari', *Art Bulletin*, LXIII, 1971, pp. 196–213.

——, 'Reply to Ann Sutherland Harris', *Art Bulletin*, LIV, 1972, pp. 118–120.

——, 'Ut Pictor Poeta: Meaning in Titian's Poesie', *New Literary History*, III, 1971–1972, pp. 527–546.

——, 'Titian's Presentation of the Virgin, The Second Door', *Burlington Magazine*, CXV, 1973, p. 603.

G. Roscoe, *Vita e pontificato di Leo X*, Italian translation from English and notes by Count Luigi Bossi, Milan, 1817, 6 vols.

H. I. Rose, *Hygini Fabulae*, Leyden, 1934.

Jacob Rosenberg, *Rembrandt*, Cambridge, 1948; third edition London, 1968.

Mark W. Roskill, see: Dolce.

Filippo Rossi, *Descrizione di Roma antica-moderna*, edition Rome, 1727, 2 vol.

Pasquale Rotondi, *Il palazzo ducale di Urbino*, Urbino, 1950, 2 vols.

Rotterdam: *Catalogus Schilderijen tot 1800*, Museum Boymans –van Beuningen, Rotterdam, 1962.

Benjamin Rowland, *The Classical Tradition in Western Art*, Cambridge (Mass.), 1963.

Rubens' Inventory 1640:

Paul Lacroix, 'Catalogue des tableaux et objets d'art qui faisaient partie du cabinet de Rubens', *Revue universelle des arts*, I, 1855, pp. 269–279.

William Noel Sainsbury, *Original Unpublished Papers Illustrative of the Life of Sir Peter Paul Rubens*, London, 1859, pp. 236–245.

Jean Denucé, *De Antwerpsche 'Konstkamers', inventarissen van kunstverzamelingen te Antwerp in de 16ᵉ en 17ᵉ Eeuwen*, The Hague, 1932, pp. 56–71.

Rudolf II, Prague, see: Köpl, 1889; Neumann, 1966; Perger, 1864; Urlichs, 1870; Zimmermann, 1892 and 1905.

Vincenzo Ruffo, 'Galleria Ruffo', *Bollettino d'arte*, X, 1916, pp. 21–64, 95–128, 165–192.

Eberhard Ruhmer, Review of Rodolfo Pallucchini's *Tiziano*, in *Zeitschrift für Kunstgeschichte*, XXXIV, 1971, pp. 147–152.

——, and others, *Schack-Galerie*, Munich, 1969.

A. G. B. Russell, 'Perseus and Andromeda' (letter), *Burlington Magazine*, XIV, 1909, p. 368.

Eduard A. Safarik, 'The Origin and Fate of the Imstenraed Collection', *Sbornik Prace*, Bruno, XIII, 1964, pp. 171–182.

William N. Sainsbury, *Original Unpublished Papers Illustrative of the Life of Sir Peter Paul Rubens*, London, 1859.

Luigi Salerno, 'The Picture Gallery of Vincenzo Giustiniani', *Burlington Magazine*, CII, 1960, pp. 21–27, 93–104, 135–148.

Marqués de Saltillo, 'La herencia de Pompeyo Leoni', *Boletín de la Sociedad Española de Excursiones*, XLII, 1934, pp. 95–121.

Roberto Salvini, *La galleria degli Uffizi, Catalogo dei dipinti*, Florence, 1964.

Francisco J. Sánchez Cantón, *Catálogo de las pinturas del Instituto de Valencia de Don Juan*, Madrid, 1922.

——, *Fuentes literarias para la historia del arte español*, I–V, Madrid, 1923–1941.

——, 'El primer inventario del Palacio del Pardo, 1564', *Archivo español de arte y arqueología*, X, 1934, pp. 69–75.

——, *La colección Cambó*, Barcelona, 1955.

——, 'El legado Cambó a Barcelona, *Goya*, no. 9, 1955, pp. 154–161.

——, *Inventarios reales, bienes muebles que pertenecieron a Felipe II*, Madrid, 1956–1959, 2 vols.

——, *Catálogo de las pinturas*, Museo del Prado, Madrid, 1963; and earlier editions.

See also: Alcázar, Madrid.

Domingo Sánchez Loro, *La inquietud postrimera de Carlos V*, Cáceres, 1958.

Joachim von Sandrart, *Academie der Bau, Bild, und Mahlerey Künste* (1675), edition by A. R. Peltzer, Munich, 1925.

Donato Sanminiatelli, *Domenico Beccafumi*, Milan, 1967.

Francesco Sansovino, *Delle cose notabili che sono in Venetia*, Venice, 1561.

——, *L'Historia di Casa Orsini*, Venice, 1565.

——, *Venetia*, Venice, 1581; edition with additions by Stringa, Venice, 1604; edition with additions by S. Martinioni, Venice, 1663.

Giuseppe della Santa, 'Tre documenti tizianeschi inediti', *Venezia, Studi di arte e storia*, I, 1920, pp. 259–262.

Padre Francisco de los Santos, 'Descripción de San Lorenzo del Escorial', 1657 y 1698, in Sánchez Cantón, *Fuentes literarias para la historia del arte español*, II, Madrid, 1933, pp. 225–319.

Marino Sanuto, *Diarii*, 1496–1533, published Venice, 1879–1902, 58 vols.

G. M. Sargeaunt, 'The Classic Pastoral and Giorgione', essay in his *Classical Studies*, London, 1929, pp. 164–186.

Henri Sauval (1620–1670), *Histoire et recherches des antiquités de la ville de Paris* (c. 1655), published Paris, 1724, 3 vols.

Simona Savini-Branca, *Il collezionismo veneziano nel '600*, Padua, 1964.

Fritz Saxl, 'Pagan Sacrifice in the Italian Renaissance', *Journal of the Warburg Institute*, II, 1938–1939, pp. 346–367.

——, *Lectures*, London, 1957, 2 vols.

F. Scanelli, *Il microcosmo della pittura*, Cesena, 1657.

Georg Scharf, *Catalogue raisonné or List of the Pictures at Blenheim Palace*, London, 1862.

Julius von Schlosser, 'Eine Reliefserie des Antonio Lombardi', *Jahrbuch der Allerhöchsten Kaiserlichen Kunsthistorischen Sammlungen*, XXXI, 1913, pp. 87–102.

J. Schmidt, 'La toilette de Vénus du Titien, l'original et les répliques', *Starye Godoy*, 1907, pp. 216–223.

Ulrich Schmidt, *Städtisches Museum, Wiesbaden, Gemälde Katalog*, Wiesbaden, 1967.

F. Schmidt-Degener, 'A Dosso Dossi in the Boymans Museum', *Burlington Magazine*, XXVIII, 1915–1916, pp. 20–23.

Laurie Schneider, 'A Note on the Iconography of Titian's Last Painting', *Arte veneta*, XXIII, 1969, pp. 218–219.

Rudolf Schrey, 'Tizians Gemälde Jupiter und Kallisto, bekannt als Himmlische und Irdische Liebe', *Kunstchronik*, N.F., XXVI, 1914–1915, pp. 567–574.

Otto Schubert, *El barroco en España*, Madrid, 1924.

Paul Schubring, *Cassoni Truhen und Truhenbilder der italienischen Frührenaissance*, Leipzig, 1915; also edition 1923, 2 vols.

Juergen Schulz 'Vasari at Venice', *Burlington Magazine*, CIII, 1961, pp. 500–511.

——, 'A Forgotten Chapter in the Early History of Quadratura Painting, the Fratelli Rosa', *Burlington Magazine*, CIII, 1961, pp. 90–102.

——, 'Titian's Ceiling in the Scuola di San Giovanni Evangelista', *Art Bulletin*, XLVIII, 1966, pp. 88–94.

——, *Venetian Painted Ceilings of the Renaissance*, Berkeley, 1968.

——, 'The Printed Plans and Panoramic Views of Venice', in *Saggi e Memorie*, VII, 1970, pp. 1–82.

Giovanna Scirè, 'Appunti sul Silvio', *Arte veneta*, XXIII, 1969, pp. 210–217.

Angelo M. G. Scorza, *Enciclopedia araldica italiana*, Genoa, n.d. [1955].

Angelo Scrinzi, 'Ricevute di Tiziano per il pagamento della pala Pesaro ai Frari', *Venezia. Studi di arte e storia*, I, 1920, pp. 258–259.

Carl Seeger, see: Darmstadt.

Narcisco Sentenach, 'Cuadros famosos condenados al fuego', *Boletín de la Real Academia de Bellas Artes de San Fernando*, 2 época, IV, no. 57, 1921, pp. 46–55.

Seville: *Exposición de las últimas adquisiciones*, Reales Alcázares, Seville, May–June, 1970.

A. C. Sewter and D. Maxwell White, 'Variations on a Theme of Titian', *Apollo*, February 1972, pp. 88–95.

Oskar Seyffert, *A Dictionary of Classical Antiquities*, edition 1901, London, edited by H. Nettleship and J. E. Sandys; also edition 1957.

Charles Seymour, *Sculpture in Italy, 1400 to 1500*, London and Baltimore, 1966.

Jean Seznec, *The Survival of the Pagan Gods*, New York, 1953.

Maurice L. Shapiro, 'Titian's Rape of Europa', *Gazette des beaux-arts*, 6 période, LXXVII, 1971, pp. 109–116.

Fern Rusk Shapley, 'Giovanni Bellini and Cornaro's Gazelle', *Gazette des beaux-arts*, XXVIII, 1945, pp. 27–30.

——, *The Samuel H. Kress Collection*, El Paso Museum of Art, 1961.

——, *Paintings from the Samuel H. Kress Collection. Italian Schools. XV–XVI Century*, London, 1968.

——, 'Titian's Venus with a Mirror', *Studies in the History of Art*, Washington, 1971–1972, pp. 93–105.

——, *Paintings from the Samuel H. Kress Collection. Italian Schools. XVI–XVIII Century*, London, 1973.

John Shearman, 'Titian's Portrait of Giulio Romano', *Burlington Magazine*, CVII, 1965, pp. 172–177.

——, *Raphael's Cartoons in the Collection of Her Majesty the Queen and the Tapestries for the Sistine Chapel*, London, 1972.

——: see also: White and Shearman, 1958.

Padre Joseph de Sigüenza, 'Historia de la orden de San Gerónimo', 1599, in Sánchez Cantón, *Fuentes literarias para la historia del arte español*, I, 1923, pp. 345–448.

Simancas, Archivo General, see: Beer, 1891; Cloulas, 1967; Fabbro, 1967.

Henry Simonsfeld, *Der Fondaco dei Tedeschi in Venedig*, Stuttgart, 1887.

Staale Sinding-Larsen, 'Titian's Madonna di Ca Pesaro', *Acta ad Archaeologiam et Artium Historiam Pertinentia*, Institutum Romanum Norvegiae, Rome, 1962, I, pp. 139–169.

Oswald Sirén, *Dessins et tableaux de la renaissance italienne dans les collections de Suède*, Stockholm, 1902.

——, *Italienska tavlor och teckningar i Nationalmuseum och andra svenska och finska Samlingar*, Stockholm, 1933.

——, *Catalogue descriptif des collections de peintures du Musée National*, Stockholm, 1938.

Rodolfo Siviero, 'Discorso . . . il 9 novembre 1947, alla Farnesina per l'inaugurazione della Mostra dei Capolavori Italiani recuperati in Germania', *Accademia Nazionale dei Lincei, Rendiconti della classe di scienze morali, storiche e filologiche*, serie VIII, II, 1947 [1948], pp. 1–27, in Italian and English (reprint).

Lars Skarsgård, *Research and Reasoning, A Case Study on an Historical Inquiry. Diana and Actaeon, A Study in Artistic Innovation*, Göteborg, 1968 (a pseudo-scientific analysis without art-historical value; X-rays reproduced).

Alastair Smart, 'Titian and the Toro Farnese', *Apollo*, 85, 1967, pp. 420–431.

A. H. Smith, *A Catalogue of Sculpture in the Department of Greek and Roman Antiquities*, London, British Museum, 1904.

Gertrude P. Smith, 'The Canon in Titian's Bacchanal', *Renaissance News*, VI, 1953, pp. 52–55.

A. I. Somof, *Catalogue de la galerie des tableaux*, St. Petersburg, 1899.

R. Soprani and Carlo G. Ratti, *Delle vite de pittori, scultori ed architetti genovesi*, Genoa, 1768–1769.

Giambattista Soravia, *Le chiese di Venezia*, Venice, 1823.

Lauren Soth, 'Two Paintings by Correggio', *Art Bulletin*, XLVI, 1964, pp. 539–544; Letter, *loc. cit.*, 1965, p. 544.

Annemarie Spahn, *Palma Vecchio*, Leipzig, 1932.

Giuseppe Spezi, *Lettere inedite del Cardinale Pietro Bembo*, Rome, 1962.

Patritio Spini, in Cavriolo, *Chronica di rebus brixianorum*, i.e. Delle historie bresciane di M. Helio Cavriolo fatte volgari da molto rev. don Patritio Spini, Brescia, 1585. Translation and supplement by Spini (pp. 257–344).

Vittorio Spreti e collab., *Enciclopedia storico-nobiliare italiana*, Milan, 1928–1936, 7 vols.

Marquess of Stafford:
 Catalogue raisonné of the Pictures . . . Marquess of Stafford, in the Gallery of Cleveland House, London, 1808.

Marquess of Stafford: *continued*

Engravings of the most Noble, the Marquess of Stafford's Collection of Pictures in London, by William Young Ottley and P. W. Tomkins, Esq., engraver, London, 1818, 4 vols.

Catalogue of the Collection of Pictures . . . Marquess of Stafford at Cleveland House, London, 1825, I.

Catalogue of Pictures in the Gallery at Stafford House, London, 1862.

See also: Bridgewater.

Franz von Stampart and Anton von Prenners, 'Prodromus zum Theatrum Artis Pictoriae' (1735), edited by Heinrich Zimmermann, *Jahrbuch der Kunsthistorischen Sammlungen des Allerhöchsten Kaiserhauses*, Vienna, VII, 1888, II. Theil, pp. VII–XIV, pls. 1–30.

Wolfgang Stechow, *Apollo and Daphne*, Berlin, 1932.

——, 'Rembrandt and Titian', *Art Quarterly*, V, 1942, pp. 135–146.

——, *Rubens and the Classical Tradition*, Cambridge, Harvard University Press, 1968.

Ernst Steinmann, 'Tizians himmlische und irdische Liebe', *Mecklenburger Nachrichten*, Schwerin, 1904.

Charles Sterling, 'Notes brèves sur quelques tableaux vénitiens inconnus à Dallas', *Arte veneta*, VIII, 1954, pp. 265–271.

Alfred Stix, 'Tizians Diana und Kallisto in der Kaiserlichen Gemäldegalerie in Wien', *Jahrbuch der Kunsthistorischen Sammlungen des Allerhöchsten Kaiserhauses*, Vienna, XXXI, 1913–1914, pp. 335–346.

—— and Erich von Strohmer, *Die fürstlich Liechtensteinsche Gemäldegalerie in Wien*, Vienna, 1938.

J. Stockbauer, *Die Kunstbestrebungen am Bayerischen Hofe unter Herzog Albert V. und seinem Nachfolger Wilhelm V. Quellenschriften für Kunstgeschichte*, Vienna, VIII, 1874: 'Jacob Strada', pp. 29–52; 'Niccolo Stoppio', pp. 53–69.

Stockholm:

Notices descriptives des tableaux du Musée National de Stockholm, Stockholm, 1910.

Konstens Venedigs, Stockholm, National Museum, 1962–1963.

Christina Queen of Sweden, Exhibition, Stockholm, National Museum, 1966.

See also: Sirén.

David Stone, Jr., 'The Source of Titian's Rape of Europa', *Art Bulletin*, LIV, 1972, pp. 42–49.

Storffer, *Gemaltes Inventarium der Aufstellung der Gemäldegalerie in der Stallburg*, Vienna, 1720–1733.

Jacopo Strada (Jacobus de Strada), *Epitome thesauri antiquitatum, hoc est, impp. rom. orientalium et occidentalium iconum ex antiquis numismatibus quam fidelissimè deliniatarum Ex Museo Jacobi Stradi*, Lyon, 1553. French edition, translated by Jean Louveau d'Orléans, Lyon, 1553.

Sir Robert Strange, *A Collection of Historical Prints Engraved from the Pictures of the Most Celebrated Painters*, London, 1769.

Erich von Strohmer, see: Alfred Stix.

Arthur Strong, *Masterpieces in the Duke of Devonshire's Collection of Pictures*, London, 1901.

Eugenie Strong, 'Terra Mater or Italia', *Journal of Roman Studies*, XXVII, 1937, pp. 114–126.

W. G. Studdert-Kennedy, 'Titian: the Fitzwilliam Venus', *Burlington Magazine*, C, 1958, pp. 349–351.

Margaret Stuffmann, 'Les tableaux de la collection de Pierre Crozat', *Gazette des beaux-arts*, 6 période, LXXII, 1968, pp. 13–125.

Stuttgart: *Katalog der Staatsgalerie Stuttgart, Alte Meister*, Stuttgart, 1962.

Gaius Suetonius, *Lives of the Twelve Caesars*, translated by J. C. Rolfe, London and New York, Loeb Library, 1914, 2 vols.

Wilhelm Suida, *Genua*, Leipzig, 1906.

——, 'Rivendicazione a Tiziano', *Vita artistica*, II, 1927, pp. 206–215.

——, 'Die Ausstellung italienischer Kunst in London', *Belvedere*, IX, part 2, 1930, pp. 35–45.

——, 'Alcune opere sconosciute di Tiziano', *Dedalo*, XI, part 4, 1931, pp. 894–901.

——, 'Tizians Kind mit Taube', *Belvedere*, XI, 1932, pp. 164–166.

——, 'Tizians frühestes Danaëbild', *Belvedere*, XII, 1934, pp. 72–75.

——, *Titien* (French edition), Paris, 1935.

——, 'Giorgione, nouvelles attributions', *Gazette des beaux-arts*, 6 période, XIV, 1935, pp. 80–94.

——, 'Epilog zur Tizian-Ausstellung in Venedig', *Pantheon*, XVII, 1936, pp. 102–104.

——, 'Tizian, die beiden Campagnola und Ugo da Carpi', *Critica d'arte*, I, 1936, pp. 286–288.

——, *Manifestazioni parmesi nel IV Centenario della morte di Correggio*, Correggio, 1936.

——, 'Forgotten Splendor in Titian's Treasury', *Art in America*, XXIX, 1941, pp. 3–13.

——, 'Titian's Portraits, Originals and Reconstructions', *Gazette des beaux-arts*, 6th series, XXIX, 1946, pp. 139–152.

——, *Catalogue of Paintings*, The John and Mable Ringling Museum of Art, Sarasota, 1949.

——, *Paintings and Sculpture from the Kress Collection* (acquired 1945–1951), Washington, National Gallery of Art, 1951.

——, 'Miscellanea Tizianesca, I', *Arte veneta*, VI, 1952, pp. 27–41.

——, 'Spigolature Giorgionesche', *Arte veneta*, VIII, 1954, pp. 153–171.

——, 'Miscellanea Tizianesca, II', *Arte veneta*, X, 1956, pp. 71–81.

——, 'Miscellanea Tizianesca, III: La Venere Holkham', *Arte veneta*, XI, 1957, pp. 71–74.

——, 'Miscellanea Tizianesca, IV', *Arte veneta*, XIII–XIV, 1959–1960, pp. 62–67.

—— and Fern R. Shapley, *Paintings and Sculpture from the Kress Collection* (acquired 1951–1956), Washington, National Gallery of Art, 1956.

Ann Sutherland (Harris), see: Harris.

Denys Sutton, 'The Boymans–van Beuningen Museum', *Apollo*, July 1967.

Barbara Sweeny, *John G. Johnson Collection, Catalogue of Flemish and Dutch Paintings*, Philadelphia, 1972.

Frederick A. Sweet, 'An Education of Cupid by Titian', *Bulletin of the Chicago Art Institute*, XXXVII, no. 5, 1943, pp. 66–68.

Eva Tea, 'La pala Pesaro e la Immacolata', Ecclesia, *Rivista mensile*, Vatican City, XVII, 1958, pp. 602–605.

David Teniers II, *Theatrum pictorium*, Antwerp and Brussels, 1660; another edition, Antwerp, 1684. The numbers on the Teniers plates vary in different printings of the work.

G. de Tervarent, *Attributs et symboles dans l'art profane, 1450–1600*, Geneva, 1958–1959, 2 vols.

Moritz Thausing, 'Tizian und die Herzogin Eleanor von Urbino', *Zeitschrift für bildende Kunst*, XIII, 1878, pp. 257–267, 305–315.

——, *Wiener Kunstbriefe*, Leipzig, 1884.

Henry Thode, *Tintoretto*, Leipzig, 1901.

——, *Michelangelo und das Ende der Renaissance*, Berlin, 1908–1912.

Georg Martin Thomas, 'G. B. Milesios Beschreibung des deutschen Hauses in Venedig (1715)', *Königliche Bayerische Akademie der Wissenschaft*, I, cl. XVI, Bd. II, 1881, pp. 19–51.

G. H. Thompson, 'The Literary Sources of Titian's Bacchus and Ariadne', *The Classical Journal*, L. I, 1956, pp. 259–264.

Stefano Ticozzi, *Vite dei pittori Vecelli di Cadore*, Milan, 1817 (letters on pages 310–313 are copied without acknowledgement from Dolce, 1559, pp. 228–232; Bottari-Ticozzi, 1822, I, pp. 329–331; II, pp. 24–28, also repeat them).

Thyssen-Bornemisza Foundation, Lugano, see: Rudolf Heinemann.

Hans Tietze, *Tizian*, Vienna, 1936, 2 vols.

——, 'Die öffentlichen Gemäldesammlungen in Kanada', *Pantheon*, XVIII, 1936, pp. 180–184.

——, 'The Faun and the Nymph in the Boymans Museum at Rotterdam', *Art Quarterly*, II, 1939, pp. 207–212.

——, *Four Centuries of Venetian Painting*, Toledo, Museum of Art, 1940.

——, 'La mostra di Giorgione e la sua cerchia a Baltimora', *Arte veneta*, I, 1947, pp. 140–142.

——, 'Venetian Renaissance Drawings in Swedish Collections', *Gazette des beaux-arts*, 6 période, XXXV, 1949, pp. 177–186.

——, *Tizian Gemälde und Zeichnungen*, London, 1950 (also an English edition).

——, 'An Early Version of Titian's Danaë. An analysis of Titian's Replicas', *Arte veneta*, VIII, 1954, pp. 199–208.

—— and Erica Tietze-Conrat, 'Tizian Studien', *Jahrbuch der Kunsthistorischen Sammlungen in Wien*, N.F., X, 1936, pp. 137–192.

—— and Erica Tietze-Conrat, 'Domenico Campagnola's Graphic Art', *Print Collectors' Quarterly*, XXVI, 1939, pp. 311–333, 445–465.

—— and Erica Tietze-Conrat, *The Drawings of the Venetian Painters*, New York, 1944; reprint with preface by David Rosand, 1969.

—— and Erica Tietze-Conrat, 'The Allendale Nativity in the National Gallery', *Art Bulletin*, XXXI, 1949, pp. 11–20.

—— and Erica Tietze-Conrat, 'L'Orfeo attribuito al Bellini della National Gallery di Washington, *Arte veneta*, II, 1949, pp. 90–95.

Erica Tietze-Conrat, 'Zu Tizians Schlacht von Cadore', *Mitteilungen der Gesellschaft für Vervielfältigende Kunst*, XLVIII, 1925, *Beilage der Graphischen Künste*, pp. 42–44.

——, 'Titian's cavalli', *Old Master Drawings*, X, no. 40, 1936, pp. 54–57 (study of drawings at Florence, Munich, and Oxford).

——, 'Decorative Paintings of the Venetian Renaissance Reconstructed from Drawings', *Art Quarterly*, III, 1940, pp. 15–39.

——, 'A Rediscovered Early Masterpiece by Titian', *Art in America*, XXIX, 1941, pp. 144–151.

——, 'Neglected Contemporary Sources Relating to Michelangelo and Titian', *Art Bulletin*, XXV, 1943, pp. 154–159.

——, 'Titian as a Letter Writer', *Art Bulletin*, XXVI, 1944, pp. 117–123.

——, 'The Holkham Venus in the Metropolitan Museum', *Art Bulletin*, XXVI, 1944, pp. 266–270.

——, 'Letter to the Editor about the Holkham Venus', *Art Bulletin*, XXVII, 1945, p. 83.

——, 'Titian's Battle of Cadore', *Art Bulletin*, XXVII, 1945, pp. 205–208.

——, 'The Wemyss Allegory in the Art Institute of Chicago', *Art Bulletin*, XXVII, 1945, pp. 269–271.

——, 'Titian's Workshop in his Late Years', *Art Bulletin*, XXVIII, 1946, pp. 76–88.

——, 'Titian's Design for the Battle of Cadore', *Gazette des beaux-arts*, 6 période, XXIV, 1948, pp. 237–242.

——, 'Das Skizzenbuch des Van Dyck als Quelle für die Tizianforschung', *Critica d'arte*, XXXII, 1950, pp. 425–442.

——, Letter on the quince, *Art Bulletin*, XXXIII, 1951, pp. 71–72.

——, 'The Pesaro Madonna, A Footnote on Titian', *Gazette des beaux-arts*, 6 période, XLII, 1953, pp. 177–182.

——, 'Un soffitto di Tiziano a Brescia, conservato in un disegno del Rubens', *Arte veneta*, VIII, 1954, pp. 209–210.

——, 'Titian as Landscape Painter', *Gazette des beaux-arts*, 6 période, XLV, 1955, pp. 11–20.

——, 'Archeologia tizianesca', *Arte veneta*, X, 1956, pp. 82–89.

——, 'Giorgione and the *pezze di figure*', *Il mondo antico nel Rinascimento*, Florence, 1958, pp. 245–246.

——, Review of Bernard Berenson's *Venetian School*, *Art Bulletin*, XL, 1958, pp. 347–354.

Filippo Titi, *Descrizioni delle pitture, sculture e architetture . . . in Roma*, Rome, 1763.

Tizianello, *Vita dell' insigne pittore Tiziano Vecellio*, 1622, edition Venice, 1809.

Charles de Tolnay, *Michelangelo, The Medici Chapel*, III, Princeton, 1948; IV, 1954.

——, 'Über Tizians Himmlische und Irdische Liebe', *Neue Zürcher Zeitung*, 9 August 1970, p. 39.

Bernardo Tommaseo and Niccolò Bellini, *Dizionario della lingua italiana*, Rome, 1879, 8 vols.

P. A. Tomory, 'Profane Love in Italian Early and High Baroque Painting', *Essays in the History of Art Presented to Rudolf Wittkower*, London, 1967, pp. 182–187.

Piero Torritti, *La Galleria Durazzo-Pallavicini a Genova*, Genoa, 1967.

Elizabeth Trapier, 'Sir Arthur Hopton and the Interchange of Paintings Between England and Spain in the Seventeenth Century', *Connoisseur*, no. 165, 1967, pp. 60–63.

Wilhelm Treue, *Art Plunder*, London, 1960.

Luca L. Trevisan, *Giorgione*, Venice, 1950.

Günter Tschmeltisch, 'Allegorien', *Artis*, XXIV, Heft 3, 1972, pp. 24–27.

A. von Tschudi, *Katalog der königlichen Alten Pinakothek*, Munich, 1911.

A. Richard Turner, *The Vision of Landscape in Renaissance Italy*, Princeton, 1966.

Uffizi, see: Florence.

Lina P. Urban, 'La Festa della Sensa nelle arti e nell' iconografia', *Studi veneziani*, X, 1968, pp. 291–353.

Urbino Inventories, see: Gotti, 1875; Gronau, 1904.

Ludwig Urlichs, 'Beiträge zur Geschichte der Kunstbestrebungen und Sammlungen Kaiser Rudolf II', *Zeitschrift für bildende Kunst*, V, 1870, pp. 47–53, 136–142.

Francesco Valcanover, *Mostra dei Vecellio*, Belluno, 1951.

——, 'La mostra dei Vecellio a Belluno', *Arte veneta*, V, pp. 201–208.

——, *Tutta la pittura di Tiziano*, Milan, 1960, 2 vols.; edition in one volume, 1969.

——, 'Gli affreschi di Tiziano al Fondaco dei Tedeschi', *Arte veneta*, XXI, 1967, pp. 266–268.

Wilhelm R. Valentiner, *The Henry Goldman Collection*, New York, 1922.

——, *Das unbekannte Meisterwerk*, Berlin, 1930.

——, *Paintings at Lynnewood Hall*, Elkins Park, 1931, editor of 3 volume work.
 See also: Raleigh, 1956.

van der Bercken, see: Bercken.

Abraham van der Doort, *Catalogue of the Collections of Charles I, 1639*, edited by Oliver Millar, Glasgow, The Walpole Society, XXXVII, 1958–1960.
 See also: Charles I of England.

Albert Van der Put, 'Two Drawings of the Fêtes at Binche for Charles V and Philip II', *Journal of the Warburg and Courtauld Institutes*, III, 1939–1940, pp. 49–55.

Sir Anthony van Dyck:
 Michael Jaffé, *Van Dyck's Antwerp Sketchbook* (c. 1615–1620), London, 1966, 2 vols.
 'Italian Sketchbook', 1622–1627: Original manuscript now in the British Museum, published by Lionel Cust, London, 1902; also, Gert Adriani, *Van Dycks Italienisches Skizzenbuch*, Vienna, 1940. See also, Cust, 1902.

J. G. van Gelder, 'The Triumph of Scipio by Rubens', *Duits Quarterly*, 8, 1965, pp. 3–19.

——, 'Jan de Bisschop 1628–1671', *Oud Holland*, LXXXVI, 1971, pp. 201–288.

Raimond van Marle, *The Development of the Italian Schools of Painting*, XVII, 1935.

Giorgio Vasari, *Le Vite de gli architettori, pittori et scultori*, Florence, 1550, vol. III, pp. 577–581 (life of Giorgione); p. 581 (ten lines devoted to Titian. Vasari says that since he is still alive there is no reason 'qui ragionarne'.)

——, *Le Vite dei più eccellenti pittori, scultori, ed architettori*, 1568, III, pp. 805–822; edition by Gaetano Milanesi, Florence, 1875–1885, reprint 1906; edition by Paola Barocchi, vols. 1–3, Florence, 1967, 1971.

Vasi, 'Itinéraire', Rome, edition 1793.

Cesare Vecellio, *Habiti antichi et moderni*, Venice, 2nd edition, 1598.

Tiziano Vecellio, l'Oratore (1538–1610), *Oratio ad Principem Aloysium Mocenium habita VI Kal. Januarii 1571*, Venice, 1571 (i.e. 1572) [also in A. Riccoboni, *Orationes*, Padua, 1573].

——, *Anthologia overo raccolta di fiori poetici in morte del Signore Tiziano Vecellio*, Venice, 1621.

Miguel Velasco Aguirre, *Catálogo de los grabados de la Biblioteca del Palacio*, Madrid, 1934.

Adolfo Venturi, *La R. Galleria Estense in Modena*, Modena, 1882.

——, 'I due Dossi', *Archivio storico dell' arte*, V, 1892, pp. 440–443; VI, 1893, pp. 48–62, 130–135, 219–224.

——, *Il Museo e Galleria Borghese*, Rome, 1893.

——, 'Nelle pinacoteche minori d'Italia', *Archivio storico dell' arte*, VI, 1893, pp. 409–441.

——, 'La Galleria Nazionale di Roma', *Le Gallerie Nazionale Italiane*, II, 1896, pp. 75–138.

——, 'Per Tiziano', *L'Arte*, XXIX, 1926, pp. 201–202.

——, *Storia dell' arte*, Milan, 1928, IX, part 3; 1934, IX, part 7; X, part 1, 1935 (sculpture).

——, *Studi dal vero*, Milan, 1927.

——, 'L'esposizione della pittura ferrarese del rinascimento', *L'Arte*, XXXVI, 1933, pp. 267–290.

——, 'Tiziano Vecellio: Danaë', *L'Arte*, XLI, 1938, pp. 191–192.

Lionello Venturi, 'Le Compagnie della Calza', *Nuovo archivio veneto*, XVI, 1908, pp. 161–221; XVII, 1909, pp. 140–233.

——, 'Pietro, Lorenzo Luzzo and Morto da Feltre', *L'Arte*, XIII, 1910, pp. 362–376.

——, 'Saggio sulle opere d'arte italiana a Pietroburgo', *L'Arte*, XIV, 1912, pp. 121–146.

——, *Giorgione e il giorgionismo*, Milan, 1913.

——, 'Nella collezione Nemes', *L'Arte*, XXXIV, 1931, pp. 250–266.

——, *Pitture italiane in America*, New York, 1931; English edition, New York, 1933.

Lionello Venturi, 'Contributi a Tiziano', *L'Arte*, XXV, 1932, pp. 481–497.

——, *Giorgione*, Rome, 1954.

——, 'Giorgione', *Encyclopedia of World Art*, New York, VI, 1962, pp. 330–339.

Giuseppe Venturini, 'Giovanni Maria Verdizotti, pittore e incisore', *Bollettino del Museo Civico di Padova*, LIX, 1970, pp. 33–73.

Ridolfo Venuti, *Roma antica e moderna*, Rome, 1745; another edition 1766.

Vergil, *Eclogues, Georgics and Aeneid*, translation by H. Rushton Fairclough, London, Loeb Library, 1930.

Egon Verheyen, 'Eros et Anteros, L'Education de Cupidon et la prétendue Antiope de Corrège', *Gazette des beaux-arts*, VI période, LXV, 1965, pp. 321–340.

——, Letter, *Art Bulletin*, XLVII, 1965, pp. 542–543.

——, 'Tizians Eitelkeit des Irdischen Prudentia et Vanitas', *Pantheon*, XXIV, 1966, pp. 88–99.

——, 'Correggio's Amore di Giove', *Journal of the Warburg and Courtauld Institutes*, XXIX, 1966, pp. 160–192.

——, 'Jacopo Strada, Mantuan Drawings', *Art Bulletin*, XLIX, 1967, pp. 62–70.

——, 'Die Sinngehalt von Giorgiones Laura', *Pantheon*, XXVI, 1968, pp. 220–227.

——, 'Die Sala di Ovidio im Palazzo del Te', *Römisches Jahrbuch für Kunstgeschichte*, XII, 1969, pp. 161–170.

Cornelius Vermeule, *European Art and the Classical Past*, Cambridge (Mass.), 1964.

——, 'The Dal Pozzo Album of Drawings of Classical Antiquities', *Transactions of the Philosophical Society*, L, 1960, part 5; *idem*, LVI, part 2, 1966, pp. 1–170.

George Vertue, *Note Books* (1713–1756), vols. I, VI, edition Walpole Society, Glasgow, XIX–XX, 1932, 1947.

Vienna:
 Akademie der Bildenden Künste, see: Eigenberger, 1927.
 Kunsthistorisches Museum, see: Engerth, 1884; Gluck and Schaeffer, 1907; Lhotsky, 1941–1945; Klauner and Oberhammer, 1960.
 Sezession Galerie: *Ausstellung der Meisterwerke italienischer Renaissance-Kunst*, Sezession Galerie, 1924.

Fédéric Villot, *Notice des tableaux . . . Musée National du Louvre*, Paris, 1874.

Philippe de Vitry, *Les oeuvres*, Rheims, 1850.

Hans Vogel, *Katalog der staatlichen Gemäldegalerie zu Kassel*, Cassel, 1958.

Hans von Voltelini, 'Urkunden und Regesten aus dem K. u. K. Haus-, Hof- und Staats-archiv in Wien', *Jahrbuch der Kunsthistorischen Sammlungen des Allerhöchsten Kaiserhauses*, Vienna, XI, 1890, II. Theil, pp. I–LXXXIII; XIII, 1892, II. Theil, pp. XXVI–CLXXIV; XV, 1894, II. Theil, pp. XLIX–CLXXIX; XIX, 1898, II. Theil, pp. I–CXVI.

Von: Names with von are alphabetized under the patronymic.

Hermann Voss, 'Über Gemälde und Zeichnungen von Meistern aus dem Kreise Michelangelos', *Jahrbuch der königlich preuszischen Kunstsammlungen*, XXXIV, 1913, pp. 297–320.

——, 'Handzeichnungen alter Meister im Leipziger Museum', *Jahrbuch für bildende Kunst*, N.F. XXIV, 1912–1913, pp. 221–236.

——, *Die Malerei der Spätrenaissance*, Berlin, 1920.

G. F. Waagen, *Kunstwerke und Künstler in England und in Paris*, Berlin, 1837–1839, 3 vols.

——, *Treasures of Art in Great Britain*, London, 1854, 3 vols.; also reprint edition, London, 1970.

——, *Galleries and Cabinets of Art in Great Britain*, London, 1857; also reprint edition, London, 1970.

Hugo Wagner, 'Nochmals zu Tizians Amor Sacro e Profano', *Neue Zürcher Zeitung*, 11 October 1970, p. 50.

Emil Waldmann, *Tizian*, Munich, 1922.

John Walker, *Bellini and Titian at Ferrara*, London, 1956.

Wallace Collection, London: *Pictures and Drawings*, London, edition 1968.

Horace Walpole, *The Letters*, Oxford, 1914, 9 vols.

William T. Walsh, *Philip II*, London, 1937.

Washington, National Gallery:
 Preliminary Catalogue of Paintings and Sculpture, National Gallery of Art, 1941.
 Paintings and Sculpture from the Samuel H. Kress Collection, Washington, 1956 and 1959.
 Summary Catalogue of European Paintings and Sculpture, Washington, 1965.
 See also: Shapley, 1968, 1971–1972, and 1973.

Ellis K. Waterhouse, 'Paintings from Venice for Seventeenth-Century England', *Italian Studies*, VII, 1952, pp. 1–23.

——, *Titian's Diana and Actaeon*, Charlton Lectures on Art, King's College, Newcastle upon Tyne, Oxford Press, 1952.

——, 'The Italian Exhibition at Birmingham', *Burlington Magazine*, XCVII, 1955, pp. 292–295.

——, *Italian Art and Britain*, London, 1960.

——, 'Titian's Diana and Actaeon', *The Listener*, LXIV, 15 September 1960, pp. 432–433.

——, 'Queen Christina's Italian Pictures in England', *Queen Christina of Sweden, Documents and Studies*, Stockholm, 1966.

Zygmut Wázbínski, 'Tycjan, nowy Apelles, a roli antycznego mitu w sztuce Renesansu', *Rocznik historii sztuki*, VIII, 1970, pp. 47–68.

H. B. Wehle, 'Titian's Venus from Holkham', *Bulletin of the Metropolitan Museum of Art*, XXXI, 1936, pp. 183–187.

——, *Catalogue of Italian, Spanish, and Byzantine Paintings*, New York, Metropolitan Museum, 1940.

——, 'Letter to the Editor about the Holkham Venus', *Art Bulletin*, XXVII, 1945, pp. 82–83.

Evelyn Wellington, *Catalogue of the Collection at Apsley House*, London, 1901, 2 vols.
 See also: Apsley House.

Carolus Wendel, *Scholia in Apollonium Rhodium Vetera*, Berlin, 1935.

Harold E. Wethey, *El Greco and His School*, Princeton, 1962, 2 vols; revised Spanish edition, Madrid, 1967, 2 vols.

——, 'Los retratos de Felipe II por Tiziano', *Archivo español de arte*, 1969, pp. 129–138.

——, *The Paintings of Titian*.

Volume I, *The Religious Paintings*, London, 1969.

Volume II, *The Portraits*, London, 1971.

——, 'Titian's Ecce Homo and Mater Dolorosa', *Acts, Twenty-second International Congress of the History of Art, Budapest, 1969*, Budapest, 1972, pp. 751–754, 7 illus.

——, 'Titian's Adam and Eve and Philip II', *Acts, Twenty-third International Congress of the History of Art, Granada, 1973* (in press).

John White and John Shearman, 'Raphael's Tapestries and their Cartoons', *Art Bulletin*, XL, 1958, pp. 193–221.

William T. Whitley, *Artists and their Friends in England, 1700–1799*, London, 1928, 2 vols.

Franz Wickhoff, 'Der Saal des grossen Rathes zu Venedig in seinem alten Schmucke', *Repertorium für Kunstwissenschaft*, VI, 1883, pp. 1–37.

——, 'Les écoles italiennes au musée de Vienne', *Gazette des beaux-arts*, 3. période, IX, 1893, pp. 5–18, 130–147.

——, 'Giorgiones Bilder zu römischen Heldengedichten', *Jahrbuch der königlich preuszischen Kunstsammlungen*, XVI, 1895, pp. 34–43.

——, Review of G. Gronau's *Titian*, in *Kunstgeschichtliche Anzeigen*, 1904, pp. 113–117.

——, 'Eine Zeichnung Tizians', *Jahrbuch der K. K. Zentralkommission*, III, 1909, p. 24.

Manuel Wielandt, 'Die verschollenen Imperator-Bilder Tizians in der königlichen Residenz zu München', *Zeitschrift für bildende Kunst*, N.F., XIX, 1908, pp. 101–108.

Wiesbaden, 1967, see: Ulrich Schmidt.

Johannes Wilde, 'Wiedergefundene Gemälde aus der Sammlung des Erzherzogs Leopold Wilhelm', *Jahrbuch der Kunsthistorischen Sammlungen in Wien*, N.F., IV, 1930, pp. 245–266.

——, in *Katalog der Gemäldegalerie*, Vienna, 1938.

——, 'The Hall of the Great Council of Florence', *Journal of the Warburg and Courtauld Institutes*, VII, 1944, pp. 65–81.

——, (in preparation), *Lectures on Venetian Painting*, edited by Sir Anthony Blunt.

Edgar Wind, *Bellini's Feast of the Gods*, Cambridge (Mass.), 1948.

——, *Pagan Mysteries of the Renaissance*, New Haven, 1958; also edition London, 1968.

——, *Giorgione's Tempesta*, Oxford, 1969.

E. Winner, *Katalog der Ausstellung, Zeichner sehen die Antike*, Berlin, 1967.

Carl Winter, *The Fitzwilliam Museum*, Cambridge, 1958.

Emanuel Winternitz, 'The Inspired Musician, A Sixteenth-Century Musical Pastiche', *Burlington Magazine*, C, 1958, pp. 48–55.

——, *Musical Instruments and their Symbolism in Western Art*, London, 1967.

Rachel Wischnitzer-Bernstein, 'A New Interpretation of Titian's Sacred and Profane Love', *Gazette des beaux-arts*, 6 series, XXIII, 1943, pp. 89–98.

Rudolf Wittkower, 'Transformations of Minerva in Renaissance Imagery', *Journal of the Warburg Institute*, II, 1938–1939, pp. 194–205.

——, 'Titian's Allegory of Religion Succoured by Spain', *Journal of the Warburg Institute*, III, 1939–1940, pp. 138–141.

——, 'L'Arcadia e il Giorgionismo', *Umanesimo europeo e umanesimo veneziano*, edited by Vittore Branca, Venice, 1963, pp. 473–484.

Karl Woermann, *Katalog der königlichen Gemälde-Galerie zu Dresden*, Dresden, 1887, and also 1902.

Wolfgang Wolters, 'Der Progammentwurf zur Dekoration des Dogenpalastes nach dem Brand von 20. Dezember 1577', *Mitteilungen der Kunsthistorischen Instituts in Florenz*, XII, 1965–1966, pp. 271–318.

——, *Plastische Deckendecorationen des Cinquecento in Venedig und im Veneto*, Berlin, 1968.

John Woodward, *Ecclesiastical Heraldry*, London, 1894.

Sir Richard Worsley, *Catalogue Raisonné of the Principal Paintings, Sculptures, and Drawings at Eppuldurcombe House*, London, 1804.

Oskar Wulff, 'Farbe, Licht und Schatten in Tizians Bildgestaltung', *Jahrbuch der königlich preuszischen Kunstsammlungen*, LXII, 1941, pp. 108–144, 171–200.

Arthur Young, *Echoes of Two Cultures*, Pittsburgh, 1964.

Domenico Zaccarini, *Le Opere d'arte del castello estense*, Ferrara, 1924.

Baldassare Zamboni, *Memorie intorno alle pubbliche fabbriche più insigni della città di Brescia*, Brescia, 1778.

Pietro Zampetti, *Giorgione e i Giorgioneschi*, Venice, 1955.

——, 'Postille alla mostra di Giorgione', *Arte veneta*, IX, 1955, pp. 54–70.

—— and Virgilio Lilli, *Giorgione*, Milan, 1968.

Antonio Maria Zanetti, *Descrizione di tutte le pubbliche pitture*, Venice, 1733.

——, *Varie pitture a fresco dei principali maestri veneziani*, Venice, 1760.

——, *Della pittura veneziana e delle opere pubbliche dei veneziani maestri*, Venice, 1771.

——, *Della pittura veneziana*, Venice, 1797.

F. Zanotto, *Pinacoteca della Imp. reg. accademia veneta*, Venice, 1834.

Julián Zarco Cuevas, 'Inventario . . . donados por el rey don Felipe II, años 1571–1598', *Boletín de la Real Academia de la Historia*, XCVI, 1930, pp. 545–668; XCVII, 1930, pp. 35–95, 134–144.

Manuel R. Zarco del Valle, 'Documentos inéditos para la historia de las bellas artes en España', *Colección de documentos inéditos para la historia de España*, LV, 1870, pp. 591–613.

——, 'Unveröffentlichte Beiträge zur Geschichte der Kunstbestrebungen Karl V und Philipp II', *Jahrbuch der Kunsthistorischen Sammlungen des Allerhöchsten Kaiserhauses*, VII, 1888, pp. 221–237.

Jan Zarnowski, 'L'Atelier de Titien: Girolamo Dente',
 Dawna Sztuka, I, 1938, pp. 107–130.
Federico Zeri and Elizabeth E. Gardner, *Italian Paintings,
 Venetian School*, New York, Metropolitan Museum of Art,
 1973.
Henri Zerner, *L'École de Fontainebleau, Gravures*, Paris, 1969.
Jerrold Ziff, 'Backgrounds, Introduction of Architecture
 and Landscape, A Lecture by J. M. W. Turner', *Journal
 of the Warburg and Courtauld Institutes*, XXVI, 1963, pp.
 124–147.
Ernst Zimmermann, *Die Landschaft in der venezianischen
 Malerei bis Zum Tode Tizians*, Leipzig, 1893.
Heinrich Zimmermann, 'Urkunden, Akten, und Regesten

aus dem Archiv des K. K. Ministerium des Innern',
 *Jahrbuch der kunsthistorischen Sammlungen des Allerhöchsten
 Kaiserhauses*, VII, 1888, pp. XV–LXXXIV.
——, 'Zur richtigen Datirung eines Portraits von Tizian in
 der Wiener Kaiserlichen Gemälde-Galerie', *Mittheilungen
 des Instituts für Oesterreichische Geschichtsforschung*, Inns-
 bruck, 1901, VI, Ergänzungsband, pp. 830–857.
——, 'Das Inventar der Prager Schatz- und Kunstkammer
 von 6. Dezember 1621', *Jahrbuch der Kunsthistorischen
 Sammlungen des Allerhöchsten Kaiserhauses*, Vienna, XXV,
 1905, II. Theil, pp. XIII–LI.
A. Zorzi, E. Bassi, T. Pignatti, C. Semenzato, *Il Palazzo
 Ducale di Venezia*, Venice, 1972.

Titian's Letter to Charles V. Rome, 8 December 1545 (Paris, Fondation Custodia)

CATALOGUE RAISONNÉ

Arranged alphabetically by subject; pictures of the same subject appear chronologically.

Dimensions are cited in all cases height × width.

Archaic units of measure have been calculated in centimetres as follows:
braccio 64 cm.; *palmo romano* 22.34 cm.; *vara* 83.5 cm.

1. Allegory of the Marchese del Vasto (so-called)

Plates 68–71

Canvas. 1.21 × 1.07 m.

Paris, Louvre.

About 1530–1535.

This allegorical portrait has a wistfulness which has puzzled and fascinated nearly all students. Although the man in armour has the appearance of a portrait, it is generally agreed that he is not Alfonso d'Avalos, Marchese del Vasto, a rather despicable character who fell into disgrace and was removed from his post as governor of Milan in 1546 by Charles V (see Wethey, II, 1971, Cat. nos. 9, 10). Nor does the lady with the crystal sphere recall d'Avalos' wife, Mary of Aragon. The various and diverse explanations of the iconography are recounted below; among them that of Liselotte Möller inspires considerable confidence.

The main colours, now much faded, include a dark-green curtain at the left, against which the soldier (?) in armour and red sleeves stands out prominently. The seated lady wears a loose white blouse or *camicia*, a dark-green skirt, and a rose scarf which falls from her shoulders, upon her lap. The woman at the right, with crown of myrtle (?), is in a light-yellow blouse and blue scarf, while Cupid's ultramarine blue wings still survive rather vividly.

Iconography: Of the various theories about the 'Allegory of the Marchese del Vasto' the most fanciful is Hourticq's (1919, pp. 222–232), who in his usual romantic vein thought that the man in armour was Titian and the woman, Cecilia, the painter's wife, who had died in 1530. Nothing about the picture gives any plausibility to this idea. There is only the all-pervading sadness, implying that death may have intervened.

The name of the 'Allegory of the Marchese del Vasto' is known as early as 1639, when Van der Doort compiled an inventory of the collection of Charles I of England (Millar edition, 1960, p. 104). Some writers such as Crowe and Cavalcaselle (1877, II, pp. 373–376) believed in the tradition that Alfonso d'Avalos, the Marchese del Vasto, and his wife

Mary of Aragon were the principal figures, but they as Victorians were distressed because 'her bosom is imperfectly covered'. That detail of the nude breast is common in Titian's paintings as well as in those of other High Renaissance masters. Its adoption from antique sculpture is self-evident, as well as its appearance in allegorical figures and goddesses. Renaissance costume is familiar enough (for instance, see Cesare Vecellio, 1598) to demonstrate that women of the sixteenth century did not actually wear that kind of décolletage.

Walter Friedländer, in his last article before his death (1967, pp. 51–52), returned to the original identification of the man in armour and the seated woman as the Marchese del Vasto and Mary of Aragon. He struck out anew in seeing the girl wearing a crown (more likely a wreath of myrtle) at the right as Vesta, protectress of domestic peace. Cupid is already domesticated, and he presents his bundle of arrows to the bride, while the figure with a basket of flowers (male or female?) becomes Hymen, i.e. Marriage. Thus the elderly scholar sought to solve the riddle.

The most erudite and most complex theory was Panofsky's (1939, pp. 160–166): an 'Allegory of Marriage' in which the man and woman are not only bride and groom but also Mars (in armour) and Venus. The globe held by the lady is said to symbolize harmony because of its perfect shape. In spite of Panofsky's sheer necromancy in these matters, a great stretch of the imagination is required to accept this interpretation and that of the three figures to the right as Cupid with a bundle of twigs (representing 'unity'), the girl wearing a myrtle wreath as 'Marital Faith' and the third figure lifting a basket of roses (?) above her or his head (Plate 70) as 'Hope', because of the pose. The closest analogy in Titian's preserved work is *Lavinia with a Tray of Fruit* in Berlin (Wethey, II, 1971, Cat. no. 60; also this volume, Addenda II, Cat. no. 60), reasonably identified as *Pomona*. A lost composition of *Pomona with a Tray of Melons* is recorded in a drawing in Van Dyck's 'Italian Sketchbook' (Plate 71A). The close similarity in the poses and attitudes of these three figures provides at least some evidence of a relationship in iconography. It is beside the point that Titian

adopted a similar composition in his Madrid *Salome*, who holds the tray bearing the severed head of St. John the Baptist (Wethey, I, 1969, Cat. no. 141, and II, 1971, Cat. no. 60, variant 3).

Thirty years later, Panofsky (1969, pp. 126–129) repeated essentially the same iconographical analysis, but he added a photograph of the original drawing on the canvas, which had come to light when the picture was relined in 1962. In the drawing (Plate 71) the most significant variations lie in the omission of the globe and the placing of the man's hand on his own chest rather than upon the woman's breast. Leave-taking is evident in the attitudes of the man and wife, and thus arises the implication that one of them had died, an explanation that would account for the sadness that envelops the picture.

Quite the contrary in point of view was Hartlaub's belief (1941, pp. 250–252; also 1951, p. 170) that the crystal ball is divination into the future and that the seated woman is 'Prudence'. Following on the ideas of Hartlaub is Liselotte Möller's study of the imagery of the sphere (1952, pp.168–171). For her the *Allegory of the Marchese del Vasto* is a 'portrait moralisé' in which the woman as Prudence looks into the sphere to foresee the future, but the specific historical identification of the man in armour and Prudence escapes solution.

Condition: Cleaned in 1962, yet the picture is still much darkened. It has suffered from surface damage because of old restorations.

History: Purchased in Spain by Charles I of England (van der Doort, 1639, Millar edition, 1960, p. 16, no. 10); sale of Charles I's collection, 7 September 1649 (LR 2/124, folio 191r, as the Marquis de Guasto by Titian; also Millar, 1972, p. 256, no. 13).
History in France as reconstructed by Bailly-Engerand, 1899, pp. 72–73: Louis XIV's collection, Le Brun Inventory, 1683, no. 54; 1715, Hotel d'Antin, Paris; 1737, Versailles; Lépicié, 1752, pp. 34–35, described as the 'Marquis de Guast' (del Vasto) and his wife; subsequently to the Louvre.

Bibliography: See also above; Villot, 1874, pp. 288–289, no. 470; C. and C., 1877, I, pp. 373–376; Gronau, 1904, p. 284 (Titian, *c.* 1530–1535; an obscure subject); Hourticq, 1919, pp. 222–232 (Titian and his wife Cecilia, a commemoration, *c.* 1531); *Mostra di Tiziano*, 1935, no. 30 (*c.* 1532); Suida, 1935, pp. 74, 175 (Titian, *c.* 1530–1540; he says that the woman with the globe is Fortuna and the others, Venus, Cupid, and Abundance); Tietze, 1936, II, p. 306 (*c.* 1532); Berenson, 1957, p. 190, no. 1589; Valcanover, 1960, I, pl. 131 ('Allegory', *c.* 1530); Stockholm, 1962, no. 90 (*c.* 1530); Pallucchini, 1969, p. 265, figs. 203–204 (Titian, *c.* 1530–1532).

COPIES:

1. Hampton Court (in storage), no. 577; canvas, 1·22 × 1·073 m. The better of two copies, both of which were made when the original was in the collection of Charles I. The second copy is Hampton Court, no. 4, canvas, 1·01 × 1·023 m.
2. Longleat House, Marquess of Bath; English copy, seventeenth century, size of the original.
3. Richmond, Ham House, water colour, about 20 × 20 cm.; by David des Granges, seventeenth century.
4. Windsor Castle, Royal Library (Plate 185); by Peter Oliver; Inventory of Charles I, 1639, '. . . a Coppy after Titian being the Marquess de Gwasto w^ch peece is dated 1629 whereof the Principall in oyle Cullo^rs is in the first—privy lodging room No. 10: Conteyning 5 half figures' (van der Doort, Millar edition, 1960, p. 104; Holmes, 1906, p. 109; illustrated by Cundall, 1933, p. 359).

VARIANTS, Seventeenth Century:
Several pictures are free adaptations after Titian, possibly by Alessandro Varotari and his shop, which were presumably sold as originals by Titian. The Venus with Cupid resting against her back is borrowed from the famous composition of *Cupid Blindfolded* (Plate 155) in the Villa Borghese. A painting of the mid-seventeenth century by Jan Breughel II, called *Interior of a Collector's Studio*, shows a picture over a door of this same type (*Apollo*, CXV, 1972, no. 124, p. 143, adv.).
1. Barcelona, Ignacio Canals Tarrats; illustrated by Espasa-Calpe, Barcelona, LXII, p. 229; a composition like that of No. 2 below.
2. Genoa, Durazzo-Pallavicini Palace; canvas, 1·14 × 1·19 m. The seated woman holds an urn as in No. 6 below, but the young man is a naked Bacchus, rather than a knight in armour as in the Louvre original (Torritti, 1967, pp. 76–80, illustrated, as by Titian and workshop).
3. Munich, Alte Pinakothek (in storage); canvas, 1·15 × 1·32 m. (Plate 186); a seated woman (Venus?) holds a bronze mirror as Cupid rests against her back (derived from the Villa Borghese picture). The nude male holding a bunch of grapes must be intended to be Bacchus. The kneeling woman at the right is accompanied by a satyr, who holds a basket of fruit over her head and thus accounts for her identification as Ceres. The iconographic elements have been recklessly pieced together by the early Baroque forger (see also Cat. no. X–3). Damiano Mazza also painted similar compositions that Ridolfi (1648–Hadeln, I, p. 223) described as 'Deità, Amori, e Satiri con panieri di frutti'. Variant no. 3 was first cited in the Munich Residenz in 1618. Since 1969 in the Stadtresidenz, Landshut.
Bibliography: C. and C., 1877, II, p. 452 (later than Titian's time); Morelli, 1893, II, p. 61 (not even school of Titian);

Suida, 1935, pp. 74, 175, pl. 215b (workshop); Buchner, Munich, 1936, no. 484 (1116) (workshop of Titian, *c.* 1535–1545); Munich, 1957, p. 103, no. 484 (workshop); Kultzen and Eikemeier, 1971, pp. 189–191, no. 484 (Titian's workshop?).

4. Munich, Alte Pinakothek (in storage); panel, 1·263× 1·29 m. This item is considerably worse than no. 3, above. The woman holds an urn, but otherwise the iconographic elements are the same as in the other example at Munich (Kultzen and Eikemeier, 1971, p. 191, as school of Antwerp, *c.* 1570–1580). Cassiano dal Pozzo (1626, folio 122) described a similar composition in the Alcázar at Madrid. He thought that the kneeling girl was Psyche (see Literary Reference no. 2) and the painter, Titian.

5. Unknown location; canvas, 0·95 × 1·27 m. (Plate 187). The subject here is turned into a Vanity picture with the man holding a mirror, which reflects otherwise unseen jewels. The nymph at the right, playing a lute, also represents a departure from the original. Sold by the Kunsthistorisches Museum of Vienna to the de Boer Gallery of Amsterdam on 27 July 1937 in an exchange of pictures; last cited in 1946 in the possession of A. F. Mondschein (also known as Frederick Mont) of New York. These data were kindly supplied by the Vienna Museum in 1973.

Bibliography: C. and C., 1877, I, p. 376, note (partly by Titian); Engerth, 1884, I, p. 354, no. 504 (Titian).

6. Vienna, Kunsthistorisches Museum (in the reserves); canvas, 0·95 × 1·27 m. (Plate 188). The woman holds an urn and the man at her left lifts up a small white bowl.

Bibliography: C. and C., 1877, I, p. 376, note (partly by Titian); Engerth, 1884, I, p. 354, no. 503 (Titian); Suida, 1935, pp. 74, 176, pl. 222A (uncertain attribution); Tschmeltisch, 1972, pp. 24–27 (self-portrait of Titian with wife!).

LITERARY REFERENCES:

1. Madrid, Alcázar: This picture apparently resembled the Baroque forgeries listed under Variants, nos. 1–6.

In the Alcázar Inventory of 1686, no. 884, it is described as follows: 'Otra pintura de la Diosa Ceres que le ofreze diferentes frutas y Venus tapando los ojos a Cúpido de vara y tres quartas de ancho y vara y quarta de alto de mano dal ticiano' (Bottineau, 1958, p. 324). Buen Retiro, Inventory, 1747, no. 277.

2. Madrid, Alcázar: A second item is recorded as 'A Woman who holds a vase and a satyr and other figures' (Inventory, 1666, no. 702; Inventory, 1686, no. 875; also Bottineau, 1958, p. 323). Compare Variants, nos. 4 and 6. Mentioned by Richard Cumberland as in the new Royal Palace in 1787 (Cumberland, 1787, p. 19). In 1626 (folio 122) Cassiano dal Pozzo called it a 'fable of Psyche' and assumed Titian to be the author.

Andrians, see: Cat. no. 15.

Bacchus and Ariadne, see: Cat. no. 14.

2. Boy with Dogs Plate 169

Canvas. 0·992 × 1·17 m.
Rotterdam, Boymans–Van Beuningen Museum.
About 1570–1575.

The meaning of this work has not been clarified. It does not correspond to the *Cupid with Two Dogs*, attributed to Paolo Veronese in the Alte Pinakothek in Munich, where Cupid in the centre holds by a chain two symmetrical beasts. There the subject appears to be heraldic and to have no connection with Titian's composition. Panofsky suggested that the theme here might be 'Cupid mastering two dogs of different temper' (Panofsky, 1969, p. 171, note). They are surely of different sex and the implication that the white hound has fathered the newly born puppies seems fairly obvious. See further mention in the text.

That the *Boy with Dogs* could be a fragment of a *Venus and Adonis*, as Tietze proposed (1950, p. 395), must be ruled out, since in Titian's compositions of the subject (Plates 84, 97, 98) the dogs are straining at the leash, as Adonis is about to leave the goddess. Tietze seems to have overlooked the fact that one is a mother-dog nursing her pups. Any relation to Pietro Testa's print of *Venus and Adonis* (Bartsch, XX, p. 222, no. 25) is a matter of Titian's influence upon the Baroque master.

Condition: A recent technical examination has proved that the picture is a fragment of a large painting; dimensions are usually given wrongly as 1·28 × 1·80 m. The very darkened and generally smudged condition of the sky and of the shapeless houses in the centre make the setting difficult to interpret.

Possible History: The original owner might have been Agabrio Serbelloni (1508–1580), a military architect who worked for both Charles V and Philip II (Thieme-Becker, XXX, 1936, p. 505). Vasari (1568–Milanesi, VII, p. 265) mentions this man, to whose descendants the painting belonged.

Certain History: Serbelloni Collection, Milan (Tietze, 1936, II, p. 308); Arnold Seligman, New York, 1931 (L. Venturi, 1931, pl. 388, first publication); van Beuningen Collection, Rotterdam, 1931; acquired by the museum in 1958 (Sutton, 1967, p. 3).

Bibliography: L. Venturi, 1931, pl. 388 (Titian, late); Hannema, 1934, no. 386 (Titian); Suida, 1935, pp. 116, 186 (Titian); Tietze, 1936, I, pp. 247–248; II, p. 308 (Titian, *c.* 1565); Tietze, 1950, p. 395 (Titian, *c.* 1565); Hannema, 1952, no. 32 (late Titian); dell'Acqua, 1955, p. 132 (Titian,

c. 1565); Berenson, 1957, p. 192 (under Vierhouten; late Titian, fragment); Rotterdam, 1962, p. 141, no. 2569 (Titian, *c.* 1565); Pallucchini, 1969, p. 328, figs. 541–544 (Titian, *c.* 1570–1575); Panofsky, 1969, p. 171, note (iconography).

3. Il Bravo (Trebonius assaulted by Caius Lucius) Plate 27

Canvas. 0·75 × 0·67 m.

Vienna, Kunsthistorisches Museum.

Titian (?).

About 1520–1525.

Iconography: The first writer to name the literary source of this picture was Carlo Ridolfi (1648, edition Hadeln, I, p. 101), who referred to Valerius Maximus, Book VI, and called the story 'Caelius Plotius assaulted by Claudius'. Boschini (1660, edition 1966, p. 56), copying Ridolfi, repeated the names of the characters, stating that the picture was in the collection of the Archduke Leopold Wilhelm. In another work, *Le ricche minere,* he described the composition fully in a section devoted to the art of Giorgione (Boschini, 1674, edition 1966, p. 709).

Edgar Wind (1969, pp. 7–11) has recently clarified the story and the names of the characters, which were confused in Renaissance publications of Valerius Maximus. Plutarch's rendering of the story identifies the assailant as Caius Lucius (not Claudius) and the virtuous youth wearing the wreath as Trebonius (not Caelius Plotius). The handsome hero slew his homosexual attacker, and when later brought to trial, he, Trebonius, was rewarded by Marius, even though uncle of the villain, with the Roman garland for his valour in self-defence (*Plutarch's Lives,* Loeb Classical Library, IX, London, 1920, pp. 497–498). Hence the artist provided the happy ending in the form of a garland before the episode had run its unexpected course.

Attribution: The puzzle of the attribution of *Il Bravo* is so perplexing as to evade definitive solution. The possibility exists that Marcantonio Michiel in 1528 meant this picture when he spoke of 'two figures attacking each other, by Titian'. On the other hand, during the seventeenth century writers regarded the work as a major example of Giorgione's art. The borderline between Titian and Giorgione has never been set to everyone's satisfaction. The Vienna gallery now gives *Il Bravo* to Titian, and Italian critics of today have a bias in favour of his authorship.

Dating: The placing of this picture *c.* 1520–1525, well after Giorgione's death, is based on the costume of the attacker, i.e. the rippled armour and the fashionable red slashed-sleeve giving the effect of ribbons. In Italian painting this latter detail appears first in the fifteen-twenties, for example in Lorenzo Lotto's St. Lucy frescoes, Suardi Chapel at Trescore (Bergamo), begun in 1524 (Berenson, 1955, pl. 146). There appears to be no certain example of this kind of sleeve in Italy in the first decade of the sixteenth century during Giorgione's lifetime.

Condition: Crackled on the surface, but in a generally good state; the eyebrows of Trebonius retouched; the armour of Caius Lucius repainted, according to Dr. Klauner. Trebonius' hand and sword are barely visible in the lower centre.

Possible History: Venice, House of Zuanantonio Venier, 1528: 'Le due meze figure che si assaltano forono de Titiano.' It may be this picture (Marcantonio Michiel, edition 1888, p. 98).

Certain History: Duke of Hamilton, 1639–1643, Inventory 15, no. 24: 'A bare arme goeing to kyll a younge man, one more excell't piece of Tyssian or jorione' (Garas, 1967, pp. 52, 64); Archduke Leopold Wilhelm, Vienna, 1659, no. 237, *Il Bravo* by Giorgione (Berger, 1883, p. c). *Il Bravo* is visible in the foreground of David Tenier's *Leopold Wilhelm's Picture Gallery at Brussels* (Vienna); Stallburg (Storffer, I, 1720, no. 164, Giorgione); Belvedere Palace, Vienna (Mechel, 1783, p. 9, no. 31, Giorgione).

Bibliography: Van Dyck's 'Italian Sketchbook', 1622–1627, folio 65v, unidentified; Teniers, 1660, pl. 23 (Giorgione); Ridolfi (1648)-Hadeln, I, p. 101 (Giorgione); Boschini, 1660, edition 1966, p. 709 (Giorgione, then in Archduke Leopold Wilhelm's Collection); C. and C., 1871, II, p. 152 (school of Palma il Vecchio) Morelli, 1893, p. 21 (Cariani); Longhi, 1927, edition 1967, pp. 237, 458 (Titian); Suida, 1927, pp. 206–215; *idem,* 1935, pp. 30, 160 (Titian, *c.* 1520); Wilde, 1933, pp. 121–123 (Master of the Self-Portraits); Hermanin, 1930, p. 144 (Giorgione); Pergola, 1955, p. 105 (anonymous); Zampetti, 1955, p. 120, no. 51 (Giorgione); Baldass, 1957, pp. 134–136 (Titian); Berenson, 1957, p. 127 (Palma il Vecchio after a lost Giorgione); Klauner and Oberhammer, 1960, pp. 135–136, no. 709 (Titian); Valcanover, 1960, I, pl. 100 (Titian); *idem,* 1969, no. 97 (Titian); L. Venturi, 1962, p. 334 (Palma il Vecchio); Oberhammer, 1964, p. 134 (Titian); Baldass and Heinz, 1965, pp. 177–178, no. 42 (Titian); Klauner, Oberhammer, and Heinz, 1966, p. 54, no. 119 (Titian); Pignatti, 1969, pp. 137–138, no. A61 (Titian, *c.* 1515–1520); Pallucchini, 1969, p. 256, figs. 156–157 (Titian, *c.* 1520–1525); Wind, 1969, pp. 7–11 (copy of Giorgione, perhaps by Cariani); Panofsky, 1969 (omitted); Calvesi, 1970, p. 192 (Titian).

COPY:

London, Victoria and Albert Museum; canvas, 0·775 × 0·635 m. (Kaufmann, 1973, no. 341).

LITERARY REFERENCE:
Collection of Bartolomeo della Nave, Venice, 'A Souldier who drawing his dagger seiseth upon a Young Man', *palmi* 3½×3 (*c.* 0·78×0·67 m.); Varotari, il Padovanino (Waterhouse, 1960, pp. 12, 20, no. 203). This same item, also cited in the Duke of Hamilton's Inventory, 1649, no. 203, was a copy by Varotari of Cat. no. 3 (Garas, 1967, p. 76).

Concert champêtre, see: Pastoral Concert, Cat. no. 29.

4. Cupid Blindfolded (Education or Chastisement of Cupid) Plates 155, 158, 159

Canvas. 1·18×1·85 m.

Rome, Villa Borghese.

About 1565.

For further consideration of the place of the picture in the late career of the artist, see the text.

Iconography: The subject has been named the *Three Graces* rather consistently from the time of the earliest mention by Francucci in 1613. The Graces at the right hold Cupid's bow and arrows, while his mother Venus (also regarded as one of the Graces) binds his eyes so that he may not regain his weapons and stir up amorous misadventures in the world. The very nature of the blindfolding is associated with evil. Here the concept of two Cupids (Eros and Anteros) is clearly presented (see Pauly, 1907, X, pp. 483–543 and also Seyfert, 1901, pp. 225–226). Anteros, the god of sensual love, receives the blindfold, while Eros, the god of mutual love, whispers in his mother's ear, as he urges her to make his brother harmless.

Panofsky, in his learned study of the Blind Cupid (1939, pp. 95–128), developed a more complex explanation of the meaning of the two Graces who hold the bow and arrows, At first he interpreted them as Marital Love and Chastity. Thirty years later (1969, pp. 129–137) he modified their identities to become Pleasure and Chasity, but it is difficult to see how their attributes communicate these meanings.

Walter Friedländer, in his last article, written just before his death (1967, pp. 51–52), abandoned the traditional theories about the Borghese picture and held that Vesta, not Venus, is binding Cupid's eyes, and that her two assistants are Vestal Virgins. An attempt to interpret the woman who holds the bow as Diana and the other holding the arrows as one of her nymphs is no more successful (Wind, 1958, pp. 76–78). Where is Diana's attribute of the crescent moon or any other object to identify her? The fact that Franciscus van den Wyngaerde's print of *Cupid Blindfolded* is mislabelled with the caption 'Omnia Vincit Amor' (Paris, Bibliothèque Nationale, BC8, folio 55) demonstrates nothing but the confusion in the mind of the seventeenth-century engraver.

Condition: In a very bad state, the surface severely rubbed, losses of paint everywhere; the pink sky has turned brown at the right, but the distant blue Alpine mountains still survive intact. The lower left side of Venus is in a very bad and confused state.

History: Probably acquired by Scipione Borghese from Cardinal Paolo Sfondrato in 1608; the first mention in the Palazzo Borghese is presumably that of 1613, when Annibale Durante made a frame; Francucci in 1613 cites it as the 'Three Graces'; it appears in all of the Borghese inventories thereafter (Pergola, 1955, I, pp. 131–132); Borghese Inventory, 1693, no. 277: 'The Three Graces' (Pergola, 1964, p. 456).

Bibliography: See also above; Francucci, 1613, stanze 362–367; Van Dyck's 'Italian Sketchbook', *c.* 1622–1627 (Adriani, 1940, folio 113); Ridolfi (1648)-Hadeln, I, p. 197 (Three Graces); Manilli, 1650, p. 64 ('Venus and two nymphs'); C. and C., 1877, II, pp. 355–356 (*c.* 1565); Gronau, *Titian*, 1904, p. 295 (Titian, *c.* 1568); Valentiner, 1930, I, p. 25; Fogolari, 1935, no. 84 (*c.* 1560); Suida, 1935, pp. 125, 176; Tietze, 1936, II, p. 308; Pergola, 1955, I, pp. 131–132 (with further bibliography); Berenson, 1957, p. 190 (late Titian); Valcanover, 1960, II, pls. 114–116; Pallucchini, 1969, I, pp. 321–322, figs. 505–507 (Titian, *c.* 1566–1568); Panofsky, 1969, pp. 129–137.

COPIES AND VARIANTS:

1. Genoa, Palazzo Balbi, copy (Morelli, 1892, I, p. 235; lost or sold?).

2. Karlstad, Landsresidenset (on loan from Stockholm Museum, Inventory, N. M. 205); canvas, 1·12×1·53 m., hard copy (data in the Witt Library, Courtauld Institute, London).

3. Seville, Museo de Bellas Artes; canvas, 1·21×1·85 m. (Plate 223). This mechanical Italian copy has hard modelling and rather harsh colours. It was, moreover, considerably restored and repainted in 1969–1970. The picture is first identifiable in the Alcázar Inventory of 1686, a fact which more or less assures us that some Spanish courtier or ambassador to Rome purchased it in Rome under the illusion that he had an original. Gifts of this sort to the king were by no means unusual, and frequently important works of art entered the royal collection in this way, for example the Ferrara *Bacchanals* (Cat. nos. 13, 15).

History: Madrid, Alcázar, Bóvedas de Ticiano, Cupid Blindfolded by Venus, by Titian, 1¼×7 quarters ('siete quartas', *sic*), i.e. 1·043×1·46 m.; located next to the door opening upon the park; Alcázar, Inventory 1686, no. 883 (Bottineau, 1958, p. 324); Inventory 1700, no. 504. In April 1970 the picture was sent to Seville on permanent loan from

the storage of the Prado Museum, Inventory no. 2557 (Seville, *Exposición*, 1970, p. 12).

4. Location unknown, Venus and two Cupids; copy of left side of Borghese picture (*Apollo*, XI, 1930, Supplement, p. v).

LITERARY REFERENCE:
Van Dyck's copy (lost), his inventory, 1644: 'Una fictione Poetica di 3 Donne et due [?] Cupidetti' (Müller-Rostock, 1922, p. 22, no. 20).

Cupid Blindfolded, see also: Cat. no. X–5.

5. Danaë with Cupid Plate 81

Canvas. 1·20 × 1·72 m.

Naples, Gallerie Nazionali, Capodimonte.

1545–1546.

Iconography: The legend of the Danaë numbers among the amorous exploits of Jupiter, who in the form of a golden shower attained the girl, though she was locked in a brazen tower. The fullest account is that in Boccaccio's *Genealogie Deorum* (edition 1951, I, chapter 23). Ovid in his *Metamorphoses* (Book IV, 607–613) makes reference to the episode: 'There was one only, Acrisius, the son of Abas, sprung from the same stock, who forbade the entrance of Bacchus within the walls of his city, Argos, who violently opposed the god, and did not admit that he was the son of Jove. Nor did he admit that Perseus was the son of Jove, whom Danaë had conceived of a golden shower. And yet, such is the power of truth, Acrisius in the end was sorry that he had repulsed the god and had not acknowledged his grandson.' In Ovid's *Amores* and *Ars Amatoria* there are further brief allusions.

Condition: The surface of the paint has been excessively scrubbed, most of all upon the legs and torso of the Danaë, The head and left shoulder are smudged and thick with old repaint, and in the pale pink curtain at the left very little colour remains.

On its recovery from the Austrian salt mine in 1947, 'the *Danaë* was covered with mould, and the underpainting in tempera with oil finish in impasto makes such paintings highly sensitive to damp. The projection of colour along the cracks in Titian's painting, which are due to former rebacking, had swollen in the case of the *Danaë* and the *Lavinia* to an extent which would have been dangerous were the canvases suddenly dried. But with careful precautions the paintings were restored and the cracks and colours brought back to normal' (report of Rodolfo Siviero, 1947, p. 27).

History: Painted at Rome in 1545–1546. Michelangelo praised the picture but with the reservation that it was a pity

that the Venetians did not learn to draw (according to Vasari (1568)-Milanesi, VII, p. 447); Lodovico Dolce (1557, edition 1960, p. 161; edition Roskill, 1968, pp. 110–111) leaves no doubt that he is speaking of the Farnese *Danaë*, when he writes of 'that loveliest of nude figures for the Cardinal Farnese, which Michelangelo saw with amazement more than once'; eighty years later Ridolfi thought that the picture had been ordered by Ottavio Farnese (Ridolfi (1648)-Hadeln, I, p. 178). Following the lead of Crowe and Cavalcaselle (1877, II, p. 119) most writers have preferred to believe that Ottavio, a layman, rather than Cardinal Alessandro Farnese, ordered this frankly erotic composition. This erroneous history has become a commonly accepted 'fact', which even the most recent writers have repeated (Pallucchini, 1969, p. 283; Panofsky, 1969, p. 144).

It seems unlikely that Ottavio ever owned the *Danaë* and the *Venus and Adonis* (Cat. no. L–19), since he would most probably have taken his possessions to Parma, when he settled there as duke in 1551 (see Wethey, II, 1971, Cat. no. L–14). In 1581 the *Danaë* was located in Cardinal Farnese's apartment in Rome (Gronau, 1936, p. 255). In 1648 the canvas still hung in the Palazzo Farnese at Rome, as Ridolfi stated, a fact confirmed by a hitherto unknown inventory of 1649 (to be published by Charles Hope). Nevertheless, the *Danaë* does not appear among works shipped from Rome to Parma in 1662 (Filangieri di Candida, 1902, pp. 267–270). It turns up for the first time at the Palazzo del Giardino, Inventory 1680, size *braccia* 2 *once* 2½ × *braccia* 3 *once* 1½, i.e. about 1·39 × 1·90 m. (Campori, 1870, p. 212; also Filangieri di Candida, 1902, p. 277, no. 16); Palazzo del Giardino, Inventory *c.* 1710, no. 87, 'Tiziano Danae e pioggia d'oro', same size as above (Filangieri di Candida, 1902, p. 282); taken to Naples about 1759 (Rinaldis, *loc. cit.*); seen in the royal gallery at Capodimonte in 1780 (Jones, edition 1946, p. 100); 1798 transferred to Palermo from the royal palace at Portici; Palermo Inventory 1807, no. 5 (Filangieri di Candida, 1902, p. 320); 1815 returned to Naples (*loc. cit.*, p. 237).

The *Danaë* from Naples was looted by the Hermann Göring division during World War II and later discovered in the Austrian salt mine at Bad Aussee. It was brought to the Munich Collecting Point on 15 July 1945 and returned to the Italian government 13 August 1947. For this information I am indebted to Dr. Rike Wankmüller, who was in 1972 in charge of the archives of the Oberfinanzdirektion at Munich (letter of 14 March 1972 directed to me). Professore Italo Faldi, director of the Gallerie Nazionali at Rome, also assisted me in solving the puzzle of the Göring *Danaë*.

The report of the recovery of this and other pictures was made by Dr. Rodolfo Siviero in a lecture at the Accademia dei Lincei in Rome on 9 November 1947 (Siviero, 1948, pp. 5–15 in Italian; pp. 19–27 in English). An illustration

appeared in the *Sunday News*, New York, 14 December 1947 (clipping in the files of the Frick Art Reference Library).

Bibliography: See also above; Ridolfi (1648)–Hadeln, I, p. 178 (repeats Vasari); C. and C., 1877, II, pp. 119–122; Phillips, 1898, p. 78 (the best version); Gronau, *Titian*, 1904, p. 294; Rinaldis, 1911, pp. 141–144; edition 1927, pp. 325–327; Fischel, 1924, pp. 130–131; Suida, 1935, pp. 117, 175; Tietze, 1936, II, p. 302; Bock von Wülfingen, 1953, pp. 68–84; the same article in a booklet, 1958, pp. 3–32; Valcanover, 1960, II, pl. 4; Molajoli, 1964, p. 46; Pallucchini, 1969, p. 283, figs. 301–303; Panofsky, 1969, pp. 144–147.

COPIES:

1. Bayonne, Musée Bonnat; the figure of Danaë alone, drawing on beige paper, 188×294 mm., Italian copy (Bean, 1960, no. 175, illustrated). Attributed to Rubens by Jaffé (1966, p. 129).
2. Bombay, Prince of Wales Museum; canvas, 1·143× 1·626 m.; modern copy (photograph, Witt Library, Courtauld Institute, London).
3. Cobham Hall, Lord Darnley (formerly); canvas, 1·385× 1·867 m.; the description in the sales catalogue seems to correspond to the Naples composition with the addition of a salver and ewer at the left (Waagen, 1854, III, p. 19: too feeble for Titian; C. and C., 1877, II, p. 230, note: Venetian adaptation of the Naples original). Sold with Darnley Collection at Christie's, London, 1 May 1925 (*APC*, IV, 1924–1925, no. 5021). E. K. Waterhouse reports that the picture which he saw at the 1925 sale was mediocre and that a dealer purchased it for 160 guineas. A sketch by Cavalcaselle confirms the composition (Victoria and Albert Museum, 72C, folio 1286).
4. Germantown (New York), Willard B. Golovin (in 1971); Plate 195; canvas, 1·067×1·626 m.; copy of the Naples original; first published by Tietze as an original *c.* 1540, earlier than the Naples *Danaë* (Tietze, 1954, pp. 206–208). Tietze thought in 1954 that the Golovin picture might be the one from Northwick Park, but that item remained at Northwick until 1966 (see below, copy 10). Panofsky, 1969, p. 144, note 14, called it a workshop variant; he, nevertheless, confused it with the Hickox version (now in the Art Institute, Chicago), which has no Cupid and no nursemaid (see Cat. no. X-10). Valcanover, 1969, no. 274 (workshop of Titian); Pallucchini, 1969, p. 284 (workshop derivation).
5. Imbersago (Como), Villa Mombello, Princess Pio, possibly the same item as Cat. no. 7, Literary Reference, no. 5.
6. Liverpool, Clements Collection; copy; Photograph, Witt Library, Courtauld Institute, London; unknown to the Walker Art Gallery, Liverpool.
7. London, Dudley House; small variant, canvas, 0·965×

1·473 m.; exhibited at Royal Academy 1873 (C. and C., 1877, II, p. 123, note; Graves, 1914, p. 1321; Rinaldis, 1911, p. 144).
8. London, Wallace Collection; canvas, 0·32×0·447 m.; small copy, eighteenth century (?). *History:* Sir Richard Worsley purchased it in Italy about 1793–1797, as a copy by Salvatore Rosa (Worsley, 1804, p. 39); Colonel Sibthorpe (sale London, Christie's, 9–12 April 1856, no. 555); purchased by Lord Hertford in 1856. *Bibliography:* C. and C., 1877, II, p. 123, note (copy); Wallace Collection, Catalogue, 1968, pp. 325–326.
9. Madrid, Museo Cerralbo; Inventory no. 4714; red chalk, 220×221 mm.; free adaptation of the Naples version; certainly a work of the seventeenth century and unlike Titian's drawings; sketch of a full-length draped woman in reverse position. (Battisti, 1954, p. 195, figs. 5, 6 as Titian.)
10. Northwick Park, Lord Northwick (formerly) and descendants, the Spencer-Churchills; canvas, 1·17×1·727 m., weak copy. Photograph, Witt Library, Courtauld Institute, London. *History:* Said to have been purchased from a Prince Belvedere of Naples by Lord Northwick in 1795; sold by Spencer-Churchill at Christie's, London, 25 February 1966, no. 52 (*APC*, XLIII, 1965–1966, no. 2223). *Bibliography:* Northwick catalogue, 1864, no. 60 (Titian); C. and C., 1877, II, p. 123, note (copy); Borenius and Cust, 1921, no. 74.
11. Prague, Nostitz Collection; canvas, 1·13×1·71 m. (Nostitz catalogue, 1905, p. 57, no. 225; listed in an inventory of 1765); cited by C. and C., 1877, II, p. 122, note (later feeble copy).
12. Unknown location: Miscellaneous mediocre copies: Jongoli Collection, Florence; sale of William II, Stuttgart, 26–27 October 1920, canvas, 1·20×1·69 m.; R. Bunny, London (photographs of the above in the Witt Library, Courtauld Institute, London); a *Danaë*, apparently of the Naples type, exhibited at Milan in 1874 and at Angers in 1875 (C. and C., 1877, II, p. 230, note).

FREE ADAPTATIONS (Naples type):

1. Bassano del Grappa, Museo Civico, in storage (1971); canvas, 1·30×0·90 m.; crude version with a dog at the feet of the Danaë instead of Cupid.
2. Venice, Accademia; *Venus*, canvas, 0·60×0·78 m.; freely based on Titian's *Danaë*, with no Cupid (C. and C., 1877, II, p. 123, note, attributed to Contarini; Moschini Marconi, 1962, p. 110, no. 181, illustrated, attributed to Giovanni Contarini, late sixteenth century).

6. Danaë with Nursemaid

Plates 83, 85, 90

Canvas. 1·29×1·80 m. Colour reproduction

Madrid, Prado Museum.

Documented 1553–1554. Not signed.

Iconography: The source here is primarily Boccaccio's *Genealogie Deorum* (edition 1951, chapter 23) and to some extent Ovid's *Metamorphoses*, IV, 607–613, as for the Naples version (Cat. no. 5), but with the important change that a nursemaid or maidservant catches some of the golden rain in her apron. Replacing the Cupid at Naples (Plate 81), she seems to have been introduced into the legend by the Greek poet Apollonius of Rhodes (third century, B.C.): 'He [Acrisius] carried Danaë off to Argos and in the hall of his house he made a brazen chamber beneath the earth, and he led her into it with a nurse' (Wendel, 1935, p. 305). I can find no such reference in Ovid's *Ars Amatoria*, III, 415–416 (given by Panofsky, 1969, p. 145, note 16). Horace does allude to the subject: 'Tower of bronze, doors of oak, and the strict guard of watch-dogs had quite protected imprisoned Danaë from nocturnal lovers, had not Jupiter and Venus laughed at Acrisius, anxious keeper of the hidden maiden. For they knew that the way would be safe and open, when the god had turned to gold' (Horace, Odes III, XVI, 1–8).

Condition: In an exceptionally fine state of preservation; not cleaned recently. An analysis of the condition and the colours was made by Keller (1969, pp. 139–142), but it is a mistake to assume that the *Danaë* was damaged in the fire of the Alcázar in 1734, since the flames did not reach the 'Bóvedas de Ticiano' (see note 409), where this picture was located. There is some inpaint on the right hip and the abdomen; no X-rays of this picture have been made. The Alcázar Inventory, 1636, folio 50, describes in the upper part an eagle of Jupiter, which no longer exists, owing to reduction in size of the canvas ('en lo alto una águila con las impresas de Jupiter'); slightly earlier Cassiano dal Pozzo (1626, folio 121v) makes note of Jupiter's face but no eagle.

Documentation: Titian's letter of 23 March 1553 to Philip makes the first reference to *le poesie* (C. and C., 1877, II, p. 505; Cloulas, 1967, p. 217), by which he must have meant the *Danaë* and the *Venus and Adonis*, since both were delivered by the following year.
An undated letter from Titian to Philip speaks of having already sent the *Danaë* and of the intention to have the *Venus and Adonis* ready soon. It was published by Titian's friend Dolce (in 1554 and 1559, pp. 229–230) without date, but it must have been written before Philip's marriage to Mary Tudor in August 1554, since he is still called 'Principe Serenissimo' in 1554 (letter republished by Ticozzi, 1817, pp. 311–312; also Bottari, edition 1822, I, pp. 329–330 and again II, p. 25; C. and C., 1877, II, p. 227, note 2).
The *Danaë* presumably reached Madrid before Philip embarked for England at the port of La Coruña on 13 July 1554 (Walsh, 1937, p. 133), since Titian assumed that Philip had already seen the picture.
For other letters concerning the *Venus and Adonis*, see Cat. no. 40, Documentation.
The hypothesis that Philip II ordered the *Danaë* because he had seen at Genoa in 1548 the Farnese version, which had been done in Rome in 1545–1546 (Plate 81) (Gould, 1964, p. 113), encounters two major objections. It is not at all true that Ottavio Farnese, who had married Charles V's illegitimate daughter, Margaret, was the owner of the picture (see Cat. no. 5, History). Secondly the detailed chronicle of Philip's visit to Italy in November–December 1548 shows that Ottavio never went to Genoa to meet the heir to the Spanish throne. Pope Paul III appointed as special ambassador for the occasion the Archbishop of Matera (Calvete de Estrella, edition 1930, I, p. 36). Philip was lodged in the Renaissance villa of Andrea Doria in Genoa. Ottavio joined Philip at the moment of departure of the Spanish party from Villafranca, north of Mantua. He accompanied the prince for ten miles to Gottolengo (Calvete de Estrella, edition 1873, pp. 35–109; edition 1930, I, p. 114), and the following day he departed. It seems unlikely that he took any paintings on this short visit. If he had, courtesy would have required that he make presents of them to Philip.

History in Spain: The first mention of the mythological pictures in the Alcázar (Royal Palace) at Madrid in a hall next to the Garden of Roman Emperors is vague: 'fábulas de mano del gran Ticiano' (González Dávila, 1623, p. 310). Three years later Cassiano dal Pozzo (1626, folio 121v) specifically describes 'la favola di Danae e Giove in pioggia d'oro ... è una vecchia ritrattata con estrema diligenza'. It hung next to the *Rape of Europa*, and not even in the same room with its intended companion, the *Venus and Adonis*.
Very strange is the next citation by Vicente Carducho in 1633, who classified the *Danaë* as a copy (Carducho, edition 1933, p. 108). That is unquestionably an error, because two pages later he speaks of the *Diana*, *Europa*, and *Danaë* which had been packed as gifts for Charles I of England but were never sent (*loc. cit.*, p. 110).
The Alcázar Inventory of 1636 (folio 50) reveals that the pictures had been moved to the 'Pieza última de las bóvedas que tiene bentana al lebante en que su Magestad retira después de comer' and that the *Danaë* hung to the right of the *Venus and Adonis* and next to the *Perseus and Andromeda*. Meantime the vaulted rooms on the ground floor had been reconstructed.
In the Alcázar Inventory of 1666, the *Danaë*, no. 699, hung between Veronese's *Venus and Adonis* and Titian's *Venus at her Toilet* in the 'Galería baja del jardín de los emperadores' on the south-west (see text, Part V). Inventory 1686, no. 872, now called the 'Bóvedas de Ticiano' (see Bottineau, 1958,

p. 322). Inventory 1700, no. 494; the Inventory of 1734, no. 36, after the destruction of the Alcázar by fire, classifies the picture as undamaged ('bien tratado', i.e. 'well treated'). At the death of Philip V the royal collection was in the Palace of Buen Retiro; Inventory 1747, no. 158, Titian's *Danaë.*

When the new Royal Palace became ready for occupancy many of the nudes, including the *Danaë,* were transferred to a neighbouring building called the Casa de Reveque (Ponz, 1776, VI, Del Alcázar, 62); 1762 removed from the Royal Palace for safekeeping by the painter Mengs, who kept them in his own house; 1792–1796 the prudish Charles IV of Spain planned to have the nudes destroyed by fire, among them the *Danaë,* 1796–1827 kept in the Academia de San Fernando under lock and key (Sentenach, 1921, pp. 46–55; Beroqui, 1946, pp. 151–153); 1827 removed to the Prado Museum.

Bibliography: See also above; Vasari (1568), no mention; Madrazo, 1872, p. 679, no. 458 (confused with Cat. no. X–13 in London); C. and C., 1877, II, pp. 227–230; Phillips, 1898, p. 78 (symbolic of the lowest and most venal form of love!); Gronau, *Titian,* 1904, p. 141, 303; Fischel, 1924, p. 186; Suida, 1935, pp. 118, 175; Tietze, 1936, II, p. 298; Beroqui, 1946, pp. 137–140; Berenson, 1957, p. 187; Valcanover, 1960, II, pl. 58; Keller, 1969, pp. 134–142; Pallucchini, 1969, pp. 139, 300, figs. 386, 387, colour reproduction XLII; Panofsky, 1969, pp. 23, 144–150.

PURPORTED RELATED SKETCH:
Drawing, Bayonne, Musée Bonnat; caricatured head; bistre ink on beige paper, 45×43 mm. Inventory no. 617a, correctly classified at Bayonne as Italian School, sixteenth century (Bean, 1960, no. 254). This sketch of a head was recently attributed to Titian and proposed as a study for the nursemaid in the *Danaë* of the Prado Museum (Bauch, 1965, pp. 37–39, fig. 3; accepted by Panofsky, 1969, p. 149, note 32). Neither proposition is convincing, for the quality of the drawing does not suggest Titian. Moreover, it shows an old man with prominent Adam's apple and a cap on the back of his bald head who does not resemble the nursemaid. They have in common only the profile position.

7. **Danaë with Nursemaid** Plate 82
Canvas. 1·35×1·52 m.
Vienna, Kunsthistorisches Museum.
Signed at lower right on the bed: TITIANVS AEQVES. CAES.
Titian and workshop.
About 1555–1560.

This version, later than the one sent to Philip II in 1554, differs in that the maidservant now holds a large golden salver to catch the golden rain. A cluster of roses and a few coins lie upon the bed. Particularly lovely are the rose curtain against the white sheet and the pillows and the delicate rose flesh-tints of the blonde Danaë, whose pose and soft sensuality of body are nearest to the Madrid *Danaë* (Plate 83). Although the Vienna picture is a work of good quality, it is generally agreed that accessories and perhaps the nursemaid were left in part to an assistant.

Condition: Somewhat crackled, but generally well preserved.

History: On 27 July 1600 Cardinal Montalto at Rome wrote to Emperor Rudolf II at Prague that he was sending, apparently as a gift, a picture of the *Danaë* by Titian; on 21 August the Emperor wrote a letter of thanks to the Cardinal (Voltelini, 1898, p. XVI, nos. 16,184 and 16,185); listed in the Prague inventories 1638 and 1718; taken to Vienna in 1723, no. 202 (Klauner and Oberhammer, 1960, p. 142, no. 720).
Engerth mistakenly thought that the Vienna *Danaë* had previously been the property of Cardinal Granvelle at Besançon (Engerth, 1884, p. 351, no. 500). That version, now lost, was still at Besançon in 1607 according to the inventory of that year (see Literary Reference no. 2).

Bibliography: See also above; Ridolfi (1648)–Hadeln, I, p. 196 (reference to Rudolf's *Danaë*); Storffer, 1733, III, p. 135; Stampart, 1735, edition 1888, pl. 10; Mechel, 1783, p. 27, no. 44; C. and C., 1877, II, p. 230 (Titian assisted by Cesare Vecellio or Girolamo Dente); Engerth, 1884, p. 351, no. 500; Phillips, 1898, p. 78 (workshop); Suida, 1935, pp. 118, 213 (late Titian; gives wrong history); Tietze, 1936 and 1950 (omitted!); Zarnowski, 1938, p. 122 (Titian assisted by Girolamo Dente); Tietze–Conrat, 1956, pp. 82–84 (Titian); Berenson, 1957, p. 191 (Titian in great part); Valcanover, 1960, II, pl. 60 (largely autograph); Klauner and Oberhammer, 1960, no. 720 (partly workshop); Keller, 1969, p. 193 (replica); Pallucchini, 1969, p. 309, fig. 448 (Titian and workshop, 1555–1560); Panofsky, 1969, p. 149, note 13 (replica).

VARIANT BY TENIERS:
In Teniers' painting of the *Gallery of Archduke Leopold at Brussels* (c. 1651), now in the Prado Museum at Madrid, one of the pictures is a *Danaë* labelled 'Titianus' (Plates 202, 204). It resembles no other example, original or copy, in many respects: the Danaë looks upward to our left as she holds the large plate with her right hand and rests her left arm across her middle. The attitude of the nursemaid at the right and the introduction of a large hound are unprecedented. The conclusion that this picture is a free invention by a *seicento* imitator of Titian, probably Teniers himself, is further

supported by the clearly Baroque draping of the canopy over the Danaë and by the non-Titianesque landscape.

Further mystery is added by the fact that this same composition (reversed in the print) is repeated in the *Theatrum Pictorium* (Teniers, 1660, pl. 74), representing the pictures in Archduke Leopold Wilhelm's Collection at Brussels. The Vienna *Danaë* is not included with Leopold's pictures because that version was then in the Hapsburg Collection at Prague (see Cat. no. 7). The Teniers–Titian *Danaë* seems not to have been taken from Brussels to Vienna when the Archduke changed his residence, since it does not appear in the inventory of his collection after the move (also Plate 210).

COPIES (*Danaë*, Vienna type):

1. London, Lady Malmesbury, sale, 1876 (C. and C., II, p. 230, note).

2. Unknown location; canvas, 1·405×1·675 m.; probably by a follower of Titian; inscribed: TITIANVS FECIT. The maidservant holds the large platter as in the Vienna picture, while the roses and the coins upon the bed have been increased in quantity. *History:* Not from the Orléans Collection, Paris, as sometimes claimed; Earl of Pembroke; J. L. Markerow, London; Sedelmeyer, Paris, sale 1895, no. 58; Rodman Wannamaker, Philadelphia; Nemes Collection, sale Munich, 16 June 1931, no. 33 (Plate 198); gift to the Berlin Staatliche Museen in 1936; acquired by Joseph Goebbels 1938 (information from the Berlin Museum archives in 1970). Pallucchini, 1969, p. 309, states incorrectly that the picture is still in the Berlin Museum.

LITERARY REFERENCES (various types):

1. Antonio Moro copied the Madrid *Danaë* (Palomino, 1724, edition 1947, pp. 779–780).

2. Besançon, Granvelle Palace, *Danaë* by Titian; canvas, 3×5½ *pouces*, i.e. about 0·97×1·78 m.; Inventory of 1607, no. 462 (Castan, 1867, p. 127). See also Cat. no. X–12, History.

3. London, W. Young Ottley Collection, sale at Christie's, 16 May 1801, no. 49 (Buchanan, 1824, II, p. 30; obviously a copy because of the small price paid for it).

4. Parma, Palazzo del Giardino; copy by Francesco Quattro Case (*c.* 1670) after the Farnese–Naples original, *braccia 2 once* 3 × *braccia 2 once* 4, i.e. about 1·40×1·45 m. (Campori, 1870, p. 280; C. and C., 1877, II, p. 122; Rinaldis, 1911, p. 144).

5. Rome, Prince Pio, Inventory 1742 and also 1776; 'Danaë with a Boy' (Cittadella, 1868, I, p. 556; C. and C., 1877, II, p. 122, note). See also Cat. no. 5, copy 5.

6. Wrexham, Major W. Cornwallis West; exhibited at the Royal Academy in 1876 as a copy, type unspecified (Graves, 1914, III, p. 1323).

7. Unknown location; type unspecified; canvas, 2 *pies* 3 *pouces*×3 *pies* 1 *pouce*, i.e. about 0·73×1·00 m.; sale of

Cardinal Fesch, from Palazzo Ricci, Rome (Fesch catalogue, 1845, II, p. 144).

Danaë, see also: Omnia Vanitas, Cat. no. X–30.

8. Death of Actaeon

Canvas. 1·79× 1·98 m.

London, National Gallery.

Plates 151–153

Colour reproduction

Projected about 1559–1560; painted about 1570–1575.

Iconography: The tragic sequel to the legend of Diana and Actaeon, recounted in Ovid's *Metamorphoses*, III, 191–252, has been illustrated by no other great master. Titian normally chose the gayer moments in the lives of the gods, possibly one of the reasons why the *Death of Actaeon* was never delivered to Philip II. Ovid wrote: '... "Now you are free to tell that you have seen me all unrobed—if you can tell." No more than this she spoke; but on the head which she had sprinkled she caused to grow the horns of the long-lived stag, stretched out his neck, sharpened his ear-tips, gave feet in place of hands, changed his arms into long legs, and clothed his body with a spotted hide. And last of all she planted fear within his heart. Away in flight goes Autonoë's heroic son, marvelling to find himself so swift of foot. But when he sees his features and his horns in a clear pool, "Oh, woe is me!" he tries to say; but no words come. ... The whole pack, keen with the lust of blood, over crags, over cliffs, over trackless rocks, where the way is hard, where there is no way at all, follow on. He flees over the very ground where he has oft-times pursued; he flees (the pity of it!) his own faithful hounds. He longs to cry out: "I am Actaeon! Recognize your own master!" But words fail his desire ... and well might he wish to see, not to feel, the fierce doing of his own hounds. They throng him on every side and, plunging their muzzles in his flesh, mangle their master under the deceiving form of the deer. Nor, as they say, till he had been done to death by many wounds, was the wrath of the quiver-bearing goddess appeased. ...'

Condition: In excellent condition; some final glazes were not added, but losses are minimal. The string on the bow and the arrow were apparently never painted. X-rays made at the Courtauld Institute (Plate 152A) in 1961 show that Titian changed the position of Diana more than once before deciding on the final pose.

History: The X-rays and the unfinished state of the *Death of Actaeon* are the chief evidence for the belief that the London picture may be the work begun by Titian in 1559, since the artist never shipped it to Philip II, as he had originally intended. A letter from Titian to Philip II, dated 19 June

1559, promises that he will furnish a *Europa* and an *Actaeon attacked by his dogs*; on 22 April 1560 Titian writes that he will complete the fable of *Europa*, but he never again mentions the other picture (C. and C., 1877, II, pp. 275–276, 512–513, 534; Cloulas, 1967, pp. 233, 245, 246, 253). Nor does it appear in any of the Spanish sources, such as the royal inventories, or the writings of Carducho and Cassiano dal Pozzo. The reasons why Titian never delivered the *Death of Actaeon* to Philip are not difficult to deduce. First the subject is rather gruesome, and secondly it does not form a suitable companion piece in theme or in composition to the gay and spirited *Rape of Europa* (Plate 141), as already noted.

Collection of Archduke Leopold Wilhelm. The belief that this *Death of Actaeon* had belonged to Leopold Wilhelm was advanced by Fischel (1924, pp. 197, 320); repeated in the catalogue of the Royal Academy exhibition (London, 1930, p. 114, no. 169). When Borenius wrote the catalogue of the Harewood Collection (1936, no. 68), he accepted the theory that the picture had passed from Leopold Wilhelm to Queen Christina, and this history has been adopted by Tietze (1936, II, p. 293), the organizers of the exhibition of Queen Christina (Stockholm, 1966, pp. 247, 436), and Panofsky (1969, p. 162, note 63).

A *Death of Actaeon* is included in the publication of the archduke's collection, *Theatrum Pictorium* in 1660, pl. 73, 9 × 12 *palmi*. However, in the print the figure of Diana is complete, whereas the London version cuts through the goddess's left leg and skirt. This print represents a second larger version of the same subject, which came from the della Nave and Hamilton Collections (see Literary Reference no. 4).

Panofsky's suggestion that Queen Christina had purchased hers from Leopold Wilhelm on her visit to Brussels in 1655 is correct. The picture appears at the upper right in the *Gallery of Leopold Wilhelm at Brussels* by Teniers (*c.* 1651), now in the Musée Royal at Brussels (Plate 210), where the frame cuts through the foot and skirt of Diana just as in the London masterpiece (Plate 152). The dimensions of Christina's canvas were given as 7½ × 8 *palmi* (1·67 × 1·787 m.) and that size compares favourably with the London painting (1·79 × 1·98 m.).

From the time Queen Christina came into the possession of her *Death of Actaeon*, the history of her version is continuous and unbroken. The first listing is in the Inventory of 1662, folio 45, after she had settled in the Palazzo Riario, Rome: 'Diana in piedi in atto di havere saettato Atteone che lontano si vede preso da cani in una bellissima figura al naturale alta palmi otto e mezzo e larga palmi nove e mezzo, Di Titiano.' Queen Christina also had a smaller copy, perhaps by Teniers (Inventory 1662, folio 56). For other dimensions see below. At the death of Queen Christina, Inventory 1689, no. 14 (Granberg, 1897, p. 36, no. 37; also Campori, 1870, p. 339);

10

Inventory of 1721, no. 9, 7½ × 8 *palmi* (Granberg, *loc. cit.*, Appendix III, p. 14); bequeathed by Queen Christina to Cardinal Decio Azzolino, 1689; Marchese Pompeo Azzolino, 1689–1692; sale to Prince Odescalchi, 1692, no. 14; Odescalchi Collection, Rome, 1692–1721: 'Nota dei quadri della Regina Christina', no. 48, 'Diana alla Caccia quale avuto scoperto Atteone che la mirava nel trasmutarlo in Cervo . . . di Titiano'; Inventory of Livio Odescalchi, 1713, folio 70v; Odescalchi sale to the Duc d'Orléans, 1721, no. 9 (Odescalchi archives (Rome)); Orléans Collection, 1721–1792 (Dubois de Saint Gelais, 1737, p. 471; Couché, 1786, pl. x).

At the sale of the Orléans Collection in London in 1798, Sir Abraham Hume purchased the picture for 200 guineas, a modest sum since the *Diana and Actaeon* (Cat. no. 9) and the *Diana and Callisto* (Cat. no. 10), now at Edinburgh, brought 2500 guineas probably for the pair (Buchanan, 1824, I, p. 113). It was apparently shown at the British Institution, 1819, no. 118, as a sketch (Graves, 1914, III, p. 1316). Lord Alford inherited the picture in 1845; it was bequeathed to Lord Brownlow, who owned it *c.* 1850–1919 (Waagen, 1854, II, pp. 313–314). Lord Brownlow sold the picture to Lord Harewood through Colnaghi's (Waterhouse, 1966, p. 374, no. 58). Lent by the Harewood estate to the National Gallery in London from *c.* 1961 to 1971; sale at Christie's 25 June 1971; purchased for J. Paul Getty through Julius Weitzner for £1,680,000; acquired by the National Gallery with the aid of public subscription in 1972.

Bibliography: See also above; Vasari (not mentioned); C. and C., 1877 (not mentioned); Waagen, 1838, II, p. 17 (Titian); Gronau, 1904 (omitted); Fry, 1911, p. 162 (favourable account, Titian); Borenius, 1936, pp. 34–37 (Titian); Suida, 1935, pp. 123, 177 (Titian, 1559); Tietze, 1936, II, p. 293 (Titian, *c.* 1560); Hetzer, 1940, p. 166 (attributed to the author of the Naples *Annunciation*); Berenson, 1957, p. 186 (Titian, 1559); Valcanover, 1960, II, pl. 87 (Titian, 1559); Keller, 1969, pp. 162–165 (Titian; left third repainted *c.* 1650); Pallucchini, 1969, p. 307 (Titian, 1559); Panofsky, 1969, pp. 161–163 (Titian, *c.* 1568).

LITERARY REFERENCES:

1. London, Benjamin West (formerly); canvas, 1·245 × 1·803 m. (Benjamin West sale, Christie's, 23 June 1820, p. 21, no. 85, claimed to be the original).

2. Rome, Palazzo Riario, Queen Christina (formerly); she then owned the London original as well as a smaller copy: 'Una Diana in piedi in atto di haver saettato Atteone alta palmi sei e larga palmi sette [1·34 × 1·56 m.]—viene da Titiano' (Christina's Inventory 1662, folio 56).

3. Vienna, Maximilian II; in 1568 a *Death of Actaeon* was probably sold by Titian to Maximilian II (Voltelini, 1893,

p. XLVII, no. 8804). This picture might have passed to Emperor Rudolf II at Prague, but it has not been located in the Prague inventories. If it belonged to Rudolf II, it would then have been captured by the Swedes for Queen Christina, but it does not appear in the booty from Prague either. Panofsky thought that the item of 1568 was inherited by Archduke Leopold Wilhelm, who then sold it to Queen Christina (Panofsky, 1969, p. 162, note 63). However, this version must have been finished, unlike the London original. The fact is that we have no idea what happened to the seven 'fables' bought from Titian by Maximilian II excepting only the *Diana and Callisto*, which is still in Vienna (Cat. no. 11).

4. Vienna, Leopold Wilhelm (earlier in Brussels); (Plate 211) a large picture measuring 9 × 12 *palmi* (about 2·01 × 2·68 m.; Teniers, 1660, pl. 73). The collection of Bartolomeo della Nave, Venice, 1630, was sold to Lord Feilding on behalf of the Marquess of Hamilton; Hamilton Inventory 1638–1639, no. 9: 'A Diana Shooting Adonis [*sic*] in the form of a Hart not quite finished. Pal. 12 × 10. Titian' (i.e. 2·23 × 2·68 m.; Waterhouse, 1952, pp. 8, 15, no. 9). The order of the height versus width is reversed in this inventory, but it should be noticed that the dimensions of these two correspond and those of Queen Christina's picture were much smaller (7½ × 8 *palmi*). See above, Cat. no. 8, History. The Hamilton Collection went to Brussels between 1648 and 1651. This second version remained in the Austrian collections and last appeared in Stampart's print in 1735 (edition 1888, pl. 18).

9. Diana and Actaeon

Plates 142, 144–147

Canvas. 1·88 × 2·06 m.

Colour reproduction

Edinburgh, National Gallery of Scotland, on loan from the Duke of Sutherland.

Documented 1556–1559.

For a general discussion of both Cat. nos. 9 and 10 see the text.

Iconography: The fullest source of the legend of Diana and Actaeon is Ovid's *Metamorphoses*, III, 138–252. Although Boccaccio's *Genealogie deorum* was equally familiar, his extremely brief account does not explain all of the elements in Titian's picture. Ovid, on the other hand, goes on to considerable length in his description of Actaeon's mishap and the terrible fate which ensued. 'There was a vale in that region, thick grown with pine and cypress with their sharp needles. 'Twas called Gargaphie, the sacred haunt of high-girt Diana. In its most secret nook there was a well-shaded grotto, wrought by no artist's hand. But Nature by her own cunning had imitated art; for she had shaped a native arch of the living rock and soft tufa. A sparkling spring with its slender stream babbled on one side and widened into a pool

girt with grassy banks. Here the goddess of the wild woods, when weary with the chase, was wont to bathe her maiden limbs in the crystal water. On this day, having come to the grotto, she gives to the keeping of her armour-bearer among her nymphs her hunting spear, her quiver, and her unstrung bow; another takes on her arm the robe she has laid by; two unbind her sandals from her feet. But Theban Crocale, defter than the rest, binds into a knot the locks which have fallen down her mistress' neck, her own locks streaming the while. Others bring water, Nephele, Hyale and Rhanis, Psecas and Phiale, and pour it out from their capacious urns. And while Titania is bathing there in her accustomed pool, lo! Cadmus' grandson, his day's toil deferred, comes wandering through the unfamiliar woods with unsure footsteps, and enters Diana's grove; for so fate would have it. As soon as he entered the grotto bedewed with fountain spray, the naked nymphs smote upon their breasts at sight of the man, and filled all the grove with their shrill, sudden cries.'

Condition: The two pictures of *Diana and Actaeon* and *Diana and Callisto* are still magnificent works of art despite damage inflicted in transportation, relining, varnishing, and restoration. Kennedy North's report upon their condition, when he cleaned them, contains a number of specific statements. In addition, the X-rays made in 1932, now in the archives of the museum at Edinburgh, supply further data.

The pictures of the Orléans Collection at Paris had been heavily varnished according to a letter of Walpole to Lord Stafford in 1771. That general statement about the collection as a whole doubtless applied to the Titians as well. Kennedy North reported that the relining was British, when he began his restorations, and therefore it must have taken place about 1800. He also confirms the existence of heavy varnish and some repaint before 1932 (Kennedy North, 1933, pp. 10–15; Keller, 1969, pp. 149–152).

Although the recent restorer attested that he added 'no painting, glazing or scumbling of any kind', an examination of the picture leaves the impression that he was over-zealous in removing earlier retouchings and varnish. Many parts of the pictures are now reduced to the bare canvases, and that was not the case in the photographs taken before the restoration of 1932.

Of the two canvases, the *Diana and Actaeon* is in much the better condition. The crackle on the bodies of Actaeon and Diana does not interfere with enjoyment of the picture, if the spectator assumes a reasonable distance. Diana's body is, however, much rubbed on the edges, and her right foot is badly damaged. Best preserved are the Negress at the extreme right and the seated girl closest to Actaeon. The landscape appears to have escaped the over-zealous activities of restorers.

A signature TITIANVS F on the pier below the stag's skull was

removed in 1932 on the theory that it was not placed there by the artist.

The *Diana and Callisto* is far more badly damaged than the companion piece. The worst is the figure of Diana herself, the face nearly destroyed and her entire body badly scrubbed and damaged. There seems to be less paint left than before the restoration, but presumably Diana as the main figure had been over-restored. The veil placed upon her middle in post-Titian days was removed in 1932. Differences of opinion will always exist as to whether it is preferable to leave some old repaint rather than to remove it and thus reduce the figure down to the canvas.

In cleaning off the veil that had been added to Callisto's abdomen nothing is left but unpainted canvas. That accounts for what appears in photographs to be a deep shadow. The peculiar area of Callisto's navel is also raw canvas now, because of the removal of over-painting.

Among the figures that have survived relatively intact are the standing girl at the extreme left (although an added veil over her abdomen was removed), the most distant girl in this group, and the group of nymphs to the right beyond Diana. Repaired noses are the major shortcomings here.

The landscape and the fountain have come down through the centuries in remarkably beautiful condition, again a testimony to the fact that they were left alone by restorers who wanted to improve the figures. Like all old pictures on canvas, they have been cut down somewhat, but not excessively, on all sides. Professor Ellis K. Waterhouse, who saw the pictures and the X-rays in Kennedy North's laboratory in 1932, reported that several evidences of Titian's changes in plan, as he painted the pictures, could be deduced. Most notable were the addition of the rose-coloured curtain as an afterthought in the *Diana and Actaeon*, the transformation of a white-skinned servant into the Negress at the extreme right (Waterhouse, 1960, pp. 432–433), and the change from a round to a square pier in the ruined architecture.

Documentation: That the two *poesie* dedicated to Diana were in process by 1556 is based on Titian's letter of 22 September 1559, in which he apologized for the delay and stated that they had been begun three years earlier ('tre anni e più') (C. and C., 1877, II, pp. 278, 515–516; Cloulas, 1967, p. 238). Titian's letter to Philip II dated at Venice on 19 June 1559 had previously claimed that they were finished and ready to ship (C. and C., 1877, II, pp. 275–276, 512–513; Cloulas, 1967, p. 233). Philip replied quickly from Ghent on 13 July 1559 ordering them to be sent to Genoa for shipment to Spain. He asked Titian himself to oversee the packing of them in boxes so that they would not be damaged (Cloulas, 1967, p. 236, with correct date). The same letter was first published by Ridolfi in 1648 but with the wrong date of 13 July 1558 (Ridolfi–Hadeln, I, pp. 186–187). Both Díaz del Valle in 1659 (edition 1933, pp. 345–346) and Palomino (1724, edition 1947, p. 794), copying Ridolfi, repeated the letter and the same erroneous date. Philip on the same day, 13 July 1559, also sent instructions to García Hernández telling him to be responsible for the safe shipment of the pictures. At the same time he ordered them to be delivered to the ambassador Figueroa at Genoa with directions that they should go to the Spanish port of Cartagena. Other goods including glass ('los vidrios') were to be in the same shipment (Zarco del Valle, 1888, pp. 232–233; Cloulas, 1967, p. 237).

García Hernández at Venice answered Philip on 3 August 1559 with the information that Titian would finish the two canvases in another twenty days and that the glass panes and the wine and water glasses would be forwarded at the same time (C. and C., 1877, II, pp. 277, 515; Cloulas, 1967, p. 238). On 22 September 1559 Titian wrote to Philip the good news that he was delivering the two works *Actaeon* and *Callisto* as well as the *Entombment* (C. and C., 1877, II, pp. 279–281, 515–517; Cloulas, 1967, pp. 238–240). García Hernández on 11 October 1559, always in Venice, confirmed the fact that 'eight days ago' the glass ware as well as the *Dianas* and three other pictures had been consigned to the ambassador Figueroa at Genoa (C. and C., 1877, II, pp. 281, 517; Beroqui, 1946, pp. 155–156; Cloulas, 1967, p. 242, with complete letter). Finally the next summer (!), on 11 August 1560, Philip notified García Hernández that the glass ware and pictures had reached Cartagena and that he was expecting them 'here soon'. As indicated on the letter, he wrote at Toledo, where he was living that year, in the Alcázar, ever since his marriage to Isabelle de Valois on 3 January 1560. 'Los quadros y vidrios que avíales remitido a Génova llegaron ya en Cartagena y aquí los espero brevemente' (Beer, 1891, p. CLXVI, no. 8454). It is true that the subjects of the pictures are not given, but there can be no doubt that the same items and the glass ware are those shipped on 11 October 1559. Some months later, on 24 March 1560, the artist wrote to Philip to inquire if the pictures had arrived and if they had pleased his majesty and he repeated the same inquiry on 22 April 1560 (C. and C., 1877, II, pp. 517–518; Cloulas, 1967, pp. 242–244). Not until a year later, on 2 April, did Titian write again that he had heard indirectly that Philip liked the 'Diana at the Fountain' and the 'Callisto' (C. and C., 1877, II, pp. 519–520; Cloulas, 1967, p. 245). Philip perhaps never bothered to pay for them, a fact mentioned in the famous letter of 1574 in which the artist listed a series of masterpieces which remained unpaid for (C. and C., 1877, II, p. 540; Cloulas, 1967, p. 280; and note 266 in this volume).

History in Spain: The fact that Philip had the Diana pictures

delivered to him in Toledo has never before been recognized by any historian. This detail has considerable importance, for it helps to demonstrate that he transferred his favourite works from one palace to another, wherever he was residing at the time. In May 1561 Philip and the court moved to Madrid to the castle (Alcázar) there, which Charles V had begun to modernize about 1537 (Iñiguez Almech, 1952, p. 63). It is almost certain that he removed the works of art from Toledo at that time.

We have no specific indication, however, where Philip kept his mythological pictures in the later part of his reign. They do not appear in the inventory of the Alcázar in Madrid made after his death, and it seems likely that they were in the palace at Aranjuez in 1600, the inventory of which has been lost.

In 1623 the mythological pictures by Titian were hung in the Alcázar at Madrid in a gallery overlooking the Garden of the Emperors (González Davila, 1623, p. 310). That is the first specific mention of them in Madrid. The same year on the visit to Madrid of Charles I of England the *Dianas* were packed to be shipped as a gift to him, but they were withheld when the marriage negotiations collapsed (Carducho, 1633, edition 1933, pp. 108, 110).

On the visit of the legation of Cardinal Francesco Barberini as representative of Urban VIII in 1626, Cassiano dal Pozzo, his secretary, described the rooms on the ground floor of the palace, already called 'las bóvedas' (the vaulted rooms), in one of which were the two legends of Diana by Titian (Pozzo, 1626, folio 121).

Ten years later the Alcázar Inventory of 1636, folio 50, is more specific in indicating the exact room on the north side toward the east ('Pieza última de las bóvedas que tiene bentana al lebante en que su Magestad retira después de comer'). The descriptions of the two compositions are also detailed and exact.

The Alcázar Inventory of 1666, which was compiled by Juan Bautista del Mazo after Philip IV's death, places the pictures in the 'Galería baja del jardín de los emperadores', no. 694, *Diana and Callisto*, no. 696, *Diana and Actaeon*, each valued at 4000 ducats. In 1686 the same rooms containing pictures by Titian are now called 'las Bóvedas de Ticiano', no. 867, *Diana and Callisto*, no. 869 *Diana and Actaeon*; Alcázar Inventory 1700, nos. 489 and 491 (see also Bottineau, 1958, pp. 321–322).

Post-Spanish History: In 1704 Philip V presented both pictures to the French ambassador, the Duc de Gramont (Bottineau, 1960, pp. 233–234, note). He in turn made a gift of them to the French regent, the Duc d'Orléans. In the Orléans Collection at the Palais Royal in Paris, *c.* 1706–1792 (Dubois de Saint Gelais, 1737, pp. 465–468; Couché, 1786, pls. III, VI). With the French Revolution the Duc d'Orléans

sold his collection; the Duke of Bridgewater purchased the *Diana and Actaeon* and *Diana and Callisto* in London in 1798 (Buchanan, 1824, I, pp. 19, 112–113) and they have remained in the possession of his descendants ever since: Marquess of Stafford (Stafford, 1808, nos. 84, 104; Ottley, 1818, nos. 10, 11, pls. 5, 7; Stafford, 1825, no. 61, 62); Lord Ellesmere (*Bridgewater*, 1907, no. 17, 18); Duke of Sutherland, on loan to the National Gallery of Scotland since 1946 (Edinburgh, 1970, pp. 96–97).

Bibliography: See also above; Boschini 1660, edition 1966, pp. 332–333; Vasari (1568)–Milanesi, VII, p. 452 (a mistaken note by Milanesi declares that the originals are in the Prado Museum at Madrid; see below, Copy no. 1); Jameson, 1844, p. 129, no. 114; Waagen, 1854, II, pp. 31–32; C. and C., 1877, II, pp. 276–289, 512–519; A. Stix, 1914, pp. 335–346; Fry, 1933, pp. 3–10; Richter, 1933, pp. 3–5 (superficial account); Suida, 1935, pp. 122, 177; Tietze, 1936, I, pp. 219–220, II, p. 292; Waterhouse, 1952 (the major study); *idem*, 1960, pp. 432–433; Valcanover, 1960, II, pls. 85, 86; Skarsgård, 1968 (X-rays reproduced); Keller, 1969, pp. 49–62 (analysis of colour); Pallucchini, 1969, pp. 160–162, 306; Panofsky, 1969, pp. 154–163; Edinburgh, 1970, pp. 96–97.

COPIES:

1. Madrid, Prado Museum, Cat. no. 423 (in storage in 1974); *Diana and Actaeon*, canvas, 0·96 × 1·07 m. No one has been successful in identifying the copyist who saw Titian's originals, now in Edinburgh, when they were in the royal collection in Madrid, although it is of no great consequence who the Baroque painter was.

These literal copies [*Diana and Callisto* is now in Seville, see Cat. no. 10, copy 6] cannot be attributed to Juan Bautista del Mazo since Mazo compiled the Alcázar Inventory of 1666; if he had been the painter, his name would have been recorded then and in the Inventory of 1686.

The statement of Jusepe Martínez in 1675 that a man named Pablo Esquert, who had been in Titian's shop in Venice, had copied Titian's *poesias* in the Royal Palace for the Duque de Villahermosa, is only a remote possibility for identification (Martínez, edition 1934, p. 47; Beroqui, 1946, p. 146, note). Beroqui (*loc. cit.*) suggested that in the mid-seventeenth century the *Diana and Callisto* was at El Pardo Palace, but it must have been *Diana and Actaeon* since the Alcázar Inventory of 1686, no. 804, cites only one item, which is unmistakably *Diana and Callisto*: in the 'Pasillos al pie de la escalera de la Galería del Cierzo', 'unas ninfas en un baño y un País', $1\frac{1}{4} \times 1\frac{1}{2}$ *varas*, copy of Titian. This picture recurs in the Alcázar Inventory 1700, no. 442; 1734, no. 201, 'Baño de Diana, copia de Ticiano'; 1747, no. 116, 'Baño de Diana ... original de Ticiano'. Still another picture called 'Baños de Ticiano copia del Ticiano' is listed at Buen Retiro Palace

in the Inventory of 1746, no. 274. In 1772 both *Diana and Actaeon* and *Diana and Callisto* were apparently in Buen Retiro Palace; still there in 1800 (Ceán Bermúdez, v, p. 40). They passed to the Prado Museum in 1827 (Beroqui, 1946, p. 146). *Bibliography:* See also above; Madrazo, 1843, p. 156, nos. 728, 729 (Titian); *idem*, 1873, pp. 89–90, nos. 482, 483 (copies); C. and C., 1877, II, pp. 283–284, notes (with wrong attribution to Mazo); Beroqui, 1946, pp. 145–146 (major account); Bottineau, 1958, p. 314 (confused here); Prado catalogue, 1963, pp. 708–709, nos. 423, 424; Keller, 1968, pp. 94–95 (copies of the seventeenth century; analysis of the colours).

2. Prague, Count Nostitz in 1905; canvas, 0·53 ×0·61 m.; Nostitz Inventory, 1819 (C. and C., 1877, II, p. 289, note, feeble copy; Bergner, 1905, p. 57, no. 224).

3. Richmond (Petersham), Ham House; canvas, 1·78 × 2·07 m.; mediocre copy, probably eighteenth-century (seen by the author in 1968).

4. Rotterdam, Boymans–van Beuningen Museum; canvas, 0·565×0·675 m.; formerly Brocklesby Park, Earl of Yarborough; a good copy, probably purchased in Venice in 1793–1797 by Sir Richard Worsley, whose collection passed by inheritance to the Earls of Yarborough; sold London, Christie's, 12 July 1929, no. 104, to V. Bloch, £1775 (*APC*, VIII, 1928–1929, no. 13,981). *Bibliography:* Worsley, 1804, p. 39; Waagen, II, p. 87, IV, p. 66 (as Titian's original sketch); C. and C., 1877, II, p. 289, note (copy); Rotterdam, 1962, p. 142, no. 2332 (follower of Titian).

5. Sevenoaks (Kent), Knole House, National Trust; attributed to Padovanino; canvas, 1·715×1·943 m. (Gore, 1969, p. 247). Photograph in the Witt Library, Courtauld Institute, London.

6. Vienna, Kunsthistorisches Museum; free version of good quality, attributed to Andrea Schiavone; canvas, 0·93 × 0·97 m. *Bibliography:* Engerth, 1884, I, p. 298 (Schiavone); Fröhlich–Bum, 1913, p. 205, fig. 62 (Schiavone); Berenson, 1957, p. 162 (Schiavone after Titian).

7. Unknown location; poor free copy; 0·573 ×0·667 m.; Sedelmeyer, Paris, in 1894 (photograph in the Witt Library, Courtauld Institute, London).

LITERARY REFERENCES:
1. Antwerp, Rubens' Inventory 1640, no. 44, as a copy by Rubens (Lacroix, 1855, p. 271; Denucé, 1932, p. 58). Rubens copied the 'Baños' by Titian in Madrid in 1628 (Pacheco, 1638, edition 1656, I, p. 153).

2. London, Collection of Charles I; Rubens' copy after Titian; sold on 31 May 1650 to Gaspars (Millar, 1972, p. 187, no. 19).

3. London, Duke of Buckingham, York House, 1635 (Fairfax, 1758, p. 2, no. 13, 3¼ *pieds* (0·99 m.); C. and C., 1877, II, p. 289, note; Davies, 1906–1907, p. 382).

4. London, sale Charles Jervas to W. Carey, 1740, no. 496, 26 (courtesy of Frank Simpson).

5. London, M. de Piles to P. Wales, 29 April 1742 (courtesy of Frank Simpson).

6. London, anonymous sale, 1806 (Victoria and Albert Library, London: *Picture Sales*, IV, 1805–1806, p. 23).

7. Madrid, Estate of Pompeo Leoni, 1609; cited as follows: 'una pintura grande sacada del Tiziano de la poesía de Acteon con Diana (Leoni, 1934, p. 108).

8. Paris, Comte de Vaudreuil, 1784; 20×25 *pouces*, claimed to be from the Orléans Collection (Blanc, 1858, II, p. 96); because of the similar size it may possibly be the item later at Brocklesby Park (Copies extant, no. 4); previously Nogaret 20×25 *pouces* (i.e. 0·55 ×0·676 m.; Blanc, 1858, I, pp. 61, 375; Mireur, 1912, VII, p. 289).

9. Prague, Inventory of 1621, no. 1175 (Zimmermann, 1905, p. xlv).

10. Rome, Lucien Bonaparte; sold in Paris, 11 November 1841, no. 3 (Bonaparte–Guattani, 1808, II, p. 115; Bonaparte, 1812, Cat. no. 75).

11. Venice, 1568, in a letter of 28 November, Veit von Dornberg, the imperial envoy, informed Emperor Maximilian II that Titian had offered for sale seven mythological pictures, among them the *Fable of Actaeon at the Fountain* (Voltelini, 1892, p. XLVII, no. 8804). This picture has disappeared. If purchased by Maximilian, Teniers' copy (Plate 214) (canvas, 0·375 ×0·36 m., in London, Kenwood, on indefinite loan to the Iveagh Bequest from the Executors of the late Princess Royal) could have been made from it. Teniers could not have followed the original, then in Madrid and now on loan by the Duke of Sutherland at Edinburgh (Cat. no. 9, Plate 142).

10. **Diana and Callisto** Plates 143, 148–150
Canvas. 1·88×2·06 m.
Edinburgh, National Gallery of Scotland, on loan from the Duke of Sutherland.
Signed on the plinth of the fountain: TITIANVS F
Documented 1556–1559.

Iconography: Ovid in the *Metamorphoses* tells how Jupiter took the form of Diana to win the confidence of Callisto, whom he promptly seduced. Later Diana, on discovering the girl's pregnancy, banished her, and after the birth of Callisto's son, Juno transformed her into a bear. Subsequently Callisto's own son was about to slay her when Jupiter elevated both into constellations in the heavens. Although Ovid also relates the story in the *Fasti*, II, 153–192, Titian follows the details as described in the *Metamorphoses*, II, 457–465: 'The place delighted her and she dipped her feet into the water: "... Come, no one is near to see; let us

disrobe and bathe us in the brook." The Arcadian blushed, and, while all the rest obeyed, she only sought excuses for delay. But her companions forced her to comply, and there her shame was openly confessed. As she stood terrorstricken, vainly striving to hide her state, Diana cried: "Begone! and pollute not our sacred pool"; and so expelled her from her company.'

Condition: The same as that of Cat. no. 9.

Documentation: The same as that of Cat. no. 9.

History: The same as that of Cat. no. 9.

Bibliography: The same as that of Cat. no. 9; also Panofsky, 1969, pp. 158–160.

COPIES (Sutherland type):
1. Hamburg, Kunsthalle; drawing in pen and sepia, 99 × 109 mm.; partial copy, including Callisto and a nymph, attributed to Rubens by Jaffé (Hamburg, 1971, pp. 41–42); attribution not accepted orally by Müller Hofstede (1972).
2. Knowsley (Lancashire), Earl of Derby; canvas, 1·86 × 1·98 m.; attributed to Rubens by Jaffé (Hamburg, 1971, pp. 42–46), who assigns no date to the picture on the dubious grounds that the copies made by Rubens at Madrid in 1628 were not carefully done. However, the superb *Adam and Eve* was surely painted in 1628 (see Wethey, I, 1969, p. 63). If by Rubens, Lord Derby's copy would reasonably be placed in 1603 on the artist's first visit to Spain. It turns up in the collection of an Earl of Derby in 1729 (Jaffé, *op. cit.*). The picture in Rubens' Inventory of 1640, no. 43 (see below Literary References, nos. 2 and 3) may have been purchased by Charles I of England.
3. London, Viscount Boyne, sale Christie's, London, 1 June 1962, canvas, 1·93 × 2·057 m. (*APC*, XXXIX, 1961–1962, no. 4773).
4. Rome, Accademia di San Luca; weak copy of the left side of the picture; wrongly attributed to Varotari (C. and C., 1877, II, p. 289, note; copy. Photograph Alinari 7144).
5. Sevenoaks (Kent), Knole House, National Trust; companion to *Diana and Actaeon* (Cat. no. 9, copy 5); photograph in the Witt Library, Courtauld Institute, London.
6. Seville, Museo de Bellas Artes; canvas, 0·98 × 1·07 m. In April 1970 sent to Seville on permanent loan from the Prado Museum, Cat. no. 424. Its companion *Diana and Actaeon* remains in storage at the Prado Museum, Cat. no. 423 in 1974. *Bibliography:* Madrid, Alcázar Inv. 1686, no. 804, 1¼ × 1½ *varas*, i.e. 1·04 × 1·25 m. probably this item

(Bottineau, 1958, p. 314); Seville, *Exposición*, 1970, p. 13 fig. 41a; perhaps *Baños de Ticiano*, Inventory of Buen Retiro Palace, 1746, no. 274. See also *Diana and Actaeon*, Cat. no. 9, copy 1.

LITERARY REFERENCES (probably the Sutherland type):
1. An 'abbozzatura' of *Diana and Callisto* passed to Tintoretto after Titian's death (Ridolfi [1648]–Hadeln, I, p. 207).
2. Antwerp, Rubens Inventory, 1640, no. 43, as a copy by Rubens (Lacroix, 1855, p. 271; Denucé, 1932, p. 59). See also Copies, no. 2, Knowsley, Lord Derby.
3. London, Collection of Charles I; *Diana and Callisto* by Rubens after Titian; sold after the king's death on 31 May 1650 to Gaspars (Millar, 1972, p. 201, no. 249).
4. London, Duke of Buckingham, York House, 1635 (Davies, 1907, p. 379; not in the catalogue by Fairfax, 1758).
5. London, Morton sale to Dr. Ward, large cartoon, 1738–1739, no. 48 (courtesy of Frank Simpson).
6. London, British Institution, lent by Lord Francis Egerton, 1839 (Graves, 1914, III, p. 1318).
7. London, sketch, exhibited at Suffolk St. by Sir W. Beechey (Graves, 1914, III, p. 1320).
8. London, Benjamin West's Collection; 'Bath of Diana' [*sic*], sale at Christie's London, 1824, no. 78.

11. Diana and Callisto Plate 154

Canvas. 1·83 × 2·00 m.
Vienna, Kunsthistorisches Museum.
Titian and workshop.
About 1566.

See the text for the relation of this picture to Cat. no. 10.

Condition: Before 1651, when Teniers copied the picture, drapery seems to have been added to the figures of Callisto and the girl at the extreme left. In Cort's print of 1566 (Plate 216) the drapery is missing. During the relining and cleaning of the canvas in 1912 the drawing on the back of the canvas was photographed (Stix, 1914, p. 338, Tafel XLIII). It was discovered that the standing nude woman at the left was at first like the same figure in Edinburgh (Plate 143) and therefore that Titian modified that part of the composition as he worked upon the Vienna version.
In general the canvas is well preserved, despite some crackle and surface damage (Stix, 1914, pp. 353–354).

History: Almost certainly one of the seven 'fables' offered on 28 November 1568 by Titian through the imperial ambassador Veit von Dornberg to Emperor Maximilian II

(Voltelini, 1892, pp. XLVII–XLVIII, nos. 8804–8808). On 25 February 1569 von Dornberg was authorized to pay Titian 100 *kronen* for a picture, subject unspecified (Freyczi, 1887, no. 4424). The closeness of dates virtually assures the assumption that the same picture is involved. Only the *Diana and Callisto* seems to have materialized. Collection of Archduke Leopold Wilhelm, at Brussels, included by Teniers in the large painting of the *Gallery of the Archduke Leopold Wilhelm at Brussels* (*c.* 1651), now in the Prado Museum at Madrid (Plate 212). The picture does not appear in the Vienna Inventory of 1659, a situation that exists in other instances too, but it is included in Teniers *Theatrum pictorium*, 1660, pl. 96. At the Stallburg in 1720–1733, copied by von Storffer, III, p. 136; later moved to the Belvedere Palace and eventually to the Kunsthistorisches Museum.

Bibliography: See also above; Boschini, 1660, edition 1966, pp. 332–333; Stampart, 1735, edition 1888, pl. 21; Michel, 1783, no. 43 (Titian); C. and C., 1877, II, pp. 288–289 (Titian assisted by Orazio Vecellio, Girolamo Dente and Andrea Schiavone); Engerth, 1884, I, pp. 352–353 (Titian); Stix, 1914, pp. 335–346 (major study); Suida, 1935, pp. 122, 177 (Titian); Zarnowski, 1938, pp. 103–108 (Girolamo Dente, assistant to Titian); Tietze, 1936, I, p. 220, II, p. 316 (mainly workshop); Hetzer, 1940, p. 166 (workshop); Berenson, 1957 (omitted!); Klauner and Oberhammer, 1960, pp. 143–145, no. 723 (Titian, *c.* 1566); Valcanover, 1960, pl. 86 (Titian and workshop); Pallucchini, 1969, p. 315 (Titian and workshop, *c.* 1560–1566); Keller, 1969, pp. 95–99 (workshop); Panofsky, 1969, pp. 160–162 (Titian and workshop).

ENGRAVING:
By Cornelius Cort (Plate 216). This composition is not identical with the Vienna picture (Plate 154), but it has more points in common with it than with the version belonging to the Duke of Sutherland (Plate 143). The fountain with large round basin topped by a figure of Diana with a stag is essentially the same in the first two works. The half-kneeling nymph who strips the drapery from Callisto is nearer to the girl in Vienna than to the standing woman in Edinburgh. The greatest changes in the print involve the tall narrow format and the consequently high trees. Various speculations have been made whether Titian actually painted a canvas like the Cort print (Stix, 1914, p. 335); in fact he usually supplied the engraver with a drawing. *Bibliography:* Ridolfi (1648)–Hadeln, I, p. 202 (mention); Boschini, 1660, edition 1966, p. 333 (refers to Cort); Bierens de Haan, 1948, pp. 159–161.

COPIES (Vienna type):
1. Rome, Lucien Bonaparte, formerly (Bonaparte, 1812, Cat. no. 76, engraving, as by Palma il Vecchio!).

2. Vienna, Academy of Fine Arts; copy by Teniers; panel, 0·355 ×0·48 m. (Eigenberger, 1927, I, p. 400, no. 667).

Education of Cupid, see:
 Cupid Blindfolded, Cat. nos. 4 and X–5.
 Venus, Mercury and Cupid, Cat. no. X–43.

Ferrara Bacchanals (Cat. nos. 12—15)

12. **Feast of the Gods** Plates 38c, 46, 47
Canvas. 1·70 ×1·88 m.
Washington, National Gallery of Art, Widener Collection.
Signed and dated: Joannes bellinus venetus MDXIIII.
Background repainted by Titian, about 1529.

The general elements of Giovanni Bellini's late style in this picture and the significance of Titian's landscape are reserved for the text.

Condition: This aspect has been discussed at length by Walker, 1956.

Iconography: The *Feast of the Gods* has been recognized as a free illustration of a long passage in Ovid's *Fasti*, I, 391–440. Hourticq (1919, p. 148) sensed that Ovid lay in the background but nothing more specific. Edgar Wind's theory that Pietro Bembo prepared the scheme for this composition encounters too many unrealizable suppositions (Wind, 1948), especially that it was intended to commemorate the wedding of Isabella d'Este's brother, Alfonso d'Este, to Lucrezia Borgia, which had taken place as far back as 1502 (Wind, 1948, pp. 27–28).
At the extreme right Lotis reclines asleep as Priapus approaches in the hope of seduction and is about to draw off her garment. Just at that moment the ass at the extreme left brays and awakens her, whereupon Priapus flees. In a second version by Ovid the girl is changed to Vesta (*Fasti*, VI, 319–348), Latin goddess of the hearth and dedicated to a vow of chastity.
The entire subject-matter of the *Feast of the Gods* is satirical, and Bellini surely painted his picture with that point of view. The other gods in the comedy are easily identifiable, reading from left to right: a satyr with a jug of wine upon his head, Silenus standing beside the ass; the infant Bacchus kneeling draws wine from a cask, and the bald Silvanus, god of the woods, sits behind the cask. Mercury, wearing his large hat and holding a caduceus, is prominent in the foreground, an intentionally clumsy figure for the normally swift messenger

of the gods. Jupiter, just to his right, is a short bewreathed man drinking from a silver goblet, about as unprepossessing and ungodlike as possible. Behind him a satyr with a bowl of wine on his head stands next to the nymph with a bowl in her hand. The seated woman, Cybele, who holds a quince, generally regarded as a symbol of marriage, sits beside Neptune, a rustic-looking fellow, whose venturesome right hand is in an unmistakable sign of intimacy. Partly on the basis of this detail, Edgar Wind went so far as to identify this pair as Lucrezia Borgia and her husband Alfonso d'Este. Their faces show not the slightest resemblance to portraits of the aristocratic ruler of Ferrara and his famous wife. Other nearby figures are composition-fillers, that is, the Pan in profile and the two erect dignified nymphs, one carrying a jar upon her head. Only the bared breasts give any suggestion of antique conventions. A buxom, dishevelled Ceres sits or kneels in front of the second nymph. The small, seated Apollo inconspicuously drinks wine from a cup, and he, too, is as unlike as possible the symbol of male physical beauty. He does, indeed, resemble a dwarf rather than a normal man. It has been suggested that the popularity of dwarfs at the court of Mantua and Ferrara may have accounted for these short figures in the *Feast of the Gods* (Plate 46), yet we have no proof that Giovanni Bellini ever visited these principalities. The non-classical and thoroughly ungodlike appearance and deportment are in my opinion intentional. Giovanni Bellini brought these personalities down to earth, made them gently comical, and at the same time painted a beautiful picture. Wind's further attempts to identify members of the d'Este court in the *Feast of the Gods* include Bacchus as Ercole d'Este, the small son of Alfonso d'Este and Lucrezia Borgia, and he went even farther afield to make Pietro Bembo into Silenus and Giovanni Bellini (self-portrait) into Silvanus. All of these proposals are too far-fetched to be taken seriously (see Dionisotti, 1950, pp. 237–239).

Documentation: The commission for the *Feast of the Gods* was probably arranged between Giovanni Bellini and Alfonso d'Este in 1513. An earlier date is unlikely because the War of the League of Cambrai cut Venice off from Ferrara and Mantua during the years 1509–1512 (Walker, 1956, pp. 18–19). On 14 November 1514 Giovanni Bellini was paid 85 gold ducats by Alfonso d'Este for a picture (Campori, 1874, p. 582). Although the subject is unnamed, Bellini's signature and the date 1514 on the *Feast of the Gods* leave no doubt that this work is involved. Crowe and Cavalcaselle (1877, 1, p. 174) thought that Bellini completed the work then. They referred to the phrase 'instante domino nostro' in the document of payment as meaning 'in the very presence of Alfonso'. It should be translated 'at our lord's insistence' (Panofsky, 1969, p. 5, note). Edgar Wind advanced a theory that Isabella d'Este first

ordered the picture for her *Grotta* at Mantua and that Pietro Bembo devised the story. He associated the picture with a series of letters between Giovanni Bellini and Pietro Bembo, who interceded with Giovanni on Isabella's behalf in 1505, since she had tried unsuccessfully to obtain a painting by his hand. The latest reference to the affair is Isabella's letter to Bembo on 11 May 1506. Wind decided that Alfonso d'Este's *Feast of the Gods* is the picture promised to Isabella in 1506 and that somehow Alfonso extracted it from Bellini for himself. Few other scholars have accepted this and a number of other extravagant speculations by Wind (1948, pp. 21–35).

Titian's Part in the Feast of the Gods: John Walker (1956, pp. 17–29), in his exhaustive book devoted to this picture, has argued that Titian assisted the elderly Bellini in the early stages before Bellini signed and dated the canvas in 1514. The numerous reasons he brought forward do not convince, for Titian was already an established artist when he finished his frescoes on the Fondaco dei Tedeschi c. 1509 and was even better known after the completion of the Paduan series in 1511 (Wethey, 1, 1969, Cat. nos. 93–95 and in the present volume). Titian had painted such celebrated works as the *Sacred and Profane Love* in 1514 (Plates 20–25) and the *Three Ages of Man* (Plates 13–16) at the same period. The *Feast of the Gods* would have been signed jointly if the two artists had produced it in collaboration in 1514.

Vasari's account of the *Feast of the Gods* includes the statement that Titian was summoned to complete the picture because Giovanni Bellini was old. Yet Giovanni signed and dated two masterpieces even later, in 1515. They are the exquisite *Lady at Her Toilet* in Vienna (Plate 28) and the *Fra Teodoro of Urbino as St. Dominic* in the National Gallery in London. It does not seem reasonable to assume that Giovanni was too feeble to finish the *Feast of the Gods*. The X-rays made in the preparation of Walker's monograph on the Ferrara pictures have been studied in the most exhaustive detail possible. The interpretation of the changes has brought wide differences of opinion. It is not my purpose to repeat or summarize them here. Walker has been followed by most critics in the belief that Titian made numerous changes in order to bring the static and essentially Quattrocento work of Bellini into greater harmony with his own three compositions for the same room. Giles Robertson occupies the opposite pole on this subject in his belief that Giovanni Bellini himself introduced erotic touches such as the exposing of the naked breasts of Lotis and the two standing nymphs—at the express request of Alfonso d'Este in 1514, when the painter delivered the picture to Ferrara (Robertson, 1968, pp. 145–150).

Nearly everyone agrees that the landscape background at the left with the mountainous distance and the leaves of the trees

at the right are entirely by Titian. The X-rays reveal a screen of strongly silhouetted trees across the entire background, which is obviously in Giovanni Bellini's style. The most problematical is the so-called second or intermediate repainting of the left side of the landscape. Here the X-rays show two different sets of trees—some short and the others reaching to the top of the canvas. That the painter of the second background was Dosso Dossi was first proposed tentatively by Walker, who, however, thought it strange that Vasari did not mention his participation. The most recent writer on the subject, Charles Hope (1971, p. 718), feels rather strongly that Dosso Dossi must have been entrusted with this alteration, since as court painter in residence he was at hand. On stylistic grounds little can be demonstrated, since we are dealing only with X-rays.

If, as I believe, it is reasonable that Titian did the final repainting of the landscape, the masses of foliage and the mountainous section at the left, his purpose was to bring unity into the decoration of the room, known as the *Camerino d'alabastro*. In the final arrangement, as agreed by nearly everyone (see Battisti, 1960, p. 125, fig. 63; Hope, 1971, pp. 644–646), the *Feast of the Gods* occupied the centre of the long wall between Titian's *Andrians* at the left and the *Worship of Venus* at the right. Then Titian certainly reworked the entire background to make the *Feast of the Gods* harmonize better with his own paintings, both in technique and in colour (see Figure 27: Plan of Alfonso d'Este's *Studiolo*).

The dating of Titian's landscape was set *c.* 1525–1530 by Walker and the Tietzes (Walker, 1956, p. 28, note 41) on stylistic grounds. In that period an exact time can be established from 27 January for one month and from 28 April to 18 June 1529 as already noted by Charles Hope (1971, p. 718). During those twelve weeks Titian was accompanied by five people, certainly his assistants and servants, so that he must have been involved in a major undertaking. It would reasonably be devoted to putting the last touches on the *Feast of the Gods* and perhaps on his own three pictures in the same gallery (Documents in Venturi, 1928, p. 124). For the month of March–April, the artist, having been at Mantua, then returned to Ferrara to finish up (Campori, 1874, p. 600).

History: In 1598 the *Feast of the Gods* was taken from Ferrara to Rome by Cardinal Pietro Aldobrandini (see note 172); the Aldobrandini Inventory of 1603 was prepared by G. B. Agucchi (Onofrio, 1964, p. 205, no. 204); the picture reappears in Olympia Aldobrandini's Inventory, 1626, no. 101 (Pergola, 1960, p. 432); later in Olympia Aldobrandini-Pamphili's Inventory, before 1665, no. 204 (Onofrio, 1964, p. 205); Inventory at the death of Donna Olympia, 1682, no. 325 (Pergola, 1963, p. 75).

In the mid-eighteenth century the picture appears to have hung in the Palazzo Doria–Pamphili on the Corso. Titi (1763, p. 320) refers to pictures by Titian and other Venetians 'tra quali uno singolare di Giovanni Bellini'. The intermarriages and dividing up of the Aldobrandini collections between the Doria–Pamphili and the Borghese make for a very complicated situation. Both in 1682 and again in the eighteenth century a second son of the Borghese was assigned the title of Prince Aldobrandini (see Pergola, 1962, pp. 316–317; also Gould, 1959, p. 107 on this subject). In 1796, at the time of a dispute between the Colonna and Borghese families over the Aldobrandini inheritance, the *Feast of the Gods* and *Bacchus and Ariadne* (Plates 46, 48) were purchased by the two Camuccini brothers, who were painter-dealers. The Duke of Northumberland acquired the entire Camuccini collection in 1856, and he took most of it, including the *Feast of the Gods*, to Alnwick Castle (Waagen, 1857, pp. 465, 467). In the twentieth century the picture passed through the hands of the London dealer, Arthur J. Sulley, and thereafter of Carl W. Hamilton of New York (Walker, 1956, p. 79) before it was purchased by Joseph Widener of Philadelphia in 1908; Widener bequest to the National Gallery of Art in 1942.

Bibliography: See also above; Vasari (1568)–Milanesi, VII, p. 433; Ridolfi (1648)–Hadeln, I, pp. 74, 158 (follows Vasari); C. and C., 1877, I, pp. 173–175 (accepted the landscape as repainted by Titian); Berenson, 1931, p. 106 (Widener catalogue); Suida, 1935, p. 19 (landscape by Titian); Wind, 1948; Walker, 1956; Berenson, 1957, p. 36 (landscape by Titian, except the trees at the right); Valcanover, 1960, I, fig. 110 (follows Walker's theories); Washington, 1965, p. 12, no. 597; Robertson, 1968, pp. 139–152 (long and sensible discussion); Panofsky, 1969, pp. 4–5 and note (believed in Titian's intervention twice, first in 1514 (!) and then later in the 1520's); Pallucchini, 1969, p. 250, figs. 113, 114 (dates Titian's background in 1516); Hope, 1971, p. 718 (Titian's landscape added in 1529).

COPIES:

1. Edinburgh, National Gallery of Scotland; canvas, 1·74 × 1·924; attributed to Poussin at the gallery (Edinburgh, 1970, p. 70, no. 458; Walker, 1956, fig. 32, Poussin; accepted as by Poussin by Anthony Blunt, 1966, pp. 138–139, no. 201).
2. Rome, Castel Sant'Angelo; canvas, *c.* 1·70 × 1·88 m.; not by Poussin (Blunt, 1966, p. 139); possibly by Vincenzo Camuccini, the painter and dealer who sold the original to the Duke of Northumberland (Walker, 1956, pp. 107–108, fig. 54).
3. Venice, Italico Brass Collection (formerly); mediocre copy (Van Marle, 1935, p. 337; Walker, 1956, pp. 108–109, fig. 55).

13. **Worship of Venus** Plates 38d, 39, 42–45

Canvas. 1·72 × 1·75 m.

Madrid, Prado Museum.

Documented 1518–1519.

Signed on the white cloth in the foreground: TICIANVS F.

The letters 'N.102.D' preceding the signature correspond to the Aldobrandini Inventory of 1603, where the number is 202 (Onofrio, 1964, p. 204). In later cleanings the numerals seem to have been retouched as 102. The *Andrians* (Plates 57–64) is signed in the same way and preceded by the numerals 201, which is also the number in the Aldobrandini Inventory of 1603 (Onofrio, *loc. cit.*). In the Prado catalogue, nos. 418 and 419, these numerals are incorrectly reported as 101 and 102.

Condition: The surface is slightly dirty and the paint blistered in various places. A horizontal crease as a result of folding for shipment is hardly visible. The Prado authorities hope to undertake steps for conservation soon.

Literary Source: That Philostratus the Elder's *Imagines* was followed with surprising exactness has long been recognized. Alfonso d'Este surely specified this text, for we know that he had borrowed his sister's (Isabella d'Este) copy of the work, which she had a difficult time to retrieve. See Isabella's letters of 1515 and 1516 in which she entreated the return of her book and the translation from the Greek (Walker, 1956, p. 40, note 56).

As early as Ridolfi (1648–Hadeln, I, p. 160) this source was recognized and probably had been current knowledge from the start. Crowe and Cavalcaselle quoted the passage (1877, I, pp. 192–194) and John Walker reprinted the full translation from the Loeb edition. The same version is repeated here for convenience sake.

'See, Cupids are gathering apples; and if there are many of them, do not be surprised. For they are children of the Nymphs and govern all mortal kind, and they are many because of the many things men love; and they say that it is heavenly love which manages the affairs of the gods in heaven. Do you catch aught of the fragrance hovering over the garden, or are your senses dull? But listen carefully; for along with my description of the garden the fragrance of the apples also will come to you.

'Here run straight rows of trees with space left free between them to walk in, and tender grass borders the paths, fit to be a couch for one to lie upon. On the ends of the branches apples golden and red and yellow invite the whole swarm of Cupids to harvest them. The Cupids' quivers are studded with gold, and golden also are the darts in them; but bare of these and untrammelled the whole band flits about, for they have hung their quivers on the apple trees; and in the grass lie their broidered mantles, and countless are the colours thereof. Neither do the Cupids wear crowns on their heads, for their hair suffices. Their wings, dark blue and purple and in some cases golden, all but beat the very air and make harmonious music. Ah, the baskets into which they gather the apples! What abundance of sardonyx, of emeralds, adorns them, and the pearls are true pearls; but the workmanship must be attributed to Hephaestus! But the Cupids need no ladders wrought by him to reach the trees, for aloft they fly even to where the apples hang.

'Not to speak of the Cupids that are dancing or running about or sleeping, or how they enjoy eating the apples, let us see what is the meaning of these others. For here are four of them, the most beautiful of all, withdrawn from the rest; two of them are throwing an apple back and forth, and the second pair are engaged in archery, one shooting at his companion and the latter shooting back. . . .

'. . . Be sure that Aphrodite is there, where the Nymphs, I doubt not, have established a shrine to her, because she has made them mothers of Cupids and therefore blest in their children. The silver mirror, that golden sandal, the golden brooches, all these objects have been hung there not without a purpose. They proclaim that they belong to Aphrodite, and her name is inscribed on them, and they are said to be gifts of the Nymphs. And the Cupids bring first-fruits of the Apples, and gathering around they pray to her that their orchard may prosper.' (Philostratus the Elder, *Imagines*, I, 6, translation Arthur Fairbanks, The Loeb Classical Library, London and New York, 1931).

Chronology of Documents: The *Worship of Venus* seems initially to have been commissioned from Fra Bartolomeo about March 1516 (Hope, 1971, p. 712, note 1), but he died 31 October 1517. He had delivered a *Head of the Saviour* to Alfonso's wife, Lucrezia Borgia, according to a letter of 14 June 1517 (Cittadella, 1868, II, p. 594). Richard Förster (1922, pp. 134–135) first discovered that the friar's drawing in the Uffizi (Plate 40) is clearly preparatory for the *Worship of Venus* and bears an obvious relation to Titian's painting of the subject (repeated by Edgar Wind (1948, p. 59) and all subsequent writers). Although Titian and two assistants were lodged in the castle at Ferrara from 31 January until 22 March 1516 (Campori, 1874, p. 584; Venturi, 1928, p. 103), there is no evidence that he was then involved in the series of paintings for the *Studiolo*—for reasons explained elsewhere. After Fra Bartolomeo's death in October 1517, the commission for the *Worship of Venus* passed to Titian. The artist's agreement to paint it is documented in a letter recently discovered by Charles Hope (1971, p. 715, note 10). Dated 9 March 1518, Tebaldi's letter to Alfonso reads, 'Magistro Titian mi ha hogi dato le qui alligate sue, e mi ha

dicto haver più desiderio servir la Excellentia Vostra in farli quello quadro . . . è per mettere ogni altra cosa da canto'.

Alfonso's desire to have the picture by San Mar . . . (?) was thought too precipitous by Titian, when he wrote the duke on 1 April 1518 (Campori, 1874, p. 587). In this same letter he acknowledged receipt of the canvas and stretcher for the picture. It is obvious from Titian's letter that Alfonso sent him specific instructions, for the artist writes: 'The information included seems to me so beautiful and ingenious . . . that I am all the more confirmed in my opinion that the greatness of the art of ancient painters was in great part and above all aided by those great Princes, who most ingeniously ordered them . . .' ('la informatione inclusa la mi è parsa tanto bella et ingeniosa . . . tanto più mi son confirmato in una oppinione [sic] che la grandezza de l'arte di pictori antichi era in gran parte, anzi in tutto aiutata da quelli gran Principi, quali ingeniosissimi li ordinaveno di che poi haveano tanta fama et laude').

Another letter, of 23 April 1518, seems to refer to a drawing which Alfonso had sent to Titian, and it has already been suggested by Walker (1956, p. 44) that Fra Bartolomeo's study (Plate 40) was involved here. Tebaldi, the d'Este agent in Venice, writes to his lordship, 'I gave him the paper where the small figure was sketched and annotated those words for his instruction' ('gli dedi la carta ove era bozata la figurina et annotato quelle parole per sua istruccione'). The 'words' might have been Philostratus' description which Titian followed so closely. In the same letter Tebaldi states that Titian wants to know where on the wall his picture is to be placed, for he remembers three spaces for pictures on one wall (Campori, 1874, p. 587, gives the date as 22 April, while Charles Hope, 1971, p. 646, note 35, corrects it to read 23 April; also Venturi, 1928, p. 106).

Finally Tebaldi wrote on 10 October 1519 that on Sunday Titian would bring the picture to Ferrara by boat and finish it there (Venturi, loc. cit., p. 107).

History of the Worship of Venus and The Andrians: In 1598, on the extinction of the legitimate branch of the d'Este family, the Ferrarese territories passed to the papacy. Cardinal Pietro Aldobrandini took these and other pictures to Rome, as reported in Roncaglia's letter of 1 December 1598 (see note 174). The Inventory of Cardinal Pietro Aldobrandini, prepared by G. B. Agucchi in 1603, reports both items as: 'no. 201, un quadro grande con un ballo di molte figure baccanti di Titiano' [The *Andrians*], and 'no. 202, un quadro grande con molti putti che giocano di Titiano' [*Worship of Venus*] (Onofrio, 1964, p. 204). A note at the side of each item reports that both were given in 1621 to Cardinal Ludovisi ('fu donato dalla Ecc.ma Signora al Sig. Cardinale Ludovisi l'anno 1621' and 'questa donatione l'offatta ad instantia delli miei figli, Olimpia Aldobrandina'.

The reigning pope, Gregory XV (1621–1623), was a Ludovisi and the explanation of such an important gift from the Aldobrandini family is therefore readily understood. The two pictures next figure in the Ludovisi Inventory of 1633, no. 29, 'un quadro grande alto palmi dieci chiamato il Baccanale, di molte figure, et in particolare una dormiente nuda con le bandinelle di Taffetta rosso in Merletto d'oro attorno e fiocche, i cordone di mano del Titiano' [*The Andrians*]; no. 30, 'un quadro grande compagna alto palmi dieci con un gioco d'Amoretti, con una statua in paese etc' [*Worship of Venus*] (Garas, 1967, p. 343). The identical description of rose taffetta and gold lace bows (fiocche) and cord in the second picture must refer to draperies placed over the frames to protect the pictures from dust.

In 1637 Niccolò Ludovisi, Prince of Piombino, presented the *Worship of Venus* and *The Andrians* to Philip IV of Spain. Boschini (1660, edition 1966, pp. 168–172) states that Cardinal Ludovico Ludovisi made the gift to Spain, but he was mistaken since this cardinal had died in 1632, and Titian's masterpieces still remained in Rome (see the Ludovisi Inventory of 1633). Beroqui (1925, p. 151; 1946, p. 22) had already suspected that the Prince of Piombino was the donor, even before the publication of this inventory. The fact is that the pictures were shipped via Naples in care of the viceroy, the Conde de Monterrey. Boschini (1660, edition 1966, pp. 194–195) reports that they created a sensation when shown in Naples and that Domenichino, then painting in the chapel of San Gennaro, wept. His emotional outbreak was evidently caused at his disappointment that such great works were leaving Italy.

The Conde de Monterrey left for Madrid on 12 November 1637 (Parrino, 1692, II, p. 253). Sir Arthur Hopton, British secretary in the Spanish capital, mentioned in a letter of 26 July 1638 that Philip IV had received within the year a number of fine paintings brought from Italy by the Conde de Monterrey, among them a *Bacchanal* by Titian (letter published by Sainsbury, 1859, p. 353; reprinted by Walker, 1956, p. 77; Trapier, 1967, p. 62).

The arrival of the Titians is also closely recorded in an unpublished letter of 27 February 1638, written at Madrid by Bernardo Monanni, secretary of the Medicean legation (Mediceo 4964; mentioned in *Archivio di Stato in Firenze, Archivio Mediceo del Principato. Inventario sommario*, Rome, 1951, p. 169. I am much indebted to Mrs. Enriqueta Harris Frankfort, who discovered the letter and sent me a photographic copy of it.) The pertinent passage in this letter reads as follows: 'and, moreover, on that occasion he presented His Majesty some pictures of great importance which had been given to him by the Count of Monterrey, his brother. from those that he has brought from Italy in large quantity; and they were well received by His Majesty, who is well informed, and they say that there is one [which is] very

celebrated by Titian.' ('e di più ancora, in quell'occasione presentò (?) alla Maestà alcuni quadri di pittura di gran realvo [sic] che haveva dati al R (?) il Conte di Monterey suo fratello di quelli che egli ha portato d'Italia in gran quantità: et furono molto accetti a S. Maestà . . . et dicono se ne sia uno assai celebre di Tiziano.').

Subsequent history of the Worship of Venus: In the Alcázar Inventories it is traceable as follows: Galería baja, 'Baccanario de niños de mano del Tiçiano', Inventory 1666, no. 691, value 4000 ducats; Inventory 1686, no. 864, 'un bacanario de niños' (Bottineau, 1958, p. 320); Inventory, 1700, no. 486; Inventory 1734, after the fire, no. 40, 'un juego de niños, escuela de Ticiano [!], bien tratado'; Buen Retiro Palace: Inventory 1746, no. 40, 'un juego original de Ticiano, 9000 reales'; New Royal Palace: 1776 in the drawing room of the Princess (Ponz, 1776, VI, Del Alcázar, 49); Prado, 1963 and 1970, no. 419.

Subsequent history of The Andrians: In the Galería baja 'Otra del mismo tamaño *las Bodas de Ariana* quando se casso con Baco y ella dormida de mano de Tiçiano'; Inventory 1666, no. 697, value 4000 ducats; Inventory 1686, no. 870, 'las bodas de Ariadne' (Bottineau, 1958, p. 322); Alcázar Inventory, 1700, no. 492, '2000 doblones'; Inventory 1734, after the Alcázar fire, no. 33, 'un bacanario original de Ticiano, bien tratado'; Buen Retiro Palace: Inventory 1746, no. 33, 'bacanario original de Ticiano, 9000 reales'; New Royal Palace: 1776 in the room of the Princess (Ponz, 1776, VI, del Alcázar, 49); apparently sent to the Prado Museum about 1827, along with its companion; not exhibited there until some time after the death of Ferdinand VII in 1833, since they were considered too indecent for public view. The two pictures appear in Madrazo's catalogue of the Prado for the first time in 1843: no. 852 *Worship of Venus*; no. 864 *The Andrians*. In the Prado catalogues of 1963 and 1970 they are nos. 418 and 419.

COPIES (*Worship of Venus*):
1. Rubens, canvas, 1·95×2·90 m.; Stockholm, National Museum of Art (Plate 65); See *The Andrians*, Cat. no. 15, copy 1, for discussion of the problems involved in the two copies by Rubens after Titian.
2. Bergamo, Accademia Carrara; canvas, 1·75×1·78 m.; by A. Varotari, il Padovanino (Boschini, 1660, edition 1966, p. 198; C. and C., 1877, I, p. 264, mention in note; Walker, 1956, p. 40, fig. 57; Bergamo, 1967, p. 91, no. 428).
3. Dortmund, Cremer Collection; canvas, 1·69×1·69 m.; accurate copy; formerly in the Demidoff Collection at Villa San Donato, Florence (*Gazette des beaux-arts*, XIII, 1892, p. 429; photograph in Frick Library, New York).

4. Venice, Private Collection; canvas, 1·20×1·28, copy (Pallucchini, 1962, pp. 122–123).

LITERARY REFERENCES (*Worship of Venus*):
Leningrad, Hermitage (lost?); canvas, 1·23×1·03 m.; until 1845–1850 in the catalogue of the Barbarigo della Terrazza Collection, Venice (Bevilacqua, 1845, no. 78); sold to Czar Nicholas of Russia in 1850 (Levi, 1900, p. 288, no. 78). Although listed as by Titian, it must have been a copy, perhaps like *The Andrians* by Varotari. The picture may have been lost or sent on loan from the Hermitage Museum to some provincial collection.

PRINT:
An engraving by Podestà, dated 1636 (Plate 41), carries a dedication to Cassiano dal Pozzo. A fine example is in the Bibliothèque Nationale, Paris, Cabinet des Estampes, BC8, folio 71. The engraving (composition in reverse) demonstrates unmistakably that the right side of the painting has been cut down.

14. Bacchus and Ariadne

Plates 48–56
Colour reproduction

Canvas. 1·75×1·90 m.
London, National Gallery.
Signed on the urn at the left: TICIANVS F.
Dated December 1520–December 1522.

The picture as a work of art is examined in the text.

Condition: Cleaned and rebacked with new canvas in 1967–1969. Because of inadequate backing an improper glue employed in a restoration of some years ago had seeped through and was destroying Titian's colours. The figures have survived virtually intact and the green of the trees has been brilliantly rehabilitated. The severest damage had occurred in the ultramarine sky at the upper left, where much of the original paint had already been replaced in earlier restorations.

Iconography: Much argument has raged over the exact literary sources of Titian's *Bacchus and Ariadne*. That certain details are selected from more than one poetic work is obvious, but the scene surely represents the *First Meeting of Bacchus and Ariadne*. Ariadne was wandering about distractedly as Theseus sailed away (ship on left horizon) from the island of Naxos, when Bacchus approached with his train and leapt from his chariot. The drunken Silenus on the back of the donkey is conspicuously asleep in the right background. It has been shown that Titian was acquainted with Ovid's *Ars Amatoria* (Thompson, 1956, pp. 259–264). 'Just as she came from sleep, clad in an ungirt tunic, barefoot,

with yellow hair unbound, she cried upon Theseus over the deaf waters, while an innocent shower bedewed her tender cheeks. She clamoured and wept together, but both became her; nor was she made less comely by her tears. Again she beats her soft bosom with her hands, and cries, "He is gone, the faithless one; what will become of me?" "What will become of me?" she cries: then o'er all the shore cymbals resounded and drums beaten by frenzied hands. She fainted for fear, and broke off her latest words; no blood was there in her lifeless frame. Lo! Bacchanals with tresses streaming behind them, lo! wanton Satyrs, the god's forerunning band; lo! drunken old Silenus scarce sits his crookbacked ass, and leaning clings to the mane before him. While he pursues the Bacchanals, and the Bacchanals free and again attack, and while the unskilful horseman urges his beast with a rod, he falls off the long-eared ass and topples head-foremost and the Satyrs cry, "Come, get up, father, get up!" And now on his car, that he [Bacchus] had covered with grape-clusters, the god was giving the golden reins to his yoked tigers: voice, colour—and Theseus, all were gone from the girl; thrice did she essay flight, thrice did fear restrain her. She shuddered, as when dry stalks are shaken by the wind, as when the light rush trembles in the watery marsh. "Lo, here am I", said the god to her, "a more faithful lover; have no fear, Gnosian maid, thou shalt be the spouse of Bacchus. For thy gift take the sky; as a star in the sky thou shall be gazed at; the Cretan Crown shall often guide the doubtful bark." He spoke, and lest she should fear the tigers leapt down from the chariot; the sand gave place to his alighting foot; and clasping her to his bosom (for she had no strength to fight) he bore her away; easy is it for a god to be all-powerful.' (*Ars Amatoria*, I, 529–562).

Since the time of Ridolfi (1648–Hadeln, I, p. 159) Catullus' *Carmina* (LXIV, 50–266) has also been recognized as one of Titian's sources, for it does indeed explain a number of figures. Catullus describes the scenes as embroidered on a royal marriage bed. Here are the satyrs, the clashing of timbrels, in a riotous procession the man girded with writhing serpents, whom many writers mistook for Laocoön, and the tossing of the limb of a mangled steer (upper right edge).

Edgar Wind (1948, pp. 56–57) took an opposed view in this as in most matters concerning the Ferrara pictures. He preferred to interpret the *Bacchus and Ariadne* (Plate 48) in London as their separation rather than the first meeting. I find it indeed difficult to regard the leap toward Ariadne as departure. Wind's argument is that Ariadne is usually said to have been asleep when Bacchus first spied her. She is, in fact, asleep in *The Andrians* (Plate 58), so Titian took care of that part of the story. On the positive side is the fact that the god places her crown of stars in heaven at their leave-taking. Ovid's *Fasti*, III, 507–516, records the creation of the crown of nine stars, but it is also mentioned on their first meeting. Angus Easson (1969, pp. 396–397) now comes forward with Ovid's *Metamorphoses*, VIII, 169–182 as the more important source, since Ariadne is awake at their first meeting and the number of stars in the crown is not specified. Titian painted eight stars rather than the nine indicated in the *Fasti*.

Panofsky (1969, p. 141) is certainly correct in insisting on multiple derivation with respect to textual as well as visual sources in the *Bacchus and Ariadne*. In fact, the problem has become so involved that the orange has been squeezed dry, but thank heaven we still have the picture to enjoy. Titian included several elements from various sources, although he did not attempt to make the events simultaneous. The spotted beasts that draw Bacchus' chariot are really Indian cheetahs (Gould, 1959, p. 105, note 6; Panofsky, 1969, p. 143). They would imply that Bacchus had just returned from India.

Documentation: Titian's *Bacchus and Ariadne* replaced a work that Alfonso d'Este had ordered from Raphael but that was never delivered. Although Alfonso apparently began negotiations in 1516 (Gould, 1959, pp. 6–9), Raphael died on 6 April 1520, after he had finished only a drawing for the picture. The subject was said in March 1517 to have been a *Triumph of Bacchus*; when Raphael heard in September 1517 that a Friulan painter, Pellegrino da San Daniele, had used his drawing for a picture of that subject, he wanted to change the theme (Gould, *loc. cit.*; Golzio, 1936, pp. 53–55). Later, in November 1517, Raphael sent Alfonso a gift of the cartoon which he had used in painting a history of Leo IV (Golzio, pp. 62–63), i.e. *The Battle of Ostia* (Figure 28) in the Vatican halls, to assuage the duke's anger for his delay. On 21 September 1518 Raphael sent another gift to Ferrara, this time the cartoon of the painting of *St. Michael* (Paris, Louvre), which he had just completed for the king of France (Golzio, 1936, pp. 74–75). At the end of the year Alfonso applied for another cartoon, the one for the portrait of *Giovanna d'Aragona* (Paris, Louvre), which Raphael obliged by sending to Ferrara. But the artist notified Alfonso that he had sent a pupil to Naples to prepare the cartoon and therefore it was not a work by his own hand (Golzio, 1936, pp. 76–77).

The only reference to a drawing of a *Hunt of Meleager* occurs in Bagnacavallo's letter to Alfonso d'Este on the last of February 1519 (Golzio, 1936, p. 93). He states that Raphael had promised to send both pictures by Easter. Such a promise was obviously impossible of fulfillment, since only drawings of the two subjects existed at that date. All other references mention only the *Triumph of Bacchus*, the work for which Alfonso d'Este had made an advance payment early in 1518 (Golzio, 1936, pp. 55, 64). In January and March 1520 there

was still correspondence for a picture to be painted for Alfonso, yet, as so frequently, no subject was mentioned (Golzio, pp. 105–106). On 6 April, the night of Good Friday, Raphael died, it was said of a fever, but basically from overwork.

Titian inherited the commission of the picture that Alfonso had originally hoped Raphael would paint. It would appear that very shortly, perhaps within a month, Titian made a trip to Ferrara, to repair damage done to one of his pictures by the varnish, which had altered the colours (Venturi, 1928, p. 110). At this time Titian must have agreed to paint the *Bacchus and Ariadne*. During the entire year Titian delayed and Alfonso protested.

Meantime the Duke demanded the return of fifty ducats which he had paid in advance to Raphael for the undelivered picture, '*una* pictura', probably the *Triumph of Bacchus* (Golzio, 1936, pp. 122–125). In none of these documents is there any mention of a *Hunt of Meleager*, a fact that convinces me that Alfonso d'Este had not accepted Raphael's offer to supply this subject (Gould, 1969, pp. 12–14, holds a contrary opinion). Finally on 25 November 1520 Tebaldi reported to his master that Titian had not received the stretcher and canvas, which Alfonso had promised to send (Venturi, 1928, pp. 111–112). On 20 December the same Ferrarese agent wrote that the needed materials, canvas and stretcher, had then arrived at Venice.

Later on 4 March (Hope, 1973, p. 810), 1522, with nothing apparently accomplished, Tebaldi recommended to the duke that he send Titian some funds 'so that he might have something to spend' ('affine che epso habia da spendere'). Results were thereafter forthcoming and on 31 August the ambassador in Venice had seen in Titian's studio what was obviously the *Bacchus and Ariadne*. Tebaldi wrote: 'Yesterday I saw the canvas of your Excellency in which there are ten figures, a chariot ('carro') and animals that draw it, etc.' (Venturi, 1928, p. 116). The artist promised its completion by October. On 9 December the news came from Venice that Titian would come before Christmas to bring the picture and also another of a *Lady* ('uno quadro d'una donna'), perhaps the *Flora* (Cat. no. 17). Payments of January 1523 prove that delivery had actually occurred (Campori, 1874, pp. 590–597; Venturi, 1928, p. 115).

History: In 1598, on the extinction of the d'Este family at Ferrara, the three pictures by Titian and Giovanni Bellini's *Feast of the Gods* were transported by Cardinal Pietro Aldobrandini to the family palace in Rome (see note 172). The *Bacchus and Ariadne* is recorded in the Aldobrandini Inventories as follows: Aldobrandini Inventory, prepared by G. B. Agucchi in 1603, no. 203, 'Un quadro grande di Bacco sù un carro con satire e donne atorno, di Titiano' (Onofrio, 1964, p. 205); Aldobrandini Inventory 1626, no.

100, the same description (Pergola, 1960, p. 432); Aldobrandini Inventory 'before 1665', no. 203, 'Un quadro in tela grande con un baccanale alto p. sette con cornice dorata di mano di Titiano, segnato n. 203' (Onofrio, 1964, p. 205); Aldobrandini Inventory 1682, no. 314, the same description 'di mano di Titiano come a d° Inventario a fogli 213 N° 203 et a quello del Sig. Cardinale a fogli 121' (Pergola, 1963, p. 74).

The *Bacchus and Ariadne* was seen in the Aldobrandini Palace at Monte Magnanapoli in 1620 (Orbaan, 1920, p. 359). This palace still exists but it is now the Istituto Internazionale per l'Unificazione del Diritto Privato. As late as 1796 both the *Bacchus and Ariadne* and Bellini's *Feast of the Gods* remained in the Aldobrandini Palace in Rome. During the upheaval caused by the Napoleonic invasion, the Italian nobility were obliged to sell pictures, and these two celebrated compositions became the property of the Camuccini brothers, who took advantage of the situation to deal in works of art. Mr. Irvine, a British agent in Italy, purchased the *Bacchus and Ariadne* for William Buchanan, also a dealer, in 1806 at the reported price of 9000 crowns according to a letter of 31 May 1806 (Buchanan, 1824, I, pp. 116–117; II, pp. 135–136, 142–143, 173–174). The following year Lord Kinnaird acquired the masterpiece; purchased in 1813 by Delahante; exhibited by another owner, Thomas Hamlet, at the British Institution in 1816; purchased by the National Gallery in 1826 (Gould, 1959, pp. 102–107, gives an exhaustive account of the picture).

COPIES:

1. Alnwick Castle, Duke of Northumberland (formerly); copy wrongly attributed to Poussin (C. and C., 1877, I, p. 265, as Poussin; Blunt, 1966, omitted).
2. Bergamo, Accademia Carrara; canvas, 1·75×1·85 m.; by Padovanino (Walker, 1956, fig. 67; Bergamo, 1967, p. 91, no. 423).
3. Florence, Pitti Gallery (in storage); partial copy (Walker, 1956, fig. 68); it was acquired in 1792 in an exchange of pictures effected with the Vienna Imperial Gallery (Gotti, 1875, p. 403, no. 1). A similar item turns up in Ridolfi (1648)– Hadeln, I, p. 197.
4. Rome, Accademia di San Luca, partial copy, no. 231.

LITERARY REFERENCES:

1. La Granja (Segovia); copy by Carlo Maratta, purchased by Philip V; Inventory of 1724 (edition, *Revista*, 1876, p. 145, nos. 2 and 13); Inventory of La Granja, 1814, no. 125 (MS., Archivo del Palacio, Madrid); also mentioned by Bottineau, 1960, p. 454 and Pérez Sánchez, 1965, p. 302.
2. Rome; a copy by Cavaliere d'Arpino, according to a manuscript note in Baglione, see photographic reprint, edition 1935, p. 372; Haskell, 1963, p. 25, note 4.

3. Rome, Queen Christina's collection in 1689 (Campori, 1870, p. 345); copy said to be by Francesco Albano.

4. Rome, Salviati Collection, Inventory of 1794, p. 10, no. 50; $5\frac{1}{2} \times 6$ *palmi*, i.e. 1·23×1·34 m.; as a copy after Titian (Pergola, 1960, p. 310).

5. Rome, Barberini Collection; a copy by 'Il Maltese' in the Inventory of 1631, where it is said to have been copied from a picture in the Aldobrandini Collection: 'Un quadro, d'un baccanario, con un satiretto, che tira la testa di un vitello, copiata dal Maltese da un di Titiano, che hanno li signori Aldobrandini' (Orbaan, 1920, p. 512). The identification of the copyist, 'Il Maltese', remains a mystery. Later the Barberini owned copies of all four of the pictures from Ferrara: 'quattro Baccanali del Tiziano'; obviously seventeenth-century copies, made before the *Worship of Venus* and the *Andrians* (Plates 39, 57) were shipped to Spain in 1637. They are mentioned as originals by Filippo Rossi, edition 1727, II, p. 357.

ENGRAVING:

G. A. Podestà's, made in Rome and dated 1636, with a dedication to Fabio della Corgna; a good example in the Bibliothèque Nationale, Paris, Cabinet des Estampes, BC8, folio 73 (illustrated by Walker, 1956, fig. 70).

15. The Andrians (Bacchanal)

Plates 57–64

Canvas. 1·75×1·93 m.

Colour reproduction

Madrid, Prado Museum.

About 1523–1525.

Signed on a small ribbon at the edge of 'Violante's' blouse: TICIANVS F. (in cursive letters, restored).

Just below the signature appears 'No. 201', which is the inventory number of this picture in the Aldobrandini Inventory of 1603 (Onofrio, 1964, p. 204). See the text, for the study of *The Andrians* in relation to the Ferrara Bacchanals as a whole.

Condition: Although the general effect of the painting is excellent, it needs conservation. The curious bloom, i.e. a white deposit, in the left foreground is particularly noticeable. Retouchings upon the body of Ariadne are also detectable with the naked eye. Neither of the Prado canvases in this series has been X-rayed. The leaves added over Ariadne's middle, when the picture was in Cardinal Aldobrandini's collection in the early seventeenth century, were cleaned off in the Prado Museum c. 1840 (Beroqui, 1946, p. 17).

Iconography: The subject-matter of the *Andrians* is drawn from Philostratus the Elder's *Imagines* (edition 1931, I, section 25), the choice of Alfonso d'Este quite certainly, as shown elsewhere. The passage reads as follows: 'The stream of wine which is on the island of Andros, and the Andrians who have become drunken from the river, are the subject of this painting. For by the act of Dionysus the earth of the Andrians is so charged with wine that it burst forth and sends up for them a river: if you have water in mind, the quantity is not great, but if wine, it is a great river—yes, divine! . . . 'These things, methinks, the men, crowned with ivy and bryony, are singing to their wives and children, some dancing on either bank, some reclining. . . .

'Consider, however, what is to be seen in the painting: The river lies on a couch of grape-clusters, pouring out its stream, a river undiluted and of agitated appearance; thyrsi grow about it like reeds about bodies of water, and if one goes along past the land and these drinking groups on it, he comes at length on Tritons at the river's mouth, who are dipping up the wine in sea-shells. Some of it they drink, some they blow out in streams, and of the Tritons some are drunken and dancing. Dionysus also sails to the revels of Andros and, his ship now moored in the harbour, he leads a mixed throng of Satyrs and Bacchantes and all the Sileni. He leads Laughter and Revel, two spirits most gay and most fond of the drinking-bout, that with the greatest delight he may reap the river's harvest.'

Titian used his imagination to a greater extent in this, seemingly the last of the three paintings destined for Ferrara. Ariadne at the extreme right (Plate 58) lies asleep with wine here, rather than in the episode where Bacchus first encounters her after the desertion of Theseus (Plate 48). Theseus' departing ship upon the horizon, its sails full with the wind, is visible between the waving arms of the two dancing male Bacchantes (Plate 61)—(not Dionysus' ship). The fat-bellied man at the extreme left, drinking deeply from the jug, fits the role of Silenus, whether or not that was Titian's specific intention. Further remarks upon the characters and their activities in the Andrians are reserved for the text.

Documentation: After the delivery of *Bacchus and Ariadne* to Ferrara just before Christmas 1522 and the notation of payment on 30 January 1523, Titian engaged in considerable further activity for Alfonso d'Este. Although the lacunae in notices and payments are numerous (Campori, 1874, pp. 596–597; Venturi, 1928, p. 115), there is good reason to believe that the *Andrians* was in preparation at this time, as Cecil Gould has already proposed (1969, pp. 12–14). He is quite correct stating that no earlier references could possibly be concerned with the *Andrians*. I do not discern any stylistic elements very cogent in the arguments to make the *Andrians* later than the *Bacchus and Ariadne*. Nevertheless, the fact that Titian continued to paint for Alfonso d'Este in 1523–1525 is good reason to place the *Andrians* here rather than earlier.

Charles Hope (1971, p. 717) has also accepted this new chronology, which places the *Andrians* after rather than before the *Bacchus and Ariadne*. On the other hand, earlier writers had reversed the order. Walker (1956, p. 46) thought that Titian's visits to Ferrara and the payments of 1523–1525 had to do with the repainting of the *Feast of the Gods*. As we have seen, the twelve weeks that Titian spent at Ferrara in the period January to June 1529 seem to be a more reasonable time for the last work on the *Feast of the Gods* and thus the ultimate conclusion of the decoration of the *Camerino d'alabastro*.

History: See the *Worship of Venus*, Cat. no. 13, which has the same history of collections.

DRAWINGS:
1. Van Dyck, 'Italian Sketchbook', 1622–1627 (Adriani edition, 1940, folio 56; see also Nordenfalk, 1938, p. 33).
2. Madrid, Biblioteca Nacional; Bacchanal, 233 × 336 mm.; a separate piece 96 × 133 mm.; sepia on paper, quadriculated. This composition is a remote derivation from *The Andrians*; only the sleeping Ariadne, varied in pose, is clearly derived from Titian's painting. It was attributed to Titian by Barcia (1906, no. 7643) and by Battisti (1954, pp. 191–192), who stressed its relationship to *The Andrians*.
3. Paris, Bibliothèque Nationale; Castiglione's drawing, no. 47,C2800, is a careful sketch after *The Andrians*, which shows slightly more space at each side (Walker, 1956, pp. 115–116, fig. 63).

ENGRAVING:
Gian Antonio Podestà; dedicated to Fabio della Corgna; c. 1636. The composition is reversed. A good example in the Bibliothèque Nationale, Paris (Walker, 1956, fig. 58). The leaves over Ariadne's middle were subsequent additions to the original painting (see above, Cat. no. 15, Condition).

COPIES:
1. Rubens' copy, now in Stockholm, National Museum (Plate 66); *The Andrians*, canvas, 1·95 × 2·09 m.; the *Worship of Venus*, canvas, 1·95 × 2·09 m. (Cat. no. 13, copy 1). Philip IV purchased these two copies by Rubens from the painter's estate, Inventory 1640, nos. 81, 82 (see Lacroix, 1855, p. 272; Sainsbury, 1859, p. 238; Denucé, 1932, p. 60). Since neither picture is traceable in the Inventories of the Alcázar at Madrid, they must have adorned some other royal palace. In 1776 they were located in the New Royal Palace at Madrid in the salon of the Infante don Gabriel de Borbón (Ponz, 1776, VI, Del Alcázar, 57). Both were looted from the Royal Palace by Napoleonic troops, perhaps by Joseph Bonaparte himself. Acquired by Maréchal Bernadotte, who became king of Sweden as Charles XIV in 1818; his successor,

Charles XV of Sweden, later gave them to the National Museum.
The great mystery about Rubens' copies is that the style of painting is too late for him to have done them in Rome during his last stay there in 1607–1608. Then he surely saw the originals in the Aldobrandini Palace. On Rubens' last visit to Madrid in 1628 the originals were still in Rome. Possibly he had made early copies in Rome in 1607–1608 and later he might have redone his own work *c.* 1630–1635. This solution was also proposed by Gustav Glück (1933, p. 319). The free rendition of the Stockholm copies with their numerous variations in details by no means implies that Rubens worked directly from Titian's originals. The colours also differ so widely from Titian's that Rubens must have followed his own earlier copies. *Further bibliography:* C. and C., 1877, I, p. 265; Nordenfalk, 1938, pp. 40–47; Walker, 1956, pp. 83–92, 113–114, figs. 40, 41; Bottineau, 1958, p. 322 (mention); Fehl, 1972, pp. 159–162.
2. Bergamo, Accademia Carrara; canvas, 1·75 × 1·88 m.; copy by Alessandro Varotari, il Padovanino (Boschini, 1660, edition 1966, pp. 198–199; C. and C., 1877, I, p. 265; Walker, 1956, p. 112, fig. 59; Bergamo, 1967, p. 90, no. 430).
3. Edinburgh, National Gallery of Scotland (in storage); canvas, 1·676 × 2·178 m.; Ariadne is partially draped here. Grautoff rather boldly attributed this copy to Nicolas Poussin (Grautoff, 1914, II, p. 42). *Bibliography:* Walker, 1956, p. 115, fig. 61 (seventeenth-century copy); Edinburgh, 1957, no. 103 (Copy); Blunt, 1966, p. 178 (not by Poussin); Edinburgh, 1970, p. 142.
4. Florence, Guicciardini Palace; considered a copy by Sebastiano Ricci or Andrea Celesti, i.e. Venetian School of the eighteenth century (C. and C., 1877, I, p. 265, note).
5. London, Private Collection; canvas, 1·727 × 1·905 m.; an unsigned article of 1930 attributed the picture to Titian with revisions by Poussin (*Apollo*, XII, 1930, pp. 285–287)! This version was sold at Sotheby's on 21 May 1935, no. 23, as from the R. W. Cater Collection (*APC*, XIV, 1934–1935, no. 4963; Blunt, 1966, p. 138 (a copy, not by Poussin).
6. Rome, Ministero degli Affari Esteri, on loan from the Galleria Nazionale, Inventory no. 1357 (Photograph, G. F. N., Rome, no. E45134).
7. Saltram Park (Devon); canvas, 1·727 × 1·88 m.; copy, seventeenth century and a smaller English copy (Gore, 1969, p. 253).
8. Unlisted copies: Photographs of numerous mediocre copies are available in the Witt Library of the Courtauld Institute in London and in the Frick Art Reference Library in New York.

LITERARY REFERENCES:
1. La Granja (Segovia), Palace of San Ildefonso; a copy by Carlo Maratta, which was purchased along with his collection

by Philip V in 1722; mentioned as late as the Inventory of 1814, no. 126 (Maratta, Inventory, edition *Revista*, 1876, nos. 2 and 13; Battisti, 1960, p. 87; Pérez Sánchez, 1965, p. 302). The devastating fire of 2 January 1918 probably destroyed this and many other works by Maratta (Bottineau, 1960, pp. 378, 569–570).

2. Leningrad, Hermitage (lost?), canvas, 1·17×1·27 m.; attributed to A. Varotari, il Padovanino; the picture appears in the Barbarigo della Terrazza Collection in 1845 (Bevilacqua, 1845, no. 8); it passed to Czar Nicholas of Russia on his purchase of the famous collection in 1850 (Levi, 1900, p. 286, no. 8). Since then it has disappeared either into the great storage of the Hermitage or perhaps lent to some provincial museum.

3. London, York House, Duke of Buckingham, Inventory 1635, detail, 'Sleeping Venus [Ariadne] and Cupid Pissing' (Davies, 1906–1907, p. 380). A similar item appeared in the Scarpa sale at Sambon's, Milan, on 14 November 1895, no. 21; canvas, 0·72×0·94 m.; photograph in the Witt Library, Courtauld Institute, London. Cesare d'Este's inventory at Modena in 1685 has the same subject (Campori, 1870, p. 324).

4. London, Walsh Porter sales, Christie's, 14 April 1810, no. 51 and again on 6 May 1826, no. 10.

Bibliography (for the *Worship of Venus, Bacchus and Ariadne*, and *The Andrians*): The bibliographical references are cited throughout the catalogue and the text, but for convenience the major items are repeated here. Vasari (1568)–Milanesi, VII, pp. 433–434; Boschini (1660) edition 1966, pp. 194–195); Campori, 1874, pp. 581–620 (letters and documents); C. and C., 1877, I, pp. 170–195, 225–232; A. Venturi, 1882, p. 114 (letter of Roncaglia); *idem*, 1928, IX, part 3, pp. 94–183 (collection of documents); Beroqui, 1925 and 1946; Wind, 1948; Walker, 1956; Bottineau, 1958, p. 320 (Spanish inventories); Battisti, 1960; Gould, 1959, pp. 102–107; *idem*, 1969, p. 128; Mezzetti, 1965, p. 137; Pallucchini, 1969, pp. 253–254, 257; Panofsky, 1969, pp. 96–102, 141–144; Hope, 1971, pp. 641–650; *idem*, 1972, pp. 712–721.

Fête champêtre, see: Pastoral Concert, Cat. no. 29.

16. Flaying of Marsyas Plates 170–172
Canvas. 2·13×2·075 m.
Kremsier, Archiepiscopal Palace.
Fragmentary signature on the stone in the foreground: [TITIA]NVS P[INXIT].
About 1570–1575.

Consult the text for the general consideration of this important painting.

Iconography: Ovid's version of the Marsyas legend follows: 'Then, when this unknown storyteller had told the destruction of the Lycian peasants, another recalled the satyr [Marsyas] whom the son [Apollo] of Latona had conquered in a contest on Pallas' reed, and punished. "Why do you tear me from myself?" he cried. "Oh, I repent! Oh, a flute is not worth such a price." As he screams, his skin is stripped off the surface of his body and he is all one wound: blood flows down on every side.... The country people, the sylvan deities, fauns and his brother satyrs, and Olympus, whom even then he still loved, the nymphs, all wept for him, and every shepherd who fed his woolly sheep or horned kine on those mountains. The fruitful earth was soaked, and soaking caught those tears and drank them deep into her veins. Changing these then to water, she sent them forth into the free air. Thence the stream within its sloping banks ran down quickly to the sea, and had the name Marsyas, the clearest river in all Phrygia.' (*Metamorphoses*, VI, 382–400).

Winternitz (1967, p. 156) considers Apollo to be the young musician at the left. Neumann in his monograph on the *Flaying of Marsyas* also accepts him as Apollo, but he regards the kneeling man at the left, crowned with laurel, as Apollo again in a double appearance in the same picture. On the other hand, Professor Fehl identifies only the kneeling man as Apollo, in part because Ovid makes him the executioner, who pulls off the skin of the victim. Yet in the first passage by Ovid quoted above, no specific name of the executioner is given. In a later passage Apollo is described as follows: 'Phoebus' golden head was wreathed with laurel of Parnassus and his mantle, dipped in Tyrian blue, swept the ground' (Ovid, *Metamorphoses*, XI, 165–166). For Professor Fehl the musician is Olympus, a pupil of Marsyas, and he objects to identifying this youth as Apollo for lack of the laurel wreath and in fact the rose tunic is not the usual costume of the normally nude god. In this particular detail Titian may have followed Ovid, as just quoted, rather than the conventions of ancient sculpture. Paris Bordone's picture of *Apollo between Midas and Marsyas* shows the god clothed in a fur vest and cloak, and he holds the lyre. Both Neumann and Fehl have investigated the esoteric aspects of the subject and the psychological attitude of Renaissance man toward such divine symbolism. Edgar Wind, too, makes out a case for the 'relative powers of Dionysian darkness and Apollonian clarity... a tragic ordeal of purification' (Wind, ed. 1968, pp. 171–176). Today it is more difficult to see beyond the horror of the pictorial representation and to be sympathetic with gods who are so implacably cruel toward mankind.

Condition: Cut down at the top about 7 cm.; 1·5 cm. added at the left and 7 cm. at the right, in the eighteenth century. Restored by Dr. Fischl at Kremsier (Neumann, 1962).

11

History: Probably purchased by Lady Arundel in Italy *c.* 1620; first known in the collection of Lord Arundel, Inventory of 1655, no. 356 (Cust, 1911, p. 279; Hervey, 1921, p. 488, no. 356); apparently bought in 1654 from the Arundel estate by Franz Imsteraed, a nephew of the famous collector, Eberhard Jabach (Safarik, 1964, pp. 173–178); acquired at a lottery in 1673 by Bishop Karl von Lichtenstein at Olmütz; it later passed to the archiepiscopal palace at Kremsier, Czechoslovakia; Kremsier Inventory in 1800 (Dostal, 1930, no. 25).

Bibliography: See also above; Dostal, 1924, pp. 32–40 (first publication); Benesch, 1928, pp. 22–24 (late Titian); Dostal in Valentiner, 1930, no. 26 (late Titian); Suida, 1935, pp. 125, 178 (late Titian); Tietze, 1936, I, p. 247; II, p. 291 (late Titian); *idem*, 1950, p. 374; Hetzer, 1940, p. 167 (not Titian); Berenson, 1957, p. 186 (late Titian); Wind, 1958, p. 142 (iconography); Valcanover, 1960, pl. 143 (late masterpiece); Neumann, 1961, pp. 325–367; *idem*, in English, edition 1962 (booklet, exhaustive account); Pallucchini, 1969, pp. 197–198, 329, figs. 547–550, colour plate LXIV (Titian, *c.* 1570–1576); Panofsky, 1969, p. 171 (questions the attribution to Titian); Fehl, 1969, pp. 1387–1415 (important study).

LITERARY REFERENCES AND VERSIONS:
1. Modena, a version in an inventory of the early eighteenth century (Tietze, 1936, I, p. 247; mentioned but with no source for his information).
2. Paris, sale, 1815 (Mireur, VII, p. 290). Described as the contest between Apollo and Marsyas in the presence of Midas, Minerva, an old man and Jupiter at the right. Sold as Titian for 80 francs. This item can have had no connection with Titian.
3. Rome, private collection; a very bad copy with variations in details (photograph in the Biblioteca Hertziana, Rome; called to my attention by Dr. Safarik).
4. Venice, Michele Spietra (dealer); the same subject, according to the Inventory of 1656 (Levi, 1900, II, p. 21, after Titian; Savini–Branca, 1964, p. 136).

17. **Flora** Plate 35
Canvas. 0·79 × 0·63 m.
Florence, Uffizi.
About 1520–1522.

A consideration of the style of this picture is to be found in the text.

Iconography: In his lengthy study of the iconography of Flora, Julius Held (1961, pp. 201–218) said that she was not only the goddess of flowers, but was also frequently associated with courtesans. Boccaccio in his *De Claris Mulieribus* described her as Flora the Meretricious, Goddess of Flowers and wife of Zephyr ('De Flora meritrice Dea Florum et Zephiri conjuge') (Held, 1961, pp. 208–209). All agree that no note of coarseness or vulgarity appears in Titian's *Flora*, but rather a Giorgionesque pensiveness with an added touch of the antique. Joachim van Sandrart's print has the following caption:

'Vere viret tellus, placido perfusa liquore
A Zephyro, et blando turgida flore viget
Flora modis veris, Titiani pectus amore
Implet, et huic similes illaqueare parat.'

Sandrart's implication that she was Titian's mistress is another of the romantic theories that the beautiful ladies in his pictures were amorously allied to the painter.

The strangest of all proposals about *Flora* was Jacob Burckhardt's (1859, edition 1955, III, p. 249, note 3), that she is dressed as a Renaissance bride. Dr. Emma Mellencamp in her splendid article on Titian's *Flora* (1969, pp. 174–177) has demolished for all time the theory that sixteenth-century ladies (brides or not) ever appeared in the *camicia*, which was the under-garment, let alone that they ever exposed one breast in public. Her conclusion, that Flora's garb is essentially that of a nymph with flying golden hair ('con li capelli d'oro sparsi') *all'antica*, is the inescapable truth of the matter.

Condition: A fine crackle covers the canvas, particularly over the garment and on the left hand; slightly dirty; the print by Sandrart (*c.* 1639) proves that the canvas has been cut down on both sides and on the lower edge.

Dating: Flora may be the 'picture of a lady' that Tebaldi mentioned in a letter of 9 December 1522 as having been painted for Alfonso d'Este (Campori, 1874, p. 596). This suggestion was made by Charles Hope.

History: Alfonso López, Spanish international agent; sold by him at Amsterdam in 1639 (Block, 1946, pp. 184–185); purchased by Archduke Leopold Wilhelm, but not listed in his Inventory of 1659; nor is *Flora* included among the prints of Teniers' *Theatrum Pictorium* of 1660, which illustrates the major pictures of the Archduke's collection; for the first time it appears in Stampart and Prenner, 1735, pl. 6, but without the name of an artist; it was sent to Florence in 1793 on an exchange of pictures between the Austrians and the Florentines (Florence, Uffizi, 1926, p. 84, no. 1462; the document is not published by Gotti). This fact alone proves that Titian's masterpiece was not highly regarded in earlier periods.

Bibliography: See also above; C. and C., 1877, I, pp. 270–273

(Titian, 1520's); Gronau, *Titian*, 1904, pp. 45, 289 (*c.* 1515); Hourticq, 1919, pp. 130, 136, 276; Hetzer, 1920, pp. 56–58 (Titian, *c.* 1520); Suida, 1935, pp. 31, 158 (early Titian); Fogolari, 1935, no. 9 (*c.* 1515); Tietze, 1936, II, p. 290 (*c.* 1515); Paris, 1954, no. 49 (*c.* 1516–1518); Berenson, 1957, p. 186 (early Titian); Valcanover, 1960, I, pl. 60 (*c.* 1515); Salvini, 1964, p. 71, no. 1462; Mellencamp, 1969, pp. 174–177; Pallucchini, 1969, pp. 32–33, 247, fig. 94 (*c.* 1514–1515).

COPIES:

1. Madrid, Duke of Alba (photograph in the *London Illustrated News*, 23 January 1937). Cardinal Mazarin in his testament bequeathed a *Flora* by Titian to don Luis de Haro, an ancestor of the Alba family (Cosnac, 1885, p. 256).
2. Venice, Pesaro Estate; canvas, 1·10 × 0·88 m.; shown holding a skull instead of flowers. This late forgery, perhaps eighteenth-century, is published as 'Giorgione's mother as the Magdalen' (Trevisan, 1950, p. 124).
3. Venice. Marshal Johann Matthias von Schulenberg of Hannover had in his house at Venice a picture that appears to have been a *Flora*, according to an inventory, *c.* 1750, no. 90 (Binion, 1970, p. 298).

18. **Fondaco Frescoes** (mostly destroyed) Figures 1–16
Venice, Fondaco dei Tedeschi (now the Central Post Office).
Giorgione, about 1508; Titian, about 1509.

Documentation: The full discussion of the Fondaco dei Tedeschi will be found in the text. On 8 November 1508 a decree was issued by the Signoria (government of Venice) that a valuation be made of Giorgione's frescoes. Giovanni Bellini, who then held the salt patent, which gave him a certain income and other privileges, appointed three men to make the valuation: Vittore Carpaccio, Lazaro Bastiani, and a now unknown Vittore de Matio. On 11 December 1508 Giorgione's frescoes on the façade were estimated as worth 150 ducats but the artist settled for 130 ducats (documentation in Gualandi, III, 1842, pp. 90–92 taken from manuscripts in the Archivio del Magistrato del Sale 1491–1529 and 1505–1514; also Gaye II, 1840, p. 137; repeated by Justi, 1926, II, p. 64; Richter, 1937, p. 303; Pignatti, 1969, p. 159). It is to be noticed that Titian's name is not mentioned in this payment and that it refers only to the façade which gives on the Grand Canal. Therefore Titian's frescoes on the southern façade were not included. In fact we have no record at all of how much he was paid or when. Vasari (1568-Milanesi, VII, p. 429) merely says that a member of the Barbarigo family obtained the commission for him; this statement may be true, since Bernardo Barbarigo held the office of Commissioner of the salt monopoly (C. and C., 1877, I, p. 94). Titian probably began in 1509, but he must have ended his

work at the Fondaco before he went to Padua in 1510 to paint three scenes of the *Life of St. Anthony of Padua* in the Scuola del Santo (Wethey, I, 1969, Cat. nos. 93–95). Therefore I have suggested a date of 1509–1510 for Titian's activity on the Fondaco dei Tedeschi.

The fragments preserved, but in ruinous condition, are Giorgione's *Female Nude* (Figure 4), 2·50 × 1·40 m.; Titian's *Allegory of Justice*, 2·12 × 3·45 m. (Figures 9, 10); Titian's frieze of *Putti and Fantastic Beasts, c.* 2·12 × 3·00 m. (Figure 11). These three now belong to the Accademia at Venice, but are not always shown in the galleries. A third fragment by Titian is a *Compagno della Calza* (Figure 16), unexhibited to the public, in the Ducal Palace. It is clearly not the figure illustrated by Zanetti in 1760 (Figure 15). Both wear the striped particoloured hose of their society of young aristocrats. The *Compagno* in the Ducal Palace, like Giorgione's *Female Nude*, was detached in 1937, whereas the other two larger sections were transferred to canvas in 1967.

History of the Building, 1505–1509: The mediaeval building, destroyed by fire on 28 January 1505, was replaced by the present structure, which, despite various restorations and its ultimate adaptation as the central post office, remains essentially intact. By decree of the Venetian senate of 19 June 1505 the new structure was authorized but with the strange provision that no marble and no sculpture of any kind was to be used on the building (Arch. di Stato, Collegio dei Pregadi: quoted by C. and C., 1877, I, p. 84; also Paoletti, 1893, p. 282). The architects in charge appear to have been a German, Giacomo Tedesco, who prepared the model in 1505, and the Venetian, Giorgio Spavento. The following reports of progress demonstrate that interest in the project ran high:

15 March 1507, the roof was under construction (Sanuto, VII, col. 30);

5 April 1507, the roof is finished and the inscription carved in marble: DUCATUS LEONARDO LOREDANI INCLYTI DUCIS ANNO SEXTO (Sanuto, VII, col. 42).

21 July 1508, the Fondaco had been nearly completed, reports Sanuto: 'Noto che il fontego di todeschi, fabricato, era a bon termine . . . Et ita factum fuit, et perhò ne ho voluto far memoria (*loc. cit.*, col. 589).

Later entries show that the workmen continued to put the last decorative touches on the interior.

1 August 1508, Tuesday, Mass was said in the court of the Fondaco: 'Fo cantà una messa, preparata in corte dil fontego di todeschi, fabrichato novamente; opera bellissima; . . . et tutavia dentro si va compiando, et depenzando di fuora via, tamen non li core fitto, si non al primo di marzo 1509 si comenzerà . . . (Sanuto, VII, col. 597; quoted by Richter, 1937, p. 303, and Pignatti, 1969, p. 159).

12 August 1508, business was conducted in the Fondaco, although the interior still contained men at work: 'In questi zorni, tedeschi, ritornati in fontego nuovo a far le so merchadantie, qual perhò si va lavorando, feno assa merchadi con nostri per la fiera maxime di zenxari e altri; et le galie di Alexandria, carge et con grandissimo haver si aspetava di dì in dì' (Sanuto, col. 608).

18 February 1509, a festival held by the Germans in the Fondaco: 'In questo zorno fu fato in fontego novo di todeschi certa festa solita, di porcho, a mazar da li orbi; et fo fato certa custione' (Sanuto, VII, col. 756).

The history of the rebuilding of the Fondaco was in great part reconstructed by Crowe and Cavalcaselle (1877, I, pp. 80–96). They used principally the account of Herr Elze (1871 and later edition 1881). One of the most important sources is G. B. Milesio's history of the Fondaco, written in 1715 (published by G. M. Thomas in 1881). Milesio's history of the building and of the organization of merchants is traced from the beginnings in 1268, but in a rather disorganized and non-chronological way. The author had access to documents in the Fondaco archives and he gives, moreover, a description of the large and important collection of paintings by Venetian masters in the halls of the Fondaco. He also provides details about the frescoes on Titian's southern façade, which other writers do not record. Selvatico in 1847 (p. 168) lamented that the restorations of 1836 had destroyed the remains of Giorgione's façade 'which included two stupendous figures by Giorgione which were among the best preserved'!! They were on the south side of the two turrets, each of which was decorated with a sculptured lion of St. Mark on the west. Both turrets were eliminated for no apparent reason other than to modernize! Paoletti, in his brief account of the Fondaco's architecture (1893, pp. 282–283), also comments on the restorations of 1836 and on the unfortunate elimination of the turrets, the destruction of traces of the frescoes, and then apparently the replacement of the traditional chimneys in the shape of an inverted bell by the present characterless outlets. Other restorations of 1908 and 1937 were necessary for the preservation of the fabric (Brunetti and Dazzi, 1941), but again some original details were lost forever by thoughtless and needless destruction, both on the outside and inside of the Fondaco.

Bibliography: Dolce (1557), ed. 1960, pp. 164, 201; *idem*, ed. Roskill, 1968, pp. 116, 186, 266, 324; Vasari (1568)–Milanesi, IV, pp. 95–97 (Giorgione), VII, pp. 428–429 (Titian); Sansovino (1581), ed. 1663, p. 366; Ridolfi (1648)–Hadeln, I, p. 100 (Giorgione), pp. 154–155 (Titian); Boschini, 1664, pp. 140–141; Zanetti, 1760, pls. 1–7; Milesio (1775), published by Georg M. Thomas, 1881, pp. 19–50; C. and C., 1877, I, pp. 80–94 (account of the rebuilding and of Titian's frescoes on the Merceria); Simonsfeld, 1887, I, pp. 347–348, II, pp. 109–110 (history of the building); Hetzer, 1920, pp. 1–13 (analysis of the frescoes); Foscari, 1936, pp. 36–46 (account of the frescoes); Tietze, 1936, I, Tafeln, III, IV; Richter, 1937, p. 243, pls. XLII, XLIII, LIII; Zampetti, 1955, p. 46 (*Female Nude* by Giorgione); Tietze–Conrat (1956), 1958, pp. 245–248 (theory of a collection of antique sculptures); Valcanover, 1960, I, pp. 78–79 (resumen); Moschini Marconi, 1962, pp. 125–126 (Giorgione's *Female Nude*); Valcanover, 1967, pp. 266–268 (frieze recently transferred); Pignatti, 1969, pp. 22–24, 102–103, pls. 55–56, 244–248 (Titian); Pallucchini, 1969, pp. 3–7, figs. 11–14 (Titian); Mariacher, 1971, pp. 43–49, figs. 20–21a (exhibition of detached frescoes).

19. 'The Four Condemned' Plates 99–104

A. Tityus, canvas, 2·53 × 2·17 m.

B. Sisyphus, canvas, 2·37 × 2·16 m.

C. Tantalus (lost; see engraving, Plate 104).

D. Ixion (lost).

Madrid, Museo del Prado.

Documented 1548–1549; Tantalus 1553.

The Problems: The greatest confusion has existed as to how many of the 'Four Condemned' were painted for Mary of Hungary by Titian and as to their identities. Lodovico Dolce, a close friend of the master, states in his *Dialogo*, published in 1557, that the subjects were *Tityus, Tantalus,* and *Sisyphus* (Dolce–Roskill, 1968, p. 193). He is confirmed by Calvete de Estrella (1552, edition 1873, II, p. 84), who described the festivals given by Mary of Hungary, sister of Charles V and then regent of the Netherlands, at her Château de Binche near Brussels on 28 August 1549 in honour of her brother and his heir, Prince Philip. There he saw three pictures over the windows of a great hall, representing *Prometheus* [really *Tityus*], *Sisyphus,* and *Tantalus.* Although Calvete de Estrella did not include Titian's name as the artist, no one has ever doubted that the first two are the works that Titian painted for the Spanish regent in 1548–1549. The drawings of the Great Hall, preserved in a private collection, are nearly illegible so far as the pictures on the walls are concerned. Panofsky wrote that he could discern *Tityus* as well as *Sisyphus* on the right wall (Panofsky, 1969, p. 148; van der Put and Popham, 1939, pp. 49–57).

However, discrepancies immediately arise because only two pictures of the 'Four Condemned' had arrived when Granvelle wrote to Titian on 21 June 1549. One would have to assume that the third either reached Brussels in the next two months, i.e. before the festivals at Binche, or that it (*Tantalus*) was painted by Miguel Coxie (see below, Documentation, item 5). The one other contemporary witness, Nicolaes Juvenell, seems to confirm the latter, since he

reported that he had seen 'two famous pictures by Titian' in Mary of Hungary's palace [at Binche], and that year would logically be 1549. The account of his visit there, to be sure, is delayed by more than a century, since it was published by Sandrart (1675, edition Peltzer, 1925, pp. 135–136).

The next data in chronological sequence regarding these pictures appear in Mary of Hungary's letter of 28 August 1553 to the imperial ambassador at Venice. She stated that she had been promised pictures by Titian, among which the *Tantalus* had not been delivered.

Three years later, in September 1556, Mary of Hungary moved to Cigales, near Valladolid, with some of her possessions, and there she died on 17 October 1558. The fourth criminal, *Ixion*, turns up in Mary's Inventory of 1558 and in several later royal inventories until disappearance after the fire of 1734. No copy, print, or drawing of this work has survived.

Iconography: Panofsky was the first (1939, p. 217; repeated in 1969, p. 148) to call attention to the source of the 'Four Condemned' in Ovid's *Metamorphoses*, IV, 451–461: 'The Goddess [Juno] summoned the Furies, sisters born of night, a divinity deadly and implacable. Before Hell's closed gates of adamant they sat, combing the while black snakes from their hair. When they recognized Juno approaching through the thick gloom, the goddesses arose. This place is called the Accursed Place. Here Tityus offered his vitals to be torn, lying stretched out over nine broad acres. Thy lips can catch no water, Tantalus, and the tree that overhangs ever eludes thee. Thou, Sisyphus, dost either push or chase the rock that must always be rolling down the hill again. There whirls Ixion on his wheel, both following himself and fleeing all in one.'

Tityus (Plates 99, 101–103): His endless torture by a vulture preying on his liver was imposed for having violated Latona (*Odyssey*, XI, 779–794). An important and lengthy iconographic study of Prometheus, which includes the problem of his confusion with Tityus, was published by Olga Raggio (1958, pp. 44–62).

Sisyphus (Plate 100): The explanation for the eternal punishment of Sispyhus is not given by Homer (*Odyssey*, XI, 807–818) and remains obscure (see 'Sisyphus', *Encyclopaedia Britannica*, 11th edition, 1911, XXV, p. 161). The strange iconography of Sisyphus carrying the stone on his shoulder, instead of rolling it up the hill as described in the *Metamorphoses*, occurs in the drawing of the Great Hall at Binche and in an illustrated edition of Ovid printed in Venice in 1522, an example of which is now in the Vatican Library (Prince d'Essling, I, 1907, p. 234 and figure on p. 238). Vasari specifically described Titian's painting as a 'Sisyphus in Hell who carries a stone' (Vasari (1568)–Milanesi, VII, p. 451). See also note 318.

Tantalus: The cause of the perennial torment of Tantalus is likewise not given by Homer (*Odyssey*, XI, 794–806), though his misery through thirst and hunger is described in detail. Ovid (*Metamorphoses*, VI, 408–409) provides the horrifying explanation that Tantalus had killed and served up his own son Pelops to the gods at table; other writers tell different tales (see 'Tantalus', *Encyclopaedia Britannica*, 11th edition, 1911, XXVI, p. 401).

Ixion: In his status as a guest at Olympus, Ixion tried to seduce Juno, who provided a cloud substitute by which he became the father of the Centaurs; he was condemned to roll forever on a fiery wheel in the underworld (see 'Ixion', *Encyclopaedia Britannica*, 11th edition, 1911, XV, p. 102).

Condition: X-rays of the *Tityus* and *Sisyphus* were made in Madrid in January 1974 to determine both the authenticity and degree of restoration of these canvases. The extremely faint underpaint and the numerous *pentimenti* especially in the *Tityus* are evidence that the picture is indeed Titian's original. The position of the giant's head appears to have been shifted from frontality before arriving at the present three-quarter direction. The head of the eagle (Plate 101A) shows the state of this detail clearly and the limited degree of paint losses.

The *Sisyphus* reveals far more paint losses in the X-rays with the resultant greater degree of inpaint. These facts account in part for the less interesting quality of the picture, which is, nevertheless, Titian's work.

The theory that these pictures are copies by Alonso Sánchez Coello is disproved by their quality as well as Palomino's statement (1724, edition 1947, p. 804) that the Spanish artist signed and dated his copies, which have been lost since 1734.

Documentation and History: [For the sake of chronological completeness all documents are repeated here].

1. Granvelle's letter to Titian dated 21 June 1549 states that 'the queen' (i.e. Mary of Hungary) has shown me your two pictures of the 'pene infernali' (Zarco del Valle, 1888, pp. 227–228; also quoted by Beroqui, 1946, p. 102).

2. In August 1549 Calvete de Estrella, the official chronicler of Prince Philip on his first foreign travels to Italy, Germany, and the Netherlands, described the paintings that he saw in the summer palace, the Château de Binche: 'On remarque audessus des fenétres trois tableaux peints avec un art merveilleux, l'un représentant *Promethée* [really *Tityus*] enchainé sur le Caucase et un aigle lui dévorant la foie; l'autre *Sisyphe* roulant son bloc de pierre au haut d'un mont, [in Titian's picture as well as in the drawing (van der Put, 1939, p. 52) he carries rather than rolls the stone, a fact that suggests a slip of memory by Calvete de Estrella]; le troisième *Tantale* à qui se dérobent l'eau et les fruits' (Calvete de Estrella, edition 1873, II, p. 84). These pictures

were removed from Binche just before its sack and destruction by the French late in July 1554 (Henne, 1859, x, pp. 130–133).

3. In Mary of Hungary's letter, written in French at Brussels on 28 August 1553 and addressed to the imperial ambassador at Venice, she states that she has received some of the pictures she had ordered from Titian but that among those that he has still promised is the *Tantalus* (Beroqui, 1946, letter in Tormo's appendix, pp. 181–182; Cloulas, 1967, p. 221).

4. Mary of Hungary's Collection, Inventory 1556 (Pinchart, 1856, p. 141, nos. 40, 41), undoubtedly prepared at Brussels, known in Spanish copies: 'dos lienzos pintados de mano de Tician con un *Ixion* pintado y el otro de *Tantalo*, viejos y gastados que estaban en la casa de Vinz' [Binche] (Simancas, Legajo 1093, folio 155). This description of *Tantalus* and *Ixion*, characterizing the pictures as old and worn ('viejos y gastados'), suggests that they were torn out of their frames before the French army sacked the palace at Binche. They had in fact been painted recently.

5. Mary of Hungary's Collection at Cigales (Valladolid), Spanish version of the same inventory dated 1558 (Beer, 1891, p. CLXIV, no. 86: 'dos lienzos pintados de mano de tician con un Ygion [Ixion] y el otro Tantalo viejos y gastados que estaban en la casa de Vinst [*sic*], según parece, por el dicho inventario'; no. 87: 'otro lienzo pintado en él un Tantalo de maestre Myguel, según parece por el dicho inventario (Simancas, Legajo 1017, folio 145v [these descriptions seem to have been copies from an original Brussels inventory, since the wording is exactly the same, and the item by Maestre Miguel is included in both cases]).

6. Another series of unpublished papers among Mary of Hungary's inventories escaped the attention of Pinchart and Beer. They had probably not been sorted out from the hundreds of bundles of unclassified documents at Simancas. 'Datta de retratos e lienços e papeles en que estan algunas cosas pintadas, Legajo 1017, folio 3v' (names of painters are omitted in these documents). Dated 19 October 1558. 'En la villa de Cigales . . . en presencia de la serenisima princesa de Portugal y Infanta de Castilla' [Princess Juana, daughter of Charles V]. Apparently Juana took over the items in this section but the *Sisyphus* and *Tityus* and other pictures were handed over to Philip II almost immediately. 'La dicha serenisima princesa de Portugal al dicho Matoso [su tesorero] dos lienços grandes el uno de [*Xion*?!] con *prometeo* [Tityus] y otro de *tantalo* [surely by Titian] como parece en el dicho entrego. La serenisima princesa y al dicho Matoso otro lienço grande de *tantalo* como parece en el dicho entrego [probably by Maestre Miguel]. La sra. princesa y al dicho Matoso en su dicho otro lienço grande pintado en ello *Sisifo* como parece en el dicho entrego [surely by Titian].'

7. By 1566 Philip II had the paintings on display in Madrid. A poet, Mal-Lara, reports in that year that, being in Madrid, he was charged to write verses about six pictures which he thought were all by Titian: *Prometheus, Tityus, Tantalus, Ixion, Sisyphus,* and the *Daughters of Danao* [*sic*]. The confusion of the poet is obvious in that he had five 'Furias', *Prometheus,* of course, by mistake. At this time the king wanted the pictures restored, in Spanish 'aderezar' [literally, 'improved'] (Beroqui, 1946, pp. 104–105).

In 1599 Jacob Cuelvis (folio 107) saw in the Madrid Alcázar four 'tormenta' which he called 'Titig e vultur, Athlos portar montem, Tantalus and Icarus' [Ixion]!

8. In 1626 Cassiano dal Pozzo reported (folio 48) having seen a *Tityus* by Titian in the 'Pieça Nueva' of the Alcázar at Madrid. He also mentions a *Tityus* by El Mudo in the same room, but this was a mistake of his Spanish host because the copy is known to have been the work of Sánchez Coello. Then he lists 'due altre Titÿ', a proof that even such a learned man as Cassiano dal Pozzo was in a state of confusion about the subjects.

9. Prior to 1626 the pictures were hung in a smaller room, the 'Sala de las Furias', which kept that name even after they were moved to the large hall, then called the 'Pieça Nueva'. Carducho, 1633 (edition 1933, p. 108) lists the four '*Furias*' [for the use of the word *Furiae* or *Furias* in this sense see note 316]: *Sisyphus, Tityus, Tantalus,* and *Ixion,* and he states that the last two are by Titian and the first two are copies by Alonso Sánchez Coello, whereas the reverse is true. Here the structure of the sentence may be the source of the error, since he speaks of the last ('estos últimos') and the first ('los dos primeros'). However, Carducho made other serious mistakes in calling the *Danaë* (my Cat. no. 6) a copy after Titian.

10. Madrid, Alcázar, Inventory 1636, folio 14: in the Pieça Nueva 'quatro lienços grandes quadrados . . . en que están pintadas al olio las quatro Furias que las dos de ellas son de mano de Ticiano y las otras dos de Alonso Sánchez [Coello] y que son de Sisifo y Tantalo las de Ticiano y las de Ticio y Ixion del dicho Alonso Sánchez.' The authorship of the pictures is at variance with Carducho's account.

11. Alcázar Inventories, Salón de los Espejos, 1666 [this part of the manuscript is lost]; Inventory 1686, nos. 59–62, 'quatro pinturas y quales de las furias de tres varas de alto y dos y media de ancho [i.e. 2·505 × 2·087 m.] originales del Ticiano; *idem* in Inventory 1700, no. 3 (summary of this material in Bottineau, 1958, p. 40).

12. At the time of the fire of 1734 they were still in the Salón de los Espejos, the section of the palace that suffered most. Inventory 1734 (after the fire), no. 63: '*Tizio,* maltratado, sin bastidor ni marco . . . original de Ticiano' (i.e. in bad condition without stretcher or frame, suggesting that the picture was cut from the frame in order to save it); no. 64: '*Sisifo,* maltratado en sumo grado' (very badly treated). However in the case of *Tityus* the actual surface

and the X-rays do not suggest severe damage and much repaint because of the fire. *Tantalus* and *Ixion* and Sánchez Coello's copies disappeared at this time. See also Bottineau, 1960, pp. 229, 494.

13. Buen Retiro, Inventory of 1747, at the death of Philip V, no. 31: 'Ticio con un buitre que le come las entrañas, original de Ticiano'; no. 32: 'otro de surijo cargando con un Peñasco [*Sisyphus*] también original de Ticiano'. This inventory is clearly correct.

14. New Royal Palace, in the antechamber of the King's rooms, *Sisyphus* and *Prometheus* [really *Tityus*], two large pictures by Titian (Ponz, 1776, VI, Del Alcázar, 31).

15. In 1816 a large number of the pictures in the Royal Palace were taken to the Academia de San Fernando (Inventory 1816, nos. 31, 32, 'Ticio de Ticiano' and 'Sisifo de Ticiano'; transferred to the Prado before 1828.

Bibliography: See also above; Dolce (1557)–Roskill, p. 192, 335–336, *Tityus, Tantalus*, and *Sisyphus*, done for Spain; Vasari (1568)–Milanesi, VII, p. 451: 'for Queen Mary he made a *Prometheus* who is bound to Mount Caucasus and is lacerated by Jupiter's eagle; and a *Sisyphus* in hell who carries a stone, and *Tityus* gnawed by a vulture . . . and a *Tantalus* of the same size.' [In footnote 3, Milanesi incorrectly states that all were destroyed in the fire of El Pardo Palace and that only copies of *Prometheus* and *Sisyphus* by Sánchez Coello remain. None of these pictures was ever at El Pardo. Crowe and Cavalcaselle made the same error.] Ridolfi (1648)–Hadeln, I, p. 192 [Ridolfi, who had his information at third or fourth hand, gave the subjects as *Tantalus, Prometheus, Sisyphus*, and *Europa*!]. Cosimo III dei Medici on his voyage to Spain in 1668–1669 reports having seen in the Alcázar *Tizio, Tantalo, Sisifo*, and *Issione* [Ixion], all of which he thought were the works of Titian (Medici, edition 1933, p. 124).

Palomino in 1724 (edition 1947, p. 804) gives a totally scrambled account, which again demonstrates the general confusion about the so-called *Furias*. He is correct in saying that the pictures in 1724 were in the Salón Grande [de los Espejos] and that they had formerly been hung in a smaller room called the Sala de las Furias. Then he goes on to say that *Tantalus* and *Ixion* are originals by Titian and that Sánchez Coello copied the other two [without saying where he saw the originals]. Palomino further states that Philip also ordered Sánchez Coello to make smaller copies of all four and that they were signed and dated 1554. In that year Mary of Hungary still had her pictures at Binche and shortly afterwards at Brussels, so the date may have been 1564. Sánchez Coello could not have seen any of them until after her death in 1558, when Philip II inherited her collection. Madrazo, 1843, *Sisyphus*, p. 162, no. 756; *Tityus*, p. 170, no. 787 (wrongly called *Prometheus*).

C. and C., 1877, II, p. 187 (they incorrectly identified *Tityus* as *Prometheus*. They also stated erroneously that all of the originals were destroyed in the fire at El Pardo (1604). They mistakenly ascribed the surviving pictures to Sánchez Coello); Justi, 1889, p. 183 (surviving pictures not by Sánchez Coello); Panofsky, 1939, p. 217 (discussed the iconographic source in Ovid, IV, 455–461); Beroqui, 1926, pp. 155–156, 248–253, 305 (Titian); idem, 1946, pp. 101–107 *Sisyphus* and *Tityus*); Suida, 1935, pp. 95, 120, 176, 177 (mentioned them as *Prometheus* and *Sisyphus*); Tietze, 1936, II, pp. 298–299 (Titian, c. 1550); Berenson, 1957, p. 188, nos. 426, 427 (Titian); Valcanover, 1960, II, pls. 30, 31, p. 55 (inconclusive); Prado catalogue, 1963, no. 426, *Sisyphus*, and no. 427, *Tityus*; Pallucchini, 1969, pp. 126, 127, 291, figs. 340, 341 (Titian, 1548–1549); loc. cit., p. 339, fig. 589, Sanuto print of *Tantalus*; Panofsky, 1969, pp. 147–149 (Titian, 1548–1549; corrected the iconography).

PRINTS:

1. *Tityus* (called *Prometheus*) by Cornelius Cort, dated 1566 (Plate 103). Size 0·38×0·294 m. Examples in Madrid, Biblioteca del Palacio; Munich, Kupferstich-Kabinett; and Paris, Bibliothèque Nationale. Since it is in reverse, it was doubtless engraved after Titian's drawing (Mauroner, 1941, p. 54, no. 9; Bierens de Haan, 1948, pp. 174–175, no. 192).

2. *Tityus* (called *Prometheus*) by Martino Rota, signed and dated 1570, not reversed and so from Cort. The position of the lowered hand follows Cort rather than Titian's painting (Plate 99). (Bartsch, XVI, p. 281, no. 106; Mauroner, 1941, p. 56, no. 8; Bierens de Haan, 1948, p. 175, as a copy of Cort).

3. *Tantalus* (Plate 104) by Giulio Sanuto (engraved c. 1565), probably copied from Titian's drawing (Passavant, VI, p. 107, no. 16; Mauroner, 1941, p. 57, no. 2; Pallucchini, 1969, fig. 589).

DRAWINGS:

1. Paris, Louvre; *Tityus* (called *Prometheus*), Inventory no. 5518; pen and bistre, 127×103 mm.; from the collection of Mariette in 1775 (Blanc, 1857, I, p. 283; Mariette thought his 'Titian' worthy of Michelangelo: *Abecedario* [1720], 1858, p. 322). The *Tityus* was accepted as by Titian and illustrated by Lafenestre, 1886, p. 237. Tietze and Tietze-Conrat refer to it as a mediocre drawing by the circle of Titian (1944, p. 330, no. 1999, pl. LXXIV). Their judgment will surely prevail in this case, where the copyist may have followed Martino Rota's engraving.

2. Unknown location: *Sisyphus*, blue paper, 285×105·4 mm.; formerly in the collection of Sir Peter Lely; Dr. and Mrs. Francis Springell, sale, London, Sotheby's 28 June 1962, purchased by Agnew and Company £1,100 (*APC*, XXXIX, 1961–1962, no. 5496). Wrongly identified as *Sisyphus*, this drawing shows a nude male figure, full length

in side view, who holds a rectangular object and a long piece of drapery on his right shoulder. Despite the good quality of the draughtsmanship, an attribution to Titian cannot be maintained.

LITERARY REFERENCES (all of these items were probably copies):

1. Brussels, Collection of Mary of Hungary, *Tantalus* by Maese Miguel, i.e. Michael Coxie (Brussels Inventory, 1656 (1658), in Pinchart, 1856, p. 141, no. 42).

2. Guadalajara, Palace of the Duque del Infantado, *Tityus*, seen there in 1626 by Cassiano dal Pozzo, and correctly identified, i.e. not confused with *Prometheus*, as other writers before and since have done (Pozzo, 1626, folio 27). The size is given as about 7 or 8 *braccia* high and 5 *braccia* long, i.e. 4·08×2·90 m. as against the Prado canvas, no. 427, which measures 2·53×2·17 m. However, Cassiano dal Pozzo's is a visual approximation, and he may have included the frame. Although he specifies the picture as a famous work by Titian, it surely was a copy, unless the king had given or lent him the Prado original.

3. London, York House, Duke of Buckingham, *Sisyphus* by Titian (Davies, 1907, p. 380; Fairfax, catalogue 1758, p. 41, no. 10).

4. Madrid, Alcázar, Pieça Nueva, *Tityus* by El Mudo, a mistaken reference to a copy by Alonso Sánchez Coello (Cassiano dal Pozzo, 1626, folio 48).

5. Prague, from the collection of Rudolf II: *Ixion* (?), *Sisyphus*, and *Tantalus*, specified as copies in the Inventory of 1621 (Zimmermann, 1905, p. XLV, nos. 1189, 1191, p. XLVI, nos. 1217, 1218). They may have been copied from the pictures in the Hapsburg royal collection at Madrid.

6. Venice, Barbarigo della Terraza, *Tityus*, but wrongly called *Prometheus* (Bevilacqua, 1845, p. 47); sold to the Czar of Russia in 1850 as *Prometheus*, canvas, 1·18×1·00 m.; since then it has disappeared, perhaps into storage at the Hermitage (Levi, 1900, p. 287, no. 54).

20. Hannibal (?) Plate 67
Canvas. 1·225×1·02 m.
New York, Private Collection.
About 1532–1534.

It is altogether probable that this picture, published for the first time by Pallucchini in 1969 as a fragment from a larger composition, is really the *Hannibal* from the della Rovere Collection at Urbino. The Urbino documents, transcribed by Gronau (1904, pp. 13–15), first refer, on 9 July 1532, to the fact that Titian had agreed to paint the subject, and later on 23 March 1534 (*loc. cit.*, p. 17) to a letter from the Duke of Urbino acknowledging its arrival.

The strange part of the matter is the letter written by the agent Leonardi to Duke Francesco Maria on 9 July 1532, in which he writes, 'Sebastiano Serlio tells me that Titian has begun the Hannibal and that it will be finished soon ... saying that in the sculpture he has found that there is a shield on the right arm ... and concluding that it seems to him that the shield is badly placed and that doing it thus it would not be successful and his opinion ... to have the left arm rest upon the sword and with the baton of captain in the right hand' (Gronau, 1936, pp. 86–91). If Titian used an antique bust as a model, it almost certainly did not represent Hannibal (see below).

The Pesaro Inventory of the della Rovere Collection in 1624, no. 45, lists: 'un quadro in tela di huomo con morione e scudo', i.e. 'a picture on canvas of an armed man with helmet and shield' (Gronau, 1904, p. 9). The della Rovere Inventory of 1631, no. 12, records 'Annibale Cartaginese di Tiziano' (Gotti, 1872, p. 334). In the Medici Inventory of 1687 a picture is described as *Hannibal* in half length with a helmet on his head and sword in his hand by Giulio Romano (Gronau, 1904, p. 9). The inconsistencies of these references are obvious, so that a solid case for the picture is impossible to achieve.

The problem of a classical model for Hannibal is very complex because of the lack of any certain portrait on coins. A tentative identification of Hannibal is found on a Punic coin in the Instituto de Valencia de Don Juan at Madrid (Robinson, 1956, pp. 39–40, 50, Plate II, no. 6b). The elephant on the obverse is the main reason for believing that the classical profile wearing a laurel wreath may indeed be an idealization of the Carthaginian. Far greater speculation involves the theory that a handsome bronze bust at Volubilis, Mauretania (formerly French Morocco), can reasonably be thought to represent the African general (Picard, 1964, pp. 195–207).

The quality of Titian's portrait of a warrior in Roman-Renaissance costume is absolutely extraordinary. The strength and vigour of the figure as well as the pictorial beauty of the work provide some idea of the achievement that Titian's lost *Roman Emperors* (Figures 34–45) must have been. The massive physique in the Mannerist spirit, to which Titian was exposed when he saw the compositions of Giulio Romano at Mantua, is already fully developed here in 1532–1534. A comparable style appears in the portrait of *Andrea Gritti* (c. 1535–1538) in Washington (Wethey, II, 1971, Cat. no. 50). Pallucchini and others continue to date these works 1540–1545. The Medusa head upon the shield of Hannibal suggests that his enemies will be turned to stone as were those of Perseus (Ovid, *Metamorphoses*, V, 230–235).

Condition: Almost perfect despite a fine crackle and a hole, which has been repaired, to the left of the arm holding the sword.

History: See also above. The later history of this picture is mysterious. Said to have been purchased in Paris by a Florentine collector in 1960, the portrait is now in private hands in New York City.

Bibliography: See also above; Vasari in his life of Titian does not cite the portrait of Hannibal by the master, but curiously enough he makes reference (VII, p. 444) to an ancient carnelian stone with an intaglio figure said to be Hannibal. This identification was undoubtedly mistaken ('un ritratto d'Anniballe Cartaginese intagliato d'una corniuola antica'); C. and C., 1877, II, p. 476 (lost); Gronau, 1904, pp. 9, 15–17; *idem*, 1936, pp. 63, 85–86, 90–91; Pallucchini, 1969, p. 282, figs. 291, 292 (as a *Warrior* by Titian, *c.* 1540–1545).

21. Jupiter and Antiope (The Pardo Venus) Plates 74–76

Canvas. 1·96×3·85 m.

Paris, Louvre.

Probably about 1535–1540; retouched *c.* 1560 before shipment to Philip II of Spain.

The iconography and stylistic matters have been placed in the text.

Condition: Hofer's theory (1966, pp. 346–350) that 60 cm. of canvas were added in a later period at the left side is not confirmed by the Louvre authorities, who believe that the extension occurred when Titian was painting the picture. This masterpiece was not damaged in the fire at El Pardo Palace on 13 March 1604 (not 1608) when the portrait gallery was totally destroyed (see below under History). It did suffer in a fire at the Louvre in 1661. Old restorations were removed in 1688, at which time it underwent careful conservation. Further retouchings and repaintings took place in the eighteenth century. Another relining was necessitated in 1829 (Engerand, 1898, p. 158) and the most recent restoration of the varnish is recorded in 1949. The infra-red photographs in the picture's dossier of the Service de Documentation at the Louvre show very clearly that numerous paint losses exist throughout and that little of the original paint remains on the body of the 'Venus–Antiope'. A general report on the condition of the picture, made by Madeleine Hours in 1963. is available in the dossier at the Louvre.

Dating: C. and C., 1877, II, p. 319 (style recalls the Ferrara Bacchanals, but (p. 405) wrongly dated 1567); Gronau, *Titian*, 1904, p. 284 (perhaps an early work, finished *c.* 1550); Fischel, 1907, p. 162 (*c.* 1560); Suida, 1935, pp. 73, 123, 167 (begun *c.* 1520, finished much later); Hetzer, 1940, p. 163 (*c.* 1550); *Mostra di Tiziano*, 1935, p. 167, no. 82 (*c.* 1560); Tietze, 1936, I, pp. 156–157; II, p. 306 (*c.* 1535–1540, later retouched); Klauner, 1958, pp. 144–146 (*c.* 1535–1540); Hofer, 1961, p. 354 (*c.* 1530–1533, after Titian moved to larger quarters in the Casa Grande; finished 1567); Pallucchini, 1969, pp. 86–87, 276–277, figs. 259–261 (*c.* 1540–1542); Panofsky, 1969, p. 192 (begun 1515, resumed 1540, finished 1567; misled by C. and C.).

History in Spain: The first mention of the *Jupiter and Antiope* in Spain occurs in the El Pardo Inventory of 1564, where it is described as 'un lienzo de danae de ticiano pintor' (Sánchez Cantón, 1934, p. 71 and also Calandre, 1953, p. 153). This picture could not possibly have been the *Danaë* that Titian shipped to Philip II in 1554 and was paired with the *Venus and Adonis* (see Cat. no. 6, Documentation and Cat. no. 40, Documentation).

The description of the *Jupiter and Antiope* by Argote de Molina in 1582 in his account of El Pardo Palace leaves no doubt that the present work was involved: 'above the doorway there is painted in oil by the hand of the great Titian, Jupiter transformed into a satyr, contemplating the beauty of the lovely Antiope, who is asleep' (Calandre, 1953, p. 39). The gallery of portraits of the royal family, ten of which were by Titian, was destroyed by fire on 13 March 1604, as recorded by the contemporary *Anales* of Pinelo (edition 1931, pp. 67–68; see also Calandre, 1953, p. 70; Wethey, II, 1971, p. 203). The *Jupiter and Antiope* was not damaged at this time. In the El Pardo Inventory of 1614–1617 the picture is listed as in the Sala de la Antecámara, i.e. in the main section of the palace, which is still intact. It is described in a confused style as 'Un lienzo grande del Ticiano . . . de la Venus Danae [*sic*] con un sátiro a los pies'. A marginal note states that the picture was taken away by the Prince of Wales ('Este lienço lo llevó el Principe de Galles'). MS. in the Archivo del Palacio, Madrid, Legajo 27, folio 2v. Reports of the gift by Philip IV to Charles, Prince of Wales, on his visit to Madrid in 1623 are recorded by other contemporaries (Carducho, 1633, edition 1933, p. 109; 'Relación, 9 sept. 1623', Archivo del Palacio, Madrid; also Madrazo, 1884, pp. 111–112).

The *Jupiter and Antiope* is recorded as 'La nuda con il paese con il satiro' by Titian in his letter of 1574 to Philip II's secretary, Antonio Pérez, among the fourteen important works for which he had received no payment (C. and C., 1877, II, pp. 405, 540; Cloulas, 1967, p. 280; also Wethey, III, note 266). C. and C. have caused confusion by adding dates to the list on p. 405.

The 'Pardo Venus' has frequently and incorrectly been thought to be a picture cited in a letter of 6 December 1567, written by the Spanish consul at Venice, Thomas de Çornoça, to Philip II, and described simply as 'otro quadro de Venus' (Zarco del Valle, 1888, p. 234; Cloulas, 1967, p. 274). That work was in all probability the lost *Venus at Her Toilet with*

One Cupid. This item is also included in Titian's letter of 2 December 1567 to Philip II as 'una Venere ignuda' (C. and C., 1877, II, pp. 536–537; Cloulas, 1967, pp. 272–273, agrees that this picture is the 'Venus con amor chi li tiene lo specchio': Cat. no. L–27, Dating).

Post-Spanish History: Van der Doort's catalogue of Charles I's collection, 1639 (Millar edition, 1960, p. 19, no. 16, size 6 ft. 6 × 12 ft. 11). Sale of Charles I's collection, 7 September 1649, LR 2/124, folio 189v (Millar, 1972, p. 310, no. 184); also Harley MS. 4898, folio 218, no. 184, 'The Great Venus de Parde, done by Tytsian sold to Colonel Hutcheson, ye 8 November 1649 for £600' (see also Nutthall, 1965, p. 306). Cardinal Mazarin had his agent purchase it in London in 1653 (Cosnac, 1885, p. 242). The picture was later described when in the Palais Mazarin (Sauval, c. 1660, published 1724, II, p. 178). It thereafter passed to the possession of Louis XIV in 1661 (Hulftegger, 1954, p. 131). The theory that Jabach owned the painting before Mazarin acquired it is incorrect (Bailly-Engerand, 1899, p. 70). Damaged in a fire at the Louvre in 1661; relined and restored in 1688, at which time it was called *Venus and Adonis.* Le Brun's Inventory of 1683, no. 119; in 1715 in the hotel of the Duc d'Antin at Paris; at the Louvre in 1737; again restored in 1749; Lépicié in 1752 gave the subject as *Jupiter and Antiope*; briefly at the Luxembourg Palace; since 1785 at the Louvre (Bailly-Engerand, 1899, pp. 70–72, reconstructed the history from the time of Louis XIV).

Bibliography: See also above; Vasari and Ridolfi (no mention); Palomino (1724), edition Madrid 1947, p. 793 (cited); Villot, 1874, p. 286, no. 468 (with incorrect history of collections); Hourticq, 1919 (doubted that the subject is *Jupiter and Antiope*); Gronau, *Titian*, 1904, p. 284 (*Jupiter and Antiope*); Suida, 1935, pp. 123, 167 (suggested that the picture was begun for Alfonso d'Este, abandoned at the time of his death in 1534, and finished much later); Tietze, 1936, II, p. 306 (an early picture, shipped to Spain about 1567); Berenson, 1957, p. 190 (as 'Venus du Pardo', restored); Valcanover, 1960, I, pl. 153 (follows Tietze); Hofer, 1961, pp. 341–360; Morassi, 1964, colour plate 28 (dated c. 1560; wrongly states that it was damaged by fire in Spain in 1608 [*sic*]; also incorrectly placed in Jabach's collection); Panofsky, 1969, pp. 190–193 (see text for his opinions).

COPY:
Richmond, Petersham, Ham House; canvas, 1·98 × 3·685 m.; English copy made after 1623 and before 1649, during the period when the original now in the Louvre belonged to the collection of Charles I of England. I am indebted to Mr. C. M. Kauffmann, assistant keeper of the Victoria and Albert Museum, for data regarding the picture.

22. Lady at Her Toilet Plate 31

Canvas. 0·96 × 0·76 m.

Paris, Louvre.

About 1515.

The exquisite qualities of design and the great reticence with which the subject is handled place the Louvre version far ahead of the other variants by Titian or his school (see Cat. nos. 23, 24).

Iconography: The present tendency is to regard the *Lady at Her Toilet* as a symbol of the vanities of life. The man holds a large round convex mirror at the right side of the picture and a smaller, rectangular one to the left. He stands subordinated in shadow, but his glance is not disinterested, and the off-the-shoulder disarray of the woman's costume further implies an erotic situation. The first finger of her left hand touches the top of the perfume jar with the intent of placing drops of the bewitching liquid upon her body. If Titian intended the picture to remind the viewer that love and beauty are ephemeral and that old age and death lie ahead, he did not emphasize this aspect, as did other artists such as Hans Baldung Grien, by the inclusion of a death's-head in the mirror. Panofsky believed that this gloomy view of Vanity was present in Titian's mind and described the subject as 'beauty looking at herself in a mirror and suddenly seeing there transience and death' (Panofsky, 1969, pp. 91–94; likewise Verheyen, 1966, pp. 94–98). Thematically a close parallel to Titian's painting is Paris Bordone's *Courtesan at Her Toilet* in the Earl Spencer collection at Althorp (Verheyen, *loc. cit.*, p. 97, fig. 12), where the vulgarity of interpretation leaves no doubt that the woman, both breasts nude, is a courtesan, who opens her empty jewel box, which the man holding the mirror will fill in return for her favours. I would doubt that in either case the lady sees death in the mirror but rather that the artist points out to us, the onlookers, that beauty and erotic love are transient.

Another opinion of the *Lady at Her Toilet* sees it as a genre picture with clearly erotic implications. Hartlaub specifically denies any intention of *Vanitas* symbolism (1951, p. 83), and he illustrates several pictures of ladies with a looking glass throughout the Renaissance and Baroque periods. It is impossible to be certain what Titian had in mind, but he surely did not insist upon symbolism here, as he did in the *Vanitas–Sibyl* in Munich (Cat. no. 37).

The use of reflections in a round mirror of convex surface appears to have started with Jan van Eyck's *Arnolfini and His Bride* (1434) now in the National Gallery at London. It was taken up by Petrus Christus in his *St. Eligius in His Shop* (New York, Metropolitan Museum) and by the Master of Flémalle in his *Werl Altarpiece* at Madrid. In these cases the

study of the visual image fascinated the painter, and there seems to be little evidence of any symbolic intention (see Bialostocki, 1970, pp. 159–176). From Flemish and German painting it passed to Venice, where the round mirror with a reflection turns up in Giovanni Bellini's small allegorical picture of a nude woman (Accademia), variously dated from 1480 to 1500 (Robertson, 1968, pp. 106–107, pl. LXXXIV). In Giovanni's exquisite *Lady at Her Toilet* (Plate 28) of 1515 and Titian's picture with the same title in Paris (Plate 31) there are actually two mirrors, but it is in the large round mirror in the background that the back of the girl's head is reflected. The fact that Bellini's mirrors are round, but neither of them convex, is of no great consequence.

Rejected Identifications: The Inventories of Charles I of England variously entitle the Louvre picture a 'Courtesan' or 'Titian and His Mistress' (see History). Ticozzi's ardently presented theory (1817, pp. 58–63) that the picture now in Washington (Cat. no. X–17) represented Alfonso d'Este and Laura dei Dianti was extended to include the other related compositions. With some reservations Crowe and Cavalcaselle considered the possibility that the *Lady at Her Toilet* did indeed involve these portraits (C. and C., 1877, I, pp. 266–267), but they thought the man resembled the gentleman in the portrait at Madrid, then identified as Alfonso. Nowadays, however, it is quite certain that the Madrid picture represents *Federico Gonzaga* (Wethey, II, 1971, Plates 36, 37). The portrait of *Laura dei Dianti* to which Vasari refers (Milanesi edition, VII, p. 435) is without any doubt the one now in the Kisters Collection at Kreuzlingen Wethey, II, 1971, Plate 41). The lack of resemblance to either person in the Louvre canvas eliminates any such romantic theory. Although Hourticq recognized that fact, he mused over another identification, even more remote, that the lovers were Francisco de los Cobos and Cornelia Malaspina. Even less evidence exists since Titian's portraits of both people are lost (Wethey, II, 1971, Cat. no. L–8a and Cat. no. L–22). Finally, however, Hourticq came to the conclusion that the lovers were Federico Gonzaga and Isabella Boschetti (Hourticq, 1919, pp. 220–226).

Condition: The picture has suffered through two recorded major operations of relining and restoration in 1751 and 1792 (Bailly-Engerand, 1899, pp. 74–75); recent X-rays show glue applied with a circular stroke with a coarse brush in relining (Hours, 1968, pp. 52–53). Cut down slightly at both sides.

History: Gonzaga Collection, Mantua; Gonzaga Inventory of sale to Charles I of England in 1627 (Luzio, 1913, p. 116, no. 328: 'Una donna scapigliata e un giovane con una sfera, opera di Titiano'); the item cited in Charles I's catalogue by van der Doort in 1639 (Millar edition, 1960, p. 21, no. 6)

may be the Louvre picture: 'an Italian Woemans picture with her arme naked dressing herselfe and a man by houlding a Lookeing glass to her Being by Permensius halfe figures Soe bigge as life Painted upon cloath', size 41 × 33 inches (i.e. 1·042 × 0·838 m.).

On the other hand, an entirely different canvas may be involved in the above description, since van der Doort does not call it a 'Mantua peece', as he usually does when an item from the Gonzaga Collection is involved, and he attributes it to Parmigianino. The alternative possibility is that Charles I gave Titian's original to Van Dyck, since an example of the subject by Titian appears in the Inventory of Van Dyck's estate in 1644 (Literary Reference, Cat. no. 24). In that case it would be assumed that Charles I reacquired Titian's *Lady at Her Toilet* from the artist's estate.

In the sale following the death of Charles I, the Louvre picture appears in several of the documents: Appraisal of 1649, 'Tytsian and His Mistress' (Manuscript No. 79A, Victoria and Albert Library, p. 4); 'Tytsian and Mrs after ye Life' (LR 2/124, 1649, folio 191v; Somerset House, 1650, 'La maitresse de Tissian' (Cosnac, 1885, p. 415; Millar, 1972, p. 315, no. 269, sold to Murray, 23 October 1651). Jabach, Cologne, bought it; forced to sell to Louis XIV in 1671 (de Grouchy, 1894, p. 23); Le Brun's Versailles Inventory, 1683, no. 31; Paillet Inventory, 1695; Versailles Inventory, 1709; Lépicié, 1752, pp. 35–36; Hôtel de la Surintendance, 1760 and 1784; 1792 at the Louvre (Bailly-Engerand, 1899, pp. 74–75, history of the picture in the French royal collection).

Bibliography: See also above; Villot, 1874, p. 289, no. 471 (Titian); C. and C., 1877, I, pp. 266–270 (Titian; apparently they dated the picture c. 1520); Gronau, 1904, p. 285 (Titian, 1510–1515); Hetzer, 1920, pp. 54–56 (early Titian); Waldmann, 1922, pp. 217–218 (replica, not Titian!); Fischel, 1924, p. 32 (Titian, 1510–1515); Heinemann, 1928, pp. 51–52 (much restored); A. Venturi, 1928, p. 230 (as Dossoesque copy!); Suida, 1935, pp. 30, 158 (Titian, 1520); *Mostra di Tiziano*, 1935, no. 10 (Titian, c. 1515); Tietze, 1936, II, p. 305; *idem*, 1950, p. 392 (Titian, c. 1512–1515); Berenson, 1957, p. 189 (Titian, 1512–1515); Valcanover, 1960, I, pl. 59 (Titian, early); *idem*, 1969, no. 52 (Titian, 1512–1515); Pallucchini, 1969, p. 246 (Titian, 1514–1515).

23. **Lady at Her Toilet** Plate 32

Canvas. 0·92 × 0·725 m.

Barcelona, Museo de Artes Decorativas.

Titian and workshop.

About 1520.

On the whole the quality compares favourably with the Louvre version, although a trifle harder, particularly the face

of the woman, even before the damage of 1936–1938. Her green dress, white underdress (*camicia*), and the blue drapery at the right are very similar. The variations from the Louvre picture involve the black rather than red costume of the man and the addition of a comb upon the parapet in the foreground. The original appearance of both canvases can only be speculated upon, in view of the numerous restorations both have suffered. The slightly greater breadth of the woman's figure in the Barcelona example is the reason for suggesting a later date than for the first version.

Condition: In the Spanish civil war of 1936–1938 both faces were slashed through the eyes with a knife, but the bodies remained untouched. Even though the restoration, done at the Prado Museum in 1940, was skilfully carried out, the scars can be detected. The familiar Titianesque opalescence of the finger-nails and other subtleties remain, although faded with time.

History: Imperiale Collection, Genoa, 1661, as by Pordenone, 4×3½ *palmi* [i.e. 0·89×0·78 m.] (Luzio, 1913, p. 306); purchased from Imperiale by Queen Christina in 1661; Queen Christina's Collection, Rome, 1661–1689; Inventory 1662, no. 172, folio 57, as Pordenone; 1689, no. 148 as Pordenone (Campori, 1870, p. 359; Waterhouse, 1966, p. 374, no. 62); bequeathed by Queen Christina to Cardinal Azzolino, 1689; Marchese Pompeo Azzolino, Rome, 1689–1692; Odescalchi Collection, Rome, 1692–1721: 'Nota dei quadri', no. 53 in the Odescalchi Archives: 'Tiziano da se stesso ritrattato con la sua femina ennamorata vestita al naturale ne' suoi proprii habiti e mezzo spogliata e Tiziano dietro ad essa tiene uno specchio. Opera di suo gusto alto palmi quattro largo tre'; Odescalchi Inventory, Rome, 1713, folio 77, no. 150, as Titian; Odescalchi sale to the Duke of Orléans, 1721, folio 3v, no. 1, as Titian; Orléans Collection, Paris, 1721–1792 (Dubois de Saint Gelais, 1727, p. 470 and Couché, 1786, pl. VII as Titian); sale of the Orléans Collection in London, 1798, bought in by Mr. Bryan (Buchanan, 1824, I, p. 113, no. 7); sale 10 May 1804 to Dircknick Holmfeld, Copenhagen (Stockholm, 1966, p. 481, no. 1187); E. W. Lake, sale, London, 7 April 1848, no. 70 (Waterhouse, 1966, no. 62); Wilhelm Löwenfeld, Munich, c. 1880–1906; Nemes Collection, Budapest, 1906–c. 1930; Cambó Collection, Buenos Aires and Barcelona, date of purchase from Nemes unrecorded (c. 1930?); bequeathed to the museum in Barcelona in 1947 (Sánchez Cantón, 1955, pp. 71–73).

Bibliography: See also above; C. and C., 1877, I, p. 269 (note; not seen by them); Gronau, 1904 (unknown to him); Kilenyi, Budapest, 1906 (Titian; but with wrong history of earlier collections); Waldmann, 1922, pp. 18, 217–218 (Titian; the original of which the Louvre picture is a replica!); F.

Heinemann, 1928, pp. 49–50 (early Titian, much restored); A. Venturi, 1928, p. 231 (the original of this subject); Suida, 1935, p. 158 (good replica); Tietze, 1936, II, p. 305; *idem*, 1950, p. 392 (mention under Paris); Stockholm, 1966, p. 481, no. 1187 (Titian, c. 1512–1515); Valcanover, 1969, under no. 52, the Paris version (of lesser quality); Panofsky, 1969 (not mentioned); Pallucchini, 1969, p. 246 (school of Titian; this picture is made into two separate items listed under the Paris and the Prague versions).

24. **Lady at Her Toilet** Plate 29

Canvas. 0·83 ×0·79 m.

Prague, Castle.

Titian and workshop.

About 1520.

Here the dark-haired, bearded man of the Louvre and Barcelona versions (Plates 31, 32) is replaced by a young boy, not more than sixteen years old. His bluish-white turban and red costume are also at variance with the others, and there is no certainty that in the Prague picture he should be regarded as a lover rather than a servant. The general quality of the picture, when seen in the original, does not measure up to the others just mentioned, even considering the poor state of preservation. Every aspect of the execution and of the expressions of the figures is far weaker. At Prague the comb is added upon the parapet as at Barcelona, and the position of the lady's hand upon the perfume bottle is modified.

Condition: The canvas has been scrubbed and then retouched with greenish highlights upon the skirt, unlike the other versions. The picture has been reduced in height by 0·57 m. since 1737 and decreased somewhat at the sides (see History). Cleaned and restored in 1962–1965.

History: A picture of the same subject in the Prague Inventory of 1685 seems undoubtedly to be this item. The Prague Inventory of 1737, no. 23, gives the dimensions of 1·40×0·865 m. The picture hung unnoticed in an office of the Castle of Prague until about 1962 (Gottheiner, 1965, p. 605).

Bibliography: Gottheiner, 1965, p. 605 (Titian, early); Neumann, 1966, pp. 60–61, *idem*, 1967, pp. 271–281 (Titian, 1512–1515); Pallucchini, 1969, p. 246 (Titian, c. 1514–1515); Panofsky, 1969, pp. 91–92, note (not the original version of the Louvre picture).

COPIES:

1. Isola Bella, Prince Borromeo; canvas, 1·50×1·10 m.; a mediocre copy, in which the youth wears a white turban. Seen by the author in 1969.

2. London, Earl of Durham (formerly); the boy repeats the Prague version, canvas, 1·093×0·915; hard poor copy; Durham sale, London, Christie's, 27 November, 1957, no. 115 (*APC*, xxx, 1957–1958, no. 1221).

COPIES AND VARIANTS:

1. Berlin, Staatliche Museum (now lost). Miniature, 8·5× 7·5 cm.; it might have been a copy made by Peter Oliver when the picture in the Louvre belonged to Charles I of England; sold by the Berlin Museum at Lepke sale (Berlin, 5–7 November 1907, no. 228, after Titian).
2. Brussels, Bezine Collection (1927); poor copy; panel, 1·00×0·75 m. (data in the Louvre archives).
3. London, Lord Malmesbury; canvas, 0·89×0·737 m. (C. and C., 1877, II, p. 462: probably by Pietro della Vecchia; formerly Fesch Collection; sold in London, 1 July 1876 as Giorgione: Graves, 1921, III, p. 361).
4. Melun Museum; weak copy, canvas, 0·50×0·50 m.; sent there from the Louvre Museum, Paris, in 1872 (Louvre archives).
5. Munich, Suida collection; poor quality; canvas, 1·00× 0·97 m. (sale Munich, Helbing, 18 May 1914, no. 96; gloves and jewellery in the foreground).
6. Toulouse, Dr. C. Bimes (1957); canvas, 1·10×0·90 m. (data in the Louvre archives).

COPIES OF THE WOMAN ALONE:

1. Baldham, Munich; much restored; canvas, 0·877× 0·695 m.; Frédéric de Leyen, Bloemenheim; Paolini, Rome; owned by Jacob Heimann in New York in 1940, when Tietze published it as an original by Titian (1940, no. 62). *Bibliography*: Heinemann, 1967, pp. 210–213, as by Titian; includes names of various owners.
2. London, Grosvenor House; copy of the woman alone (C. and C., 1877, II, p. 461). The same as no. 1 above?
3. Venice, private collection; canvas, 0·75×0·655 m.; remote and very bad copy (Roccaboni, 1947, no. 29, fig. 37).

HISTORICAL REFERENCE:

Brussels, Archduke Leopold Wilhelm; *Lady at Her Toilet* (Plate 30). Detail of David Teniers II's *Gallery of the Archduke Leopold Wilhelm at Brussels*, Madrid, Prado (Plate 202).
This item was owned by the archduke when he lived at Brussels, but he did not take it to Vienna, for it does not appear in the Vienna inventory of 1659 or later.
In his copy (*c.* 1651) Teniers treated Titian's composition with some freedom, eliminating the parapet in the foreground and substituting a high chest in the right background for the round convex mirror. Here he placed the enigmatic letters V V P, which I have earlier suggested might mean VECELLIUS VENETUS PINXIT (Wethey, II, 1971, note 56), since these letters must be regarded as an invention of

Teniers in this instance. The boy is young here, as in the Prague example, but he does not wear a turban. Therefore, though proof is lacking, Leopold Wilhelm's picture may have been a modified composition by Titian himself.

LITERARY REFERENCES:

1. Anthony Van Dyck, Inventory of 1644 after his death: 'Una corteggiana con un specchio et un huomo' by Titian (Müller-Rostock, 1922, p. 22, no. 4). As stated above, Charles I of England may have purchased this picture from Van Dyck's estate.
2. Paris, Collection of Philippe de Champaigne, Inventory of 1674 (Guiffrey and Grouchy, 1892, p. 184, no. 55).

25. **Landscape with Roger and Angelica** Plate 137
Bistre ink on beige paper. 256×405 mm.
Bayonne, Musée Bonnat.
Inscribed: *Titianus*.
About 1550.

The inscription, at the lower right near the woman's elbow, appears to be in the same ink as the drawing, and might therefore be a signature. Cornelius Cort's engraving is dated 1565, but Titian's preparatory drawing is generally placed *c.* 1550. In other cases Cort's engraving (1566) is much later than the painting from which it derives, as for example the *Trinity* (*Gloria*) of 1554 (Wethey, I, 1969, Cat. no. 149, Plates 105–109). Titian prepared drawings specifically for Cort, who did not therefore make his engraving from the finished picture.

Iconography: The subject of the present work has been much disputed. *Perseus and Andromeda* cannot be the theme, since Perseus should ride the winged horse Pegasus, whereas here the armoured knight in the clouds, swinging his sword, bestrides a lion-like monster. Neither can Angelica and Medoro from Ariosto's *Orlando Furioso* be involved: the episode in which Orlando kills Medoro's horse is unconnected with this drawing (Ariosto, canto XXIX, 58–65). Roger (Ruggiero), riding a fantastic beast, does after great difficulties liberate Angelica (Ariosto, *Orlando Furioso*, 1534, canto X, 107–112), who had been bound naked to a rock to be devoured by a monster. The fullest consideration of the iconography is Bierens de Haan's in his monograph on Cort's prints (1948, pp. 205–207). Tietze's proposal (1936, II, pl. 180) of 'Medea and Jason' (Cat. no. L–10) cannot be shown to correspond to the drawing; that idea rests solely on the fact that Titian remarked in a letter to Philip II that he would send him a painting of that subject (see Cat. no. 30, History).

COPIES:
Copies of this drawing exist in the British Museum, in the Louvre, and at Chatsworth (Bean, 1960, no. 173).

PRINT:
Cornelius Cort, 1565, after this drawing (Plate 224). Ridolfi (1648)–Hadeln, I, p. 202, mistakenly described it as a reproduction of the Wallace picture of *Perseus and Andromeda* (Cat. no. 30). His mistake was repeated by Sandrart (1675), edition 1925, p. 290; and also by Crowe and Cavalcaselle, 1877, II, p. 249, note. The full solution was reached by Bierens de Haan, 1948, p. 205, no. 222.

Bibliography: See also bibliography of the print; Tietze, 1936, II, p. 318, fig. 160 (Titian); Tietze and Tietze-Conrat, 1936, p. 162, figs. 136, 137 (Titian, *c.* 1540–1550); *idem*, 1944, p. 312, no. 1872, pl. 69; Mayer, 1937, p. 299; *idem*, 1938, p. 299 (at best a copy of Titian); Frölich-Bum, 1938 (as Cort's study for his engraving); Bierens de Haan, 1948, p. 205, no. 222 (as *Roger and Angelica* by Titian); Bean, 1960, no. 173 (Titian); Pallucchini, 1969, pp. 143, 333, fig. 570 (Titian, *Roger and Angelica*, *c*, 1546–1550).

26. Lucretia Plate 37
Canvas. 0·952×0·622 m.
Hampton Court Palace, Royal Collection
About 1520.

See the passage about this picture in the text.

Condition: Now enlarged to 1·086×0·635 m.; the paint is very crackled; restored several times. The head and neck have suffered greatly from careless repainting.

History: Gonzaga Collection, Mantua, Inventory 1627: 'un cuadro dipintovi una Lucretia romana ignuda opera di Titiano' (Luzio, 1913, p. 131, no. 615); also letter of 1631 'Lucretia naked' (Sainsbury, 1859, p. 326); Collection of Charles I in the 'Cabbonett roome', no. 4, '. . . a standing Lucrecia houlding with her left hand a redd vale over her face, and a dagger in—her hand to stabb her selfe, an intire figure halfe soe big as the life . . . Done by Titian' 3 f 2–2 f' [0·965×0·61 m.] (van der Doort, 1639, Millar edition, 1960, p. 77, no. 4). In another manuscript is the item: 'A Standing Lucretia halfe so big as the life with a dagger in her right hand blinding her eyes with a redd vale. By Titian' (*loc. cit.*, p. 207).
Sale of Charles I's collection after his death 'Pictures Belonging to King Charles I', 1649, Victoria and Albert Museum, MS. 79A, no. 12, at St. James's, £200; 'Une Lucrèce debout par Tissian . . . £200' (Cosnac, 1885, p. 417); Harley MS.

4898, folio 497, sold to Mr. Baggley, ye 23 October 1651, £200; also Nutthall, 1965, p. 306, sold to Mr. Baggley; according to Millar (1972, p. 267, no. 179) it was sold to G. Greene on the same day for £200; repurchased for Charles II; James II (Cust, 1928, pp. 49–51).

Bibliography: C. and C., 1877, II, pp. 464–465 (Venetian follower of Titian); Gronau, 1904 (omitted); Cust, 1928, pp. 49–51 (Titian); Collins Baker, 1929, no. 75 (school of Titian); Berenson, 1932, p. 570, no. 108 and 1957, p. 186 (early Titian, in great part); Suida, 1935, pp. 126, 186 (Titian); Tietze, 1936 (omitted); *idem*, 1950, p. 376 (Titian); Borenius, 1942, p. 185 (Titian); Valcanover, 1960, I, fig. 114 (Titian); *idem*, 1969, no. 119 (Titian, 1523); Pallucchini, 1969, p. 257, fig. 159 (Titian, *c.* 1520–1524).

COPY:
London, Lord Malmesbury; Bolognese copy of the *Lucretia* at Hampton Court (C. and C., 1877, II, p. 462); exhibited at Leeds, 1868, p. 24, no. 208; London, Christie's, 10 May 1879, bought in (Graves, 1914, III, p. 213).

LITERARY REFERENCE:
Huesca (Spain), Lastanova Palace (*c.* 1650): *Lucretia* by Titian (Sánchez Cantón, *Fuentes literarias*, v, 1941, p. 296).

See also: *Tarquin and Lucretia*, Cat. nos. 34, 35, X–33, and X–34.

Marsyas, see: *Flaying of Marsyas*, Cat. no. 16.

27. Nymph and Shepherd Plates 168, 202, 203
Canvas. 1·496×1·87 m.
Vienna, Kunsthistorisches Museum.
About 1570–1575.

Consult the text for the criticism of the painting.

Iconography: Tietze suggested that the subject might be the *Endymion and Diana* that Titian offered to Maximilian II in 1568 (Voltelini, 1892, p. XLVII, no. 8804), but no crescent moon or other attribute identifies the goddess. The Vienna catalogue favours the legend of *Venus and Anchises*, parents of Aeneas. The title of *Venus and Adonis*, assigned to the picture in the Duke of Hamilton's Inventory of 1649 (no. 12: Garas, 1967, pp. 53–75), is obviously mistaken, since Adonis' hunting dogs nowhere appear. Panofsky (1969, pp. 169–171) put forward a claim for *Oenone and Paris*, and sought the literary source in Ovid's *Heroides* (v, 11–15). It concerns Paris when he was still a lowly shepherd, unaware that he was a prince and before his acquisition of Helen of Troy. Never-

theless, none of these subjects is demonstrably the right one to the exclusion of all others. Nobody has doubted the attribution to Titian.

Condition: Very darkened and crackled, although restored in 1937; added canvas removed; the landscape is not entirely finished, even taking into consideration the late style of the picture.

History: Bartolomeo della Nave, Venice, no. 19, until 1636; Duke of Hamilton, London, 1638–1649 (Waterhouse, 1952, p. 15, no. 19); Hamilton Inventory, 1649, no. 12 (Garas, 1967, pp. 53–75); Archduke Leopold Wilhelm, Inventory, 1659, no. 174; Belvedere Palace, Vienna, in 1816.

Bibliography: See also above; Teniers, 1660, no. 60 (Titian); Storffer, 1733, III, p. 142; Stampart and Prenner, 1735, illustrated, then at Stallburg, Vienna; Mechel, 1783, p. 26, no. 42; C. and C., 1877 (omitted); Engerth, 1884, p. 372, no. 523; Gronau, *Titian*, 1904, pp. 198–199, 277 (late Titian); Suida, 1935, pp. 127, 178; Tietze, 1936, I, pp. 238–239; II, p. 316; Jedlicka, 1947, pp. 37–52; Saxl, 1957, pp. 171–172; Berenson, 1957, p. 192 (late Titian); Klauner and Ober-hammer, 1960, p. 147, no. 727; Oberhammer, 1960, Tafel 7; Valcanover, 1960, II, pls. 141–142 (c. 1570); Morassi, 1964, pl. 37, in colour; Pallucchini, 1969, p. 328, figs. 545–546 (c. 1570–1575); Panofsky, 1969, pp. 168–171.

COPY:

Treviso, Museo Civico; canvas, 1·53 × 1·86 m.; hard copy, doubtfully attributed to Palma il Giovane, on coarse canvas and with dull colours; it shows that Titian's original has been cut down on both sides; gift to the museum by Conte Alvise Giustiniani (Menegazzi, 1964, p. 164, illustrated).

28. Orpheus and Eurydice Plate 11

Panel. 0·39 × 0·53 m.

Bergamo, Accademia Carrara.

Titian.

About 1510.

By far the closest to Titian among the several *cassone* panels attributed to him with some degree of generosity by various critics is the one representing the story of *Orpheus and Eurydice*. Here the rocky landscape and the vegetation, particularly in the right distance, are very similar indeed to the backgrounds in the documented frescoes by Titian in the Scuola del Santo at Padua (Wethey, I, 1969, Plates 139–143). The brownish tone of the landscape, due in large part to chemical changes in the pigment, which was originally green, is familiar in a number of the master's landscape settings. There is a dash and vigour about the forces of nature, created by the irregular shapes of the rocks, while in the left distance the campanile of St. Mark's rises serenely against the pale-blue and white sky.

Iconography: The principal source for the legend of Orpheus and Eurydice was probably Ovid's *Metamorphoses* (x, 1–63), plus Vergil's *Georgics* (see note 92).

Condition: In such wretched condition that the landscape and its details are hardly discernible.

History: Lochis Collection, Bergamo.

Bibliography: Cook, 1907, pp. 89, 154 (Giorgione); L. Venturi, 1913, pp. 255–256 (follower of Giorgione); Schubring, 1923, p. 416, no. 883 (Giorgione); Longhi, 1927 (no mention of the Bergamo *cassone* panel, despite various writers' statement to the contrary); Suida, 1935, pp. 16, 184 (early Titian); Richter, 1937, p. 208 (copy after Giorgione); Morassi, 1942, p. 181; *idem*, 1954, pp. 191–193 (early Titian); Longhi, 1946, p. 64 (Titian before 1510); Ottino della Chiesa, 1955, pp. 124–126 (follower of Giorgione); Zampetti, 1955, p. 172 (Titian); Berenson, 1957, p. 85 (copy after Giorgione); Valcanover, 1960, I, pls. 8–9 (early Titian); Pignatti, 1969, p. 115, no. A3 (Titian); Pallucchini, 1969, pp. 10, 234, figs. 20–21 (Titian, c. 1509–1510); Freedberg, 1971, p. 478, note 40 (Titian, 1507–1508).

29. Pastoral Concert (Fête Champêtre) Plates 2, 3

Canvas. 1·10 × 1·38 m.

Paris, Louvre.

Giorgione, largely completed by Titian.

About 1510–1511.

See the text for the consideration of authorship, iconography, and style of the *Pastoral Concert*.

Condition: Among the early tamperings with the picture is the reported enlargement in 1695 (i.e. probably a relining) and in 1788 a cleaning and varnishing (Bailly-Engerand, 1899, p. 65). The report of the conservation of the picture in 1949 by Madeleine Hours of the Louvre (1953, p. 310) revealed that the X-rays show the standing woman in a more frontal position, the legs uncrossed, and her head turned toward the seated figures. The final glazes were added before that section was totally dry. The diagonal hill between her and the seated lutanist was judged to be old repaint. In her latest comment Mme. Hours (1964, p. 155) is even more convincing in her opinion that Titian repainted the standing nude and the landscape.

Probable Early History: The *Pastoral Concert* first appears in the collection of Jabach, who was obliged to sell most of his pictures to Louis XIV at a low price in 1671 (Grouchy, p. 23, no. 44). It has been suggested that Jabach had purchased the *Pastoral Concert*, along with the Holbeins (now in the Louvre also), from the estate of Thomas Howard, Earl of Arundel (Hultegger, 1954 (1955), pp. 126–127). An inventory of 1655 was compiled after the death of Lady Arundel at Amsterdam in 1654, but the exact circumstances of the sale of pictures to Jabach at this time are unclarified. [It should be remarked that a large number of paintings appear to have been purchased by Lady Arundel during her lengthy residence in Venice in 1622. See Hervey, 1921, pp. 198–219].

A very important fact has been recently published by Professor Haskell (1971, p. 547) to the effect that an apparent copy appears in one of the Arundel sales at Antwerp in 1684. It is described as follows: 'Lute Players and Ladies, very artistic and outstandingly fine', attributed to Giorgione (see Arundel *Catalogues*, 1684, no. 1). Since the original was already at Versailles, it seems to me almost certain that this copy would have been made when the Louvre picture still belonged to Lady Arundel. The custom of painting copies of famous works in the past is proven by the Inventory of 1713 of the Odescalchi Collection in Rome, which possessed several originals by Titian and between two and five copies of each (Wethey, I, 1969, p. 4, note 27).

Another piece of circumstantial evidence for the Louvre picture having been in Amsterdam in the Arundel Collection is the existence of a drawing of the *Pastoral Concert* by Jan de Bisschop (1628–1671), and an engraving by A. Blooteling (1640–1690) (Haskell, 1971, pp. 545–546). Both of these Dutchmen were active just at the right moment. They might conceivably have seen the version sold in Amsterdam in 1684, but their replicas are good enough to speculate that they had access to the original rather than to a copy.

False History: It has long been assumed that the *Pastoral Concert* originally belonged to the Gonzaga Collection in Mantua, that it passed to Charles I of England, that it was purchased by Jabach, sold by him to Mazarin, who bequeathed it to Louis XIV (Villot, 1874, p. 27; Bailly-Engerand, 1899, p. 64, under Barbarelli). All of this history is pure supposition, based on the fact that some of the Louvre pictures have passed through these collections. However, the connection between Jabach and Mazarin is in most cases incorrect, since Jabach was really forced to sell his pictures directly to Louis XIV in 1671 and not through Mazarin (died 1661).

The *Pastoral Concert*, moreover, does not turn up in the Mantuan inventories; it cannot be found in van der Doort's catalogue (1639) of Charles I's collection or in any of the inventories of the sales of his pictures after the king's execu-

tion. Nevertheless, this false history has been repeated in every monograph on Titian and on Giorgione through the year 1970. Gronau in 1908 (p. 428, no. XIV) pointed out that the picture first appeared in Jabach's collection. Patricia Egan in 1959 (p. 304, note) called attention to the fact that this legend of Mantua and Charles I must be rejected, but little or no heed was paid. Professor Francis Haskell again corrected the traditional history of the *Pastoral Concert* in a recent lecture (1971, p. 546).

Later History: Le Brun's Inventory of Louis XIV's pictures, 1683, no. 205, as Giorgione; Paillet, 1695, still at Versailles; Hôtel d'Antin, Paris, 1715–1737, taken there by the Duc d'Antin after Louis XIV's death; 1737 at the Louvre, removed to Versailles; Hôtel de la Surintendance in 1760; later taken to the Louvre permanently (Bailly-Engerand, 1899, pp. 64–65).

Bibliography: See also above; Lavallée, 1804, III, pl. 213 (Giorgione); Waagen, 1839, III, pp. 461–462 (Palma il Vecchio); C. and C., 1871, II, pp. 146–147 (an imitator or a follower of Sebastiano del Piombo); Villot, 1874, p. 27 (under Barbarelli, i.e. Giorgione; wrong history); Wickhoff, 1893, p. 135 (Domenico Campagnola); Morelli, 1893, II, p. 292 (Giorgione); Lafenestre, 1886, p. 28 (Titian); Burckhardt (1898), edition 1911, p. 464 (Domenico Campagnola); Cook, 1907, p. 153 (Giorgione); Gronau, 1908, p. 428 (Giorgione, 1508); *idem*, 1921, p. 88 (same opinion); Lionello Venturi, 1913, pp. 164–166 (Sebastiano del Piombo); *idem*, 1962, col. 333 (if by Giorgione, a late work); Hourticq, 1919, pp. 8–32 (Titian); *idem*, 1930, pp. 150–151 (Titian); L. Justi, 1926, I, cat. no. 37 (Giorgione); A. Venturi, 1928, part III, p. 38 (Giorgione); Longhi (1927), reprint 1967, I, p. 235 (Titian); Ferriguto, 1933, pp. 355–356 (Giorgionesque Titian); Suida, 1935, pp. 25, 26, 156 (Titian); Tietze, 1936, I, p. 65, II, p. 306 (probably by Giorgione and finished by Sebastiano del Piombo); *idem*, 1950, p. 392 (same opinion); Richter, 1937, pp. 232–233 (Giorgione, c. 1505–1510, near the Fondaco dei Tedeschi); Castelfranco, 1953, pp. 298–310 (Giorgione; standing nude and heads of youths repainted by Titian); Pergola, 1955, pp. 39–42 (Giorgione); Zampetti, 1955, pp. 104–109 (Titian alone); Berenson, 1957, p. 84 (Giorgione); Klauner, 1958, p. 142 (Giorgione; trees at right by Titian); Valcanover, 1960, pls. 20–21 (Titian, perhaps from Isabella d'Este's collection); Morassi, 1964, pl. I (Titian, 1509–1510; colour plate); *idem*, 1967, p. 135 (Titian, Giorgionesque); Baldass and Heinz, 1965, pl. 38 (Giorgione and Titian); Turner, 1966, p. 102 (Giorgione, finished by Titian c. 1512); Wind, 1969, p. 41, note 76 (Giorgione); Pignatti, 1969, pp. 129–131 (entirely by Titian in his Giorgionesque period, c. 1511); Pallucchini, 1969, pp. 20–21, 239 (designed and begun by Giorgione, completed by Titian after 1510);

Panofsky, 1969 (not mentioned); Calvesi, 1970, p. 206 (Titian, on a project of Giorgione); Freedberg, 1971, pp. 89–90 (Titian in Giorgione's style, c. 1510–1511).

COPIES:
1. Paris, Institut Néerlandais; by Jan de Bisschop (1628–1671), brush and wash, 260×360 mm. (Haskell, 1971, p. 546; Roberts, 1971, p. 33; Van Gelder, 1971, fig. 50).
2. Venice, Biblioteca Marciana, watercolour by G. B. Cavalcaselle, in 1852; 100×140 mm. (illustrated by Moretti, 1973, cat. no. 87).

EARLY ENGRAVINGS:
Mid-seventeenth-century, by A. Blooteling (1640–1690), a minor Dutch engraver (Haskell, 1971, p. 546).
1750, by Nicolas Dupuy.
1804, by Chataigner and Villerey.

30. **Perseus and Andromeda** Plates 134–136
Canvas. 1·83×1·99 m.
London, Wallace Collection.
Not signed.
Documented 1554–1556.

Titian's letter of 1554 implies that *Perseus and Andromeda* was originally intended to be a companion to *Medea and Jason*, a work traceable only in that single reference and probably never painted (see below: Dating). The suggestion that the *Rape of Europa* (Cat. no. 32) was composed to balance the *Perseus and Andromeda* (Panofsky, 1969, pp. 163–168) seems contradicted by Titian's own statement in 1559 that the former went with the *Death of Actaeon* (Cat. no. 8).
Among diverse sources proposed for the figure of Andromeda have been: a drawing of the Risen Christ by Michelangelo (Thode, 1912, III, p. 675; Suida, 1935, p. 121); an antique type of the abducted Ganymede (Tietze, 1936, I, p. 218); and an antique sculpture of a daughter of Niobe (Brendel, 1955, p. 122). Gould's theory that Titian's Andromeda is influenced in pose by the seated Andromeda in the bronze relief from Cellini's *Perseus*, now in the Bargello in Florence, does not seem very convincing in view of the fact that Titian's lady is in a semi-floating, semi-standing position. Her powerful physique and the *contrapposto* do reflect the artist's familiarity with Central Italian art, particularly Michelangelo's, yet withal her body is more feminine and graceful than any work by the great Florentine.

Iconography: Extracts from Ovid's lengthy account of the story of Perseus and Andromeda in the *Metamorphoses* (Book IV, 663–752, translation by F. J. Miller) follow:
'. . . There unrighteous Ammon had bidden Andromeda,

though innocent, to pay the penalty of her mother's words. As soon as Perseus saw her there bound by the arms to a rough cliff—save that her hair gently stirred in the breeze, and the warm tears were trickling down her cheeks, he would have thought her a marble statue—he took fire unwitting, and stood dumb. Smitten by the sight of her exquisite beauty, he almost forgot to move his wings in the air. Then, when he alighted near the maiden, he said: "Oh! those are not the chains you deserve to wear, but rather those that link fond lovers together! Tell me, for I would know, your country's name and yours, and why you are chained here." She was silent at first, for, being a maid, she did not dare address a man; she would have hidden her face modestly with her hands but that her hands were bound. . . . But see! as a swift ship with its sharp beak plows the waves, driven by stout rowers' sweating arms, so does the monster come, rolling back the water from either side as his breast surges through. And now he was as far from the cliff as is the space through which a Balearic sling can send its whizzing bullet; when suddenly the youth, springing up from the earth, mounted high into the clouds. When the monster saw the hero's shadow on the surface of the sea, he savagely attacked the shadow. And as the bird of Jove, when it has seen in an open field a serpent sunning its mottled body, swoops down upon him from behind; and, lest the serpent twist back his deadly fangs, the bird buries deep his sharp claws in the creature's scaly neck; so did Perseus, plunging headlong in a swift swoop through the empty air, attack the roaring monster from above, and in his right shoulder buried his sword clear down to the curved hook. . . . And even till this day the same nature has remained in coral so that they harden when exposed to air, and what was a pliant twig beneath the sea is turned to stone above.'

Condition: X-rays taken in 1962 reveal a figure at the right side which appears to be Andromeda, who was later transferred to the left (Gould, 1963, pp. 112–113; Blunt, 1963, p. 281). Van Dyck's drawing (Plate 206), after a drawing by Titian, also includes two Andromedas.
An alternative theory holds that this second figure was a first idea for Perseus (Wallace Collection, 1968, p. 319). For the hypothesis that the figures in the X-ray may be an abandoned composition for the 'Theft of the Golden Fleece', see Cat. no. L–10.
The colours throughout have much darkened, and the picture has lost its original brilliance, which is further obscured by the thick glass covering it. The nude body of Andromeda has suffered numerous scars.

Dating: A picture of this subject was painted for Philip II of Spain, a fact proven by an undated letter of 1554 with congratulations to Philip on his new 'regno' (i.e. his marriage

to Queen Mary Tudor of England on 25 August 1554), in which Titian stated that he would shortly send *Perseus and Andromeda* as well as *Medea and Jason* (Dolce, *Lettere di diversi eccelentissimi huomini*, Venice, 1559, pp. 231–232; repeated by Ticozzi, 1817, p. 312; Bottari, 1822, II, pp. 27–28). On 10 September 1554 Titian wrote to Juan de Benavides about the same matters mentioned in the other letter, thus surely placing the one to Philip II on the same day of 1554 (Cloulas, 1967, p. 227, note 2).

On 4 May 1556 Philip at Brussels instructed his ambassador Francisco de Vargas at Venice to make sure that the pictures would not be damaged like *Adonis* (see Cat. no. 40, *Documentation*). Philip repeated the request on 3 June 1556; and on 7 September 1556, then at Ghent, he acknowledged receipt of 'the paintings', as having arrived in good condition (letters of 1556: C. and C., II, 1877, p. 511; Italian edition, II, 1878, pp. 194–195; *Calendar*, XIII, 1954, p. 275, also Cloulas; all three letters in Cloulas, 1967, pp. 227, note 4, 230–231; letter of 7 September in Beer, 1891, p. CLXV, no. 8443, gives a wrong date of 1557).

Titian's friend Lodovico Dolce in 1557 confirmed the fact that Titian had painted an *Andromeda* for Philip II (Dolce, 1557, edition 1960, p. 205; Dolce–Roskill, pp. 193, 336, who accepts the dates 1554–1556 for the *Andromeda*).

Incorrect Dating: The proposal to date the *Perseus and Andromeda* between 1566 and 1568, advanced by the catalogue of the Wallace Collection, is unacceptable (Wallace, 1968, p. 321). Nevertheless, Bierens de Haan has already shown that there is a confusion with the *Landscape with Roger and Angelica* and Cort's print of it (see Cat. no. 25, Plates 137, 224). In reality, Titian supplied the engraver with drawings or a replica in these cases as well as in numerous others. For instance, Titian's *Trinity*, which was delivered to Charles V in 1554, but much later was reproduced by Cornelius Cort in an engraving dated 1566 (Wethey, I, 1969, pp. 165–166). Cort lived in Titian's house in 1565–1566 for the purpose of engraving the artist's works. He departed for Rome late in 1566 but returned to Venice for a short time in 1571–1572 (Bierens de Haan, 1948, pp. 7–8, 11).

Panofsky dated the Wallace picture in 1567 and made it a companion piece to the *Rape of Europa* (1559–1562) on the theory that Vasari saw the *Perseus and Andromeda* in Titian's studio during his visit to Venice in 1566. But Vasari in listing these pictures stated specifically that they were in the possession of the king of Spain: 'Le quali pitture sono appresso al re catolico tenute molto care' (Vasari (1568)–Milanesi, VII, p. 452). If Vasari saw any of the mythological pictures, they were replicas or other versions. As Panofsky suggested, he might have examined the replicas offered to Maximilian II in 1568 (Voltelini, 1892, p. XLVII, no. 8804). Panofsky associated the *Perseus and Andromeda* with a ship-

ment from Titian in 1567 (no day or month cited). Of the four letters of that year, dated 25 January, 30 October, 2 December, and 6 December (Cloulas, 1967, pp. 271–274, published in full), not one mentions a picture of this subject. Titian on 6 December 1567 informed Philip that he was shipping the *Martyrdom of St. Lawrence* (Wethey, I, 1969, Cat. no. 115, Plate 181) and a nude *Venus* ('Venere ignuda'), which cannot possibly refer to the *Perseus and Andromeda* (see Cat. no. L–27, Dating). Hofer first (1966, p. 342) incorrectly identified the *Andromeda* with this 'Venere ignuda' and so dated the picture 1567, although Dolce ten years earlier had mentioned the *Andromeda*, sent Philip II.

Subsequent History: Since the *Perseus and Andromeda* was shipped to Philip in the Netherlands, we have no absolute proof that he took the picture to Spain. The probability is strong that he did so, however, in view of the copy recorded in Madrid. Hetzer (1940, p. 166) wrongly stated that Titian shipped the picture directly to Spain (instead of to the Netherlands), an error repeated by others.

The fact is that Cassiano dal Pozzo in 1626 first described the *Andromeda* and called it a copy after Titian. He located it next to the *Venus and Adonis* (Plate 84) in a room preceding the two large halls of the 'Bóvedas' (Pozzo, 1626, folio 121). Carducho in 1633 repeated that it was a copy, and he mistakenly said the same of the *Venus and Adonis* (edition 1933, p. 108). Ridolfi (1648–Hadeln, I, p. 190) simply lists the *Andromeda* among Philip II's pictures.

The problem is to explain how the original *Perseus and Andromeda* left the Spanish royal collection and came into the possession of Anthony Van Dyck. There is a possibility that Philip II gave it to the sculptor, Pompeo Leoni, either as a gift or in partial payment for his vast commission for the bronze statues of the Escorial high altar and the effigies of Charles V and Philip II (see Literary Reference no. 1). In 1617, nine years after Pompeo Leoni's death, Philip III still owed the enormous sum of 8000 ducats for the Escorial tombs (Saltillo, 1934, p. 102), and it can be assumed that the debt was never paid. In that event Van Dyck would have purchased the picture from the heirs of Pompeo Leoni. Although Charles I in 1623 is known to have acquired pictures in Madrid from the Leoni estate (Carducho, 1633, edition 1933, p. 109), no evidence exists that he ever owned the *Perseus and Andromeda*.

The Inventory of Van Dyck's collection includes 'L'Andromeda con Perseo e il monstro' by Titian (Inventory 1644, no. 2; Müller-Rostock, 1922, pp. 22–23). Next the Earl of Northumberland acquired an 'Andromeda' by Titian from the Fleming's estate in 1645–1646. If this was the Wallace picture, as appears probable, the Earl of Northumberland must have sold it to la Vrillière before 1652, since it no longer appears at Alnwick Castle at that date (information

supplied by Mr. Robert A. Cecil of the Wallace Collection, who received it from the present Duke of Northumberland). By 1655 the *Perseus and Andromeda* hung in the palace of the Duc de la Vrillière at Paris, and it was said to have formerly belonged to the King of Spain and to Sir Anthony Van Dyck (Sauval, 1724, II, pp. 232–233). Now Sauval, who wrote his book in the mid-seventeenth century, is a reliable source, and he got the information from the Duc de la Vrillière himself, a little over a decade after Van Dyck's death.

In 1705 the Hôtel de la Vrillière was sold to Louis Raulin-Rouillé, whose widow retained the *Perseus and Andromeda* on the sale of the palace to the Count of Toulouse in 1712 (data from the archives of the Banque de France, kindly supplied by Mr. Robert A. Cecil). The picture must have been sold by Mme. Raulin-Rouillé to the Duc d'Orléans since it next appears in the Orléans catalogue (Dubois de Saint Gelais, 1727, p. 475). There the source is given as the la Vrillière Collection. The picture remained in the Palais Royal at Paris until the French Revolution (Couché, 1786–1808, pl. v), when the entire Orléans collection passed to England (Buchanan, 1824, I, p. 112, no. 5, with the incorrect statement that the *Perseus and Andromeda* had belonged to Charles I).

Bryan's sale, London, 14 February 1800, no. 65 (not sold); Coxe, Burrell and Foster sale, London, 27 March 1805, no. 58; Sir G. Page Turner sale, 19–20 April 1815, no. 204, £362, bought by the Earl of Yarmouth, later 3rd Marquess of Hertford, father of the founder of the Wallace Collection (Wallace Collection, 1968, p. 322). In the nineteenth century it hung in the Marquess of Hertford's house in London, placed in a bathroom, until rediscovered by Sir Claude Phillips in 1900 (Phillips, 1900; Wallace Collection, 1968, p. 322).

Bibliography: See also above; Dolce, 1557 (edition 1960, p. 205; 1968, pp. 193, 336); Vasari (1568)–Milanesi, VII, p. 452 (Andromeda for Philip II); Van Dyck's 'Italian Sketchbook', 1622–1627, pl. 110 (two sketches of Andromeda's figure); Waagen, 1857, p. 79 ('by Veronese... approaching Titian'); C. and C., 1877, II, pp. 237, 248–249 (mention only); Suida, 1935, pp. 121, 178; Tietze, 1936, II, p. 295; Berenson, 1957, p. 187 (late Titian); Valcanover, 1960, II, pl. 89; Gould, 1963, pp. 112–117, 413–414 (*c.* 1554); Wallace Collection, 1968, pp. 318–322 (as datable 1566–1568); Pallucchini, 1969, pp. 309–310, pl. 449 (as datable 1553–1562); Panofsky, 1969, pp. 163, 166–168 (incorrectly as 1567); Keller, 1969, pp. 42–49 (*c.* 1565).

COPIES:

1. Gerona, Museo de Bellas Artes (in storage at the Museo del Prado, Madrid, 1971–1974); canvas, 1·75 × 2·07 m. (Plate 208); an academic Spanish copy *c.* 1570–1575 of the Wallace original. The hard modelling and strong clear colours show no understanding of Titian's technique or colour harmonies. The canvas (no. 2354) was cleaned and restored at the Prado in 1971 after having been on loan at Gerona since 6 March 1882 (records in the library of the Prado Museum).

History: This copy was probably made when Philip II disposed of the original now in the Wallace Collection, London. It is first mentioned by Cassiano dal Pozzo in 1626 (folio 121) as a copy after Titian, when he saw it in the Alcázar at Madrid; Carducho in 1633 also classified it as a copy (edition 1933, p. 108); Alcázar Inventory 1636, folio 50, 'Pieza última de las bóvedas que tiene bentana al lebante', *Perseus and Andromeda*, copy of Titian; Alcázar Inventory 1666, no. 683, value 200 ducats; 1686, no. 856 (Bottineau, 1958, p. 319); 1700, no. 478, in the same location; the Inventory of 1734, no. 29, after the fire of the Alcázar, describes it as in good condition: 'otro de dos varas de alto y dos y tercia de ancho [1·67 × 1·90 m.] de Andromeda y Perseo, con marco negro; bien tratado, copia del Ticiano'; Inventory of Buen Retiro, 1746, after the death of Philip V, no. 186, 'otra de Andromeda y Perseo de dos varas y quarta de largo y dos de caida, copia del ticiano, maltratada'. This item was apparently at that time in storage [Inventory of 1794, no. 1117] until sent to Gerona in 1882. The picture does not appear in the New Royal Palace in the later eighteenth century, nor do any of the catalogues of the Prado Museum list it in the nineteenth century.

2. Leningrad, Hermitage (in storage in 1971); canvas, 1·975 × 1·925 m.; a weak, inaccurate copy (Plate 207) of the Wallace picture. Somof, 1899, p. 135, no. 135 [*sic*], (school of Titian); L. Venturi, 1912, p. 146 (copy by Varotari); Leningrad, 1958, omitted.

Mr. Robert A. Cecil of the Wallace Collection has pointed out the probability that Prince Eugene of Savoy's copy of the *Perseus and Andromeda*, at Vienna in the eighteenth century [it is engraved in *Résidences mémorables de l'incomparable Héros de notre siècle*, Vienna, 1781, pl. 3 (Russell, 1909, p. 368; Kleiner, 1965, illus.)], is the one now in the Hermitage. It may be the one bought by Prince Alexander Kurakin, Russian ambassador at Vienna in 1807–1808. The hypothesis, suggested by Mr. Cecil, seems reasonable that it thereafter passed to the Naryschkin Collection in Leningrad, from which the Hermitage purchased it in 1831 (Somof, 1899, p. 135).

3. Perugia, Penna Gallery; copy of Titian's *Perseus and Andromeda* attributed to Pordenone (C. and C., 1871, II, p. 288, note 1; also edition 1912, III, p. 179).

LITERARY REFERENCES:

1. Madrid, Inventory of Pompeo Leoni, 1609: 'Una tabla

grande de la Andromeda con Mercurio [*sic*] que mata a un dragón que viene del Ticiano. 550 reales [50 ducats]'. The price is rather high for a copy, but the obscure language 'que viene' may refer to one.

Another item is reported in 1609 as in the Leoni house in Milan: 'Una Andromeda de Ticiano deshecha' (Saltillo, 1934, pp. 103, 110).

2. Madrid, Antonio Pérez, Inventory 1585, folio 473, a large picture: 'Andromeda encadenado y Perseo volando'. Although no artist is mentioned, the picture may have been a copy after Titian or even the original, which Philip II might have given to Antonio Pérez. The same Inventory (folios 474, 476) contains Correggio's *Ganymede* and *Jupiter and Io*, now in Vienna, likewise without the name of the artist. The king (in theory) presented them to Pérez (Engerth, 1884, pp. 116–118, cat. nos. 160, 161; Lomazzo, 1584, p. 212).

PRINTS:
1. For the mistaken identification of Cort's engraving (1565) of *Ruggiero Freeing Angelica* with this picture of *Perseus and Andromeda*, see Cat. no. 25.
2. Print by Fontana, 1562.
3. Print by Fernando Bertelli, not dated, not reversed; example in the British Museum (information, courtesy of Mr. Robert A. Cecil).

DRAWING (Plate 206):
Van Dyck in the 'Italian Sketchbook' (Adriani edition, 1940, p. 73, pl. 110v). The curious fact is that Andromeda appears twice, very much as in the X-rays (see Cat. no. 30, Condition). Apparently Van Dyck copied a lost drawing by Titian himself.

WRONG ATTRIBUTION:
Rennes, Museum; by the school of Veronese; 1·95 × 1·35 m.; originally at Versailles as by Titian: Le Brun Inventory 1683, no. 199; in 1752 at the Louvre; lent to the Museum at Montauban in 1872 (Bailly-Engerand, 1899, p. 69; C. and C., 1877, II, p. 249, note, mention as at the Louvre in 1752; Gould, 1963, p. 114, fig. 23).

Pomona, see Addenda II, Cat. no. 60.

31. **Putti at Games** Plate 197
Canvas. 0·787 in height, varying in width up to 2·21 m.
Chambéry, Musée des Beaux-Arts.
Provincetown, Mass., Walter J. Chrysler Collection.
Workshop of Titian.
About 1550.

The main hall of Titian's palace, the Casa Grande, was decorated with a continuous frieze of *Putti at Games*, which

was cut into pieces when removed from the house about 1830. In the frieze some *putti* are playing dice, two are spinning tops, two ride a see-saw, some wave wands, and others ride piggy-back. The eight in the museum at Chambéry comprise the major part of them. The Chrysler Collection possesses one piece (0·787 × 2·21 m.), and another, destroyed during World War II, belonged to the Brinckmann Collection in Munich. They are charming and decorative works, for which Titian probably furnished sketches or drawings to be carried out by his assistants. The Sala del Consiglio dei Dieci in the Ducal Palace at Venice is decorated with a frieze of *putti*, c. 1550, by Giambattista Zelotti, somewhat in the same tradition.

Condition: The state of the canvases is variable, but those at Chambéry have suffered most, largely because they were white-washed at one time in the early nineteenth century. The repainting was carried out rather ruthlessly and clumsily.

History: Casa Grande, Titian's house in Venice; passed to the Barbarigo family in 1581. Francesco Breve, who lived in the house in 1817–1830, had them removed and sold. The eight pieces at Chambéry were a gift of Baron Gariod of Florence in 1877. The Chrysler fragment came from the Lanckoronski Collection in Vienna (1935–1953). All of them were doubtless sold from the Casa Grande about 1830.

Bibliography: Cadorin, 1833, p. 32 (mention); C. and C., 1877, II, p. 46, note (mention); Suida, 1952, pp. 32–33; *idem*, 1935, p. 124, pl. 225 (mention of Lanckoronski panel and the one in the Brinckmann Collection in Munich; Titian, *c.* 1560); Manning, 1956, pp. 26–27, fig. 25; *idem*, 1962, pp. 50–52 (Titian and workshop); Berenson, 1957 (omitted); Valcanover, 1960 (omitted); Pallucchini, 1969 (omitted).

32. **Rape of Europa** Plates 138–141
Canvas. 1·78 × 2·05 m.
Boston, Isabella Stewart Gardner Museum.
Signed beneath the Cupid: TITIANVS P
Documented 1559–1562.

See the text for further consideration of this picture.

Iconography: Titian's major literary sources are Ovid's *Metamorphoses* and *Fasti*, in the second of which it is made clear that Jupiter resumed his godly form once the girl had been safely abducted. Lucian's account, in the *Dialogues of the Seagods*, XV (edition 1888, pp. 83–85), closely repeats Ovid. Lucian adds Loves who hover above the water, but they carry torches instead of the more traditional bows and arrows. *Metamorphoses*, II, 843–875:
'He spoke, and quickly the cattle were driven from the

mountain and headed for the shore, as Jove had directed, to a spot where the great king's daughter was accustomed to play in company with her Tyrian maidens. Majesty and love do not go well together, nor tarry long in the same dwelling-place. And so the father and ruler of the gods, who wields in his right hand the three-forked lightning, whose nod shakes the world, laid aside his royal majesty along with his sceptre, and took upon him the form of a bull. In this form he mingled with the cattle, lowed like the rest, and wandered around, beautiful to behold, on the young grass. His colour was white as the untrodden snow, which has not yet been melted by the rainy south-wind. . . . But, although he seemed so gentle, she was afraid at first to touch him. Presently she drew near, and held out flowers to his snow-white lips. The disguised lover rejoiced and, as a foretaste of future joy, kissed her hands. Even so he could scarce restrain his passion. And now he jumps sportively about on the grass, now lays his snowy body down on the yellow sands; and, when her fear has little by little been allayed, he yields his breast for her maiden hands to pat and his horns to entwine with garlands of fresh flowers. The princess even dares to sit upon his back, little knowing upon whom she rests. The god little by little edges away from the dry land, and sets his borrowed hoofs in the shallow water; then he goes further out and soon is in full flight with his prize on the open ocean. She trembles with fear and looks back at the receding shore, holding fast a horn with one hand and resting the other on the creature's back. And her fluttering garments stream behind her in the wind.'

Fasti, V, 603–618: 'The day before the Ides marks the time when the Bull lifts his starry front. This constellation is explained by a familiar tale. Jupiter in the shape of a bull offered his back to the Tyrian maid and wore horns on his false brow. She held the bull's mane in her right hand, her drapery in her left; and her very fear lent her fresh grace. The breeze fills the robe on her bosom, it stirs her yellow hair; Sidonian damsel, thus indeed it became thee to meet the gaze of Jove. Oft did she withdraw her girlish soles from the sea, and feared the contact of the dashing wave; often the god knowingly plunged his back into the billows that she might cling the closer to his neck. On reaching the shore, Jupiter stood without any horns, and the bull was turned into the god. The bull passed into the sky: thou, Sidonian damsel, wast got with child by Jupiter, and a third part of the earth doth bear thy name.'

The inclusion of Europa in Horace's *Odes* (III, xxvii) led M. L. Shapiro (1971, pp. 109–116) to reinterpret the *Rape of Europa* according to stoic ethic. He considers the brown fish just below the white bull as a symbol of Fear, the Dolphin with *putto* astride him as Joy, the Cupid flying above who holds bow and arrows as Desire, and the drapery that flutters behind as Europa's virginal girdle. He alone perceives

a cross on the other Cupid's chest, who therefore signified Pain. A considerable degree of subjectivity is involved in these theories.

That Titian was familiar with Ovid is undeniable, since more than one of his mythologies was indebted to that source. There is little reason why he should have consulted a poem by an obscure writer of antiquity named Moschus (second century B.C.), as Panofsky has already stated (see Brunet, III, 1862, col. 1920). The Italian translation from the Greek novel by Achilles Tatius (second century A.D.) is an entirely different matter, since it was brought out in Titian's immediate circle. Lodovico Dolce, Titian's friend, made a partial translation from the Greek into Italian of Achilles Tatius' *Dell'Amore di Leucippe et di Clitophonte*, issued in 1546, and a complete Italian edition by Angelo Coccio appeared in 1550, almost a decade before Titian painted the *Rape of Europa*. Recently David Stone Jr. (1972, pp. 47–49) and David Rosand (1971–1972, pp. 542–544) independently arrived at the same conclusion that Titian was familiar with Achilles Tatius. Rosand adds the significant information that a Latin translation in 1544 had been dedicated to Diego Hurtado de Mendoza, Charles V's envoy in Venice, and that the Spaniard owned the original Greek manuscript [for the question of Hurtado de Mendoza's portrait by Titian, see Wethey, II, 1971, Cat. nos. 52 and L–19]. The fact is that Titian's painting contains several elements that must have been suggested by Achilles' novel, in which a picture of the *Rape of Europa* is described: i.e. the dolphin, the Cupids, the mountains, as well as details of Europa's position on the bull's back (Achilles Tatius, English translation, 1917, pp. 7–9). The convincing relations here render any dependence on Titian's part upon little wood-cuts by Bernard Salomon (1557) unlikely in view of the originality and imaginative powers of a great master (Panofsky, 1969, p. 165, fig. 178). Moreover, Titian's *Perseus and Andromeda*, documented 1554–1556 (Cat. no. 30), antedates Salomon's print and the *Rape of Europa* (Cat. no. 32) was begun at least by 1559.

Condition: 'in almost perfect preservation' (Hendy, 1931, p. 370). The print of the picture when in the Orléans Collection shows considerably more sky above and more space at the sides (Couché, 1786–1788, pl. II).

Dating: On 19 June 1559 Titian's letter to Philip II includes a promise to send later two *poesie* which he had already begun: 'l'una di Europa sopra il Tauro, altra di Atheone lacerato da i cani suoi' (C. and C., 1877, II, p. 513; Cloulas, 1967, p. 233); Philip II on 13 July 1559 inquires about 'las otras dos poesias' (Cloulas, 1967, p. 236); Titian on 22 April 1560 mentions as unfinished the 'Giove con Europa' and again on 2 April 1561, on 17 August 1561, and on 22 October 1561 (C. and C., 1877, II, pp. 518, 520, 521, 533; Cloulas,

1967, pp. 244, 245, 246, 249); finally the picture was shipped to Spain via Genoa according to letters of 10 April and 26 April 1562 (C. and C., 1877, II, p. 524; Cloulas, 1967, pp. 252, 253).

The *Rape of Europa* last appears in the correspondence in Titian's famous letter of 22 December 1574 listing fourteen major works for which Philip had never paid him (C. and C., 1877, II, p. 540; Cloulas, 1967, p. 280; Wethey, III, note 266).

Later History: The first precise description of the *Rape of Europa* in the lower vaulted galleries (Bóvedas) of the Alcázar at Madrid is supplied by Cassiano dal Pozzo in 1626 (folio 121v) when it hung next to the *Danaë* (Plate 83): 'il ratto d'Europa che attenendosi al corn del toro sta con una delle coscie rinicchiata su esso un bellissimo scorcio. La bizzarria e resoluzione di quell'Animale e la franchezza con che varca l'onde, il timore e delicateza . . . non si più desidera di più'.

At the time Vicente Carducho wrote, in 1633 the picture still hung in the Alcázar (edition 1933, p. 110); the same author gives the information that the *Rape of Europa* had been boxed to be sent to England but was never shipped when the marriage negotiations between Charles I and Philip IV's sister failed; Alcázar, Inventory 1636, folio 50, in the king's summer quarters (see Chapter V) which had been reconstructed and rearranged since 1626. Here several of Titian's mythological works were exhibited. The *Rape of Europa* apparently hung between one of the Diana pictures (Cat. nos. 9, 10) and the *Venus and Adonis* (Cat. no. 40).

Further rearrangement of the 'Bóvedas' under Velázquez left the *Rape of Europa* in one of the new long galleries; in the Alcázar Inventory 1666, no. 695, valued at the very high price of 4000 ducats; Inventory 1686, no. 868 (Bottineau, 1958, p. 322); Inventory 1700, no. 489, same location.

On 26 August 1704 Philip V gave this picture and the two *Dianas* (Cat. nos. 9, 10) to the French ambassador, the Duc de Gramont (Bottineau, 1960, p. 233). Gramont presented them to the Duc d'Orléans, and they remained in the Palais Royal at Paris (*c.* 1706–1792) until the French Revolution (Dubois de Saint Gelais, 1727, p. 473; Couché, 1786–1788, pl. II). [In stating that the history of the *Rape of Europa* can be traced back only to the Duc de Gramont, Panofsky (1969, p. 164, note) overlooked Titian's several letters from 1559 to 1574 as well as the Spanish inventories published by Bottineau].

On the transfer of the Orléans Collection to London, the *Rape of Europa* was purchased by Lord Berwick (Buchanan, 1824, I, p. 112, no. 2; Bryan's sale, 7 May 1804, no. 47); acquired before 1824 by the Earl of Darnley at Cobham Hall (Bryan, *loc. cit.*); purchased from Lord Darnley by Isabella Stewart Gardner in 1896 through Bernard Berenson (Hendy, 1931, p. 374).

Bibliography: See also above; Vasari (1568)–Milanesi, VII, p. 452 (mention as painted for Philip II); C. and C., 1877, II, pp. 319–324, 513–524, 540 (letters); Hendy, 1931, pp. 370–375 (detailed account); Suida, 1935, pp. 121–122, 177; Tietze, 1936, II, p. 285; Valcanover, 1960, II, pl. 88; Pope, 1960; Carpenter, 1962, pp. 246–249 (philosophical essay); Pallucchini, 1969, pp. 312–313, figs. 462–464 (dated 1559–1562); Panofsky, 1969, pp. 164–168.

COPIES:

1. Boston, Isabella Stewart Gardner Museum; pen and wash on paper, 0.34 × 0.40 m.; copy attributed to Van Dyck after Rubens' copy of Titian (Hendy, 1931, p. 375).

2. London, Dulwich College Gallery, Catalogue 1926, no. 273; canvas, 0.46 × 0.555 m. (Hendy, 1931, p. 375); sketch copy, eighteenth century.

3. London, Wallace Collection; canvas, 0.59 × 0.72 m.; copy of uncertain date and not necessarily Spanish. *History:* Sir Joshua Reynolds, sale Christie's, London, 13 March 1795, no. 57; Bryan Gallery, 1807; Sir Francis Baring; W. Y. Ottley; Dawson Turner, 1852; G. T. Braine, sale 6 April 1857, no. 49, purchased by the Marquess of Hertford (Wallace Collection, 1968, p. 325). *Bibliography:* See also above; Waagen, 1854, III, p. 18 (Titian's original sketch); C. and C., 1877, II, p. 324 (copy by Mazo).

4. Madrid, José de Salamanca; formerly collection of José de Madrazo; copy (Beroqui, 1946, p. 147).

5. Madrid, Prado Museum (Plate 209); canvas, 1.81 × 2.00 m.; believed to be Rubens' copy made in Madrid in 1628 (Pacheco, 1638, edition 1956, I, p. 153); Rubens' Inventory 1641, no. 46 (Lacroix, 1855, p. 271; Denucé, 1932, p. 58); purchased from Rubens' estate by the Spanish crown; New Royal Palace in 1776 (Ponz, VI, Del Alcázar, 35, as Titian). *Bibliography:* See also above; Rooses, 1890, III, p. 91, no. 608 (Rubens in 1628); Hendy, 1931, p. 375 (perhaps not Rubens' copy); Sánchez Cantón, 1963, p. 598, cat. no. 1693 (Rubens).

6. Rokeby Hall, Yorkshire (Cook, 1896, p. 340; Hendy, 1931, p. 375, mention).

7. Collection of Archduke Leopold Wilhelm, a *Rape of Europa*, in mountainous landscape with tiny figures, as by Titian, Inventory 1659, no. 214, 4½ × 5½ *Spann* [0.936 × 1.144 m.] (Berger, 1883, p. XCVIII). This item might conceivably be the painting offered for sale by Titian in 1568 (see Literary Reference no. 6).

The print in Teniers' *Theatrum pictorium*, no. 69, identified this composition, which is repeated in a small painted version by Teniers in the Art Institute at Chicago; panel, 0.217 × 0.312 m.; illustrated by Suida, 1941, fig. 4.

Another example, radically modified particularly in the landscape, is in the Ringling Museum, Sarasota; canvas,

0·502×0·71 m.; there attributed to a Flemish Baroque painter (Suida, 1949, p. 63, no. 62; *idem*, 1941, fig. 5). The mediocre drawings published by Suida have no connections with these compositions (Suida, 1941, pp. 12–13, illustrations of the pictures in Chicago and Sarasota).

LITERARY REFERENCES:

1. La Granja Palace (Segovia); copy by Carlo Maratta, possibly after Titian or Veronese (Inventory of La Granja, 1814, no. 467). The inventory of the purchase of one hundred and twenty-four pictures by Philip V from Maratta's estate contains several copies after Titian and a *Rape of Europa* after Veronese (Battisti, 1960, p. 87).

2. London, Duque de Villahermosa. This Spanish nobleman said that when he was in England (*c.* 1554–1555) he received a *Rape of Europa* as a gift from Titian (Sánchez Cantón, v, 1941, p. 340; Beroqui, 1946, p. 142). One cannot even speculate on the composition of this lost work, but it may have been an earlier version of Philip II's picture, the date of which is 1559–1562.

3. London, Earl of Kent, in the eighteenth century; copy by Michael Cross ordered by Charles I (*Vertue Notebooks*, II, edition *Walpole Studies*, XX, 1932, pp. 146–147).

4. Madrid, El Pardo Palace, copy of Titian's *Rape of Europa* (Inventory 1674, no. 61).

5. Rome, Massimi Collection, Inventory 1677: 'Una Europa longa palmi 1½ scarsa, alta 1 palmo scarsa, di mano di Titiano' [0·2234×0·335 m.] (Orbaan, 1920, p. 519).

6. Venice, a *Rape of Europa* by Titian offered in 1568 to Maximilian II of Austria in a letter of the imperial envoy Veit von Dornberg (Voltelini, 1892, p. XLVII, no. 8804).

33. Sacred and Profane Love (Amor Sacro e Profano)

Plates 17–25

Canvas. 1·18×2·79 m.

Rome, Villa Borghese.

About 1514.

In reviewing the vast bibliography on *Sacred and Profane Love*, which deals chiefly with iconographic interpretations, the great beauty of the picture is often nearly forgotten. A consideration of its style and its place in the artist's career has been reserved for the text.

Condition: The black band on all four sides [4·5 cm. at the top edge and *c.* 2 cm. on the lower edge] appears to be subsequent to the original painting since a few details can be seen through the black pigment. Apparently added in part to accommodate a modern frame, some of the band seems also to cover a ragged edge. The picture is in good condition for its age, with a general surface crackle. The

gallery does not have a record of the date of its relining (Pergola, 1955, I, p. 129), and the last mentioned conservation took place in 1919 (information by courtesy of Dr. Ferrara). Chemical changes account for the generally very dark vegetation, which retains only a hint of the original green that one still sees in many sections of the *Bacchus and Ariadne* in London (Plates 48, 49).

At the lower left beside the clothed woman is the head of an animal in profile about 32 cm. broad, variously interpreted as that of a dog or a cow. This detail was first discovered by the author in June 1973 when he had a colour transparency made of this section of the picture. The animal's head appears to have been painted over, either by Titian himself or at a later date. Since no X-rays of the picture have been made and no equipment to prepare them is available in the Borghese Gallery, it is not possible to obtain further and more decisive data. Now that the head is known to exist, it can be vaguely detected with the naked eye. The iconographic significance of this detail is elusive but it may eventually prove to be considerable. The peculiar rose-bush in the foreground rising in the centre of the sarcophagus is very darkened, and the landscape at the lower left side of the picture has become nearly unreadable. In the right mid-foreground, in large part undecipherable, one can discern at the extreme right the base of a broken column with an ivy plant. Beyond the light brown area are a flock of sheep and some huntsmen with dogs and a rabbit; the lake and village remain well intact. On the high side at the extreme upper left there also survive with reasonable clarity the buildings of a town, over which loom two vast round towers.

The Subject: Before reviewing the numerous theories as to the meaning of *Sacred and Profane Love*, it must be pointed out that nearly all of them are products of the poetic imagination of a score of scholars. Except for the rather obvious identification of the nude girl as Venus and the *putto* as Cupid, attributes are wanting to justify most of the other figures as symbols of a great variety of people and abstract ideas. Cupid is surely stirring water in the sarcophagus and not blood! What the urn contains is impossible to conjecture—the guesses have ranged from white roses to blood. In his description of the Villa Borghese, written in 1613, Francucci refers to the picture as 'Beauty Adorned and Unadorned' ('Beltà disornata e Beltà ornata'). An early approach to the present title makes its initial bow in the inventory of 1693 as 'Donna Divina e Profana'; 'Two Seated Ladies' in Montelatici (1700, p. 288); Vasi (1792, p. 366) established the name 'Amor Sacro e Profano', according to Pergola (1955, p. 129), but this must be a manuscript item since it is not to be found in Vasi's *Itinerario* of 1777.

The British traveller John Evelyn in his *Diaries* (edition 1955,

II, p. 285) spoke of the two admirable Venuses, perhaps referring just to this picture or more likely to two pictures, i.e. *Sacred and Profane Love* and *Cupid Blindfolded* (Cat. no. 4). The most widely accepted interpretation of the meaning of *Sacred and Profane Love* is Panofsky's allegorical explanation, which he began to develop over forty years ago (Panofsky, 1930, pp. 173–180). A fuller account was forthcoming in his Bryn Mawr lectures (1939, pp. 150–160), where he denied any 'neo-mediaeval moralism' but declared the picture a document of 'Neoplatonic humanism'. To put it briefly, the two ladies represent the twin Venuses: the celestial Venus is the beautiful nude goddess of love at the right and the clothed woman is the earthly Venus, who stands for the generative forces of nature. Cupid stirs the waters in an ancient sarcophagus, but Panofsky said in a footnote that the relief had not been explained. He reinforced his argument with impressive references to Lucian, Guarino of Verona, and Leon Battista Alberti, and drew upon his vast knowledge of humanistic literature and legend to make a strong case for his Neoplatonic theory. The first person actually to hint at an association of the picture with the twin Venuses of Ficino's *De Amore* was Petersen (1906, p. 186).

A close approach to Panofsky's view is Freyhan's conception of the dual character of *Caritas* (Charity). The nude woman holds a lamp, whose flame represents 'divine love', while the clothed woman with a wreath of flowers in her hair, flowers upon her lap, and a 'jewel box' has the attributes of *Caritas Misericordia* (Freyhan, 1948, pp. 85–86).

In his very last and most fully developed exposition of the Twin Venuses, Celestial and Terrestrial, Panofsky adds a number of details such as the fact that the flaming vase held by the nude Venus has elsewhere been held by the goddess of love, in refutation of Edgar Wind's challenge that this object is not suitable for the goddess (Panofsky, 1969, p. 115, note 16 and fig. 132). Panofsky also adds an analysis of the reliefs on the sarcophagus, which he had left unexplained thirty years earlier. He disagrees totally with the idea that the horse represents Chastity (see below) and on the contrary calls the unbridled beast the symbol of unbridled passion, but this statement is not forcefully argued. The scene of punishment has widely been recognized as Mars beating Adonis, the young lover of Venus (Mars, of course, not being even Venus' legitimate husband). Here Panofsky floats into the realm of fantasy and regards the punishment as the 'chastisement of bestial love'. How far apart scholars can be is demonstrated by the explanation of the same scene as the 'Flaying of Marsyas' (see below: Larsen, 1955, pp. 95–96). But nothing about this relief gives any support to such an idea.

Panofsky's brilliantly written essay (1969) on *Sacred and Profane Love* must be read by everyone interested in the subject, even though some concepts are difficult to follow.

This writer can see no reason to give a complete résumé of all his theories here. The herm at the extreme left is Priapus, as no one who looks at his genitalia can doubt. Saxl (1938–1939, pp. 362–363) certainly came close to the truth when he called the left side of the sarcophagus a sacrifice to Priapus. Edgar Wind passed off the whole problem rather briefly, perhaps too briefly, when he titled the picture as the *Fountain of Love* where two women meet. He hinted at Human Love and Celestial Love (again verging upon Panofsky) largely because of the presence of Cupid, but he held that neither figure is given an attribute of Venus. The closed vessel (not a mandoline or a lute as others have claimed) beneath the clothed woman's arm he contrasted to the open vessel [*sic*] of the nude woman (Wind, 1958, pp. 122–128). Thus he confined himself primarily to a rebuttal of Panofsky.

The second most plausible interpretation of *Sacred and Profane Love* is Walter Friedlaender's (1938, pp. 320–324). He regarded, as have others, the scene on the sarcophagus as Mars whipping Adonis for his love affair with Venus, while she stands naked and helplessly by at the right (Plate 17). The horse in this respect may belong to Mars, the war-god and lover of Venus (who was just another more powerful lover). Friedlaender identified the clothed woman as Polia, the chaste and cold-blooded heroine of Francesco Colonna's *Hypnerotomachia* (Venice, 1499), whose complex story he charmingly gave in resumé. The relief beneath Polia would then relate her dream that two wild men pulled her hair. Because of this dream Polia abandoned her vows of chastity and devoted herself to Adonis. All ends happily as she decides to join Poliphilo, who loves her, and they are placed under Venus' protection.

The most important part of the story in Friedlaender's mind was the transformation of white into red roses. In coming to Adonis' aid Venus cut her leg in the thorns of the rose bushes. Cupid caught her blood in an oyster shell and placed it in the sarcophagus, and thus Cupid achieved the creation of red roses. Actually this part of the story is not illustrated, and the best one can say is that it is implied. Nobody agrees as to the purpose of the covered bowl beneath the clothed girl's left arm. Friedlaender imagined that it contains roses which are still white. He, without reservations, rejected Panofsky's Neoplatonic conception of 'higher or less high love'.

A reprise of Friedlaender's article appeared in a well-written survey of the whole problem by Wischnitzer-Bernstein (1943, pp. 89–98). She added further data in defence of Francesco Colonna's *Hypnerotomachia* as the source of the entire picture. She amplified the significance of the unsaddled and riderless horse. On comparison with a woodcut in the book of 1499, she saw the horse as a symbol of virginity, which the *putto* or Eros is attempting unsuccessfully to mount (contrast Panofsky's statement that the horse means unbridled passion). The partially concealed man at the left,

arm upraised to help Cupid, she regarded as a herm, related to the cult of Priapus and thus a sex symbol.

Agreement on the extraordinary beauty of *Sacred and Profane Love* alone can be achieved. Both interpretations of the subject by Panofsky and Friedlaender and their followers are plausible. If Titian intended Neoplatonic symbolism, then one of his learned friends supplied the libretto.

THE ESCUTCHEONS:

The discovery that the shield in the centre of the reliefs of the sarcophagus refers to the Aurelio family was made by Gnoli (1902, p. 178), who found in a manuscript in Rome a line drawing labelled simply 'Aurelio'. Final proof that it belonged to Niccolò Aurelio of Venice came later, thanks to the research of Minerbi (1939, pp. 191–194), who found three manuscripts in the Biblioteca Correr at Venice with the Aurelio coat-of-arms. Hitherto unpublished is the Aurelio escutcheon (Plate 22) in the Cancelleria of the Ducal Palace at Venice, which is decorated with the coats-of-arms of the Grand Chancellors and the dates when they held that office. In the upper half on a blue field appear in profile the forequarters of a lion; below is a blue ribbon on a gold field. It can be described in heraldic terms as 'party per fess, the chief azure, a lion issuant or, the base or, a bend wavy azure'. Since the Cancelleria is not open to the public, it was not possible to verify the colour of the lion, which is given alternately as gold ('or') and silver ('argent').

No-one has hitherto noticed the existence of a second escutcheon in this painting. In the bottom of the beautiful fluted silver bowl on the rim of the sarcophagus is a coat-of-arms (Plate 20A) consisting of three blue bars on a silver field ('argent, three bars azure'), the device of the Bagarotto family of Padua (Scorza, n.d., *c.* 1955, Vol. 1). For the marriage of Niccolò Aurelio, then secretary of the Council of Ten, in mid-May 1514 to the daughter of the renowned professor of canon law of Padua, Bertuccio Bagarotto, who had been executed for treason by the Venetian state in 1509, see below, History. [Contributed by Alice S. Wethey, who discovered the second escutcheon].

History: Now that a second escutcheon has been identified in this picture, it seems certain that Niccolò Aurelio, from 1507 secretary of the Council of Ten (Sanuto, VI, column 537, 25 Jan. 1507) and briefly in 1523–1524 Grand Chancellor of Venice (Sanuto, XXXIV, column 376, 23 Aug. 1523 and XXXVI, column 413, 19 June 1524, ff.), commissioned it in celebration of his marriage in 1514 to Laura Bagarotto of Padua (Codex Cicogna no. 1701, 'Grancancellieri', 1843, f. 105, Venice, Biblioteca Correr). The conjecture is incorrect that *Sacred and Profane Love* was painted for Alfonso I d'Este with Laura dei Dianti as model (proposed by Palmarini, 1902) and that Cardinal Scipione Borghese acquired it from Ferrara.

The cardinal, nephew of Pope Paul V, probably bought the canvas in 1608 from the estate of the Milanese cardinal Paolo Sfondrato. It figures in the Borghese Inventory of 1613, and thereafter remained in the Borghese Collection until it was sold in 1902, along with the Villa Borghese and its collections, to the Italian government (Pergola, 1955, I, p. 129; *idem*, 1964, pp. 454, 464).

The texts of the notices of the marriage of Niccolò Aurelio are as follows:

Sanuto, XVIII, column 199, 17 May 1514: 'Non voglio restar di scriver una cosa notanda: come Nicolò Aurelio secretario dil Consejo di X è mariadado in una fia fo dil Bertuzi Bagaroto, che fo apichato, vedoa, fo moglie di Francesco Lombardo, qual à bona dota, et par habi auto licentia dal Principe, consieri e Cai di X; *tamen* di questo molto se parloe.'

Sanuto, XIX, columns 246–247, 15 November 1514: 'Fo conduto ozi con una barcha armata per l'Adexe Nicolò Sanguinazo rebello padoan. . . . fu posto in la preson Forte . . . et in piaza era molta zente venuta perchè fo dito ozi vol apicharlo in mezo le do Colone; . . . Ma nel Consejo di X . . . alcuni . . . voleano farlo apichar *publice*; altri parlono contra, dicendo è mal a far questi spectaculi et è bon farlo strangular in preson. Et cussi fo terminato, . . . E nota, fu fato morir a voce senza altra ballotation fata, che mai più nel Consejo di X fu fato questo; ma per esser rebelo lo meritava. E nota, queto fo cugnato di Bertuzi Bagaroto et barba di la moglie à tolto Nicolò Aurelio secretario dil Consejo di X, che fo fia di dito Bagaroto, vedoa.'

Sanuto, XX, column 368, 7 July 1515: '. . . per causa di una dona, qual fo garzona di Nicolò Aurelio secretario dil Consejo di X, maridata in . . .' [here the omission is Sanuto's].

Among the many references in Sanuto to Dr. Bertuccio Bagarotto are: VIII, column 543, 17 July 1509, a list of the houses in Padua sacked by Venetian troops on the retaking of the city from Emperor Maximilian, among them those of Ilario Sanguinazzo, Niccolò Sanguinazzo, and Bertuccio Bagarotto; VIII, column 543, 21 July 1509, nine Paduan rebels, including Dr. Bagarotto, sent under guard to Venice; IX, column 295, November 1509, three of the Paduans condemned to be hanged; IX, column 358–359, 1 December 1509, the prisoners escorted from prison, 'il terzo, Bertuzi Bagaroto dotor, qual lezeva *publice in jure canonico* a Padoa et havia 300 ducati a l'anno di la Signoria, era richo e famoso . . . qual disse moriva innocente et non era stà rebello . . .'; XV, column 453, 5 January 1513, a first reference to 'la caxa fo di Bertuzi Bagaroto dotor, che fo apicato, qual è bellissima ai Eremitani', the handsome dwelling confiscated by the Venetian state and used by it for many years as temporary residence for Venetian officials in Padua. For a modern biography of Bagarotto, see Abbondanza, 1963.

It is difficult to avoid the impression that the scenes of

violence in the sculptured frieze on the fountain-sarcophagus of *Sacred and Profane Love* form a veiled reference to the troubled history of the Sanguinazzo-Bagarotto family.

[data from Sanuto compiled by Alice S. Wethey].

CHRONOLOGICAL SUMMARY OF OTHER THEORIES AS TO THE MEANING OF '*Sacred and Profane Love*':

1. 'Two Ladies at a Fountain' (Ridolfi (1648)–Hadeln, I, p. 197).
2. Lafenestre (1886, pp. 27–28) saw in the picture only a hymn to beauty. 'It is the beautiful dream of a summer evening' and 'tout parle d'amour', he wrote in elegant French.
3. Among the earliest theories as to a literary source for *Sacred and Profane Love* was that of Franz Wickhoff (1895, pp. 41–43). Venus and her son are unmistakable, he said, and then he asked if the clothed woman was Helen of Troy, Campaspe, Myrrha (mother of Adonis) or Medea. He proposed the source as Valerius Flaccus, *Argonautica*, VII, 194–406, where Venus urges Medea to follow Jason. His identification of the theme gained the approval of Gnoli (1902), pp. 180–181).
4. Wickhoff and Gnoli were roundly contradicted by Palmarini (1903, pp. 40–43), who quoted from Valerius Flaccus' tale that Venus, not as the goddess of love, but as a fully dressed Circe 'con la verga fatata' appeared to Medea in her bedroom. He disproved any possible relationship to *Sacred and Profane Love*. Palmarini had added his own interpretation of the picture as the Fountain of Ardenna or the Fountain of Love and he sought the literary source in Bojardo's *Orlando Innamorato*, part I, canto III, 38, in a slightly earlier article (1902, pp. 410–422). He also insisted in both essays that the model was Laura Dianti, and perforce painted for Alfonso I d'Este (c. 1518–1520). This literary source has gained no adherents, nor has anyone believed in his theory as to the model.
5. The title ought to be *Earthly and Heavenly Beauty* according to Petersen (1906, pp. 182–187), who also lent considerable importance to the spring and saw the landscape backgrounds at each side as reflecting the character and significance of each lady. In this respect as well as in the twin Venuses (Ficino, *De Amore*), he clearly anticipated Panofsky.
6. The general acceptance of the nude beauty as Venus with her son Cupid was followed by Ozzola, who, on the other hand, thought that she was beseeching Helen of Troy at the left to follow Paris. In this scheme of things the horse on the sarcophagus becomes the Trojan Horse, and the scene at the right represents Menelaos murdering Deiphobus, husband of Helen, while the nude woman at the right is Helen herself (Ozzola, 1906, pp. 298–302). Although the author introduced lines from the *Aeneid*, the Trojan story has met with little success in relation to *Sacred and Profane Love*.

7. Olga von Gerstfeldt (1910, pp. 365–376), after a review of the numerous theories advanced up to that time, proposed that the picture was painted in commemoration of the marriage of the person whose shield adorns the sarcophagus. She discounted the probability of any mythological or literary source and interpreted the picture with reference to Titian's presumed love affair with Violante. She saw a jasmin wreath (whereas Panofsky and Wind correctly called it myrtle) on the head of the girl at the left as reflecting a Venetian proverb 'parer un zeuzamin', i.e. 'beautiful as a jasmin'. She correctly emphasized the great similarity in the heads of the beautiful young women of *Sacred and Profane Love*, the *Salome* of the Doria-Pamphili Gallery, Rome (Wethey, I, 1969, Plate 149), *Flora* (Plate 35), the *Lady at Her Toilet* (Plate 31), and Palma Vecchio's so-called *Violante* (Wethey, II, 1971, Plate 222).

Undoubtedly she was right in noting these relationships, since they represent a Venetian type of ideal feminine beauty, particularly Titian's, but that all of them are hymns to the artist's beloved is another and dubious matter. In fact, we have no reason to believe that the so-called Violante, said to be Palma Vecchio's daughter, ever existed (see Wethey, I, 1969, p. 13).

8. One of the least acceptable of the many and various identifications of the two ladies of *Sacred and Profane Love* was Poppelreuter's (1913, pp. 41–56). He made a claim for Sappho, the poetess, as the dressed figure at the left, resting her left arm upon a mandoline [*sic*]. This object has been regarded by everyone else as an urn or box. The nude figure at the right (Venus in practically everybody else's opinion) to him became a Naiad, i.e. a water-nymph ('Nixe des Wasserquells'). The lamp is the light of Hope. Cupid is simply a *putto* playing in the water. Despite the learned tone of this article and quotations from Greek and Latin, no subsequent writer has followed Poppelreuter's rather extravagant leads, which are largely products of the imagination.

9. It remained for Schrey (1914–1915, pp. 567–574) to see the nude Venus as Jupiter masquerading as Diana. In Ovid's story (see Cat. no. 10), he thus seduced Callisto (the dressed girl) and begot her with child. The lack of a crescent moon or any other of Diana's attributes rules out this attempt to find a 'different' solution.

10. Hourticq (1917, pp. 288–298) held quite reasonably that Venus at the right and Cupid are unmistakable, while the other might be Helen of Troy. On the tomb at the right Mars beats Adonis while Venus attempts to intervene. Her foot is injured by thorns and the blood along with her tears creates the red roses. The sarcophagus contains Adonis' blood! He also concludes that the urn in Venus' upraised hand contains drops of blood. He proposes that the dressed girl is Violante, following the disquisition of Olga von

Gerstfeldt with the amorous spirit of a true Frenchman. In 1919 (pp. 126–137) Hourticq repeated most of the same ideas. He anticipated Friedlaender's (see above: The Subject) more scholarly association of the *Sacred and Profane Love* with Francesco Colonna's *Hypnerotomachia* (1499) and he saw in the detail on the sarcophagus at the right (Plate 17) the scene of the jealous Mars beating Adonis for his love of Venus, who stands helplessly by (also from Francesco Colonna). Yet thereupon he launched into his favourite theme that the beautiful females in Titian's early works all represent Violante, his presumed mistress, as above: 'La Fontaine d'Amour'.

11. At the very same time that Hourticq (1917 and 1919) introduced Francesco Colonna's *Hypnerotomachia* as an explanation of *Sacred and Profane Love*, an Italian scholar, Clerici, quite independently arrived at a similar conclusion (1919, pp. 183–203, 240–248). One must recall that World War I was in full tide and that the two men could not have known each other's studies. Clerici reasoned fairly simply that Titian illustrated the story of the love of Polifilo with a minimum of reference to symbolism and without a full explanation of the scenes on the sarcophagus.

12. Adolfo Venturi (1928, pp. 220–226), apparently bored by the whole controversy, felt it sufficient to regard *Sacred and Profane Love* as an 'Allegory of Spring'. But he was quite wrong in hinting that this might be the 'bagno' promised to Alfonso d'Este (letter of 1517: see Wethey, I, 1969, p. 12; Campori, 1874, p. 584).

13. Minerbi turned to Homer and the Odyssey (1939, pp. 210–264) in seeing the nude woman as Calypso accompanied by Cupid, while at the left the fully clothed lady is Penelope. Even in the landscape he discerned episodes of the Odyssey. The reliefs on the sarcophagus became the legend of Apollo and Daphne from Ovid's *Metamorphoses*. But where lies any hint of a girl being transformed into a laurel tree, pursued by her would-be lover? The fact is that Minerbi, for all of his scholarship, along with Larsen in 1955 and Schrey in 1915, leads in the list of implausible literary sources.

14. The least reasonable of all attempts to give a new twist to *Sacred and Profane Love* is B. I. Larsen's (1955, pp. 81–96). The nude woman now becomes Psyche, whose marriage to Cupid is opposed by his mother Venus, the seated clothed woman at the left. The generally accepted view that the sarcophagus shows Mars beating Adonis now turns into the 'Flaying of Marsyas' and the riderless horse becomes Pegasus. All other arguments are discarded without much ado and Raphael's *Cupid and Psyche* frescoes in the Farnesina at Rome are adduced to support the new argument.

15. Cantelupe (1964, pp. 216–227) in an excellently written article sees a picture which 'fuses pagan eroticism with Christian symbolism'. He straddles the fence in saying that the dual aspect of Platonic and Christian love 'records the reconciliation that humanists, scholars, poets, painters, and philosophers had dreamed of'. He too argues that the scene on the sarcophagus represents Mars flogging Adonis. Yet when he sees Adonis as a prefiguration of Christ, he is unconvincing. The Cupid is compared to the angel in the troubled waters of Bethesda, and so the tomb is both that of Christ and Adonis. This idea, too, had been inferred by Wischnitzer-Bernstein (1943, pp. 97–98). Thus we are really back with the *Ovide moralisé* (see Vitry, edition 1850).

16. Charles de Tolnay (1970, p. 39) interprets the nude woman as Venus holding the lamp lighted with the flame of love. To him the landscape at the right signifies two kinds of love: pastoral love exemplified by the amorous couple, and religious love symbolized by the church steeple in the distance. The clothed woman at the left is Chastity, whose character is reinforced by the steep landscape and fortified tower upon the hill. Much less reasonable is the suggestion that the sarcophagus shows at the left the Rape of the Sabines and at the right Cain Slaying Abel, while the waterspout is described as phallic.

17. Hugo Wagner (1970, no. 472, p. 50) returned, after a résumé of earlier theories, to the belief that the clothed woman is Polia from Francesco Colonna's *Poliphili Hypnerotomachia* (Venice, 1499) and that Venus is urging her to follow the call of love. Wagner independently discovered Sanuto's reference to Niccolò Aurelio's marriage to Bertuccio Bagarotto's daughter in 1514 (see above, History).

Bibliography: Vasari (1568)–Milanesi, VII (unknown to Vasari); Ridolfi (1648)–Hadeln, I, p. 197; C. and C., 1877, I, pp. 62–67 (description only); Thausing, 1884, pp. 324–326 ('A Maiden with Venus and Cupid at a Spring'. She has myrtle in her hair and a closed casket under her arm); A. Venturi, 1893, pp. 103–104 (an allegory with perhaps some reference to a spring); Gronau, *Titian*, 1904, pp. 35–37, 295 (*c.* 1512); Ricketts, 1910, pp. 42–44, 181 (*c.* 1512; accepted the Medea legend); Hetzer, 1920, pp. 45–48 (*c.* 1514); Mayer, 1939, p. 89 (partial data on the life of Niccolò Aurelio, based on Sanuto); Suida, 1935, pp. 28, 158 (rejected all explanations of the iconography; *c.* 1513–1515); Tietze, 1936, II, p. 307 (*c.* 1515–1516); Panofsky, 1939, pp. 150–160; Hartlaub 1941, pp. 252–253 (an esoteric and confused divagation on the iconography); *idem*, 1950, pp. 35–49 (more mysto-magic about divination and the Oracle of Love); Morassi, 1942, p. 20, pls. 5, 6 (*c.* 1515; iconography perhaps Virtue and Vice); Pergola, 1955, I, pp. 129–130 (review of the various theories and complete bibliography up to 1955); *idem*, 1964, pp. 454, 464 (Borghese Inventory of 1693, no. 235); Valcanover, 1960, I, pls. 64–69 (*c.* 1515); Cantelupe, 1964, pp. 218–227 (see above); Panofsky, 1969, pp. 110–119 (*c.* 1515); Pallucchini, 1969, pp. 247–248, figs. 99–101, pl. XV (*c.* 1515–1516); Tolnay, 1970, p. 39.

34. Tarquin and Lucretia　　　Plates 161, 164, 166, 239B

Canvas. 1·889 × 1·454 m.

Cambridge, Fitzwilliam Museum.

Signed in capitals in red pigment on the slipper at the lower right: TITIANVS F.

About 1568–1571.

Because of Crowe's and Cavalcaselle's Victorian dislike for the subject and the fact that the action is violent, the picture has never received the attention it deserves. Further details about the style of this masterpiece are reserved for the text.

Iconography: The major source for the legend of Tarquin and Lucretia is Livy's *History of Rome* (Book I, chapter 58), where he relates that Sextus Tarquin, a relative, was given shelter for the night by his kinsman Collatinus. In the middle of the night he went to the room of Collatinus' wife Lucretia, who resisted his advances. He threatened to kill both her and a male slave and thereafter to claim that he had slain them both for adultery. Thus Lucretia was forced to submit, but the next morning she confessed her shame to her husband and thereupon stabbed herself to death. Subsequently Tarquin was exiled and slain. Lucretia became in legend a symbol of the heroism of Roman women and their chastity. In Ovid's version the death of Tarquin marked the end of the rule of the Etruscan kings over Rome. Titian may have read Livy and also Ovid, who includes the story in his *Fasti* (II, 725–852). Boccaccio's *De Claris Mulieribus* provided an easily available source, in which Lucretia's virtue is extolled. Extracts from the charming translation of Boccaccio's work into English by Henry Parker, Lord Morley, c. 1534–1547 read as follows: 'Lucres, the verey ledare and teacher of the Romaynes chastyte, and the moste holy example of the auncyente wyffes, she was the daughter of Lucyus Spuryus, a man hyghly extemyde in honoure emonge the Romaynes ... Tarquyne, that ment all otherwyse then the chaste lady dyde, when he perceyuyde that all the housholde were at quete, he entrede the chambre of Lucres with hys sworde nakyde in hys hande, ... he sayde to hyr: 'If thow thus withstande me, I shall sley a churle and lay hym in thy bedde and reporte that for the loue I had to Collatyn, fyndynge the enbrasyde in hys armes, that I slewe youe bothe.' The poore Lucres, vppon thyes wordes quakynge all in dreede, pawsede and, fearynge that so great an infamye myght cum thereof, if so she shulde be slayne agaynste hyr wyll offrede to hym hyr chaste body. ... And all though the fowlle acte of Sextus was after well reuengyde, yet this was not all, but for thys acte of Lucres, Rome, that was in boundage before, by hyr obteynede for euer fredome and lyberty' (edition London, 1943, pp. 156–159). For an account of the legend of Tarquin and Lucretia in literary sources see Young, 1964, pp. 59–108.

Condition: The picture makes an excellent impression although the catalogue of the Fitzwilliam Museum (Goodison and Robertson, 1967, p. 172) reports damage by heat in relining. The parts that have suffered most are Lucretia's body, Tarquin's right arm, a spot on his bare leg, and the small servant at the left. Cleaned in 1959. The canvas did not suffer in the Alcázar fire of 1734, in the Inventory of which (no. 18) it is said to be in good condition, i.e. 'bien tratado.' The fact that it was still in its frame after the fire proves that it was not removed in haste from the 'Bóvedas de Ticiano: otro cuadro de Ticiano ... con marco negro y bien tratado de Lucrecia y Tarchino.'

Dating: In Titian's letter dated Venice 1 August 1571 he stated that he believed that Philip already had received 'Lucretia romana violata da Tarquino' (C. and C., 1877, II, pp. 391, 538; Cloulas, 1967, p. 276). The following day Guzmán de Silva, the Spanish ambassador in Venice, announced to Philip that Antonio Tiepolo, the Venetian ambassador, would take the picture with him via Genoa (Zarco del Valle, 1888, pp. 234–235; Cloulas, 1967, p. 277). In view of Titian's methods of working over a canvas for months or years, the inception should be placed about 1568.

Later History: First described by Cassiano dal Pozzo, who saw it in 1626 (folio 122) in one of the vaulted chambers of the Alcázar at Madrid with other mythological pictures: 'da questa sala s'entra in una altra saletta che risponde con le finestre in un giardinetto segreto in una delle facciate di questo v'è Tarquinio che con pugnale minaccia Lucretia ignuda, che è bellissima figura, se ben alquanto soverchio piena l'habito di Tarquinio è alla moderna che non gli da molta gratia, e toglie che quel'inverisimiltudine d'esso non s'intende'.

Mentioned by Carducho in 1633 among Titian's works (edition 1933, p. 108) but without its specific location in the palace. The Alcázar Inventory of 1636, folio 49v, *Tarquin and Lucretia*, placed in the 'Pieza última de las Bovedas', hung next to Titian's *Adam and Eve* (Wethey, I, 1969, Plate 162) and *Venus and Cupid with the Organist* (Plate 105). The rooms had been rearranged in this period, as explained in the text. Alcázar Inventory 1666, not listed but some folios are lost; Alcázar Inventory 1686, no. 880 in the 'Bóvedas de Ticiano' (Bottineau, 1958, p. 324); Alcázar Inventory 1700, no. 501; Alcázar Inventory 1734, no. 18; Inventory 1747, no. 170, then in Buen Retiro; New Royal Palace, the queen's apartment (Ponz 1776, tomo VI, Del Alcázar, 43; Ceán Bermúdez, 1800, V, p. 40). The history of the picture since it left Spain has been reconstructed by Goodison and Robertson (1967, II, p. 172). Joseph Bonaparte was successful in taking the *Tarquin and Lucretia* with him when he fled from Spain in 1813. A sale at Christie's, 24 May 1845, no. 71, listed as

'Property of a Distinguished Foreign Nobleman', is identi-
fied by Professor Ellis K. Waterhouse as Joseph Bonaparte in
reference to *Cabinet de l'amateur*, 1845–1846, IV, p. 94, in
which he is so described. *Tarquin and Lucretia*, no. 71 in this
sale (1845), was bought in but sold thereafter to C. J.
Nieuwenhuys; William Coningham sale Christie's 9 June
1849, no. 57, bought in; Lord Northwick, sale 29 July 1859,
no. 1001. By a strange error Waagen (1854, II, p. 155; also
C. and C., 1877, II, p. 393) placed the picture in the Marquess
of Hertford's collection; Nieuwenhuys (1859–1879), sale
Christie's 17 July 1886, no. 53; bought by Charles Fairfax
Murray, who sold it to Charles Butler; Charles Butler, sale
Christie's 25 May 1911, no. 95; bought by Agnew and
resold to Charles Fairfax Murray, London, in 1911; his gift
to the Fitzwilliam Museum in 1918.

Bibliography: See also above; C. and C., 1877, II, pp. 391–394
(unfavourable evaluation); Suida, 1935, pp. 126–127, 178
(with incorrect history); Tietze, 1936, II, p. 285; Berenson,
1957, p. 184 (partly autograph); Winter, 1958, p. 53 (Titian,
1570); Valcanover, 1960, II, pl. 136 (Titian, 1571); Goodison
and Robertson, 1967, no. 914, pp. 172–175 (major account);
Pallucchini, 1969, p. 325, fig. 527, colour pl. LVIII (Titian,
1570–1571); Panofsky, 1969, p. 139, note 1 (mention).

PRINT:
Cornelius Cort, dated 1571 (Plate 229). 370×265 mm.
(Bierens de Haan, pp. 175–176, no. 193, confuses the history
of the Bordeaux version with the one in Cambridge.)
The costume of Tarquin, the headdress of Lucretia and other
details are at variance with the Cambridge original, while
the composition is reversed. Undoubtedly Titian provided a
special drawing for the engraver.

COPY:
Sibiu (Rumania), Brukenthal Museum (Plate 230); canvas,
1·98×1·46 m. The composition follows the same direction
as the Cambridge original, not Cort's engraving in reverse.
However, the details of costume and draperies are closer to
the print, a fact which implies that the copyist was acquainted
with both.

IMITATION:
Brunswick (Germany), Herzog Anton Ulrich Museum;
canvas, 1·80×1·56 m.; German painter *c.* 1720; purchased
in 1740 as the work of Palma il Vecchio (Adriani, 1969,
p. 493). A still later variant of this ugly composition with a
false signature TITIANVS F belonged to Dr. H. S. Schaeffer
at Berlin in 1927. Photograph in the Witt Library, Courtauld
Institute, London. [In January 1974 this latter item was
placed on exhibition at the William Rockhill Nelson Gallery
of Art as attributed to Titian and his workshop. Canvas,
1·81×1·555 m.; Kansas City: *Handbook*, 1973, p. 88].

35. **Tarquin and Lucretia** Plate 165
Canvas. 1·93×1·43 m.
Bordeaux, Musée des Beaux-Arts.
Workshop or copy.
Sixteenth century.

The inferiority of this picture to Titian's original in Cam-
bridge (Cat. no. 34) is evident at first glance in every aspect:
in expressiveness, in the drawing, in the handling of paint,
and in the colour. Nothing about the figures measures up to
the original, a fact not explained by the changes in postures,
which consist of the lowered sword of Tarquin and the
averted head of Lucretia at Bordeaux. The draperies and
costumes are weakly rendered in the second version and the
boy at the lower left omitted. From a technical point of view
the long sweeping brush-strokes of this canvas are entirely
different from Titian's own short strokes on the Cambridge
original.

Condition: The crease through the centre of the picture
indicates that the canvas was folded at some time for ship-
ment, but the vertical crease at the right denotes neither that
nor repair, but instead the original sewing together of the
cloth. When in Charles I's collection, it was described as
'defaced' (see History, below); relined, cleaned and varnished
in 1788 (Bailly-Engerand, 1899, p. 72); the technical report
by the Louvre laboratories states that it was damaged by fire
in 1870; restored and X-rayed in 1964 (Barnaud and Hours,
1964, pp. 19–30).

History: Probably purchased by Lord Arundel in Venice
during his stay there in 1613 (Hervey, 1921, pp. 74–80);
mentioned as in his collection by Tizianello in 1622
(Tizianello, edition 1809, p. XIII; cited by Ridolfi (1648)–
Hadeln, I, p. 196). In the collection of Charles I of England
in 1639, described in van der Doort's Inventory (Millar
edition, 1960, p. 14, no. 1, p. 230) in Whitehall Palace:
'Done by Tichian. Inprimis A defaced Tarquin and Lucrecia
given to yu M. by my Lord Marshall intire figures So bigg
as life ... 75×51 inches' [1·905×1·295 m.]. Sale of Charles
I's collection, 1649, cited in LR 2/124, folio 9r, 'Lucretia &
Tarquin figures by Tytsian' sold to Webb 25 Oct. 1649
(Millar, 1972, p. 70, no. 30). Acquired by Cardinal Mazarin,
Inventory 1661, no. 913 (Cosnac, 1885, p. 288). Collection
of Louis XIV, Le Brun Inventory 1683, no. 120; Lépicié,
1752, p. 32; Hôtel de la Surintendance, Paris, in 1760; sent
to the museum at Bordeaux in 1802 (Bailly-Engerand, 1899,
p. 72); on loan in the town hall at Mérignac (1934–1964);
returned to the Bordeaux Museum in 1964 (Bordeaux, 1964,
no. 28).

Bibliography: Lacour and Delpit, 1855, no. 8 (Titian); Gué, 1862, no. 492 (Titian); C. and C., 1877, II, pp. 392–393 (confused history); Ingersoll-Smouse, 1926, pp. 89–92 (Titian, late); Suida, 1935, p. 178 (with history confused with the Cambridge picture); Tietze, 1936, II, p. 285 (under Cambridge; no opinion); Berenson, 1957 (omitted); Valcanover, 1960, II, p. 62 (lost); Martin-Méry, 1964, p. 16, no. 28 (Titian); Barnaud and Hours, 1964, pp. 16–30 (Titian; major study); Paris, 1965–1966, p. 237 (Titian); Goodison and Robertson, 1967, pp. 173–174 (copy of the Cambridge original); Panofsky, 1969 (omitted); Pallucchini, 1969, pp. 325–326, fig. 528 (Titian, *c.* 1570–1571).

Tarquin and Lucretia, see also: Cat. nos. X–33, X–34.

Lucretia, see: Cat. no. 26.

36. Three Ages of Man Plates 13–16

Canvas. 0·902 × 1·512 m. Colour reproduction

Edinburgh, National Gallery of Scotland, on loan from the Duke of Sutherland.

About 1512–1515.

The style and iconography of this picture are examined in the text.

Condition: The removal of old varnish and repaint in 1966 has eliminated the generally greenish cast that formerly characterized the canvas (Edinburgh, 1970, pp. 98–99). The numerous small scars in the surface do not interfere with the beauty of the picture. A large area on the youth's chest just below the neck is 'inpainted' according to the restoration technique of the present day, which leaves damaged areas visible. Other spots are detectable on the side of his face, his shoulder, and legs. Similar spots can be observed on the girl's neck, breasts, nose, cheek and lip, while her fingers are rather badly damaged. The foremost prone baby has suffered somewhat in the face (examined by the author in 1963 and in June 1973).

Professor Giles Robertson's important article (1971, pp. 721–726) on the X-rays, recently made, of this picture reveals a number of important facts. The girl's head at first turned slightly toward the spectator and there was more drapery around the middle of the youth. The old man in the background had four skulls as in the copies in the Doria-Pamphili Collection and in the Villa Borghese (Plates 175, 176). Robertson's remark that Titian reduced the skulls to two in order to maintain the series of two throughout the picture is plausible. As for the several buildings in the background of the X-rays, I believe that Titian experimented here and that the outlines are too vague to assure any particular re-

lationship to the background of the Lefèbre engraving. Cupid's quiver appears to have hung in the dead tree of the Edinburgh original, while in the Lefèbre reproduction (Plate 177) it seems to be a cross. The X-rays report variations in the three babies, two of whom might have been winged, as in the print.

History: According to Sandrart this picture was first owned by 'the Cardinal of Augsburg', who has been identified by Peltzer as Otto Truchsess von Waldburg (1514–1573) (Sandrart, 1675, edition by Peltzer, 1925, pp. 272, 413). Sandrart is obviously mistaken in stating that Titian painted the work at Augsburg, a city he visited in 1548 and in 1550–1551; the style places it *c.* 1515. On the second trip Titian took several pictures with him, undoubtedly for sale, as his letter to Aretino of 11 November 1550 states (Marcolini, 1552, I, pp. 146–149; C. and C., 1877, II, p. 198). It is altogether possible that the *Three Ages of Man* was among them. Cardinal von Waldburg, a major figure at Rome during the reign of Paul III, a leader of the Counter-Reformation (Moroni, 1856, LXXXI, pp. 145–147), visited Augsburg at this period, specifically in August 1549 (Pastor, 1914, XII, p. 440 note). Even though Sandrart seems to have confused Vasari's account of Paris Bordone with that of Titian (Sandrart–Peltzer, p. 413), he describes the picture accurately, and he states that a member of the von Walberg (i.e. Waldburg) family of Augsburg sold it to Queen Christina, who was living in Rome. [For the dubious theory that Cardinal von Waldburg had purchased his picture from Giovanni da Castel Bolognese, see Literary References, no. 1, below.] Sandrart, the queen's contemporary, is confirmed by Christina's Inventory of the Palazzo Riario, Rome, 1662, folio 45, where the picture is specifically reported and the dimensions recorded as 'alta palmi cinque e larga palmi sei e tre quarti' (1·117 × 1·50 m.). The *Three Ages of Man* is not among the pictures in the Antwerp Inventory of 1656, made prior to the shipment of Christina's effects to Rome. The acquisition of the picture from Augsburg must have been arranged during her travels through Germany and Austria enroute to Rome in the fall of 1655, when she herself visited Augsburg. As already noted she had the picture in Rome in 1662. [In the catalogue of the Queen Christina Exhibition it is incorrectly stated that she acquired the *Three Ages of Man* from the Aldobrandini at Rome after 1682 (Stockholm, 1966, p. 483, no. 1192); the same statement is made by Pergola, see below, copy no. 5].

After Queen Christina's death, Inventory 1689, no. 44 (Campori, 1870, p. 344; Granberg, 1897, p. 34, no. 28; Waterhouse, 1966, p. 374, no. 56); bequeathed to Cardinal Decio Azzolino, 1689; inherited by Marchese Pompeo Azzolino, who had it 1689–1692; Odescalchi Collection, Rome, 1692–1721: sale by Azzolino to Prince Livio

Odescalchi, 1692, folio 466v, no. 44, 'Vita humana'; 'Nota dei quadri della Regina Christina', no date, no. 41: 'La vita humana, quadro il più famoso . . .' Prince Livio Odescalchi, Rome, Inventory 1713, folio 82v, no. 174, 'La vita humana'; in the same inventory there are three copies of the picture, folio 42, nos. 96, 97, 98. Odescalchi sale to the Duc d'Orléans 1721, folio lv, no. 19, 'Vita humana' by Titian (documents in the Odescalchi archives; also partially in Granberg, 1897). Orléans Collection, Palais Royal, Paris, 1721–1792 (Dubois de Saint Gelais, 1727, p. 469; Couché, 1786, pl. xvi; also a print by Ravenet). The 'Allegory of Human Life' was purchased by the Duke of Bridgewater in London 1798 (Buchanan, 1824, I, p. 114, no. 16), and the picture has since remained in the possession of his descendants: Marquess of Stafford (Stafford, 1808, p. 34, no. 24; Ottley, 1818, no. 8, pl. 5; Stafford, 1825, I, p. 22, no. 36); Lord Ellesmere (Bridgewater, 1907, p. 16, no. 77); Duke of Sutherland, on loan at the National Gallery of Scotland, Edinburgh, since 1946 (Edinburgh, 1970, pp. 98–99).

Bibliography: See also above; Jameson, 1844, p. 112, no. 113 (called the 'Four Ages of Man'!); Waagen, 1854, II, pp. 30–31 (with confused history); C. and C., 1877, I, pp. 204–206 (Giorgionesque Titian); Gronau, 1904, p. 281 (Titian, 1510–1512); Hetzer, 1920, pp. 49–51; *idem*, 1940, p. 161 (perhaps a copy or a repainted original; early style); Tietze, 1936, II, p. 292 (Titian, *c.* 1515); Berenson, 1957, p. 185 (early Titian); Valcanover, 1960, I, pl. 48 (Titian, *c.* 1512); Pallucchini, 1969, p. 243, figs. 77–79 (Titian, *c.* 1512); Panofsky, 1969, pp. 94–99; Robertson, 1971, pp. 721–726 (X-rays; important study).

COPIES:

1. Drawing, Van Dyck's 'Antwerp Sketchbook' (Jaffé, 1966, II, pl. 59r); a free drawing of the two lovers at the left, probably done from a copy at Antwerp or from a sketch by Rubens.

2. Bayonne, Musée Bonnat; pen and bistre, 149 × 161 mm.; a repetition of the drawing in Christ Church Gallery, Oxford, but in reverse (Bean, 1960, no. 217).

3. Oxford, Ashmolean Museum (in storage); canvas, 0·84 × 0·91 m.; accurate copy of the two lovers only; bequest of Miss Mable Rice in 1939.

4. Oxford, Christ Church Gallery; pen and ink on paper, entirely covered with red chalk; 187 × 321 mm. The figures on the left are fully dressed, though derived from the *Three Ages of Man*. He plays a lute and the girl holds a flute. The drawing is usually classified as by the school of Giorgione, but it may be later (Colvin, 1903, II, pl. 37; Parker, 1958, no. 22; Christ Church, 1960, no. 26).

5. Rome, Villa Borghese (Plate 176); canvas, 0·94 × 1·53 m.; described as a copy in 1700 (Montelatici, 1700, p. 297);

attributed to Sassoferrato since 1833 (C. and C., 1877, I, p. 206, note, as a copy; Pergola, I, 1955, p. 133, no. 237).

Paola della Pergola speculated that this copy was made in 1682 and that an original in the Aldobrandini Collection was sold to Queen Christina at that time. Such a theory is impossible, however, because Queen Christina purchased her painting, now in Edinburgh, from the heirs of the Cardinal of Augsburg (see above, Cat. no. 36, History) in 1655, and it is included in her collection at Rome in 1662. There is no proof that the Aldobrandini version was ever sold to anybody (see below, copy 6).

The attribution to Sassoferrato has never been challenged, but it is totally devoid of reasonable foundation. The whole picture is dark and dull, the girl's dress a deep red and the youth's loin-cloth a dark grey. Major facts are that the landscape background at the right in both the Borghese and Doria pictures is the same and differs notably from the Edinburgh original, and that the Gothic chapel to the left of the dead tree at Edinburgh is replaced by a long palace to the right of the tree in the two copies in Rome. Virtually the same building occurs in the backgrounds of the *Noli Me Tangere* in London, the *Sacred and Profane Love* in Rome, and of the Giorgione–Titian *Sleeping Venus* in Dresden (Plates 5, 6, 9, 18). Another major variation involves the old man seated in the landscape in the middle distance, who holds two skulls in the Edinburgh original. In both the Borghese and Doria copies he has four skulls and a human bone lies by his feet (see above, Cat. no. 36, Condition). So far as the main figures are concerned, the Borghese copyist repeated them rather summarily, while the Doria copyist clung more closely to the physical types in Titian's picture at Edinburgh. Nevertheless, both late versions in Rome appear to be dependent on another lost original.

Whether the Aldobrandini family, whose pictures passed by inheritance into the Doria and Borghese Collections, ever had an original of the *Three Ages of Man* by Titian cannot be determined with finality, although the Inventories of 1603, 1626, and 1682 say so (see next item). The better quality of the Doria picture suggests that it is the one that was classified as an original by Titian in the seventeenth century and that the picture in the Villa Borghese is a late copy of it, perhaps made in 1682 when the Aldobrandini properties were divided between two heirs (full data by Pergola, I, 1955, p. 133, no. 237, fig. 237).

6. Rome, Doria-Pamphili Collection (Plate 175); in 1972 located in one of the many rented apartments in the second Doria Palace, which is opposite the Palazzo Venezia; canvas, 0·94 × 1·94 m. This version is probably the same canvas that appears in the Aldobrandini Inventory of 1603, no. 248 (Onofrio, 1964, p. 207), again in the Inventory of 1626, no. 248, as by Titian (Pergola, 1960, pp. 432, 442, no. 123). The identical item reappears in the Aldobrandini Inventory of

1682, no. 24, as an original, the size given as 'alto quattro palmi' (i.e. 0·89 m.), which corresponds to this copy (Pergola, 1963, p. 75, no. 328). Just eighteen years later, in 1700, the Borghese picture was described as a copy (Montelatici, 1700, p. 297; Pergola, *loc. cit.*). As already suggested under Copy 5, it may be that the Villa Borghese copy was made from the Doria picture when the Aldobrandini Collection was divided between the two heirs in 1682. If there really existed another original (now lost) in the Aldobrandini Collection, then both of the extant replicas were made from it. The Doria version has been classified as a copy for the past century at least (C. and C., 1877, I, p. 206, copy; manuscript by Piancastelli in 1891, as a copy, quoted by Pergola, I, 1955, p. 133). The colours are dull and the sky a dark green-blue, but the quality in general is perhaps slightly superior to the Villa Borghese item.

7. Unknown location; canvas, 0·927×1·473 m.; free, weak copy of the Doria-Pamphili version, formerly Manfrin Collection, Venice; later Alexander Barker, London, subsequently Lord Dudley, London (C. and C., 1877, I, p. 206, note, copy; Jacob Burckhardt in 1898 (p. 406) mistakenly thought that this item, then in Lord Dudley's possession, was the source of the Borghese version, item no. 6, above); Dudley sale, London, Christie's, 25 June 1892, no. 66, bought by Farrer; G. O. Farrer of Sandhurst Lodge, sale London, Sotheby's, 5 February 1947, £80 (*APC*, XXV, 1946–1947, no. 2828), probably to John and Johanna Bass, Miami Beach, Florida. Berenson (1957, p. 143) attributed this canvas to Polidoro Lanzani. Photograph in the Witt Library, Courtauld Institute, London.

8. Unknown location; canvas, 0·825×1·46 m.; mediocre copy of the Edinburgh picture; Düsseldorf, Leiffmann sale, 12 November, 1932, no. 48; photograph, Witt Library, Courtauld Institute, London.

PRINT:

Print (Plate 177) by Valentin Lefèbre published at Venice in 1680–1682 in *Opera selectiora quae Titianus . . . et Paulus Caliari Veronensis*. The composition differs notably from the preserved paintings in the omission of the old man with the skulls, in the elimination of the recorder in the girl's left hand, and in the addition of two large buildings to the left of the chapel of the Edinburgh original. The quality of Lefèbre's print is exceptionally mediocre, but it may be that he reproduced an apocryphal composition that existed in Venice in the second half of the seventeenth century (Panofsky, 1969, p. 96, note 15, as an earlier version than the Edinburgh picture). If Lefèbre copied another original (Robertson, 1971, p. 726) by Titian himself, then the old man with skulls had been painted over by 1680. Titian himself would never have omitted Old Age; that omission reflects the copyist's ignorance of the meaning of the subject.

Lefèbre's print also lacks the flock of sheep in the background, and the girl's coiffure with braids and long hair is peculiar.

A drawing by Jan de Bisschop (*c.* 1650), location unknown, also omits the old man with skulls, but the whole scene is freely rendered (van Gelder, 1971, fig. 52).

LITERARY REFERENCES:

1. Faenza, Giovanni da Castel Bolognese, a collector who had lived in Venice (Vasari (1568)–Milanesi, VII, p. 435, early Titian; C. and C., 1877, I, p. 206, note). Vasari's knowledge of this picture of the *Three Ages of Man* at Faenza may have been acquired during his trip north from Florence to Venice in 1566. Many writers have assumed that Cardinal Otto Truchsess von Waldburg of Augsburg bought it subsequently. However, the cardinal died in 1573, leaving a span of only seven years for the presumed change of ownership. For the reasons why the Augsburg picture is more likely another version of the same picture, see above Cat. no. 36, History.

2. London, Lord Arundel, Inventory made at Amsterdam in 1655: 'A Shepherd with a Girl and three putti' (Hervey, 1921, p. 489, no. 385).

3. Genoa, Cassinelli Collection (Ridolfi (1648)–Hadeln, I, pp. 100–101): this extremely vague passage describing half-length figures of a woman with a baby and a soldier was wrongly thought to represent the *Three Ages of Man* by Crowe and Cavalcaselle (1871, II, p. 168, as incorrectly attributed to Giorgione).

4. Rome, Prince Livio Odescalchi, Inventory 1713, folio 42, nos. 96, 97, 98: three copies of the Edinburgh original, which was also in the same collection.

5. Venice, Niccolò Renieri lottery of December 1666, as by Giorgione: 'largo quarte 11 in circa, alto 6 e meza'; the original catalogue is reproduced by Savini-Branca (1964, p. 98). Cited by various authors: Martinioni in Sansovino-Martinioni, 1663, p. 377, also as Giorgione; Campori, 1870, p. 443; C. and C., 1877, I, p. 206, note; L. Venturi, 1913, pp. 361–362 (incorrectly proposed that this item passed to Queen Christina).

The description of the picture both in the sale and by Martinioni includes an old man in the centre warming himself at a fire ('un vecchio che si scalda al fuoco'). This incorrect variation in the iconography is enough to imply that the work was a forgery.

Three Graces, see: Cupid Blindfolded, Cat. nos. 4 and X–5.

37. **Vanity, Allegory of** Plate 34

Canvas. 0·97×0·812 m.

Munich, Alte Pinakothek.

About 1520.

CATALOGUE NO. 38

The rather hard quality of the modelling of the face has given rise to doubts about Titian's authorship, although the pose, the green dress and the off-shoulder neck-line resemble the *Lady at Her Toilet* in the Louvre (Plate 31). Even granting some uncertainty, the attribution to Titian seems the most reasonable and is widely acknowledged today. The face, more classical than might be expected so early in Titian's career, may have been retouched in the mid-sixteenth century, when it is believed that the jewels were added in the mirror.

In his exhaustive study of the Munich picture Dr. Verheyen (1966, pp. 88–99) emphasized the iconography of the *Vanitas* theme (see also Hartlaub, 1951, pp. 124, 134). The gold coins and jewels, signifying the ephemeral nature of worldly possessions, are contrasted to the old lady with a spindle, who symbolizes Virtue, and her spindle, Industry (Panofsky, 1969, pp. 93–94). Much the same elements are present in another *Vanity* picture in Munich, considered to be a copy after Palma Vecchio (Verheyen, *loc. cit.*, fig. 9), where the vulgarity of the woman allows of no other interpretation. A whole series of related works appeared in the Venetian School of this period, the purpose of which was often more erotic than truly moralizing. Titian in the Louvre composition (Plate 31) handled the theme with such delicacy that its true meaning has always been controversial.

Condition: X-rays reveal that the tilt of the head was twice modified during the painting of the picture (Verheyen, 1966, p. 89). A. L. Mayer proposed that the mirror was added in the seventeenth century, replacing a book held by a *Sibyl* (Mayer, 1926, p. 52). It is more likely that only the jewels are modifications of the middle of the sixteenth century. The jewelled brooch with a large sapphire and rubies is shown to be similar to that worn by the Empress Isabella in the Prado portrait (Verheyen, *loc. cit.*, pp. 92–93). This type of jewel, however, reappears in the portrait of *Lavinia as Matron* in the Dresden Gallery (Wethey, II, 1971, Plates 149, 188) and is related to other jewellery designs of the same period.

History: The statement in the Munich catalogue (1958, p. 102, no. 483) that the picture belonged to Emperor Rudolf II is not confirmed by Rudolf's inventories; the first notice is 1618 in the Munich Residenz as by Palma il Vecchio; the picture appears in the Schleissheim Castle Inventories of 1748 and 1750 (as Salviati); in other inventories there until 1775, attributed variously to Palma, Giorgione and Titian; 1787 taken to the Hofgarten at Munich; 1836 to the Alte Pinakothek (Verheyen, 1966, pp. 88, 96–97, note); Kultzen and Eikemeier, 1971, p. 171).

Bibliography: C. and C., 1871, II, p. 150 (Pordenone);

Morelli, 1890, II, pp. 21–23 (entirely Titian); Reber, 1895, p. 224, no. 1110 (early Titian); Gronau, *Titian*, 1904, p. 287 (early Titian); Tschudi, 1911, p. 165, no. 1110 (early Titian); Hetzer, 1920, p. 58 (copy of Titian); Suida, 1935, pp. 31, 158 (early Titian); Tietze, 1936, II, p. 301 (perhaps a copy of a lost Titian *c.* 1515); Berenson, 1957, p. 188 (Titian, *c.* 1515); Valcanover, 1960, I, pl. 58 (early Titian); *idem*, 1969, no. 54 (resumé of opinions); Verheyen, 1966, pp. 88–99 (Titian; full publication); Pallucchini, 1969, p. 245 (Titian, *c.* 1514, with additions by Sustris, *c.* 1550); Panofsky, 1969, pp. 93–94 (Titian, *c.* 1515, the jewels added in the mid-sixteenth century); Kultzen and Eikemeier, 1971, pp. 171–173 (*c.* 1510–1512).

COPY:
Pavia, S. Francesco di Paola (C. and C., 1871, II, p. 150).

VARIANTS, *Sibyl with a Book:*
1. Budapest, Museum; poor copy in storage; formerly Fasetti, Venice; then Ladislas Pyrker, Venice (Richter, 1937, p. 236).
2. Marostica, Sorio-Melchiori, formerly (C. and C., 1871, p. 150; Richter, 1937, p. 236, wrongly said to be identical with no. 3 below; Pignatti, 1969, p. 144, no. C 7, fig. 223, calls it Palmesque). It is clearly not the Cook picture, discussed below.
3. Richmond, Cook Collection (formerly); said to be in an Italian collection today (Richter, 1937, pp. 235–236, pl. LXV, says it is after a prototype by Giorgione; Verheyen, 1966, p. 98, note 12).
4. Rome, Vincenzo Giustiniani, Inventory 1638 (Landon, 1812, p. 129, fig. 61, as Giorgione; Salerno, 1960, p. 136, no. 29; Pignatti, 1969, p. 152).
5. Venice, Giovanni Battista Sanuto (Ridolfi (1648)–Hadeln, I, p. 102).
6. Venice, Andrea Vendramin, 1627; a *Sibyl with a Book* (Borenius, 1913, I, pl. 70; Richter, 1937, p. 235, as item 3 above).

Vasto, Allegory of the Marchese del, see Cat. no. 1.

38. (Sleeping) Venus Plates 6, 7, 9
Canvas. 1·085 × 1·75 m.
Dresden, Staatliche Gemäldegalerie.
Giorgione and Titian.
About 1510–1511.

The epoch-making originality of Giorgione's *Sleeping Venus* and the unequalled charm of the picture have been widely acknowledged. The inspiration afforded Titian in his own development of the same subject is given due attention in

the text. There also Titian's landscape and his Cupid (now painted over) are considered in relation to the general development of the master in his youth.

Condition: Relined in 1843 at the time that the Cupid was painted out and the toes of the right foot of Venus eliminated (Posse, 1929, p. 84). A report of the X-rays shows that the Cupid was seated at the feet of Venus and that he held a bird in his left hand and an arrow in the right (Posse, 1931, pp. 29–35). The reconstruction of the Cupid by Posse has been challenged by Richter, who doubted that the bird can really have been detected in the X-ray (Richter, 1937, pp. 214–216). Posse's arguments were, however, based on the X-rays, whereas Carlo Gamba only advanced an earlier theory (IX, 1928, pp. 205–209) that the *Cupid* in Vienna (my Cat. no. X–7; Plate 179) is a copy of the lost detail of the *Sleeping Venus*. The most convincing aspect of this argument is the close similarity of the landscape backgrounds. Recent X-rays, taken by the technical staff of the Dresden Museum, were shown to me in May 1973. They confirm the numerous losses and extensive old repaint.

Documentation: Rarely is a work of art so convincingly documented as the Dresden *Sleeping Venus*. When Marcantonio Michiel saw the picture in 1525 in the house of Gerolamo Marcello at Venice, he described it as follows: 'La tela della Venere nuda, che dorme in uno paese, cun Cupidine, fo de mano de Zorzo da Castelfranco; ma lo paese et Cupidine forono finiti da Titiano' ('The canvas of the nude Venus who sleeps in a landscape, with Cupid, was by the hand of Zorzo da Castelfranco, but the landscape and Cupid were finished by Titian'; Michiel, edition of 1800 by Jacopo Morelli, p. 66; edition of 1884 by Frizzoni, p. 169). More than a century later Ridolfi, without knowledge of Michiel's treatise, reported the same information about the *Sleeping Venus*, which still belonged to the same family: 'Una deliciosa Venere ignuda dormiente è in Casa Marcella [*sic*] e a piedi è Cupido con Angellino in mano, che fu terminato da Titiano' (Ridolfi (1648)–Hadeln, I, p. 102). The *Sleeping Venus*, long thought to have been lost, was rediscovered in the Dresden Museum about 1875 (Morelli, edition 1880, pp. 192–197; preface dated 1877).

History: (Fullest account by Posse, 1931, pp. 29–35); Casa Marcello, Venice, already cited there in 1525 and 1648. On 26 January 1699 August der Starke, Elector of Saxony, purchased the picture from a French dealer, C. Le Roy, as the work of Giorgione. An Inventory of 1707 lists it as *Venus and Cupid*, an original by Giorgione. Later Inventories, of 1722 and 1728–1751, changed the attribution to Titian (Posse, 1929, pp. 83–84). In 1843 the Cupid was painted over because of the poor condition of that section of the canvas.

Subsequently, and for the first time, the attribution was changed in 1856 to a copy of Titian by Sassoferrato! (Posse, 1931, *loc. cit.*; Hübner, 1872, p. 123, no. 236).

The Controversy: Louis Hourticq at first accepted Morelli's discovery of the *Sleeping Venus* in Dresden as the work seen in the Casa Marcello by Michiel in 1525 (Hourticq, 1919, pp. 246–249). In 1930, however, he changed his mind and in an incomprehensibly vitriolic attack on Morelli, deceased in 1891, he declared the Italian critic mistaken and insisted that Titian alone was the author of the Dresden masterpiece (Hourticq, 1930, pp. 64–74).

Gino Fogolari raised the issue of a picture by Giorgione still in the Casa Marcello in Venice in the year 1732 and whether that could have been the one seen by Michiel rather than the one that entered the collection of August of Saxony in 1699 (Fogolari, 1934, pp. 232–239). However, the reference of 1732 reads 'un cuadro bellissimo di Zorzon' (a most beautiful picture by Giorgione), and no subject is given. Inasmuch as there were four pictures by Giorgione in the Casa Marcello in 1525 (Michiel, edition 1884, pp. 168–170), i.e. a *St. Jerome*, two portraits, and the *Sleeping Venus*, the reference of 1732 is not compelling.

The next person to enter the arena was Wilhelm Suida, who declared (1935, pp. 16, 18) the *Sleeping Venus* to be the work of Titian alone and not to be associated with the picture by Giorgione of the Casa Marcello. In 1946 (pp. 149–152) he expanded his views and held that Boschini's verses about a picture of Venus in the Casa Marcello in 1660 do not correspond to the Dresden picture. These verses are indeed peculiar and do not seem to describe the same work that Marcantonio Michiel saw in 1525:

'Venere de Zorzon in Ca' Marcello a San Tomà'
In Ca' Marcello pur, con nobil' arte,
M'ha depenta Zorzon da Castel Franco,
Che, per retrarme natural un fianco,
Restè contento e amirativo Marte.

(Boschini, 1660, edition 1966, p. 664).

This may indeed be an entirely different composition representing *Mars and Venus* in which Venus has her back turned. Pignatti has already interpreted Boschini in this way (1969, p. 107). Suida had decided that the *Sleeping Venus* in Dresden must have a provenance from the Muselli Collection at Verona, 'Una Venere nuda che dorme prostrata a terra, le servono le braccia di guanciale, con amore a' piedi, tenuta per di Titiano.'

In conclusion, I have given considerable space to the objections of Hourticq and Suida to the identification of the Dresden *Venus* with the painting by Giorgione and Titian seen in the Casa Marcello at Venice in 1525. Their views seem weak and ineffectually supported. Virtually all other students of Venetian painting (see Bibliography) have

accepted Morelli's discovery, and Giorgione's *Sleeping Venus* has been almost universally recognized as one of the major achievements of Renaissance art.

Bibliography: See also above, especially History. Dresden, catalogue, 1765, p. 229, no. 322 (*Venus* by Titian); Hübner, 1872, p. 123, no. 236 (called a fine copy after Titian, probably by Sassoferrato); C. and C., 1877, I, p. 275 (as a copy of the Darmstadt *Venus* [Cat. no. X–36], but doubtfully attributed to Sassoferrato); Morelli, 1880, pp. 192–197; *idem*, 1891, pp. 286–291; *idem*, II, 1893, pp. 220–224 (identification of the Dresden picture as by Giorgione and Titian); Woermann, 1887, p. 93, no. 185 (Giorgione with landscape by Titian; the attribution changed at Dresden to follow Morelli's discovery); Gronau, *Titian*, 1904, p. 98 (Giorgione with landscape by Titian); *idem*, 1908, pp. 431–433 (same opinion); L. Venturi, 1913, pp. 96–100 (Giorgione and Titian); Justi, 1926, I, pp. 205–222, II, p. 97 (Giorgione and Titian); Posse, 1929, pp. 83–84, no. 185 (history of the picture); *idem*, 1931, pp. 28–35 (a still fuller account of the picture and of the Cupid); Suida, 1935, pp. 16, 18, 73, 166 (entirely by Titian, *c.* 1520, not from Casa Marcello); Tietze, 1936, II, p. 287 (Giorgione and Titian); Richter, 1937, pp. 214–215 (Titian and Giorgione; a thorough study); Hetzer, 1940, p. 162 (Giorgione and Titian); Ragghianti, 1940–1941, p. 17 (insisted that Titian painted the entire picture); Morassi, 1942, p. 176 (entirely by Titian); Oettinger, 1944, pp. 113–139 (entirely by Titian); Zampetti, 1955, p. 68 (Giorgione, finished by Titian); Berenson, 1957, pp. 84, 185 (Giorgione, finished by Titian); Valcanover, 1960, I, pl. 41 (landscape by Titian); Heinz, 1965, pp. 162–164 (Giorgione and Titian); Pallucchini, 1969, p. 239, fig. 54 (Giorgione and Titian); Pignatti, 1969, pp. 65–67, 107–108, no. 23 (Giorgione and Titian).

COPIES:

So many mediocre copies and derivations of this famous picture exist that it is not worthwhile to list all of them. Photographs of several are to be found in the Witt Library of the Courtauld Institute in London and in the Frick Art Reference Library in New York. *Art Prices Current*, XXI (1941–1942), XXII (1943–1944), XXVIII (1950–1951), XXIX (1951–1952), XXXII (1954–1955) record others.
1. Cambridge, Fitzwilliam Museum; canvas, 0·993 × 1·66 m.; Venetian School, XVII–XVIII Century; free copy of the figure of the Dresden picture but with landscape much changed and the elimination of the Cupid; a dog sits upright at the left beside Venus (C. and C., 1877, I, p. 275, note, as a copy by Varotari of the Darmstadt *Venus*, Cat. no. X–36; Cambridge, 1902, no. 154, as Varotari). There are no flowers scattered on the bed here, as in the Darmstadt item. The attribution to Varotari, il Padovanino, cannot be

maintained. Crowe and Cavalcaselle automatically attributed school pieces and copies to this seventeenth-century painter, who has in reality a very distinctive style.
2. Madrid, Academia de San Fernando, in storage; canvas, 1·07 × 1·69 m.; presumed to have been copied from the lost *Sleeping Venus* of the Royal Collection (Cat. no. L–15); both the figure and the landscape represent variations on the composition of the *Sleeping Venus* in Dresden (Plate 9). There are no roses scattered on the couch, as in other variants of Giorgione's original, called the *Sleeping Venus with Roses* (Cat. no. X–36). The preserved copy, attributed to Luis Eusebi, *c.* 1800 (Beroqui, 1946, p. 85) may have been done after the Alba-Godoy picture (Cat. no. L–16) rather than the king's (Pérez Sánchez, 1964, no. 350; illustrated by Beroqui, 1946, p. 84).

PRINT:

By Lefèbre, 1682 (Plate 182). The print, which shows a *Sleeping Venus* in the pose of the Dresden picture (Plate 9), but reversed, is labelled Titian. However, this date of 1682 is too late to serve as a reliable document for an attribution of the Dresden *Venus* to Titian, an argument used by Morassi (1942, p. 176; *idem*, 1954, p. 185). Mentioned as a copy by Crowe and Cavalcaselle (1877, I, p. 275, note); Richter (1937, p. 215) correctly observed that Lefèbre's print may reflect a lost picture once attributed to Titian.
The print is closely related to a drawing in reverse at Chantilly, where three sleeping Cupids accompany Venus. Pen and wash, 85 × 245 mm. Lafenestre, 1886, preface (as Titian); Tietze and Tietze-Conrat, 1944, no. 1980 (as a follower of Titian; Meiss, 1966, fig. 16). The landscape is simpler than in the print. A still more simplified version in Van Dyck's 'Italian Sketchbook' (Adriani edition, 1940, pl. 118v).

39. Venus Anadyomene Plate 36

Canvas. 0·76 × 0·57 m.
Edinburgh, National Gallery of Scotland, on loan from the Duke of Sutherland.
About 1525.

The general critical study of this picture is in the text.

Condition: Cleaned and X-rayed in 1932; the X-rays revealed that the artist slightly modified the inclination of the head as he painted (Edinburgh, 1970, p. 97). The nose and face in general are somewhat retouched, and there are a few scars on the body and in the hair, but the beauty of the picture is not fatally impaired.

Theoretical History: The theory must be rejected that the *Venus Anadyomene* is the work called 'Il bagno' (Gronau,

Titian, 1904, pp. 53, 281) that Titian promised to paint for Alfonso d'Este of Ferrara in a letter of 19 February 1517 (Campori, 1874, p. 585). Much later, on 5 February 1530, in a letter from Giacomo Malatesta to Federico Gonzaga mention is made of a picture of bathing women, described as 'Le Donne del Bagno è solamente designato' (C. and C., 1877, I, p. 446). This work, still only designed, was apparently never finished (see also Panofsky, 1969, p. 97).

A remote possibility is that the Edinburgh *Venus* is the item, in the sale of Charles I of England, called 'A Curtizan in her haire by Tytsian' sold for only £16 (Millar, 1970, p. 320, no. 335). The omission of any reference to the water would be strange indeed and the small sum paid does not imply an important picture.

Among the pictures of Charles I's collection exhibited for sale in 1650 is another item 'Vénus sortant de la mer'. The entry is precise as to subject but no artist is assigned and the price of £15 is again too low (Cosnac, 1885, p. 414, no. 51). The only reason for considering these paintings at all is the fact that Queen Christina, who later owned the *Venus Anadyomene*, did purchase from Charles I's sale.

Certain History: Queen Christina's Collection in the Palazzo Riario at Rome, Inventory 1662, folio 45 (Stockholm, 1966, p. 481); Inventory after Christina's death, Rome, 1689, no. 23 (Campori, 1870, p. 341; Granberg, 1897, no. 27; Waterhouse, 1966, p. 374, no. 57); Cardinal Decio Azzolino, 1689; Marchese Pompeo Azzolino, 1689–1692; sale to Prince Livio Odescalchi, 1692, folio 466, no. 23; Odescalchi Collection, Rome, 1692–1721; 'Nota dei quadri della Regina Cristina' (undated), no. 58; Inventory Odescalchi, 1713, folio 83, no. 182, 'Venere nel bagno', and also two copies of the same, folio 51, nos. 181, 182; Odescalchi sale to the Duc d'Orléans, 1721, folio 2v, no. 41 (Odescalchi Archives, Rome); Orléans Collection, Palais Royal, Paris, 1721–1792 (Dubois de Saint Gelais, p. 470; Couché, 1786, pl. XIX); 1792, sale of Orléans Collection; Duke of Bridgewater from 1798 (Buchanan, 1824, I, p. 115, no. 20); by inheritance to his descendants: Marquess of Stafford (Stafford, 1808, p. 97, no. 94; Ottley, 1818, no. 12, pl. 7; Stafford, 1825, p. 37, no. 64); Lord Ellesmere (Bridgewater, 1907, p. 5, no. 19); Duke of Sutherland, on loan to the National Gallery of Scotland since 1946 (Edinburgh, 1970, p. 97).

Bibliography: See also above; Hume, 1829, p. 98; Jameson, 1844, p. 130, no. 116; Waagen, 1854, II, p. 31 (later in date than the *Three Ages of Man*); C. and C., 1877, I, pp. 275–277; Gronau, *Titian*, 1904, p. 281 (*c.* 1515–1520); Hetzer, 1920, pp. 141–142 (rejected Titian's authorship, but changed his mind in 1940); Richter, 1931, p. 53 (*c.* 1530); Suida, 1935, pp. 43, 72, 160 (1517); Tietze, 1936, II, p. 292 (*c.* 1520); Mayer, 1937, p. 307 (*c.* 1530); Hetzer, 1940, p. 162 (Titian,

c. 1530); Berenson, 1957, p. 185; Valcanover, 1960, I, pls. 90–91 (*c.* 1520); Stockholm, 1966, p. 481, no. 1188; Pallucchini, 1969, p. 257 (*c.* 1520–1522).

COPIES:

1. Brussels, Exhibition at Palais Bourbon, lent by the dealer Neumans, 1927 (photograph, Witt Library, Courtauld Institute, London).

2. The studies of bathing women in Van Dyck's 'Antwerp Sketchbook' (*c.* 1615–1620) do not seem necessarily to have been inspired by Titian (Jaffé, 1966, II, p. 240).

40. **Venus and Adonis** (Prado type)

Plates 84, 86, 87, 89, 91, 92

Canvas. 1·86×2·07 m.

Madrid, Prado Museum.

Documented 1553–1554.

Iconography: The literary source is Ovid's *Metamorphoses*, X, 532–559, *passim*, 705–709: 'She stays away even from the skies; Adonis is preferred to heaven. She holds him fast, is his companion and, though her wont has always been to take her ease in the shade, and to enhance her beauty by fostering it, now, over the mountain ridges, through the woods, over rocky places set with thorns, she ranges with her garments girt up to her knees after the manner of Diana. . . . She warns you, too, Adonis, to fear these beasts, if only it were of any avail to warn. "Be brave against timorous creatures", she says; "but against bold creatures boldness is not safe . . . But now I am aweary with my unaccustomed toil; and see, a poplar, happily at hand, invites us with its shade, and here is grassy turf for couch. I would fain rest here on the grass with you." So saying, she reclined upon the ground and, pillowing her head against his breast and mingling kisses with her words, . . . "These beasts, and with them all other savage things which turn not their backs in flight, but offer their breasts to battle, do you, for my sake, dear boy, avoid, lest your manly courage be the ruin of us both." Thus the goddess warned and through the air, drawn by her swans, she took her way; but the boy's manly courage would not brook advice . . .'

Panofsky advanced the ingenious idea (1969, p. 153) that Shakespeare had some knowledge of Titian's composition, because the great writer in his poem *Venus and Adonis* (published in 1593) wrote that Adonis 'breaketh from the sweet embrace' and then leaves the goddess in the night, thus abandoning her, contrary to Ovid's account. Shakespeare could never have seen Titian's original painting, which reached London in 1554 and must have been shipped to Philip in Brussels after the death of his wife, Queen Mary, in November 1558. That Shakespeare, born six years later, would have had knowledge of one of the mediocre prints

after Titian by Martino Rota or Giulio Sanuto (Mauroner, 1941, pp. 55, 57, fig. 49) is highly doubtful. The major obstacle to Panofsky's theory, however, lies in the extraordinary independence of tradition manifested in Shakespeare's poem. Students of his sources admit a knowledge of Ovid's *Metamorphoses* but equally significant are his debts to Spenser and Marlowe (Rollins, 1938, pp. 385–388, 391, 397–399; also Bush, 1963, pp. 137–148). The behaviour of the reluctant boy Adonis before the advances of the determined and experienced Venus in Shakespeare's poem bears the most tenuous similarity, if any, to Titian's interpretation. Gilbert Highet and others believed that Shakespeare based his reluctant Adonis on Ovid's story of Salmacis and Hermaphroditus (Highet, 1967, p. 620, note 35). Ronsard, the contemporary French poet, in his interpretation also has Adonis abandon Venus, whose grief at his death is bitter (Harrison and Leon, 1939, pp. 153–173).

Beroqui's proposal (1946, pp. 140–141) that Titian might have been partially inspired by Diego Hurtado de Mendoza's poem *Fábula de Adonis*, published in Venice in 1553, is historically possible, since he was well acquainted with Charles V's ambassador to Venice, whose portrait he had painted in 1541 (see Wethey, II, 1971, Cat. no. L–19). However, nothing in the poem is specifically significant in relation to the picture. Although Diego Hurtado de Mendoza held the post of Spanish ambassador to Venice slightly earlier (1539–1546), he was a celebrated humanist and a collector of Greek, Latin, and Arabic manuscripts, which now form the nucleus of the great Escorial library (see Wethey, II, 1971, Cat. no. L–19).

Condition: Still visible is the horizontal crease through the centre of the canvas, of which Philip complained on the arrival of the picture in England in 1554 (see *Documentation*). Otherwise the general state of the picture is satisfactory, for it was not damaged in the fire that destroyed the Alcázar in 1734. Approximately ten centimetres were added vertically at the left side, perhaps in the eighteenth century. Cleaned in 1967. The one X-ray photograph in the Prado files is that of Adonis' head, which shows some paint losses on his face and neck. The naked eye can discern various spots of inpainting upon both bodies. Madrazo (1872, p. 678, no. 455) wrongly states that it was restored by Juan García de Miranda in 1734. This error has been often repeated by later writers (see notes 411–412).

Documentation: On 6 December 1554 Philip, then in London, in acknowledging the arrival of the *Venus and Adonis* complained that the canvas had been folded in packing it, so that it had a crease through the middle (the crease still remains to this day). He wrote instructions to Vargas, who was in Venice, that no further pictures be shipped until he gave

directions (C. and C., 1877, II, p. 509; Cloulas, 1967, p. 227; Panofsky was in error in stating that this picture was sent first to Madrid and from there forwarded to London: see Panofsky, 1969, p. 150).

Titian's previous letter of 1554 or possibly 1553 to Philip does not yet call him 'king of England'. It contains the information that the *Danaë* (see Cat. no. 6) had already been shipped and that the companion piece, the *Venus and Adonis*, will be ready soon (Dolce, 1559, pp. 229–230, letter undated; copied from Dolce by Ticozzi, 1817, pp. 311–312; Bottari, edition 1822, I, pp. 329–330 and again II, p. 25; Cloulas, 1967, p. 227). In Dolce's edition of 1559 he adds the title 'king of England'.

Another famous letter also demonstrates that the artist planned the mythological pictures in pairs (Dolce, 1559, pp. 231–232, addressed to the 'king of England' and undated but obviously written in 1554; Ticozzi, 1817, p. 312; Bottari, edition 1822, II, p. 27; Cloulas, 1967, p. 227, note 2). Titian explained them as follows: 'Because the *Danaë*, which I have already sent to your Majesty, was visible entirely in the front part, I have wanted in this other *poesia* to vary and show the opposite part [of the body], so that it will make the room in which they are to hang, more pleasing to see' ('E perchè la Danae che io mandai già a Vostra Maestà, si vedeva tutta dalla parte dinanzi, ho voluto in quest'altra poesia variare, e farle mostrare la contraria parte, acciocchè riesca il camerino dove hanno da stare, più grazioso alla vista.') This passage has sometimes loosely and incorrectly been translated to read 'to show the nude female body'. On 10 September 1554 [misprinted in Dolce as 1552] the artist wrote to Juan de Benavides that he was dispatching the *Venus and Adonis* (Dolce, 1554 and 1559, pp. 230–231; Ticozzi, 1817, p. 313, with correct date of 1554; Bottari, edition 1822, I, pp. 330–331, with the wrong date of 1552). The letter to Philip (quoted above) apparently accompanied the shipment of the picture on the same day.

That Dolce's letter (1554, pp. 530–534) to Alessandro Contarini was written after the *Venus and Adonis* had been dispatched to England is shown by slips in memory, such as the statement that Venus sits upon a cloth of peacock blue instead of the correct colour, dark red.

History in Spain: No exact information is available as to when or how the picture was later transferred from London to Madrid. The first specific notice of the *Venus and Adonis* by title in Madrid occurs in Cassiano dal Pozzo's journal of 1626 (folio 121), when it was hanging in one of the lower rooms of the Alcázar called the 'Bóvedas' and there described as 'a rincontro della è Venere ignuda, che mostrando tutto l'indietro assisa su un sasso, si rivolta con la testa verso Adone sforzandosi di ritenerlo dalla caccia, è opera finissima e si vede alla stampa.' This picture was located in a room alongside

the *Perseus and Andromeda*! Vicente Carducho in his discussion of the pictures by Titian in the Alcázar in 1633 (edition 1933, p. 108) labels the picture 'Diana and Cephalus', a very strange blunder in view of his usually well-informed writings.

The Alcázar Inventory of 1636 (folio 50v) shows that the Bóvedas had been rearranged in the new summer quarters in the northern wing of the palace. In the 'Pieza última de las bóvedas que tiene bentana al lebante en que su Magestad retira después de comer' the *Venus and Adonis* hung between the *Danaë* (Cat. no. 6) and the *Rape of Europa* (Cat. no. 32). Under Velázquez's drastic rehanging of the royal collection after 1643, the Titians were placed in a gallery later known as the 'Bóvedas de Ticiano' on the south side adjacent to the Garden of Roman Emperors. The Inventory of 1666, no. 693, locates together the *Venus and Adonis*, the *Orpheus* (Cat. no. X–31), and the *Diana and Actaeon* and the *Diana and Callisto* (Cat. nos. 9, 10) and farther away the *Danaë*, all in the 'Galería baja del jardín de los emperadores' [Garden of the Roman Emperors]. Inventory 1686, no. 866, in the same gallery, now called the 'Bóvedas de Ticiano' (also Bottineau, 1958, pp. 318–321). Inventory of 1700, no. 488. The Inventory of 1734, no. 31, after the fire that destroyed the Alcázar, classifies the picture as undamaged ('bien tratado'). Buen Retiro Palace after the death of Philip V, Inventory 1747, folio 220. In the new Royal Palace the *Venus and Adonis* was first placed in the king's dressing-room but shortly moved to another section of the palace called the Casa de Reveque (Ponz, 1776, VI, Del Alcázar, 35 and 62). Because Charles IV wanted the pictures with nudes burned up, they were sent to the Real Academia de San Fernando and kept under lock and key from 1796 to 1827. Transferred to the Prado in 1827 (Beroqui, 1933, p. 121). The picture was not exhibited until after the death of Ferdinand VII in 1833. First appearance in the Madrazo catalogue, 1843, p. 174, no. 801.

Bibliography: See also above; Lodovico Dolce's letter to Alessandro Contarini describing Titian's painting of *Venus and Adonis* was originally published in *Lettere di diversi . . . huomini*, Venice, 1554, pp. 530–534; quoted by Ticozzi, 1817, pp. 207–209; also Bottari, 1822, III, pp. 377–382; also Dolce-Roskill, 1968, pp. 212–217 with English translation; a Spanish translation of Dolce's letter in Beroqui, 1946, pp. 184–186; Dolce, 1557, edition 1960, p. 205 (mention); Vasari (1568)–Milanesi, VII, p. 451 (mention); Ridolfi (1648)–Hadeln, I, p. 190 (mention); Boschini, 1660, edition 1966, p. 55 (mention); Cicogna, 1830, III, p. 236 (reference to Dolce's letter; 'Inventario general', Museo de Prado, 1857, p. 165, no. 801; C. and C., 1877, II, pp. 227, 237–239 (by Titian and Orazio Vecellio!); Phillips, 1898, pp. 79–80; Gronau, *Titian*, 1904, pp. 181–182, 303; Fischel,

1924, p. 191; Holmes, 1924, pp. 16–21; Mayer, 1925, pp. 274–279; Suida, 1935, pp. 120, 177; Tietze, 1936, II, p. 298; Hetzer, 1940, p. 166; Beroqui, 1946, pp. 140–143; Berenson, 1957, p. 187; Valcanover, 1960, II, pl. 57; Prado catalogue, 1963, no. 422; Keller, 1969, pp. 131–136; Pallucchini, 1969, p. 299; Panofsky, 1969, pp. 150–154 (on literary sources).

ENGRAVING:

By Giulio Sanuto, dated 1559. The inscription states that the original is in the collection of the King of Spain, although the print diverges from the painting in that the shape is vertical. *Bibliography:* Mauroner, 1941, p. 57, fig. 49.

41. **Venus and Adonis** (Prado type) Plate 93, 94
Canvas. 1·771 × 1·873 m.
London, National Gallery.
Titian and workshop.
About 1555.

The composition here is identical to the major work of the group in Madrid, which was painted for Philip II. The slightly more boyish face of Adonis in the London example is the main distinction between the two. In quality, however, this canvas does not measure up to Philip's picture by a considerable margin, a fact not discernible in photographs. Adonis' drapery is a darker red in London and nearer to the velvet upon which Venus sits. In the sky at the upper right Venus' chariot drawn by swans is clearly visible.

Sir Charles Holmes, former director of the National Gallery in London, tried to make out a case for his picture being earlier than the one in Madrid. His theory was supported by A. L. Mayer, who classified the canvas as unfinished, perhaps because of the rather dull brown colour of the landscape. Tietze-Conrat advanced this line of reasoning a step further by declaring it a sketch (*modello*) c. 1553 which was used for repetitions in Titian's workshop. However, the canvas is much too large to have been a *modello*, which normally is a smaller study for a larger composition. Moreover, Mrs. Tietze's remarks and the date of her article lead one to believe that she had not seen either the London or the Madrid painting for many years (Tietze-Conrat, 1946, p. 85).

Condition: The whole picture was darkened and crackled, and somewhat dirty. The canvas has never been cut down, according to Gould, who gives a complete account of the extensive retouchings in the sky. The back of Venus was once painted over with drapery in watercolour when in the Colonna Collection. This was cleaned off in the early nineteenth century, but the scars still remain. Conservation took place in 1924 (Gould, 1959, pp. 98–99, p. 101, note 2), followed by further measures taken in 1973. Weak passages are noted in the landscape and in the painting of the urn.

History: Since the Colonna archives remain unpublished and difficult of access, the earlier provenances are unknown; Palazzo Colonna, Rome (catalogue of 1783, no. 116); acquired by Alexander Day *c.* 1800; bought in May 1801 by Angerstein, London (Buchanan, 1824, II, p. 4, no. 1); purchased from him by the National Gallery in 1824 (Gould, 1959, p. 101).

Bibliography: See also above; Waagen, 1854, I, p. 333 (good school copy); C. and C., 1877, II, p. 239 (workshop); Holmes, 1924, pp. 16–22 (Titian, *c.* 1545); Mayer, 1925, pp. 274–275 (unfinished, earlier than the Prado version); Suida, 1935 (omitted); Tietze, 1936, II, p. 294 (Titian); Berenson, 1957, p. 187 (partly by Titian); Gould, 1959, pp. 98–102 (fullest account); Valcanover, 1960, II, pl. 56 (Titian); Panofsky, 1969, p. 150, note 34; Pallucchini, 1969, pp. 142, 300 (Titian, *c.* 1553–1555, later than the Prado version).

42. **Venus and Adonis** (Prado type) Plate 190

Canvas. 1·575 × 2·007 m.
Somerley, Ringwood (Hampshire), Earl of Normanton.
Titian and workshop.
About 1555.

The quality of this item appears to be of superior workshop type, so far as one can judge considering its high position on the wall and its rather deteriorated condition in 1971. It corresponds exactly to the print of *Venus and Adonis* in the Orléans Collection, in which the sleeping Cupid clutches his bow in his arms (Plate 189).

Condition: Badly in need of conservation because of the dry condition of the pigment; the numerous paint losses are especially noticeable on Venus' back.

History: Traceable to the collection of Queen Christina in the Palazzo Riario, Rome, in 1662. It appears in the Inventory of 1689 at her death (see also Waterhouse, 1966, p. 374). The Odescalchi inventories include it in 1692 and 1713, and in the sale of their collection to the Duke of Orléans in 1721 (see below copy 6). The Orléans picture was sold to Lord Fitzhugh according to Buchanan (1824, I, p. 114, no. 15, no size given); purchased from Fitzhugh by Lord Normanton in 1844 (Waterhouse, *loc. cit.*).

Bibliography: See also above; Waagen, 1857, p. 366 (Titian, superior to the London picture); Roldit, 1904, p. 16, illustrated (Titian and workshop); Inventory, Somerley, 1948; Gould, 1959, p. 100 (mention).

COPIES (*Venus and Adonis*, Prado type):
1. Leeds, Harewood House (formerly); canvas, 0·648 × 0·75 m.; bequest of the Marquess of Clanricarde to the Earl of Harewood, 1916 (Borenius, 1936, no. 69, copy); sold at Christie's 2 July 1965, no. 69, £588.
2. Longniddry (East Lothian), Gosford House, Earl of Wemyss; canvas, 1·73 × 1·956 m. In 1967 this picture was still at Gosford House, but in 1971 the owner would give me no information as to its whereabouts. *Bibliography:* Waagen, 1857, p. 63 ('by the master'); C. and C., 1877, II, p. 239, note (school of Titian; then in possession of Lord Elcho, ancestor of the Earl of Wemyss).
3. Paris, de Marignane Collection; panel (?), 1·117 × 1·016 m.; superficial late copy; attributed by Tietze-Conrat to Orazio Vecellio (1946, p. 79, fig. 1).
4. Prague, Nostitz Collection; canvas, 0·575 × 0·80 m.; first mentioned in 1765 inventory (Bergner, 1905, no. 223, Titian replica; C. and C., 1877, II, p. 239, note, school of Titian).
5. Richmond (Petersham), Ham House; canvas, 1·79 × 2·05 m.; mediocre copy, seventeenth century (?). The composition follows the Prado version, in which there are three dogs and a sleeping Cupid. The canvas has been reduced on all sides except the right. Mr. C. M. Kauffmann, assistant keeper at the Victoria and Albert Museum, has kindly supplied me with information about the picture and has searched the Dysart inventories of 1679 and 1683 without encountering a reference to this work. It was probably acquired in the time of Elizabeth, Countess of Dysart (died 1698); bequeathed by the Earl of Dysart in 1948 to the nation.
6. Unknown location; canvas, 1·78 × 2·00 m.; probably a replica by Titian's workshop about 1560. This picture (Plate 191) was last known in the collection of Baron von Heyl of Munich, sold 28–29 October 1930, no. 144, pl. VI, certified by Hadeln as Titian; illustrated in *Art News*, 4 October 1930, p. 14; Mayer, 1930, p. 482 (Titian).
Sir Abraham Hume (1829, p. 65) gave the provenance of this example as the Orléans Collection and he wrote that it was presented to Benjamin West rather than sold. The dimensions of the picture in the Orléans Collection as published by Couché (1786, pl. XV) are given as 5 *pieds* 7 *pouces* × 6 *pieds* 2 *pouces* (i.e. 1·81 × 2·00 m.). They conform closely to the canvas under discussion.
Nevertheless, the print in the Orléans catalogue (Couché, 1786, pl. XV) proves that this item belongs to the Earl of Normanton (Cat. no. 42, Plate 190), for the sleeping Cupid holds his bow, while the bow in the Heyl version hangs in the tree. Two paintings of *Venus and Adonis* were sold to the Duke of Orléans when he acquired the Odescalchi Collection, formerly Queen Christina's. Christina at one time owned three versions of *Venus and Adonis* and the Odescalchi

Inventory of 1713 mentions two more copies of one of them, presumably painted about 1700 (see below).

Hume supplied the further data, to the effect that West's picture passed to Hart Davis, who in turn sold it to Sir William Miles of Leigh Court. Miles exhibited it at the British Institution in 1822 (Graves, 1914, III, p. 1316). There both Waagen and the collaborators, Crowe and Cavalcaselle, saw the picture and characterized it as the work of a follower of Titian (Waagen, 1854, III, p. 182; C. and C., 1877, II, p. 151, note). A descendant, Sir Cecil Miles, put it on sale on 13 May 1899 (Graves, 1921, III, p. 213) and it subsequently became the property of Baron von Heyl.

LITERARY REFERENCES (*Venus and Adonis*, Prado type):
1. Copy made by Rubens in Madrid, Rubens Inventory 1640, no. 45 (Lacroix, 1855, p. 271). Pacheco confirms that Rubens copied the picture at Madrid in 1628 (Pacheco, 1638, edition 1956, I, p. 153).
Van Dyck's drawing of the figure of Venus in his 'Antwerp Sketchbook' (Jaffé, 1966, II, plate 50 verso) could have been made from Rubens' version. In that event, however, Rubens would also have made, on his visit to Spain in 1603, a complete copy or a pen sketch which was available to his pupil, c. 1615–1620 (Jaffé, 1966, I, pp. 48–49 for dating of the 'Antwerp Sketchbook').
2. Madrid, Alcázar, in the tower (Pieza de la Torre), Inventory 1686, no. 660, copy of Titian (Bottineau, 1958, p. 304); Inventory 1666, no. 193; Inventory 1700, no. 355. The original by Titian was in the Bóvedas (see Cat. no. 40); Inventory 1734 (after the fire), *Venus and Adonis*, copy, 2¼ *varas* long (1·88 m.), badly treated ('maltratado').
3. Madrid, El Pardo Palace, Inventory 1674, no. 64; Inventory 1700, no. 7210, copy of Titian.
4. Rome, Collection of Queen Christina (later Odescalchi and Orléans).
Queen Christina owned two versions of *Venus and Adonis*, one with two dogs, a second with three dogs, and a copy of the latter, according to her Rome Inventory of 1662:

Item 1: Venus and Adonis, with Two Dogs.
History: Antwerp Inventory 1656, 'Venus and Adonis', not described, by Titian (Denucé, 1932, p. 178). This item probably was part of the booty taken by the Swedes at Prague in 1648: Prague, Inventory 1621, no. 1054, 'Venus und Adonis vom Ticiano, Orig.' (Zimmermann, 1905, p. XLIII); also earlier Inventory (of Rudolf II, about 1598?), folio 38b, 'Venus und Adonis vom Titian' (Perger, 1864, p. 108; first specific mention of two dogs: Rome, Palazzo Riario, Inventory 1662, folio 45, 'Adone con Venere e con dui cani . . . alto palmi 7 e largo palmi 5 [1·56×1·117 m.] . . . di Titiano'; 'Nota dei quadri della Regina di Svezia', c. 1690, no. 43: '. . . e due bellissimi cani con Cupido che sotto

l'arbore dorme . . . di Titiano' (Odescalchi archives); Azzolino sale to Odescalchi, 1692, no. 17 or no. 151; Odescalchi sale to the Duke of Orléans, 1721, two items, not described, folio 3, no. 58 and folio 6v, no. 27.

Item 2: Venus and Adonis with Three Dogs and Cupid Asleep under the Trees (Prado type).
History: Rome, Palazzo Riario, Inventory 1662, folio 45: 'Adone in atto di partir alla caccia con tre cani alla mano trattenuto da Venere che l'abraccia ignuda e seduta in schiena sopra una veste di velluto. Un bellissimo paese con un amore adormentato sotto gli alberi, figure grandi al naturale, con cornice liscia indorata, alta palmi otto e mezzo e larga palmi nove' [1·90×2·01 m.]. The same description is repeated in the copy (see Item 3, below), but the size of 8½ ×9 *palmi* is reduced to 3 ×2⅔ *palmi* in the unframed copy. Christina's Inventory 1689, the same description but the size 6½×8 *palmi* [1·45×1·79 m.] (Campori, 1870, p. 340; Granberg, 1897, no. 17 or 30); Odescalchi archives, 'Nota dei quadri della Regina di Svezia', c. 1690, no. 55, now 'alta sopra cinque palmi e largo sopra quattro', i.e. 5 ×4 *palmi* [1·17×0·89 m.], but the language indicates that this dimension was given as a vague memory approximation; Odescalchi Inventory 1692, folio 466, no. 17 or no. 151 (no dimensions); Odescalchi Inventory 1713, folio 84v, 'originale di Titiano' (no dimensions); Odescalchi sale to Duke of Orléans, 1721, there were two items: folio 3, no. 58 and folio 6v, no. 27.

Item 3: COPY, Venus and Adonis with Three Dogs (Prado type).
History: Rome, Palazzo Riario, Queen Christina, Inventory 1662, folio 57. The words repeat exactly the description of the larger original given to Titian himself (Item 2, above). The size is different, however, 'piccole figure alto palmi tree largo palmi dui e tre quarti [0·67×0·61 m.] senza cornice. Viene da Titiano'; Inventory 1689, *Venus and Adonis*, 3 ×2⅔ *palmi*, no artist given (Campori, 1870, pp. 359–360); Odescalchi Inventory 1692, folio 470v, no. 151, 3 ×2½ *palmi*.

5. Rome, Odescalchi Inventory, 1713, folio 42, six copies of Titian, nos. 90–95; although Cupid is described as asleep, that detail occurs in both Items 1 and 2.

See above, copy 6.

43. Venus and Adonis　　　　　　　　　　　　　　　Plate 97
Canvas. 1·067×1·334 m.
New York, Metropolitan Museum of Art.
Titian and workshop.
About 1560–1565.

The composition represented by the lost Farnese picture (Cat. no. L–19) and by the versions in New York and

Washington (Cat. nos. 43, 44) is essentially the same as that of the major work at Madrid (Cat. no. 40) so far as the figures of Venus and Adonis are concerned. The literary sources remain, of course, identical in all cases. The major differences in the Farnese type involve the landscape, which is cut off just above the heads, thus eliminating much of the trees at the left and reducing the height of the canvas. The landscape at the right in the Farnese type is more summary and the number of dogs is reduced from three to two. Instead of the sleeping Cupid in a foreshortened position in the left background, he is now awake, clutching a dove and visible only as to head and shoulders, while he gazes engrossed in the drama enacted by his mother and her young lover, Adonis. His bow and quiver of arrows hang upon the tree above. The over-turned urn at the lower left in the Prado picture is eliminated in the Farnese variant of the composition. By general agreement these canvases are later than the Madrid picture, which was painted for Philip II in 1553–1554, chiefly because the brush work is looser and freer. Colours remain constant in all versions, although more neutralized and in this way far less richly decorative.

Condition: Somewhat darkened and retouched.

History: Palazzo Mariscotti, Rome, where the Camuccini Brothers (dealers) purchased it. Mr. Irvine wrote to Buchanan from Rome on 30 June 1804 that he had acquired the picture from 'the younger Camuccini' (Buchanan, 1824, I, p. 123; II, p. 153). It then passed into the collection of Lord Darnley at Cobham Hall (1804–1925); seen there by Waagen in 1854 (Waagen, III, p. 18); sold at Christie's, London, 1 May 1925, no. 79; Knoedler and Co., New York, 1925; acquired by Jules Bache, New York, in 1927; bequeathed to the Metropolitan Museum of Art in 1944.

Bibliography: See also above; C. and C., 1877, II, pp. 151–152, note (a later copy; wrong provenance from Bologna); Suida, 1932–1933, pl. 318; *idem*, 1935, pp. 120–121, 186 (Titian); Tietze, 1936 (omitted); *idem*, 1950, p. 403 (workshop); New York, *Bache Collection*, 1937, p. 17; Berenson, 1957, p. 189 (Titian); Valcanover, 1960, II, pl. 91 (Titian); Pallucchini, 1969, pp. 299, 315, fig. 475 (Titian, *c.* 1560–1565; the Orléans Collection is incorrectly given as the provenance; Zeri and Gardner, 1973, pp. 81–82 (Titian, late 1560's; landscape by workshop).

44. Venus and Adonis Plate 98
Canvas. 1·068 × 1·36 m.
Washington, National Gallery of Art, Widener Collection.
Titian and workshop.
About 1560–1565.

The discussion of the *Venus and Adonis* in New York (Cat. no. 43) applies, so far as the elements of the composition are concerned, to its near twin in Washington. Slight variations do exist, for instance the omission of Cupid's bow and quiver upon the tree, which are present in Cat. no. 43 (New York), and the modifications of details of Adonis' costume and boots. The darker colour values and increased muddiness are explicable, to some degree at least, by the less favourable state of preservation.

Condition: Darkened and dirty still, although cleaned in 1930.

History: Probably from the Barbarigo Palace at San Polo (mentioned by Boschini, 1660, edition 1966, p. 664; Savini Branca, 1964, p. 184). It is said to have been purchased from the Barbarigo family about 1675 by Lord Sunderland (Dibdin, 1822, p. 13).
John Evelyn reported on 15 January 1679 and again in 1685 (edition 1955, IV, pp. 162, 403) having seen the picture at London in the house of the Earl of Sunderland, formerly the residence of the Duke of Buckingham. [Another picture of *Venus and Adonis* remained in the Barbarigo Collection, size 1·26 × 1·06 [*sic*] until the sale of that entire collection to the Czar of Russia in 1850. See Levi, 1900, II, p. 287, no. 48. Branca, 1964, p. 184. It may have been a copy made when Lord Sunderland purchased the original in 1675. At any event the picture has disappeared, although it could be lost in the vast reserves of the Hermitage Museum at Leningrad or lent by them to some provincial museum in Russia].
Inherited by Earl Spencer at Althorp; sold by Earl Spencer to Agnew, London, in 1922; Arthur J. Sulley, London, in 1924; Widener Collection, Philadelphia, 1925–1942; bequest to the National Gallery of Art in 1942.

Bibliography: Fry, 1923, p. 54 (Titian; then at Agnew's in London); Holmes, 1924, p. 21, pl. 2; Valentiner and Burchard, 1930, pl. 24 (Titian); Mayer, 1925, p. 276 (Titian); Suida, 1935, p. 120 (Titian); Tietze, 1936 (omitted); *idem*, 1950, p. 402 (perhaps Titian's *modello*); Berenson, 1957, p. 192 (late Titian); Valcanover, 1960, II, pl. 90 (Titian); Washington, 1965, no. 680 (Titian); Pallucchini, 1969, p. 315, fig. 476 (Titian, *c.* 1560–1565, badly preserved).

VARIANTS:
1. Ilchester, Melbury House, Viscountess Galway; canvas, 1·143 × 1·397 m., copy; two dogs at the right and Cupid awake at the left. Lady Ilchester stated in a letter of January 1966 that it was a copy. *Collections:* Earl of Ilchester until 1964; by inheritance to the present owner.
2. London, Payn Collection (sale, Christie's, 28 March 1952, cat. no. 31); canvas, 0·673 × 0·94 m.; very weak copy. Photograph, Witt Library, Courtauld Institute, London.

3. London, Thomas Howard, Earl of Arundel, Inventory 1655 (Hervey, 1921, p. 489, no. 381). Peter Oliver copied this picture in a miniature, dated 1631, which is now at Burghley House (Plate 193). Reference was made to that fact when the miniature belonged to the collection of Charles I of England at Whitehall Palace, as verified by van der Doort's Inventory of 1639 (Holmes, 1906, p. 110; Millar, 1960, pp. 104, 214). The composition adheres to the Farnese type (Plate 97) in that two dogs are present instead of three and Cupid, awake, holds a dove. It differs from the version now in Washington in the position of the larger dog, who looks toward the lovers instead of heavenward.

The miniature by Peter Oliver is so similar to the Titian school piece, formerly kept in storage at Vienna (see below, Free Variant no. 3) that the latter may well be the Arundel picture. The arrangement of Venus' hair, the drapery beneath her, the costume of Adonis, and the omission of his staff are identical in the two cases. The presence of the Cupid and two doves in the miniature is the only major variation.

4. Unknown location; exact, competent, but later copy; canvas, 0·58×0·48 m.; photograph by Paul Becker, Ixelles (deceased by 1970) in the Witt Library, Courtauld Institute, London.

ENGRAVING:

The print by Raphael Sadeler II (Plate 96) corresponds exactly to the Washington picture even in the details of Adonis' costume and the omission of Cupid's bow and quiver. The date 1610 indicates that Sadeler copied the picture when it was in the Barbarigo Collection at Venice.

FREE VARIANTS:

1. Unknown location; *Venus and Adonis* with three dogs, 2 *palmi* (0·446 m.); collection of Bartolomeo della Nave, Venice; Lord Fielding, Marquess of Hamilton, in 1639 (Waterhouse, 1952, p. 15, no. 21) Hamilton Inventory of 1638, no. 186: 'A peice of Venus and Adonis and 3 doggs. Cupid sleeping upon a hyllocke hard by, his Bowe and quiver hanginge upon a tree of Titian' (Garas, 1967, p. 67); Hamilton Inventory of 1648: '14. Une Vénus et Adonis avec 3 chiens, 2 pa. quarrie' (Garas, *loc. cit.*, p. 75); Archduke Leopold Wilhelm, Vienna, 1659, no. 309 (Berger, 1883, p. CIV; canvas, 3 *Spann* 1 *Finger*×2 *Spann* 9 *Finger* (0·65 × 0·45 m.). This item is not the school piece formerly kept in storage in Vienna but lost in World War II (see below, no. 3).

2. Unknown location. Another picture illustrated as at the Stallburg in 1735, then attributed to Andrea Schiavone, was vertical in format and showed three dogs and Cupid awake with a dove at the left. Teniers, 1660, pl. 127, as Schiavone. See also Stampart, 1735, edition 1888, pl. 17. A miniature

painted copy of this lost work is in the John G. Johnson Collection in Philadelphia, there formerly attributed to David Teniers II after Titian; panel, 0·225×0·172 m. (Johnson Catalogue, 1941, p. 39, no. 695; also Sweeney, 1972, p. 85, no. 695).

3. Vienna, Kunsthistorisches Museum (formerly; lost in World War II); canvas, 0·96×1·18 m. (Plate 192). The size does not conform to the smaller picture in Archduke Leopold Wilhelm's Collection (see Free Variants, nos. 1, 2). This is a rather free adaptation of the type of composition that has only two dogs, but the Cupid holding the dove is omitted. The staff usually held in Adonis' right hand is lacking, and instead he rests his hand upon the goddess' back. The closest approach to this composition is seen in Peter Oliver's miniature after a picture then in the collection of the Earl of Arundel (Plate 193). The Cupid and two doves are wanting at Vienna. It most probably is really Arundel's picture, with these details painted over (see above, Variant no. 3). *Bibliography:* Engerth, 1884, p. 372, no. 524 (school piece); C. and C., 1877, II, p. 152, note (school piece); Glück and Schaeffer, 1907, no. 151 (school piece).

LITERARY REFERENCES (types unknown):

1. Genoa, Francesco Lonari (formerly) (Ridolfi (1648)–Hadeln, I, p. 198).

2. Genoa, Lomellini Palace (Hume, 1829, p. 45; C. and C., 1877, II, p. 239, note).

3. London, Charles I sale, Inventory 7 September 1649, LR 2/124, folio 188r, Somerset House, 'Venus and Adonis, coppie after Titian'; sale at Somerset House, 1650, Venus and Adonis as by Titian (Cosnac, 1885, p. 414, no. 35); Charles I sale, October 1651, as a copy by Oliver, but the price £80 suggests an original, since copies usually sold for £8 (Millar, 1972, p. 258, no. 35); two items here: 70×68 *pouces*, i.e. 1·89×1·83 m., purchased by Jabach; later owned by Mme. Lenglier in 1788 (Blanc, 1858, II, p. 119).

4. London, Sir Peter Lely, canvas, 1·677×2·235 m. (Hume, 1829, p. 102).

5. London, Bryan sale, 1798 (Buchanan, 1824, I, p. 291, no. 41).

6. Milan, Marchese Serra in 1657 (Scanelli, 1657, p. 222; C. and C., 1877, II, p. 239 note).

7. Paris, Prince de Carignan; sale 1742; 68×72 *pouces*, i.e. about 1·83×1·94 m. (Blanc, 1857, I, p. 33); possibly identical with no. 3.

8. Venice, Camillo Sordi, in 1612, *Venus and Adonis* by Titian offered for sale to the Duke of Mantua (Luzio, 1913, p. 110).

9. Venice, Titian's studio, in 1568; *Venus and Adonis* offered to Emperor Maximilian II at Vienna in a letter written by Veit von Dornberg, his ambassador at Venice (Voltelini, 1892, p. XLVII, no. 8804).

45. Venus and Cupid with a Lute Player

Plates 121, 122, 124

Canvas. 1·65×2·094 m.

New York, Metropolitan Museum of Art.

Titian.

About 1565–1570.

See the text for style and relationships to other pictures.

Condition: The picture was surely left unfinished at the time of Titian's death. Unpainted areas still remain in the immediate foreground, i.e. the white section of the couch beneath the lutanist and the open book for music, which is still blank. The X-rays which Hubert von Sonnenberg kindly showed to me reveal a slight shift in the position of Venus' head. Mr. von Sonnenberg, former chief of the conservation department of the Metropolitan Museum, believes that the very beautiful head was retouched by one of Titian's followers. The paint differs somewhat here, and there are further retouchings upon the curtain. To the large tree in the centre background some brilliant white highlights were added by this second artist. Mr. von Sonnenberg will publish a detailed technical study of the Holkham Venus in a forthcoming issue of the *Metropolitan Museum of Art Bulletin.* Mr. Evans (1947, pp. 123–125) made similar observations on the condition of the picture, but his historical data were faulty and his assumption that the picture was once in Tintoretto's shop has no documentary basis.
A horizontal crease through the centre shows that the canvas was once folded when shipped (see also Cat. no. 40, Condition). Cut down on the lower edge.

The Controversy: In 1944 Erica Tietze-Conrat attempted to demonstrate that the Holkham *Venus and Cupid with the Lute Player* is the picture once owned by Joachim van Sandrart, who described the identical subject and called it the work of Jacopo Tintoretto the Younger (Sandrart, 1675, edition 1925, p. 328). She correctly concluded that Sandrart meant Domenico Tintoretto, since that was the name of the great Tintoretto's son. Otherwise very little of her argument is in any way acceptable, and she attempted to prove the clearly unprovable, just as she did in her claim that Titian's *Pesaro Madonna* represents the dogma of the Immaculate Conception (see Wethey, I, 1969, p. 102; also this volume, Addenda I, Cat. no. 55). In both cases she was demonstrably mistaken.
Titian's Holkham *Venus* is known to have been purchased in Rome by the Earl of Leicester from Prince Pio c. 1760–1765. Tietze-Conrat ignored this fact, and she did not explain how Sandrart's picture could have reached Prince Pio's collection. More important is the lack of any stylistic relationship to the

school of Tintoretto in a picture which is clearly by Titian. It is no longer necessary to review her complex arguments since they have fallen into dust. At the time a sensational controversy developed in the form of a letter from Mr. Wehle of the Metropolitan Museum to the *Art Bulletin* (1945, p. 83) and Tietze-Conrat's heated reply (*loc. cit.*) and her further letter (*loc. cit.*, 1948, p. 78). Meantime her husband, Dr. Hans Tietze, dared to reject her theory (1950, pp. 389–390) but she clung to it to the end (1958, p. 351).

Dating: By general agreement a late work. Only Hadeln proposed that the figures were painted c. 1540 and the landscape added c. 1560.

History: Prince Pio, Ferrara and Rome: the inventory of 1742, when in the Palazzo Falconieri in Rome contains an item 'una Venere ignuda a giacere con Cupido ed un soldato del Tiziano Scudi 9000' (Cittadella, 1864 and 1868, I, p. 556). Venuti, 1745, I, p. 352, records that in the Palazzo Pio, built into Pompey's theatre, there were two Venuses by Titian; the edition of 1767, p. 480, uses the past tense; purchased from that collection according to Holkham Hall inventory of 1765; Beatniffe, 1773, p. 22 (as at Holkham), *Strangers Guide to Holkham,* 1817 (as formerly Prince Pio at Rome); Earl of Leicester, Holkham Hall until c. 1930; New York, Metropolitan Museum, purchased 1936.

Bibliography: See also above; Hume, 1829, p. 96 (Titian at Holkham Hall); Waagen (not included); C. and C., 1877, II, p. 159 note (as a copy); Richter, 1931, pp. 53–59 (Titian, c. 1560; the New York version the original, of which the Cambridge picture is a replica); Hadeln, 1932, pp. 273–278 (as by Titian, the original prototype of the Cambridge picture); *Mostra di Tiziano,* 1935, p. 205 (perhaps Francesco Assonica's picture; but that is an error, for Assonica's *Venus* is in the Prado Museum, Cat. no. 50, Plate 113); Suida, 1935, 119, 175 (Titian); Wehle, 1936, pp. 182–187; *idem,* 1940, pp. 195–196 (Titian, 1562–1565); Tietze, 1936, II, p. 303 (a late work with assistance, prototype for the Cambridge and Dresden pictures); Hetzer, 1940, p. 164 (doubtfully by Titian); Duveen, 1941, no. 163 (Titian); Tietze-Conrat, 1944, pp. 266–270 (Domenico Tintoretto); Tietze, 1950, pp. 389–390 (suggests Titian as the probable author); Suida, 1957, pp. 71–74 (Titian, c. 1560); Berenson, 1957, p. 189 (late Titian); Valcanover, 1960, II, pl. 72 (late Titian); Tietze-Conrat, 1958, p. 351 (persisted in her attribution of the picture to Domenico Tintoretto); Pallucchini, 1969, p. 316, figs. 478, 479 (Titian and assistants, c. 1562–1564); Panofsky, 1969, pp. 124–125 (iconography); Zeri and Gardner, 1973, pp. 77–79 (Titian, c. 1560–1565, completed by a Venetian artist in the late sixteenth century).

COPIES:

1. Dresden, Staatliche Gemäldegalerie (formerly; lost in World War II); canvas, 1·42×2·08 m.; free adaptation of the late seventeenth century. *History:* Warsaw Gallery in 1748; at Dresden in 1751, identified as Philip II and the Princess of Eboli! *Bibliography:* C. and C., 1877, II, pp. 159–160 (Andrea Celesti); Posse, 1929, pp. 90–91, illustrated (copy of the seventeenth century); Richter, 1931, p. 54 (copy of the late seventeenth century); Ebert, 1963, p. 151 (reference to the loss of the picture in World War II).

2. Unknown location; *Venus Alone* (Holkham type); canvas, 1·40×2·00 m.; formerly London, Henry Roche; photograph in the Witt Library, Courtauld Institute, London.

46. Venus and Cupid with a Lute Player

Plates 123, 125

Canvas. 1·505×1·968 m.
Cambridge (England), Fitzwilliam Museum.
Titian and workshop.
About 1565.

Extreme views have been expressed about this picture, first by Crowe and Cavalcaselle, who declared it a seventeenth-century copy. Certainly such a judgment is incorrect, but neither does the picture have the quality of a work entirely by Titian's own hand, as Hadeln and Studdert-Kennedy insisted. Cat. no. 45 appears somewhat later in style, and a few minor details, such as the sheets of music, are incomplete. Further consideration of style and iconography are found in the text.

Condition: Cleaned in 1950 and later by Buttery in 1965, the condition is fairly satisfactory on the whole, although repairs to the canvas can be detected in the nose, eye, and lip of the lute player and on Venus' left breast. The reds of the curtain have darkened considerably, as usually is the case. X-rays have recently disclosed the fact that the head of Venus was at first in left profile and that of Cupid in full face (Goodison, 1965, pp. 521–522). A. V. B. Norman, curator of armour at the Wallace Collection, kindly informed me that the lutanist's sword was entirely repainted in the nineteenth century but that the X-rays show a sixteenth-century type underneath. Nevertheless, the sword in the New York picture is similar (Plate 122).

History: Emperor Rudolf II (died 1612) (see next item, History); Prague Inventory, 1621 (Zimmermann, 1905, part II, p. xxxix, no. 891); 1648 taken by the Swedes with the booty on the capture of Prague; 1652 Stockholm Inventory, no. 83 (Geffroy, 1855, p. 178); 1656 Christina's Antwerp Inventory: it might be the item called 'Une Cortisane couchante de Titian' (Denucé, 1932, p. 178); 1662

Christina's Inventory, Palazzo Riario, Rome (not listed); 1689, Inventory at Christina's death (Campori, 1870, p. 339; Granberg, 1897, p. 35, no. 31); 1689 inherited by Cardinal Azzolino; 1692, no. 15 sold by his heir Pompeo Azzolino to Cardinal Livio Odescalchi (Odescalchi archives, undated 'Nota dei quadri', no. 44); 1713 Inventory on death of Cardinal Livio Odescalchi (Odescalchi archives, v, D2, folio 39V, no. 49); 1721 Odescalchi sale to the Duke of Orléans (Odescalchi archives, VB no. 1, no. 18, folio 3, no. 60); 1721–1792 Orléans Collection, Paris, then said to represent Philip II and mistress (Dubois de Saint Gelais, 1727, p. 478; Couché, 1786, pl. III); 1798 purchased by Viscount Fitzwilliam for 1000 guineas from the Orléans sale (Buchanan, 1824, I, p. 112, no. 4); 1816 bequeathed to the Fitzwilliam Museum.

Bibliography: Waagen, 1854, III, pp. 446–447 (Titian; heads of Venus and Cupid are repainted); C. and C., 1877, II, p. 159, note (seventeenth-century copy); Richter, 1931, pp. 53–59 (replica by a follower of Titian); Hadeln, 1932, pp. 273–278 (Titian, c. 1560); Suida, 1935, p. 119 (Titian); Tietze (mention); Brendel, 1946, pp. 65–75 (discussion of the iconography); Berenson, 1957, p. 184 (Titian in great part); Suida, 1957, p. 74 (replica); Studdert-Kennedy, 1958, pp. 349–351; Winter, 1958, p. 52 (Titian); Valcanover, 1960, II, pl. 73 (Titian, late); Goodison, 1965, pp. 521–522 (Titian; draperies and accessories by the workshop; he holds that the Holkham *Venus* is derived from the one in Cambridge); Goodison and Robertson, 1967, no. 129, pp. 167–172 (thorough account); Pallucchini, 1969, p. 316, figs. 477, 480 (Titian and workshop, c. 1560–1562); Panofsky, 1969, pp. 124–125 (iconography).

47. Venus and Cupid with an Organist

Plates 105, 106, 108

Canvas. 1·48×2·17 m.
Madrid, Prado Museum.
Signed in large capitals in the centre upon the parapet:
TITIANVS F
About 1545–1548.

See the text for a general consideration of the painting.

The signature: The signature here (Plate 239A) is authentic, and there is no reason to doubt it, as most people have done since the time of Crowe and Cavalcaselle.

Condition: The effect of the composition as a whole and the beauty of the figures in their original conception remain despite paint losses and their replacement long ago. The naked eye can detect them on close examination, and un-

doubtedly X-rays, if available, would reveal interesting facts. The red curtain at the upper right is much superior in quality and in state of conservation to the velvet of plum colour upon which Venus lies. The diverse opinions expressed about the authenticity of the picture are of dubious significance, since they are not based upon knowledge of the vicissitudes and the resultant condition of the canvas (see History). This *Venus* is unquestionably by Titian himself. Madrazo (1872, p. 679, no. 461) made his usual mistake of saying that this picture was restored by Juan de Miranda after the fire of 1734. For my clarification of this repeated error see notes 411, 412.

The painting has improved greatly as a result of the cleaning of 1966, during which the green trees of the landscape emerged far more brilliantly. The horizontal crease in the canvas, just above the heads, must survive from the packing in Titian's shop. The same thing was done in the case of the *Venus and Adonis* (see Cat. no. 40, Condition; Plate 84).

History: The generally accepted theory holds that the Prado *Venus*, no. 421, is identical with the work that Titian painted for Charles V. Diego Hurtado de Mendoza, imperial ambassador in Venice, informed Charles on 5 October 1545, that Titian had painted for him 'un quadro de fantasia' (Cloulas, 1967, p. 206). In his letter of 8 December 1545, when in Rome, the artist announced his intention of presenting the Emperor with a picture of *Venus* (see letter, page 126). Later, on 1 September 1548, when in Augsburg, Titian wrote to the Bishop of Arras, Antoine Perrenot, later Cardinal Granvelle (Wethey, II, 1971, Plate 153), that he had brought a *Venus* to Augsburg, 'as was commanded in the name of his majesty' (Zarco del Valle, VII, 1888, p. 222). Panofsky (1969, p. 121, note 33) is in error in saying, 'There is ... no evidence to show that the picture was ... even accepted by him'. Ridolfi (1648–Hadeln, I, p. 180) also confirms the existence of this *Venus*.

This picture appears in none of the Spanish or Brussels inventories of Charles V, Mary of Hungary, or Philip II. Consequently it has been concluded that Charles V gave it to Cardinal Granvelle, because this subject did exist later in the Granvelle collection. Many years after the Cardinal's death, his nephew and heir, the Comte de Cantecroy, sold a number of works from the Granvelle Palace in Besançon to Emperor Rudolf II, according to a letter of 24 July 1600. One item is described as 'Un quadro in tela d'una Venere in sul letto con un organista di Titian' (Zimmermann, 1888, p. L, no. 4656). The presumption is that shortly afterward, in 1603 or 1604, Rudolf II sent this same picture to Philip III in an exchange which transferred Correggio's *Leda* and *Ganymede* from Madrid to Prague (Beroqui, 1946, p. 79). Here is the weak link in the sequence, because we have no document of any kind to indicate what happened to Rudolf II's *Venus* by

Titian. The probability is strong that he presented it in an exchange to Philip III, but final proof is wanting.

Actually the Correggio originals went to Prague instead of the copies as promised (Voltelini, 1898, no. 16433). Carducho (1633, edition 1933, p. 79) confused the whole affair by predating it to the reign of Philip II.

History in Spain: The earliest description of the picture in the Spanish royal palace at Madrid is that of Cassiano dal Pozzo 1626, folio 122): 'L'historia nell' altra v'è una Venere ignuda su un letto con Cupido e a piè del letto, uno, che sonando un segalo, ò organetto, si rivolta a vederLa, finge poi un aperto di Paese bellissimo, il quale termina mostrando come un grandissimo viale di due filari di Alberi.'

It next makes an appearance in the Alcázar Inventory of 1636 (folio 50) in the 'Pieça última de las bóvedas' where it is cited as follows: 'Un lienço de mano del ticiano en que es la benus desnuda y Cupido quela esta abraçando y a los pies un hombre que esta tañendo un organo, tiene cortinas Carmesies y un pais con una fuente, la moldura es dorada y tiene de largo ocho pies.'

Successive inventories place it in the 'Galería baja del jardín de los emperadores': in 1666, no. 689 (valued at 1000 ducats); in 1686, no. 862 (Bottineau, 1958, p. 320); Alcázar Inventory, 1700, no. 484; Inventory of 1734, no. 25, after the great fire, it is said to be well treated ('bien tratado'), i.e. not damaged; Inventory of 1747, folio 220: 'Venus y Cupido y un manzebo tocando el órgano, original de Ticiano'; sequestered in the Academia de San Fernando, 1796–1827; transferred to the Prado Museum in 1827.

Bibliography: See also above; C. and C., 1877, II, p. 159 (by a follower; they state incorrectly that the signature is not authentic); Gronau, *Titian*, 1904, p. 304 (partly by Titian, especially the landscape; Gronau wrongly associated the picture with one shipped to Spain in 1567, i.e. my Cat. no. L–27); Suida, 1935, pp. 118, 175 (Titian, *c.* 1550); Tietze, 1936, II, p. 298 (Titian's workshop); Beroqui, 1946, pp. 78–81 (Titian); Berenson, 1957, p. 187 (Titian in great part); Valcanover, 1960, II, pl. 32 (Titian); Prado catalogue, 1963, no. 421 (Titian); Pallucchini, 1969, p. 290, figs. 338, 339 (Titian, *c.* 1548; the curtains by the workshop); Panofsky, 1969, pp. 122–123, note (Titian; superior to the second Prado *Venus*, my Cat. no. 50).

48. **Venus and Cupid with an Organist** (Prince Philip of Spain) Plates 114–120, 238G

Canvas. 1·15 × 2·10 m.

Berlin-Dahlem, Staatliche Gemäldegalerie.

Signed in large capitals on the chair at the left: TITIANVS F.

About 1548–1549.

Philip II as a very young man with blue eyes, curly chestnut hair and thin moustache seems to be identifiable here as the organist, a fact that is valuable in establishing the history of this picture. In no other mythological subject does he appear, although in the past he was incorrectly identified as the lute player of the *Venus* at Cambridge (Plate 123).

Condition: X-rays taken in the summer of 1973 have been kindly made available to me by Dr. Erich Schleier of the Berlin gallery. They reveal that Titian changed the contour of the organist's body slightly and also made adjustments in the placing of the goddess' feet. The major losses are in the sky and in the area above Venus' knees. The flesh tones have been worn somewhat, and Venus' cheek and forehead have been retouched. In general, however, the condition of the picture is satisfactory.

Presumed History: Titian was called to Milan to meet Prince Philip on his first voyage beyond the borders of Spain. The artist left Venice on the 19 December 1548 and remained in Milan until 7 January 1549 (Letters in Zarco del Valle, 1888 p. 226 and Beer, 1891, p. CXLIII, nos. 8367–8372). On 29 January 1549 a payment of 1000 *escudos* (ducats) for certain portraits ('ciertos retratos') may have included the Berlin *Venus and Cupid with an Organist* (Wethey, *Archivo*, 1969, pp. 130–133). Among the lost portraits must have been the one sent to Mary Tudor in connection with the negotiations that climaxed in the marriage of the Spanish prince to the Queen of England. In that picture Philip wore a blue cloak trimmed with white wolf's fur (Wethey, *loc. cit.*; Wethey, II, 1971, pp. 41–43 and Cat. no. L–25).

Relatively Certain History: The suggestion (Wethey, II, 1971, p. 43, note 154) that the picture may have passed from Catalina, Philip's daughter, to the house of Savoy and thence to Prince Pio is doubtless very uncertain. Without any question it was in the collection of Prince Pio, in whose Inventory of 1742, when in the Palazzo Falconieri at Rome, it is described as follows: 'una Venere a giacere con Cupido ed un uomo che suona l'organo con un cagnolino di Tiziano. Scudi 9000' (Cittadella, editions 1864 and 1868, I, p. 556). The same collection also contained the *Venus and Cupid with the Lute Player*, now in New York (Cat. no. 45, History). That the Berlin version came from Prince Pio was first pointed out by Hadeln (1932, p. 277). The Berlin museum acquired it from a Viennese dealer in 1918, and at that time the director, Wilhelm Bode, did not disclose the ultimate provenance. He restricted himself to saying that it had been on sale in Paris from the collection of a Spanish prince who had lived in Italy (Bode, 1918, p. 94). Bode later (1926, p. 2) again reported the source as the collection of a 'Spanish Orléans prince', who lived in Italy, and said that it must

have been in Spain originally. Two copies of the Berlin picture in Spain support this theory (see below, Copies nos. 3 and 4). The Pio family is partly Spanish and partly Italian. The present Princess Pio, the young widow of the Marqués de Castel Rodrigo, maintains the family collection in the beautiful Villa Mombello at Imbersago (Como).

Bibliography: Bode, 1918, pp. 94–106 (first publication); *idem*, 1926, p. 187; Kühnel-Kunze, 1931, p. 485 (Titian, *c.* 1548-1550); Suida, 1935, pp. 119, 175 (Titian); Tietze, 1936, II, p. 284 (Titian, *c.* 1550); Suida, 1957, pp. 72–74 (Titian); Berenson, 1957, p. 184 (Titian in great part); Valcanover, 1960, II, pl. 34 (Titian, *c.* 1550); Pallucchini, 1969, p. 295, figs. 365, 366 (Titian, *c.* 1550–1552); Panofsky, 1969, p. 122 (Philip II as organist); Wethey, I, 1969, pp. 129–138; Wethey, II, 1971, pp. 42–43 (portrait of Prince Philip as organist, *c.* 1548).

COPIES:

1. Berlin, Dr. Otto Burchard in 1926; hard mechanical copy, possibly late sixteenth century (illustrated by Bode, 1926, p. 4; See also Bode, 1926, pp. 187–188).
2. Berlin, Charles de Bulet; school piece, much restored (Mayer, 1931, p. 307).
3. Edinburgh, Holyrood House, canvas, 1·143 × 2·12 m.; very crude copy. It is said to be listed in the Inventory of the Duke of Hamilton in 1704, no. 108. The Duke of Medinaceli gave it to the Earl of Arlington when he was ambassador to Spain. Data in the Witt Library of the Courtauld Institute, London, state among other details that it is a copy 'of the original which was burnt in the Escarialon [*sic*] Spaine'. The Escorial monastery could never have had a picture of this subject, even in the royal apartments. The importance of this notice lies in the fact that the original in Berlin was at one time in Spain and that it belonged to the Pio family, branches of which lived in both Italy and Spain.
4. Madrid, Duquesa del Arco in 1972; hard copy, canvas, 1·13 × 2·00 m. (Moreno photograph, no. 6309, in the Laboratorio Fotográfico, Madrid). It was inherited by the Duquesa del Arco from her father, the Duque de Fernán Núñez of Madrid. A Prince Pio was the great-grandfather of the present owner, and this copy must have been made in the seventeenth century, when the Berlin picture belonged to the Pio Collection in Italy. The size of the copy corresponds closely to that of the original.

VARIANT:

Venus with Doves, canvas, 1·10 × 2·15 m.; private collection (Gherardesca, Florence?) (in 1942), sixteenth–seventeenth century. This variant of the Berlin *Venus* (Plate 114) omits the Cupid and replaces the organist with a huge urn and two doves. Otherwise the original is rather closely reproduced by an academic copyist. *History:* claimed to have belonged

to a Russian princess and to have been exhibited formerly at the Hermitage; passed by marriage to a noble Tuscan family. *Bibliography:* Fiocco, 1942 (Titian, *c.* 1540).

SKETCH:
Stockholm, National Museum; oil on brown paper, 222 × 293 mm.; *Maltese Dog* (Plate 119) not identical in pose to the dog in the Berlin *Venus and the Organ Player* (Plates 114–120), but the spirit and style are closer than to other dogs that appear in Titian's paintings. Sirén (1902, cat. no. 462) assigned the sketch to Domenico Campagnola, but the attribution to Titian is reasonable enough (Tietze, 1949, pp. 181–183; Stockholm, 1962, no. 94).

49. Venus and Cupid with a Partridge Plate 107
Canvas. 1·39 × 1·95 m.
Florence, Uffizi.
Titian and workshop.
About 1550.

For a discussion of the style of the picture and the symbolism of the partridge, see the text and note 326.

Condition: Relined and cleaned in 1869 (E. Ridolfi, III, 1897, p. 175). A general crackle invests the entire surface and the colours are dulled by the poor condition of the canvas.

Proposed History: The suggestion that the Uffizi *Venus with a Partridge* was painted for Charles V (Panofsky, 1969, p. 121, note 33) cannot be maintained. The Uffizi picture is a weak version, in which Titian had only a limited part. In view of the fact that the artist wrote Charles V from Rome on 8 December 1545 that he was preparing a *Venus* for the Emperor, that picture could not have been a workshop piece (see Cat. no. 47, History). Titian ultimately delivered his *Venus* to Fugger, the Emperor's agent in Augsburg, in September 1548 (Zarco del Valle, 1888, p. 222) along with several very famous pictures including the *Charles V at Mühlberg* (Wethey, II, 1971, Cat. no. 21, Plates 141–144), the *Charles V and the Empress Isabella* (Wethey, II, 1971, Cat. no. L–6, Plate 151), and the single portrait of *Empress Isabella* (Wethey, II, 1971, Cat. no. 53, Plate 147).
Diego Hurtado de Mendoza and Aretino also allude to the *Venus* of the Emperor in letters of 1545 and 1553. A further reason for rejecting Panofsky's suggested provenance is that the Uffizi *Venus* belonged to Paolo Giordano Orsini, who presented it to Cosimo II dei Medici in 1618. How Charles V's property reached Giordano Orsini would need to be explained. It is much more probable that Charles V's canvas is the signed *Venus and Cupid with the Organ Player*, now in the Prado Museum (Cat. no. 47, History).

Certain History: Gift of Paolo Giordano Orsini to Cosimo II dei Medici in 1618; Antonio dei Medici, bequeathed to the Uffizi in 1632; Inventory of 1635–1639, no. 29 (Florence, Uffizi, 1926, p. 87, no. 1421). An earlier Giordano Orsini (died 1564) had his portrait painted by Titian (Sansovino, 1565, folio 86; reference courtesy of Jennifer Fletcher). This *condottiere* was the probable first owner of the Uffizi *Venus*.

Bibliography: See also above; Ridolfi (1648)–Hadeln, I, p. 197 (mention as in the Medici Collection); C. and C., 1877, II, pp. 155–157, 166 (Titian, with enthusiasm; they assumed a provenance from Urbino of this *Venus* also); Gronau, *Titian,* 1904, p. 290 (not from Urbino, as previously thought); Suida, 1935, pp. 118, 175 (Titian, *c.* 1550); Tietze, 1936, II, p. 290 (no comment); Berenson, 1957, p. 186 (late Titian); Valcanover, 1960, pl. 35 (largely workshop); Reff, 1963, pp. 360–361 (iconography); Salvini, 1964, p. 69, no. 1431 (Titian and workshop, *c.* 1560); Pallucchini, 1969, p. 293, fig. 350 (largely workshop, *c.* 1550; not intended for Charles V).

50. Venus and Dog with an Organist Plates 109–113
Canvas. 1·36 × 2·20 m.
Madrid, Prado Museum.
Titian and workshop.
Not signed.
About 1550.

This composition, so very similar to Prado no. 421 (my Cat. no. 47, Plate 105), lacks the Cupid, who is replaced by a dog. Pleasure and eroticism, inherent in the subject, are symbolized by the dog, the stag, and the embracing couple in the left background. On the basin of the satyr fountain a peacock is perched, exactly as in the other composition, while a stag nearby makes ready for amorous play with his mate.
Since the often-suggested similarity of the organist to Ottavio Farnese involves primarily the rather long Italian nose (see Wethey, II, 1971, Plates 127, 128), the proposal cannot be taken seriously. The richness of tones survives in the rose curtain and plum-red velvet cover beneath the goddess's body, as well as in the golden sleeves and breeches of the organist against his black doublet. His costume differs markedly from that of the youthful organist in the other Prado version (Plates 108, 109).

Condition: Madrazo, in the Addenda of his catalogue, 1872, p. 679, no. 459, states incorrectly that this picture was restored by Juan de Miranda after the fire of 1734. For an explanation of this error, see note 412, and also below under History. Severe damage by water in 1814, when the French army dropped it in a river (see below, History); subsequent

restoration by Bonnemaison in Paris; cleaned in 1965, but the entire composition has darkened beyond renewal. Examination by the naked eye reveals serious paint losses, clearly detectable in the region of Venus's right knee, both lower legs, and across the lower abdomen. The flat grey sky is entirely restoration, a fact particularly noticeable on comparison with Cat. no. 47.

History: When recorded by Van Dyck in his 'Italian Sketchbook', folio 111 (Plate 111), it was (*c.* 1622) in Venice; Francesco Assonica, Venice (Ridolfi, 1648–Hadeln, I, p. 194, who states that this picture went to England); Charles I of England (van der Doort, 1639, Millar edition 1960, p. 15, no. 5, 52×87 inches; known in a print, dedicated to John Evelyn by the Englishman, Richard Gaywood, dated 1656, who must have seen the picture *c.* 1650 (*Connoisseur,* CXIII, December 1944, p. 97); for other English copies see below; Commonwealth sale first to Col. Hutchinson, 8 November 1649, £165 (Millar, 1972, p. 299, no. 17); repurchased by the Spanish ambassador (Symmonds, Egerton MS. no. 1636, British Museum, dated 1650–1652, folio 101).
First appears in Madrid in the Alcázar Inventory 1666, no. 685, in the 'Pieça de la Galería Baja', described as 'una Venus echada desnuda con un perrillo de mano de Ticiano, 400 ducados'; Alcázar Inventory 1686, no. 858, in the 'Bóvedas de Ticiano' (Bottineau, 1958, p. 319); Inventory 1700, no. 480; Inventory 1734, no. 27, after the fire in the Alcázar, 'Venus con el perrito y una figura de espalda, . . . bien tratado'; Inventory 1747, folio 220v, 'otro lienzo del mismo tamaño y asumpto al excepción de faltanle el niño y tiene en su lugar un perrillo, original de ticiano'; sequestered in the Academia de San Fernando, Madrid, in 1796; taken to Paris by the French in 1814, returned to Spain in 1816; in the Academia de San Fernando previous to transfer to the Prado Museum in 1827.

Bibliography: See also above; C. and C., 1877, II, p. 158, note (follower of Titian); Gronau, *Titian,* 1904, p. 304 (Titian; he confused the history with that of my Cat. no. 47, because of lack of knowledge of the Spanish inventories); Suida, 1935, pp. 118, 175 (Titian, *c.* 1550); Tietze, 1936, II, p. 298 (Titian and workshop, perhaps 1545); Beroqui, 1946, pp. 78–84 (Titian's workshop); Berenson, 1957, p. 187 (Titian); Valcanover, 1960, II, pl. 33 (incomplete history); Prado catalogue, 1963 and 1972, no. 420; Pallucchini, 1969, p. 293, figs. 339, 348, 349 (Titian and workshop, *c.* 1548–1550).

COPIES:
1. Brescia, Fenaroli Gallery (formerly); C. and C., 1877, II, p. 159 (copy).
2. Hampton Court Palace, in storage, numbered both 2 and 1125; canvas, 0·914×1·358 m.; a copy made when the

Prado original was in Charles I's collection, *c.* 1640; inscribed as follows: 'with Soc. Ottavio F' (Farnese).
3. Port Sunlight, Lever Collection; remote English copy, *c.* 1640 (photograph in the Witt Library, Courtauld Institute, London).
4. Richmond (Petersham), Ham House; canvas, 1·765 × 2·172 m.; this mediocre English copy must be dated *c.* 1640, when the original was in England. The red velvet bed-cover has been changed to grey in this case.
5. The Hague, copy formerly in the collection of William II of Holland; sold to M. Brondgeest in 1850 (C. and C., 1877, II, p. 159, note); earlier mentioned as in William's collection by Blanc (1858, II, p. 480).

51. Venus at Her Toilet with Two Cupids

Plates 127–129
Canvas. 1·245×1·055 m. Colour reproduction
Washington, National Gallery of Art, Mellon Collection.
About 1552–1555.

Only this version of *Venus at Her Toilet,* which exists in so many variations and versions, is entirely by Titian's own hand. It is also unique in the detail of the Cupid about to place a crown of flowers and leaves upon the goddess's head. Titian did employ this same motive in a different composition, i.e. the *Venus and Cupid with a Lute Player,* one in New York and the other in Cambridge (Plates 122, 123). It should be observed that the Cupid at the right side looks into the mirror rather than out at the spectator, as in the so-called Crasso-type (Plate 126).
One of the most extraordinary facts about this masterpiece is that Titian never sold it, for it remained in his house, the Casa Grande, at his death (see below: History). Possibly he was too fond of the picture to part with it. See further data in the text.

Condition: The colours have darkened somewhat, but the X-rays made in 1971 confirm the excellent condition of the work. Tiny losses occur only on the lips of Venus and on the head, shoulders, and hips of the Cupid at the right. As he painted, Titian made slight alterations in the position of Venus's right arm and fingers. At first he had placed a white *camicia* over the torso, similar to that seen in another version, now known in Rubens' copy (Cat. no. L–27, Plate 132).
In view of the superb preservation of Cat. no. 51, Cavalcaselle's notes made in 1865 characterizing the canvas as ruinous come as a surprise (see Moretti, 1973, no. 95 with sketches and notations from the material in the Biblioteca Marciana at Venice). The picture must have been sagging in its frame at that time.
The sensational discovery, provided by the X-rays, shows that Titian re-used a canvas on which he had begun to paint

a double portrait in a horizontal position, i.e. 1·055×1·245 m. (Plate 218). Because of the braided coiffure of the woman, this portrait is datable about 1545, on comparison with Titian's portrait of the *Empress Isabella* in the Prado Museum (Wethey, II, 1971, Cat. no. 53, Plate 147). Mrs. Shapley has suggested that the abandoned composition, visible in the X-rays, may have been intended as an allegorical subject, somewhat like the *Allegory of the Marchese del Vasto* (Plate 68) in the Louvre. At any event Titian abandoned this picture and re-used the canvas in a vertical position for *Venus at Her Toilet* (Shapley, 1971–1972, pp. 93–105, a complete account).

History: At the time of Titian's death in 1576 the *Venus at Her Toilet with Two Cupids* was in his house, the Casa Grande, which was purchased in 1581, with its contents, by Cristoforo Barbarigo; willed to his son Andrea in 1600 (Cadorin, 1833, p. 113); cited in the Barbarigo Collection by Ridolfi (Ridolfi (1648)–Hadeln, I, p. 200); mentioned as in the Barbarigo Collection in 1663 (Sansovino-Martinioni, 1663, p. 374); Barbarigo Catalogue, 1845 (Bevilacqua, 1845, pp. 65–67; sale to Czar Nicholas of Russia in 1850; Levi, 1900, p. 288, no. 78; Savini Branca, 1964, p. 184, by error not included); Hermitage Museum, Leningrad; purchased by Andrew Mellon from the Hermitage Museum in 1930–1931; gift to the National Gallery in Washington in 1937 (Washington, 1941, p. 196, no. 34).

Bibliography: See also above; C. and C., 1877, II, pp. 334–336 (Titian; the only original of this type); Somof, 1899, p. 133, no. 99 (Titian's original); Kilènyi, 1906 (copy of the Nemes picture, i.e. Cat. no. 52); Schmidt, 1907, pp. 216–223 (study of various versions); Poglayen-Neuwall, 1929, pp. 174–175, 196 (Titian, c. 1555); *idem*, 1934, pp. 363, 382 (studies of numerous versions); Suida, 1935, pp. 119, 176 (Titian); Tietze, 1936, II, p. 314 (Titian, c. 1555); Berenson, 1957, p. 192 (Titian); Valcanover, 1960, II, pl. 62 (Titian, c. 1555; only autograph work of the subject); Pallucchini, 1969, p. 302, figs. 396, 397, colour reproduction XLIII (Titian, c. 1555); Shapley, 1971–1972, pp. 93–105 (major study).

52. Venus at Her Toilet with Two Cupids (Nemes version) Plate 130

Canvas. 1·175×1·01 m.

Cologne, Wallraf-Richartz Museum (formerly Nemes and Adolf Hitler).

Titian's workshop.

About 1555.

Venus, with rose-velvet drapery over her knees and accompanied by two Cupids, is placed against a green curtain.

Although the general quality of the picture is good, it has nearly always been assigned to the workshop and correctly. An early attribution in 1638 to Francesco Vecellio is certainly worthy of consideration (see below: History). Only Mayer, Berchem and Waldmann believed it to be by Titian's own hand and identified it as Niccolò Crasso's picture, of which Ridolfi wrote (see Cat. no. L–26). Poglayen-Neuwall, on the contrary, held it to be a copy or replica. As in the Washington *Venus*, two Cupids are present, one of them holding the mirror, but the centre Cupid does not place a wreath upon the goddess' head. Here the Cupid on the right side looks into the mirror, as in the Washington picture, and unlike the so-called Crasso type, where he turns toward the spectator.

Condition: The picture had only one Cupid at the right when in the collection of Archduke Leopold Wilhelm (Plate 215). In the early part of the twentieth century Hugo von Kilényi, who then owned the work, had it cleaned and the second Cupid in the centre emerged (Kilényi, 1906; Gronau, 1907, pp. 7, 12). The canvas is much repainted (Klesse, 1973, p. 131).

History: The earliest trace of this picture goes back to the collection of Bartolommeo della Nave, at the time of the sale to the Duke of Hamilton c. 1638: 'a Venus looking in a glass and Cupid, by Titian's brother p. 6×5' [i.e. 1·34×1·17 m.] (Waterhouse, 1952, p. 18, no. 139). A later inventory of the Duke of Hamilton, in 1649, reads as follows, 'Une Vénus aussi grande que le naturel qui se regarde dans un miroir tenu par un Cupidon' (Garas, 1967, p. 76, no. 17; *idem*, 1968, p. 190). The picture was purchased by Archduke Leopold Wilhelm, then in Brussels, and published by Teniers, 1660, no. 93 (Plate 215). The Vienna inventory of Leopold Wilhelm of 1659 lists it, no. 11, as 'said to be by Titian' ('man halt es seye von dem Titiano', Berger, 1883, p. LXXXVII).

The prints of the royal collections at the Stallburg, Vienna, in 1735 include it (Stampart and Prenner, 1735, pl. 8, as Titian). Vienna Inventory 1772, no. 453 [then Prince Auersperg?]; apparently taken to the royal palace at Buda in 1781 (Garas, 1969, pp. 91, 98).

The relatively little importance attached to this picture is reflected in the fact that it was sold in an auction at the royal palace of Ofen in 1856, no. 1130 (Garas, 1968, pp. 186–187); Lobasinszky Collection, Budapest, c. 1895; purchased by Hugo von Kilényi at the end of the nineteenth century (Kilényi, 1906); sold by Kilényi in 1917, no. 136 (Garas, *loc. cit.*); acquired by von Nemes, Budapest, in 1917 and sold 16–19 June 1931, no. 32; Buchenau Collection, Niendorf bei Lübeck (Poglayen-Neuwall, 1934, p. 360); Steinmeyer, Berlin, agent for Adolf Hitler, bought the

picture for Hitler's projected museum at Linz; Munich, Oberfinanzdirektion, deposit of Nazi possessions after World War II, 1945–1970; on loan from the Government of the German Federal Republic to the museum in Cologne since 1968 (the information about this item concerning Linz was kindly furnished by Dr. Rike Wankmüller of the Oberfinanzdirektion).

Bibliography: C. and C., 1877 (no mention); Kilényi, 1906 (then the owner of the picture who thought it an original. He reported that the second Cupid in the middle had been painted over); Waldmann, 1922, p. 174 (Titian); Berchen, 1924, pp. 113 (Titian); Mayer–Berchen, 1927, p. 197, colour plate (Titian); Poglayen-Neuwall, 1929, pp. 171–172, 197; *idem,* 1934, pp. 360–364, 383 (workshop of Titian; detailed account); Suida, 1935, pp. 119, 176 (Titian); Tietze, 1936 (omitted); Wulff, 1941, pp. 196–197 (Titian and assistant; the Washington picture a replica!); Berenson, 1957 (omitted); Valcanover, 1960, p. 39, under pl. 62 (not autograph); Pallucchini, 1969, p. 302 (replica of the Washington picture); Cologne, 1973, pp. 130–135 (extensive account and bibliography).

COPIES:
Copies after Cat. no. 52 when in the possession of Archduke Leopold Wilhelm. At this time the centre Cupid had been painted over while the Cupid at the right looks toward the mirror (reversed in the print).
1. Dresden, Gemäldegalerie; canvas, 1·15×1·00 m. (Posse, 1929, p. 91, no. 178), in storage in 1973; another different version, 1·31×0·953 m. (Posse, no. 179), not seen in 1973.
2. Magdeburg, Gemäldegalerie; panel, 0·215×0·165 m.; by David Teniers II; probably a model for the *Theatrum pictorium* (Poglayen-Neuwall, 1934, p. 383).
3. Munich, Consul O. Heilmann-Schwaneck (in 1934); panel, 0·23×0·17 m.; by David Teniers II, perhaps from the Duke of Marlborough's Collection at Blenheim, sale 24 July 1886, no. 120 (Poglayen-Neuwall, 1934, p. 383, fig. 14).

53. **Venus at Her Toilet with One Cupid** Plate 131
Canvas. 1·17×0·89 m.
Stockholm, Karl and Dagmar Bergsten (Queen Christina and Orléans version).
Workshop of Titian.
About 1555.

The Cupid looks into the mirror and is in this way related to the example that belonged to Archduke Leopold Wilhelm, at the time the central Cupid was painted over (Plate 215). An unusual detail in the Stockholm version is Cupid's bow, which the goddess holds in her right hand upon her lap. By general agreement the Stockholm *Venus* is considered a workshop production, despite its provenance from such celebrated collections as those of Emperor Rudolf II, Queen Christina, and the Duke of Orléans.

Condition: No technical report on Cat. no. 53 is available. The complex history of this picture alone leaves little doubt that it has been restored and relined more than once.

Wrong History: The Granvelle Collection at Besançon in 1607 contained a picture of this subject: 'peinture d'une femme avec un Cupido tenant un miroir' (Castan, 1867, p. 118, no. 94), 4 *pieds* 2 *polces*×3 *pieds* 9 *polces,* i.e. 1·35×1·22 m.

Certain History: Collection of Rudolf II at Prague, Inventory 1598 and 6 December 1621, no. 1037: 'Ein nackend Weib in einem Spiegel von Tizian' [*sic*] (Zimmermann, 1905, p. 105); carried off by the Swedes in the sack of Prague in 1648, no. 292 (Stockholm, 1966, pp. 483–484); Queen Christina's Inventory of 1652, nos. 91 or 154 (two items), at Stockholm (Geffroy, 1855, p. 171): 'Cupid with a mirror and a Nude Woman'; Christina's Inventory at Antwerp, 1656 (Denucé, p. 178); Christina's Inventory of the Palazzo Riario, Rome, in 1662, no. 21: 'Donna che si specchia ignuda...e un Amorino che gli tiene lo Specchio...alta palmi cinque e tre quarti e larga palma cinque' (1·28×1·12 m.); Inventory at Queen Christina's death in Rome in 1689 (Campori, 1870, p. 342, described in detail; also Granberg 1896 and 1897); bequeathed by Christina to Cardinal Decio Azzolino, Rome, 1689; inherited by Marchese Pompeo Azzolino, Rome, 1689; 'Nota dei quadri della Regina Christina di Svezia', c. 1689–1692, folio 2, no. 45: 'Famoso quadro della Venere ignuda...tiene l'arco di Cupido, vi fa tenere da Cupido in piedi ignudo sopra letto lo specchio'; Prince Livio Odescalchi, purchased the collection in 1692, folio 466v, no. 28: 'Donna ignuda che si specchia'; Inventory at the death of Prince Livio Odescalchi, 1713, folio 81, no. 163: 'Venere che si specchia con Cupido di Tiziano', and four copies, folio 45, nos. 113, 114, folio 45v, no. 118, folio 50, no. 167; sale by Baltassare Odescalchi to the Duke of Orléans, 2 September 1721; Orléans Collection, Paris (Dubois de Saint Gelais, 1727, pp. 474–475; Couché, 1786–1788, pl. IX); Orléans sale to England, 1792–1798; purchased by the Earl of Darnley in 1798, no. 9, for 300 guineas (Buchanan, 1824, I, p. 113); Darnley sale, Cobham Hall (London, Christie's, 1 May 1925, no. 81); purchased by Karl Bergsten, Stockholm.

Bibliography: Hume, 1829, p. 96; Waagen, 1854, III, p. 19 (then at Cobham Hall; the condition of the picture forestalled any judgment); C. and C., 1877, II, p. 336 (copy of the Dresden picture; see Cat. no. 52, copy 1); Sirén, 1933, pp.

153–154, pl. 101 (Titian); Poglayen-Neuwall, 1929, pp. 182–183; *idem*, 1934, pp. 359–360, 363, fig. 11 (school piece); Tietze, 1936 (omitted); Wulff, 1941, p. 194 (good workshop); Asplund, 1943, p. 2; Berenson, 1957 (omitted); Valcanover, 1960, II, p. 40 (workshop); Stockholm, 1966, pp. 483–484 (workshop); Pallucchini, 1969 (omitted).

COPY:

Wiesbaden, Staatliche Museum; canvas, 1·21 ×1·075 m.; on loan from the Staatliche Museen, Berlin. The Cupid looks inward and Venus holds a bow on her lap. *History:* Giustiniani Collection, Rome, Inventory 1638 (Salerno, 1960, p. 136, no. 21; Paris sale, Delaroche, 1812, p. 35, no. 37; Landon, 1812, p. 95, fig. 44). *Bibliography:* Bode and Meyer, 1878, p. 403, no. 189 (copy); *idem*, 1883, p. 477; edition 1886, p. 190 (on loan to the Städtische Museum at Stettin from 1884); Kühnel-Kunze, 1931, p. 647; Poglayen-Neuwall, 1934, pp. 363, 383, no. 5 (copy); Wulff, 1941, pp. 193–194 (Titian and assistant); Schmidt, 1967, under Titian, unpaged, illustrated, cat. no. 385 (workshop of Titian).

LITERARY REFERENCES:

1. Rome, Palazzo Falconieri, Collection of Prince Pio, *Venus at Her Toilet* ('una Venere che si specchia . . . di Tiziano'), reported by Venuti, 1745, I, p. 313; *idem*, 1766, p. 230. No further data are available as to the details of the composition.
2. Rome, Prince Livio Odescalchi. Four copies of this picture are recorded in the Inventory of Prince Livio Odescalchi, Rome, in 1713, folio 45, nos. 113, 114; folio 45v, no. 118; and folio 50, no. 167.

54. **Venus of Urbino** Plates 72, 73

Canvas. 1·195 ×1·65 m.
Florence, Uffizi.
Documented 1538.

A consideration of the style of the *Venus of Urbino* and its relationship to the *Sleeping Venus* at Dresden, as well as later interpretations of the subject by Titian, are reserved for the text. Thausing's speculations (1878, pp. 262–269) that the Duchess of Urbino, Eleanora Gonzaga della Rovere, was the model for the *Venus of Urbino* and also for *La Bella* (Wethey, II, 1971, pp. 23, 81–82, Plate 71) have long ago been laid to rest by scholars. Yet Berenson as late as 1906 thought that the head was a portrait of the duchess. A casual comparison of the prim, tight-lipped lady in her portrait at the Uffizi (Wethey, II, 1971, Plates 69, 70) shows how unacceptable such an idea was. In the case of the *Girl in a Fur Coat* (Wethey, II, 1971, pp. 23, 106, Plate 73), the

same model may have served for her and the *Venus*. Gronau long ago (*Titian*, 1904, pp. 95–96, 290) pointed out that the Urbino documents are quite clear in their references to these pictures as 'la nuda' (*Venus*) and 'a lady in a blue dress' (*La Bella*).

The interpretation of the *Venus* as symbolizing marital love and fidelity is doubtless nearer to the truth than the Victorian tradition, still maintained by Tietze and later writers, that she is merely a hymn to voluptuous carnality and that the model was a Venetian courtesan. Theodore Reff (1963, pp. 359–366) points out that, according to Leone Ebreo, roses (held in her right hand) are assigned to Venus for their beauty and sweet scent, and that the myrtle in the flower pot upon the window sill also refers to Venus, because the plant is sweetly scented and 'like love it is ever blooming.' The dog at the goddess's feet, a well-known symbol of fidelity, when placed at the feet of a female effigy in mediaeval and Renaissance tombs, may also mean luxury, but it should be stressed that Titian appears to have been fond of dogs. He included one in the portrait of *Eleanora Gonzaga della Rovere, Duchess of Urbino* (Wethey, II, 1971, Plate 70), where a symbolic intention would be difficult to argue.

To interpret the maidservants, who seek the goddess's garments in the chest in the background, as the Horae who clothe Venus after her birth and conduct her to the assembly of the Gods (Reff) appears slightly extravagant. Surely no hint of the Birth of Venus lingers in this picture and that interpretation would not be appropriate to the goddess as the Divinity of Marital Love.

If the picture was painted to commemorate a wedding, it must be, as Reff cautiously points out, that of Guidobaldo II della Rovere, who was married in 1534 to the ten-year-old Giulia Varano.

Condition: Although a fine crackle covers the entire surface of the paint, the colour is fresher and lighter than in many pictures of the Cinquecento. The green curtain has darkened with time more noticeably than other parts of the composition.

History: In letters of 9 March 1538 and 1 May 1538 Guidobaldo II della Rovere, Duke of Camerino and shortly after of Urbino, urged his agent Leonardi at Venice to obtain the picture from Titian which he called 'la donna nuda' (the nude lady) (documents published by Gronau, 1904, Beiheft, pp. 6, 10, 19, documents XXXI and XXXIII). The *Venus* was at one time in the Villa Poggio Imperiale near Pesaro but mostly in the Ducal Palace in Urbino; seen by Vasari at Urbino in 1548 (Gronau, 1904, p. 10); in 1631 it was brought to Florence by Vittoria della Rovere on her engagement to Ferdinando II dei Medici (Gotti, 1872, pp. 102–103, 333, no. 7).

Bibliography: See also above; Vasari (1568)–Milanesi, VII, 443–444; Ridolfi (1648)–Hadeln, I, pp. 174, 197 (incorrectly stated that the *Venus of Urbino* was painted for Francesco Maria I della Rovere, rather than for Guidobaldo II; likewise Vasari); C. and C., 1877, I, pp. 389–391; Gronau, *Titian*, 1904, pp. 95–96, 290 (not a portrait of the Duchess); Berenson, 1906, p. 141 (the head a portrait of the Duchess Eleanora Gonzaga della Rovere); Florence, Uffizi, 1926, p. 86, no. 1437; *Mostra di Tiziano*, 1935, p. 75; Suida, 1935, pp. 72–73, 166 (emphasizes the relationship to the Dresden *Sleeping Venus*); Tietze, 1936, II, p. 290; Berenson, 1957, p. 186 (Titian, 1538); Valcanover, 1960, I, pl. 155; Reff, 1963, pp. 359–366 (symbolism); Pallucchini, 1969, pp. 271–272 (Titian, 1538); Panofsky, 1969, p. 21.

COPIES:

1. Baltimore, Walters Art Gallery; copy by Ingres, signed and dated 1822; canvas, 1·158×1·79 m. (Randall, 1965, pp. 366–369).
2. Ecija (Sevilla), Ayuntamiento; canvas, 0·97×1·59 m.; Spanish copy with drapery added (Hernández Díaz and others, 1951, p. 251, fig. 679).
3. Florence, Uffizi; copy in storage (C. and C., 1877, I, p. 391, copy).
4. Hampton Court; copies in storage in 1964; no. 569, canvas, 1·093×1·66 m.; no. 1108, canvas, 1·11×1·645 m.; mediocre copies and very dirty.
5. London, Butler Johnstone Collection (formerly); previously Munro Collection (Waagen, 1854, II, p. 133, an original by Titian; C. and C., 1877, I, p. 391, copy).
6. Nantes, Musée des Beaux-Arts; canvas, 1·15×1·64 m.; acquired in 1849 (Nantes, 1913, p. 76, no. 173, old copy).
7. Paris, Mme. Ernest Rouart; sketch copy by Edouard Manet, *c.* 1853–1856 (Reff, 1964, p. 119).

VARIANT:

1. Amsterdam, Rijksmuseum: 'Venus from the Villa Borghese', canvas, 1·116×1·86 m. By Lambert Sustris, *c.* 1550. The pose of the Venus awake is suggested by the *Venus of Urbino*, while roses are scattered upon the bed in this case. The background reveals an attendant playing a spinet in addition to the two women at the *cassone*. Buchanan (1824, I, p. 123) claimed that he paid £1500 for this item, which he said that he had bought from the Villa Borghese. Hume (1829, pp. 67–68) described it with great enthusiasm as representing Titian's 'finest manner'. Buchanan sold it to Mr. Willett, from whom it passed to Mr. Neeld before 1829. Neeld sale, 10 July 1945, £115, 10s. (*APC*, XXIII, no. 3644, as Titian); Tomás Harris, London, sold it to Amsterdam in 1946.
Bibliography: Waagen, 1854, II, p. 244 (Titian and assistant); Berenson, 1957, p. 167, pl. 1242 (Sustris); Amsterdam, 1961,

p. 296, no. 2279 (Sustris); Ballarin, 1962, p. 63 (Sustris); *idem*, 1962–1963, p. 364 (Sustris).
2. Rome, Villa Borghese (storage); canvas, 1·18×1·80 m.; copy made *c.* 1820 to replace the original bought by Buchanan (no. 1, just above); illustrated by Wilde, 1934, pp. 170–171. Attributed by Longhi (1928, p. 181, edition 1967, p. 335, note 50) to Marco Libero (1640–1725), but with the reservation that it had a modern look. Pergola (1955, p. 138, no. 248), without knowledge of Buchanan's purchase, published the copy as an original by Sustris.

DRAWING:

A drawing, 276×400 mm., after the variant from the Villa Borghese, is in the Fogg Museum at Harvard (Mongan and Sachs, 1940, p. 100, no. 190).

LITERARY REFERENCES:

1. La Granja, Palace of San Ildefonso (Spain); Collection of Elizabeth Farnese; Inventory of La Granja, 1746, no. 666: a copy, called an original: '. . . de mano del Ticiano una Venus en la cama en la mano derecha un ramillete de rosas y a los lejos una muger y una niña sacando ropa de una arca de quatro pies y dos dedos de alto seis meno quarto de ancho.'
2. London, Collection of Charles I; miniature (6×9 inches) by Peter Oliver: 'done by Peter Oliver after Titian . . . lying alonge a naked woeman on her backe—whereby in the Chamber a farr of in a little a—waiteing woeman kneeleing to reach some thinge out of a Chest and another waiteing woeman comeing after bringing a long a piller, whereof my Lord Chamblaine hath the Princpall in oyle Cullors the lim'd peece being dated 1638' (van der Doort, 1639, Millar edition, 1960, p. 105).

55. **Wisdom (Sapienza)** Plates 162, 163
Canvas. 1·77×1·77 (octagon).
Venice, Library of St. Mark's, Vestibule.
About 1560–1562.

The *quadratura* enframement (architectural illusionism) for Titian's *Wisdom* was carried out by Cristoforo Rosa in 1559–1560, and the evaluation of the work set by Titian and Jacopo Sansovino in April 1560. It is assumed that immediately thereafter Titian accepted the contract for his painting, but no document survives in this connection (Schulz, 1961, pp. 95–96). The subject was called *History* by Ridolfi (1648)–Hadeln, I, p. 202), the first writer to make reference to the picture or to attribute it to Titian. The title *Wisdom (Sapienza)* is generally accepted today, primarily because that subject appears suitable for the location at the entrance to the Library. According to Ripa (edition 1618, p. 455) Sapienza should hold a flaming lamp in the right hand and a book in the left. It has recently been suggested

that she may be holding a mirror as in Bocchi's *Symbolicarum* of 1555 (Ivanof, 1968, p. 65), here supported by a putto.

Condition: In the photograph the surface of the painting appears to have been rubbed during a restoration at an unknown date. The heavy white highlights may have been retouched, although Titian certainly exaggerated them because of the high position of the canvas above the spectator. The picture was lowered for examination in July 1974.

Bibliography: Ridolfi (1648)–Hadeln, I, p. 202 (called *History*); Boschini, 1664, sestiere di S. Marco, p. 67 ('Una donnina con un breve in mano . . . di Tiziano'); Moschini, 1815, II, p. 490 (*Sapienza*, i.e. *Wisdom*, by Titian); C. and C., 1877, II, pp. 294–296 (praised and dated 1559); *Mostra di Tiziano*, 1935, no. 83 (*c.* 1560); Suida, 1935, pp. 125, 182 (*History, c.* 1560); Norris, 1935, p. 128 (*c.* 1560); Tietze, 1936, II, p. 310; *idem*, 1950, p. 394 (workshop of Titian, 1559); Berenson, 1957, p. 191 (*Wisdom*; late Titian); Valcanover, 1960, II, pls. 80–81 (after 1559); Schulz, 1968, pp. 95–96 (thorough account, datable 1560–1562); Pallucchini, 1969, p. 311, figs. 454, 455 (after 1560).

Worship of Venus, see Cat. no. 13.

APPENDIX

SCHOOL PIECES, DOUBTFUL AND WRONG ATTRIBUTIONS

The Appendix includes paintings sometimes attributed to Titian, but which in the author's opinion are occasionally Giorgionesque works, as well as many pictures by followers and imitators.

X–1. **Adonis**

Canvas. 0·985 × 0·686 m.

New York, Metropolitan Museum of Art (in storage?).

Venetian School.

Early seventeenth century.

This figure, in three-quarter length, is an early Baroque imitation loosely based on Titian's Adonis.

Bibliography: Mason Perkins, 1920–1921, pp. 223–226 (Titian); Detroit, 1928, no. 11, illustrated (Titian); George Blumenthal, New York; gift to the Metropolitan Museum of Art, New York in 1941, Inventory no. 41,100.11 (Allen and Gardner, 1954, p. 96).

X–2. **Adonis, Birth of** Plate 10
Polydorus, Death of

Panel. Each 0·35 × 1·62 m.

Padua, Museo Civico.

Giorgionesque painter.

About 1505–1510.

The backgrounds of the two *cassone* panels consist of a flat, unmodulated blue, rather vivid but without any suggestion of space or atmosphere. The figures are sketchily painted in a technique difficult to associate with the great masters, Giorgione and Titian, with whom they are frequently associated. The best figure, that of a youth with halberd, must be the one who has just chopped off Polydorus' head. The animation of the executioner is achieved by fluttering black ribbons; while today he looks to us highly picturesque and rather elegant in his yellow hose, black jerkin, and a rose-coloured hat. The various attributions, listed in the bibliography, show a trend on the part of Italian critics to favour Titian as the painter, but there is little stylistic evidence to support that position.

Iconography: The panel of the *Birth of Adonis* is clearly based on the account given in Ovid's *Metamorphoses*, x, 298–518. Myrrha, daughter of Cinyras, developed an incestuous passion for her father. Through the intrigues of the girl's nursemaid she was brought to his bed, while he, in a drunken state, was unaware of her identity. Thus the fair Adonis was conceived. The pair of lovers lying in the landscape at the extreme left must be Myrrha and Cinyras. The rabbit and the buck and hind lying near the centre of the panel refer to the reproductive forces of nature. To the right three women and a man pull the baby Adonis from a tree, in which a small head is all that is left of Myrrha. Herein the metamorphosis lies, for Myrrha in her disgrace had fled to the 'Sabean land', where she was transformed into a tree, just prior to the birth of her son.

The seated, fully clothed girl at the right may be Venus, for she is about to place a wreath of flowers on her own head, and she holds another in her lap. In Ovid's *Metamorphoses* the meeting of Venus and Adonis follows immediately after the account of his birth. For Ovid's and Titian's versions of their love affair see Cat. no. 40.

The *Death of Polydorus*, which is less clearly told in the Padua panel, also derives from Ovid's *Metamorphoses* (XIII, 525–575). Polydorus, son of Priam and Hecuba, who were king and queen of Troy at the time of its destruction, was sent to Polymestor, the king of Thrace, to hide the Trojan gold for safe-keeping. Polymestor with his lust for the treasure had the youth murdered. The decapitated Polydorus and the assassins appear at the right. The naked aged woman at the left would be the elderly mother, Hecuba, who gained her revenge by tearing out Polymestor's eyes, after which she was transformed into a bitch. The sad, dreamy girl seated near her may represent a captive Trojan woman (women in Ovid) who helped Hecuba carry out the deed.

Condition: Both panels are badly preserved and have suffered from incompetent cleaning and scrubbing in the past.

History: Ridolfi (1648–Hadeln, I, p. 99) records three pictures by Giorgione in Casa Vidmani (Widman) in Venice, which he describes as the *Birth of Adonis*, the *Embrace of Venus*, and the *Death of Adonis*. It would be convenient to believe that the *cassone* panels now in Padua are the very same, but the subjects do not really correspond; bequest of Conte Leonardo Emo Capodilista in 1864 to the Museo Civico.

Bibliography: A. Venturi, 1893, p. 412 (Giorgione); Cook, 1900, p. 56 (Giorgione); L. Venturi, 1913, p. 207 (Romanino); Schubring, 1915 or 1923, p. 415, nos. 877, 878, pl. 184 (Giorgione); A. Venturi, 1928, pp. 813–814 (Romanino); Berenson, 1932, p. 81 (Romanino); Richter, 1937, p. 231 (follower of Giorgione); Morassi, 1942, p. 182 (early Titian); Pallucchini, 1946, p. 125 (Cariani); Morassi, 1954, p. 191 (early Titian); Berenson, 1957, p. 86 (Giorgionesque furniture painter); Grossato, 1957, pp. 172–173 (Titian?); Valcanover, 1960, pls. 4–7 (early Titian); Panofsky, 1969, p. 140, note 3 (doubtful attribution to Titian); Pignatti, 1969, p. 128 (Master of the Phillips Astrologer); Pallucchini, 1969, pp. 231–232, pls. 4–7 (Titian, *c.* 1506–1508); Freedberg, 1971, p. 477, note 40 (early Titian).

X–3. **Allegory of Venus and Cupid**

Canvas. 1·299×1·55 m.

Chicago, Art Institute.

Damiano Mazza or Lambert Sustris.

About 1565.

The attribution of this rather facile combination of elements from Titian's *Cupid Blindfolded* and the so-called *Allegory of the Marchese del Vasto* (Plates 68–71, 155, 156) has puzzled nearly all critics. A later variant, in Munich (Plate 186), is very close to Varotari, il Padovanino, who probably passed it off as an original by Titian. Tietze-Conrat (1945, pp. 269–271) assigned the Chicago picture to Damiano Mazza but retouched by Sir Joshua Reynolds. She also called attention to two pictures with similar subjects in the Donati Collection at Santa Maria Formosa in Venice, which Ridolfi (1648–Hadeln, I, pp. 223–224) described as compositions by Mazza containing Deities, Cupids, Satyrs with baskets of fruit, doves, and flowers. It is apparent then that Damiano Mazza did paint works of related themes. Consequently on a literary basis Mazza as author is a reasonable supposition. Recently, however, the Art Institute has added the name of Lambert Sustris, an attribution supported by Alessandro Ballarin, the major authority on this Dutch follower of Titian.

Tietze-Conrat's idea that the Chicago picture may in some way reflect Titian's lost composition listed in Mary of Hungary's Inventory (Cat. no. L–23) is less convincing, since Cupid is said to be 'behind' Venus in that work.

History: Wemyss Collection, Gosford House, exhibited in the British Institution, London, in 1835 and 1858 (Graves, 1914, pp. 1318, 1319); Wildenstein Gallery, Paris, 1930; Baron Thyssen, Lugano; Wildenstein Gallery, New York; Mr. and Mrs. Charles H. Worcester, Chicago, 1936–1943; gift to the Art Institute in 1943 (Sweet, 1943, p. 66).

Bibliography: See also above; C. and C., 1877, II, p. 468 (then in the Wemyss Collection, 'very modern'); Valentiner, 1930, I, no. 25 (Titian); Tietze-Conrat, 1945, pp. 269–270 (major study; attributed to Damiano Mazza); L. Venturi, 1932, pp. 484–487 (Titian); Panofsky, 1939, p. 165, note 127 (a *pasticcio* by a 'mediocre imitator'); Sweet, 1943, pp. 66–68 (Titian); Berenson, 1957, p. 184 (partly by Titian; the subject the *Reconciliation of Venus and Psyche*); Valcanover, 1960, II, p. 70 (follower of Titian); Chicago, 1961, p. 307 (Damiano Mazza); Ballarin, 1962, pp. 76–77; *idem*, 1962–1963, p. 364 (Lambert Sustris, *c.* 1565); *idem*, 1965, p. 71 (Sustris); Pallucchini, 1969, p. 265 (perhaps by Sustris).

X–4. **Apollo and Daphne** Plate 12

Panel. 0·64×1·30 m.

Venice, Seminario Patriarcale.

Giorgionesque Painter.

About 1512.

Attribution, style, and iconography have been discussed in the text.

Condition: Restored in 1955, but still scrubbed and heavily varnished.

History: Formerly in the Manfredini collection at Venice.

Bibliography: Ridolfi (1648)–Hadeln, I, p. 98 (Giorgione); C. and C., 1871, II, p. 165 (probably Schiavone); Morelli, 1880, p. 162 (Giorgione); A. Venturi, 1893, p. 412 (Giorgione); Cook, 1900, pp. 34–35 (Giorgione); L. Venturi, 1913, p. 273 (Schiavone); Fröhlich-Bum, 1913, p. 215 (neither Schiavone nor Titian); Schubring, 1915, p. 415, no. 879, pl. 184 (Giorgione?); Richter, 1937, p. 249 (possibly Domenico Mancini); Morassi, 1942, p. 181 (follower of Giorgione); Pallucchini, 1946, p. 131, no. 227 (Paris Bordone); Tietze and Tietze-Conrat, 1949, p. 94 (Giulio Campagnola); Zampetti, 1955, p. 168 (follower of Titian); Berenson, 1957, p. 84 (in part Giorgione); Canova, 1964, p. 114 (Paris Bordone); *idem*, 1968, p. 172, figs. 1–2 (Paris Bordone); Pignatti, 1969, p. 136, no. A57, pl. 176 (Paris Bordone?); Freedberg, 1971, p. 496, note 40 (Paris Bordone).

X–5. **Cupid Blindfolded** Plates 156, 160

Canvas. 1·224×0·973 m.

Washington, National Gallery of Art, Samuel H. Kress Collection.

Follower of Titian (Lambert Sustris?).

About 1570.

The poses of Venus and both Cupids are directly based upon the left side of Titian's *Cupid Blindfolded* in the Villa Borghese (Plates 155, 159). See further in the text.

Condition: The arm of a woman holding a tray is partially visible at the upper right. This detail, formerly painted over in blue, proves that the composition was originally much larger. 'The flesh tones are slightly abraded except for the face of Venus; . . . cleaned in 1948' (Shapley, 1968, p. 188).

History: Baroness Kenloss, Scotland; Miss Mary G. Close-Smith, Baycott Manor, Buckinghamshire; Contini-Bonacossi Collection, Florence; purchased by Kress in 1950 (Shapley, 1968, p. 188).

Bibliography: Rich, *Worcester Catalogue*, 1938, frontispiece (Damiano Mazza); Suida, 1951, p. 116 (Titian); *idem*, 1952, pp. 36–38 (Titian, *c.* 1555; earlier than the *Education of Cupid* in the Villa Borghese); Pergola, 1955, p. 132 (Titian; derived from the Villa Borghese picture); Berenson, 1957 (omitted); Valcanover, 1960, II, p. 71, pl. 176 (doubtful attribution); Chicago, 1961, p. 307 (Damiano Mazza); Shapley, 1968, pp. 188–189 (follower of Titian); Pallucchini, 1969, p. 310, figs. 452, 453, colour plate LI (Titian, *c.* 1560–1562).

X–6. Cupid Holding a Dove

Canvas. 0·35 ×0·49 m.

London, National Gallery.

Copy.

Sixteenth or seventeenth century.

This copy of a detail, with the wings omitted, from Titian's *Venus and Adonis* of the Farnese type (Plate 95) was formerly attributed to Varotari il Padovanino for no good reason.

Bibliography: Suida, 1932, p. 165 (Padovanino); Gould, 1959, pp. 123–124, no. 933 (copy after Titian).

Another version: Lucerne, private collection; canvas, 0·345× 0·507 m.; Suida, 1932 and 1935, pp. 72, 174, pl. 210 (Titian).

X–7. Cupid in a Loggia Plate 179

Canvas. 0·76 ×0·74 m.

Vienna, Akademie der Bildenden Künste.

Venetian School.

About 1520.

In this fragment a Cupid is seated upon a wall against a brownish landscape, which closely repeats Titian's background in Giorgione's *Sleeping Venus* at Dresden (Plates 6,

9). Since a small section of the nude leg is visible at the lower left, the whole composition may have been similar to Giorgione's, except that the goddess appears to have been lying upon a couch rather than in the open air upon the ground. The X-rays of the Dresden picture, although difficult to interpret, leave some doubt that the Cupid at the feet of Venus was exactly like Cat. no. X–7. The Giorgione Cupid, now painted over, is interpreted by Posse (1931, pp. 29–31) as seated, holding a bow and arrow. This hypothetical reconstruction still leaves the question unresolved as to the exact pose of the Dresden Cupid. Even though the quality is superior, the fragmentary condition of the *Cupid in a Loggia* as well as the extensive retouching make an attribution to Titian, or any other known master, hazardous.

Condition: Much restored (Eigenberger, 1927, p. 410).

History: Lambert bequest in 1821.

Bibliography: C. and C., 1877, II, p. 457 (doubtful attribution); Ricketts, 1910, p. 176 (early Titian; damaged); Hetzer, 1920, p. 140 (follower of Veronese); Fischel, 1924, p. 269 (doubtful attribution); Eigenberger, 1927, pp. 410–411, no. 466 (possibly by Titian's workshop); Gamba, IX, 1928, pp. 205–209 (as copied from the *Sleeping Venus* in Dresden (Cat. no. 38)); Venturi, 1928, p. 246 (Titian); Berenson, 1932, p. 576, and 1957, p. 192 (copy of Giorgione's *Sleeping Venus* in Dresden); Suida, 1935, p. 73 (early Titian, fragment); Tietze, 1936 (omitted); Oettinger, 1944, pp. 113–125 (Titian; repeating the Cupid of the Dresden *Venus*); Baldass, 1957, pp. 131–133 (Titian); Valcanover, 1960 (omitted); *idem*, 1969, no. 625 (wrong attribution); Pallucchini, 1969 (omitted).

COPY:

Italy, Private Collection (Richter, 1933, p. 218, pl. II D).

X–8. Cupid with Tambourine Plate 181

Canvas. 0·517 ×0·51 m.

Vienna, Kunsthistorisches Museum.

Venetian School (Francesco Vecellio?).

About 1530.

This much restored picture is a charming work with an unmistakably Titianesque character. Although frequently regarded as by Titian's own hand in the past, few critics accept it as such today. Since Francesco Vecellio included virtually the same figure in the altarpiece at Domegge (see below), an attribution to him would be reasonable.

Condition: Teniers' print shows a taller picture; considerably retouched.

History: Archduke Leopold Wilhelm, Inventory 1659, no. 241.

Bibliography: Teniers, 1660, pl. 80 (Titian); Mechel, 1784, no. 57 (Titian); Engerth, 1884, p. 353, no. 502 (Titian); C. and C., 1877, II, p. 456 (doubtful attribution); Gronau, 1904, p. 277 (Titian, *c.* 1510); Ricketts, 1910, p. 175 (probably by Francesco Vecellio); Cook, 1912, pp. 89–91 (Titian; damaged); Venturi, 1928, p. 226 (Titian); Suida, 1932, pp. 164–166 (Titian); *idem,* 1935, pp. 28, 160 (Titian); Tietze, 1936 (omitted); Suida, 1952, p. 31 (Titian); Berenson, 1957 (omitted); Valcanover, 1960, I, p. 96 (not Titian); Klauner and Oberhammer, 1960 (omitted); Pallucchini, 1969 (omitted); Panofsky, 1969 (omitted); Benesch, 1971, pp. 130–132 (reprinted from 1957; as Lorenzo Lotto).

COPY:

Nice, O. Kosek; *Cupid with Tambourine in a Landscape* is a copy of the Vienna Cupid with a landscape added; canvas, 0·655 × 1·06 m. (Suida, 1952, pp. 31–32). The figure also puts in an appearance in Francesco Vecellio's altar in the church of S. Rocco at Domegge in the province of Belluno (Valcanover, 1951, p. 25).

LITERARY REFERENCE:

Rome, Doria-Pamphili Collection, Inventory, 1684, folio 370v, the same subject: 'Un angelo che sona il tamburo, mano di Titiano' (Doria-Pamphili archives; courtesy of Dr. Jörg Garms).

X–9. **Cupid with Wheel of Fortune** Plate 157
Canvas. 0·66 × 0·552 m.

Washington, National Gallery, Samuel H. Kress Collection.

Follower of Veronese.

About 1560.

A painting of great charm, in grisaille, it is attributed to Titian on comparison with the cherubs in the *Assumption* (1516–1518). Even so the style does not closely approximate Titian's, as Mrs. Shapley in her catalogue of the Kress Collection agrees. Berenson proposed Romanino orally, but he listed the picture as Titian's in his last edition, whereas the Tietzes were reminded of Giulio Campi's frescoes in San Sigismondo at Cremona.

The puzzling iconography raises another problem which has not yet been resolved. Edgar Wind (1958, p. 93) interpreted the theme as Cupid setting in motion the wheel of fortune, while the oxhead symbolizes his patience.

Condition: In general well preserved.

History: Viani Collection, Rome (in 1931); Contini-Bonacossi, Florence (1935); Kress Collection (1935).

Bibliography: Suida, 1931, pp. 895–898 (Titian); Suida, 1935, pp. 71, 160, pl. 56 (Titian, *c.* 1518); Berenson, 1957, p. 192 (Titian); Valcanover, 1960, I, p. 96 (not Titian); *idem,* 1969, no. 629 (not Titian); Shapley, 1968, p. 186, no. K 390 (full account; attributed to Titian); Pallucchini, 1969 (omitted).

X–10. **Danaë** Plate 201
Canvas. 1·206 × 1·696 m.

Chicago, Art Institute (on loan; property of the Barker Welfare Foundation).

Follower or workshop of Titian.

About 1570–1580.

Hadeln, who first published this picture in 1926, tried to make out a case for a date close to the Naples *Danaë* of 1545–1546 (Plate 81). Actually it is a variant of the Madrid original of 1554 (Plate 83) in the pose of the figure, including the placing of the right arm and hand, as well as in the presence of the sleeping puppy. The notable variation is the omission of the Cupid (Naples) and the nursemaid (Madrid and Vienna). The head of Jupiter emerges quite clearly in the clouds, a detail that occurs, but less conspicuously, at Vienna (Plate 82). The curtain, shaped like a canopy, is also derived from the same source.

The distant landscape at the right has no precedent in Titian's compositions of the subject. The trees and the distant mountains are comparable in a general way with the background of the *Magdalen* in Paolo Candiani's Collection at Busto Arsizio (Wethey, I, 1969, Plates 184, 186). Titian's own brushwork is freer, and his mountains have the characteristic deep ultramarine blue, not present in Cat. no. X–10. The golden rain descends in the shape of coins in Titian's autograph pictures of *Danaë* in Naples, Madrid, and Vienna (Plates 81–83). More literally drops of golden rain are represented in Cat. no. X–10 and in the early Baroque imitation in the Duke of Wellington's Collection (Cat. no. X–13, Plate 200).

Condition: Relined, old repaint removed, and subsequently inpainted at the Art Institute of Chicago over a period of two years (1971–1973). When seen in the laboratory of the museum after rehabilitation, the picture was in better condition than it could have been for about two hundred years. Ultraviolet light brought out very clearly the numerous losses on the body of the Danaë, which were especially severe in the face, the right breast (entirely rebuilt), the abdomen and the right leg. The poor original drawing of the right foot

was revealed both by ultraviolet light and by the X-ray. The curtain in the upper left corner has been considerably in-painted, while the landscape has suffered less than other parts of the canvas. On the whole, the photograph (Plate 201) makes a better impression than the original picture, in which the distortions of the face and its excessive redness are distressing.

I am indebted to the curator, David Farmer, and to members of the conservation department for their courtesy in allowing me full access to the material in the laboratory of the Art Institute in October 1973.

History: Unidentified early collector whose mark WEPLC and the number 27 were located on the back of the canvas (Nagler, v, p. 333); Earl of Chesterfield; Walter Richardson, London, 1921 (according to a note in the Berenson Library, I Tatti, Florence); Annesley Gore, London (Hadeln, 1926, p. 78); Mr. and Mrs. Howard Spaulding, Chicago, from 1927; the latter remarried as Mrs. Charles V. Hickox, New York, before 1940; her bequest to the Barker Welfare Foundation in 1970.

Bibliography: Hadeln, 1926, pp. 78, 83 (first publication; as Titian); Rich, 1928, pp. 62–63 (Titian); Detroit, 1928, fig. 13 (Titian); Panofsky, 1933, p. 211, note (late copy, workshop); New York World's Fair, 1940 (Titian, 1540–1550); Berenson, 1957, p. 189 (Hickox Collection; Titian); Valcanover, 1960, II, p. 65; *idem*, 1969, no. 277 (variant of the workshop); Pallucchini, 1969, pp. 139, 293, fig. 351 (Titian in great part, *c.* 1550–1552); Panofsky, 1969, p. 144, note 14 (workshop; wrongly confused with the Golovin picture, see Cat. no. 5, copy 4).

X–11. **Danaë** (alone)

Canvas. 1·36 × 1·845 m.

Location unknown.

Copy after Titian.

Mid-sixteenth century.

The figure is copied from the Naples version, including the drapery over the leg, but the Cupid is omitted.

Presumed History (according to Suida, 1935, p. 175): Gonzaga Castle at Novellara; acquired by François Raymond, agent of Napoleon's army in Italy, in 1796–1797; various un-specified owners in Paris; Princess Galitzine; exhibited at Madrid in the Academia de San Fernando in 1877.

Later History: Russian Corporation, New York, 1920 (?); Lucerne, dealer, 1935; Lucerne, Ernst Plancha, 1962.

Bibliography: Suida, 1934, pp. 72–75; *idem*, 1935, pp. 117–118, 175, pl. 211 (Titian).

X–12. **Danaë with Nursemaid** Plate 199

Canvas. 1·20 × 1·87 m.

Leningrad, Hermitage Museum.

Follower of Titian.

About 1560.

If Titian himself had any part in this picture, it would have been to retouch the body of Danaë, which is a repetition of the Prado original (Plate 83). The faulty drawing of the head and the ropy hair are unthinkable as the work of a master. The mediocrity of the figure of the nursemaid together with the over-precision and elaboration of the costume and the keys do not correspond to Titian style, nor does the coarse bedspread beneath the Danaë's left foot.

Condition: Generally in a good state of preservation.

History: Marquis de la Vrillière in 1633, when he published a poem about his picture; Sieur Thévenin, Paris; Sieur Bourvalais, Paris; Crozat Collection, Paris, catalogue 1755, no. 35 (Duvaux [1748–1758], edition 1873, I, p. CCCXV; Stuffmann, 1968, p. 76, no. 156); Catherine the Great purchased the Crozat Collection in 1772 (Lacroix, 1861, p. 254, no. 802; Somof, 1899, pp. 133–134).

The earlier proposal that this picture belonged to the Comte de Cantecroix of the Granvelle family is incorrect because that canvas was much smaller; see Cat. no. 7, Literary Reference 2).

Bibliography: See also above; *Titiani pictoris celeberrimi Danae*, Paris, 1633 (collection of poems dedicated to the picture); C. and C., 1877, II, p. 230 (Titian and workshop); Phillips, 1898, p. 78 (workshop); Somof, 1899, pp. 133–134 (with wrong dimensions; Titian); Gronau, *Titian*, 1904, p. 301 (Titian); L. Venturi, 1912, p. 146 (school replica); A. Venturi, 1928, p. 338 (workshop); Suida, 1935, p. 118 (of lesser quality); Tietze, 1936, II, p. 291 (workshop); Berenson, 1957, p. 186 (great part by Titian); Leningrad, 1958, I, p. 189, no. 121 (Titian); Valcanover, 1960, II, pl. 59 (Titian and workshop); Fomiciova, 1960, no. 37 (colour reproduction); *idem*, 1967, pp. 61–63 (Titian, *c.* 1545–1546; as close to the Naples version); Keller, 1969, p. 193 (replica of the Prado version); Pallucchini, 1969, pp. 140, 304, fig. 406 (Titian and workshop, *c.* 1555–1558).

PRINT:

By Louis Desplaces, when the painting was in the Crozat Collection; an original impression is in the Witt Library, Courtauld Institute, London.

X–13. Danaë with Nursemaid (variant) Plate 200
Canvas. 1·146×1·92 m.
London, Apsley House, Duke of Wellington.
Imitator of Titian.
Seventeenth century (About 1610).

The position of Danaë's body is closest to that of the Naples version (Plate 81), although here she has white drapery over her left instead of her right knee. The colour, on the whole, is superior to the draughtsmanship; the blue-and-rose covers placed upon the white sheets of the bed enhance the larger area of the handsome rose curtain. The old nursemaid at the right, catching the golden rain (no longer coins) in a cloth, varies greatly from the corresponding figure in the Prado *Danaë* (Plate 83) in every respect, i.e. physical type, drapery, and pose. There is no possibility that the Wellington *Danaë* issued from Titian's workshop. However beautiful the goddess and the painting of the flesh, the types of the figures are much later, *c.* 1610, and rather close in style to Varotari, il Padovanino (1588–1648).

Condition: Satisfactory. One wonders whether the pronounced highlights are retouchings by Velázquez, who purchased the work in Italy for Philip IV.

History: Purchased in Italy by Velázquez in 1629–1631, payment made to Velázquez in 1634 (Zarco del Valle, LV, 1870, p. 621); Buen Retiro Palace, Madrid, Inventory 1701, no. 787 (size 2⅓ *varas* square, i.e. 1·95 m.; one must assume that the height is erroneously given); Inventory 1789, no. 1274 (size given as 1⅓×2½ *varas*, i.e. 1·11×2·08 m.; since dimensions are always approximate, these correspond to the Wellington picture); 1793 sent to the R. Academia de San Fernando (Beroqui, 1946, pp. 139–140); the number 787 appears in the lower right corner of the picture; captured by the Duke of Wellington with the baggage of Joseph Bonaparte at the victory of Vitoria in 1813 and shipped to England; a letter from Fernán Núñez, on 29 November 1816, told Wellington to keep the treasure (Wellington, 1901, I, p. 198, no. 256).

Bibliography: See also above; Hume, 1829, p. 88; C. and C., 1877, II, p. 230 (copy by Mazo of the Leningrad *Danaë*); Phillips, 1898, p. 78 (atelier replica of Hermitage picture); Wellington, *loc. cit.*; Beroqui, 1946, pp. 138–140 (doubtful attribution, but certainly not Spanish).

WRONG ATTRIBUTIONS (various types):
1. Alexandria, J. Ducas Collection; canvas, 1·23×1·74 m.; composition in reverse copied from a print (photograph, Witt Library, Courtauld Institute, London).

2. Bologna, Umberto Pini; canvas, 0·70×0·42 m.; Bolognese, seventeenth century; no resemblance to Titian's composition or to his style (A. Venturi, XLI, 1938, pp. 191–192, fig. 4, Titian!).
3. Unknown location; head of *Danaë*, canvas, 0·3678× 0·28 m.; Coesvelt Collection, London, sale 1836, no. 58; later Lord Lansdowne, London (not in the sale at Christie's, 7 March 1930).

X–14. Death of Actaeon
Canvas. 1·245×1·83 m.
Raleigh (North Carolina), Museum of Art.
Agostino Carracci.
About 1600.

This handsome early Baroque composition is unrelated to Titian's work although it is believed to be the canvas attributed to him and sometimes to Giorgione in the following collections: (1) It appears to be the item once owned by Charles I of England containing twelve figures, as by Giorgione (van der Doort, 1639, Millar edition, 1960, p. 42); Waagen, 1854, II, p. 471, no. 3, 0·99×1·83 m.). (2) It was attributed to Titian, when in the collection of Benjamin West, London, 1·27×1·803 m., sale London, 19 June 1819, no. 82 and 24 June 1820, no. 77, bought in both times (Graves, 1921, III, p. 211). The West family finally sold it to Ronald Sutherland, Lord Gower, in 1898. The picture had been the subject of considerable controversy throughout the nineteenth century, an account of which is given by William T. Whitley in his book on English artists (Whitley, 1928, II, pp. 31–34). The Raleigh catalogue contains only the information that the *Death of Actaeon* formerly belonged to Lord Derwent.

Bibliography: See also above; Gower, 1902, pp. 332–333 (as Giorgione); Raleigh, 1956, p. 78, fig. 180 (as Agostino Carracci).

X–15. Diana with Hunting Dog
Canvas. 1·20×0·96 m.
Unknown location.
Bolognese School.
About 1600.

In a thoroughly unconvincing article Tancred Borenius attributed this picture to Titian on comparison with the portrait of *Lavinia with a Tray of Fruit* (Wethey, II, 1971, Plate 191) in Berlin. He suggested the influence of Bronzino and Parmigianino because of the Venetian artist's visit to Rome in 1545–1546. This item may be one of the early

Baroque forgeries purporting to be by Titian (see Wethey, I, 1969, pp. 3–4). A related composition, also wrongly given to Titian, belonged to the Archduke Leopold Wilhelm (Teniers, 1660, pl. 87).

History: A. S. Drey, Munich, in 1933.

Bibliography: Borenius, 1933, pp. 152–157 (Titian, *c.* 1550).

Education of Cupid, see:
 Cupid Blindfolded, Cat. nos. 4, X–5.

X–16. Ganymede, Rape of
Canvas. 1·77 × 1·866 m.
London, National Gallery.
Damiano Mazza.
About 1580.

Very little is known of this minor Venetian painter, whose career has been partially reconstructed by Hadeln (1913). The earliest mention of him is a payment for an altarpiece of SS. Felice and Fortunato in the parish church of Noale in 1573. Although Crowe and Cavalcaselle thought that the picture might have been designed by Titian and painted by Mazza, the composition does not seem Titianesque. The bold foreshortening of Ganymede and the highly decorative pattern created by the eagle's black wings against the rose drapery show closer affinities to Jacopo Tintoretto and Giuseppe Porta Salviati. Nevertheless, the picture is very impressive and in general of high quality.

Condition: Said to have been restored in Rome by Carlo Maratta (Ramdohr, 1787, II, p. 72); originally an octagon, but enlarged to form a rectangle; the condition is remarkably good; cleaned at the National Gallery, London, in 1955 (Gould, 1959, p. 55).

History: This picture is very probably the one that Ridolfi originally saw in the ceiling of a room in the Assonica Palace at Padua (Ridolfi, 1648–Hadeln, I, p. 224, writes in the past tense); the Assonica picture probably passed to the Salviati Collection, Florence or Rome; went by marriage in 1717 to the Colonna at Rome (Mariette, 1720, edition 1858, V, p. 321); Colonna Collection, Rome (Cunego's engraving of 1770 places it there, attributed to Titian); brought to England by Mr. Day in 1800, as from the Colonna Gallery (Buchanan, 1824, II, p. 4); Mr. Angerstein acquired it in 1801; purchased by the National Gallery, London, in 1824 (history reconstructed by Gould, 1959, pp. 55–56).

Bibliography: See also above; Buchanan, 1824, II, p. 4 (Titian, from the Colonna Palace); Waagen, 1854, I, p. 332 (admirable work by Titian); C. and C., 1877, II, p. 459 (perhaps designed by Titian and painted by Damiano Mazza); Hadeln, 1913, p. 252 (detailed report); *National Gallery, Illustrations, Italian School,* London, 1937, p. 358; Gould, 1959, pp. 55–56 (complete account, including the provenance and bibliography of the London version); London, 1973, illus., p. 453.

SECOND VERSION:
Kreuzlingen, Heinz Kisters; canvas, 0·68 × 0·68 m.; sold at Christie's, anonymous sale, 2 February 1961, no. 72, as by Tintoretto (*APC,* XXXVIII, 1960–1961, no. 2560, sold to Rothman); Dr. Hans Wendland, Paris; purchased from him by Herr Kisters in 1962.

 The existence of two versions of the *Ganymede* is confirmed by Mündler's notebook, which records that he saw at Padua in 1856 a replica of the picture in London (Gould, 1959, p. 56). Kisters believes that his version is the one engraved by Audran (*c.* 1666–1669) and that he owns a work by Titian *c.* 1550, which was copied by Damiano Mazza (letter from Kisters dated 11 July 1973).

DRAWING:
Windsor Castle; red and black chalk, octagon, 328 × 247 mm.; copy after X–16 (Popham and Wilde, 1949, no. 418).

X–17. Lady at Her Toilet Plate 183
Canvas. 0·915 × 0·82 m.
Washington, National Gallery of Art, Samuel H. Kress Collection.
Venetian School.
Sixteenth century.

This variant, in which the lady becomes a nude, is very far removed from Titian and from his original in the Louvre (Plate 31). In 1816 a controversy raged between Leopoldo Cicognara, who certified the work as an authentic Titian, and the Accademia di San Luca in Rome. In a letter signed by Giuseppe A. Guattani it was held quite correctly that this painting is a derivative composition by an unknown Venetian painter.
Both Cicognara and Ticozzi insisted that the lady was Laura Eustocchio or dei Dianti (Wethey, II, 1971, Cat. no. 24), mistress of Alfonso d'Este (Cicognara, 1816; Ticozzi, 1817, pp. 59–63). Following the same mood Hourticq, always with 'l'amour' in mind, made a claim for Federico Gonzaga (Wethey, II, 1971, Cat. no. 49) and his mistress Isabella Boschetti.

Condition: Only X-rays would reveal the extent of restoration.

History: Conti Benacosi, Ferrara (given as source in the Pourtalès-Gorgier sale; certainly from a Ferrarese collection); collection of Conte Leopoldo Cicognara, Ferrara (until 1815); sold to 'Lord Stuart', British ambassador to Vienna; because of the controversy over the attribution to Titian, Cicognara took the picture back (C. and C., 1877, I, p. 269, note); Cicognara later, *c.* 1821, resold it to Pourtalès Gorgier, Paris (sale Paris, 27–31 March 1865, p. 43, no. 118); Baron Michele Lazzaroni, Paris; Duveen, London; Henry Goldman, New York (Valentiner, 1922, no. 6); Kress Collection, New York (purchased 1937); gift to the National Gallery of Art.

Bibliography: Cicognara, 1816, engraving of the picture as frontispiece; Ticozzi, 1817, pp. 59–63 (Titian); Campori, 1874, p. 613 (copy); C. and C., 1877, I, p. 269, note (replica); Malamani, 1888, pp. 112–130 (account of the controversy); Gronau, *Titian*, 1904, p. 285 (replica); Justi, 1908, II, p. 169 (as having disappeared); Waldmann, 1922, p. 218 (variant by Titian); Valentiner, 1922, pp. 90–96 (Titian); Fischel, 1924, p. 33 (Titian); A. Venturi, 1928, p. 231 (Titian); Heinemann, 1928, p. 52 (follower of Titian); L. Venturi, 1933, pl. 508 (Titian); Suida, 1935, pp. 30, 167 (Titian); Tietze, 1936, II, p. 303; *idem*, 1950 (follower of Titian); Duveen, 1941, no. 154 (Titian); Longhi, *Viatico*, 1946, p. 65 (not Titian); Berenson, 1957, p. 192 (studio); Valcanover, 1960, I, p. 96 (studio of Titian); *idem*, 1969, no. 53 (workshop); Washington, 1965, p. 129, no. 370 (Titian); Shapley, 1968, pp. 189–190 (follower of Titian; an exhaustive account); Pallucchini, 1969, p. 246 (under the Paris version, as badly preserved).

X–18. Landscape with Endymion

Panel. 0·28 × 1·27 m.
Merion (Pennsylvania), Barnes Collection.
Follower of Titian.
About 1520.

The shape of this picture as well as the material (on panel) establishes it as coming from a *cassone*. Although a handsome work, it does not measure up to Titian himself.

History: Unknown.

Bibliography: Pallucchini, *Arte veneta*, 1950, p. 185 (Titian); Tietze-Conrat, 1955, p. 16 (studio of Titian); Berenson, 1957, p. 188, pl. 963 (Titian); Valcanover, 1960, I, pl. 91 (doubtful attribution); Meiss, 1966, pp. 353–354 (follower of Titian); Morassi, 1967, p. 134 (Titian); Pallucchini, 1969, pp. 9, 234, figs. 18, 19 (Titian, *c.* 1508–1510).

X–19. Landscape with Shepherd and Flocks

Canvas. 1·17 × 0·985 m.
Hampton Court Palace.
Copy by a follower of Titian.
Sixteenth century.

The landscape is so closely based upon Titian that Tietze thought that it might be a fragment of a larger picture. The fairly large size of the present item, if a fragment, would, however, imply a composition bigger than anything on record in Titian's period. Critics are virtually unanimous in agreeing that Cat. no. X–19 is technically inferior to Titian's own work.

Condition: Very darkened so as to be scarcely visible; probably damaged by repaint.

Bibliography: C. and C., 1877, II, p. 219 (mention only; then at Windsor Castle); Wickhoff, 1904, p. 116 (Domenico Campagnola); Fischel, 1907, p. 227 (school piece); Zimmerman, 1893, p. 127 (Domenico Campagnola); Frölich-Bum, 1913, p. 119 (A. Schiavone); Constable, 1929–1930, p. 750 (Cariani); Buscaroli, 1935, p. 173 (pupil of Titian, after the master's drawing); Suida, 1935, pp. 78, 166 (follower of Titian); Tietze, 1936, p. 292 (fragment of a large picture; indecisive as to authorship); Berenson, 1957, p. 186 (at Hampton Court; Titian); Valcanover, 1960, I, p. 100, pl. 213 (follower of Titian); Pallucchini, 1969, p. 267, fig. 211 (copy).

X–20. Landscape with Shepherd and Sheep

Panel. 0·42 × 0·66 m.
Milan, Private collection.
Imitator of Titian.
Early seventeenth century.

This Baroque forgery with its flat shapeless brushwork does not come close to Titian's style of painting. The Corot-like tree with its thin branches makes one wonder if it could be a modern imitation, yet Pietro della Vecchia might have achieved something as interesting as this pleasant but feeble landscape. The fleeing maiden in fluttering drapery, pursued by a satyr, indicates familiarity with the *Orpheus and Eurydice* at Bergamo (Plate 11), while the loosely formulated castle on the hill and the walled town in the distance are weakly related to similar views in drawings by the Giorgionesque–Titianesque school.

Bibliography: Zampetti, 1955, p. 134 (Palma il Vecchio); Pallucchini, 1969, p. 231, figs. 1, 2 (Titian, early).

X–21. **Landscape with Two Satyrs and a Nymph**

Panel. 0·37×0·775.

Milan, Private collection (art trade).

Imitator of Titian.

Early seventeenth century.

This badly composed picture appears to be a Baroque imitation. The two large urns, one upright and one fallen, are lifted from such Titian originals as the *Bacchus and Ariadne* (Plate 48) and *Venus and Adonis* (Plate 84). The dog comes from the *Pardo Venus* (Plate 74), while the trees, the distant mountains and buildings are superficial imitations of the master from Cadore. The satyrs and the nymph cannot even be described as Titianesque.

Bibliography: Morassi, 1954, p. 192 (Titian, early); Valcanover, 1960 (omitted); Pallucchini, 1969, p. 231, fig. 3 (Titian, 1506–1508!).

X–22. **Leda and the Swan**
Girl with a Baby and a Youth

Panel, each 0·12×0·19 m.

Padua, Museo Civico.

Giorgionesque painter.

About 1505–1510.

These tiny panels, approaching the quality of miniatures, must have been intended for a jewel box or a container for a lady's toilet articles. The extensive blue backgrounds in both imply an essentially decorative intention in their high degree of stylization. Although neither seems to suggest the hand of a great and highly original master, attributions have rotated around Giorgione and Titian. The pleasing but by no means extraordinary quality of the little pictures does not seem to me to merit such exalted names. Early classified as from the hand of an anonymous Giorgionesque painter by Gronau (1908), that still remains the best solution. The *Astrologer* (Pignatti, 1969, fig. 140) in the Phillips Memorial Gallery may be by the same painter.

Iconography: The visitation of Jupiter to Leda in the form of a swan is too familiar to merit comment.
The subject of the other panel, a seated youth and a seated girl holding a baby, bears some relation to the theme of Giorgione's *Tempesta*. Little attention has been paid to the subject of this little known work, which Schubring tentatively identified as *Jason and Hypsipyle* (Schubring, 1915,

p. 416). It involves Jason's amorous adventures on Lemnos (Ovid, *Heroides*, VI), which resulted in two babies.

Condition: Seemingly damaged (Grossato, 1957, p. 64).

History: Bequest of Conte Leonardo Emo Capodilista in 1864 to the Museo Civico at Padua.

Bibliography: See also above; Cook, 1900, p. 90 (Giorgione); Gronau, 1908, p. 506 (Giorgionesque); L. Venturi, 1913, p. 254 (anonymous Giorgionesque painter); Schubring, 1915 or 1923, p. 416, nos. 880–882, pl. 185 (school of Giorgione); Richter, 1937 (omitted); Morassi, 1942, p. 159 (Giorgione); Pallucchini, 1947, p. 32 (Giorgione?); Zampetti, 1955, p. 28 (Giorgione); Grossato, 1957, pp. 65–66 (Giorgione?); Berenson, 1957, p. 86 (Giorgionesque furniture painter); Pignatti, 1969, p. 128, nos. A40, A41, pls. 138, 139 (attributed to the Master of the Phillips *Astrologer*); Pallucchini, 1969 (omitted); Freedberg, 1971, p. 477, note 40 (Titian! he also gives the Phillips picture to Titian).

X–23. **The Lovers** (Three Figures)

Panel transferred to canvas. 0·74×0·635 m.

Hampton Court Palace (in storage).

Venetian School.

About 1525.

The man in a rose costume has his right hand inside the girl's green blouse as he fondles her breast. The onlooker, a youth dressed in black in the upper right corner, seems to be awaiting his turn. In the past this erotic item has been given to Giorgione or to Titian, for the latter of whom Lionel Cust argued seriously (1906, pp. 71–73; and 1916, p. 373). In the same article Herbert Cook preferred Paris Bordone (1916, pp. 73–79). None of these painters was capable of such sentimentality, bad taste, and poor painting, not even Paris Bordone, whose picture *The Lovers* in the Brera at Milan (Canova, 1964, p. 107 and fig. 22) is of far superior quality. Moreover, the motivation is rather different, for the Lovers hold a rosary in their two hands in the foreground. The second man's presence is difficult to explain except for compositional reasons.

Condition: Panel transferred to canvas; in very bad condition.

History: Presumably in the collection of Charles I as Titian since the picture has his insignia on the back; later collection of James II as Giorgione (C. and C., 1871, II, p. 149, note 1).

Bibliography: See also above; C. and C., 1871, II, pp. 148–149 (possibly Giorgione); Cook, 1907, p. 150 (probably derived

from an original by Giorgione; badly preserved); Hadeln (1914) in Ridolfi (1648)–Hadeln, I, p. 170 (copy of a lost original by Titian, called *Pompey and Cornelia*).

RELATED VERSIONS:

1. Sketch by Van Dyck, labelled Titian ('Italian Sketch-book', *c.* 1622–1627, Adriani edition, 1940, pl. 115v).
2. Bergamo, Cereza Collection; copy of the type in the English Royal Collection; signed by Ambrogio Figino (1550–1595), a Milanese painter. *Bibliography:* Locatelli Milesi, 1916, pp. 308–313; Cust, 1916, p. 373.
3. Florence, Casa Buonarroti; variously and erroneously attributed to Giorgione, to Sebastiano del Piombo, and to Titian. *Bibliography:* C. and C., 1871, II, p. 149, note I (probably an old copy); L. Venturi, 1913, pp. 262–263 (Giorgionesque); Cust, 1916, p. 72; Cook, 1916, p. 74; Justi, 1926, II, p. 278 (Giorgionesque); Longhi (1927), reprint 1967, I, p. 235 (copy after a lost Titian).
4. Llantrissant (Glamorgan), Tal y Garn, Mr. Godfrey Clark; probably from Pesaro and formerly William II, King of Holland. *Bibliography:* C. and C., 1871, II, p. 149, note I (probably an old copy); Cust, 1916, p. 373.

See also:

Washington, National Gallery of Art, Kress Collection: *Double Portrait* (2 figures), Cat. no. 51, Condition.

X–24. **Lucretia** Plate 233

Canvas. 1·00 × 75 m.

Vienna, Kunsthistorisches Museum (in storage).

North Italian or Venetian School (Nadalino da Murano?).

Late sixteenth century.

The old attribution of this composition to Titian has been abandoned by everyone save Suida. The style, technique, and costume betray the mind of a late imitator who used the frontal pose which has a long tradition. Well known examples of this pose are Dürer's *Lucretia* (1518) in Munich and Rembrandt's *Lucretia*, now in Washington. Suida also published another *Lucretia* (Suida, 1935, pl. 227b) as Titian's, whereas it is obviously the mediocre production of a late follower.

Condition: Much overpainted.

History: A 'Lucretia Romana' by Nadalino da Murano appears in the inventory of Bartolomeo della Nave's collection after it had passed to the Duke of Hamilton in England about 1639 (Waterhouse, 1952, p. 18, no. 129). Since this collection was acquired in part by Archduke Leopold Wilhelm *c.* 1648, there is a remote possibility that

Cat. no. X–24 is the same picture. However, there is little possibility of verification with the style of this obscure painter. Actually the *Lucretia* in Vienna may be later, *c.* 1630. Collection of Archduke Leopold Wilhelm (Teniers, 1660, pl. 84; Stampart and Prenner, 1735, pl. 25 (Titian); Mechel, 1784, p. 28, no. 52 (formerly inscribed *Sibi Titianus faciebat*).

Bibliography: See also above. C. and C., II, pp. 426–427 (late Titian! retouched); Engerth, 1884, I, p. 350, no. 499 (Titian); Gluck, 1907 (omitted); Suida, 1935, p. 126, pl. 227a (Titian); Klauner and Oberhammer, 1960 (omitted).

VARIANT:

Lucretia Stabbing Herself; canvas, 1·225 × 0·58 m.; unknown location; Venetian School, about 1510. A revoltingly bad picture, accepted by some critics as an early work of Titian; formerly given to a follower of Romanino. *Bibliography:* Suida, 1935, p. 155, fig. III (as early Titian; then in a dealer's possession at Munich); Tietze, 1936 (omitted); Berenson, 1757 (omitted); Valcanover, 1960, I, pl. I (early Titian); Pallucchini, 1969, p. 232, fig. 10 (Titian, 1508); Freedberg, 1971, p. 478, note 40 (Titian).

X–25. **Mythological Arcadian Scene** [perhaps Moses and the Burning Bush]

Canvas. 0·599 × 1·448 m.

London, Courtauld Institute, Collection of Lord Lee of Fareham.

Giorgionesque.

About 1510.

This rather charming Arcadian scene, in which a youth removes his shoes as his shepherd's staff lies at his side, does not conform to the usual conception of the prophet Moses on Mt. Sinai (Exodus, 3), nor does the bush appear to burn. Although on canvas, it has the misleading appearance of a *cassone* panel with an essentially decorative purpose. The picture has been scrubbed down to the canvas, leaving so little surface of paint as to make any attribution hazardous. The design and colour do not suggest the hand of a major artist, yet the work has frequently been assigned to Giorgione and to Titian. It causes wonder as to how many writers have seen this total wreck of a once fine painting. Photographs flatter it to an unusual degree, since they report outlines and not paint surfaces. The trees and bushes at the left cannot be said to recall closely the work of Titian or Giorgione.

Condition: Totally ruinous.

History: Most probably the collection of Galeazzo Dondi Orologio, Padua, in 1750. Waterhouse, who reconstructed

216 APPENDIX

the history of the picture, believes that the letters and escutcheon on the back are his: G. GA. D. H. He cites a picture of *Moses* in this collection (see Levi, 1900, p. 220), Marchese Galeazzo and Michele Dondi dall'Orologio, Padua, in 1855, where Moses is described as removing his shoes (Waterhouse, 1955, p. 295).

Bibliography: Richter, 1937, p. 236 (Giorgione); Morassi, 1954, p. 194 (Titian?); Waterhouse, 1955, p. 295 (probably Giorgione, surely not Titian); Berenson, 1957, p. 86 (Giorgionesque); Valcanover, 1960, I, p. 91 (perhaps early Titian); Lee, 1967, p. 28, no. 57 (ascribed to Giorgione); Pignatti, 1969, p. 122, cat. no. A21, pl. 173 (early Titian); Pallucchini, 1969 (omitted); Freedberg, 1971, p. 477, note 40 (early Titian).

X–26. **Nymph and Faun** Plate 226
Canvas on panel. 0·63 ×0·535 m.
Rotterdam, Boymans–van Beuningen Museum.
Follower of Titian.
About 1550.

The earlier attribution of this picture to Dosso Dossi has been abandoned, and there is little to recommend the later theory that it should be assigned to Titian, advanced by Suida and both Tietzes. Hans Tietze's argument includes mention of a drawing (with no specific reference) in the Museo Correr in Venice, which, he said, shows a similar composition in Titian's studio. Felton Gibbons proposed Paris Bordone, although I am more inclined to a minor Titianesque Venetian such as Damiano Mazza.
On the back of the picture is painted an olive tree and the legend: 'Infoelix fatum cadit ah! de ramis oliva.' The satyr wears a crown of grape leaves indicative presumably of his fondness of wine and adherence to the erotic behaviour of a follower of Bacchus. The girl's drapery is red over a white *camicia*.

Condition: Badly damaged in a fire in 1864 (Rotterdam, 1962, p. 141, no. 1172). The face and hair of the satyr are severely blistered.

History: First notice in the Boymans catalogue in 1811; Boymans bequest to the museum in 1847. A picture of this subject in the Barbarigo Collection has been proposed as the Rotterdam item, but that version was on canvas, 0·95 × 0·79 m., called 'Pane e Siringa' (Pan and Syrinx) (suggested by Tietze, 1950 with reference to Ridolfi (1648)–Hadeln, I, p. 200). The fact that this picture was sold to Russia in 1850 along with the entire Barbarigo Collection eliminates such a theory (Levi, 1900, p. 288, no. 80). This unimportant work

seems to have been consigned to the immense storage at the Hermitage, since it does not appear in the catalogue.

Bibliography: See also above; Schmidt Degener, 1915, pp. 20–23 (Dosso Dossi); Suida, 1935, pp. 72, 123 (Titian, *c.* 1550); Tietze, 1939, pp. 207–213 (Titian, *c.* 1540); Tietze, 1950, pp. 395–396, fig. 228 (Titian, *c.* 1560); Tietze-Conrat, 1955, pp. 15–19 (Titian; she adds the *Arcadia* of Lodovico Dolce as a source); Berenson, 1957 (omitted); Rotterdam, 1962, p. 141, no. 1172 (attributed to Titian); Gibbons, 1968, p. 261, no. 180 (Paris Bordone, *c.* 1535); Pallucchini, 1969 (omitted).

RELATED WORK:
Geneva, J. B. (Suida, 1935, p. 123, pl. 319).

X–27. **Nymph and Satyr** Plate 227
Canvas over wood. Oval, 0·61×0·51 m.
Munich, Alte Pinakothek (in storage).
Follower of Titian.
About 1550.

The style and quality of the picture are so remote from Titian that no arguments need be advanced to justify the classification of it as an unimportant school piece, perhaps by Damiano Mazza.

Condition: So badly scrubbed that little paint surface remains.

History: Kurfürstliche Galerie, Schleissheim, 1748, no. 253; Alte Pinakothek, 1836.

Bibliography: Morelli, 1907, II, p. 22 (not Titian); Reber, 1907 (not listed); A. Venturi, 1926, pp. 201–202 (attribution changed from Veronese to Titian); *idem*, 1927, p. 277 (Titian); *idem*, 1928, p. 337 (Titian); Munich, 1930, no. 475 (school of Titian); Suida, 1935, p. 123, pl. 232 (Titian); Kultzen and Eikemeier, 1971, pp. 192–193 (follower of Titian).

X–28. **Nymph and Satyr** Plate 228
Canvas. 0·99 ×0·807 m.
Detroit, Institute of Arts (in storage).
Follower of Titian (Girolamo Dente).
About 1565.

The ivy-crowned nymph has a fur-lined, brown-coloured wrap draped about her in a generally darkish picture. Her pose is clearly based upon Titian's *Salome* in the Prado Museum (Wethey, I, 1969, Plate 192). This design, at least twice repeated in Titian's workshop (Wethey, II, 1971, Plates 191–193), is considerably coarsened in the Detroit version.

Condition: Some dryness of paint surface, but in relatively good condition.

History: James E. Scripps Collection; purchased at Florence (Catalogue, 1889, no. 18); gift to the Institute of Arts in 1889.

Bibliography: Zarnowsky, 1938, pp. 122–123 (Girolamo Dente); Tietze, 1939, p. 212 (Giovanni Contarini); Detroit 1944, cat. no. 229 (workshop); Pallucchini, 1969, p. 214, fig. 653 (Girolamo Dentes di Tiziano).

X–29. **Nymph and Satyr** Plate 222
Canvas. 0·965 × 1·308 m.
Petworth (Sussex), Petworth House, National Trust.
Follower of Titian.
About 1570.

This composition is undeniably close to that of Titian's lost *Mars and Venus* (Plate 221), and Van Dyck's drawing (Plate 225). Tietze-Conrat (1956, pp. 82–85) attempted to identify the design at Petworth with a lost original by Titian mentioned in a letter of 1574 to Philip II's minister as among the unpaid items (C. and C., 1877, II, p. 540; Cloulas, 1967, p. 280). More commonly this work, which the painter described as 'La nuda con il paese con il satiro', has been thought to be the *Jupiter and Antiope* in the Louvre (known as the *Pardo Venus*) (Plates 74–76). Since the latter was originally in the Spanish royal collection, the chance is greater that the usual theory is correct. No picture of the subject of the Petworth copy is traceable in Spain.
A recent X-ray (1974) reveals a flat helmet (Mercury?), her arm about his neck, and his hand upon her rump.

Bibliography: Tietze-Conrat, 1956, pp. 82–85 (copy after Titian); Gore, 1969, p. 250 (Titian?).

X–30. **Omnia Vanitas**
Canvas. 0·803 × 0·994 m.
Glasgow, Glasgow Art Gallery (in storage).
Bolognese School.
About 1650.

The inscription TITIANUS CADUBRI [*sic*] on the plaque overhead in the Glasgow version is replaced by *Omnia Vanitas* in the example in Rome. The engraving (in reverse) by Lefèbre, of the second half of the seventeenth century, is labelled: *V. Lefèbre del. et sculp.... Titiano* [*sic*] *Inv. et P... I. Van Campen Formis Venetus.* Lefèbre probably followed the composition which in the later seventeenth century is said to have belonged to the Widman Collection in Venice.

15

In the Glasgow catalogue of 1935 the picture was identified as a *Danaë* by Titian for the obvious reason that the composition is indeed remotely based upon the great Venetian's pictures of that subject.
The remarkable part is that this obviously Bolognese picture of the Seicento should have passed for the work of Titian in that century. Its similarity in style to the *Danaë*, formerly in London at Bridgewater House, then ascribed to Domenichino and now attributed by Posner to Francesco Albani (Posner, 1971, cat. no. 153, pl. 153a), is obvious. The painter surely belonged to the circle of the Carracci, imitating Titian, so that the picture is in reality a Baroque forgery. Only Antonio Morassi in recent years has taken this composition seriously as a copy of a lost original by Titian.
Obviously the subject is an allegory of *Vanitas*. At the foot of the bed lie the crown and sceptre, symbols of royal authority. The large silver urn draped with jewels, the coins on the floor and in sacks, all refer to the Vanities of earthly things. In Lefèbre's print smoke issues from the urn, a symbol of the ephemeral nature of life and its possessions.

History: McLellan Collection (Glasgow, 1935, p. 315, no. 190; the gallery authorities seem to think that their picture came from the Widman Collection, Venice); Hume (1829, p. 65) saw the subject in that Venetian collection in 1786, but it had the inscription 'Omnia Vanitas'. Therefore it more likely passed to Rome (see below, Other Versions, no. 3).

Bibliography: See also above; Waagen, 1857, p. 460 (signature not authentic; Venetian School; then in McLellan Collection); C. and C., 1877, II, p. 431 (seems to imitate Cesare Vecellio); Glasgow, 1935, p. 315, no. 190 (*Danaë* by Titian); Morassi, 1954, pp. 182–183 (copy of a lost Titian!); Morelli, 1876–1891, published 1960 under J. P. Richter and Morelli, p. 281 (Bolognese, style of Guido Reni); Pallucchini, 1969, fig. 597 (as after Titian).

OTHER VERSIONS:
1. Düsseldorf, Academy; pen and sepia (C. and C., 1877, II, p. 430, not Titian).
2. Madrid, Museo Cerralbo; drawing, no. 11a (not Titian).
3. Rome, Accademia di San Luca (Plate 205); canvas, 1·20 × 1·302 m. (C. and C., 1877, II, pp. 430–431, perhaps by Cesare Vecellio; photo Anderson 1234).
4. Wimborne (Dorset), Kingston Lacy, H. J. Ralph Bankes; canvas, 1·257 × 1·194 m. (C. and C., 1877, II, p. 431, 'Omnia Vanitas' on the tablet, similar to the Rome picture; Waagen, 1857, p. 378, not seen, from the Marescalchi Collection, Bologna).

PRINTS:
By Lefèbre and by Gottfred Saiter.

X-31. **Orpheus**

Canvas. 1·65×1·08 m.

Madrid, Prado Museum.

Venetian School.

About 1575.

Originally attributed to Titian, it was assigned to Padovanino by Crowe and Cavalcaselle in 1877. The figure is derived from a composition of *The Contest Between Apollo and Marsyas*, the right half of which is preserved in a print by Giulio Sanuto (1562), who incorrectly ascribed the original to Correggio. Large painted versions of the so-called Correggio exist in Leningrad and elsewhere, which Voss (1913) assigned to Bronzino. He believed that the Leningrad example was the work by Bronzino delivered to Guidobaldo, Duke of Urbino, in 1532.

The composition of the Hermitage picture is twice the width of that in Sanuto's print, and it includes the Flaying of Marsyas after his defeat by Apollo. The attribution to Bronzino has been challenged by others, including Arthur McComb (1928), who gave the Hermitage picture to an unknown master of the school of Parma. For a related subject by the Genoese painter, Sinibaldo Scorza, see below Literary Reference, no. 3.

So far as the present writer is concerned the Prado *Orpheus* and other examples, listed below, are not related to Titian in any way. Neither do they show any specific similarity to the work of Alessandro Varotari, il Padovanino, to whom Crowe and Cavalcaselle attributed such a wide variety of unrelated works. The general quality and the colour point to some late Venetian who painted these pleasant and clearly successful pictures. Tietze and Tietze-Conrat (1936, pp. 144–145) recognized the Madrid and Apsley House pictures as partial copies after Bronzino.

History: Madrazo Catalogue, 1910, no. 266, collection of Charles II, but he was probably wrong. Isabella Farnese's collection at La Granja, 1746, as Titian.

Bibliography: C. and C., 1877, II, p. 461 (Padovanino); Voss, 1913 (the Leningrad picture to Bronzino); *idem*, 1920, I, pp. 209–211, illustrated; Suida, 1935, pp. 120, 166 (Titian and assistants); A. Venturi, 1927, p. 281 (Titian); McComb, 1928, p. 106 (Hermitage picture to school of Parma); Tietze and E. Tietze-Conrat, 1936, pp. 144–145 (Padovanino after Bronzino); Prado cat., 1963, no. 266 (as Varotari il Padovanino).

OTHER VERSIONS:

1. London, Apsley House, Museum (Plate 232), canvas, 1·435×1·11 m.; Venetian School, c. 1575; formerly in the Royal Collection at Madrid, which must have had two pictures of the same subject. The style appears Venetian in this rather handsome picture, in which Orpheus sits upon rose drapery and the animals are charmingly painted. *History:* Inventory Alcázar, 1666, no. 692 (Titian, 300 ducats); Inventory, 1686, no. 865; Inventory, 1700, no. 487; Inventory, 1734, no. 24, after the fire, first marked 'copia', they changed it to an original 'well treated'; Alcázar, Madrid, Inventory 1746, no. 24 (as Titian); Ponz, 1776, VI, Del Alcázar, 32, in the King's Room and called Bassano; captured with the baggage of Joseph Bonaparte at the battle of Vitoria in 1813. *Bibliography:* C. and C., 1877, II, p. 461 (Varotari, il Padovanino; Wellington, 1901, II, p. 375, cat. no. 35 (as Bassano); *Apsley House*, 1965, fig. 2 (Venetian school).

2. Vienna, Horney Collection; canvas, 1·53×1·04 m.; Suida, 1935, pp. 120, 166, pl. 118 (Titian and assistants).

LITERARY REFERENCES TO RELATED WORKS:

1. Guadalajara, Duque del Infantado, in 1626: 'un altro Quadro di Titiano, un Orfeo ignudo sedente sopra un panno rosso con diversi animali e Alberi che dicon essere di mano d'un tal Pombo [*sic*, i.e. Sebastiano del Piombo] (Cassiano dal Pozzo, 1626, folio 27v). This picture may have passed later into the Spanish Royal Collection and conceivably might be the Apsley House version.

2. Rome, Palazzo Riario, Queen Christina. Inventory, 1689, after her death: 'Un quadro grande con Orfeo a sedere in piedi ad un arbore che sona la lira, circondato da gran numero di animali . . . tele . . . 5½×9½ palmi' [1·23×2·12 m.] (Campori, 1870, p. 366).

3. Rome, Palazzo Riario, Queen Christina; Inventory 1689: 'un altro quadro con Orfeo in paese con molti animale, due figure come di pastori e tre satiri che lo stanno guardando, di mano di Sinibaldo Scorza, in tela a giacere 2¼×4 palmi meno un dito' [0·50×0·89 m.] (Campori, 1874, p. 349). Sinibaldo Scorza (1589–1631) was a minor Genoese master whose several pictures in Queen Christina's collection apparently are no longer traceable (S. Scorza in Thieme-Becker, XXX, 1936, pp. 404–405).

X-32. **Rape of Proserpina**

Canvas. 0·66×0·959 m.

Cambridge, Fitzwilliam Museum.

Christopher Schwarz.

About 1570.

The nineteenth-century attribution to Titian succeeded the identification of the artist as Lambert Sustris, when the picture was in the Orléans Collection. The recent establishment of the painter as Christopher Schwarz (1548–1592), who lived in Venice in 1570–1573, appears to be definitive.

History: In a letter of 7 February 1534 (Gaye, 1840, II, pp. 251–252) Federico Gonzaga asked Titian to paint two pictures for his brother Ferrante Gonzaga, who wished to send them to Spain ('donare in Spagna'). He did not specify to whom, hence they could not have been intended for the Emperor Charles V. One of them was to be a *Rape of Proserpina*, but the second subject was left to Titian's discretion. Although Tietze-Conrat (1956, pp. 86–87) assumed that they were delivered, we have no further record of them. The Mantua Inventory of 1627 lists the subject but at the low price of *lire 36* and without an author specified (D'Arco, II, p. 159; Luzio, 1913, p. 108, no. 259).

A *Proserpina* attributed to Titian when in the Coesvelt Collection in London is among the pictures given to Titian by Mrs. Jameson in the past century (1836, no. 39). Crowe and Cavalcaselle saw a *Rape of Proserpina* in the collection of Mr. J. Evelyn Denison, which they called a copy (1877, I, pp. 400–402, note). Mr. Denison lent it to the Manchester exhibition in 1857, where it was said to have come from the Orléans Gallery (Bürger, 1857, p. 79). The fact that the print in the Orléans catalogue (1786, no number) corresponds to the Cambridge picture is rather convincing evidence that one item is involved. Another engraving by Raphael Sadeler II also exists, but the Cambridge authorities do not suggest an Orléans provenance for their version. The same picture figured in the exhibition held at Leeds in 1868, no. 211. Denison sale, London, Christie's, 23 June 1933, no. 59, £273; gift of Viscount Rothermere to the Fitzwilliam Museum in 1936.

Bibliography: See also above; Dubois de Saint Gelais, 1737, p. 286 (Sustris); Berenson, 1957, p. 168, pl. 1247 (as Lambert Sustris); Geissler, 1960, p. 182 (C. Schwarz); Ballarin, 1962–1963, pp. 335–340, 364 (Sustris; the Orléans picture); Goodison and Robertson, 1967, II, pp. 187–190 (C. Schwarz).

X–33. **Tarquin and Lucretia** Plate 33

Panel. 0·84 × 0·68 m.
Vienna, Kunsthistorisches Museum.
Palma il Vecchio.
About 1525.

When in the collection of Charles I of England, this panel bore the name of Titian, to be superseded by that of Palma il Vecchio in the nineteenth century. Since Longhi in 1927 switched to Titian, the Italian scholars and Suida have followed suit, as part of the re-attribution of many borderline cases to the greater master. To be sure the composition, with a woman in half length and a secondary figure of a man behind her, is one that Titian employed in the *Lady at Her Toilet* (Plate 31). Yet many Venetians often adopted a successful composition, thereby maintaining a uniformity of school, as witness Venetian portraiture from the time of Antonello da Messina and Giovanni Bellini through the first quarter of the sixteenth century.

To most non-Italians the name of Palma il Vecchio best fits the *Tarquin and Lucretia* in Vienna, at the time when Palma tried most to approximate the work of the young Titian. The general effect of the physical type and the handsome design of the girl's costume come close indeed to the *Lady at Her Toilet* (Plate 31) and the *Flora* (Plate 35). Still, Palma's Lucretia does not have quite the same classical regularity of features, and the colour differs considerably, particularly the vivid green of Lucretia's drapery, which is unlike Titian's more subtle colour tones. Ridolfi (1648–Hadeln, I, p. 170) does state that Titian painted a *Tarquin and Lucretia* in half length, but that does not clinch this attribution.

Palma's adoption of the Hellenistic hair-style, characterized by a knotted lock in the front centre, is not common in Venetian painting. It occurs more frequently in sculpture, even as early as c. 1492–1495 in the coiffure of *Temperance* on Tullio Lombardo's tomb of Andrea Vendramin (Planiscig, 1921, p. 238). Mosca's *Eurydice c.* 1515–1522 (*loc. cit.*, p. 269) is an example contemporary with our *Tarquin and Lucretia*. Earlier cases abound in Renaissance Rome and in later figures by Jacopo Sansovino in Venice. The sources lie in antique sculptures such as Pius III's *Three Graces* (Siena Cathedral, Library; in 1503 in Rome), the *Crouching Venus* in Naples (Figure 23), and numerous other Hellenistic sculptures.

Condition: The man's head is either totally repainted or was added about 1600. Dr. Klauner favours the latter explanation. During the original execution of the work, the arrangement of the drapery over Lucretia's bosom was redesigned, a fact visible to the naked eye as well as in X-rays. A green band can be seen under the white bodice. The left breast, nude originally, was covered by the bodice at a later period. Compare Peter Oliver's copy in miniature (Plate 184), painted c. 1630–1640, before the costume was made more modest.

Iconography: The traditional title of the picture is *Tarquin and Lucretia*, yet the expression of the sad man in the background ill befits the lustful Tarquin. For that reason Engerth identified him as Collatinus, Lucretia's husband, faced with Lucretia's determination to commit suicide after her violation by Tarquin (see Engerth, 1884, I, p. 227). If the man was added c. 1600 (see above) that would explain his peculiar appearance. A full account of the Roman legend is included in Cat. no. 34.

History: Gonzaga Collection, Mantua, perhaps Inventory

1627, no. 7: 'un quadro con sopra dipinto una Lucretia romana di mano di Titiano' (Luzio, 1913, p. 90). Another item of the same subject may be the picture at Hampton Court (see Cat. no. 26, History). London, collection of Charles I, 'Item: Above the doore A Lucrecia having a daggr in her right hand and a Mans face behind, being Tarquin . . . Half a figure Soe bigg as the life. done upon a board. Done. By Tichin. 2 fo 7–2 fo 2. (i.e. 0·788 × 0·66 m.) In the third privie Lodging Room' (no. 15) (Van der Doort, 1639, Millar edition, 1960, pp. 22, 230).

Charles I, Inventory for sale after his death: LR 2/124, folio 9r; 1649, 'Lucretia and Tarquin by Tytsian', £70 at Whitehall; Harley MSS. 4898, folio 151, no. 30, 23 October 1951, £70; purchased by Archduke Leopold Wilhelm, his Inventory Vienna, 1659, no. 403 (Berger, 1883, p. cviii); (Charles I sale, Millar, 1970, p. 70).

Bibliography: See also above; Stampart and Prenner, 1735, pl. 6; C. and C., 1871, II, pp. 475–476 (Palma il Vecchio); Engerth, 1884, I, p. 227, no. 321 (as Palma); Morelli, 1890, I, p. 313 (Palma); Gronau (omitted); Longhi, 1927 (reprint 1967), pp. 237, 458 (Titian); Spahn, 1932, p. 198 (not Palma); Berenson, 1932, p. 412, no. 136 and 1957, p. 126 (Palma il Vecchio); Klauner and Oberhammer, 1960 (omitted, although exhibited as Titian); Valcanover, 1960, I, pl. 52 (Titian); Oberhammer, 1964, pp. 131–134 (Titian); Mariacher, 1968, p. 111 (Titian); Pallucchini, 1969, pp. 40, 250, fig. 111, colour plate XVIII (Titian, *c.* 1515–1516); Panofsky (omitted).

COPIES:
1. Florence, Uffizi, by A. Varotari, il Padovanino; canvas, 0·94 × 0·75 m. (C. and C., 1877, II, p. 476, note, Varotari; Florence, Uffizi, 1926, p. 113, no. 963, Varotari, purchased in 1799; Thieme-Becker, 1940, p. 116, Varotari).
2. Hampton Court; poor old copy (C. and C., 1877, II, p. 476, note).
3. London, Victoria and Albert Museum; Peter Oliver's miniature copy, signed (Plate 184); panel *c.* 1630–1640, when the original was in Charles I's collection. Lucretia is in a white blouse with the left breast uncovered, and green drapery. The man wears red.
4. Lost miniature copy: Collection of Charles I, London, no. 69: '. . . a Lucretia with a dagger in her right hand—in greene and white drapery a Tarquin being by, wch by vernishing the greene Cullors over flowen and the ground wrinckled . . . given to yor Maty by Sir James Paumer whereof the Principall being in oyle Cullors and remains in the third privy lodging room at whitehall above the dore being No. 15 there.' 'Don by Sr James Paumer after Titian given to yor Maty' 'o f 4–0 f 3 3/4' [0·12 × 0·095 cm.] (Van der Doort, 1639, Millar edition, 1960, p. 120).

X–34. Tarquin and Lucretia Plate 167

Canvas. 1·14 × 1·00 m.

Vienna, Akademie der Bildenden Künste.

Follower of Titian [Palma il Giovane (?)].

About 1580.

Reasons for rejecting the attribution are advanced in the text. Anny Popp's theory that the canvas is a fragment which originally measured 1·93 × 1·132 m. and that the composition conforms to Cornelius Cort's print of 1571 has not been accepted by recent writers. Her assumption that the Vienna picture is the unnamed work Titian told Philip II that he was preparing in a letter of 26 October 1568 (C. and C., 1877, II, pp. 388–389, 537–538; Cloulas, 1967, p. 275) is rash at best. If Titian's vague allusions concerned a *Tarquin and Lucretia* as Anny Popp supposed, she was demonstrably in error, since that picture, delivered to Philip II in 1571, is now in the Fitzwilliam Museum in Cambridge (Plate 164). Waldmann (1922), pp. 186, 236) alone accepted Popp's conclusions, and he added a further error by suggesting that the Vienna version had formerly belonged to Charles I of England, whereas that picture is now in Bordeaux (Plate 165).

Condition: Apparently a sketch rather than an unfinished canvas.

History: Vienna, Schroff Collection; sale 11 November 1907, no. 114, Pisko Gallery, Vienna, as by Paolo Veronese; purchased by the Vienna Academy.

Bibliography: Bode, 1915, p. 17 (late Titian, then in storage); Popp, 1921, pp. 9–13 (late Titian); Eigenberger, 1927, p. 407, no. 1304 (late Titian); *Mostra di Tiziano*, 1935, p. 197 (incorrectly identifies the Vienna picture with that of the Earl of Arundel, which is presumably the Bordeaux item (Cat. no. 35, History); Suida, 1935, pp. 127, 178 (late Titian); Tietze, 1936, I, p. 244, II, p. 314, colour print (as Titian's sketch); Berenson, 1957 (omitted); Valcanover, 1960, II, pls. 137–138 (Titian); Morassi, 1964, plate 38 in colour (as Titian, a late masterpiece); Panofsky, 1969, p. 139, note 1 (a late revised version of the Cambridge *Tarquin and Lucretia*); Palluchini, 1969, p. 326, fig. 529 (Titian, *c.* 1571).

See also: *Lucretia*, Cat. no. X–24.

X–35. Triumph of Love Plate 217

Canvas, mounted on panel. Tondo, 0·863 m. diameter.

London, David McKenna.

Venetian School.

About 1560.

Berenson suggested that it might be a ceiling painting. Cavalcaselle sketched the picture and labelled it Titian in 1875 but too late to include it in his monograph (C. and C., 'Notes', London, V. and A.).

History: John Robert Udney, Christie's, 15 May 1829, no. 80; William Graham, sale, 10 April 1886, no. 484 (bought in); Lady Jekyll (by inheritance); Colonel H. Jekyll, sale no. 160.

Bibliography: Suida, 1935 (omitted); Tietze, 1936 (omitted); Berenson, 1957, p. 187 (Titian); Waterhouse, 1960, p. 42, no. 79 (Titian); Valcanover, 1960 (omitted); Pallucchini, 1969 (omitted).

X–36. (Sleeping) Venus with Roses (Darmstadt type)

Plate 180

Canvas. 1·33 × 1·69 m.
Darmstadt, Landesmuseum, Gemälde Galerie.
German adaptation of Giorgione or Titian.
Seventeenth century.

The goddess lies upon a couch as in the *Venus of Urbino* (Plate 73), unlike Giorgione's Venus, whose body is protected from the ground by a sheet and by pillows under her shoulders. The pose is based on Giorgione's Dresden *Venus* (Plate 9), but the Cupid, now painted over in the original, is omitted in the Darmstadt variant. The quality is hard and poor in this specimen, where the couch is strewn with roses, and the draperies are a coarse red. The structures in the right background are also loosely based upon the Dresden composition. However, the walled city has no resemblance to the buildings that Titian introduced in his landscapes. Yet the existence of other versions of the *Sleeping Venus with Roses* implies a lost original by Titian. The lost *Sleeping Venus* of the Spanish royal collections (Cat. no. L–15) has been proposed as the prototype of these pictures, even though the copy in the Academia de San Fernando (Cat. no. 38, copy 2) has no roses and the buildings in the right distance are nearer to those in John Boydell's print (Engraving no. 1, below). Hermanin was convinced that Giorgione painted an original of the *Sleeping Venus with Roses*, and he proposed to associate it with a nude owned by Marcantonio Michiel (Hermanin, 1933, pp. 114–116). As a matter of fact Michiel's words are: 'et è il nudo che ho io in pittura de listesso Zorzi' (Michiel, edition 1884, p. 230). The subject is not said to be Venus or even a female figure ('la nuda'), and it remains difficult to explain the masculine form of the word ('nudo').
Why Crowe and Cavalcaselle regarded the Darmstadt *Venus* as a repainted original is difficult to understand.

Condition: Very badly preserved; much restored.

History: Collection of Cardinal Louis de Rohan, Strasburg (as by Titian; see Darmstadt, 1914, p. 166).

Bibliography: Darmstadt, 1843, p. 126, no. 588 (Titian); C. and C., 1877, I, pp. 274–275 (repainted original by Titian); Morelli, 1880, p. 197; Morelli, 1893, II, p. 224, note 1 (German copy, XVII century); Darmstadt, 1914, p. 167, no. 313 (German copy of lost Titian, XVII century); Beroqui, 1946, pp. 84–85 (copy of lost original).

VERSIONS:

1. Detroit, Heirs of Minerva Maiullo; *Sleeping Venus with Roses*; canvas, 1·19 × 1·68 m., German, seventeenth century; a version related to the Darmstadt picture (Hermanin, 1933, pp. 100–101, illustrated); one rose here.
2. Dresden, Staatliche Gemäldegalerie; formerly no. 236, no longer in the Dresden catalogue (C. and C., 1877, I, p. 275, note; copy).
3. London, Dudley House, formerly (C. and C., 1877, I, p. 275, note, Bolognese copy; Morelli, 1883, p. 168, note 2, copy of the Darmstadt type).
4. London, Dulwich College Gallery; canvas, 1·01 × 1·835 m.; a Cupid with arrow and a loggia are added (C. and C., 1877, I, p. 275, Venetian, late sixteenth-century; Dulwich, 1926, no. 484, Venetian school).
5. Madrid, Dr. Xavier de Salas; canvas, 1·63 × 1·114 m.; purchased from a Madrid dealer in 1935. The red curtain and red cover upon the couch, as well as the roses scattered about, place this example in the same category of the *Sleeping Venus with Roses*. A central landscape and buildings in the right distance are related to the *Sleeping Venus* in Dresden.
6. Munich, Alte Pinakothek, in storage in 1971; canvas, 0·64 × 0·95 m. (Inventory 2716–4842, photo no. 51/284); formerly Rothenburg, Gemäldegalerie. In this free variant the background consists of a wall with a window, in which stands an urn with flowers. Over the red velvet couch are strewn flowers, as in the Darmstadt type.
7. Rejavick, Private Collection; canvas, 0·46 × 0·65 m.; formerly in the collection of the Duke of Wellington, who bought it from J. C. Barrett in 1859 (C. and C., 1877, I, p. 275, note, copy; see also Wellington, 1901, p. 220, no. 201). The late Duke of Wellington in 1965 supplied the information that he had recently sold this version.

ENGRAVINGS:

1. By John Boydell in 1781 of a picture then in the collection of Philip Metcalfe (Richter, 1931, p. 54). The type of composition is related to the Darmstadt picture even as to roses, but the landscape shows dependence upon the Dresden *Sleeping Venus* (Plate 9).
2. Vienna, Albertina, and Paris, Bibliothèque Nationale;

dated 1593. It repeats the composition of the Detroit example, even as to the architecture, which differs slightly from that in the right background of the Dresden *Sleeping Venus* (Hermanin, 1933, p. 116; Oettinger, 1944, pp. 126–127), but there are no roses.

See also: Cat. no. L–18.

X–37. **Venus Alone at Her Toilet** Plate 133
Canvas. 1·20 × 0·85 m.
Venice, Ca' d'Oro.
Follower of Titian.
Sixteenth century.

Workshop would be the most optimistic label that one could place upon this work. Based upon Titian's composition in Washington (Plates 127–129), it is an adaptation with the omission of the Cupids and the mirror. The resultant pose lacks motivation. Yet Wulff tried to establish this item as the first of all of Titian's versions of the subject (Wulff, 1941, pp. 191–192). Poglayen-Neuwall (1947, pp. 195–196) replied, stressing the impossibility of accepting it as by Titian's own hand, much less as the prototype for others of related subjects. The supposed inscription TITIANVS is fragmentary and highly debatable as a signature.

Condition: Restored in 1972. Photographs of the canvas when stripped of earlier restorations reveal paint losses and crackle on the face equal to at least thirty per cent of the area. The right hand too has suffered badly, and one suspects that large areas of the body are totally repainted.

History: Baron Giorgio Franchetti, Venice; donated to the Museum of the Ca' d'Oro.

Bibliography: Poglayen-Neuwall, 1929, p. 199; *idem*, 1934, pp. 371–372, 384, fig. 12; *idem*, 1947, pp. 195–196 (school of Titian); *Mostra di Tiziano*, 1935, p. 103, no. 80 (Titian, c. 1559); Suida, 1935, p. 119 (Titian); *idem*, 1936, pp. 102–103 (not Titian and not signed); Wulff, 1941, pp. 191–192 (Titian's own and the earliest); Berenson, 1957 (omitted); Valcanover, 1960, II, p. 71, fig. 175 (partly by Titian); Pallucchini, 1969, p. 302, no. 3 (workshop).

VARIANT:
Munich, Residenz (not exhibited; lost?); canvas, 1·26 × 0·93 m.; a late free and mediocre version in which the goddess is partially clothed (Poglayen-Neuwall, 1929, p. 199; *idem*, 1934, pp. 370, 384, fig. 20; copy, seventeenth century).

X–38. **Venus Dressed at Her Toilet with One Cupid**
Canvas. 0·935 × 0·737 m.
London, Courtauld Institute Galleries.
School of Veronese.
About 1575.

Although this composition shows familiarity with Titian's *Venus at Her Toilet*, the positions of the arms and the attitude of Cupid holding the mirror do not follow Titian's prototype (Plate 132).

History: Baron Alfred de Rothschild; Countess of Carnarvon; Lord Lee of Fareham; bequeathed to the Courtauld Institute in 1947, received in 1958.

Bibliography: Hadeln, 1929, pp. 115–116 (Paolo Veronese); Poglayen-Neuwall, 1929, p. 198; *idem*, 1934, pp. 372, 375, 383, no. 1, fig. 15 (follower of Veronese); Suida, 1935, pp. 119, 176 (Veronese after Titian); Berenson, 1957, p. 133 (Veronese); Courtauld Institute, 1962, pp. 26–27; Shapley, 1971–1972, pp. 93–97, fig. 2.

VARIANTS:
1. Florence, Corsini Collection; canvas, a remote variant probably by Varotari (Gerspach, 1906, p. 21, Titian; Poglayen-Neuwall, 1934, p. 384, fig. 19, Varotari).
2. Partenkirchen (Bavaria), Dr. F. Wigger; canvas, 0·886 × 0·72 m.; formerly in storage at the Kunsthistorisches Museum, Vienna (Poglayen-Neuwall, 1934, p. 383, no. 2, copy of the circle of Veronese; Suida, 1935, pp. 119, 176, pl. 224, an original by Titian!).
3. Rome, Accademia di San Luca; canvas, 1·00 × 0·80 m. (Poglayen-Neuwall, 1934, p. 383, no. 3, fig. 16, copy; Golzio, 1939, p. 21, no. 279, attributed to Carletto Caliari).

X–39. **Venus and Adonis** (Barberini type) Plate 194
Canvas. 0·762 × 1·04 m.
Alnwick Castle, Duke of Northumberland.
Imitator of Titian.
Seventeenth century.

The extraordinary fact is that Crowe and Cavalcaselle wrote with the greatest enthusiasm of this small picture, which they ranked above the masterpiece in the Prado Museum (Plate 84). The preposterous cap worn by Adonis and the general awkwardness of the composition leave the impression that this variant of the Prado version, like that in Rome (Cat. no. X–40), owes nothing to Titian himself.

Condition: In a fair state but the sky is muddy, perhaps because of chemical changes in the pigment.

History: The Roman dealer Pietro Camuccini claimed to have purchased the picture from the Barberini Palace. The Duke of Northumberland acquired this item along with the entire Camuccini Collection in 1856; exhibited at the British Institution in 1857 (Graves, 1914, III, p. 1319, no. 6).

Bibliography: See also above; Waagen, 1857, p. 468 (Titian's original sketch); C. and C., 1877, II, pp. 150–151, 238 (Titian: the best version!); Collins Baker, 1930, no. 716, pl. 33 (a copy); Gould, 1959, p. 100 (sketch copy).

X–40. **Venus and Adonis** (Barberini type) Plate 196
Canvas. 1·87×1·84 m.
Rome, Palazzo Barberini, Galleria Nazionale.
Follower of Titian.
Late sixteenth century.

This mediocre school piece, in which Adonis wears a ridiculous red hat and has rose ribbons on his quiver, is not only coarsely painted but so clumsily based upon the Prado composition as to eliminate Titian's own participation. A related design and no better quality characterize the example at Alnwick Castle (Cat. no. X–39), where Cupid is wanting. The vertical shape of the picture allows for the inclusion of more of the trees and the sky than in the Prado original.

Condition: Still dirty and in poor condition despite recent restoration in 1959.

Supposed History: The theory that this canvas once formed part of Queen Christina's Collection in Rome and then passed to the Odescalchi is untenable. The Odescalchi Collection was sold to the Duke of Orléans in 1721, and there is no evidence that any part of it was disposed elsewhere.
Known History: Torlonia Collection, Rome; bequest to the Galleria Nazionale in 1829 (Venturi, 1896, p. 110).

Bibliography: See also above; A. Venturi, 1896, p. 119 (old copy); Fischel, 1924 (omitted); Rinaldis, 1932, p. IV (workshop); Suida, 1935, p. 120 (workshop); Tietze, 1936 (omitted); Carpegna, 1954, p. 59 (workshop of Titian); Berenson, 1957 (omitted); Valcanover, 1960, II, p. 68 (attributed); Levey, 1962, fig. 223 (studio); Stockholm, 1966, p. 483, no. 1191 (with incorrect provenance from Prague and from Queen Christina's Collection; studio replica); Pallucchini, 1969 (omitted).

COPIES:
1. London, Dulwich College Gallery, no. 209; canvas, 1·835×1·896 m.; weak copy (C. and C., 1877, II, p. 239,

note: late weak copy; photographs in the Witt Library, Courtauld Institute, London).
2. Venice, Prefettura (on loan from the Accademia); canvas, 0·62×0·52 m.; crude copy in vertical format (Moschini Marconi, 1962, p. 263, no. 456, illustrated).

X–41. **Venus and Cupid**
Canvas. 0·96×0·66 m.
Unknown location.
Lambert Sustris.
About 1565.

This very beautiful picture is typical of Lambert Sustris and quite unlike Titian in both composition and physical types. The attribution to the greater master by Fischel and Fiocco has been correctly rejected by Ballarin, who points out the influence of Veronese on Sustris here.

History: Wendland Collection, Lugano, in 1933; Milan, Private Collection, in 1957.

Bibliography: Fischel, 1933, p. 21 (Titian); Fiocco, 1957, pp. 202–204 (Titian); Ballarin, 1962, p. 81, note 39 (Sustris, c. 1565); *idem*, 1962–1963, p. 364 (Lambert Sustris).

Venus Blindfolding Cupid, see:
 Cupid Blindfolded, Cat. nos. 4, X–5.

X–42. **Venus with Satyr and Cupid**
Canvas. 1·15×1·10 m.
Rome, Villa Borghese.
Venetian School.
About 1600–1625.

Paola della Pergola (1955, I, pp. 136–137, no. 244) insists that an original by Paolo Veronese is reflected here. Surely a work of the early seventeenth century, this picture records a lost original of the Venetian School which Van Dyck saw c. 1622–1623, and wrongly labelled Titian.

Bibliography: Van Dyck, 'Italian Sketchbook' (Andriani edition, 1940, p. 76, Abb. 11, pl. 114); Pergola, 1955, *loc. cit.*; Tietze-Conrat, 1945, p. 270 (unrelated to Titian).

X–43. **Venus, Mercury, and Cupid** (Education of Cupid)
 Plate 231
Canvas. 1·816×1·169 m.
El Paso (Texas), El Paso Museum of Art, Samuel H. Kress Collection.
Follower of Titian (Lambert Sustris?).
About 1560.

The utter mediocrity of this picture cannot be explained by the various past restorations. The Mannerist scale of Venus's figure is not close to Titian, and the general effect approaches slick facility. The attribution to Lambert Sustris (Pallucchini, 1969, p. 347) is understandable. Mrs. Shapley, Federico Zeri and Ballarin now accept the painting as a work of Sustris.

Condition: Cleaned in 1950 by Modestini; originally about 30 cm. wider; losses are very slight, chiefly on the body of Venus (Shapley, 1968, p. 187).

History: Emperor Rudolf II at Prague, Inventory *c.* 1598 (Perger, 1864, p. 106); Prague Inventory, 1621, no. 952 (Zimmermann, 1905, p. XL); Christina at Stockholm, 1652, no. 87 (Geoffroy, 1855, p. 167); Queen Christina, Antwerp Inventory, 1656 (Denucé, 1932, p. 179); Palazzo Riario, Rome, Inventory 1662, folio 45; Inventory at Queen Christina's death in Rome, 1689 (Campori, 1870, p. 339); Queen Christina's bequest to Cardinal Decio Azzolino, 1689; inherited by Marchese Pompeo Azzolino, 1689–1692; 'Nota dei quadri della Regina Christina di Svezia', *c.* 1689–1692, no. 51.
Purchase of Christina's collection by Prince Livio Odescalchi from Pompeo Azzolino, 1692, folio 466, no. 13; Inventory at the death of Livio Odescalchi, 1713, folio 77, no. 160 and also three copies (see below); Odescalchi sale to the Duke of Orléans, 2 September 1721, no. 10.
Orléans Collection, Paris, 1721–1792 (Dubois de Saint Gelais, 1727, pp. 475–476; Couché, 1786, I, pl. XI); purchased from the Orléans sale by the Earl of Gower, Marquess of Stafford (Buchanan, 1824, I, p. 113, no. 11); Stafford House (Stafford, 1862, no. 18); sale of the fourth Duke of Sutherland (London, Christie's, 11 July 1913, no. 89); Arthur L. Nicolson, London, 1935; Paul Drey, New York; purchase by the Kress Foundation in 1950 (Shapley, 1968, p. 187).

Bibliography: See also History; Jameson, 1844, p. 200 (Titian); Waagen, 1854, II, p. 60 (a feeble work); C. and C., 1877, II, p. 463 (assigned it to Andrea Schiavone); Suida, 1935, pp. 74, 167, pl. 119 (Titian); Tietze, 1936 (omitted); Suida, 1952, pp. 33–36 (Titian); Berenson, 1957 (omitted); Valcanover, 1960, II, p. 65, pl. 151 (doubtful attribution); Shapley, 1961, no. 28 (studio of Titian); *idem,* 1968, pp. 187–188 (full account; studio of Titian); Pallucchini, 1969, p. 347, fig. 658 (Lambert Sustris); Shapley, 1973, Addenda to 1968, II, p. 187, K 1694 (Lambert Sustris; quotes Ballarin's written opinion agreeing to Sustris).

COPIES (Literary Reference):
Rome, Odescalchi Collection (formerly); three copies from the original in the same collection: Odescalchi Inventory 1713, folio 43, nos. 104–106.

X–44. **Venus and Wounded Cupid** ('L'Amour piqué')

Plate 178

Canvas. 1·12 × 1·40 m.
London, Wallace Collection.
Venetian School.
About 1520.

The weak quality seems to me to exclude the painting from the realm of any major artist. The landscape clearly betrays knowledge of the works of Giorgione and the young Titian, thus accounting for the attribution by various critics to these masters. The huge, powerful figures of the same theme in Van Dyck's 'Italian Sketchbook' (Adriani, 1940, pl. 117) must have been copied from a lost original. The drawing differs from the Wallace picture also in the fact that Cupid holds his bow in his right hand there and that it lies upon the ground here.

History: Forest Collection, Paris; Orléans Collection, Palais Royal, Paris (Dubois de Saint Gelais, 1727, p. 167; Couché, II, 1786–1788, pl. VI, Giorgione); Bryan Collection, sale, London, 1800 (Buchanan, 1824, I, p. 126, no. 6, as Giorgione); later in the collections of Sir Simon Clarke; Lord Suffolk; and Walsh Porter (sale, London, Christie's, 14 April 1810; again, 6 May 1826, no. 5); G. J. Pringle at Manchester, and Lord Northwick; Northwick sale, 10 August 1859, no. 996, purchased by the Marquess of Hertford (Wallace Collection, 1968, pp. 323–324).
Condition: Very much scrubbed and repainted.

Bibliography: See also above; Waagen, 1854, III, p. 202 (Catena); C. and C., 1871, II, p. 168 (incorrectly still placed in Lord Northwick's collection; as in the style of Varotari); Cook, 1907, pp. 93–94, 151 (Giorgione, damaged); Holmes, 1925, p. 272 (follower of Palma); Hendy, 1925, pp. 236–239 (attributed to Titian); Fröhlich-Bum, 1929, pp. 8–13 (Giorgione); Suida, 1935, pp. 29, 184 (*Nymph attacked by Cupid,* by Titian, *c.* 1510); Berenson, 1957, p. 187 (early Titian, repainted); Morassi, 1967, p. 135 (Titian, 1508–1512); Wallace Collection, 1968 (Titian, 1515–1525); Valcanover, 1969, no. 62 (generally attributed to Titian); Pallucchini and Pignatti, 1969 (omitted).

COPY:
Follina (Treviso), Marchese Serra di Cassana; probably late sixteenth century; canvas, 1·04 × 1·42 m.

LOST WORKS

L–1. Allegories of Brescia (destroyed in 1575)

Figures 66, 68

Brescia, Palazzo Comunale, Great Hall.

Documented in 1565–1568.

The detailed descriptions of the three allegories in the ceiling of the Palazzo Comunale are contained in a document of instructions sent by the Brescian authorities to Titian in 1565. No specific clue reveals the identity of the author of this elaborate *libretto* for the three paintings. Zamboni (1778, p. 77, note 33) thought that the most likely candidate would be Francesco Richini (*c.* 1518–1568), an architect, painter, and poet, who possessed a considerable knowledge of mythology and of antiquity (see also Fenaroli, 1877, pp. 200–201).

In May 1563 Cristoforo Rosa agreed to carry out the decorative part of the ceiling of the Council Hall, which was covered in an elaborate scheme of architectural illusionism. He spent five and a half years on this commission, only to see it destroyed by fire seven years later (Schulz, 1961, pp. 96–97). A contemporary description of the Council Hall (supplement to Cavriolo by Spini, 1585, pp. 320, 332–334) is so verbose, repetitious and confused that it is extremely difficult to distill a few important facts. He tells us that the Great Hall of the Palazzo Publico on the main square was destroyed by fire in January 1575. The *Allegory of Ceres and Bacchus* is incorrectly called 'Pallas and Bacchus'. The passage ends with a paean of praise for this 'Open Paradise' ('e girandosi intorno si è lecito di vedere in ogni parte il Paradiso aperto').

History of the Commission: In the autumn of 1564 Titian visited Brescia to arrange for the painting of the three canvases and he received an advance payment of 150 *scudi*. The trip to Brescia is remarked upon in García Hernández's letter to Gonzalo Pérez on 9 October 1564 (C. and C., 1877, II, p. 533; Cloulas, 1967, p. 267). In the fall of 1568 the *Allegory of Brescia* and *Vulcan with the Cyclopes* were exhibited by Titian in the church of San Bartolommeo al Rialto at Venice (G. B. Cadorin, 1875 and 1878). At the end of October the three were taken by Orazio Vecellio to Brescia and placed in the hands of Cristoforo Rosa, who is called Titian's *confidente* (Zamboni, 1778, p. 143). When Orazio went to collect payment in January 1569, the sum of 1000 ducats was offered because the three works did not seem to be by Titian himself, a judgment that Orazio refused to accept (Cadorin, 1878, p. 13). Finally Titian wrote a long and dignified letter of compromise to the bishop of Brescia on 3 June 1569, asking that the affair be considered closed (all data published by Zamboni, 1778, pp. 75–80, 139–144). Documents: see below pp. 251–255.

Bibliography: See also above; Vasari (1568)–Milanesi, VI, pp. 510–511 ('tre quadri di pitture a olio di braccia dieci l'uno, iquali dipinge Tiziano vecchio'); Spini in Cavriolo, 1585, pp. 320, 332–334; Ridolfi (1648)–Hadeln, I, pp. 177, 272 (mention); Zamboni, 1778, pp. 76–80; original description and letters: pp. 139–144; C. and C., 1877, II, pp. 345, 383–386; Cadorin, 1878 (based upon the documents in Zamboni); Tietze, 1936, II, p. 285 (brief resumé); Tietze-Conrat, 1954, pp. 209–210 (Rubens' drawing); Valcanover, 1960, II, p. 59, pl. 197; Pallucchini, 1969, pp. 181–182, 185, 339, fig. 590.

L–2. Angelica and Medoro

Inventory of Alessandro Ruffinelli, Rome, 1647, '115. Un quadro d'Angelica, e Medoro—viene da Titiano con Cornice fatta di Mischio di grandezza p.mi 5 incirca per traverso.' We have no proof that Titian ever painted this subject, although the drawing at Bayonne (Cat. no. 25) has occasionally been said incorrectly to illustrate this theme from Ariosto's *Orlando Furioso*.

Bibliography: Lewine, 1962, p. 313.

L–3. The Battle (on canvas)

Figures 51–61

Venice, Doge's Palace, Hall of the Great Council.

Documented: First project 1513–1516; final project 1537–1538.

The Subject: The subject of the mural was given simply as the 'Battle' by early writers, first by Dolce in 1557 (edition Roskill, 1968, p. 190). Slightly later, in his description of the mural, Francesco Sansovino called it the *Battle of Spoleto* (Sansovino, 1581, edition 1663, p. 327), and placed it as number 5, in the series of twenty-two murals in the Great Hall of the Ducal Palace, all devoted to the struggle between Pope Alexander III and Emperor Frederick Barbarossa. To add to the confusion, Vasari (1568–Milanesi, VII, p. 439) erroneously dubbed it the Battle of Chiaradadda (i.e. Agnadello), in which the Venetians were disastrously defeated. It is generally agreed that the Great Council was not in the habit of commemorating such a catastrophe. No one has yet proposed that Vasari, who was not a great admirer of the Venetians, knew perfectly well that the battle had been lost, and that he so named the picture with sarcastic intention.

Ticozzi (1817, p. 114) and Borghini in 1584 (p. 526) followed Vasari in this detail, as they did in many other respects. Vasari was again the obvious source of Vicente Carducho, who spelled it at Madrid in 1633 as Geradada (edition 1933, p. 77). An early case in which the mural becomes the *Battle of Cadore* is in the inventory of Bartolomeo della Nave's collection, c. 1639 (Waterhouse, 1952, p. 19, no. 162). Ridolfi (1648–Hadeln, I, pp. 165–166) in a lengthy description confirms the same tradition, and virtually every writer since has accepted the subject as the battle of March 1508 (described by Sanuto, VII, columns 347–351), when the Venetians defeated the Emperor Maximilian I near Titian's birthplace of Cadore. It is interesting to note that none of these early writers was troubled that a recent battle should be inserted in a series of semi-legendary events of the twelfth century.

Guariento had painted (c. 1365–1368) that mythical event, the *Battle of Spoleto*, on the wall of the Sala del Gran Consiglio on the side facing the island of San Giorgio. Below his large fresco were the words: VRBS SPOLETANA QVAE SOLA PAPAE FAVEBAT OBSESSA ET VICTA AB IMPERATORE DELETUR (Lorenzi, 1868, p. 61). This battle supposedly took place between the imperial German forces and those of the pope Alexander III in 1155 and in it the Venetians had no part. The Venetian enthusiasm for the Alexander series lay in their gratitude to the pope for his defence of their state. The largest part of this series had been painted by the Bellini family. Gentile had done numbers 9–14 and Giovanni numbers 8, 20–22. To Carpaccio were apparently assigned numbers 18, 19 and to Alvise Vivarini number 15 (see Wickhoff, 1883, pp. 14–32), although Vivarini originally had three (Lorenzi, 1868, no. 296). In addition to Titian's *Battle* the most recent were those of Tintoretto (numbers 1 and 4), Veronese's (number 3), Pordenone's (numbers 6, 7) and Orazio Vecellio's (number 2, my Cat. no. L–4), all of them having subjects of the Alexander–Frederick Barbarossa legend.

In the devastating fire of 1577 the entire set of murals was destroyed. They were replaced by the present series of great historical canvases (see Zorzi, Bassi, Pignatti, 1972, pp. 277–283). After the fire there was a change in the subject matter and the legend of Alexander III was reduced to one wall on the side of the court. For one of the compartments of the ceiling Francesco Bassano painted the *Battle of Cadore*. Here, in addition to the Cornaro banner, the flag of Venice with the Lion of St. Mark quite reasonably and correctly is carried by the Venetian soldiers. The wall toward San Giorgio, on which Titian's canvas was formerly located, received a series of episodes dedicated to the Fourth Crusade and the Venetian Conquest of Constantinople (1201–1204). One of the most exhaustive accounts of the problem of the *Battle of Cadore* versus the *Battle of Spoleto* was that of Crowe

and Cavalcaselle, who held that the latter title was employed in order not to offend Emperor Charles V, whose grandfather had been defeated at Cadore (C. and C., 1877, II, pp. 8–17). They pointed out that the inscription below Guariento's fresco, quoted above, was omitted when Titian covered it, and they thought that Andrea Gritti, the Doge, proposed a change to the *Battle of Cadore*, a recent and highly significant Venetian victory.

Tietze-Conrat in her scholarly account of the problem (1945, pp. 205–208) preferred to believe that Titian's mural was a slightly new version of the old *Battle of Spoleto*. She argued that later artists such as the Bellini and Titian merely revised and *restored* the old frescoes of Guariento, Pisanello and Gentile da Fabriano 'retaining as much as possible of the old compositions'. She credited Wickhoff (1883, pp. 1–37) with this 'brilliant discovery' (Tietze-Conrat, 1945, p. 206). She even speculated that Titian took over the framework of Guariento's original composition—the castle on the mountain and the deeply embedded river. She also placed considerable importance upon the fact that Guariento gave horses a prominent part in the scene, just as Titian did. Marcantonio Michiel (edition 1888, p. 34), in 1537, writing of Guariento's frescoes in the Palazzo del Capitano at Padua refers to 'the history of Spoleto in the Consiglio at Venice, the history which Titian *covered*' ('l'istoria de Spoliti nel consiglio de Venetia, la qual istoria Titiano coperse'). Nothing about the small painted copy of Titian's lost *Battle*, the engravings, or the studies for horsemen supports her hypothesis of following the general disposition of an older composition (Figures 51–54, 59–61). Moreover, a canvas placed over Guariento's fresco could hardly be even a remote restoration.

The vast historical canvases in the Sala del Gran Consiglio of the Ducal Palace, all of them done after the fire of 1577, prove that each artist painted in the style of his own period. Even Tietze-Conrat agreed that Francesco Bassano's *Battle of Cadore*, which replaced Titian's lost work and still exists in the ceiling of the Hall of the Great Council, shows no points of contact with Titian's composition. The Alpine landscape in Fontana's print and the Uffizi copy (Figures 51 and 54) lend credence to the belief that Titian was inspired by his native countryside.

The device on the very prominent banner carried by the apparently retreating soldiers on the left side in Fontana's engraving after Titian's *Battle* (Figure 54), as well as in the painted copy in the Uffizi (Figure 51), is certainly the black eagle of the Empire, but it is not clear whether it is the double-headed eagle of the Hapsburgs or the single-headed eagle of the Hohenstaufens. Almost lost in the distance behind the action on the bridge is a massed, motionless group of soldiers displaying several battle flags, the most conspicuous of which is a large one bearing a white cross on a red ground. This is the symbol of the Christian church,

which continued to be used occasionally during the Renaissance at papal coronations and appeared on the banner carried at the entry of Julius II into Bologna during the War of the League of Cambrai (Galbreath, 1930, p. 5). Since this composition apparently represents the battle of Spoleto between Alexander III and Emperor Frederick Barbarossa, it is curious that these soldiers with the cross banner are encamped in the distance and do not participate.

On the other hand, observers who interpret this scene as the battle at Cadore of 1508, with the retreating Austrian forces at the left and the victorious Venetians at the right, find no aid in solving the problem of the subject matter in the other flags in the composition. The identity of the banner of the galloping victorious soldiers on the right side in Fontana's engraving has not been satisfactorily established. It shows three lions *passant [guardant]*, asserted by Crowe and Cavalcaselle (1877, II, pp. 11, 13), followed by Panofsky (1969, p. 181), to be the device of Giorgio Cornaro, brother of Queen Caterina Cornaro, one of the Venetian leaders in the campaign of Cadore. However, as the dispatches to the Venetian government, published in Sanuto's diaries, demonstrate (letter of d'Alviano to Doge Leonardo Loredan, 10 March 1508, Sanuto, VII, columns 347-351), Cornaro, who was 'provveditore', was not even on the field. A few hours after the battle, Cornaro wrote to the Serenissima that he had 'seen at Valle the place of the conflict, nearly 1100 corpses strewn about, and it was all snow and blood' ('aver visto a Valle il locho di conflito, corpi si spogliavano fin 1100 qui, era neve e sangue'; Sanuto, VII, column 330). Tietze-Conrat (1945, p. 206) explained the presumed presence of the Cornaro arms in Titian's *Battle* because the Doge Marco Cornaro in 1365-1368 had commissioned the *Battle of Spoleto*, which Guariento had painted in fresco on the same portion of the wall. She did not establish what the Cornaro arms might be.

The Cornaro escutcheon was normally gold and blue 'per pale' (divided vertically down the centre) charged with a crown counterchanged. Francesco Bassano in his *Battle of Cadore* painted the more elaborate coat-of-arms used by the branch to which Giorgio and Queen Caterina Cornaro belonged: the above device impaled with a quartered shield showing at the upper left a cross of St. John of Jerusalem, red on a silver field, at the upper right a lion rampant red (?) on a field of silver with two bars azure, at the lower left and right apparently similar quarters with a lion rampant (colour indistinguishable) on a field of silver, a gold crown over the head of the lion [Rietstap, 1884, gives different colours for all of these quarterings]. This quartered shield is the escutcheon of the Lusignan kings of Cyprus, and only Queen Caterina as wife and widow of the last Lusignan ruler actually had a right to it. However, it appears in Venice on the tombs of her close relatives for some generations.

The three passant beasts in Fontana's print [properly called leopards or lions passant guardant; see above, note 248] occur on no Cornaro escutcheon whatever, and since neither the elder nor the younger Crollalanza (1886, 1964) lists such a device, they apparently existed on no other Venetian coat-of-arms either. However, they do appear in the German regions on the borders of the Venetian domains. In the late mediaeval wall paintings of the Castle of Runkelstein in the outskirts of Bolzano in the Tirol, a frieze of escutcheons in the Neidhartsaal shows one with a field of gold charged with three black leopards (Neuwith, 1893, fig. 33), but the text does not identify it. The three leopards were also the device of the Austrian province of Carinthia, which then bordered the Venetian lands on the north-east. A sixteenth-century battle standard of Carinthia, with three black leopards on a field of gold, hangs in the Corridoio dei Cardinali in the Museo di Palazzo Venezia, Rome.

The fourth battle flag, striped horizontally in silver and red, which appears in the painted copy in the Uffizi (Figure 51), as well as in Fontana's print and another anonymous print (Figure 52), is identified by Panofsky (1969, p. 181) as that of Bartolomeo d'Alviano, the Venetian general at Cadore. However, the d'Alviano shield is quartered, the first quarter displaying four gold lilies on a blue field, the second a red rose on a field of silver, the third a red cross on a field of silver, and the fourth diagonally striped ('Bandato') with red and silver. This escutcheon was not used by Bartolomeo d'Alviano on his battle-flag, which, extraordinarily enough, displayed a unicorn purifying a spring (Gelli, 1916, pp. 640-641). Oddly, the horizontally striped banner is identical with that of the great Venier family of Venice, whose only connection with the Battle of Cadore seems to be that an Alvise Venier was a 'Savio' of the Great Council during the tense period of late 1507 and early 1508, just prior and subsequent to the conflict. [For all of these escutcheons see Rietstap, 1884; Rolland, 1938; and Crollalanza, 1888]. That this red and silver banner is also that of the city of Cremona (Spreti, 1928-1936, IV, p. 849) likewise provides no clarification of the subject. Cremona joined the Lombard League against Frederick Barbarossa, but took no part in the decisive battle of Legnano of 1176 when Barbarossa was defeated. From 1499 to 1512 Cremona was under Venetian rule and Titian may have thought the flag suitable for Spoleto (see *Encyclopaedia Britannica*, 11th edition, VII, pp. 407-408 and XVI, pp. 379-380). [Material on escutcheons and battle flags and the data from Sanuto contributed by Alice S. Wethey].

Documentation:

9 August 1494: 'Piero Peroxin [Perugino] el qual ha tolto adepenzer nela Sala de gran Conseio uno Campo tra una fenestra e l'altra in ver San Zorzi tra el qual Campo et el

Campo de la historia dela Charitade, e uno altro campo over quadro; el qual campo ha tolto a depenzer si e da una fenestra al altra e sono tre volti compidi e mezo, nel qual die depenzer tanti dogi quanti achadera et quella historia quando il Papa scampo da Roma et la bataia seguida di soto, havendo a compir quella cossa achade in cima di le finestre oltra la mitade' (Lorenzi, 1868, p. 111, no. 237). This document refers only to 'that story when the pope escaped from Rome and the battle which followed', i.e. the mythical battle at Spoleto (see Lorenzo, p. 61, no. 153).

On 31 May 1513 Titian had been granted by the Council of Ten his petition to paint a 'Battle' for the Sala del Gran Consiglio ('de venir a depenzer nel Mazor Conseio . . . dal teller nel qual e quella bataglia de la banda verso de piaza ch'è la più difficile'). He asked for the broker's patent ('Sansaria in Fontego di Todeschi') whenever it would become vacant ('che quovismodo venira ad vachar') under the same conditions as those then held by Giovanni Bellini (Lorenzi, 1868, p. 157, no. 337; p. 219, no. 462). He did not ask to replace his former teacher (see Crowe and Cavalcaselle, who imagined a quarrel between the elderly Giovanni Bellini and Titian; refuted by Wethey, I, 1969, pp. 10–11). Sanuto (XVI, column 316) under date of 29 May 1513 refers to the same petition and authorization to paint in the Gran Consejo without salary like the other artists: 'In questo Consejo di X simplice, fu preso che Tiziano pytor debbi lavorar in sala dil Gran Consejo come i altri pytori, senza però alcun salario, ma la expectativa solita darsi a quelli hanno pynto ch'è stà Zentil et Zuan Belin et Vetor Scarpaza.'

Ten months later, on 20 March 1514, the Council of Ten revoked any promise of a future patent (Lorenzi, 1868, p. 159, no. 341). They also decreed on 20 April 1514 that 'Antonio Buxei and Lodovico de Zuane de Veniexia' be given no more salary (Lorenzi, 1868, p. 160, no. 342). These two men were probably Titian's helpers ('garzoni'). Titian replied on 28 November 1514 that he did not ask for the broker's patent before the death of Giovanni Bellini and that he requested only money for the colours and the salaries of his two helpers ('do mei zoveni et dagino di colori'). The Council of Ten then agreed (Lorenzi, no. 344). Titian also explained that he had already prepared *modelli* (small finished studies) for his picture (i.e. the 'Battle') and that they were in his studio in the house of the Duke of Milan at San Samuele (Lorenzi, 1868, pp. 160–161, nos. 344, 345). This is an important detail because it proves that as early as 1514 Titian did prepare *modelli*, i.e. relatively detailed studies for important compositions. We have no record at all of the artist's ideas for the battle scene at that time. Suida's theory that the first scheme in 1514 is reflected in Domenico Campagnola's scramble of nude men dated 1517 (Suida, 1936, p. 287, fig. 12) carries no conviction.

They contain no remote hint of Titian's style then or at any other time. At the end of December 1515 Sanuto (XXI, column 426) made the laconic statement that the Colegio had made a new contract with Titian. This item probably concerns the 'Battle'.

18 January 1516: Titian claimed that he had long worked on the picture first commissioned of Perugino. He asked only for payment for colours and the salaries of two youths who assisted him and half of the 400 ducats promised to Perugino. The Council agreed to pay for colours and 300 ducats on completion of the work (Lorenzi, 1868, pp. 165–166). One of the strongest arguments in favour of the subject being the *Battle of Spoleto* is this statement by Titian that this commission had first been given to Perugino.

On 29 November 1516 the venerable Giovanni Bellini died and a few days later, on 5 December, Titian's application for the salt brokerage (Sansaria), which was the only source of payment, was conceded by the Council of Ten (Lorenzi, 1868, p. 166, no. 356). The document of 1537 confirms that Titian received the vacancy left by Giovanni Bellini on 5 December 1516 (Lorenzi, p. 219, no. 462): 'da poi del 1516 a 5 di Decembre fu dechiareto che senza spettar la vacantia di essa dovesse entrar in quella che haveva Zuan Bellini cum conditione che fusse obligato depinger el teler de la bataglia'. The early documents are confusing, because only in a few cases do they specify which of two murals in the Sala del Gran Consiglio was involved. Moreover, the Council frequently reversed its decisions. The entry of 31 May 1513 specifically identifies the 'Battle' whereas those of 1522 and 1523 refer to the completion of the *Humiliation of Emperor Frederick Barbarossa* (Lorenzi, 1868, p. 175, no. 373), because that was next to the door and not on the wall facing the church of San Giorgio (Cat. no. L–6). Moreover, in 1581 Sansovino observed that the *Humiliation* was Titian's first mural (Sansovino, 1581, folio 129v).

The 'Battle' was repeatedly put off after the completion of the *Humiliation* in 1523. The artist's fame had spread abroad, and requests for his services came from the great princes of Italy, as well as from Emperor Charles V. Finally on 23 June 1537 the Great Council stated that Titian had contracted to paint the 'Battle' in 1513, and threatened to demand the reimbursement of all moneys given hitherto to him ('L'andera parte che il ditto Tician de Cadore pictor sia per auctorita di questo conseglio obligato et astretto ad restituir alla Signoria nostra tuti li danari ch l'ha avuto della predetta sansaria per il tempo ch'el non ha lavorato sopra el teler predetto nella sala, come e ben ragionevole'; Lorenzi, 1868, p. 219, no. 462). Thereupon, Titian set to work and finished the *Battle* in great part that summer, as proved by Aretino's letter of 9 November 1537 (*Lettere*, edition 1957, I, pp. 78–79; a mention only in a letter to Titian). Nevertheless, some work remained to be done as late as 30 November 1537, when a

laconic document concedes to Titian permission to continue his painting in the Sala del Gran Consiglio (Ludwig, 1911, p. 134). Finally on 10 August 1538 Benedetto Agnello, Mantuan ambassador at Venice, wrote to Federico Gonzaga that Titian had finished the picture in the Sala del Gran Consiglio so that he could then devote his time to the painting of the *Roman Emperors* for Mantua (Luzio, 1900, p. 209).

Further Bibliography: Vasari (1568)–Milanesi, VII, p. 439; Gilbert, 1869, pp. 154–191 (a long account of the actual battle at Cadore but without knowledge of d'Alviano's letter); C. and C., 1877, II, pp. 6–17 (identified as the *Battle of Cadore*); Lafenestre, 1886, pp. 176–181; Wickhoff, 1883, pp. 1–37 (general history of the murals in the Sala del Gran Consiglio until their destruction by fire in 1577); Gronau, *Titian*, 1904, pp. 110–114 (*Battle of Cadore*); Hourticq, 1930, pp. 162–169 (argues for the concealing of the title of the *Battle of Cadore* because of Venetian friendship with Charles V, whose grandfather's forces were defeated there); Tietze, 1936, I, pp. 129–131; Suida, 1935, pp. 76–78 (description of the copies); Tietze-Conrat, 1945, pp. 205–208 (opinions cited in the text); Panofsky, 1969, pp. 180–182 (accepted the subject as the *Battle of Cadore*); Pallucchini, 1969, pp. 88–89, figs. 565, 566 (*Battle of Cadore*; Leonardesque influences).

DRAWINGS:
The several important drawings by Titian for the mural of the *Battle* are unprecedented in number among all of the artist's preparatory studies for his paintings. They are listed below, more or less in order of importance.

1. The Battle Figure 53
Paris, Louvre, Inventory no. 21,788.
Black crayon with highlights in white chalk on blue paper, which is squared. 383×445 mm.
Collector's mark: M. L. [Musée du Louvre].
Titian.
About 1537.

The rapid nature of this sketch giving the general conception of the large mural explains why it was overlooked as a work of no importance until Tietze-Conrat (1948, pp. 237–242) realized for the first time its extraordinarily high quality and its undoubted significance as Titian's first study for the mural. The shape of this drawing is further evidence that the mural was less oblong than the engraving by Fontana, who added a group of soldiers on horseback and the banner with three lions passant at the right side (Figure 54). None of these additional elements exists in Titian's preliminary sketch in Paris, in the painted copy of the Uffizi, in Rubens' drawing in Antwerp, or in the anonymous print in Vienna (Figures 51, 52, 56).

Bibliography: Tietze-Conrat, *op. cit.*, 1948; Paris, Louvre, 1962, no. 18; Paris, Louvre, Dessins, 1965, no. 104 (for *Battle of the Bridge*); Bacou, 1968, no. 46 (Titian, study for *Battle of the Bridge*); Pallucchini, 1969, p. 332, fig. 565 (*c.* 1537, study for *Battle of Cadore*); Panofsky, 1969, pp. 179–182, fig. 189 (likewise).

2. Horseman and Head of a Wounded Man
Figures 55, 59
Greenish paper. Black crayon and gesso, 524×395 mm.
Florence, Uffizi, Gabinetto dei Disegni, Inventory no. 12,915F.
Titian.
About 1537.

The soldier on horseback had already been associated with Titian's studies for the *Battle* by Gino Fogolari in his catalogue for the *Mostra di Tiziano* in 1935 (p. 213, no. XIV). Tietze-Conrat (1936, fig. 52) supported this discovery, which is now widely accepted. The same horseman is identifiable at the left side in Cort's print and in the Uffizi painting next to the Imperial banner.
On the reverse of the sheet is the head of an anguished, wounded man, which has been called a study of a Moor (?) for the *Battle of Cadore* and related in style to the captive at the extreme left in the Pesaro Madonna (Tietze and Tietze-Conrat, 1944, p. 317, no. 1908). Were there any Moors in this battle? That possibility has not been established. It seems sufficient to regard the head as a study of the terrible pain which a victim of the battle was suffering.

Bibliography: Loeser, 1922 (not listed); *Mostra di Tiziano*, 1935, p. 211, no. XIV (for *Battle of Cadore*); Tietze-Conrat, 1936, fig. 52 (Titian, for the *Battle of Cadore*); Tietze and Tietze-Conrat, 1936, pp. 155–156, and 191, nos. 20, 21; Tietze, 1950, p. 407 (same opinion); Suida, 1936, p. 104 (mention of Horseman, Florence); Fröhlich-Bum, 1938, p. 445 (the Uffizi horseman and the head do not even belong to Titian's circle!); Tietze and Tietze-Conrat, 1944, p. 317, no. 1908 (study for *Battle of Cadore*, c. 1525); Pallucchini, 1969, p. 332, fig. 566 (study for *Battle of Cadore*, c. 1537); Panofsky, 1969 (no mention).

3. Horseman Figure 61
Blue paper. Black crayon with white highlights on squared paper, 350×250 mm.
Munich, Graphische Sammlung, Inventory no. 2981.
Titian.
About 1537.

A soldier, in armour of the antique type which gives the appearance of a nude body, holds a sword in his right hand over the horse's head and in the left he carries a shield. A large helmet appears to carry plumes at the top. Drapery, flying from beneath his right arm, adds to the excitement created by the rearing horse. Beneath the horse lies a prone man in a foreshortened position with his legs forward. The charging horse somewhat recalls that of the Uffizi drawing but no group exactly like the Munich rider can be recognized in the Cort print or in the Uffizi painting. Herein lies the reason for the Tietzes' doubts that it belongs to the so-called *Cadore* composition. Nevertheless, changes in an artist's intentions are by no means infrequent.

History: Collection of Elector Karl Theodor von der Pfalz.

Condition: A few smudged spots on the paper. The number 410 in a modern hand is written in the lower centre.

Bibliography: Hadeln, 1924 (omitted); Baumeister, 1924, p. 20 (both the Munich and Oxford drawings were preparatory for the *Battle of Cadore*); Frölich-Bum, 1928, p. 197, no. 30 (study for *Battle of Cadore*); Tietze-Conrat, 1936, pp. 54–57; Tietze, 1936, fig. 268; Tietze and Tietze-Conrat, 1936, pp. 155–156; *idem*, 1944, p. 321, no. A1941; Tietze, 1950, p. 408 (in all references they doubt the association of the Munich drawing with the so-called *Cadore* and suggest that Titian prepared this study in connection with Orazio Vecellio's mural of a *Battle between Frederick Barbarossa and the Romans* (1562–1564), since Vasari (1568–Milanesi, v, p. 588) reported that Titian had helped his son (see Cat. no. L–4); Dussler, 1938 and also 1948, no. 33 (*c.* 1535, for *Cadore*); Ames, 1962, no. 212 (Titian, no explanation); Pallucchini, 1969, pp. 173–174, 333, fig. 573 (*c.* 1562–1564, study for Orazio Vecellio's mural, thus accepting the Tietzes' theory).

4. Horseman Figure 60

Black chalk on grey paper. 274×262 mm.; paper squared with red chalk.

Oxford, Ashmolean Museum, Cat. no. 718.

About 1537.

Colvin (1903–1907) first proposed that this drawing was part of a study for a *Conversion of St. Paul*. Josiah Gilbert (1868, p. 188) had associated the *Horseman* with the *Battle of Cadore* and this opinion is the one which has largely prevailed. The drawing does have a convincing counterpart in the man in the left foreground of Fontana's print (Figure 54), and in Rubens' drawing (Figure 56), the one who is about to fall

off the frightened horse. Tietze-Conrat in 1936 believed that the drawing was preparatory to Orazio Vecellio's mural of a battle (Cat. no. L–4) between the Romans and Frederick Barbarossa (Vasari (1568)–Milanesi, vi, p. 589), and Pallucchini in 1969 supported this view.

Condition: Discoloured by several water spots on the lower and right edges.

History: (As published by Parker, 1956, ii, pp. 384–386): Lanière Collection (Lugt, no. 2886); J. Richardson (Lugt, no. 2184); Benjamin West (Lugt, no. 419; sale 10 June 1820, no. 85); Lawrence (Lugt, no. 2445); Esdaile Collection (Lugt, no. 2617); Wellesley Collection (sale Sotheby's, 4 July 1866, no. 1598); Josiah Gilbert; gift of Mrs. Gilbert in 1895 to the Ashmolean Museum.

Bibliography: Gilbert, 1868, p. 188 (see above); C. and C., 1877, ii, pp. 16–17 (rejected the attribution to Titian of the Oxford drawing); Colvin, 1903–1907, ii, pl. 40 (study for a *Conversion of St. Paul*); Hadeln, 1913, fig. 9 (study for *Battle of Cadore*); Hadeln, 1924, fig. 26 (not surely for the *Battle of Cadore*); Fröhlich-Bum, 1928, p. 197, no. 28 (study for the *Battle of Cadore*); *Mostra di Tiziano*, 1935, no. xiii (for the *Battle of Cadore*; in that catalogue but never shown); Tietze, 1936, ii, fig. 267; Tietze-Conrat, 1936, pp. 54–57, fig. 53 (study for Orazio Vecellio's mural of 1562–1564); Tietze and Tietze-Conrat, 1936, pp. 155–156; *idem*, 1944, p. 323, no. 1949; Tietze, 1950, p. 408 (same opinion); Parker, 1956, pp. 384–386, no. 718; Ames, 1962, no. 213 (Titian, no explanation); Parker, 1958, no. 20 (for *Battle of Cadore*); Pallucchini, 1969, pp. 173–174 (study for Orazio Vecellio's mural, *c.* 1562–1564).

RELATED WORK:

Head of a Frightened Horse.

Black chalk. 290×273 mm.

Location unknown (formerly Dr. Johann Török).

In 1972 Mrs. Fröhlich-Bum was unable to supply further information about this drawing, which she had seen about forty-four years earlier. The owner, Reverend Török, was last listed in the Pittsburgh telephone directory in 1942 (information by courtesy of Leon Arkus, director of the Museum of Art at Pittsburgh). The attribution appears reasonable, although difficult to confirm in a small illustration.

History: Wilhelm König's collection, Vienna; Dr. Johann Török, Vienna; Török sale, American Art Galleries, New York, 8 November 1928, no. 147, illustrated.

Bibliography: Frölich-Bum, 1928, p. 198 (Titian, for the *Battle of Cadore*); Leporini, 1927, fig. 29 (Titian); Tietze-Conrat, 1936, p. 158, note 57 (Titian, for the wood-cut in the *Destruction of Pharaoh* by Domenico delle Greche after Titian's design); Tietze and Tietze-Conrat, 1944, p. 325, no. 1965 (similar horse in the *Passage of the Red Sea* (1549) (same subject and same opinion).

PRINTS:

1. Giulio Fontana (Figure 54). The print is inscribed at the lower right: *Titianus inventor Julius Fontana Veronen*, and at the left: *appresso Luca Garimoni*. Said to be dated 1569 (Bartsch, XVI, 1870, p. 214), but I can find only *Titianus inventor* on the prints in Paris and in the Warburg Institute, London. The procession of horsemen at the right side and the banner with the lions passant guardant were added by the engraver, who omitted the flag with rose stripes on white that is found in the three other representations of the *Battle* (Figures 51–53). He modified the composition to a broader shape and also added details in the landscape.

2. Anonymous Print, Vienna, Albertina (Figure 52); cited by Tietze-Conrat, 1924, p. 43, Abb. 2, this composition corresponds to the painted copy in the Uffizi (Figure 51) and in general elements to the drawing in the Louvre (Figure 53). It helps to prove that the procession of horsemen and the large flag with 'leopards' [lions passant guardant] were added by Giulio Fontana, the engraver, at the right side of his print.

COPIES:

1. Antwerp, Cabinet des Dessins, Musée Plantin-Moretus (Figure 56). *The Battle*, 410×536 mm., pen and wash, heightened with white; attributed to Rubens. This drawing reproduces, in sketchy style, the anonymous print rather than the left side of Fontana's print (Figure 54) after Titian's *Battle Scene*. Dr. Justus Müller Hofstede doubts (orally) that the quality justifies the attribution to Rubens. *History:* Crozat sale, Paris, 1741, no. 814; Lempereur sale, 24–28 June 1773, no. 295, sold to 'Francois', described as 'La Bataille de Ghiaradda' (this first reference was known to Jaffé, 1958, p. 236, note); another reference to the same drawing in the same Lempereur sale is dated 1775 and is said to represent the Venetian victory over the imperial forces, accompanied by a poor print (Blanc, 1857, I, p. 305); Pougnan Dijonval (cat., 1810, p. 38, no. 682); sold 1810 by Morel de Vindé to Samuel Woodburn; from him purchased by Sir Thomas Lawrence; after Lawrence's death in 1830, again acquired by Woodburn, who exhibited it in 1835 with a collection of 100 Rubens drawings (see *Lawrence Gallery*, 1835, no. 9); sold after Woodburn's death, Christie's, London, 4 June 1860, no. 801; H. de Kat (1867); J. F. Ellinckhuysen, Rotterdam (sale, 1878); M. Koster, Brussels, 1878–1907 (Rooses, V, 1892, p. 206, no. 1394; the collections

previous to Sir Thomas Lawrence are different in Rooses' catalogue); Max Rooses (1907), his gift in 1913 to the City of Antwerp (parts of this history were reconstructed by van Gelder (1965, pp. 6–7). *Bibliography:* See also above; Delen, 1938, I, p. 62, cat. no. 189, plate XXXIV (Rubens, 1600–1608; Delen presumed that the drawing was copied from the oil painting in the Uffizi (Figure 51); his list of collections before that of Sir Thomas Lawrence conforms to Rooses'; he established the dates of Koster's ownership); Panofsky, 1969, p. 180 (Rubens).

2. Bergamo, Accademia Carrara. *Head of a Girl* (Figure 57), paper mounted on wood, 370×250 mm. This head corresponds to the figure in the lower right of the copy of *The Battle* in the Uffizi (Figure 51). The fragment, discovered by Fischel in 1922, when it was exhibited as by a follower of Veronese, is most surely a copy. Hourticq's insistence that it is by Titian himself would be difficult to maintain for a fragment on paper. One would have to assume that it was ripped out of Titian's original cartoon. The girl was picked out for special praise when Dolce devoted a few lines to the mural of the *Battle* (1557-edition Roskill, 1968, p. 191): 'The latter includes a young woman who has fallen into a ditch and is climbing out. She uses the bank for support with a stretch of the leg which is highly natural; and the leg gives the impression not of painting but of actual flesh'. *History:* Gift of Galleria Lochis in 1869; an inscription on the back includes the date of 1809 and the name of the city of Bologna. It presumably has reference to a collection in Bologna. *Bibliography:* Fischel, 1924, p. 84 (Titian; perhaps a study for the *Battle of Cadore*); Hourticq, 1930, pp. 166–169 (unquestionably by Titian himself); Tietze, 1936, II, p. 284 (more likely a copy by Leonardo Corona or another follower of Titian). Other writers have omitted this item.

3. Florence, Uffizi (in storage); *The Battle* (Figure 51), canvas, 1·21×1·35 m. According to Carlo Ridolfi (1648)–Hadeln, II, pp. 101–102, Leonardo Corona (1561–1605) made a painted copy of Titian's mural and passed it off as an original by the master. As Corona was only sixteen in 1577, when the original was destroyed by fire, the legend of his copy is difficult to take seriously. Strangely enough, Crowe and Cavalcaselle (1877, II, p. 17) accepted Ridolfi's story literally. *History:* Bequest of Cardinal Leopoldo dei Medici in 1675. *Bibliography:* Uffizi Inventory, 1704, no. 2750; Uffizi, 1927, no. 964. See further in the text.

4. Vienna, Albertina, Inventory no. 8331; paper, bistre, pen and wash, 392×278 mm.; Rubens' drawing apparently based on the left side of Fontana's engraving (Figure 54). Professor Justus Müller Hofstede believes that the old attribution of this sheet to Rubens, *c.* 1600, is correct. Crowe and Cavalcaselle (1877, II, p. 14) suggested that the Albertina drawing may have been copied by Rubens from

an original Titian drawing that is among the items in the Fleming's Inventory of 1640, no. 10 (Lacroix, 1855, p. 270 or Denucé, 1932, p. 57). However, the brief description 'Un dessein de chevaulx de Titian' is not very strong evidence for this theory.

LITERARY REFERENCES:
1. London, Charles I's collection; 'A Battle and a Bridge after Tytsian by Parriss Bouden' (Millar, 1972, p. 272, no. 255; Harley MS., no. 4898, folio 507, no. 225).
2. Oxford, New Inn Hall, Dr. Wellesley; a painted copy; mentioned by C. and C., 1877, II, p. 17; present location unknown.
3. Venice, Bartolomeo della Nave; listed as a 'Conflict of Cadore', square, *palmi* 3 by Leonardo Corona; Marquess of Hamilton, Inventory 1639, no. 162 (Waterhouse, 1952, p. 19); it recurs in the Hamilton Inventory of 1649, no. 20, and passed thereafter to the Collection of Archduke Leopold Wilhelm, Inventory 1659, p. XCVIII, no. 202. [Another battle scene is reproduced by Stampart and Prenner, 1735, pl. 10, engraved; see Garas, 1968, p. 214, no. 202, who assumes that it illustrates the *Battle of Cadore*, but there is no similarity in composition or subject matter.] The description in the Inventory of Leopold Wilhelm of 1659 says that his copy was on wood, and mentions a yellow banner with a black eagle: '202. Ein Stuckh von Öhlfarb auf Holcz, warin ein Pferdt-vndt Fueszvolckher, darunter zu sehen ein gelbes Fändl, darauff ein schwartzer Adler, vndt auf der Seithen ein Statt in Brandt. . . . hoch 4 Span 2 Finger vnd 3 Span 7 Finger brait, Von dem Titiano Copey.'

DERIVATIONS:
1. Bremen, Kunsthalle; Pieter Lastman's *Battle between Constantine and Maxentius*, Inventory no. 1903/4, canvas, 1·615×1·705 m. Clearly inspired by Fontana's engraving of Titian's *Battle* so far as the predominance of the bridge is concerned; Evers, 1942, pp. 227–232, fig. 133; Friese, 1911, fig. 11.
2. Munich, Alte Pinakothek, Rubens' *Battle of the Amazons* (Figure 58); panel, 1·21×1·655 m.; datable 1615. *Bibliography:* Rooses, III, 1890, p. 52, no. 57; Munich, 1958, no. 334.
3. Naples, Gallerie Nazionali di Capodimonte; Luca Giordano's *Battle of the Amazons*, 1·18×1·70 m. Ferrari and Scavizzi, 1966, II, p. 161, fig. 318.

L–4. Battle between the Forces of Emperor Frederick Barbarossa and the Roman Barons near Castel Sant' Angelo (destroyed by fire in 1577)

Canvas(?).

Documented 1562–1564.

Orazio Vecellio.

On 23 October 1562 the Venetian State allotted funds for three new pictures for the hall of the Gran Consiglio (Lorenzi, 1868, pp. 311–314, doc. 665). Neither the artists nor subjects were specified. Two years later, on 12 August 1564, Orazio Vecellio received a payment of 100 ducats for this picture ('Horatio Vecelio falto uno delli quadri novi': Lorenzi, *op. cit.*, p. 326, doc. 689). An additional sum of 100 ducats for the same work is recorded on the last of February 1564, 'more veneto' i.e. 1565 (Lorenzi, *op. cit.*, p. 329, doc. 695). Sansovino (edition 1663, pp. 326–327) in 1581 left the earliest description of this mural, 'In the second [mural] there was represented a fight which took place between the followers of the Emperor (Frederick Barbarossa) and the Roman people. The Germans being suspicious at the wile of some barons, they fought on the fields of Nero and the Germans were pursued almost to the pavilion of the Emperor, and this was the work of Oratio Vecellio, son of Titian, where among other notable things one saw an armed horse of great beauty and there was an inscription:

ROMANI FAMILIAM IMPERATORIS A PRATO NERONIS

A description of the picture by Giorgio Vasari (1568–Milanesi, VI, p. 589), who also saw it before the devastating fire in the Ducal Palace in 1577, reads '. . . a fore-shortened horse which jumps over an armed soldier which is very beautiful, but some think that Orazio was aided by Titian, his father, in this work'. On the basis of this statement, Tietze-Conrat in 1936 and later collaborating with her husband in 1944, preferred to date the two drawings of *Soldier on Horseback*, one in Munich and the other in Oxford (Figures 60, 61), in 1562 and to regard them as studies for Orazio's *Battle*. Other writers have continued to consider them as preparatory for Titian's *The Battle* and datable about 1535. The Tietzes placed the Uffizi drawing much earlier *c.* 1525, a study for the *Battle of Cadore* (see Cat. no. L–3, item no. 2). The Oxford *Horseman* (Figure 60) has a close counterpart in Titian's *The Battle*, but the rider on the sheet at Munich (Figure 61) cannot be paralleled there. However it may be a study which Titian decided he did not need. The chief argument in favour of this drawing as preparatory for Orazio's mural is Vasari's mention of a 'foreshortened horse who jumps over an armed soldier'. There the matter rests without positive resolution.

Bibliography: See also above; Ridolfi (1648)–Hadeln, I, p. 221, essentially repeats Vasari since the mural was destroyed long before his birth; C. and C., 1877, II, p. 485 (mention); Panofsky, 1969 (omitted); Pallucchini, 1969, pp. 173–174, 211, fig. 573, accepts Titian's drawings at Munich and Oxford as preparatory for this mural rather than for *the Battle* (Cat. no. L–3, Figures 60, 61).

Brescia, Allegories of, see: Cat. no. L–1.

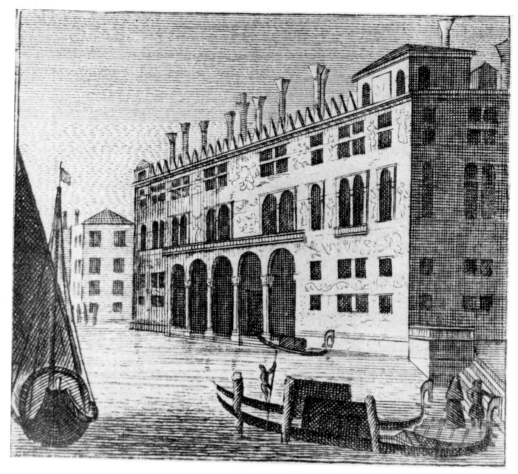

Fig. 1. Albrizzi's Print: *Fondaco dei Tedeschi* (1772)

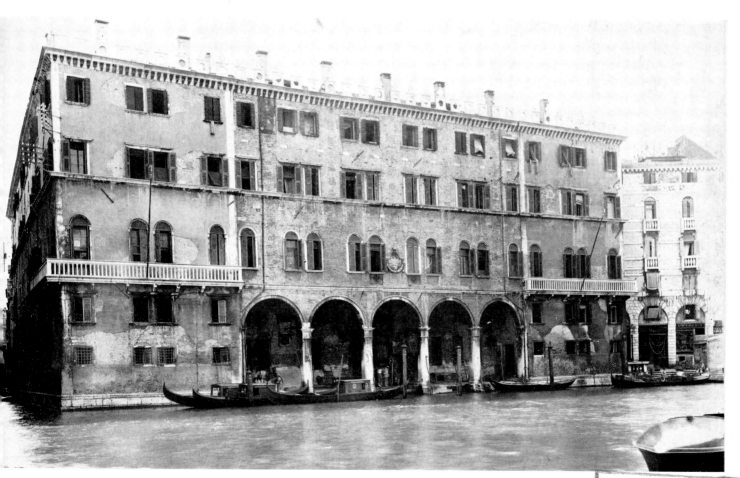

Fig. 2. *Fondaco dei Tedeschi*, Western Façade (*c.* 1930)

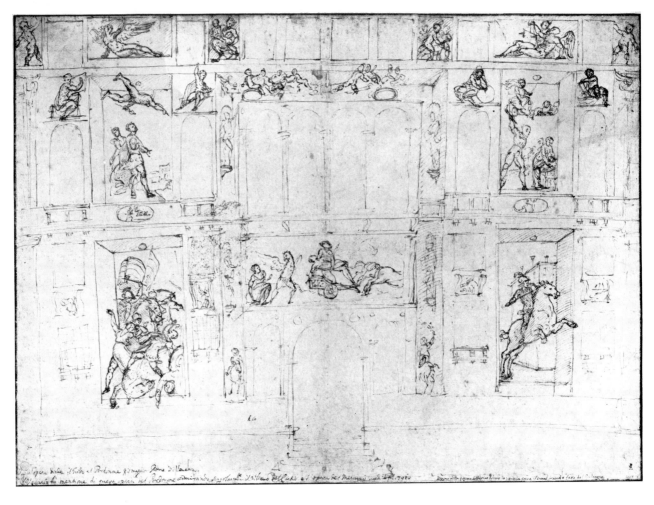

Fig. 3. Drawing of the *Façade of the Palazzo d'Anna*. Sixteenth century. London, Victoria and Albert Museum

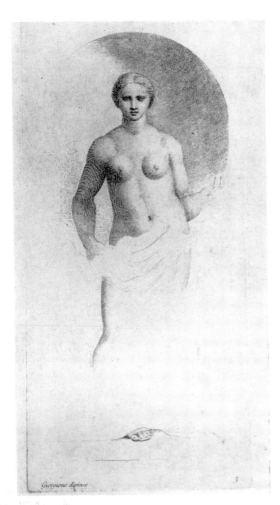

Fig. 4. Giorgione: *Female Nude*
(after Zanetti, 1760)

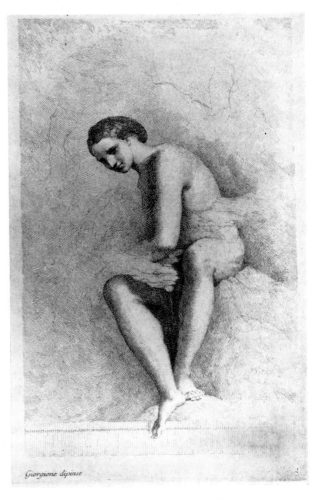

Fig. 5. Giorgione: *Seated Nude Girl*
(after Zanetti, 1760)

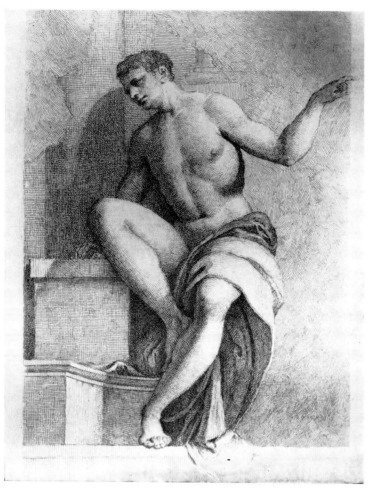

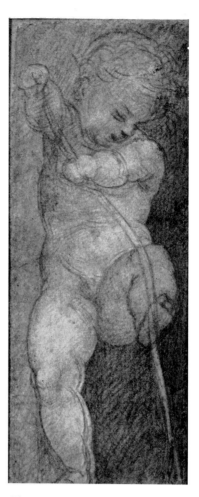

Fig. 6. Giorgione: *Seated Nude Male* (after Zanetti, 1760)

Fig. 7. Giorgione: *Cupid Bending a Bow*. About 1508. New York, Metropolitan Museum of Art

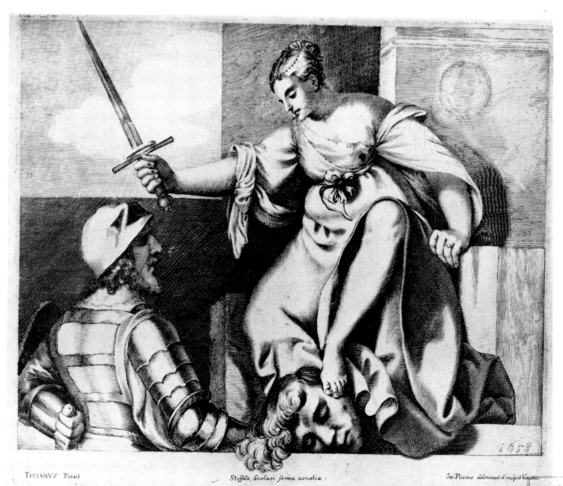

TICIANVS Pinxit Steffa'o, Scolari forma venetia. Jac Piccino delineavit à sculpit Venetiis

Fig. 8. Titian: *Allegory of Justice*. About 1509 (print by Jacopo Piccino, 1658)

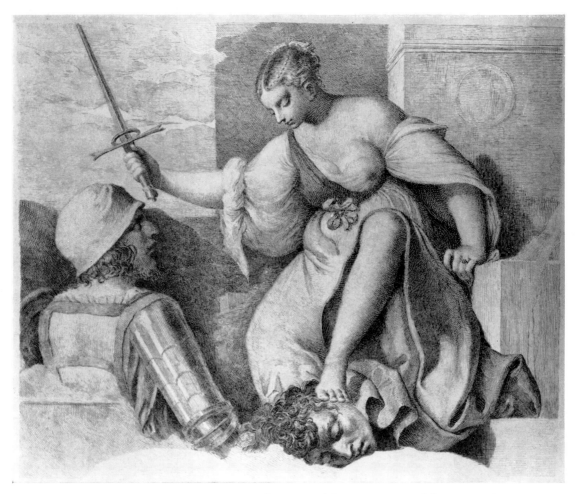

Fig. 9. Titian: *Allegory of Justice*. About 1509 (after Zanetti, 1760) (Cat. no. 18)

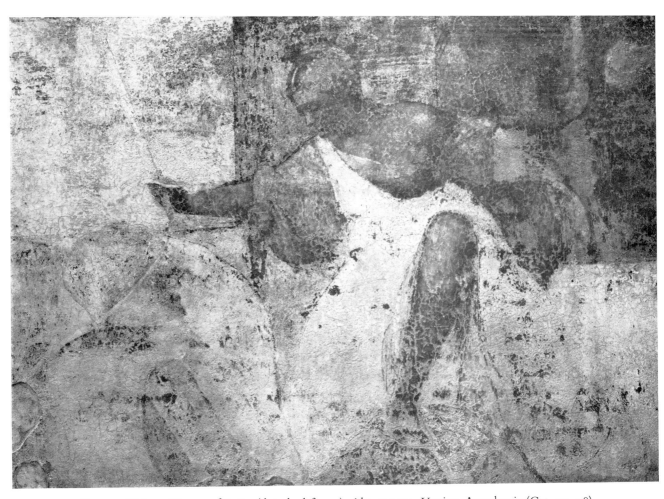

Fig. 10. Titian: *Allegory of Justice* (detached fresco). About 1509. Venice, Accademia (Cat. no. 18)

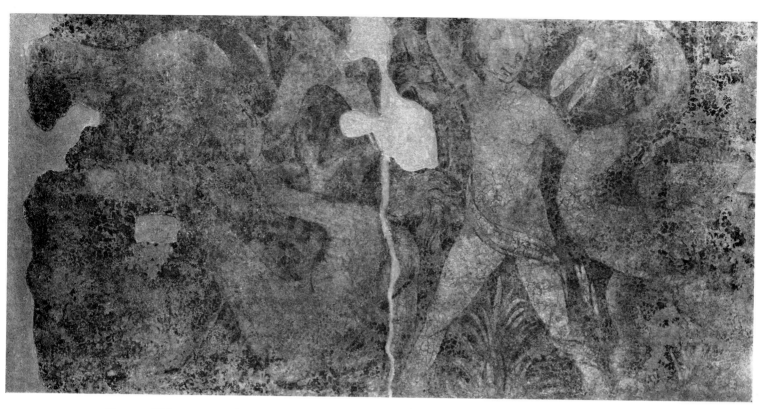

Fig. 11. Titian: *Putti and Fantastic Beasts* (detached fresco). About 1509. Venice, Accademia (Cat. no. 18)

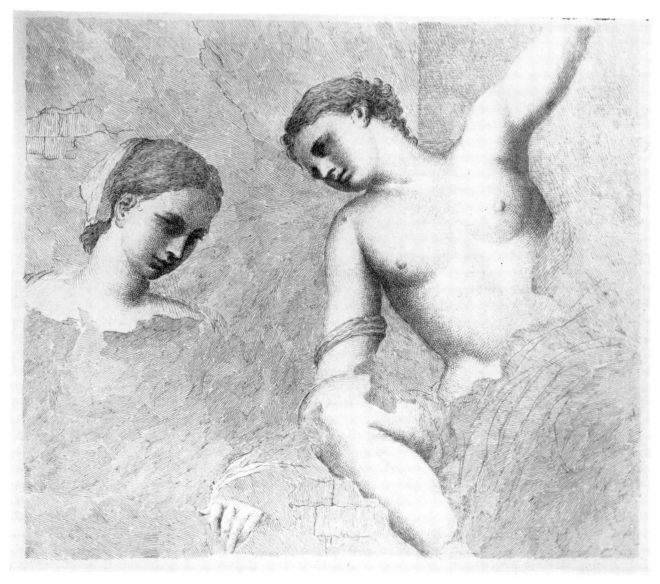

Fig. 12. Titian: *Two Female Nudes*. About 1509 (after Zanetti, 1760) (Cat. no. 18)

Fig. 13. Titian: *Eve* (print by Jacopo Piccino, 1658)
(Cat. no. 18)

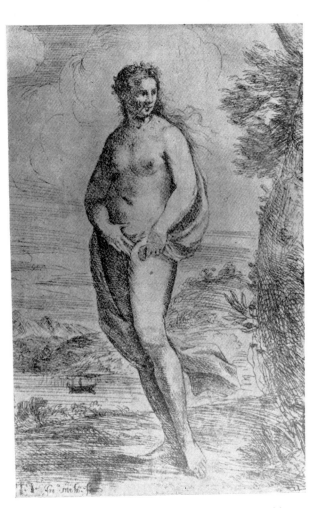

Fig. 14. François Mole (Mollo), after Titian (?):
Female Nude

Fig. 15. Titian: *Campagno della Calza.*
About 1509 (after Zanetti, 1760).
Venice, Fondaco dei Tedeschi (Cat. no. 18)

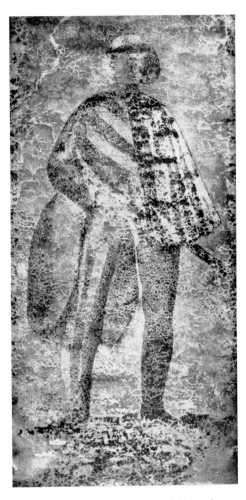

Fig. 16. Titian: *Campagno della Calza.*
About 1509. Venice, Ducal Palace
(Cat. no. 18)

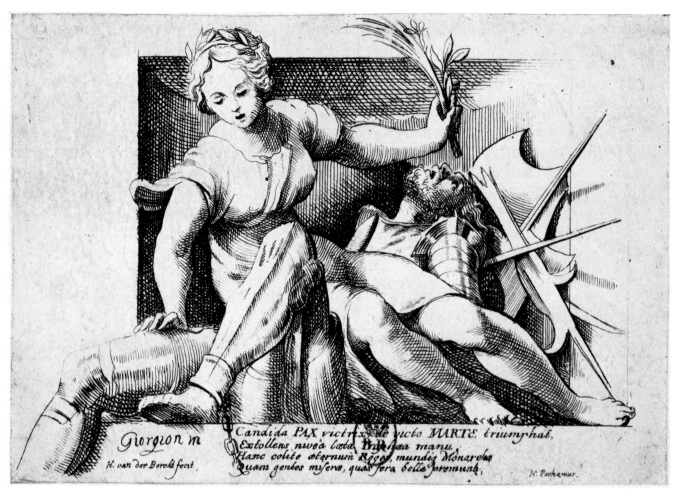

Fig. 17. Hendrik van der Borcht: *Allegory of Peace* (after Giorgione). Early seventeenth century

Fig. 18. Titian: *Assumption of the Virgin*.
1516–1518. Venice, S. Maria dei Frari

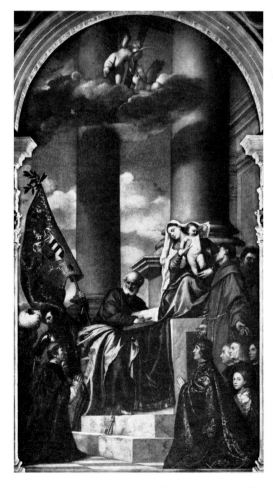

Fig. 19. Titian: *Madonna of the Pesaro Family*.
1519–1526. Venice, S. Maria dei Frari

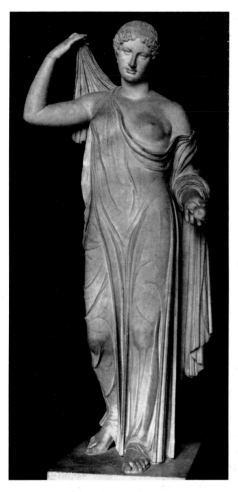

Fig. 20. Roman copy after Alcamenes: *Venus Genetrix*. Paris, Louvre

Fig. 21. Roman School: *Venus Anadyomene*. Rome, Museo Vaticano

Fig. 22. Roman copy after Lysippos: *Cupid Bending His Bow*. London, British Museum

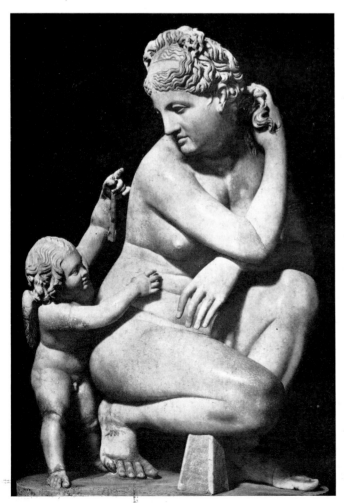

Fig. 23. Roman School: *Crouching Venus*. Naples, Museo Nazionale

Fig. 23A. Roman School: *Lady at Her Toilet*. About 50 B.C. Pompeii, Villa dei Misteri

Fig. 24. School of Pergamon or Roman Copy: *Sleeping Ariadne* (so-called). Rome, Museo Vaticano

Fig. 25. Antonio Lombardo: *Contest between Athena and Poseidon*. 1508.
Leningrad, Hermitage Museum

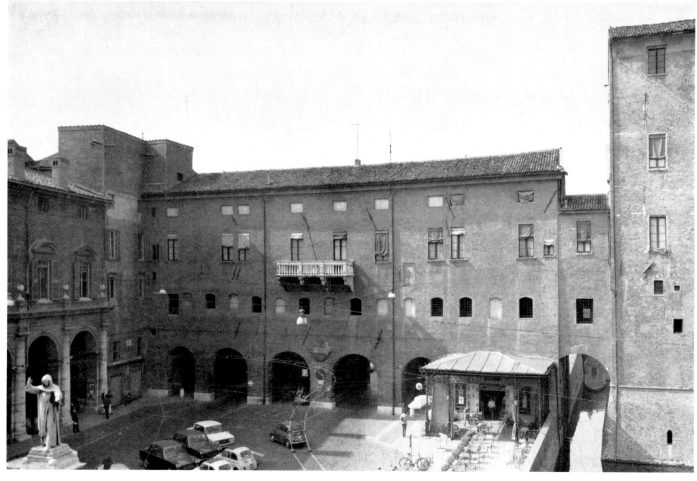

Fig. 26. Ferrara, d'Este Castle, *Via Coperta* (photo, Ralph Lieberman)

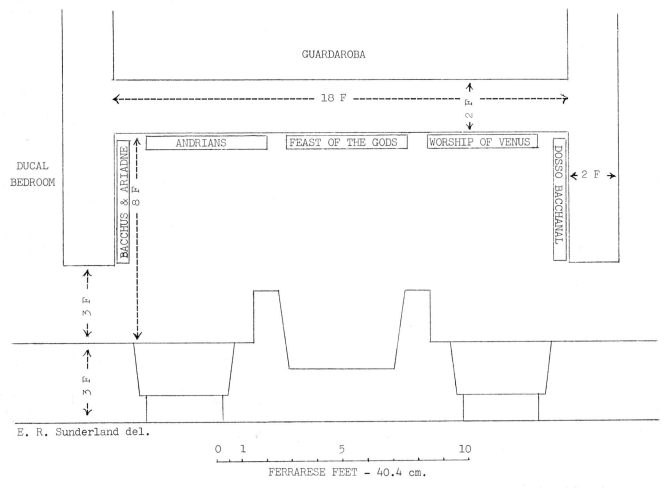

E. R. Sunderland del.

FERRARESE FEET - 40.4 cm.

Fig. 27. Ferrara, Plan of Alfonso d'Este's *Studiolo*

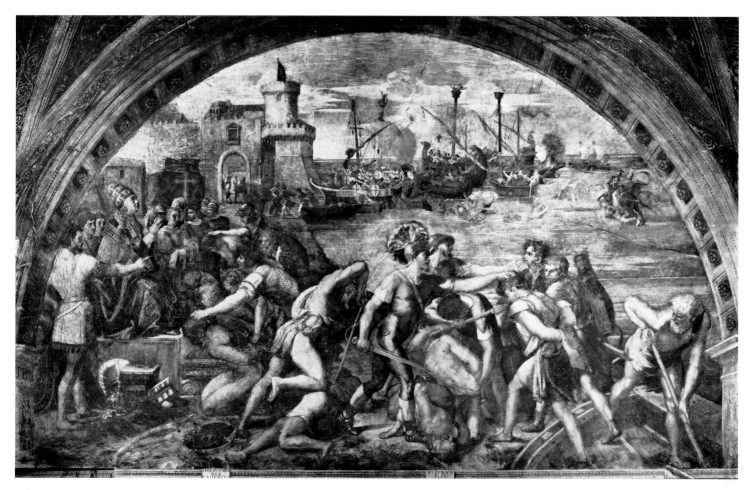

Fig. 28. Raphael and Giulio Romano: *Leo IV's Victory over the Saracens at Ostia*. 1515–1516. Rome, Vatican Palace, Sala dell'Incendio

Fig. 29. Federico Zuccaro: *Humiliation of Emperor Frederick Barbarossa*.
1582. Venice, Ducal Palace

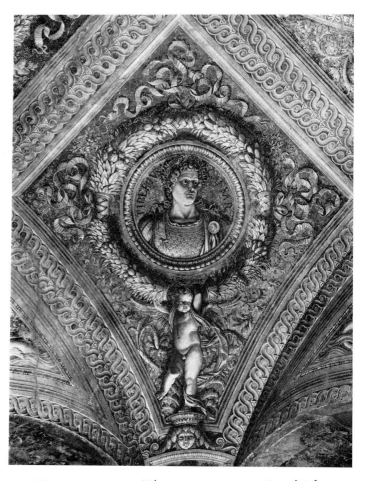

Fig. 30. Mantegna: *Tiberius*. 1474. Mantua, Ducal Palace,
Camera degli Sposi

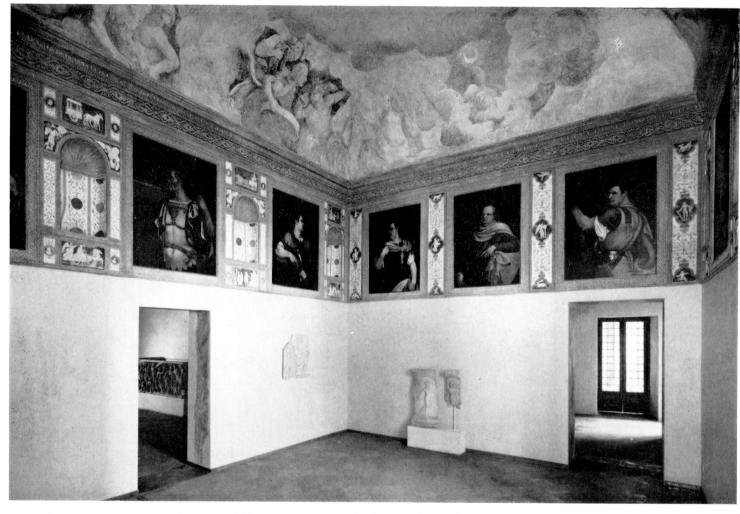

Fig. 31. Mantua, Ducal Palace, *Gabinetto dei Cesari*

Fig. 32. Copy after Titian: *Julius Caesar*. Sixteenth
century. Formerly Barcelona, Schaffer Collection (Cat. no. L–12,
Copy no. 2)

Fig. 33. Aegidius Sadeler: *Livia*. Engraving. About 1593

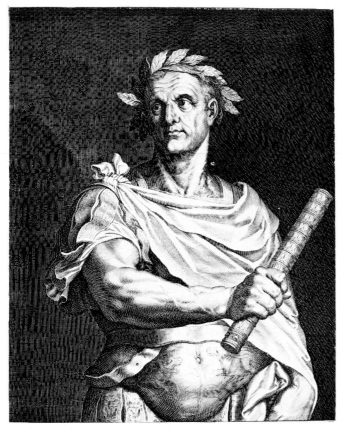

Fig. 34. *Julius Caesar* (Cat. no. L–12–I)

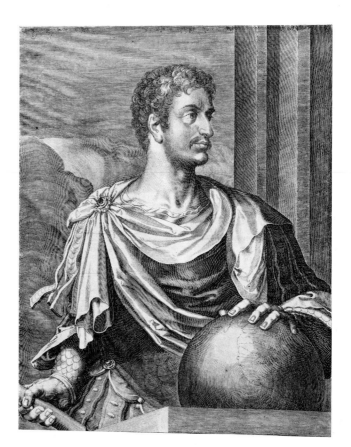

Fig. 35. *Augustus* (Cat. no. L–12–II)

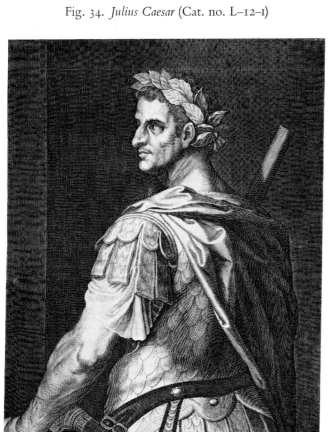

Fig. 36. *Tiberius* (Cat. no. L–12–III)

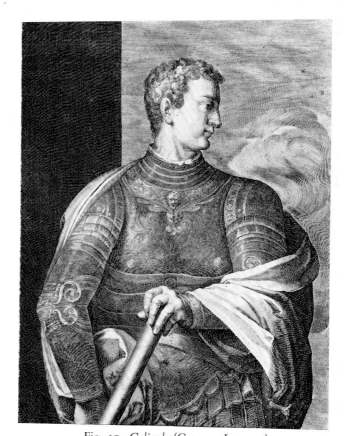

Fig. 37. *Caligula* (Cat. no. L–12–IV)

Aegidius Sadeler: Engravings after Titian's *Roman Emperors*. About 1593

Fig. 34a.
Coin of Julius Caesar

Fig. 35a.
Coin of Augustus

Fig. 36a.
Coin of Tiberius

Fig. 37a.
Coin of Caligula

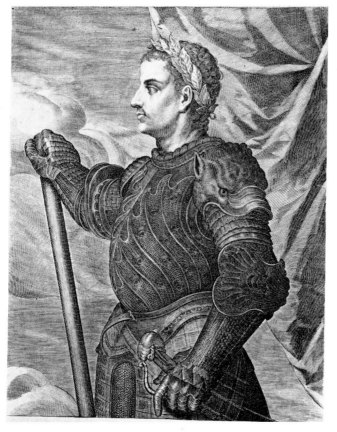

Fig. 38. *Claudius* (Cat. no. L–12–v)

Fig. 39. Filippo Negroni: Cuirass of Guidobaldo II della Rovere. About 1529. Florence, Bargello

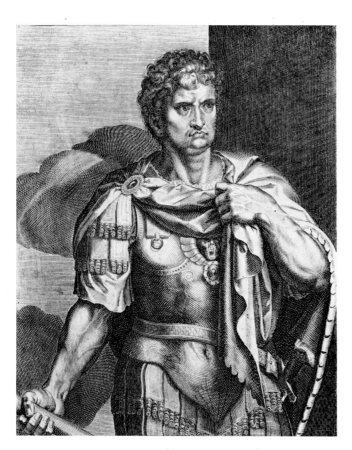

Fig. 40. *Nero* (Cat. no. L–12–vi)

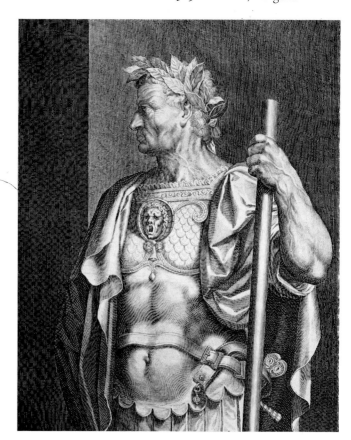

Fig. 41. *Galba* (Cat. no. L–12–vii)

Aegidius Sadeler: Engravings after Titian's *Roman Emperors*. About 1593

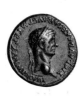

Fig. 38a.
Coin of Claudius

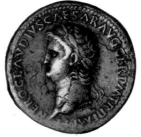

Fig. 40a.
Coin of Nero

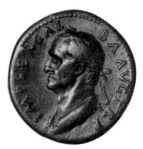

Fig. 41a.
Coin of Galba

Fig. 42. *Otho* (Cat. no. L–12–VIII)

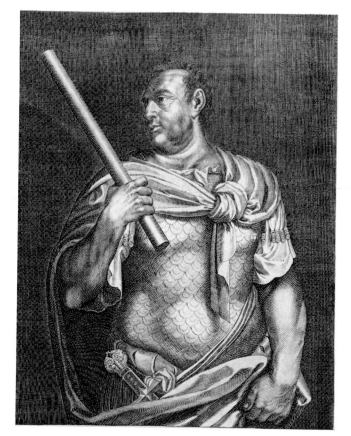

Fig. 43. *Vitellius* (Cat. no. L–12–IX)

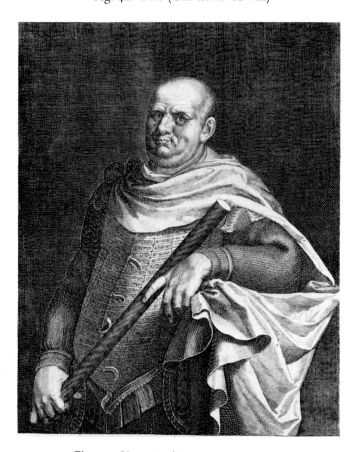

Fig. 44. *Vespasian* (Cat. no. L–12–X)

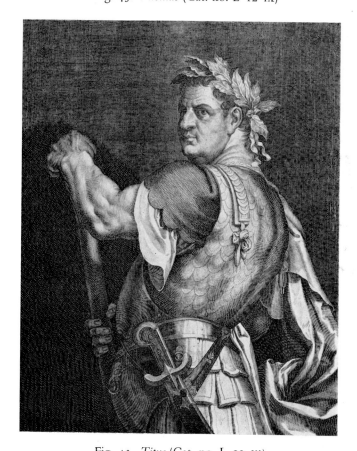

Fig. 45. *Titus* (Cat. no. L–12–XI)

Aegidius Sadeler: Engravings after Titian's *Roman Emperors*. About 1593

Fig. 42a.
Coin of Otho

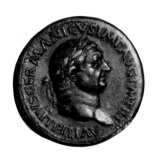

Fig. 43a.
Coin of Vitellius

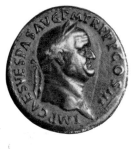

Fig. 44a.
Coin of Vespasian

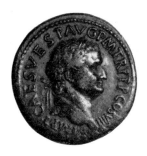

Fig. 45a.
Coin of Titus

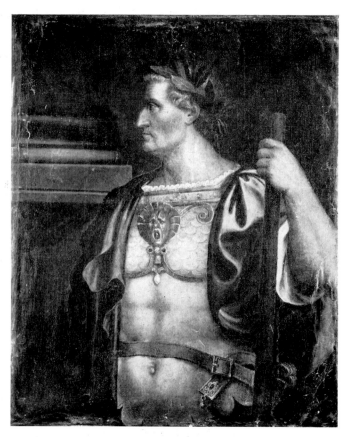

Fig. 46. Aegidius Sadeler after Bernardino Campi:
Domitian (1562). About 1593

Fig. 47. Bernardino Campi (?): *Galba* (Cf. Fig. 41). 1562.
Mantua, Ducal Palace (Cat. no. L–12–VII)

Fig. 46a. Coin of Domitian

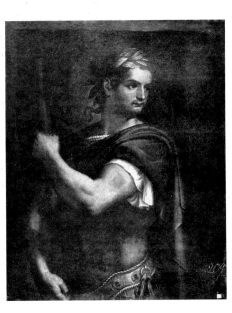

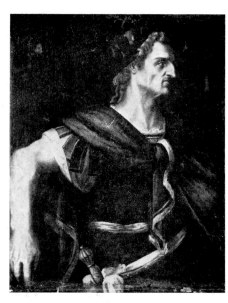

Fig. 48. Titian (?): Study for *Vitellius* (?)
(Cf. Fig. 43). Madrid, Biblioteca
Nacional

Fig. 49. Bernardino Campi (?): *Roman
Emperor.* 1562. Naples, Gallerie Nazionali
(in storage) (Cat. no. L–12, Naples, XIII)

Fig. 50. Unknown painter: *Roman Em-
peror.* Sixteenth century. Mantua, Ducal
Palace, Sala di Ganimede

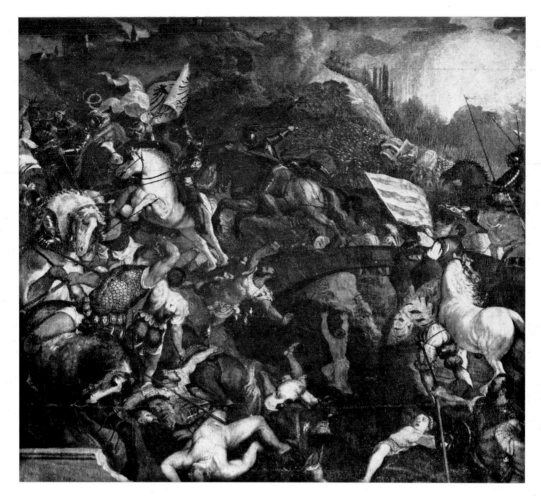

Fig. 51. After Titian: *The Battle*. Florence, Uffizi (in storage) (Cat. no. L–3, copy 3)

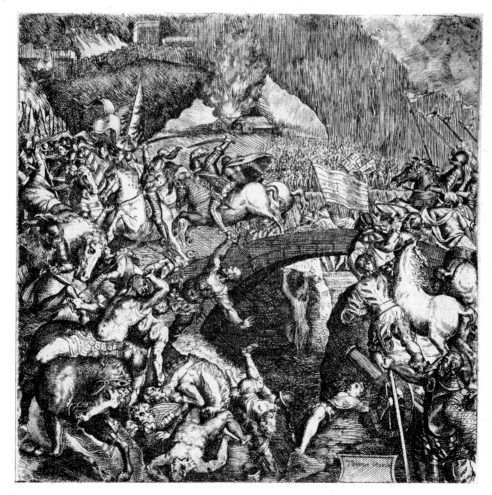

Fig. 52. Anonymous Print: After Titian's *Battle*. About 1560. Vienna, Albertina
(Cat. no. L–3, print 2)

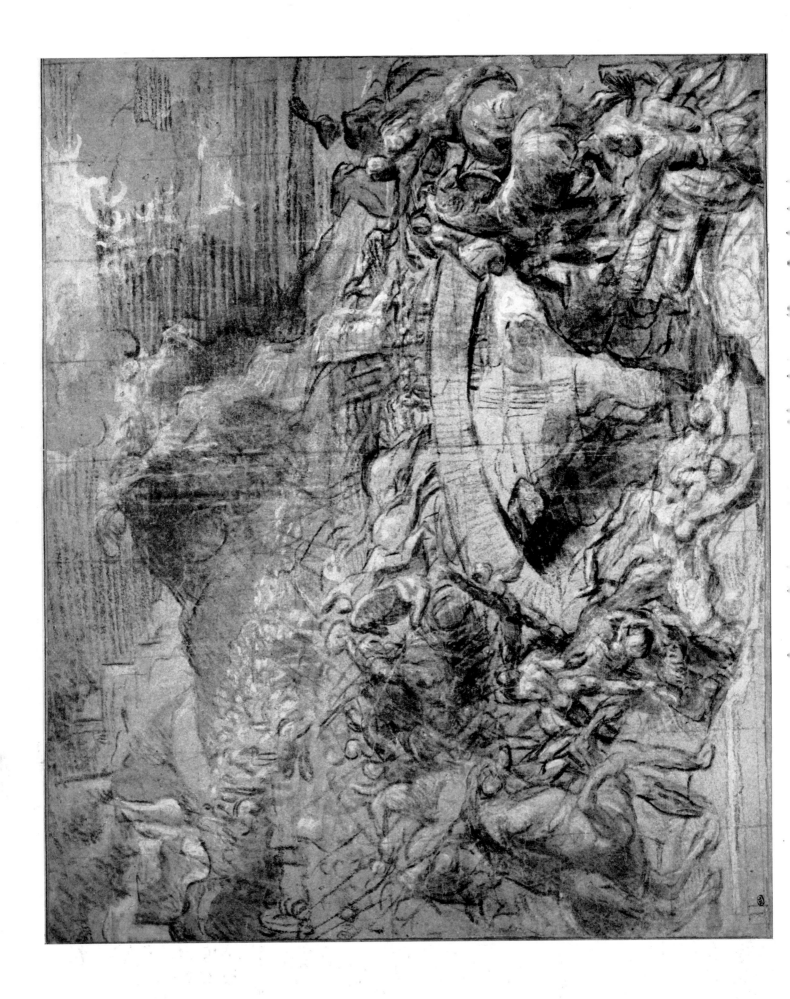

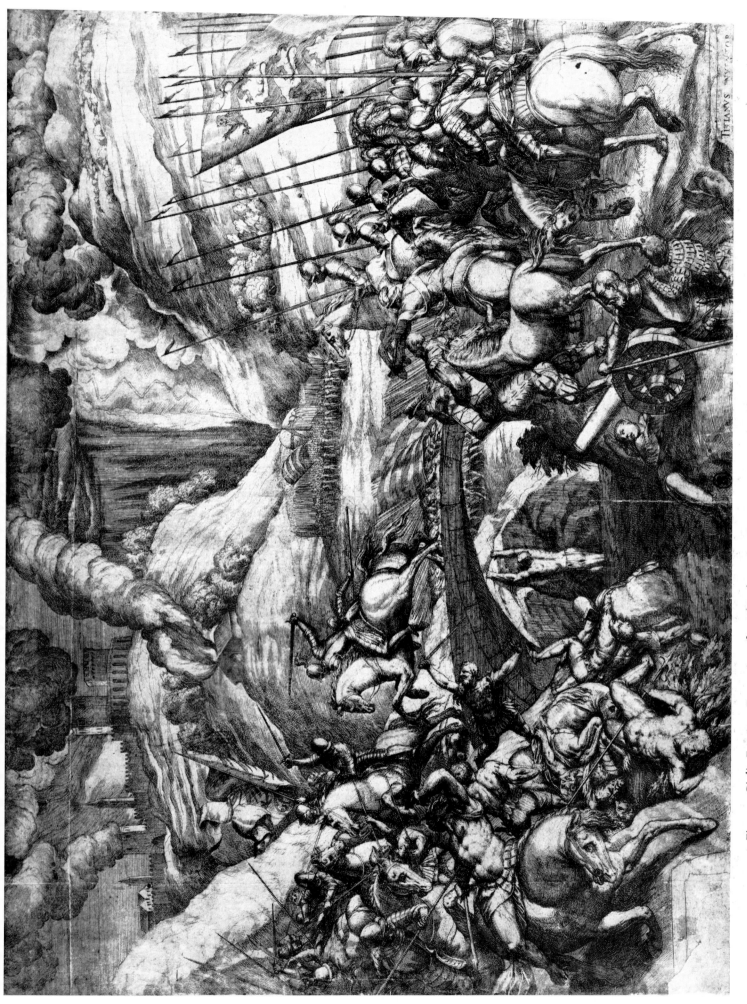

Fig. 54. Giulio Fontana: Engraving after Titian's *Battle*. About 1569. Paris, Bibliothèque Nationale (Cat. no. L–3, print 1)

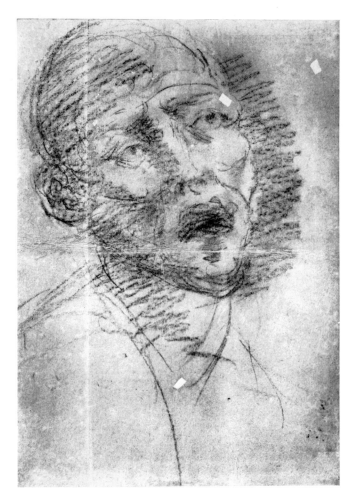

Fig. 55. Titian: *Wounded Man*. Study for *The Battle*.
About 1537. Florence, Uffizi, Gabinetto dei Disegni
(Cat. no. L–3, drawing 2)

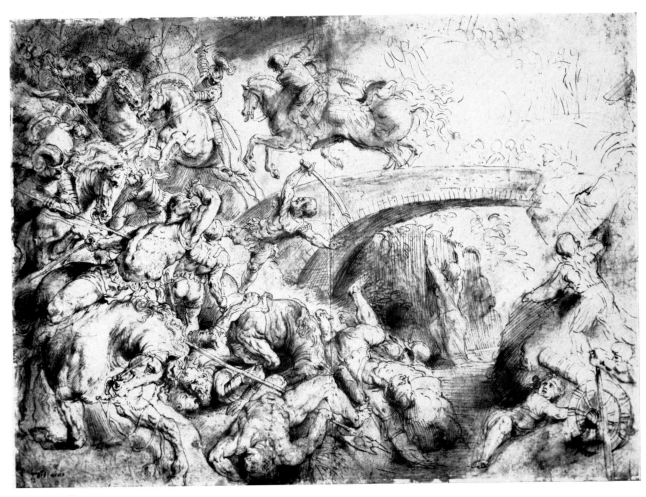

Fig. 56. Attributed to Rubens: Drawing after Titian's *Battle*. About 1602. Antwerp, Musée Plantin-Moretus,
Cabinet des Dessins (Cat. no. L–3, copy 1)

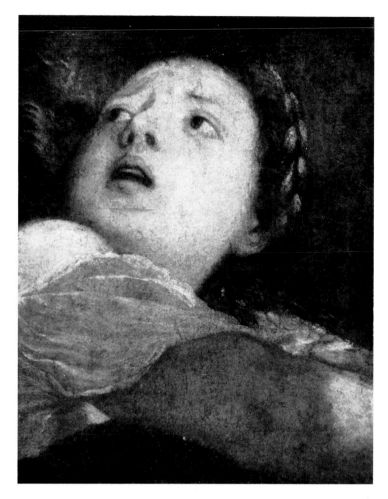

Fig. 57. After Titian: *Head of a Girl*. About 1550.
Bergamo, Accademia Carrara (Cat. no. L-3, copy 2)

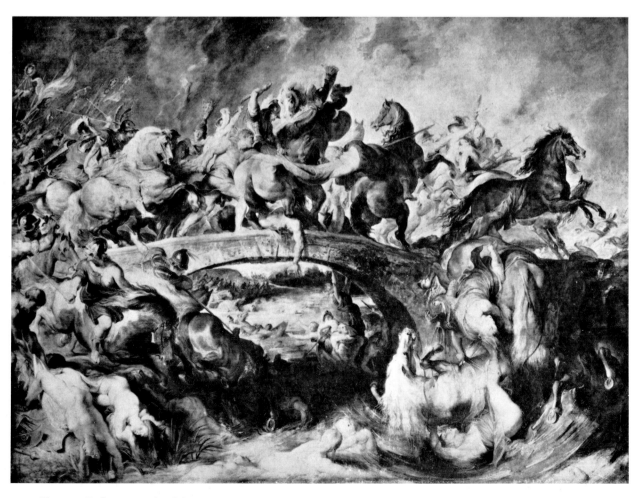

Fig. 58. Rubens: *Battle of the Amazons*. About 1615. Munich, Alte Pinakothek (Cat. no. L-3, derivation 2)

Fig. 59. Titian: *Horseman*. Study for *The Battle*. About 1537. Florence, Uffizi, Gabinetto dei Disegni (Cat. no. L–3, drawing 2)

Fig. 60. Titian: *Horseman*. Study for *The Battle*. About 1537. Oxford, Ashmolean Museum (Cat. no. L–3, drawing 4)

Fig. 61. Titian: *Horseman*. Study for *The Battle*. About 1537. Munich, Staatliche Graphische Sammlung (Cat. no. L–3, drawing 3)

Fig. 62. Madrid, Alcázar in 1626. Ground Floor. Rome, Vatican Library

Fig. 63. Madrid, Alcázar in 1626. Main Floor. Rome, Vatican Library

Fig. 64. Madrid, Alcázar. Model of Façade. About 1626. Madrid, Museo Municipal

Fig. 65. Madrid, Alcázar. Main Floor. About 1660. Justi's Plan

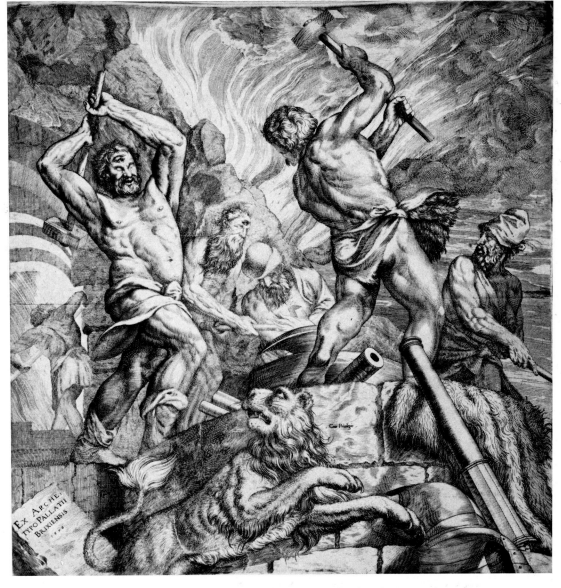

Fig. 66. Cornelius Cort after Titian: *Forge of Vulcan* (engraving). 1572.
Vienna, Albertina (Cat. no. L–1)

Fig. 67. Coins of Domitian and Vespasian

Fig. 68. Rubens after Titian (1564–1568): *Allegory of Brescia*. About 1608 (?). London, British Museum (Cat. no. L–1)

L-5. Endymion and Diana

In a letter of 1568 to Maximilian II, his ambassador Veit von Dornberg announced that several pictures by Titian were for sale. The *Endymion and Diana* has been lost, although an attempt has been made to identify it with the *Nymph and Shepherd* in Vienna (Cat. no. 27).

Bibliography: Voltelini, 1892, p. XLVII, no. 8804.

Fondaco dei Tedeschi frescoes, see Cat. no. 18.

L-6. The Humiliation of Emperor Frederick Barbarossa by Pope Alexander III (and a series of Doges' portraits)

Canvas.

Documented 1522–1523.

See further consideration of the lost mural in the text.

Documentation: Titian must have received the commission to paint the *Humiliation* after the death of Giovanni Bellini on 29 November 1516 (Lorenzi, 1868, p. 166, nos. 354 and 356). For reasons why this document cannot concern the *Battle* which was assigned to Titian at the end of May 1513, see Cat. no. L-3, Documentation.

3 July 1518. The Council of Ten complained that Titian had not worked on the painting for a long time ('non lavora su el Tellaro disegnatoli') and he was ordered to start work within eight days: 'in termene de zorni octo proximi et deba haver dato principio a lavorar el dito Tellaro et continuar fino a la perfetion di quello, aliter sue Magnificencie la fara depenzer et fornir a spese di dito ser Titiano' (Lorenzi, 1868, p. 171, no. 366).

11 August 1522. The Council ordered him to complete the work by June 1523, otherwise he must return the ducats [the total of 300 has been promised] already received from his broker's patent in the salt monopoly and he will be removed from that office of the Fondaco dei Tedeschi ('habia persa la espectativa de la Sansaria . . . et sia tenuto ad restituir ogni danaro ch' el havesse thocato . . . computando in questi Ducati 300 . . . non debi haver danaro alcuno per conto de i azuri ne per altri colori, ma se resti sopra al patto con lui sopra de cio fatti.'). A note in the margin, dated 20 July 1523, implies that Titian had completed the picture (Lorenzi, 1868, p. 175, no. 373). This reference is the last among the documents relating to the *Humiliation*.

Bibliography: It has generally been assumed that Giovanni Bellini had begun the *Humiliation of Emperor Frederick Barbarossa*, because of a statement by Vasari (1568–Milanesi,

VII, p. 432). The citation in Sanuto is extremely vague, but in the documents of the Ducal Palace published by Lorenzi (1868, no. 296) Giovanni is shown to have inherited Alvise Vivarini's three unfinished pictures (also Ludwig, 1905, p. 23). The *Humiliation* had not been begun by Alvise, and it is probable that Giovanni Bellini had only sketched the general outlines of his composition before his death (see Wethey, I, 1969, pp. 11–12; by a strange aberration the word, fresco, was used once in Wethey, II, 1971, p. 2). Dolce in 1557 (edition 1960, p. 168; Roskill edition, 1968, pp. 124–127) and Sansovino (1561, p. 18) connect only Titian's name with the lost mural (*idem*, 1581, fol. 129v). Borghini in 1584 (edition 1807, III, p. 87) thought in error that Giorgione had begun the *Humiliation of Frederick Barbarossa*, and Ridolfi (1648–Hadeln, I, p. 106) repeated with caution that others believed that Giovanni Bellini was the first artist involved; C. and C., 1877, I, pp. 165–168 (as begun by Bellini); Tietze-Conrat (1940, pp. 19–21) went so far as to propose that the *Humiliation* painted by Federico Zuccaro (Figure 29) after the fire of 1577 still reflects the earlier composition of Bellini and Titian. Further on the subject see Urban, 1968, pp. 291–317; Huse, 1972, pp. 56–71.

L-7. Landscape

Canvas.

Madrid, Collection of Philip II.

1552.

A landscape is recorded in Titian's letter to Prince Philip, dated 11 October 1552, with the information that Ambassador Vargas in Venice had consigned it to the Bishop of Segovia for transportation (C. and C., 1877, II, p. 505; republished by Cloulas, 1967, p. 215).

The Alcázar Inventories list two landscapes attributed to Titian in the Galería del Mediodía, one of the principal large halls which lost so heavily in the fire of 1734. One landscape, inserted into the wall, measured only $1\frac{1}{4} \times \frac{1}{4}$ *varas* ($1 \cdot 043 \times 0 \cdot 208$ m.) and was valued at the low price of ten ducats in 1666 (no. 583); in 1700 (no. 72) the price became fifteen doubloons (Bottineau, 1958, p. 154, no. 261). A second landscape, labelled Titian, and located in the same room, had similar dimensions, $1\frac{1}{4} \times \frac{1}{3}$ *varas* ($1 \cdot 043 \times 0 \cdot 275$ m.). This item rated 20 ducats in 1666 and fifteen doubloons in 1700 (Bottineau, 1958, p. 158, no. 284). Whether these two small pictures, possibly a pair, had anything to do with Titian is doubtful, and it is even less likely that they are identical with the shipment of 1552. The Alcázar Inventory of 1636, folio 18 ff., lists several Flemish landscapes in the Galería del Mediodía without including dimensions, so we are left with no grounds for speculation, particularly in view of the considerable rebuilding and rearrangement of the Alcázar in the seventeenth century.

16

L–8. Leda

No dimensions.

Rome, Pamphili Collection.

Probably a wrong attribution.

Bibliography: Pergola, 1962, p. 322, note 36: 'Una Leda attribuita a Tiziano era elencata al N. 434 del Fidecommisso Pamphili, ma non esiste più (Cfr. Cat. Sestieri N. 434).'

L–9. Mars and Venus Plate 221

Canvas. 0·97×1·23 m.

Vienna, Kunsthistorisches Museum (in reserves).

Copy of a lost original.

Late sixteenth century.

That an original of the composition by Titian existed can be deduced from Van Dyck's rather fine drawing (Plate 225) in the 'Italian Sketchbook' *c.* 1622–1627. The general style would suggest a late date, *c.* 1560. Van Dyck labelled the sheet 'Titian Signore Grimaldo', a name which suggests a Genoese collection, yet no trace of the picture in the Grimaldi Collection has been forthcoming.

Venus lies upon a white sheet and pillow placed upon a red couch, and Mars wears rose-coloured armour. His helmet and sword lie at the left side, while Cupid in white flies above at the right, equipped with bow and arrows.

Bibliography: Engerth, 1884, I, pp. 373–374, no. 525 (school of Titian); Adriani, 1940, p. 68, Abb. 10, pl. 106; Tietze-Conrat, 1956, pp. 82–85 (workshop of Titian); Berenson, 1957, p. 191, no. 153 (copy?, late).

LITERARY REFERENCES:

1. London, Earl of Arundel, Inventory 1655 (Cust, 1911, p. 324, no. 21; Hervey, 1921, p. 489, no. 382).
2. Milan, Estate of Pompeo Leoni in 1617; a *Mars and Venus* by Titian (see Saltillo, 1934, p. 103).
3. Paris, M. Dutartre, sale Paris, 19 March 1804, p. 30, no. 34, as Titian; canvas, 18×15 *pieds.*

L–10. Medea and Jason

The fact that Lodovico Dolce, surely one of Titian's advisers in matters of iconography, wrote a play entitled *Medea* (1557) is significant in the choice of this subject. The picture, however, almost certainly was never painted. In a letter datable 1554 and addressed to the 'King of England' (Philip of Spain) Titian said that he would send a *Medea and Jason* as a companion to *Perseus and Andromeda*: 'Tosto manderò la poesia di Perseo et Andromeda che havrà un'altra vista

differente da queste et così Medea et Jasone et spero con l'aiuto di Dio mandarle oltre queste cose una opera devotissima . . .' (Dolce, *Lettere*, 1554 and 1559, pp. 231–232; copied by Ticozzi, 1817, p. 312 and Bottari, 1822, II, pp. 27–28. The first part of this same letter is cited in Cat. no. 30, *Dating*).

No further reference ever appeared in connection with this subject. Cloulas, 1967, p. 227, note 4, considered the picture as lost; Roskill, 1968, p. 336, gave the same opinion.

Keller (1969, pp. 143–145) argued that the composition of a 'Theft of the Golden Fleece by Jason' might be the subject revealed in the X-rays of the *Perseus and Andromeda* (Gould, 1963, p. 115). Visually the relationship of this episode to the Medea sarcophagus at Basel (Keller, Abb. 5) does not seem very compelling. Moreover, the text of Titian's letter, quoted above, implies that the *Perseus and Andromeda* had been nearly finished previous to the *Medea and Jason*. The rarity of this theme in Venetian and even in Italian art is also significant, notwithstanding the suitability of it for the Spanish Hapsburgs, who since 1519 had been in control of the Burgundian military order of the Knights of the Golden Fleece.

If Ridolfi's account is to be trusted (Ridolfi (1648)–Hadeln, I, pp. 205–206), a situation similar to that of the *Medea* involves three mythological pictures, begun by Titian but never finished because of the death of the patron, Ippolito d'Este, Cardinal from Ferrara. Since the Cardinal died in 1572 these would have been late works by the artist.

The subjects were the *Sacrifice of Iphigenia*, the *Sacrifice of a Girl to Diana*, and a *Trial and Proof of Chastity*, the last mentioned derived from the Loves of Leucippe and Clitophon (Achilles Tatius, VIII). Lodovico Dolce's play, *Ifigenia*, first published in 1551, and his Italian translation of Achilles Tatius, issued at Venice in 1546, are again evidence of Dolce's close association with Titian in the selection of mythological themes for paintings.

L–11. Nude Woman Putting on Her Smock

Collection of Charles I in 1639.

The evidence is strong that an original painting of this subject by Titian existed when Van Dyck recorded it in the 'Italian Sketchbook', *c.* 1622–1623 (Plate 111), on the same page with the *Venus and Dog with an Organist* (Cat. no. 50, Plate 113). Since this latter picture was then in the possession of Francesco Assonica at Venice, both works more than likely belonged to him. A picture of the subject was acquired by Charles I of England from the Duchess of Buckingham in an exchange arrangement, undoubtedly after she had bought the original in Venice. The entry in van der Doort's Inventory of Charles I's collection in 1639 reads as follows (Millar edition, 1960, p. 15, no. 4): 'A Sitting Naked

Woeman with both hands putting on her Smocke which yu M Chaunged with the Dutches of Buckingham for one of yu Mai^ts Mantua peeces. Done by Tician.' 38 × 30 inches (0·965 × 0·762 m.). The same item recurs in various inventories of the sale of Charles I's collection after his death. The Symmonds notes (Egerton MS. 1636, folio 104) read: 'Titian, a Wench putting on her frock', but the name of the purchaser is undecipherable. In the major inventory, LR 2/124, folio 9, no. 32 (Millar, 1972, p. 70, no. 32, from Whitehall, sold to G. Greene) and Harley MS. 4998, folio 151, no. 32, 'A Naked Woeman putting on her Smock by Tytsian', sold to Mr. Buggley ye 23 october 1651 for £25. The same subject appears in James II's collection (Chiffinch, 1758, p. 41, no. 476).

VARIANTS:

The following mediocre English variants exist in storage at Hampton Court Palace:
1. Hampton Court, no. 1111 (old number 129); canvas, 0·993 × 0·806 m.
2. Hampton Court, no. 1110; canvas, 0·996 × 0·787 m.; a still worse copy. Collins Baker, 1929 (omitted).

These pictures do not correspond in exact details to Van Dyck's drawing, but the derivation from the lost Titian is evident. The coiffure with braids corresponds roughly to the style about 1545, as best seen in Titian's portrait of the *Empress Isabella* in the Prado Museum (Wethey, II, 1971, Cat. no. 53, Plate 147).

L–12. **Roman Emperors** Figures 31, 34–45
Documented 1536–1539.

Since the entire set of *Roman Emperors* exists only in copies, they are listed together under a single catalogue number, with the numeral on Sadeler's prints given by him to each Emperor. The order of the prints follows that of Suetonius and of Titian. Suetonius was born *c.* A.D. 69. Among his writings on history, festivals, grammar, etc., the *Twelve Caesars*, published in A.D. 120, is the most widely known, and several printed editions of it appeared before and during Titian's lifetime (see note 237). The set of *Roman Emperors*, eleven only, painted by Titian, as well as a different engraved series by Andrea Schiavone, follow Suetonius directly.

The Roman historian held an office in the service of the Emperor Hadrian, whom he does not write about, but he surely had access to original documents. Nonetheless, his style is chatty and anecdotal, characterized by lurid detail and scandalous episodes (notably about the depraved Nero and his decadent successors), rather than that of sober history (see Suetonius, translated by J. C. Rolfe; for his life, also Espasa-Calpe, LVIII, 1927, p. 515).

The stylistic discussion of the *Emperors* is found in the text.

Condition: The total destruction of all of Titian's *Emperors* in the great fire of the Alcázar in Madrid in 1734 is explained below under *History*. The originals were restored at Mantua in 1611 by Francesco Borgani (D'Arco, 1857, I, p. 80). When they belonged to Charles I of England, Anthony Van Dyck was paid '5 li' for mending *Galbus* on 8 August 1635. He also received '20 li' for a *Vitellius*. It has been assumed, first by Lionel Cust, who published the record of payments (1900, p. 99), that Titian's *Vitellius* was 'hopelessly damaged' and that it was discarded and replaced by Van Dyck's copy. However this may be, we have no proof that such was the case. At any event Aegidius Sadeler's prints are a major source of our knowledge of the appearances of the *Emperors*, and his *Vitellius* is after Titian's, not after Van Dyck's.

Documentation: In May 1536, during Titian's visit to Mantua, he probably arranged to paint the series of *Roman Emperors*. Benedetto Agnello informed Isabella d'Este at the time that the artist had gone to Mantua (Braghirolli, 1881, pp. 29–30; Gaye, 1840, II, p. 262); 10 July 1536, Calandra stated that Titian has promised the portraits of 'Cesari' to Federico Gonzaga (Braghirolli, 1881, p. 84); 26 March 1537, Federico wrote to Titian that he would like to have the 'Cesari' by May (*loc. cit.*, p. 85); 6 April 1537, *Augustus* had been shipped and two others nearly finished. Titian in the same letter thanked Federico for the gift of a 'casacca' (great coat) (C. and C., I, pp. 421, 459). 3 September 1537, Benedetto Agnello, the Mantuan ambassador at Venice, reported to Federico Gonzaga that in eight days Titian would deliver three 'Cesari', but we do not know whether the promise was kept (C. and C., 1877, II, p. 497; Braghirolli, 1881, pp. 85–86); 10 August 1538 Titian agreed to attend to the *Emperors* (Luzio, 1890, p. 209 also 1913, p. 89); 23 August 1538 Agnello wrote that the 'Caesars' will be ready soon (C. and C., 1877, II, p. 498; Braghirolli, 1881, p. 86); 18 September 1538, the Caesars will be finished soon, but Titian has gone to Pesaro with the Duke of Urbino (C. and C., 1877, II, pp. 498–499; Braghirolli, 1881, p. 87); 4 January 1540, a letter about the payment for the boxes for shipping the *Emperors* (unpublished; to be reproduced in full by Charles Hope, who discovered the letter). A partial summary of Italian documents of 1537–1538 in Adolfo Venturi, 1928, pp. 137–138.

History of the collections: The Mantuan Inventory of 1627 lists eleven *Emperors* by Titian and one by Giulio Romano, 'Undici quadri dipinti con li ritrati delli imperatori tutti di mano di Titiano ... un altro quadro simili di un imperatore di mano di Giulio Romano' (D'Arco, 1857, II, p. 153; Luzio, 1913, pp. 89–90). The attribution of the twelfth to Giulio Romano is made for the first time here. It is an error. Bernardino Campi added the *Domitian* in 1562 as recorded

during the artist's own life-time (Lamo, 1584, pp. 77–78). In 1627–1628, because of the loss of a war and financial necessity, the Mantuan government arranged to sell virtually the entire Gonzaga Collection to Charles I of England; 1628, letters from Daniel Nys to Endymion Porter about the sale (Sainsbury, 1859, pp. 320, 324–326) speak of twelve *Emperors* by Titian.

London, Collection of Charles I: Only seven of Titian's *Emperors*, all in half length, are recorded in the picture gallery of St. James's Palace: *Julius Caesar, Augustus, Tiberius, Claudius, Nero, Galba,* and *Otho* (van der Doort's catalogue, 1639, Millar edition, 1960, pp. 226–227, 235). The location of the other four is unknown. Seven equestrian portraits by Giulio Romano were hung in the same hall (*loc. cit.*). For Van Dyck's restorations see above under Condition.

Sale of Charles I's collection after his execution: Inventory of 7 September 1649 (LR 2/124, folio 166v, no. 219), 12 *Emperors* by Titian. The Harley MS. 4898 (folio 502, no. 219) records them correctly as 11 *Emperors* by Titian, sold to Captain Stone 'ye 30 october 1651' for £1200; likewise in MS. 79A, Victoria and Albert Museum, London, but again called 12 *Emperors* (1649, no. 15). Sold to Stone, 23 October 1651 (Millar, 1972, p. 270, no. 219). Captain Stone, son of a well-known sculptor, Nicholas Stone, resold the *Emperors* to Alonso de Cárdenas, Spanish ambassador in London (Nuttall, 1965, p. 309).

Madrid, Alcázar, in the Galería del Mediodía, the 12 [*sic*] *Emperors* by Titian (really 11) appear in the inventories of 1666 (nos. 541–552); 1686 (nos. 219–230), and 1700 (no. 54) [Bottineau, 1958, pp. 150–151].

Cosimo III dei Medici on his visit to Spain in 1668–1669 (edition 1933, p. 123) saw them in 'la salla dorata' and correctly gave the number as 11 'Caesars'. This citation has been unnoticed hitherto.

They were all destroyed in the great fire of 1734 because they were hung too high in the second storey to be saved. This contemporary evidence has been published by Beroqui and Bottineau. The report after the fire was summarized by Beroqui (B.S.E.E., 1930, pp. 192–193). Bottineau gave the full text of Jean Ranc's report on 5 January 1735: 'Du Grand Salon il ne s'est perdu que les Portraicts des 12 Empereurs qui etoient en haut près du plafond, et ceux qui étaient dans la meme ligne' (Bottineau, 1960, pp. 493, 624). Writers on Titian up to the present have relied on Karl Justi's very summary and incomplete account which gives no information other than the installation of the portraits in the Galería del Mediodía in 1652 and their 'apparent' destruction by fire in 1734 (Justi, 1889, p. 183). The authors of books as late as 1969 have been unfamiliar with Beroqui's (1930) and Bottineau's publications (1958, 1960).

Bibliography: Dolce (1557)–Roskill, pp. 194–195 (says he used 'medaglie' and 'marmi antichi' to derive the features of the Caesars); Vasari (1568)–Milanesi, VII, p. 442 (Titian did 12 *Emperors* and Giulio Romano painted a story to accompany each); Lomazzo, 1584, p. 432 (praises Titian's Caesars); Ridolfi (1648)–Hadeln, I, p. 173 (expands upon Vasari and wrongly states again that Titian painted 12 Emperors); Sainsbury, 1859, pp. 324–326; C. and C., 1877, I, pp. 420–424, II, pp. 497–499; Suida, 1935, pp. 75–76, 167; Tietze, 1936, I, pp. 140–142; Valcanover, 1960, I, p. 86, II, pl. 191 (mention; says their history in Spain is unknown); Verheyen, 1966, pp. 170–175; *idem*, 1967, pp. 62–67 (on Strada's drawings); Pallucchini, 1969, pp. 57, 89–90, 341–342, figs. 607–618 (says there is no trace of them after they went to Spain!).

The Twelve Caesars:

I. Julius Caesar (100/102 B.C.–44 B.C.).

II. Octavius Augustus (63 B.C.–A.D. 14; Emperor 27 B.C.–A.D. 14).

III. Tiberius Caesar (42 B.C.–A.D. 37; Emperor A.D. 14–37).

IV. Caesar Caligula: His real name was Julius Caesar Germanicus (A.D. 12–41; Emperor A.D. 37–41).

V. Claudius Caesar (Claudius Caesar Augustus Germanicus; 10 B.C.–A.D. 54; Emperor A.D. 41–54).

VI. Nero Claudius Caesar (A.D. 37–68; Emperor A.D. 54–68).

VII. Servius Galba (c. 4 B.C.–A.D. 69; Emperor 9 June A.D. 68–15 January 69).

VIII. Salvius Otho (A.D. 32–69; Emperor 15 January to 15 April A.D. 69).

IX. Aulus Vitellius (A.D. 15–69; Emperor 15 April A.D. 69 to 22 December 69).

X. Vespasianus Augustus (Titus Flavius Vespasianus, A.D 9–79; Emperor A.D. 70–79).

XI. Titus Vespasian (Titus Flavius Vespasianus; A.D. 39–81; Emperor A.D. 79–81).

XII. Flavius Domitian (Titus Flavius Domitianus; A.D. 51–96; Emperor A.D. 81–96).

ENGRAVINGS: Figures 34–46

1. The twelve *Emperors* by Aegidius Sadeler were most probably executed at Mantua after Titian's eleven original paintings and the *Domitian* by Bernardino Campi, when Sadeler visited Italy in 1593 and 1594. Born in Antwerp in 1570, he became court painter to Rudolf II at Prague, where he died in 1629. He is known to have been in Rome and Naples (Uhlemann, in Thieme-Becker, XXIX, 1935, p. 299). Complete sets of Aegidius' prints exist in the Biblioteca del Palacio at Madrid and in the Graphische Sammlung at Munich. He also engraved twelve lavishly dressed *Empresses*, which he paired with the *Emperors* in a highly Northern late Mannerist style. The compositions of the *Empresses* must be Sadeler's own invention, since they have nothing to do with

Titian. We reproduce Sadeler's *Empress Livia Drusilla* (Figure 33), wife of Augustus.

Marcus Sadeler (1614–1660), apparently a cousin of Aegidius, born in Munich, worked in Prague and reissued the entire series of twenty-four prints *c.* 1640 (Bénézit, VII, 1954, p. 462). The plates had clearly been restored and recut, for the impressions are darker and coarser than those by Aegidius. The print rooms of the Rijksmuseum at Amsterdam and the Bibliothèque Nationale in Paris have complete sets of these later impressions.

2. Twelve *Emperors* by Andrea Schiavone with oval Mannerist architectural enframement. Although Bartsch (XVI, 1870, pp. 79–83) lists them as after Titian, they do not correspond to Sadeler's prints after Titian or the painted copies. Fröhlich-Bum (1913, pp. 163–164) rejected the prints as after Titian.

DRAWINGS:

1. Düsseldorf, Kunstmuseum. Copies of the eleven *Roman Emperors* painted by Titian. They have been reasonably attributed to Jacopo Strada (*c.* 1568–1569), by Egon Verheyen (1966, pp. 170–174, and 1967, p. 66). He rejected the former identification of them in the museum as the work of Pietro Santi Bartoli (1635–1700). Since Titian's pictures left Mantua in 1628, the latter artist could never have seen them. The drawings of the individual figures are reasonably accurate so far as one can judge by a comparison with Sadeler's engravings and the painted copies in Mantua and in Naples. They suggest the hand of an architectural draughtsman in their precision and general hardness with little suggestion of expressiveness in the faces. The weakest in that respect are *Tiberius, Claudius, Nero,* and *Titus.* Strada added details in the background which occur neither in Sadeler's prints nor in the painted copies, for instance the armour and shields on the pilaster behind *Augustus,* the semi-circular niches added to *Julius Caesar* and *Tiberius,* the elaborate setting given to the *Otho,* and the curtain which accompanies *Claudius* and *Titus.* A partially visible column at the left of *Galba* does occur in the painted copies at Mantua and Naples, but it has been eliminated in Sadeler's engraving.

2. Madrid, Biblioteca Nacional. *Vitellius* (?). The rather fine drawing (Figure 48) is tentatively attributed to Titian (Barcia, 1906, no. 7645, crayon, 242 × 177 mm.).

THE SETS OF COPIES:

In 1562 the Marchese di Pescara commissioned Bernardino Campi to copy the eleven *Emperors* by Titian from the originals in the Ducal Palace at Mantua. During the following two years Campi completed four other sets: for the Emperor Ferdinand I of Austria (died 1564), the Duke of Alba, the Duque de Sesa, and Ringomes [*sic*; probably Ruy Gómez, Prince of Eboli]. These data could not be more

reliable since they are recounted in Alessandro Lamo's biography of the artist, published in 1584 (pp. 77–78), when Campi (1522–1585/90) was still alive and at the height of his fame. Campi, according to Lamo, added a twelfth *Emperor,* a *Domitian,* which was said to be indistinguishable from Titian's own. The attribution of *Domitian* to Giulio Romano is given in the Mantuan Inventory of 1627 (see History). The fact that Titian did not paint the *Domitian* has already been noted by Verheyen, who suggested that Strada's omission of him in the Düsseldorf drawings indicated that Strada knew that Titian was not the author. Verheyen suggested that Sadeler composed the *Domitian* (Verheyen, 1966, p. 170, note 62). The later history of these copies is relatively clear. That of the Marchese di Pescara ended in the d'Avalos palace at Naples, since he was a prominent member of the d'Avalos family of Naples and Ischia, and they are now in storage in the Naples Gallery. Philip II of Spain had a set (see Literary Reference no. 3), which must have been given to him by one of the Spanish notables in Italy, either the Duke of Alba (viceroy of Naples, 1555–1558) or the Duque de Sesa, or Ruy Gómez de Silva (died 1573). Another complete set was ordered by Antonio Pérez in 1574, then prime minister of Philip II; the copies were made by Fermo Ghisoni, a follower of Giulio Romano (see Literary Reference no. 4).

The following documentation is quoted from Lamo (1584, pp. 77–78): Bernardino Campi 'e di servire al Marchese di Pescara in andar a Mantova alle nozze del Duca Guglielmo e di contrafare gli undici imperadori, che quivi nel Palazzo Ducale si retrovavano, di mano di Titiano come fece, di dipoi di sua mano V'aggunse in puochissimo tempo il duodecimo che fu Domitiano e imitò talmente la bella e robusta maniera di Titiano che mostrando e offerendo tutti i duodici ritratti al Marchese egli, ne tampuoco i più intendenti dell'arte sapevano distinguere. . . . il Marchese . . . donò a Bernardino duocento scudi.

D'indi a due anni poscia fece quattro copie di detti Imperadori una per la M. Cesarea, una per il Duca d'Alba, una per il duca di Sessa, e l'altra per Ringomes.'

Letter Milan 1562, 1 December: Marchese di Pescara gave Campi special privileges because of his satisfaction with the *Emperors.*

1. Mantua, Ducal Palace, Gabinetto dei Cesari (Figure 31): *Eleven Roman Emperors,* copies after Titian, attributed to Bernardino Campi; restored in 1966–1968. Ozzola (1953, p. 41) attributed them to Pietro Fachetti (1535–1614), a Mantuan, but without much reason. Approximately 1·32 × 1·06 m.

I. *Julius Caesar,* blue drapery over golden brown armour.
II. *Augustus,* pink drapery and a golden globe.
III. *Tiberius,* scaled pinkish armour and golden drapery; laurel wreath on the head.

IV. *Caligula*, black armour with gold classical ornament—the best of the series at Mantua.

V. *Claudius*, black armour and a rose curtain. He wears the cuirass lent by Guidobaldo II della Rovere, Duke of Urbino.

VI. *Nero*, rose-brown armour and yellow drapery.

VII. *Galba* (Fig. 47), pale blue armour, scaled in the upper part, greenish-blue drapery. The base of the column at the left also appears in the Naples copy and in the Düsseldorf drawing, but not in Sadeler's engraving.

VIII. *Otho*, black steel armour and a golden leather cape in scale pattern. The rocky background is barely visible.

IX. *Vitellius*, dark scaled armour and pink drapery.

X. *Vespasian*, red brigandine, sleeves of grey chain mail, and red drapery.

XI. *Titus*, pale-yellow scaled armour, chain mail at the shoulders with white cloth below.

Provenance: Acquired from a Milanese dealer (?) in 1927 (Cottafavi, 1927–1928, pp. 622–623; Paccagnini, 1969, p. 153).

2. Munich, Residenz:

Twelve *Roman Emperors*, copies made at Mantua in 1567–1568 and delivered by Jacopo Strada to Munich in 1568 (see Verheyen, 1967, pp. 64–65; also Holst, 1951, p. 131). In 1730–1732 François Cuvilliers incorporated them in the new rococo interiors of the palace where they are used as overdoors in a series of three rooms, the last of which is a throne room. In 1908 the painter Manuel Wielandt decided that they were Titian's originals and so published an article on the subject (Wielandt, 1908, pp. 101–108). Habich (1908, pp. 189–191) immediately replied that the paintings were obviously copies, and Gronau added his even more vigorous voice to the denial of any possibility of Titian's originals being involved (Gronau, 1908, pp. 31–34).

3. Naples, Gallerie Nazionali (in storage):

Eleven Emperors, copies of Titian, by Bernardino Campi, all of them in very bad condition; approximately 1·32 × 1·06 m.

I. and II. *Julius Caesar* and *Augustus*. On loan from the Naples Museum, at the Villa Roseberry, Posilippo, an official Naples residence of the president of Italy. Augustus has a heavy beard in this version.

III. *Tiberius*. In pink leather armour of a scale design, he wears greenish drapery.

IV. *Caligula*. His dark greenish-black armour is damascened in gold.

V. *Claudius*. His black steel Renaissance armour, now in the Bargello at Florence (Figure 39) was lent to Titian by Guidobaldo II della Rovere. Against a red curtain his black hair and green laurel wreath stand out effectively.

VI. *Nero*. The brutal face of the degenerate Nero dominates here as in other copies. His leather armour of rose-brown is partially covered at the right by light yellow drapery.

VII. *Galba*. Blue drapery covers both shoulders over his brown leather armour. The column on left background is present in the Naples and Mantua painted copies and in the Düsseldorf drawing but not in Aegidius Sadeler's engraving.

VIII. *Otho*. Black steel armour is played against the rose-brown shoulder cape of scale design.

IX. *Vitellius*. In this instance the scale design of rather vivid green armour predominates over the rose drapery. His greyish hair bears a laurel wreath, whereas in Sadeler's print after Titian the hair appears to be black and the wreath is missing.

X. *Vespasian*. The bald old man wears a red brigandine with gold rivets and sleeves of grey chain mail, and red drapery as well.

XI. *Titus*. To his pale-rose armour of leather, grey chain-mail sleeves, and grey flaps are contrasted the golden-yellow drapery and the green laurel wreath with pink ribbon over his black hair. Professor Ruth Kennedy (1956, p. 239) proposed that Cardinal Grimani's *Vitellius* was the model for Titian's *Titus*. However, the Vitellius bust now in the Museo Archeologico at Venice is a Renaissance imitation, which was donated by Giacomo Contarini in 1714.

[XII. *Domitian*. Numbers among Sadeler's prints after Titian, but is not present in the copies at Naples. Lamo in 1584, p. 78, identifies him as added by Bernardino Campi].

XIII. Unidentified Emperor by B. Campi (?) (Figure 49). This man does not conform exactly to any of Sadeler's twelve prints and therefore constitutes a thirteenth item. The style is in general based upon Titian as seen in the engravings. He wears green drapery over pale-green armour and has a green laurel wreath over his black hair.

History: Formerly in the d'Avalos Collection at Naples, bequeathed to the museum in 1882. They are doubtless the copies Bernardino Campi painted in 1562 (Lamo, 1584, p. 77).

Bibliography: C. and C., 1877, I, pp. 422–423 (poor copies); Rinaldis, II, 1911, p. 518 (copies from the d'Avalos Collection).

INDIVIDUAL COPIES:

1. Amiens, Musée de Picardie, *Vitellius*, canvas, 1·37 × 1·07 m.; bequeathed to the museum in 1863 by Paul Gerillot; incorrectly said to have come from the Palazzo del Té at Mantua (Amiens, 1899, p. 124, no. 300); a burly figure in brown armour with a rose sash and a blue ribbon on the sword, brown baton (Gnoli, 1908, p. 156, attributed). This copy agrees with Sadeler's print (Figure 43), no. IX, but the quality of the painting is coarse and hard, with deep shadows that suggest the seventeenth century (photograph, Archives Photographiques, Paris).

2. Barcelona, Schaffer Collection (in 1932); canvas, 1·30 × 1·06 m. *Julius Caesar* (Figure 32); well painted with a soft touch, it conforms to Sadeler's engraving (Figure 34). *Otho,*

although by the same hand apparently, is weak in general effect. A few trees in the background and the ivy upon the wall at the left must reflect Titian's original. This background corresponds to Jacopo Strada's drawing at Düsseldorf, whereas Sadeler has greatly simplified the setting (photo Mas. no. C69961).

3. Cheltenham, Thirlestaine House, Lord Northwick; *Vitellius*, said to have come from the Orléans Collection and earlier from Queen Christina (Literary Reference no. 10). *Vespasian*, probably had the same provenance. Both figured in the Northwick sale, 26 July 1859, nos. 150, 151 (Waagen, 1854, III, p. 197; C. and C., 1877, II, pp. 423–424).

4. Grantham, Belton House, Lord Brownlow, until 1923. *Otho*, canvas, 1·37×0·977 m.; greatly praised and wrongly thought to be an original study by Titian (Hume, 1829, p. 29, and Waagen, 1854, II, p. 313). It most recently appeared in the Thomas sale, New York, Parke-Bernet, 5 March 1952, no. 74. *Former history:* purchased by Sir Abraham Hume in Venice; by inheritance to Lord Alford and later the Earl of Brownlow. The Brownlow sale, London, 4 May 1923 (*APC*, II, 1923, nos. 4488–4489), included *Titus*, canvas, 1·27×0·978 m., lot no. 58, which Hume had purchased from Giovanni Sasso in Venice c. 1786–1800, and also a *Caligula* of the same size, lot no. 57.

In 1857 Sir Abraham Hume lent six paintings of *Roman Emperors* to the celebrated exhibition at Manchester. They were at that time identified as *Julius Caesar, Tiberius, Caligula, Claudius, Galba*, and *Otho* (Manchester, 1857, nos. 264–269); Bürger (1857, p. 77) wrote them off as copies, as did Crowe and Cavalcaselle (1877, I, p. 423).

5. Hannover, Provincial Gallery; a set of twelve copies on copper (Phillips, 1896, pp. 98–99).

6. Orwell Park (Ipswich), Mr. Tomline. *Julius Caesar*, oval shape, in profile (Waagen, 1854, III, p. 443, 'very like Titian'; C. and C., 1877, II, p. 423, copy).

7. Padua, Museo Civico (in storage). These mediocre painted copies were made from the Sadeler prints since they repeat the Roman numerals upon the canvases and they include the Empresses. *Julius Caesar* I, *Augustus* II, *Tiberius* III, *Caligula* IIII, *Claudius* V, *Nero* VI, *Vespasian* X, *Titus* XI, *Domitian* XII (after Campi). This set must originally have comprised the full twelve Emperors and twelve Empresses. The ladies who survive are *Pompeia* I, *Livia* II, *Caesonia* IV, *Elia Petina* V, *Messalina* VI, *Flavia* X, and *Domitia Longina* XII. Photographs and negatives belong to the Fondazione Cini at Venice.

8. Rome, Officer's Club, Palazzo Barberini, *Augustus, Caligula, Galba, Vespasian, Titus* (seen in 1963; dark, inferior copies in miserable condition. Photographs G.F.N., Rome, numbers E68895–99).

9. Venice, Accademia (in storage), *Vespasian*, canvas, 0·74×0·61 m. (Moschini Marconi, 1962, no. 455).

LITERARY REFERENCES:

1. Fano, Bishop Ippolito Capilupi bequeathed a set of copies of the *Twelve Emperors* to his nephew in his will of 1580 (D'Arco, II, p. 112; C. and C., 1877, I, p. 422, note).

2. Ferrara, Palazzo dei Diamanti, a set of copies of twelve *Emperors*, said to be by Annibale Carracci, presented c. 1604 to the Conde de Fuentes, the Spanish governor at Milan (Venturi, 1882, p. 126; *Mostra dei Carracci*, 1956, p. 96; Posner, 1971, I, p. 159, note 12).

3. Madrid, Philip II, series of *Emperors*, most probably by Bernardino Campi, sent to him from Rome c. 1563 (see next item with Khevenhüller's letter of 1586).

4. Madrid, Antonio Pérez, minister of Philip II, who fell into disgrace in 1579; copies ordered by Pérez from Fermo Ghisoni in 1574 (Thieme Becker, XIII, 1920, p. 570), recorded in the Pérez Inventory of 1585, folio 475v: 'doce quadros medianos de doce emperadores romanos'. Khevenhüller, the imperial ambassador, notified Rudolf II on 26 April 1586 that they were for sale from Pérez's collection, along with Parmigianino's *Cupid*, as well as Correggio's *Ganymede* (Voltelini, 1892, no. 9433), but he did not identify the painter in any of the three cases. He remarked: 'sobre los emperadores . . . sabiendo que su majestad cathólica no los toma, como creo que sará, porque ya tiene otros duplicados que le enviaron de Roma'. It would appear that Philip II already had copies when Titian's originals were still in Mantua. They may have been the Campi set painted for Ruy Gómez, Prince of Eboli, and husband of the celebrated Princess of Eboli.

5. Padua, Galeazzo Dondi Orologia in 1750. A frieze with twelve Emperors, copied by Domenico Fetti after Titian (Levi, 1900, II, p. 225. Notice by the courtesy of Pamela Askew).

6. Parma, Palazzo Giardino, Farnese Collection, Inventory 1680, twelve *Emperors* of Titian, copies by 'Carazzi' [*sic*] (Campori, 1870, p. 207). Crowe and Cavalcaselle (I, p. 422) assumed that Agostino Carracci carried out these copies for Ranuccio Farnese. They seem to have been in the Palazzo Farnese at Rome, Inventory 1653, folio 356, and are assigned by Posner (1971, I, p. 159, note 12) to Annibale; also in the unpublished Inventory of 1649 of the Palazzo Farnese (courtesy of Charles Hope).

7. Penshurst, Lord Leicester, Twelve *Roman Emperors*, after Titian (Vertue, *Notebooks*, II, p. 52). They must have been copied when the originals belonged to Charles I.

8. Prague, Inventory of 1621, no. 1282 (Zimmermann, 1905, p. XLVII), a set of twelve *Emperors* and twelve *Empresses*. The *Emperors* might have been purchased from Antonio Pérez's estate (no. 4, above). The *Empresses* may have been copied from Sadeler's prints.

9. Prague Inventory, 1721, nos. 440 and 445, two Roman *Emperors* after Titian (Köpl, 1889, no. 6232).

10. Rome, Palazzo Riario, Queen Christina, three *Emperors* by Titian purchased from the collection of Giovanni Vincenzo Imperiale of Genoa in 1661 (Luzio, 1913, p. 306); Inventory, Palazzo Riario, 1662, folio 45: Three *Emperors*, $5\frac{1}{2} \times 4\frac{1}{2}$ *palmi*.

Only two are reported in Christina's Inventory of 1689 at her death: 'un ritratto dell' Imperatore romano . . . di Tiziano; *Vitellio* . . . di Tiziano, $5\frac{1}{2} \times 4$ palmi' (Campori, 1870, p. 352).

'Nota de quadri della Regina Cristina di Svezia', *c.* 1689–1692 (three pictures): no. 49, *Emperor Vitellius*, $5\frac{1}{2} \times 4$ *palmi* (1·23 ×0·89 m.) con cornice; no. 50, *Emperor Vespasian* with large baton; no. 59, '*Ritratto di Imperatore con clamide ropa*'; bequeathed by Queen Christina to Cardinal Decio Azzolino; Pompeo Azzolino's sale to Prince Livio Odescalchi, 1692 (two mentioned): 'Imperatore Romano, maggiore di naturale' (folio 468, no. 94), '*Imperatore Vitellio*' (no. 95). Inventory 1713 at death of Prince Odescalchi: 'Un *Cesare* di Tiziano' (folio 84v, no. 187); *Carlo Magno Imperatore* [*sic*] originale di Tiziano (folio 70v, no. 105); and three others called copies: '*Giulio Cesare*, copia di Tiziano' (folio 46, nos. 122, 123), '*Imperatore Vitellio* (no. 124), copia di Tiziano' (this item is classified as an original in other inventories). Odescalchi sale to the Duke of Orléans, 2 September 1721: three items, folio 3, no. 56, 'Imperatore romano grande più del natural mezza figura', no. 57, Titiano. 'Il compagno simile', folio 4, no. 42, 'Imperatore con clamide'; Orléans Collection, Paris, 1721–1792 (Dubois de Saint Gelais, 1737, pp. 461, 472, Otho and Vespasian); Buchanan, 1824, I, p. 115: *Vespasian* and *Vitellius* are reported as sold for 20 guineas each to Mr. Cosway, who resold them to Lord Northwick (see Individual Copies, no. 3).

11. Venice in 1628; a set of copies ordered from an unknown painter, Giovanni Arisio da Viadana, after the originals, then in Venice enroute to England (Parazzi, 1894, III, p. 215; Luzio, 1913, pp. 157–158. Notice by courtesy of Pamela Askew).

L–13. Sleeping Venus and Cupid
Rome, Aldobrandini Collection.
Canvas. 4 × 6 *palmi* (0·89 × 1·34 m.).

This item first turns up in the Aldobrandini Inventory of 1603, no. 238: 'Una Venere con Amore, che dorme, ignudo, in cuadro grande, di Titiano'. It recurs in the Inventory of 1626, no. 189; again in 1665, no. 238; and finally in 1682, no. 171, with the dimensions, 'alto palmi sei', i.e. 1·34 m. (Pergola, 1960, p. 435; 1963, p. 66; Onofrio, 1964, p. 206).

L–14. Sleeping Venus (without Cupid)
Rome, Ludovisi Collection.
Canvas. 4 × 6 *palmi* (0·89 × 1·34 m.).

Ridolfi (1648)–Hadeln, I, p. 197, describes it as 'una delicata Venere, poco meno del naturale, posta a dormire'. The Ludovisi Inventory of 1633, no. 21, includes this *Sleeping Venus*, which Klara Garas believes was among the pictures presented to Philip IV of Spain in 1637 by Prince Niccolò Ludovisi (Garas, 1967, p. 340; Beroqui, 1926, p. 87, and 1946, p. 84, held the same opinion). Ridolfi's reference to the picture as still in the Ludovisi Collection several years later (1646) does not invalidate the theory, because he also locates Titian's *Worship of Venus* there, whereas we know that it had gone to Madrid in 1637 (Cat. no. 13). Nevertheless, there is no documentary evidence that the Ludovisi *Sleeping Venus* is identical with the following item (Cat. no. L–15). On the other side of the argument, it may be significant that no *Sleeping Venus* by Titian in Madrid was known to Vicente Carducho when he wrote his *Dialogo* in 1633 (edition, 1933, pp. 108–109).

L–15. Sleeping Venus (without Cupid)
Madrid, Alcázar, Bóvedas de Ticiano.
Canvas. 1·04 × 1·67 m. (approximately).

History: Alcázar Inventory 1666, no. 705; Inventory 1686, no. 881 (Bottineau, 1958, p. 324). Again included in the Alcázar Inventory 1700, no. 502. The picture is located in the same position in these three inventories and described as 'otro de dos varas de largo y vara y quarta de alto [1·04 × 1·67 m.; in reverse order in the inventory] de una Venus dormida de mano del . . . Ticiano'; not identifiable in the Inventory of 1734 after the fire, because of the brief descriptions; Inventory of Buen Retiro after the death of Philip V, 1747, folio 220: 'Otro de Venus [y adonis] dormida original de Ticiano, de dos varas de largo y vara y tercia de cabida' [the inclusion of Adonis here is surely an error, but the size corresponds to the entry of 1700]. When Ponz wrote in 1776, the *Sleeping Venus* had been consigned to a building adjoining the royal palace, called the Casa de Reveque, along with other nudes, because Charles III considered them obscene! Ponz described it as 'Venus . . . está dormida sobre un lecho, y es de los desnudos más singulares que pueden verse del referido autor' (Ponz, 1776, tomo VI, Del Alcázar, 62; edition 1947, p. 533); listed among the items sequestered, in Richard Cumberland's catalogue, 1787, p. 115. Bottineau states that Joseph Bonaparte carried off the picture and that it was lost. There seems to be no proof of this assumption, but the chaotic situation of the Napoleonic period and the disappearance of the painting make it reasonable. Nevertheless, this picture leaves several problems unsolved: Ponz notes that she lay on a couch, and hence she does not appear to be the one copied by Eusebi (Beroqui, 1946, p. 84). The sizes also vary.

L–16. **Sleeping Venus**
Madrid, Collection of the Duke of Alba.
Doubtless a copy.

Ponz in 1776 gave a reserved evaluation of the picture as reminiscent of Pordenone: 'Por de Ticiano es tenida una Venus echada de cara [lying down, face forward], en que se ve algo del estilo de Pordenone' (Ponz, 1776, v, septima división, 10; edition 1947, p. 498). Later the canvas passed into the collection of Godoy, the all-powerful prime minister of Charles IV. Under the Napoleonic occupation his possessions were impounded in 1808 (Sentenach, 1921, pp. 46–55; Beroqui, 1926, pp. 87–88; 1946, pp. 84–85, thought mistakenly that the Alba-Godoy *Venus*, i.e. Cat. no. L–16, had been in the royal collection).
Buchanan in 1813 purchased this *Sleeping Venus* [*sic*], along with Velázquez's *Rokeby Venus* (London, National Gallery), and other masterpieces, but he reported that 'The Titian, it is believed, has also been sent back to Spain' (Buchanan, 1824, II, pp. 243, no. 5, 246–247). No further trace of Titian's *Venus* is known and the work must be regarded as destroyed.

L–17. **Sleeping Venus**
London, Earl of Arundel.

According to a letter of 25 April 1615 Sir Dudley Carleton purchased in Italy a *Sleeping Venus* by Titian for the Earl of Somerset (Sainsbury, 1859, pp. 274–275). Later the picture turns up in the Inventory of 1655 of the Earl of Arundel, who had acquired it from Lord Somerset (Cust, 1911, p. 283; Hervey, 1921, p. 488, no. 353).

L–18. **Sleeping Venus with Roses and Cupid**
Rome, Queen Christina and later Prince Livio Odescalchi.

The fullest description of this picture is found in the inventory of Queen Christina's estate after her death in 1689. It is clear that the goddess's pose followed that of Giorgione's *Sleeping Venus* in Dresden. At her feet the standing Cupid with an arrow, which has pricked his left hand, differs from Giorgione's seated Cupid. The roses scattered upon the couch have the flowers in common with the *Sleeping Venus with Roses* (Cat. no. X–36, Plate 180), but that version omits Cupid.
The Inventory of 1689 reads as follows: 'Un quadro di una Venere che dorme ignuda a giacere sopra un letto sparso di rose; tiene la mano destra sopra il capo e con la sinistra si copra nelli parti . . . [*sic*]. Con un amorino in piedi che col dardo punge la detta mano sinistra. Con veduta di bel paese, figure grandi al naturale di Tiziano . . . alta pmi quattro e quarto e larga pmi sette e un terzo' [0·949 × 1·638 m.]

(Campori, 1870, pp. 340–341). The earlier history of Queen Christina's picture is uncertain. It might be the 'Reclining Nude Woman and Cupid' of the Inventory of 1652, no. 113 (Geoffroy, 1855, p. 184).
In the purchase of Christina's collection from Pompeo Azzolino by Prince Livio Odescalchi, it is unmistakably 'Venere ignuda che dorme . . . amore le porge la mano' (1692, folio 466, no. 21). A fuller account is available in the undated description of her pictures, i.e. 'Nota dei quadri della Regina Cristina', *c.* 1689–1692, no. 52: 'Venere colloca sopra un letto di velluto cremesi seminato di rose tutta ignuda che dorme e Cupido ignudo di Tiziano'.
At the death of Prince Livio Odescalchi, Inventory 1713, folio 81, no. 163: 'Venere che dorme, di Tiziano . . . della Regina di Svezia'.
Baldassare Odescalchi sale to the Duke of Orléans, Inventory 1721, folio 3, no. 55: 'Venere dormendo con amore piangendo bislongo sopra campo di velluto e veduta di paese e rose seminate'. After the picture passed to the Orléans Collection it disappeared, probably consigned to a less important location than the Palais Royal in Paris.

L–19. **Venus and Adonis** (so-called Farnese type)

Plate 95

Canvas. About 1·23 × 1·49 m.
Rome and Parma, Farnese Collection.
1545–1546 or about 1560.

History: If Ridolfi (1648–Hadeln, I, p. 179) is correct in his implication that Titian painted a *Venus and Adonis* in Rome in 1545–1546, as a pendant to the *Danaë* (Cat. no. 5), that work anticipated the composition for Philip II which is now in Madrid, dated 1553–1554 (Cat. no. 6). Ridolfi wrote that the painting was in the Palazzo Farnese at Rome. Confirmation of his statement is found in an unpublished inventory of the Palazzo Farnese dated 1649 which includes the *Venus and Adonis* as well as the *Danaë* now in Naples (a recent discovery by Charles Hope, to be published by him). These pictures were not included among the works shipped to Parma in 1662, but they must have been sent not long afterwards. The *Venus and Adonis* does appear at Parma in the Inventory of 1680 (Campori, 1870, p. 211). In the 'Chamber of Venus' the picture is cited as measuring *braccio* 1 *once* 11 by *braccia* 2 *once* 4, i.e. about 1·23 × 1·49 m. The dimensions of the Naples *Danaë* now measure 1·20 × 1·72, but the size given in the inventory of 1680 must have included the frame since they are listed as the equivalent of 1·39 × 1·90 m. (see Cat. no. 5). Related pictures of *Venus and Adonis* are smaller: in Washington (Cat. no. 44) and New York (Cat. no. 43) the sizes are 1·068 × 1·36 and 1·06 × 1·334 m., respectively. In these two later versions, Cupid (awake) holds a dove, and

the number of hounds has been reduced from three to two as in the Farnese composition.

The Inventory of 1680 at Parma includes the following description, which clearly relates to a composition of the Washington–New York type: 'Una Venere che siede sopra di un panno cremesi, abbraccia Adone che con la sinistra tiene duoi levrieri et un amorino con una colomba in mano, di Tiziano.' This same item is repeated in one more inventory of the Palazzo del Giardino, *c.* 1710, no. 109, with the same size and similar description (Filangieri di Candida, 1902, pp. 220, 282). Thereafter it fails to reappear. Yet William Buchanan in 1824 quotes a letter from Mr. Irvine dated in Rome, 30 June 1804 in which he describes the picture now in New York (Plate 97) and states that it is 'more like the one at Capodimonte at Naples, engraved by Strange, where the Cupid is not asleep' (Buchanan, 1824, II, p. 153). Therefore the Farnese *Venus and Adonis* disappeared in the early nineteenth century without leaving any trace today. The print by Sir Robert Strange in 1769 (Plate 95) is supposedly after the Farnese canvas. Nevertheless, doubt remains that Strange's print in reality reproduces the Farnese picture (in reverse), particularly if Titian painted the original as early as 1545–1546.

Crowe and Cavalcaselle (1877, II, p. 151) made reference to the *Venus and Adonis* of the Farnese Collection as lost, and they list examples of the same type of composition. But they did not distinguish correctly between the Farnese type and the Barberini composition at Alnwick Castle, where Adonis wears a cap (Cat. no. X–39).

Raffael Sadeler II in 1610 made his print (Plate 96) from the picture in the Barbarigo Collection which is now in Washington (Cat. no. 44).

L–20. Venus and Cupid
Lord Arundel's Collection.

In the Inventory of 1655, compiled after the death of Lady Arundel, there appear two pictures that are simply called *Venus and Cupid* by Titian, without further details so that it is impossible to trace them (Cust, 1911, pp. 283–284; Hervey, 1921, p. 488, no. 354 and 383).
For the *Sleeping Venus*, see Cat. no. L–17.

L–21. Venus and Cupid
Duke of Buckingham, Sale at Antwerp, 1648.

The citation of this item in a manuscript (British Museum, Addington MS. 17915, 198.L.6, item no. 18) carries no dimensions and only the words, 'Une autre [tableau] d'une Vénus toute nude et un Cupidon'. The English version also omits the dimensions: 'A naked Venus with a Cupid' (Fairfax, 1758, no. 18).

L–22. Venus and Cupid
Rome, Alessandro Ruffinelli, in 1647.

This picture is called a *Venus and Cupid* after Titian; no type of composition is indicated (Lewine, 1962, p. 312, no. 83).

L–23. Venus and Cupid with Psyche
Brussels, Collection of Mary of Hungary.

A picture of this subject is included among the works of Titian in the Inventory of Mary of Hungary at Cigales in 1558 (see Mary of Hungary, 1856, p. 141, no. 37). Thereafter it disappeared and today no version is known of the theme which is described as 'Venus and Cupid behind her, when Psyche was presented to Venus' ('La diosa Vénus y Cúpido detrás de ella cuando Siches se presentaba ante Venus'). This composition does not seem to correspond to the 'Deity, Cupids, and Satyrs' which Ridolfi (1648–Hadeln, I, p. 223) ascribed to Damiano Mazza.

See also: Cat. no. I, Variant 3 in Munich.

L–24. Venus at Her Toilet with One Cupid
London, York House, Duke of Buckingham (George Villiers), 1635–1648.
Canvas. 1·22 × 0·915 m.

An inventory of the pictures of the Duke of Buckingham at York House at London in 1635 makes note of a 'Venus Looking in a Glass (copy)' (Davies, 1907, p. 379). Although Cupid is not mentioned here, the picture may be identical with the work that appears in the inventory of 1648. A manuscript catalogue (British Museum, Addington MS. 17915, 198.L.6) lists item no. 6: 'Une Vénus se mirant dans un miroir et Cupidón, haulte 4 pieds large 3'. An English inventory, also of 1648 at the time the collection was sold at Antwerp, reads: 'A Venus looking in a Glass with a Cupid near her, 4 × 3 feet' (i.e. 1·22 × 0·915 m.) Poglayen-Neuwall's proposal (1934, p. 360) that this picture was purchased by Archduke Leopold Wilhelm in 1648 is not acceptable because his composition came from the collection of Bartolomeo della Nave (see Cat. no. 52, History).

L–25. Venus at Her Toilet with One Cupid

In this version the one Cupid, at the right, looks out at the spectator. Here we have a variation of the so-called Crasso type, in which two cupids hold the mirror (Cat. no. L–26, Plate 126).

COPIES:
1. Cassel, Gemäldegalerie, in storage; canvas, 1·39 × 0·96 m.;

signed Gilles Coignet, 1579 (Eisenmann, 1888, p. 291, no. 451; Poglayen-Neuwall, 1934, pp. 366, 383, fig. 7).
2. Hampton Court Palace, in storage; panel, 1·073 × 0·857 m. (Poglayen-Neuwall, 1934, p. 383, fig. 8, Flemish copy).
3. Magdeburg, Gemäldegalerie; canvas, 1·28 × 0·97 m. (Poglayen-Neuwall, 1934, pp. 366, 382, fig. 6, copy).

L–26. Venus at Her Toilet with Two Cupids (so-called Crasso type) Plate 126
About 1552–1555.

Ridolfi in 1648 described this picture as a 'Venus who is looking in a mirror and two Cupids', then in the collection of Niccolò Crasso at Venice. It has generally been assumed that various workshop replicas maintain the composition of the Crasso prototype. In this case the major variation from the Washington picture is that both Cupids hold the mirror, whereas in the other case (Plate 127) the middle Cupid is about to place a wreath of flowers upon the head of the goddess. Actually there is no proof as to the attitudes of the Cupids in the Crasso version, but Van Dyck's sketch copy (c. 1622) appears to be the most reliable reflection of it.

Bibliography: Van Dyck, *Italian Sketchbook*, 1622–1627, Adriani edition, 1940, pp. 79–80, pl. 119v; Ridolfi (1648)-Hadeln, I, p. 194.

COPIES:
Venus at Her Toilet with Two Cupids (Cupid at the right looks at the spectator):
1. Van Dyck, 'Italian Sketchbook', 1622–1627; (Plate 126). The best argument for the existence of an original of this type lies in Van Dyck's drawing. It is probable that his source was Niccolò Crasso's picture, and that he made the drawing in Venice. Clearly Van Dyck did not copy the Barbarigo–Washington original (Plate 127).
2. Leningrad, Hermitage (in storage); canvas, 1·30 × 1·105 m.; from the collection of Josephine Bonaparte at Malmaison. (C. and C., 1877, II, p. 336, note, school piece; Somof, 1899, p. 133, no. 99, copy; Poglayen-Neuwall, 1934, pp. 363, 382, fig. 3, workshop replica).
3. London, Lord Ashburton; destroyed by fire in 1873 (*Art Union*, 3 February 1873, p. 12, column C); one Cupid looks at Venus and the other at the spectator; drawings by Cavalcaselle in V. and A., London, folio 1512 and in Venice, Marciana, It. VII 2033; Padovanino or Contarini suggested as author. The picture was described anonymously as 'Venus Admiring Herself in a Looking Glass, three-quarter length . . . colouring of a luscious golden glow' (*Art Union*, 1847, pp. 122–127).
Waagen (1838, II, p. 269 and 1854, II, p. 100) is the only other writer to give an adequate reference to this picture, which he characterized as follows: 'a remarkably powerful and finely modelled example of the so-often repeated *Venus Holding a Mirror to Cupid*' [*sic*]. By contrast Crowe and Cavalcaselle (1877, II, p. 336, note) called it 'a copy by Contarin or Varotari', and vaguely referred to it as 'till lately preserved in the collection of Lord Ashburton'.
4. London, Mrs. Wakefield (in 1934). Poglayen-Neuwall, 1934, pp. 363, 382, fig. 4 (copy). This author's suggestion that this example might have come from Lord Ashburton's collection is invalid, since the latter's picture was destroyed.
5. Moscow, Museum of Fine Arts (Pushkin); canvas, 1·14 × 0·98 m., seventeenth century (Schmidt, 1907, pp. 216–223, workshop replica; Poglayen-Neuwall, 1934, pp. 363, 382, no. 4, fig. 5, copy). The picture was no longer traceable at Moscow or Leningrad in 1972 according to the curators at both museums.

L–27. Venus Clothed at Her Toilet with One Cupid
Madrid, Royal Palace (formerly).
Datable about 1565–1567.

The original by Titian, which was in the Royal Palace at Madrid, numbered among the items that Joseph Bonaparte, Napoleonic King of Spain, succeeded in carrying off, when he fled to France. The major part of his loot fell into the hands of the Duke of Wellington, after the battle of Vitoria, and now forms the collection at Apsley House in London (Wellington, 1901, Introduction). The *Venus Clothed* must have been lost in the battle.

Iconography: The significant innovation in this composition is the covering of Venus' body with a white chemise, although the breasts are carefully revealed. The detailed description of the picture in the Madrid inventory of 1636 establishes the fact that Rubens' copy (see below, Copy no. 1), now in the Thyssen-Bornemisza Collection at Lugano, reproduces in every detail Titian's original, which was painted for Philip II and remained in Spain until the Napoleonic period.
Titian must have been informed of Philip II's increased prudishness, since the artist sent him this partially clothed goddess rather than the much more resplendent picture now in Washington. At this same period the master's activities for Philip II were chiefly concentrated on religious works for the Escorial such as the *Last Supper* and the *Martyrdom of St. Lawrence* (Wethey, I, 1969, Cat. nos. 46 and 115). Further comment upon the iconography of the subject is reserved for the text.

Dating: A picture of a *Venus* is mentioned in letters from the Spanish consul at Venice, Thomas de Zornoza, to Philip II

under dates of 2 December and 6 December 1567 (Zarco del Valle, 1888, p. 234; Cloulas, 1967, pp. 272, 274). On the second occasion Zornoza announced that a *Venus* was being shipped at the same time as the *Martyrdom of St. Lawrence*. It is assumed that Cat. no. L–27 was this item, which is cited more specifically in the famous letter from Titian to Antonio Pérez on 22 December 1574. Then, in his complaint that he had not received any payment for many important pictures, Titian called it 'una Venere con Amor che gli tiene lo Specchio' (C. and C., 1877, II, p. 540; Cloulas, 1967, p. 280); Wethey, III, note 266.

History: See also above. In 1626 Cassiano dal Pozzo (folio 122) was specific in noting that Venus wore a shift ('Una Venere in camiscia che si riguarda in uno specchio tenuto da Cupido . . . di Titiano'). In 1633 Vicente Carducho praised the picture, to which he referred as *Venus with a Mirror* ('una Venus a quien sumestra el espejo': edition 1933, p. 108). At that time it hung in the new large hall ('el salón grande') of the Royal Palace. By 1636 the painting had been transferred to His Majesty's summer bedroom and in that Inventory, folio 36, the full account of the jewels worn by the goddess proves that Rubens (Plate 132) accurately adhered to Titian's model ('Una pintura al olio de una Venus los pechos desnudos con ropa de lebantar carmesi con una brazalete de perlas en la mano derecha y en el dedo de la izquierda un anillo y un cupido delante de ella desnudo con un espejo en que ella esta mirando, es de mano de Ticiano'.) The Alcázar Inventory, Madrid, 1666, nos. 701 and 703, contains two items of the subject, the first valued at 300 ducats and the second at 400 ducats. Both are said to be originals by Titian. The second one must have been a copy, in spite of the fact that the court painter and son-in-law of Velázquez, Juan Bautista del Mazo, prepared this inventory. No. 701 is said to be 'vara y quarto en quadro' [1·044 × 1·044 m.], but these dimensions are approximate since these pictures were surely not square. No. 703 is said to be the same size but with figures in different attitudes ('con diferentes actitudes').
The Alcázar Inventory of 1686, nos. 874 and 876, contains the same items with the same descriptions. The first, 'Otra de vara y quarto en quadro de Venus con el niño que tiene un espejo de mano de Ticiano (see also Bottineau, 1958, p. 323).
The Alcázar Inventory of 1700, no. 496 repeats the first item as by Titian. In 1700, no. 498 is the second item [i.e. 1666, no. 703, and 1686, no. 876] and here it is called a copy ('parece copia de Ticiano'), although the value is given as 250 *doblones* and the presumed original is set at 150 *doblones*. The conclusion is that the men who prepared these inventories were not connoisseurs. In the Inventory of 1734, no. 22, 'Venus y Cúpido, $1\frac{2}{3} \times 1\frac{1}{2}$ varas' is called a copy of

Titian. At the time of the disastrous fire of 1734, which destroyed the Alcázar, the 'Bóvedas de Ticiano' escaped without serious damage. In the Inventory after the fire, No. 25, a *Venus and Cupid* ('otro de vara y media de Venus y Cupido'), was given a clean bill of health as 'bien tratado' (in good condition).
The brief notations in the Inventory of 1747, after Philip V's death, make identifications difficult. The *Venus at Her Toilet with Cupid* should be no. 25 again: 'Otro cuadro de vara y media en quadro de Venus y Cupido original de Ticiano en seis mil reales'. The alternative is the one called a copy in 1734, no. 22: 'Otro de vara y dos tercias de alto y vara y media de ancho de Venus y Cupido original de Ticiano en nueve mil reales'. These contradictions in price and authenticity are beyond explanation except in the ignorance of the compilers.
In the new Royal Palace (Palacio Nuevo) Ponz saw the picture (now only one item) in the King's bedroom in 1776 (Ponz, 1776, tomo VI, Del Alcázar 31): 'Otra Venus hay mirándose en un espejo que le presenta un Cúpido.'
The shift worn by Venus [so quaintly described by Richard Cumberland in 1787, see note 342] appears to have saved her from banishment along with the other nudes, which Charles IV wanted to be burned up (Senetenach, 1921). Those pictures in large part still survive in the Prado Museum. The *Venus at Her Toilet with One Cupid* remained on view in the Royal Palace with the result that the picture was looted by Joseph Bonaparte, who succeeded in exporting it for sale in Paris or London (see beginning of the present item, Cat. no. L–27).

COPIES:

1. Lugano, Thyssen-Bornemisza Collection; canvas, 1·30 × 1·10 m.; copy by Rubens, datable 1628 (Plate 132). The original was among the Titians in the Spanish royal collection which Rubens copied in 1628 according to Francisco Pacheco, who cites the picture as 'Venus y Cúpido' (Pacheco, 1638, edition 1956, I, p. 153). The item in Rubens' Inventory of 1640, no. 48, is probably the same one: 'Venus qui se mire avec Cupido', copy of Titian (Lacroix, 1855, p. 271). The Thyssen-Bornemisza Foundation purchased the painting from the Charles-León Cardon sale (Paris, June 1921, no. 79, illustrated). *Other Bibliography:* Poglayen-Neuwall, 1929, pp. 188–191; *idem*, 1934, pp. 376, 384, fig. 18 (formerly in the Cardon Collection); R. J. Heinemann, 1958, p. 90; Held, 1967, pp. 188–192 (dated Rubens' copy in the 1620's, but without reference to Pacheco).
2. Munich, Alte Pinakothek (in storage; formerly exhibited in Augsburg, Gemäldegalerie); from Schleissheim (Inventory 1775, no. 19); in Regensburg 1949–1959; canvas, 1·15 × 1·01 m. This mediocre copy is surely not Spanish. *Bibliography:* C. and C., 1877, II, p. 336, note (copy);

Augsburg, 1912, p. 76, no. 2303 (copy); Poglayen-Neuwall, 1934, p. 384, fig. 17 (then in Augsburg, copy); Kultzen and Eikemeier, 1971, pp. 197–198 (copy of Titian).

VARIANT:

Munich, Oberfinanzdirektion; *Venus and Cupid without Mirror*; canvas, 1·29 × 1·01 m., Inventory no. 8766 (3986); Venetian School, late sixteenth century, remote from Titian.

Venus is seated and Cupid rides hobby-horse on her left leg. Prince Brancaccio purchased the picture on 26 July 1943 at the Frankfurt sale of Marchesa Concetta Serra di Cassana of Follina (Treviso) for 60,000 DM. It was intended for Adolf Hitler's museum at Linz (Information made available through the courtesy of Dr. Rike Wankmüller of the Oberfinanzdirektion in 1970).

DOCUMENTS AND VARIA

Titian's Signatures

THROUGHOUT his long career Titian varied his method of signing his pictures for reasons that in some instances are easy to deduce. His earliest are the simplest: merely the initials T.V. (Ticiano Vecellio) on two portraits of *c.* 1512, those of the *Gentleman in Blue* and *La Schiavona*, both by chance in the National Gallery at London.[1] He placed them upon the parapet in the foreground, a compositional device that he inherited from Giovanni Bellini and Giorgione. In slightly later works he adopted the full first name spelled with a 'C' as TICIANO or the Latinized variant TICIANVS. In hand written documents such as the payments for the *Madonna of the Pesaro Family* (1519–1526) he wrote 'Ticiano' and sometimes in correspondence he signed 'Tician' or 'Tician Vecellio', following Venetian usage which tended to omit a final o.[2] It should be made clear that he never, never used the Tuscan z ('Tiziano') in any piece of correspondence or upon any painting.

The earliest Latinized name appears on the Pharisee's collar in the *Tribute Money* at Dresden (*c.* 1516) as TICIANVS F,[3] while the great *Assumption* (1516–1518) in the Frari has TICIANVS without the F inscribed upon the tomb in the lower centre.[4] The Brescia *Resurrection* has a fuller version placed upon the end of the column below St. Sebastian: TICIANVS FACIEBAT MDXXII.[5] Another slightly earlier case of a date distinguishes the *Madonna and Child with SS. Francis and Aloysius and Alvise Gozzi as Donor* at Ancona. The great ecclesiastic who ordered the painting may have insisted upon the lengthy Latin inscription which is unique in Titian's whole career: ALOYXIVS GOTIVS RAGVSINVS FECIT FIERI M.D.X.X. TITIANVS CADORINVS PINXIT.[6] The inclusion of a date is by no means common.

In the case of the *Supper at Emmaus* in Paris the shortened name TICIAN may be due to the loss of the last two letters or to the small space upon the left table leg.[7]

Shadowed capital letters are definitely rare, although they do occur upon a famous portrait the *Man with the Glove* (*c.* 1520–1522) in Paris (Plate 238A) as TICIANVS,[8] while the *Giacomo Doria* at Luton Hoo, although signed in the same fashion is a work of definitely secondary significance.[9] *Federico II Gonzaga*, an altogether charming portrait of the twenty-three-years old aristocrat, is signed in an oblique position upon the belt in a most unusual way but with the letters TICIANVS F (Plate 238B).[10] Another similar instance is the case of *Laura dei Dianti* with the same signature in tiny red letters on the narrow metal band upon her right sleeve.[11] One of the best preserved signatures in the fifteen-twenties appears upon the urn at the left in the *Bacchus and Ariadne* (1520–1522) which again reads, and very clearly here: TICIANVS F (Plate 56). The case of *The Andrians* (*c.* 1523–1525) in the same series from Ferrara is the most curious of all, for the small cursive letters TICIANUS F (Plate 238C) are found upon a tiny ribbon on the edge of a girl's low-cut blouse. Although the name has been inexpertly retouched and the no. 201 (the number in the Aldobrandini Inventory of 1603) added, the signature must be authentic.[12] As long ago as the mid-seventeenth century Ridolfi observed the intimate location of the signature and also the two violets tucked in the blouse nearby. He came to the conclusion that the girl's name was Violante who perforce must have been Titian's mistress at this time. Boschini elaborated further upon the theory to the extent that the girl was Palma il Vecchio's daughter, but it has been shown that he never had one.[13] A fragmentary restored and perhaps even dubious signature on the portrait of a *Gentleman* (*c.* 1525–1530) in Berlin (Plate 238D) is virtually illegible. It was incorrectly

1. Wethey, II, 1971, Cat. no. 40, Plate 3, and Cat. no. 95, Plate 14. The mysterious v v on certain portraits surely does not constitute a signature. The problem is examined in Wethey, II, 1971, page 11, note 56.
2. See C. and C., 1877, I, pp. 441–456. After 1530 he appears to have written his name more consistently as *Titiano*. In the Venetian dialect names such as Contarini, Delfino, etc., drop the final vowel.
3. Wethey, I, 1969, Cat. no. 147.
4. Wethey, I, 1969, Cat. no. 14, Plate 22.
5. Wethey, I, 1969, Cat. no. 92, Plate 74.
6. Wethey, I, 1969, Cat. no. 66. Signature and inscription on the *cartello* in the lower centre, partially in cursive letters.
7. Wethey, I, 1969, Cat. no. 143. The c occurs here as late as *c.* 1535.
8. Wethey, II, 1971, Cat. no. 64. Because of a typographical error the signature is printed TITIANVS. The F has probably disappeared

with time. In speaking of Titian's early Giorgionesque portrait of a member of the Barbarigo family, Vasari describes the signature as 'scritto in ombra il suo nome'. It is possible that he meant this type with shadowed letters on the *Man with the Glove* (Plate 238A).
9. Wethey, II, 1971, Cat. no. 25. The puzzling situation here also lies in the presence of an earlier signature on a mid-period portrait *c.* 1540–1545.
10. Wethey, II, 1971, Cat. no. 49. The signature, although somewhat carelessly retouched, definitely has a c.
11. Wethey, II, 1971, Cat. no. 24.
12. Wethey, III, this volume, Cat. no. 15. All three of the pictures from Ferrara have the early signature: TICIANVS F.
13. For the legend of Violante and portraits thought to represent her, see Wethey, I, 1969, p. 13; *idem*, II, 1971, page 13, note 60, and Cat. X–115, the portrait in Vienna by Palma il Vecchio.

read and even retouched as TI ZIAN VS F, whereas no authentic example of a signature by the artist in this form exists.[14] In conclusion it may be said that the Latinized Venetian form of the artist's signature TICIANVS is most frequently met in the fifteen-twenties.[15]

The most widely used signature by the artist from about 1530 onward is TITIANVS F. In this decade Titian became an internationally known master, as painter to Emperor Charles V, who knighted him in May 1533. Therefore, it would seem, he largely abandoned the local Venetian spelling of his name for a fully Latinized form. In this way he adhered to the popular Renaissance fashion of translating one's name into Latin. Only occasionally he spelled out the second word, FACIEBAT, as in the prominently placed inscription located in the very centre of the composition of the *Madonna and Saints* in the Pinacoteca Vaticana.[16] Occasionally too Titian wrote FECIT and the fact is well-known that he insisted upon his authorship of the late *Annunciation* (c. 1560–1565) in San Salvatore at Venice with the words TITIANVS FECIT FECIT!![17] On the other hand, TITIANVS F. occurs again and again, sometimes with lighter coloured letters against a dark ground as in the *Duke of Urbino* (1536–1538) at Florence (Plate 238E), the *Venus and Cupid with an Organist* (c. 1548–1549) in Berlin (Plate 238G) and the same subject (c. 1545–1548) in Madrid (Plate 239A).[18] Here the letters are formed very precisely almost as though done with a stencil. Dark letters also occur in many instances, as for example on the portrait of *Clarice Strozzi* (1542) in Berlin (Plate 238F). A very late signature such as that of the

Tarquin and Lucretia (c. 1568–1571) in Cambridge is painted on the slipper (Plate 239B) at the lower right in well-formed but freely brushed letters. This looser signature corresponds logically to the late illusionistic style of the paintings themselves in this period. It might be observed that the location of the signature varies, but that it most frequently occupies a relatively inconspicuous space at the lower right or left. The large signature, so conspicuously placed in the middle of the *Madonna and Saints* of the Pinacoteca Vaticana constitutes a divergence, probably explainable by Titian's youth at that period.

By exception Titian chose cursive letters for his signature *Titianvs P* on the famous painting of the *Trinity*, delivered to Charles V in 1554.[19] The reason seems fairly obvious, however, since the letters are written upon Ezekiel's scroll (Plate 239C), and the curving shapes throughout are more harmonious than Latin capitals would have been. The letter 'P' for 'Pinxit' is also unusual, but not unique, for Titian substituted it for F on the *Magdalens* in Naples and Leningrad as well as on the *St. Nicholas of Bari* in Venice and on two very late mythological subjects, the *Rape of Europa* and the *Flaying of Marsyas*.[20] All of them in this group except the *St. Mary Magdalen* in Naples are late compositions.

Most extraordinary is the fact that Titian rarely included his title of knight, i.e. 'Eqves Caesaris', bestowed by Charles V in 1533, as we have seen. Even in works intended for Charles V and Philip II he usually made no allusion to his title.[21] The famous portraits of both rulers rarely have signatures at all, nor do the portraits of Paul III. The

14. I have read it as TICIANVS (Wethey, II, 1971, Cat. no. 46) partly because that is the most common form in the fifteen-twenties. This picture, although labelled Titian by Van Dyck as is well known, carried the label of Tintoretto until the early twentieth century. Apparently ANVS F are the only relatively certain letters. Posse (1913, I, p. 177, no. 301) made an error in interpreting the name as TIZIANVS and that error was repeated by Kühnel-Kunze (1931, p. 485, no. 301). Tietze (1936, II, p. 284) more reasonably assumed the signature to read TICIANVS. I am indebted to Dr. Erich Schleier, curator of painting in Berlin, for his courtesy in supplying me with this photograph (Plate 238D) and others of Titian's paintings in Berlin.

15. The very strange and smudged letters on the *St. Dominic* of the Villa Borghese (Wethey, I, 1969, Cat. no. 99) which read TICIAN$_V^S$ are probably apocryphal. The late date of the picture, c. 1565, also adds to doubts of its authenticity. Two portraits of the forties bear the signature TICIANVS: see Wethey, II, Cat. no. 47, *Gentleman*, c. 1540, Boston; and Cat. no. 71, *Martino Pasqualigo*, c. 1545–1546, Washington. The *St. John the Baptist* in the Accademia, Venice (Wethey, I, 1969, Cat. no. 109) also has this form of signature.

16. Wethey, I, 1969, Cat. no. 63, Plate 23.

17. *Loc. cit.*, Cat. no. 11.

18. Eighteen religious compositions have the form TITIANVS F, although it is uncertain in a few instances whether the F is lost or was never included. A photograph of the signature on the

Ancona *Crucifixion* (Wethey, I, 1969, Cat. no. 114) is reproduced in volume I, Plate 202. A very strange case, never satisfactorily explained, is the *Christ Carrying the Cross*, a superb composition in the Prado Museum (Wethey, I, 1969, Cat. no. 23), where above the TITIANVS (F?) are the letters I. B. The theory that Giovanni Bellini and Titian collaborated on this composition, c. 1560!, has long been abandoned. My suggestion that it might refer to the engraver Giulio Bonasone is unfortunately weakened by the lack of any engraving of this picture.

On portraits Titian only rarely inscribed his signature. Twelve have the most frequently adopted form, TITIANVS, while only twenty-three of the one hundred and seventeen items in Wethey, II, 1971, have any form of signature.

The mythological paintings, although perhaps among the most celebrated, number only fifty-five in my volume III. Ten signatures constitute a small total. Such famous works as the *poesie* for Philip II, only two are signed (Cat. nos. 10, 32). Doubtless the artist thought that he was so well-known that any such documentation was irrelevant.

19. Wethey, I, 1969, Cat. no. 149, Plates 105–109. The Spanish word 'Gloria' meaning 'Heaven' was first used by Padre Sigüenza in 1599, and it has no esoteric significance.

20. Wethey, I, 1969, Cat. nos. 122, 123, 131; *idem*, III, Cat. nos. 16 and 32.

21. See also, 'Titian's Titles and Devices'.

earliest certain occasion, at least in preserved paintings, when the artist signed the full title TITIANVS EQVES CES. F was in 1543 on the great *Christ Before Pilate* done for Giovanni d'Anna (van Haanen), a Flemish merchant who lived in Venice.[22] The *Doge Andrea Gritti* (c. 1533–1538), now in Washington, has a shortened legend, TITIANVS E. F, which for that reason has often been considered apocryphal.[23] Nevertheless, the full-length *Philip II* (c. 1554) in Naples, generally regarded as partly by the workshop, also has an elliptical inscription, TITIANVS EQVES C. F.[24] Two religious paintings sent to Philip II in Titian's late career that include the title of knighthood are the *Entombment* (1559) with the elaborate golden lettered TITIANVS VECELLIVS OPVS AEQVES CAES. F (Plate 239D) and the *Christ Carrying the Cross* (c. 1565) with TITIANVS AEQ. CAES. F.[25] The *Allegorical Portrait of Philip II* (1573–1575) differs in the again unusual cursive letters (Plate 239E) and a slightly different inscription, *Titianus Vecelius eques Caes. fecit*, on a paper attached to a column.[26] At the height of his career on one of his great works, the *Martyrdom of St. Lawrence* (1548–1557), painted for the Massolo-Querini, Titian spelled it out: TITIANVS VECELIVS AEQVES F.[27] A small detail, the omission of 'Caesaris' (of the Emperor) may be a clue to the little stress Titian gave to his title. The Hapsburg empire was very frequently at odds with the Venetian state. One need only to refer to the Venetian victory in the Battle of Cadore and Maximilian's occupation of Padua in 1509.[28] Even so it is curious that Titian did not more frequently refer to his title, when his pictures were directly destined for his great Hapsburg patrons, Charles V and Philip II.[29]

Titian's Titles and Devices

THE knighthood and patent of nobility and the coat-of-arms, conferred on Titian by Charles V in 1533,[30] seem to have caused little change in his pattern of living. He had already moved into the Casa Grande in 1531 after the imperial coronation at Bologna. His titles of Knight of the

Golden Spur and Count Palatine, purely honorary when he received them, decreased in importance in the following decade, when Paul III Farnese (1534–1549) conceded to the Contarini family the privilege of bestowing them.[31] Nothing survives to show that Titian ever referred to himself as Count. Only seven of his hundreds of pictures are signed EQVES, i.e. 'knight',[32] and he wrote of himself as *cavaliere* only in his last rather pathetic letter to Philip II in February 1576, though he painted himself at least three times wearing the golden chain of knighthood.[33] Likewise, his handsome escutcheon, decoratively illuminated on the diploma of 1533 (Frontispiece), remained largely unused throughout his lifetime. No carving or decorative fresco of his palace seems to have carried it; it does not appear on his *Self-Portraits*, and he apparently reproduced it only once, in his last picture, the unfinished *Pietà* intended for his own tomb.[34]

The reason for this avoidance of display was in all probability political, for after the War of the League of Cambrai the relations between Venice and the Empire were those of correct civility only. Charles V had indeed passed through Venetian territory in 1532, visiting Bassano and Verona,[35] but omitting Venice itself. In a curious side-drama, the imperial ambassadors to Venice from early in the reign of Charles V had been charged with the fruitless mission of inducing the Serenissima to restore to the family the confiscated house and property of Dr. Bertuccio Bagarotto of Padua.[36]

Further investigation into the bearings in Titian's escutcheon makes it clear that imperial politics dictated those chosen. The silver, gold, and black device[37] can be described thus: A fess sable, the chief or with a double-headed eagle sable, the base argent, a chevron sable. The fess, the black band occupying the horizontal centre of the shield, represents the belt of honour given by a sovereign as a reward for eminent services.[38] The chief, the upper third of the shield, with its golden field and black double-headed eagle is obviously the device of the Empire, traditionally forming the upper part of arms conferred by an Emperor.[39]

22. Wethey, I, 1969, Cat. no. 21, Plates 90, 91, now in Vienna.
23. Wethey, II, 1971, Cat. no. 50.
24. *Loc. cit.*, Cat. no. 79.
25. Wethey, I, 1969, Cat. nos. 24, 37.
26. Wethey, II, 1971, Cat. no. 84.
27. Wethey, I, 1969, Cat. no. 114.
28. See this volume, Cat. no. L–3 and Cat. no. 33, History.
29. The only mythological painting signed TITIANVS AEQVES CAES. is the *Danaë and Nursemaid* in Vienna, which Cardinal Montalto sent from Rome in 1600 as a gift to Emperor Rudolf II at Prague (Cat. no. 7, History).
30. Wethey, I, 1969, p. 22, note 124; II, 1971, p. 4, note 20, p. 21, note 88.

31. Crollalanza, 1964, pp. 179, 454–455; Guelfi-Camajani, 1940, pp. 162–165.
32. See above, Signatures.
33. Venturi, 1928, p. 183; Wethey, II, 1971, Cat. nos. 104, 105, L–33.
34. Wethey, I, 1969, Cat. no. 86; III, 1975, Addenda I, p. 262.
35. Sanuto, LVII, 1532, cols. 194, 217.
36. See Cat. no. 33, *Sacred and Profane Love*, Escutcheons and History; Sanuto, XXVIII, Jan. 1520, col. 228; XXXV, 14 June 1524, cols. 385, 386; LIII, 10 April 1530, col. 133, 21 April 1530, col. 164, 8 July 1530, col. 335, 13 July 1530, col. 343, 16 July 1530, col. 350.
37. Wethey, II, 1971, p. 21, note 88.
38. Copinger, 1910, p. 48.
39. Crollalanza, 1964, pp. 148, 255, 'capo dell' impero'; see also Cat. no. L–3, *The Battle*, Subject.

The base, the lower third of the shield, not by accident consists of the escutcheon of the city of Udine, a black chevron on a silver field. Udine's historical relationship to Cadore was long-lasting and important. From 1027, with only one five-year gap in the fourteenth century, Cadore along with the whole province of Friuli was part of the vast temporal holdings of the Patriarchate of Aquileia, the largest ecclesiastical–civil principate of northern Italy, whose seat was Udine from 1238 down to 1420, when it passed under the dominion of Venice. Udine had been the gift of Emperor Otto II to the Patriarch Rodoaldo in 983, and during the centuries of independent existence of this extensive domain relations were cordial between it and its German neighbour, some of the patriarchs even being German. Undoubtedly the arms of Udine were incorporated in the lower part of Titian's shield in reference to the ancient friendship between the Empire and the Patriarchate of Aquileia.[40] Thus it may be seen that Titian's escutcheon involved allusions that would indeed have been unpolitic to publicize in Venice.

Pertinent to this section is the matter of Titian's *impresa*. Although nothing has come to light to indicate that Titian actually ever used an *impresa* or motto, from time to time scholars have mentioned one ascribed to him. Panofsky[41] wrote: 'We should not forget that Titian's personal *impresa* was a she-bear licking her cub into shape and thus exemplifying the proud motto: NATURA POTENTIOR ARS, "Art is more powerful than nature".' However, half a century earlier Gelli in his treatise on devices[42] made the dry comment that people would like to attribute it to Titian and pointed out the motto's derivation from a classical source. Guy de Tervarent in his book on symbols[43] explained the legend of the she-bear and noted Titian's use of it together with the motto. As the source for the ascription to Titian, he cited the last figure in Book I of Lodovico Dolce, *Imprese nobili e ingeniose*, Venice, 1578 [first edition 1562]. The possibility exists that Titian's friend Dolce invented it and introduced it in his book as one eminently suitable for the use of a great painter (Plate 240).

[Alice S. Wethey]

Titian's Painted Clocks

ON seven occasions between 1536 and 1558 Titian included a small table clock in the setting of a portrait, each of the upright rectangular shape referred to as a 'tower' in early

descriptions and inventories.[44] All but one seem clearly of Italian Renaissance design. In the first four instances, the *Duchess of Urbino*, 1536–1538 (Wethey, II, 1971, Cat. no. 87), *Paul III and Grandsons*, 1546 (Wethey, II, 1971, Cat. no. 76), *Charles V and the Empress Isabella*, 1548 (Wethey, II, 1971, Cat. no. L–6), and *Antoine Perrenot*, then Bishop of Arras, not yet cardinal (Wethey, II, 1971, Cat. no. 77), the rectangular clock cases, surmounted by a dome, have flat pilasters on the corners and a simple entablature. The two later clearly Italian examples, those in the *Knight with a Clock*, 1550–1552 (Wethey, II, 1971, Cat. no. 58) and *Fabritius Salvaresio*, 1558 (Wethey, II, 1971, Cat. no. 92) exhibit more fully developed architectural articulation, with attached columns on the corners and the entablature broken out over them. The earliest and the latest of these six clocks have five human figures as finials. The other three with pilasters have simple pyramidal forms in these locations, while the knight's clock has urn-shaped finials. The seventh clock, that in the portrait of *Cardinal Cristoforo Madruzzo*, 1552 (Wethey, II, 1971, Cat. no. 62), seems to be a special case. It shows the same general shape as the others, but without architectural members, and its pointed, four-sided dome with traceried ornamentation is surmounted by a standing figure. Curiously and rather lopsidedly drawn, with Gothic motifs quite alien to Titian or his workshop, it may have been added by another hand or applied over another clock of more Italianate design. Nevertheless, this very clock was seen by Cavalcaselle in the Casa Valentino at Trent in 1865 (see Addenda II, Cat. no. 62).

Various questions immediately present themselves. Are they primarily status symbols and in that case actual clocks owned by the sitters?[45] In the Madruzzo portrait the answer seems to be in the affirmative, because of Cavalcaselle's testimony. But the situation is not nearly so clear in the other portraits. These are all remarkably simple clocks for an age which was enamoured of these new mechanical gadgets, an age when a 'clock-master' was usually employed in any court and potentates and princelings normally collected clocks. The great exhibition held in Toledo in 1958, commemorating the four-hundredth anniversary of the death of Emperor Charles V,[46] had among its treasures twenty-four clocks dating from the sixteenth century. There were wall clocks, cross-shaped, drum-shaped, oval, hexagonal, octagonal, some with cases of gilded or enamelled metal, others with panels of rock crystal, all with ornamentation diverse beyond ready description, a few showing retarded Gothic motifs. The table clocks were even more

40. T. C. I., *Friuli, Venezia Giulia*, Milan, edition 1963, p. 284; Lazzarini and del Puppo, 1901, pp. 7–14, 51–55; Espasa-Calpe, V, 'Aquileya' and LXV, 'Udine').
41. Panofsky, 1969, p. 14.
42. Gelli, 1916, p. 420, no. 1101.

43. Guy de Tervarent, 1958–1959, II, col. 293.
44. Sánchez Cantón, 1956–1959, II, pp. 309–332, nos. 4615–4752.
45. Panofsky, 1969, p. 89.
46. *Carlos V*, 1958, pp. 301–305, pls. CCLXXIX, CCLXXX.

bewildering in their variety, hexagonal, octagonal, drum-shaped, square, cylindrical, some were astronomical clocks or alarm clocks, various of them were 'tower-shaped' with the face vertical, others were horizontal with the face on top.

In a later exhibition in Madrid in 1965,[47] dedicated to clocks alone, there were also paintings showing clocks and books dealing with them. On the cover of the catalogue appears a photograph in full colour of a magnificent table clock of c. 1550 made for the Emperor Charles V. A high hexagonal basement storey of ebony is articulated with Corinthian colonnettes of gilded bronze with niches between of lapis lazuli, in which stand mythological figures likewise of gilded bronze. A circular frieze supported by the colonnettes forms a platform for an open pavilion constructed of Tuscan colonnettes. The circular and very wide frieze of this upper order displays in front the dial of the clock itself and around its circumference the escutcheons of the chief possessions of the Spanish crown: Castile, León, Toledo, Aragon, Galicia, Valencia, Navarre, Granada, the Two Sicilies, ancient Sicily, Croatia [!], and Jerusalem [!]. The pavilion is crowned by a high domed lantern with arched opening and a finial in the form of a nude standing figure. Seated within the pavilion is the automated figure of the Emperor himself, clad in imperial robes, his right hand grasping the sceptre, which moves to sound the hours.[48] Such a clock is a far cry indeed from the sober little 'tower' clock that Titian painted on the table between the figures of the Emperor and his Empress.

Every kind of fantasy was employed in designing these clocks. In the Madrid exhibition of 1965 was an Augsburg clock of c. 1555 in the shape of a unicorn, whose eyes moved with the escapement and whose mouth opened and shut at the sounding of the hours.[49] Another sixteenth-century clock made in Nuremberg is composed of a monkey holding a shield, on which is the clock face. When the hours strike the monkey raises a mirror to look into it, while a small negro behind him shakes a stick.[50] In the collection of clocks formed by Charles V were: a clock like a gate with a calendar of the months, a round clock which indicated the minutes, the clock of the Sirens with two dials, the clock with the elephant and castle and Venus and Adonis, a small rectangular clock with the imperial arms, which the Emperor carried with him, and many others.[51] Particularly elaborate

clocks were sent as princely gifts from one ruler to another, such as the astonishingly complicated one presented by the Duke of Urbino to Philip II, which included a sculptured group, a writing desk, a chandelier, paper holder, and clock.[52]

The conclusion seems inescapable that the clock in the double portrait of the Emperor and Empress could not represent an object lent by Charles V for the convenience of the painter. The same seems to be true in the cases of the *Duchess of Urbino*, of *Paul III with his Grandsons*, and of that great churchman–statesman, *Antoine Perrenot*. For status symbols not one of them could have chosen clocks of such simple design. Since we know nothing whatever about the history of the personages in the *Knight with the Clock* and *Fabritius Salvaresio*, perhaps no conclusions can be safely drawn in connection with the appearance of a clock in their portraits. On the other hand, all six clocks in these portraits are so much alike, four of an early Renaissance and two of a high Renaissance design, that it seems highly likely that they are variations on clocks owned by Titian himself.

The further question arises of a deeper symbolic meaning in these objects. Do they imply the transience of Time and Death, as suggested by Panofsky?[53] In the north in this period, clocks and hour-glasses were commonly associated with such ideas, and as Panofsky has pointed out, German table clocks often bore inscriptions to the effect that 'one of these hours will be the last'.[54] Comparative data on Italian clocks are not available and a compilation of Italian portraits with clocks lies outside the scope of a monograph on Titian. However, the joyous spirit of the Italian Renaissance was not overlaid with the lugubrious ideas of the transience of life that are so readily visible in the art of Germany and Flanders. Titian himself in none of his portraits shows the slightest tendency to a morbid preoccupation with death and the next world. Finally, in the one picture that might well be an example of a *memento mori*, the double portrait of the Emperor and his long-dead wife, it is remarkable that the face of the clock is turned away from the observer. Thus we are not shown its dread marking of the hours, we see only its decorative case. It seems quite in order to suggest that Titian used clocks in these portraits, as he used flora and fauna elsewhere, as decorative accents to enliven a composition, not inevitably as iconographic symbols.

[Alice S. Wethey]

47. Madrid, 1965.
48. *Loc. cit.*, p. 12.
49. *Loc. cit.*, p. 10.
50. *Loc. cit.*, p. 11; a similar one in *Carlos V*, 1958, no. 950, pl. CCLXXX.
51. Sánchez Cantón, 1956–1958, I, pp. XL, XLI.
52. *Loc. cit.*, p. XLI.
53. Panofsky, 1969, p. 90.
54. *Loc. cit.*

Num. I V.

Scrittura in nome della Città mandata a Tiziano

Avvertimenti Generali.

DI che grandezza abbiano ad effere le Figure della Soffitta a noi non s'appartiene di parlarne, percioche el giudiciofiffimo Re di Pittori con ragione di profpettiva confiderando la diftantia del loco ben faprà farle in modo, che fi lafciaranno vedere piutofto maggiori alquanto, che minori del naturale. Ma perche nel proporre del argumento, che a noi s'afpetta, fa molto a propofito il ragionare del fito, s'ha da confiderare, che la porta del Palazzo è pofta a tramontana, & dovendo la pittura fervire principalmente all'occhio di chi entra, fa meftiere che le Figure fiano anco effe a tramontana, perche effendo riguardate di fotto in fu, convien che l'huomo piegando indietro el capo, & alzando la faccia in quello fteffo modo le riguardi, che farebbe, fe egli fuffe fupino co'l capo a tramontana, la onde altramente facendo fi vedrebbono al riverfo di che le mira, non togliendofi però l'arbitrio al Pittore di accorciare quanto li parerà, & fpecialmente quelle figure, che poferanno in aria.

Appreffo perche fa molto a propofito all'ordine delle cofe il fapere quale fia la deftra, & la finiftra de le Figure voglia in che attitudine fi ftiano, o dove elle rifguardino, fi confiderano, come fe tutte guardaffero a terra, così intendendo fempre levante per la deftra, per la finiftra ponente.

Primo Quadro.

Nel quadro, overo ottavo de mezzo entrano fei figure, una Brefcia, Minerva, Marte, e tre Nimphe Najadi, ciò è Dee di fiumi. La Brefcia ftia nella aria fofpefa contra mezzo nella più degna, & ecelente parte dello fpatio in forma di belliffima Donna con grave, maturo & venerando afpetto, ornata ricamente, il capo fenza corona però, o regal abito, veftita a longo all'antica di vefte bianchiffima cinta di fafcia azurra, habbia le braccia ignudi, & la mamella deftra, agroppando le vefti fu la finiftra fpalla, & fotto il deftro fianco, ftendendo il braccio deftro porga verfo levante una ftatua d'oro, quafi facendone altrui dono, piegando ancho co'l fguardo in quella parte, & in atto pietofo, & manfueto poggifi fopra el petto la finiftra. Sia la ftatua d'oro un fimulacro della fede, non fconcia di grandezza, ma tale che ben fe difcerna al baffo. E' quefta fede veftita a longo con certo manto fopra accolto al finiftro braccio, nella finiftra ha il corno della divitia, ftende la deftra aperta in atto di congiungerla, o vogliamo dire di toccare altrui la mano. Una tale fi ritrova nei riverfi di Vefpafiano in rame, quefta ancora farà bene, che fia volta a levante, come la Brefcia ifteffa che la porge. Tenga Brefcia la pelle del Leone, con la mazza di Hercole fott'i piedi, alludendo all'openione dell'antica origine.

La Minerva (intendendo della pacifica, non della Pallade guerriera) fi depinga nell' aria alla deftra parte de la Brefcia, cio è verfo levante, giovane, che tenga del civile, con gli occhi di color cileftro, & i capelli in dietro fparfi. Habbia in capo una

cellata antica fenza orecchie nel modo quafi che fi vede in alcune monete Ateniefi d'argento, tutta adorata con la sfinge in mezzo per cimiero, & doi griffoni dai lati fcolpitici per ornamento di baffo rilievo. La Sfinge è un certo monftro, detto trifor-me, annoverato da alcuni tra le fpecie de le Scimie, o vero gatti mamoni. Ha faccia, petto, & mamelle di donna, ha le ali grandi, il refto è di leone con longa coda. Al-cuna fe ne vede in pittura, & anco di rilievo nelle medaglie antiche. Il Griffone è un mifto d'Aquila, & Leone, & è affai noto.

Sia veftita Minerva d'habito Virginale a tre falde, o vero con trei vefti. Tenga con la finiftra un fcudo rotondo di criftallo poggiato appreffo i piedi. Habbia un ra-mo di oliva con i frutti ne la deftra, & la Civetta a piedi. Riguardi verfo la Brefcia.

Il Marte ftia anch'effo in aria a la finiftra de la Brefcia da ponente, & verfo lei rivolto; huomo grande robufto, terribile, & feroce nell'afpetto gli occhi infocati con fguardo minaciofo, & atroce, armato da foldato ricamente all'antica con elmo lucente fopra modo, & nella rilevata crefta un lupo, o vero piume per cimiero, la corazza dorata tutta, & difegnata leggermente a moftri fpaventevoli con la fua fal-da antica, con braccia, & gambe ignude fuori che de gli ufati a mezza gamba. Ten-ga con la finiftra un bel fcudo rotondo d'argento, o vero di fanguinofa luce poggiato appreffo i piedi, & con la deftra l'arma inhaftata, come fi vede tra i riverfi di An-tonin Pio in rame. Habbia l'augello Pico appreffo i piedi.

Le tre Nimphe fiano pofte ne la più baffa parte de lo fpatio, affife in varj modi fopra l'herbe, belle in habito vago, & nimphale, in parte ignude, con fue ghirlande in tefta di canna & altre herbe de fiumi, piene le man de' fiori. Tenga ciafcuna fot-to el braccio, o vicino un'urna di aqua verfata, come fanno li altri fiumi. L'una verfo ponente, alquanto de l'altre maggiore habbia l'urna di ferro anco maggiore, la feguente di piombo, la terza a levante di criftallo tenendola nel verfare alquanto fofpefa. Sia quefta Nimpha più de le due giovane, & gentile, & d'habito più fchiet-to, ma non del tutto bianco come Brefcia.

Secondo Quadro.

Ne l'altro ottavo, che è verfo ponente, facciafi Vulcano con i Ciclopia la fucina. Sia la fucina co'l foco in una gran Caverna di faffi dirupati, ofcura da fe, fe non quanto l'alluma el foco, affumicata, & in parte arfa da l'eceffivo calore. Siano ivi intorno varj ftromenti, & opere fabrili, & fpetialmente d'arme fabricate.

Il Vulcano è un vecchio brutto, & zoppo magro nel vifo, & in tutto il corpo fu-liginofo, & lordo, come fono i fabri, con capelletto al antica di color cileftro, d'il refto va ignudo o vero con pochi ftrazzi. I Ciclopi miniftri de' Vulcano fiano trei al-meno di eceffiva ftatura, ben nerbuti & robufti, di tutto ignudi, con un fol occhio grande & rotondo nella fronte. Tenga el Vulcano con la tenaglia nella finiftra un pez-zo di arme affocate fopra l'incudine battendolo con la deftra con mediocre martello, al quale rifpondano i Ciclopi a due mani con più pefanti magli, alzando fra loro per ordine le braccia, & alternando i colpi; & quando la grandezza di corpi lafciaffe lo-go a maggior numero, vi fi potrebbe aggiongere un quarto garzone per attendere a li mantici, & al foco. Il cavar le minere, & il fondere il ferro fi lafciaranno a dietro per non potervi capir tante cofe fenza confonder l'occhio di lontano. Facendovi ani-mali vi ftarà bene il leone, & rifponderà a li Animali del Quadro di levante, che vedremo.

Terzo Quadro.

Nel terzo ottavo posto verso levante anderà depinto una Cerere, un Bacco, & doi Fiumi. La Cerere si depinga ne l'aria in logo principale, & riguardevole. Facciasi donna di matronale maestà, bella sì di fattezza, ma non già morbida, & delicata, come arsa dal Sole & dimagrata alquanto da la fatica. Habbia i capelli sparsi con ghirlanda di spiche di formento, mista d' alcuno papavero, vestita a longo di cangiante verde giallo, in habito di nimpha, cinta al traverso & recinta più basso, con braccia ignudi, & scalza, come nelle Medaglie di Vespasiano in rame, & in argento. Habbia nella man destra un fascio di milio, & di Lino intero, nella sinistra una fiacola di pino accesa, doi draghi a piedi, & un aratro vicino. Siano i draghi cresuti co 'l tergo a nodi, le squamme risplendenti a macchie di color d' oro & rosso; altri vi mette i piedi con l' indice più longo de' l'altre dita. Facendovi i piedi, vi si convengono l' ale.

Il Bacco stia alla sinistra di Cerere tenendo il secondo & men pregiato loco. Sia Bacco un bel giovine delicato, & senza barba, con i crini longhi, & sparsi, con due cornette picciole alle tempie, con viso allegro, festevole, & ridente, alquanto licentioso & dissoluto, & in ogni suo atto effeminato & lascivo, grasso com' huomo di buontempo, ma non isconcio, come fanno alcuni. Sia coronato di Hedera con li suoi corimbi, o vero baccole suso, & qualche rosa dentro. Del resto ignudo, o vero con li coturni, che sono stivaletti a mezza gamba per l' autorità di Virgilio. Porga con la man destra vue mature con i pampini attaccati. Habbia il tirso ne la sinistra, cio è un bastone adorno, tutto coperto di Hedera, & una pelle di Tigre accolta al braccio manco, con tigre pantera, o cervier vivo appresso i piedi.

I Fiumi stiano a basso, come dicemmo de le Nimphe nel primo. Per l'uno da la parte di ponente si faccia un Vecchio assai grande & robusto con la faccia cerulea quasi verdegiante con barba & capelli longhi, canuti, & distesi, come se fussero bagnati, & le corna in capo, & ghirlanda di canne, sedendo tra' gionchi, musco, & qualche frondi. S' appoggi co 'l sinistro braccio sopra una grande urna d' oro, che versa aqua abbondante, & tenendo con la medesima mano un corno di divitia. Sostenti con la destra un bel trofeo. Sotto habbia un manto verde, che rivoltato alcuna parte del corpo gli ricopra, lasciandolo per lo più ignudo. L' altro dall' altra parte men vecchio, & men grande del primo, pur con le corna, corona & habito medesimo giacendo tra l'herbe palustre, tenga l' urna d'argento sotto l'un braccio versata, nell'altra mano il corno di divitia senza trofeo alcuno.

Num. V.

Lettere di Tiziano

Lett. I.

Molto Magn. Signori miei Ossmi.

HO ricevuto gli avvertimenti, che le M. V. mi hanno mandato, in materia delle Pitture; i quali mi sono paruti bellissimi, di modo che per conto della Poesia io mi ritrovo illuminato assai. Onde essendo così bene, e distintamente ragguagliato delle invenzioni, e del desiderio loro, io mi sforzerò di far tutto quello, che si richiederà all'arte, & alla qualità dell' opera per honor mio, & per servitio di questa Magn. Città, alla quale io non sono meno affezionato, che a Venetia mia propria Pa-

tria, fi per le fue eccellenti qualità, come per li molti miei Amici, e Patroni, che
io mi fento di avere in lei. Solò mi doglio non aver avuto più prefto tal informazio-
ne, perchè di già io farei un pezzo più innanzi: ma io credo che la cortefia di V. M.
habbia differito l'opera per compaffione, che elle hanno hauto di me, volendo che io
non mi affaticaffi in quefti caldi paffati troppo nojofi. Onde le ne ringrazio, e le ne
bacio le mani, certificandole che io non farei reftato, nè per la noja del caldo, nè
per altro più importante accidente di fervir le M. V. le quali m'haveranno per ifcu-
fato, fe per tal rifpetto la cofa converrà diferirfi ad effer fornita qualche giorno di
più. Et a V. M. offerendo, & raccomandandomi di core, le bacio le mani. Di Ve-
netia alli XX. di Agofto MDLXV. Servo aff. Titiano Vecellio P.

Lett. 2.

Hora che per gratìa di Dio ho ridotto a compimento le Pitture da V. S. ordina-
temi, ficcome già promeffi alli Signori Ambafciatori, fon venuto con quefte a far mio
debito di avifarle di tanto: & infieme a fupplicarle a degnarfi di far quella debita
provifione, che fi conviene alla ifpeditione di quefto negocio. Nel quale io mi fono
affaticato con ogni ftudio per far opera conveniente alla promeffa, & al honor mio.
Et con offerirmi a V. S. per quanto io vaglio in loro fervitio, molto mi raccomando
in fua buona gratia. Di Venetia alli XXVI. di Giugno MDLXVIII. Ser. deditiff. Ti-
tiano Vecellio P.

Lett. 3.

Per effer ftato impedìto parte da certa mia indifpofitione, & parte alcuni giorni
fuor della Città, non ho potuto prima che ora dar rifpofta alle Lettere di V. S. mol-
to Magnifiche, alle quali defiderava rifponder prima con gli effetti, che con le paro-
le: ma poiche per effer le Pitture alquanto finiftre da maneggiar in dar loro la ver-
nice in certi luoghi, la qual non fi può afciugar, fenza metter al fole, con brevità,
onde farei tenuto forfe poco cortefe in non rifponder alle fue Lettere dirò a V. S., che
quanto prima farà poffibile metterò il tutto all'ordine con lo Sp. Nuntio, & li con-
fegnerò tutte le pitture, acciò che le S. V. fe ne prevagliano, & veggano da gli ef-
fetti, quando elle faranno pofte al loro loco, quale fia ftata l'opera mia in fervirle.
Et con pregarle riverentemente a comandarmi, molto mi raccomando in fua buona
gratia. Di Venetia l'ultimo di Luglio MDLXVIII. Ser. aff. Titiano Vecellio.

Lett. 4.

Illmo & Rmo Monfig. Dopo molto tempo, che io non ho fatto riverentia a V. S.
Illma & Rma vengo hora con quefte lettere a fornir mio debito, & infieme a fuppli-
carla a voler degnarmi del fuo favore nel negotio, che io ho con quella Mag. Città.
Et acciò che V. S. Illma & Rma fapia in che termine io mi ritrovo per quefto, le
dirò, che havendo Horatio mio figlio portate le Pitture da me fatte non fenza mio
grande incomodo per fervire a quei Sigg., da loro gli fu rifpofto, che fe ben non pare-
va loro di riconofcer, che elle foffero di mia mano, non di meno farebbono, che io
reftarei fatisfatto, & così dopoi diedero ordine, che mi foffero pagati quei danari, che
effi fanno per mio compiuto pagamento. Onde il detto Horatio, che vedeva la poca
conofcenza, che moftravano haver delle cofe mie, & l'intereffe mio fi dell'honore,
come del utile, non volfe accettarli. Ma perche defidero di vederne il fine al tutto

per via della giuſtitia, quando non ſi poſſa farlo altrimente, ho voluto prima tentare ſe col mezzo di V. S. Illma & Rma io poteſſi venir a qualche honeſta conditione con eſſi loro, per non parer troppo rigoroſo, e per reſtarmi ſeco con buona pace, non eſſendo di mio coſtume, nè di mio diletto il litigare, ſe non quando ſon coſtretto a farlo per forza. Dunque io la ſupplico per l'amor, che la molta ſua corteſia mi porta, & per l'antica mia ſervitù, & devotione verſo di lei, che ella voglia trametterſi in queſto, acciò che io poſſa ridurmi ſeco a qualche honeſto patto, e reſtar ſervitore delle loro Signorie, ſi come ho cominciato di eſſere per l'amore di quelli miei Patroni, per ragion di quali fui chiamato a queſt'opera, & per la fama della loro liberalità, tramettendo io le opere del mio Re, & de' molti altri miei Signori di queſta Città. La ragione con la quale mi vorebbono tener quello, che di ragione mi aſpetta, è che io mi ſon contentato di ſtar a quello, che fuſſe giudicato valer detta opera; & quella per la quale io non intendo di voler ſogiacer a tanta perdita è, che la coſa deve eſſer giudicata da perſone perite nell'arte, ciò è da Pittori, e da Pittori eccellenti, ſe bene io mi contentai, che il giudicio di quei due Dottori nominati ne lo ſcritto, mi poteſſe levare qualche ſomma di denaro, che al honeſtà ſi conveniſſe, da quella ſtima, che io inteſi ſotto bona fede, deve eſſere fatta da Maeſtri dell'arte, i quali ſi del eſſer l'opera di mia mano, come della valuta doveſſero dar loro informatione lontana da ogni ſoſpetto di fraude, e di malignità, come perſone ſincere, e da ambidue le parti elette a queſto, perchè quando queſto non ſi faccia, ſe ben foſſe chiamato uno Ariſtotile a far queſto giuditio, egli non ſarebbe atto a giudicare, nè la diverſità delle maniere, nè la difficoltà dell'arte. Adunque rimettaſi il giuditio in mano d'huomini eccellenti dell'arte della Pittura, & poi ſe ſaranno giudicate quelle Pitture non eſſere di mano, & non meritar maggior premio di quello, che quei Signori mi vogliono dare, ſon contento (giurando queſto ſu la mia fede in mano di V. S. Illma e Revma) di reſtituire loro anco quel tutto, che per caparra mi han dato per l'addietro, non che di non dimandare loro altro già mai. Et ſe pur eſſi non vogliono accettare queſta mia offerta per non goderſi delle mie fatiche con alcun gravame di conſcientia, mi offero di laſciar loro cento Scudi della ſomma, che li Periti giudicaranno, che io meriti, purche il giuditio venga fatto da perſone ſincere. Non è certo queſto il premio, che io aſpettava dalle loro larghe promeſſe, & che mi porgeva quel gran concetto, che io haveva della liberalità loro, & tanto più havendomi eſſi Signori fatto fare una di quelle Pitture ad un modo ſecondo l'arbitrio mio, & poi fattomi rifarla al loro modo ſenza alcun rifacimento del tempo, & de la ſpeſa in ciò corſa, oltra li molti intereſſi patiti in viaggio nel condurmi a Breſcia la prima volta, & nel mandar poi Horatio nel tempo del verno a portar dette Pitture per la moleſtia fattami dai loro litigioſi proteſti. Però pregarò di novo V. S. Illma & Rma a degnarſi di pregarli per ſua infinita benignità di contentarſi del dovere, perche non reſti coſì machiato l'honor mio, & perchè io poſſa rimanere in quel bono concetto, che io ho avuto ſempre della ſplendidezza di quella Magnif. & generoſa Città, per ciò che io faccio profeſſione d'eſſer perſona ragionevole, ond'io mi contenterò ſempre del honeſto, & del dovere, trattandoſi queſto negotio amorevolmente; che ſe altro occorrerà, io mi condurò contra mia voglia a volerla vedere per via della giuſtitia, & mi dolerò eternamente de' fatti loro. Et con queſto facendo fine, & raccomandandomi di core a V. S. Rma le baccio le mani. Di Venetia 3. Zugno MDLXIX. Aff. Ser. Titiano Vecellio.

Addenda to Volume I

THE RELIGIOUS PAINTINGS

Cat. no. 1. **Adam and Eve,** Madrid.

About 1550; retouched 1571.

In representations of the *Temptation of Adam and Eve* from the early Christian period onward, Adam is usually, although not always, placed at the left of the Tree of Knowledge and Eve at the right. Titian's Adam is seated at the left and Eve stands to the right, as she reaches eagerly for the forbidden fruit. The similarity of this composition to Raphael's fresco in the Stanza della Segnatura of the Vatican has already been stressed in Volume I. To the contrary, the reversed positions and the Eve with her back turned in the fresco of the Vatican *logge* do not resemble Titian's arrangement. Nor is there any significant relation to Dürer's print (1504), where Adam stands and the setting is totally unrelated to the Venetian work. The presence of the fox near Titian's Eve, probably a symbol of deceit or evil, is the only detail in common (the fox stands for the devil, according to Panofsky, 1969, p. 28).

Genesis 3 allots Eve the role of picking the forbidden fruit from a tree of unspecified kind. Titian, like others before and after him, chose to represent apples, but his tree has bark resembling that of a cherry tree and the long leaves are those of the *laurus nobilis*, the laurel or bay tree (Rehder, 1949, p. 901; good illustration in *Webster's New International Dictionary*, second edition, 1937). The identifications were kindly made for me by Warren H. Wagner, Professor of Botany at the University of Michigan. The second tree is unmistakably a fig (*ficus carica*, Rehder, 1949, pp. 192–193), with the leaves of which, Genesis states, Adam and Eve covered their newly discovered nakedness. Titian sacrificed botanical exactness in order to exploit the decorative qualities in the setting of this handsome picture of the *Temptation of Adam and Eve* (I am indebted to Doris Birmingham for suggestions concerning the iconography in an unpublished seminar report).

History: The *Adam and Eve,* as well as an *Entombment* (Wethey, I, Cat. no. 38), were surely the gifts of the Venetian State to Antonio Pérez, Philip II's then powerful minister. The Venetian ambassador, Leonardo Donà, urged the Council of Ten in a series of letters dated 1571–1572 to present pictures by Titian to Pérez (Donà, 1963, I, pp. 390–391; II, 486–487). On 8 February 1571 the Council of Ten approved the gift and sent one of their members to Titian's house to select two pictures for Pérez, one to be religious and the second a 'beautiful history' ('qualche bella istoria')

(Baschet, 1859, pp. 78–79). It appears, however, that two religious subjects were selected. Titian himself in his letter of 22 December 1574 to Antonio Pérez remarked that he was delighted that his pictures, done for the minister, had pleased. The artist also referred to portraits of Pérez and his wife that he was finishing, but they seem never to have been completed before Titian's death less than two years later (C. and C., 1877, II, p. 539; Cloulas, 1967, pp. 278–279). Finally, the 'Adam and Eve by Titian' is the first item in the list of paintings in the Inventory of Antonio Pérez's estate, dated 1585 (see Pérez, folio 472). It is the only picture in this document to which an artist's name is attached, whereas Correggio's *Leda* and *Ganymede* are cited only by subject. [Gonzalo Pérez, father of Antonio, and earlier a secretary to Philip II, was promised a painting of the *Madonna* by Titian according to a letter of 8 March 1564 (Ridolfi, 1648–Hadeln, I, p. 190). Among his debts, listed in his testament in 1566, is an item of 400 ducats owed to the painter (González Palencia, 1946, II, p. 593). No trace of this painting is found in the inventory of his son and universal heir, Antonio Pérez.]

The *Adam and Eve* thereafter passed into Philip II's own collection. In Philip's Inventory (1600) after his death, it hung in the sacristy of the chapel in the Alcázar at Madrid. Cassiano dal Pozzo (1626, folio 48) saw it, then placed in the Sala Grande (the Great Hall) over the southern entrance to the Alcázar (Figures 63–65). Before 1636 all of the major paintings by Titian had been gathered into one room in the king's summer quarters on the north east (Inventory 1636, folios 49v–50). When Velásquez re-arranged the installations in the Royal Palace in the mid-century, the *Adam and Eve* and the mythological paintings were transferred to a long formal gallery in the semi-subterranean regions of the southern and western wings (Inventory 1666, no. 706 and Inventory 1686, no. 882; Bottineau, 1958, p. 324). For the first time in 1686 the vaulted galleries were called the 'Bóvedas de Ticiano'. There the *Adam and Eve* remained in 1700 (no. 503), and at the time of the great fire of 1734 (no. 28), it was said only to be 'somewhat damaged by old retouching'. After the death of Philip V the Inventory of 1746 (folios 220v–221) places the work in Buen Retiro Palace. On the completion of the New Royal Palace it was hung in the king's apartments along with other masterpieces (Ponz, 1776, VI, Del Alcázar, 31). It entered the new Museo del Prado in 1827 (Beroqui, 1933, p. 121).

Dating: My dating of the *Adam and Eve* about 1550 has been challenged by an 'anonymous' critic. It is confirmed, however, by an X-ray of Eve's body, which shows no trace of

the leaves over her middle (I am indebted to Dr. Xavier de Salas, director of the Prado Museum, who for the first time allowed me to see the X-ray, which had been taken about 1932). Titian may have added the unusually large and decorative leaves to an earlier picture of *c.* 1550, and he doubtless retouched it somewhat also in 1571, when the decision was made to send it to Spain. It has not been established whether or not the prominent fig leaves over Adam's body are also an afterthought. The painting was sent to Spain at the period when the puritanic reaction was at its height under Pope Pius V, and when Philip II had become increasingly pious.

I am informed by Richard Buck of Oberlin, a technical expert, that the green of the leaves would not register in the X-rays when placed over white lead, used in the flesh tones.

Condition: It should be noted that the condition of the *Adam and Eve* is satisfactory, except for a section on Adam's left side and the repainted signature. The blurred silhouette on his right side appears to be caused by the emergence of *pentimenti.* The picture hung in the 'Bóvedas de Ticiano' at the time of the Alcázar fire of 1734 and escaped damage, as already stated in Volume I. There is no evidence at all that it was restored by Juan García de Miranda after the fire, as Madrazo wrote in just one edition of the Prado catalogue (1872, p. 678, no. 456). Madrazo himself in subsequent catalogues omitted this misinformation. However, Crowe and Cavalcaselle quoted it (1877, II, p. 406, note) and it has been repeated down to the year 1969. See the present volume, notes 410, 411 and 412, for further information about García de Miranda (see also Wethey, 'Titian's *Adam and Eve*', 1973).

Cat. no. 5. **Adoration of the Kings,** Cleveland.

History: Samuel Rogers' sale, 2 May 1856, p. 70, no. 700, wrongly ascribed to Bassano and said to have been in Benjamin West's collection.

UNKNOWN AND LOST VERSIONS:
1. The *Adoration* from the Palazzo Balbi, Genoa, is the picture by Jacopo Bassano, now in the National Gallery of Scotland, Edinburgh (Edinburgh, 1970, pp. 4–5). The wrong attribution to Titian in the early nineteenth century led me to believe that the Balbi picture was the Cleveland example. The constant confusion between Titian and Bassano at that period has created several problems.

Cat. no. 10. **Annunciation,** Aranjuez.

See note 217 in the present volume.

COPIES:
2. Lord Rothermere's copy is now in London, Kilburn Park Road, church.

Cat. no. 11. **Annunciation,** Venice, S. Salvatore.

Dating: About 1560–1565. Antonio Cornovi Della Vecchia left funds for this altar in his testament dated 1559. The dedication, at first intended to be St. Augustine, was changed to the Annunciation. Jacopo Sansovino designed the stone altar-frame for this famous painting by Titian (Tassini, 'Vecchi cittadini veneziani', 1888, MS, Correr, Venice, IX. D. I, vol. v, f. 60). The escutcheon of the Della Vecchia [party per fess; in the chief a half figure of Abundance, crowned, carrying her cornucopia; in the base a single lily] appears in the lower corners of the frame. The bones of Antonio's father (died 1549, age 62) were interred in front of the altar as indicated by the tomb slab in the floor.

Cat. no. 13. **Apparition of Christ to the Madonna,** Medole.

Stolen in April 1968 but shortly recovered; restoration in the Istituto Centrale di Restauro, Rome in 1968–1970. At that time all later overpainting was removed and extensive losses in the Madonna's robe and Christ's drapery were inpainted. Present dimensions are: canvas, $2 \cdot 76 \times 1 \cdot 98$ m. I am indebted to Dr. Giovanni Urbani for permission to see the picture when under restoration and for photographs taken on completion of the work.

Cat. no. 14. **Assumption,** Venice.

Cleaned and conservation measures taken by the restorer, Antonio Lazzarin, in 1974 to exterminate the worms from the back of the panel. He also infiltrated sixteen litres of resin to overcome the excessive dryness. The colour of the painting has assumed a new radiance.

Mantegna's great *Assumption* from the Eremitani in Padua, transferred to canvas and thus saved from destruction in World War II, was exhibited in all its grandeur in the Palazzo del Ragione in Padua in 1974. Titian's inspiration surely lay in this great work, which gives the lie to Ridolfi's (1648–Hadeln, I, p. 163) naive legend that Titian's *Assumption* did not meet with approval until the ambassador of the Emperor (which Emperor?) wanted to buy it (see notes 127, 128).

Cat. no. 15. **Assumption of the Virgin,** Verona.

Dating: 1530–1532. A bequest by Galesio Nichesola, bishop of Belluno, provided funds for the altar in 1527. The painting was not in place in March 1530, but is recorded there by 27 November 1532 (Brenzoni, 1957, pp. 338–341; Eberhardt, 1971, pp. 222–223).

Cat. no. 26. **Christ Crowned with Thorns,** Paris.

Condition: The plan to transfer the picture from wood to canvas in 1967–1968 has been abandoned (Hours and Delbourgo, 1970, pp. 4–7).

Cat. no. 28. **Christ Mocked,** St. Louis.

Probable History: Infante Sebastián Gabriel de Borbón; Pedro de Borbón, Duque de Durcal, sale New York, 1889, p. 14, no. 59, by Titian, described in a pencil annotation in the catalogue in the New York Public Library, not sold; Durcal sale, Paris, Hôtel Drouot, 1890, p. 25, no. 48, 1·12 × 0·96 m.

RELATED WORK:
Leningrad, Hermitage; in 1972 in storage, Moscow, Pushkin Museum.

Cat. no. 31. **Crucifixion,** Ancona.

Stolen from the church of San Domenico, 1 March 1972 but recovered two weeks later.

Cat. no. 33. **Ecce Homo,** Sibiu.

An adaptation by Van Dyck in Munich, private collection (Genoa, 1955, pl. 95); canvas, 1·01 × 0·98 m.

Cat. no. 50, Plate 12, **Madonna and Child,** Lugano.

The photograph reproduced here is recent and excellent, presented to me by the curator of the collection in 1967 (contrary to the statement of an 'anonymous' reviewer). Despite the signature, the attribution to Titian is very definitely a border-line case. As a matter of fact the name TITIANVS in gold letters on the footstool does not conform to the artist's usual signatures (see the discussion of Titian's signatures in this volume). Nor do the heads of the Madonna and Child resemble the master's style. Both Tietze and Berenson rejected the attribution to Titian.

Cat. no. 51. **Madonna and Child with Angels** (lunette) Venice, Ducal Palace.

History: Vasari describes the fresco as at the foot of a stairway in the Ducal Palace (Vasari (1568)–Milanesi, VII, p. 439). Ridolfi gives a more precise account: 'A piè delle scale del medesimo Palagio è la figura di Nostra Donna sopra le nubi, la quale con soave vezzo ammira il bambino Giesù stesola nel virginal grembo. Qual pittura come sopra humana è rispettata dal tempo' (Ridolfi (1648)–Hadeln, I, pp. 166–167). The condition of the fresco had deteriorated when Crowe and Cavalcaselle saw it one hundred years ago, for they characterized it as much repainted (C. and C., 1877, II, p. 296, note). They added the exact location as on the stair-

case near the Scala dei Giganti; a brief mention is likewise recorded by Zanetti (1771, p. 231), who placed it 'at the foot of the covered stairway by which the Signoria descends to the church.' In the Titian exhibition of 1935 the fresco was said to have been transferred to canvas at the beginning of the nineteenth century (*Mostra di Tiziano,* p. 65, no. 23), whereas that removal clearly took place at the end of the century.

Dating: Because of the severely damaged state, the dating of the transferred fresco is problematic. In favour of the relatively early period are Valcanover and Wethey *c.* 1523, while Tietze held out for 1540 (Tietze, 1936, II, p. 310) and Pallucchini (1969, p. 268, figs. 214, 215) for 1532–1535.
The active Child with kicking legs and swinging arms became a stock feature in Francesco Vecellio's pictures of the *Madonna and Child* at Verona, Munich and San Diego (Wethey, I, 1969, Plates 205, 206, 209).

Correction: The quotation from Sanuto, *Diarii,* XXXV, column 254, under 6 December 1523, refers to a *Madonna and Child with Saints and Andrea Gritti as Donor,* located in the church of S. Niccolò, a chapel in the Ducal Palace near the stairway (Ridolfi (1648)–Hadeln, I, p. 166). That work, also in fresco, was totally destroyed, apparently with the demolition of the church *c.* 1797 (Gronau, 1900, p. 76; *Titian,* 1904, p. 73).
Still another votive picture of the *Madonna and Saints with Andrea Gritti* in the Sala dei Pregadi of the Ducal Palace is described by Sanuto on 6 October 1531 (Sanuto, LV, column 19): 'Io vidi in Colegio il quadro novo posto con la persona et effigie di questo Serenissimo qual se inzenochia davanti una Nostra Donna col putin in brazo, et San Marco lo apresenta, e dadrio la Nostra Donna è tre santi, San Bernardin, Sant' Alvise et Santa Marina.' Von Hadeln identified the composition of this work on canvas in an anonymous woodcut of the *Madonna and Saints* where Doge Francesco Donato replaces Doge Andrea Gritti (Hadeln, 1913, pp. 234–238). The woodcut is a reworking of a drawing by Titian during the reign of Donato as Doge in 1545–1553 (also reproduced by Mauroner, 1941, pp. 46–47, no. 24, pl. 36; and by Tietze, 1936, I, Tafel XVIII, II, p. 311). The AR of the inscription FRANCISCUS DONATO DUX VENETIAR does not constitute the signature of an unknown monogrammist, but the word is an abbreviation of 'VENE-TIARUM' (Dreyer, 1972, cat. no. 23).

Cat. no. 55. **Madonna of the Pesaro Family,** Venice (Figure 19)

The fanciful theory that the two large columns in this painting are not Titianesque and that they were added later

in the seventeenth century (Sinding-Larsen, 1962, pp. 138–139; Rosand, 1971, pp. 200–207) reminds one of the attempt to prove that Sir Francis Bacon wrote Shakespeare's plays. It is well known that Titian originally planned a setting within a church, then transformed it into this spectacularly imaginative composition. A change of plan also took place in the *Madonna and Child with Six Saints* in the Vatican Pinocoteca (Wethey, I, 1969, Cat. no. 63, Plate 23), where X-rays show that Titian's first idea was a centrally composed scheme similar to Giovanni Bellini's San Zaccaria altarpiece. Ann Sutherland Harris (1972, pp. 116–118, with reply by Rosand, pp. 118–120) has so thoroughly demolished the arguments advanced in favour of the Pesaro theory that I shall treat the whole matter with brevity.

The final and indisputable technical proof that the painting was all done at one period (1519–1526) was provided by Professor Francesco Valcanover, soprintendente alle Gallerie at Venice, who recently examined the entire canvas with an ultra-violet lamp and could detect no changes in any part of the composition.

None of the early references to Titian's epoch-making composition makes any allusion to a seventeenth-century transformation of a presumed earlier composition. Titian by the mid-seventeenth century had the reputation of a demi-god, and it is unthinkable that any one would have tampered with a great altarpiece in the Frari, and that, if such a thing had been possible, the matter would have escaped mention by the contemporary writers Martinioni, Ridolfi, and Boschini. Moreover, Lefèbre's well-known print of 1682 includes the legend 'Titianus Vecellius Cad. Invent. et pinxit'.

Still more important is the fact that other painters early adopted aspects of his composition of the Pesaro Madonna. The columns in the organ-shutters of S. Salvatore at Venice, painted by Francesco Vecellio in 1530–1535 (Berenson, 1957, pl. 939) are related, though not identical. Elements in Domenico Campagnola's *Madonna and Saints*, dated 1537 (Berenson, 1957, pl. 1028), come directly from the Pesaro Madonna. Most important is Paolo Veronese's *Madonna and Saints c.* 1551 in San Francesco della Vigna at Venice, so obviously inspired by the Pesaro Madonna that no one can doubt it. Even earlier, *c.* 1528, Pordenone's *Dispute on the Immaculate Conception* in the Naples Gallery (Berenson, 1957, pl. 874) includes giant columns in perspective. The same artist's drawing for an *Altar of St. Mark* (Fiocco, 1943, pl. 216) is set against giant columns in space; in both a cloud with figures also floats in front of the foremost column. Lambert Sustris' *Madonna and Saints c.* 1560 in S. Maria in Vanzo at Padua (Ridolfi (1648)–Hadeln, I, p. 225; Palluc-chini, 1969, fig. 657) is likewise unthinkable without the precedent of Titian's masterpiece. A forerunner with a background of large columns may have existed in the

Seated Nude Male by Giorgione on the Fondaco dei Tedeschi in 1508 (Figure 6).

The *Madonna of the Pesaro Family* (Figure 19) is a devotional picture, dated 1519–1526, in which members of the family kneel in adoration of the Madonna and Child. It also commemorates the papal victory at Santa Maura on 30 August 1502, when Jacopo Pesaro, kneeling at the left, led the papal armada against the Turks (see Wethey, I, 1969, Cat. no. 132). The large banner of Pope Alexander VI includes Jacopo Pesaro's escutcheon in the lower section. The knight in armour, who holds the banner, as well as the bound Turk are obvious references to this victory. The *Madonna of the Pesaro Family* has nothing at all to do with the dogma of the Immaculate Conception. Sinding-Larsen (1962, p. 140) at least had the good sense to reject the theories of Tietze-Conrat (1953, pp. 177–182) and Eva Tea (1958, pp. 602–605) to the contrary.

Since the history of the Pesaro Chapel has not been published, the surviving documents about it have some significance. In reality this 'chapel' is the wall space to contain an altar rather than an architectural unit projecting from the aisle. In 1499 Lodovico Querini's testament specified funds to acquire the 'Cappella della Concezione'. On 3 September 1513 funds were allocated for his burial here and for the celebration of two masses daily for his soul and those of his mother and of the widow of Andrea Querini (Archivio di Stato, Venice, Frari I, busta 3, folio 17, index of testaments). On 3 January 1518 Magister Germanicus and the friars ceded the Cappella della Concezione Maria to Jacopo Pesaro and gave permission to place his tomb in the wall (Frari, busta 5, old registro no. 31, A. di S.). Jacopo's testament of 9 March 1542 ordered 1000 masses (Registro I, busto I, interno 7; this material now survives in references in the Index). In 1542 he also left funds for masses six days per week for the soul of Pope Alexander VI (Ludwig, 1911, p. 133).

The document of payments to Titian for the Pesaro Madonna (see Wethey, I, 1969, Cat. no. 55, History) has been published several times. The sheet has been in the Museo Correr since 1910 (reproduced in facsimile, Cheyney, 1872, p. 31). Titian received with the contract on 28 April 1519 a sum of 10 ducats, three more amounts the same year totalling 41 ducats, 3 payments of 10 ducats each in 1522, a further sum of 15 ducats in 1525 and the final instalments on 29 May and 30 June 1526 (see also Scrinzi, 1920, pp. 258–259), apparently a total of 102 ducats for this masterpiece.

Nowhere is it stated that the altar was inaugurated on 8 December 1526. Tietze-Conrat introduced this error (1953, p. 177) and Panofsky (1969, p. 79) reported that it 'was solemnly unveiled on December 8, 1526'. The fact is that Sanuto reports that the festival was celebrated that year at several churches, including the Frari at the Pesaro altar: '1526, a di 8. Fo la Conception di la Madonna, et si varda,

et fassi la festa a la Misericordia, etiam in molte altre chiese et ai Frari menori a l'altar hanno fatto i Pexari in chiesa' (Sanuto XLIII, column 396).

In order to set this matter straight, the celebration of the festival of the Immaculate Conception is recorded by Sanuto as follows; 1508, 'si varda et in diverse chiese si fa solenne feste (VII, column 684); 1515, 'a la chiesa di Servi (XXI, column 359); 1517, 'Fo grandissima pioza la note, la matina e tutto il zorno; la festa si varda per la terra da pochi anni in qua, et ai Frati Menori et a la Misericordia' (XXV, column 125); 1518, 'si fa solenne feste maxime ai Frari menori et a San Jacomo di l'Orio. Etiam in la Scuola di la Misericordia, la qual ha electo questa Nostra Dona per la sua festa' (XXVI, column 246); 1520, 'et si fa festa per la terra' (XXVIII, column 112); 1521, 'et si fa festa solene a la Misericordia, etiam a San Marzilian qual fu la prima chiesa dove si celebrava tal zorno in questa terra; etiam fu fato bella festa a li Frati menori' (XXXII, column 216); 1526—quoted above; 1529, 'Fo fato belissima festa a la Misericordia . . . Item in chiesa di Frati menori a l'altar novo di Pexari dal Caro' (LII, columns 331–332); 1530, 'a la Misericordia fu fato una solenne festa' (LIV, column 167); 1532, 'Fo la Conception de la Madona. Fo pioza la matina e quasi tutto il zorno' (LVII, column 323). In some other years Sanuto merely noted the 8 December as the festival of the Immaculate Conception without reference to any church. [Data from Sanuto assembled by Alice S. Wethey].

Much later, in 1582, the Pesaro altar was granted a special privilege by Pope Gregory XIII. At that time the inscription GREGORIANO must have been added to the frieze of the altar, as previously noted (Wethey, I, 1969, Cat. no. 55, Iconography). On the great round pier opposite the altar is an inscription, now virtually illegible, which was transcribed by Soravia (1823, II, p. 133):

GREGORIVS XIII. PONT. MAX. CAROLI PISAVRI TORCELII
EPISCOPI EXORATV CONCEPT. VIRG. MARIAE ARAE
EIVS PRAECLARAE DOMVS SVMPTIBVS OLIM DICATAE
PERPETVVM ANIMAE A PVRGATORIO LIBERANDAE
QVOVIS ET QVOTIES HIC CELEBRANTE PRIVILEGIVM,
NEC NON EIVSDEM CONCEPT. FRATERNITATEM ROMAE
ARCHI CONFRATERNITATI CONCEPT. CVM IISDEM
INDVLGENTIIS AGGREGARI CONCESSIT, QVOD, VT
OMNIBVS INNOTESCAT, SCVLPENDVM CVRAVIT.
M.D.LXXXII.X.KL SEPT.

Benedict XIV confirmed the same privilege in 1751, as recorded in another inscription farther down on the pier. A statuette of the Madonna and Child, a piece of the Pisan school of the fourteenth century, occupies a small niche in this pier but it was absent for some months in 1972–1973. Paravia (1822, p. 7) explained the cult of the Immaculate Conception as associated with the statuette. He correctly commented that the Pala Pesaro has no emblem to associate it with that cult.

Cat. no. 59. **Madonna and Child with St. Catherine and the Infant Baptist in a Landscape,** London.

VARIANTS:

1. A painting on canvas, 1·20 × 1·57 m. in Bologna, Private Collection (Pallucchini, 1969, p. 295, fig. 362, as Titian, c. 1550–1552, from an English collection). In this work, based upon the variant in the Pitti Gallery (Wethey, I, 1969, Plate 33), the Infant Baptist stands rather than kneels. Obviously a copy with variations, it appears to be by Polidoro Lanzani at his best.

2. *Madonna and Child with St. Catherine and the Infant Baptist*; canvas, 0·95 × 0·87 m.; Milan, Private Collection (Pallucchini, 1969, p. 295, fig. 363, colour reproduction, as Titian, c. 1550–1552). An entirely different composition with the Madonna seated in the centre, it does not depend upon a prototype by Titian. The painter appears again to be Polidoro Lanzani. According to Pallucchini, labels on the frame give the source as the Eastlake and Kenyon collections.

Cat. no. 60. **Madonna and Child with St. Catherine and a Rabbit,** Paris.

Condition: X-rays show that a tiny rabbit at the right among the flowers was painted out by Titian (Hours, 1950; *idem*, 1964, p. 103). The hindquarters of a third rabbit are clearly visible to the naked eye at the right edge of the canvas.

History: Gonzaga Collection, Mantua in 1530; probably Cardinal Richelieu (died 1642), Paris; his heir, the Duc de Richelieu, sold the picture in 1665 to Louis XIV (Ferraton, 1949, pp. 439, 444).

COPIES:

2. San José (California), Douglas Speck, formerly of Bridgend Glam., Wales. Canvas, 1·34 × 0·95 m. Mr. Speck in 1972 insisted that he had the original, which he thought had belonged to Charles I of England. This item, tall with added landscape, appears in photographs to be a seventeenth-century copy.

The Berlin copy sold to Edsel Ford of Detroit about 1928 is another item, smaller without the added sky. Unknown location and unknown dimensions (Freund, 1928, p. 35, colour print).

Cat. no. 62. **Madonna and Child with SS. Catherine and Luke,** Kreuzlingen.

COPIES:

3. Dallas (Texas), Museum of Fine Arts; canvas, 1·295 × 1·70 m. St. Catherine is replaced by a male donor as in the

variant at Hampton Court (Sterling, 1954, p. 268; Berenson, 1957, p. 184, as studio).

4. Windsor Castle, Royal Library, miniature by Peter Oliver after the Hampton Court version (Richard Holmes, 1906, p. 110, illustrated).

Cat. no. 63. **Madonna and Six Saints,** Rome, Pinacoteca Vaticana.

Panel, transferred to canvas.

In a recent important article Professor von Einem (1971, pp. 99–114) records the dimensions as 3·84×2·64 m., whereas the same Vatican authorities (his source) gave me the size in 1964 as 4·23×2·90 m. At that time the canvas had not been mounted upon a new stretcher, the probable reason for the discrepancy. The semi-circular top, containing the dove, was cut off between 1820 and 1829 as proven by prints, the first of which includes it and the second of which eliminates it (von Einem, *loc. cit.*, pp. 101 and 112 note 8a). The same author is inclined to believe that the first, re-tardataire composition revealed by the X-rays may have been designed by the eighteen-year-old Paris Bordone who, according to Vasari (VII, p. 462), at first received the com-mission. The story that the older and jealous Titian got it away from him sounds apocryphal.

Von Einem favours a date for the Vatican *pala* contemporary with the *Assumption* at Verona, i.e. *c.* 1530–1532 (see above in these Addenda, Cat. no. 15). Although a number of writers have dated the Vatican picture as late as the 1540's, the close similarity of the Madonna and angels to the upper part of the *Madonna and Child with SS. Francis and Aloysius and Donor* (1520) at Ancona (Wethey, I, 1969, Plate 24) is convincing evidence for my early date, *c.* 1520–1525. More-over, SS. Peter and Paul are compatible with the Apostles of the Frari *Assumption* of 1516–1518 (Wethey, I, 1969, Plate 22), and the St. Sebastian is an early figure. The curious broken, semi-circular wall in the background of the Vatican *pala* is reasonably enough thought to reflect the Bellini compositions of a Madonna and Child enthroned in an apsidal chapel of a church.

History: Purchased in 1770 by the British consul at Venice, John Udney (known there as Zuan Udini).

COPY:

St. Sebastian. New York, private collection, in 1970; canvas, 1·88×0·965 m.; this figure, copied from the Vatican paint-ing, is set against a landscape; inscribed TICIANVS on a stone in the left foreground.

Cat. no. 81. **Noli Me Tangere,** Madrid, Prado Museum.

Condition: Cleaned in 1962. An old X-ray, *c.* 1930, made available in 1972, shows extreme losses on Christ's face.

Cat. no. 86. **Pietà,** Venice.

The inscriptions accompanying the figure of Moses were transcribed on the print in Zanotto's book published in 1831. The Latin letters MOYSES are still legible in the painting upon the pedestal beneath the prophet's feet, while the Greek letters above his head have disappeared. Zanotto gave them as *MOYΣHΣ IEPON*. Although it is possible or even probable that the letters had been restored before Zanotto's time, it is reasonable to assume that they were original and the invention of a Renaissance humanist who was a friend of either Titian or Palma il Giovane. There seems to be a play upon words in the similar appearance but different meaning of the Latin and the Greek. The translation of the Greek, given in my first volume as 'Sacred Place of the Muse' was and has again been confirmed by classical scholars. It is thus not a mis-translation as had been stated and it does not appear to mean 'Temple of Moses' (inscription in Zanotto, 1831; repeated by Rosand, 1971, p. 212, note 73).

Recently Bruyn (1973, p. 74, note 35) has challenged the authenticity of the inscriptions, and he has proposed that the last section above Moses' head was on a strip of canvas added by Sebastiano Santi in 1828. Still it does not seem reasonable that Zanotto would have published the inscription as authentic only three years later in 1831. Zanotto recorded the size of the *Pietà* as 3·92×4·26 m.; in the *Mostra di Tiziano* (1935, p. 203) the canvas was said to measure 3·55×3·51 m., but the breadth in the photograph published in the catalogue was much greater than the height. The dimensions have been reduced since 1954 to 3·53×3·48 m., so that the shape has become slightly taller than it is wide. These changes by restorers of the past hundred and fifty years have created considerable confusion.

In the same article Bruyn (1973, pp. 66–73) calls attention to two heads of an *Entombment* underneath the present painting. He concludes that this abandoned composition was a studio version related to the major painting in the Prado Museum (Wethey, I, 1969, Plate 76), although it appears extremely difficult to reach such a judgment of the blurred shapes in X-rays. [Moschini Marconi's earlier report of the same X-rays, taken in 1953–1954, mentions a large mask in the lower part of the architectural niche and a different attitude in the large angel with the lighted candle.] Bruyn's sugges-tion that Bonasone's print (1563) records the studio *Entomb-ment* in the Prado (Wethey, I, 1969, Cat. no. 38) is conjectural, as he admits. My late date for this version, *c.* 1570, also hypothetical, is in part based upon the fact that it was apparently sent to Antonio Pérez as a gift of the Venetian State in 1572.

So far as the kneeling saint in Titian's late *Pietà* is concerned, I can see no reason to disassociate it from Titian's other late figures of St. Jerome or to doubt that the artist represented himself in this figure. It is logical to believe that Titian painted his own escutcheon here and that he included tiny figures of Orazio and himself as donors. Bruyn's theory that a later artist, perhaps Palma il Giovane, added these details is untenable. It is unlikely that Palma would even have known what the master's escutcheon was (see colour reproduction; Titian's Titles and Devices). That Titian's votive plaque is part of a long-standing tradition was shown by Gogolari (1922, p. 598). A curious circumstance is the existence on the back of the canvas of two horses (Moschini, 1957, pp. 79–81), one of which is painted in perspective diminution. Neither can be attributed to Titian, and the idea that the larger one might be heraldic will not be sustained by students of heraldry.

In a recent article (Meyer zur Capellen, 1971, pp. 117–132) the kneeling figure is unconvincingly identified as Job rather than St. Jerome. A hypothetical location of the Chapel of the Crucifix next to the choir and the reasons why the *Pietà* was not placed in the Frari are examined.

It might be added that the fig leaves at the upper left clearly refer to the Temptation and the Fall of Man, which were redeemed by Christ's sacrifice.

Oberhammer's study of the *Pietà* (1971, pp. 152–161) is in large part concerned with the technical aspects of the painting and with the present condition of the canvas. Bruyn (*loc. cit.*, pp. 67–68) also calls attention to the dimensions of the strips of canvas which comprise the present picture. He proposes that the main group was begun as early as *c.* 1557, and he recalls Wilde's theory of an early date (*c.* 1551). Even if this is true, the picture in its final state fits into the artist's late style. If it was begun a quarter century earlier, the new theory of a different destination at that time would gain support.

The fifth in this flurry of recent studies of the *Pietà* is by Kate Dorment, a graduate student at Columbia University (1972 [i.e. 1973], pp. 399–418). This author begins with a quotation from Crowe and Cavalcaselle, who so dramatically described Titian's death. [Their great monograph on the artist was published in London in 1877, not in 1881, the year in which a reprint of the first edition was issued.] She accepts as fact that Titian died of the plague, although the presumption is far more convincing that his demise came as the result of old age, since he was buried the following day in the Frari and not consigned to the communal grave of the plague-stricken (see Wethey, I, 1969, pp. 33–34; see also note 12 in the present volume). So far as the architectural setting is concerned Mrs. Dorment confirms the study by Forsmann (1967, pp. 110–111), while the various comparisons to ancient Roman altars, Roman and Renaissance

gates, Roman and Renaissance fountains have a marginal validity. Nevertheless, she does insist upon Titian's close personal and emotional association with the *Pietà*, a circumstance that rightly contradicts Bruyn's theories, quoted above.

Cat. no. 87. **Presentation of the Virgin,** Venice.
A document recently discovered by David Rosand (1973, p. 603) proves that the second door at the left, which cuts into Titian's painting, was added in 1572.

Cat. no. 90. **Rest on the Flight into Egypt,** Longleat.

COPY:
London, Victoria and Albert Museum, miniature by Peter Oliver, dated 1628, after the version once in Charles I's collection (Van der Doort's catalogue, Millar edition, 1960, p. 103, no. 3). The canvas formerly in the Contini-Bonacossi Collection, Florence, resembles the miniature and therefore must have belonged to the English monarch.

Cat. no. 92. **Resurrection Altarpiece,** Brescia.

COPIES:
1. Épinal, Musée des Beaux-Arts. The *St. Sebastian* after the Brescia altar was attributed to Giuseppe Caletti (1600–1660) of Ferrara by Ivanof (1965, pp. 258, 262; also Riccomini, 1969, no. 67). The mediocre copy, kept in storage, does not merit this attribution.

LOST COPIES:
1. Formerly Blenheim, Duke of Marlborough. A sketch among Cavalcaselle's notes (London, V. and A., 72. c. 9. unpaged) records a *St Sebastian* which is unlike the Brescia figure (C. and C., 1877, II, p. 466).

Cat. no. 93. **Miracle of the Speaking Infant,** Padua.

DRAWING:
Paris, Institut Néerlandais, 142 × 306 mm., attributed to Titian (Lugt, 1962, p. 55, no. 73), but it is surely a copy.

Cat. no. 96. **St. Catherine of Alexandria in Prayer,** Boston.

Recent X-rays show that the sword and crown were part of the original painting (Blodget, 1969, p. 554; Kenseth, 1969, pp. 175–188). Therefore the theory that the saint was originally St. Catherine of Siena will probably be abandoned.

Cat. no. 107. **St. Jerome in Penitence,** Lugano.

A. S. Berkes, director of the Thyssen-Bornemisza Collection, informed me in a letter of 29 February 1972 that the drawing

on the back of the canvas, published by Pallucchini (1969, fig. 575), is no longer visible after the relining.

Cat. no. 108a. **St. Jerome** (lost).

The Venetian ambassador Hieronimo Lippomano presented this picture to Philip II by request, according to a letter to the Doge under date of 18 August 1587 (*Calendar*, Venice, VIII, nos. 563, 564). No further notice of this work is traceable.

Cat. no. 110. **St. John the Baptist,** Escorial.

A second version of this picture in a private collection at Novara (Pallucchini, 1969, p. 320, fig. 500); canvas, 1·87 × 1·16 m. In a photograph it cannot be determined whether it is a much restored original or a copy. Pallucchini pointed out that it might be Titian's painting of the Baptist once in the house of Niccolò Cornaro at Venice (Sansovino-Martinioni, 1663, p. 375).

Cat. no. 113. **St. John the Hospitaler,** Venice.

The incorrect reading of a date upon the altar (not upon the painting) as 1533 was corrected by Tietze to 1633 (Tietze, 1936, p. 312), who also dated the picture about 1550. Pallucchini (1969, p. 287) places it *c.* 1545–1547.

Cat. no. 114. **St. Lawrence, Martyrdom of,** Venice.

Transferred from panel to canvas in 1873; last cleaned and restored in 1959 by Pelliccioli (Mariacher, 1971, p. 52).

Cat. no. 115. **St. Lawrence, Martyrdom of,** Escorial.

The statement that the painting was installed in the Escorial in 1567 (Panofsky, 1969, pp. 53–57) is incorrect. Philip II sent it to the Escorial in 1574 (Zarco Cuevas, 1930, p. 43, no. 995; Wethey, I, 1969, Cat. no. 115, History). The construction was not far enough advanced to receive any pictures as early as 1567. Panofsky identifies the statue on the pedestal at the left as Vesta. The engraving by Cornelius Cort is dated 1571 (typographical error as 1541).

Cat. no. 122. **St. Mary Magdalen,** Naples.

VARIANT:
Rome, Art Market (?); canvas, 1·11 × 0·79 m. (Pallucchini, 1969, p. 325, figs. 525, 526, as Titian, *c.* 1570–1575). In the photograph this sketch-like picture appears highly dubious.

Cat. no. 133. **St. Peter Martyr, Martyrdom of** (destroyed).

Originally on wood; transferred from wood to canvas in Paris about 1800. The panel had been badly waterlogged in

the ship *enroute* from Venice to Paris (Beaucamp, 1939, I, p. 270; Treue, 1960, p. 155).

The size of 5·80 × 3·20 m., given by Lavallée (1804, II, pl. 133) at that period, is relatively correct. The dimensions of the altar frame that encloses the copy by Niccolò Cassana in SS. Giovanni e Paolo at Venice today are 5·58 × 3·22 m. The large dimensions seem to be confirmed by Jerónimo Sánchez's copy, formerly at the Escorial, which in a letter to Philip II in 1575 (Zarco del Valle, 1888, p. 235) was said to measure $7\frac{1}{3} \times 4$ *varas* or 6·12 × 3·54 m. The Escorial Inventory of 1584 varies only slightly in recording the size as $6\frac{3}{4} \times 4$ *varas* or 5·63 × 3·54 m. (Zarco Cuevas, 1930, item 1014), not surprising because dimensions were usually given approximately in round numbers.

Fragments of the wood purported to have survived the fire of 1867 were known to Frimmel (1917, pp. 33–38). He also believed that Titian's original study was in a Viennese collection. In the illustration (pl. XVII) the quality of the oil sketch looks inferior. [Copy on the altar in Venice, also attributed to J. C. Loth: Ewald, 1965, no. 336].

COPIES:
11. London, Brinsley Ford; canvas, 1·14 × 0·94 m.; seventeenth-century; purchased about 1790 by Benjamin Booth, an ancestor of the present owner (data furnished by the owner; also Roberts, 1971, p. 35, no. 175).

Cat. no. 136. **St. Stephen, Stoning of,** Lille.

The attribution to Titian must now be withdrawn because of the documentation in favour of a minor Spanish painter, Diego Polo (1620–1655). The inventory of Don Sebastián de Borbón, 1876, no. 669, and another in 1887, no. 1388, contain this picture with the attribution to Diego Polo. The Lille museum purchased it from a Paris dealer in 1888; Lille catalogue, 1893, as by Tintoretto. The re-attribution to Diego Polo was the discovery of Pérez Sánchez (1969, pp. 48–50). Berenson (1906, p. 87) listed the work as by Beccaruzzi, but since 1918 it has commonly carried the name of Titian. The puzzle is to explain the high quality of the painting, unless Diego Polo knew a lost original by Titian. Could it in any way reflect Titian's festival decorations for the church of Santo Stefano at Venice in March 1541? The style then would have been earlier, and we have no details about this little-known project (Giustinian, 1642, p. 115; Schulz, 1961, p. 5).

Cat. no. 145. **Tobias and the Angel,** Venice.

COPIES:
3. London, Private collection in 1972. X-rays prove the canvas to have been re-used in Titian's workshop (Wethey,

III, Plates 219, 220). A portrait of a lady with her hair arranged with braids, similar to those of the *Empress Isabella* in 1548 (Wethey, II, 1971, Cat. no. 53, Plate 147) appears underneath.

Cat. no. 147. **Tribute Money,** Dresden.

The conservation of 1963–1964 successfully refixed the blistered paint to the panel.

At Ferrara the picture was kept in 1543 in the first Golden Room in the castle and not, as Vasari stated, in an armoire in the *studiolo* (see the present volume, note 172). In fact the small dimensions of this room with its array of paintings would have left no space for an armoire.

Cat. no. X–4. Giorgione, **Christ and the Adulteress,** Glasgow.

The half-length figure of a man (canvas, 0·47×0·45 m.), cut out of the picture at some unknown date, was purchased by the Art Gallery of Glasgow at Sotheby's sale of Major D. M. Allnatt's estate on 30 June 1971, no. 21. It had previously belonged to Arthur Sachs of New York and Paris.

Addenda to Volume II

THE PORTRAITS

Cat. no. 1. **Giovanni Francesco Acquaviva d'Aragona, Duke of Atri,** Cassel.

A medal inscribed 'Franciscus Acquavivus Dux Hadriae', in the Münzenkabinett at Vienna, will be published as the work of Alessandro Vittoria by Dr. Manfred Leithe-Jasper. Since the beard on the medal does not correspond to that in Titian's portrait, the problem of the sitter's identity is unresolved.

Cat. no. 3. **Seigneur d Aramon,** Milan.
The date 1541–1542 is not part of the inscription.

Cat. no. 18. **Giovanni Battista Castaldo**

Sotheby, London, sale 8 December 1971, purchased by Dr. J. E. Winter of Arichat (Nova Scotia). On loan by him to the Residenzgalerie, Salzburg.

Cat. no. 19. **Count Baldassare Castiglione,** Dublin.

Through a typographical error the date, '1523', was placed in the inscription of the sitter's name, which itself is apocryphal.

Cat. no. 25. **Giacomo Doria,** Luton Hoo.

From a Neapolitan collection, the property of descendants of Doria; Haskard and Son sold it to Agnew and Sons; purchased by Sir Julius Wernher in 1898 (information by courtesy of E. K. Waterhouse).

Cat. no. 26. **Alfonso I d'Este, Duke of Ferrara,** New York.

In the new catalogue of *The Venetian School, Metropolitan Museum of Art*, p. 72, Federico Zeri writes as follows about this portrait: 'The problem of authorship must be left open, but it should be noted that, even though a copy, the picture shows in the rendering of forms and particularly in the details of the head, a close link with the early style of Peter Paul Rubens.'

A thorough study with X-rays would help to solve the controversy involving this picture.

On the other hand, Hubert von Sonnenberg, chief conservator at the Metropolitan Museum, has authorized me to quote his belief that the painting was executed in the sixteenth century and that it cannot in his opinion have been painted in the period of Rubens' activity. Dr. Justus Müller Hofstede of the University of Bonn, a major specialist on Rubens' early work, rejects the idea that Cat. no. 26 is a copy by Rubens. Dr. Julius Held, another Rubens' authority, agrees with this latter opinion.

It is worth noting that Titian himself painted in 1555 replicas of his own portrait of Alfonso I d'Este and another of Ercole II d'Este on commission of Granate [*sic*] (Venturi, 1928, p. 161). Neither of these works has survived. Titian might have made a replica at that time of another lost portrait of Alfonso d'Este painted in 1535–1536 (Wethey, II, 1971, Cat. no. L–10).

Cat. no. 27. **Isabella d'Este,** Vienna.

The letter (under *Documentation*) from Pietro Bembo to Girolamo Querini on 24 December 1543 must refer to the portrait of Elizabetta Querini (Cat. no. L–26).

Cat. no. 28. **Falconer,** Omaha.

Signed TICIANUS F.

About 1530.

In the time of Crowe and Cavalcaselle (II, pp. 18–20) an inscription on the back of the Omaha portrait identified the sitter as Giorgio Cornaro, brother of Queen Caterina

Cornaro, the man who was *proveditore* of the Venetian forces during the Battle of Cadore. Three recently discovered inventories of the Cornaro family confirm the provenance of the *Falconer* from that collection, leaving the identity of the man uncertain: 4 March 1593 (MS., Biblioteca Correr, Venice, PDC 2151/16, f. 36, no. 6). In the second inventory of 1684 he is called Marco Corner ('Un ritratto con spavarier in mano de S. Marco Corner del Titiano'). The third inventory (published) of 4 June 1699 repeats the item but again without the name of the falconer (Loredana Olivato, 1973, p. 49, no. 16). These references were most generously given to me by Miss Jennifer Fletcher of the Courtauld Institute. Although the Falconer may well be a Cornaro, the omission of the given name in two of the three inventories leaves the question open as to his exact identity.

OTHER VERSIONS:
3. London, Lord Chesham, is now in a private collection in Rome. Canvas, 1·00×0·86 m. Another item sold at Sotheby's, London, in 1952 is a mediocre copy, now in a collection at Caracas, Venezuela.

Cat. no. 30. **Pierluigi Farnese and Standard Bearer,** Naples.

It appears in the unpublished Inventory of 1649 of the Palazzo Farnese in Rome, and it therefore cannot have been at Caprarola.

Cat. no. 32. **Farnese Gentleman,** Pommersfelden.

The identification of the escutcheon as that of a member of the Farnese family cannot be maintained. According to the description by Arslan (1930–1931, p. 1365), it consists of 'sei gigli e, in capo, le chiavi in croce decussata sormontate dal padiglione', i.e., 'six lilies and, in the chief, keys in a St. Andrew's cross surmounted by an umbrella'. While the device of this 'chief' (i.e., the upper third of the shield) is that of a papal 'gonfaloniere', a post that was indeed held by several members of the Farnese family (all of whom are known), it cannot be demonstrated that a 'chief' ever existed in any period in the Farnese coat-of-arms with its gold field and six dark blue lilies. Furthermore, when the device indicating this papal title was introduced into the Farnese arms (as in the Farnese Gallery in Rome at the end of the sixteenth century) it appeared on a 'pale of augmentation' or vertical strip occupying the centre of the shield (see Galbreath, 1930, pp. 61, 62 and figure 121). Five members of the Farnese family occupied the post of 'gonfaloniere' from 1546 to 1641, when the title was abolished (*loc. cit.,* pp. 58–59).
It should also be pointed out that the photograph of the Pommersfelden portrait clearly indicates bright (gold?)

lilies on a dark (dark blue?) ground and a bright (gold?) chief with light-coloured keys and umbrella. Crollalanza (1964, pp. 318–319) lists thirty-eight devices with lilies and of them only Farnese and Porcia show six. The Porcia arms are of blue with six gold lilies and a 'chief' of gold with no device. However, no sixteenth-century member of a Porcia (Portia or Porzia) family is listed in Moroni's vast ecclesiastical dictionary (1840–1879), so the crossed keys and papal umbrella representing the 'gonfalone pontificio' cannot reasonably occur in that escutcheon. In the sixteenth century the Porcia seem to have been only a rather inconspicuous noble family of Friuli with no connections with the papacy (see Wethey, II, 1971, Cat. no. 85). In addition the title of papal 'gonfaloniere' was an exceedingly high honour described by Moroni (vol. 31, p. 271) as the 'antica e sublime dignità' of the Holy See, conferred on sovereigns, princes and very distinguished personages [including, of course, members of papal families]. Consequently the appearance of such a device on the portrait of an unknown gentleman is so unlikely as to render suspect the authenticity of the escutcheon. [Alice S. Wethey].

Cat. no. 38. **Francis I**

M. Clement de Coppet sold the portrait to Semcesen, a dealer of Oslo, in 1970–1971.

Cat. no. 46. **Gentleman,** Berlin.

Signed: [TICI]ANVS F.
The fragmentary signature (Plate 238D) was incorrectly read as 'Tiziano' with a 'z'. See Posse, 1909, p. 193, no. 301; Kühnel-Kunze, 1931, p. 485; see also the discussion of Titian's signatures in this volume.

Cat. no. 47. **Gentleman,** Boston.

History: Collection of Frederick Pratt.

Cat. no. 49. **Federico II Gonzaga,** Madrid.

A hard copy of the Prado original is in the Musée Jacquemart-André, Paris.

Cat. no. 53. **Empress Isabella,** Madrid.

Painted on a re-used canvas. An old X-ray in the Prado Museum, first made available by Dr. Xavier de Salas in 1972, reveals a woman's head beneath the landscape.

Cat. no. 57. **Knight of Santiago,** Munich.

In Wethey, II, the attribution is assigned to Titian (?). I must now agree with Kultzen and Eikemeier (1971, p. 187) that the portrait should be classified as by a follower.

18

Cat. no. 60. **Lavinia (so-called) with a Tray of Fruit (Pomona)**, Berlin–Dahlem.

This original by Titian was doubtless intended to represent Pomona. Her diadem as well as the fruit identify her as the Roman goddess. Although the popular belief that Titian's daughter Lavinia served as model for various idealized girls has a romantic appeal, there are variations among them. The *Pomona* in Berlin has blue eyes, while the so-called *Lavinia as Bride* in Dresden (Wethey, II, 1971, Cat. no. 59) is brown-eyed.

A strip of canvas was added at the right side of the *Pomona* at some early date, probably to adapt the picture to a frame. Here the mediocre landscape background has been much repainted. Dr. Erich Schleier kindly informed me in 1973 that recent X-rays reveal that the portrait of a doge was begun upon this canvas and then abandoned.

Variant 4, published by Pallucchini (1971, pp. 114–125) as an original, appears to be a copy.

Cat. no. 62. **Cardinal Cristoforo Madruzzo**, São Paulo.

Dating: The date 1552 appears twice upon the portrait as well as the sitter's age of 39, as previously indicated. Charles Hope informs me, however, that the letter of 10 July 1542 states that Titian has painted a portrait of Madruzzo (Bonelli, 1762, III, p. 402). Therefore an earlier portrait by Titian must be the allusion here. Another letter from Cardinal Alessandro Farnese to Madruzzo requests that Titian and his brother be allowed to have wood cut in a forest owned by the cardinal (*loc. cit.*).

The clock shown in the portrait was seen in 1865 by Cavalcaselle in the Casa Valentino, according to his unpublished note (Venice, Marciana, It. IV 2031 (12,272).

Cat. no. 64. **Man with the Glove**, Paris.

If the item in the Gonzaga Inventory (1627, no. 324: Luzio, 1913, p. 116) should read 'un Giovinetto ignudo' rather than 'un Giovinetto ignoto', then it cannot be the same as Cat. no. 64.

Cat. no. 68. **Niccolò Orsini**, Baltimore.

Certain History: The ownership by Canon J. L. White-Thompson, an error in *Art Prices Current*, 1923–1924, no. 1588, must be eliminated.

Cat. no. 72. **Paul III without Cap**, Naples.

COPIES:

1. Sold by the Duke of Northumberland a few years ago.

Cat. no. 77A. **Gerolamo Melchiorre and Francesco Santo Pesaro** Plate 234

Canvas. 0·913 ×0·77 m.

Scotland, Private Collection.

About 1542.

This handsome double portrait of two young boys of the Pesaro family was discovered by Michael Jaffé in a Scottish mansion and published in an excellent and thorough account in the *Burlington Magazine* in 1971. Through a genealogical study of the Pesaro family, he established that the two sons of Benetto Pesaro and Lucrezia Valier were born on 30 June 1536 and 7 November 1537 respectively. Professor Jaffé has demonstrated that the style of the picture corresponds to the portraits of *Ranuccio Farnese* in Washington (Wethey, II, 1971, Cat. no. 31, Plates 109, 113) and *Clarice Strozzi* in Berlin (*loc. cit.*, Cat. no. 101, Plate 101 and colour reproduction, page 28). I am indebted to Professor Jaffé for making a photograph of Cat. no. 77A available for reproduction.

Condition: Cleaned by Mr. John Brealey. The X-rays, published by Jaffé, reveal slight adjustments in the positions of the figures as Titian developed the composition.

History: Listed in an inventory of 1797 in the Ca' Pesaro at S. Stae, item no. 68, as by Titian: 'Ritratti di due Giovanetti' (Jaffé, 1971, p. 696); sold by Abate Luigi Celotti in 1828 to James Irvine, the Scottish dealer, who purchased the double portrait for Sir William Forbes of Pitsligo (Edinburgh); exhibited in 1883 by Lord Clinton at the Royal Scottish Academy, Edinburgh, as 'Titian: Two Princes of the Pesaro Family' (Graves, 1813–1912, IV, p. 2200, no. 238).

Bibliography: See also above; Jaffé, 1971, pp. 696–701 (contains all data in reference to this picture).

Cat. no. 81. **Philip II Seated Wearing a Crown**, Cincinnati. Plates 236, 237

A new Titian is revealed in the X-ray photographs (Plate 236), first made in 1971, of this portrait of Philip II. The true brilliancy of the artist's brushwork in this full-scale sketch (*modello*) reappears in these X-rays, and in addition they show that the gloved left hand, now weak and blurred by overpaint, is actually fully structured and that the sceptre, which disappears behind the arm of the chair, was originally entirely visible. Another surprise occurs in the golden damask hanging behind Philip, where the deftly painted white rosettes are so swiftly evolved. The rest of the pattern of the textile with its elaborate trellis-like design of almond shapes and interlaces enclosing tulip buds and flowers, all in red, may have been added later. On the other hand, the

handsome filigree crown with its splendid brushwork remains intact in the shadowgraphs.

The last time that Titian saw Prince Philip was in Augsburg in May 1551. The crown, which does not appear so much askew in the original as it does in a photograph, would have been added in August 1554, when the artist learned of the prince's marriage to Queen Mary Tudor of England. It may well have been painted at the suggestion of Francisco de Vargas, Spanish ambassador to Venice. The presence of the crown in the X-rays appears to exclude the possibility that it could have been superimposed a great many years later. It is an odd circumstance that 'one crown of gold, worked in filigree' is listed in Philip II's Inventory after his death (Sánchez Cantón, 1956–1959, I, p. 345, no. 2621). The fact is that Spanish rulers had no coronation ceremony and apparently rarely, if ever, wore a crown. Even Charles V was never crowned as King of Spain, and he wore only the imperial crown of the Holy Roman Empire.

Panofsky (1969, p. 83, note) was correct in his proposal that the Cincinnati portrait at one time showed Philip wearing a beret, as in the Geneva version. A letter written on 11 May 1911 by Frau von Lenbach to Agnew and Sons in London states that her husband, the German painter, some time before 1884 removed the beret and so revealed the crown (*Portraits of Philip II of Spain and Francis I of France by Titian*, booklet published by Agnew and Sons, London, 1912). Lady Gregory in her biography of Sir Hugh Lane (1921, p. 193) mistakenly reported that Lane cleaned away the crown after he bought the picture c. 1911–1912. Only Roskill (1968, p. 252, note 82) was aware of Lenbach's elimination of the beret.

The existence of a cap over the crown is further documented by two of Cavalcaselle's drawings in the Biblioteca Marciana at Venice (It. IV. 2031 (12,272), which I shall publish later. Two points of the crown were visible even then, but there was never a real landscape to be seen through the window. Here Cavalcaselle wrote the word *cielo* (sky).

The Cincinnati portrait and the *Francis I* in Harewood House at Leeds (Wethey, II, 1971, Cat. no. 36) were purchased by Lenbach from the Barbarigo-Giustiniani of Padua about 1880. He also acquired the *Andrea Gritti* in New York (Wethey, II, Cat. no. 51), then promptly resold it to Baron von Heyl at Darmstadt. Cavalcaselle's drawing of the Gritti portrait is published by Elizabeth Gardner (1972, p. 74; see also Zeri and Gardner, 1973, pp. 76–77).

The second version of *Philip II Seated*, in Geneva (Wethey, II, 1971, Cat. no. 82), must have been painted after the Cincinnati portrait had been modified by the concealment of the crown with a beret and by the transformation of the damask hanging. The landscape through a window exists only in this picture, and there is no evidence in the X-rays that the first composition ever had one. This fact may still

indicate that Crowe and Cavalcaselle (1877, II, pp. 206–209) saw both versions, although they refer only to the Barbarigo-Giustiniani Collection in Padua, where the portrait then hung. Both Panofsky and Tietze-Conrat were uncertain as to which of the two portraits Crowe and Cavalcaselle had seen. As formerly stated (Wethey, II, 1971, Cat. no. 81), the known dimensions of the canvas leave no possible doubt that the Cincinnati picture is the one from Padua.

The present darkened condition of the painting is explained by the authorities of the Cincinnati museum as due to old discoloured varnish, which could be removed only at the risk of destroying Titian's original glazes. The edges of the canvas provide evidence that the left edge has been trimmed, perhaps by an inch, according to the conservator, Mr. F. Cornelius.

It is generally agreed that the *Philip II* in Cincinnati was kept in Titian's studio for use as a full-scale *modello* to be followed, so far as the head was concerned, in his portraits of the king.

Cat. no. 84. Philip II, Allegorical Portrait of (Allegory of the Victory of Lepanto), Madrid, 1573–1575.

The victory of the Holy League (Spain, Venice, and the papacy) over the Turks at Lepanto on 7 October 1571 was hailed as the great event of the century. A man named Titianus Vecellius, speaking for the people of Cadore, delivered a speech on 6 January 1571 (Venetian style; i.e. 1572) before Alvise Mocenigo, the Venetian Doge, and the Great Council extolling the performance of the Venetian navy. The six-page booklet that reproduces the speech exists in very few copies, one of which was cited by a bibliophile owner, F. R. Martin (1923, pp. 304–305). Another belongs to the library of the Museo Romántico in Barcelona (information, courtesy of Dr. Xavier de Salas) and three copies are in the Biblioteca Marciana at Venice and still another is in the New York Public Library. The belief that the speaker was the great painter from Cadore is mistaken. Cicogna (1847, index, Vecellio) seems to have known him to be a relative called Tiziano l'Oratore. On the other hand, Andrea da Mosto, historian of the Venetian doges (1966, p. 340), assumes that the orator was the great painter himself. He was, on the contrary, a learned man and minor poet, who received sixty ducats from the town of Cadore for delivering his speech before the Doge (see Ciani, edition 1940, pp. 552–553; Fabbiani, 1971, pp. 708–710).

Cat. no. 103. Gabriele Tadini, Winterthur.

Another portrait (Plate 235), in the Accademia Tadini at Lovere, on canvas, 0·525 × 0·72 m., is based on a medal, of which an exemplar exists in the Biblioteca Civica at

Bergamo. The date of the portrait appears to be *c.* 1600, definitely later than Titian's time. The director of the museum, Don Gian Angelico Scalzi, was most gracious in supplying me with a photograph and other data in 1972.

Cat. no. X–26. Courtesan (so-called), Los Angeles.

A related portrait belonged to Lord Malmesbury, 1876; William Graham, 1886; and Sir Alexander Henderson, 1914; now the property of Lord Farington at Buscot Park (Berkshire) (information by courtesy of E. K. Waterhouse).

Cat. no. X-48. Gentleman, Paris, Arthur Sachs; now in the Cleveland Museum of Art, as by Lorenzo Lotto (Cleveland, 1955, pl. XI).

Cat. no. X–63. Group Portrait. Washington, National Gallery of Art

In 1974 this picture was placed on exhibition with an attribution to Titian and Assistant; more suitable would be an artist of the rank of Bernardino Licinio. The three portraits are now said to represent Cardinal Marco Cornaro, Girolamo Cornaro, his brother, in the centre, and, the boy at the left, Girolamo's son, Marco, about to receive a benefice.

Cat. no. X–65. Johann Friedrich, Elector of Saxony, in Armour, Madrid.

Old X-rays at the Prado Museum, first made available in 1972, show no pentimenti. The fact would confirm that the portrait is a copy rather than a ruined original.

Cat. no. X–78. Andrea Navagero, Detroit.

Related item, no. 1. A portrait, formerly in the Palace of the Chancellor at Berlin, is inscribed 'Andreas Navagero MDXXV'. Thought to have been destroyed in World War II, it was seen in the reserves of the Bode Museum at East Berlin in June 1973.

Cat. no. X–84. Archbishop Vincenzo (?) Querini, Kansas City.

By a close follower of Titian (Kansas City, *Handbook*, 1973, p. 261).

Cat. no. L–9A. Catherine of Austria. About 1548–1549.

· This daughter of Emperor Ferdinand I married Federico III Gonzaga, son of Francesco III Gonzaga, but her husband died

very young. Titian promised in 1549 to finish her portrait and a copy for her father (Luzio, 1890, p. 210). Her portrait, probably by Seisenegger, has recently been wrongly attributed to Titian: canvas, 1·76×1·12 m. (Hardy, 1971, pp. 21–27).

Cat. no. L–20. Empress Isabella Seated, in Black

COPIES:

2. Now owned by the Marqués de Santo Domingo, Madrid, it was purchased at the Roblot Delondre sale (copy 5). The owner of the Altamira-Madrazo picture (canvas, 2·04 × 1·16 m.) is unknown.

Cat. no. L–24A. Empress Maria, wife of Maximilian II.

The only reference to this portrait occurs in a letter of 11 June 1564 (C. and C., 1877, II, p. 531; Cloulas, 1967, p. 261), written by García Hernández in Venice to Philip II, wherein it is stated that the portrait by Titian is ready for shipment. The artist must have prepared it from a German model, since he could never have seen the Empress Maria. Titian had earlier painted portraits of the Empress Isabella, wife of Charles V, in this fashion, after her death (Wethey, II, 1971, Cat. nos. 53, L–6, L–20).

Biography: Maria (1528–1603), the second child of Charles V and Isabella, married in 1548 her first cousin Maximilian, the son of the Emperor Ferdinand (1503–1564), who was the brother of Charles V. In 1576, after having borne fifteen children, she retired as a widow to the Franciscan convent of the Descalzas Reales in Madrid. There she lived for another twenty-seven years. After her death she was interred in a large, sober monument in the upper choir of the church of the Descalzas. A handsome full-length portrait of the young Empress-to-be in the Prado Museum is signed by Antonio Moro and dated 1551 (Prado catalogue, no. 2110, canvas, 1·81×0·90 m.; see Reade, 1951, pl. 2). She appears as an elderly widow in another full-length painting, in the nunnery at Madrid (Palma, 1653, folios IV–2; *Charles-Quint,* 1955, p. 63; *Carlos V,* 1958, p. 103).

Cat. no. L–26. Elisabetta Querini Massola

Copy 1, Paris, Louvre. Now on loan at Toulouse, Musée des Augustins, there attributed to Veronese.

Cat. no. L–27. Soliman the Great, Sultan of Turkey

4. Equestrian Portrait.

In a letter of 13 September 1561, addressed to Cardinal Ercole Gonzaga, Titian promised to paint an equestrian portrait of Soliman (Luzio, 1890, p. 208).

CHRONOLOGICAL LIST OF TITIAN'S PAINTINGS

Abbreviations:

W. I = Wethey, *Titian, The Religious Paintings*, London, Phaidon Press, 1969.
W. II = Wethey, *Titian, The Portraits*, London, Phaidon Press, 1971.
W. III = Wethey, *Titian, The Mythological and Historical Paintings*, London, Phaidon Press, 1975.

c. 1505	
Giorgione, *Tempest*, Venice	W. III, Plate 1
1508–1509	
Giorgione and Titian, Frescoes, Fondaco dei Tedeschi, Venice	W. III, Cat. no. 18, Figures 1–16
c. 1510	
Orpheus and Eurydice, Bergamo	W. III, Cat. no. 28, Plate 11
Giorgione, *Fugger Youth*, Munich	W. II, Cat. no. X–42, Plate 11
Christ Carrying the Cross, Venice, Scuola di S. Rocco	W. I, Cat. no. 22, Plate 64
Madonna and Child (Gypsy Madonna), Vienna	W. I, Cat. no. 47, Plates 1, 3
Holy Family with a Shepherd, London	W. I, Cat. no. 43, Plate 8
Holy Family with St. John the Baptist and Donor, Edinburgh	W. I, Cat. no. 42, Plate 6
Man of Sorrows, Venice, Scuola di S. Rocco	W. I, Cat. no. 75, Plate 63
Knight of Malta, Florence, Uffizi	W. II, Cat. no. 56, Plate 5
c. 1510–1511	
Giorgione, *Sleeping Venus*, finished by Titian, *c.* 1511, Dresden	W. III, Cat. no. 38, Plates 6, 7, 9
Giorgione and Titian, *Pastoral Concert*, Paris	W. III, Cat. no. 29, Plates 2, 3
c. 1510–1512	
The Concert, Florence, Pitti	W. II, Cat. no. 23, Plates 8–10
1511, summer	
Three Miracles of St. Anthony of Padua, Padua	W. I, Cat. nos. 93–95, Plates 139–143 W. III, Addenda 1
c. 1511	
Madonna and Child, New York	W. I, Cat. no. 48, Plate 5
Christ and the Adulteress, Vienna	W. I, Cat. no. 17, Plate 70
c. 1511–1512	
St. Mark Enthroned, Venice	W. I, Cat. no. 119, Plates 147, 148
La Schiavona, London	W. II, Cat. no. 95, Plates 13–16
c. 1512	
Gentleman in Blue, London	W. II, Cat. no. 40, Plates 3–4
Young Lady (drawing), Florence, Uffizi	W. II, Cat. no. 114, Plate 17
Gentleman with Flashing Eyes, Ickworth	W. II, Cat. no. 41, Plate 12
Jacopo Sannazaro, Hampton Court	W. II, Cat. no. 93, Plate 19
Ariosto (so-called), Indianapolis	W. II, Cat. no. 7, Plate 217
St. Peter Enthroned, Adored by Pope Alexander VI and Jacopo Pesaro, Antwerp	W. I, Cat. no. 132, Plates 144–146
Noli me Tangere, London	W. I, Cat. no. 80, Plate 71
c. 1512–1515	
Young Man with Cap and Gloves, Garrowby Hall	W. II, Cat. no. 115, Plate 20, Colour Reproduction
1512–1515	
Three Ages of Man, Edinburgh	W. III, Cat. no. 36, Plates 13–16, Colour Reproduction
1514	
Sacred and Profane Love, Rome	W. III, Cat. no. 33, Plates 20–25
c. 1515	
Baptism, Rome	W. I, Cat. no. 16, Plate 65
Rest on the Flight into Egypt, Longleat	W. I, Cat. no. 90, Plate 7 W. III, Addenda 1
Madonna of the Cherries, Vienna	W. I, Cat. no. 49, Plate 4
c. 1515?	
Madonna and Child, Lugano (Titian?, or Paris Bordone, *c.* 1530)	W. I, Cat. no. 50, Plate 12 W. III, Addenda 1
c. 1515	
Madonna and Child with SS. Dorothy and George, Madrid	W. I, Cat. no. 65, Plate 13
Gentleman in Plumed Hat, Petworth	W. II, Cat. no. 42, Plate 18

Lady at Her Toilet, Paris — W. III, Cat. no. 22, Plate 31

Salome, Rome, Doria-Pamphili Collection — W. I, Cat. no. 137, Plate 149

c. 1515–1518

Parma, the Physician, Vienna — W. II, Cat. no. 70, Plate 23

Gentleman in a Black Beret, Copenhagen — W. II, Cat. no. 43, Plate 24

c. 1515–1520

Madonna and Child with SS. Catherine and Dominic and a Donor, La Gaida — W. I, Cat. no. 61, Plate 9

c. 1516

Young Man in a Red Cap, Frankfurt — W. II, Cat. no. 117, Plate 21

Young Man in a Red Cap, New York, Frick Collection — W. II, Cat. no. 116, Plate 22

St. George, Venice, Cini Collection — W. I, Cat. no. 102, Plate 150

Tribute Money, Dresden — W. I, Cat. no. 147, Plates 67, 68 W. III, Addenda I

1516–1518

Assumption, Venice, Frari — W. I, Cat. no. 14, Plates 17–22 W. III, Addenda I

1518–1525

Ferrara Bacchanals, Washington, Madrid, London — W. III, Cat. nos. 12–15, Plates 38–64, 238C, Colour Reproductions

c. 1519

Annunciation, Treviso — W. I, Cat. no. 6, Plates 56, 57

c. 1519–1526

Pesaro Madonna, Venice, Frari — W. I, Cat. no. 55, Plates 28–31 W. III, Addenda I

1520

Madonna and SS. Francis and Aloysius and Donor, Ancona — W. I, Cat. no. 66, Plates 24, 25, 27

c. 1520

Lucretia, Hampton Court Palace — W. III, Cat. no. 26, Plate 37

Vanity, Munich — W. III, Cat. no. 37, Plate 34

Madonna and Child with St. Anthony Abbot and the Infant Baptist, Florence, Uffizi — W. I, Cat. no. 58, Plate 10

Madonna and Child with Four Saints, Dresden — W. I, Cat. no. 67, Plate 14

Madonna and Child with Three Saints, Paris — W. I, Cat. no. 72, Plate 15

Madonna and Child with Three Saints, Vienna — W. I, Cat. no. 73, Plate 16

Lady at Her Toilet, Barcelona — W. III, Cat. no. 23, Plate 32

Lady at Her Toilet, Prague — W. III, Cat. no. 24, Plate 29

c. 1520–1522

Man with a Glove, Paris — W. II, Cat. no. 64, Plates 29–32 W. III, Addenda II Plate 238A

Gentleman, Paris — W. II, Cat. no. 44, Plate 33

Gentleman, Munich — W. II, Cat. no. 45, Plate 34

Flora, Florence, Uffizi — W. III, Cat. no. 17, Plate 35

c. 1520–1525

Madonna and Child and Six Saints, Vatican — W. I, Cat. no. 63, Plate 23 W. III, Addenda I

Il Bravo, Vienna — W. III, Cat. no. 3, Plate 27

c. 1520–1530

Christ, Bust of, Vienna (storage) — W. I, Cat. no. 20

1521

Judgment of Solomon, Vicenza — W. I, p. 10, note 50

1522

Resurrection Altarpiece, Brescia — W. I, Cat. no. 92, Plate 72 W. III, Addenda I

1522–1523

Humiliation of Frederick Barbarossa by Pope Alexander III — W. III, Cat. no. L–6

1523

Madonna and Child with Angels, Venice — W. I, Cat. no. 51, Plate 26 W. III, Addenda I

c. 1523

Federico II Gonzaga, Madrid — W. II, Cat. no. 49, Plates 36, 37 W. III, Addenda II, Plate 238B

St. Christopher (fresco), Venice — W. I, Cat. no. 98, Plates 151, 152

Baldassare Castiglione, Dublin — W. II, Cat. no. 19, Plate 39 W. III, Addenda II

c. 1523–1525 *Alfonso I, d'Este*, New York	W. II, Cat. no. 26, Plate 40 W. III, Addenda II
Laura dei Dianti, Kreuzlingen	W. II, Cat. no. 24, Plates 41–43
c. 1525 *Venus Anadyomene*, Edinburgh	W. III, Cat. no. 39, Plate 36
c. 1525–1530 *Gentleman*, Berlin	W. II, Cat. no. 46, Plate 35 W. III, Addenda II, Plate 238D
c. 1526 *Vincenzo or Tommaso Mosti*, Florence, Pitti	W. II, Cat. no. 67, Plate 44
Farnese Gentleman (so-called), Pommersfelden	W. II, Cat. no. 32, Plate 228 W. III, Addenda II
1526–1530 *Martyrdom of St. Peter Martyr*, Venice, formerly (lost)	W. I, Cat. no. 133, Plates 153, 154 W. III, Addenda I
c. 1526–1532 *Entombment*, Paris	W. I, Cat. no. 36, Plate 75
1530 *Charles V with Drawn Sword* (lost)	W. II, Cat. no. L–3, Plates 48, 49
Cornelia Malaspina (lost)	W. II, Cat. no. L–22
c. 1530 *Gregorio Vecellio*, Milan	W. II, Cat. no. 109, Plate 45
Falconer, Omaha	W. II, Cat. no. 28, Plate 38 W. III, Addenda II,
Annunciation, Venice, Scuola di San Rocco	W. I, Cat. no. 9, Plate 58
1530 *Madonna and Child with St. Catherine* *and a Rabbit*, Paris	W. I, Cat. no. 60, Plate 34 W. III, Addenda II
c. 1530 *Madonna and Child with St. Catherine* *and the Infant Baptist*, London	W. I, Cat. no. 59, Plate 35, Colour Reproduction
1530–1532 (not 1535) *Assumption*, Verona	W. I, Cat. no. 15, Plates 43–45 W. III, Addenda I
1530–1535 *St. Mary Magdalen in Penitence*, Florence, Pitti	W. I, Cat. no. 120, Plate 182
c. 1530–1535 *Allegory of the Marchese del Vasto* (so-called), Paris	W. III, Cat. no. 1, Plates 68–71
Diego Hurtado de Mendoza (wrongly called), Florence, Pitti	W. II, Cat. no. 52, Plate 60
c. 1530–1540 *Madonna and Child and St. Dorothy* (workshop), Philadelphia	W. I, Cat. no. 14, Plate 32
1531 *St. Jerome in Penitence*, Paris	W. I, Cat. no. 104, Plate 155
Supper at Emmaus, Brocklesby Park	W. I, Cat. no. 142, Plate 87
Madonna and Child and Four Saints *and Andrea Gritti and Donor* (destroyed), Venice	W. I, Cat. no. 69
c. 1532 *Andrea dei Franceschi*, Detroit	W. II, Cat. no. 34, Plate 63
Andrea dei Franceschi (workshop), Washington	W. II, Cat. no. 35, Plate 61
1532–1533 *Nativity* (for Duke of Urbino), Florence, Pitti (storage)	W. I, Cat. no. 79
c. 1532–1534 *Hannibal* (?), Private collection	W. III, Cat. no. 20, Plate 67
Bust of Christ, Florence, Pitti	W. I, Cat. no. 19, Plate 92
1533 *Charles V with Hound*, Madrid	W. II, Cat. no. 20, Plates 51, 55
Charles V in Armour with Baton (lost)	W. II, Cat. no. L–4
Alfonso d'Avalos, Marchese del Vasto, *with Page*, Paris	W. II, Cat. no. 9, Plate 56
Ippolito dei Medici, Florence, Pitti	W. II, Cat. no. 66, Plate 65
1534–1536 *Isabella d'Este*, Vienna	W. II, Cat. no. 27, Plate 72 W. III, Addenda II
c. 1534–1538 *Presentation of the Virgin*, Venice	W. I, Cat. no. 87, Plates 36–39 W. III, Addenda I
c. 1535 *Rest on the Flight into Egypt*, Escorial	W. I, Cat. no. 91, Plate 40

Madonna and Child with St. Agnes and the Infant Baptist, Dijon	W. I, Cat. no. 56, Plate 42
Supper at Emmaus, Paris	W. I, Cat. no. 143, Plates 88, 89
Count Antonio Porcia, Milan	W. II, Cat. no. 85, Plate 64
Girl in a Fur Coat, Vienna	W. II, Cat. no. 48, Plate 73
1535–1538	
Andrea Gritti, Washington	W. II, Cat. no. 50, Plates 74–77
1535–1540 (retouched 1560)	
Jupiter and Antiope (El Pardo Venus), Paris	W. III, Cat. no. 21, Plates 74–76
1536	
La Bella, Florence, Pitti	W. II, Cat. no. 14, Plate 71
Annunciation (given to the Empress Isabella, lost)	W. I, Cat. no. 10, Plate 59 W. III, Addenda I
***c.* 1536**	
Giulio Romano, London	W. II, Cat. no. 86, Plate 82
1536–1538	
Georges d'Armagnac and his Secretary Guillaume Philandrier, Alnwick Castle	W. II, Cat. no. 8, Plate 135
Francesco Maria I della Rovere, Duke of Urbino, Florence, Uffizi	W. II, Cat. nos. 88, 89, Plates 66–68 W. III, Plate 238E
Eleanora Gonzaga della Rovere, Duchess of Urbino, Florence, Uffizi	W. II, Cat. no. 87, Plates 69, 70
1536–1539	
Roman Emperors (lost)	W. III, Cat. no. L–12, Figures 31–50
1537–1538	
The Battle (lost)	W. III, Cat. no. L–3, Figures 51–61
1538	
Venus of Urbino, Florence, Uffizi	W. III, Cat. no. 54, Plates 72, 73
***c.* 1538**	
Francis I (modello), Leeds	W. II, Cat. no. 36, Plate 78
Gabriele Tadini, Winterthur	W. II, Cat. no. 103, Plate 85 W. III, Addenda II, Plate 235
***c.* 1538–1540**	
Filetto and Son, Vienna	W. II, Cat. no. 33, Plates 131, 133, 134

***c.* 1539**	
Francis I, Paris	W. II, Cat. no. 37, Plate 79
Francis I (formerly Geneva)	W. II, Cat. no. 38, Plates 80, 81 W. III, Addenda II
1539–1541	
Alfonso d'Avalos, Marchese del Vasto, Allocution of, Madrid	W. II, Cat. no. 10, Plates 57, 58
***c.* 1540**	
Vincenzo Cappello, Washington	W. II, Cat. no. 17, Plates 88, 89
Cardinal Pietro Bembo, Washington	W. II, Cat. no. 15, Plate 90
Gentleman with a Book (Titian?), Boston	W. II, Cat. no. 47, Plate 111 W. III, Addenda II
Friend of Titian, San Francisco	W. II, Cat. no. 39, Plates 91, 92
Benedetto Varchi, Vienna	W. II, Cat. no. 108 Plate 83
***c.* 1540–1545**	
Temptation of Christ, Minneapolis	W. I, Cat. no. 144, Plate 110
Giacomo Doria, Luton Hoo	W. II, Cat. no. 25, Plate 86 W. III, Addenda II
Young Englishman, Florence, Pitti	W. II, Cat. no. 113, Plates 100, 101
1541–1542	
Seigneur d'Aramon, Milan	W. II, Cat. no. 3, Plate 102 W. III, Addenda II
1542	
Clarice Strozzi, Berlin-Dahlem	W. II, Cat. no. 101, Plates 106–108, Colour Reproduction W. III, Plate 238F
Ranuccio Farnese, Washington	W. II, Cat. no. 31, Plates 109, 113, 114
***c.* 1542**	
Gerolamo Melchiorre and Francesco Santo Pesaro, Scotland, Private collection	W. III, Addenda II Cat. no. 77A, Plate 234
1542	
Francisco de los Cobos (lost)	W. II, Cat. no. L–8a
***c.* 1542**	
Doge Niccolò Marcello, Vatican	W. II, Cat. no. 65, Plate 105

Knight of Santiago, Munich (follower of Titian)	W. II, Cat. no. 57, Plate 87 W. III, Addenda II	*Portrait of a Lady* (underpaint), London	W. III, Addenda I, Cat. no. 145, Plates 219, 220
1542–1544 *Last Supper* and *Resurrection*, Urbino	W. I, Cat. no. 45, Plates 94, 95	**1545** *Cardinal Alessandro Farnese*, Naples	W. II, Cat. no. 29, Plate 132
1542–1547 *Madonna and Child Appearing to SS. Peter and Andrew*, Serravalle	W. I, Cat. no. 70, Plates 46, 48	**1545–1546** *Paul III with Cap* (damaged), Naples	W. II, Cat. no. 73, Plate 118
1543 *Paul III without Cap*, Naples	W. II, Cat. no. 72, Plates 115–117 W. III, Addenda II	*Paul III with Cap*, Leningrad	W. II, Cat. no. 74, Plate 119
Christ Before Pilate, Vienna	W. I, Cat. no. 21, Plates 90, 91	*Paul III with Cap*, Vienna	W. II, Cat. no. 75, Plate 120
1543–1544 *Old Testament Scenes*, Venice	W. I, Cat. nos. 82–84, Plates 157–159	*c.* **1545–1546** *Venetian Girl*, Naples	W. II, Cat. no. 111, Plate 194
c. **1543–1545** *Madonna and Child with SS. Peter and Paul* (workshop, repainted), Roganzuolo	W. I, Cat. no. 71, Plate 51	*Martino Pasqualigo*, Washington	W. II, Cat. no. 71, Plate 103
1543–1547 *The Vendramin Family*, London	W. II, Cat. no. 110, Plates 136–140, Colour Reproduction	**1545–1546** *Julius II* (after Raphael), Florence, Pitti	W. II, Cat. no. 55, Plates 122, 125
		Cardinal Pietro Bembo (ruinous), Naples	W. II, Cat. no. 16, Plate 254
		Venus and Adonis (lost) (for Cardinal Alessandro Farnese)	W. III, Cat. no. L–19
1544 *Sperone Speroni* (workshop of Titian), Treviso	W. II, Cat. no. 98, Plate 104	*Danaë with Cupid*, Naples (for Cardinal Alessandro Farnese)	W. III, Cat. no. 5, Plate 81
1544–1545 *Empress Isabella, Seated, Dressed in Black* (lost)	W. II, Cat. no. L–20 Plate 150 W. III, Addenda II	*Paul III and Grandsons*, Naples	W. II, Cat. no. 76, Plates 126–129, Colour Reproduction
1544–1547 *Vision of St. John the Evangelist on Patmos*, Washington	W. I, Cat. nos. 111, 112, Plate 156	*c.* **1545–1547** *Giulia Varano*, Duchess of Urbino, Florence, Pitti	W. II, Cat. no. 90, Plate 148
c. **1544–1545** *Daniele Barbaro*, Ottawa	W. II, Cat. no. 11, Plate 95	*c.* **1545–1548** *Venus and Cupid with an Organist*, Madrid	W. III, Cat. no. 47, Plates 105, 106, 108, 239A
c. **1545** *Daniele Barbaro*, Madrid	W. II, Cat. no. 12, Plates 93, 94	*c.* **1545–1550** *St. Francis Receiving the Stigmata*, Trapani	W. I, Cat. no. 100, Plate 163
Pietro Aretino, Florence, Pitti	W. II, Cat. no. 5, Plate 96	*St. John the Baptist*, Venice	W. I, Cat. no. 109, Plate 165
Sixtus IV (Titian and workshop), Florence, Uffizi	W. II, Cat. no. 97, Plate 124	**1546** *Pierluigi Farnese and Standard Bearer* (damaged), Naples	W. II, Cat. no. 30, Plate 123 W. III, Addenda II
Double Portrait (underpaint), Washington	W. III, Cat. no. 51, Plate 218	*c.* **1546–1550** *Christ Crowned with Thorns*, Paris	W. I, Cat. no. 26, Plates 132, 134 W. III, Addenda I
Francesco Savorgnan della Torre, Kingston Lacy	W. II, Cat. no. 94, Plate 98		

1547

Ecce Homo, Madrid — W. I, Cat. no. 32, Plate 96

1548

Charles V in Armour with Baton (lost) — W. II, Cat. no. L–5

Charles V at Mühlberg, Madrid — W. II, Cat. no. 21, Plates 141–144

Charles V Seated, Munich — W. II, Cat. no. 22, Plates 145, 146

Charles V and the Empress Isabella (lost) — W. II, Cat. no. L–6, Plate 151 (Rubens' copy)

Empress Isabella, Madrid — W. II, Cat. no. 53, Plates 147, 149 / W. III, Addenda II

Antoine Perrenot, Cardinal Granvelle, Kansas City — W. II, Cat. no. 77, Plate 153

Giovanni Battista di Castaldo, Salzburg (on loan) — W. II, Cat. no. 18, Plates 154–157 / W. III, Addenda II

c. 1548

Pietro Aretino, New York — W. II, Cat. no. 6, Plate 99

Nicholas Perrenot, Seigneur de Granvelle (workshop), Besançon — W. II, Cat. no. X–82, Plate 152

1548–1549

The *Four Condemned*, Madrid — W. III, Cat. no. 19, Plates 99–104

Catherine of Austria (lost) — W. III, Addenda II, Cat. no. L–9a

Philip II as Prince (lost) — W. II, Cat. no. L–25

c. 1548–1549

Venus and Cupid with an Organist (Prince Philip), Berlin–Dahlem — W. II, Plates 170, 171; W. III, Cat. no. 48, Plates 114, 115, 117–120, 238G

1548–1557

Martyrdom of St. Lawrence, Venice — W. I, Cat. no. 114, Plates 178, 179 / W. III, Addenda I

1550

Antonio Anselmi, Lugano — W. II, Cat. no. 2, Plate 158

c. 1550

Scholar with a Black Beard, Copenhagen — W. II, Cat. no. 96, Plate 160

Pentecost, Venice — W. I, Cat. no. 85, Plate 104

St. James Major, Venice — W. I, Cat. no. 103, Plate 160

Venus and Dog with an Organist, Madrid — W. III, Cat. no. 50, Plates 109–113

Tobias and the Angel, Venice — W. I, Cat. no. 145, Plate 161

St. John the Hospitaller, Venice — W. I, Cat. no. 113, Plate 166 / W. III, Addenda I

Venus and Cupid with a Partridge, Florence, Uffizi — W. III, Cat. no. 49, Plate 107

St. Mary Magdalen in Penitence, Naples — W. I, Cat. no. 122, Plate 183 / W. III, Addenda I

Landscape with Roger and Angelica (drawing), Bayonne — W. III, Cat. no. 25, Plate 137

c. 1550 (retouched c. 1571?)

Adam and Eve (*Temptation*), Madrid — W. I, Cat. no. 1, Plate 162 / W. III, Addenda I

c. 1550

Putti at Games (workshop), Chambéry — W. III, Cat. no. 31, Plates 195, 197

Titian's Self-Portrait, Berlin–Dahlem — W. II, Cat. no. 104, Plates 209, 213

1550–1551

Johann Friedrich, Elector of Saxony, Vienna — W. II, Cat. no. 54, Plate 159

Philip II in Armour, Madrid — W. II, Cat. no. 78, Plates 174–176

c. 1550–1552

Knight with a Clock, Madrid — W. II, Cat. no. 58, Plate 161

c. 1551 (crown added in 1554)

Philip II Seated Wearing a Crown, Cincinnati — W. II, Cat. no. 81, Plate 181 / W. III, Addenda II, Plates 236, 237

c. 1551–1554

Trinity ('La Gloria'), Madrid — W. I, Cat. no. 149, Plates 105–109 / W. III, Plate 239C

1552

Ludovico Beccadelli, Florence, Uffizi — W. II, Cat. no. 13, Plate 164

Cristoforo Madruzzo, Cardinal and Bishop of Trent, São Paulo — W. II, Cat. no. 62, Plate 166 / W. III, Addenda II

Giovanni Acquaviva, Duke of Atri, Cassel — W. II, Cat. no. 1, Plates 167–169 / W. III, Addenda II

Landscape (for Prince Philip of Spain) (lost) — W. III, Cat. no. L–7

St. Margaret, Escorial — W. I, Cat. no. 116, Plate 175

1552–1553
Guidobaldo II della Rovere and His W. II, Cat. no. 91,
 Son, Private collection Plate 165
c. 1552–1555
Venus at Her Toilet with Two W. III, Cat. no. 51,
 Cupids, Washington Plates 127–129,
 Colour
 Reproduction
Venus at Her Toilet with Two W. III, Cat. no.
 Cupids (Crasso type) (lost) L–26, Plate 126
1553
Noli Me Tangere (fragment), Madrid W. I, Cat. no. 81,
 Plate 103
 W. III, Addenda I
Philip II (half length) (workshop), W. II, Cat. no. 83,
 Madrid Plate 177
1553–1554
Danaë with Nursemaid, Madrid W. III, Cat. no. 6,
 Plates 83, 85, 89,
 Colour
 Reproduction
Venus and Adonis, Madrid W. III, Cat. no. 40,
 Plates 84, 86, 87,
 90–92
1554
Mater Dolorosa, Madrid W. I, Cat. no. 77,
 Plate 97
c. 1554
Apparition of Christ to the W. I, Cat. no. 13,
 Madonna, Medole Plate 111
 W. III, Addenda I
Philip II, Naples W. II, Cat. no. 79,
 Plate 179
Philip II, Florence, Pitti W. II, Cat. no. 80,
 Plate 180
Medea and Jason (lost?) W. III, Cat. no.
 L–10
1554–1556
Doge Francesco Venier, Lugano W. II, Cat. no. 112,
 Plates 184–186
c. 1554–1556
Perseus and Andromeda, London W. III, Cat. no. 30,
 Plates 134–136
c. 1555
Venus at Her Toilet with Two W. III, Cat. no. 52,
 Cupids (workshop), Cologne Plate 130
Venus at Her Toilet with One Cupid W. III, Cat. no. 53,
 (workshop), Stockholm Plate 131
Venus and Adonis (workshop), W. III, Cat. no. 41,
 London Plates 93, 94
Venus and Adonis, Somerley W. III, Cat. no. 42,
 Plate 190

Lavinia with a Tray of Fruit W. II, Cat. no. 60,
 (Pomona), Berlin–Dahlem Plate 191
 W. III, Addenda II
Lavinia as Bride (so-called), Dresden W. II, Cat. no. 59,
 Plates 187, 189
Salome, Madrid W. I, Cat. no. 141,
 Plate 192
 W. III, Cat. no. 60,
 Variant 3, Plate
 192
Christ on the Cross, Escorial W. I, Cat. no. 29,
 Plate 113
St. Jerome in Penitence, Milan W. I, Cat. no. 105,
 Plate 171
St. Jerome in Penitence (workshop), W. I, Cat. no. 106,
 Rome Plate 169
Mater Dolorosa, Madrid W. I, Cat. no. 76,
 Plate 101
Madonna and Child with the W. I, Cat. no. 68,
 Magdalen, Leningrad Plate 52
c. 1555–1560
Danaë with Nursemaid, Vienna W. III, Cat. no. 7,
 Plate 82
c. 1556
Philip II Seated, Geneva W. II, Cat. no. 82,
 Plate 182
1557
Adoration of the Kings (Titian and W. I, Cat. no. 2,
 workshop), Milan Plate 119
c. 1557
Annunciation, Naples, Gallerie W. I, Cat. no. 12,
 Nazionali (on loan from S. Plate 60
 Domenico Maggiore)
c. 1557–1564
Last Supper, Escorial W. I, Cat. no. 46,
 Plates 116–118
1558
Standard for the Feast of San Cicogna, VI, II,
 Bernardino (lost) p. 706
Crucifixion, Ancona W. I, Cat. no. 31,
 Plates 114, 115
 W. III, Addenda I
Fabrizio Salvaresio, Vienna W. II, Cat. no. 92,
 Plates 199, 203
c. 1558
Archbishop Filippo Archinto, W. II, Cat. no. 4,
 Philadelphia Plate 162
1559
Entombment, Madrid W. I, Cat. no. 37,
 Plates 76–78
 W. III, Plate 239D

Diana and Actaeon, Edinburgh	W. III, Cat. no. 9, Plates 142, 144–147, Colour Reproduction
Diana and Callisto, Edinburgh	W. III, Cat. no. 10, Plates 143, 148–150
c. 1559	
Irene di Spilembergo, Private Collection	W. II, Cat. no. 99, Plate 190
1559–1560	
Adoration of the Kings, Escorial	W. I, Cat. no. 3, Plate 120
Death of Actaeon, London (completed *c.* 1570–1575)	W. III, Cat. no. 8, Plates 151–153, Colour Reproduction
1559–1562	
Rape of Europa, Boston	W. III, Cat. no. 32, Plates 138–141
c. 1560	
Filippo Strozzi, Vienna	W. II, Cat. no. 102, Plate 200
Adoration of the Kings (Titian and workshop), Madrid	W. I, Cat. no. 4, Plate 121
Madonna and Child, Rome, Luigi Albertini	W. I, Cat. no. 52, Plate 54
Lavinia as Matron, Dresden	W. II, Cat. no. 61, Plate 188
Ecce Homo, Sibiu	W. I, Cat. no. 33, Plate 98 W. III, Addenda I
Ecce Homo, Dublin	W. I, Cat. no. 34, Plate 100
Madonna and Child with SS. Andrew and Tiziano, and Titian as Donor, Pieve di Cadore	W. I, Cat. no. 57, Plate 47
St. John the Baptist, Escorial and Novara	W. I, Cat. no. 110, Plate 167 W. III, Addenda I
Irene di Spilembergo (Titian and Pace), Washington	W. II, Cat. no. X–89, Plate 196
Madonna and Child with SS. Catherine and Luke, Kreuzlingen, Heinz Kisters	W. I, Cat. no. 62, Plate 53 W. III, Addenda I
Christ Carrying the Cross, Madrid	W. I, Cat. no. 23, Plate 129
St. Mary Magdalen in Penitence, Busto Arsizio	W. I, Cat. no. 124, Plates 184, 186
St. Mary Magdalen in Penitence, Leningrad	W. I, Cat. no. 123, Plate 185
c. 1560–1562	
Wisdom, Venice, Libreria Marciana, Vestibule	W. III, Cat. no. 55, Plates 162, 163
c. 1560–1565	
Annunciation, Venice, S. Salvatore	W. I, Cat. no. 11, Plate 62 W. III, Addenda I
Transfiguration, Venice, S. Salvatore	W. I, Cat. no. 146, Plate 124
Man with a Flute, Detroit	W. II, Cat. no. 63, Plate 201
Venus and Adonis, New York	W. III, Cat. no. 43, Plate 97
Venus and Adonis, Washington	W. III, Cat. no. 44, Plate 98
St. Mary Magdalen in Penitence, Genoa	W. I, Cat. no. 128
1561	
Antonio Palma, Dresden	W. II, Cat. no. 69, Plates 204, 205
St. Mary Magdalen in Penitence (destroyed), Escorial	W. I, Cat. no. 127
c. 1561	
Niccolò Orsini, Baltimore	W. II, Cat. no. 68, Plate 202 W. III, Addenda II
St. Francis Receiving the Stigmata, Ascoli Piceno	W. I, Cat. no. 101, Plate 164
1562	
Agony in the Garden, Madrid	W. I, Cat. no. 6, Plate 125
c. 1562–1565	
Madonna and Child in an Evening Landscape, Munich	W. I, Cat. no. 53, Plates 49, 50
1563	
St. Nicholas of Bari (Titian and workshop), Venice, S. Sebastiano	W. I, Cat. no. 131, Plate 170
Agony in the Garden, Escorial	W. I, Cat. no. 7, Plate 126
1564	
Ecce Homo and Mater Dolorosa (lost)	W. I, Cat. no. 35
Empress Maria (lost)	W. III, Addenda II, Cat. no. L–24a
1564–1567	
Martyrdom of St. Lawrence, Escorial	W. I, Cat. no. 115, Plate 181 W. III, Addenda I
1565–1568	
Allegories of Brescia	W. III, Cat. no. L–1, Figs. 66, 68
c. 1565	
Christ Carrying the Cross, Madrid	W. I, Cat. no. 24, Plate 127

St. Dominic, Rome, Villa Borghese	W. I, Cat. no. 99, Plate 187	*c. 1570*	
Christ Carrying the Cross, Leningrad	W. I, Cat. no. 25, Plate 128	*Tarquin and Lucretia* (workshop of Titian), Bordeaux	W. III, Cat. no. 35, Plate 165
Cupid Blindfolded, Rome, Villa Borghese	W. III, Cat. no. 4, Plates 155, 158, 159	*Entombment* (workshop), Madrid	W. I, Cat. no. 38, Plate 80
Titian's Self Portrait (drawing), Florence, Uffizi	W. II, Cat. no. 106, Plate 210	*c. 1570* *Madonna Nursing the Child*, London	W. I, Cat. no. 54, Plate 55
St. Margaret, Madrid	W. I, Cat. no. 117, Plate 173	*Judith*, Detroit	W. I, Cat. no. 44, Plate 193
Venus and Cupid with a Lute Player, Cambridge	W. III, Cat. no. 46, Plates 123, 125	*Judith* (main figure repainted later), Private Collection	W. I, Cat. no. 44, Version 2
c. 1565–1567 *Venus Clothed at Her Toilet with One Cupid*,	W. III, Cat. no. L–27, Plate 132	*Christ Blessing*, Leningrad	W. I, Cat. no. 18, Plate 93
c. 1565–1570 *St. Margaret*, Kreuzlingen	W. I, Cat. no. 118, Plate 174	*Titian, Orazio Vecellio, and Marco Vecellio* (*Allegory of Prudence*), London	W. II, Cat. no. 107, Plates 211, 212
Venus and Cupid with a Lute Player, New York	W. III, Cat. no. 45, Plates 121, 122, 124	*St. Jerome in Penitence*, Lugano	W. I, Cat. no. 107, Plate 172 W. III, Addenda I
c. 1565–1570 *Titian's Self-Portrait*, Madrid	W. II, Cat. no. 105, Plate 1	*c. 1570–1575* *Nymph and Shepherd*, Vienna	W. III, Cat. no. 27, Plates 168, 202, 203
c. 1566 *Christ on the Cross with the Good Thief*, Bologna	W. I, Cat. no. 30, Plate 112	*Boy with Dogs*, Rotterdam	W. III, Cat. no. 2, Plate 169
Diana and Callisto, Vienna	W. III, Cat. no. 11, Plate 154	*Flaying of Marsyas*, Kremsier	W. III, Cat. no. 16, Plates 170–172
Adoration of the Kings, Cleveland	W. I, Cat. no. 5, Plates 122, 123 W. III, Addenda I	*c. 1570–1576* *Christ Crowned with Thorns*, Munich	W. I, Cat. no. 27, Plates 133, 135
1567 *Venus Clothed at Her Toilet with One Cupid*	W. III, Cat. no. L–27	*c. 1572–1575* *Religion Succoured by Spain*, Madrid	W. I, Cat. no. 88, Plate 196
1567–1568 *Jacopo Strada*, Vienna	W. II, Cat. no. 100, Plates 206, 207	*c. 1573* *Madonna of Mercy* (workshop of Titian), Florence, Pitti	W. I, Cat. no. 74, Plate 200
1568 *Endymion and Diana*	W. III, Cat. no. L–5	*1573–1575* *Philip II, Allegory of Lepanto*, Madrid	W. II, Cat. no. 84, Plate 183
Tribute Money, London	W. I, Cat. no. 148, Plate 131		W. III, Addenda II, Plate 239E
c. 1568 *St. Catherine of Alexandria in Prayer* (workshop of Titian), Boston	W. I, Cat. no. 96, Plate 188 W. III, Addenda I	*1575* *St. Jerome in Penitence*, Escorial	W. I, Cat. no. 108, Plate 195
c. 1568–1571 *Tarquin and Lucretia*, Cambridge	W. III, Cat. no. 34, Plates 161, 164, 239B	*c. 1575* *Religion Succoured by Spain* (workshop replica), Rome, Doria-Pamphili Collection	W. I, Cat. no. 89, Plate 197
		St. Sebastian, Leningrad	W. I, Cat. no. 134, Plate 194
		Christ Mocked, St. Louis	W. I, Cat. no. 28, Plate 102 W. III, Addenda I

Entombment (workshop), Vienna W. I, Cat. no. 39,
 Plate 83

c. [1555–]1576
Faith Adored by Doge Grimani W. I, Cat. no. 40,
 (Titian and workshop Plate 201
 primarily), Venice, Doge's Palace

1576
Pietà, Venice, Accademia W. I, Cat. no. 86,
 (completed by Palma Giovane) Plates 136–138
 W. III, Addenda I

PLATES

PLATES

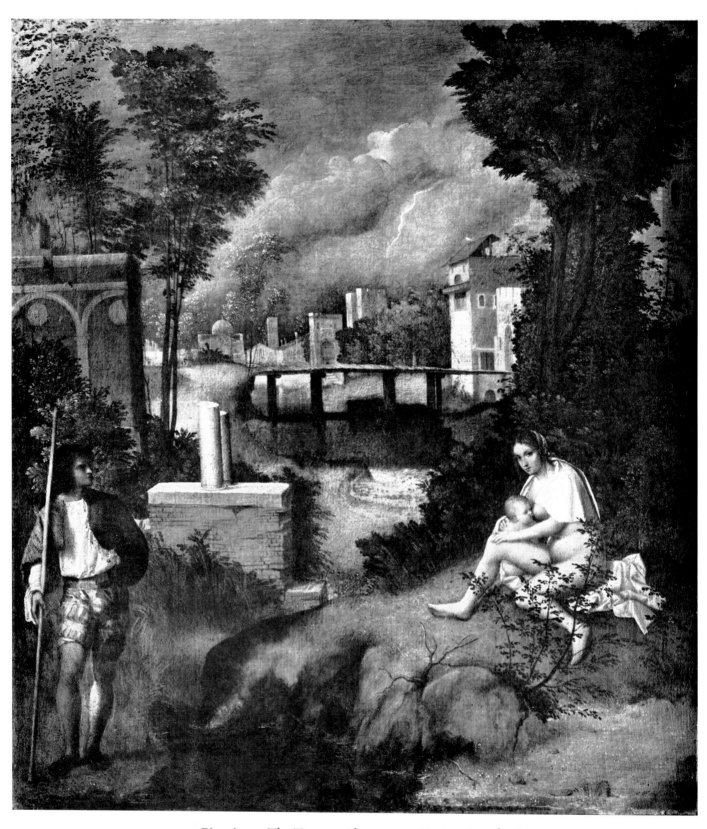

1. Giorgione: *The Tempest*. About 1505. Venice, Accademia

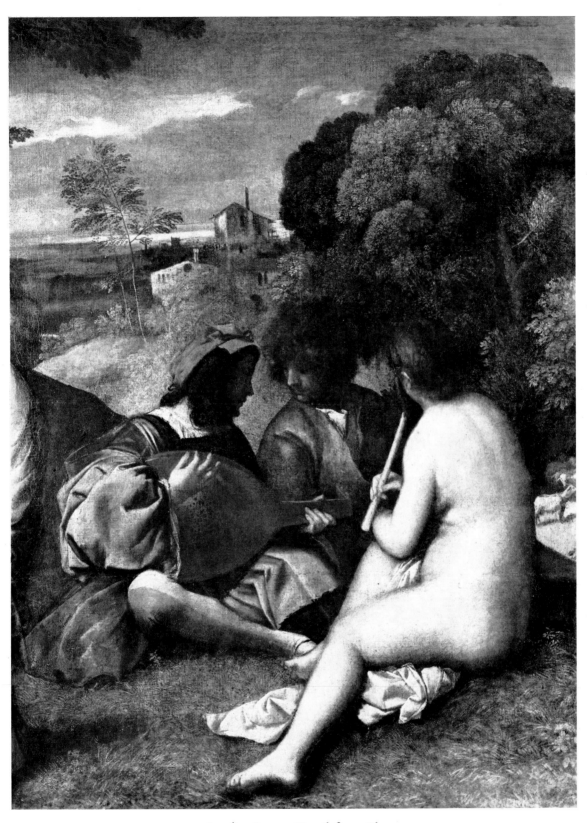

2. *Arcadian Lovers*. Detail from Plate 3

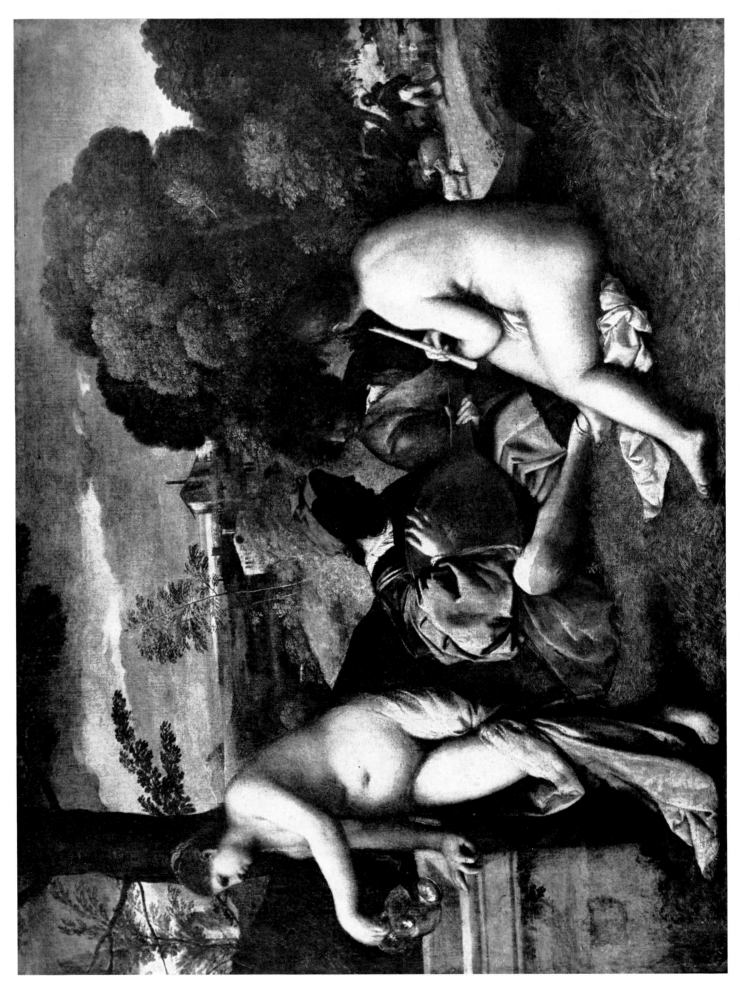

3. Giorgione and Titian: *Pastoral Concert*. About 1510–1511. Paris, Louvre (Cat. no. 29)

4. Follower of Titian: *Arcadian Musicians* (drawing). About 1510. London, British Museum

5. Titian: *Detail of Noli Me Tangere*. About 1510. London, National Gallery

6. *Landscape*. Detail from Plate 9

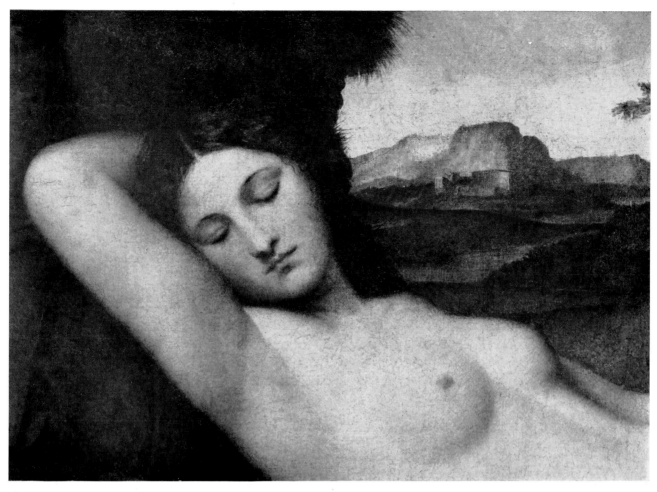

7. *Sleeping Venus*. Detail from Plate 9

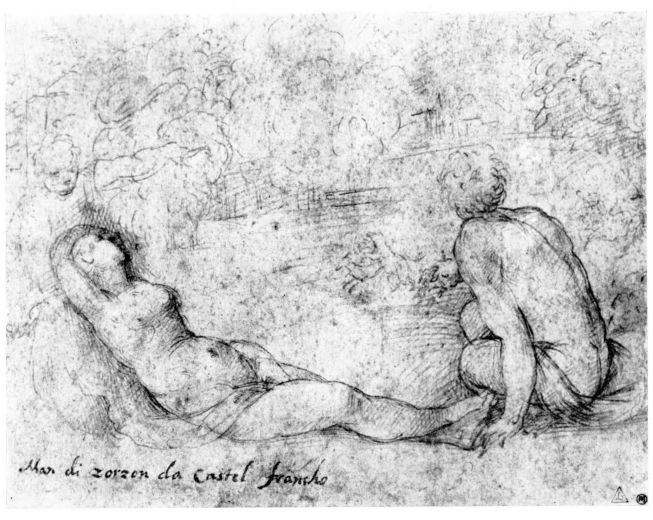

8. Giorgione: *Sleeping Nude* (Drawing). About 1510. Darmstadt, Hessisches Landesmuseum

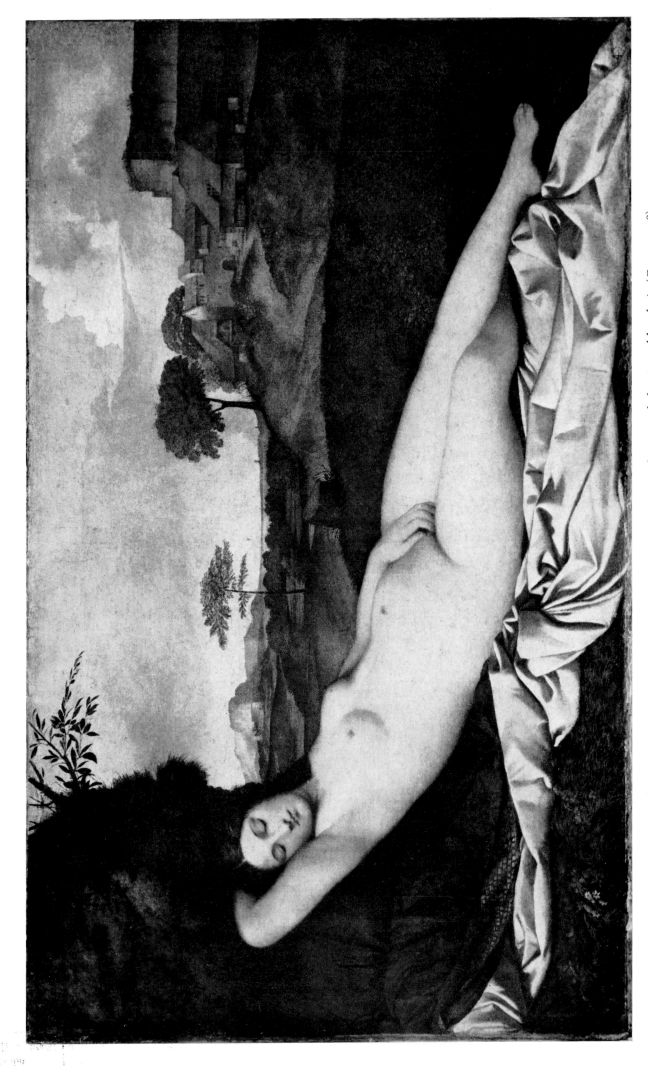

9. Giorgione and Titian: *Sleeping Venus*. About 1510–1511. Dresden, Staatliche Gemäldegalerie (Cat. no. 38)

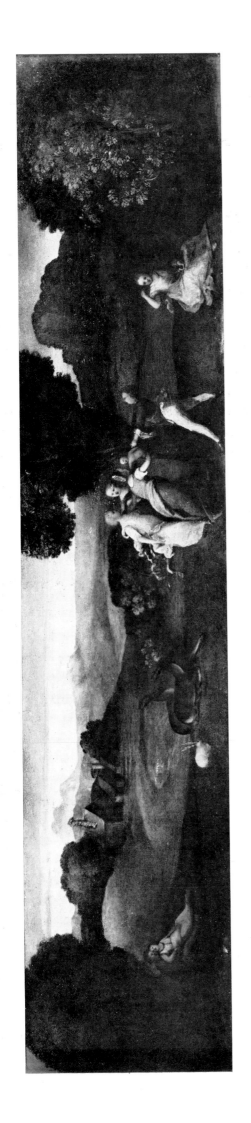

10. Giorgionesque Painter: *Birth of Adonis* and *Death of Polydorus*. About 1505–1510. Padua, Museo Civico (Cat. no. X–2)

11. Titian: *Orpheus and Eurydice*. About 1510. Bergamo, Accademia Carrara (Cat. no. 28)

12. Giorgionesque Painter: *Apollo and Daphne* (before restoration). About 1512. Venice, Seminario Patriarcale (Cat. no. X-4)

13. Titian: *Three Ages of Man*. About 1515. Edinburgh, National Gallery of Scotland, on loan from the Duke of Sutherland (Cat. no. 36)

15. *Head of the Girl. Detail from Plate 13*

14. *Head of the Youth. Detail from Plate 13*

16. *Landscape*. Detail from Plate 13

17. *Sarcophagus*. Detail from Plate 20

18. *Landscape*. Detail from Plate 20

19. *Landscape*. Detail from Plate 20

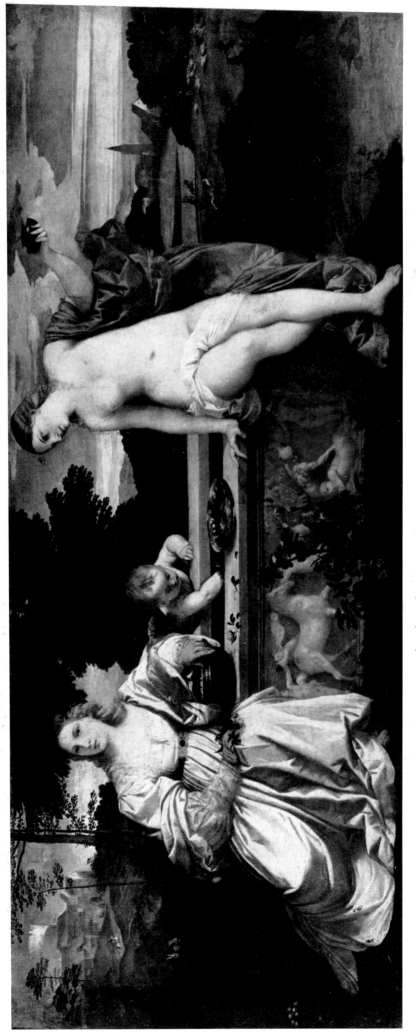

20. Titian: *Sacred and Profane Love*. About 1514. Rome, Villa Borghese (Cat. no. 33)

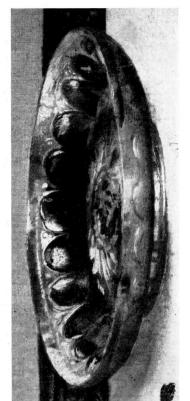

21. *Sarcophagus with Escutcheon. Detail of Plate 20*

22. *Escutcheon of Niccolò Aurelio. Dated 1523. Venice, Ducal Palace*

20A. *Silver bowl with Bagarotto Escutcheon. Detail from Plate 20*

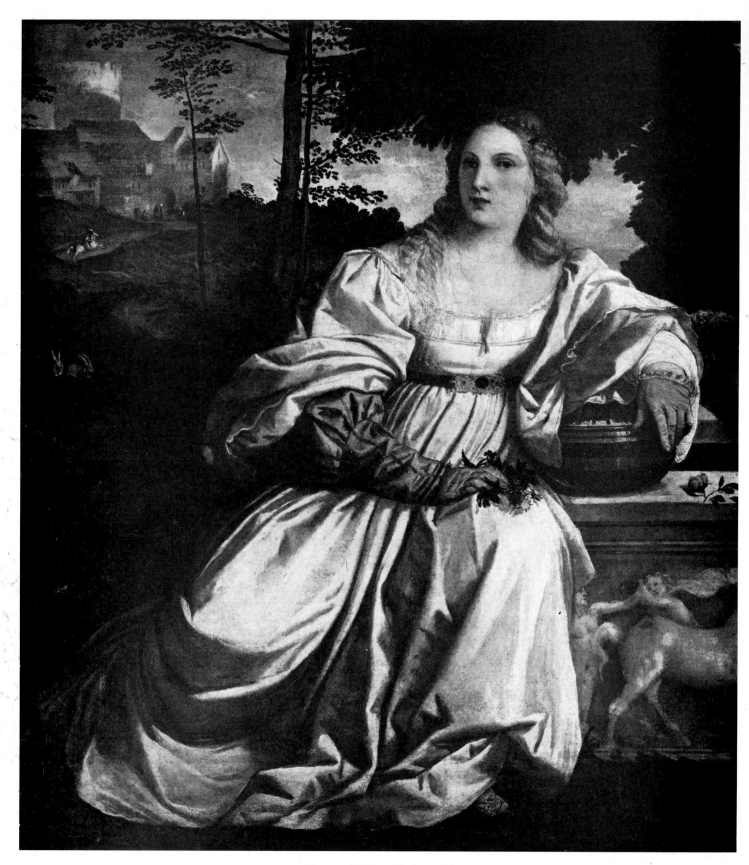

23. *Chastity* (?). Detail from Plate 20

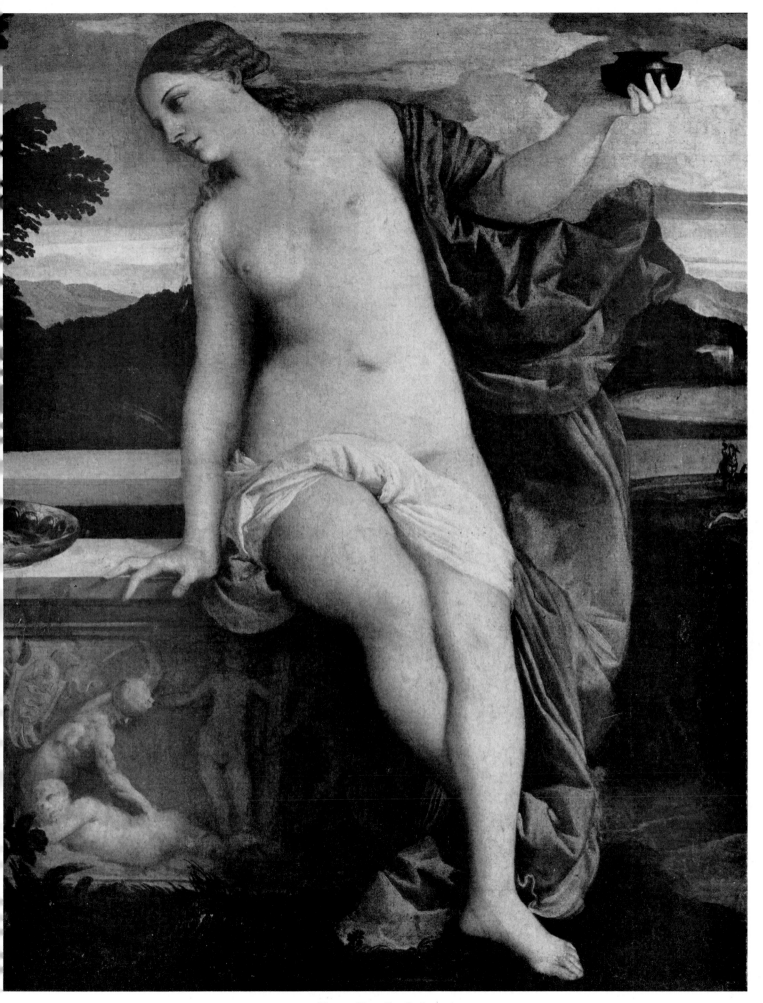

24. *Venus.* Detail of Plate 20

25. *White Horse*. Detail from Plate 20

26. *Bronze Horses*. Fourth century A.D. Venice, San Marco

27. Titian (?): *Il Bravo*. About 1520–1525. Vienna, Kunsthistorisches Museum (Cat. no. 3)

28. Giovanni Bellini: *Lady at Her Toilet.* Dated 1515. Vienna, Kunsthistorisches Museum

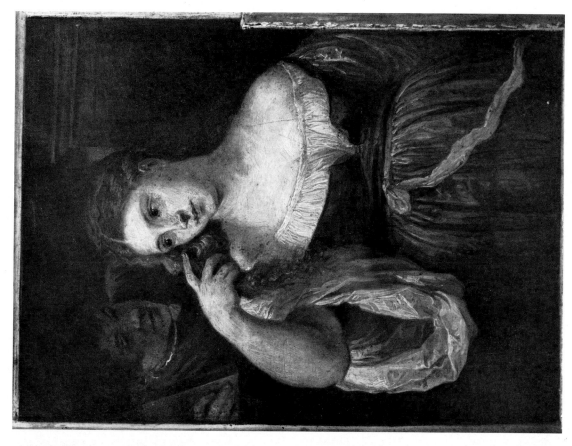

30. David Teniers II (after Titian): Detail of *Leopold Wilhelm in His Gallery at Brussels*. About 1651, Madrid, Prado Museum

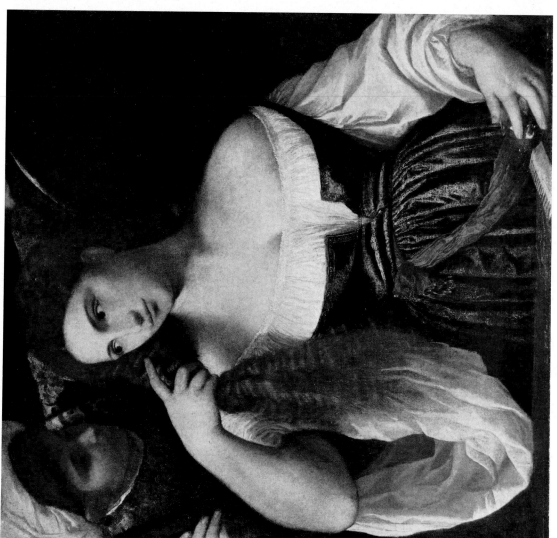

29. Titian and workshop: *Lady at Her Toilet*. About 1520. Prague, Castle Museum (Cat. no. 24)

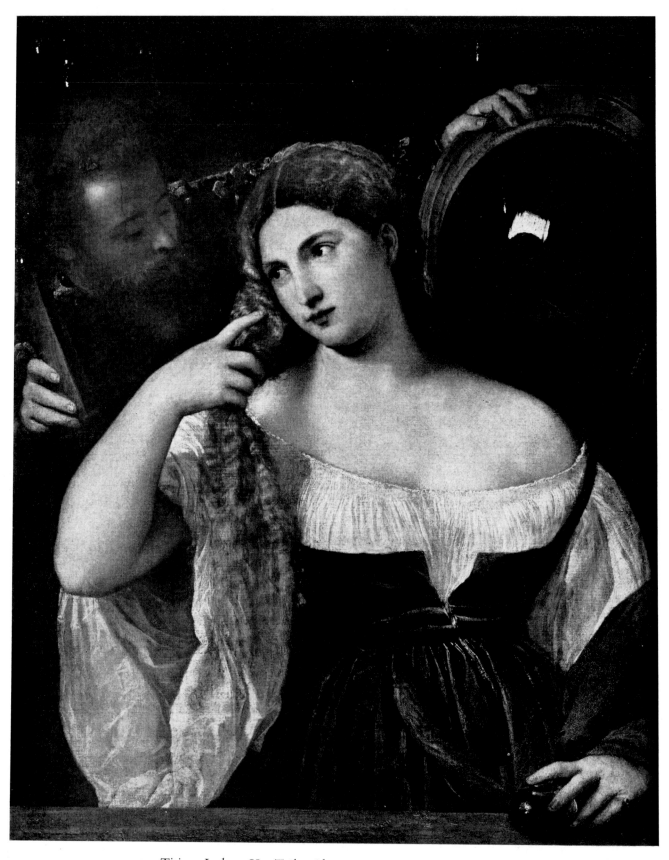

31. Titian: *Lady at Her Toilet*. About 1515. Paris, Louvre (Cat. no. 22)

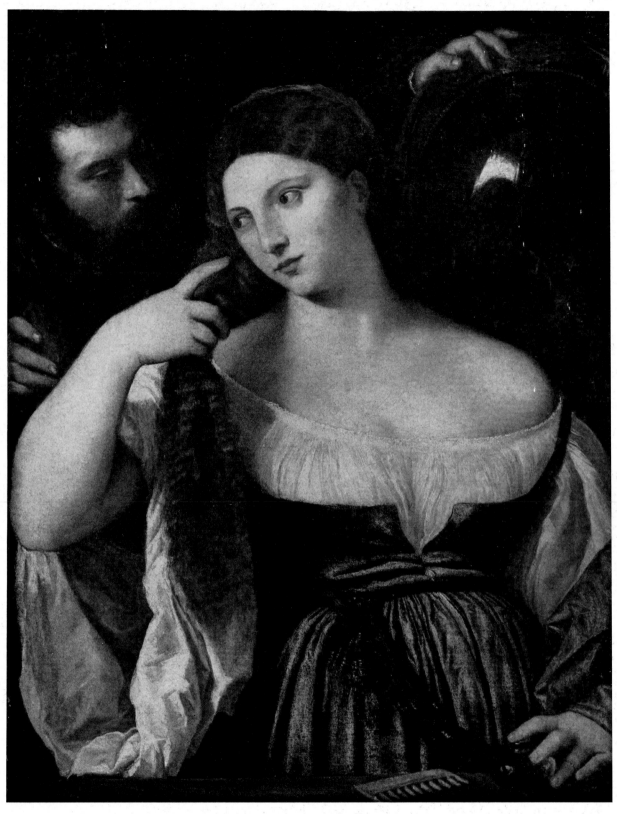

32. Titian and workshop: *Lady at Her Toilet* (restored). About 1520. Barcelona, Museo de Artes Decorativas
(Cat. no. 23)

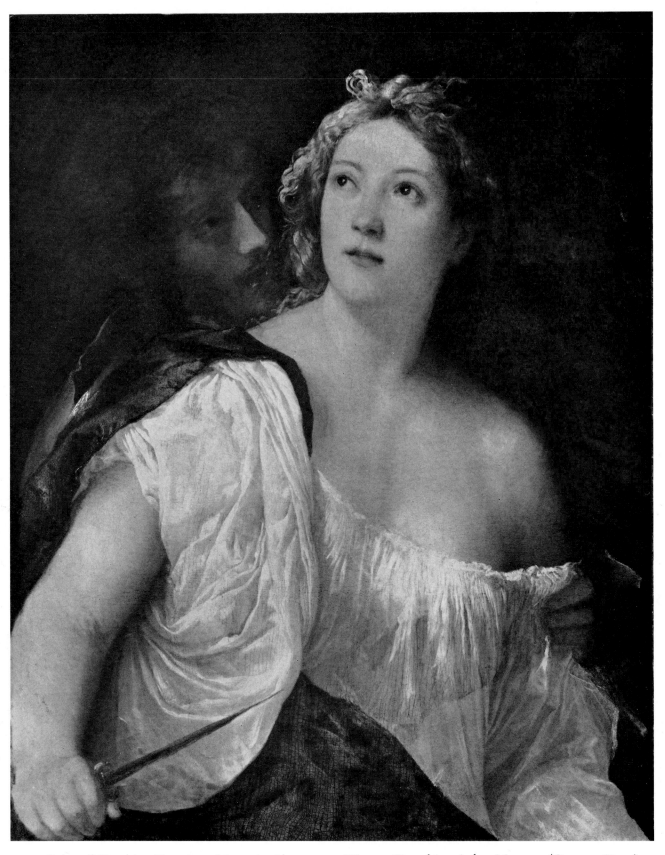

33. Palma il Vecchio: *Tarquin and Lucretia*. About 1525. Vienna, Kunsthistorisches Museum (Cat. no. X–33)

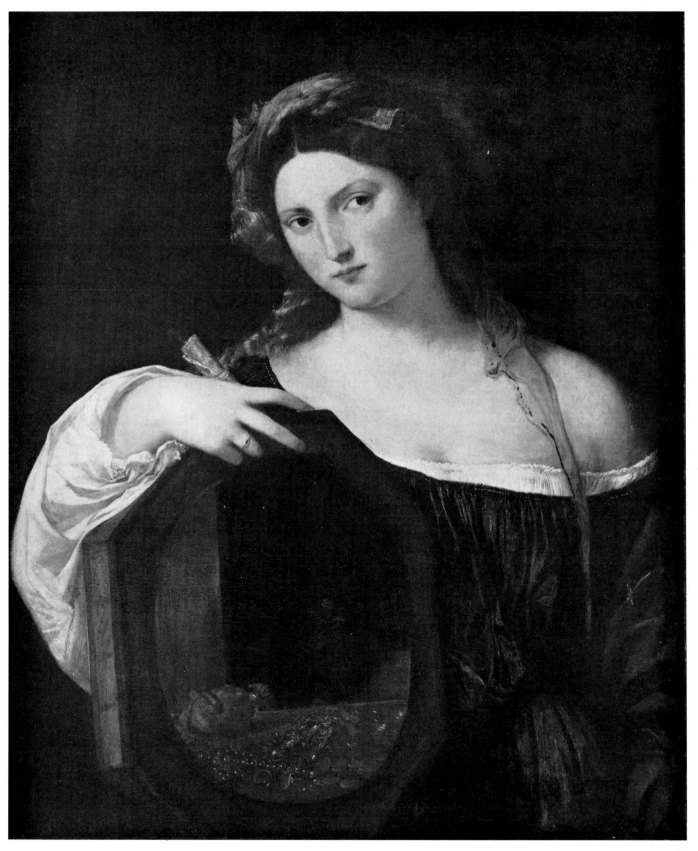

34. Titian: *Allegory of Vanity*. About 1520. Munich, Alte Pinakothek (Cat. no. 37)

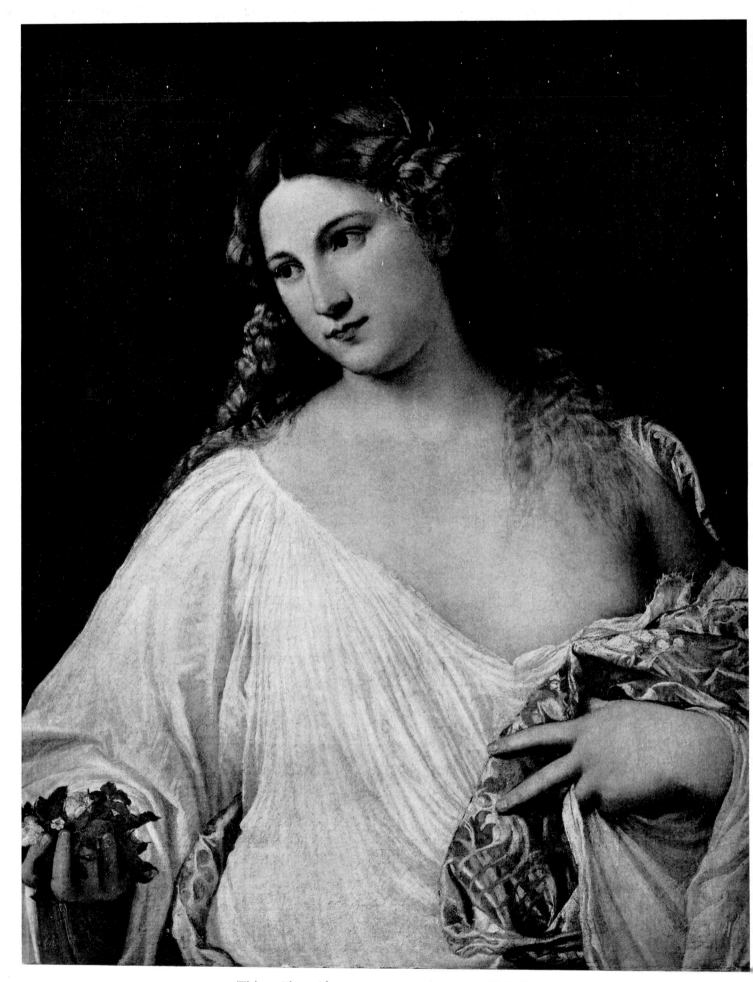

35. Titian: *Flora*. About 1520–1522. Florence, Uffizi (Cat. no. 17)

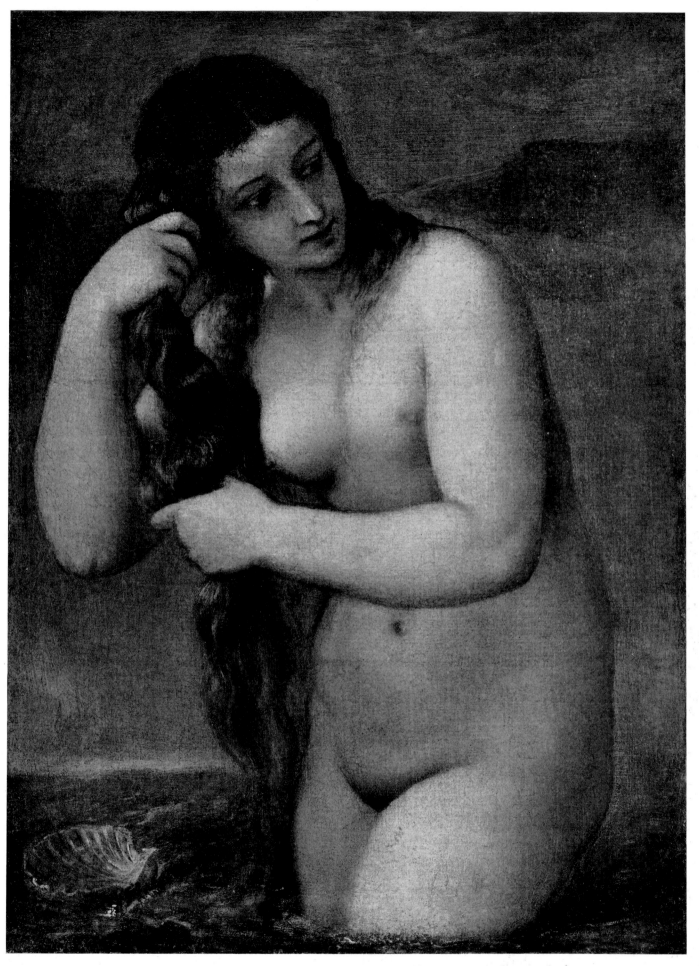

36. Titian: *Venus Anadyomene*. About 1525. Edinburgh, National Gallery of Scotland, on loan from the Duke of Sutherland (Cat. no. 39)

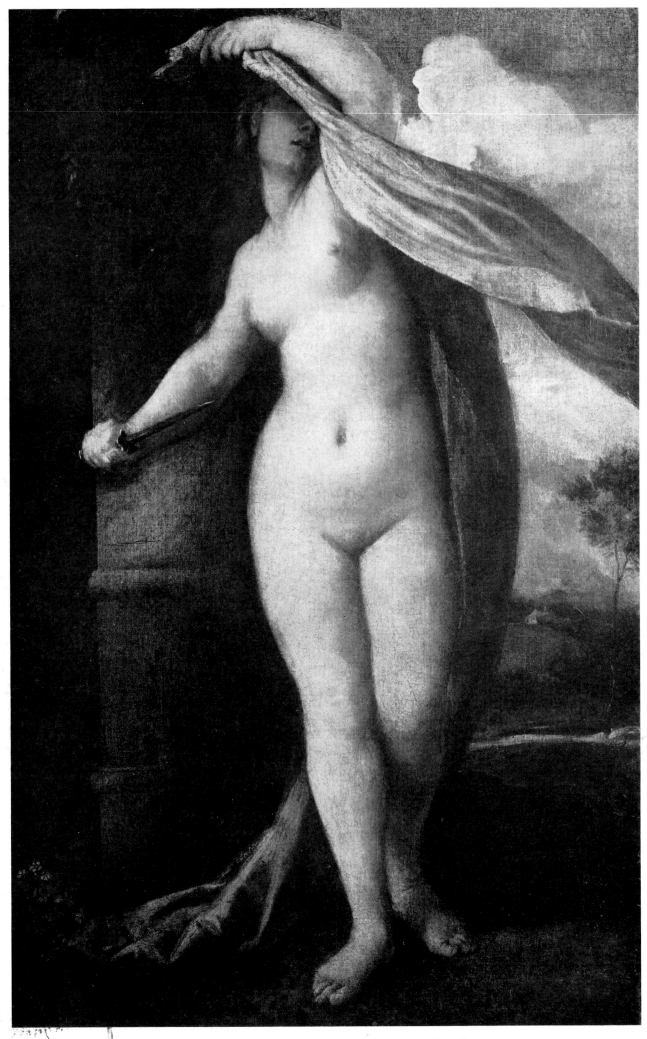

37. Titian: *Lucretia*. About 1520. Hampton Court Palace, Royal Collection (Cat. no. 26)

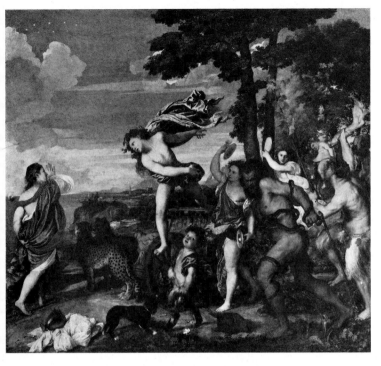

a. *Bacchus and Ariadne*

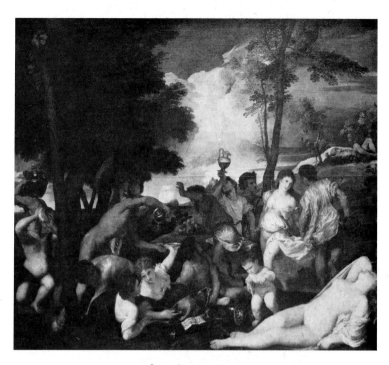

b. *The Andrians*

c. *Feast of the Gods*

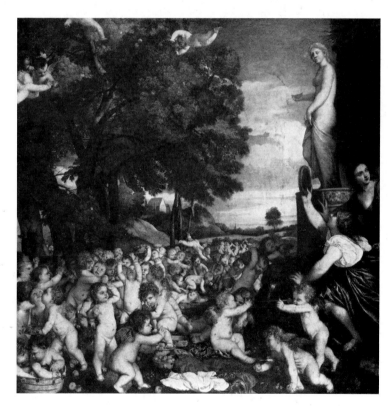

d. *Worship of Venus*

38. Ferrara, *Studiolo* of Alfonso d'Este. Arrangement of Paintings by Titian and Giovanni Bellini
(Cat. nos. 12–15)

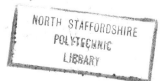

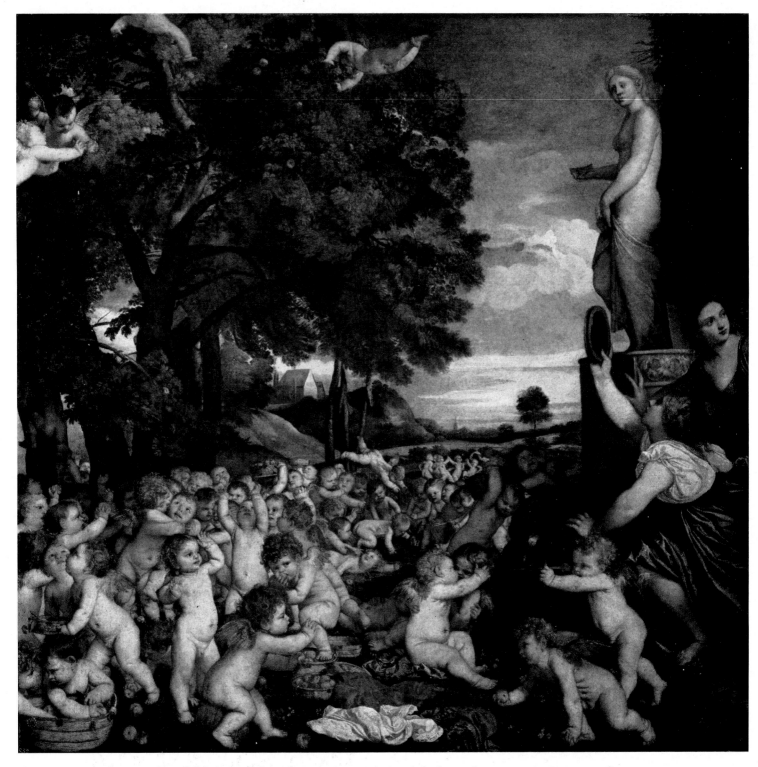

39. Titian: *Worship of Venus*. 1518–1519. Madrid, Prado Museum (Cat. no. 13)

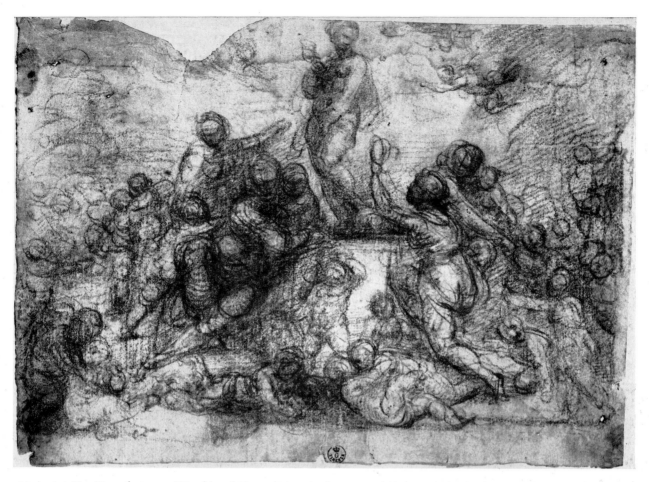

40. Fra Bartolomeo: *Worship of Venus* (Drawing). 1517. Florence, Uffizi, Gabinetto dei Disegni

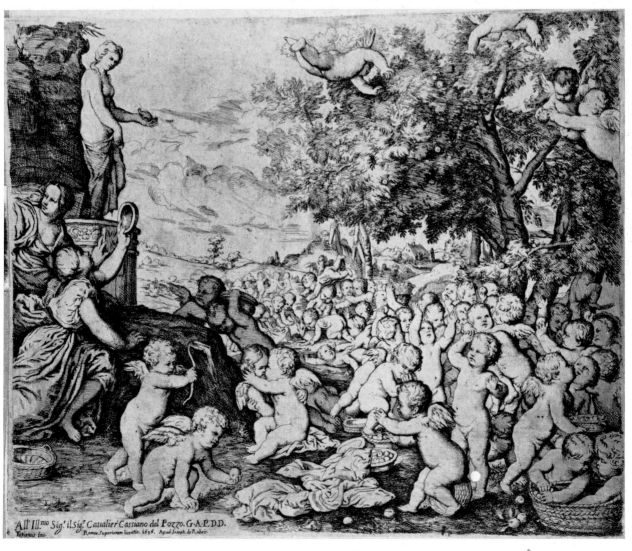

41. Podestà's engraving after Titian: *Worship of Venus*. 1636 (Cat. no. 13, print)

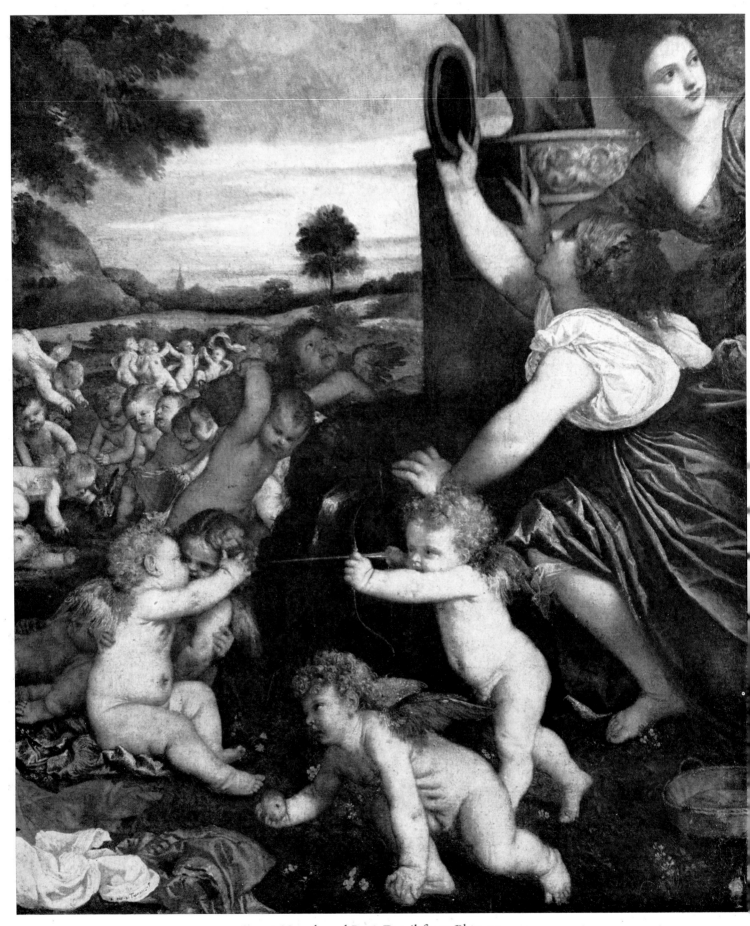

42. *Nymphs and Putti*. Detail from Plate 39

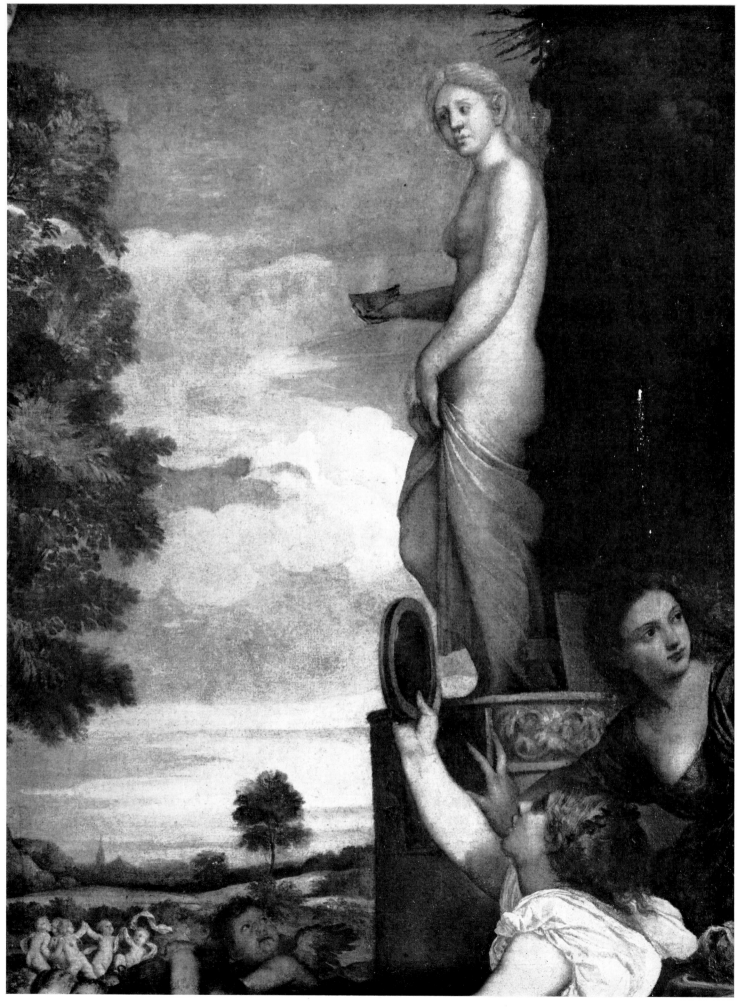

43. *Statue of Venus*. Detail from Plate 39

44. *Putti*. Detail from Plate 39

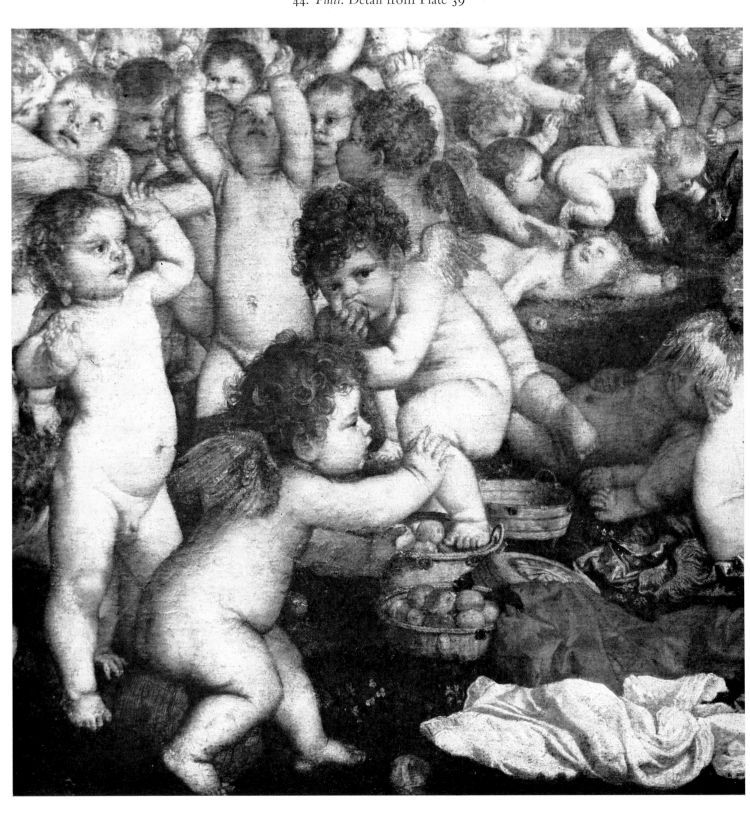

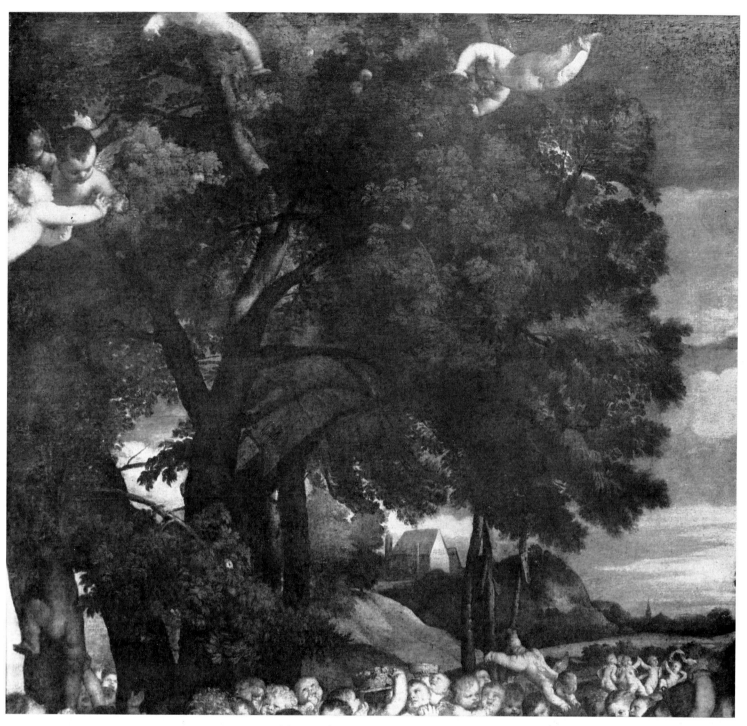

45. *Trees and Putti*. Detail from Plate 39

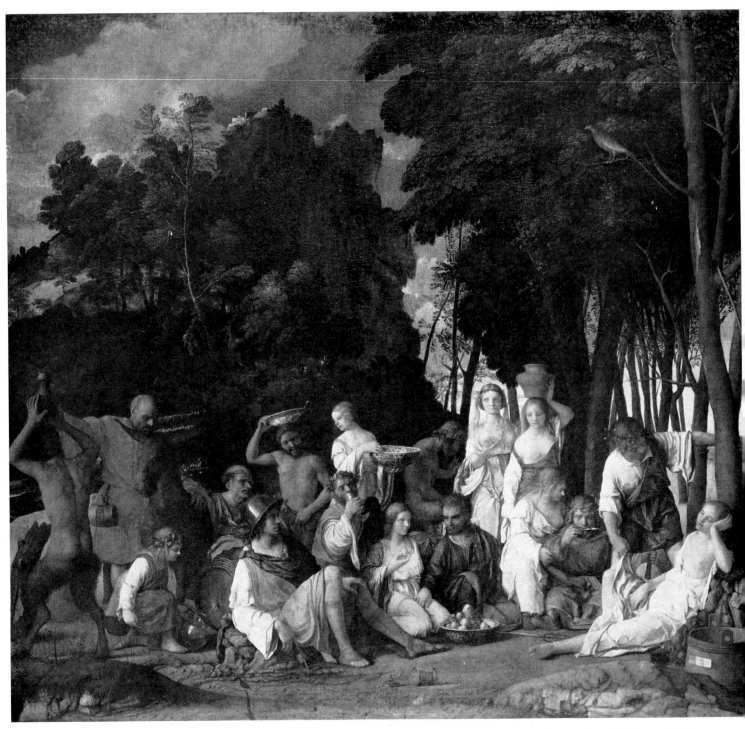

46. Giovanni Bellini and Titian: *Feast of the Gods*. 1514 and later. Washington, National Gallery of Art, Widener Collection
(Cat. no. 12)

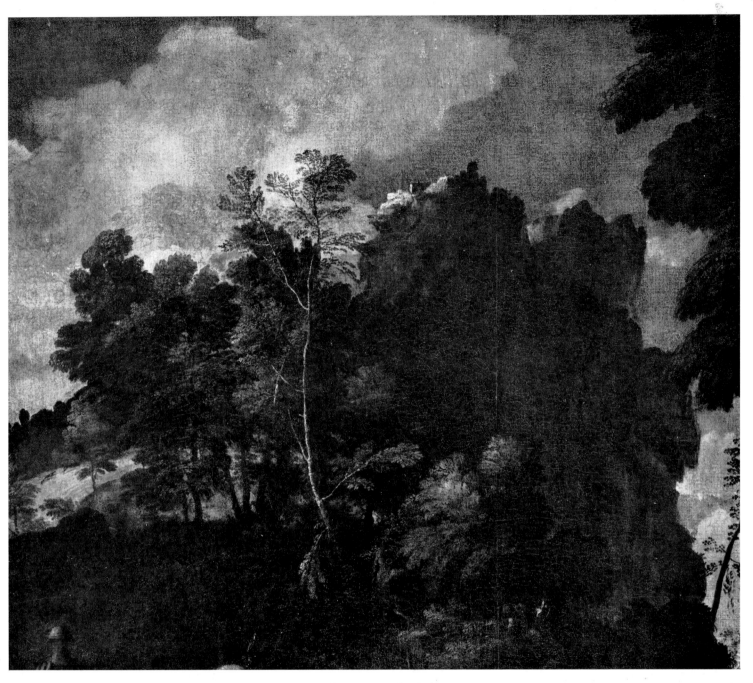

47. *Landscape*. Detail of Plate 46

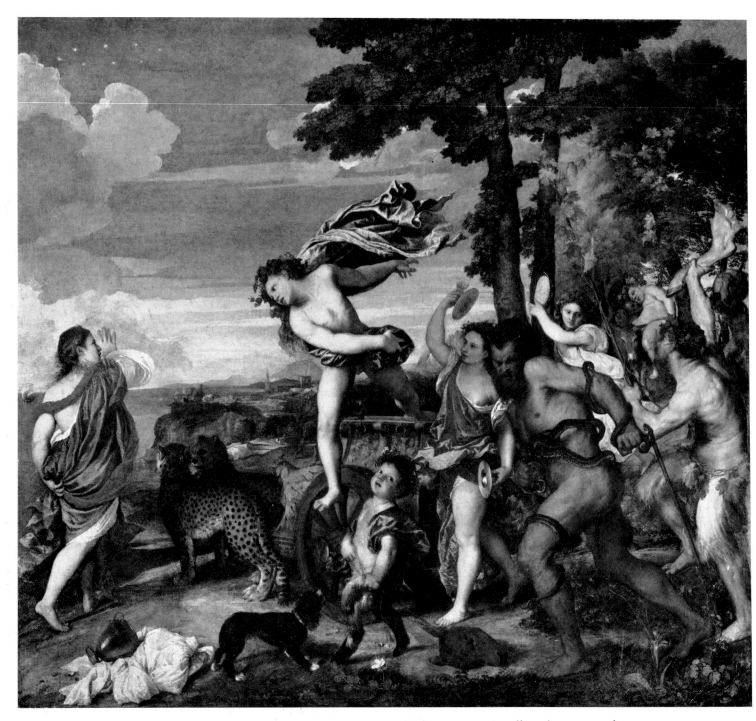

48. Titian: *Bacchus and Ariadne*. 1520–1522. London, National Gallery (Cat. no. 14)

49. *Trees*. Detail from Plate 48

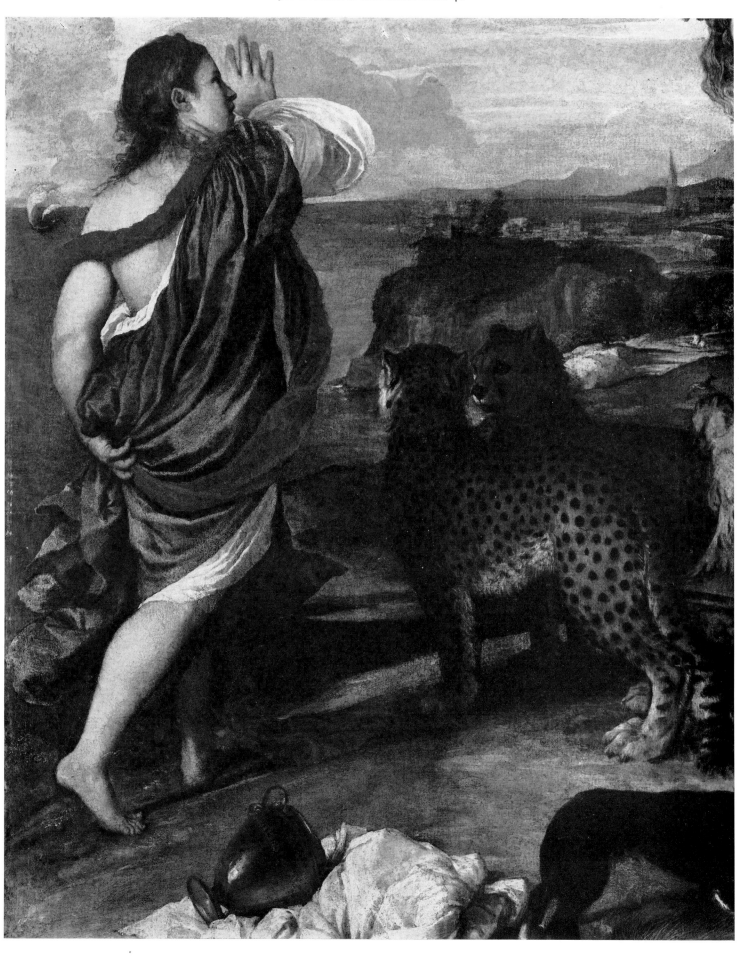

50. *Ariadne*. Detail from Plate 48

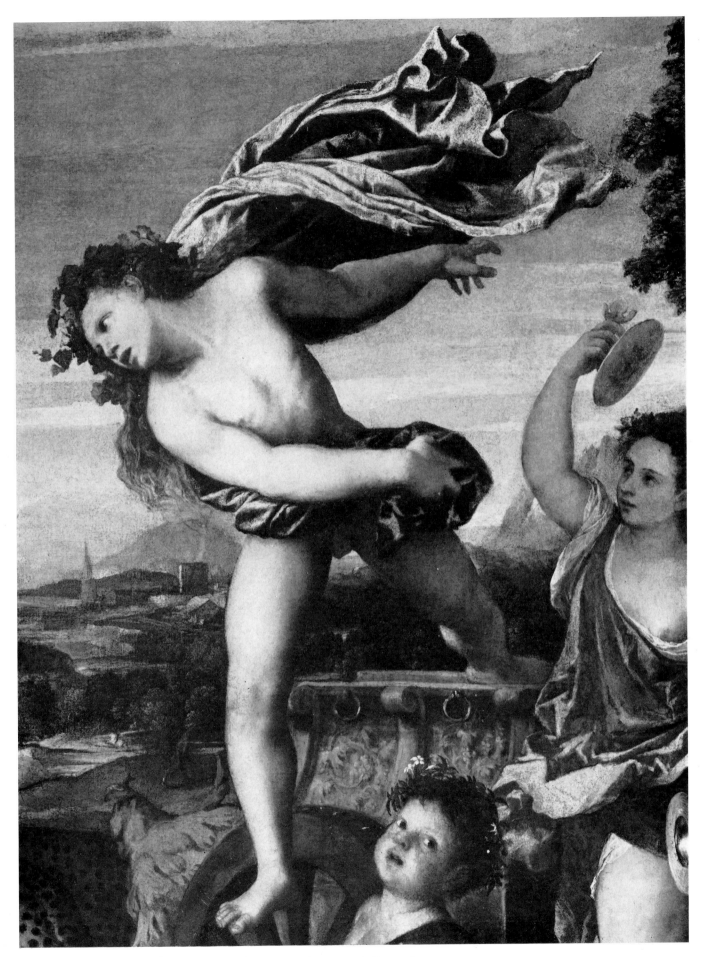

51. *Bacchus.* Detail from Plate 48

52. *Satyr Infant*. Detail from Plate 48

53. *Nymph*. Detail from Plate 48

54. *Followers of Bacchus*. Detail from Plate 48

55. Roman relief: *Bacchanal*. About 100 A.D. London, British Museum

56. *Urn with Signature*. Detail from Plate 48

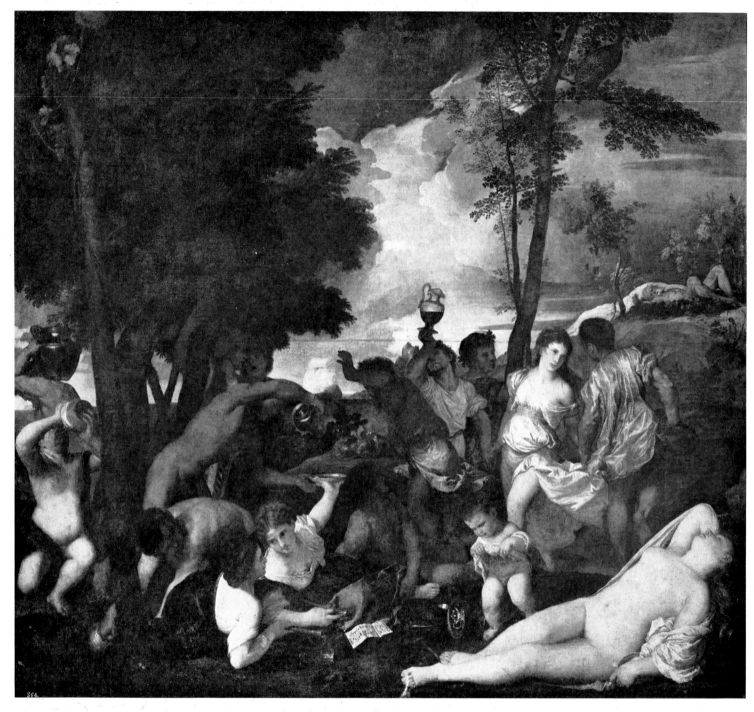

57. Titian: *The Andrians*. About 1523–1525. Madrid, Prado Museum (Cat. no. 15)

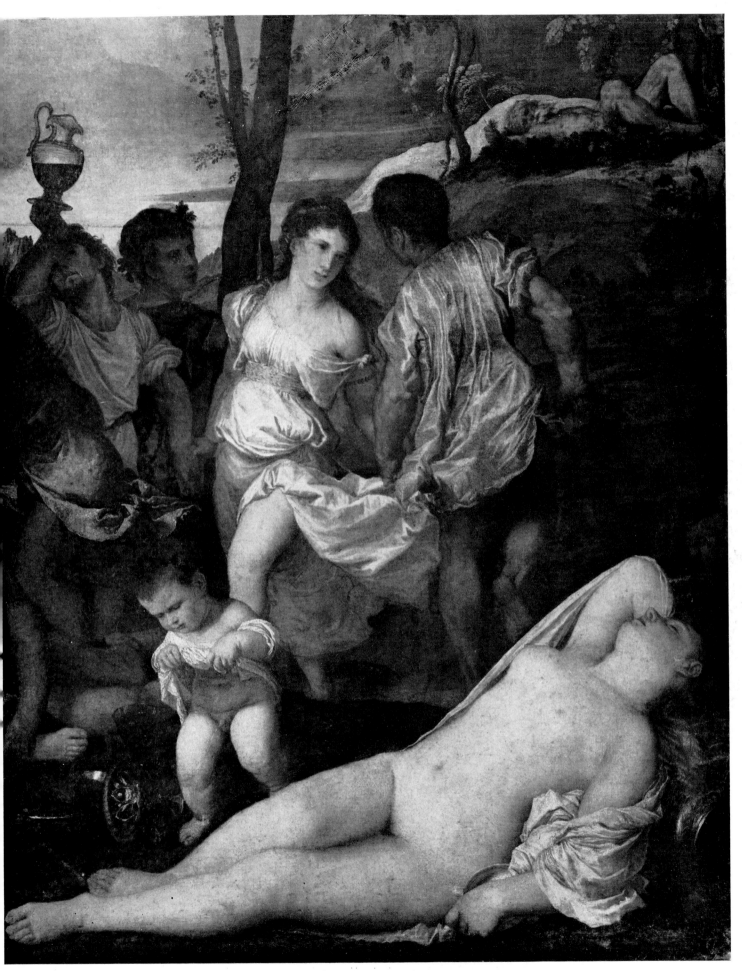

58. *Sleeping Ariadne and Revellers*. Detail from Plate 57

59. *Guinea fowl*. Detail from Plate 57

60. The *Canon* by Adrian Willaert. Detail from Plate 57

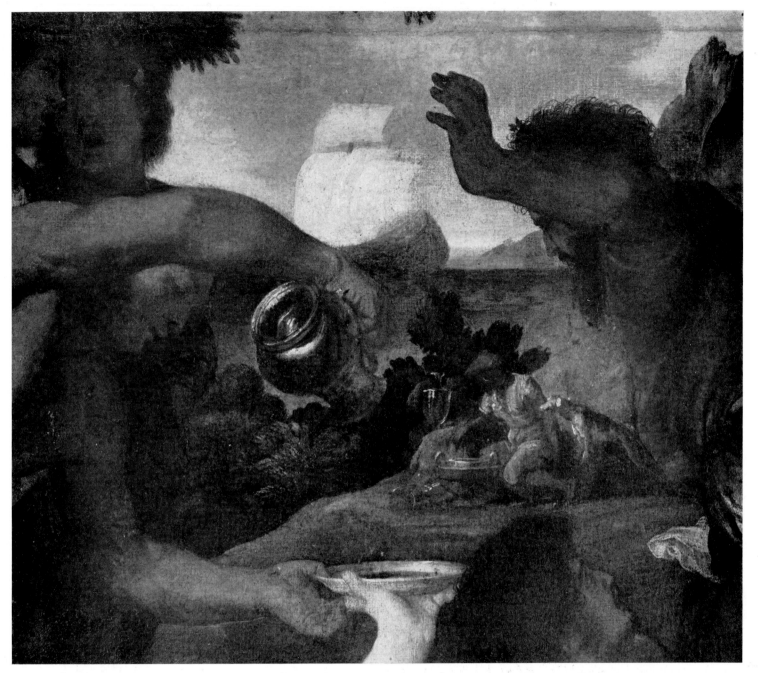

61. *Revellers and Theseus' Ship.* Detail from Plate 57

62. Mantuan School: Drawing after a *Roman Sarcophagus.* About 1480. Berlin, Kupferstichkabinett

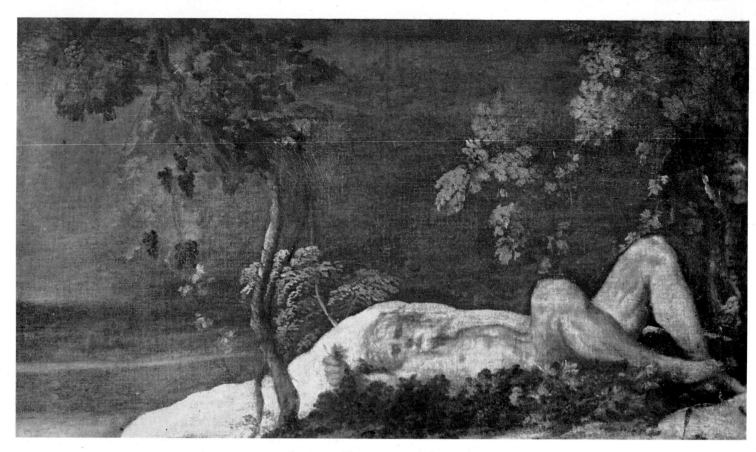

63. *Sleeping Old Man*. Detail from Plate 57

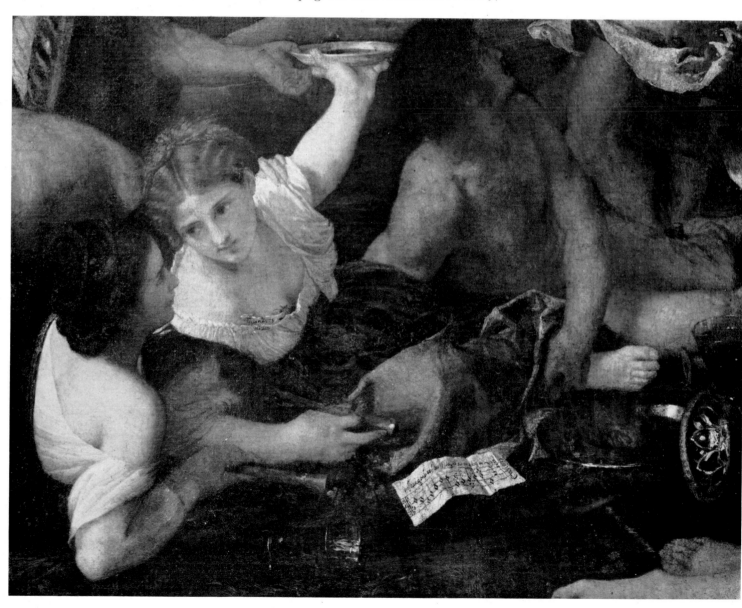

64. *Reclining Revellers*. Detail from Plate 57

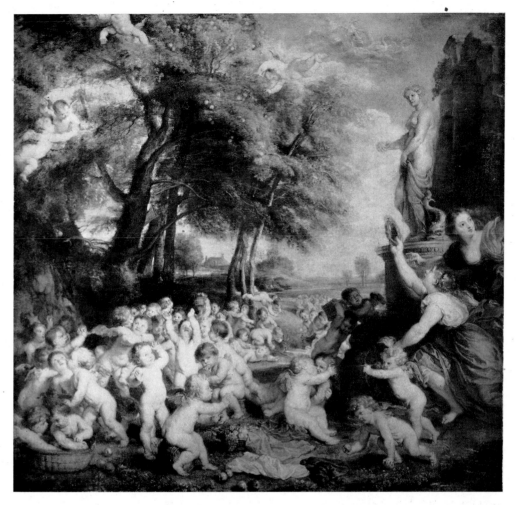

65. Rubens after Titian: *Worship of Venus*. About 1630. Stockholm, National Museum

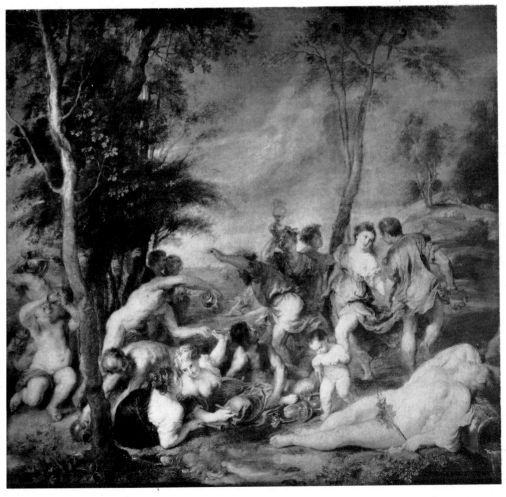

66. Rubens after Titian; *The Andrians*. About 1630. Stockholm, National Museum

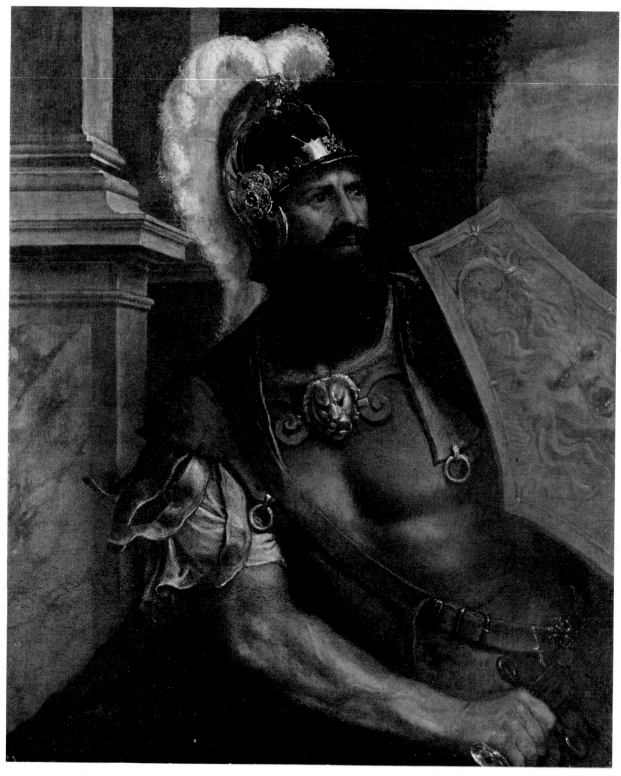

67. Titian: *Hannibal* (?). 1532–1534. New York, Private Collection (Cat. no. 20)

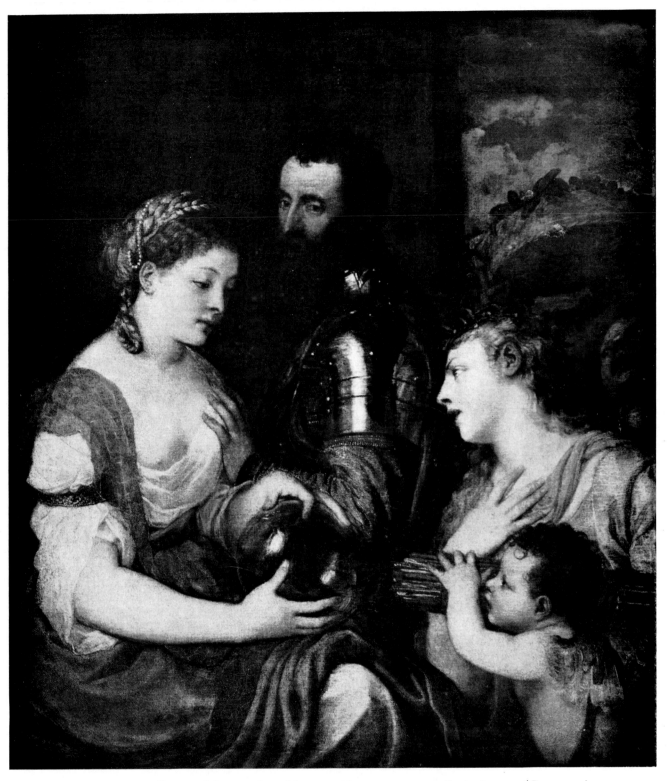

68. Titian: *Allegory of the Marchese del Vasto*. About 1530–1535. Paris, Louvre (Cat. no. 1)

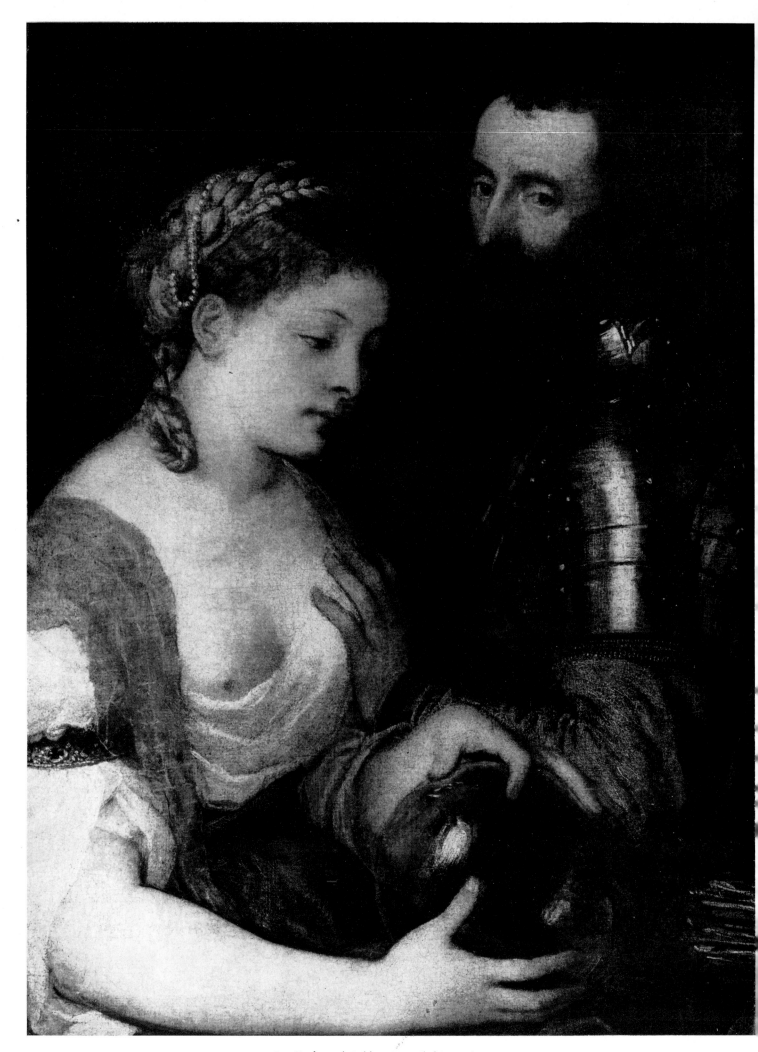

69. *Lady and Soldier*. Detail from Plate 68

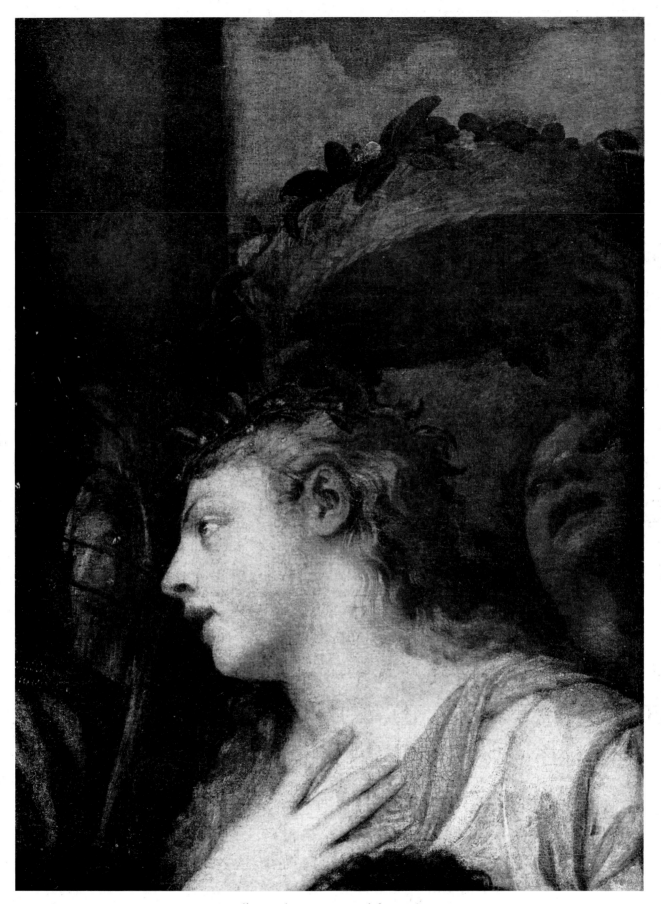

70. *Allegorical Figures.* Detail from Plate 68

71. *Preparatory Drawing.* Cf. Plate 68

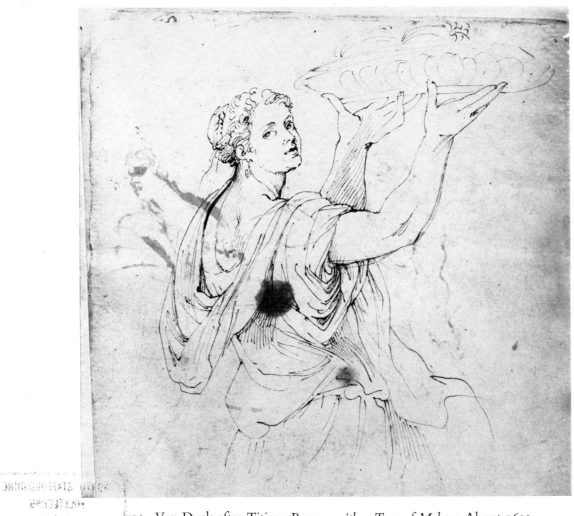

71A. Van Dyck after Titian: *Pomona with a Tray of Melons.* About 1622.
London, British Museum

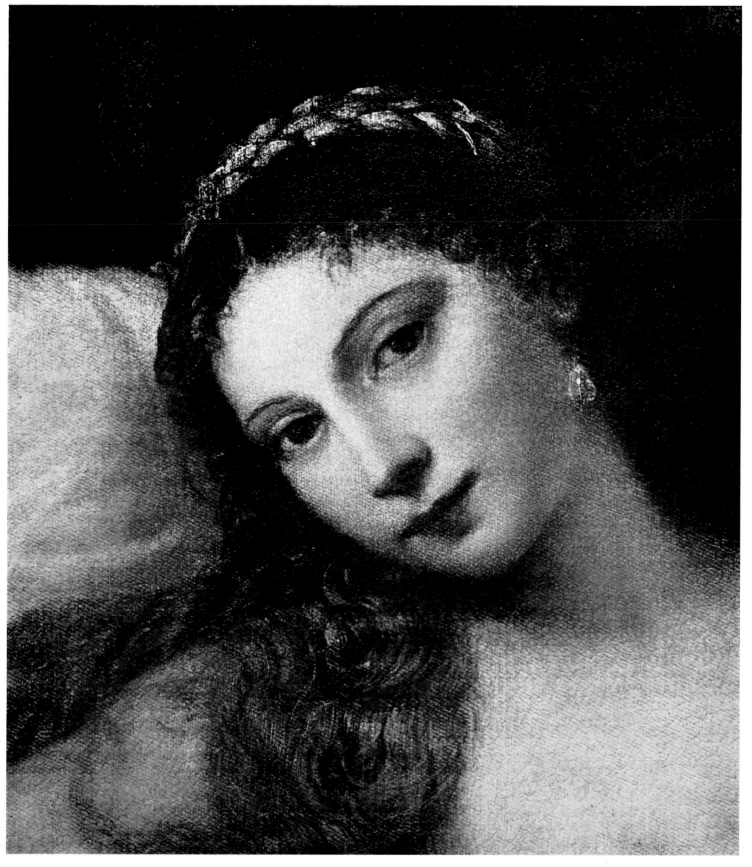

72. *Head of Venus*. Detail from Plate 73

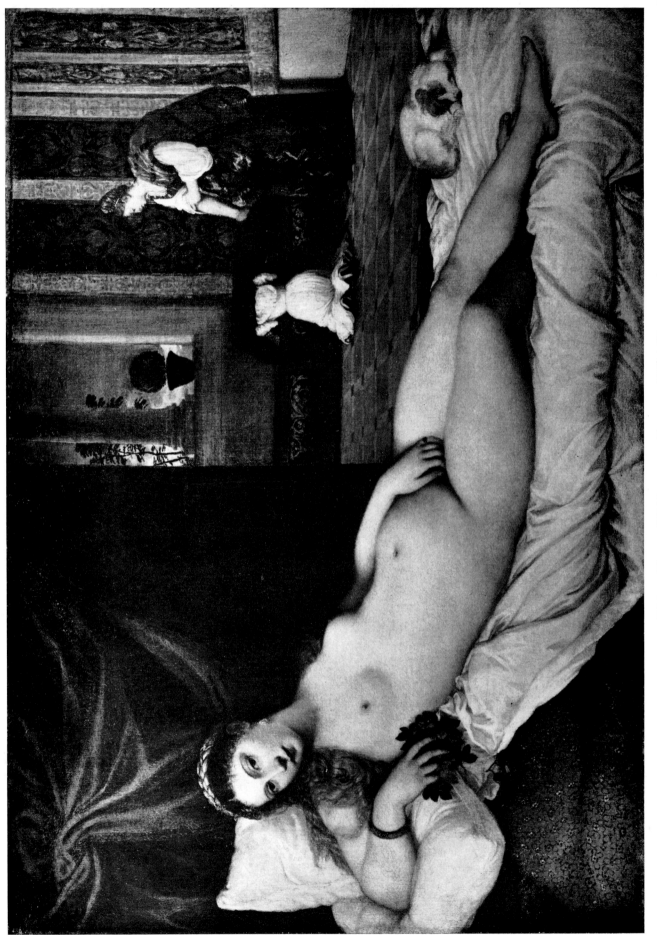

73. Titian: *Venus of Urbino.* 1538. Florence, Uffizi (Cat. no. 54)

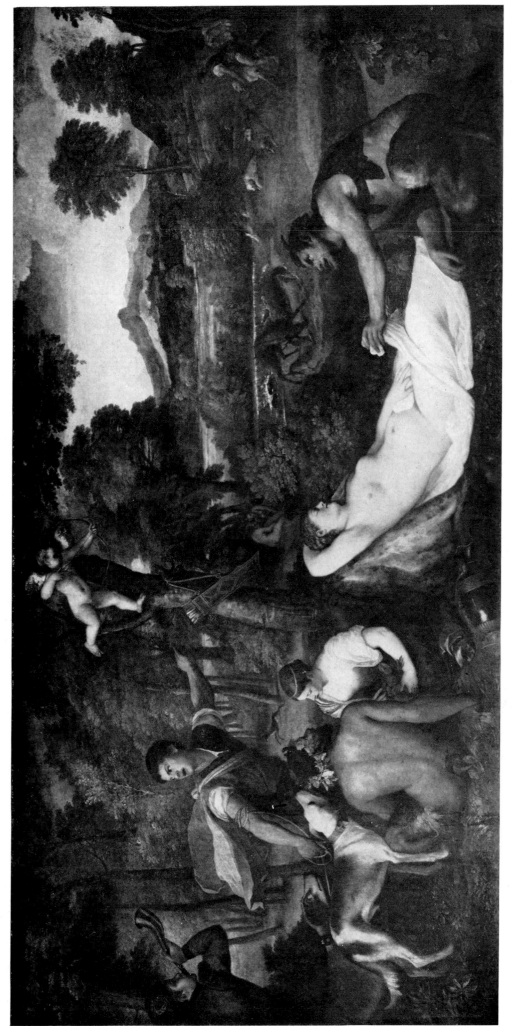

74. Titian: *Jupiter and Antiope (Pardo Venus)*. About 1535–1540; retouched *c.* 1560. Paris, Louvre (Cat. no. 21)

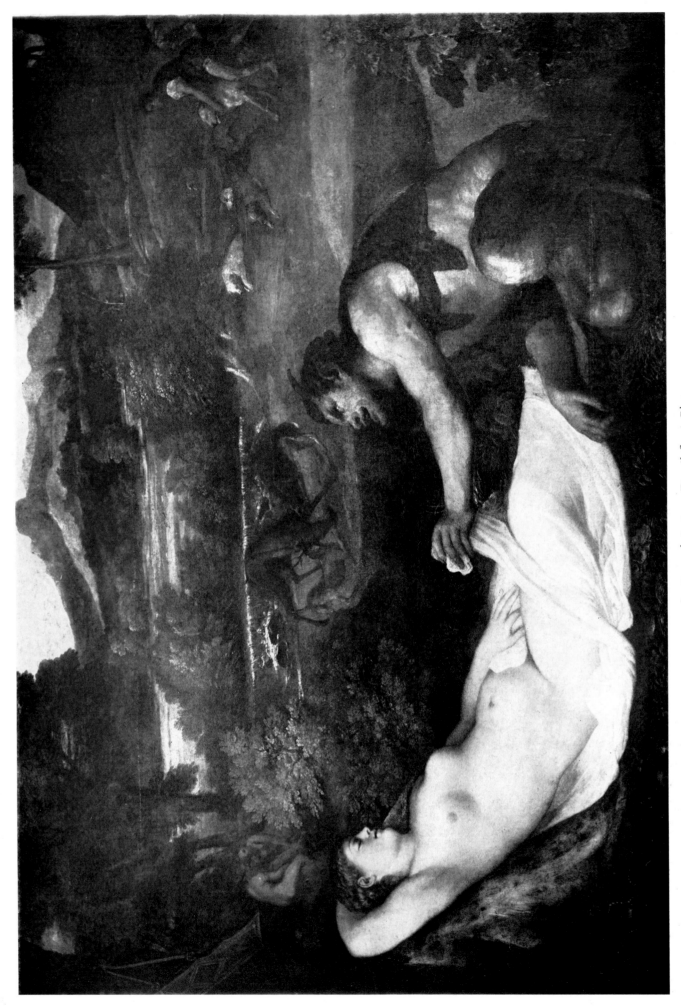

75. *Jupiter and Antiope*. Detail from Plate 74

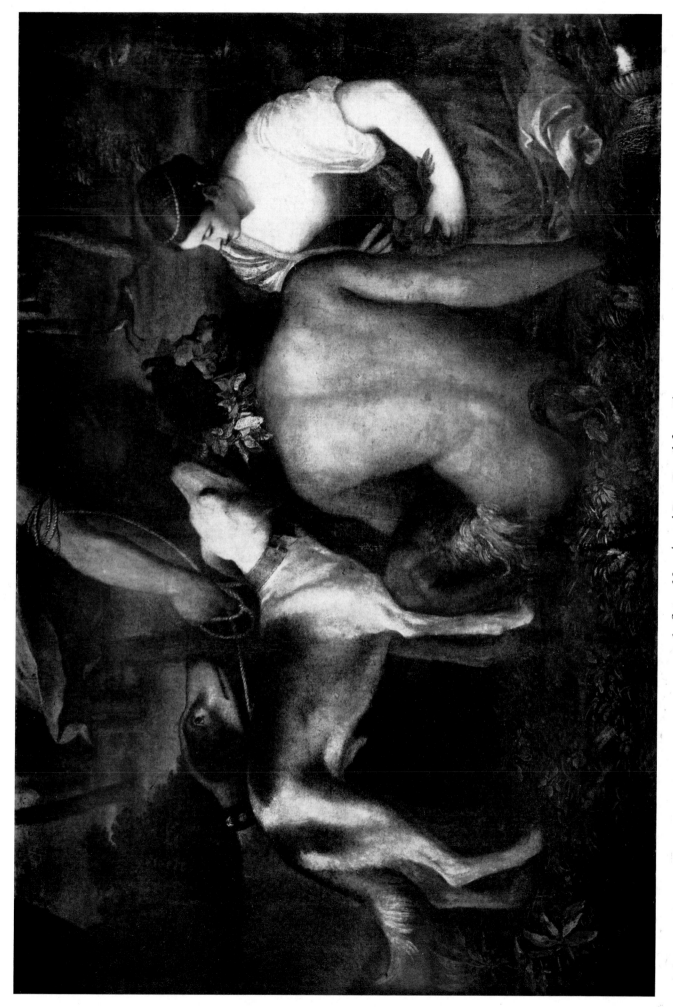

76. Satyr, Nymph, and Dog. Detail from Plate 74

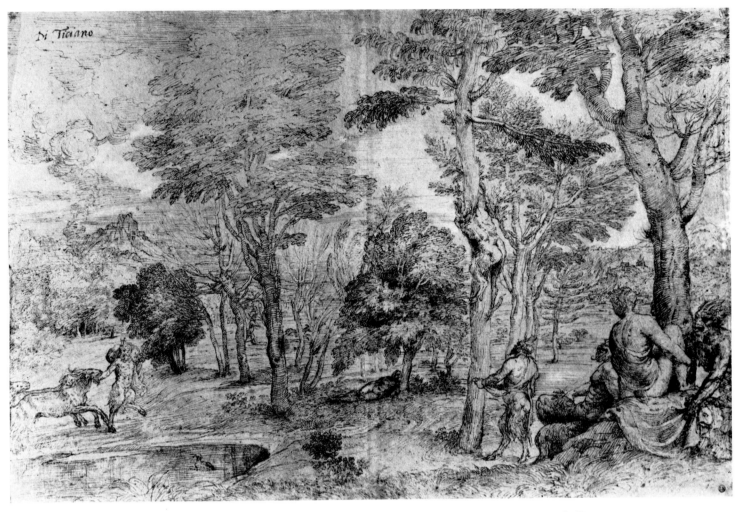

77. *Landscape with Nymphs and Satyrs* (drawing). About 1535. Bayonne, Musée Bonnat

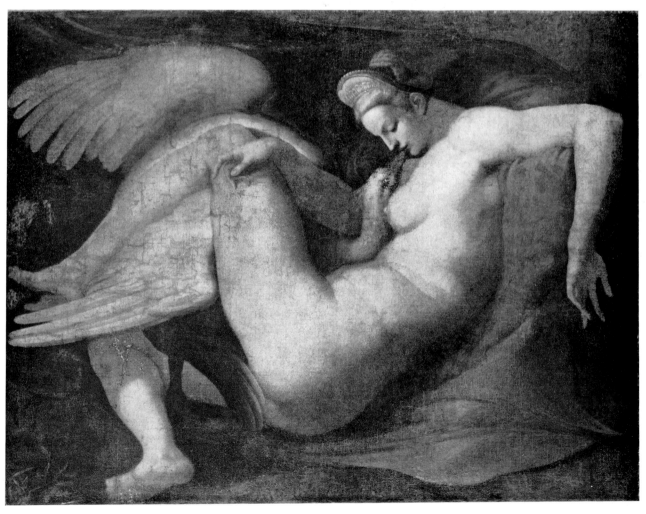

78. After Michelangelo: *Leda and the Swan*. Sixteenth century. London, National Gallery

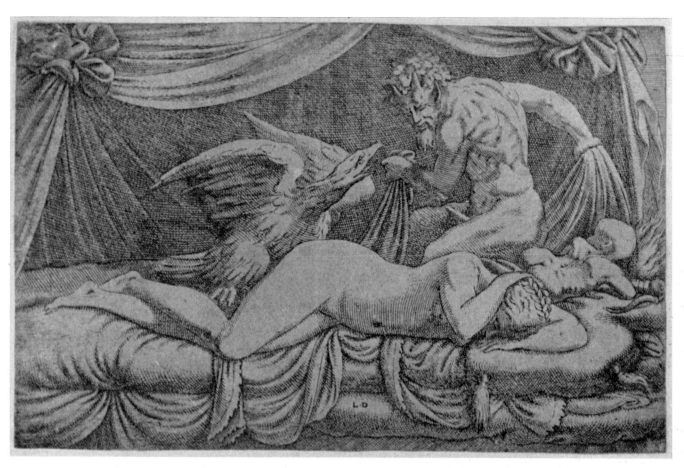

79. Master L. D. after Primaticcio: *Jupiter and Antiope*. Paris, Bibliothèque Nationale

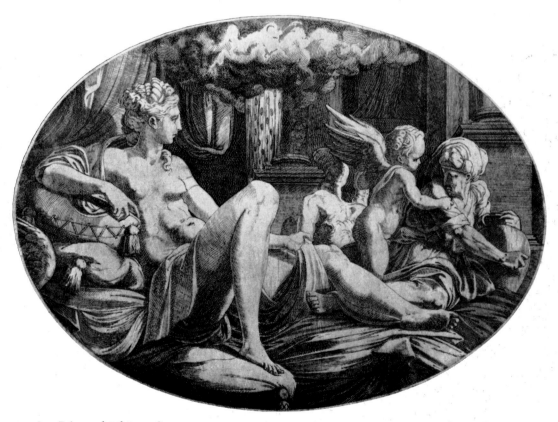

80. Léonard Thiry after Primaticcio: *Danaë with Cupid and Nursemaid* (engraving).
London, British Museum

81. Titian: *Danaë with Cupid*. 1545–1546. Naples, Gallerie Nazionali. (Cat. no. 5)

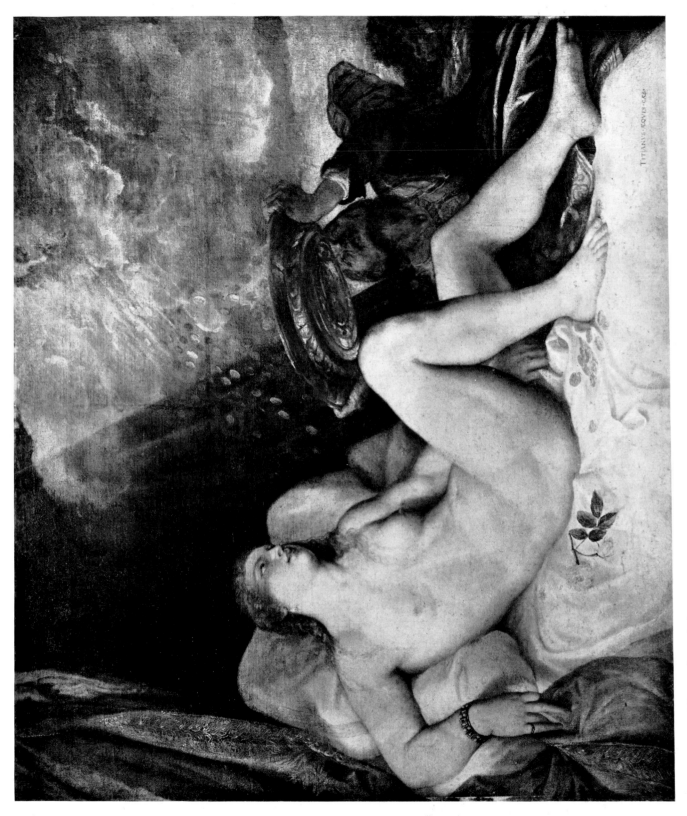

TITIANS LOVE GAS

82. Titian and workshop: *Danaë with Nursemaid*. About 1555–1560. Vienna, Kunsthistorisches Museum (Cat. no. 7)

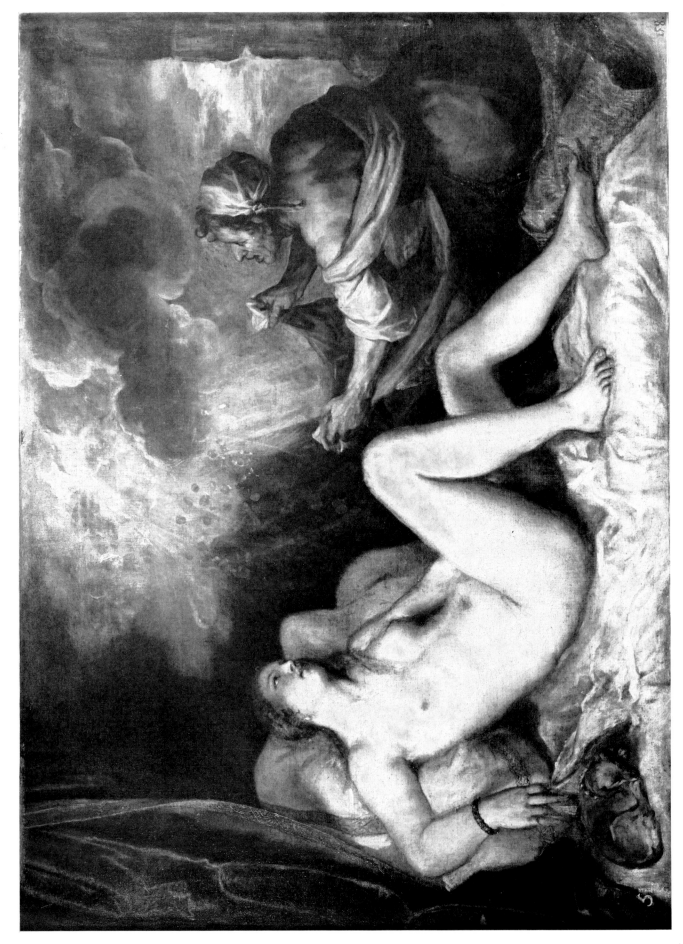

83. Titian: *Danaë with Nursemaid*. 1553–1554. Madrid, Prado Museum (Cat. no. 6)

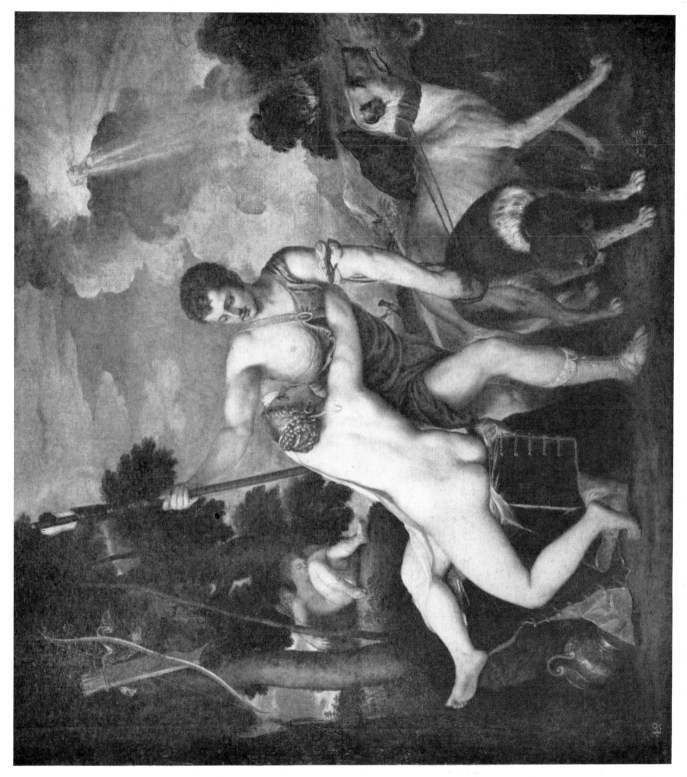

84. Titian: *Venus and Adonis*. 1553–1554. Madrid, Prado Museum (Cat. no. 40)

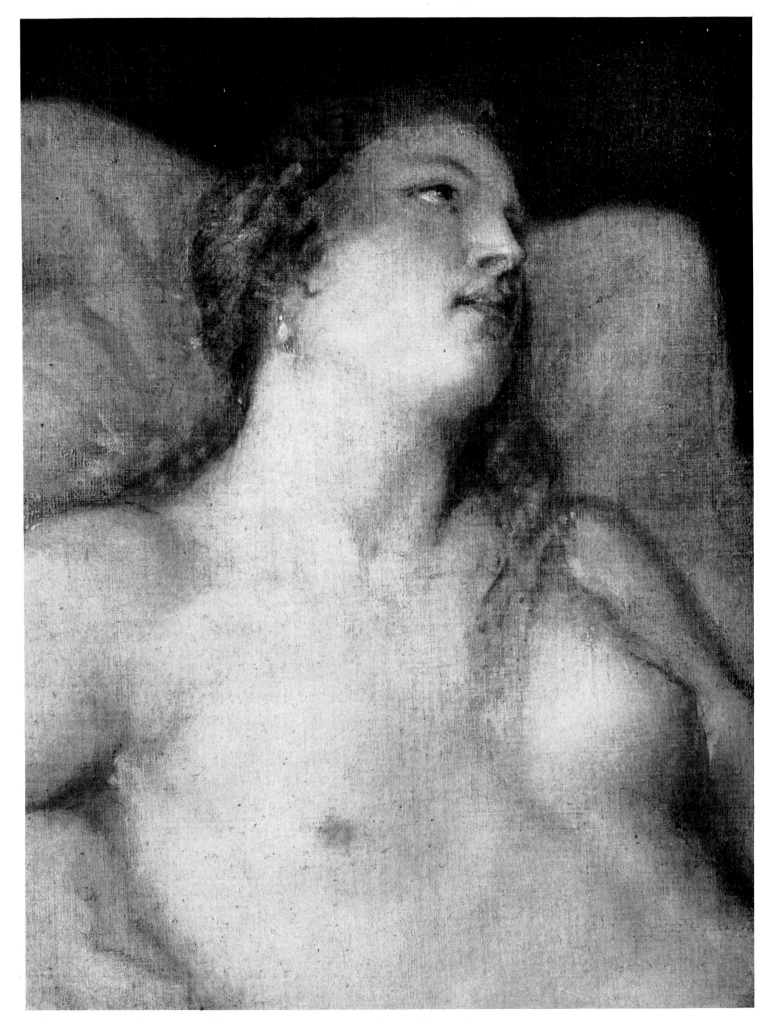

85. *Danaë*. Detail from Plate 83

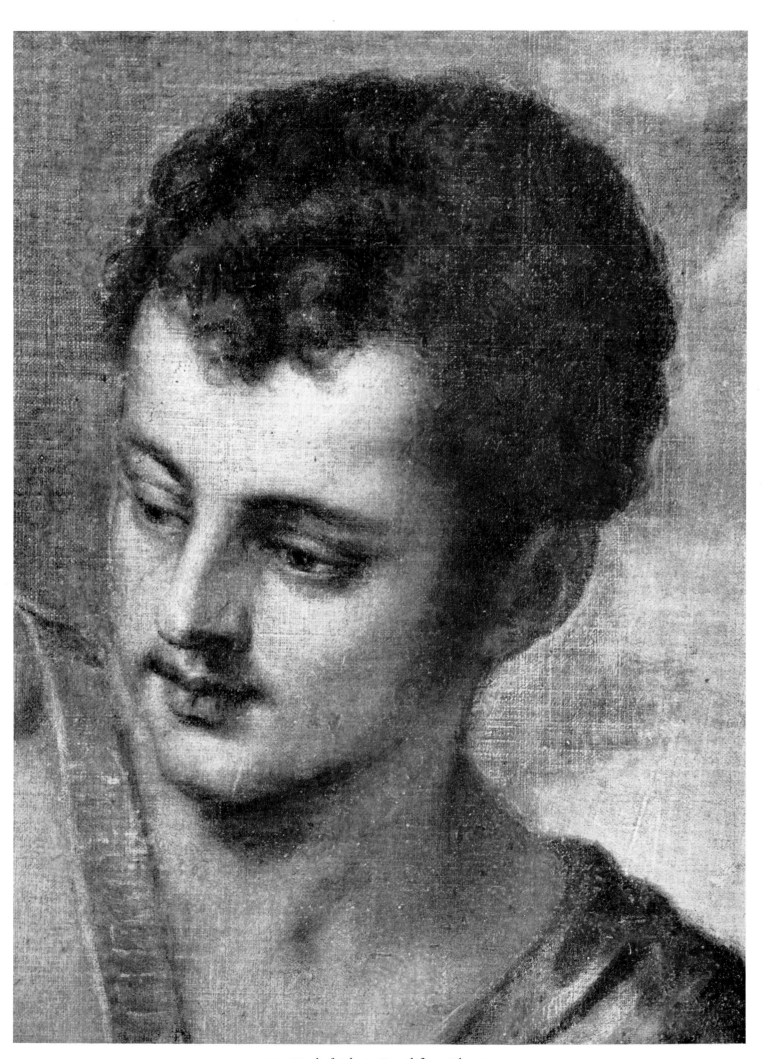

86. *Head of Adonis.* Detail from Plate 84

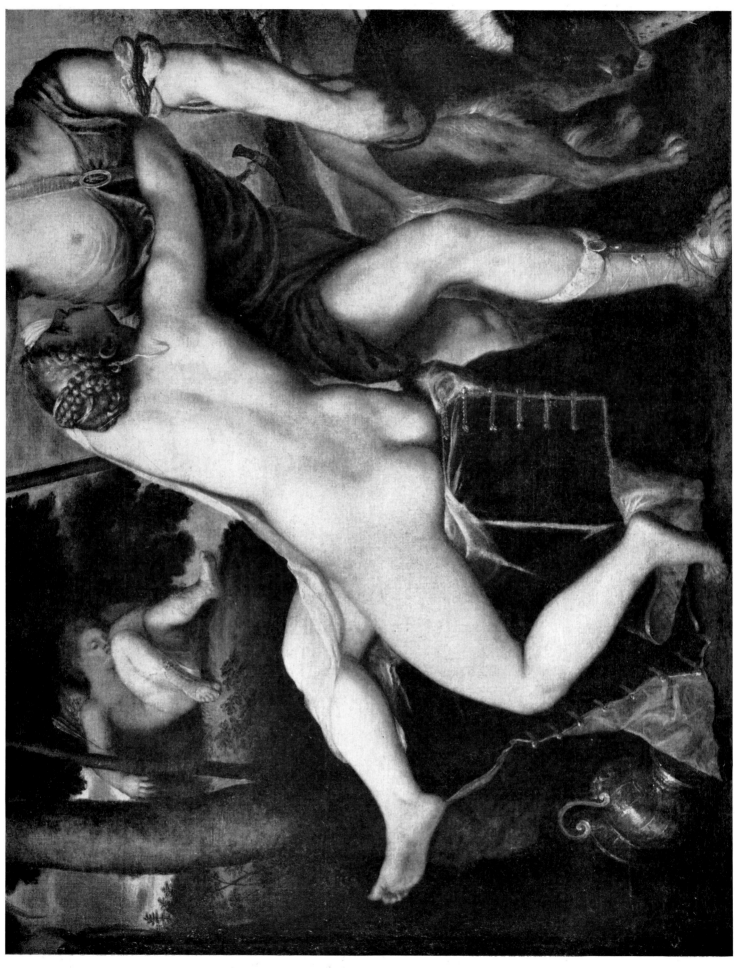

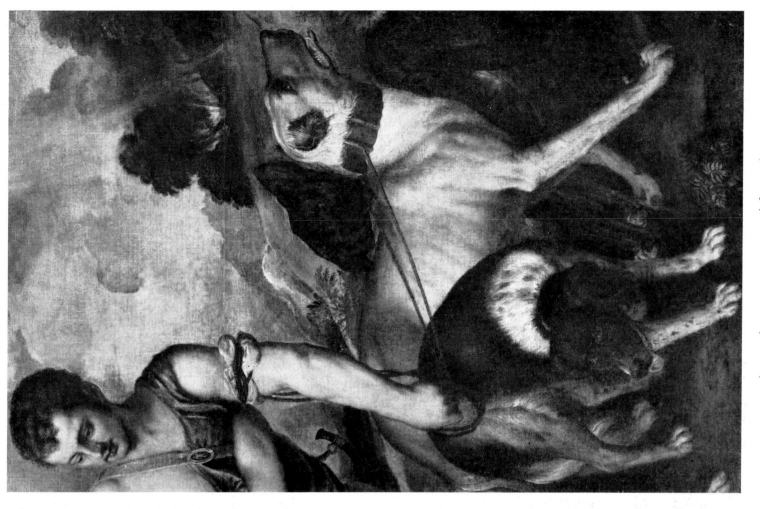

89. *Adonis and Hunting Dogs.* Detail from Plate 84

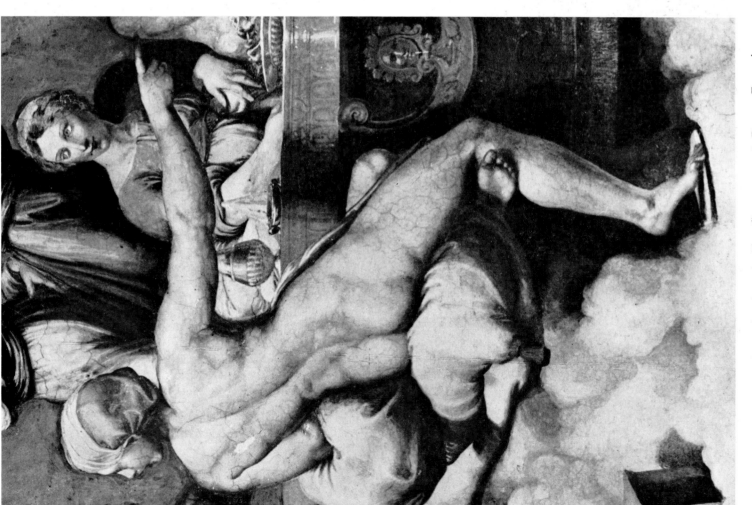

88. Raphael: *Banquet of Cupid and Psyche* (detail). 1517–1518. Rome, Farnesina

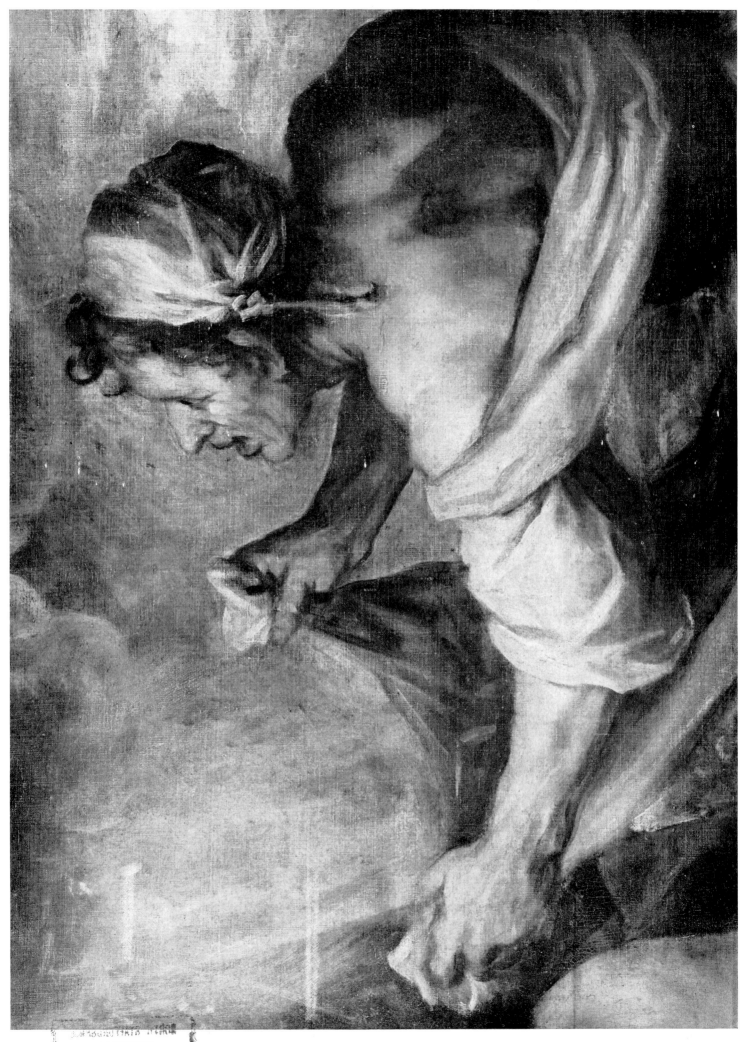

88 *Nursemaid.* Detail from Plate 82

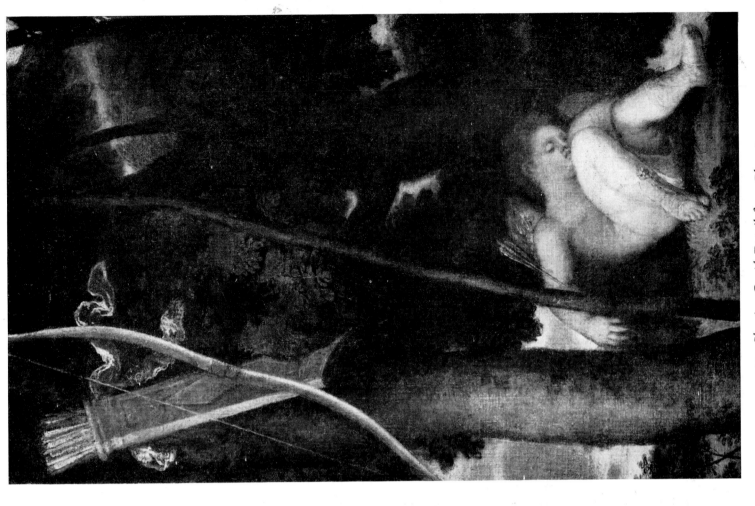

92. *Sleeping Cupid.* Detail from Plate 84

91. *Venus in the Clouds.* Detail from Plate 84

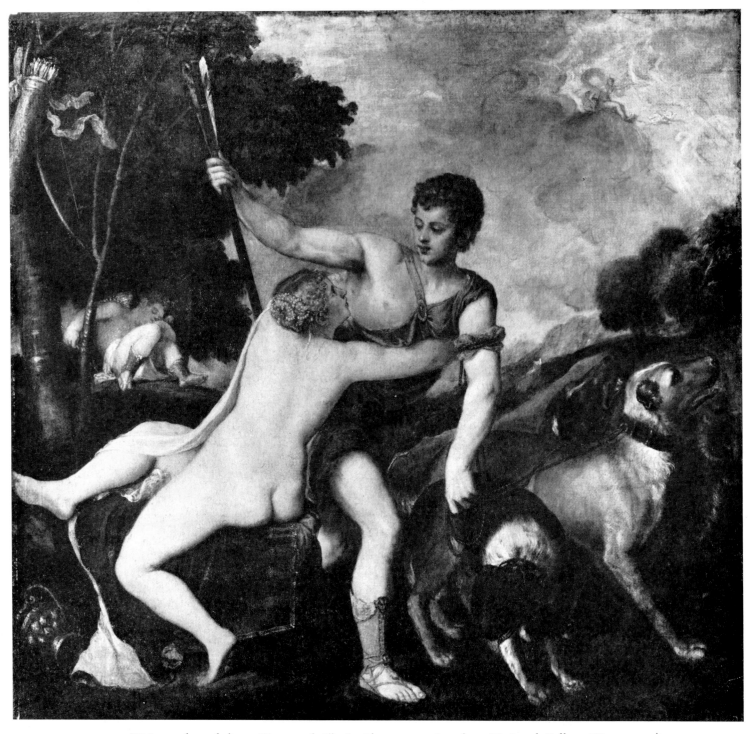

93. Titian and workshop: *Venus and Adonis*. About 1555. London, National Gallery (Cat. no. 41)

94. *Head of Venus.* Detail from Plate 93

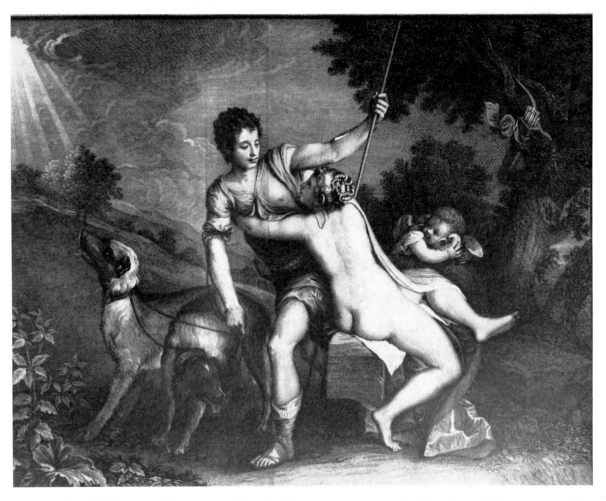

95. Sir Robert Strange's engraving (1769) after Titian: *Venus and Adonis* (so-called Farnese type). (Cat. no. L–19)

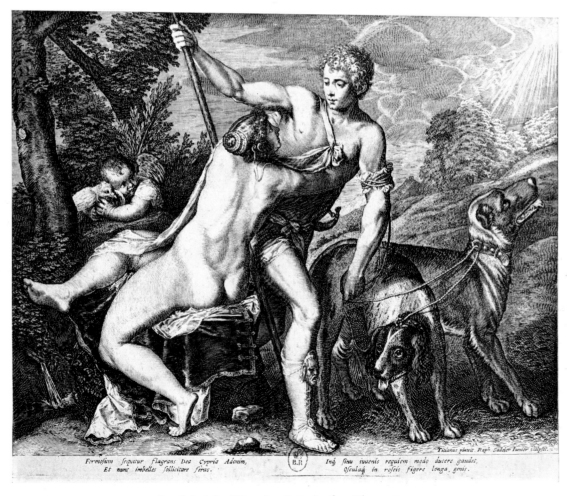

Formosum sequitur flagrans Dea Cypria Adonim,
Et nunc imbelles sollicitare feras.

Inq́ sinu tuuenis requiem modo ducere gaudet,
Ofculaq́ in rofeis figere longa, genis.

96. Raphael Sadeler II's print (1610) after Plate 98

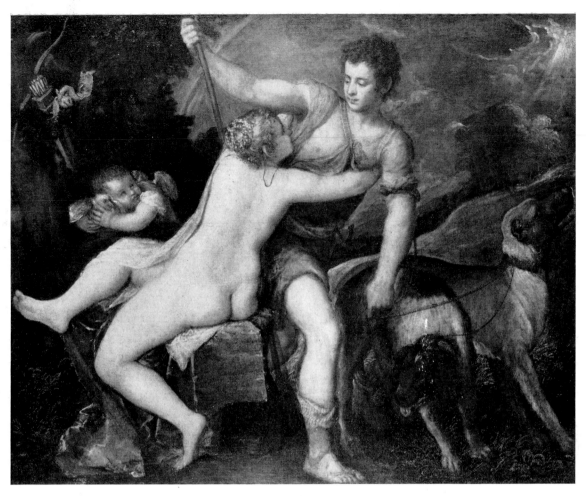

97. Titian and workshop: *Venus and Adonis*. About 1560–1565. New York, Metropolitan Museum of Art (Cat. no. 43)

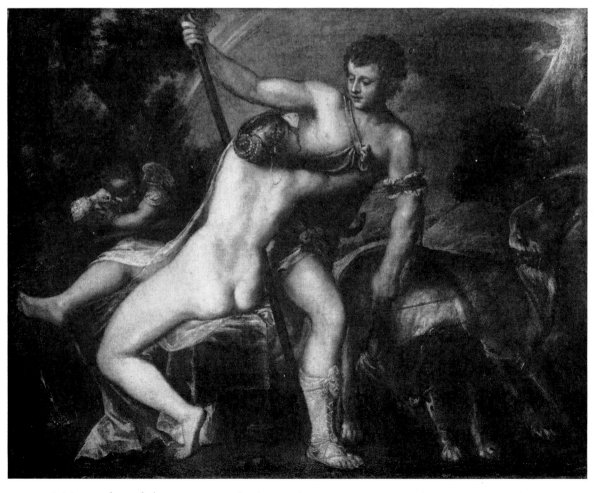

98. Titian and workshop: *Venus and Adonis*. About 1560–1565. Washington, National Gallery of Art, Widener Collection (Cat. no. 44)

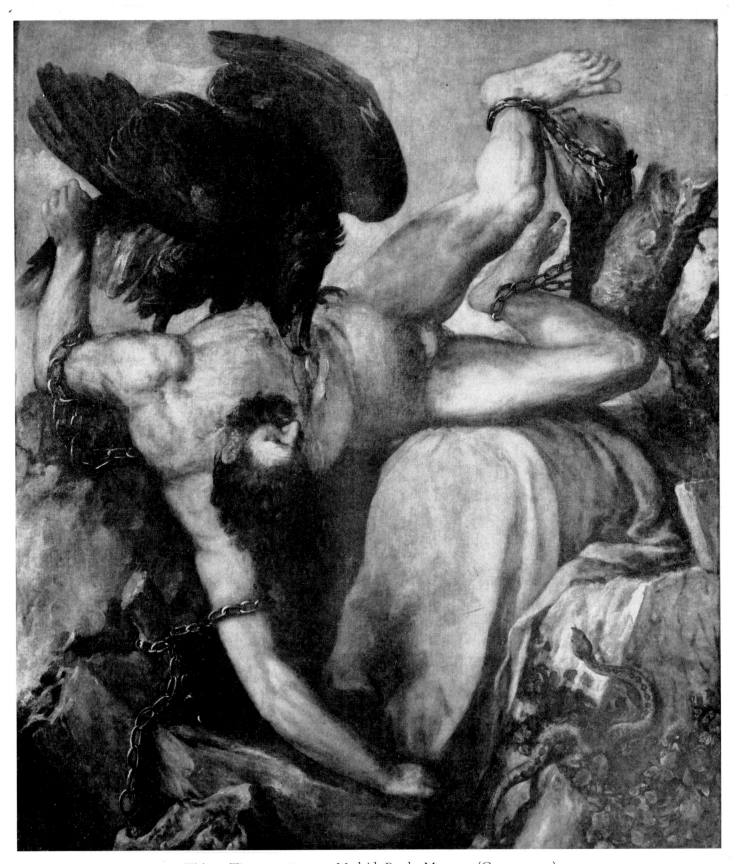

99. Titian: *Tityus*. 1548–1549. Madrid, Prado Museum (Cat. no. 19A)

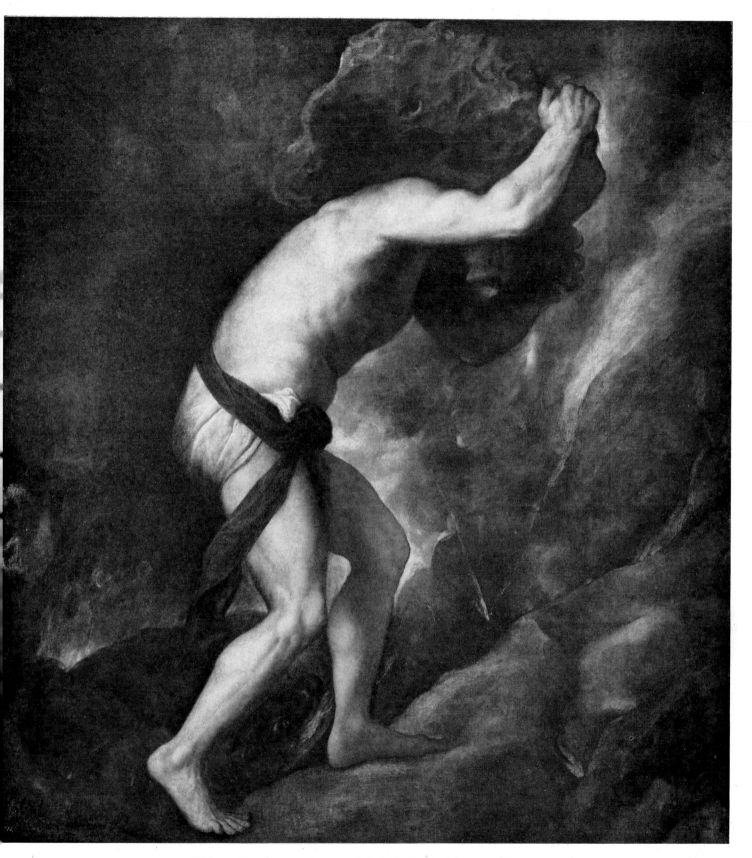

100. Titian: *Sisyphus*. 1548–1549. Madrid, Prado Museum (Cat. no. 19B)

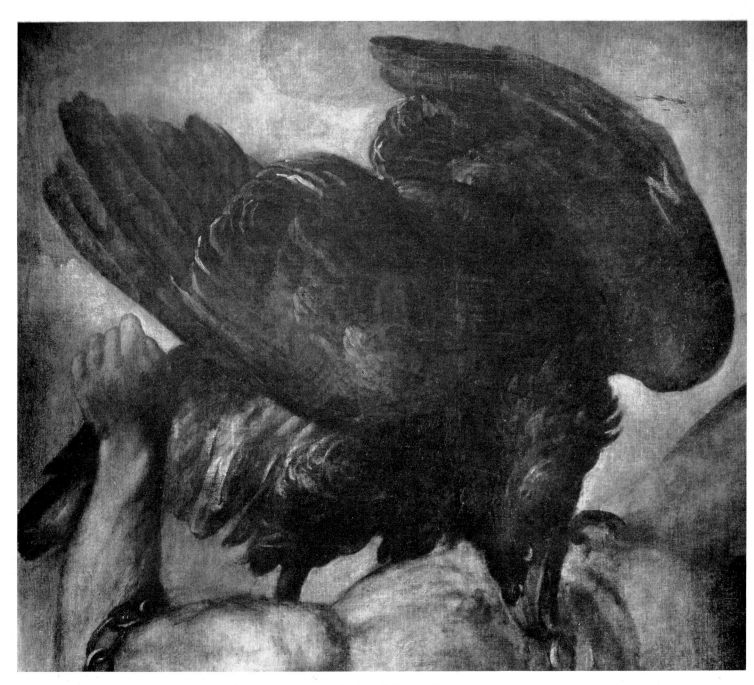

101. *Eagle*. Detail from Plate 99

101A. *Head of the Eagle*. X-ray detail from Plate 101, turned upright

102. *Head of Tityus*. Detail from Plate 99

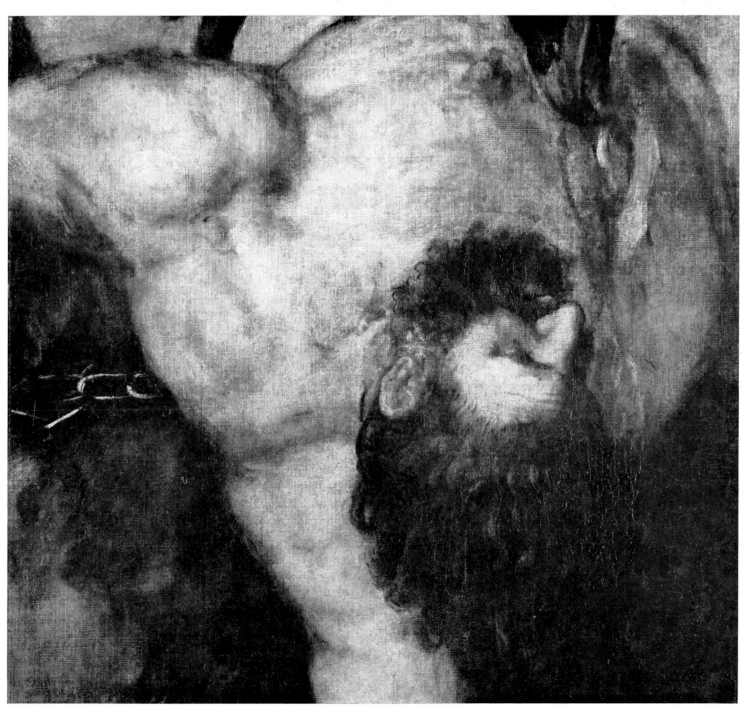

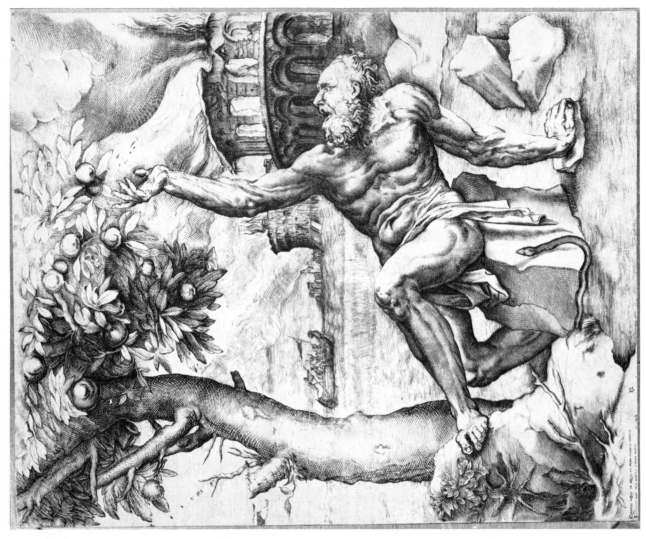

104. Giulio Sanuto's engraving after Titian: *Tantalus*. About 1565 (Cat. no. 19, print no. 3)

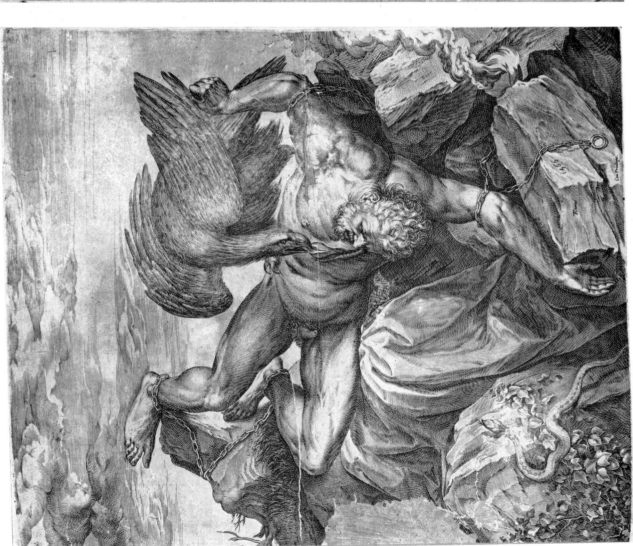

103. Cornelius Cort's engraving after Titian: *Tityus*. 1566 (Cat. no. 19, print no. 1)

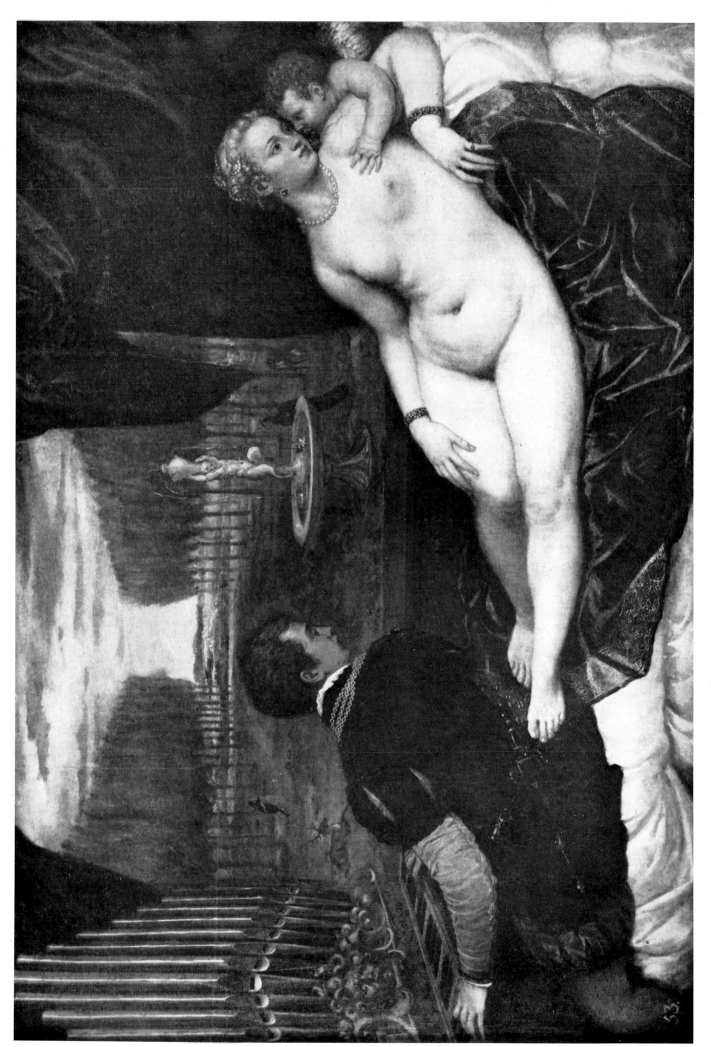

105. Titian: *Venus and Cupid with an Organist*. 1545–1548. Madrid, Prado Museum (Cat. no. 47)

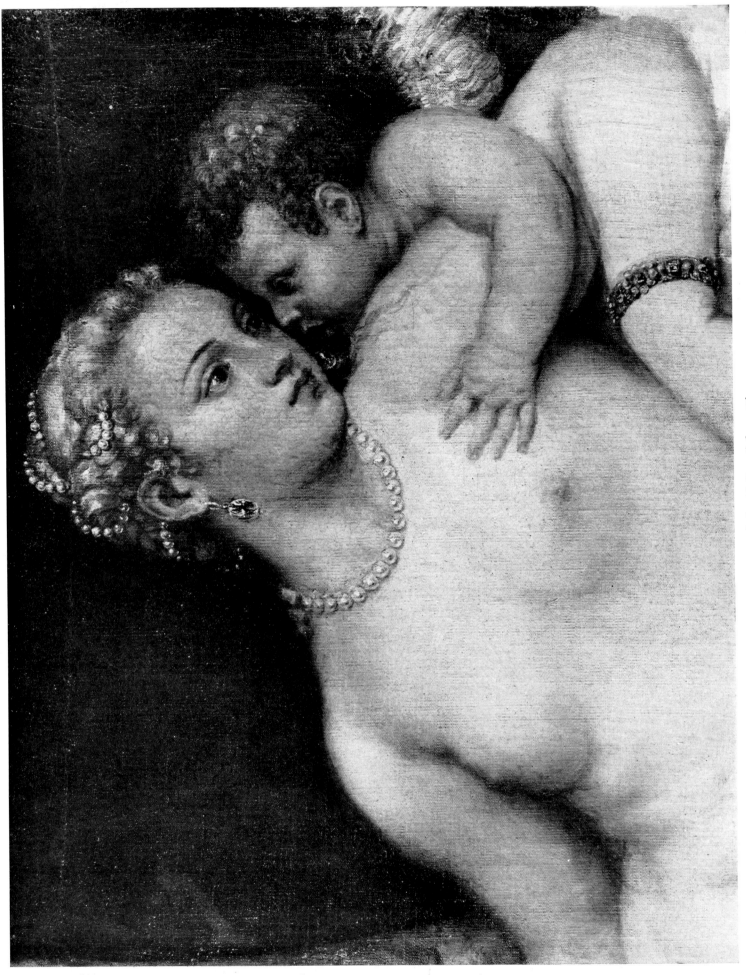

106. *Venus and Cupid*. Detail from Plate 105

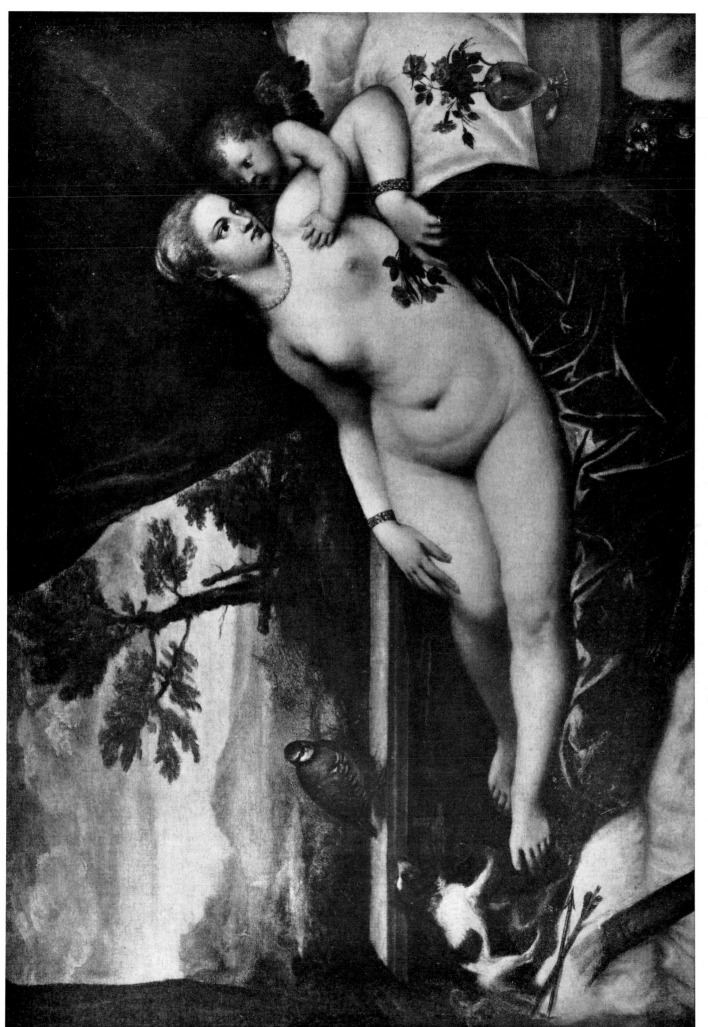

107. Titian and workshop: *Venus and Cupid with a Partridge*. About 1550. Florence, Uffizi (Cat. no. 49)

108. *Organist and Landscape*. Detail from Plate 105

109. *Organist and Landscape*. Detail from Plate 113

111. Van Dyck after Titian: *Venus and Dog with an Organist* (Cf. Plate 113). About 1622.
London, British Museum

110. *Landscape.* Detail from Plate 113

112. *Venus.* Detail from Plate 113

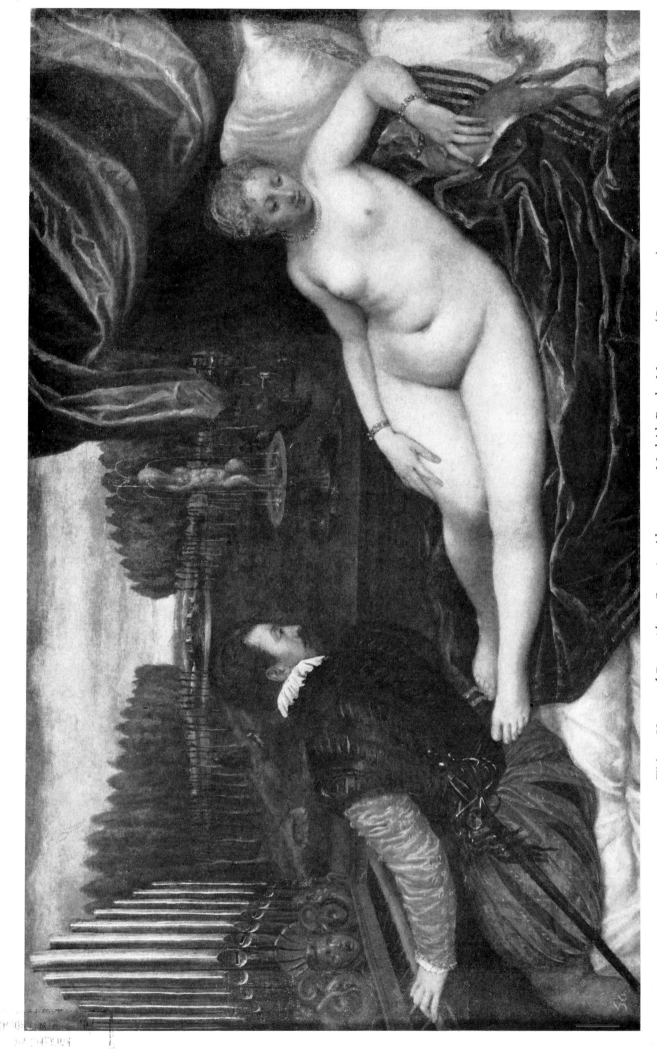

113. Titian: *Venus and Dog with an Organist*. About 1550. Madrid, Prado Museum (Cat. no. 50)

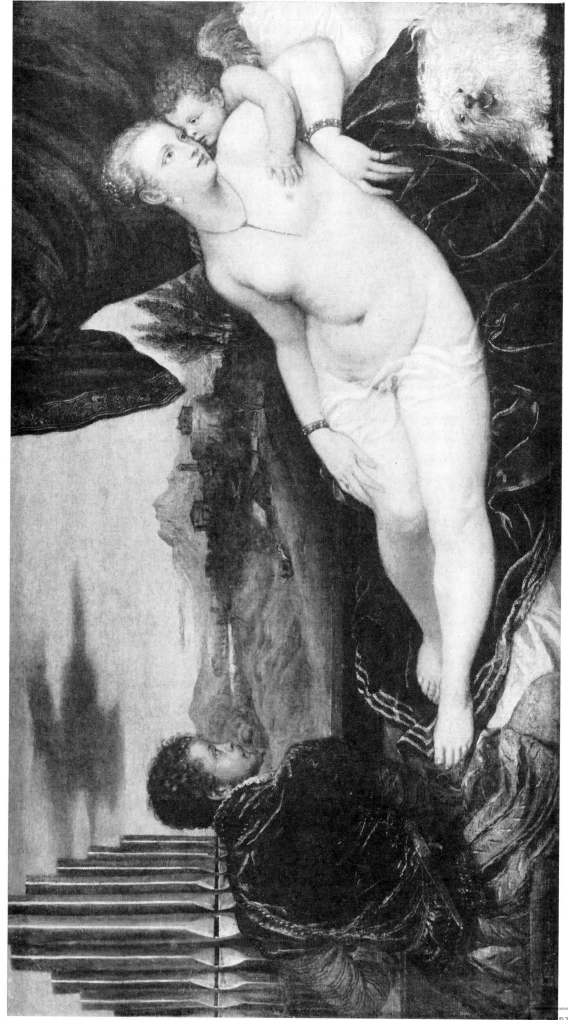

114. Titian: *Venus and Cupid with Prince Philip as Organist*. About 1548–1549. Berlin–Dahlem, Staatliche Gemäldegalerie (Cat. no. 48)

116. Workshop of Pompeo Leoni: *Prince Philip*. About 1548.
New York, Metropolitan Museum

115. *Prince Philip as an Organist*. Detail from Plate 114

118. *Venus and Cupid.* Detail from Plate 114

117. *Landscape.* Detail from Plate 114

119. Titian: *Maltese Dog* (drawing). About 1550. Stockholm, National Museum

120. *Maltese Dog*. Detail from Plate 114

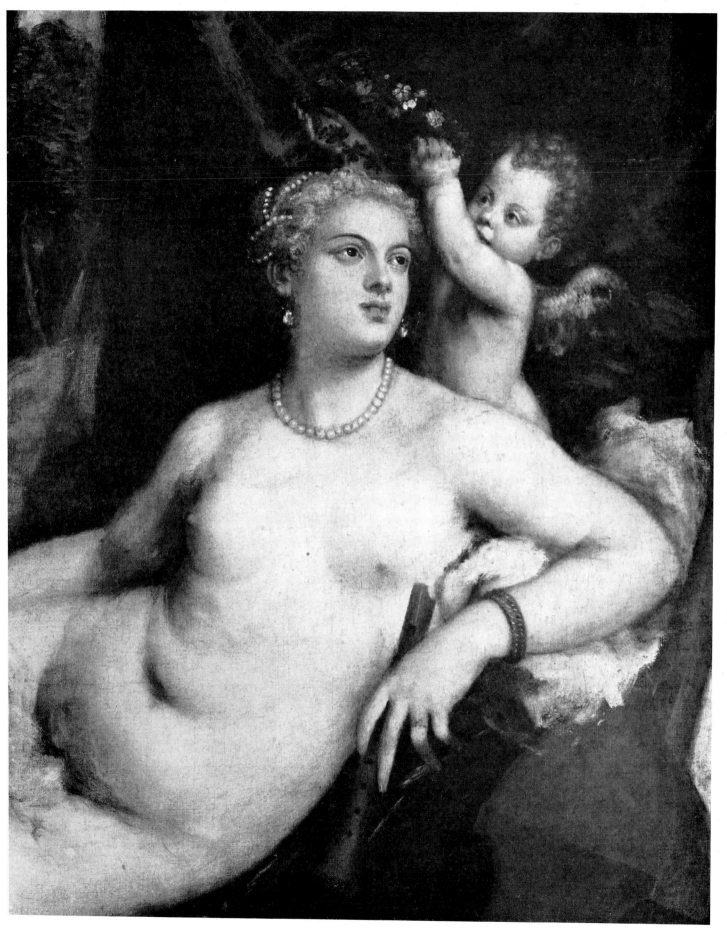

121. *Venus and Cupid*. Detail from Plate 122

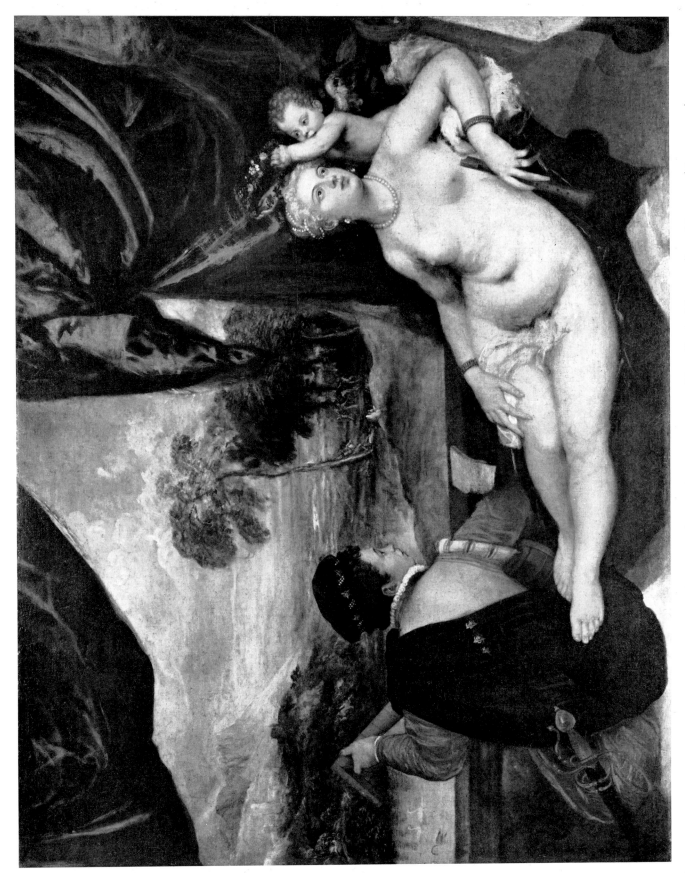

122. Titian: *Venus and Cupid with a Lute Player*. About 1565–1570. New York, Metropolitan Museum (Cat. no. 45)

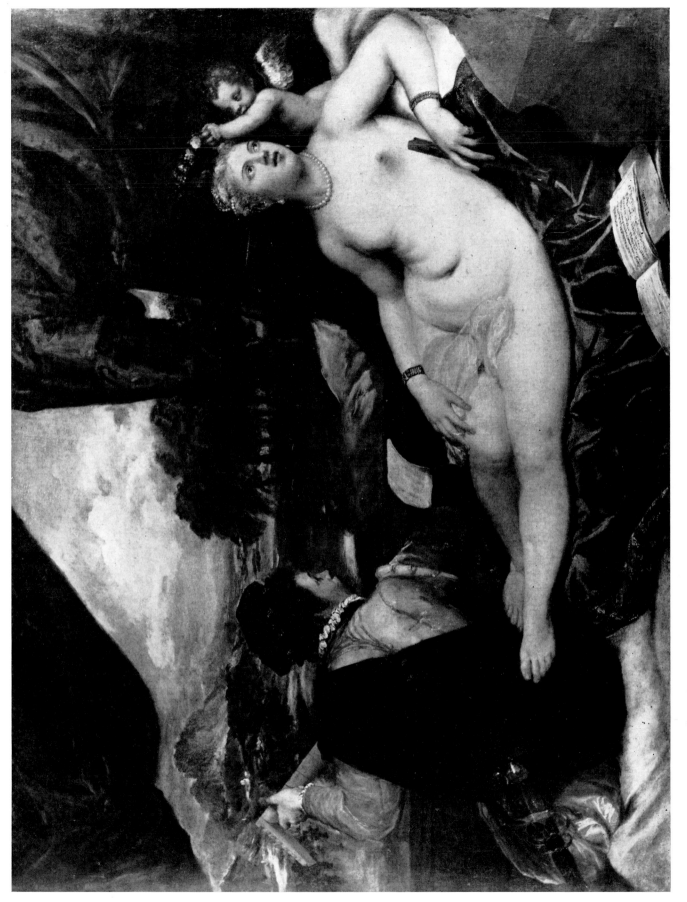

123. Titian and workshop: *Venus and Cupid with a Lute Player*. About 1565. Cambridge, Fitzwilliam Museum (Cat. no. 46)

124. *Lute Player and Landscape.* Detail from Plate 122

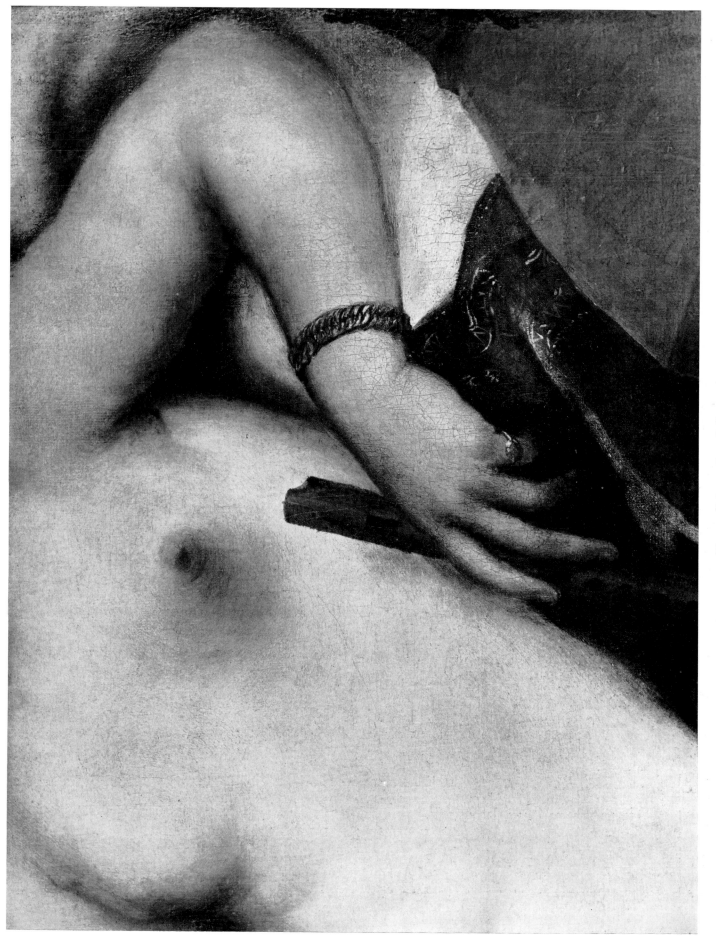

125. *Torso of Venus.* Detail from Plate 123

126. Sir Anthony Van Dyck, Sketch after Titian: *Venus at Her Toilet with Two Cupids*. About 1622. London, British Museum (Cat. no. L–26)

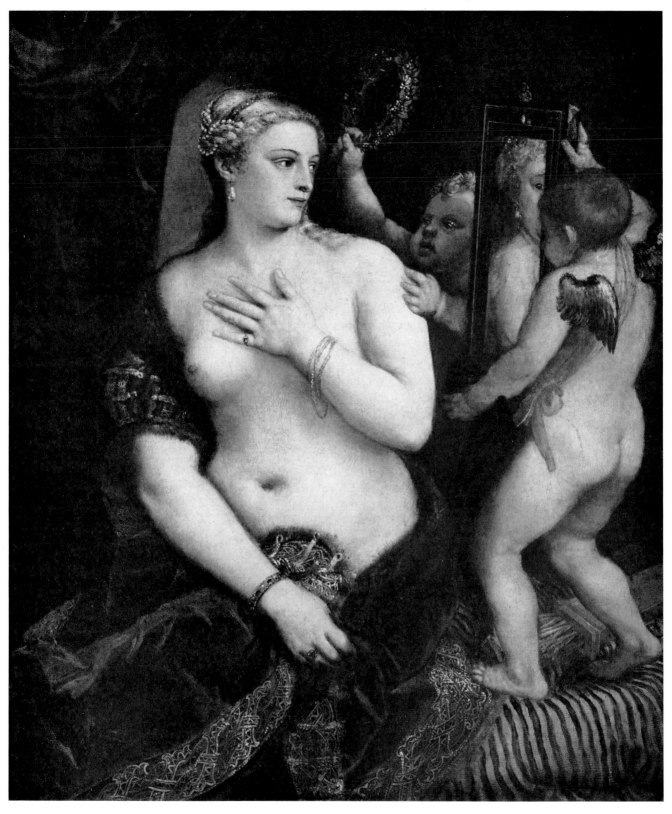

127. Titian: *Venus at Her Toilet with two Cupids*. About 1552–1555. Washington, National Gallery of Art, Mellon Collection (Cat. no. 51)

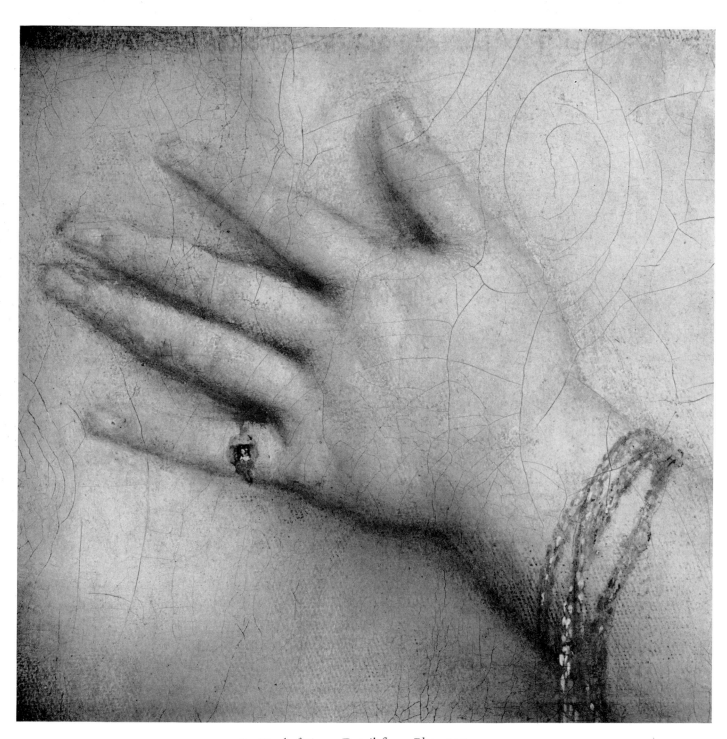

128. *Hand of Venus*. Detail from Plate 127

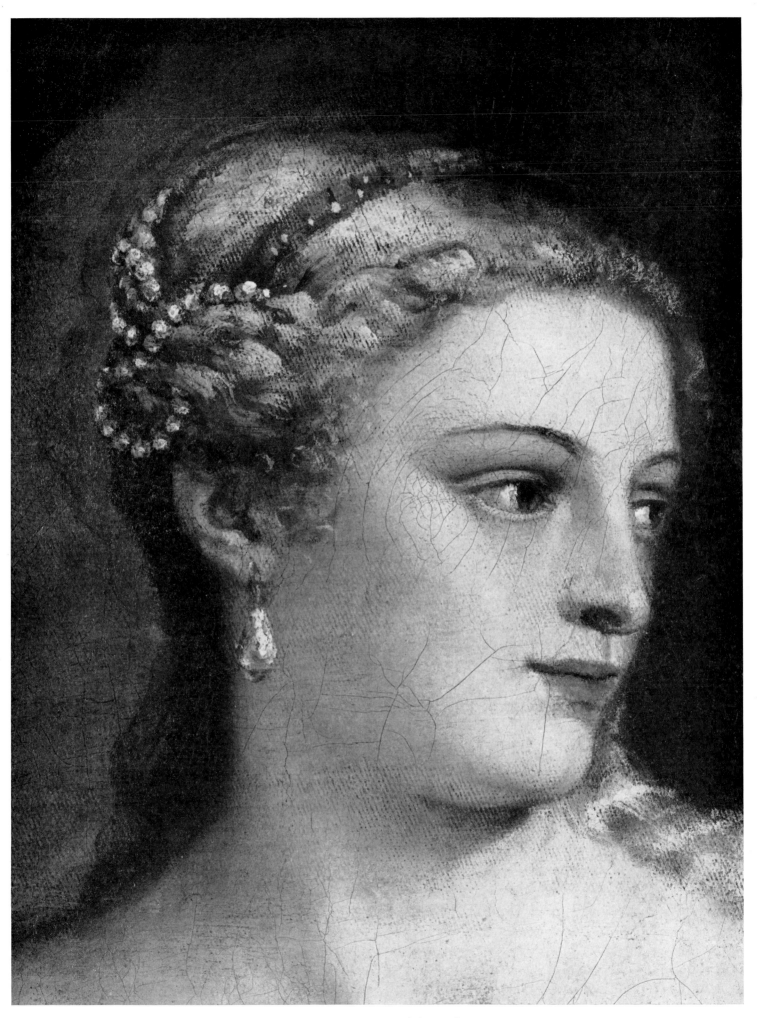

129. *Head of Venus*. Detail from Plate 127

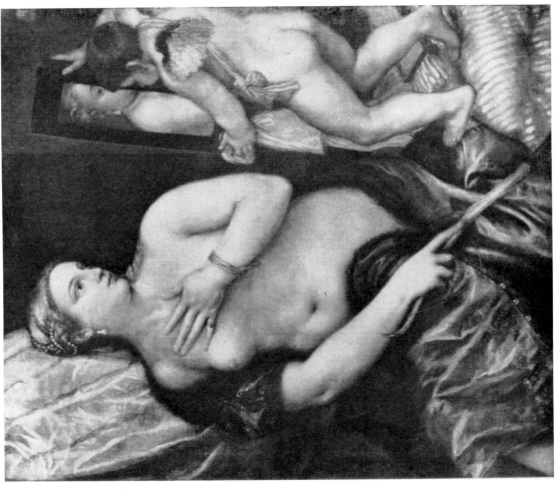

131. Workshop of Titian: *Venus at Her Toilet with One Cupid.* About 1555.
Stockholm, Karl and Dagmar Bergsten (Cat. no. 53)

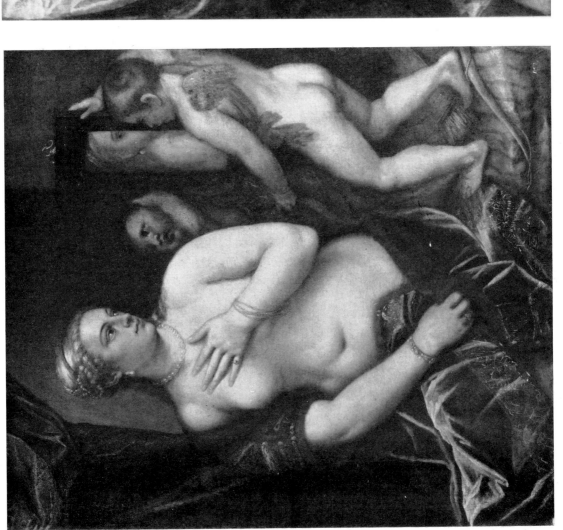

130. Workshop of Titian: *Venus at Her Toilet with Two Cupids.* About 1555.
Cologne, Wallraf-Richartz Museum (Cat. no. 52)

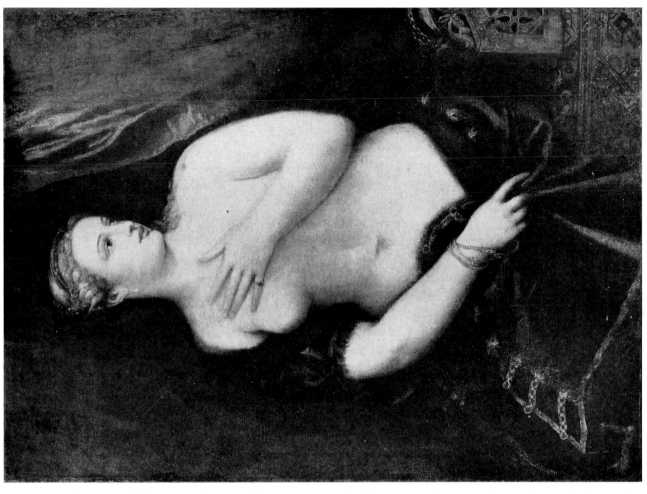

133. Follower of Titian: *Venus Alone at Her Toilet*. Sixteenth century. Venice, Ca' d'Oro (Cat. no. X–37)

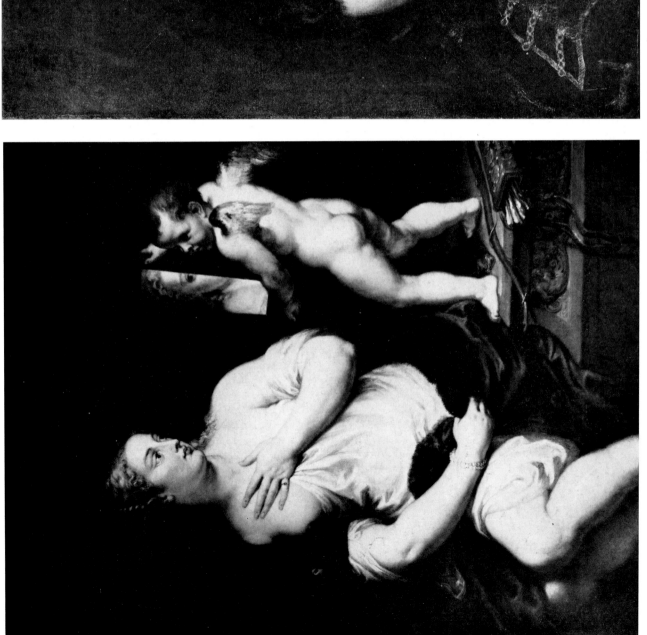

132. Rubens after Titian: *Venus at Her Toilet with One Cupid*. 1628. Lugano, Thyssen–Bornemisza Collection (Cat. no. L–27, Copy 1)

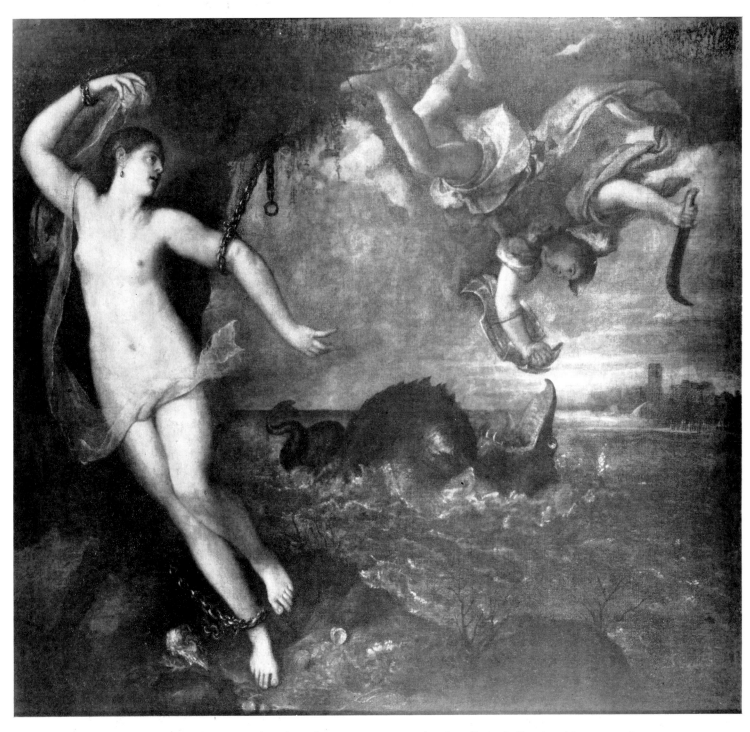

134. Titian: *Perseus and Andromeda*. 1554–1556. London, Wallace Collection (Cat. no. 30)

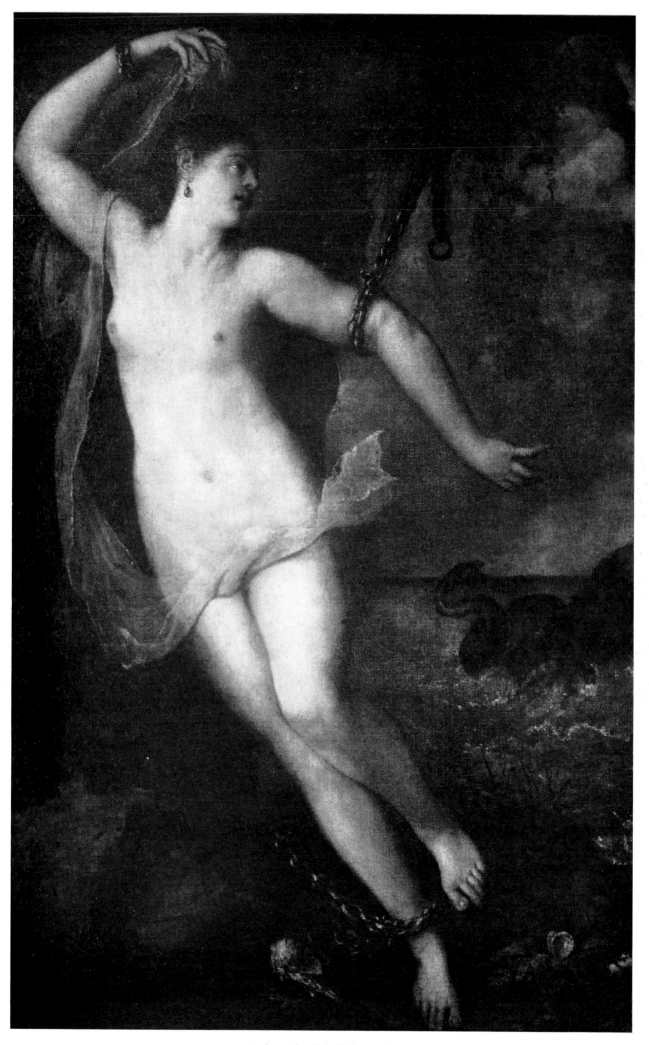

135. *Andromeda.* Detail from Plate 134

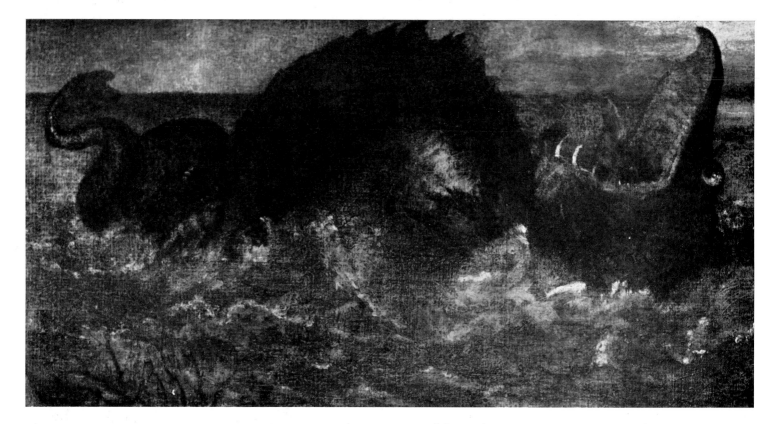

136. *Sea and Monster*. Detail from Plate 134

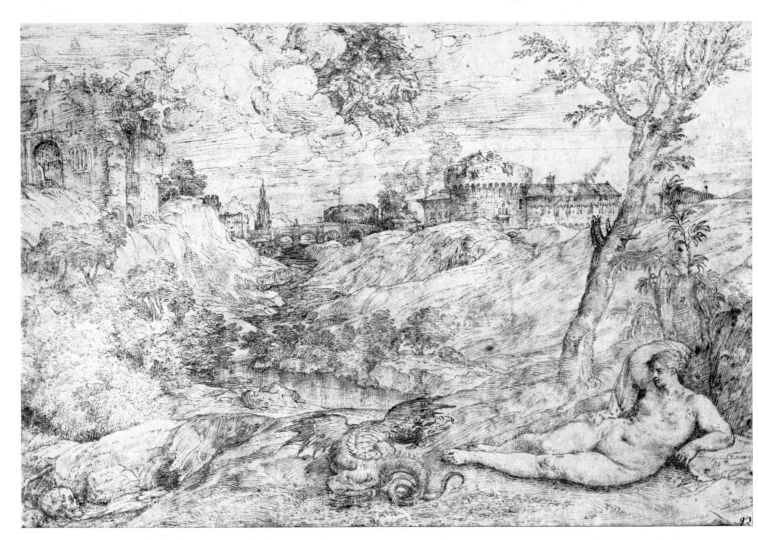

137. Titian: *Landscape with Roger and Angelica*. About 1550. Bayonne, Musée Bonnat (Cat. no. 25)

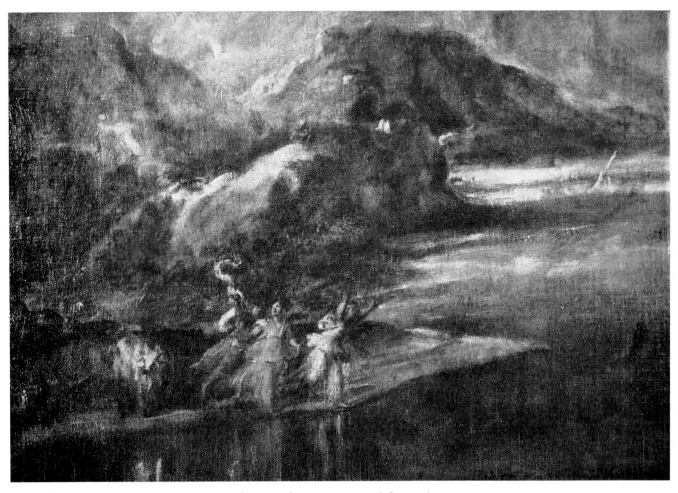

138. *Landscape and Seascape.* Detail from Plate 141

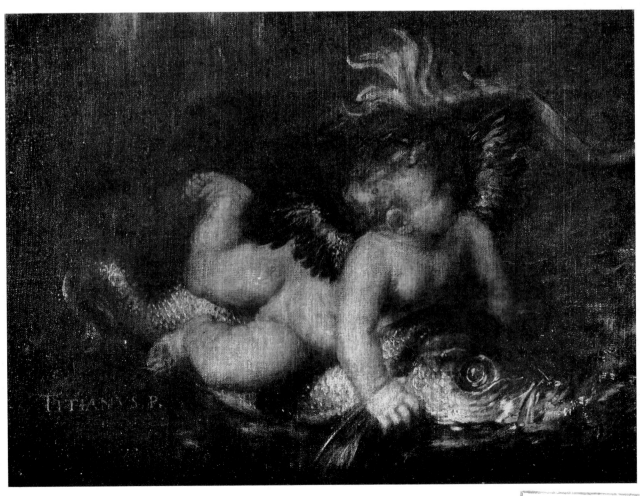

139. *Putto Riding a Dolphin.* Detail from Plate 141

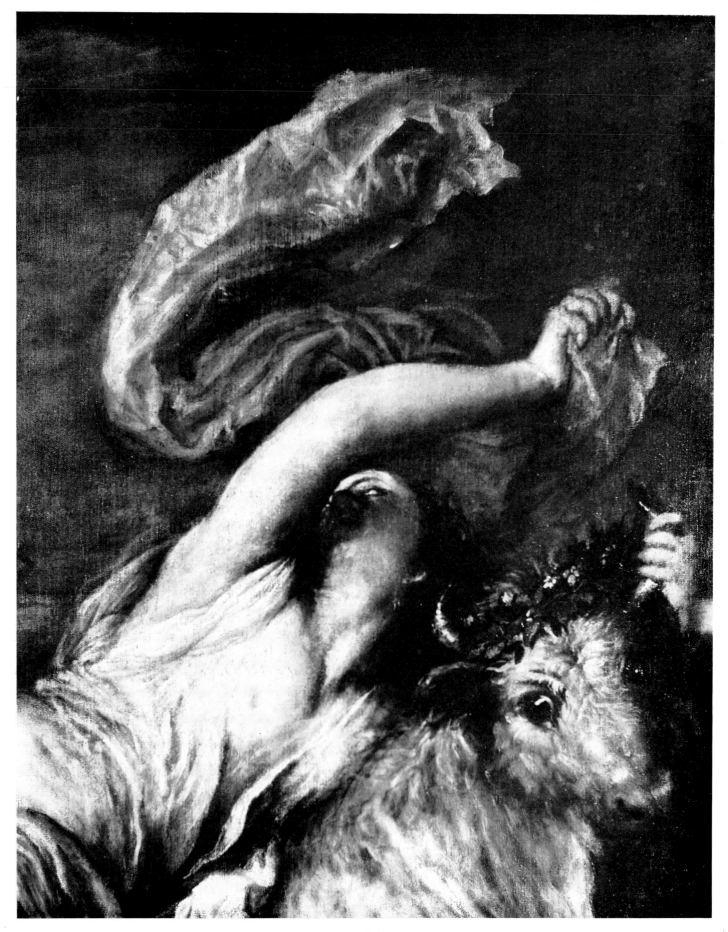

140. *Europa.* Detail from Plate 141

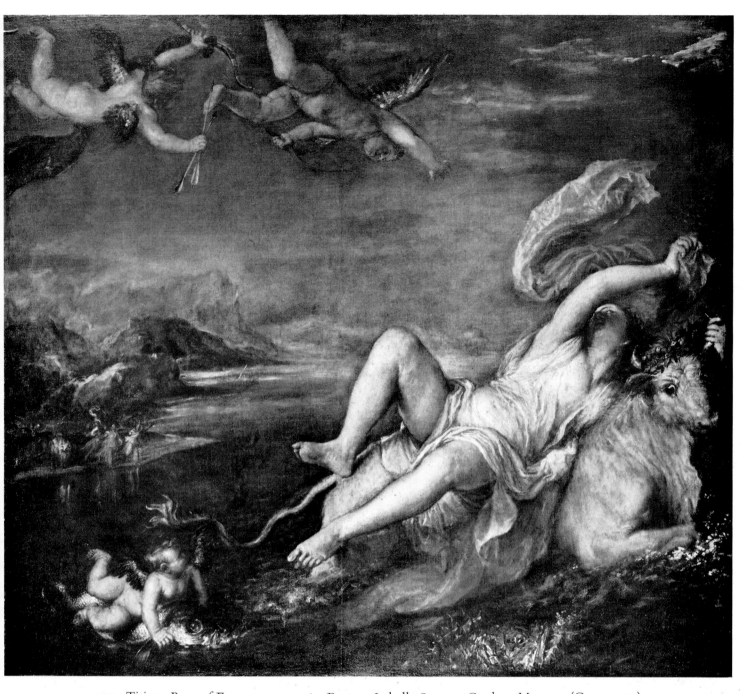

141. Titian: *Rape of Europa*. 1559–1562. Boston, Isabella Stewart Gardner Museum (Cat. no. 32)

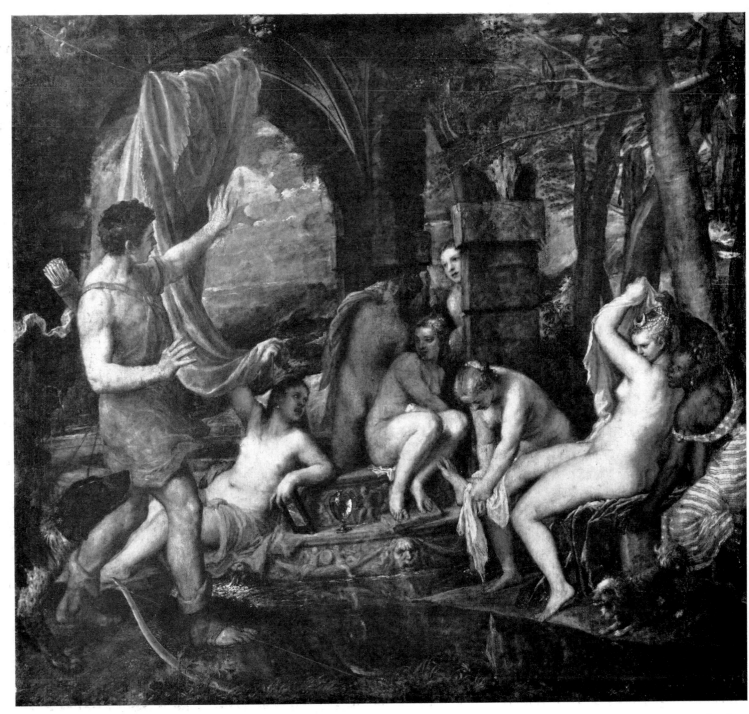

142. Titian: *Diana and Actaeon*. 1556–1559. Edinburgh, National Gallery of Scotland, on loan from the Duke of Sutherland
(Cat. no. 9)

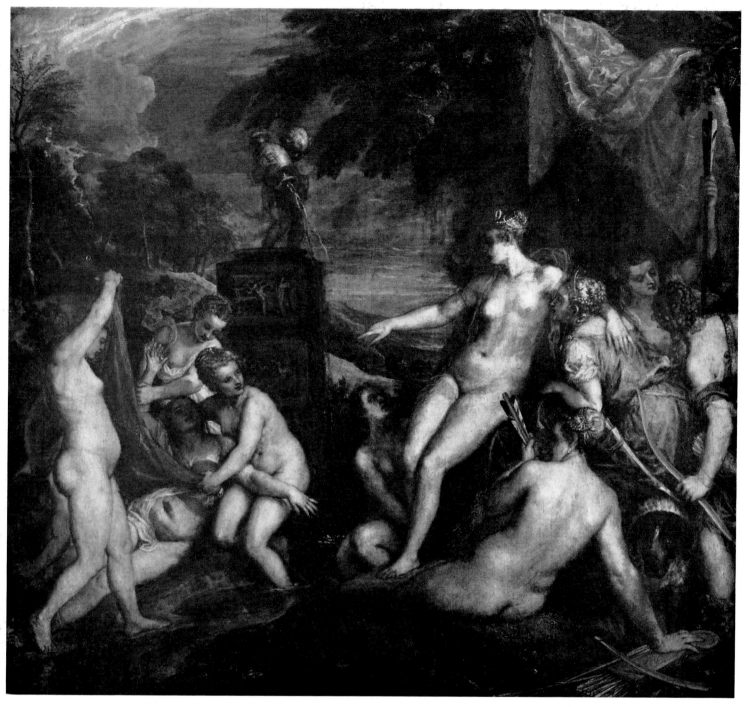

143. Titian: *Diana and Callisto*. 1556–1559. Edinburgh, National Gallery of Scotland, on loan from the Duke of Sutherland
(Cat. no. 10)

144. *Actaeon*. Detail from Plate 142

145. *Diana*. Detail from Plate 142

146. *Nymph*. Detail from Plate 142

147. *Bathing Nymphs*. Detail from Plate 142

149. *Diana and Attendants*. Detail from Plate 143

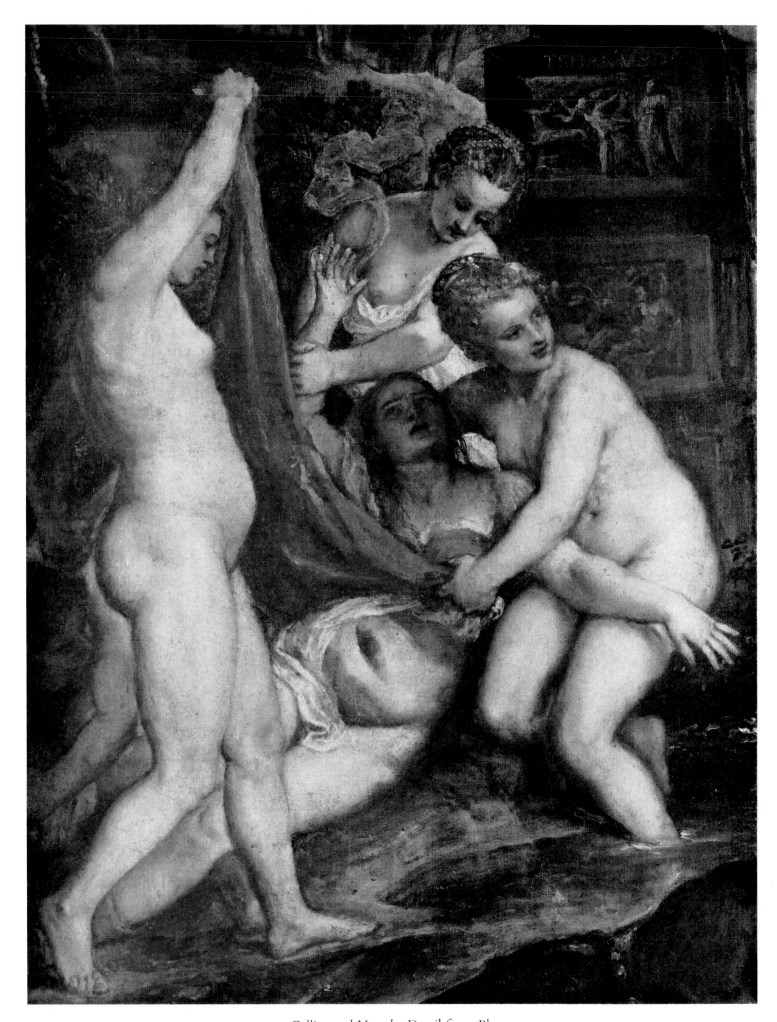

150. *Callisto and Nymphs*. Detail from Plate 143

151. *Actaeon Transformed into a Stag.* Detail from Plate 152

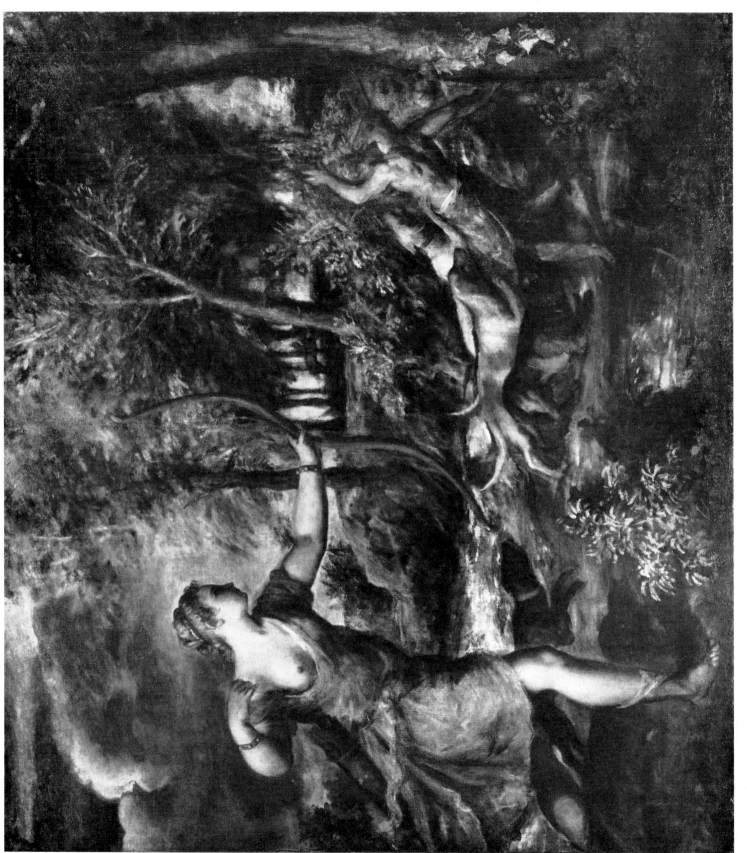

152. Titian: *Death of Actaeon*. About 1559; 1570–1575. London, National Gallery (Cat. no. 8)

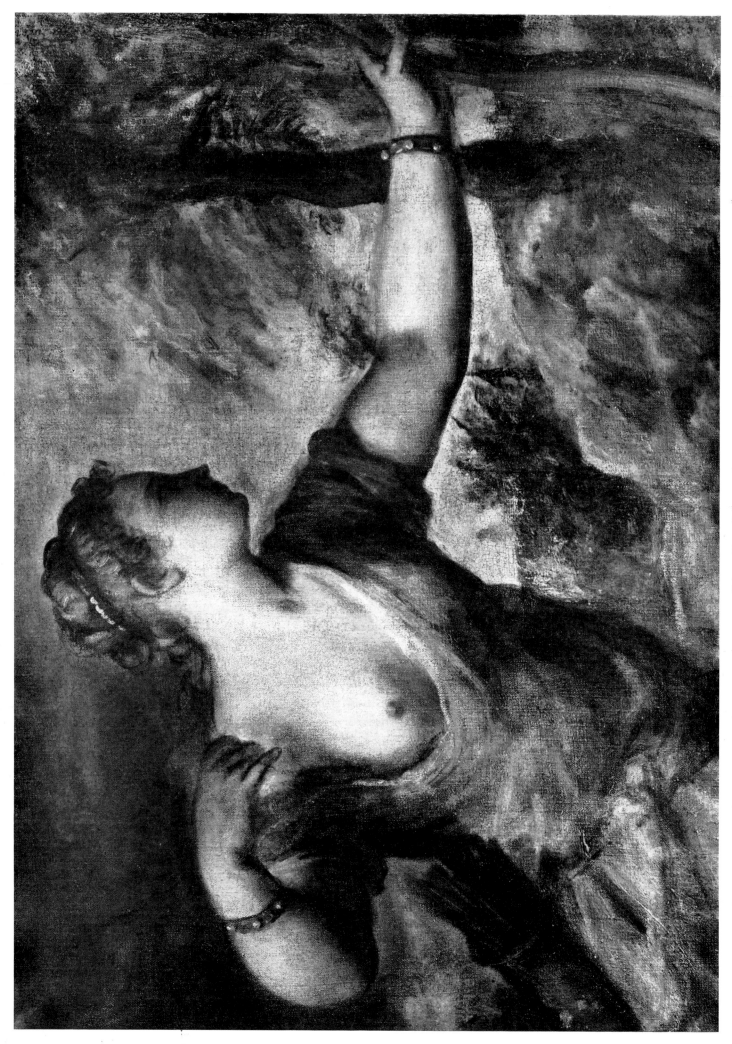

153. *Diana*. Detail from Plate 152

154. Titian and workshop: *Diana and Callisto*. About 1566. Vienna, Kunsthistorisches Museum (Cat. no. 11)

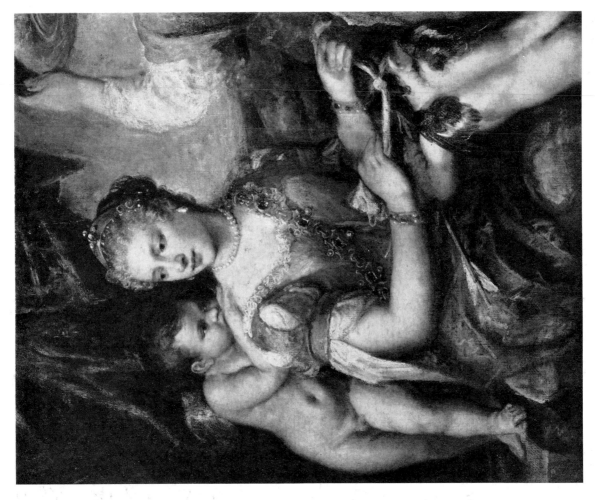

156. Follower of Titian: *Cupid Blindfolded*. About 1570. Washington, National Gallery of Art, Kress Collection (Cat. no. X–5)

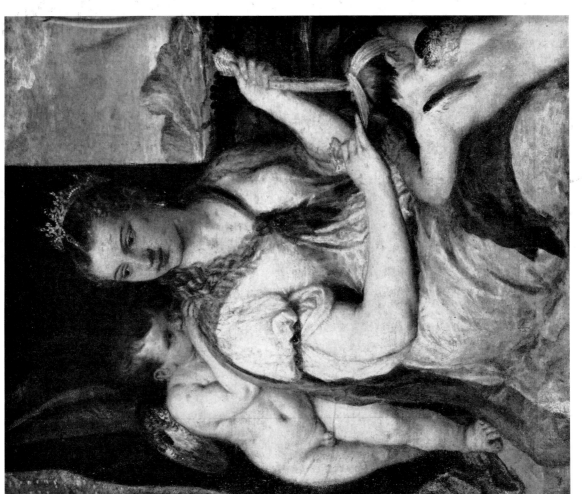

155. *Venus and Two Cupids*. Detail from Plate 159

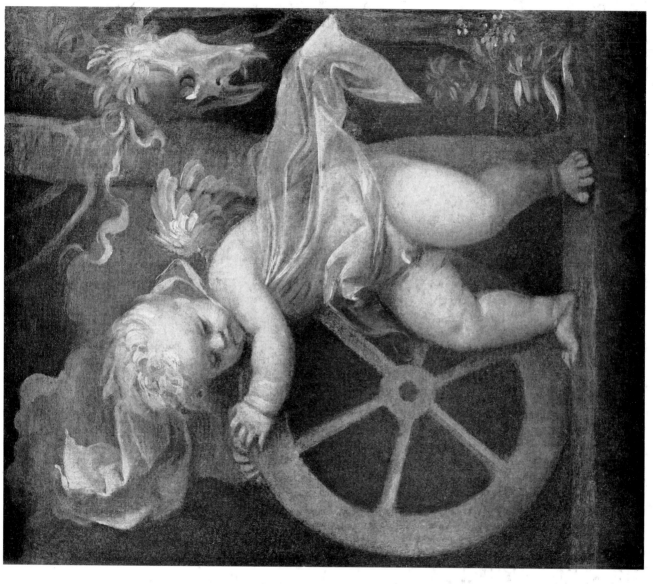

157. Follower of Veronese. *Cupid with a Wheel of Fortune.* About 1560. Washington, National Gallery of Art, Kress Collection (Cat. no. X–9)

158. *Anteros*. Detail from Plate 159

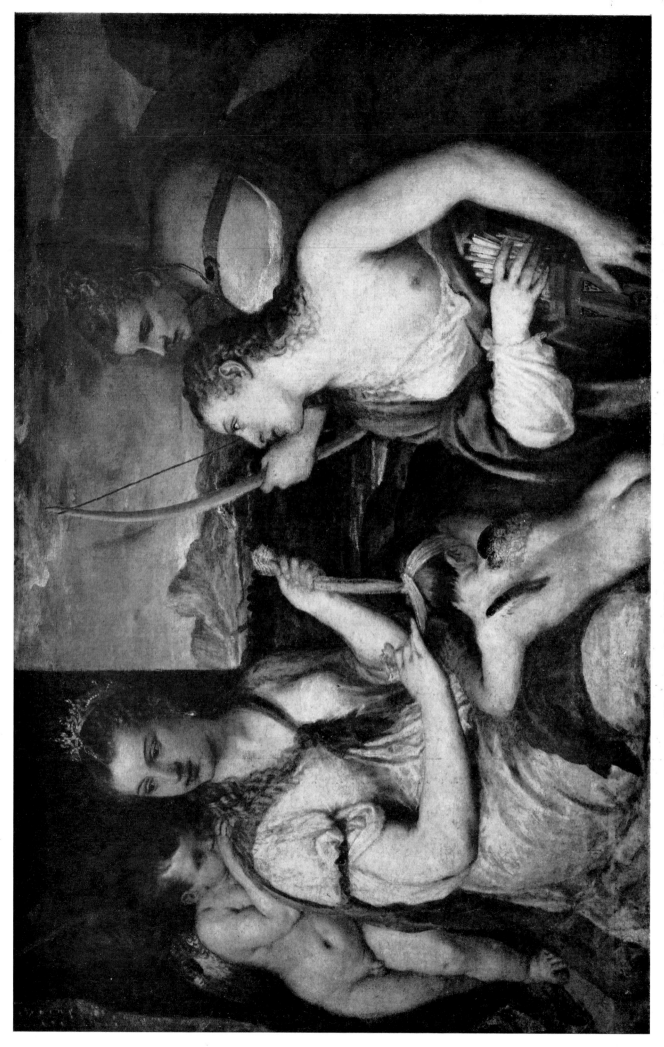

159. Titian: *Cupid Blindfolded*. About 1565. Rome, Villa Borghese (Cat. no. 4)

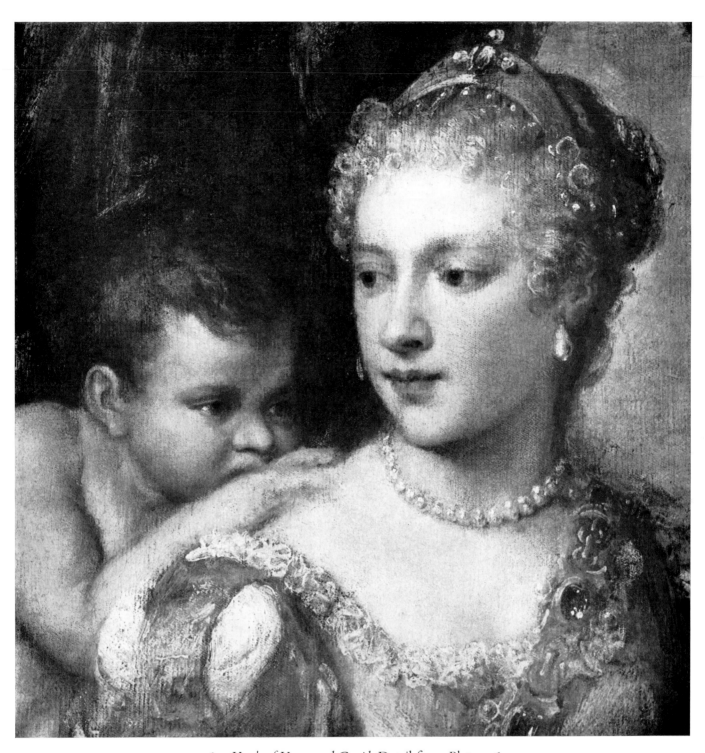

160. *Heads of Venus and Cupid*. Detail from Plate 156

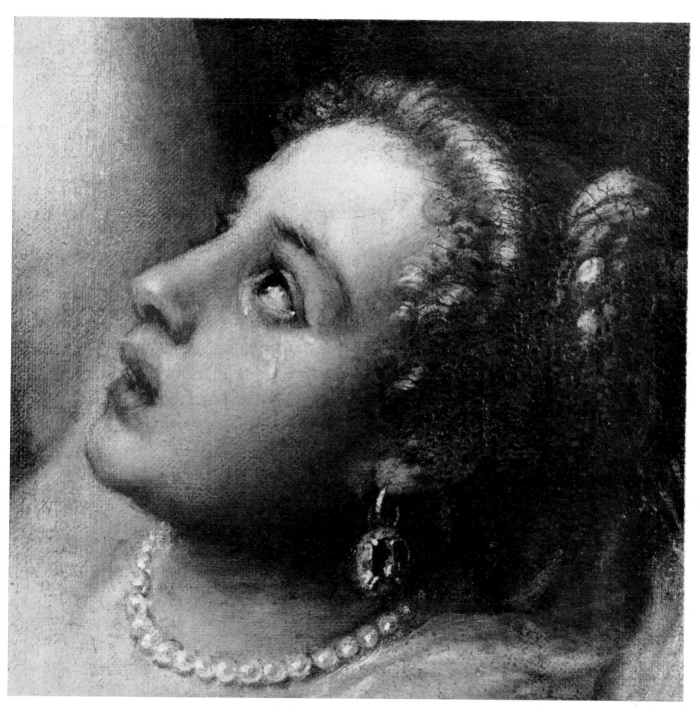

161. *Head of Lucretia*. Detail from Plate 164

162. Titian: *Wisdom*. About 1560–1562. Venice, Library of St. Mark, Vestibule (Cat. no. 55)

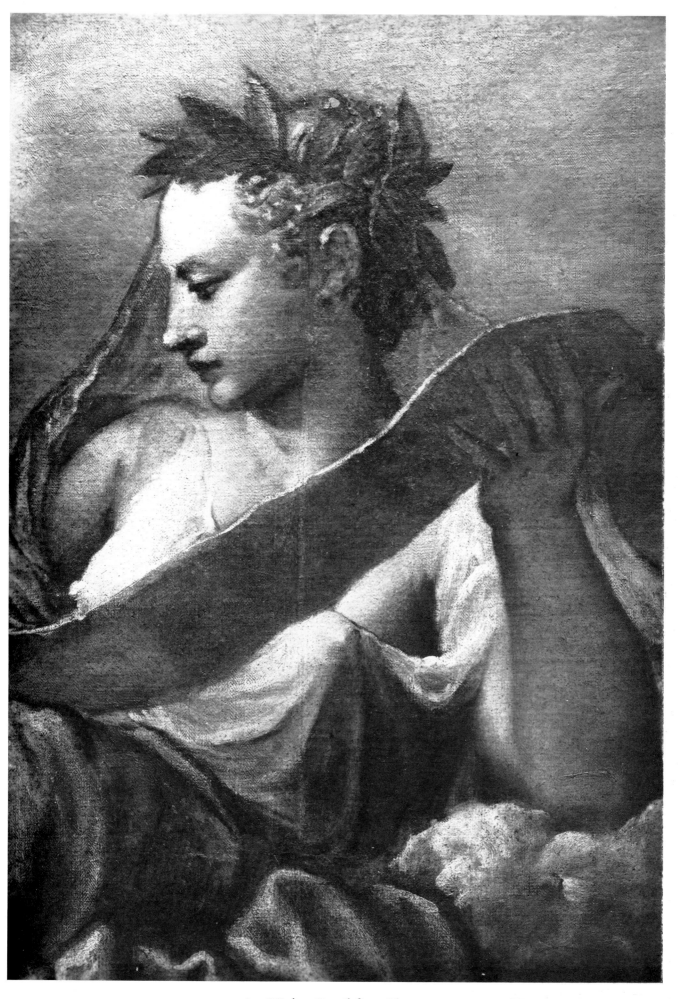

163. *Wisdom.* Detail from Plate 162

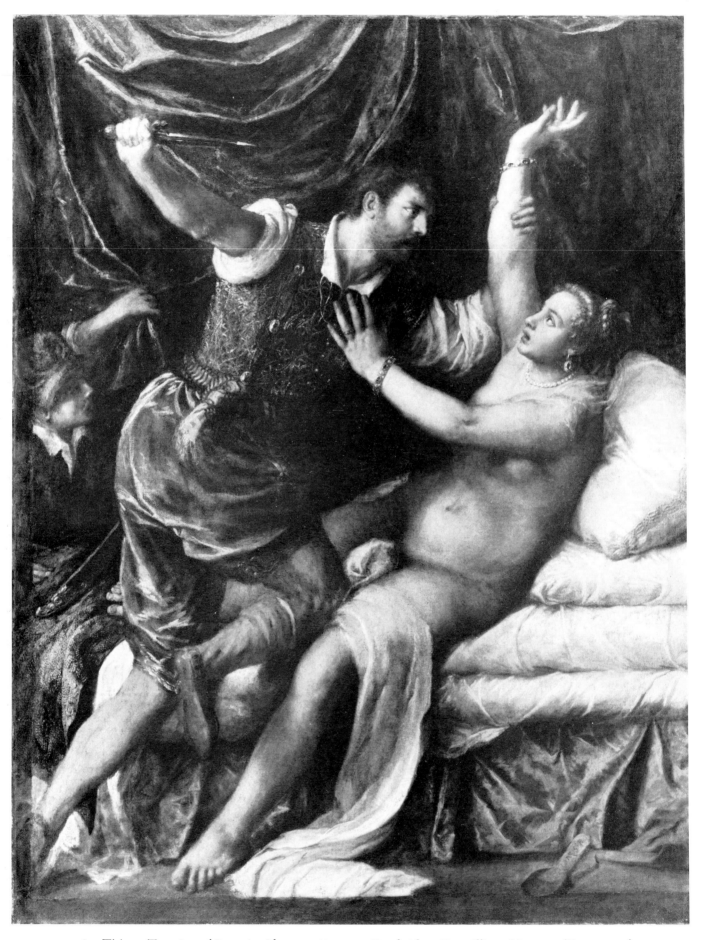

164. Titian: *Tarquin and Lucretia*. About 1568–1571. Cambridge, Fitzwilliam Museum (Cat. no. 34)

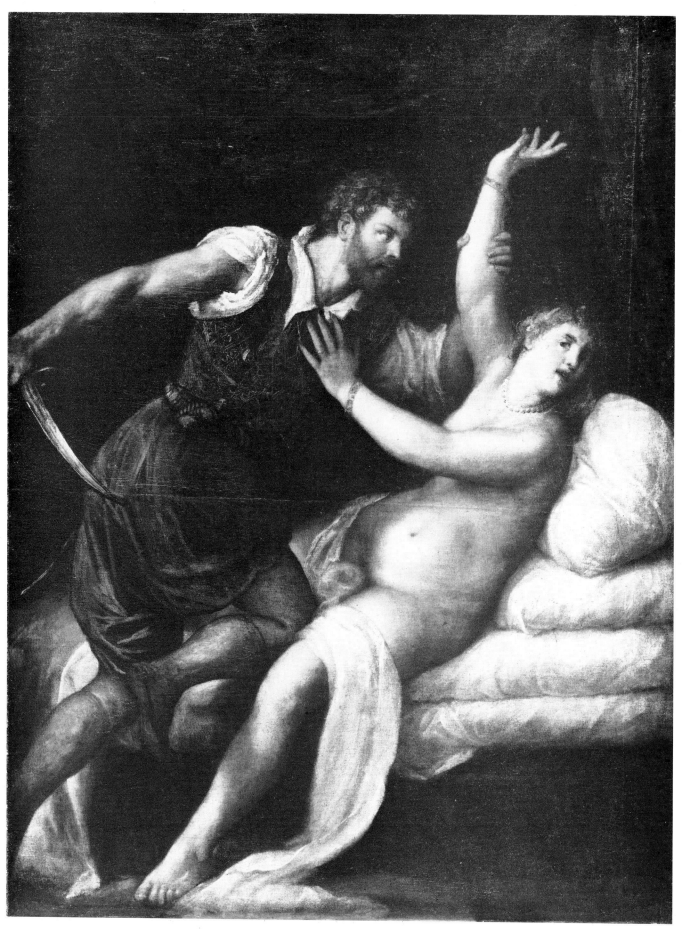

165. Workshop of Titian: *Tarquin and Lucretia*. Sixteenth century. Bordeaux, Musée des Beaux-Arts (Cat. no. 35)

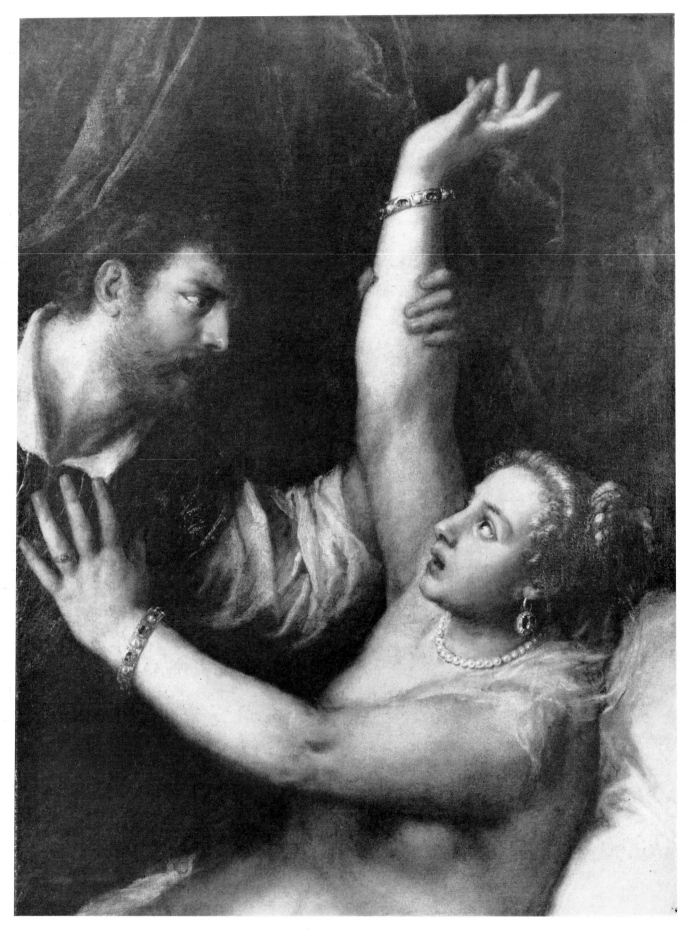

166. *Tarquin and Lucretia.* Detail of Plate 164

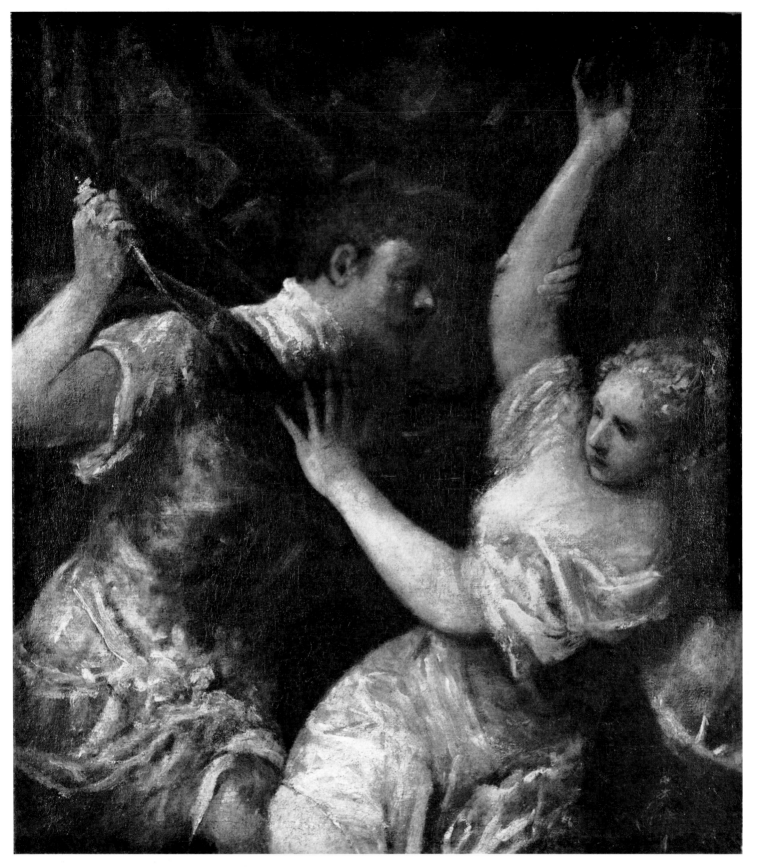

167. Follower of Titian: *Tarquin and Lucretia*. About 1580. Vienna, Akademie der Bildenden Künste (Cat. no. X–34)

168. Titian: *Nymph and Shepherd*. About 1570–1575. Vienna, Kunsthistorisches Museum (Cat. no. 27)

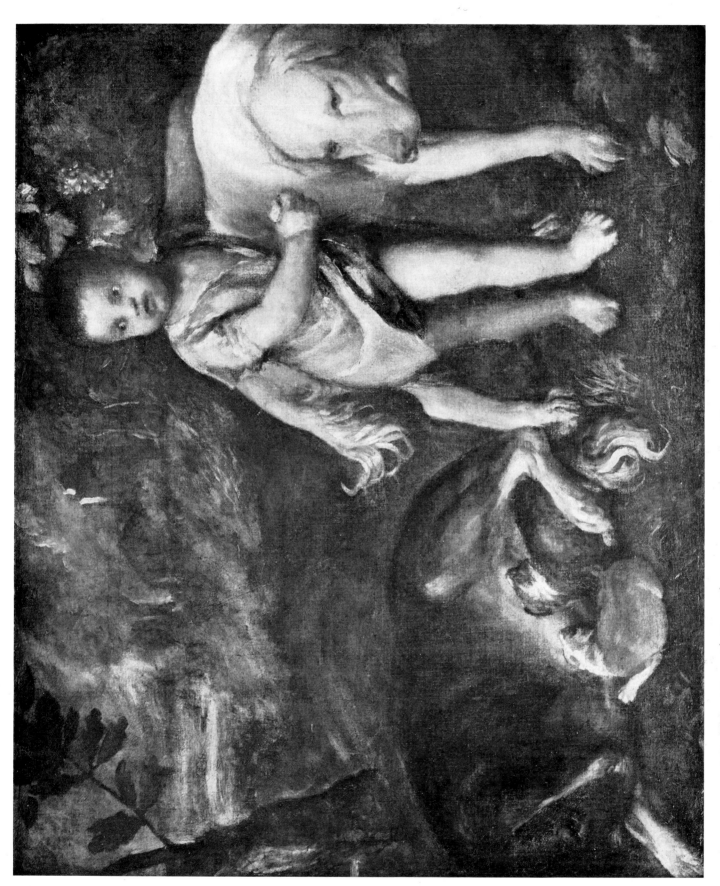

169. Titian: *Boy with Dogs*. About 1570–1575. Rotterdam, Boymans–van Beuningen Museum (Cat. no. 2)

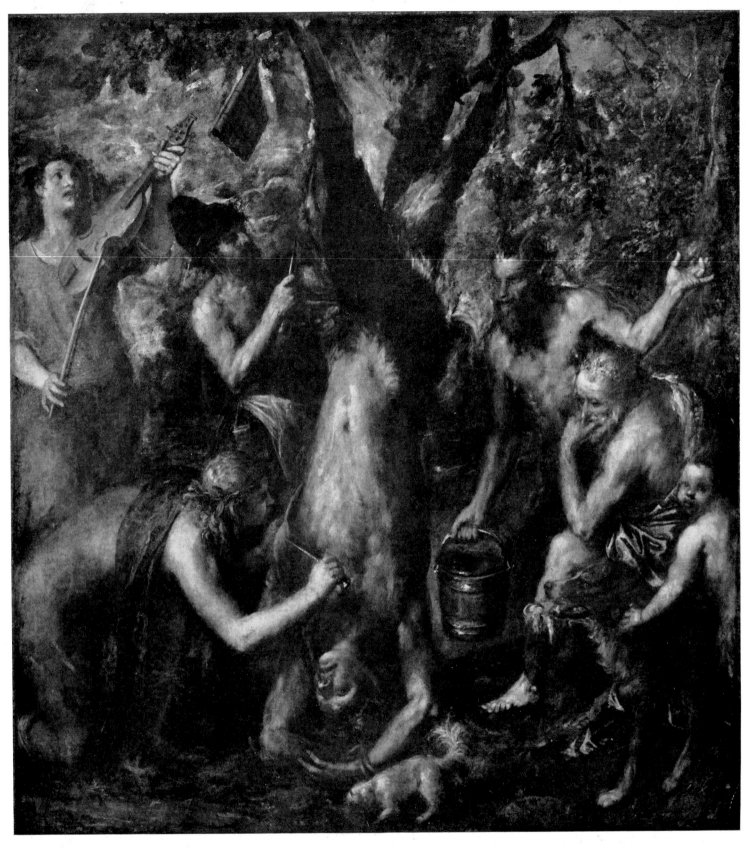

170. Titian: *Flaying of Marsyas*. About 1570–1575. Kremsier, Archiepiscopal Palace (Cat. no. 16)

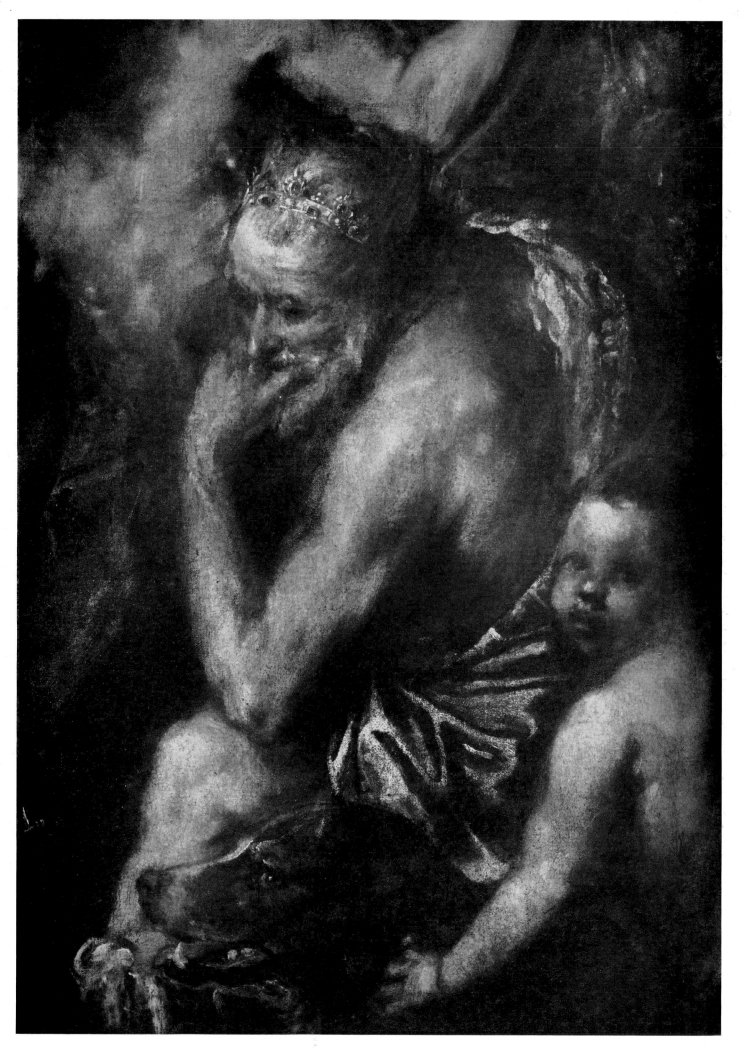

171. *Midas.* Detail from Plate 170

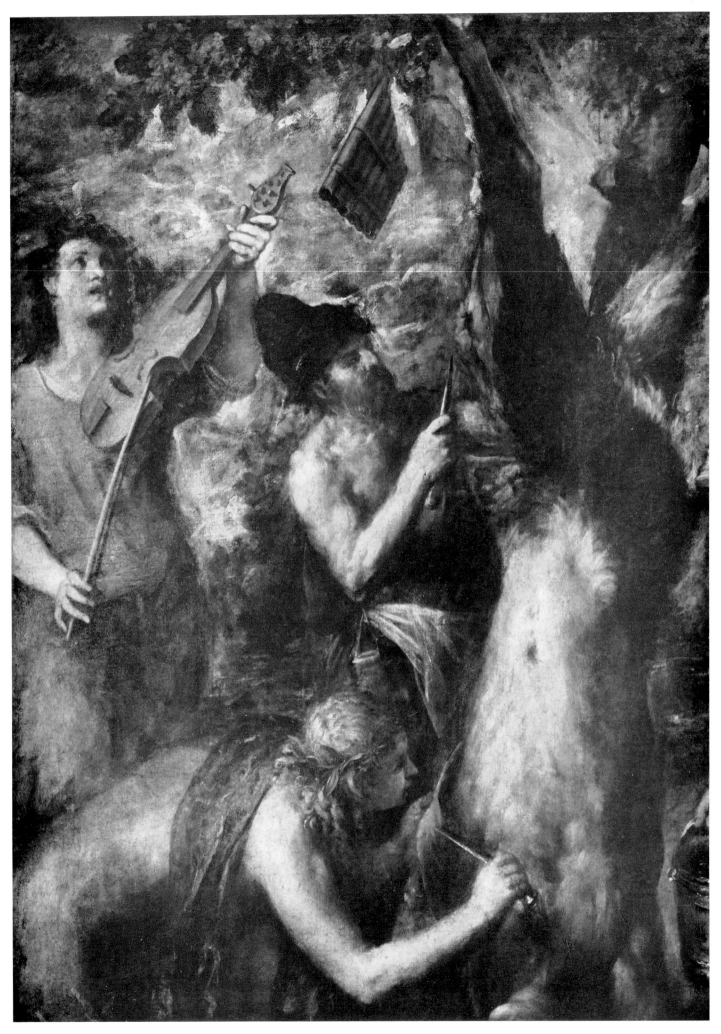

172. *Marsyas Flayed*. Detail from Plate 170

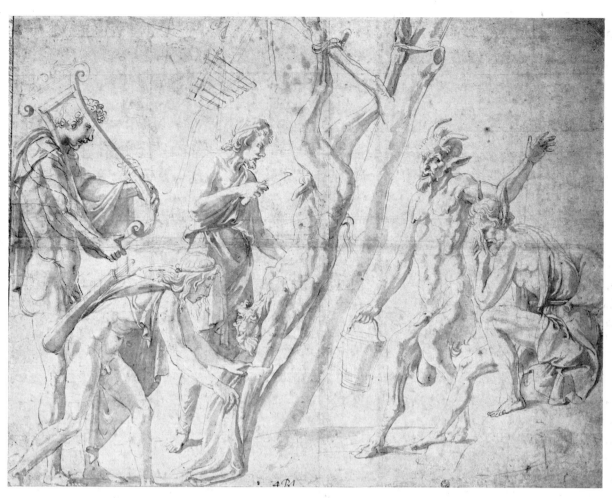

173. Giulio Romano: *Flaying of Marsyas* (drawing). About 1526. Paris, Louvre, Cabinet des Dessins

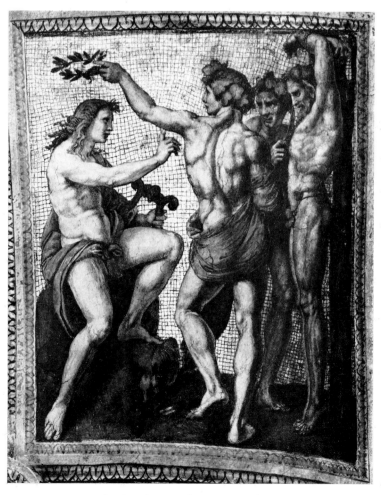

174. Raphael: *Flaying of Marsyas*. About 1510.
Rome, Vatican Palace

APPENDIX

175. Copy of Titian: *Three Ages of Man*. Late sixteenth century. Rome, Doria Pamphili Collection (Cat. no. 36, copy 6)

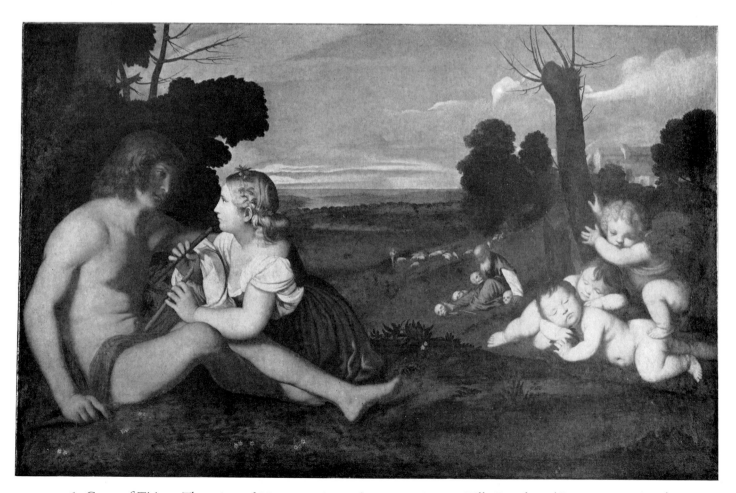

176. Copy of Titian: *Three Ages of Man*. Late sixteenth century. Rome, Villa Borghese (Cat. no. 36, copy 5)

177. Lefèbre after Titian: *Three Ages of Man*. 1682 (Cat. no. 36, print)

178. Venetian School: *Venus and Wounded Cupid*. About 1520. London, Wallace Collection
(Cat. no. X–44)

179. Venetian School: *Cupid in a Loggia*. About 1520. Vienna, Akademie
der Bildenden Künste (Cat. no. X–7)

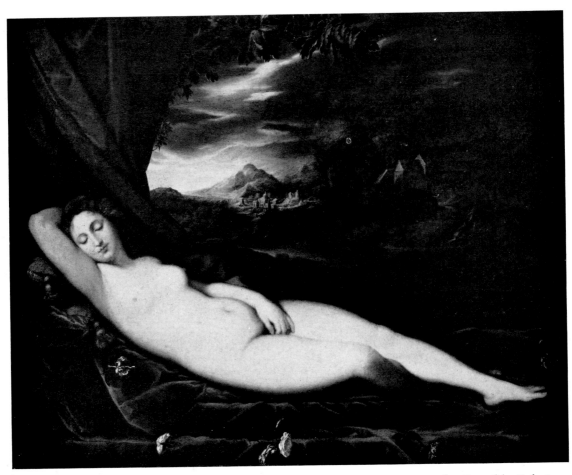

180. German Adaptation: *Sleeping Venus*. Seventeenth century. Darmstadt, Gemälde Galerie
(Cat. no. X–36)

181. Venetian School (Francesco Vecellio?): *Cupid with Tambourine*. Vienna,
Kunsthistorisches Museum (Cat. no. X–8)

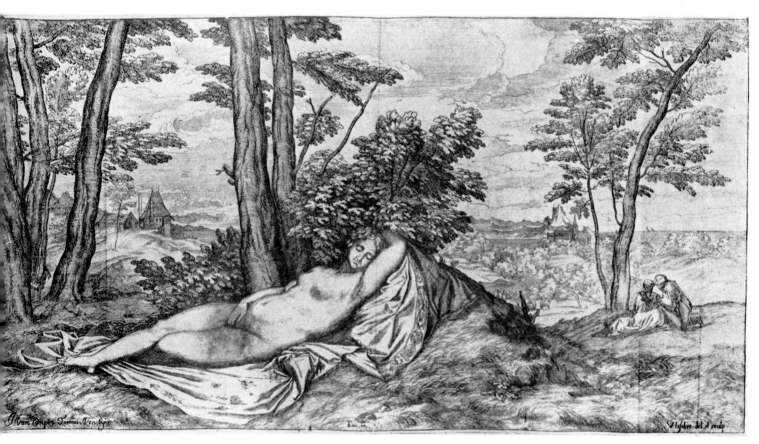

182. Lefèbre: *Venus Asleep in a Landscape*. 1682. London, British Museum (Cat. no. 38, print)

183. Venetian School: *Lady at Her Toilet*. Sixteenth century. Washington, National Gallery of Art (Cat. no. X–17)

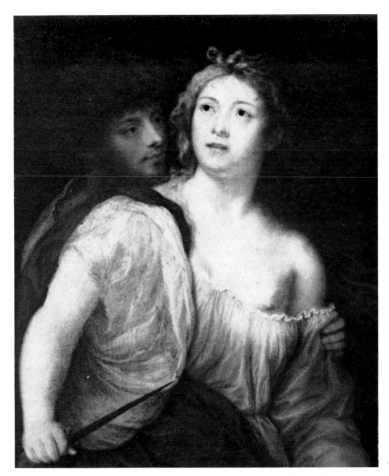

184. Peter Oliver after Palma il Vecchio: *Tarquin and Lucretia*.
About 1630–1640. London, Victoria and Albert Museum
(Cat. no. X–33, copy 3) (Cf. Plate 33)

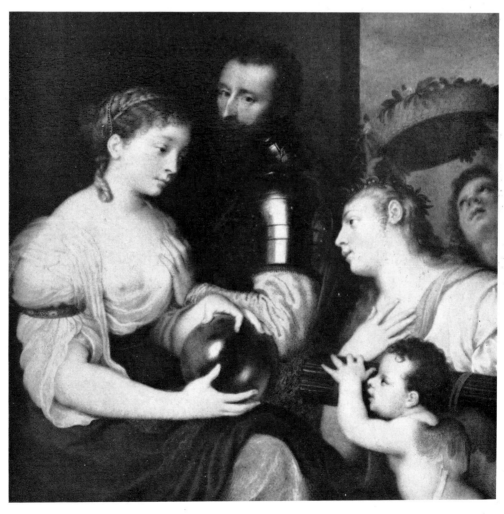

185. Peter Oliver after Titian: *Allegory of the Marchese del Vasto*. 1629. Windsor Castle,
Royal Library (Cat. no. 1, copy 4) (Cf. Plate 68)

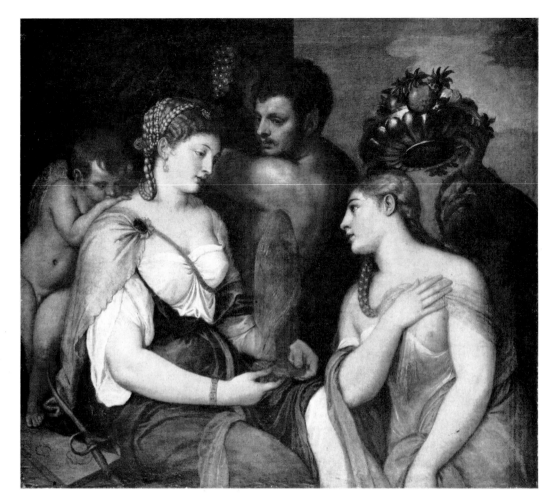

186. Alessandro Varotari (?): *Allegory*. Seventeenth century. Munich, Alte Pinakothek
(Cat. no. 1, variant 3)

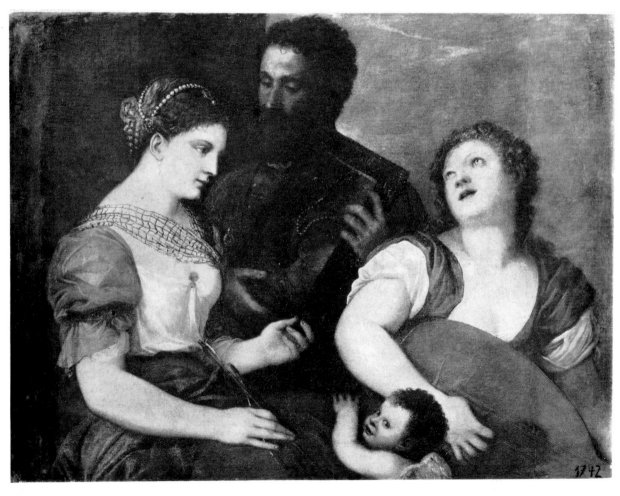

187. Alessandro Varotari (?): *Allegory of Vanity*. Seventeenth century. Unknown location
(Cat. no. 1, variant 5)

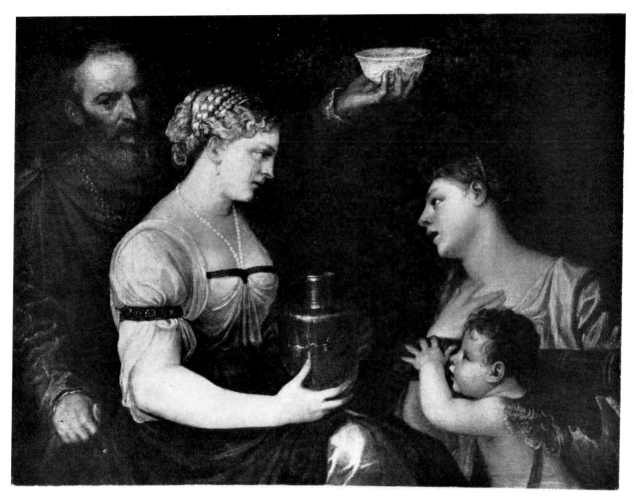

188. Alessandro Varotari (?): *Allegory*. Seventeenth century. Vienna, Kunsthistorisches Museum
(Cat. no. 1, variant 6)

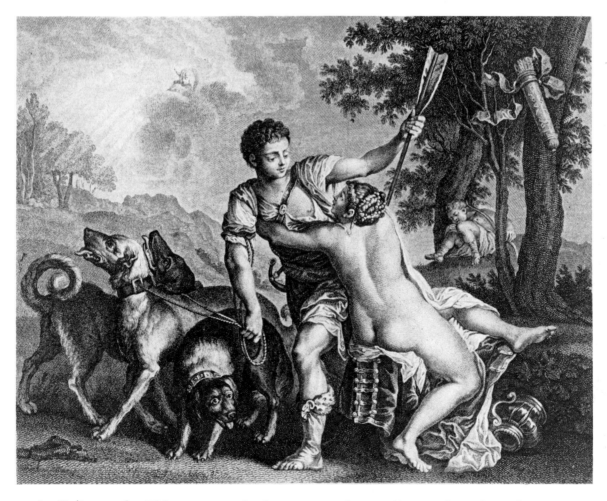

189. Delignon after Titian: *Venus and Adonis*. Paris, Orléans Collection (formerly) (Cf. Plate 190)

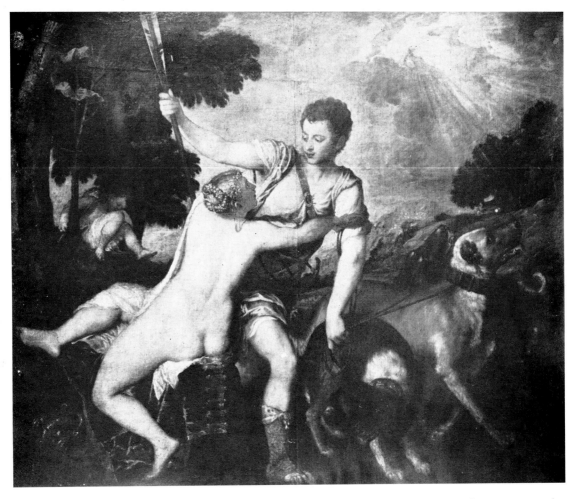

190. Titian and workshop: *Venus and Adonis* (Prado type). About 1555. Somerley, Ringwood.
Earl of Normanton (Cat. no. 42)

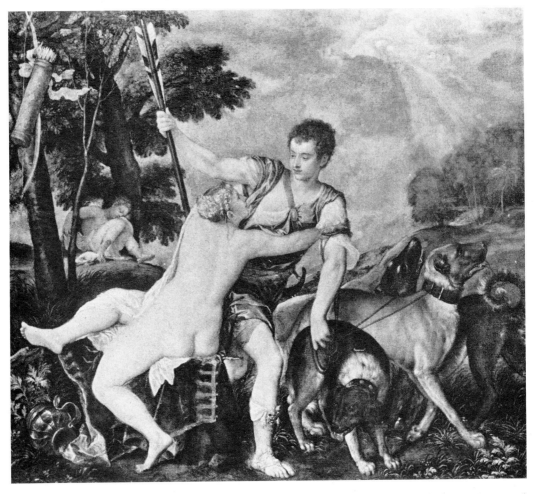

191. After Titian: *Venus and Adonis.* Sixteenth century. Formerly Orléans Collection and
Baron von Heyl (Cat. no. 42, copy 6)

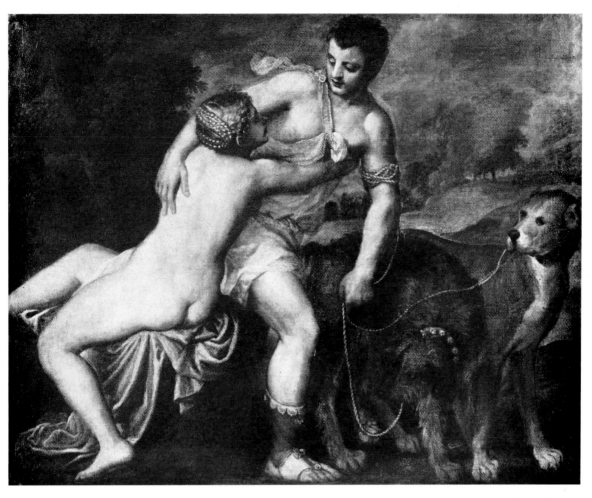

192. Follower of Titian: *Venus and Adonis*. Vienna, Kunsthistorisches Museum (lost in 1945)
(Cat. no. 44, free variant 3)

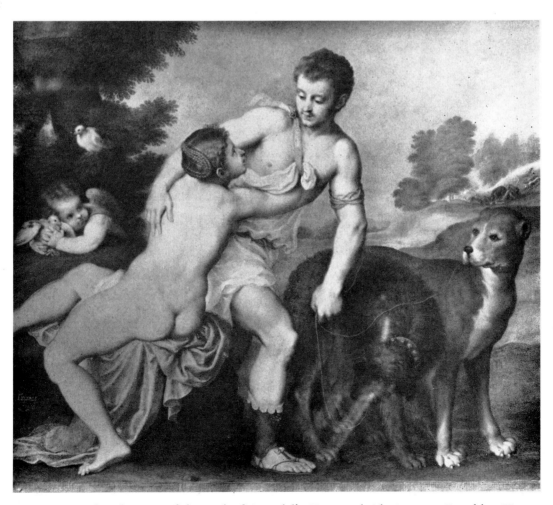

193. Peter Oliver's copy of the Earl of Arundel's *Venus and Adonis*. 1631. Burghley House
(Cat. no. 44, variant 3)

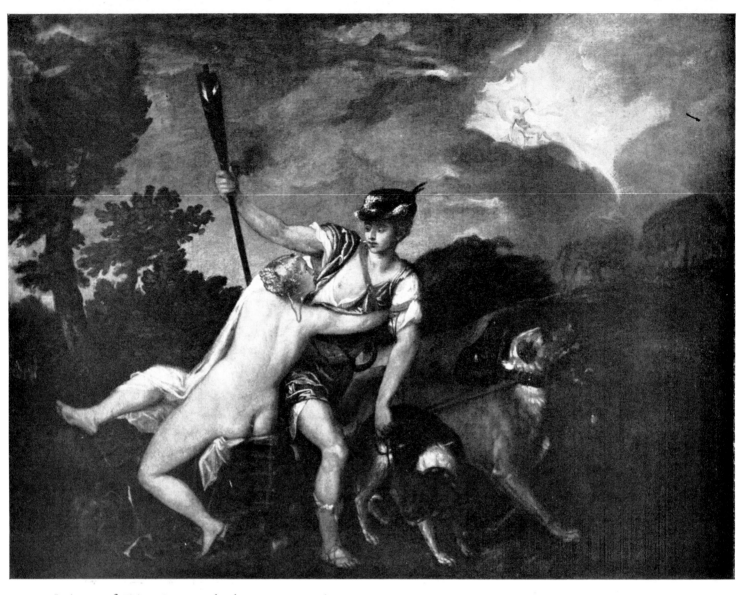

194. Imitator of Titian: *Venus and Adonis*. Seventeenth century. Alnwick Castle, Duke of Northumberland (Cat. no. X–39)

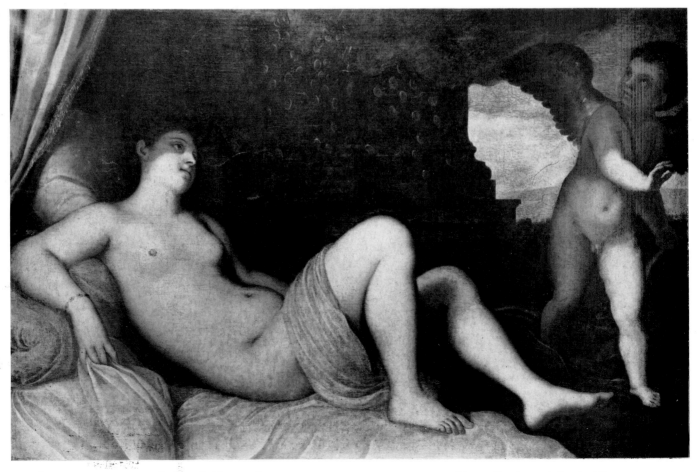

195. After Titian: *Danaë with Cupid*. Sixteenth century. Germantown (New York), Willard B. Golovin (Cat. no. 5, copy 4)

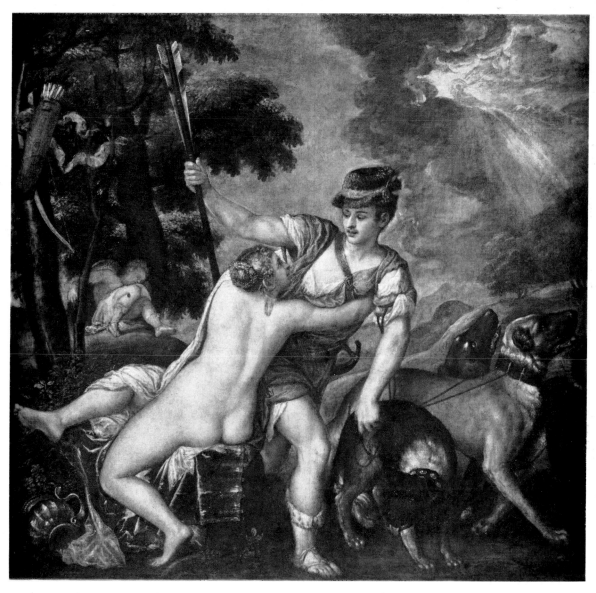

196. Follower of Titian: *Venus and Adonis*. Late sixteenth century. Rome, Galleria Nazionale, Palazzo Barberini (Cat. no. X–40)

197. Workshop of Titian: *Putti at Games*. About 1550. Chambéry, Musée des Beaux-Arts (Cat. no. 31)

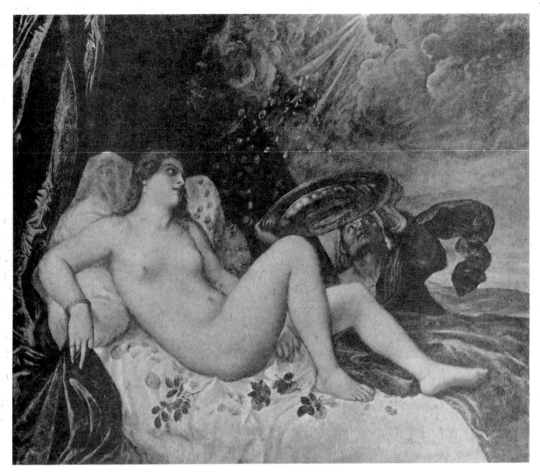

198. After Titian: *Danaë with Nursemaid*. Sixteenth century. Formerly Budapest, von Nemes Collection, later Berlin, Joseph Goebbels (Cat. no. 7, copy 2)

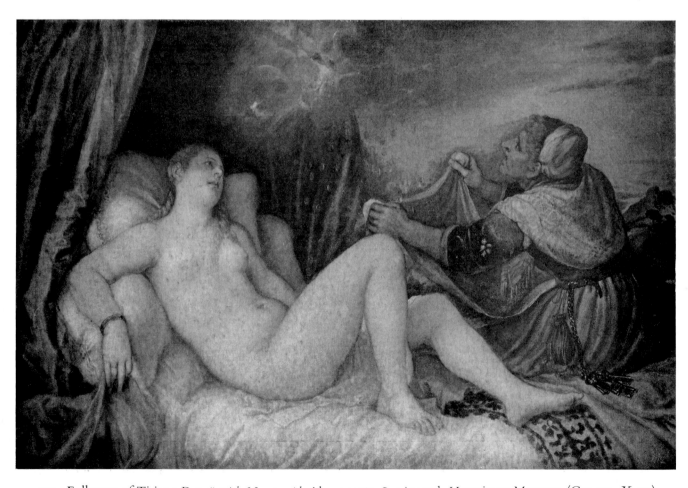

199. Follower of Titian: *Danaë with Nursemaid*. About 1560. Leningrad, Hermitage Museum (Cat. no. X–12)

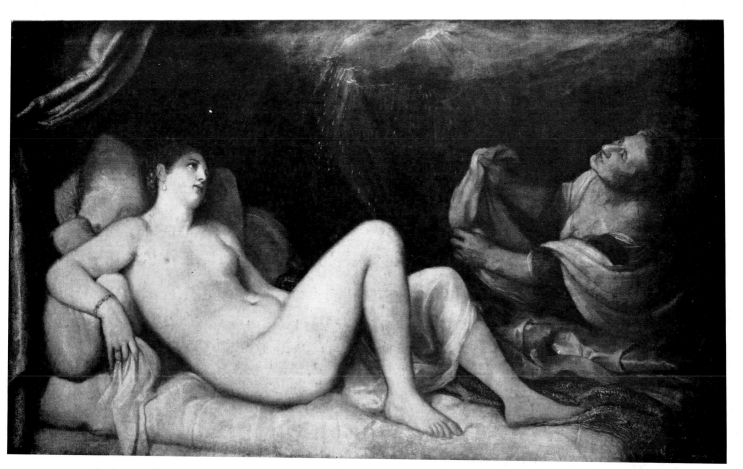

200. Imitator of Titian: *Danaë with Nursemaid*. About 1610. London, Duke of Wellington (Cat. no. X–13)

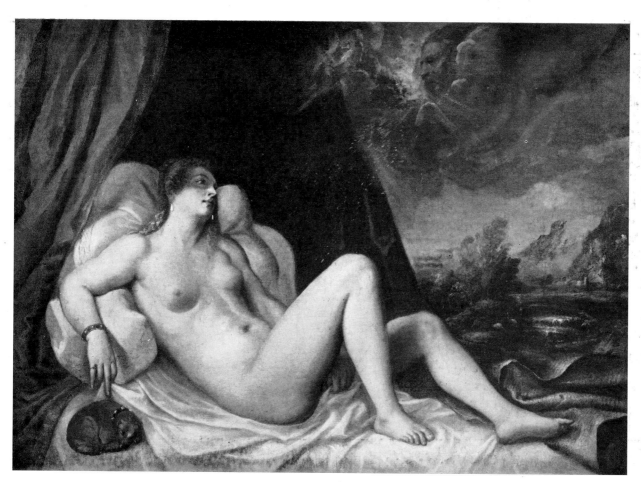

201. Follower or workshop of Titian: *Danaë*. About 1570–1580. Chicago, Art Institute, Property of the
Barber Welfare Foundation (Cat. no. X–10)

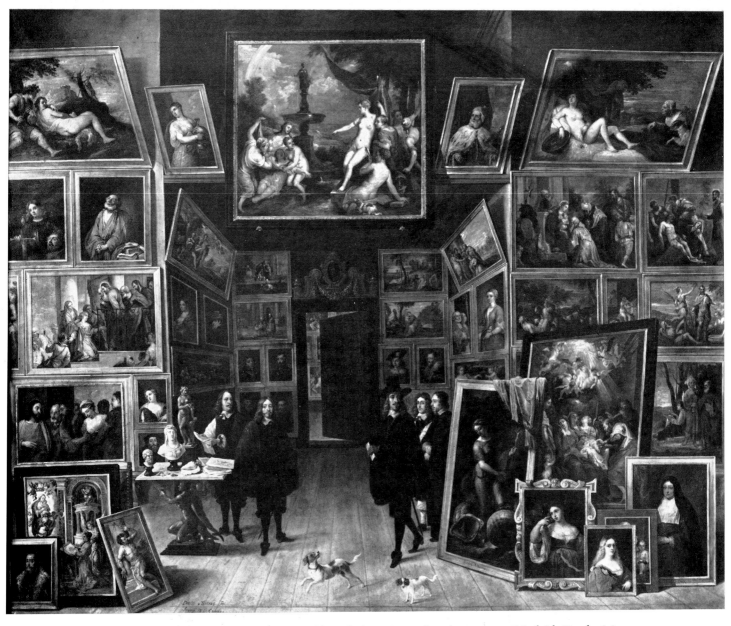

202. David Teniers II: *Gallery of Leopold Wilhelm at Brussels*. About 1651. Madrid, Prado Museum

203. *Nymph and Shepherd*. Detail from Plate 202 (Cf. Plate 168)

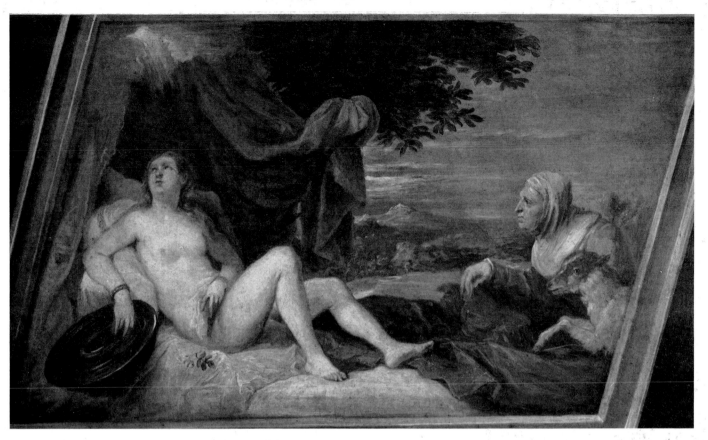

204. *Danaë*. Detail from Plate 202 (Cat. no. 7, variant by Teniers)

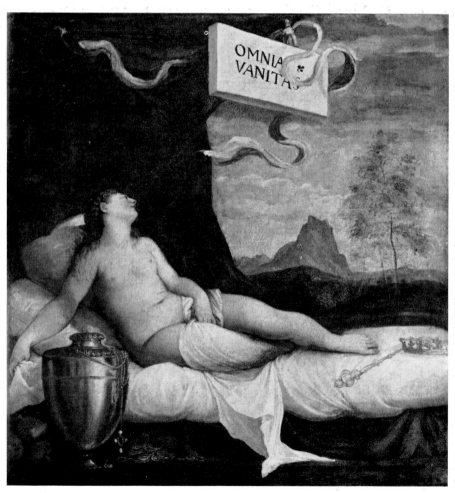

205. Bolognese School: *Omnia Vanitas*. About 1650. Rome, Accademia di
San Luca (Cat. no. X–30, version 3)

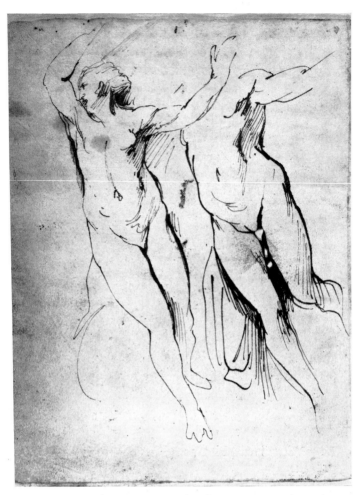

206. Sir Anthony Van Dyck after Titian: *Andromeda.*
About 1622. London, British Museum

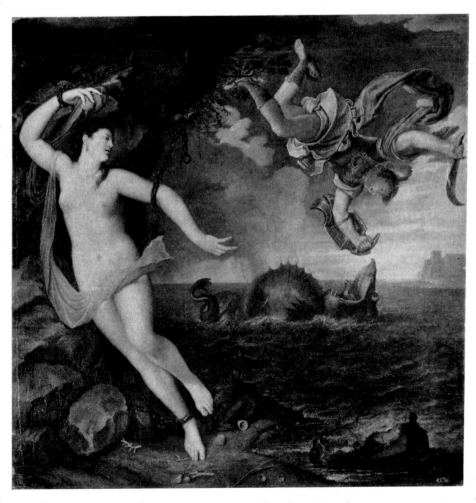

207. Copy after Titian: *Perseus and Andromeda.* About 1580.
Leningrad, Hermitage Museum (Cat. no. 30, copy 2)

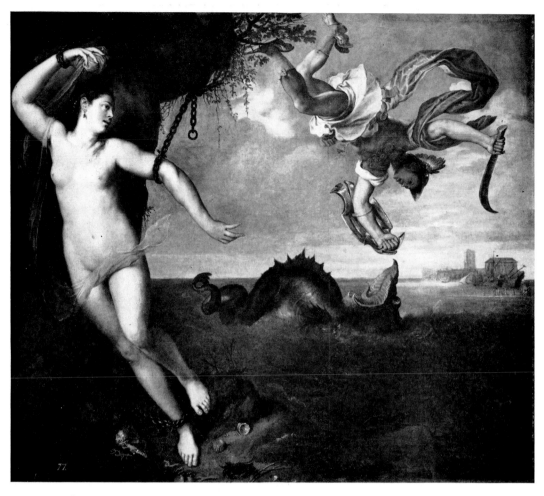

208. Copy after Titian: *Perseus and Andromeda*. About 1570–1575. Gerona, Museo de Bellas Artes
(Cat. no. 30, copy 1)

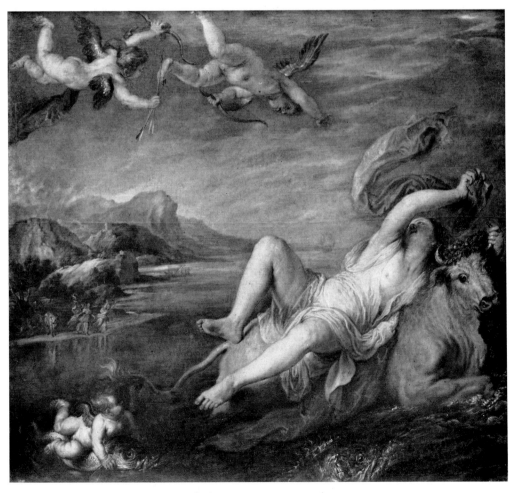

209. Rubens after Titian: *Rape of Europa*. 1628. Madrid, Prado Museum
(Cat. no. 32, copy 5)

210. David Teniers II: *Gallery of Leopold Wilhelm at Brussels*. About 1651. Brussels, Musée Royal des Beaux-Arts

211. Lisebetius after Titian: *Death of Actaeon*. About 1658. Teniers, *Theatrum Pictorium*

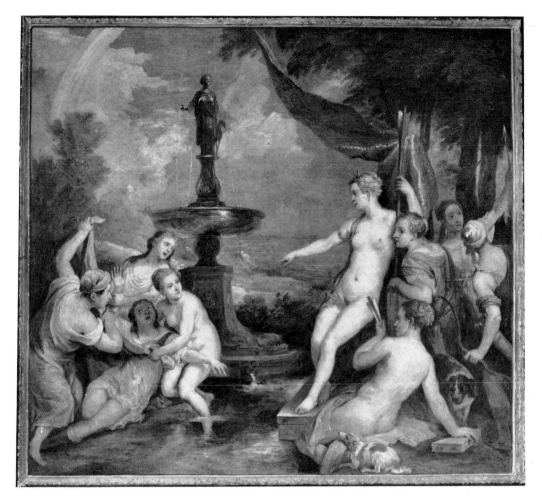

212. *Diana and Callisto* (Cf. Plate 154). Detail from Plate 202

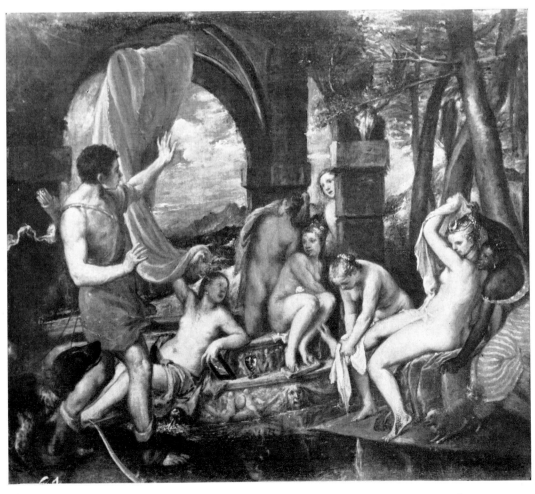

213. Copy after Titian: *Diana and Actaeon*. Seventeenth century. Madrid, Prado Museum
(Cat. no. 9, copy 1)

215. Lucas Vorsterman after Titian: *Venus at Her Toilet*. About 1658.
Teniers, *Theatrum Pictorium*

214. David Teniers II after Titian: *Diana and Actaeon* (Cf. Plate 142). About 1651.
London, Kenwood; on loan from the Executors of the Princess Royal
(Cat. no. 9, Literary Reference 11)

217. Venetian School: *Triumph of Love*. About 1560. London, David McKenna
(Cat. no. X–35)

216. Cornelius Cort after Titian: *Diana and Callisto*. About 1565 (Cf. Plate 154).
Vienna, Albertina (Cat. no. 11, engraving)

218. Titian: *Double Portrait*. Underpaint of Plate 127. About 1545. Washington, National Gallery of Art (Cat. no. 51, Condition)

220. Workshop of Titian: *Tobias and the Angel*. About 1550.
London, Private Collection

219. Titian: *Portrait of a Lady*. About 1545. Underpaint of Plate 220
(Addenda I, Cat. no. 145)

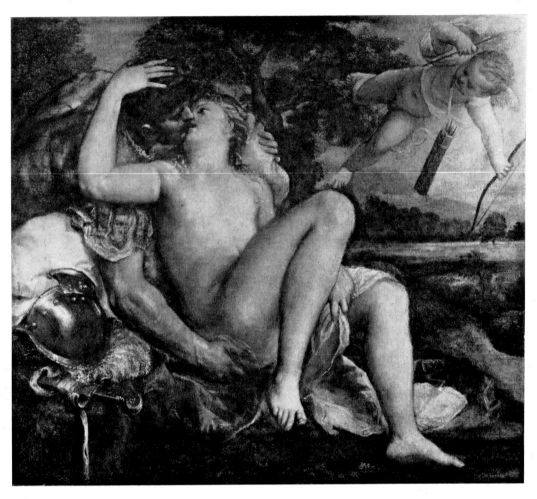

221. Copy after Titian: *Mars and Venus*. Late sixteenth century. Vienna,
Kunsthistorisches Museum (in reserves) (Cat. no. L–9)

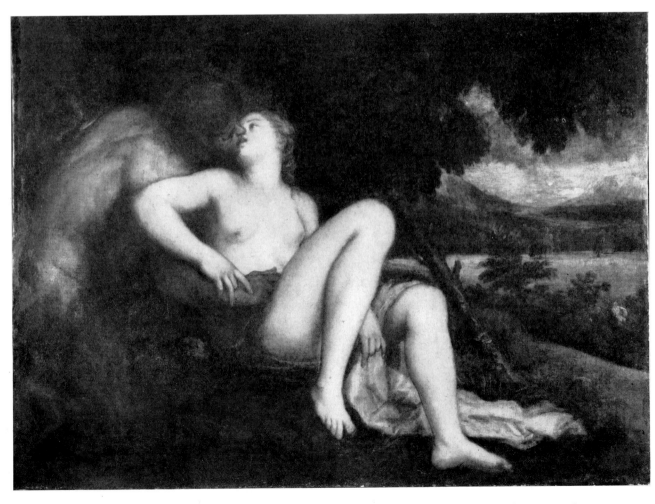

222. Follower of Titian: *Nymph and Satyr*. About 1570. Petworth House (Sussex), National Trust
(Cat. no. X–29)

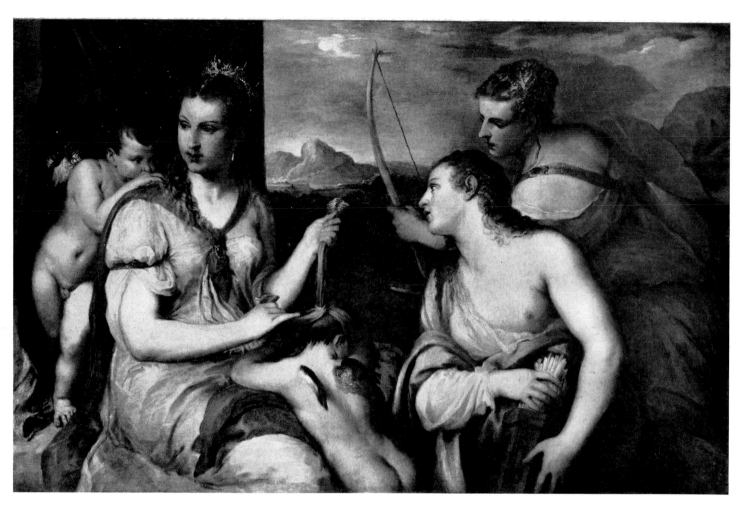

223. Copy after Titian: *Cupid Blindfolded*. Seville, Museo de Bellas Artes (Cat. no. 4, copy 3). Cf. Plate 159

224. Cornelius Cort after Titian: *Landscape with Roger and Angelica* (Cf. Plate 137). 1565.
Madrid, Biblioteca Nacional (Cat. no. 25, print)

226. Follower of Titian: *Nymph and Satyr*. About 1550. Rotterdam, Boymans–van Beuningen Museum (Cat. no. X–26)

225. Sir Anthony Van Dyck after Titian: *Mars and Venus*. About 1622. London, British Museum

227. Follower of Titian: *Nymph and Satyr*. About 1550. Munich,
Alte Pinakothek (in storage) (Cat. no. X–27)

228. Follower of Titian (Girolamo Dente). *Nymph and Satyr*. About 1565.
Detroit, Institute of Arts (storage) (Cat. no. X–28)

230. Copy after Titian: *Tarquin and Lucretia.* Late sixteenth century.
Sibiu (Rumania), Brukenthal Museum (Cat. no. 34, copy)

229. Cornelius Cort after Titian: *Tarquin and Lucretia.* 1571. Vienna, Albertina
(Cat. no. 34, print)

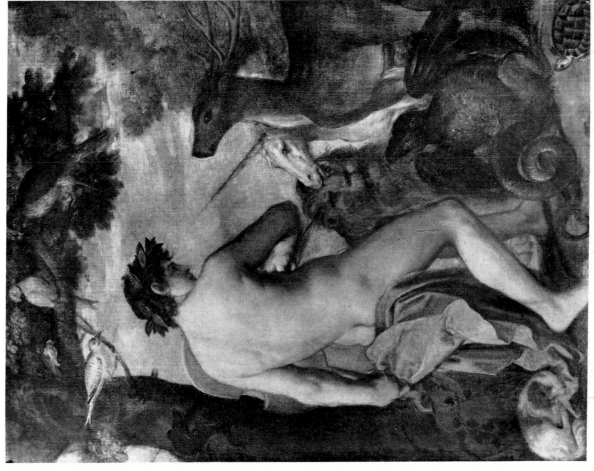

232. Venetian School: *Orpheus*. About 1575. London, Apsley House, Wellington Museum (Cat. no. X-31, version 1)

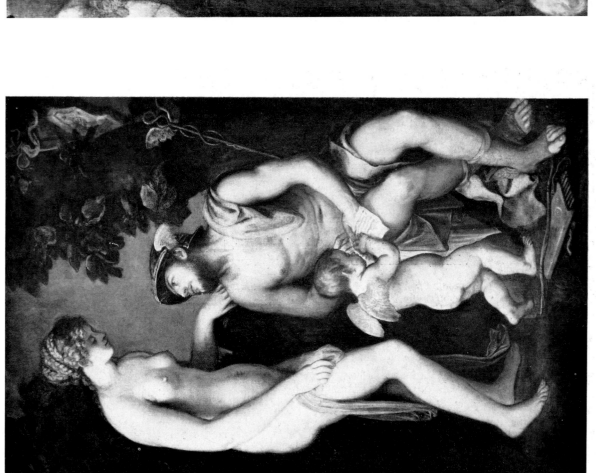

231. Follower of Titian: *Venus, Mercury, and Cupid*. About 1560. El Paso (Texas), El Paso Museum of Art, Samuel H. Kress Collection (Cat. no. X-43)

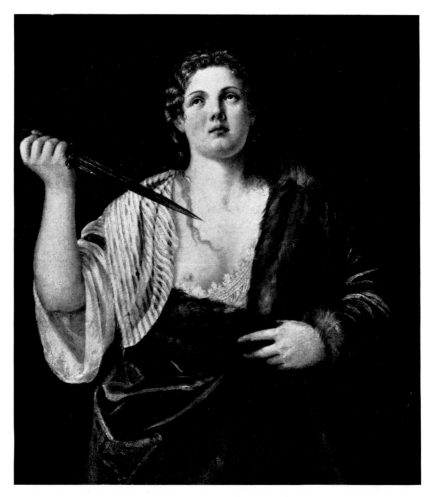

233. North Italian or Venetian School: *Lucretia*. Late sixteenth century.
Vienna, Kunsthistorisches Museum (storage) (Cat. no. X–24)

ADDENDA TO VOLUME TWO

AND

SIGNATURES

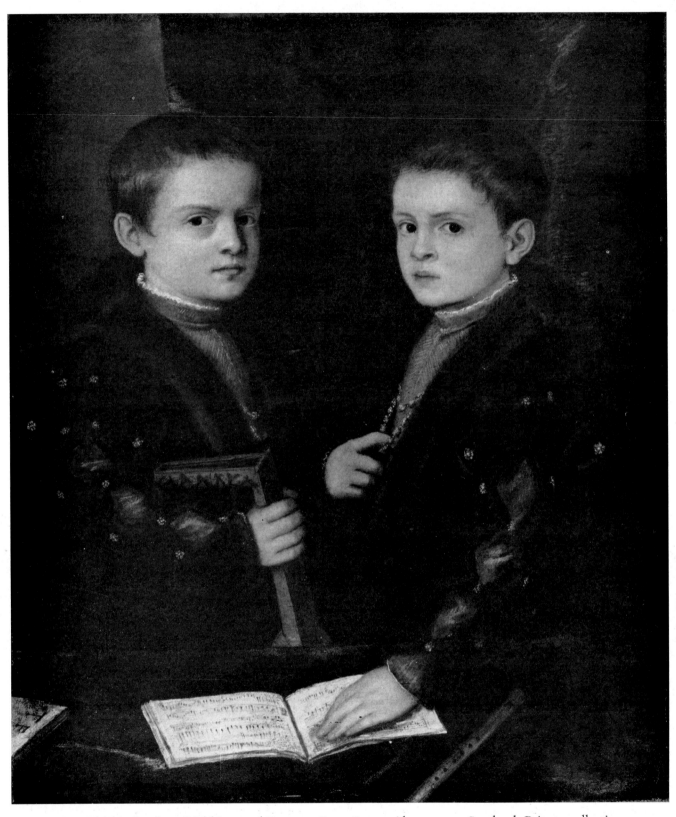

234. Titian: *Gerolamo Melchiorre and Francesco Santo Pesaro*. About 1542. Scotland, Private collection
(Addenda II, Cat. no. 77A)

235. North Italian School: *Gabriele Tadino*. About 1600.
Lovere, Galleria Tadini (Addenda II, Cat. no. 103)

236. Titian: *Philip II, Seated with Crown*. Cincinnati Art Museum
(Addenda II, Cat. no. 81)

237. X–Ray of Plate 236

238A. *Man with the Glove*. About 1520–1522. Paris, Louvre

238B. *Federico II Gonzaga*. About 1523. Madrid, Prado Museum

238C. The *Andrians*. About 1523–1525. Madrid, Prado Museum

238E. *Duke of Urbino*. 1536–1538. Florence, Uffizi

238D. *Gentleman*. About 1525–1530. Berlin–Dahlem, Staatliche Gemäldegalerie

238F. *Clarice Strozzi*. 1542. Berlin–Dahlem, Staatliche Gemäldegalerie

238G. *Venus and Cupid with an Organist*. About 1548–1549. Berlin–Dahlem, Staatliche Gemäldegalerie

239A. *Venus and Cupid with an Organist*. About 1545–1548. Madrid, Prado Museum

239B. *Tarquin and Lucretia*. About 1568–1571. Cambridge, Fitzwilliam Museum

239C. *Trinity (Gloria)*. 1554. Madrid,
Prado Museum

239E. *Philip II, Allegorical Portrait of (Allegory of Lepanto)*. 1573–1575. Madrid, Prado Museum

239D. *Entombment*. 1559. Madrid, Prado Museum

240. *Titian's Impresa* (from Dolce, 1562 and 1578)

INDEX

This Index is divided into two parts: an Index of Names and Subjects and an Index of Places. The latter starts on page 474. Numerals refer to pages unless otherwise specified.

INDEX OF NAMES AND SUBJECTS

INDEX OF PLACES

BIBLIOGRAPHICAL POSTSCRIPT

Cesare Greppi, *Tiziano e la corte di Spagna, Documenti dell'Archivio Generale di Simancas*, Madrid, Istituto Italiano di Cultura, January 1975.